CONTENTS

CONTRIBUTORS

Demir Barlas is a Ph.D student at Cornell University with wide-ranging interests in history, literature, performance, and religion. He has published scholarly work on Abolitionism, Ottoman history, the American Civil War, Muslim performance, the Qur'an, and the philosophy of sport.

Stephen Bartley initiated and organized the contemporary and twentieth-century art auctions at Bonhams in the 1970s. For twenty-five years he was a gallery owner in Chelsea exhibiting living artists. He is now a consultant specializing in modern British works of art.

Rebecca Baugniet is a freelance writer living in Montreal, Québec with her husband, artist Dave Hogg, and their three children. Rebecca studied art history at Concordia University and can be found roaming museums and galleries when she is not in the kitchen testing recipes for her cookbooks.

James Beechey is an art historian and writer. His areas of expertise include the Bloomsbury group (he was co-author of the 1999 Tate exhibition catalogue), Picasso, on whom he is curating a forthcoming exhibition for the Tate gallery, and the general period of early twentieth-century British and French art. He also writes for the *Tate* magazine.

Erik Bijzet is from Amsterdam in the Netherlands. He finished his Master's degree in the History of Art and Visual Culture at the University of Oxford in the summer of 2008. He has published a number of articles on early modern sculpture, the focus of his studies, and also on museum history.

Bill Bingham is a London-based radio journalist and actor. He was born in Bournemouth but grew up in Leeds, Yorkshire, and moved to Liverpool in his mid-teens just in time for the music explosion of the late-50s/early-60s. He has appeared on stage and in several television dramas and soaps, but mostly earns his living writing and reporting news and presenting radio programmes, television documentaries, and arts reviews. He collects contemporary painting and sculpture.

Alan Byrne was born in Liverpool, England, in 1946. On leaving school in 1962 he attended evening classes at Liverpool College of Art, and moved to London in 1964 to study at The London College of Fashion. He attended Hornsey school of Art (1967–68) before studying Fine Art at Walthamstow College of Art. He has worked mostly part-time in community arts projects and teaching, while practising and exhibiting as a painter and photographer.

Hermione Calvocoressi was born in London and grew up in Edinburgh, Scotland. After studying History of Art at University College London, she worked at the International Affairs think tank Chatham House. While working in Kabul for an NGO involved in the revival of Afghan art and architecture, she wrote stories about the lives of Afghan artists for a UN calendar. She has written for Scotland's national newspaper, *The Herald*, the *London Student*, *Prospect Magazine*,, and a chapter on Afghan Art for the book *Windows into Afghan Culture*.

Denis Casey hails from Co. Kerry, Ireland. He graduated from University College Dublin with a B.A. in History and a M.A. in Medieval Studies. He is currently a Robert Gardiner scholar at the University of Cambridge and is working towards a Ph.D in the department of Anglo-Saxon, Norse and Celtic.

Chiara Marchini Camia was born in Belgium in 1985, and holds dual Italian and Swiss citizenships. She graduated with a B.A. in German and History of Art from University College London in 2007. Her interests are early twentieth-century German and Austrian architecture, and contemporary critical and curatorial practice. She is currently reading for an MSt in History of Art and Visual Culture at the University of Oxford, and is a Raw Canvas member of staff at the Tate Modern.

Nigel Cawthorne was born in Britain, and is the author of over a hundred books, including the successful *Art of…* series published by Hamlyn in the 1990s. His works are available in over twenty

opposite Georges Seurat's
Une Baignade, Asnières.

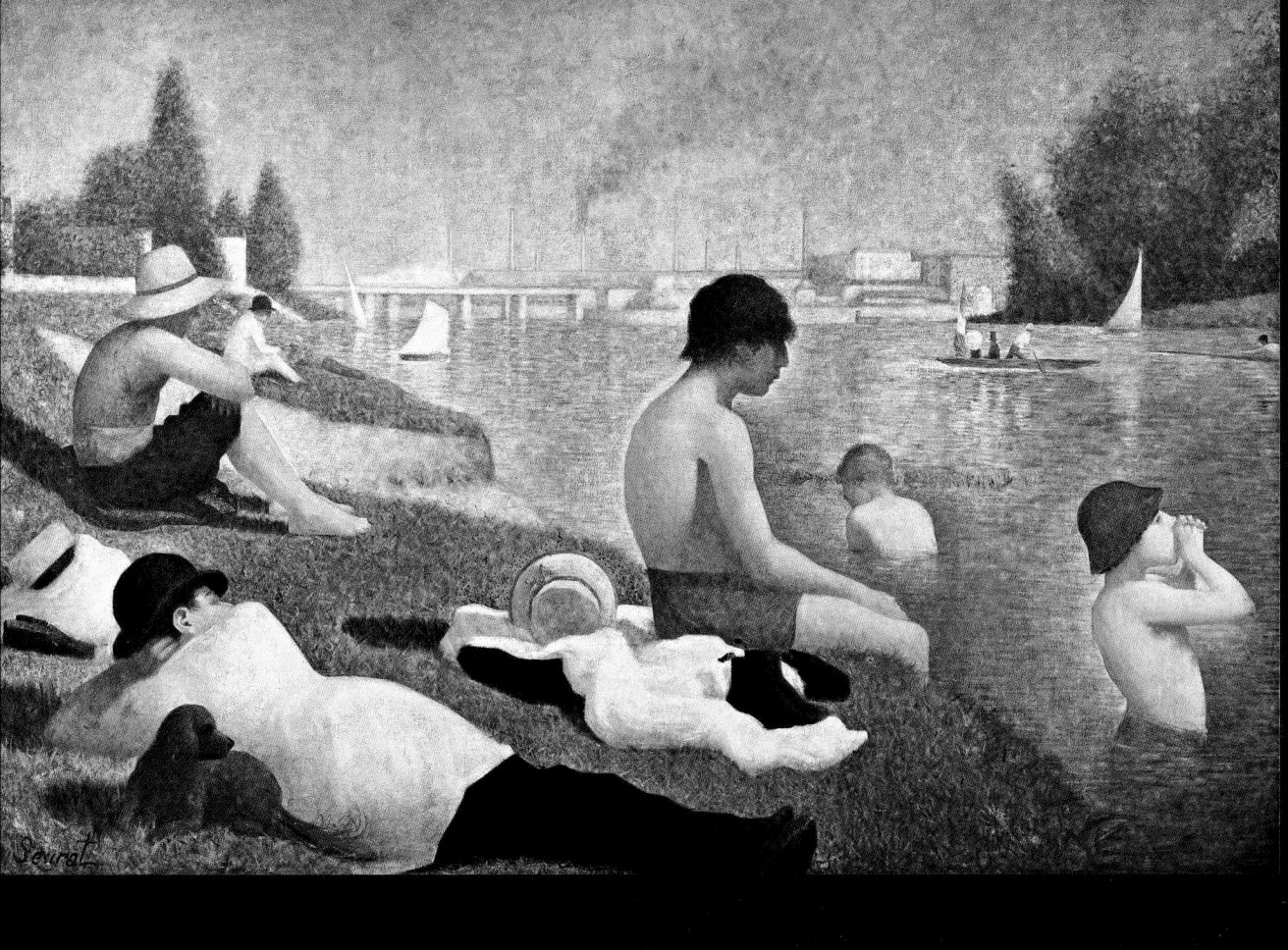

Seurat

languages and include titles on all areas of contemporary culture including fashion, music, architecture, design, film, sculpture, and painting.

John Cornelius Artist, musician, and writer, John was born in 1949 in Liverpool, England. A degree in Fine Art from Liverpool College of Art, and later an Art Teachers' Diploma, led to teaching posts in London. In addition to various magazine contributions, his best known written work is his illustrated book on Merseyside's bohemian quarter entitled *Liverpool 8*, published by John Murray (London) in 1982, and republished by Liverpool University Press in 2001.

Brian Davies is a journalist and author who admits to being "passionate about Modern art." Brian writes on design and innovation for a wide range of UK-based journals and newspapers including the *Guardian*, the *Independent*, and *GQ* magazine, as well as the in-house publications for a number of museums. He has also been the recipient of a Periodical Publishers Association award, and runs the Creative Dream Company developing new multi-media projects with artists, including the Royal Academy.

Bryan Doubt A Canadian, Bryan is a graduate in Art History, having won the prestigious Pinsky Medal (awarded to the highest ranking graduate) for his work. He also holds an M.A. in Literature, and teaches at Concordia University and Champlain Regional College in Montreal.

Emma Doubt is pursuing graduate studies in the History of Art, with a particular focus on postcolonial art. She is a writer and editor for the art history journal *Canvas* affiliated with McGill University in Montreal, Canada.

Samantha Edgley was born in Kent, England. In 2006 she graduated from the University of Kent with a First Class honors degree in the History & Theory of Art and was awarded the Rotary Prize. Studying History of Art & Visual Culture at Oxford University, she is the President of the St Cross Art Appreciation Society. Her main research areas are photographic art and postmodernism.

Emily Evans was born in Liverpool in 1969 and grew up in London. After attending Central St Martins College of Art she has worked in fashion, designing retail concepts for international brands including Kookai, Disney, and Topshop. She also freelances as a writer, contributing to a number of books on fashion, the visual arts, and popular culture. She is Trustee of Chelsea Arts Club Trust – an art student based charity, and a Steward of the Artists' General Benevolent Institution.

Mike Evans is a writer and editor with a long-standing interest in the visual arts. In 1984 he curated The Art of the Beatles exhibition at the Walker Art Gallery in Liverpool, the Seibu gallery in Tokyo, and the Turm Kunst gallery in Cologne. He has edited a number of books on art including the *Art Of....* series for UK publisher Hamlyn, and as author over a dozen books have included *The Art of the Beatles*, *The Making of Raging Bull*, and his 2007 account of the Beat Generation writers *The Beats*.

Aimee George is a native of San Francisco, California and started her training in art history at the University of St Andrews in Scotland. There she wrote her thesis, entitled *The Sickness of Reason: Goya's Images of Madness*. For her Master's diploma at Oxford University her research included culinary cross-pollination in the Grand Tour of the Nineteenth century, and the cultural appropriation of Hausmann's Paris.

Carolyn Gowdy Born in Seattle, Carolyn has been based in London since 1977. She studied at the University of Washington, Seattle (1972–74), Rhode Island School of Design, Providence (1974–76, BFA), and the Royal College of Art, London (1977–80, M.A.). Gowdy has worked internationally as an illustrator and is renowned for narrative paintings, drawings, and collages populated by a cast of idiosyncratic characters amidst playful, reflective, and philosophical imagery. She is also a poet and experimental artist.

Sophie Halart Born in Grenoble, France, in 1984, Sophie initially studied French and Anglo-Saxon Literature. She moved to the UK in 2003 and graduated from the University of York with a B.A. in History of Art and English Literature, and an M.A. in Culture Industry at Goldsmiths College, London. Her initial speciality was Modern French Art and the work of Cézanne. Her main field of research is now Contemporary Art, especially the place of the body in the work of women artists.

Rebecca Harris was born in Surrey, England, in 1977. Since graduating in 2000 with a degree in Art History from the

University of East Anglia in Norwich she has worked in several arts organizations including *Modern Painters* magazine, Tate Britain, and the Hauser & Wirth Gallery. She received an M.A. in Curating from Goldsmiths College, London, in 2005. While maintaining her own curatorial practice, she has also worked for, among others, the Victoria & Albert Museum, as a researcher and writer with an expertise in Modernism, Post Modernism and Contemporary Art practice.

Martin Holman, a native Londoner, held senior positions at London's Whitechapel Art Gallery and Camden Arts Centre before becoming a freelance writer, curator, and galleries consultant in 1992. His writing about contemporary art has appeared in numerous catalog introductions and journals, including *Artscribe*, *London Magazine*, *Times Educational Supplement*, *Miser & Now*, and *Art World*. He has worked closely with artists on exhibitions and commissioned six temporary public artworks.

Ana Finel Honigman is a New York and London-based critic currently reading for a D.Phil in the History of Art at Oxford University. She regularly curates exhibitions and writes on contemporary art for fashion and art magazines including *Art in America*, *Artnet.com*, *AnOther Magazine*, *Art Journal*, *ArtReview*, *Artnews*, *Time Out*, *I-D*, *Dazed & Confused*, British *Vogue*, *Grazia*, the *Guardian* Art & Architecture blog, and *Harper's Bazaar*. She is also the Art Editor for *Alef*, a Middle Easter fashion and culture magazine, Senior Art writer for *Style.com*, and Senior London Correspondent for the Saatchi magazine website.

Heather Hund was born in Lubbock, Texas, in 1983. She attended Southern Methodist University in Dallas, Texas, where she was the recipient of the Presidential Scholarship and graduated Summa Cum Laude with a B.A. in French, a B.B.A. in Finance, and a Minor in the History of Art. Upon graduation, she worked at Goldman, Sachs & Co. before pursuing a Master's degree in the History of Art at the University of Oxford, specializing in Renaissance art.

Mariko Kato has just completed a Masters degree at Oxford University. She is an arts writer for the *Japan Times*, and a freelance writer for various publications including the arts and literary journal *International Gallerie*. She is also a contributor to the *Defining Moments in History*.

Sue King Born in England, Susan comes from a fine art background, having studied painting in London and New York. She spent some years in New York, teaching and lecturing in fine art and art history. As a practicing artist she has exhibited in the UK, New York, and Barcelona. Taking a break from fine art practice to concentrate on art history, she was until recently a Senior Lecturer in Art History and Theory, specializing in Modernism, at the University of Westminster, London. She has now returned to painting full-time.

Erik Kohn writes about film and culture for a number of publications, including *New York Press*, *The Hollywood Reporter,* and *Heeb*. He holds a B.A. in cinema studies from New York University.

Lucy Lubbock, a Graduate of the Courtauld Institute, is a freelance writer and art historian. Having worked in the commercial art world, she has contributed to a number of periodicals and dictionaries including the *Macmillan Dictionary of Art* and the photographic magazine *Hotshoe*. She lives in Fulham, London, with her husband (who runs a photographic archive and press agency) and their four children.

Esmay Luck-Hille was born in London, England in 1987. With a passion for both practical art and the history of art from a young age she went on to study History of Art at Oxford University. She completed her degree in 2008 and wrote her dissertation on Britain and Surrealism in the 1930s. Her main areas of interest are early twentieth-century European art and art in the Italian Renaissance.

Catherine Marcangeli is a graduate of the Paris Ecole Normale Supérieure. She was a Fulbright Scholar at New York University's Institute of Fine Arts and holds a Doctorate in Art History from the Sorbonne Nouvelle, Paris. She is now a Senior Lecturer at the University of Paris VII and at Columbia University in Paris, specializing in twentieth-century art. She is also an exhibition curator, and recently edited a volume of poems and paintings, *Adrian Henri, Selected and Unpublished*.

Ian McKay is a writer and academic based in the UK. He began writing on art in the 1980s, and has contributed to numerous journals internationally. From the mid-1990s he has maintained editorial positions for several art and culture titles, and is currently Special Correspondent for the photography journal *Photoicon*. As

Senior Lecturer in Media & Visual Arts at Southampton Solent University, he also maintains a specialist research interest in Holocaust cinema and the work of the Italian film director Liliana Cavani.

Jay Mullins Having finished a Broadcasting course at Ravensbourne College in Chislehurst, England, Jay Mullins is also a freelance writer and previously worked as an editor for a B2B website. His long-term ambition is to write a novel.

Kate Mulvey London-based Kate is a freelance journalist/writer. She writes regularly for the UK *Sunday Times*, *Daily Mail*, *Daily Express,* and *Daily Telegraph*, on fashion, social comment, arts, and lifestyle. She is also a regular contributor on BBC Radio 4 and 5. She is co-author of *Decades of Beauty*, and a contributing author to the reference books *Key Moments in Fashion* and *Vintage Fashion*.

Dr Elizabeth Purdy is a political scientist and freelance writer who is also involved with women's issues. In addition to social science, she has published in a variety of fields that include history, the arts, popular culture, and science.

Adelia Sabatini After completing two years of literary "classe preparatoire" in her native France, Adelia started a BA at Oxford University, working on a dissertation on the works of Piero della Francesca and other Quattrocento artists. While at Oxford, she wrote for the *Isis* magazine (on World War I *Vogue*), contributed to the *Oxford Student* (culture section) and became Vice-president of Oxford Contemporary Arts Society.

Graham Vickers was born in West Bromwich, England, in 1943 and studied at Leeds and Manchester Colleges of Art in the 1960s. He is a freelance writer specializing in art, design, and architecture, and has written several books on design and advertising as well as co-writing a biography of Jack Kerouac's *On The Road* buddy Neal Cassady. His latest book, *Chasing Lolita*, explores popular culture's impact on one of twentieth century literature's most controversial heroines.

Mike von Joel was born in Yorkshire. He started writing about art in the 1970s. He was editor of the seminal *Art Line* newspaper between 1982-1994. Currently he is editor of the international magazine of art and photography, *Photoicon*, and founding editor of the free UK art newspaper, *State of Art*.

Richard Walker Having seen active service in World War II, Richard worked for the Tate Gallery as a picture cataloguer in the post-war years, and as Picture Adviser for the Minstry of Works from 1949 to 1976. He was also the curator of the Palace of Westminster for over twenty years, and has been a cataloguer and catalogue writer for, among many prestigious British institutions, the National Portrait Gallery, the Royal Collection, and the National Trust.

left Anish Kapoor's *Marsyas*.

opposite Mexican painter Frida Kahlo.

INTRODUCTION

In an age when technical change has occurred at a rate unprecedented in previous eras, the visual arts of the past century and a half have diversified in ways unimaginable to earlier generations of painters and sculptors. Since the advent of photography in the latter half of the nineteenth century, not only the practice but the very function of representational art has been challenged again and again.

In putting together a reference work covering "modern" art therefore, it was decided at the outset to begin with the Impressionists, whose radical innovations in the second half of the nineteenth century heralded the process away from "pure" representation, increasingly seen as the role of the photographer.

This move towards abstraction of one kind or another was, of course, just one tendency that characterized painting and sculpture at the dawn of the twentieth century. It was an era where scientific progress was impacting on people's everyday lives as never before, far removed from the artists ivory tower (or lonely garret). From radio communication to manned flight, motion pictures to mass production, within a couple of decades the world saw changes on an unparalleled scale, and all would impact almost immediately on the arts.

The biggest technological influence on painting was undoubtedly the development of photography. Suddenly artists, in their traditional role of both portrait painters and visual chroniclers of all aspects of life, seemed threatened with redundancy. But the challenge of the camera resulted in the liberation rather than extinction of the visual arts. Impressionism, Cubism, Expressionism, Surrealism and a myriad other "isms" came about when painters and sculptors were freed from the obligation of pure representation, while at the same time realist art would survive and prosper in its many manifestations.

And no sooner had the photographed image turned the world of art upside down than moving pictures arrived, creating an even more seductive illusion of reality than its static forerunner. And illusion it was, in more ways than one. Not only did the frame-by-frame projection of continuous photographs create the appearance of motion, but the new "movies" offered all sorts of other "special effects" with which their creators could manipulate reality. At the same time, the idea of the manipulation and deconstruction of what was perceived as "real" in the observed world, was central to simultaneous developments in art like Cubism.

Other areas where the expanding boundaries of knowledge would excite the artist's imagination ranged from the anthropological study of "primitive" societies (inspiring an African influence in Picasso's work, for instance), to Freud's experiments in psychoanalysis and the subconscious which informed

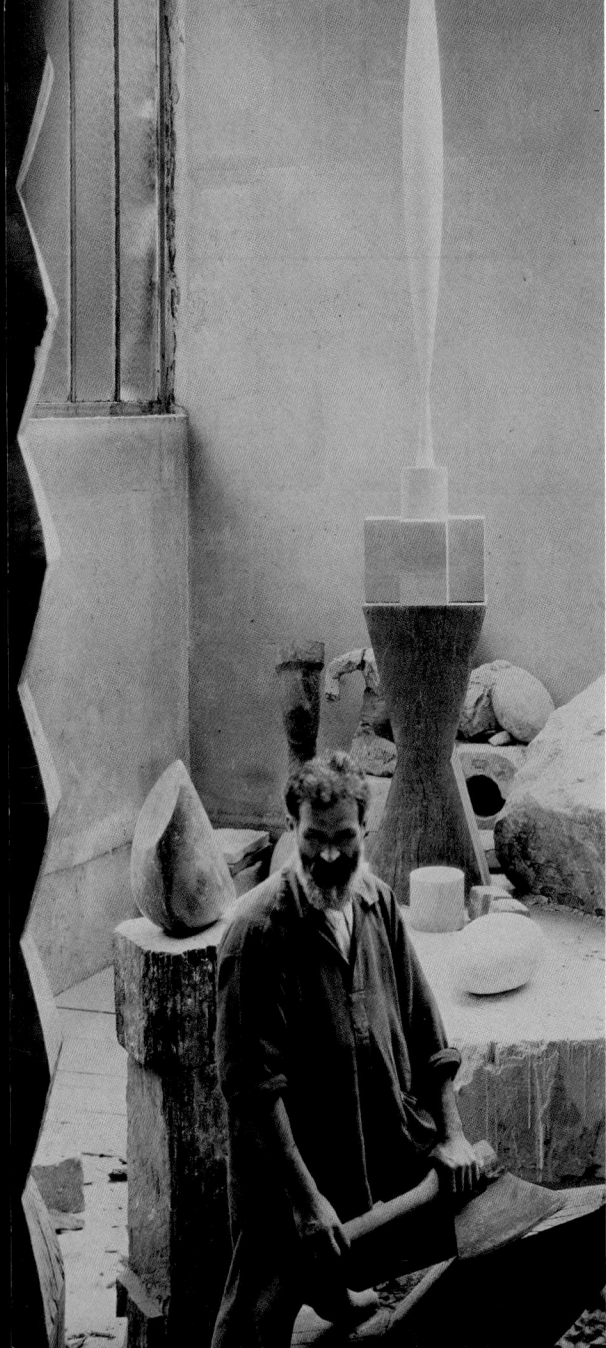

the ideas of the Surrealists. Plus there was the sheer dynamic of the machine-driven age of the airplane and motor car, reflected in art as diverse as that of the Constructivists (and subsequently the Bauhaus), Futurists, and mid-century Pop artists.

There has also been radical change in the very nature of the art itself, in the materials used, and the means by which it's been disseminated. From the pioneering use of plastic by the Russian Cubist sculptor Archipenko through 1960s "mixed media" Happenings to the video installations that are an integral part of contemporary gallery art, the last century or so has seen a huge increase in the variety of mediums employed by artists. Some techniques, such as silkscreen and photolitho, have changed the nature of the "uniqueness" of artworks inasmuch as they can be replicated ad infinitum; Andy Warhol's soup cans and "production line" portraits posed the question "is it art?" as radically as any conceptual pieces forty years later, questions which indeed had first been raised by the Dadaists even earlier in the century.

With these influences and stimuli as numerous as the artists and artworks themselves, entries in the book cover not just the participants and their output, but also events which triggered change, and the key figures who, while not being practising artists, were seminal players in the history of modern art. Where would Pollock have been without his early advocate Clement Greenberg, or Picasso minus the patronage of Ambroise Vollard?

From Eadweard Muybridge's early experiments in moving pictures to the Art Deco triumph of the Empire State Building, from the the outbreak of two World Wars to man's first tentative steps on the Moon, historical moments of import in the evolution of modern art are included here alongside the particular details of artists' debuts, seminal shows, and sometimes premature deaths. The theory behind various art movements has often seemed as important as the practice, so no such catalogue of key happenings would be complete without mention of the seminal magazines and manifestoes which marked the intellectual birth pangs of much twentieth-century art. Likewise parallel developments in other genres which touched visual artists are listed, such as Bauhaus architecture, jazz music, and New Wave cinema.

No art movement has been without the critics, gallery owners, writers, and other movers and shakers who have often been the link between the pioneer creator and the world at large. Particularly in an age of increasingly easy and universal communication, few artists' works make their mark

left Romanian sculptor Constantin Brancusi in his studio.

opposite German performance artist Joseph Beuys.

restricted to the confines of the studio, but out there in the arenas of intellectual discourse, public exhibition, and the often unavoidable reality of the commercial market place.

Alongside the events and people who have shaped recent art history, specific exhibitions have been of equal importance. The very first public manifestation of the Impressionists was via the Salon des Refusés in Paris in 1874, a reaction to the conservative attitudes of the official Salon which rejected their work and defined establishment art of the time. Breakthrough shows since then have helped launch virtually every new movement that has come along, be it Cubism, Surrealism, Abstract Expressionism, Pop Art, or twenty-first-century conceptual art. And some grandiose civic projects, such as the 1900 Paris World's Fair or 1951's Festival of Britain, have successfully presented cutting-edge art in the context of the broader cultural and scientific developments of their era.

What we would call "Western" art has, since the days of the Impressionists, become increasingly internationalized. Increasing communication with traditional cultures outside the Euro-North American axis has resulted in a greater understanding of art from every part of the world. Post-Impressionists like Paul Gaugin were consciously influenced by Japanese art in their work, and the indigenous art of Africa, Australasia, and the South Pacific have all been celebrated and made their mark on contemporary art in the West. Meanwhile modern art movements have sprung up in the previously traditional strongholds of India, China, Japan, Latin America, and elsewhere. These too, have their place in the one thousand entries that follow.

Because of the sheer diversity of styles and influences referenced it has been essential to employ a team of writers with a variety of specialization. Drawn from the worlds of mainstream journalism, art history, gallery curating, and academia – and the occasional practising artist – the forty-plus contributors represent expertise in the numerous disciplines and genres covered herein. The actual entries fall into five categories: Artist, Artwork, Exhibition, Event, and (non-artist) Person. Arranged chronologically – in the case of Artists and Persons the order is defined by a seminal occurance or point in their life – the book reads as a catalog of important junctures in the many-faceted development of modern art, making an easily accessed work of reference which covers not just the art, but the broader cultural and social history, since the emergence of the then-shockingly controversial Impressionists in the 1860s.

Mike Evans

Key Artwork *Le Déjeuner sur l'Herbe*
Edouard Manet

If Manet's (1832–83) *The Absinthe Drinker* (1858–9) had been rejected by the Salon mainly because of its unsettling realism, *Le Déjeuner sur l'Herbe* (*Luncheon on the Grass*) was refused because it was thought to add sexual impropriety to mundanity. Two fully clothed men enjoy the company of a naked woman while a second woman wades in the water behind them. The treatment is sketchy, even perfunctory, and if the composition recalled works by Raphael and Giorgione, to bourgeois taste the end result was more suggestive of contemporary debauchery than classical elegance.

The idea for the painting came to Manet when he was watching bathers at Argenteuil, northwest of Paris. It was originally titled *Le Bain* when it was consigned to the Salon des Refusés in 1863. The public hostility it aroused there would trigger Manet's influence upon a group of iconoclastic young painters from which the Impressionists would emerge.

The potency of *Le Déjeuner* resided in its fusing of classical composition with a looser technique and contemporary subject matter. It remains open to question whether Manet actually sought to be confrontational or whether borrowing classical compositions was simply his way of responding to a tradition he respected. Whatever the case, *Le Déjeuner sur l'Herbe* was the first of two catalysts (the second was Manet's *Olympia*) that kick-started Impressionism by reinventing what a painting might be about and demonstrating how a looser technique might be the way to achieve it.

Graham Vickers

Date 1863

Country France

Medium Oil on canvas

Collection Musée d'Orsay, Paris, France

Why It's Key *Déjeuner* was the painting that heralded Impressionism.

opposite *Le Déjeuner sur l'Herbe*

14

Key Exhibition
Salon des Refusés

On May 15, 1863, the Salon des Refusés (Salon of the Refused) opened its exhibition of the works rejected by the jury of the official Salon that had been controlled by the Académie Royale de Peinture et de Sculpture (later the École des Beaux-Arts) since it began in 1667. Protests by the rejected artists led Emperor Napoleon III to order a separate exhibition for those who had been refused, officially known as the Salon des Ouvrages de Peinture, Sculpture, Gravure, Lithographie et Architecture Refusés par le Jury de 1863 (Salon of the Work of Painting, Sculpture, Engraving, Lithography and Architecture Refused by the Jury of 1863).

Exhibitors at the Parisian event included Paul Cézanne, Camille Pissarro, Johan Jongkind, Armand Guillaumin, Henri Fantin-Latour, James Whistler, who showed *The White Girl*, and Edouard Manet, whose *Le Déjeuner sur l'Herbe* caused a scandal. The Salon des Refusés drew huge crowds, the majority of whom came to mock. However, it allowed new painters, whose radical works did not meet with the approval of the hidebound academicians who controlled art in Paris, to show their work in public.

Although it was never formally repeated, the Salon des Refusés set a precedent for the Impressionist exhibitions beginning in 1874 and other unofficial salons later in the century, such as the Salon des Indépendants of 1884.

Nigel Cawthorne

Date 1863

Country France

Why It's Key Salon des Refusés broke the official Salon's stranglehold on French art.

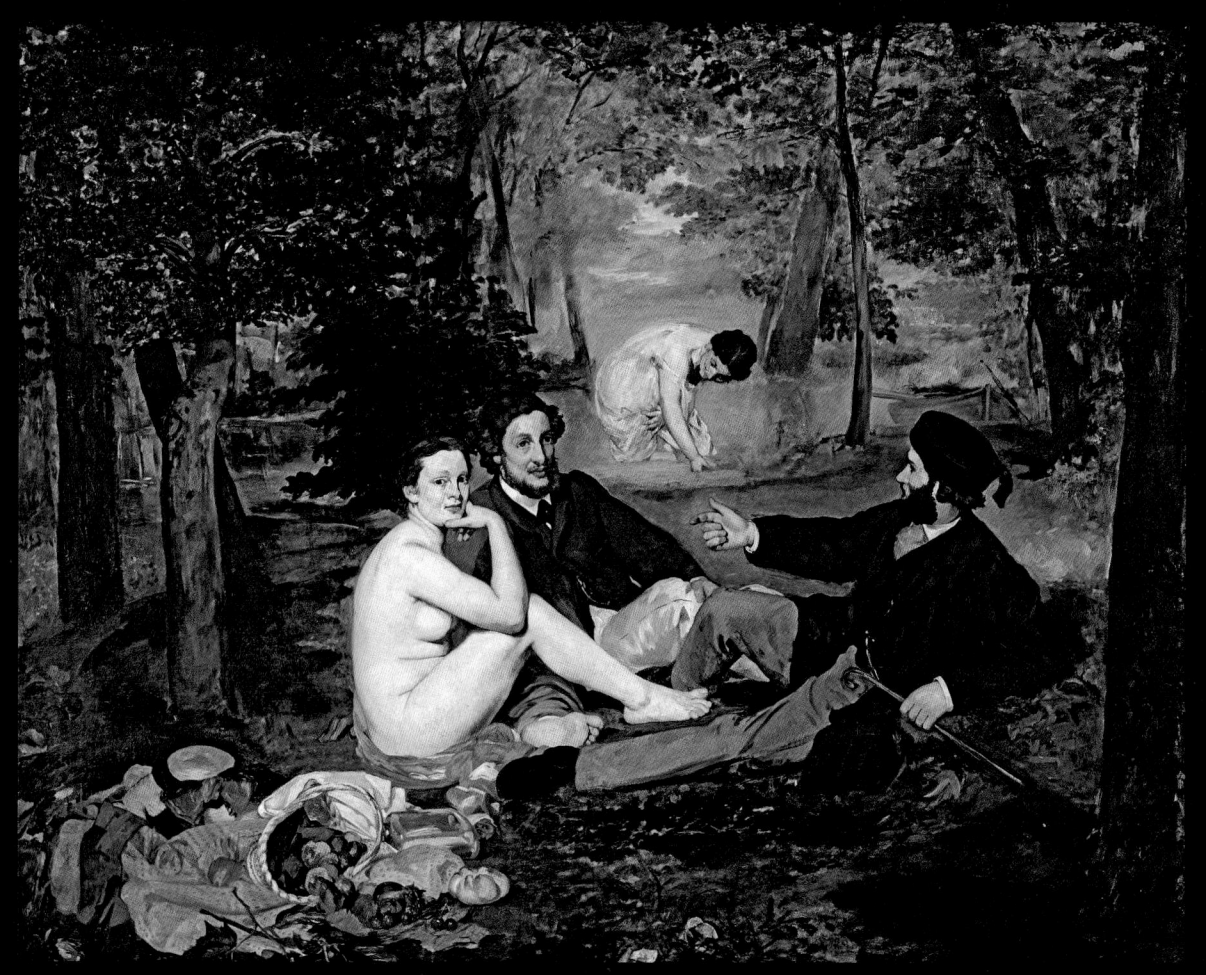

Key Artwork *The Little White Girl: Symphony in White No 2* James A.M. Whistler

The mirror image of the *Little White Girl* gives away her enormous sadness. Why is she so gloomy? Maybe she's contemplating her current circumstances, perhaps an uncertain future, or is it because she's fed up having to stand still for the notoriously tetchy artist? The chaste dreamer was Whistler's (1834–1903) beautiful, witty and wayward lover, Joanna Hiffernan, the fiery redhead who inspired much of his new Impressionistic work.

This second of Whistler's three *Girls in White* reflects the American expatriate's fascination with Japan – the pots on the mantelpiece, the flowers, and her fan reinforce a composition that has a strong Japanese-print flavour. The addition of Symphony to the titles was to steer viewers towards reading them as color patterns, and have them take in the paintings'

mood rather than their subjects or narratives. This was the principal reason that the first *The White Girl: Symphony in White No 1* (1862), shown initially in London and then Paris, caused such controversy.

Such was its effect that the poet Algernon Swinburne wrote an ode to lost love about No. 2, *Before the Mirror*, which Whistler enjoyed so much he had the verses written on gold paper and pasted onto the original frame.

As for the model, she was soon to be Whistler's ex-lover after she agreed to pose for Gustave Courbet's (1819–1877) erotic image of lesbian post-coital rapture, *The Sleepers*. It's rumoured she was also the model for his shockingly frank *Origin of the World*.
Bill Bingham

Date 1864

Country UK

Medium Oil on canvas

Collection Tate Britain, London

Why It's Key This painting is the second in a trio of Symphonies in White and shows the influence of Japanese art on Whistler, who was one of the central figures in the Aesthetic Movement.

16

Key Artist **Edouard Manet**
Olympia causes uproar

Born in Paris in 1832 to a well-off family, Manet was expected to follow his father into a law career, but his uncle introduced him to the Louvre where the young Manet became inspired by the Old Masters. From 1850 to 1856 he trained under Thomas Couture and then opened his own studio. His first submission to the Salon, *The Absinthe Drinker* (1859), was rejected.

Manet's early style was characterized by loose brush strokes and a contemporary subject matter that owed nothing to the Old Masters he loved. He had two paintings accepted by the Salon in 1861, but another rejection followed in 1863 when his *Déjeuner sur l'Herbe* caused a stir with its al fresco group of fully clothed men and undressed women. It was relegated to the Salon des Refusés, the new home for notable Salon rejections.

Manet's fondness for painting naked women who were neither remote nor idealized was evident in another 1863 painting subsequently submitted to the 1865 Salon. His starkly painted *Olympia* seemed almost calculated to offend, parodying Titian's *Venus of Urbino* while showing a naked and self-assured prostitute attended by her black maid. *Olympia* was rejected but Manet was adopted by the avant-garde as a reluctant hero. In later years he took to working outside, adopting some of the techniques of the Impressionists.

Many of his resulting works were much freer and lighter but Manet seemingly became more interested in the actual process of painting than in ideas or subject matter, a tendency reflected in his last major painting, *A Bar at the Folies Bergères*.
Graham Vickers

Date 1865

Born/Died 1832–1883

Nationality French

First exhibited 1861

Why It's Key Painterly approach prefigured the concerns of modern art.

Key Event **Muybridge begins chronophotography with racehorse pictures**

Born in England in 1830, Eadweard Muybridge emigrated to America as a young man, coming to prominence as a photographer with *Yosemite: Its wonders and Its Beauties* in 1868. In 1872, he was hired by the former governor of California Leland Stanford to test his theory that, at one point, a trotting horse would have all four hooves off the ground, but his studies were interrupted when he was tried for the murder of his wife's lover. Though acquitted, he spent some years taking publicity shots for Stanford's Union Pacific Railroad in Mexico and Central America before returning to the project in 1877.

Developing a shutter that gave an exposure of one thousandth of a second, his new photographs proved Leland's contention, and when they were published in July 1877 they were so different from artists' usual depictions of a trotting horse that they caused a sensation. Muybridge went on to use banks of 12 to 24 cameras operated by wires tripped by an animal in motion. The results were widely disbelieved, so he toured with a zoopraxiscope, a projector that showed slides printed on a rotating disc in rapid succession – an important forerunner of motion pictures.

Having fallen out with Leland, he went on to work for the University of Pennsylvania, taking over 100,000 pictures of people in motion as a reference for artists and scientists. These were published as *Animal Locomotion* in 1887. His work can be seen in the Stanford University Museum of Art, the University of California, Berkeley, the Science Museum, London, and Kingston-upon-Thames Public Library in Surrey, England.
Nigel Cawthorne

When 1872

Country UK/USA

Why It's Key Photographic development that demonstrated that motion can fool the eye, and paved the way for motion pictures.

1860–1909

17

Key Exhibition
First Impressionist exhibition

The 1872–73 postwar boom was followed in France by a great depression, making it difficult for art dealer Durand Ruel to carry on supporting his protégés. With little chance of being selected for the official Salon, Claude Monet and others set out to organize their own group exhibit. The photographer Nadar lent his studio near the Opéra Garnier, Paris, and the show opened in 1874, for a month. In deliberate contrast to the Salon system, the paintings, watercolors, pastels, etchings, and drawings were to be hung according to size, for better visibility, and in alphabetical order, for fairness.

Some of the thirty-obne participants were established artists, such as Eugène Boudin, whose sketchy beaches and seascapes had greatly influenced the young Monet. Yet controversy focused on Degas, Guillaumin, Monet, Morisot, Pissarro, Renoir, and Sisley's treatment of space, color, and loose brushwork. Monet's Impression, *Soleil Levant* (*Impression, Sunrise*), painted from a window in Le Havre, showed the shimmering effects of light on water. It was singled out for attention, with critic Louis Leroy declaring that "Wallpaper in its embryonic state is more finished than that seascape."

The exhibit attracted 3,500 visitors. While a few acknowledged the innovative qualities of the works on display, most scoffed at these "Impressionists," and critic Emile Cardon mocked: "Dirty three-quarters of a canvas with black and white, rub the rest with yellow, dot it with red and blue blobs at random, and you will have an impression of spring before which the initiates will swoon in ecstasy."
Catherine Marcangeli

Date 1874

Country France

Why It's Key The exhibition that gave Impressionism its name.

Key Artist **Edgar Degas** Exhibits at the first show of Société Anonyme des Artistes

The son of a Parisian banker, Hilaire-Germain-Edgar Degas was the eldest of five children. Though expected to pursue a law career, Edgar studied art under Louis Lamothe (a pupil of Ingres) and attended the École des Beaux-Arts before making a personal study of the Old Masters in the Louvre and Italy. A meeting with Manet in 1862 prompted a major shift in Degas' approach as he abandoned historical paintings (such as his *Young Spartans Exercising*, c.1860) for contemporary subject matter.

Degas quickly became a dazzling chronicler of quotidian life, his paintings featuring theatrical performers, laundresses, horse racing, and café society. This was still informed by the superb draftsmanship he had perfected in his studies, but he was now exclusively allied with the Impressionists.

As his eyesight deteriorated, his work became more textured and tactile. He produced wax sculptures – mainly small, unexhibited pieces, the most famous being his child ballerina with a real fabric tutu: *Little Fourteen-year-old Dancer*, a piece later cast in bronze. Degas also mixed different types of paint in the same picture and sometimes steamed his pastels, producing more fluid, impressionistic paintings that bordered on pastiche of the movement he had embraced but that, ironically, was now losing its impetus.

By 1900 Degas was virtually blind, but in the final years of his life his reputation was acknowledged by his peers and he was hailed as the greatest artist of his day. His personal stature added gravitas to the already significant Impressionist revolution.

Graham Vickers

Date 1874

Born/Died 1834–1917

Nationality French

First exhibited 1865

Why It's Key The "limited company" of artists stage the first Impressionist exhibition, which heralds a turning point in the history of art.

opposite *Three Dancers with Hair in Braids* by Edgar Degas.

Key Artist **Berthe Morisot** *The Cradle* shown in first Impressionist exhibition

Berthe Morisot was born into the privileged, cultured world of the *haut-bourgeoisie*. The family moved in creative circles and Morisot took early art classes with Camille Corot. Both Berthe and her sister Edma became painters. Her father built a studio in their garden for his daughters, the family even claiming a kinship to Fragonard. Berthe subsequently married Eugene Manet, brother of the painter Edouard; she was also to develop a close relationship to Renoir.

In line with evolving social attitudes to women, Morisot's work was accepted by the official Salon de Paris in 1864 and she continued to exhibit every year to 1873, the year before the inaugural Impressionist Exhibition at the photographic studio of Nadar.

Morisot's social origins informed all her work. She eschewed street scenes and the nude – both familiar

ingredients of contemporary French painting – and focused on domestic scenarios that reflected both the restrictions and interests of a woman of her class, including the birth of her only daughter, Julie, in 1878. *The Cradle* shows her treasured sister, Edma, shortly after the birth of her second child, Blanche. As well as depicting a tender domestic scene, it also echoes changing attitudes in France toward childbirth and infants, the adoption of the "English" practice of the "nursery" and the decline of the wet nurse in fashionable society.

Alongside Mary Cassatt, Berthe Morisot is considered one of the major women artists of the nineteenth century and an integral part of a group that included Manet, Renoir, Degas, Pissaro, and Cézanne.

Mike von Joel

Date 1874

Born/Died 1841–1895

Nationality French

Why It's Key The subject demonstrates the strength (and limitations) of Morisot's oeuvre and an authentic female interpretation of the Impressionist doctrine.

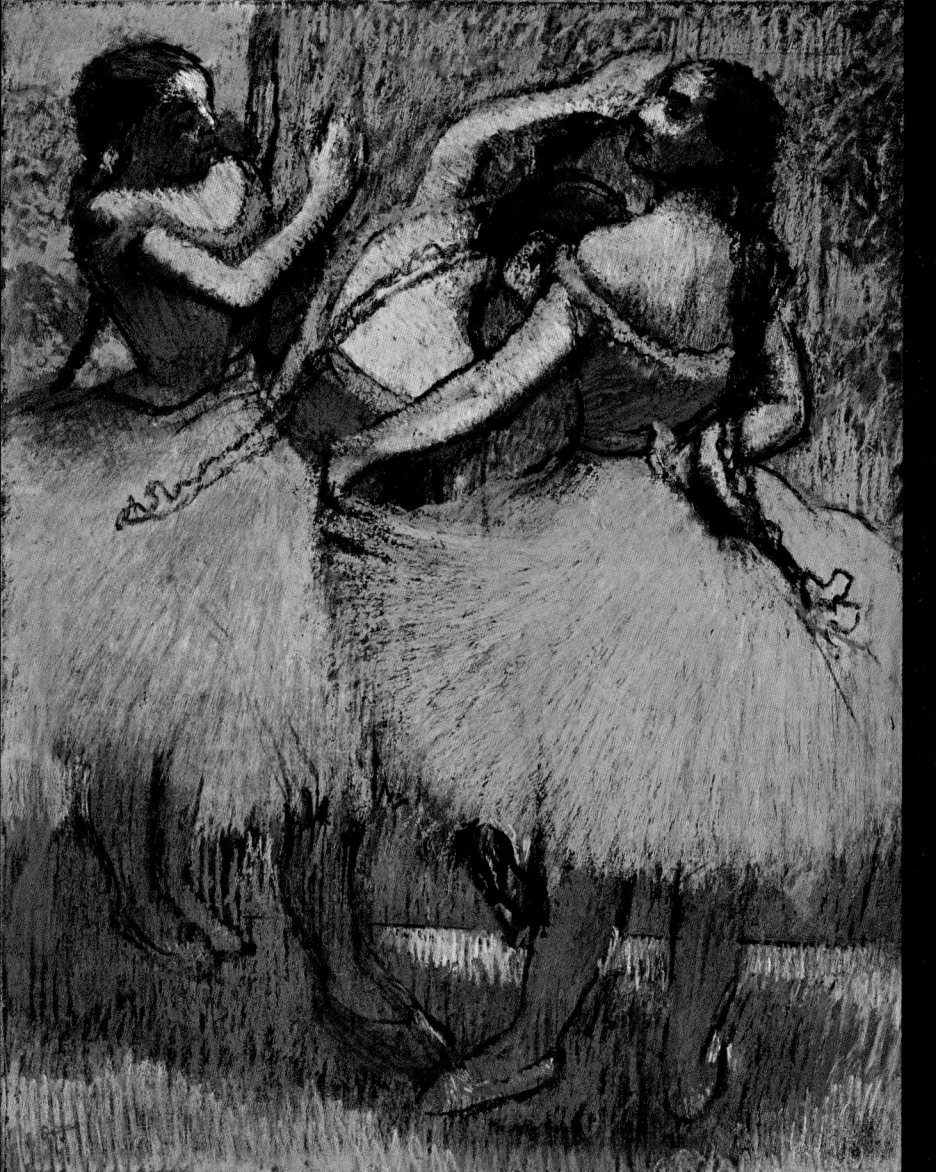

Key Artist **Pierre Auguste Renoir**
Six Paintings in first Impressionist Exhibition

From a poor background, Renoir began life as a painter in 1854 – in a porcelain factory, learning dexterity and a familiarity with light, fresh colors. When he entered the 1862 studio of Gleyre, he met artists Monet, Sisley, and Bazille, who were to become lifelong friends. They shared the revolutionary's antipathy to the old lions of the official Salon, a natural outcome being a salon of their own.

The first exhibition of the Société Anonyme des Artistes was held in 1874. The catalog was edited by Renoir's brother, Edmond, and Renoir included six oil paintings and one pastel by himself. Others exhibiting were Monet, Berthe Morisot, Degas, Camille Pissarro, Cézanne, and Armand Guillaumin. Edouard Manet was noticeably absent. With a low attendance and lack of sales, it was a financial disaster – but this key moment in art history was recorded for eternity in what was meant as a derogatory review by the critic, Jules Castagnary: "One would have to create the new term, Impressionists. They are impressionists in the sense that they render not a landscape but the sensation produced by a landscape."

With a growing reputation and financial stability, by 1880 Renoir had outgrown Impressionism. Toward the end of the century he confronted new concerns, with the mature nude studies at the epicentre, and a personal battle with ill health. He lived to see his status as French "master" endorsed by the Louvre in 1919.
Mike von Joel

Date 1874

Born/Died 1841–1919

Nationality French

Why It's Key Renoir's spirited rejection of the established Salon system precipitated a seismic shift in the evolution of painting, with which he will always be associated, and the concept of "avant-garde."

Key Artist **Alfred Sisley** Exhibits
with the Impressionists for the first time

Born in Paris to wealthy English parents, Alfred Sisley was sent to London for an apprenticeship in commerce, though he spent much of his time studying the works of Constable and Turner. Returning to Paris in 1862, he enrolled in the École Nationale des Beaux-Arts as a student in the studio of Charles Gleyre. There he met Claude Monet, Pierre-Auguste Renoir, and Jean-Frédéric Bazille, beginning a lifelong association with the group that later called themselves the Impressionists.

The Franco-Prussian War of 1870–71 ruined Sisley's family and left him penniless. He decided to support himself as a painter, though the rest of his life was a constant struggle against poverty. He was essentially a landscape painter in the English tradition – a style that also influenced Monet and Pissarro.

With them, plus Renoir, Morisot, Degas, Boudin, and Cézanne, he exhibited in the first Impressionist exhibition in 1874 and participated in four of the eight group exhibitions. Although in some ways the purest of all the Impressionists, he failed to gain the recognition enjoyed by Monet, Pissarro, and Renoir. His spirit broken, he went to live in solitude in Moret-sur-Loing, near Fontainebleau, where he died virtually forgotten. Soon after his death, however, his talent became widely recognized and the price of his work soared.

Generally considered his masterpiece, *Flood at Port-Marly* hangs in the Louvre. Other notable paintings include *Snow at Louveciennes* in the Phillips Collection in Washington D.C. and *Road at Louveciennes* in the Musée Masséna, Nice.
Nigel Cawthorne

Date 1874

Born/Died 1839–1899

Nationality British

First exhibited 1874

Why It's Key One of the founders of French Impressionism.

Key Artwork *Le Bal au Moulin de la Galette*
Pierre Auguste Renoir

Though usually associated with landscape painting, the Impressionists often addressed contemporary urban subject matter. In the 1876 Second Impressionist exhibit at Durand Ruel's gallery, Paris, Monet showed *St Lazare Station*, with its locomotive smoke rising like dense clouds, while Renoir (1841–1919) presented his *Ball at the Moulin de la Galette*. The Moulin (windmill), a Montmartre landmark turned into a dance hall in 1870, attracted a mostly working-class clientèle – a social group Renoir and Monet had previously depicted on Sunday outings to the country or by the River Seine.

From 1873, Renoir kept a studio in Montmartre and frequented the local cafés and cabarets. He was a regular at the Moulin de la Galette, to which he dedicated one of his largest compositions. Faithful to the principles of plein-air painting, he carried the cumbersome canvas to the Moulin most days, to paint on site, and used non-professional models.

Teeming with activity, the painting is structured along a diagonal that separates the dancers in the background from Renoir's friends, at a table in the foreground. The sense of spontaneity and dynamism is enhanced by the loose brushwork and by the treatment of light falling fleetingly through the trees to animate dresses and faces with specks of color. Renoir showed the same disregard for the conventional use of local color in his *Bust of a Young Woman in the Sun* (also 1876), prompting a critic to bemoan: "One should explain to Mr Renoir that the bust of a woman is not a lump of decomposing flesh speckled with green or purple spots reminiscent of a putrefying corpse!"
Catherine Marcangeli

Date 1876

Country France,

Medium Oil on canvas

Collection Musée d'Orsay, Paris, France

Why It's Key A depiction of modern Parisian leisure and an Impressionist study in light, movement, and color.

1860–1909

Key Artwork *L'étoile ou La Danseuse sur la Scène*
Edgar Degas

Degas (1834–1917) exhibited in seven of the eight Impressionist exhibitions. However, the discipline of the accomplished draftsman was at odds with the basic free-form techniques of his fellow painters and he evolved his own related style. He brought his immense drawing skills to bear on theatrical subjects, depicting racecourses, theaters, cafés, music halls, and boudoirs. Degas was fascinated by female dancers, milliners, and laundresses, attempting to catch his subjects in natural and spontaneous poses.

The fashion for Japanese prints is reflected in Degas' choice of composition (oblique and asymmetrical angles). *L'étoile ou La Danseuse sur la Scène* (The Star or Dancer on the Stage) was exhibited at the third Impressionist exhibition in 1877. It is a pastel over monotype, a process which fascinated Degas. Although only a single print can be taken from an ink drawing on a metal plate, it is possible to secure a second, fainter image. This in turn can be worked on, and pastel was Degas' preferred medium. *The Star* is also unusual in that it depicts an actual ballet performance as opposed to a rehearsal, but even then Degas avoids sentiment and the off-stage personnel are shown without the grace of the dancer.

The unusual light effects he achieved in this "view from the box" were commented on by critics at the time. In fact, Degas was heading for a problem with his eyesight at this time, which badly affected him in the 1880s. His images became less defined and more "impressionist" in appearance.
Mike von Joel

Date 1876–77

Country France

Medium Pastel on paper

Collection Musée d'Orsay, Paris, France

Why It's Key It exemplifies Degas' response to encroaching blindness, where a more Impressionist style and the pastel medium combine to create elegant and expressive studies.

Key Artwork *A Bar at the Folies Bergères*
Edouard Manet

In spite of his failing health, Manet (1832–83) spent much time sketching at the Folies Bergères, a variety-show hall opened in 1880. The composition focuses on the barmaid, Suzon, who looks directly, albeit pensively, at us. The mirror behind her reflects an animated scene, but she seems frozen in time. In spite of the gas chandeliers and state-of-the-art electric globes, the scene is steeped in a unifying light, as it was painted in Manet's studio.

The treatment of space destabilizes the viewer, who is deprived of a fixed and reassuring viewpoint: if we are facing Suzon, then we shouldn't be able to see her back in the mirror; as for her customer, his reflection is painted as if from another point of view altogether. The horizontal lines of the counter or the balcony and the vertical lines of the pillars or the bottles provide a series of frames that structure the painting, but also deny traditional perspective. Space is further flattened by the use of the mirror, as the reflections of objects that are further away become blurred in a way reminiscent of photographic depth of field.

These manipulations contributes to make the space more shallow, emphasizing the sense that the young woman is caught between the mirror and the counter; she looks at us, but is also an object of desire for the bourgeois customer we catch a glimpse of – reminding us that many barmaids also granted sexual favours. A modern scene for "the painter of modern life."

Catherine Marcangeli

Date 1882

Country France

Medium Oil on canvas

Collection Courtauld Institute, London, UK

Why It's Key The last great composition by "the painter of modern life," presented at the 1882 Salon.

opposite
A Bar at the Folies Bergères

22

Key Artist **Elizabeth Armstrong Forbes**
Canadian artist begins etching in France

Elizabeth Forbes exhibited regularly after 1883 when a painting, entitled *Summer*, was selected for the prestigious annual exhibition at the Royal Academy of Arts, London. She was, however, more admired at this time for her drypoint etchings; by 1885, when three were exhibited at the RA, they had brought her to the attention of Whistler and Sickert. Depicting genre scenes often derived from drawings made of working people in British and European rural outposts and fishing villages, these images were influenced in style and subject matter by the naturalist idiom of the French painters Millet and, especially, Jules Bastien-Lepage. As a student at New York's Art Students' League, Forbes first encountered their work through her teachers, who included William Merrit Chase.

Born in Ottawa, Forbes had lived in London, Munich, New York, and the Brittany region of France (where she began etching at Pont-Aven) before returning to England in 1883. She spent summer 1884 with Chase's students in Zandvoort, Holland, before settling in autumn 1885 in Newlyn, a fishing port in far southwest England, which was becoming a colony for British artists dedicated to open-air narrative figure painting in the Lepage style. Abandoning etching as impractical, Forbes concentrated on working in oil, watercolor, and gouache, making numerous scenes featuring fishing families, particularly their women and children. In 1889 she married the leading painter amongst the town's artists, Alexander Stanhope Forbes.

Martin Holman

Date 1882

Born/Died 1859–1912

Nationality Canadian

Why It's Key Admired as a printmaker by Whistler and Sickert, she became known for paintings of children.

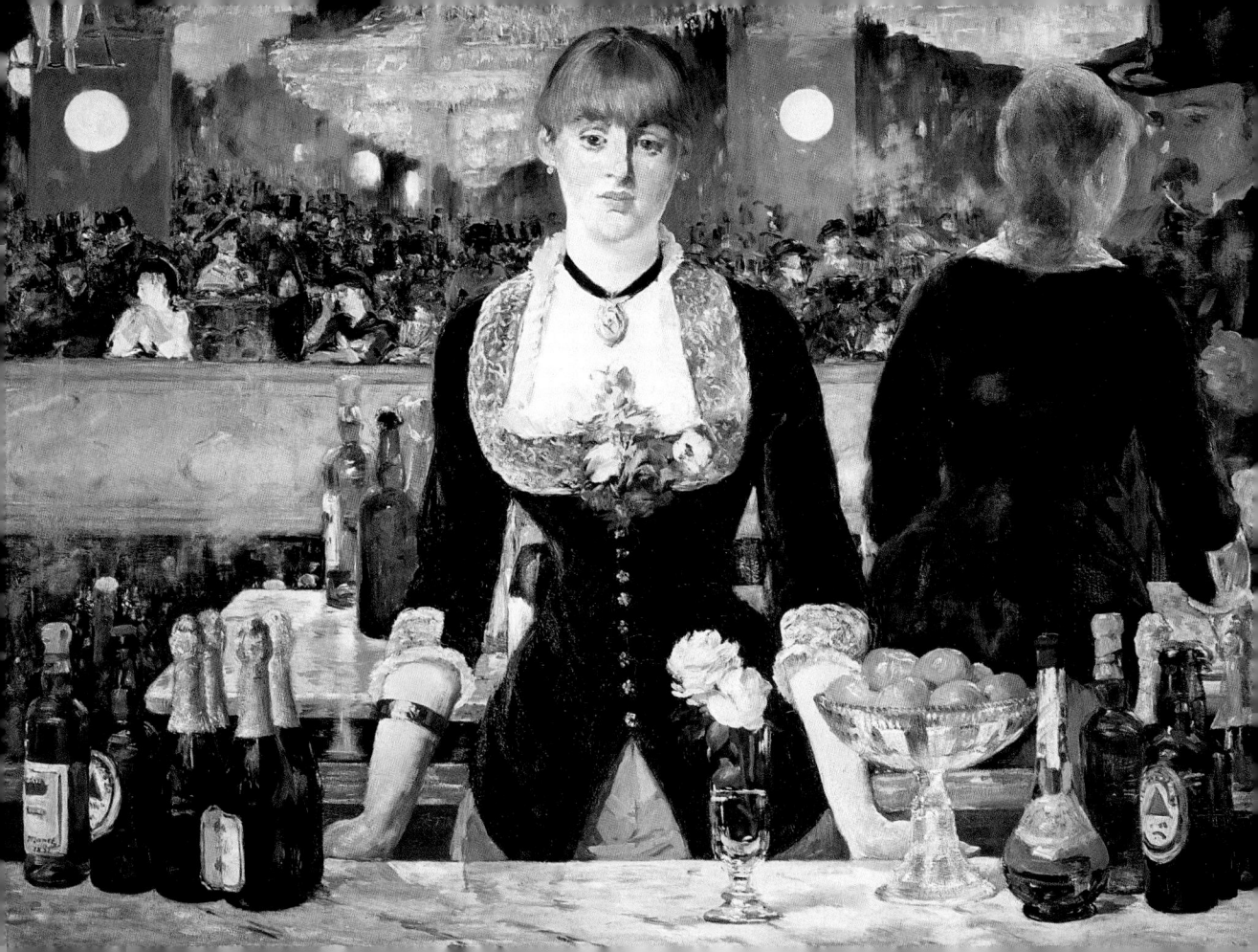

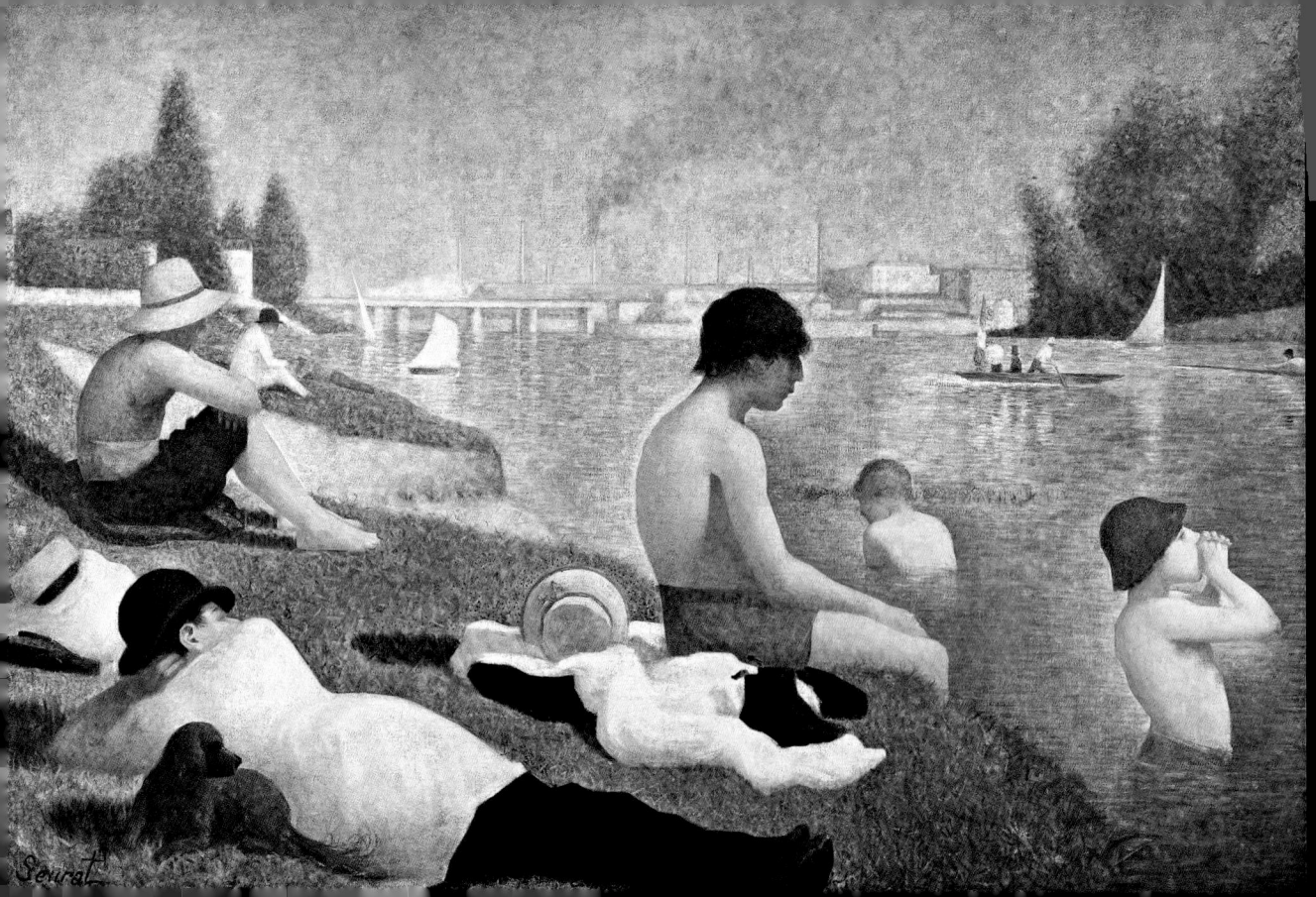
Seurat

Key Artwork *Une Baignade, Asnières* (*Bathing at Asnières*) Georges Seurat

In May 1884, Georges Seurat (1859–1891) met Paul Signac (1863–1935). The latter was immediately struck by Seurat's disciplined working methods and his interest in the new theories of color expounded by Chevreul and others. Signac duly became Seurat's most constant disciple.

On June 11, 1884, Signac and Seurat helped found the Société des Artistes Indépendants. Seurat exhibited a canvas so large it had to be located in a Parisian bar: the *Bathing at Asnières*. In this painting Seurat had taken all the tenets of his classical training and knowledge of history painting (defined by large canvasses of epic subject matter) and readdressed the equation with a Neo-Impressionist sensibility. His subject was a common riverbank scene with locals swimming and sunbathing.

The scale was heroic, but the treatment was Pointillist in approach (also known as Divisionist). Seurat invokes Chevreul's law of Simultaneous Contrast: "Where the eye sees two contiguous colors they appear as dissimilar as possible; both in their optical composition and in the height of their tone." This effect is sometimes referred to as irradiation, a phenomenon of light that makes objects stand out from one another. Thus in the brilliant green grass of the riverbank there are strokes of the complementary colors, and red with hues of pink.

Later, in 1886–1887, Seurat reworked the canvas, applying small spots, or points, of color: blue and orange on the back of the seated bather, orange, yellow, and blue on the hat of the boy in the water.

Mike von Joel

Date 1883–1884

Country France

Medium Oil on canvas

Collection National Gallery, London

Why It's Key In *Bathing at Asnières* Seurat introduces the Pointillist technique to a large-scale work, paving the way for his masterpiece, *Sunday Afternoon on the Island of La Grande Jatte* (1884–1886).

opposite *Une Baignade, Asnières*

Key Exhibition
Salon des Indépendants

During the late nineteenth century, avant-garde artists such as the Impressionists found themselves excluded by the official Salon in Paris. In 1884, they banded together to form the Société des Artistes Indépendants and held an exhibition in the Pavillion in Paris.

With the authorization of the Ministry of Fine Arts this "group of independent artists" held its first show in rooms supplied by the City of Paris. Unlike the official Salon run by the Académie Royale de Peinture et de Sculpture, there was no jury to select which paintings were to be hung. The Salon des Indépendants was opened to all artists, who paid a small hanging fee, and this first "free" exhibition of contemporary art showed more than five thousand works by over four hundred artists.

The first show included works by Paul Gauguin, Vincent van Gogh, Paul Cézanne, Henri de Toulouse-Lautrec, Paul Signac, Henri-Edmond Cross, Odilon Redon, and Georges Seurat, whose *Bathing at Asnières* was refused by the official Salon that year.

The Salon des Indépendants established itself as an annual event. Both amateur and professional artists showed their work there, with Henri Rousseau, Pierre Bonnard, and Henri Matisse among the many important names who exhibited during its early years. Since 1920 it has been held in the Grand Palais in Paris, and remains an important outlet for the avant-garde.

Nigel Cawthorne

Date 1884

Country France

Why It's Key Established an outlet for artists barred from the official Salon, affording exposure for Impressionists, Fauvists, and other avant-garde groups.

Key Artist **Paul Signac**
Signac meets Monet and Seurat

As a precocious adolescent, Paul Signac went to the exhibitions held by the Impressionists. At the age of sixteen, he was famously thrown out of the 1880 fifth Impressionist exhibition by Gauguin for making a sketch of a Degas. He claimed that it was the paintings of Monet in a June 1880 exhibition that led him to a career as an Impressionist painter. In May 1884, Signac met his hero, Monet, in Paris and also Georges Seurat. Struck by the latter's systematic working methods and theory of colors based on Chevreul and Henry, he became Seurat's faithful supporter. On June 11,1884, Signac, Seurat, Charles Angrand, and Henri Edmond Cross formed the Société des Artistes Indépendants. Both Seurat and Signac avidly read Charles Blanc, Charles Henry and other optical treatises by David Sutter and Ogden Rood.

The eighth and last exhibition of the Impressionists in 1886 included Seurat and Signac, despite opposition from Degas and Eugène Manet. Neo-Impressionism (or Pointillism) created a sensation in the form of Seurat's *Sunday Afternoon on the Island of La Grande Jatte* (1884–1886) and rapidly became an influential style. Camille Pissarro briefly adopted Pointillism in January 1886. In 1887 Signac met Vincent van Gogh in Paris; they painted together and van Gogh himself tried the Pointillist technique in *Self Portrait* (1887). Monet also experimented in the series *Haystacks* (1891) and *Rouen Cathedral* (1894). The tragic early death of Seurat in 1891 at only thirty-one precipitated the collapse of the movement.

Mike von Joel

Date 1884

Born/Died 1863–1935

Nationality French

Why It's Key Signac avidly supported Seurat in the evolution of Pointillism, and even Monet and Van Gogh experimented with the color theory.

Key Event
Coca-Cola® logotype created

The invention of what was to become one of the world's most valuable brands was a rather humble process. In May of 1886, a pharmacist in Covington, Georgia, John Stith Pemberton, made up his original soft drink formula in a three-legged brass kettle in his backyard. It was his response to local prohibition, which forced him to create a non-alcoholic drink to replace his earlier concoction, French Wine Coca. At the time, any carbonated drink was considered medicinal, so his new brew was originally sold as a patent medicine. Coca leaves and kola nuts were the key ingredients and they suggested the name Coca-Cola® – although not to Pemberton himself, but to his bookkeeper, Frank Robinson.

It proved a happy suggestion but Robinson went on to devise something even more valuable: a logotype that is still going strong well over a century later. Employing the predominant style of formal handwriting used in America from the mid-nineteenth century – Spencerian Script – Robinson created the flowing Coca-Cola® logotype with its two balanced C's and its serpentine flourishes, top and bottom.

The drink's formula would change and so would the brand's ownership, but Frank Robinson's elegant penmanship had created an indestructible asset – a universally recognizable trademark. Robinson had given the world one of its earliest demonstrations of how visual merit might no longer be restricted to the province of fine art, but might also be pressed into commercial service. He might have been an inadvertent commercial artist, but he was an artist nonetheless.

Graham Vickers

Date 1886

Where USA

Why It's Key An early example of how visual flair became an essential constituent in the creation of a brand – and subsequently the most enduring American graphic icon.

opposite Early Coca-Cola® advert.

Drink
Coca-Cola
TRADE MARK
REGISTERED

DELICIOUS AND REFRESHING

A STAR DRINK

5¢ *Morning, Evening, Night – At Home or Abroad.*
Traveling or Resting – Working or Recreating 5¢
SOLD EVERYWHERE

Key Artwork *Sunflowers*
Vincent van Gogh

Given Vincent van Gogh's (1853–1890) fame and the stupendous prices his paintings achieve, it is easy to forget he created his oeuvre within a mere ten-year period. The peak of his productivity was in 1888, when he left the loneliness and negative effects of metropolitan Paris for Provence and the "Yellow House" in Arles. It was the period of the infamous nine-week collaboration with Paul Gauguin between October and December 1888, and the mental breakdown that culminated with the incident of the slashed ear lobe. It was also the period in which van Gogh painted a series of sunflowers, where color becomes an expressive, emotional tool more than ever.

In a fit of increasing excitement over Gauguin's arrival, doomed to end in the psychiatric hospital in Saint-Rémy, van Gogh worked on sunflower studies for his guest's room. Gauguin notes in his journal that Vincent is "disturbed." Van Gogh wrote to his brother Theo in August 1888: "I am hard at it, painting with the enthusiasm of a Marseillais eating bouillabaisse, which won't surprise you when you know that what I'm at is the painting of some sunflowers. If I carry out this idea there will be a dozen panels… I am working at it every morning from sunrise on, for the flowers fade so quickly. I am now on the fourth picture of sunflowers. This fourth one is a bunch of 14 flowers … it gives a singular effect."

There remain six canvases extant – a seventh was destroyed in World War II. The artist revisited this subject and the various later versions and replicas are much debated among van Gogh scholars.

Mike von Joel

Date 1888–1889

Country France

Medium Oil on canvas

Collection Example at National Gallery, London

Why It's Key The light and heat of Arles, plus newly available pigments, provoked Vincent van Gogh's most productive, colorful period, epitomized by a series of exuberant studies of sunflowers in a vase.

opposite Sunflowers

Key Event
First meeting of the Nabis

Denis, Bonnard, Sérusier, Vuillard, Roussel, Maillol, and Vallotton constituted a group of young artists who met regularly at Sérusier's atelier in Paris. In the fall of 1888, Sérusier returned from Pont-Aven in Brittany with a Talisman – a landscape painted in the arbitrary colors and flat cloisonniste technique he had learned from Gauguin.

Calling themselves the Nabis (Prophets) they stressed the spiritual dimension of an art that must not reproduce the appearance of nature, but express the artist's inner world with simplicity and with stylized lines inspired by Japanese prints. In his 1890 manifesto for the group Maurice Denis insisted that a painting, "before being a war horse, a nude woman or some anecdote, is essentially a flat surface covered with colors arranged in a certain order," thus anticipating by decades the definitions of art given by Roger Fry or Clement Greenberg.

Theirs was a syncretic art that aspired to the condition of music or poetry, as Denis emphasized: "why not do in painting what the poets do with their metaphors: accentuate, to the point of deformation, the curve of a beautiful shoulder, …emphasize the symmetry of the branches of a tree that is undisturbed by the wind?" The Nabis did not, however, confine themselves to some ethereal ivory tower. Vallotton depicted workers and their plight, Bonnard and Sérusier designed backdrops for the anarchist Théâtre de l'Œuvre, and most of the Nabis frequented the avant-garde cabarets of Montmartre, such as the Chat Noir, often depicted by Toulouse-Lautrec.

Catherine Marcangeli

Date 1888

Country France

Why It's Key A transition between the aesthetic principles of Gauguin and Symbolism.

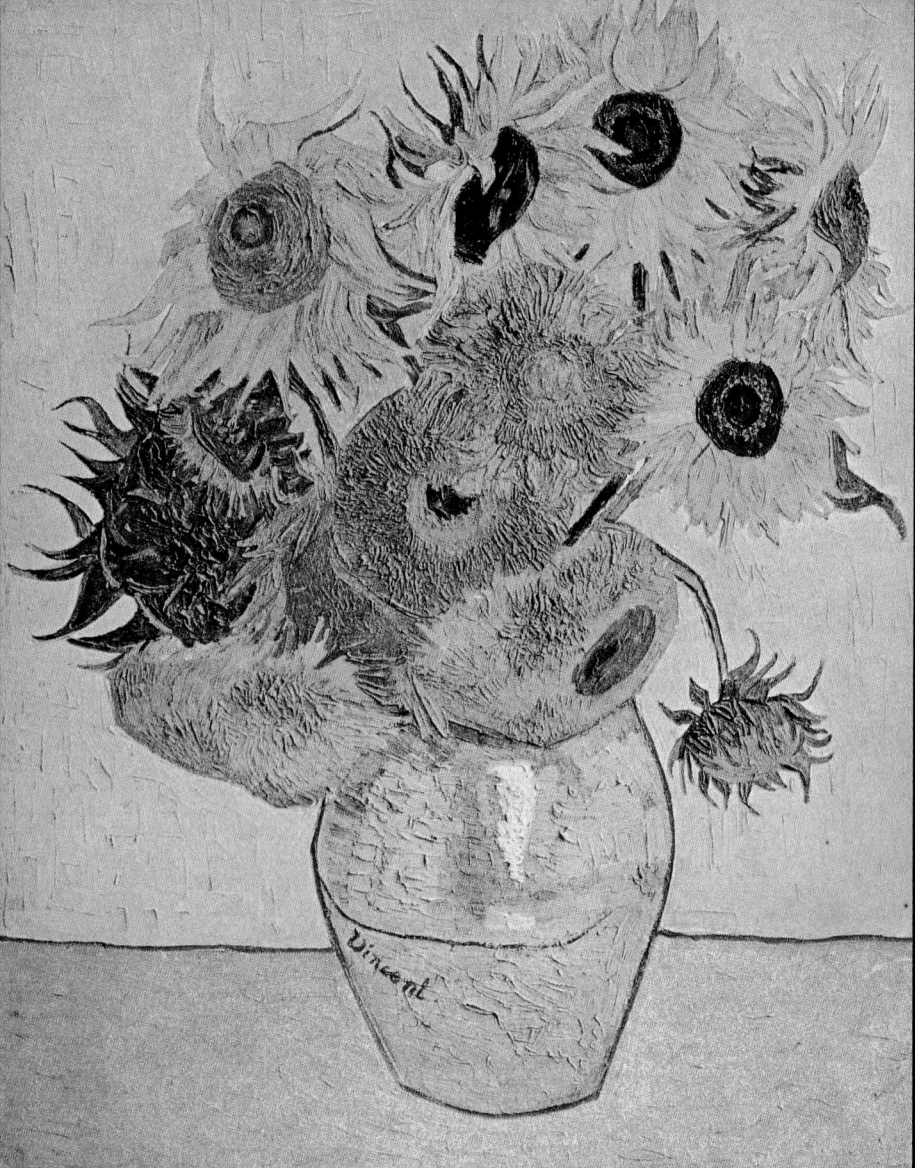

Key Artist **Paul Gauguin** *Vision After the Sermon* marks a turning point in French art

Born in Paris to a French father and half-Peruvian mother, Eugene-Henri-Paul Gauguin first exhibited in Impressionist exhibitions in 1880, 1881, and 1882 after forming a pivotal friendship with artist Camille Pissarro. His early work was solidly in the Impressionist mode until *Vision After the Sermon* (1888) was painted when he moved to Brittany. *Vision* marked his break with Impressionism and a move toward a more primitive style. The use of intense colours and clear-cut shapes against a dramatic red background, together with a subject matter that combines the visionary and the real, marked a turning point in French painting.

Influenced by Japanese prints and the art of other non-Western cultures, in 1888 Gauguin met painter Emile Bernard with whom he experimented with a new form of painting, Cloisonnism, and a move away from imitative art to an art of "Synthesis" and expression of the artist's feelings.

In 1981 he abandoned his wife and civilized society and traveled to Tahiti. He produced paintings that depict the physical beauty of the people and the myths of their folk traditions, the acclaimed masterpiece of which was *Where Do We Come From? What Are We? Where Are We Going?* (1897–1898). Dissipated by drugs, he died in 1903 in French Polynesia.

Gauguin was an important Post-Impressionist – his work marks the genesis of abstract art. Gauguin's adoption of a primitive lifestyle, incorporation of motifs from native art in his paintings, and use of distorted perspective, was to influence Matisse and the Fauves, Picasso, and the German Expressionists.

Kate Mulvey

Date 1888

Born/Died 1848–1903

Nationality French

First exhibited 1880

Why It's Key Founder of Synthesis method and Primitivism.

Key Event
Completion of the Eiffel Tower

When organizing the International Exposition of 1889, the government in France held a competition for the design of a monument to commemorate the centenary of the French Revolution. Among the more than one hundred plans submitted was the proposal by Gustave Eiffel for a 984ft open-lattice wrought iron tower. It would be twice as high as the dome of St Peter's in Rome or the Great Pyramid in Giza, and tower above the 555ft Washington Monument, completed in 1884, the tallest tower to date.

The design was greeted with amazement and skepticism. However, Eiffel was a noted engineer who had used metal lattice successfully, building bridges and as the skeleton of the Statue of Liberty in New York harbor. Using a small workforce and prefabricated elements, he completed the tower on schedule and under budget.

Georges Seurat painted it in 1889 and it appeared in the work of Henri Rousseau, Marc Chagall, Henri Rivière, and Raoul Dufy. The Cubist Robert Delaunay used it as a basis for abstraction in 1910. It inspired the Constructivist sculptor Naum Gabo and his brother, the painter Antoine Pevsner, and Vladimir Tatlin called Eiffel "the first Constructivist".

The tower was to have been dismantled in 1909, but has endured as a symbol of Paris and of modernity. It remained the tallest building in the world until the completion of the Chrysler Building in New York City in 1930.

Nigel Cawthorne

Date 1889

Country France

Why It's Key Revolutionary method of construction made the Eiffel Tower a symbol of modernity.

Key Artist **James Ensor**
The Entry of Christ Into Brussels causes uproar

Born in Ostend to a British father and Flemish mother, James Ensor first exhibited in 1881 after spending three years at the Beaux-Arts Academy in Brussels, one of the rare periods he spent outside his native city. Initially, works like *The Damsel in Distress* (1882) featured sombre-looking interiors, portraits, and landscapes, before his palette changed radically around 1883 to employ brighter, more starkly contrasting colors.

That same year saw Ensor helping found the Belgian avant-garde group Les XX, which organized an annual exhibition over the next ten years that included Claude Monet, Camille Pissarro, and Vincent van Gogh. His own work during that period was marked by a macabre flamboyance, with skeletons and grotesque masked figures playing center stage.

The most celebrated of these visual extravaganzas came in 1888 when he painted his large-scale *The Entry of Christ Into Brussels in 1889*. The haloed Jesus is surrounded by a mob of Ensor's caricature clowns and Mardi Gras-like carnival folk, amid banners emblazoned with political slogans. The picture caused a scandal in 1889, was rejected by Les XX, with which Ensor then parted company, and was not shown publicly until 1929. But, with its aggressive style and deeply personal imagery, *The Entry of Christ* was a forerunner of twentieth-century Expressionism.

Ensor continued to exhibit, finding acceptance after the turn of the century, when he was even made a baron by the Belgian monarch. He continued to paint until his death in 1949.

Mike Evans

Date 1889

Born/Died 1860–1949

Nationality Belgian

First exhibited 1881

Why It's Key Precursor of Expressionism.

31

Key Artist **Odilon Redon** Pioneer of Symbolism exhibits at the Salon des Indépendants

Redon first went to Paris in 1859 to study architecture, then as a painter briefly attending Gérôme's atelier. However, after a mental breakdown he returned home to Bordeaux, where he studied engraving under Bresdin. From 1879 to around 1900 he worked exclusively in black and white (producing charcoal drawings and over 160 published lithographs). Then he turned to luminous color, working in pastels, watercolors and oils. Subjects were taken from contemporary literature and poetry, notably by his friend Mallarmé, who also translated the writings of Edgar Allan Poe, a seminal influence on the Symbolists. Various mythical and religious images frequently appear in his work, including Fallen Angel, Sphinx, and Cyclops in, for example, his lithographic series *Les Origines* from 1883.

Redon exhibited at the Salon des Indépendants in 1889 and at the eighth Impressionist exhibition, although he found these artists too bound by external appearances. In his words they were: "True parasites of the object." Redon's subtle use of color and his fluid painterly style create an overall effect that is dreamlike and ethereal. He imbued the simplest of objects, like the flowers in *Wild Flowers* (c.1905) (Winterthur), with a sense of mystery. He wrote later in life (in *A Soi-même*): "I believe I have made an expressive, suggestive, indeterminate art." Redon paved the way for Surrealism, both in his strange and disturbing images, and his Freudian fascination with interpreting dreams.

Lucy Lubbock

Date 1889

Born/Died 1840–1916

Nationality French

First exhibited 1881

Why It's Key Redon was a leading influence on the Symbolists.

Key Artist **Vincent van Gogh** Death by suicide of the highly influential Post-Impressionist

Three days before his suicide, Van Gogh wrote his brother, Theo, two final letters, only one of which he sent – the other was found on his body. He was a prolific letter writer, and his collected writings have been extensively analyzed in an attempt to unravel the causes of his malady. The suicide may have been triggered by something as simple as Theo indicating he might not be able to continue his financial support. The obsessive brooding over minor things and the deep melancholy Van Gogh experienced dictated his approach to everything, from a zealot's devotion to the Bible, a passion for literature, to his extreme behavior and, above all, his manic dedication to art.

Van Gogh's problems were internal and the move to Auvers in 1890 offered no solutions. Emile Bernard left a detailed contemporary account of the artist's final hours: "On Sunday evening he went into the Auvers countryside, left his easel against a haystack and went behind the Château and shot himself with a revolver... he fell, but he got up and fell again three times and then returned to the inn where he lived [Ravoux, Place de la Mairie] without saying anything to anyone about his injury. Finally [at 1:30 a.m. on Tuesday] he expired, smoking [the] pipe he had not wanted to put down, and explaining that his suicide was absolutely calculated and lucid."

In the room where he used to paint, van Gogh's wooden coffin was bedecked with sunflowers. Dr Gachet, Emile Bernard, art dealer and friend Julien "Père" Tanguy, and other artists, including Lucien Pissarro, came from Paris for the funeral.
Mike von Joel

Date 1890

Born/Died 1853–1890

Nationality Dutch

Why It's Key Van Gogh created the populist notions of great art and the tortured genius, and also laid the foundations for Expressionist painting.

32

Key Artwork *Wheat Field with Crows*
Vincent van Gogh

In a letter to his brother Theo, Vincent van Gogh (1853–1890) made the link between his own increasing depression and the sense of foreboding evoked by the landscape at Auvers, France, before him: "They are vast fields of wheat under troubled skies, and I did not need to go out of my way to try to express sadness and extreme loneliness." Not long after writing that, the painter walked out into those same fields, took out a revolver, and shot himself in the chest. He died from his wounds two days later, on July 29, 1890.

Van Gogh employed an unusual "double square" canvas for this and several other pictures during this period at Auvers-sur-Oise, achieving a panoramic effect that draws the viewer in as if watching a wide-screen movie. And what we experience is no picture postcard scene, but a disorienting vista where, instead of leading naturally to the horizon, the lines of three paths converge into the foreground. A distinct sense of unease permeates the view, where the shimmering heat of summer is oppressive rather than liberating, and the "troubled skies" darken menacingly almost as we watch.

The broad, hurried strokes suggest van Gogh felt the end was near – he was frantically producing one or even two paintings a day during this terminal spell of personal torment. And the jet-black crows, now reminiscent of the winged menace in Alfred Hitchcock's 1963 film *The Birds*, add to the ominous atmosphere of impending doom.
Mike Evans

Date 1890

Country France

Medium Oils

Collection Van Gogh Museum, Amsterdam

Why It's Key One of van Gogh's final pictures, indicating the mental anguish that led to his suicide shortly afterwards.

opposite *Wheat Field with Crows*

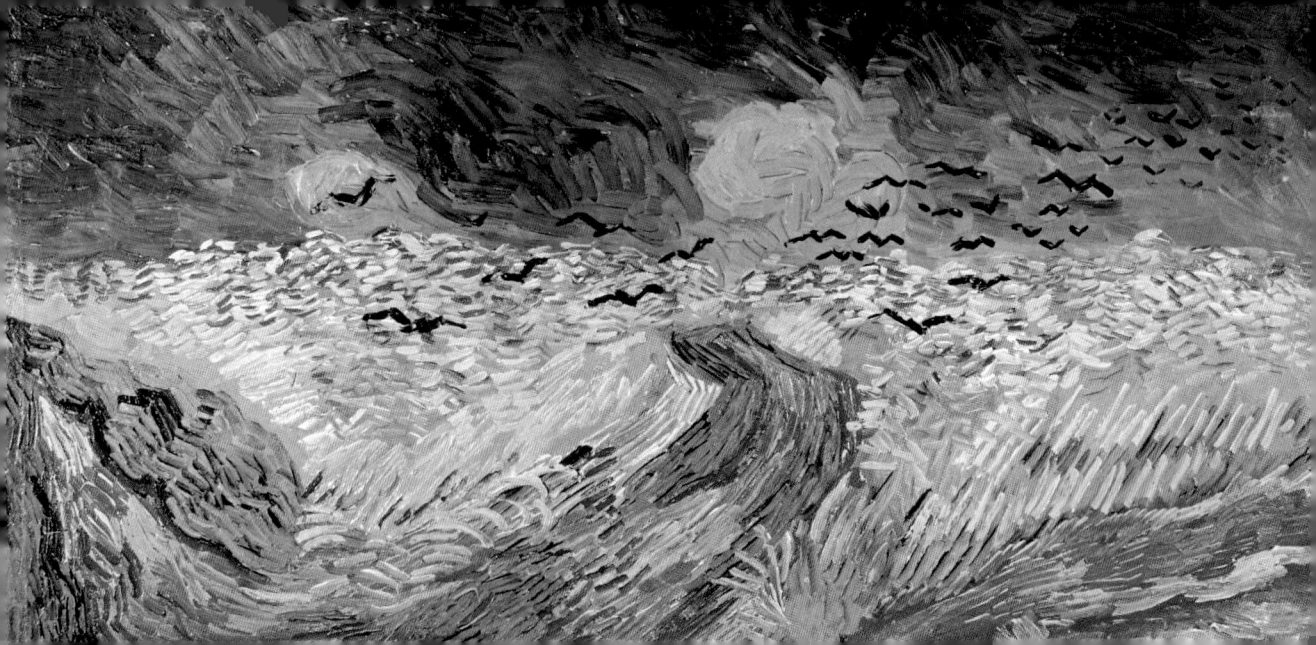

Key Artist **George Seurat**
Death of important Neo-Impressionist pioneer

From harbor scenes to *Bathing at Asnières* (1883–4) or *A Sunday Afternoon on the Island of La Grande Jatte* (1886), Seurat's subject matter was not unlike that of the Impressionists. Yet his scientific brand of Impressionism, which he dubbed Chromoluminarism, was no longer concerned with capturing fleeting light effects. Basing his approach on the Laws of Simultaneous Contrast, he did not mix colors on his palette, but juxtaposed tiny dots of pure color directly onto the canvas, leaving the dots to alter each other's tonalities; the mixing of colors thus happened in the eye of the beholder. The spontaneity and immediacy associated with Impressionism gave way to meticulously planned compositions, based on numerous studies, imbuing Seurat's pictures with a stylized, almost hieratic quality.

Shortly before his death, Seurat exhibited *The Circus*, unfinished, at the eighth Salon des Indépendants. A clown, seen from the back, leads us into the ring. In this scene of leisure, the spectators sit motionless in a background structured by vertical and horizontal lines, the bourgeois closer to the show, the working class further up, befitting social hierarchies. The performers' energy is conveyed by color contrasts, by a multiplicity of viewpoints, and by the ascending lines, diagonals, and arabesques that are synonymous with vitality.

The impact of Seurat's pioneering principles and treatment of color and brushstrokes had a lasting impact on European art, be it in the early Pointillist works of Matisse or Braque, or in the Divisionist approach of Italian Futurism.

Catherine Marcangeli

Date 1891

Born/Died 1859–1891

Nationality French

Why It's Key Seurat had a seminal influence on development of Pointillism and Divisionism.

1860-1909

34

Key Artist **Félix Vallotton**
Seminal woodcut, *Portrait of Paul Verlaine*

The Swiss-born artist Félix Vallotton moved to Paris in 1882 to study at the Académie Julian. His early, Ingres-like, paintings were academic, but he soon emerged as an innovator, not least in his modern approach to woodcut.

By 1891, Paul Verlaine (1844–1896), notorious for his affair with Arthur Rimbaud, his drug and alcohol addictions, and his decadent lifestyle, was revered as a major fin de siècle figure. His verse had been set to music by Gabriel Fauré and Claude Debussy, and his collection *Sagesse* (1881) had been illustrated by Maurice Denis, Vallotton's fellow Nabi, in 1889.

Verlaine's subtle moods and feelings, summoned up through gentle musicality, could but be congenial to the Nabis' idea of art. Vallotton's *Portrait of Paul Verlaine* displays a similar subtlety, as a fluid and

delicate line suggests rather than draws Verlaine's features. The influence of Japanese woodblock prints is visible in the simplified details and patterns, as well as in his signature. Like Gauguin, Vallotton cut his blocks himself. He dispensed with the modeling usually achieved through hatching, creating contrasts between large flat areas of unmodulated black and white.

Like other Nabis, Vallotton didn't confine himself to Symbolist subject matter: His bold style served political or social comment as he depicted police repression, anarchist demonstrations, or fashion-conscious Parisians in satirical designs published by the *Revue Blanche* and other periodicals. Though he carried on producing woodcuts until 1915, the 1890s remain his most original and prolific period in the medium.

Catherine Marcangeli

Date 1891

Birth/Death 1865–1925

Nationality Swiss

Why It's Key The Nabis painter produces his first woodcut, heralding innovative developments in the medium.

Key Artist **Paul Peel**
After the Bath wins bronze medal at Paris Salon

Born in London, Ontario of English parents, Peel was encouraged by his father, a drawing instructor and stone-carver. He studied under the English-born landscape and portrait painter William Lees Judson, who instructed him in the academic style. One of Peel's painting from this period won a prize at London's Western Fair in 1876. For the next three years, he studied at the Pennsylvania Academy of Fine Arts in Philadelphia with Christian Schussele and Thomas Eakins. In 1881, Peel painted at the artists' colony in Pont-Aven, Brittany, then moved to Paris where he enrolled in the Ecole des Beaux-Arts. His painting *La Première Notion* was accepted for the Salon of the Société des Artistes Français in 1883.

Returning to Ontario that fall, he won seven prizes at the Western Fair. Back in Pont-Aven, he was influence by the *juste milieu*, a compromise between the academic style and Impressionism. There in 1886, he met the Danish-born painter Isaure Fanchette Verdier, whom he married. He visited London, England, where seven of his works were exhibited in the Colonial and Indian Exhibition.

Back in Paris, studying at the Académie Julian with George Agnew Reid, his interest turned to the nude. *The Venetian Bather* and *The Modest Model* were shown at the Salon of 1889. Then, in 1891, he won the bronze medal for *After The Bath*. Sought after by collectors including Sarah Bernhardt, it was bought by the Hungarian government, but now hangs in the Art Gallery of Ontario. Peel died the following year, possibly of influenza.

Nigel Cawthorne

Date 1891

Born/Died 1860–1892

Nationality Canadian

First Exhibited 1876

Why It's Key Acknowledgement in Paris of the most influential Canadian painter of the period.

35

Key Artwork *Aristide Bruant at Les Ambassadeurs*
Henri de Toulouse-Lautrec

The Moulin Rouge was opened by Charles Zidler on October 5, 1889, on the boulevard de Clichy, Paris. Although Lautrec had a table permanently reserved, it was Jules Chéret who designed the inaugural poster. He had been producing commercial coloured lithographs since the 1860s, using a print technique invented in 1798 by Lois Senefelder. Chéret was well established as a poster artist, with a distinctive line in attractive females, not dissimilar in effect to Tiepolo.

In 1891, Zidler asked Lautrec for a replacement for Chéret's original and he created one of his most famous lithographs, *The Moulin Rouge – La Goulue*, featuring the celebrated dance duo of La Goulue (Louise Weber) and Valentin (Jules Renaudin). Lautrec draws on Japanese print techniques to capture the sense of an evening event, right down to the lanterns, which are seen only in outline, yet keep the image bright.

A year later, Lautrec was commissioned by Ducarre of Les Ambassadeurs to create an artwork for his old friend, Aristide Bruant. The singer's signature image of large brimmed hat, flamboyant scarf, walking stick, and great cloak, was translated into a dynamic graphic design – once again drawing on Japanese woodblock influences. So remarkable did this poster become across Paris, that it was reworked in variations on other occasions – where Bruant only needed to be seen in silhouette to be immediately recognized. The lithograph came of age – as an original artists' medium and not merely a process of reproduction.

Mike von Joel

Date 1892

Country France

Medium Lithograph in colors

Collection Bibliothèque Nationale, Paris

Why It's Key The artist's friendship with the celebrated cabaret singer Aristide Bruant introduced him to source material that dominated his painting from 1885 onwards. By return, his graphic work for Bruant would make the singer famous throughout France.

Key Artist **Edvard Munch**
Exhibition in Berlin closed after a week

Munch was born into a middle-class family that was plagued with ill health and mental illness. "Illness, insanity, and death were the black angels that kept watch over my cradle and accompanied me all my life," he would recall. One of his early masterpieces is *The Sick Child*, depicting his sister, who died of tuberculosis at the age of fourteen, when Munch was five.

To escape his bourgeois roots, he joined a bohemian group of writers and artists who believed in free love. Largely self-taught, he quickly outgrew the prevailing naturalist aesthetic in Norway, and after a trip to Paris in 1889 he began experimenting with Impressionism, then Post-Impressionism. He was also influenced by sexually explicit French Decadent Symbolist poetry. His frank, emotionally tortured work was savaged by Norwegian critics. In 1892 Munch was invited to exhibit by the Union of Artists in Berlin, but his work was received no better there and the Union voted to close his exhibition after one week. However, the scandal made his name in Germany. He painted his most famous work, *The Scream*, there the following year. In a series of works called *The Frieze of Life*, he examines the anguish caused by love. Illness and death are also recurring themes, as part of the angst of modern life.

He suffered a nervous breakdown in 1908 and returned to Norway in 1910, where he remained until his death in 1944. He bequeathed his remaining work to the city of Oslo, where is it on display in the National Gallery and the Munch Museum.

Nigel Cawthorne

Date 1892

Born/Died 1863–1944

Nationality Norwegian

First exhibited 1889

Why It's Key Precursor of Expressionism in his portrayal of human angst.

Key Artist **Ferdinand Hodler**
The Night causes a sensation in Paris

Born in Berne to a poor family, Hodler was orphaned at the age of twelve. After working as a sign painter, he studied under Ferdinand Sommer, who produced landscapes for tourists. In 1872, he moved to Geneva where he became a pupil of Barthélémy Menn at the Ecole des Beaux-Arts. He began producing idealized portraits of artisans, though continuing to paint landscapes. *Surprised by the Storm* was exhibited at the Concours Diday biennial in 1886.

His first success came with *The Night*, a multi-figured Symbolist picture with the themes of sleep, dreams, and death. He had moral misgivings about exhibiting it in Geneva, but in 1892 he showed *The Night* in Paris. This brought Europe-wide acclaim; he won a gold medal at the Paris World's Fair in 1900, and joined the Munich Sezession in 1903.

Hodler also accepted commissions for large-scale public works with patriotic themes, producing murals for the Schweizerische Landesausstellung in Geneva; the Weapons Room of Schweizerisches Landesmuseum in Zurich, including the controversial *Retreat of the Swiss Troops near Marignano*; the *Departure of the Jena Students for the Napoleonic Wars* for Universität Jena; and a series of civic scenes for the Rathaus in Hanover.

In 1913, he was awarded the Legion of Honor. The following year, he signed a protest against the bombardment of Reims Cathedral and was barred from all German artists' organizations. His last years were marked by illness and depression, though his work continued to be influential.

Nigel Cawthorne

Date 1892

Born/Died 1853–1918

Nationality Swiss

First Exhibited 1886

Why It's Key European-wide acclaim for most important Swiss painter of the late-nineteenth and early-twentieth century.

Key Event
Sezession

A series of Sezessions – or Secessions – took place when artists split from groups supported by the state or establishment in the German-speaking world, and embraced progressive styles. This started in Munich in 1892, when a hundred artists lead by Wilhelm Trübner and Franz von Stuck broke away from the official Artists' Association. The progressives had had the upper hand on juries for the association's salon, but when members voted for a more evenhanded approach to traditionalists, they seceded to form their own exhibiting society.

In 1897, nineteen artist who favored Art Nouveau resigned from the Association of Austrian Artists to form the Vienna Sezession under Gustave Klimt. Then in 1899, when the jury of the conservative state-run Association of Berlin Artists' salon rejected a landscape by Walter Leistikow, sixty-five young artists left to form the Berlin Sezession under Max Liebermann. It went on to champion Impressionism and Post-Impressionism. Other Sezessions were formed in Dresden, Düsseldorf, Karlsruhe, Leipzig, and Weimar.

In Budapest there was the Szecesszió which lasted from 1896 to 1914, and Rome had La Secessione in 1913. Other secessions took place under other names, such as Prague's Mánes Union of Artists in 1895 and Kraków's Sztuka Polish Artists Society in 1897. There were even secessions from secessions. In 1910, members of Die Brücke under Max Pechstein broke away from the Berlin Sezession to form the Neue Sezession.

Nigel Cawthorne

Date 1892

Country Germany

Why It's Key Rejection of the artistic establishment in favor of the avante-garde.

Key Artwork *The Scream*
Edvard Munch

Throughout his life, Edvard Munch (1863–1944) is known to have been on a continual spiritual quest. He considered art a vocation. In one moment, during recovery from alcoholism and overwhelming emotional upheaval, Munch had written: "I feel I have been loyal to the angels and that in this, my moment of greatest need, they will not desert me now."

Could *The Scream* have represented both an unconscious cry for help and a moment of awakening in the journey of a soul? This picture was painted not long after Europe witnessed blood red skies in the wake of the volcanic eruption of Krakatoa. Was something in Munch's own psyche also coming up for healing? The atmosphere swirls with alternatives, ranging from extreme danger to possibility. A fence railing divides the emotional landscape. Perhaps, on some level, it represents a division within the inner self. Is there some kind of war going on? Munch was an intuitive. He was highly sensitized to both nature and the world around him.

Munch had already lost both parents, a favorite sister, and witnessed mental illness. He had also experienced ridicule and rejection over his painting. Who are the two figures in the background? Are they also part of Munch's inner landscape? Are they simply following or are they watching, whispering, even passing judgement? Are they sleepwalking? Munch understood despair, and the pain of feeling judged, isolated, or misunderstood. He had also found a way to channel these strong emotions into his work.

Carolyn Gowdy

Date 1893

Country Norway

Why It's Key *The Scream* is Munch's best-known painting. It was part of a series later titled *The Frieze of Life*. Munch made numerous variations of this image. He also translated it into a black and white lithograph in 1895. Through his paintings and prints, Munch became associated with Symbolism and is also recognized as a precursor of Expressionism.

Key Artist **Alphonse Mucha**
Designs poster for Sarah Bernhardt

In 1894, a struggling Czech artist in Paris was alone on Christmas Day at the Lemercier printworks, proofing some lithographs, when Lemercier's manager rushed in and said Sarah Bernhardt needed a poster by New Year's Day – for Sardou's play, *Gismonda*, at the Théâtre de la Renaissance. Alphonse Mucha volunteered to work over the holiday, and on January 1, 1895, it was published. Bernhardt so loved Mucha's work that she tied him into a contract to design her posters, theater cards, and programs, plus costumes and stage sets – a collaboration that often extended to the whole production. Mucha was an overnight success at the age of thirty-four.

Alphonse (Alfons) Mucha had moved to Paris in 1887 to continue his studies at the Académie Julian whilst doing magazine illustration to survive. He briefly shared a studio with Gauguin, and gave impromptu art lessons at his lodgings. Ten years later he had a new studio, his first one-man show, and was publishing graphics with Champenois. Mucha also illustrated lavish books, *Ilsée* (1897) and *Le Pater* (1899). At the Paris World's Fair in 1900, he designed the Bosnia-Herzegovina Pavilion, and was forever associated with the Art Nouveau style – much to his personal chagrin.

He returned to Prague in 1910 to paint what he considered his masterpiece, *The Slav Epic*, a series of huge paintings depicting the history of the Slavic peoples. It was gifted to the city in 1928. Mucha's style enjoyed a revival in the 1960s, most evident in psychedelic rock posters and the work of British designers Michael English and Nigel Waymouth.
Mike von Joel

Date 1894

Born/Died 1860–1939

Nationality Czech

Why It's Key The chance commission to create a poster for "the most famous actress in Paris" elevated Mucha from penniless unknown to a household name, whose work epitomized the Art Nouveau style influence on graphic design in the Belle Epoque.

Key Artist **Laura Muntz Lyall**
Shows at Société des Artistes Français in Paris

Born in Warwickshire, England, Lyall emigrated with her family to Canada when she was a child, settling on a farm in the Muskoka District of Ontario. As a young woman she studied to be a school teacher, but her interest in art led her to take lessons in painting technique from W.C. Forster of Hamilton, Ontario. She returned briefly to England to study at the St John's Wood Art School in London. Then she moved on to Paris to study at the renowned Académie Colarossi, set up in opposition to the conservative Ecole des Beaux-Arts, which accepted female students and allowed them to draw from the male nude. There she was greatly influenced by the Impressionists.

Some of her work was exhibited at the World Columbian Exposition in Chicago, Illinois, in 1893. Then in 1894, she exhibited at the Société des Artistes Français in Paris. The following year she received an honorable mention at the Paris Salon, and became an Associate of the Royal Canadian Academy.

Returning to Canada in 1898, Lyall took a studio in Toronto, taught classes and became the first woman to be invited to exhibit at the Canadian Arts Club. However, at the age of fifty-five she married her widowed brother-in-law and took over the upbringing of her sister's eleven children. Resuming her career at sixty-four, she lived only a few more years, dying in 1930. Her work can be found at the National Museum of Canada.
Nigel Cawthorne

Date 1894

Born/Died 1860–1930

Nationality Canadian-British

First Exhibited 1893

Why It's Key First Canadian woman painter to achieve international recognition.

Key Artwork *In the Garden*
Edouard Vuillard

In the Garden is one of a series of seven large decorative panels (measuring 214 x 92cm) commissioned by the Natansons, who were good friends and prominent art patrons. Vuillard (1868–1940) was a master of subtle inference, both in his interior and outdoor scenes. In the words of the author Andre Gide, "Vuillard speaks almost in a whisper – as is only right when confidences are being exchanged."

These panels, although impressive, were not intended for public display but for the pleasure of a new generation of bourgeois patrons who wished for art that reflected their lifestyle. Figure groups, especially female, are shown chatting as children play around them. People almost become decorative objects arranged across the picture plane, with large areas of flat color (sand or sky, for example) suggesting the newly fashionable influence of Japanese prints.

Technically innovative, Vuillard used distemper instead of oil, providing a matt, non-reflective surface almost like that associated with fresco. Vuillard manages to transcend the mundane world around him, achieving an equilibrium and dreamlike harmony similar to contemporary music, exemplified in the works of composers such as Debussy and Ravel. Vuillard worked on eight different decorative projects between 1892 and 1899. He not only produced panels but also folding screens and ceramics, all of which express his desire to merge tradition with modernity.
Lucy Lubbock

Date 1894–5

Country France

Medium Distemper

Collection Musée d'Orsay, Paris

Why It's Key *In the Garden* is an important expression of the Nabis aesthetic.

Key Artwork *Le Grand Pont, Rouen*
Camille Pissarro

Pissarro's (1830–1903) view of Pont Boieldieu in Rouen is among several views of this city from his last years. Of all the Impressionists, he was perhaps one of the most conservative and restrained, more of a tonal painter than a colorist, in contrast to, for example, Monet. However, he did share Monet's preoccupation with painting in series, whether of Paris or of the port cities. In 1896 he stayed at the Hotel d'Angleterre for three months, his hotel window being the vantage point to survey the bustle of the city while remaining anonymous.

In the townscapes of this period, Pissarro retains an interest in traditional compositional format, perspective, and a geometric framework; note the sense of depth created by the diagonal of the bridge balanced by the verticals of chimneys and masts. However, his use of paint is freer and more experimental than before.

Pissarro is one of the most serious Impressionist painters in this genre, especially in his concentrated topographical analysis of weather conditions and locations. He was absorbed by the metropolitan culture of France (even though he spent most of his early life in the Caribbean), and had many friends and pupils, including Gauguin. It is no coincidence that all his sons became painters – notably, Lucien. Pissarro's work sold well, this painting, in 1900, being the first to enter an American museum.
Lucy Lubbock

Date 1896

Country France

Medium Oils

Collection Carnegie Institute, Pittsburgh

Why It's Key Typical work by a veteran Impressionist.

Key Person **William Morris** Death of the influential writer, craftsman, political thinker, and designer

After leaving Oxford University in 1855, William Morris, the son of a wealthy businessman, decided to devote his life to art. His ambition as a painter, however, was short-lived and by the 1860s he had decided his future lay in the decorative arts, tied in with an increasing commitment to political ideas.

A fervent socialist, Morris believed that the basis of art was decorative design and for ordinary people this meant the everyday designs of their environment. He reasoned that a "rebirth" of pure art could only come about by improving the conditions of the working classes, and to this end he campaigned on the political front while developing his own output as a designer.

This craft-based theory of art, along with a romantic admiration for the Middle Ages and a contempt for nineteenth-century English art, led to him setting up "The Firm" to design and manufacture furniture, fabrics, and wallpapers (the latter two would be his best-known legacy). The company, later renamed Morris & Co, which was equally famed for its stained glass, also employed the designs of the leading Pre-Raphaelite painters Edward Burne-Jones, Dante Gabriel Rossetti, Ford Madox Brown, and the pioneering Arts and Crafts architect Philip Webb.

The subsequent Arts and Crafts movement, which spearheaded British design in the Art Nouveau era of the early twentieth century, sprang directly from Morris' work. His notion that the artist/designer should be familiar with craft techniques and "honor" his material would resonate again later in the century as one of the founding principles of the Bauhaus.
Mike Evans

Date 1896

Born/Died 1834–1896

Nationality British

Why It's Key William Morris is the principal founder of the British Arts and Crafts movement.

opposite **Morris' Cray pattern** (printed cotton), 1884.

41

Key Artist **Anders Zorn** Feted Swedish Impressionist returns to his birthplace, Mora

Three themes characterized Zorn's paintings and etchings: portraits, nudes, and scenes of country life in his home province Dalarna, Sweden. A well-traveled, cosmopolitan artist who had had three U.S. presidents and several prominent businessmen sit for him, by his mid-thirties Zorn felt a strong yearning for his roots. He had always spent summers in Sweden and in 1896 he settled in the town where he had been raised by his maternal grandparents, building a house there (now a museum to him) and encouraging the revival of old local customs.

His admission to the Stockholm Academy of Fine Arts when aged fifteen acknowledged Zorn's precocious talent for drawing. Regarding the school as outdated and conservative, in 1881 he left for London, and then lived in Paris until 1896. During these years he also visited Spain, Italy, the Balkans, the United States, and North Africa. Initially exclusively a watercolor painter, he had turned to oil by 1890, developing a heavy impasto technique with luminous paint. The hallmark of his style was its vibrant brushwork, suggesting spontaneity, although his greatest strengths were his ability to bring a heightened sense of physicality to the paintings and to distribute mass within pictorial space.

While the predominant Nordic landscape idiom expressed abstract concepts of isolation and loneliness, Zorn's rural images seethed with creative and erotic impulses from nature. Red and green were favorite colors, and rural life was shown to provide the best remedy to the severe practical difficulties of the city.
Martin Holman

Date 1896

Born/Died 1860–1920

Nationality Swedish

Why It's Key Internationally successful and cosmopolitan Swedish portrait and landscape painter with vigorous Impressionist style.

Key Event
Vienna Secession

The term secession is a general one, German in origin, indicating the withdrawal from an established order. In art terms, it refers to activities by artists of the Belle Epoque who rebelled against the conservatism of the Associations and Salons that governed official exhibition platforms. The Munich Secession group was formed in 1892 in the same year Max Liebermann (later with Lovis Corinth) led the Berliner Secession, and in 1913 the Freie Secession involved Max Beckmann and Ernst Barlach. However, the most famous secession group is the Vereinigung Bildener Künstler Oesterreichs, founded in 1897 and generally known simply as the Vienna Secession.

The Vienna Secession had the advantage of electing one of the greatest of all Symbolist painters, Gustav Klimt, as its president. In 1898 the architect Joseph Olbrich was commissioned to build in the center of Vienna an exhibition hall, which became an architectural gem and masterpiece of Art Nouveau architecture. It housed Klimt's famous mural, the *Beethoven Frieze*. Above its entrance is carved the following: To the Age its Art. To the Art its Freedom.

Architecture and design were key elements and the Vienna Secession was heavily instrumental in the beginnings of modern design. In 1903, the Vienna Workshops, inspired by the English Arts and Crafts movement, was launched, and its creations are collectors' items today. Egon Schiele and Oskar Kokoschka were also associated with the Vienna group and, overall, it played a significant role in the general Art Nouveau explosion.

Mike von Joel

Date 1897

Country Austria

Why It's Key The major secessionist group, led by Gustav Klimt, is founded.

42

Key Artwork *La Trappistine*
Alphonse Mucha

The Czech artist Mucha (1860–1939) was by the late 1890s one of the leading graphic artists working in Paris. In particular his posters showing the actress Sarah Bernhardt brought him immediate fame as a leading exponent of Art Nouveau. The style, with its swirling patterns, curved lines (often epitomized by the beautiful form of a nymph-like girl), and floral motifs were to be found on anything from posters advertising beer or bicycles, to jewelry designs and book covers.

Mucha's output truly bridges "high" and "low" art. In *La Trappistine*, an elegant stylized figure in a typically elaborate headdress is both saintly female and advertiser of a beverage. The word "Trappistine," derived from *trappiste* for monk, or in this case, nun, alludes to her saintliness, as does the religious setting suggested by the stained-glass roundel behind her.

The subject, however, is secondary to decorative splendor – Mucha employs all his graphic skill (as well as the new innovations and possibilities introduced with color lithography) to create a pleasing, striking images. Mucha's work influenced many contemporaries – he also wrote his own style guide, *Documents Decoratifs*, in 1901. His legacy – which includes the revival of Art Nouveau graphics in the album covers and poster designs of the 1960s counterculture – as one of the most important European graphic artists of the period is unquestioned.

Lucy Lubbock

Date 1897

Country France

Medium Lithograph

Collection Suntory, Osaka, Japan

Why It's Key An excellent example of Art Nouveau graphic design.

Key Artist **Aubrey Beardsley**
Influential Art Nouveau illustrator dies at 25

A gifted child, Beardsley was just six years old when he first contracted the tuberculosis that would kill him. In 1889 haemorrhaging forced him to give up his job as an insurance clerk in the City of London. While trying to make his way as a writer, a meeting with the artist Sir Edward Burne-Jones led to his attending evening classes at the Westminster School for Art.

In 1892, he was commissioned to produce illustrations for a new edition of Sir Thomas Malory's *Le Morte D'Arthur*, and in 1894 he became art editor of the new literary and artistic quarterly *The Yellow Book*. That same year, he became notorious for the morbid sensuality of his illustrations for Oscar Wilde's play *Salomé*, with his bold pen-and-ink drawings that were heavily influenced by Japanese woodcuts. Although Beardsley was not a homosexual, he was dismissed

from *The Yellow Book* in 1895 in the wake of the scandal surrounding the trial of Oscar Wilde. He launched a new magazine called *The Savoy*, and continued illustrating books and plays, notably Alexander Pope's *Rape of the Lock* and Aristophanes' *Lysistrata*. He also published poems and wrote an unfinished novel, *Under the Hill* (1903).

From 1896 Beardsley was an invalid. Converting to Catholicism, he moved to France, where he died in 1898. His work was widely known and admired; influential in Art Nouveau and the Symbolist movement, it enjoyed a revival of popularity in the Art Nouveau-inspired "psychedelic" illustration of the late 1960s.

Nigel Cawthorne

Date 1898

Born/Died 1872–1898

Nationality British

First Exhibited 1893

Why It's Key Beardsley was a leading illustrator in the Aesthetic movement.

Key Artist **Gwen John**
Visits Paris for six months

Gwendolen Mary John was overshadowed in life by her flamboyant younger brother, Augustus. She had followed him to the Slade School in 1895, followed by a six-month sojourn in Paris at James McNeill Whistler's newly established Académie Carmen.

In 1904, John moved permanently to Paris, possibly to escape the omnipresence of her brother. There she began to model for the sculptor Auguste Rodin and soon became his mistress – a relationship that lasted fourteen years, until Rodin's death in 1917. She wrote him more than two thousand obsessive letters, now at the Musée Rodin in Paris, and in 1911 moved to Meudon, a suburb of Paris, to be close to him. In 1913, she became a Roman Catholic – the same year she showed in the famous New York Armory Show (*Girl Reading at the Window*).

A quirky, isolated woman given to passionate obsessions, John nevertheless had made significant friendships earlier in her career: the poet Rainer Maria Rilke; Symbolist Arthur Symons; and John Quinn, a New York connoisseur of the avant-garde who served as her exclusive agent. She had met leading artists of the day, including Picasso, Braque, and Matisse and thought Rouault "the greatest painter of our day." Her manic and intense friendship with Vera Oumançoff, sister-in-law of Jacques Maritain, has led to claims of a lesbian association.

Gwen John's oeuvre, fewer than two hundred paintings but at least several thousand drawings, has only recently been reassessed as a significant contribution to Post-Impressionist art.

Mike von Joel

Date 1898

Born/Died 1876–1939

Nationality British

Why It's Key Gwen John gained her independence from her brother, Augustus John, and associated with some of the giants of the modern art movement, temporarily offsetting her predilection for seclusion and morbid isolation.

Key Artist **Aristide Maillol**
Nabis painter turns to sculpture

Aristide Maillol began his career as a painter, closely associated with Gauguin and the Nabis, alongside whom he often exhibited. Around 1892 he began to take an interest in tapestry making and two years later he carved his first wood sculpture. In 1898 the Parisian dealer Ambroise Vollard arranged for the first bronze cast to be made of one his sculptures and thereafter, while he continued to work in other media, it was as a sculptor that Maillol made his name.

Acclaimed early on as the heir to Rodin, Maillol nonetheless eschewed the older sculptor's expressiveness in favour of a serene classicism that harked back to Greek and Roman traditions. His subject was almost exclusively the female nude: even the memorials he made to Cézanne (1912–25) and the writer and aviator Antoine Saint-Exupéry (1938) are monumental, recumbent female figures. Despite this narrow obsession, his work was continuously varied and inventive: his women, for instance, can be either brazenly erotic or shyly chaste.

Maillol achieved widespread recognition between the wars, both in Europe and America: his 1910 *Ile de France*, a life-size torso of a young girl walking through water, was the first major work to enter MoMA's permanent collection in 1929. It is now in the Metropolitan Museum of Art. Although represented in many museums (including the Musée Maillol in Paris), his large-scale sculptures are invariably best seen outdoors, where the natural surroundings emphasize their earthy forms and swelling contours, as in the Jardins du Carousel beside the Louvre.

James Beechey

Date 1898

Born/Died 1861–1944

Nationality French

Why It's Key Prompted by failing eyesight, Maillol's move to sculpture heralded a career which celebrated the classical tradition in a modern context.

Key Event
Founding of the World of Art group

The World of Art group was founded in St Petersburg, Russia, in 1898 by a group of students that included Alexander Benois, Konstantin Somov, Dmitry Filosophov, Leon Bakst, and Eugene Lansere. They organized the Exhibition of Russian and Finnish Painters at the Baron Schtieglitz Museum of Applied Arts in St Petersburg.

The following year, the *World of Art* magazine was founded with Sergei Diaghilev as its editor-in-chief. It attacked the low standards of the old Peredvizhniki school and promoted artistic individualism, calling for "Art for Art's sake," and the principles of Art Nouveau. The magazine, and the movement, concerned itself not just with painting, but with theater, book design, applied art, furniture, and interior design. Meanwhile it continued to hold exhibitions.

The first association existed up to 1904, when it divided into separate Moscow and St Petersburg groups, and the magazine ceased publication. In 1906, Diaghilev moved to Paris where, in 1909, he founded the Ballets Russes. Many members of the movement followed him to Paris to make their contribution to its productions. This gave the movement huge influence, though few people in the West saw issues of the magazine itself.

In 1910 the World of Art was revived by Alexander Benois as an exhibition organizer in Russia. It continued up to 1924, though the last exhibition was held in Paris in 1927. About 150 artists exhibited in its numerous exhibitions in Russia and abroad.

Nigel Cawthorne

Date 1898

Country Russia

Why It's Key Beginning of the revolutionary artistic movement whose influence would spread to France and elsewhere.

Key Person **Sigmund Freud**
Publishes *The Interpretation of Dreams*

While working with hysterical patients in Vienna in the 1880s and 1890s, Freud developed the theory of psychoanalysis. Mental problems, he believed, were caused by repressed memories, particularly of infantile sexual desire toward the sufferer's parents that inhabited the unconscious mind, and that a cure could be obtained by exploring these through a lengthy talking therapy. He outlined these theories in *Studies in Hysteria* published in 1895.

The "royal road" to understanding the unconscious mind, Freud said, were dreams. In 1899, he published *Die Traumdeutung*, which appeared in English as *The Interpretation of Dreams* in 1913. In it he sought to explain the meaning of his own dreams, and those recounted in his clinical practice, and maintained that the mind's energy – which he called libido – was primarily sexual. Later, in *Beyond the Pleasure Principle*, published in 1920, he postulated the "death instinct" which ran alongside sexuality and manifested itself as aggression. He also ventured into art criticism, writing studies of Leonardo da Vinci and Michelangelo's *Moses*, though these are now seen to be flawed.

While Freud showed little interest in contemporary art, his views on the unconscious and dreams were appropriated by the Surrealists. After a meeting with Salvador Dalí in London in 1938, Freud remarked wryly that it was Dalí's conscious mind that interested him.

Much of psychoanalysis has been discredited, and the evidence Freud based his theories on later held to be bogus. His grandson is the great English painter Lucian Freud.

Nigel Cawthorne

Date 1899

Born/Died 1856–1939

Nationality Austrian

Why It's Key Founder of psychoanalysis, which became one of the inspirations for Surrealism.

1860–1909

Key Artist **Max Liebermann**
Founding of avant-garde Berlin Secession

After studying under Carl Steffeck and at the Art School in Weimar, Liebermann became a leading figure in the anti-establishment Naturalist movement. Exhibiting his *Women Plucking Geese* in 1872, he was branded an "apostle of ugliness" and a "painter of filth." Visiting France in 1873, he studied the work of Gustave Courbet and Jean-François Millet, and continued to depict peasants involved in manual labor, leading some German critics to suspect that he was a political revolutionary.

Spending his summers in the Netherlands, he found new subjects for his Realism in the asylums and orphanages of Amsterdam, while continuing to portray manual laborers in Holland and Germany. While becoming a member of the Berlin Academy, he was also the founder and leader of the Berlin Secession (Sezession) of 1899, which promoted the academically unpopular styles of Impressionism and Art Nouveau. By this time, his own work showed influences of Edouard Manet and Edgar Degas. However, his refusal to accept the young Expressionists forced his resignation in 1911.

Liebrmann became president of the Academy in 1920, and was one of the most popular painters of the Weimar Republic. But as the victim of increasing attacks by Nazi agitators, he was forced to resign in 1932. He died three years later, and his wife committed suicide when forced to leave their home in Wannsee, which now houses a permanent collection of his work.

Nigel Cawthorne

Date 1899

Born/Died 1847–1935

Nationality German

First Exhibited 1872

Why It's Key Leading figure of German Impressionists breaks with conservative Berlin salon to found the Berlin Secession.

Key Artwork *Apples and Oranges*
Paul Cézanne

One of six related still lives painted between 1898 and 1899 where the artist explores the spatial and decorative possibilities of similar elements arranged on a table; fruit, vases and drapery. In this most complex and sumptuous composition there are apples on a plate and oranges in a compotier, with the remaining fruit scattered on a ruffled white cloth next to a faience jug – relatively simple objects set against the richly patterned carpet and drapery.

Each element is balanced by its opposite: in the color the deep brown, violet, green, and red of the carpet contrast with the creamy impasto applied to the whites (there are also subtle colored reflections on the cloth); in the form the perfect roundness of the fruit is set against numerous folds of cloth and carpet. Objects are arranged in a diagonal configuration rising from the lower left to the upper right, creating a tension between planar and volumetric space. Cézanne (1839–1906) applied the same exacting techniques to many scenes of Mont Sainte Victoire and to his series of figure compositions, *Large Bathers*, all dating from this most productive period. He was already well known and selling well, and even Monet and Gauguin owned works by him, or encouraged other collectors to recognize his talent.

Lucy Lubbock

Date c. 1899

Country France

Medium Oils

Collection Musee d'Orsay, Paris

Why It's Key A dynamic, early example of the still life in modern art.

Key Artwork *Water Lily Pond (Japanese Bridge)*
Claude Monet

In 1883, Claude Monet (1840–1926), the dean of Impressionism, glimpsed the sleepy village of Giverny from a window seat in a train and decided to rent a house there. Over the next forty-three years, Giverny would become the center of Monet's aesthetic universe. It was here, in the gardens of his French country house, that Monet would indulge a gentle obsession with depicting his lily pond and the Japanese bridge that crossed it. Monet worked on this landscape tirelessly for over three decades – sometimes, as in *Water Lily Pond (Japanese Bridge)*, stepping back twenty feet from the scene, but later in his career focusing in on individual floating lilies and small-scale color and reflection effects in the water.

Monet did not intend his vast numbers of water-lily landscapes to serve as atomic realities; although they efficiently captured the light effects of a particular moment and the subtle variations of perspective, they were meant to be encountered as a serial whole, an endless landscape. It is therefore useless to consider *Water Lily Pond (Japanese Bridge)* as essentially different from its many cousins. It is part of a larger narrative, one of the most ambitious and successful undertakings in art, concerned with examining miniature, humbler life at the very moment in European history dominated by themes of titanic life: the superman and the super-state. Monet's vision calmly de-aggrandized Europe's *homo tyrannicus* and insulated his own tiny cosmos of Giverny against decay. The supermen and super-states collapsed, but the water lilies remain.

Demir Barlas

Date 1900

Country France

Medium Oil on canvas

Collection Museum of Fine Arts, Boston, Massachusett

Why It's Key This painting is one of the first in a series of works centered on Monet's celebrated water garden at Giverny, which came to dominate his work at the end of his life.

opposite *Water Lily Pond (Japanese Bridge)*

Key Exhibition
The Paris World's Fair

The twentieth century was greeted in Paris with the Exposition Universelle, which attracted nearly 50 million visitors during its seven-month run (April–November, 1900). Centered on the Champ-de-Mars, south of the Eiffel Tower, the 83,000 exhibits also occupied the magnificent Grand Palais and Petit Palais (both created specially for the occasion). Other Parisian landmarks built for the Exposition included the grandiose railway stations at Gare de Lyon and Gare d'Orsay. The latter has housed the major public collection of French Impressionist art since 1986, when it became the Musée d'Orsay.

As well as heralding Art Nouveau as the latest style in architecture and design, the exhibition displayed wonders including the earliest synchronizations of moving pictures and sound (pre-dating talkies by nearly thirty years), the debut of the escalator, and even Campbell's Soup, which was awarded a gold medal.

But it was the centennial exhibit of nineteenth-century French art at the Grand Palais that was most significant in the world of painting, with the Impressionists gaining an official stamp of approval for the first time. Degas, Manet, Monet, Pissarro, Renoir, Seurat, Sisley, and others were all represented in the breakthrough exhibition. Paul Cézanne, who occupied a place of honor with three pictures on show, was also represented, finally being recognized as an important figure in French painting – though the true significance of his work was still to be realized.

Mike Evans

Date 1900

Country France

Why It's Key The Paris World's Fair provided the first official recognition of the Impressionists.

opposite French painting delineating the 1900 Paris World's Fair.

48

Key Artist **Claude Monet**
First showing of the Giverny water lily paintings

Born in Le Havre, Monet was an early convert to painting outdoors, influenced by his friend and fellow resident Eugène Boudin. In 1859 he went to Paris to study at the Académie Suisse, where he met Camille Pissarro. Then, returning to Le Havre after military service, he met the Dutch landscape painter Johan Barthold Jongkind, perhaps his most potent influence, whom he credited with "definitively" educating his eye.

Back in Paris in 1862, he joined the studio of Charles Gleyre, the Swiss painter and distinguished teacher, where he met Pierre-Auguste Renoir, Alfred Sisley, and Frédéric Bazille. Together they formed the nucleus of the Impressionists, a name only conferred later, suggested by Monet's 1872 painting *Impression: Sunrise*. Devoted to painting outside, Monet once had a trench dug to allow him to work al fresco on a giant canvas that was raised and lowered on pulleys so he could reach all of it.

Self-exiled to London during the Franco-Prussian War (1870–71), Monet painted its rivers and parks before relocating to Argenteuil, a Parisian suburb that attracted other Impressionists. By 1883, he had moved to Giverny where he would paint many pictures exploring the same scene in different light conditions, and where he created the water garden that would become the focal point of his work. At the start of the twentieth century he created his series of water lily paintings, an ever looser and more impressionistic progression that resulted in the vibrant, fluid works that remain Monet's most famous legacy.

Graham Vickers

Date 1900

Born/Died 1840–1926

Nationality French

First exhibited 1865

Why It's Key The definitive Impressionist: the movement took its name from the title of one of his pictures.

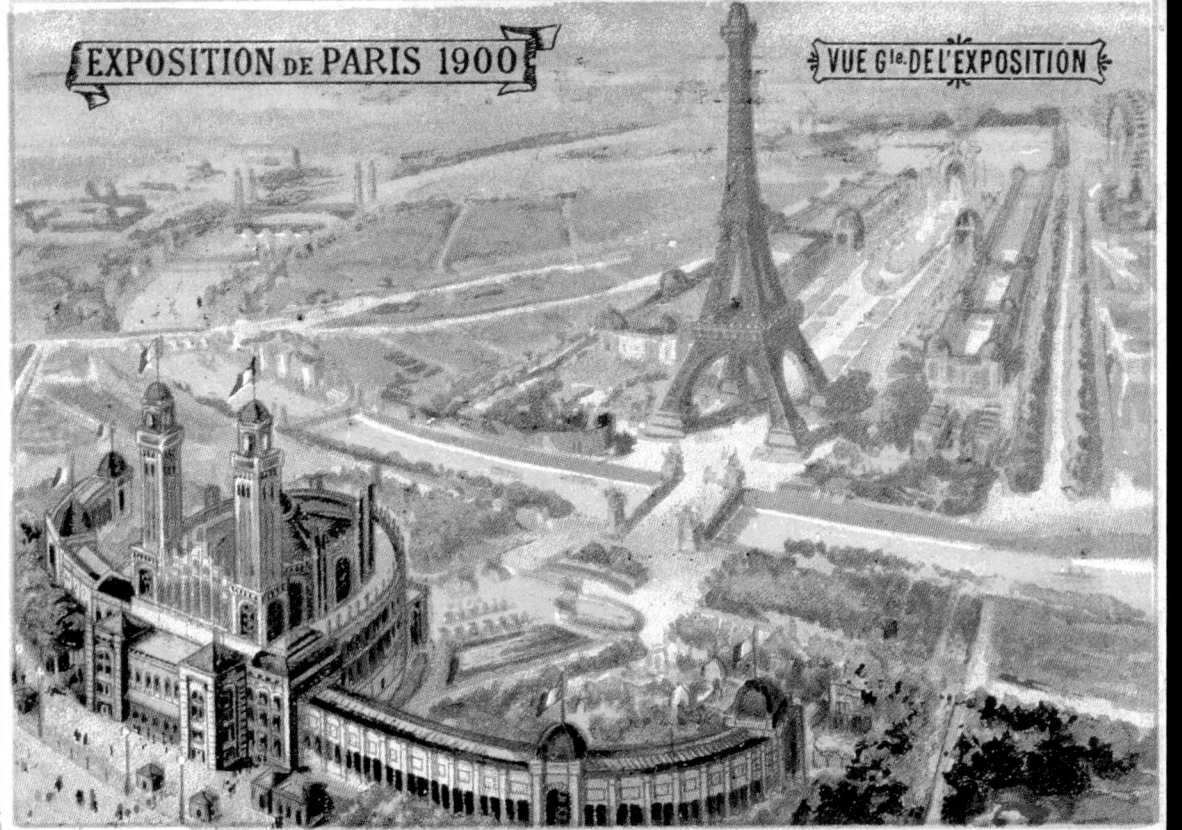

EXPOSITION DE PARIS 1900

VUE Gle. DE L'EXPOSITION

1860-1909

49

Key Person **John Ruskin**
Death of influential critic and collector

Born in London to wealthy, indulgent parents, Ruskin was a precocious child who studied voraciously, drew well, and wrote poetry. He went to Oxford in 1833 and from there made frequent trips to the Continent, publishing his first study of European architecture, "The Poetry of Architecture," in *Architectural Magazine* in 1837 and 1838.

In 1840, he met J.M.W. Turner, eulogized him in volume one of *Modern Painters*, published anonymously in 1843, and became his patron. He published *The Seven Lamps of Architecture* in 1849 and, in 1851, championed the Pre-Raphaelites who, in turn, had been influenced by his writings. *The Stones of Venice*, published between 1851 and 1853, inspired William Morris, pioneer of the Arts and Crafts movement.

Ruskin was involved in the design of the Oxford Museum of Natural History (now the University Museum) and, following Turner's death in 1851, cataloged his drawings for the National Gallery. In 1869 he was elected the first Slade Professor of Fine Art at Oxford. He became interested in idealistic politics and was an active member of the Utopian Guild of St. George. Then, in 1878, he suffered the first of a number of mental breakdowns and was insane for the last decade of his life.

Nigel Cawthorne

Date 1900

Born/Died 1819–1920

Nationality British

Why It's Key Champion of J.M.W. Turner and the Pre-Raphaelites, and inspiration to William Morris.

Key Artist **Paul Cézanne**
Official recognition at Paris World's Fair

Born in Aix-en-Provence, the son of a prosperous banker, Cézanne quit his law studies to become a painter. His school friend Emile Zola introduced him to Manet and Courbet. Having been refused entry to the Ecole des Beaux-Art in Paris, he studied at the Académie Suisse, where he met Pissarro and was later introduced to Monet, Renoir, Sisley, and Degas. Under their influence he experimented with Impressionism.

He exhibited at the Salon des Refusés in 1863, and at the first and third Impressionist Exhibitions in 1874 and 1877. However, he split from the Impressionists, explaining: "I wanted to make of Impressionism something solid and enduring, like the art in museums."

His work was savagely criticized and he had difficulty finding buyers. However, he continued his search for structure and solidity in his work, saying:

"Everything in nature is modelled after the sphere, the cone, and the cylinder. One must learn to paint from these simple figures."

From 1890 to 1905, he produced a stream of masterpieces: three versions of *Boy in a Red Waist-Coat*, ten variations of the *Mont Sainte-Victoire*, numerous still lifes, and the *Bathers* series, where he lent his new sculptural techniques to the classical nude.

Critical acclaim came with the Salon des Indépendants in 1899 and official recognition with three canvases hung in the Paris World's Fair. Younger artists who bought his work included Gauguin, Matisse, Duchamp, and Picasso, whose revolutionary *Demoiselles d'Avignon* clearly borrows from Cézanne's *Bathers*.

Nigel Cawthorne

Date 1900

Born/Died 1839–1906

Nationality French

First exhibited 1863

Why It's Key Leading Post-Impressionist, influential on Fauvism and Cubism.

opposite *Mont Sainte-Victoire Seen from la Route du Tholonet* by Paul Cezanne.

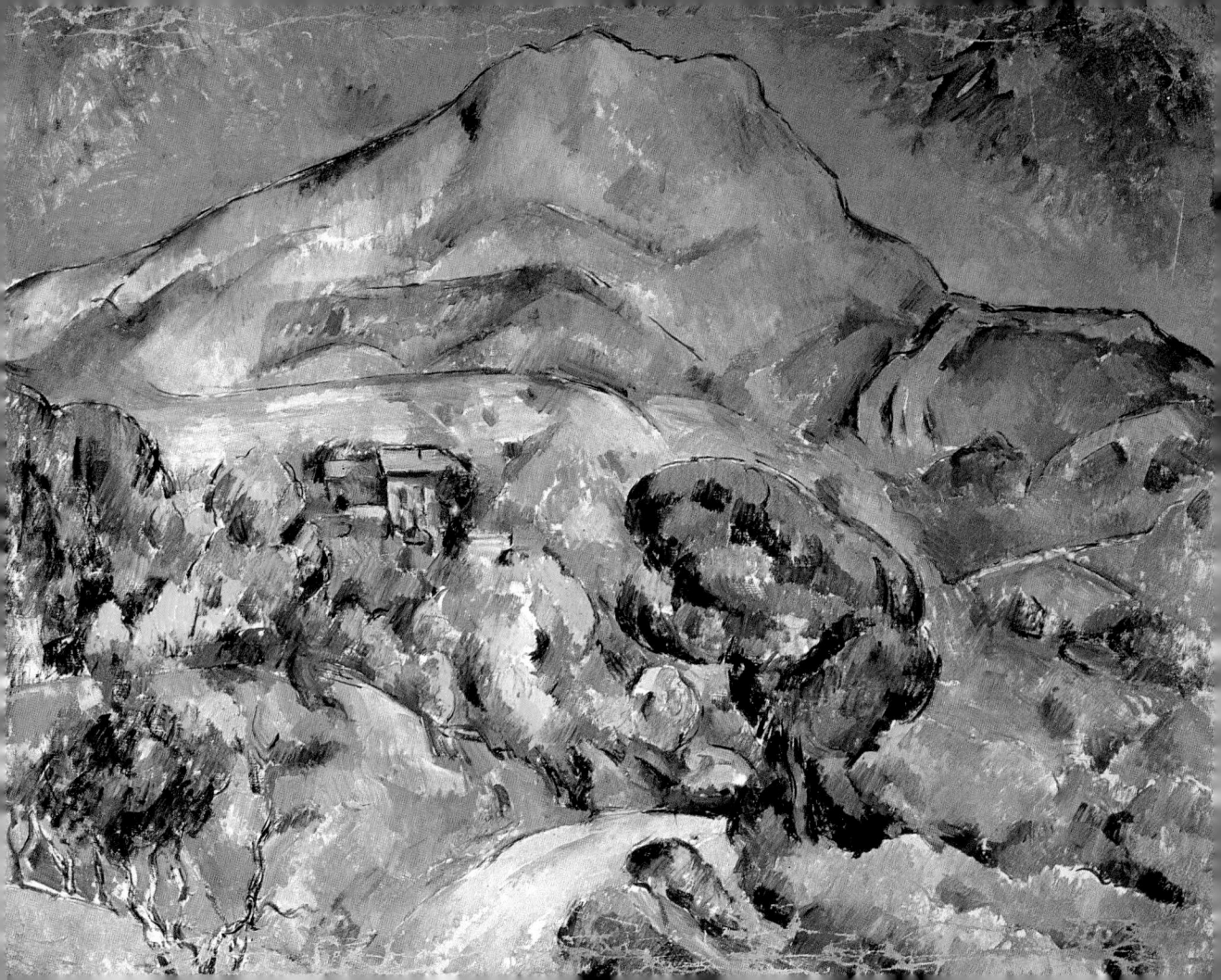

Key Artist **Mary Cassatt**
Helps introduce Impressionism to America

Mary Cassatt was born in Allegheny City, Pennsylvania into a wealthy family and enjoyed a well-traveled youth. She studied at the Pennsylvania Academy of Fine Arts from 1861 to 1865 but was disillusioned by the conservative teaching there and went to Paris, where she attended private classes. She studied the work of the Old Masters during extensive travels in Europe.

She settled in Paris, in 1874, and saw Degas' work the following year. Through her productive alliance with Degas, and her understanding of avant-garde ideas, she produced innovative paintings of bourgeois domesticity and leisure which demonstrate an economic draftsmanship and a vigorous handling of paint.

Her articulations of asymmetric compositional devices demonstrate her appreciation of Japanese printmaking. This was further developed by her visit to a Japanese print exhibition in 1890, after which she produced a series of inventive prints. By the 1890s she was pursuing these ideas in the spatial structures of her paintings, culminating in *The Boating Party* (1893–94), where she skilfully used flattened planes of color to focus attention on the central figure of a child. Some of her most intriguing paintings are those of women with children. These paintings demonstrate her use of ingenious formal methods to show the physical bond between mother and child.

Cassatt succeeded in a predominantly male profession, at a time when women's choices were circumscribed by late-nineteenth-century conventions.
Sarah Mulvey

Date 1900

Born/Died 1844–1926

Nationality American

Why It's Key In 1900 Cassatt was using her considerable influence to advise American collectors to buy French Impressionist works of art. Many Impressionist works were bequeathed to the newly formed museums in America's principal cities. Thus Cassatt helped to introduce avant-garde art to America.

Key Artist **Akseli Gallen-Kallela**
Triumph at the Paris World's Fair

Gallen-Kallela's importance for Finland went beyond his influence on the fine arts. He was the country's leading representative of Art Nouveau and implemented the idea that different art forms were equally important. His designs for textiles, furniture, metal embossing, and stained glass gave impetus to Finnish craft industries, and his woodcuts, especially depicting the national epic, the Kalevala, were unprecedented in Finnish graphics.

His painting style progressed in relation to the ideological and artistic developments of his times. While studying in Paris in 1884–90 with Jules Bastien-Lepage, his work displayed plein-air Naturalism, then shifted to liberal-national Romanticism before taking up a Symbolist approach by the early 1990s. His objective was to achieve a "Kalevala sense of reality"; not possible in Naturalism, the unified, decorative, and monumental forms of Symbolism encompassed the mystical undertone he sought in his imagery.

Gallen-Kallela's paintings show his powerful feel for nature as well as a romantic sense of patriotism, conveyed in his large-scale frescoes, like those in the Finnish pavilion at the 1900 Paris World's Fair. His spring 1890 trip to the eastern Karelia region, considered the source of the ancient Finnish spirit in its purest form, precipitated a movement among artists, writers, and composers. He traveled extensively, visiting East Africa and the USA, where Native American culture provided new inspiration for ornamental work. A new use of color appeared toward the end of his life, coinciding with his contact with German Expressionist painters.
Martin Holman

Date 1900

Born/Died 1865–1931

Nationality Finnish

Why It's Key Wide-ranging artist who became Finland's most noted Symbolist painter.

Key Person **Ambroise Vollard**
Art dealer gives Picasso first French exhibition

A large, gruff fellow, once described as "looking like a giant ape," Ambroise Vollard became one of the most important dealers at the vortex of the Paris art world from the 1890s until his death in 1939. Although a shrewd businessman – Vollard sold to adventurous collectors such as Leo Stein and Alfred Barnes – he kept the affection of the majority of his artists. His gallery on rue Lafitte, opened in September 1893, became the rendezvous for the avant-garde, and his cellar parties were a hot ticket for the fashionable art crowd. Picasso claimed "the most beautiful woman who ever lived never had her portrait painted, drawn, or engraved more often than Vollard."

Vollard first studied law in Paris before opening a gallery focused on the embryonic "School of Paris." He was fortunate that it was the golden age for modernist collectors with nerve and an "eye." With the profits he made from reselling Cézanne, Maillol, Picasso, Rouault, Gauguin, and van Gogh, Vollard published prints and illustrated books with original graphics commissioned from Maurice Denis, Odilon Redon, Degas, Rouault, Bonnard, Toulouse-Lautrec, and Picasso. All are now highly prized by collectors and museums.

As an author, Vollard wrote anecdotal biographies of his friends Cézanne, Renoir and Degas. In 1914, war forced Vollard to close his gallery. Afterwards he chose to operate as a private dealer and publisher from his home. He was killed in 1939, when his chauffeur-driven car skidded off the road on the way to Paris. The majority of his collection was sold, dispersed, or simply just disappeared during World War II.

Mike von Joel

Date 1901

Born/Died 1866–1939

Nationality French

Why It's Key This Parisian art dealer gave Cézanne, Picasso, and Maillol their first one-man shows and championed van Gogh and the Nabis.

Key Artist **Henri de Tolouse-Lautrec**
Death of visual chronicler of Montmartre life

B orn to an aristocratic family in Albi, South of France, Lautrec was disabled from childhood. Isolated from society, he dedicated himself to painting, and moved to Paris in 1872, finding refuge in the seedy district of Montmatre. There he studied with academic painters, but was influenced by Degas and Gauguin, joining the Impressionists and Symbolists in the gallery Le Barc de Boutteville in 1891, when he began to produce promotional posters. A poster done for the Moulin Rouge in 1891 marked the beginning of his reputation and connection with the image of "gay Paree." *Moulin Rouge: La Goulue* was a daring design.

He developed new techniques, involving garish colors and an exaggerated drawing style. His asymmetric composition and energy of line were influenced by Japanese woodblock prints, very much in vogue at the time, and his lithographs show the famous personalities of the French *demi-monde*.

His disability helped him identify with other outcasts from bourgeois society, and paintings executed when he lived in brothels do not hide the suffering under the surface. In *Ladies in the Dining Room* (1893) girls are shown as miserable, as they hunch over red wine in a brothel canteen.

In 1901, Lautrec died from alcoholism at the age of thirty-seven. A leading Post-Impressionist, his paintings, lithographs, and posters contributed much to the development of Art Nouveau in the 1890s. He was also an empathetic and witty chronicler of the gaudy nightlife, and his vibrant use of color influenced artists like the young Picasso.

Kate Mulvey

Date 1901

Born/Died 1864–1901

Nationality French

Why It's Key Put printmaking on the map, and was a chronicler of the decadent life of fin-de-siècle Paris.

Key Event
Establishment of the School of Nancy

Early-twentieth-century Art Nouveau extended its range with the establishment at Nancy in France of the Provincial Alliance of Art Industries, better known as the School of Nancy. It was as part of a movement to dissolve the divide between the fine arts of painting and sculpture and the "lesser" decorative arts. Founded by Emile Gallé in 1901, the Ecole de Nancy was principally supported by designers Louis Majorelle, Victor Prouvé, and the glassmaking brothers August and Jean-Antonin Daum. Their aim was to enhance the artistic content of industrially produced articles through the use of the craftsman, following the writings of the English critic John Ruskin and William Morris, founder of the Arts and Crafts movement in Britain.

Gallé himself was a glassmaker, potter, and cabinetmaker. After studying in Germany, he joined his father's glassworks, making ceramic tableware. In 1871, he travelled to London to represent the family firm at the International Exhibition. During his stay he visited the decorative arts collections at the South Kensington Museum (later the Victoria and Albert Museum) and was much influenced by what he saw there.

With Gallé as president and Majorelle as vice-president, the School of Nancy mounted an exhibition promoting its ideas in Paris in 1901. Following Gallé's death in 1904, Prouvé became president. The views of the group were propounded in the periodical *Art et industrie*, which was published from 1909 to 1914. Early work can be seen at the Musée de l'Ecole de Nancy.
Nigel Cawthorne

Date 1901

Country France

Why It's Key Introduced Art Nouveau to the broader decorative arts.

Key Artist **Edouard Vuillard** Nabis member exhibits at the Salon des Indépendants

Edouard Vuillard's father, a sea captain, died when Vuillard was sixteen, leaving the family in strained circumstances in Paris. Breaking with the family tradition of joining the army, he entered the studio of Diogène Maillart with his school friend and future brother-in-law, the painter Ker Xavier Roussel.

After studying at the Académie Julian, he entered the Ecole des Beaux-Arts, where he met Pierre Bonnard. However, another old school friend, Maurice Denis, persuaded him to join a group of artists called the Nabis – from *navi*, Hebrew for prophet or seer. Founded by Paul Sérusier, the group drew its inspiration from Paul Gauguin and the Pont-Aven school. Denis summed up their idea of painting: "A flat surface covered with colors assembled in a certain order."

Vuillard shared a studio with Sérusier, Denis, and Bonnard, and exhibited with them at their first show in 1891. They exhibited regularly together until 1899. Then in 1901, Vuillard exhibited at the Salon des Indépendants and, in 1903, at the Salon d'Automne.

With Bonnard, Vuillard founded Intimism. Using the techniques of the Impressionists, they took as their theme an exploration of domestic life. Vuillard never married and lived with his seamstress mother – whom he called his muse – in a small Paris apartment filled with richly patterned materials. She often appeared in his paintings, sweeping or sewing, though sometimes he ventured out into nearby public gardens where he depicted other intimate scenes of family life.
Nigel Cawthorne

Date 1901

Born/Died 1868–1940

Nationality French

First exhibited 1891

Why It's Key Founder of Intimism, the post-Impressionist exploration of domestic themes.

Key Artwork *Judith and the Head of Holofernes* Gustav Klimt

The woman framed by golden Assyrian foliage shudders in ecstasy. She's clutching the hair of the man she's just beheaded, after duping him with erotic promises and doping him with drink.

Sex and death were visceral and operatic themes much loved by Klimt and his Symbolist contemporaries, especially when it involved a biblical character – here a lustful woman triumphing over blind masculinity.

The story of the Jewish widow's seduction and beheading of Holofernes comes from the apocryphal Book of Judith. The parable describes how she risked her honor to save the inhabitants of her home town, under threat from marauding Assyrian hordes led by the bluff and sex-starved General. The battle-scarred campaigner can have had no chance against Klimt's sensual terrorist strolling into his siege camp.

Many believe Judith to have been Frau Bloch-Bauer, a rich Jewish Viennese wife who was an intimate of, and model for Klimt. Apart from her having facial similarities, the same gold-and-jewelled choker appears on the sitter's throat in his *Portrait of Adele Bloch-Bauer*, which in 2007 stole the record for the world's most expensive painting.

Judith I (Klimt returned to her with *Judith II* in 1909) demonstrates Klimt's interest in figurative reality and abstract patterns, a driving force behind much of Symbolism. During Klimt's lifetime, *Judith I* was listed as *Salome*, another deadly temptress, and his contemporaries couldn't accept that this highly decorative Expressionist image represented a pious Jewish heroine.
Bill Bingham

Date c.1901

Country Vienna

Medium Oil on canvas

Collection Österreichische Galerie Belvedere, Vienna

Why It's Key This painting featured an influential Jugendstil (style of youth – a German variant of Art Nouveau) image of a Jewish mythical figure, which outraged Viennese society.

Key Exhibition **First International Exhibition of Modern Decorative Art**

Art Nouveau began in Belgium in 1884 and reached an international audience at the Paris World's Fair of 1900. Two years later it had a show of its own in Turin called the Prima Esposizione Internazionale d'Arte Decorativa Moderna (April–November 1902). At the time, the city was a leader in Italy's economic growth and an important center for the development of Italian Art Nouveau, or Stile floreale, as it was known in Italy, because of its curving, floral designs (it was later called Stile Liberty after the London department store that championed the new style).

Designers from all over Europe exhibited, but most of the national pavilions and other exhibition buildings were designed by leading Italian Art Nouveau architect Raimondo D'Aronco, who was responsible for exporting architettura Liberty to the Islamic world.

However, the British pavilion was designed by Charles Rennie Mackintosh, and brought international recognition to the Glasgow school for their interiors.

Leading Turinese furniture designers Vittorio Valabrega and Agostino Lauro also participated. Lauro exhibited furniture from a room that he had designed for a villa. The room is a prime example of the Art Nouveau principle of Gesamtkunstwerk, combining architecture, furnishings, and decoration into a harmonious whole. The Milanese cabinetmaker Carlo Bugatti's exuberant exhibits also revealed Moorish influences, while the Veronese designer Carlo Zen decorated his furniture with a spaghetti-style curvilinear inlay. Germany had a large section, but the French sent few exhibitors.
Nigel Cawthorne

Date 1902

Country Italy

Why It's Key The first demonstration of how Art Nouveau came to dominate modern design internationally.

Key Event
Voyage to the Moon

The parameters of visual art had been changed irrevocably with the advent of moving pictures at the end of the nineteenth century, although initially the technical achievements of pioneers like Thomas Edison and the Lumière brothers were heralded for their entertainment potential rather than as a unique creative medium. Likewise when George Méliès premiered his film *Voyage to the Moon* (*Le Voyage dans la Lune*) to astounded Paris audiences in September 1902, its novelty value was inevitably a large part of the attraction – its first showing was actually in a fairground.

Inspired by two Jules Verne novels, *From the Earth to the Moon* and *Around the Moon*, the thirteen-minute film consisted of ten scenes played out on thirty sets, and took three months to make at the then considerable cost of 10,000 francs. One of the very earliest narrative films, it demonstrated the dramatic story-telling possibilities of the new medium with its account of a flight to the moon by six scientists. Projected toward one of the moon's "eyes" in a gigantic shell fired from a cannon, the explorers are taken prisoner by strange lunar creatures before escaping and returning to earth to a heroes' welcome.

Méliès was one of the first filmmakers to use multiple exposures, time-lapse photography, dissolves, and other technical tricks. Coming at a time when traditional disciplines were moving away from the purely representational, motion pictures, with this unprecedented potential to manipulate reality, would have an increasing influence as the century evolved.
Mike Evans

Date 1902

Country France

Why It's Key Established special effects and editing tricks as part of the language of film, exploited in later visual art from Surrealism to contemporary video installations.

opposite **Film** still from *Voyage to the Moon* (*Le Voyage dans la Lune*).

1860–1909

Key Event
The launch of *Camera Work* magazine

Camera Work was the brainchild of Alfred Stieglitz, an American photographer who had studied with painters in Berlin. Returning to America in 1890, he was determined to have photography recognized as an art form. In 1902, he formed the Photo-Secession Group to protest against the conventional photography of the time, taking his cue from the German Sezessions. He opened the 291 photography gallery, which became a hang-out for members of New York Dada.

In 1903, he began *Camera Work*. The New York magazine employed the photogravure process and high-quality paper to reproduce original photographs, along with paintings and drawings. Stieglitz believed that Pablo Picasso, Matisse, and Cézanne were legitimate themes for the magazine, alongside his promotion of photography as an art.

Camera Work enjoyed an international circulation and published pictures from European photographers. It showcased the work of Edward Steichen, Alvin Langdon Coburn, Clarence H. White, Frank Eugene, Heinrich Kühn, Baron Adolf de Meyer, James Craig Annan, Robert Demachy, Gertrude Käsabier, Alfred Stieglitz himself, and many others. It began as a Pictorialist and Symbolist magazine, with a insistence on static, structured portraits and landscapes, but gradually became a mouthpiece for modernism.

The magazine was not financially successful and it's initial circulation of a thousand declined to just five hundred for the last edition. However, it influenced the next generation of photographers and the photographic publications that followed it.
Nigel Cawthorne

Date 1903

Country USA

Why It's Key The Photo-Secessionist magazine that played a pivotal role in shaping modernism in the United States, and established photography as an art form.

Key Artist **Camille Pissarro**
Painter of painters dies in Paris

Born in the Danish West Indies, Camille Pissarro showed a precocious interest in art, sketching the island and its people while working in his father's store. When his father refused permission for him to study art, he ran away to Caracas for two years with the Danish painter Fritz Melbye, until his father relented.

In 1855, he enrolled in the Ecole des Beaux-Arts and became the pupil of Camille Corot. At the Académie Suisse, he met Monet and Cézanne, later meeting Renoir. In 1863, he exhibited in the Salon des Refusés, and in the official Salon the following year.

During the Franco-Prussian War, Pissarro fled to London with Monet, where they studied British landscapes. Returning to France, he moved from the Parisian suburbs to the village of Pontoise, which became the theme of his art for the next thirty years.

Pissarro was the only painter to exhibit in all eight Impressionist Exhibitions. He took a fatherly interest in struggling younger artists, including Gauguin, many of whom he taught. Unlike his pupils, he never rejected the principles of Impressionism and eagerly embraced the Neo-Impressionist theories of Georges Seurat, whom he met in 1885.

A successful retrospective in 1892 gave him some financial security, but a chronic eye infection made it impossible for him to work out of doors and he took to painting urban landscapes from hotel windows. He left over 1,600 paintings and 200 fine prints. His son, Lucien, settled in England, where he became part of the Fitzroy and Camden Town groups.

Nigel Cawthorne

Date 1903

Born/Died 1830–1903

Nationality French

First exhibited 1863

Why It's Key One of the fathers of Impressionism.

58

Key Artist **James Abbot McNeill Whistler**
Death of important London-based Impressionist

James Abbot McNeill Whistler died, aged sixty-nine, on July 17, 1903, three years after John Ruskin, whose spat with him twenty-five years earlier had assured his lasting fame. In 1878 Ruskin accused Whistler of "flinging a pot of paint in the public's face" when he showed *Nocturne in Black and Gold: The Falling Rocket* at the Grosvenor Gallery. The upshot was one of the most celebrated libel cases in British history: Whistler sued and won, but was awarded just a farthing (a quarter of a penny) in damages and was left bankrupt.

Whistler had a cosmopolitan upbringing: born in Massachusetts, he spent his early years in St Petersburg and studied in Paris before settling in London in 1859. In late Victorian England he quickly made a name for himself as both the most innovative artist of the period and a flamboyant personality,

renowned for his love of controversy and his biting wit. His aesthetic creed of "art for art's sake," which led to him calling his paintings "arrangements" or "harmonies," was expounded in his "Ten O'Clock Lecture," first delivered in 1885. Six years later he achieved his greatest triumph when the French State bought the best-known of his "arrangements," his *Portrait of the Artist's Mother*. A highly original decorative artist, he was also a virtuoso print-maker.

Often known as "The Master," Whistler attracted a number of pupils and disciples, most notably Walter Sickert, and in 1898 he was elected the first president of the International Society. On his death he was succeeded by Rodin, who for many years worked on, but never completed, his *Whistler Memorial*.

James Beechey

Date 1903

Born/Died 1834–1903

Nationality American

Why It's Key Highly influential painter who fused elements of Japanese decorative qualities with the style of the French Impressionists.

Key Event **America's first narrative film, *The Great Train Robbery***

The Great Train Robbery, made in 1903, was America's first narrative film. Directed and photographed by Edwin S. Porter, a former Thomas Edison cameraman, it was a one-reel, twelve-minute action picture. The precursor to Western film style, it used many of the plot components that became staples of the genre.

Based on the Broadway production of the same name, the film focuses on the true story of the Hole in the Wall Gang, led by Butch Cassidy, which held up the No.3 Union Pacific train near Table Rock, Wyoming.

The film was produced at Thomas Edison's studio and surrounding locations in New Jersey and used a number of innovative techniques, including location shooting, parallel editing, jump-cuts, or cross cuts, and the first panning shots. These in turn would impact on art generally as photographers and painters became aware of the visual implications of the new medium.

The film has fourteen scenes and, unlike prior works, there is a narrative story with multiple plot lines. Audiences were startled by the action and the use of special effects, particularly in the last scene, where the leader of the gang points his gun directly at the audience and fires. Actors included A. Cabadie, Broncho Billy Anderson, and Justus D. Barnes. There were no credits.

A milestone in film history, *The Great Train Robbery* was the most commercially successful film of its era, and promoted the idea that film was a viable commercial enterprise. It led the way for the prestigious works of Griffith, Sennett, and Chaplin ten years later.
Kate Mulvey

Date 1903

Country USA

Why It's Key It changed the motion picture industry and made film a viable commercial enterprise.

1860–1909

59

Key Artist **Pierre Bonnard** Breakthrough at Paris Salon d'Automne

Pierre Bonnard was born in Fontenay-aux-Roses, near Paris. To appease his father he started studying law in 1887, but at the same time he attended the Académie Julian, a private art school in Paris. He eventually abandoned law and joined the Ecole des Beaux-Arts, where he met Edouard Vuillard.

In 1890 he shared a studio with Vuillard and Maurice Denis. Together they joined a group of artists who called themselves the Nabis (the Prophets). They were influenced by Symbolist artists such as Gauguin, and by Japanese art. Inspired by the modernist ideal of the cross-fertilization of all the arts, Bonnard produced a range of graphic work, as well as paintings; in the early part of his career he was better known for his posters, lithographs, and illustrations. In 1893 he met his lifelong partner, Marthe, who suffered from an ailment which caused her to spend long periods bathing. Many of Bonnard's most imaginative articulations of color and composition are found in the paintings of Marthe washing and lying in her bath.

Bonnard's significance lies in the formal complexity and ambiguity he brought to the genres of the still life and the domestic interior. In his most unsettling paintings, carefully constructed viewpoints create a tension between perspectival space and the flatness of his decorative surfaces.

In 1925 he married Marthe and bought a house in Le Cannet, near Cannes, where he was exiled at the start of World War II. He spent the last years of his life there, producing, after Marthe's death in 1942, some of the most disquieting self-portraits of old age.
Sarah Mulvey

Date 1903

Birth/Death 1867–1947

Nationality French

Why It's Key Bonnard exhibited at the first Salon d'Automne in Paris and the Vienna Secession of 1903. Both these exhibitions showed artists of the European avant-garde, who were reacting against the conservatism of the official art establishments, and who influenced a younger generation of progressive artists.

Key Event
First powered flight

On December 17, 1903, Orville and Wilbur Wright flew a heavier-than-air machine, demonstrating sustained powered flight under the control of the pilot for the first time. It was a momentous occasion and, along with the development of the automobile and the skyscraper, defined the modern age.

Though people had flown in balloons since the Montgolfier brothers in 1783, the development of the airplane meant that more people had regular access to the skies, changing their viewpoint on the world. Humankind could now observe easily from above. The airplane also achieved speeds previously unattainable, and allowed art and artists to travel more freely from continent to continent. Now that humans had fulfilled the age-old wish to fly like the birds, nothing seemed unattainable.

However, powered flight's explicit influence on art had to wait until 1929 and the publication of *Manifesto dell'Aeropittura* by a group of Italian Futurists (including Marinetti) who had published the first Futurist manifesto in 1909. *Aeropittura* not only took powered flight as its theme, it also believed that the pencil, brush, or spray should emulate the movements of a plane.

The first exhibition of Aeropittura was held in Milan in 1931. Manifestos of Aeropoesia and Aeromusica appeared, and Prampolini created an Aerodanza Futuristica. But the movement did not survive the death of Marinetti and the collapse of Fascism.

From a more knowingly ironic stance, jet fighter planes feature in one of the most familiar of Pop Art images, in Roy Lichtenstein's *Whaam!*, painted in 1963.
Nigel Cawthorne

Date 1903

Country USA

Why It's Key Humankind takes to the air, heralding mass international travel and defining modernity. Aircraft would provided a potent subject matter for artists from the Italian Futurists to 1960s Pop painters and subsequent generations.

opposite The Wright brothers make the first powered flight in history.

Key Person **Ivan Morozov** Russian patron begins buying Post-Impressionist works

Like fellow collector Sergei Shchukin (1854–1936), Ivan Morozov was born into a wealthy textile family. Using their inherited money, they built up spectacular collections of modernist masterpieces by artists such as Henri Matisse and Pablo Picasso, at a time when these artists were still undervalued in Western Europe.

While Shchukin worked on instinct, focusing on one artist at a time, Morozov collected systematically, seeking to represent every major modern artist by their best work. Morozov had collected over three hundred paintings by young Russians before 1903, when he began to acquire outstanding works by French modern artists. His favorite painter was Cézanne, whose finest paintings formed a major part of his collection. He also collected Gauguin, Monet, van Gogh, Renoir, Sisley, Chagall, Pissarro, Degas, Toulouse-Lautrec, Picasso,

Matisse, and Munch, and he commissioned large decorative panels from various Nabis artists.

In 1909, Shchukin opened his house as a showcase for what became the new Russian avant-garde. Morozov preferred to keep his collection private, allowing only scholars and prominent people to visit – though he intended to bequeath his entire collection to Moscow.

After the Bolshevik Revolution in 1917, the two collections were nationalized and became the State Museum of Modern Western Art, which was closed in 1948 during Stalin's campaign against foreign and "bourgeois" influences. However, the collections were saved by the Pushkin Museum in Moscow, and the Hermitage Museum in St. Petersburg (then Leningrad), which kept them hidden in storage rooms for decades.
Nigel Cawthorne

Date 1903

Born/Died 1871–1921

Nationality Russian

Why It's Key Most important Russian collector of modern French art in the early twentieth century.

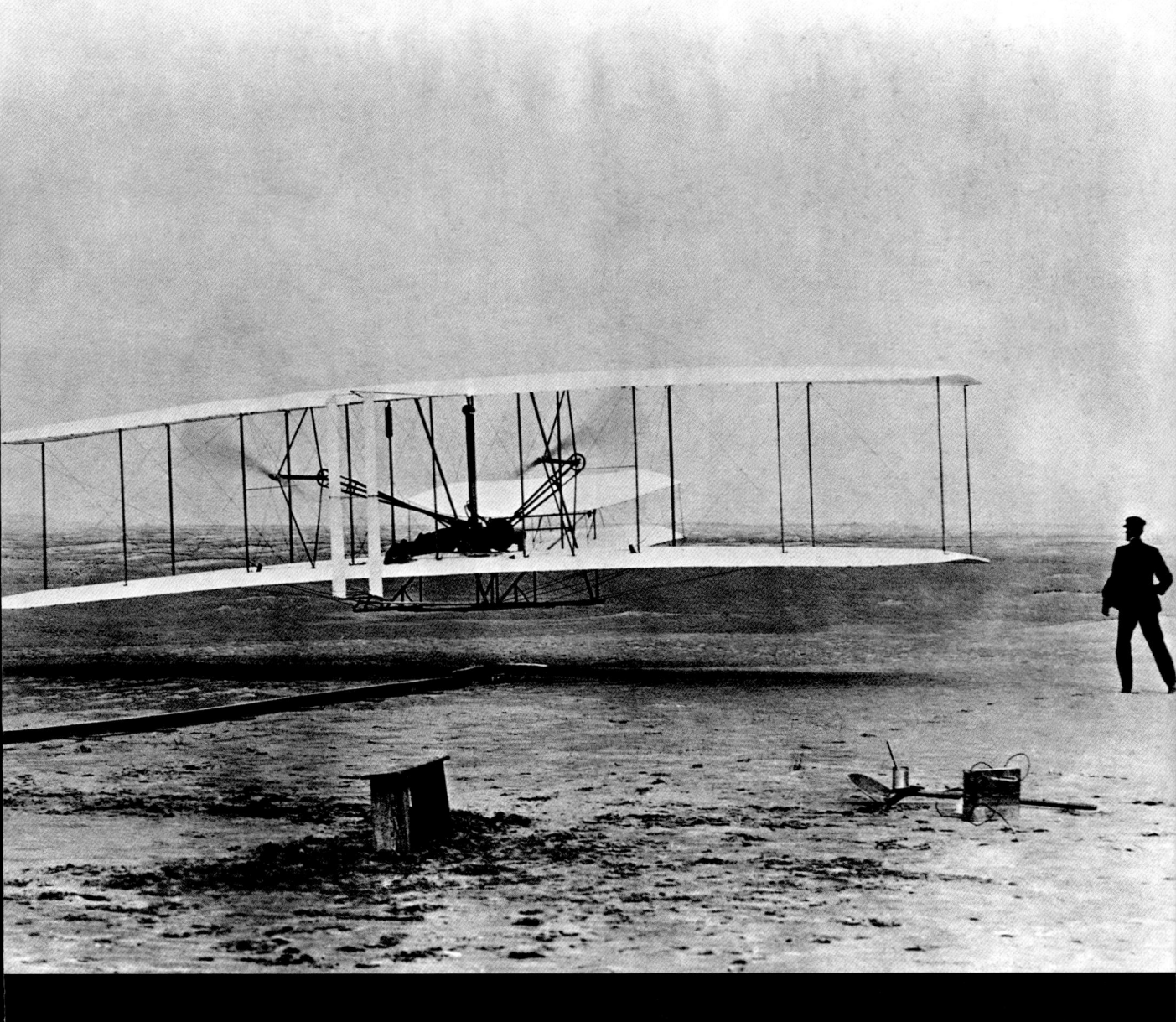

Key Event
Picasso moves into Bateau-Lavoir

The block of buildings known as Bateau-Lavoir (the laundry boat) was so called because it resembled the ramshackle river vessels in which washerwomen laundered clothes. It had been home to various artists from the 1890s, before 23-year-old Pablo Picasso moved into one of its foul-smelling rooms on May 6, 1904.

The young painter from Barcelona had already visited Paris three times since 1900, when his work first attracted attention in the Spanish section of the Grand Palais Centenniel exhibition. But now, working and sleeping in his 15-francs-a-month studio in the dilapidated Montmartre tenementat 13 rue Ravignant, he was a permanent resident of the French capital.

Artists who lived in the Bateau-Lavoir during Picasso's five-year tenure there included Juan Gris and Amedeo Modigliani. Poets Max Jacob and Andre Salmon were also resident. It was also a meeting place, centered on Picasso's studio, of other avant-garde figures, including Georges Braque, Jean Cocteau, Henri Matisse, Gertrude Stein, and Guillaume Apollinaire.

The first painting Picasso completed in the ill-lit studio (working mainly at night, by the light of a kerosene lamp) was *Woman with Crow*. This concluded his melancholic "blue period" of the previous three years, which was to be followed by his "pink period" studies of clowns, acrobats, and such. But that, too, was a brief transitory stage in the rapid development of his work. By the time he left the Bateau-Lavoir in 1909, Picasso would have shaken the art world to its foundations with *Les Demoiselles d'Avignon* (1907), one of the building blocks of Cubism.

Mike Evans

Date 1904

Country France

Why It's Key Important "colony" of avant-garde artists, where Picasso painted many major early works.

62

Key Event
Matisse visits St Tropez

The world at large discovered St Tropez after Brigitte Bardot caused an international sensation in the 1956 film *And God Created Woman*, which was set in the picturesque French Riviera fishing port. But it had long been a destination for artists, attracted by its brilliant light and tranquil setting.

Having read of the town in a Guy de Maupassant story, the Pointillist painter Paul Signac landed there in 1892 in his yacht *Olympia*. He immediately fell in love with the place and bought a house, setting up a studio and having various fellow Neo-Impressionists to visit. In the summer of 1904, he invited Henri Matisse to take part in what he called his "painting competitions."

Matisse had yet to establish a definite style when he fell under the spell of St Tropez and Signac's vibrant paintings of the harbor and bay. He was captivated by Signac's use of colored dots (or Divisionism), a technique pioneered by Seurat (who had died in 1891) and Signac, his closest acolyte.

Matisse's own work suddenly took on a new directness of approach, with sun-drenched landscapes fragmented in exuberant, bright, vivid color applied in Divisionist style. Best exemplified in *Luxe, Calme et Volupte*, which he finished in 1905, it was the precursor to Fauvism, of which Matisse would be the leading name. From then on St Tropez would flourish as a major "colony" of early twentieth-century art, acknowledged today in over fifty works in the Musée de l'Annonciade on the harborside.

Mike Evans

Date 1904

Country France

Why It's Key The first major turning point in Matisse's artistic life, marking the beginning of Fauvism.

Key Artist **Kees van Dongen** Pioneer
Fauvist becomes regular exhibitor in Paris

Van Dongen studied drawing while working as an illustrator on the newspaper *Rotterdamsche Nieuwsblad* before settling in Paris in 1897, where he worked as a porter and house painter to fund his burgeoning artistic career. From 1904 he became a regular exhibitor at the Salon des Indépendants and Salon d'Automne, alongside such major artists as Cézanne, Matisse, Munch, and Bonnard.

Van Dongen's Fauvist tendencies were overlaid with a strong, heavy technique, much influenced by his contact with the Expressionists Kirchner and Nolde, whom he met and exhibited with on a visit to Germany in 1908. He soon adopted heavy black outlines and very strong color applied in thick bold strokes. His paintings of women are particularly striking; in, for example, *The*

Red Dancer (1907), blazing color and a daring pose create a sensuous image.

Van Dongen became sought after as a painter of not only the *demi-monde*, but also fashionable society. He contributed to several periodicals, including *La Revue Blanche* and *Folle Epoque*, his lively graphic style being much influenced by Lautrec and Forain. He continued as a successful portraitist well after World War I and was awarded the Legion d'Honneur in 1926 (although he didn't become a French citizen until 1929). However, van Dongen's pre-1914 work displays the most creative power and his own bold interpretation of Fauvism.

Lucy Lubbock

Date 1904

Born/Died 1877–1968

Nationality Dutch

First exhibited 1904

Why It's Key Dynamic Fauvist also influenced by German Expressionism.

1860–1909

63

Key Event
Formation of the Bloomsbury Group

The so-called Bloomsbury Group had its origins in the University of Cambridge, which most of its male members attended around the turn of the century. It drew its name from the district of London to which the four orphaned children of the Victorian author Sir Leslie Stephen moved in 1904. The new home of Thoby, Vanessa, Virginia, and Adrian Stephen, 46 Gordon Square, became a meeting place for Thoby's Cambridge friends, one of whom, Clive Bell, married Vanessa in 1907; another, Leonard Woolf, married Virginia in 1912.

Bloomsbury was never a Group in the formal sense, but a network of friends and relations that also included the biographer Lytton Strachey, the economist Maynard Keynes, the literary critic Desmond MacCarthy, the writer and artist Roger Fry, the artist Duncan Grant, and the novelist E.M. Forster. Publicly, it was associated

with the sponsorship of Fry's two Post-Impressionist Exhibitions; the establishment of the Omega Workshops; the foundation of the Woolfs' Hogarth Press; outspoken resistance to World War I; and the creation of the Arts Council. More recently, it has become notorious for its unorthodox sexual relationships.

Bloomsbury exerted a powerful sway on cultural life in Britain between the wars. From Clive Bell's *Art* (1914), the best-selling treatise on aesthetics, via Strachey's debunking *Eminent Victorians* (1918) and Keynes' *The Economic Consequences of the Peace* (1919), a blistering attack on the Treaty of Versailles, to the experimental novels of Virginia Woolf in the 1920s and 1930s, it set the agenda for many of the artistic and political debates of the period.

James Beechey

Date 1904

Country UK

Why It's Key First coming together of what would be a highly influential catalyst in British arts and letters between the two World Wars.

Key Artist **John Sloan**
Realist painter and illustrator moves to New York

Born in Lockhaven, Pennsylvania, Sloan began working as a commercial illustrator for newspapers in Philadelphia at the age of twenty and gained national recognition for his turn-of-the-century poster style. At night, though, he studied at the Pennsylvania Academy of Fine Art, where he met Robert Henri. Through his association with Henri, he turned to oils and began depicting city life. In 1904, he followed Henri to Greenwich Village, New York, which became the scene of his most famous paintings.

In 1908 Sloan, Henri, and six others exhibited as "The Eight" as a protest against the National Academy of Design's conservative tastes. Sloan's depiction of the grittier side of urban life gave rise to the epithet "Ashcan school."

Although he was a socialist, Sloan's pictures contained no social criticism. When fellow leftists criticized his lack of political commitment, he resigned as art editor of the radical journal *The Masses*.

After the 1913 Armory Show, he became fascinated by color theory and began visiting New Mexico, one of the first artists to paint landscapes of the area. After 1920, he concentrated on the nude, developing a technique of cross-hatching in over-glazes to lend substance to his painted forms. Sloan taught art in New York and, in 1939, published his teachings in *The Gist of Art*.

Nigel Cawthorne

Date 1904

Born/Died 1871–1951

Nationality American

First exhibited 1908

Why It's Key Leader of the Ashcan school.

1860–1909

64

Key Artwork ***Boy with a Pipe***
Pablo Picasso

Following Picasso's (1881–1973) Blue Period, named because of the dominant use of blue in his paintings, Picasso began to work in pink and red tones during his Rose Period (c.1905–1906). Generally, the subjects reflect his own poverty during this period, although he went on to become a wealthy and highly celebrated painter.

Picasso's *Boy with a Pipe* depicts a rather effeminate boy wearing a garland of flowers and holding an opium pipe. This provocative picture was one of a series depicting androgynous youths in a series of works from 1905 to 1906.

Picasso's friend and biographer John Richardson identifies the boy as "P'tit Louis," a young fellow who used to hang around the painter's Bateau-Lavoir studio in Paris. Richardson also maintains that Picasso was

inspired by an erotic poem Paul Verlaine wrote about Rimbaud called *Crimen Amoris*, which refers to an "evil angel" wearing a halo of flowers. Some art historians suggest the garland of flowers transforms the boy into a deity-like figure, a popular theme in Picasso's work.

In May 2004, Sotheby's in New York sold *Boy with a Pipe* from the famed Whitney collection for a record-breaking US$104.1 million to an anonymous buyer, making it the most expensive painting ever sold at auction.

Brian Davis

Date 1905

Country France

Medium Oil on canvas

Collection Private collection

Why It's Key Picasso's Rose Period work set an all-time auction record when sold for US$104 million in 2004.

opposite *Boy with a Pipe*

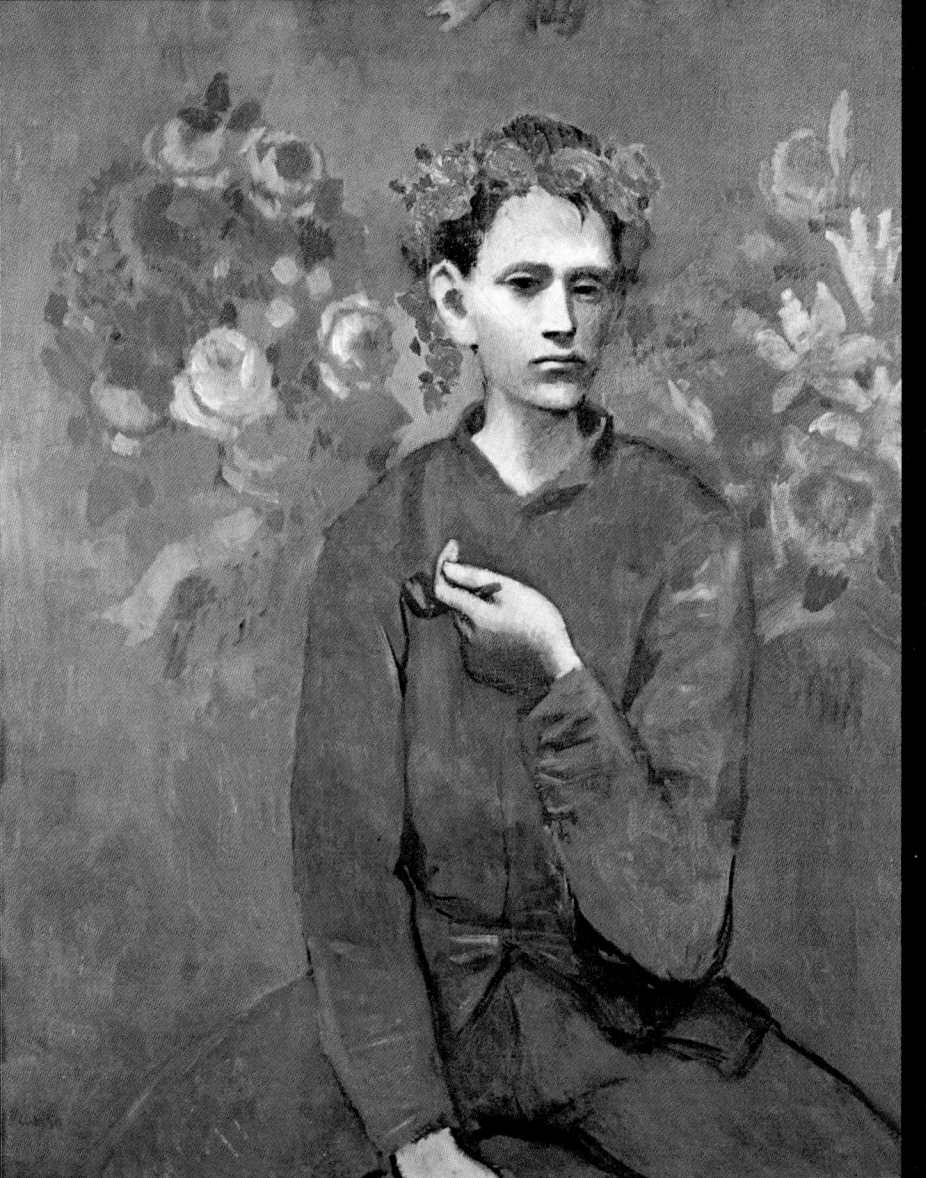

Key Event
Die Brücke (The Bridge) is founded

Die Brücke was formed on June 7, 1905 by four friends: Fritz Bleyl (1880–1966), Ernst Ludwig Kirchner (1880–1938), Erich Heckel (1883–1970), and Karl Schmidt-Rottluff (1884–1976). They were later joined by Otto Mueller (1874–1930), Emil Nolde (1867–1956), and Max Pechstein (1881–1955).

Without formal qualifications the Brücke artists needed mutual support to break into the art world. They set themselves up as a community, with Kirchner's studio as their base, sharing materials and studios as a practical solution to this problem. Their bohemian lifestyle also expressed their aim to mesh together their art and life. The frequent trips they made to paint subjects in a natural environment reflected their belief in the authenticity of nature, in opposition to the civilized values of a bourgeois urban existence.

Kirchner's manifesto of 1906 is a call to a young creative generation to join them.

The model for their work was to be found in "primitive" art, which they considered, in common with other European avant-garde artists, to show them examples of unmediated self expression. The intense colors of Fauvism – in particular the paintings of Gauguin, van Gogh, and Munch – and German medieval art inspired the formal qualities of their work. They also produced woodcuts as a more direct way of communicating with a wider audience.

In 1912 they exhibited with the Blaue Reiter artists and then showed their work at the Sonderbund exhibition in Cologne. Their collective project ceased in 1913, even though they continued to work separately.
Sarah Mulvey

Date 1905

Country Germany

Why It's Key Die Brücke was started by a group of architecture students who were studying together at the Technische Hochschule of Dresden. Together with the members of Der Blaue Reiter (The Blue Rider) group, created in Munich in 1911, they initiated German Expressionism.

Key Artist **André Derain**
Exhibits at the Third Salon d'Automne

The Salon d'Automne was created in 1903 to show the work of the Impressionists, as well as paintings, sculptures, drawings, and prints by younger artists. Matisse, Rouault, and other ex-students of Gustave Moreau were part of the Salon's renewed 1905 selection committee, eager to discard "watered-down Impressionism" and to promote the avant-garde. The exhibit ran from October through November at the Grand Palais, and featured recognized artists including Manet, Renoir, Rodin, and Cézanne, and foreign artists including Jawlensky and Kandinsky. Room VII, with its display of paintings by Matisse, Manguin, Vlaminck, Marquet, Camoin, and Derain, caused an uproar. A delicate sculpture by Marquet, set in the center of the room, the critic Louis Vauxcelles proclaimed to be: "Donatello in a cage with wild beasts!"

Derain and the Fauves rejected both the "deliquescence" of Impressionism and the rigidity of a Pointillism that had by then become something of a formula. Like Gauguin before them, they aspired to free color from its naturalistic reference, to paint red tree trunks, green faces, or bright yellow skies. Large areas of clashing, unmodulated color were juxtaposed, thus creating an acid effect, while simplified forms did away with traditional modeling or perspective.

Critics railed against the new painting, Camille Mauclair deeming it "a pot of paint flung in the face of the public." The controversy was such that French President Loubet declined to inaugurate the Salon, having been forewarned that some of the items in it were "inappropriate."
Catherine Marcangeli

Date 1905

Born/Died 1880–1954

Nationality French

Why It's Key One of the most original of the Fauve ("wild beast") painters.

Key Person **Albert Einstein**
Proposes the Special Theory of Relativity

While artists were challenging the old idea of classicism, their arguments were given new force by the physicist Albert Einstein, who single-handedly demolished not just the certainties of Newtonian physics that scientists had relied on for two centuries to explain the world, but also the nature of the universe as described by Euclid around 300 BCE. With his *Special Theory of Relativity*, published in 1905, Einstein showed that space and time were not immutable, but varied according to the relative velocity of the viewer. Einstein's world was no longer fixed. It changed according to your point of view.

Until Einstein, it was also thought that matter and energy were discrete things that could neither be created nor destroyed. With the equation $E=mc^2$, he showed that matter could be turned into energy, and energy into matter. This led to the creation of the atomic bomb.

Einstein's multidimensional universe was reflected in Cubism, and he became such a seminal figure that his image regularly appeared in art. His portrait appears in the work of Lotte Jacobi, Max Liebermann, Leonid Pasternak, Vadim Sidur, and Robert Wilson.

Einstein's work on light and electromagnetic theory led to the development of the laser and the hologram, and was reflected in the ideas of Orphism and Futurism. Erich Mendelsohn's Einstein Tower in Potsdam remains a symbol of architectural Expressionism. Mendelsohn had earlier worked on the experimental proof of Einstein's *General Theory of Relativity*, published in 1916.

Nigel Cawthorne

Date 1905

Born/Died 1879–1955

Nationality American (born German)

Why It's Key Overturned the classical work of Newtonian physics and heralded the atomic age.

Key Exhibition
Third Salon d'Automne

In 1901, the Goupil Gallery held a retrospective exhibition of van Gogh's work. The French painter Vlaminck reacted: "I was so moved that I wanted to cry with joy and despair, on that day I loved Van Gogh more than I loved my father." Van Gogh's expressionist, bold brushwork and pure color had a profound effect on a group of artists that would come together at the Grand Palais in Paris for the Third Salon d'Automne.

For the visitors of 1905, the exhibition appeared a cacophony of color, executed with no attention to the fine familiar brushwork of the Salon. Camille Mauclair of *Le Figaro*, who would later denounce Picasso's painting as "Jewish" during World War II, famously declared, "a pot of paint has been thrown in the public's face," while critic Louis Vauxcelles noticed a lone sculpture of a child by artist Albert Marquet,

surrounded by paintings, and shouted aloud: "It's Donatello among the wild beasts."

For an intense three years between 1904 and 1907, Henri Matisse (1869–1954), André Derain (1880–1954), Maurice Vlaminck (1876–1958), Georges Rouault (1871–1958), Albert Marquet (1875–1947), Charles Camoin (1879–1967), Jean Puy (1876–1960) and Kees van Dongen (1877–1968) shared common values about the direction of painting. Their joint Salle VII (de Fauves) presentation at the 1905 Salon d'Automne was certainly seen by Picasso and Braque, who would shortly take the next step forward into Cubism. It caused a great scandal, no bad thing for artists seeking to establish a reputation, and the repercussions were to echo down the next hundred years.

Mike von Joel

Date 1905

Country France

Why It's Key This exhibition marks the debut of the group dubbed the Fauves (wild beasts) and the birth of the first Modernist movement in the twentieth century.

Key Event
First major American newspaper comic strip

Until the 1890s, American newspapers – the sole, dominant means of mass communication – had been blocks of black, dense type. This tradition had been broken in 1895, when Richard Outcault developed a single panel character, The Yellow Kid, for the *New York World*. William Randolph Hearst, spotting that circulation was vastly improved by the addition of comics, launched his own color comics section in 1896, using the new, garish, polychrome printing technology. Hearst's *The American Humorist* employed innovative artists Rudolph Dirks and Fred Opper, who created wildly popular characters such as The Katzenjammer Kids and Happy Hooligan.

The comic strip came of age in 1905 with graphic genius Winsor McCay, whose Little Nemo in Slumberland is a milestone in cartoon art. McCay's

work for the *New York Herald* has been equalled to the Ash-can School for its veracity. It incorporated all the hallmarks of Modernism (figures in motion, contemporary architecture, machinery) into a whole page strip that enthralled all America. The mix of surreal stories and wild perspective combined to make Little Nemo, about a boy who dreams crazy, dislocated adventures but always wakes safely in the last panel, the most influential strip of its time.

McCay's mastery of shading and tone, printed color and form was to predict the dominant style of American comics for the next fifty years – itself a precursor to the Pop art movement of the 1960s.
Mike von Joel

Date 1905

Country USA

Why It's Key This was the first manifestation of a classless, mass media, "pop" culture graphic art form in the United States.

opposite Another pioneering comic strip, *Mutt and Jeff* by Bud Fisher.

Key Artist **Henri Matisse** Leading Fauve artist launched at Third Salon d'Automne

Born in 1869, Henri Matisse first started painting in 1889 at the age of 20. Influenced by the Post-Impressionists Paul Cézanne, Signac, and van Gogh, he started to concentrate on color in his paintings. In 1904, Matisse became interested in the colored dots of Seurat's Divisionism, which is seen in his early work.

By 1905, a new Matisse was seen when he and a group of fellow artists, known as the Fauves (wild beasts), exhibited their radical work at the 1905 Salon d'Automne. Some thought the new work barbaric, especially Matisse's use of discordant primary colors. Matisse was seen as the leader of the Fauves (other members were Othon Friesz, Raoul Dufy, and Georges Braque) and his work was initially criticized. His radical painting *Nu Bleu* (*Blue Nude*, 1907) was burned in effigy at the Armory Show in Chicago in 1913.

One of the first painters to take an interest in primitive art, Matisse drew and painted from nature. He established his style with flat, brilliant color and a fluid line. This is clearly shown in his seminal work, *The Dance* (1910), an intense painting of naturalistic ecstasy, which put Matisse on the map. He usually painted women, still lives, and interiors. Both Leo and Gertrude Stein collected his work.

After the 1920s, Matisse worked on painting, sculpture, lithography, and etching. He established a technique called *Papiers Découpés* (paper cut-outs) and in 1947 a book, *Jazz*, written and illustrated by Matisse, was published with stencil reproductions of paper cut-outs. Matisse settled in the South of France, where he remained until the end of his life in 1954.
Kate Mulvey

Date 1905

Born/Died 1869–1954

Nationality French

Why It's Key One of the leading figures in modern art, Matisse was the originator of the Fauve movement and exerted a significant influence on subsequent artists.

Key Artist **Arthur Rackham** *Rip Van Winkle* drawings make children's illustrator's reputation

Arthur Rackham is renowned for bringing scenes from classic literature alive for both children and adults. His distinctive drawing style, coupled with a sensitive use of line and color, created a theater of ethereal magic on the page.

Rackham was born in London into a family of twelve children. As a youth he began part-time study at Lambeth School for Art and continued there for seven years while also working as a clerk at an insurance company. At 25 he left this job for the financially uncertain life of a freelance illustrator, working regularly for the *Westminster Budget* and other popular magazines. His illustrations showed facility, but there was only the occasional hint of a distinctive spirit.

In 1905, however, Rackham had a breakthrough. The publisher William Heinemann commissioned him to illustrate a lavish gift book, *Rip Van Winkle*. It was within these 51 color plates that the rare qualities, which Rackham had been quietly developing, were finally liberated. Imagination sprang up between the lines of the text in a style that would become his trademark. This book was a bestseller and led to a commission to illustrate the masterpiece *Peter Pan in Kensington Gardens*, from Hodder and Stoughton.

Rackham then went on to illustrate *Alice's Adventures in Wonderland* (1907) and *A Midsummer Night's Dream* (1908), both published by Heinemann. Many other productions followed in a long and prosperous career, which continued until the very end. *Wind in the Willows* was published posthumously in 1940.

Carolyn Gowdy

Date 1905

Born/Died 1867–1939

Nationality British

Why It's Key Rackham was one of the greatest artists of the Golden Age of book illustration, a time when luxuriously printed and illustrated "gift books" were produced for both the child and adult markets.

opposite Rackham illustration for *Rip Van Winkle*. "They were ruled by an old Squaw spirit who hung up the new moons in the skies and cut up the old ones into stars."

1860–1909

71

Key Artist **Maurice de Vlaminck** Exhibits with the Fauves, causing an uproar

Born in Paris to a family of Flemish musicians, Maurice de Vlaminck first earned a living as a racing cyclist, then as a violin player. He started his painting career in 1900 after meeting André Derain, with whom he went on to rent a studio in Chatou, outside Paris, which was, ironically, an old Impressionist haunt. There they developed the principles of what was soon to be dubbed Fauvism.

The 1901 van Gogh retrospective in Paris, and the later discovery of African art through Guillaume Apollinaire, greatly influenced Vlaminck's anti-conformist approach. "Painting is like cooking," he declared. "You don't explain it, you just taste it." Proud to be untrained, and determined to ignore the conventions of his trade, he applied thick impastoes of pure intense color straight from the tube over large unmodulated areas. The white canvas sometimes showing through increased the contrasts, and acted both as a unifying light and as a disturbing element that insisted on separation rather than continuity.

When Vlaminck exhibited at the 1905 Salon d'Automne, these Fauve paintings were seen by some as evidence of a lack of skill and craftsmanship; for others, they were the aggressive work of anarchist charlatans claiming their hatred of the bourgeoisie.

By 1909, Vlaminck was experimenting with Cubist compositions; he subsequently turned to earthy landscapes, after moving to a farm in the Beauce region. In 1944 he took part in an artists' trip to Germany organized by the Vichy government, leading to accusations of betrayal after the war.

Catherine Marcangeli

Date 1905

Born/Died 1876–1958

Nationality French

Why It's Key Untrained painter's work was among the "wildest" of the Fauves.

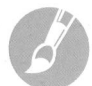

Key Artist **Karl Schmidt-Rottluff**
Co-founds Die Brücke

Born Karl Schmidt, he later adopted the name of his home town, Rottluff, near Chemnitz, Germany. He got to know Erich Heckel at school, and together they enrolled to study architecture at Dresden Technical University. With fellow architecture student Ernst Kirchner, who shared their passion for art, and painter Fritz Bleyl, they formed the group Die Brücke in 1905.

Schmitt-Rottluff soon outshone his colleagues by insisting on the use of pure primary colors, and his Expressionist paintings achieve an intensity and brilliance. After the group moved to Berlin in 1911, where it broke up, he began using increasingly reductive geometric forms, but this development was curtailed by the outbreak of war.

While serving on the Eastern Front, he did a series of religious woodcuts, an introspective examination of the effects of war that is regarded as his graphic masterpiece. In 1918 he returned to Berlin. Honors were bestowed on him when Expressionism became officially recognized in Germany, but by then he was moving towards a more spiritual and abstract idiom.

In 1937 the Nazis declared his work degenerate, and in 1941 he was forbidden to paint and expelled from the painters' guild. Much of his work was lost when his Berlin studio was destroyed during World War II. After the war, he was appointed professor at the Hochschule der Bildende Künste in West Berlin, where he would influence a new generation of painters. In 1964 he endowed the Brücke Museum, which opened in 1967 as a repository for the works of the group.
Nigel Cawthorne

Date 1905

Born/Died 1884–1976

Nationality German

First exhibited 1906

Why It's Key One of the crucial pioneers of Expressionism.

opposite *Waldbild* by Karl Schmidt-Rottluff, 1921 (oil on canvas).

72

Key Artist **Abanindranath Tagore**
Founds Bengal School of Painting

Born in 1871 into a wealthy Calcutta family, Abanindranath Tagore studied art in his spare time at Sanskrit College. His illustrations first appeared in magazines and in books written by himself and by his uncle Rabindranath, the famous poet. From 1897 he studied Western oil and watercolor painting privately, first at the Calcutta Government School of Art, then at the studio of British artist Charles Palmer.

In 1901, however, Abinandranath's discovery of an old illuminated Indo-Persian manuscript in his family library inspired him to revive the traditional values and techniques of the Mughal miniature in a modern context. His watercolor series on the life of Krishna was the first of many works in this style. In 1905, with the same aim in mind and in partnership with Ernest Binfield Havell, Principal of the Calcutta Government School of Art, he founded the Bengal School of Painting.

Teacher, sculptor, poet, playwright, actor, writer, and firm believer in Gandhi's nationalist ideal of *swadeshi* (self-sufficiency), Tagore felt strongly that Indian artists must mine their traditions to express their spiritual heritage. This idea had faded by the 1920s, but influenced other Bengali artists such as Jamini Roy to embed traditional elements in their work. Abinandranath's own best-known painting, *Bharat Mata*, shows Mother India as a young woman holding up in her four arms a book, a rice plant, prayer beads, and a white cloth, enduring symbols of India's national identity.
Catherine Nicolson

Date 1905

Born/Died 1871–1951

Nationality Indian

First Exhibited 1892

Why It's Key Leader of the modern Indian renaissance, asserting traditional artistic values in a twentieth-century context.

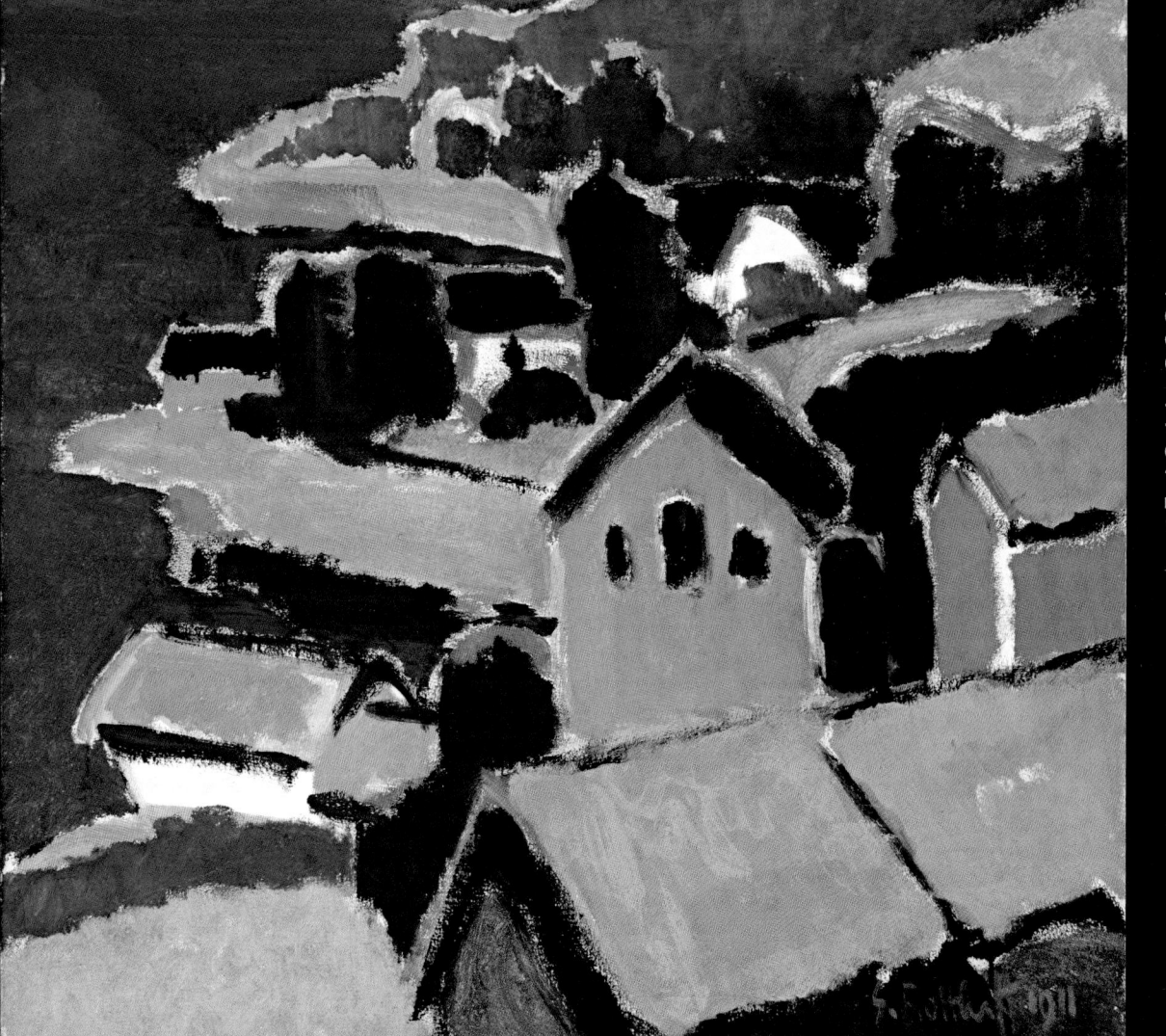

Key Event
Golden Fleece magazine launched

In the first decades of the twentieth century, many short-lived avant-garde groups and journals came and went in Russia. The symbolist-oriented *Golden Fleece* (*Zolotoe runo*) was one of the earlier and more significant ones. Funded and edited by the millionaire banker Nikolai Ryabushinsky in Moscow, the *Golden Fleece* was not just a magazine, it also sponsored and organized exhibitions of adventurous new art from Russia and Europe. It fostered some of the principles of the World of Art, a fin de siècle movement headed by Alexander Benois, the most fundamental of which was their belief that a painting should go beyond the descriptive or purposeful; rather, a painting existed in its own right, expressing the idea of "art for art's sake."

In the first issue of *Golden Fleece* magazine in 1906, the editorial took an outward-looking and international stance. Championing the avant-garde, it declared that the magazine's aim was to promote new Russian art in Europe, while in the preface Ryabushinsky gave support to the avant-garde Blue Rose group and its mystical symbolism. The first issues were printed in both Russian and French.

The first major exhibition, in 1908, demonstrated characteristics in common between Russian and European experimental art. Included were French Post-Impressionists Cézanne, van Gogh, and Gauguin, the Nabis Pierre Bonnard and Vuillard, as well as Fauvists Matisse and Derain. Also shown were the sculptural works of Maillol and Rodin. The Russians were represented by Mikhail Larianov, Natalia Goncharova, and the Blue Rose group.
Sue King

Date 1906

Country Russia

Why It's Key This influential magazine championed Russian avant-garde art and introduced it to Europe.

opposite Paintings by Felix Vallotton at the Golden Fleece exhibition in Moscow, 1908.

Key Artwork *Barges on the Thames*
(Cannon Street Bridge) André Derain

Between March 1906 and February 1907, the twenty-five-year-old André Derain (1880–1954) made three visits to London. These were undertaken at the instigation of Ambroise Vollard, who became Derain's dealer in November 1905, following that year's Salon d'Automne, at which he, Matisse, Vlaminck, and others showed in the notorious Cage aux Fauves.

Vollard, who funded Derain's visits, commissioned from him 50 paintings of London, modeled on Monet's famous series of views of the city, which had been exhibited to great acclaim in Paris in 1904. Derain filled two sketchbooks with ideas for paintings, some of which may have been made on the spot but the majority of which were executed in France. He completed only thirty paintings, and a proposed exhibition of the entire series never materialized.

Derain roamed across London, spending a good deal of time in the National Gallery and the British Museum, where he was profoundly influenced by the collections of non-Western art. He painted women and children walking in Hyde Park and the bustle of traffic in Regent Street, but the focus of his attention, as of Monet's, was the Houses of Parliament and the Thames. *Barges on the Thames* shows the stretch of the river east of Cannon Street railway bridge, looking downstream towards London Bridge and Tower Bridge. Compositionally this is one of the most ambitious of Derain's London paintings. In its loose handling of paint and bold contrasts of color it is also one of his most vivid and sophisticated contributions to the short-lived Fauvist movement.
James Beechey

Date 1906–07

Country UK

Medium Oil on canvas

Collection Leeds City Art Gallery, UK

Why It's Key This is an important example of Fauvist landscape painting.

1860–1909

74

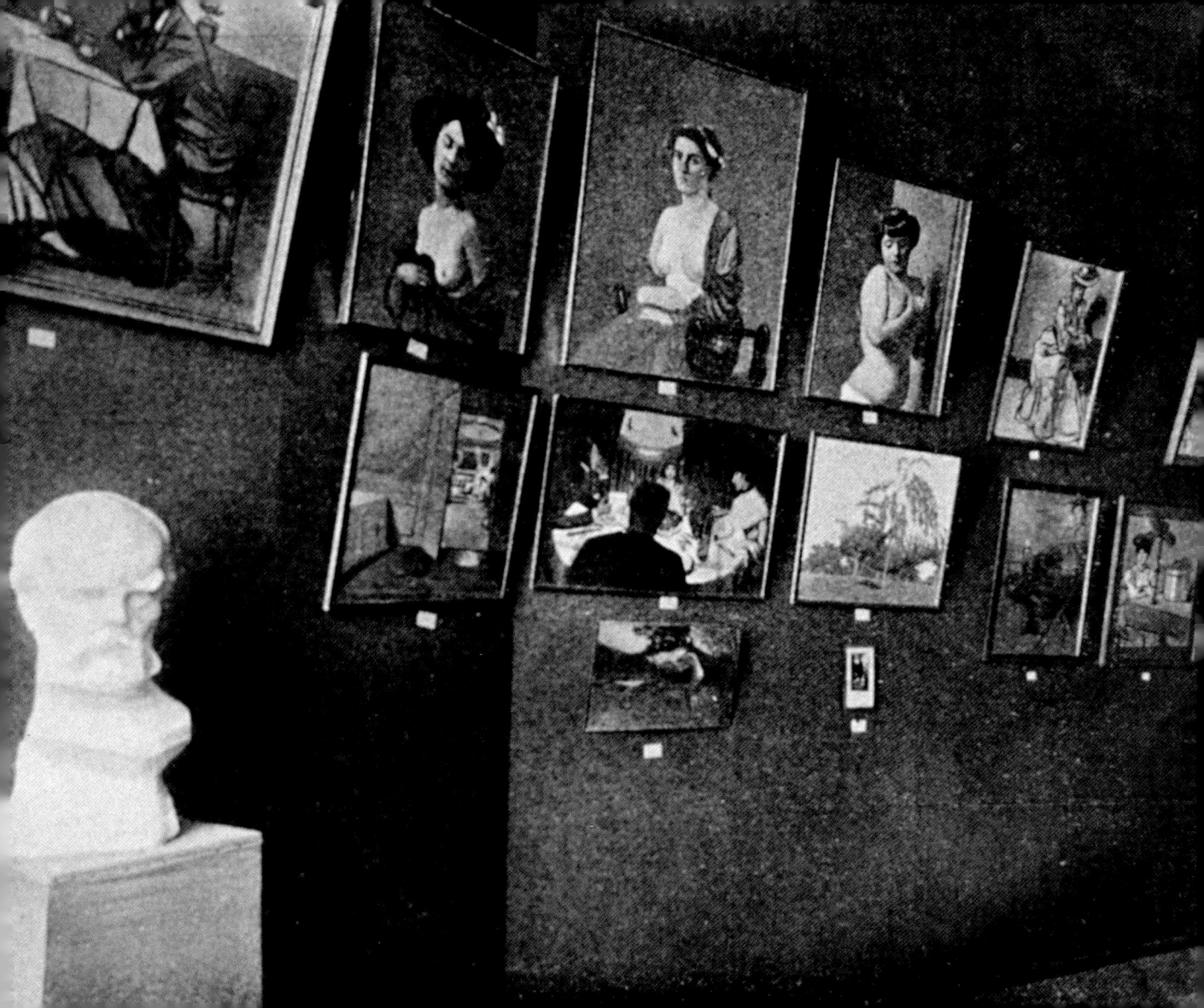

Key Artwork *Les Demoiselles D'Avignon*
Pablo Picasso

*L*es Demoiselles d'Avignon is one of the most discussed images in art history. Picasso (1881–1973) deliberately set out to create a "masterpiece" when he returned to the Bateau-Lavoir studio in 1906. He had been in Gosol, Spain, where his new works had been influenced by Greek, Iberian, and African art, using more geometric figure forms. He purchased an especially fine, large canvas and had it relined.

He was consciously ready to make a grand statement to "free art from its shackles" and "extend its frontiers" (Apollinaire). Yet the painting was anchored in tradition, with strong resonances to the classic Three Graces (the figures on left); Cézanne's monumental Bathers – blockish, angular bodies under arching trees; and El Greco's *The Opening of the Fifth Seal of the Apocalypse*.

Picasso was a dedicated visitor to the African and Oceanic collections in the Musée d'Ethnographie du Trocadéro in Paris, and a lifelong collector of tribal masks – they were to be one of his primary influences after 1906. *Les Demoiselles d'Avignon* (depicting three naked prostitutes) also has, according to Picasso expert Anne Baldassari, "strong relationship to one of the artist's growing collection of picture postcards of African subjects" – in this case, Edmond Fortier's 1906 photograph, *Types of Women in the Sudan*. The field is wide open to speculation: Picasso called it his "first exorcism picture"; André Breton called it "the birth of Cubism."

Mike Von Joel

Date 1907

Country France

Medium Oil on canvas

Collection MoMA, New York

Why It's Key Judged by history as the most pivotal painting in the development of twentieth-century art, it triggered Modernism and laid the foundations for Cubism.

opposite *Les Demoiselles D'Avignon*

Key Artist **Frances Hodgkins**
First one-woman show

*B*orn in Dunedin, New Zealand, in 1869, Frances Hodgkins exhibited for the first time in Dunedin and Christchurch in 1890, and in the same year was elected a working member of the Otago Art Society. In February of 1901, she left for England, first attending classes at the London Polytechnic, and then joining Norman Garstin's sketching class at Caudebec. She exhibited her paintings at several private galleries in London, in the Royal Academy in 1903, and again in 1905 and 1916, and had her first solo show in 1907.

By the 1920s she was a recognized fixture in the British art scene. In 1929 she became associated with the Seven and Five Society, exhibiting alongside leading British avant-garde artists such as Barbara Hepworth, Ben Nicholson, and Henry Moore.

She began to combine landscape and lyrical still life genres in her work, painting urns and jugs filled with flowers, and patterned table cloths set in the foreground of a landscape. This kind of painting was considered progressive at the time. She was particularly known for an emphasis on color, strong use of compositional elements, and a lyrical treatment of form.

From the late 1930s onwards Hodgkins continued to consider new approaches in her use of iconography, color, composition, and style. Of particular note are her still life paintings from this period, which give the appearance of semi-abstracted works. By the later stages of her career, Hodgkins had secured her position as a key figure in British modernism. She died in 1947 of bronchitis.

Kate Mulvey

Date 1907

Born/Died 1869–1947

Nationality New Zealander

Why It's Key Frances Hodgkins was one of the leading artists of British modernism.

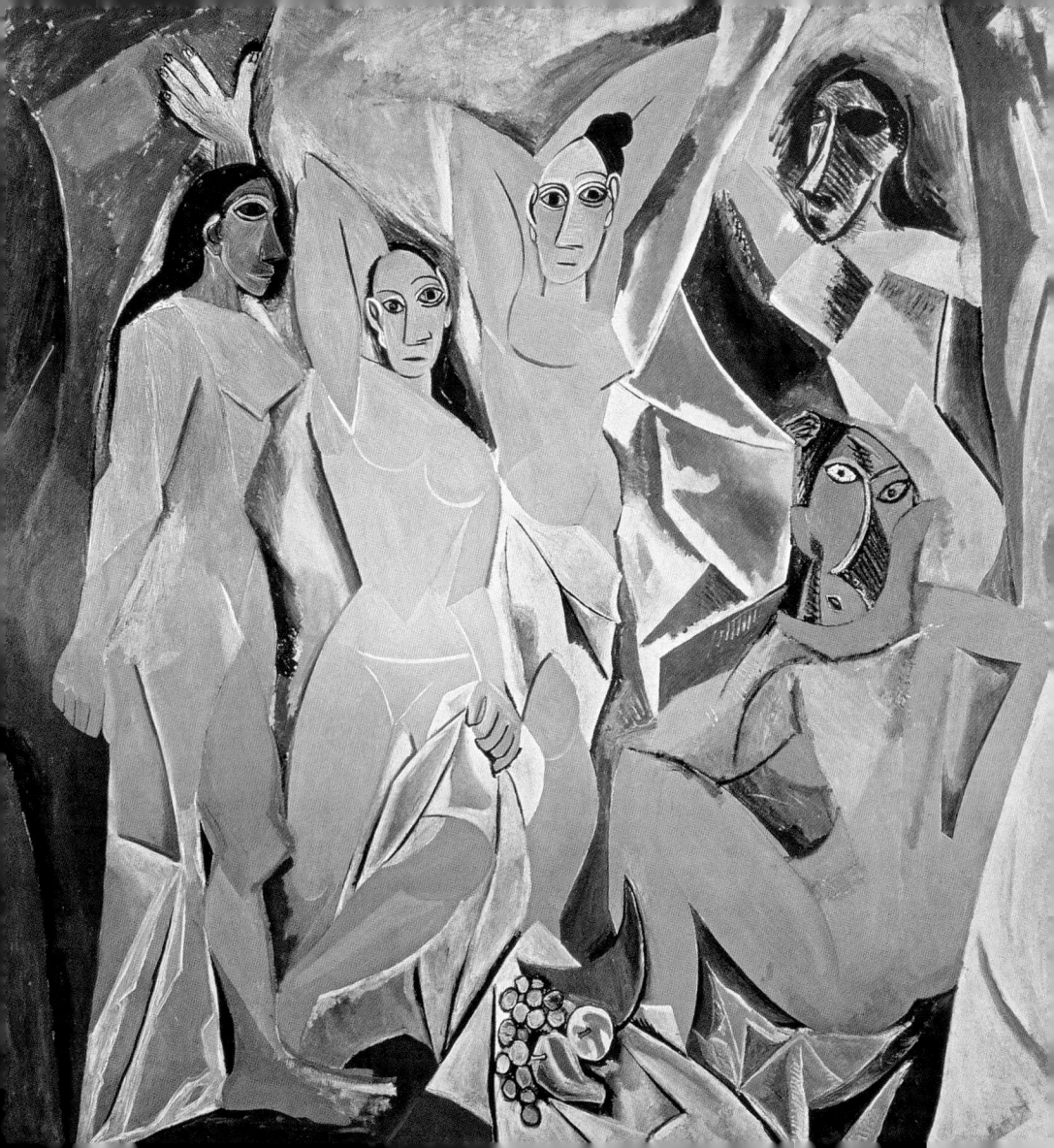

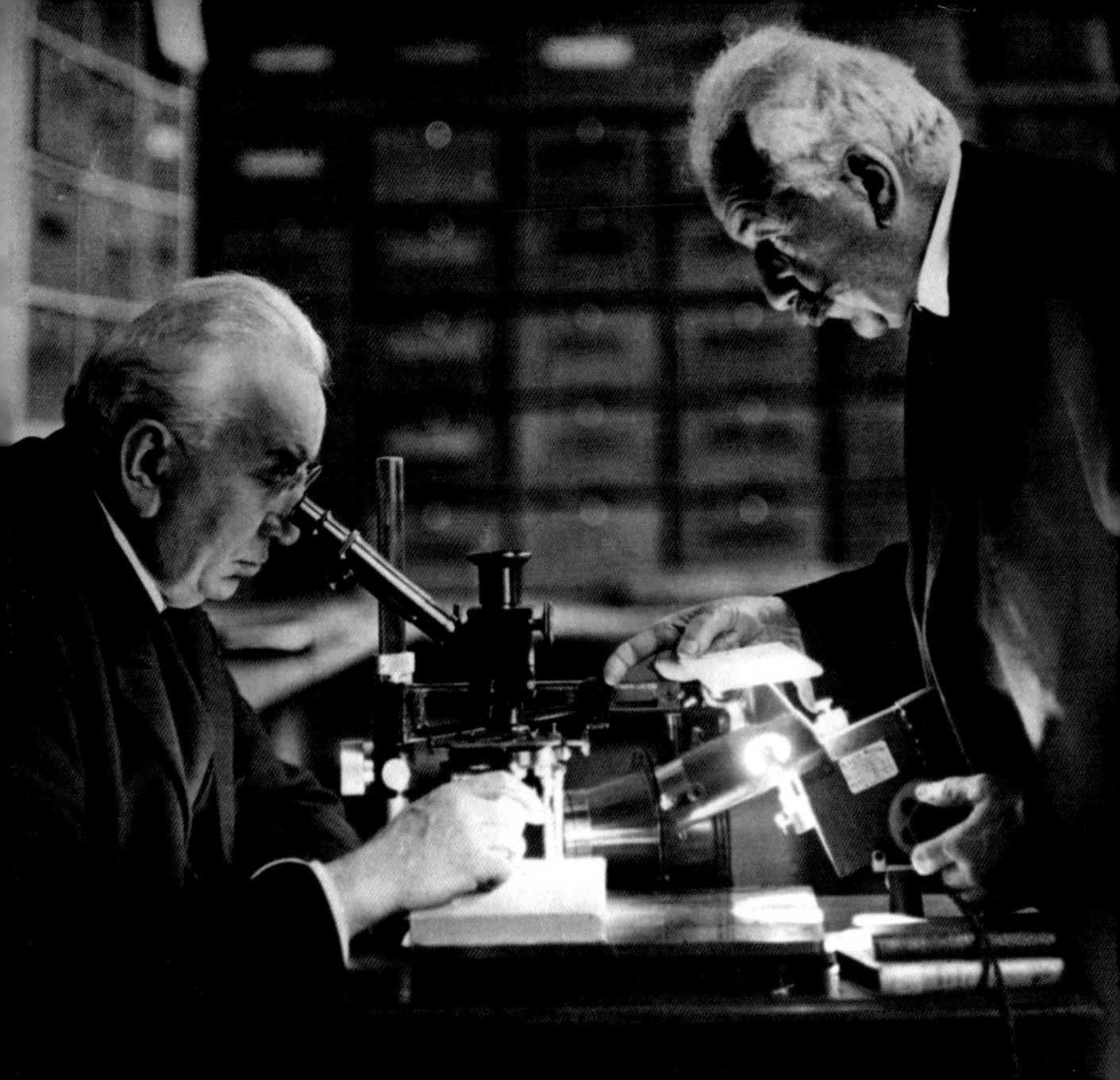

Invention of color photography

Auguste and Louis Lumière were the sons of a painter-turned-photographer who ran a successful company manufacturing photographic plates. In 1894, he saw a demonstration of Thomas Edison's kinetoscope in Paris and, returning to Lyon, described the peep-hole projector to his sons, setting them the task of combining animation with projection. They succeeded in inventing the movies.

At the same time, the brothers were developing color photography. Although they created more than forty short films in 1896, the Lumières decided that, "the cinema is an invention without any future," and in 1903 patented a color photography process, the "Autochrome Lumière," that they launched on the commercial market in 1907. Throughout much of the twentieth century, the Lumière company was a major producer of photographic products in Europe, although the brand name Lumière disappeared from the marketplace following the company's merger with Ilford.

The increasing capacity of photography to achieve the lifelike realism hitherto the province of painters, was a key factor in moves away from figurative art and toward abstraction. At the same time the development of color photography led to photolithography, allowing the easy reproduction of original works in color. And with photography challenging the realism achievable by fine art, artists struck back with the glossy photographic style of the Surrealists, particularly Salvador Dalí. Later, Andy Warhol would use color photography as the basis of his silkscreen work.

Nigel Cawthorne

Date 1907

Country France

Why It's Key The mechanical process of photography was now able to emulate many aspects of realistic painting.

opposite Auguste and Louis Lumière in their laboratory at Lyon, France.

79

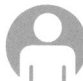

Key Person **Daniel-Henry Kahnweiler**
Key art dealer opens first gallery in Paris

Trained to follow his father with a career in finance, Kahnweiler instead chose art and settled in Paris, where at only twenty-seven he opened a small gallery at rue Vignon in 1907. In the same year, after meeting Picasso (with Ambroise Vollard, a neighbouring gallerist), he viewed *Les Demoiselles d'Avignon* in his studio and was smitten by the artist's Cubist direction.

Following his one-man show of the work of Georges Braque in 1908 (November 9–28), Kahnweiler bought forty pictures direct from Picasso, with whom he signed a contract for the first time in 1911 (Kahnweiler was famously keen on contracts). He also published books by a number of emerging literary artists, including Guillaume Apollinaire, André Malraux, and Antonin Artaud; he also wrote several monographs himself on the artists he knew best.

During World War I, Kahnweiler's German nationality prevented his return to Paris and his picture stock was confiscated while he hid in neutral Switzerland. The French government subsequently auctioned off his collection under Article 297 of the Treaty of Versailles and this event precipitated a major schism with Picasso over the fate of his works on consignment. Back in Paris in February 1920, Kahnweiler opened the Galerie Simon and became a French citizen in 1937.

As a Jew he was forced into hiding at the beginning of World War II and his wife's sister purchased his stock and business, renaming it Galerie Louise Leiris. After the liberation, Kahnweiler served as a director of this gallery until shortly before his death in 1979.

Mike von Joel

Date 1907

Born/Died 1884–1979

Nationality German

Why It's Key Kahnweiler held Georges Braque's first exhibition, and was the first to recognize the greatness of Picasso and the Cubist movement.

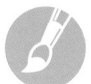

Key Artist **Pavel Kuznetsov**
Founder member of the Blue Rose group

Pavel Kuznetsov was born in Saratov in 1878. He studied locally from 1891 to 1896, then trained at the Moscow School of Painting, Sculpture, and Architecture until 1904 under Korovin and Serov. Inspired to rebellion by the more poetic work of Borisov-Musatov and Vrubel, in 1904 Kuznetsov helped organize an exhibition in Saratov called Alaya Roza (Crimson Rose), featuring dreams, visions, and archetypes in the Symbolist style. In 1907 his similar Moscow exhibition Golubaya Roza (Blue Rose) led to the foundation of the influential Blue Rose group of Symbolist painters. Members included Petr Kuznetsov, Saryan, Sudeykin, Sapunov, Krylov, Petrov-Vodkin, and Kandinsky.

The Blue Rose painters were denounced by contemporary Russian critics as decadent, though the poet Mayakovsky praised them for being "unburdened by the ballast of historical experience" and "in love with the music of color and line." Kuznetsov's *Blue Fountain* of 1905, with its enigmatic figures gathered round a fountain representing the life force, is an example of the group's aesthetic.

Kuznetzov also studied in Paris in 1905 and exhibited in the Salon d'Automne of 1906. He later taught at the Stroganov Institute (1917–1918 and in the postwar 1940s), and the Moscow Institute of Fine Arts from 1918 to 1937. Until 1921 he headed the painting section of the offical education body Narkompros, but lost his position with the advent of Stalin-inspired Socialist Realism. He died in Moscow in 1968.

Catherine Nicolson

Date 1907

Born/Died 1878–1968

Nationality Russian

First Exhibited 1904

Why It's Key Influential second generation Russian Symbolist painter.

Key Artist **Pablo Picasso**
Les Demoiselles D'Avignon

In 1906, Picasso moved to Gosol in Spain where his new works were influenced by Greek, Iberian and, particularly, African art. On his return in 1907, he was ready to paint a "masterpiece" in the cramped Paris studio at Bateau Lavoir and had a superior canvas specially prepared. It was to be a large picture (of five naked prostitutes from a half-remembered brothel in Barcelona) now known as *Les Demoiselles d'Avignon*. The features of the three women to the left were inspired by the wooden carvings on which he had worked in the summer of 1906, influenced by prehistoric Spanish sculpture in the Louvre. The two women to the right were based on the masks that Picasso saw in the African and Oceanic collections of the Musée d'Ethnographie du Trocadéro in Paris. *Les Demoiselles d'Avignon* also has a strong relationship to one of the artists collection of postcards of Sudanese women. The painting has been x-rayed and there is a second phase of painting after Picasso's visit to the Trocadéro – beneath the top layer of paint are heads in the Iberian style. Picasso's Spanish heritage is referenced in the bodies of the two caryatid-like standing nudes, and to a lesser degree the right figure, which twist like characters by El Greco.

Gertrude Stein called it "a veritable cataclysm," in 1921 Breton would call it the "birth of cubism," but Picasso's immediate circle were less impressed and he rolled the canvas away in a corner of his studio. This iconic painting has become a milestone in art, the "detonator" to Modernism and precursor to the twentieth-century century avant-garde.

Mike von Joel

Date 1907

Born/Died 1881–1973

Nationality Spanish

Why It's Key Picasso created what is generally acknowledged as the first twentieth-century masterpiece, heralding Cubism and the Modern art movement.

Key Artwork *The Harbor at Marseilles*
Paul Signac

Following in the footsteps of Seurat, Paul Signac adopted the Pointillist style to return painting to a more formal pictorial construction than Impressionism, yet the new style upheld its predecessor's focus on light phenomena. Pointillist theory made use of new scientific discoveries regarding the technology of vision, allowing the viewer's eye to mix the colors, thus achieving a more harmonious and vibrant effect.

In 1895 the anarchist writer Sébastien Faure proclaimed: "The future is light, knowledge, happiness. One does not turn back to the past, one goes, inevitably, toward the future... The golden age is not behind us; it is before us, radiant and accessible." As an anarchist himself, Signac set out to depict scenes of an idealized utopia. However, rather than believing in a mythical Arcadian setting of pure splendor, anarchists dreamt of a future for mankind that would make use of technological innovations and productivity, represented here by the man-made ships and their attendant mercantilism. Signac believed that labor and concord could create a new Eden with a collective yet autonomous spirit. In his representation of Marseilles, Signac has fused subject matter with style of depiction by showing us a scene of harmony while achieving a similarly harmonious optical effect.

Aimee George

Date 1906

Country France

Medium Oil on canvas

Collection The Hermitage Museum, St Petersburg

Why It's Key The painting is an image of the harmonious utopian society dreamt of by anarchists.

1860–1909

Key Artwork *Houses on the Banks of the Seine at Chatou* Maurice de Vlaminck

Vlaminck (1876–1958) was one of the artists referred to as "les Fauves," French for "wild beasts," by an outraged art critic after an exhibition in Paris in 1905. The term was spurred by their use of pure, jarring, often autonomous color and dynamic brushstrokes, which can be seen in this painting. Gestural brushstrokes seen prominently in the sky and trees help to create a strong sense of movement and dynamism in the scene and were possibly influenced by the post-Impressionist van Gogh. The painting also displays typical Fauvist color in its un-naturalistic use of yellow to depict the trees and unmixed colours of red, yellow, and green to create the buildings.

However, these raw and vibrant Fauvist colours are combined with the much more muted ones seen in the river and sky. They are indicative of a distinct change in Vlaminck's work, which occurred in 1907 when he started to use a much more sombre palette, influenced by Cézanne, another Post-Impressionist artist. The actual setting of the painting in Chatou is also very significant. Vlaminck and Derain, another major Fauvist painter, often painted there together. A great debate has developed as to whether an artistic "school of Chatou" existed, where the artists were united in their aims and had similar inspirations.

Esmay Luck-Hille

Date 1907

Country France

Medium Oil on canvas

Why It's Key Important Fauvist example of the so-called "School of Chatou."

Key Event
Patent filed for Bakelite

When Dr Leo Baekeland (1863–1944) patented his invention in 1907, it heralded the use of synthetic plastics as a key element in modern manufacture and design. Born in Ghent, Belgium, Baekland had emigrated to America in 1889. There his first major invention was Velox, a photographic printing paper that could be developed under artificial light. In 1899 he sold the rights to Velox to George Eastman's Kodak company for US$1 million, using the proceeds to set up his own laboratory in Yonkers, north of New York City.

Made from a fusion of carbolic acid and formaldehyde, and introduced to the world at a chemical conference in 1909, Bakelite was primarily intended as an insulation material in electrical appliances on account of its non-conductive and heat-resistant properties. But after it began to be used for the casings of those same radios and telephones, its versatility soon became apparent, with applications as diverse as kitchenware and cigarette holders, decorative objects d'art and jewelry.

Advertised by the General Bakelite Corporation as "the material of a thousand uses," Bakelite – along with subsequently developed plastics – became a staple ingredient in the Art Deco style of the 1920s. It also attracted the attention of visual artists such as the Russians Alexander Archipenko and Naum Gabo, both of whom used a variety of newly developed materials in their sculpture. But it was as the spearhead of the "plastic revolution" that has permeated every aspect of life since the mid-twentieth century, that Bakelite made its long-term impact.

Mike Evans

Date 1907

Country USA

Why It's Key The first plastic, an essential part of Art Deco design, and forerunner of other synthetic materials used in both mass-produced objects and "pure" sculpture.

82

Key Event Emily Carr visits
Sitka and discovers totem poles

Canadian artist Emily Carr first painted totem poles among the trees after she discovered "Totem Walk" in the village of Sitka, Alaska, where the totems of the Haida and Tlingit Indians had been erected for tourists in a wooded area behind the village. This, and her visit to the Sitka studio of the Minneapolis artist Theodore J. Richardson, where she saw his watercolors of the villages of the Alaskan Indians, galvanized her into her seminal decision to preserve the dying heritage of British Columbia Indians through her art.

In 1912 Carr made a six-week trip to native villages in British Columbia, visiting the Skeena River valley, the Queen Charlotte Islands, and the remote villages around Alert Bay. She lived amongst the Indians, painting and sketching their habitat and vanishing culture. Carr focused on the accuracy of her depictions of the sacred artefacts, referring to "real art treasures of a passing race," one of the great themes of her work.

In 1927 Carr's work came to the attention of the National Gallery of Canada, which invited her to an exhibition of West Coast native art. There she met Lawren Harris of the Group of Seven painters, and his encouragement led to Carr's artistic renewal after fifteen years of little painting. She began to paint native themes in a bolder, freer style, and then turned to her second great subject, the spectacular landscapes of west coast Canada. Since her death in 1945, Emily Carr has become a Canadian icon, a seminal contributor to Canadian culture and art.

Bryan Doubt

Date 1907

Country USA

Why It's Key In Sitka Emily Carr (1871–1945) conceived the idea of painting the British Columbia Indians, their totem poles, and their homes in an effort to salvage their dying heritage.

Key Artwork *Houses at L'Estaque*
Georges Braque

During the summer of 1906 Braque (1882–1963) stayed in L'Estaque, near Marseille, where several painters before him, one of whom was Paul Cézanne, had been inspired by the light and the coastal landscape. While he was there, Braque produced a series of brightly colored Fauve landscapes. When Braque returned to L'Estaque during the winter of 1906–7, the influence of Cézanne was already apparent.

Braque's landscape *Houses at L'Estaque*, painted when he stayed there during the Summer of 1908, shows a transference of Cézanne's formal innovations to a radical "materialization of a new space." Avoiding any distracting elements, Braque relinquished the vivid colors and curvilinear forms of his Fauve-inspired landscapes, and used muted earth colors and un-differentiated forms in order to concentrate on the structural function of interpenetrating geometric forms and space. Each object is lit from a different source, and is presented from a different viewpoint; traditional one-point perspective is abandoned. Forms are thrust upwards toward the ambiguous horizon line, emphasising the shallow pictorial space, and eliminating the sky.

It is open to much debate as to who, between Braque and Picasso, was responsible for initiating the analytical phase of Cubism. Picasso's *Les Demoiselles d'Avignon* was completed in 1907 at the same time as Braque's meditations on Cézanne. However, from 1907 to 1914, Braque and Picasso collaborated on a far-reaching experiment into pictorial form and space.
Sarah Mulvey

Date 1908

Country France,

Medium Oil on canvas

Collection Kunstmuseum, Berne

Why It's Key In 1908, Braque showed his L'Estaque landscapes. The critic Louis Vauxelles wrote of Braque's work that he "scorns form and reduces everything – places, figures and houses – to geometric schemes, to cubes." Thus the term Cubism was born.

Key Person **Alfred Stieglitz** Stages first U.S. exhibition of modern art at his 291 Gallery

Born in New Jersey, Stieglitz moved to Germany in 1881 with his family. He studied mechanical engineering and photography at the Polytechnic of Berlin. In 1883, Stieglitz saw a camera in a shop and bought it. By the 1890s he was famous for his photographs of street life in New York and Paris.

In 1902, he became one of the key founders of the Photo-Secession, a group of talented avant-garde artists that included Edward Steichen, Gertrude Kasebier, Clarence White, and Alvin Langdon Coburn. Their images were published in *Camera Work*, the pre-eminent quarterly photographic journal of its day. In 1905, Stieglitz founded and directed the Little Galleries of the Photo-Secession, sited in his former studio at 291 Fifth Avenue, New York. In 1908 he opened the first modern art exhibit, which featured the works of European artists including Picasso, Cézanne, and Rodin. Notably, *Nude in the Forest* was the first ever Matisse to be shown in the USA, and in 1911 Cézanne's first one-man show took place and included some twenty watercolors. These works were to influence the development of photography.

Stieglitz had a dictatorial and self-important manner that alienated everyone around him, although he could be extraordinarily kind. He was also a success with young women and his marriage to painter Georgia O'Keeffe was notable, if volatile. Stieglitz retired from active photography in 1937 because of heart disease. He died in 1946 at the age of eighty-two. A dynamic visionary, his own work alone elects him to the pantheon of great photographers of the world.
Mike von Joel

Date 1908

Born/Died 1864–1946

Nationality American

Why It's Key This small space exhibited some of the greatest twentieth-century European painters for the first time in the United States, and simultaneously made a distinct and influential contribution to the development of new styles of photography.

Key Event **Formation of the Association of Architects of the Mánes Union**

Date 1908

Country Austro-Hungarian Empire

Why It's Key Czech artists carried out a spirited and largely successful transfer of the influential Cubist aesthetic from canvas to street.

Deeply influenced by the emerging Analytical Cubism of Picasso and Braque and the self-consciously rational architecture of architects Otto Wagner and Jan Kotra, a wave of young Czech architects founded the Association of Architects of the Mánes Union in Prague in 1908. The Association of Architects imported the young movement's multi-angled surfaces, energetic lines, and prismatic vigor into the design of scores of Czech buildings, including the House of the Black Madonna in Prague, apartment blocks, residences, and spas. Members of the Association of Architects – including Pavel Janák, Josef Goár, and Otakar Novotny – proved to be innovative yet practical artists who succeeded in transferring the spirit of the Cubist aesthetic from the canvas to the living street. In this way, the Association of Architects became a cornerstone of the Czech avant-garde and helped to establish Central Europe as a vibrant locus of modernist experimentation.

Architectural Cubism remained in regional vogue until the independence of Czechoslovakia from the Austro-Hungarian Empire in 1918, at which time avant-garde Czech architects began to incorporate traditional ethnic themes and motifs into their designs. During its brief Cubist efflorescence, however, the Association of Architects made visible and important contributions to the unfolding pan-European modernist experience and prepared the way for Czech Rondocubism, a style that proved to be more durable and influential in the formation of Czech architectural identity.

Demir Barlas

Key Event
Sole exhibition of The Eight in New York

Date 1908

Country USA

Why It's Key This exhibition is an important event in the history of modern painting; while the group was short-lived, its members contributed greatly to the advance of modernism.

A group of American painters who came together in an effort to oppose prevailing traditions in art upheld by the National Academy (one member referred to the Academy as "a cemetery of art"), The Eight included five painters: Robert Henri, George Luks, William Glackens, John Sloan, and Everett Shinn, as well as Maurice Prendergast, Ernest Lawson, and Arthur Bowen Davies. These artists made up the progressive Ashcan school, which began in New York in 1908. Although agreeing on common themes such as "Art for art's sake," The Eight had different artistic styles.

The Eight shocked viewers because of their rebellious stance. The group's subject matter was realistic and departed from the norm with themes such as city life and life on the streets, preferring to depict the everyday experiences of ordinary people. They were after "the Truth" and departed from the idealized style current at the time, often portraying scenes that were at times unpleasant, including those set in bars, streets, and alleys.

They exhibited together only once, in New York in 1908. Yet despite the short-lived nature of the event and the group as a whole, they established one of the main currents in twentieth-century American painting, contributing greatly to the advance of realism in art. Their coarse, reportage style of art depicted scenes of the underbelly of urban life. The style – quick, obvious brush strokes, with thick layers and dark muted colors – was unique. The Eight used their art as a medium for social and political criticism, thus presaging future Modernist thought.

Kate Mulvey

opposite *Nude with Apple* (1910) by William Glackens, one of The Eight.

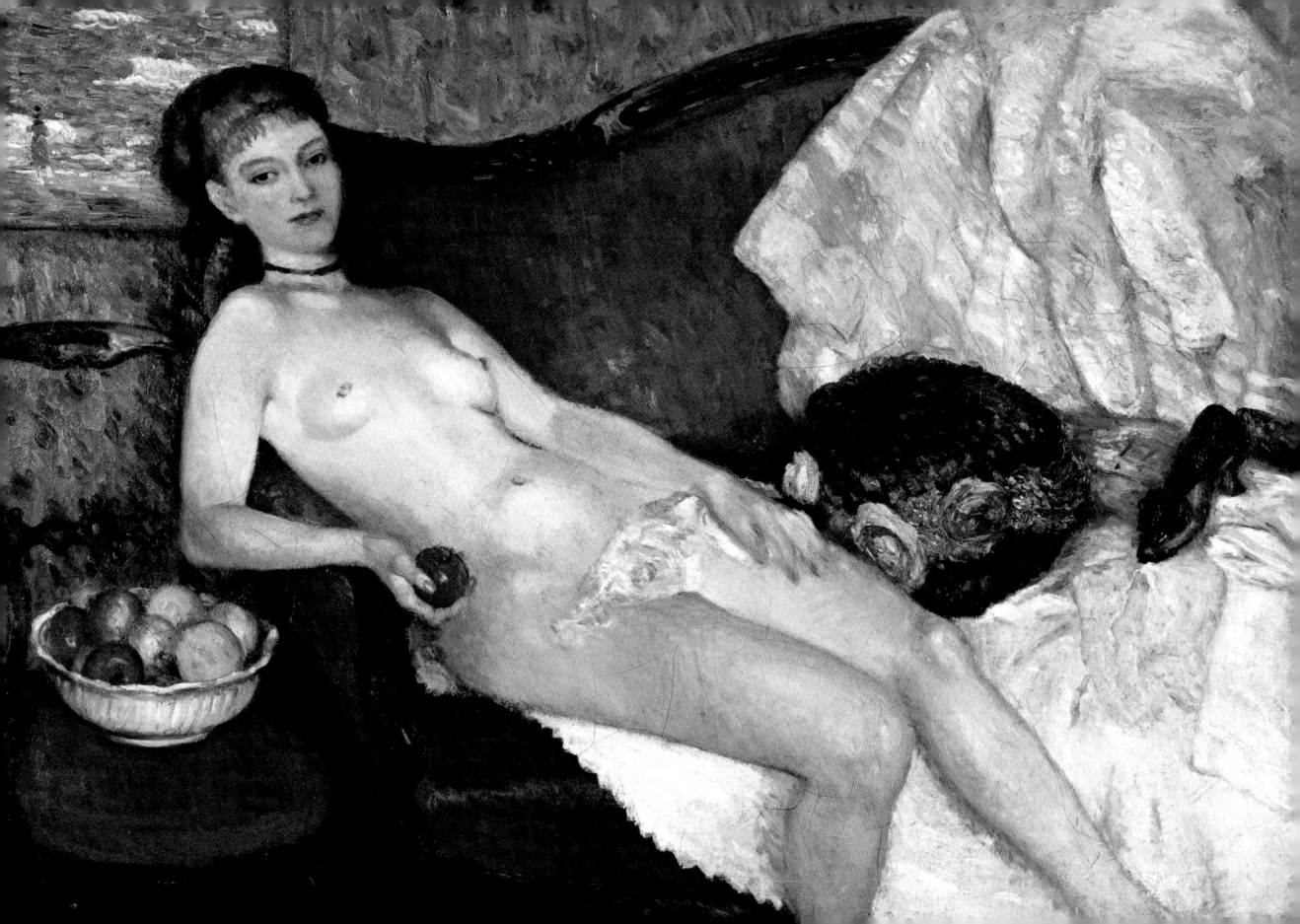

Key Artist **Jacob Epstein**
Scandal over nudes on the Strand

Born in New York of Russian-Jewish parents, Epstein was forced to abandon painting for sculpture at an early age due to poor eyesight. He studied in Paris for two years before moving to London in 1905 and becoming a British subject in 1907. That year, he was commissioned to produce a series of 18 sculptures to decorate the façade of the British Medical Association building on the Strand (now Zimbabwe House). When they were erected in 1908, his nudes caused a scandal and the National Vigilance Society began a campaign to have them removed. The support of the art establishment preserved them for the time being, but they were destroyed in 1937 when the government of Southern Rhodesia took over the building.

In 1912, he produced a winged figure for the tomb of Oscar Wilde in Père-Lachaise Cemetery, Paris. It had prominent genitals that were covered for some time by a bronze fig leaf. The following year, Epstein became a founder member of the London Group, promoting modern art in England, and produced his most famous abstract work, *The Rock Drill*, which is now in the Tate Gallery in London.

Epstein quickly returned to representational, if Expressionist, work which was often controversial. His pregnant figure, *Genesis* (1930), was displayed for a time as a sideshow in Blackpool. He continued to produce monumental work along with busts of leading figures of the day, and the figure of Christ in Llandaff Cathedral, Cardiff. He was knighted in 1954.

Brian Davis

Date 1908

Born/Died 1880–1959

Nationality British (born American)

First exhibited 1913

Why It's Key Maintained the representative tradition in sculpture, despite a flirtation with the abstract.

opposite **Jacob Epstein**

86

Key Artist **Georges Braque** Discovers Picasso's work, and becomes other major force in Cubism

Georges Braque was born in Argenteuil, the son of a decorative housepainter. In 1888 he was apprenticed to another housepainter, while studying art in Normandy. In 1902 he went to Paris to study art, and then set up his own studio.

Braque's contact with the Parisian avant-garde came when he saw Fauvist paintings at the Salon d'Automne of 1905. He had been painting in a Cézanne-inspired style until the poet Apollinaire took him to Picasso's Bateau-Lavoir studio in 1907, where he was impressed by the artist's *Demoiselles d'Avignon*.

Braque and Picasso began a process of deconstructing reality by representing the idea of the structure of the object, simultaneously integrating different viewpoints, as a reaction to the Impressionist representation of surface qualities. In 1911, Braque introduced lettering into his paintings, which had a structural function, and the following year he invented *papier collé* (collage).

In 1920s postwar Europe, artists registered their sense of devastation with a sobering rejection of the avant-garde aesthetic, and instituted what Jean Cocteau termed "a return to order." Braque developed a more conservative art in which an underlying Cubist structure is still evident.

In 1940 he moved back to Paris, where he lived during the course of World War II. The enigmatic paintings he produced in the later years are complex, multilayered accumulations of ideas, beautifully executed using ambiguous space and references to earlier Cubist compositions.

Sarah Mulvey

Date 1908

Nationality French

Born/Died 1882–1963

Why It's Key While Picasso was investigating the conceptual representation of the visual world, artists such as Braque were exploring the compositional devices that Cézanne used in his late landscapes. Braque and Picasso realized they were pursuing the same ideas, and simultaneously began work to produce the first examples of Analytical Cubism.

Key Artist **Oskar Kokoschka**
Paintings cause outcry at Vienna debut

Born in Pölarn, Austria, Kokoschka won a scholarship to the School of Arts and Crafts in Vienna and became a teacher there. Dissatisfied with the decorative arts, he studied the human figure and taught himself to paint, encouraged by the Viennese architect Adolf Loos. Kokoschka also wrote. His play, *Mörder, Hoffnung der Frauen* (*Murderer, Hope of Women*), caused an outcry, as did the figure paintings he showed at the Kunstschau exhibitions organized by Gustav Klimt in 1908 and 1909.

He moved to Berlin, where he became an illustrator for the magazine of Expressionism *Der Sturm* and had an affair with Alma Schindler, widow of Gustav Mahler. Kokoschka continued to produce figures in various styles, but united in their Expressionist intensity. Badly wounded in the Ukraine in World War I,

he convalesced in Dresden where he became professor of fine arts at the Academy.

After his work was banned by the Nazis as "degenerate art" in 1937, he fled to London, where he produced anti-war canvases. He became a British subject in 1947. After World War II, he was given an exhibition in Vienna which toured Europe and the United States, making him financially secure for the first time. He moved to Switzerland, where he continued making political art, turning to lithography, and designed tapestries and theatrical scenery.

Brian Davis

Date 1908

Born/Died 1886–1980

Nationality British (born Austrian)

First exhibited 1908

Why It's Key Leading exponent of Expressionism.

opposite **Kokoschka** poster for Art Show, Vienna, May–October 1908 (color litho).

Key Event
The Rousseau Banquet

The most celebrated "banquet" in modern art history took place in November 1908 in Picasso's studio at the Bateau-Lavoir, Montmartre. It was given in honor of Henri Rousseau ("le Douanier"), the customs official-turned-painter, whose *Portrait of a Woman* (c.1895) Picasso had recently bought for five francs from a nearby shop, the dealer who sold it having suggested to him that he could re-use the canvas.

Various conflicting accounts of the evening exist, most famously that given by Gertrude Stein. What seems clear is that it was conceived as much as a charade as a celebration. Rousseau was seated on a makeshift throne and addressed, in song and verse, by several of the guests, including Guillaume Apollinaire and André Salmon. Events became more burlesque as the revellers grew increasingly riotous: the dinner

apparently failed to materialize; the painter Marie Laurencin fell into a tray of jam tarts; Salmon was involved in a drunken brawl; and a number of gatecrashers – among whom were Ferdé, the patron of the Lapin Agile, and his donkey – supposedly appeared.

Whatever the truth of the legendary banquet, the admiration shared by the two artists for each other is undeniable. "You and I are the greatest painters of this age," Rousseau told Picasso. "You in the Egyptian style, I in the modern." After Rousseau's death in 1910, Picasso bought several more of his paintings, which remained among his most treasured possessions.

James Beechey

Date November, 1908

Country France

Why It's Key Coming together of the great names of the Paris avant-garde in honor of the French primitive painter Henri Rousseau.

Key Artist **Constantin Brancusi**
The Kiss

When a young Constantin Brancusi fled his village in Romania's Carpathian Mountains, he took with him its tradition for folk crafts. He first exhibited at the Romanian Athenaeum in 1903, and although Rodin was an early influence, he rejected the realistic style of sculpture popular at the time. His search for pure form by reducing his works to a few basic elements combined the directness of peasant carving with the modernist ideas of purity and refinement, influencing the development of twentieth-century sculpture.

In 1908, Brancusi created his first major work: *The Kiss*. It represents two lovers carved from a single block of stone (the established method was to model in clay) in a tender, loving embrace. Over time Brancusi would push these works toward pure abstraction by a long process of repetition, meditation, and refinement

to create "the Essence of Things," thereby introducing primitivism into sculpture.

In 1913 Brancusi gained international fame when he showed five of his works in the Armory Show in New York. He worked on repeated themes throughout his career and from the 1920s to 30s he was preoccupied by the theme of a bird in flight. In *Bird in Space* (1919) he captures the essence of flight by eliminating wings and feathers and reducing head and beak to a slanted oval plane.

During the 1930s, Brancusi worked on public sculpture projects, particularly a war memorial for a park in Turgu Jiu, Romania in 1935 and designed a complex that included gates, tables, stools, and a sculpture entitled *Endless Column*.

Kate Mulvey

Date 1908

Born/Died 1876–1957

Nationality Romanian

First exhibited 1903

Why It's Key Brancusi was a pioneer of abstraction in sculpture that led the way for modern sculptors.

Key Event
Launch of the Model T Ford

When the first Model T (popularly nicknamed the "Tin Lizzie") came off the production line at Henry Ford's Piquette Avenue Plant in Detroit, it would transform the social fabric of the twentieth century. Up until that time, the motorcar had been a hand-built luxury status symbol for the wealthy; now, mass-produced on a moving assembly line, it became affordable – the car which "put America on wheels."

By 1914 the Ford factory was producing one-third of a million cars a year, and when the last Model T was built in 1927 the company produced a car every 24 seconds. It was the epitome of the "machine age" dynamic that inspired avant-garde artists like the Futurists and Constructivists, though initially in war-torn Europe it meant tanks rather than family automobiles coming off the production lines.

In America the Ford revolution signalled consumerism on a scale never seen before. By mid-century, mass-produced goods dominated domestic life, from pre-packed meals and canned drinks, to fridges, washing machines, TV sets, and of course the ubiquitous motorcar. It was a brand-new, streamlined world, reflected in the slick, airbrushed works of Pop artists like James Rosenquist and Roy Lichtenstein, where the imagery of comic books and advertising served as inspiration. And with his screenprinted Coke bottles, soup cans, and iconic portraits, Andy Warhol introduced the mass-production ethos into the actual creation of his art; the name of his studio – the Factory – said it all.

Mike Evans

Date October 1, 1908

Country USA

Why It's Key Heralded industrial mass production, influencing the "mechanistic" vision of Futurists and Constructivists, and later "factory" techniques of Warhol and such. Also established the automobile as the icon of modern America, much celebrated by Pop painters.

Key Artist **George Wesley Bellows** Exhibits with fellow New York School of Art students

George Wesley Bellows was born in Columbus, Ohio in 1882. A keen athlete, he was nevertheless more interested in painting. He attended Ohio State University from 1901 to 1904, and then moved to New York to study art at the New York School of Art. He was part of the American Ashcan School and associated with The Eight – a group of free-spirited artists who rebelled against the prevailing art mores and were devoted to art that would be valued because of its basis in the everyday experiences of life.

Bellows' seminal moment came in 1908, when he and other students organized an exhibition of urban studies of New York scenes. Bold and radical, they achieved criticism and notoriety. His early work is entrenched in the Ashcan style. Bellows painted crude depictions of working class urban life, mostly in dark colors. From 1907 to 1915, he painted a series of works showing New York under snowfall.

Bellows is mainly known for his vigorous boxing scenes (1909) and other sporting images that were created in a non-academic mode. Considered crude by some, they presaged the idea of psychological realism, and also serve as an important document of the times.

Over time Bellows developed a strong social conscience, and his later work took on social messages, often depicting poverty. In 1916 he began to experiment with lithography, using dramatic contrasts of light and dark. In 1922 he moved to Woodstock, where he remained until his death in 1925.

Kate Mulvey

Date 1908

Born/Died 1882–1925

Nationality American

Why It's Key America's strongest Realist painter in the first half of the twentieth century, spanning the gap between nineteenth-century masters and psychological realists.

1860–1909

91

Key Artwork *Woman in Black Hat* Kees van Dongen

During the time his work was moving from being mainly influenced by the Fauvists to that which reflected the impact of Expressionists like Kirchner and Nolde, Kees van Dongen painted a number of portraits of women, many of them music hall actresses, which reflected this change. The model for *Woman in Black Hat* (1908) is not known, but with her flamboyant headgear and hint of a professional glamour, she could well be one of these ladies of the stage.

Though not as overtly sensual as the blazingly erotic *Red Dancer* from the previous year, the woman here exudes a restrained beauty, her pale pastel face – clearly wearing make-up – in cool contrast to the bright green of her shawl. Like much of van Dongen's work at this time, the picture features a lot of black, and yet the end result, far from being dark, is bright and colorful.

The Expressionist influence was beginning to show in his increased use of heavy black outlines, merely hinted at here but becoming more prevalent over the next few years. The dark areas in this picture – especially the black hat itself – serve to accentuate the lightness and delicacy of the central focus, which is the model's face.

As in his similar portraits from this period, Van Dongen's composition is minimal, direct in its simplicity of line, form, and use of color. He would subsequently find success as an in-demand society portrait painter and magazine illustrator, but his output, although much in vogue, would never equal the bold intensity of earlier works like this one.

Mike Evans

Date 1908

Medium Oil on canvas

Collection State Hermitage Museum, St Petersburg, Russia

Why It's Key *Woman in Black Hat* is an archetypal work by an important Fauve/Expressionist painter.

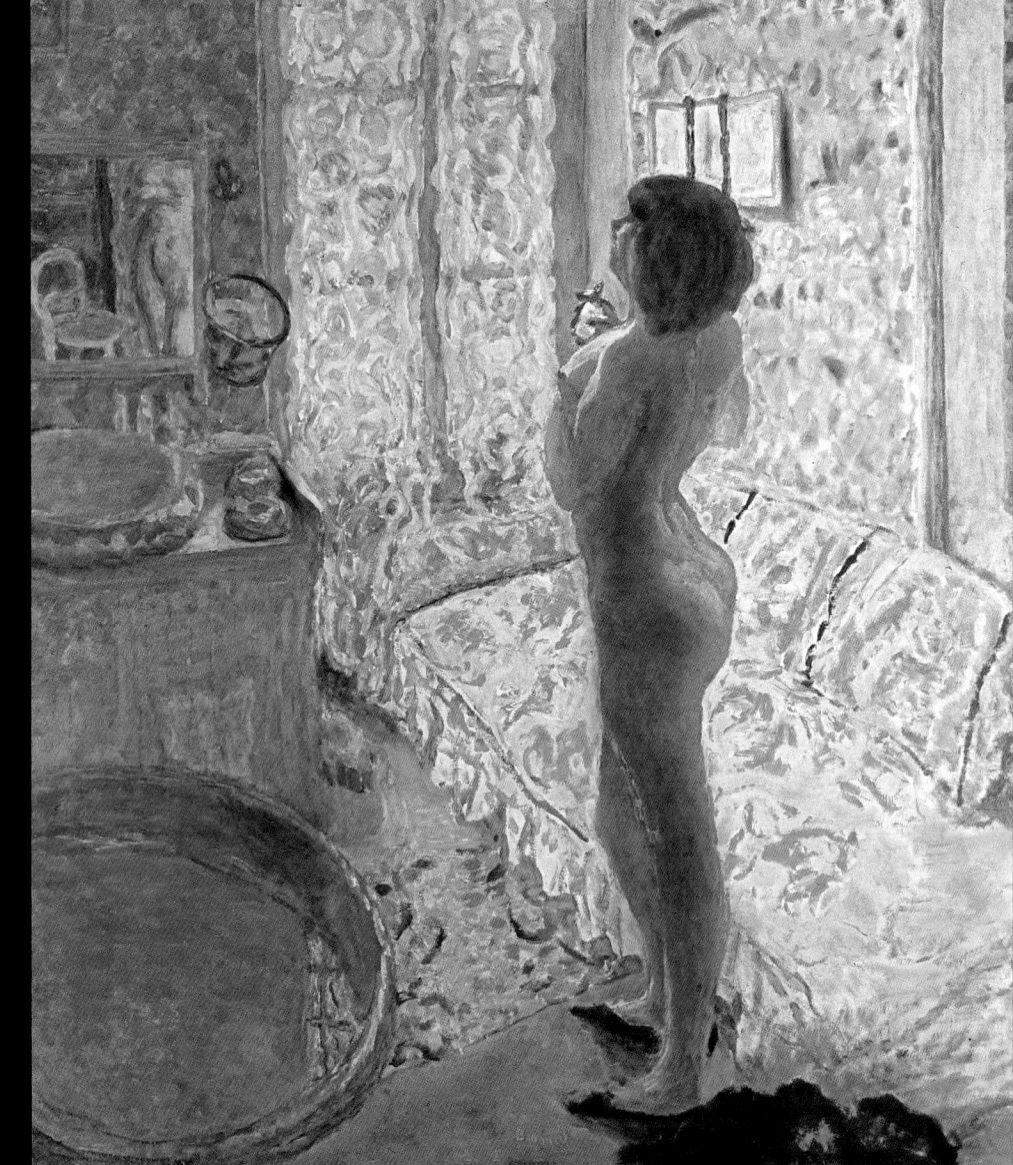

Key Artwork *Nude Against Daylight*
Pierre Bonnard

Nude Against Daylight shows Pierre Bonnard's (1867–1947) indebtedness to Impressionism, Japanese woodblock compositions, and Art Nouveau design, first developed in the prints he produced in his early career. He translates his understanding of underlying geometric structure and stylized decorative elements into a intricate dialogue between formal elements: three vertical bands, anchored by the solid standing figure of Marthe, intersected by the diagonal thrust of a divan, are enlivened by a decorative use of color laid down with exuberant brush strokes. A band of shadow, contrasted with areas of light, is articulated by a series of repeated circular shapes. Further ambiguity and complexity is created by reflections in a mirror and a pool of water in the tub, in the shaded area, which play with ideas of reflected light and image.

By the time he painted *Nude Against Daylight*, Bonnard had already discovered the work of Degas. In particular he drew on Degas' use of photography, which showed him how to crop his compositions to create unusual viewpoints and to give equal attention to peripheral objects at the edges of the canvas in the style of a snapshot. Bonnard relied on small sketches, notes on color, and photographs to recreate a scene from memory. This allowed him greater freedom to disregard naturalistic requirements, to draw upon the emotional interpretation of memory, and to use color decoratively to express those emotions. He returned to the theme of Marthe bathing from time to time, until her death in 1942.

Sarah Mulvey

Date 1908

Country France

Medium Oil on canvas

Collection Musee d'Art Moderne, Brussels

Why It's Key In 1908 Bonnard painted a series of nude studies of his future wife, Marthe, which show his experimental treatment of Impressionist form and color.

opposite *Nude Against Daylight*

93

Key Artist **Alexei von Jawlensky**
Joins Kandinsky's New Artists' Federation

Alexei von Jawlensky was born in 1864 on his aristocratic family's estate near Moscow. While at the Moscow military academy he also attended the St Petersburg Academy of Art, and during vacations visited the estate of the painter Marianne von Werefkin, with whom he emigrated to Munich in 1896. Enrolling at the Munich Art Academy, he was strongly affected by Kandinsky, its director, and also by the intense color and vigorous line of Matisse and the Fauves, whose work he encountered while traveling in France.

In 1909 Jawlensky joined Kandinsky's New Munich Artists' Federation (Neue Künstlervereinigung München), whose members believed in the intuitive expression of spiritual values. He also supported the aims of Kandinsky's more avant-garde Expressionist

group of 1911, The Blue Rider (Der Blaue Reiter). In 1914, however, war forced Jawlensky to leave Germany for Switzerland, where he began to paint large heads with an increasingly symbolic and meditative quality. This style and subject matter were to preoccupy him for the rest of his life.

Back in Germany after the war Jawlensky developed paralysis. Unable to use his hands and in great pain, he still managed, by tying on his brush, to execute a last series of over 1,500 Meditations, stark faces simplified to abstraction and blended with the image of the Orthodox cross. He died in Wiesbaden in 1941.

Catherine Nicolson

Date 1909

Born/Died 1864–1941

Nationality Russian

First Exhibited 1909

Why It's Key Important Russian contributor to Expressionism.

Key Artist **Suzanne Valadon**
Turns to painting full time

Born in Bessines-sur-Gartempe, near Limoges, the illegitimate daughter of a laundress, Valadon was brought to Paris as a child. In her teens she supported herself as a seamstress, a waitress, and a circus acrobat before becoming an artist's model. Posing for such artists as Renoir and Toulouse-Lautrec, she observed their technique and began to draw. Her first signed and dated work, *Self-portrait*, a pastel now in the Pompidou Center, Paris, comes from 1883, the year she gave birth at eighteen to Maurice Utrillo, whom she taught and mentored as a painter. He became one of Montmarte's best-known painters and later eclipsed his mother's reputation as an artist.

In 1890, she was introduced to Degas, who became her patron, organizing an exhibition for her, introducing her to collectors, and buying three of her drawings from the Salon de la Nationale in 1894. After marrying stockbroker Paul Mousis in 1896, in 1909 she left him for a painter half her age, André Utter. At this point she turned to painting full time, undertaking such large allegorical compositions as the *Joy of Life* (1911), now in the Metropolitan Museum of Art in New York.

After 1924, the dealer Berheim-Jeune showed her work regularly. Between 1927 and 1932, she had four major retrospectives and took part in the Salons of Modern Women Artists of 1933–8. Her bold female nudes defied the tradition of the passive, idealized depictions of women's bodies at the time and shocked bourgeois society; her still lifes, portraits, and landscapes, with their strong lines and vibrant colors, also showed a unique, intensely personal style.

Nigel Cawthorne

Date 1909

Born/Died 1865–1938

Nationality French

First exhibited 1894

Why It's Key A model for Renoir and Toulouse-Lautrec, the self-taught Valadon became an established artist in her own right, and the mother of Utrillo.

opposite Valadon with Maurice Utrillo (to the left) and Andre Utter (to the right).

Key Event
First Futurist Manifesto

Futurism was first announced on February 20, 1909, when the prestigious Paris newspaper *Le Figaro* published a front page "manifesto" by the thirty-three-year-old Italian poet and editor Filippo Tommaso Marinetti. Letters of outrage flooded into the newspaper offices – as intended. A spoilt son of an affluent business lawyer, Marinetti got a law degree at the University of Genoa before dedicating himself to literature. Recognizing Paris as the capital of the art world, he eschewed Milan and Rome and chose the city as the platform to launch a new, theoretical stance on Art.

A consummate showman, Marinetti numbered the paragraphs of his document as an echo of Marx and Engels' Communist Manifesto. Each appeal is guaranteed to make the establishment quiver with indignation and shake the foundations of cultured society. It glorified the new technologies of flight and the automobile and it found beauty in speed, power, and the rhythmic motion of machinery.

Marinetti's manifesto applauded violence and conflict and declared that art "can be nothing but violence, cruelty, and injustice." He proclaimed that we should "destroy the museums, the libraries, every type of academy" and sing of "the great crowds, shaken by work, by pleasure or by rioting." His own countrymen were outraged when he later declared they should burn the gondolas and ban the eating of spaghetti.

However, at home in Milan, the text is a clarion call to the painters Umberto Boccioni, Carlo Carrà, and Luigi Russolo. They are joined by Giacomo Balla and Gino Severini. Futurism is born.

Mike von Joel

Date 1909

Country France

Why It's Key The Italian poet and writer Marinetti launches Futurism.

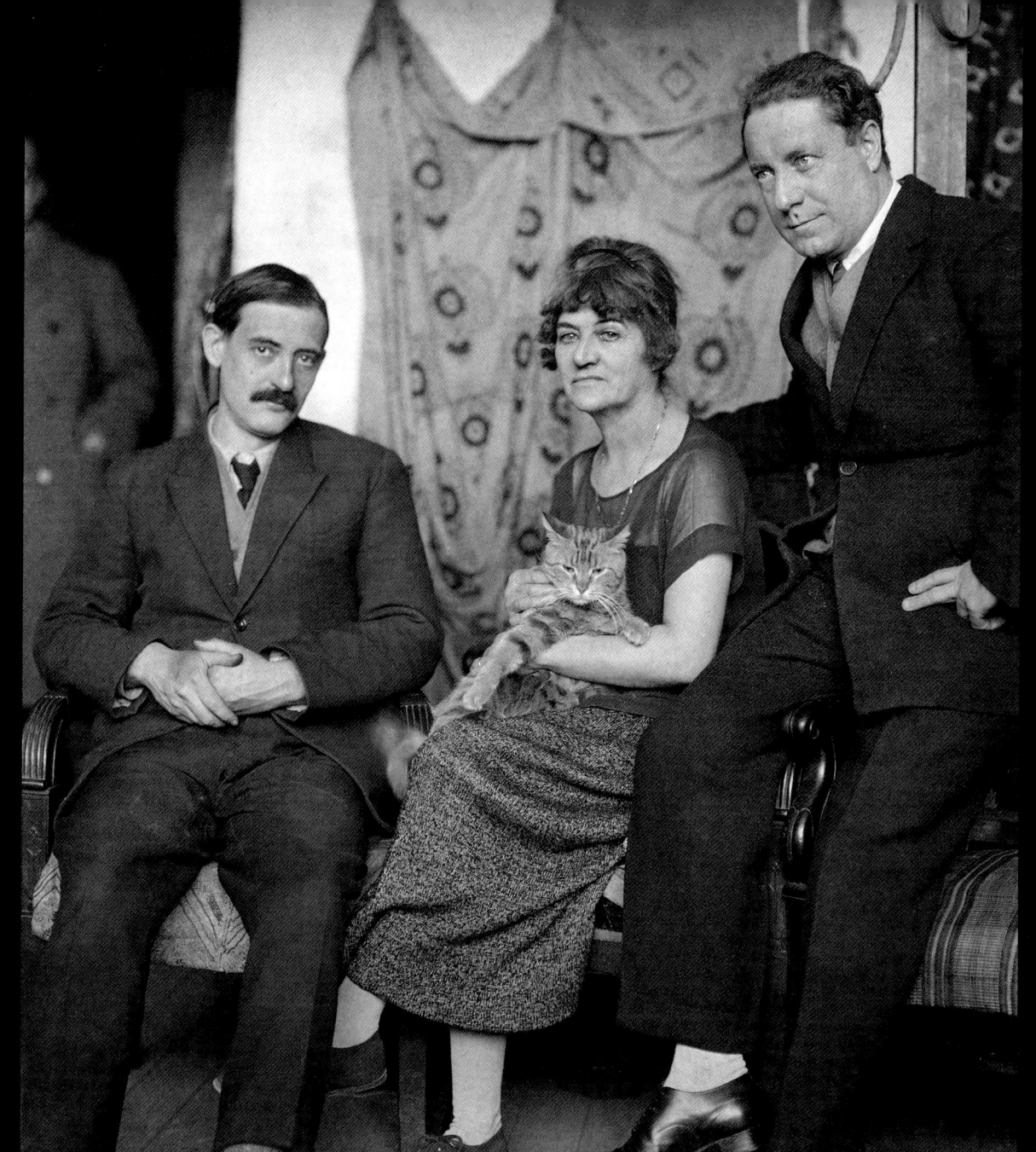

Key Artist **Robert Delaunay**
Acclaim for his first painting of the Eiffel Tower

Robert Delaunay was born in Paris to an upper class family and first exhibited in 1904 at the Salon des Indeépendants. Whilst his early work was dependent on Impressionism and Neo-Impressionism, he began to adopt Pointilist ideas in dealing with color and movement. By 1908 he was an active exponent of Cubism, and his 1909 painting *Eiffel Tower* received great acclaim, the iconic Tower becoming a recurrent theme. Characteristic of a self-designated "destructive" phase, his rhythmically disrupted or patterned forms displayed increasingly vivid colors.

Delaunay joined The Blue Rider Munich-based group in 1912. By this time he had begun painting his simultaneous *Window* pictures with their contrasts of color. This was his "constructive" phase, where translucent complementary colors were overlaid and contrasted to create a synthetic, harmonic composition. Delaunay's abstract works were revolutionary in the development of modern art. Apollinaire called the new style Orphism, where color is both form and subject.

From 1914 to 1920, Delaunay lived in Spain and Portugal with his wife, the painter Sonia Delaunay (née Terk), and returned to Paris in 1920, where two years later he began his second *Eiffel Tower* series. He experimented with materials such as sand, mosaics, and lacquered stone, which were used in his acclaimed relief series. By 1930 his work was wholly abstract, with his reliefs presenting color rhythms through disks and haloes. A friend of the Dadaists, Delaunay was not only influential on the Expressionist movement, but also the Futurists in Italy and the American Synchronists.
Kate Mulvey

Date 1909

Born/Died 1885–1941

Nationality French

First exhibited 1904

Why It's Key Key founder of Orphism, and an inspiration for the Futurists in Italy and the American Synchronists.

opposite *Champs de Mars: The Red Tower* by Robert Delaunay.

96

Key Artist **John Marin** First solo exhibition
at Alfred Stieglitz's 291 Gallery, New York

Throughout his long career, Marin was admired profusely by professionals and laymen, and one-man exhibitions occurred almost every year from 1910 until his death. In 1948 a poll of museum directors, curators, and critics organized by *Look* magazine named him the number one artist in the United States.

From 1905 to 1910 he lived in Europe where he was strongly influenced by the late etchings of an earlier American expatriate, James McNeil Whistler and the atmospheric softness in his work already displayed an interest in sublime vision. In Paris he was introduced by American photographer Edward Steichen to Alfred Stieglitz, who from 1909 regularly showed Marin's work at his New York galleries.

After his return to America, Marin created memorable watercolor paintings of New York's towering buildings in a free style reminiscent of Kandinsky. In 1914, when he moved to Maine, he began using dark slashing strokes to emphasize features in his evocative images, and to stress the picture surface. These strokes functioned to balance compositions of great energy that projected modern life's movement. Writing about his dynamic tilted cityscapes, Marin commented that "… if these new buildings move me, they must have life." By the 1920s Cubist-like interpenetrations suggesting the excitement and vertigo of high structures enhanced his style.

Late in life Marin began painting landscapes in oil that retained the central features of work on paper: their flat surface, patches of bare canvas to imply light, and the resonance of the outdoors.
Martin Holman

Date 1909

Born/Died 1870–1953

Nationality American

Why It's Key Prolific painter, known primarily for his Cubist-derived watercolors of cityscapes.

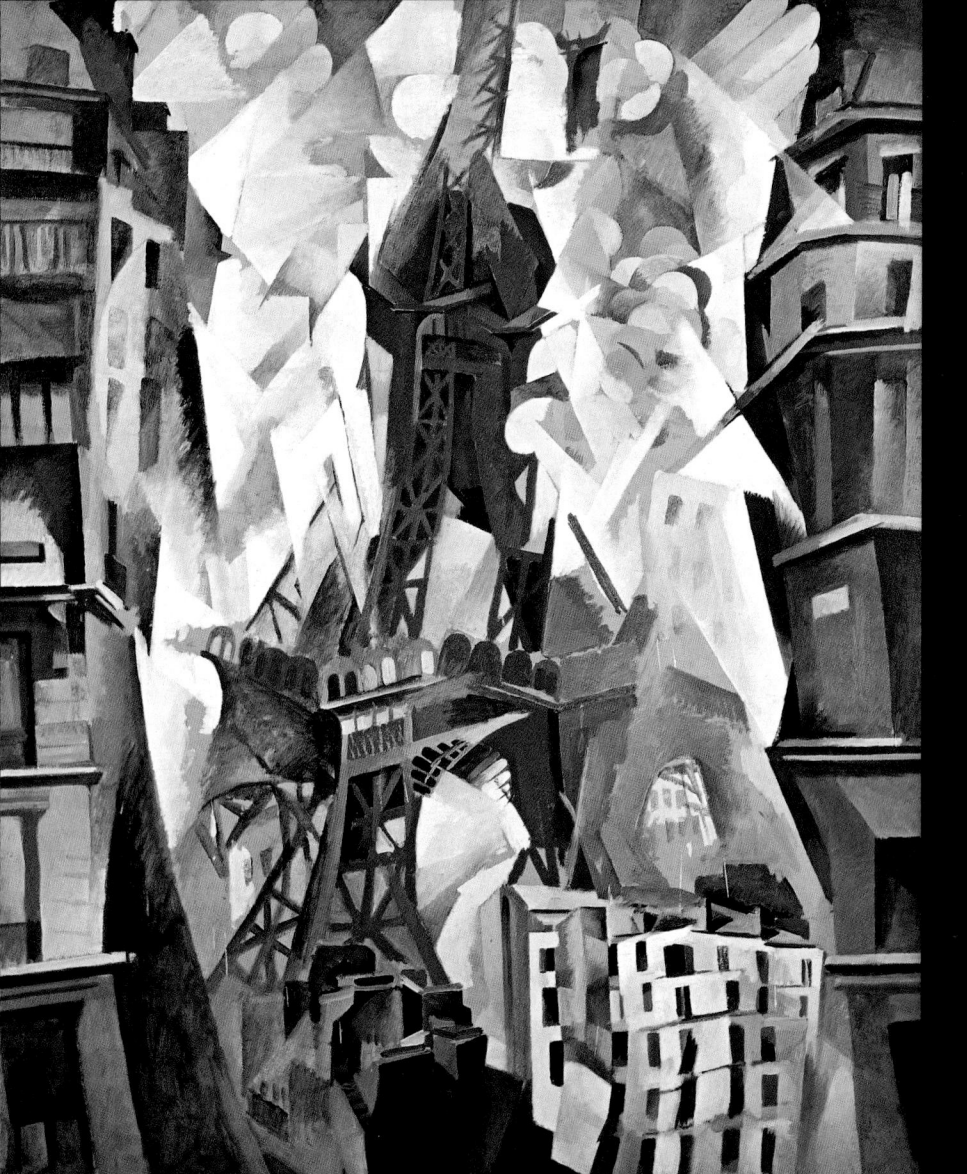

Key Artist **Marsden Hartley**
First solo exhibition at the 291 Gallery, New York

Hartley produced deeply expressive images, both abstract and figurative, adapting modernist idioms derived from Cézanne, Matisse, and Picasso to his enduring interest in earlier American styles, especially Albert Pinkham Ryder's nineteenth-century symbolic landscapes and sea scenes. Also a poet, author, and traveler, Hartley moved restlessly between places and styles, discovering inspiration in the vistas of America's southwest, southern France, the Alps, and Mexico. These periods were interspersed with protracted visits to New York, Paris, or Berlin.

With the help of Alfred Stieglitz who ran the influential gallery at 291 Fifth Avenue, New York, Hartley first visited Europe in 1912 and gravitated to Gertrude Stein's avant-garde circle in Paris. In Berlin he met Kandinsky and Franz Marc, producing "intuitive abstractions" under their influence that were shown alongside the Blue Rider artists. His German Officer paintings were patterned emblematic images of colored zigzags, stripes, and checks. Inspired by both military pageantry and Native American motifs, they were encoded portraits of a deceased male friend. Exhibited at 291 in 1916 they were criticized as "pro-German."

Seeking his own objective style, Hartley resumed representational work, returning to Paris in 1921 where a poetry collection was published the following year. Landscapes in a Cézannesque manner predominated until he rediscovered his native Maine after 1934. Dark outlines, massive volumes, and brooding romanticism characterized his last work, expressing a pantheistic response to the region's coast and mountains.

Martin Holman

Date 1909

Born/Died 1877–1943

Nationality American

Why It's Key Exponent of lyrical semi-abstraction as New York became interim capital of the avant-garde during World War I.

Key Artist **Joaquín Sorolla y Bastida**
Work exhibited in New York

Joaquín Sorolla y Bastida was born in Valencia, Spain in 1863. Orphaned at the age of two, he began studying art locally at fourteen, then at eighteen moved to Madrid, where he learned by copying Old Masters in the Prado museum. After military service he obtained a grant to study at the Spanish Academy in Rome, and also spent a year in Paris.

From 1890 Sorolla was based with his young family in Madrid, where he exhibited large salon paintings on oriental, mythological, and historical subjects. *Sad Inheritance* (*Triste herencia*, 1899), depicting crippled children sea-bathing in Valencia, won the Grand Prix and a medal of honor at the Universal Exhibition in Paris in 1900, and launched Sorolla on an extremely successful international career.

In 1909 Archer Milton Huntington invited Sorolla to exhibit for the Hispanic Society of America in New York City. During five months in America Sorolla, always a very hard worker, painted over twenty portraits, including that of President Taft. Huntington later commissioned him to paint fourteen panoramic oils to decorate the Society's library. Sorolla painted all but one in this series, *The Provinces of Spain*, on location, completing the huge project in 1919 but suffering a stroke a year later. He died in 1923 in Madrid, where much of his joyous, elegant, light-filled work, similar in style and scope to that of his friend Sargent, can be seen at his home, now the Museo Sorolla, opened in 1932.

Catherine Nicolson

Date 1909

Born/Died 1863–1923

Nationality Spanish

First Exhibited 1890

Why It's Key Internationally successful Post-Impressionist portrait and landscape artist.

Key Event
Formation of the Knave of Diamonds group

The Knave of Diamonds (Bubnovy Valet in Russian), also known as the Jack of Diamonds, was an avant-garde group of artists in Moscow who drew inspiration from contemporary Western trends including German Expressionism, Fauvism, and Cubism, as well as Russian Neo-primitivism. Its name is said to have come variously from its members' love of popular graphic art forms such as old printed playing cards, or the diamond-shaped designs on convicts' uniforms, signifying the artist's role in society as outsider and revolutionary.

The group's first exhibition, in December 1910, included portraits and still lifes by Robert Falk, Aristarkh Lentulov, Pyotr Konchalovsky, and Ilya Mashknov, whose work was strongly influenced by Cézanne and Matisse. Foreign contributors included the French Cubists Albert Gleizes, Henri Le Fauconnier, and André Lhote, as well as Wassily Kandinsky and Alexey von Jawlensky, who were living in Germany at the time. Later exhibitions featured the work of Braque, Picasso, Matisse, and Vladimir Tatlin, who went on to found Russian Constructivism.

In 1911, a faction calling itself the Donkey's Tail seceded, complaining of the Knave of Diamonds' dependence on Western models rather than Russian sources, but their place was quickly filled by new young artists. However, the Secessionists Kazimir Malevich and Ivan Klyun exhibited seventy Suprematist paintings at the group's 1916 exhibition. The Knave of Diamonds dissolved after its final exhibition in Moscow in 1917.

Nigel Cawthorne

Date 1910

Country Russia

Why It's Key Leading exponents of the avant-garde in Russia.

Key Artwork *The Dream*
Henri Rousseau

While Henri Rousseau (1884–1910) is rightly considered the dean of naïve painters, his work also presages important elements of the avant-garde. Particularly in his last work, *The Dream*, Rousseau left no doubt about his modernist credentials, and even staked a claim to postmodernity. *The Dream* is set in the jungle of imagination that haunts so much of Rousseau's work. In it, a naked European lady lies hypnotized on a sofa, staring into the distance as a black piper plays a tune in the middle of the jungle, surrounded by animals and savagely beautiful vegetation. Like Rousseau himself, the woman is entranced and not a little alienated by the exotic, which has pulled her out of her bland existence into a zone of fertile possibility.

The Dream at once anticipated European modernism's fascination with African and so-called primitive art, presciently modeled the unborn Surrealist interest in the subconscious and the dreamlike archetype, and melded the exuberant spirit of naïve painting with dark and analytical currents that intimate the coming century of war, displacement, and cultural confusion.

The Dream was no pastiche of warring ideas and techniques; it grew organically from Rousseau's wild-eyed romanticism, which was equally sensitive to the sinister, the beautiful, and the unexplained. It was Rousseau's refusal to subordinate his last painting to any one theme, to remain true to his dreamlike vision, that spans the modernist era and places him in our own postmodern time, which also refuses to be governed by absolute themes, trends, or thoughts.

Demir Barlas

Date 1910

Country France

Medium Oil on canvas

Collection Museum of Modern Art, New York

Why It's Key This last painting of Rousseau's affirms his status as a modernist painter, who anticipated the avant-garde and the Surrealists.

Key Artist **Carlo Carrà**
Signs the *Manifesto of Futurist Painters*

Carlo Carrà was born into a large and impoverished family in Piedmont in 1881 and left home at the age of twelve to work as a mural painter. By 1899 he was in Paris decorating pavilions for the next year's Exposition Universelle (World's Fair) and exploring the latest developments in French art. In 1906, he studied at Milan's Accademia di Brera, and in 1910, with Russolo, Marinetti, Balla, and Severini, signed Boccioni's *Manifesto Dei Pittori Futuristi* (Manifesto of Futurist Painters), which rejected the "cult of the past," calling "for youth, for violence, for daring" and the pursuit of dynamism in all spheres of art.

Carrà's most famous work is his *Funerali dell'anarchico Galli* (The Funeral of the Anarchist Galli) from 1911, a dramatic example of the Futurist fascination with action, change, and movement, painted in response to the police violence Carrà witnessed at the funeral of a fellow artist who was killed during the Italian general strike of 1904.

Carrà's Futurist phase ended around 1917, when he and de Chirico met in military hospital and evolved a style called *Pittura metafisica* (metaphysical painting), featuring dreamlike urban landscapes. In the 1920s this gave way to a naturalism based on Italian tradition, particularly the Renaissance masters Masaccio, Giotto, and Uccello. After 1918, despite his anarchist youth, Carrà developed ultra-nationalist and Fascist views, and followed the neo-classical guidelines for painting set up by the Italian government after 1937. He died in Milan in 1966.

Catherine Nicolson

Date 1910

Nationality Italian

Born/Died 1881–1966

First exhibited 1912

Why It's Key Leading figure in the Italian Futurist movement.

Key Artist **Marc Chagall**
Visits Paris and is influenced by the Cubists

Marc Chagall is renowned for his dreamlike, richly colored, poetic, and imaginative paintings. He was particularly influenced by the Cubist aesthetic, which dominated avant-garde circles during his first years in Paris. It was here that Chagall's primary link with Cubism came – not through Picasso and Braque, the movement's founders, but through Robert Delauney and his wife, the Russian painter Sonia Terk. For Delauney and Chagall, the formal aspects of Cubism were secondary to the expression of magic.

While many of the Cubist painters were more concerned with the formal and rigorous intellectual aspects of the aesthetic, Chagall remained committed to infusing it with imagination and storytelling. His paintings, also full of radiant color, were seen as a dazzling contribution to a new Cubist pictorial language.

His imagery sprang from the subconscious and was inspired by both his native background and the new experience of being in Paris, where he found a particular affinity with avant-garde poets, among them Blaise Cendrars and Guilliaume Apollinaire. At his studio within the artists' community, La Ruche, he painted *Half Past Three (The Poet)* with a title borrowed from Cendrars. The Cubist aesthetic sparked work with a new dynamic, structure, and set of motifs. Chagall was deconstructing images and introducing hard-edged geometric shapes to the previously softer forms, in a lyrical centrifuge of rhythm and movement. In 1912 Cendrars introduced him to Apollinaire, who became one of Chagall's greatest supporters. *Homage to Apollinaire* (1911–12) was created as a token of gratitude to this inspiring figure.

Carolyn Gowdy

Date 1910

Born/Died 1887–1985

Nationality Russian

Why It's Key From 1910 to 1914, Chagall lived in Paris. During these formative years, Cubism dominated the avant-garde scene, of which he would become a part.

opposite Marc Chagall's *Half Past Three*, 1911.

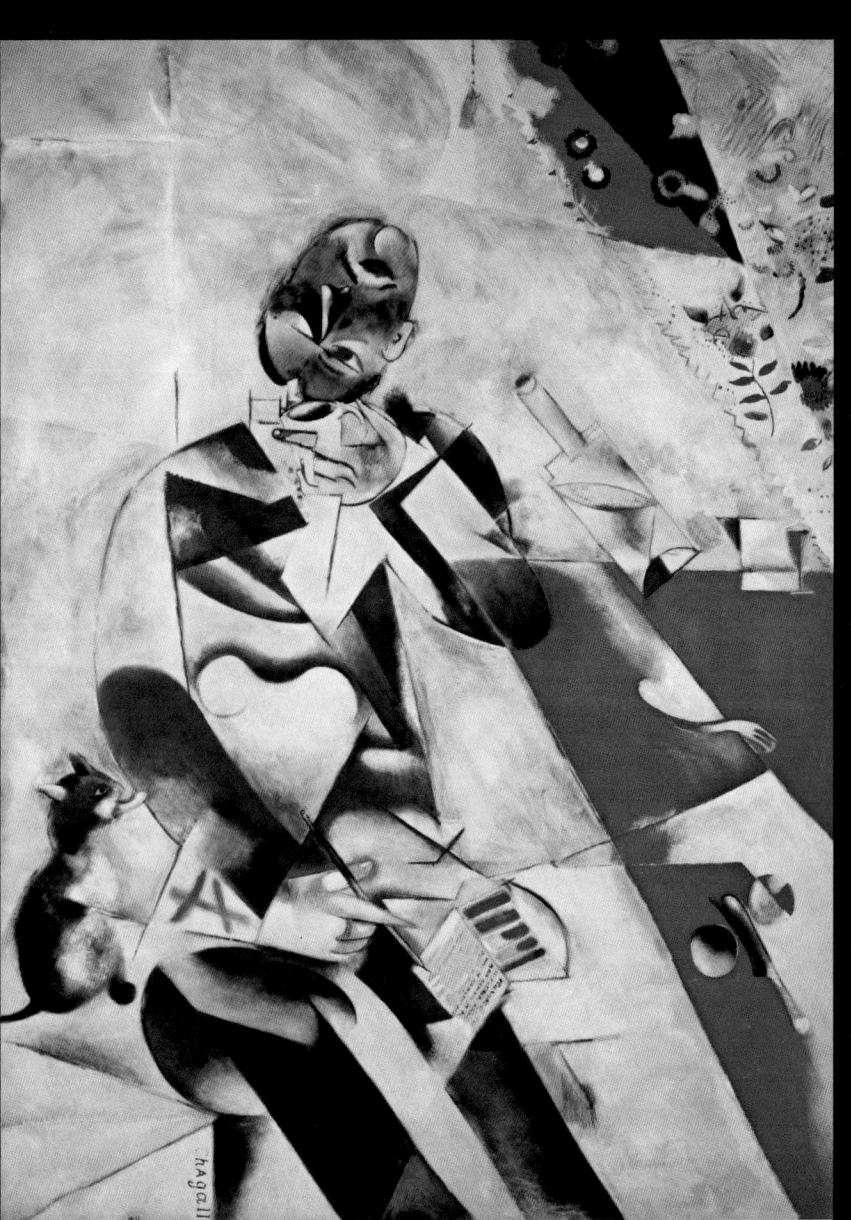

Key Event
Der Sturm magazine founded

Established in 1910 by the art critic and businessman Herweth Walden, *Der Sturm* magazine is acknowledged as one of the most important forums for German modern art in the early twentieth century, and a key promoter of Expressionism.

The term "der Sturm" (the storm) was used by Walden to symbolise the way in which Expressionism was causing a riot in Germany at the time.

The magazine began as a literary forum, attracting leading writers of the period, including Strindberg, Altenberg, Loos, and Kraus. Polemical in tone, it challenged the academic traditions and, despite criticism in the conservative press, in 1912, the magazine published the radical *Futurist Manifesto* by Italian poet Filippo Marinetti. Artists such as Ludwig Kirchner, founder of the Die Brücke group, collaborated with *Der Sturm*, as did artists from the Expressionist group Der Blaue Reiter. Walden also ran Der Sturmgalerie, a gallery that showcased Expressionist works.

In 1917, an experimental Expressionist theater, the Sturmbuhne, was founded. Sturm Abende (Storm Evenings) with poetry readings, lectures on art, discussions, and recitals, were very popular with Berlin intellectuals, as were postcards of Expressionist, Cubist, and abstract artists such as Wassily Kandinsky, Oskar Kokoschka and Rudolf Bauer.

Der Sturm also published portfolios, essays, plays, and picture books, publishing, among several important works, Apollinaire's *Les Peintres Cubistes*. By the end of the war, *Der Sturm* had become the focal point of the modern arts movement in Berlin. It closed in 1932.

Kate Mulvey

Date 1910

Country Germany

Why It's Key *Der Sturm* is acknowledged as a leader in promoting and advancing German Expressionism and modern art.

opposite Oskar Kokoschka, photographed here in 1910, was a popular artist within German Expressionist circles.

103

Key Artist **Max Weber**
Pioneer of modernism in seminal New York exhibition

Max Weber was born in Bialystok in Poland (formerly Russia) in 1881. Having emigrated to New York at the age of ten, from 1898 to 1900 he studied at the Pratt Institute under Arthur Wesley Dow, who inspired him with his forward-thinking ideas and wide knowledge of European and Far Eastern art. After five years' teaching in schools, in 1905 Weber sailed to Paris, where he attended the Académie Julian led by Jean-Paul Laurens, and exhibited at the Salon des Indépendants and Salon d'Automne. He also studied with Matisse, absorbed the modernist theories of Cézanne, Picasso, and Braque, and traveled widely in Spain, Italy, Belgium, England, and Holland.

In 1909 Weber returned to New York, where he took part in the 1910 Younger American Painters exhibition at Alfred Stieglitz's legendary gallery, 291, becoming the first artist to introduce Cubism to America. Solo exhibitions, awards, essays of art criticism, and a volume of Cubist poems (1913) followed, alongside directorship of the avant-garde Society of Independent Artists and a teaching career at the Art Students' League and the University of Minnesota.

From 1921, given the worsening European situation, Weber turned to Jewish subjects, and in 1936 became chairman of the anti-Fascist American Artists' Congress. In typical style, at the end of a long, adventurous, and highly productive career during which he had experimented vigorously with Cubism, Fauvism, Dynamism, Expressionism, and Futurism, he took up sculpture.

Catherine Nicolson

Date 1910

Born/Died 1881–1961

Nationality American-Polish

First Exhibited 1906

Why It's Key At a Gallery 291 show, Weber introduces Cubism to the United States.

Key Event
Opening of Casa Milà

Property owner Pere Milà Camps had seen the work of the revolutionary Modernist Antoni Gaudí (1852–1926) in the Catalan architect's earlier remodeling of the Neo-classical Casa Batlló, in Passeig de Gracia, Barcelona. When Camps purchased a plot at Passeig de Gracia and Provenza, he commissioned Gaudí to built an apartment block.

Gaudí planned a fantastic house with undulating, living forms. Its structure is based on wrought metallic girders and Catalan-style vaults. The street front appears like a cliff face with openings seemingly carved out of the stonework – giving the building its nickname *La Pedrera* (The Quarry). The tiled roof follows the rise and fall of the superstructure, and echoes the undulation of the façade. It is topped with twisted, faceted chimneys and ventilators, some with quasi-figural shapes.

Unfortunately, Gaudí's building was bigger than was allowed by the building regulations, but he would not budge despite huge fines being levied on Pere Milà. Eventually the city authorities gave way, waiving the building regulations due to the construction's obvious artistic merit. Gaudí was so happy that he asked for a copy of the official minutes permitting his creation. Casa Milà, which is the greatest of Gaudí's many creations in the streets and parks of the Catalan capital (including the extraordinary unfinished cathedral Sagrada Familia) was declared a World Heritage Site by UNESCO in 1984.
Brian Davis

Date 1910

Country Spain

Why It's Key: Antonio Gaudí's greatest Modernist secular work.

opposite Gaudí's Casa Milà is a masterpiece of Modernist architecture located in Barcelona.

Key Artwork *The Dance*
Henri Matisse

In 1909, the Russian collector Sergeï Shchukin commissioned two large compositions on the themes of Dance and Music for the staircase of his Moscow mansion. The figures that compose *The Dance* already appeared in the background of Matisse's (1869–1954) 1905 *Bonheur de Vivre*. Here they become even more stylized, quasi-androgynous, decorative motifs integrated into a fluid, arabesque-like movement.

At a time when Picasso and Braque experimented with a Cubist fragmentation of forms, Matisse's forays into abstraction had more to do with simplification and planeity. He rejected traditional three-dimensionality, using warm and cold colors, rather than modeling or shading, to suggest space and volume. The curves of the bodies and arms, echoed by the limit between green and blue in the background, also convey the

vitality of this Bacchic or pagan dance, a vitality which Matisse recalled witnessing during his visits to the Moulin de la Galette.

The dancers, larger than life-size, occupy the whole surface; feet, backs, and heads touch the edges of the picture, and the figures at the top seem to hunch their shoulders to fit in, as though the energy of the dance were too great to be contained by the canvas. Almost emptied of specific classical or narrative attributes, the scene seems set in some primeval Golden Age when communion with nature was still possible.

Matisse took up *The Dance* again later in a series of drawings and cut-outs culminating in the monumental and even more simplified scheme executed in 1933 at the Barnes Foundation, Merion, Pennsylvania.
Catherine Marcangeli

Date 1910

Country France

Medium Oil on canvas

Collection Hermitage Museum, Saint Petersburg

Why It's Key A decorative scheme whose simplified forms anticipate Matisse's later cut-out compositions.

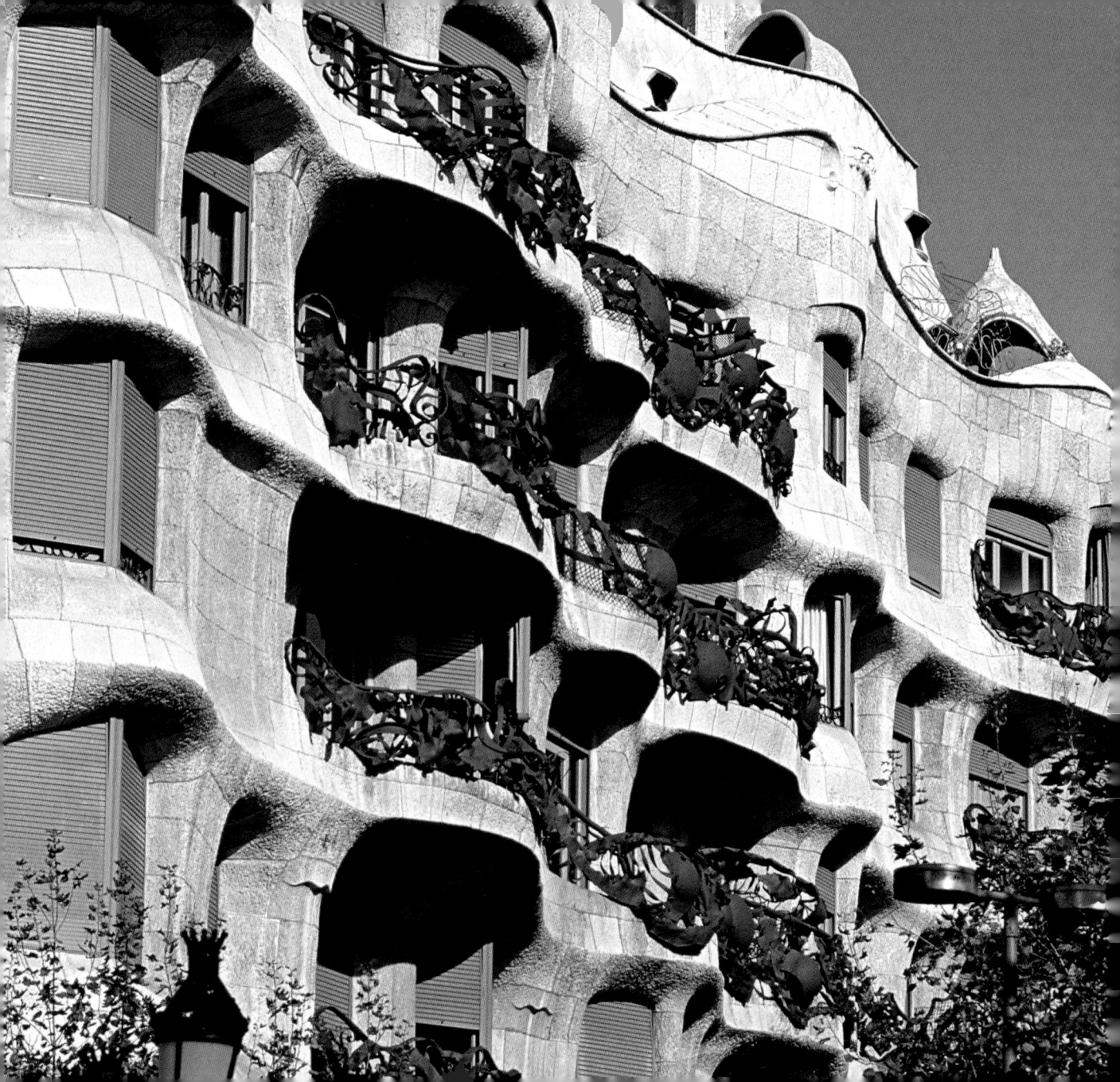

Key Artwork *First Abstract Watercolor*
Wassily Kandinsky

Russian-born painter Wassily Kandinsky (1866–1944) is one of the pioneers of Abstract Expressionism. Aged thirty he moved to Munich and became leader of Der Blaue Reiter (The Blue Rider group), which based its name on one of Kandinsky's pictures (c.1903). His early work was heavily influenced by Russian myths, but a fascination with the symbolism of color and psychology steadily grew.

From 1908 he began producing abstract works including *First Abstract Watercolor*, although some question whether this was truly the first abstract. *First Abstract Watercolor* is notable for having no continuity between shapes, line, or color.

In 1912, Kandinsky published *Uber das Geistige in der Kunst* (*Concerning the Spiritual in Art*), which was highly influential in the development and understanding of abstract art. The work examines not simply the lack of representation but the psychological effects of color, and makes comparisons between painting and music. Kandinsky considered that abstract elements were spiritual, and his theory of abstract art was heavily influenced by the popular mystic and occult beliefs of Madame Blavatsky's "theosophy" and the "anthroposophy" teachings of Rudolph Steiner. According to theosophical theory, creation is a geometric progression, starting with a single point, and creative forms can be expressed by a series of circles, triangles, and squares. Kandinsky compared the spiritual life of humanity to a large triangle and believed that artists have a mission to lead others to the top through their talent.

Brian Davies

Date c.1910

Country Germany

Medium Oil on canvas

Collection Musée National d'Art Moderne, Centre Georges Pompidou, Paris, France

Why It's Key Kandinsky's first work can be seen as a theoretical basis for abstract art.

opposite *First Abstract Watercolor*

Key Artist **Emil Nolde**
Expressionist pioneer founds New Secessionists

Emil Nolde (born Emil Hanse) was born in Nolde, Germany in 1867. From 1884 to 1891 he served as an apprentice furniture designer and cabinetmaker, working in several furniture factories in Germany and studying to become a carver and illustrator. In 1889 he became a teacher at the School of Applied Art in Karlsruhe. He moved to Munich in 1900 and was invited to become a member of the Die Brücke group (1906-08). From 1902 he adopted the name of his birthplace. After feeling unjustly rejected by the Secessionists, he founded the revolutionary group the New Secessionists (Neue Sezession) in 1910.

Nolde's earlier paintings were strongly influenced by folk art and, after he visited New Guinea (1913–14), tribal art invigorated his ideas to create a powerful new style. His painting, mostly landscapes, interiors with human figures, and biblical scenes, exhibited distortion of form, bold surface patterns, and strong, contrasting colors.

From the early 1920s Nolde supported the Nazi party, although, in spite of this, his work would be classified by Hitler as degenerate and over one thousand of his pictures would be removed from museums. From 1941 he was prohibited from painting, even in private. He nevertheless produced hundreds of watercolors, which he managed to hide. When World War II ended he was re-established in Germany as an important artist and received the country's highest civilian decoration, the German Order of Merit. As well as paintings, Nolde produced many prints, often in color.

Alan Byrne

Date 1910

Born/Died 1867–1956

Nationality German

Why It's Key Work typifies the visceral and sensual character of Expressionism in its purest form.

Key Person **Roger Fry**
Organizes the first Post-Impressionist exhibition in the UK

Originally trained as a scientist, Roger Eliot Fry first made his name as a historian of the early Italian Renaissance and as a curator at the Metropolitan Museum of Art, New York. To his great regret, he never won similar acclaim as an artist.

In 1910 Fry mounted the exhibition Manet and the Post-Impressionists at the Grafton Galleries, London, to howls of derision from much of the public and most of the press. The three artists Fry chose to represent new trends in painting were Cézanne, Gauguin, and van Gogh, all hitherto largely unknown in Britain. In the Second Post-Impressionist Exhibition in 1912, Fry presented Cézanne as the "father" of modern art and gave starring roles to Picasso and Matisse, thereby establishing the fundamental history of the development of twentieth-century art.

Fry's formalist theory of art was first popularized by his friend Clive Bell in *Art* (1914) and elaborated in his own hugely influential volume of essays, *Vision and Design* (1921). Fry founded the Omega Workshops in 1913 and as critic, teacher, lecturer, and curator he remained an instrumental figure in the London art world after World War I. He continued to write prolifically about the Old Masters at the same time as publishing essential monographs on Cézanne (1927) and Matisse (1930). Never afraid to revise his earlier opinions, the hallmark of his critical practice was, in the words of Benedict Nicolson, his "glorious refusal ever to make up his mind."

James Beechey

Date 1910

Born/Died 1866–1934

Nationality British

Why It's Key This influential critic was instrumental in introducing modern European art to Britain via his championing of the Post-Impressionists.

opposite *Self Portrait* by Roger Fry, 1928 (oil on canvas).

1910–1919

108

Key Artist **William Merric Boyd**
Begins own style of Art Nouveau ceramics

Born in Melbourne in 1888, William Merric Boyd was the eldest surviving son of the painter Arthur Merric Boyd. In 1910, after failed attempts at both agricultural and theological college, he built a small pottery for himself on a family property in Murrumbeena, just outside Melbourne. In the same year he studied drawing for a term at the National Gallery of Design, where he met his wife, Doris Gough. In 1917 Boyd went to war, staying on in England after demobilization from the Australian Flying Corps to study at the Wedgwood Potteries, as part of a rehabilitation scheme for ex-servicemen.

Boyd lived and worked with Doris at his Murrumbeena studio, called "Open Country," for the rest of his life, digging clay from his own garden and mixing his own glazes, to develop the first fine art

pottery in Australia. This achievement never paid its way, however. Suffering from epilepsy and with no flair for business, Boyd remained poor, relying on his mother's dwindling brewery inheritance for the survival of himself and his five gifted children, who all followed their parents into the arts.

Merric Boyd's ceramics have a strong Art Nouveau element, using forms inspired by the natural world, especially native flora and fauna; his wheel-thrown earthenware jug of 1937, for example, has a handle in the shape of a tree trunk branching both inside and over its surface. His sculpture was similarly naturalistic but critically neglected during his lifetime, being out of the modernist mainstream.

Catherine Nicolson

Date 1910

Born/Died 1888–1959

Nationality Australian

First Exhibited 1912

Why It's Key Boyd was the first Australian fine art potter.

Key Artist **Emile-Antoine Bourdelle**
Chooses Isadora Duncan for Paris theater frescoes

Emile-Antoine Bourdelle, born in 1861 at Montauban, left school at thirteen to work as a woodcarver in his father's cabinetmaking shop, while also taking drawing lessons from the founder of the local Ingres Museum. He then studied sculpture at art school in Toulouse, where he won a scholarship to the Ecole des Beaux-Arts in Paris, though he left after only six months in order to work independently.

In 1885 Bourdelle's *Première Victoire d'Hannibal* (*Hannibal's First Victory*), a naturalistic bronze portraying the boy Hannibal fighting with an eagle, received an honourable mention at the Salon des Artistes Français. Rodin identified the younger sculptor as "the scout of the future." Bourdelle became Rodin's assistant in 1893, but left in 1908 to follow his own more archaic preferences. His stylized *Herakles Archer*

(*Hercules the Archer*, 1909) was much admired, and from 1910 onwards many prominent pupils, including Giacometti and Maillol, came to study in Bourdelle's Montparnasse studio.

In 1903 Bourdelle had seen Isadora Duncan dance at a party for Rodin, and recognized instantly in her the embodiment of his classical ideal. When he was commissioned in 1910 to create sculptural frieze panels for the new Théâtre des Champs-Élysées he based his images on her dancing and that of Nijinsky. Successful, honored, and respected for his reintroduction of monumental sculpture to its public, outdoor role, Bourdelle died in 1929 at the home of his friend and colleague, the master caster Eugène Rudier.

Catherine Nicolson

Date 1911

Born/Died 1861–1929

Nationality French

First exhibited 1883

Why It's Key Pioneer of twentieth-century monumental sculpture.

Key Event
Der Blaue Reiter Group formed

The reasons for the formation of the Der Blaue Reiter (Blue Rider) group were familiar ones for the period. Artists wanted to be free to paint without the restrictions imposed by the established order of the day, in this case the Neue Künstler Vereinigung (NKV), which had been founded in 1909 by a number of avant-garde artists. The origins of the name itself are not clear, but it is possibly derived from the cover of an almanac that had a blue horseman on the cover, drawn by Wassily Kandinsky. A Kandinsky painting from 1903 is actually called *The Blue Rider* and he and Franz Marc shared an affinity for both the color and horses.

Established in December, 1911 by Kandinsky, Franz Marc, and Gabriele Münter, who had broken away from the NKV, the group's first appearance was entitled First Exhibition by the Editorial Board of the

Blue Rider, launched to coincide with the last show by the NKV in the same gallery in Munich. The forty-three artists that comprised the group included Albert Bloch, Robert Delaunay, Elizabeth Epstein, August Macke, and Henri Rousseau. A second exhibition, which opened in 1912 in Munich, was on a much grander scale, showing 315 works by thirty-one artists, including Picasso, Braque, Klee, and Goncharova.

Always a loose association, Der Blaue Reiter was brought to an end by World War I, in which Macke and Marc were killed. Although short-lived, Der Blaue Reiter represented a major emanation of German Expressionist painting. Nietzsche best describes the group's tenet: "Who wishes to be creative must first blast and destroy accepted values."

Mike von Joel

Date December, 1911

Country Germany

Why It's Key A brief but inspired emanation of German Expressionist painting that influenced many leading artists of the day and became a beacon for the Transavantgardia some seventy years later.

Key Artist **Sonia Delaunay**
Founds Orphism

Born Sonia Stern in 1885, the Russian painter settled in Paris in 1905. A pioneer of abstract painting (along with her husband Robert Delaunay), in 1911 she created a patchwork quilt using geometry and color, typifying Orphic Cubism – a term invented by the poet Guillaume Apollinaire. This was founded on the belief that light and color are identical and drew inspiration from the fluidity and rhythmic sensibility of music.

Delaunay also concentrated for a long time on textile design, bringing with her a Cubist sensibility to the world of print for fashion. This allowed her to explore further the fragmentation and contrasts in color that Orphic Cubism is famed for, taking it beyond the canvas and into the realms of repeated patterns and varied texture. Her hand-printed cloths brought to life the contrasting colors and graphic nature of the

Orphist's work. She returned to true painting in the 1930s and exhibited regularly across Europe from the early 1950s. Costume design also featured in her career, and she worked with the Russian composer Igor Stravinsky (1882–1971) on his ballet *Dances Concertantes*. She also worked with the dance impresario Sergei Diaghilev (1872–1929) on the Ballet Russes' 1918 production of *Cleopatra*.

Delaunay's printed textiles and painterly fashion illustrations continue to be an inspiration in the industry and her color sense (along with that of her husband Robert Delaunay and Kandinsky) had significant impact in the development of abstract art. In 1964, Delaunay became the first female artist to have a retrospective at the Louvre.

Emily Evans

Date 1911

Born/Died 1885–1979

Nationality Russian

Why It's Key Along with her husband, the artist Robert Delaunay, Sonia Delaunay developed her own version of Cubism, which became known as Orphism.

111

Key Artist **Walter Sickert**
Co-founder of Camden Town Group

The two dominant influences on British painters at the turn of the twentieth century were French art and the London Royal Academy, with its plethora of bourgeois satellites. Most painters traditionally left England to study in Paris and returned impressed with the bohemian sense of brotherhood amongst Parisian artists. Sickert, who had started as an assistant to Whistler before leaving for France, was no exception.

Camden Town was the grim district of north London where Sickert had lived since the 1890s. On his return from Venice in 1905, a group of painters, who had all been to Paris, habitually gathered in Sickert's Camden studio. When Frank Rutter, art critic of *The Sunday Times*, joined the group in 1908, he proposed that they organize themselves after the French Salon des Indépendants. Thus was formed the Allied Artists Association, formally

registered in February 1908, with forty founder members (including Walter Sickert, Harold Gilman, Frederick Spencer Gore, Lucien Pissarro, Augustus John, Henry Lamb, and Charles Ginner). The first exhibition of over 3,000 works was at the Albert Hall in London. In 1911, Sickert's circle officially became the Camden Town Group. Influenced by Gauguin and Cézanne, their subject matter was everyday life in the industrial town.

From 1905 to 1913, Sickert, clearly influenced by Degas, embarked on a radical series of nude studies depicting women in the dreary confines of his Camden studio, with an iron bed as the central motif and a sombre, dark, muddy palette. Known as the *Camden Town Nudes*, these are now regarded as his prime paintings.

Mike von Joel

Date 1911

Born/Died 1860–1942

Nationality British (born German)

Why It's Key The group was a deliberate demand for independence from the prevailing influences and traditions of the Academy and Salon, and a blueprint for the evolution of British painting in the twentieth century.

Key Artist **Gustav Klimt**
Wins first prize at the World Exhibition in Rome

Born in 1862, painter and designer Gustav Klimt was a leading member of the Vienna Secession (1898–1903), whose work railed against the conservatism of the previous generation. Much of Klimt's career was dedicated to architectural decoration and in this he considerably influenced the decorative arts and the face of his native Vienna.

Work such as Klimt's 1905 mosaic decorations of stylized trees and two sensuous figures embracing at the Palais Stoclet in Brussels (built by Josef Hoffman) extended this influence beyond Austria and raised Vienna's profile to that of other European countries in terms of creativity. Consequently, the Secessionist movement became established as an Austrian version of Art Nouveau, typified by gilded ornamentation and sensuous natural form.

Much of Klimt's painting work, mainly portraits and allegorical pieces, express this theme. Luxurious and decadent, his images are conveyed through sensuous line and rich color, and often feature gilded aspects. Klimt's is a dreamlike world that is often charged with eroticism and this can be best seen in his most famous work, *The Kiss* (1907–1908), in which a kissing couple emerge from a field of flowers in a sumptuous take on nature.

Within Klimt's portraiture work, highly decorated textiles come into play; intricately patterned, richly colored or heavily gilded cloths feature along with highly decorative Symbolist backgrounds, as seen in his 1901 piece, *Judith and Holofernes*.

Emily Evans

Date 1911

Born/Died 1862–1918

Nationality Austrian

Why It's Key Klimt was an important painter and designer associated with the Symbolist and Art Nouveau movements.

opposite *The Three Ages of Women* by Gustav Klimt, 1905 (oil on canvas).

1910–1919

113

Key Event
Publication of *Concerning the Spiritual in Art*

Russian-born artist Wassily Kandinsky (1866–1944) moved to Munich in 1892, where he became a leader of Der Blaue Reiter (The Blue Rider) group. The group's name derives from the title of one of Kandinsky's pictures from 1903. Kandinsky was one of many painters working toward the abstract in art at the time; he claimed that an undated work of 1910 was the "first abstract watercolor," though others have disputed this.

At the end of 1911 he published *Über das Geistige in der Kunst* (*Concerning the Spiritual in Art*) from notes that he had been compiling for the previous ten years. In it he discussed the spiritual foundations in art with reference to the then fashionable discipline of "theosophy," developed from Madame Blavatsky and Rudolf Steiner's

"anthroposophy," both of which were influenced by the occult. Further, Kandinsky examined the nature of artistic creation and analyzed color, form, and the role of the object in art, as well as the nature and purpose of abstraction. The work became enormously influential in the development of abstract art.

Kandinsky wrote voluminously throughout his life, and in 1926 wrote a second important treatise on abstraction called *Punkt und Linie zu Fläche* (*Point and Line to Plane*).

Brian Davis

Date 1911

Country Germany

Why It's Key Wassily Kandinsky provides the theoretical basis for abstract art with his treatise on the relationship of the mind and artistic activity.

Key Artist **Franz Marc**
German Expressionist of Der Blaue Reiter

Born in Munich to a landscape painter father and strict Calvinist mother, Marc began his training at the Akademie der Bildenden Künste in Munich in 1900, where he showed an advanced and seemingly innate sense of pictorial construction. By mid-1902, Marc was increasingly self-taught and visited Paris the following year, where he discovered a close affinity with the work of van Gogh and Gauguin. Upon his return, Marc began working independently at a studio in Munich. His work at this time was primarily devoted to illustrations of German modernist poems, and some natural studies showing the influence of van Gogh.

In 1910, Marc developed a close friendship with fellow painter August Macke, each receiving a monthly stipend from Macke's uncle, Bernhard Koehler, in exchange for an option on their paintings. Late that year, Marc met Kandinsky, Jawlensky, and Münter, among others. Their influence produced a new monumentality in pictorial construction and a color intensity reminiscent of the Fauves. In 1911, Marc and Kandinsky founded Der Blaue Reiter, and edited the almanac of the same name first published in May 1912. After meeting Robert Delaunay in 1912, formal aspects of Marc's work began to dissolve and move into purely spiritual and expressive realms. At the outbreak of World War I, Marc enlisted as a volunteer. He was later placed on the list of notable artists to be withdrawn from combat, but was killed in 1916 at the Battle of Verdun before the orders were carried out. Marc's mature work is characterized by its vivid primary colors; starkly simplistic, even Cubist portrayals of animals; and by its emotional profundity.
Amelia George

Date 1911

Born/Died 1880–1916

Nationality German

First exhibited 1911

Why It's Key Principal exponent of the German Expressionist movement and co-founder of Der Blaue Reiter.

Key Artist **August Macke**
Founder member of Blaue Reiter group

Born in Meschede in the Ruhr Valley in 1887, August Macke spent his childhood in Cologne and Bonn before moving to Düsseldorf to study art. He lived most of his creative life in Bonn, with the exception of time in Switzerland and trips to Paris, Italy, the Netherlands, and Tunisia. From 1907 onwards he visited Paris frequently, coming into contact with the Cubists and Impressionists. In 1910, through his friend Franz Marc, he met Kandinsky in Munich and in 1911 became a founder member of the Expressionist group Der Blaue Reiter (the Blue Rider), though he shared only for a while the group's non-objective, mystical, and symbolic interests, preferring "joyful living through of nature" to metaphysical speculation.

Two years later in Paris, Macke was profoundly impressed by Robert Delaunay's chromatic Cubism, named Orphism by Apollinaire, which defined space using planes of pure color alone. Macke's *Großes helles Schaufenster* (*Large Bright Shop Window*, 1912) combines the influence of Delaunay's *Windows* series with the Futurist technique of multiple, simultaneous images. Creating "living" color, wrote Macke, and discovering the "space-defining energies of color… that is our finest goal."

In 1914 Macke traveled with Klee and Louis Moilliet through Tunisia, and produced the glowing figurations of women and children in domestic interiors and exteriors, expressed in large, strongly outlined plaques of intense color, which are now regarded as his masterpieces. Later that same year, at the age of twenty-seven, he died in action in World War I.
Catherine Nicolson

Date 1911

Born/Died 1887–1914

Nationality German

First exhibited 1911

Why It's Key Master colorist, who combined German Expressionism, French Orphism and Italian Futurism.

Key Artist **Alexander Archipenko**
Shows for first time at Salon d'Automne, Paris

Alexander Archipenko, born in Kiev in 1887, studied art locally from 1902 to 1905. Dissatisfied by academicism, he progressed via Moscow to Paris, where two weeks at the Ecole des Beaux-Arts in 1909 proved equally stultifying. Instead he studied independently in the Louvre, met Picasso and Braque, and converted to Cubism, though he later insisted: "I did not take from Cubism, but added to it." His Cubist sculptures were first exhibited at the Salon des Indépendants in 1910, then from 1911 on at the Salon d'Automne.

Archipenko taught at his own art school in Paris from 1912 until the outbreak of World War I, when he moved to Nice. In 1920 he took part in the Twelfth Venice Biennale and a year later undertook a successful solo exhibition in the United States. After two years in Berlin, during which he started another college, he emigrated to the United States in 1923. He took citizenship in 1929, and continued to teach open art schools and exhibit internationally until his death in New York in 1964.

From his Cubist period on, Archipenko was a highly influential sculptor and educator. His concept of the void as a positive element, his delight in multiple angles and unusual materials like glass, acrylic, and terracotta, and his use of unconventional techniques like nailing, pasting, and tying, have since entered sculpture's mainstream vocabulary. Typical of his innovative approach is his multimedia, found object "sculpto-painting" *Cleopatra* (1957), which includes wood, Bakelite, and a necklace.

Catherine Nicolson

Date 1911

Born/Died 1887–1964

Nationality Russian-American

First exhibited 1906

Why It's Key International Modernist sculptor and champion of Cubism in the round.

1910–1919

115

Key Exhibition
First Camden Town Group exhibition

The first exhibition of the Camden Town Group – described by Charles Harrison as "one of [the] century's very few successful, modern, realist movements" – was held at the Carfax Gallery, London, in June 1911. The Group evolved out of the Fitzroy Street Group, started by Walter Sickert three years earlier.

Camden Town painting is associated with a brightly colored, densely impastoed technique and a small range of subjects: female nudes on iron bedsteads in seedy north London boarding houses; views of the modern metropolis; paintings of music halls and theaters. To this Sickert added his own unique contribution: two-figure "conversation pieces," including the notorious "Camden Town Murder" series.

Besides Sickert, the senior members of the Group were: Lucien Pissarro, son of the great Impressionist painter; Spencer Gore, one of the most outstanding British Post-Impressionists; Harold Gilman and Charles Ginner, who in 1913 launched their own Neo-Realist movement; and Robert Bevan, best known for his paintings of cab yards and horse sales. Other members included: Walter Bayes and Malcolm Drummond, both protégés of Sickert; J.B. Manson, the Group's secretary, later director of the Tate Gallery; and two essentially amateur artists, William Ratcliffe, and John Doman Turner. Augustus John, Henry Lamb, J.D. Innes, Wyndham Lewis, and Duncan Grant all contributed paintings to the Group's exhibitions but little or nothing to its house style. The Camden Town Group held two further exhibitions before being absorbed into the larger London Group in 1913.

James Beechey

Date June 1911

Country UK

Why It's Key Launch of the group of painters who established Post-Impressionism and subsequently Neo-Realism in British art. Despite its short-lived existence, its legacy persisted in the Euston Road and Kitchen Sink schools, and in the work of London-based painters such as Frank Auerbach and Leon Kossoff.

Key Person **Lucy Lloyd**
Publication of *Specimens of Bushman Folklore*

Had it not been for the publication of Lucy Lloyd's *Specimens of Bushman Folklore* in 1911, modern understanding of San rock art would not have developed greatly beyond early colonial interpretations of Bushman art as childlike and primitive.

Bushmen (or San) is a collective term for the nomadic people who once occupied much of Southern Africa. Their culture and way of life has been all but eradicated, with the exception of a small group who survive in the Kalahari Desert. Lloyd's book, along with her other work, is crucial to interpreting Bushman art, as it offers an insight into the culture and beliefs of artists whose languages and customs are no longer extant but whose works remain.

Lloyd, an Englishwoman, originally worked as an assistant to her German brother-in-law, the philologist Wilhelm Bleek, who studied the language of Xam Bushmen. Together they transcribed over 12,000 pages of material from Bushman informants, some of whom they arranged to be released from Cape Town prisons for that purpose.

Lloyd personally undertook much of Bleek's work after his death in 1875. She amassed a collection of Bushman folklore, music, and art, and was highly influential in South African folklore studies. The impressive Lloyd-Bleek collection of the University of Cape Town is a fitting tribute to the importance of Lloyd's and Bleek's work in understanding the thousands of rock paintings and carvings of Southern Africa.
Dennis Casey

Date 1911

Born/Died 1834–1914

Nationality British

Why It's Key Lloyd's book was crucial to the study of San people and their "rock art."

opposite An example of San rock art paintings at Shelter Cave, South Africa.

116

Key Artist **Wassily Kandinsky**
Founder member of the Blaue Reiter group

Born in Moscow, Kandinsky came to painting in 1895 after studying law. In 1897 he went to Munich to study under Franz von Stuck, a member of the Vienna Secession. He became active in the avant-garde in Munich and Paris. His early work combines elements of Art Nouveau and Russian folk painting, with an emphasis on strong color, influenced by his contact with Fauvism.

In 1911 he became a founder member of Der Blaue Reiter (the Blue Rider) with several German artists, including Ernst Ludwig Kirchner and August Macke, and the Swiss artist Paul Klee. In their magazine and in his own treatise, *Concerning the Spiritual in Art* (1912), Kandinsky formulated theories in which he rejected imitative or illusionistic art in favour of an expressive response to visual stimuli through the use of form and color.

World War I brought an end to the group and Kandinsky returned to Russia, then to Germany, teaching at the Bauhaus (1921–33), before settling in Paris. He had by 1912 made a complete break with traditional format; in *Composition VI* (1913), for example, lines and splashes of color swirl across the canvas, and there is no recognisable subject. The impact of art and his theories make Kandinsky the most important figure in non-representational abstraction. However, being a master of composition, he could not be said to herald the formlessness of Abstract Expressionism.
Lucy Lubbock

Date 1911

Born/Died 1866–1949

Nationality Russian

First exhibited 1901

Why It's Key Leading theoretician and pioneer of abstract painting.

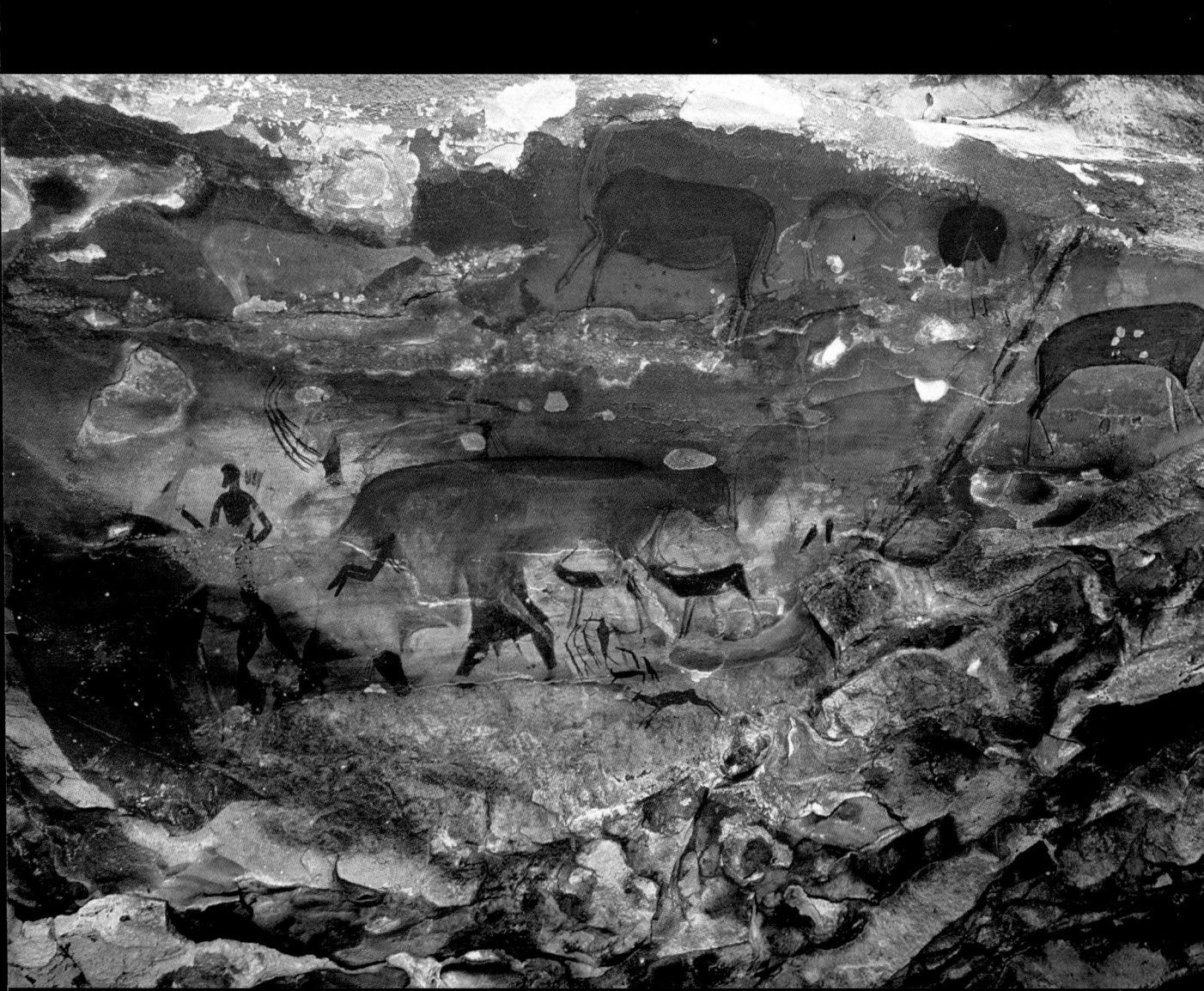

Key Artwork *I and the Village*
Marc Chagall

In *I and the Village* Chagall (1887–1985) opens up his inner world, showing a longing for the safe realm of his childhood and its happy memories. It was painted in his studio at La Ruche during his early years in Paris. The composition is inspired by Cubism, with fragmented shapes and circular elements spinning away from the center, each section filled with human and animal archetypes that form an overall narrative. Nature is represented in the form of a magical twig. It is from here that the lives of various inhabitants in the vibrant community of Vitebsk seem to emanate. One woman milks a cow, a symbol of life itself, from within the contour of a soulful lamb.

The central human figure and a beast are locked in a hypnotic gaze. Each wears a cross around its neck, indicating a common bond. Another woman, perhaps a symbol of fertility, is seen to be balancing on her head while a man approaches her with a scythe that may represent death. Houses are upside down. Reality moves beyond imagination in such a way that memories become symbols in this topsy turvy world.

Guilliaume Apollinaire, the poet who later coined the word Surrealism, was a great admirer of Chagall. He is known to have described Chagall's mystical and conceptual paintings at this time as having "surnatural" qualities. The observation predated the Surrealist movement by fifteen years.

Carolyn Gowdy

Date 1911

Country France

Medium Oil on canvas

Collection Museum of Modern Art, New York

Why It's Key One of Chagall's most distinctive paintings, made during his first visit to Paris.

opposite *Marc Chagall*

Key Exhibition
Sonderbund

In 1909, as part of the Secessionist movement that swept Europe at the turn of the century, a group of young artists in Düsseldorf established the Sonderbund westdeutscher Kunstfreunde und Künstler (the Separate League of West German Art Lovers and Artists). Between 1910 and 1912, the Sonderbund mounted three exhibitions of international modern art, the first two in Düsseldorf and the third – and most spectacular – in Cologne.

The 1912 Sonderbund took place at the Ausstellungshalle der Stadt Cöln am Aachener Tor (Cologne) from May 25 to September 30, 1912. It comprised 577 paintings by 160 artists from nine countries – Germany, France, Austria, Switzerland, Holland, Belgium, Czechoslovakia, Hungary, and Norway – together with 57 sculptures. The centrepiece of the exhibition was an astonishing display of 125 paintings by van Gogh. More modest mini-retrospectives were devoted to Gauguin, Cézanne, Picasso, and Munch. Trends in modern art, from Neo-Impressionism to Cubism, were all reviewed, with a particular emphasis given to the two avant-garde German movements, Die Brücke and Der Blaue Reiter. Other artists well represented at the Sonderbund included Bonnard, Matisse, Derain, Mondrian, and Kokoschka. The solo Old Master shown was El Greco, whose work was presented as a forerunner of Expressionism.

James Beechey

Date September 25–30, 1912

Country Germany

Why It's Key Major early retrospective of modern art. Among the visitors was Roger Fry, who borrowed several works for his Second Post-Impressionist Exhibition, and Arthur B. Davies and Walter Kuhn, organisers of the Armory Show, who took the exhibition as a model for their own ground-breaking survey of modern art.

Key Artwork *Nude Descending a Staircase*
Marcel Duchamp

At the beginning of his career, Duchamp gravitated around the Puteaux Group, which included his brothers Raymond Duchamp-Villon and Jacques Villon, as well as Cubist painters Fernand Léger, Robert Delaunay, and Jean Metzinger. He was also drawn to the way Italian Futurists like Gino Severini and Giacomo Balla attempted to decompose movement and speed.

In his *Nude Descending a Staircase*, Duchamp depicts the successive movements of a figure, its overlapping facets reminiscent of the multiple-exposure photography of Muybridge or the chronophotographs of Marey. There is nothing feminine about this mechanistic nude deprived of sensuous curves. Neither is the angularity of her body evocative of sexual provocation, as might have been the case in Picasso's boldly stylized *Demoiselles d'Avignon*. She is looking down, silently, as if concentrating on her step, while the darker space around her is fragmented into kaleidoscopic staircases.

In 1912, Duchamp was asked to withdraw the picture from the Salon des Indépendants as it was deemed "inappropriate" by fellow Cubist painters. He exhibited it at the 1913 Armory Show, an international exhibition of modern art in New York, alongside masters of French Post-Impressionism such as Cézanne and Seurat, and avant-garde European artists such as Picasso and Matisse. Duchamp's *Nude* caused a public outrage and was the subject of many press caricatures, a *New York Times* art critic comparing it to "an explosion in a shingle factory." Notorious overnight, Duchamp would again shock America with his ready-made *Fountain* in 1917.

Catherine Marcangeli

Date 1912

Country France

Medium Oil on canvas

Collection Philadelphia Museum of Art, USA

Why It's Key Duchamp associates Cubist fragmentation and Futurist motion.

opposite
Nude Descending a Staircase

120

Key Exhibition
Salon de la Section d'Or

Between 1907 and 1914 Cubism developed in Paris along two parallel but distinct strands: one centered around Picasso and Braque at the Bateau-Lavoir in Montmartre, and was austere and intellectual in character; the other, sometimes known as Salon Cubism after several of its adherents exhibited together at the 1911 Salon des Indépendants, was pictorial in essence and schematic in approach. The latter was promoted by the Puteaux Group, named after the village to the west of Paris where two of its leading members, the brothers Jacques Villon and Raymond Duchamp-Villon, lived. Because Picasso and Braque's work remained largely hidden from view, this became the public face of Cubism, causing uproar at its earliest appearances.

The broadest manifestation of Salon Cubism was the exhibition Salon de la Section d'Or, shown at the Galerie la Boëtie, Paris, for three weeks from October 10, 1912. Over 30 artists contributed almost 200 paintings and sculptures to the exhibition. Among them were were Villon, Duchamp-Villon, and their brother Marcel Duchamp (who showed *Nude Descending a Staircase, No.2*), Fernand Léger, Juan Gris, Francis Picabia, Albert Gleizes, Jean Metzinger, André Lhote, and Roger de la Fresnaye. The inaugural address was given by Guillaume Apollinaire, who also edited the accompanying publication *La Section d'Or*, the first issue of a proposed journal devoted to Cubism (which never materialized). With the outbreak of World War I, and the dispersal from Paris of many of the artists involved, the group disintegrated and many of its members turned their backs on Cubism.

James Beechey

Date October 10–30, 1912

Country France

Why It's Key Landmark Paris showing of thirty-one Cubist artists.

NU DESCENDANT UN ESCALIER

Key Artist **Morgan Russell**
Begins painting so-called "Synchromies"

Russell, together with Stanton Macdonald Wright and Patrick Henry Bruce, were the only American artists to formulate a common aesthetic program. The principles of Synchromism arose from the color theories of Neo-Impressionism, and the formal vocabulary of Orphism, a tendency in abstract art also inspired by Seurat and his circle. Russell first exhibited his Synchromies in 1913 at the Salon des Indépendants in Paris. The group's manifesto appeared the same year, and the Synchromist artists achieved their most notable public success as a homogenous grouping at the Forum Exhibition of American moderns in New York in 1916.

Initially a student of Robert Henri, Russell became totally immersed in the modernist spirit after leaving New York for Paris in 1906. He studied with Matisse who, with Picasso, opened the way to abstraction,

although he was too interested in the visual play of figures and objects to pursue it. From 1912 Russell's paintings were close in style to Delaunay and Kupka, and he was probably inspired by them. His images explored the proportions and relations of dense pure color through their structural qualities, and achieved a more robust expressiveness than his European counterparts.

By the end of Word War I, the movement had largely ceased to exist. Russell returned to representational painting and, by the 1940s, was making religious imagery. After the death of his wife, he became reclusive, living in Burgundy, France, until he moved back to the United States in 1946.

Martin Holman

Date 1912

Born/Died 1886–1953

Nationality American

Why It's Key Co-founder of brilliantly colored U.S. idiom, Synchromism.

Key Artist **Otto Freundlich**
Exhibits at Sonderbund exhibition

Otto Freundlich studied art history in Munich and Berlin. In 1909 he moved to Paris and took a studio in Montmartre's Bateau-Lavoir, where he met Picasso and Braque. He exhibited with the Cubists in Paris, Amsterdam, and in 1912 in Cologne at the hugely influential Sonderbund exhibition alongside van Gogh, Gauguin, Picasso, Cézanne, and Munch. Five months spent working in Chartres cathedral just before World War I proved a formative aesthetic experience; the medieval stained glass, as he later wrote, "left its mark upon me for life."

In 1919, after serving in the military during the war, Freundlich helped organize Cologne's first Dada exhibition, and began for the first time to paint purely abstract work, using simple geometry and pure color. In 1924 he returned to Paris, joining the anti-figuration

groups Cercle et Carré (Circle and Square) and Abstraction-Création and contributing, as a committed utopian socialist, to radical journals.

In 1937 Freundlich's primitivist sculpture *Der Neue Mensch* (*The New Man*, 1912) was featured on the cover of the guide to the Nazi traveling exhibition Die Entartete Kunst (Degenerate Art), which condemned all modern art as Jewish, degenerate, or Bolshevik. Much of Freundlich's work was subsequently destroyed by the authorities. During World War II, after Picasso had persuaded the French government to release him from internment, Freundlich took refuge in the Pyrenees to recreate his destroyed paintings. In 1943, however, he was denounced as a Jew, transported to Poland, and killed at Lublin-Majdanek concentration camp.

Catherine Nicolson

Date 1912

Born/Died 1878–1943

Nationality German

First exhibited 1911

Why It's Key Important pioneer of abstraction, who was hounded by the Nazis because of his art, and was eventually a victim of the Holocaust.

Key Artist **Jean Metzinger**
Writes *Du Cubisme* with Albert Gleizes

Born to a military family, Metzinger opted out of a martial career following the early death of his father. He studied under the portrait painter Hippolyte Touront at the Académie des Beaux-Arts in Nantes. After sending three paintings to the Salon des Indépendants in 1903, he moved to Paris, where he supported himself as an artist.

Elected to the hanging committee of the Salon des Indépendants in 1906, Metzinger joined the Neo-Impressionist revival before a critic noted that he and Robert Delaunay, with whom he exhibited in 1907, broke images down into mosaics of small "cubes." He joined the avant-garde, meeting Max Jacob, Guillaume Apollinaire, and Picasso. He met Albert Gleizes in 1909 and, at the Salon des Indépendants of 1911, they exhibited with Fernand Léger and Henri le Fauconnier in a separate room dedicated, for the first time, to Cubism. The following year, Metzinger and Gleizes published *Du Cubisme*, which contained etchings by Duchamp, Derain, Braque, Metzinger, Laurencin, Gleizes, Léger, Gris, and Picabia. This was the first substantial treatise on the new art and was translated into English in 1913.

A pacifist, Metzinger saw wartime service as a stretcher-bearer. He continued as a central figure in Cubism, but by 1922 had shifted toward Purism (which celebrated the basic, essential form of objects, with the machine as the main reference) and elements of Surrealism entered his work in the 1930s. After World War II, he revisited Cubism and, in 1947, he and Gleizes produced a deluxe, revised edition of *Du Cubisme*, this time containing work by Picasso and Villon.

Nigel Cawthorne

Date 1912

Born/Died 1883–1956

Nationality French

First exhibited 1903

Why It's Key Jean Metzinger was one of the first theorists of Cubism.

Key Artist **Albert Gleizes**
Cubist painter publishes influential pamphlet *Du Cubisme*

Albert Gleizes was both an artist and a writer, perhaps better remembered today as a theorist, rather than as an exponent, of Cubism. *Du Cubisme*, co-written with his fellow artist Jean Metzinger, and originally published in 1912, was the first substantial treatise on the movement, preceding by a year Guillaume Apollinaire's *Les Peintres Cubistes*. An English translation was published in 1913, and the pamphlet enjoyed wide international circulation before World War I.

Gleizes began his career painting in a loosely Impressionist style. In 1906 he was one of the founders of the Abbaye de Créteil, a community of artists and intellectuals dedicated to the ideals of utopian socialism. By 1911 he was a leading figure in the Puteaux Group of Cubists, and he participated in the group's major public showings – at the Salon des Indépendants in 1911, the Salon d'Automne in 1912, and the Salon de la Section d'Or, also in 1912. For Gleizes, Cubism was essentially a structural style, entailing geometric simplification, rather than a conceptual challenge to traditional means of visual perception. Some of his most dynamic, nearly abstract, works, including several views of Brooklyn Bridge, were painted in New York, where he spent the latter part of World War I. In the 1920s he became increasingly interested in the close relationship between mural painting and architecture in the Romanesque period, and in his own work attempted to achieve a synthesis of pre-Renaissance and modern art. A serial initiator of collective enterprises, Gleizes started another commune, Moly-Sabata, at Sablons, in 1927 and was a co-founder of the Abstraction-Création group in 1931.

James Beechey

Date 1912

Born/Died 1881–1953

Nationality French

Why It's Key Gleizes' tract was the first theoretical dissertation on the Cubist movement.

1910–1919

Key Artist **Juan Gris**
Exhibits *Homage to Picasso*

After studying mathematics, physics, and engineering in his native Madrid, José Victoriano Gonzáles (later known as Juan Gris) moved to Paris in 1906 to become an artist, and changed his name to Juan Gris. He met Braque and Picasso, both of whom were already developing Cubism. Through Picasso he found a studio in the Bateau-Lavoir artists' tenement and began painting seriously in 1910. Using his technical background, he devised a more scientific approach to the multiple perspective of Cubism.

Gris exhibited fifteen paintings independently in 1912. Three of them, including *Homage to Picasso*, were shown in the Salon des Indépendants that year. This brought his work to a wider audience, and established him as a painter of the first rank. He continued to develop his hard-edged geometric style,

and wrote on the theory of Cubism, later helping André Masson with his experiments in automatism.

In 1919, he had a one-man show featuring fifty of his canvases. Gris also designed costumes and sets for the Ballets Russes, and produced lithographs for Gertrude Stein's bizarrely titled *A Book Concluding With As A Wife Has A Cow: A Love Story*. Gris was seriously ill for the last seven years of his life. Among the mourners at his funeral in 1927 was his friend and former neighbor in the Bateau-Lavoir, Picasso.
Brian Davis

Date 1912

Born/Died 1887–1927

Nationality Spanish

First exhibited 1912

Why It's Key His homage to the already celebrated Picasso brought recognition to a leading practitioner and theoretician of Cubism.

1910–1919

opposite *Homage to Picasso* by Juan Gris, 1912.

125

Key Person **Vladimir Mayakovsky**
Politically active poet joins the Futurists

An enthusiastic supporter of the Russian Revolution in 1917, Mayakovsky wrote *Misteriya-Buff* (*Mystery-Bouffe*), the first Soviet play, regarded as a masterpiece of the period. For the People's Commissariat for Education he wrote extensively and traveled the Soviet Union and abroad to give lectures and recitals. After 1921 his propagandist activism was increasingly at odds with the new, conservative leadership and, prior to his suicide, he was severely castigated for his outspoken and unconventional opinions on art.

Involved in the social-democratic movement as a youth, Mayakovsky was imprisoned for eleven months in 1908, after which he renounced politics for art. Between 1911 and 1914 he studied at the Moscow School of Painting, although his first love remained writing. He determined to incorporate into poetry his

experience as a painter; the verbal devices, such as the jumbled or fragmentary words used by the Futurist group he co-formed, can be traced to earlier paintings by Larionov. By introducing ordinary speech, slang, and journalese, he attempted to democratize poetry.

Mayakovsky first came to notice in 1912 with poems attacking Symbolist art. Known for wild declamations and discussions that continued into the Moscow streets, he and his companions wore text badges and Rayonist signs painted on their cheeks. Advocating art as a revolutionary tool, he co-operated with artists as editor of *LEF*, the Constructivists' journal. Rodchenko's first printed photomontage appeared in his poem *Pro Eto*, and Rodchenko and Lissitzky featured in his first editions of post-Revolution poetry.
Martin Holman

Date 1912

Born/Died 1893–1930

Nationality Russian

Why It's Key Politically committed poet who gave Russian poetic language a new direction, and the artist a different role in society.

Key Artwork *Self Portrait with Seven Fingers*
Marc Chagall

Chagall (1887–1985) combined a passion for his Russian Jewish roots in Vitebsk with new enthusiasm for Cubist experiment in *Self Portrait with Seven Fingers* (1912–13). Chagall painted the self-portrait while based in his first Paris studio at La Ruche (The Beehive) in Montparnasse, where he and two hundred fellow artists, including Chaim Soutine and Fernand Léger, lived in extreme poverty.

Chagall grew up in a Belorussian village as the eldest son of a Hassidic laborer. He began studying at Yehuda Pen's school of painting in Vitebsk, and then moved to St Petersburg, where he studied under the stage designer Léon Bakst. In 1910 he moved to Paris and spent most of his working life in France.

Chagall constantly returned to his roots for inspiration. This self-portrait combines the feelings of being a Jewish expatriate in the modern world, a theme he would pursue for the next sixty years, and also displays the painter's early attempts to incorporate multiple points of view and the geometric shapes of Cubism into his compositions.

The number seven also has deep significance and mystical overtones in the Jewish tradition, from the seven days of creation in the Bible, to the Kabbalah, which refers to seven parallel universes. Some critics maintain that Chagall wished to imply how he creates parallel worlds on his canvases, often taking themes from Russian fairy tales to Yiddish jokes.

Brian Davis

Date 1912–13

Country France

Medium Oil on canvas

Collection Stedelijk Museum, Amsterdam

Why It's Key Chagall's first self-portrait combines Cubism with his Jewish roots.

opposite *Self Portrait with Seven Fingers*

Key Exhibition
First Futurist exhibition

Futurism had been announced in 1909, when the Paris newspaper *Le Figaro* published a manifesto by the precocious Italian poet and editor Filippo Tommaso Marinetti (allegedly an Egyptian friend of his father's was an important shareholder in the paper). From the security of an affluent family background, Marinetti called for change and innovation in society, exalting violence and conflict, and the beauty of machine power. He also demanded the destruction of formal institutions such as museums and libraries. Marinetti had coined the name "Futurism" in his bombastic manifesto, purposely intended to ignite public anger and arouse controversy in order to attract attention.

Marinetti's manifesto resonated with three painters in Milan: Umberto Boccioni, Carlo Carrà, and Luigi Russolo. In 1910, they produced two manifestos of Futurist painting to which Giacomo Balla and Gino Severini were also signatories. Although Marinetti assumed the role as leader and inspired stage manager, the Paris exhibition came about through the influence of Gino Severini, who had lived in Paris since 1906 and married Paul Fort's 16-year-old daughter, Jeanne, in 1913. He was also a friend of influential critic Félix Fénéon. Only Balla refused to participate. A group of 38 paintings was exhibited at the Bernheim-Jeune Gallery, regarded as a center of the avant-garde since exhibiting Cézanne, Seurat, van Dongen, Matisse, Rousseau, and Dufy, amongst others. In Italy the Futurist dynamic evaporated during World War I – a decidedly non-theoretical example of the force of mechanical power – but in Russia it continued to flourish into the 1920s.

Mike von Joel

Date February, 1912

Country France

Why It's Key The first group exhibition of the Futurists, which then traveled to various major European cities, including Amsterdam, Berlin, London, and Vienna; it became a blueprint presentation for all diligent avant-gardists to imitate throughout the twentieth century.

Key Person **Walter Baldwin Spencer**
First major collection of Aboriginal bark paintings

The Aboriginal bark paintings collected by Walter Baldwin Spencer at the beginning of the twentieth century, though significant in their own right, represent merely one facet of the artistic, cultural, and scientific endeavors of a true pioneer.

Spencer, an Englishman, was Professor of Biology at the University of Melbourne when he joined a scientific expedition exploring central Australia in 1894 and met the ethnologist and anthropologist F. J. Gillen. Gillen and Spencer subsequently collaborated on a number of books and Spencer spent much of his life engaged in similar anthropological pursuits.

While living with the Aborigines of Arnhem Land in the Northern Territory, Spencer amassed a considerable collection of Aboriginal bark paintings. These paintings, often representations of animals or spirits, were executed on gum-tree bark with ochre (iron oxide pigment). Perhaps the most fascinating of these are the so-called "X-Ray" paintings, which attempt to portray the internal anatomy of the animals depicted.

Spencer was not simply an anthropological and artistic magpie content to collect objects which captured his attention, but also commissioned pieces from Aboriginal artists. Likewise he patronized many white Australian artists and became a noted figure in Australian artistic and cultural life. The specimens of bark art that Spencer donated to the National Museum of Victoria (of which he was then director) form the basis of one of the most impressive collections of early Aboriginal art assembled to date.

Dennis Casey

Date 1912

Birth/Death 1860–1929

Nationality British

Why It's Key Leading anthropologist and collector, and a key figure in the appreciation of Aboriginal art.

Key Artist **Vanessa Bell** Bloomsbury Group artist experiments in Post-Impressionism

Vanessa Bell (born Vanessa Stephen) was one of the leading exponents of British Post-Impressionism. The eldest daughter of the eminent man of letters Sir Leslie Stephen and his second wife Julia Duckworth, she was born into the Victorian "intellectual aristocracy." As children she and her sister decided their respective destinies: she would be a painter and Virginia (later Virginia Woolf) would be a writer. She married the writer and art critic Clive Bell; their house at 46 Gordon Square became the headquarters of the Bloomsbury Group. Bell's art was transformed by her response to Roger Fry's two Post-Impressionist exhibitions of 1910 and 1912. Under the influence of Matisse in particular, her style was characterized by radically simplified and flattened forms – most effectively articulated in works such as *Studland Beach* (c.1912) – and by a dazzling use of color, brilliantly illustrated by her *Portrait of Mary Hutchinson* (1915). Around 1914 Bell produced some of the first purely non-representational paintings in Britain. Her flirtation with abstraction was short-lived, however, and for the remainder of her career she concentrated on still life, landscape, and domestic subjects.

From 1913 to the end of her life, Bell lived with, and frequently worked alongside, Duncan Grant. She and Grant collaborated on many schemes of interior decoration, but their individual idioms remained distinct: his exuberant, lyrical, fantastic; hers self-effacing, grave, even severe. Much of her early work was destroyed during the Blitz; what survives confirms her contribution to early British modernism.

James Beechey

Date 1912

Born/Died 1879–1961

Nationality British

Why It's Key Leading figure in the development of British modernist painting.

opposite *Conversation Piece* by Vanessa Bell, 1912.

Key Artist **Tom Thomson**
Visits Algonquin Park

Born near Claremont, Ontario, Tom Thomson grew up in Leith, near Owen Sound. In 1899, he volunteered to fight in the Second Boer War, but was rejected, and from 1901 to 1904, he worked as an engraver in Seattle, returning to Canada to work as a designer and illustrator in Toronto. In 1907 he joined the Toronto design firm Grip Ltd., where he met a number of painters who later formed the Group of Seven, pioneering Canadian artists who were intent on portraying a distinctive vision of Canada through its rugged northern Ontario landscape. Under the influence of Albert Robson, the director of Grip's engraving department, Thomson and his colleagues spent their weekends drawing and painting in the countryside around Toronto, and in 1912 he visited Algonquin Provincial Park, a wilderness area established in 1893.

The following year, he quit his job to concentrate on art. He first exhibited with the Ontario Society of Artists in 1913, becoming a member when the National Gallery of Canada bought his painting *Northern River* in 1915.

For several years, Thompson shared a studio with fellow painter and mentor A.Y. Jackson, before moving into a shack on Canoe Lake. His colorful and highly textured paintings of lakes, mountains, and trees convey a deep joy in the natural environment.

On July 8, 1917, Thomson died mysteriously while out fishing. His body was recovered from Canoe Lake a week later. A hurried inquest recorded the verdict of "death by accidental drowning." His work provided the inspiration behind the Group of Seven, formally founded in 1920.

Nigel Cawthorne

Date 1912

Born/Died 1877–1917

Nationality Canadian

First exhibited 1913

Why It's Key Tom Thompson was an influential Canadian landscape painter and one of the key members of the Group of Seven.

Key Exhibition
First Armory Show

In the wake of large, independent art exhibitions in France, Germany, Italy, and England, the International Exhibition of Modern Art (known to history as the first Armory Show), at the 69th Regiment Armory on Lexington Avenue, New York, caused a sensation. Some 1,250 paintings, sculptures, and decorative works by over 300 European and North American artists were primarily selected by Walt Kuhn and Arthur B. Davies, on behalf of the Association of American Painters and Sculptors. These included 634 works that traced the development of European art from Goya to the Cubists and a number of works by Picabia, Duchamp-Villon, and Brancusi.

Funds had been raised from art patrons Gertrude Vanderbilt Whitney and Mabel Dodge, and the exhibition went on to tour Boston and Chicago, with an even higher number of (often outraged) visitors than the New York show. The most profitable room in the show was undeniably Gallery 1, "The Cubist Room," with Marcel Duchamp's work being the major force. All four of his entries sold. The first, *Nude Descending the Staircase*, was purchased sight unseen by Fredric Torrey, an art dealer from San Francisco. And Cézanne's *Hill of the Poor* was acquired by the Metropolitan Museum of Art, indicating official acceptance of his work. Despite the critical focus on European, and primarily French, artists, over half the exhibitors were from the USA. However, writer Milton Brown, an authority on the Armory Show, has noted that the elevation of many artists after the exhibition was short-lived, a sobering check on the mythological reputation the event has attained.

Mike von Joel

Date February 17– March 15, 1913

Country USA

Why It's Key America's first public introduction to modern art, an exhibition whose influence reverberated through the whole of twentieth-century American culture.

opposite 1913 photograph showing the Armory Show exhibition hall in New York.

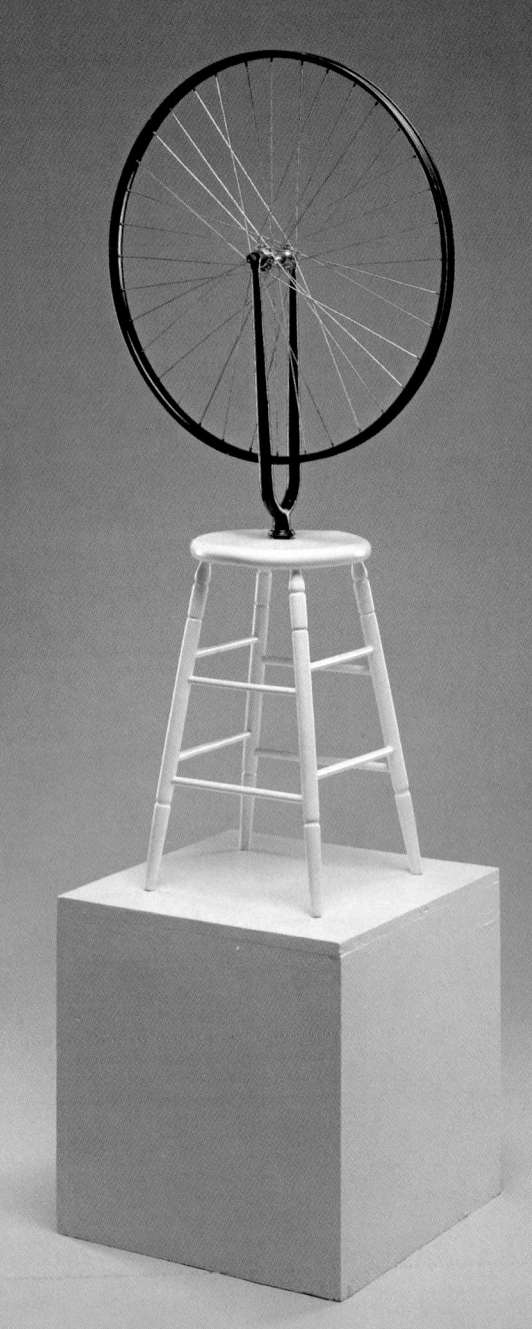

Key Artwork *Circular Forms, Sun Discs*
Robert Delaunay

Robert Delaunay was one of the central figures of Orphism – a term coined in 1912 by the poet Guillaume Apollinaire. Rooted in Cubism, the Orphists moved toward a more lyrical abstraction and the sensation caused by the bright colors that these painters sought to introduce into the drier aesthetic of Cubism.

Whilst in Paris in 1911, Delaunay did a series of paintings featuring the Eiffel Tower. However, by 1912 he had made a move into full abstraction. Having rejected Cubism's insistence on the conceptual over the perceptual, his work now presented harmonies, like music, directly to the senses. In 1913, Delaunay liberated himself from specific objects and advocated an art of pure painting. That year he painted circular form, or disc, pictures.

Delaunay was intrigued by how the interaction of colors produces sensations of depth and movement without reference to the natural world. "The breaking up of form by light creates colored planes," he said of his disc paintings. "These colored planes are the structure of the picture, and nature is no longer a subject for description but a pretext." Indeed, he had decided to abandon "images or reality that come to corrupt the order of color." The optical effect based on the faceting of color marked the culmination of his pioneering move into full abstraction following his break with Cubism early that year. Delaunay's abstract use of color was seminal in the development of abstract art.

Kate Mulvey

Date 1913

Country France

Medium Oil on canvas

Collection Museum of Modern Art, New York

Why It's Key These disc paintings were the seminal point in Robert Delaunay's career and marked the beginning of his abstract period.

Key Artist **Marcel Duchamp**
Bicycle Wheel is first "ready-made" work of art

In his studio, Duchamp decided to perch a bicycle wheel atop a stool, in the way one would place a sculpture on a pedestal. More a whimsical assemblage than a bona fide ready-made, the idea is consistent with an attraction for hypnotic motion that would resurface in Duchamp's later *Rotoreliefs* (1935). "I liked just looking at the wheel, as one looks at the flames in a fireplace," Duchamp recalled.

The term ready-made was coined in 1915 to describe objects appropriated by the artist acquiring the status of artworks. Duchamp's *Bottle Rack* (1914), for example, was picked up by the artist in Paris, and *Advance of the Broken Arm* (1915), was a snow shovel bought in a New York hardware store. His most famous work, *Fountain* (1917), was an industrially produced urinal, which he signed and placed (or displaced) in a new, artistic context. Whether the choice of these ready-mades was truly indifferent and independent from aesthetic, "retinal," criteria, as Duchamp claimed, they nevertheless raise fundamental questions: what of the craftsmanship of the artist, his originality and inspiration? Can the work be unique? When is an object an art object? To marvel at the elegant Brancusi-like curves of *Fountain* or at the perfectly proportioned snow shovel would be to misunderstand the nature of a ready-made. By accepting Duchamp's choice as an artistic gesture, we validate a concept, and enter an artistic, rather than aesthetic, relationship with the object. Such questions were addressed decades later by Warhol's mechanically reproduced works and by conceptual artists such as Joseph Kosuth.

Catherine Marcangeli

Date 1913

Born/Died 1887–1968

Nationality French

Why It's Key With his appropriation of everyday objects as "ready-mades," Duchamp introduced the notion of choice as an artistic gesture in itself, pre-dating conceptual art by half a century.

opposite *Bicycle Wheel* by Marcel Duchamp, 1913.

Key Artist **Lyonel Feininger**
Moves to Germany and joins the Blaue Reiter group

Lyonel Feininger was born in New York to German-American parents who were both musicians. At 16 he moved to Berlin to study music, then after a year changed to art, studying in Hamburg and Paris until 1893. He then worked as a caricaturist for newspapers including the *Chicago Tribune*, for which he drew children's comic strips such as The Kin-der-Kids (1906), and German humor magazines such as *Humoristische Blätter*. His drawings were also exhibited at the annual exhibition of the modernist breakaway group Berliner Secession (Berlin Secession) between 1901 and 1903.

By 1910, influenced by Cubism and Futurism, Feininger developed an individual painting style using prismatic, overlapping facets to convey three-dimensional objects. The artists of the avant-garde Blaue Reiter (Blue Rider) group, impressed by this new work, invited Feininger to exhibit with them in the first Berlin Herbstsalon of 1913, which was designed to rival the non-establishment Salon d'Automne exhibitions put on annually in Paris.

In 1919 Feininger was invited by Walter Gropius to work at the legendary Bauhaus school of art and architecture at Weimar. He remained there until its closure by the Nazis in 1933, becoming the only Meister to teach there from beginning to end. In 1937, his work having featured in the Nazi Entartete Kunst (Degenerate Art) exhibition, he and his partly Jewish wife fled Nazi Germany and returned to New York. Painter, illustrator, caricaturist, printmaker, composer, and connoisseur of the New York cityscape, Feininger died there in 1956, aged 85.

Catherine Nicolson

Date 1913

Born/Died 1871–1956

Nationality American

First exhibited 1901

Why It's Key American-born but Europe-based Cubist Expressionist painter, caricaturist and Meister at the Bauhaus.

1910–1919

Key Artwork *Ace of Clubs*
Georges Braque

In 1912, Georges Braque's *Fruit Dish and Glass* "Bar" served as the first acknowledged example of papier collé art. In 1913, Braque's *Ace of Clubs* became the second. In these works, Braque was inspired by confrère Picasso's method of collage-combined oil painting with the placement of paper and cloth elements that combined to create complex textures of both form and meaning.

After a century heavily conditioned by Braque and Picasso, it may be difficult to understand what made *Ace of Clubs* so transfixing. In a pre-war Paris still dominated by the fuzzy visual aesthetics of Romanticism, *Ace of Clubs* placed geometry front and center. This move anticipated artistic movements from Cubism proper to Suprematism and even Post-Painterly Abstraction. Moreover, in his richly allusive use of collage, Braque suggested what might be possible in this young medium. But *Ace of Clubs* was not a purely formal experiment. It was a teasing meditation on the signified and the seen. The work itself is a conceptual glance through the window of a café or a restaurant. Between the grainy wooden shutters (a nice demonstration of papier collé's ability to superimpose texture on oil) we see some grapes, a table, some playing cards, indistinct lettering, and perhaps the broken halves of a phonograph record. We think that we have seen nothing; but we have seen everything. Braque's collage, abstraction, and geometry magnificently unite the felt (a mood of afternoon anomie), the visual (the playing cards), and the conceptual (the musical rotation of the scene).

Demir Barlas

Date 1913

Country France

Medium Oil, gouache, and charcoal on canvas

Collection Musée National d'Art Moderne, Centre Georges Pompidou, Paris, France

Why It's Key This work is generally considered one of the first examples of papier collé art.

opposite *Ace of Clubs*

Key Event
Opening of the Omega Workshops

In 1912, energized by the enthusiastic response of a handful of artists to his Second Post-Impressionist exhibition, Roger Fry proposed a cooperative studio where artists could adapt their talents to applied art, both to earn a living and to enhance their own work as painters and sculptors. The idea came to fruition in July 1913 when the Omega Workshops opened its doors at 33 Fitzroy Street, London. Fry's co-directors in the enterprise were painters Duncan Grant and Vanessa Bell, and among the artists he recruited to work (anonymously) at the Omega were many associated with the Vorticist movement. But an enduring fault-line in modern British art was opened up when, in October 1913, Wyndham Lewis led a walkout of his allies from the Omega in a dispute over a commission, before going on to launch his rival Rebel Art Centre.

During the six years of its existence the Omega, besides undertaking whole schemes of interior decoration, produced an astonishing range of individual items: painted and inlaid furniture, ceramics, textiles, rugs, trays, tiles, hats, fans, and jewelry. It also published books, including a portfolio of woodcuts, and staged exhibitions, including one of children's art. The house style was characterized by spontaneous and exuberant decoration, cornucopian imagery, and riotous color. Its most successful products, however, were more austere, geometric printed linens and woven carpets, and unadorned pottery.

James Beechey

Date July 1913

Country UK

Why It's Key The Omega's legacy persisted in the decorative work produced by Bell and Grant in the 1920s and 1930s, and in the decision by firms such as Edinburgh Weavers to commission designs from leading artists.

Key Event
Formation of the London Group

On October 25, 1913, at a meeting attended by members of the Fitzroy Street and Camden Town Groups and artists associated with the Vorticist movement, the formation of a new society was proposed. Shortly afterwards the society was officially constituted as the London Group, under which name it held its first exhibition at the Goupil Galleries in the spring of 1914.

Among the founder members of the London Group was a clutch of the most promising young British artists, including Harold Gilman, Spencer Gore, Charles Ginner, Jacob Epstein, Wyndham Lewis, Henri Gaudier-Brzeska, C.R.W. Nevinson, and Edward Wadsworth. From the outset, however, the Group was riven with dissent: Walter Sickert and Lucien Pissarro both withdrew in protest at the inclusion of Wyndham

Lewis; Eric Gill declined his nomination; and during World War I Lewis, Epstein, and Wadsworth tendered their resignations. In 1917 Roger Fry was elected to membership, to be joined two years later by Vanessa Bell and Duncan Grant.

Although Fry occupied no official position, his preference for a painterly version of Post-Impressionism came to dominate the Group's exhibitions. Among prominent contributors to these in the 1920s were the sculptor Frank Dobson and the painters Mark Gertler and Matthew Smith. Henry Moore and Ben Nicholson were briefly members in the early 1930s. Later in that decade the Group provided a public platform for the Euston Road School.

James Beechey

Date October 1913

Country UK

Why It's Key Catalyst for British modern painting through the first half of the twentieth century. By the time a London Group retrospective was held at the New Burlington Galleries in 1928, its importance was beginning to wane. It nonetheless continues to mount annual exhibitions to this day.

Key Artist **Mikhail Larianov**
Publishes the Rayonist Manifesto

It is not possible to attribute the emergence or invention of abstraction to one artist or group; different artists contributed different facets toward its inevitable birth. However, in the first decades of the twentieth century, Russia was significantly positioned at the forefront of artistic experimentalism.

With Moscow at the center of avant-garde, many groups and journals appeared, and with them heated debate on which direction art should take. Mikhail Larianov, together with his wife Natalia Goncharova, was very active in this debate, much of which centered on the need to break from the influence of Cézanne. In March 1912, they took part in The Donkey's Tail, the first exhibition to distance itself from European influence and declare an independent Russian avant-garde. Larianov appears to have devised Rayonism in

1912; a year later he organized The Target exhibition, in which he announced the birth of Rayonism and issued his Rayonist Manifesto. In the manifesto he hailed Rayonist style as independent of real forms and "existing and developing according to the laws of painting." Rayonism incorporated Futurist ideas on the dynamism (movement) of light rays, but its aim was to steer art beyond abstraction to a fourth dimension out of time and space. Through intersecting light rays, represented by lines varying in length and thickness, and of contrasting colors, new forms emanate in space, which only the artist can perceive.

Rayonism only lasted until 1914, when Larianov departed for Paris with Goncharova to work as a set designer for Diaghilev at the Ballet Russes.
Sue King

Date 1913

Born/Died 1881–1964

Nationality Russian

Why It's Key In his Rayonist Manifesto Larianov laid the foundations of abstract art in Russia.

1910–1919

137

Key Artist **Maurice Prendergast**
Pioneer of American Post-Impressionism

Born in 1858 in St John's, Canada, Prendergast was apprenticed as a commercial artist. During an early stay in Paris, he met James Maurice, who introduced him to the English avant-gardists Walter Sickert and Aubrey Beardsley. After 1900, he spent more time in New York, depicting the life of the city. He became a member of the Ashcan school of The Eight, a group of early twentieth-century American artists, sometimes called the New York realists for their depiction of the bars, alleys, slums, and streets of New York.

In 1907 Prendergast returned to a Paris awash with Impressionism and other new movements. He was profoundly influenced by Cézanne and the Fauves. He integrated their modernist influences of color and abstract form into his art, and the basic modernistic doctrine of a flat visual design and bold use of color.

Prendergast developed a watercolor technique to create paintings resembling mosaics and tapestries. He devised flattened, pattern-like forms rhythmically arranged on the canvas, using bold, contrasting colors and dots, patches, and layers. The forms were simplified and shown in flat areas of bright, unmodulated colors. His paintings involved people in the pursuit of leisurely activities, yet they were painted in a modern, naturalistic style. During his early career, he predominantly used watercolors, switching to oils in later life. Over time his work became increasingly more abstract. In 1912, Prendergast served on the selection committee and played a pivotal role in the 1913 Armory Show in New York, at which he exhibited 7 works. The show marked the end of an era and the beginning of modernism.
Kate Mulvey

Date 1913

Born/Died 1858–1924

Nationality Canadian

Why It's Key Major Post-Impressionist painter and precursor to Modernism.

Key Event
Official formation of the Xiling Society

In 1904, Chinese artist Wu Changshuo became the first director of the Xiling Society of Seal Carving and Calligraphy, and under his auspices, in 1913 it became a formal organization. The society reflected Wu's personality and artistic predilections, mirroring the aging painter's interests in the genre of bird-and-flower painting and in the ancient art of seal carving. Wu, inspired by the aesthetic theory of his compatriot Zhao Zhigian, believed that the arts of calligraphy, painting, and carving shared the same aesthetic roots. As such, the Xiling Society actively encouraged member-artists to work in all three media, although in later times Xiling became primarily a center for engraving.

At the turn of the twentieth century, China had already begun to be a wasteland for artists, many of whom fled the country. The Xiling Society itself was originally founded in the final days of the Qing Dynasty, whose collapse in 1911 would trigger decades of warlordism followed by the culturally austere People's Republic of China. These political events threatened to permanently efface China's traditional arts. The formation of the Xiling Society was a counter-blast against the forces of revolution and modernity, and is one of the leading reasons for the untroubled survival of the Chinese artistic tradition. That said, Wu himself was an innovator in Chinese painting, and his work is now considered to break from the Qing-era aesthetic.

History treated Wu well, as the master's paintings, calligraphies, and engravings began to appear in the world's museum collections winning him lasting renown in China. The Xiling Society too continues to prosper.
Demir Barlas

Date 1913

Country China

Why It's Key Traditional Chinese painting and seal carving survives into the modern era thanks to a towering artist's leadership of a new school.

opposite *Spring Offerings* by Wu Changshuo, 1919 (hanging scroll; ink and color on paper). The artwork is signed "Anji Wu Changshi in his seventy-sixth year."

138

Key Person **Robert Henri**
Important teacher and 1913 Armory Show organizer

Born Robert Henry Cozad in Cincinnati, Henri changed his name after a manslaughter scandal involving his father brought disgrace on the family. After spending time in New York, Atlantic City, and Philadelphia, in 1888 he traveled to Paris to study at the Académie Julien under William-Adolphe Bouguereau, and was duly admitted into the Ecole des Beaux-Arts. In 1900 the French government purchased his painting, *La Neige*, for the Musée du Luxembourg.

In 1908, Henri organized a landmark show entitled The Eight at the Macbeth Gallery in New York. Besides his own works and those produced by the "Philadelphia Four" (Glackens, Luks, Shinn, J.F. Sloan), there were paintings by Maurice Prendergast, Ernest Lawson, and Arthur B. Davies. This was the embryonic Ashcan School, though the term was not used until 1934. The show was revolutionary in that it was the first American exhibition to be self-organized and self-selected, without a jury and prizes.

In 1910, he organized the Exhibition of Independent Artists, another no-jury, no-prize show modeled after the Salon des Indépendants in France. Works were hung alphabetically to emphasize the egalitarian philosophy. Walt Kuhn, who exhibited, would duly become key curator (along with Arthur B. Davies) in the seminal International Exhibition of Modern Art in 1913 – the now famous Armory Show. Five of Henri's paintings were included.

Henri died of cancer in the summer of 1929. He was honored with a memorial exhibition at The Metropolitan Museum of Art in 1931.
Mike von Joel

Date 1913

Born/Died 1865–1929

Nationality American

Why It's Key Robert Henri was an influential Francophile art teacher and theorist who laid the foundations for the watershed Armory Show in New York.

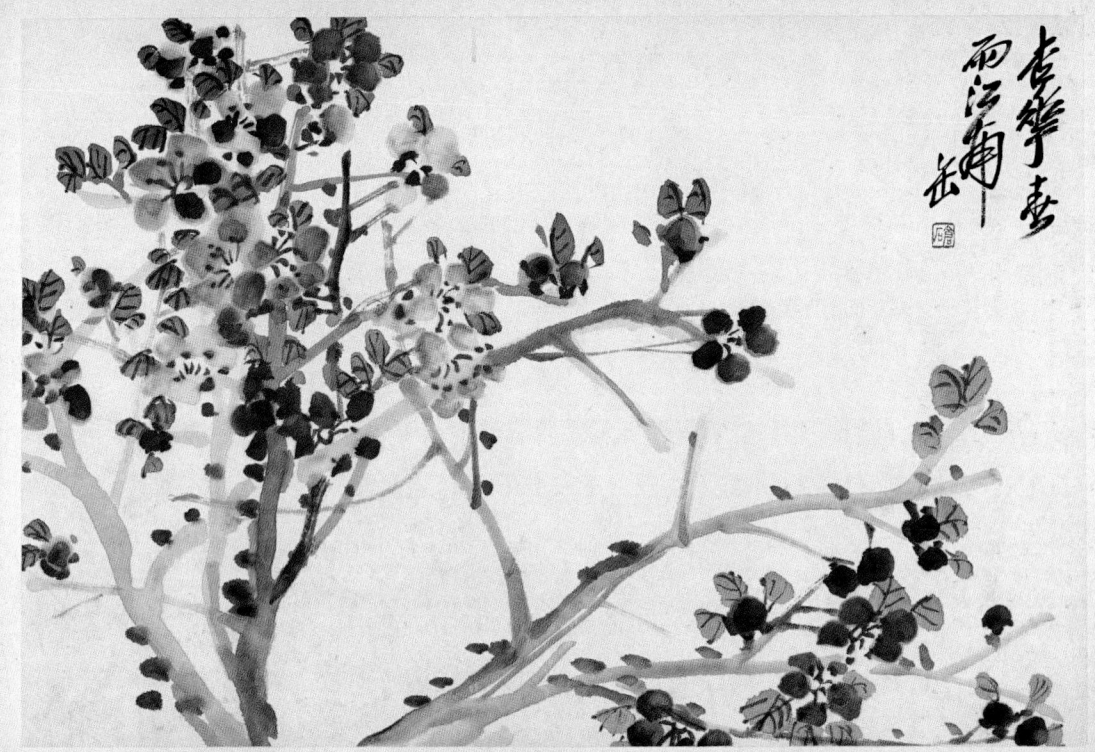

Key Event
Première of Igor Stravinsky's *The Rite of Spring*

The Russian-born composer Igor Fyodorovich Stravinsky (1882–1971) had already been hailed as a musical genius in Paris following the triumph of *The Firebird*, which he had written for the Ballets Russes in 1910. The following year he confirmed his reputation with *Petruska*. For the next season, the impresario of the Ballet Russes, Sergei Diaghilev, commissioned *The Rite of Spring*, but the difficulty of the music and the radical choreography by the celebrated dancer Vaslev Nijinsky (1889–1950), whom Stravinsky greatly admired as a dancer, but not as a musician, demanded over a hundred rehearsals and the production had to be delayed until the following year.

When it opened on May 29, 1913, *The Rite of Spring* caused a full-scale riot. The shifting rhythms and unresolved dissonances, along with the bold and suggestive choreography of violent dance steps depicting fertility rites, outraged many. Boos mixed with cheers. Arguments broke out that reached such a pitch that the dancers could not hear the orchestra. Nijinsky tried to keep the performance going by shouting out numbers and cues. Diaghilev tried to quell the uproar by switching the house lights on and off, while Stravinsky stormed out of the theater before police arrived to stop the show. However, the Modernist classic began to gain acceptance when the troupe's conductor, Pierre Monteux, introduced the score in concert the following year. By 1929, the normally staid *New York Times* was comparing it to Beethoven's *Ninth Symphony*. IN 1940, Walt Disney paid US$5,000 for the rights to use the score in his movie *Fantasia*.

Nigel Cawthorne

Date May 29, 1913

Country France

Why It's Key This concert at the Théâtre des Champs-Elysées, Paris, was a milestone in the advance of Modernism.

opposite Members of the Ballets Russes de Diaghilev dance in the Paris production of Stravinsky's *The Rite of Spring*.

Key Artist **Ernst Ludwig Kirchner**
Exhibits at the Armory and a one-man show in Germany

After studying architecture in Dresden and then painting in Munich, Kirchner returned to Dresden and became one of the founders of the Die Brücke (The Bridge) group, which held life classes in his studio. Its members drew inspiration from Neo-Impressionists and the Fauves. Other important influences were Japanese prints, and African and Polynesian art. They exhibited in Dresden in 1910.

In 1911, the Brücke group moved to Berlin, and the following year their work was included in the second show of the Blaue Reiter group in Munich. In 1913 Kirchner exhibited in the Armory Show in New York, and was given his first solo shows in Germany at the Museum Folkwang, Hagen, and the Galerie Gurlitt, Berlin. That year the Brücke group broke up. In 1914, Kirchner was drafted into the military, but after a few months he suffered a complete physical and mental breakdown. He went to a sanatorium in Switzerland to recover, settling there when he was well enough to resume painting. His later works include landscapes and studies of peasant life in Switzerland. In 1937, the Nazis declared his work "degenerate" and, after a long period of depression, he committed suicide.

Brian Davis

Date 1913

Born/Died 1880–1938

Nationality German

First exhibited 1910

Why It's Key Leader of Die Brücke group of Expressionists hailed both in New York and his German homeland.

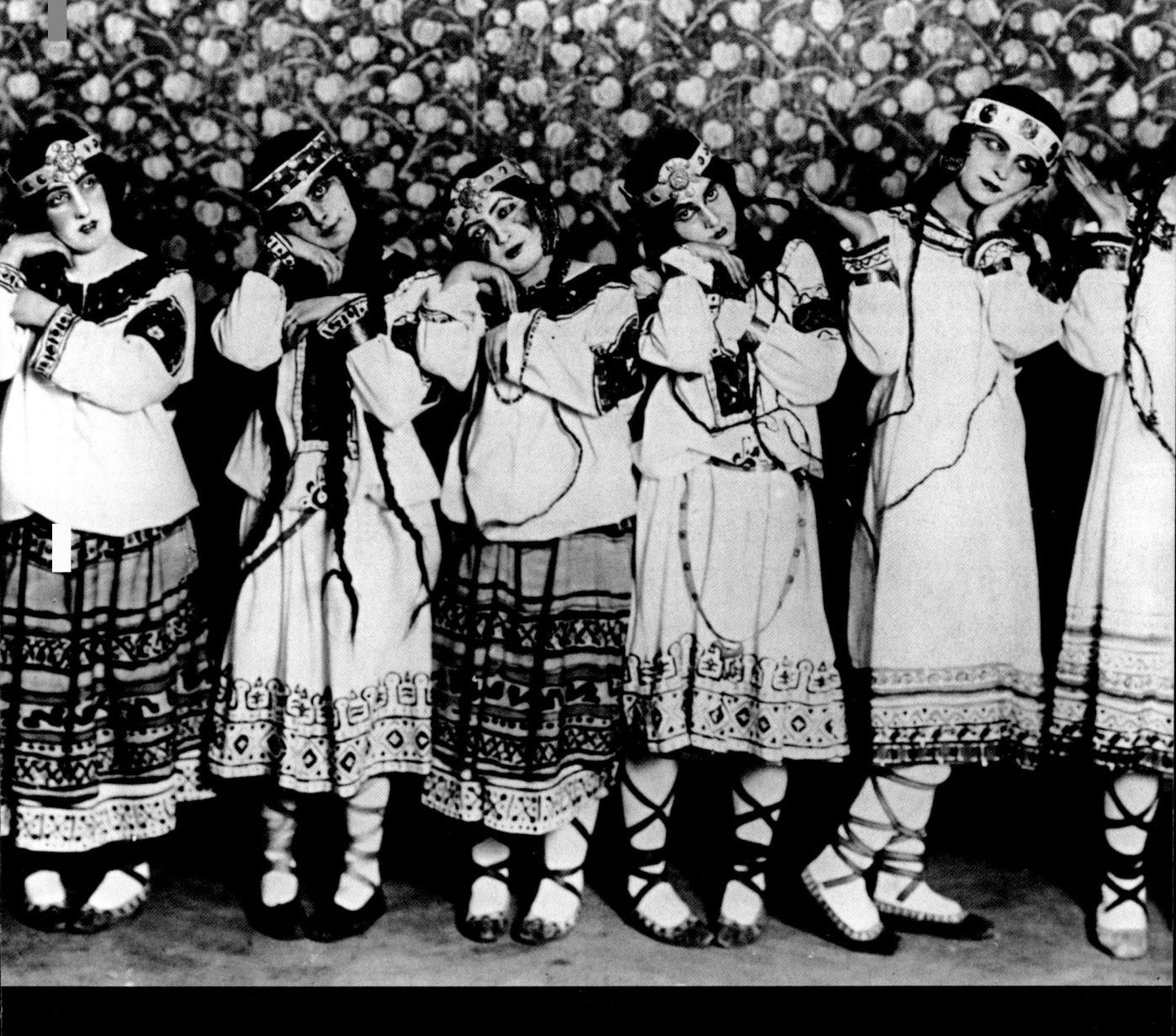

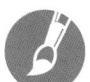

Key Artist **David Bomberg**
Visits Paris and adopts own brand of Cubism

Born the son of an immigrant Polish leather worker in the East End of London, Bomberg studied under Walter Sickert at Westminster Art School before John Singer Sargent secured him a place at the Slade School of Fine Art in 1911. Although influenced by Roger Fry's two Post-Impressionist Exhibitions and the exhibition of Italian Futurists in London in 1912, Bomberg visited Paris in 1913, where he met Modigliani and Picasso and adopted an independent Cubist style.

In the Hold (1914) shows East End dock workers fragmented by a grid, while *Mud Bath* (1914) shows half-human, half-mechanical figures in the steam baths at Whitechapel. When shown at the Chenil Gallery in July 1914, these artworks marked the height of Bomberg's career. Both are now in London's Tate Gallery.

Bomberg resisted Wyndham Lewis's attempted to co-opt him into the Vorticist movement, though he exhibited in the "Invited to Show" section of the Vorticist Exhibition in London in June 1915. During World War I, he enlisted in the Royal Engineers and worked as a war artist for the Canadian government.

Between the wars, Bomberg traveled widely and, during World War II, worked briefly as a war artist again. His work was largely neglected, although he became an influential teacher at Borough Polytechnic, London. Among his students were Leon Kossoff and Frank Auerbach.

Nigel Cawthorne

Date 1913

Born/Died 1890–1957

Nationality British

First exhibited 1914

Why It's Key David Bomberg was an influential teacher at Borough Polytechnic, London, where he taught Leon Kossoff and Frank Auerbach.

Key Artist **Emily Coonan** Canadian National
Gallery grant winner studies in Europe

Emily Coonan was a gifted figurative painter and colorist. She was born to Irish parents in Point St Charles, Québec and began her art studies at the state-funded Conseil des Arts et Manufactures in the late 1890s. From 1905 to 1912 she attended the Art Association of Montréal, becoming William Brymner's star pupil. She was also greatly influenced by the work of J.W. Morrice, and in 1912 went on a painting trip to France, Belgium, and Holland with a fellow student, Hilda Mabel May. Labeled in the Canadian press as the "prodigy from Point St. Charles," in 1913 she was awarded the first travel grant given by the National Gallery of Canada. She was unable to take this up until after the war, when she returned to Europe in 1920.

She exhibited in all four exhibitions of the Beaver Hall Group, which comprised eleven men and eight women, from January 1921 to 1922. A.Y. Jackson was the Group's president, and it emerged as Québec's counterpart to the Group of Seven in Ontario, with whom she also exhibited in 1923–24 in a traveling show of the United States. Coonan was also among those chosen to represent Canada in the British Empire Exhibition at Wembley, London.

Described as shy and rather odd, she seldom exhibited her work after 1930 and continued to live in the privacy of the family home where she was born.

Stephen Bartley

Date 1913

Born/Died 1885–1971

Nationality Canadian

First exhibited 1908

Why It's Key Winning a National Gallery of Canada travel grant was a landmark achievement, particularly for a female artist.

Key Artist **Duncan Grant**
Bloomsbury Group figure founds Omega Workshops

Duncan Grant came from a well-connected Scottish family and through one of his aunts, Lady Strachey, he entered the world of art, music, and letters, especially the Bloomsbury Group. As a young man, his radiant good looks, attractive personality, and lively intelligence immediately endeared him to Lytton Strachey, Maynard Keynes, Adrian Stephen, and also to Virginia Woolf and her sister, Vanessa Bell.

After a year in Paris, training at Jacques-Emil Blanche's studio, where he met Matisse and Picasso, he returned to London and set up as a painter, later joining Roger Fry's Omega Workshop. His early work is characterized by subdued colors, followed by a brief period of abstract painting, then his real métier in life – the production of a huge corpus of mural painting and design.

From 1916, he was joined by Vanessa Bell and together they formed an alliance and produced a stream of interior decoration, printed textiles, pottery, and furniture. Much of their work can be seen at the Courtauld Institute, Tate Britain, at Berwick church in Sussex, England, and at Charleston in Sussex, the house – which is open to the public – where they lived for nearly forty years.

Though he continued to paint, Vanessa Bell's death in 1961 marked the end of his best work. The revival of interest in the Bloomsbury Group gave him a renewed sense of pride and some amusement, and his friendship with the American painter Paul Roche some consolation. He died at Roche's home in Berkshire, far from his beloved Sussex.

Richard Walker

Date 1913

Born/Died 1885–1978

Nationality British

Why It's Key Duncan Grant was an important member of the Bloomsbury Group and influential in British art of the period.

1910–1919

143

Key Artwork *Unique Forms of Continuity in Space*
Umberto Boccioni

One of the leading Italian Futurists, Boccioni worked primarily as a painter. He worked on the ideas of movement, speed, dynamism, and modernity. After visiting the studios of Braque, Archipenko, Brancusi, and Raymond Duchamp-Villon, Boccioni decided to work in three dimensions in 1912 when he wrote that he was obsessed with sculpture.

Like other Futurists he discarded traditional techniques and by June 1913 he had created an important body of eleven plaster sculptures that were concerned primarily with movement and dynamism. *Unique Forms of Continuity in Space* is the final sculpture and solution in the series that includes *Synthesis of Human Dynamism* and *Spiral Expansion of Muscles in Movement*. Simple and successful, the figure is aerodynamically deformed by speed and is an anonymous superhuman figure striding purposefully through space. A symbol of vitality and strength, it is massive without weight and partly symbolic of the Futurist drive toward progress.

The legs are anchored to small, heavy blocks of unequal size and the figure is taking a giant stride. The taut limbs, minus his arms, convey a sense of motion and the bulging muscles half metal half flame are pulled back to reveal earlier phases of motion. A glorified image of a man/machine, it reflects ideas of the mechanized body that appeared in Futurist writings, and the Superman idea envisaged by Frederick Nietzsche. *Unique Forms of Continuity in Space*, one of Boccioni's few cast pieces, is a revolutionary work and at the forefront of the avant garde.

Kate Mulvey

Date 1913

Country Italy

Medium Bronze

Why It's Key A masterpiece, it heralded a revolution in sculpture and influenced future Modernism in sculpture.

Key Artwork *Soldiers on the March*
Jacques Villon

Born Gaston Duchamp (1875–1963), Villon was one of three Duchamp brothers ; he changed his name to distinguish himself from his artist siblings, Raymond and the more famous Marcel Duchamp. Villon, the oldest (1875–1963) began his career as a draftsman and etcher very much under the influence of Belle Epoque artists such as Helleu (1859–1927).

From 1894 until 1906, Villon worked as a caricaturist and illustrator for several magazines in Paris, during which time he produced many posters and humorous cartoons. He turned toward painting after 1906, initially influenced by Edgar Degas and Henri de Toulouse-Lautrec. By 1911 his work also shows the influence of Picasso and Braque's Cubism. Villon gathered like-minded artists in his home for regular discussions; they became known as the Puteaux Group (named after the eponymous Paris suburb) and he and others, including Francis Picabia, Robert Delaunay, and Fernand Léger, briefly exhibited under the name "Section d'Or."

1913 was pivotal for Villon's career. He created his Cubist masterpieces during that time and sold nine paintings in the New York Armory Show. *Soldiers on the March* is from this period, where forms are broken into shaded pyramidal planes. Primarily an etcher and illustrator, Villon brought a particular graphic sense of design to his Cubist works.

Calling himself a "cubist impressionist," Villon claimed his goal was "to express the perfume, the soul of things of which science only catalogues and explains the outward appearance."

Lucy Lubbock

Date 1913

Country France

Medium Oils

Why It's Key Long considered a Cubist, Jacques Villon is now recognized for his connection with Neo-Impressionism and abstract art.

144

Key Person **Eileen Gray**
Furniture designer heralds Art Deco

Irish-born Eileen Gray was one of the few women to study at London's Slade School of Fine Art in the 1890s. Inspired by a visit in 1900 to the Exposition Universelle, Gray moved to Paris to study before returning London in 1905 because her mother became ill. She became interested in lacquer techniques, something that would lead to a propitious meeting when she returned to Paris the following year: Seizo Sugawara, who was from a Japanese village famous for its lacquerwork, had gone there and he was to teach Gray for four years.

At the outbreak of World War I the couple moved to London and were supported by Gray's family. In 1917 they returned to Paris, where Gray was soon hired to decorate an apartment on rue de Lota. She won favourable reviews for this work and in 1923 she famously designed the Bedroom-Boudoir for Monte-Carlo at the Salon des Artistes Décorateurs; she then contributed to the design of the Salon d'Automne, winning praise from Le Corbusier. Now Gray was concentrating on architecture and furniture design, one critic wrote that "Eileen Gray occupies the centre of the modern movement."

Increasingly reclusive and forgotten, Gray designed and furnished herself a new home, Tempe à Pailla, and in 1937 assisted Le Corbusier in his pavilion at the Paris Exposition. Best remembered by many for her iconic Bibendum chair, Gray in fact had far wider influence. A bisexual free spirit, she remained endlessly creative, living to be ninety-eight and finding dry amusement in a late revival of her reputation.

Graham Vickers

Date 1913

Born/Died 1878–1976

Nationality Irish

Why It's Key A pioneer of the Modern Movement.

Key Artist **Kazimir Severinovich Malevich** Launches Suprematism

Malevich had been working in various avant-garde styles with Russian contemporaries such as Wassily Kandinsky and Mikhail Larionov when, in 1913, he developed a new language of creative thought while in Finland with composer Mikhail Matyushin and writer Alexei Kruchenykh. "Reason," he announced, "is a form of imprisonment," and Suprematism was born. Suprematism, derived from the Latin *supremus*, meaning ultimate or absolute, aimed to create a synthesis between geometric forms with a non-associative, yet spiritual, language. Developing the idea of alogism – the aim to free oneself from laws of causality and logic – the three Suprematists wanted to end narrative in art, eliminate the subject, and – in contrast to earlier "isms" – rejected outright everything that had gone before. That same year, Malevich applied this new approach, designing sets and costumes for his new associates' opera, *Victory over the Sun*. The onset of war was a time of upheaval, and new societies were emerging with technological development informing a reconsideration of art and return to almost basic concepts. Thus, it is no coincidence that Mondrian was at the forefront of Neoplasticism in the Netherlands at the same moment.

Malevich remained in the Soviet Union after the February Revolution in 1917, and Suprematism, for a time, became the artistic language of the new order. He explored the concept through writing and three-dimensional models and in 1927, on a trip with his painting exhibition, shared ideas with Walter Gropius and Kurt Schwitters, among others, in Germany.
Rebecca Harris

Date 1913

Born/Died 1878–1935

Nationality Polish

Why It's Key Suprematism was the first systematic school of purely abstract composition. Making quite an impact, Suprematism was further developed through the Bauhaus, changing the future of art, architecture, and industrial design.

1910–1919

145

Key Person **Guillaume Apollinaire** *Les Peintres Cubistes* establishes him as foremost publicist for the avant-garde

Born in Italy of Polish-Italian parents, Guillaume Apollinaire (born Wilhelm Apollinaris de Kostrowitsky) moved to Paris when he was eighteen and was soon a leading figure in the group which met in Picasso's studio in the Bateau-Lavoir artistic colony in Montmartre. His friends (and often collaborators) included Picasso, Marc Chagall, Jean Cocteau, Erik Satie, and Marcel Duchamp – a veritable Who's Who of the Paris avant-garde. As a critic he was a key voice in the promotion of cutting-edge art, and in 1911 joined the Puteaux Group, a branch of the Cubist movement.

With his treatise *Les Peintres Cubistes* (*The Cubist Painters*), published in 1913, Apollinaire helped define the new school of painting. In the same year, his poetry collection, *Alcools*, broke with traditional poetic style in subject matter, punctuation, and even typography. He also coined the word "Orphism" to describe the move toward abstract painting by Robert Delaunay and others.

In 1917, while recovering from a wound received in World War I, he wrote one of the earliest works described as "surrealist" – the play *Les Mamelles de Tirésias*. Apollinaire was the first to actually use the term – in the program notes for Jean Cocteau and Erik Satie's ballet *Parade*, first performed in May 1917.

A genuine mover and shaker on the progressive art scene, Apollinaire was part of the genesis of both Surrealism and Dada. He died in 1918, a victim of the Spanish flu pandemic; luminaries in his funeral cortège included Picasso, Derain, Léger, and Max Jacob.
Mike Evans

Date 1913

Born/Died 1880–1918

Nationality French (born Italian)

Why It's Key Hugely influential in the promotion of Cubism and early manifestations of Surrealism – a term which he coined. Also an innovative poet.

Key Artist **David Brown Milne**
Work exhibited in Armory Show, New York

The 1913 International Exhibition of Modern Art, at New York's 69th Regiment Armory on Lexington Avenue, is now legendary. A space rented with financial aid from Gertrude Vanderbilt Whitney and Mabel Dodge, primarily curated by Walt Kuhn and Arthur B. Davies, it housed approximately 1,250 paintings, sculptures, and decorative works by over 300 European and American artists. Of the two Canadians included, David Brown Milne would be the most illustrious.

A precocious student in his native Ontario, Milne embarked for New York in 1903 to become a commercial illustrator. There he attended the Art Students' League (1903–05) and visited galleries, where he was influenced by Monet. He also studied works by Cézanne, Brancusi, and Matisse at Stieglitz's 291 Gallery. Around 1909 he decided to become a painter, exhibiting brash avant-garde paintings with the leading art societies and enjoying regular, good reviews (including in the *New York Times*). In 1916, Milne moved to upstate New York, where his work changed dramatically in response to rural life. He finally returned to Canada in 1929 relatively unknown, and it wasn't until the mid-1930s that he matched his American status.

Although Milne spent half his career in the United States, he was a staunch Canadian nationalist. But recognition in Canada was slow – in contrast to the adulation he received in New York after the Armory Show. The influential American art critic, Clement Greenberg, claimed Milne was, along with John Marin and Marsden Hartley, among the three most important artists of his generation in North America.

Mike von Joel

Date 1913

Born/Died 1882–1953

Nationality Canadian

Why It's Key Milne is often cited as Canada's foremost painter and it is now a source of national pride that the country was represented in the historical landmark that the Armory Show proved to be.

Key Artist **Henri Laurens**
Sheet-iron sculptures anticipate Constructivism

Born in Paris in 1885, Henri Laurens worked originally as a stonemason, studying drawing at evening classes from 1899. His early sculpture was strongly influenced by Rodin, but in 1911 he began a lifelong friendship with Braque, who introduced him to Cubism and Picasso's circle. Laurens went on to exhibit at the Salon des Indépendants in 1913.

Disability kept Laurens out of World War I, enabling him to explore his Analytical Cubist ideas in precise, rectilinear, delicately geometric sculptures such as *Construction* (1915) and *Bouteille de Rhum* (*Rum Bottle*, 1916–1917). In these highly formalized works Laurens' attention to mechanically processed materials such as poster paint and sheet metal goes beyond Cubist spontaneity to anticipate Constructivism's relish for the streamlined products of the new industrial age.

After 1925, however, Laurens abandoned Cubist sculpture for massive, curvilinear bronzes, usually of female nudes drawn from Greco-Roman mythology. In 1938 he shared a Scandinavian touring exhibition with Braque and Picasso, later exhibiting at the Venice Biennale in 1948 and 1950. In 1953, his monumental bronze, *L'Amphion* (1952), for the Central University of Venezuela, won the Grand Prix for sculpture at the São Paolo Biennale. Laurens also worked extensively as an engraver, theater designer, and book illustrator. He died in Paris in 1954 and his tomb, in Montparnasse cemetery, bears one of his own large bronzes, *La Douleur* (*Grief*, 1954), a copy of his *L'Adieu* (*The Farewell*, 1941).

Catherine Nicolson

Date 1914

Born/Died 1885–1954

Nationality French

First exhibited 1913

Why It's Key Innovator in Cubist sculpture and catalyst for Constructivism.

Key Artist **Percy Wyndham Lewis**
Edits Vorticist magazine *BLAST*

Percy Wyndham Lewis (he later dropped the Percy) was born to a British mother and American father on his father's yacht off the Canadian province of Nova Scotia. Educated in England at Rugby School and at the Slade, he studied art in Paris. In 1910, Roger Fry's exhibition, Manet and the Post-Impressionists, fermented new, vigorous ideas about art in Britain. Cubism and the Italian Futurist movement had inspired discontent within the stifling Victorian class attitudes prevalent in British art circles, epitomized by the Bloomsbury Group.

In June 1914, a form of geometric abstraction appeared, supported by a group of artists and writers and complete with a manifesto and magazine, *BLAST*. The main protagonists were Wyndham Lewis, Dorothy Shakespeare, Edward Wadsworth, Richard Aldington, T.E. Hulme, T.S. Eliot, Henri Gaudier-Brzeska (killed at Verdun in 1915), and Jacob Epstein. The writer Ezra Pound coined the word Vorticism to explain the swirl of ideas and theories surrounding their basic principles. In August of that year, World War I broke out, so that the group only saw three months of peacetime. They held two main exhibitions – at the Puffin Gallery, New York – and Lewis published a second issue of *BLAST*, entitled The War Number, in 1915. After the final New York exhibition in 1917, the movement dissolved with a last blast in Lewis' pamphlet *The Caliph's Design: Architects! Where Is Your Vortex?* (1919). Lewis' status faded until he was reassessed in the 1980s by British dealer Anthony D'Offay and critic Richard Cork. Walter Sickert said Lewis was "the greatest portraitist who ever lived." T.S. Eliot called him "the most fascinating personality of our time."
Mike von Joel

Date 1914

Born/Died 1882–1957

Nationality Canadian

Why It's Key The Vorticist group, its manifesto, and its magazine were the first venture into abstract painting by British artists.

1910–1919

147

Key Artwork *Enigma of a Day*
Giorgio de Chirico

It is fitting that Giorgio de Chirico's (1888–1978) 1914 *Enigma of a Day* was once in the possession of Andre Breton, the leader of the Surrealist movement. *Enigma of a Day* neatly anticipates much of the work that Surrealism would subsequently perform in exploring the human subconscious and the mysteries of objects in unexpected but somehow meaningful juxtaposition.

Enigma of a Day was the last of de Chirico's "enigma" series, which began with his 1909 *Enigma of an Autumn Afternoon* and *Enigma of the Oracle*. The paintings were set in empty Italianate town squares inspired by de Chirico's time in Florence and Turin. After five years of de Chirico dwelling on this theme, *Enigma of a Day* is perhaps the finest of the series, the one in which line, form, and symmetry are most surely recognized. The certainty of de Chirico's vision pervades what is, after all, an impossible landscape that springs into existence precisely because of de Chirico's prophetic insistence on it.

Metaphysics is an eternally hazy subject, and de Chirico makes no attempt to domesticate it here. He portrays mystery in its purest form, refusing to untangle its underlying logic for us. Consequently, it is left up to the spectator to decide whether the enigma of this afternoon is that of nostalgia, apocalypse, or the suspension of time. De Chirico's great accomplishment is to present an empty urban template on to which we project and receive impressions from the great subconscious, whose dream-work is not visible to us but moves us anyway.
Demir Barlas

Date 1914

Country France

Medium Oil on canvas

Collection Museum of Modern Art, New York, United States

Why It's Key *Enigma of a Day*'s iconic dream-like imagery anticipated surrealism.

Key Event
Outbreak of World War I

In the build up to the outbreak of war in 1914, an interest in the mechanization of everyday life had shown itself in many modern art movements of Europe. In the opening decade of the twentieth century, Cubism (1908) and Futurism (1909) had appeared, increasingly influenced by a perceived acceleration in the speed of life and communications, as had Vorticism (1912–1915) in the UK. Within a few months of war breaking out, however, a re-evaluation of the merits of the machine age, informed by first-hand accounts of what machines were now capable of, was already underway.

C.R.W. Nevinson and David Bomberg were just two of the many artists of the period to shun the jingoistic celebration of mechanization voiced elsewhere by Futurists such as Marinetti. Both Nevinson and Bomberg developed a more organic repertoire, while other prominent artists, such as Henri Gaudier-Brzeska, lost their lives on the battlefields of France and Belgium. In his seminal history of the modern period, *The Shock of the New*, critic Robert Hughes wrote: "If you ask where is the Picasso of England, or the Ezra Pound of France, there is only one possible answer: still in the trenches." On mainland Europe, however, as the war was perceived as increasingly meaningless, artists, writers, and musicians began to develop ever more provocative modes of expression – the scandalous voice of Dada, or the proto-Surrealist production of Diaghilev's *Parade* (1917), on which Stravinsky, Satie, Picasso, and Cocteau were to collaborate. Even the austerity of expression to be found in *De Stijl* (1917) might be seen as a search for order in a world that increasingly appeared to lack any.

Ian McKay

Date August 1914

Country Europe

Why It's Key Caused artists to either re-evaluate the aesthetics of mechanization, or to develop ever more provocative modes of expression as a response to its conduct.

opposite Troops marching to the trenches – many artists fought in the war, while others developed new artistic styles as a result of being exposed to war.

1910–1919

149

Key Artist **Umberto Boccioni** Publishes
Fittura e Scultura Futuriste (Dinamismo Plastico)

Umberto Boccioni was born in 1916 in Reggio Calabria in Italy. He studied art through the Scuola Libera del Nudo at the Academia di Belle Arti in Rome in 1901. In 1902, he went to Paris to study Impressionist styles, and in 1905 he participated in the Mostra Dei Rifiuti. In 1907, he settled in Milan and was still exclusively a painter, influenced by Gaetano Previati. He began to frequent the Famiglia Artistica, a Milanese artists' society and associated with Carlo Carrà, Luigi Russolo, and, more significantly, the poet Filippo Tommaso Marinetti, who had published the first Futurist Manifesto in 1909. They became friends, and Boccioni participated in several Futurist manifestos.

In 1911 Boccioni went to Paris and frequented the Parisian avant-garde scene, meeting Picasso and Apollinaire through his friend Severini. Having initially been influenced by Cubism – one of his best-known paintings is *The City Rises* (1910) – Boccioni began concentrating on sculpture after he visited the studios of Braque, Archipenko, Brancusi, and Raymond Duchamp-Villon in 1912. The same year he exhibited at the first Futurist show in Paris, at the Galerie Bernheim-Jeune.

Boccioni published his seminal manifesto, *Pittura e Scultura Futuristica (Dinamismo Plastico)*, in 1914. It explained the artistic beliefs of Futurism and the original forms of Futuristicic sculpture. He became the leading and most representative exponent of the movement and contributed to the magazine *Lacerba*. Like fellow Futurists, he was pro-war and enrolled in the army in 1916. He died a year later, after falling off a horse on the outskirts of Verona.

Kate Mulvey

Date 1914

Born/Died 1882–1916

Nationality Italian

Why It's Key A leading proponent of Futurism, Boccioni influenced the path of Modernism in sculpture and published several important manifestos.

Key Artwork *Paris Street*
Maurice Utrillo

Utrillo's *Paris Street* appeared only ten years after the artist, the illegitimate son of model Suzanne Valadon, began to paint, having been led to the activity by his mother's belief that it could help him manage his recurring bouts of mental illness.

Utrillo's frequent institutionalizations and stormy life have come to cast too much color on our perception of his work, which is retroactively mined for indications of loneliness, alcoholism, and hysteria. But if we refuse to impose the artist's face on his work, a different impression emerges. *Paris Street*, for example, is one of a series of placid and ordinary – if energetically painted – scenes of Utrillo's native city. The Montmartre district was of special personal and aesthetic significance to Utrillo, and inevitably his work has been co-opted for Parisian postcards and other marketing material.

That *Paris Street* contains only distant human figures, and that Utrillo's work is generally devoid of the human form, is often adduced as evidence that he is in some way engaged with the loneliness of the modern. A strength of Utrillo's oeuvre is that it supports both this impression as well as the impression that his work celebrates Paris.

While painting was intended to calm Utrillo, it gave the Parisian artistic establishment evidence of a raw, and partially naïve, talent in its midst, and before long Utrillo enjoyed an international vogue.
Demir Barlas

Date 1914

Country France

Medium Oil on canvas

Collection Art Institute of Chicago, United States

Why It's key It is one of the ironies of Maurice Utrillo's (1883–1955) life that a painter who was mad, bad, and dangerous to know could paint conventional Parisian landscapes.

opposite *Paris Street*

Key Artist **Augustus John**
Paints portraits of George Bernard Shaw

Welsh-born John studied at the Slade School of Fine Art in London, where he gained a reputation as a draftsman and a bohemian. He spent long periods traveling in gypsy caravans with his growing family before World War I, and his early works, such as *Lyric Fantasy* (1911) and *Galway* (1916), both now displayed in London's Tate Britain gallery, embody an Arcadian vision of Romany life. He also lived in Paris with his wife and his mistress Dorothy McNeill who, under the gypsy name Dorelia, became his most important model.

During World War I John was briefly employed by the Canadians as a war artist in France. He also turned to portraiture to make a living. In May 1915, George Bernard Shaw sat for him for eight days. John painted "six magnificent portraits of me," Shaw wrote to Mrs. Patrick Campbell. "Unfortunately, as he kept painting

them on top of one another until our protests became overwhelming, only three portraits have survived."

John also painted the delegates to the Paris Peace Conference and many leading politicians, society ladies, and literary figures – significantly W.B. Yeats (1907), James Joyce (1930), and Dylan Thomas (1936). His international reputation swelled to the point that he appeared on the cover of *Time* magazine in 1928 and again in 1948. His sister, Gwen John, was also a noted artist who worked with James McNeill Whistler and Auguste Rodin.
Nigel Cawthorne

Date 1915

Born/Died 1878–1961

Nationality British

First exhibited 1902

Why It's Key Leading and celebrated British portraitist, who conformed to the popular stereotype of the artist as bohemian.

Maurice. Utrillo. V. 1914.

Key Artwork *Still Life with Newspaper (Fruit Dish, Glass and Lemon)* Juan Gris

Juan Gris (1887–1927) was a Spanish artist working in Paris and was most famous for his participation in Cubism. Gris is mainly associated with the public face of Cubism from around 1911–1914, exhibiting with the Section d'Or when Braque and Picasso were not showing their work publicly.

This painting is from a later date but draws upon key Cubist developments. It is an abstracted representation of a still life including a fruit dish, glass, lemon and newspaper and was influenced by the Cubist "collage" invented by Braque and Picasso in 1912. This involved assembling different forms in an oil painting or drawing. Collage created fragmentation, facetting and layering of different planes. Gris created these in oil paint by flattening the shadows of objects and placed them beside instead of behind the object.

He also layered shadows and objects whilst allowing the viewer to see parts of them that they would not be able to see in reality.

These visual devices ignore the rules of perspective and spatial divisions, defying our traditional sense of space. However, a clarity and precision of objects still remains, which is characteristic of Gris' work and is a result of his earlier days as an illustrator and caricaturist. The dominant colors of white, black and grey are a significant shift in Gris' work in general. In 1914 he was working in bright harmonious colors, and the more sombre palette may have been a result of the war.

Esmay Luck-Hille

Date 1916

Country France

Medium Oil on canvas

Collection Philip Collection, Washington, D.C.

Why It's Key Important painting which demonstrates the essential elements of Cubism.

Key Event
Artists emigrate to the United States

Between 1866 and 1915, some two million immigrants, mostly from northern Europe, came to the United States. Many were artists who helped to redefine the concept and future of American art. Scholars agree that modern art arrived in the United States with the advent of the Armory Show, held at the headquarters of the 69th Regiment in New York between February 15 and March 15, 1913. At the same time that modernism was becoming known to Americans, World War I was playing havoc with the ability of artists in war-torn countries to be productive.

Many displaced and disillusioned artists came to New York, where European-style salons had been established. The best known of these salons were those of Alfred Stieglitz, Mabel Dodge, and Walter and Louise Arensberg. Artists, writers, and other intellectuals flocked to the salons to discuss art and literature while socializing and garnering support for their work. The Arensberg Salon became the center of New York's Dada movement, promoting its strong political influence on art. Influential immigrant artists such as Marcel Duchamp, Francis Picabia, Albert Gleizes, Jean Crotti, Henri-Pierre Roché, Arthur Cravan, and Edgar Varèse became central to the redefining of American art. Other artists who played a role in this endeavour included Man Ray, Morton Schamberg, Joseph Stella, Charles Sheeler, Florine Stettheimer, Marius De Zayas, Marsden Hartley, Charles Demuth, Walter Pach, John Covert, and Arthur Dove. French-born Duchamp is generally considered the strongest influence on the changing American art scene between 1915 and 1918.

Elizabeth Purdy

Date 1915–1918

Country Europe/USA

Why It's Key Influenced the rise of Modernism in the USA and led to a key role for the USA in developing new art movements after World War I.

opposite This 1914 poster for the film *The Land of Liberty* touches on the prevailing World War I sentiment that drove artists to move to the USA in search of a more productive environment in which to work.

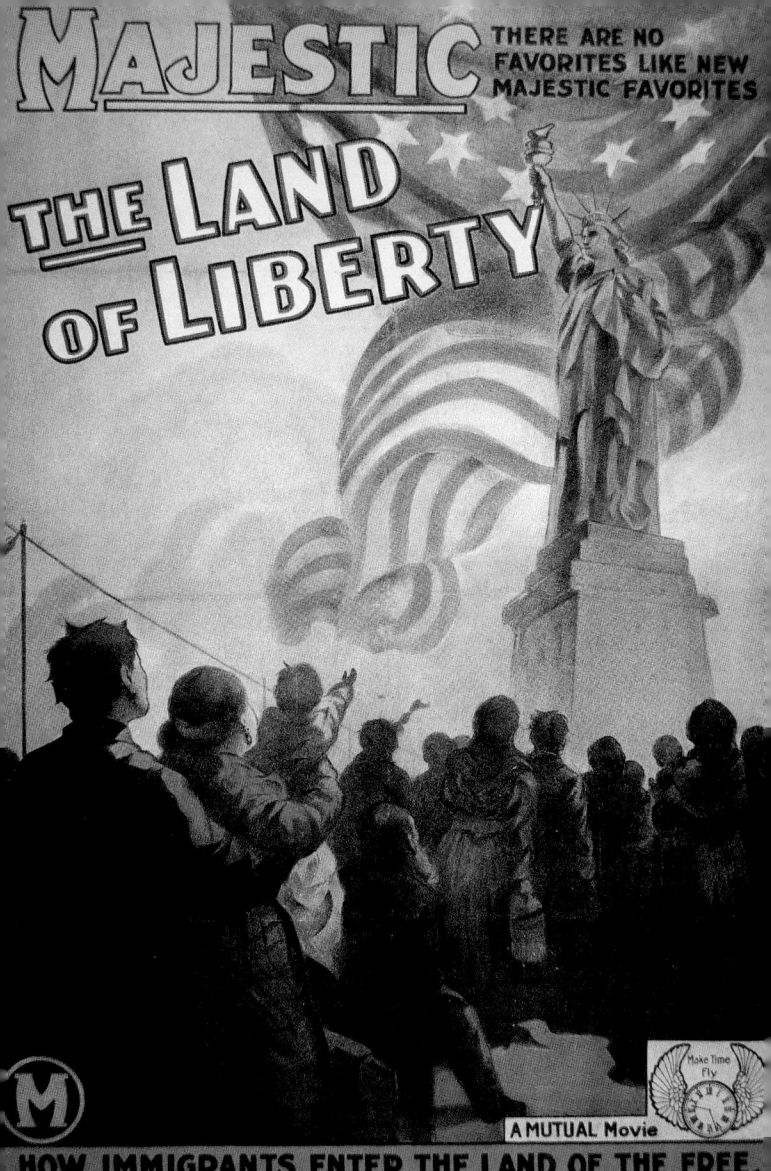

Key Artist **Ko Hui-dong** Returns from Japan after studying Western-style painting

Born in Seoul, Ko Hui-dong (pen name Chun-gok), was exposed to innovative ideas from an early age, growing up in an aristocratic family that supported the Enlightenment movement at the end of the Chosen period (1392–1910). In 1905, he studied traditional painting from Cho Sok-chin and An-Chung-sik, who ran the Sohwa Misulhoe (Calligraphy and Painting Arts Group). However, Hui-dong grew skeptical about the teaching methods of traditional painting, which relied on copying examples. In 1909, he became the first Korean student to travel to Japan to learn Western oil painting, entering the Department of Western Painting at Tokyo Art School, where he was greatly influenced by the Japanese painter Kuroda Seiki, one of the leaders of the *yo-ga* (Western-style) movement in Japanese painting. He returned to Korea in 1915, and established a new association for modern artists and calligraphers, the Sohwa Hyophoe.

Hui-dong held exhibitions and taught charcoal sketching and oil painting, fusing traditional painting styles with Western techniques. He marked the beginning of Modern Korean art, and was followed by other artists, such as Kim Kwan-ho, who also finished their studies abroad and became known as the "first generation of the oil painters."

Despite his significance, for a long time it was difficult to gain access to Hui-dong's works as most of them were owned by his family and friends. In 2005, to commemorate the fortieth anniversary of his death, the Seoul National University Museum presented a special exhibition of more than fifty surviving works.
Mariko Kato

Date 1915

Born/Died 1886–1965

Nationality Korean

Why It's Key First Korean artist to paint "Western" oil paintings.

Key Artist **Francis Picabia** Founding member of American Dadaist movement

Born in France to a Cuban diplomat and a wealthy Frenchwoman, Picabia studied at the Ecole des BeauxArts and Ecole des Arts Décoratifs. Painting in the Impressionist style, Picabia exhibited at the official Salon. In 1909, he moved into Cubism, then to its more colorful offshoot, Orphism, under the influence of Guillaume Apollinaire.

On a military mission to Cuba in 1915, he jumped ship in New York and exhibited at the Armory Show. His work was influenced by the sights and sounds of the city, following an earlier visit in 1913. With Man Ray and Marchel Duchamp, Picabia founded the American Dadaist movement and contributed to their magazine, *291*. Typical of his work at the time was the painting *Amorous Parade* (1917), which showed machine parts with obvious sexual connotations.

Back in Europe, Picabia began publishing the Dada periodical, *391*, in Barcelona. This became influential in Paris, where he returned in 1919. With leading Dadaist Tristan Tzara and Jean Arp in Zürich, he wrote Dada poems and produced other seemingly mechanistic works such as *Child Carburettor* (1919).

When Dada became swallowed up by Surrealism, Picabia turned his back on it, producing a series of *Transparencies* (1927–31) that used the outlines of images from earlier artists to ironic effect. He also produced controversially erotic female nudes, and from 1945 until his death, he recycled elements from his earlier works.
Brian Davis

Date 1915

Born/Died 1879–1953

Nationality French

First exhibited 1905

Why It's Key Pioneer of Dada in New York, Barcelona, Paris, and Zurich.

opposite Picabia's 1917 *Amorous Parade* (*Parade Amoureuse*) typifies the work of the American Dada movement.

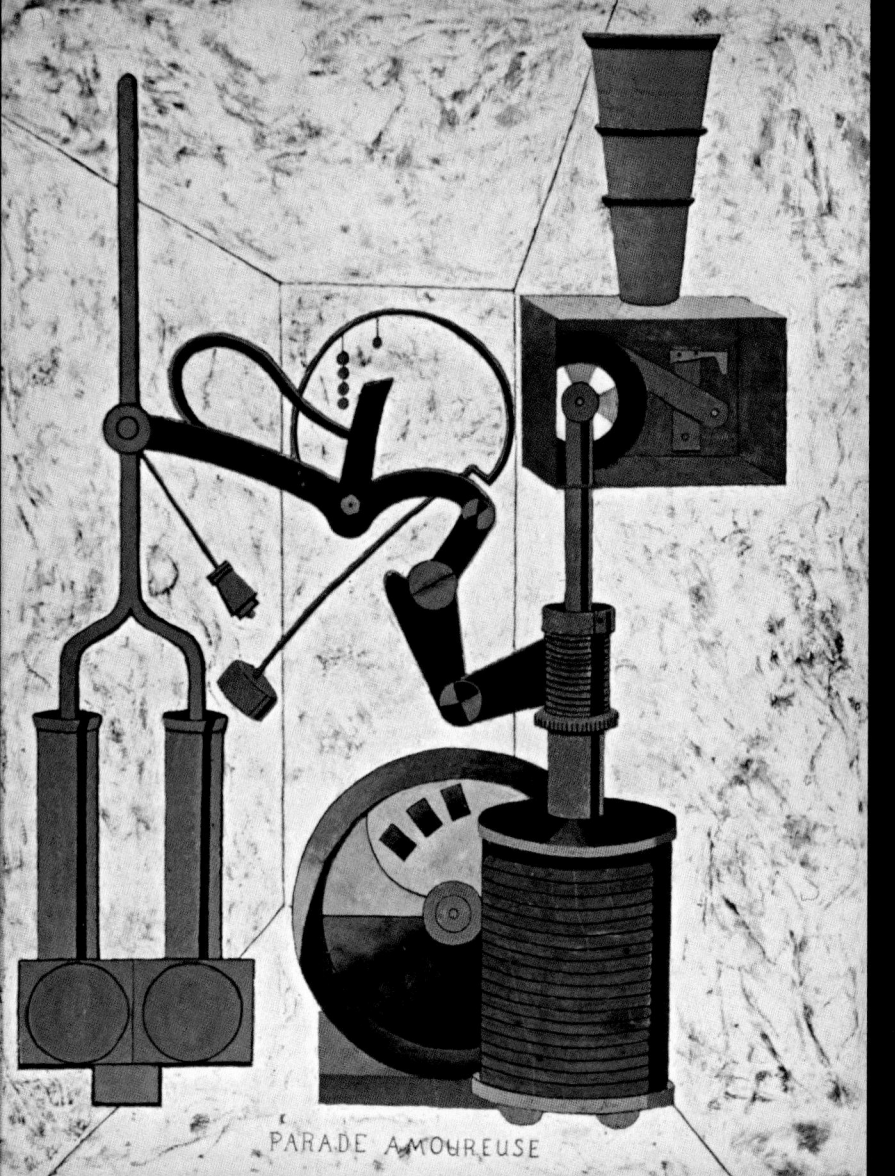

PARADE AMOUREUSE

Key Event
291 magazine founded

In 1905, the photographer Alfred Stieglitz opened a gallery at 291 Fifth Avenue in New York, where he exhibited the work of European artists as well as of the members of the Photo-Secession. This movement, reacting against pictorialism, aimed at conferring to photography a recognized artistic status. While the gallery was originally called The Little Galleries of the Photo-Secession, it soon became known as the 291 Gallery. In 1913, the French painter Picabia arrived in New York to attend the now legendary Armory Show, which was exhibiting one of his paintings. He almost immediately struck up a friendship with Stieglitz and his artistic circle. In 1915, their collaboration gave birth to the magazine *291*, edited by Picabia. Close in spirit to what Guillaume Apollinaire was doing in Paris at the same time with his Soirées de Paris, the magazine reflected the artistic dynamism in New York during the war years as European exiled artists such as Marcel Duchamp, Arthur Cravan, and Albert Gleizes developed an intense intellectual exchange with American artists such as the young Man Ray, Arthur Dove, and Charles Demuth.

Proleptical of the Dada philosophy, the magazine was an interdisciplinary work, mingling visual art, prose, poetry, and play on words. Picabia published his first mecanomorphic portraits in the magazine, using a technique which entailed the portraiture of humans through mechanical diagrams. Economic difficulties forced Stieglitz to close the 291 Gallery in 1917. The same year, Picabia returned to Europe and founded the *391* magazine in Barcelona.
Sophie Halart

Date 1915

Country USA

Why It's Key The Dada magazine, edited by Picabia, marked the beginning of a strong collaboration between European and American artists.

Key Artist **Erich Heckel**
Two Wounded Soldiers World War I woodcut

The son of a railway engineer, Heckel was born in Döbeln, Saxony, in 1883. He studied architecture before taking up art, being largely self-taught. In 1905 he helped found Die Brücke (The Bridge), a Dresden group aiming to bridge the gap between traditional Neo-Romantic German painting and modern Expressionism. The four founder members chose printmaking as the quickest and cheapest medium to spread their ideas, producing an annual Brücke-Mappe (Bridge Kit) of original graphics. In 1911 Die Brücke moved to Berlin, exhibiting in 1912 at the Cologne Sonderbund exhibition alongside artists from the French avant-garde. It disbanded in 1913.

During World War I Heckel served as a medical orderly in Flanders. This experience informed his woodcut *Zwei Verwundete* (*Two Wounded Soldiers*), which shows his bold, stark, almost brutal style and characteristic melancholy. After the Armistice Heckel entered politics, joining the radical Arbeitsrat für Kunst (Workers' Council for the Arts), which called for mass participation in art. In 1937 the Nazi Party declared Heckel a degenerate artist, forbade him to exhibit, and confiscated over seven hundred of his works.

After 1945 Heckel lived near Lake Constance, teaching at the Karlsruhe Academy from 1949 to 1956. He produced 465 woodcuts, 375 etchings, and 400 lithographs during his lifetime. Even though by 1944 all of his woodcut blocks and print plates had been destroyed by enemy bombing, he continued to produce etchings and paintings until his death at Radolfzell in 1970.
Catherine Nicolson

Date 1915

Born/Died 1883–1970

Nationality German

First exhibited 1912

Why It's Key Prominent Expressionist printmaker and founder member of Die Brücke.

Key Artist **Martiros Saryan**
Returns to Armenia after traveling in the Middle East

Martiros Saryan was born in 1880 into a large, traditional Armenian family in Nor Nakhijevan (now Rostov-on-Don) in Russia, and from 1897 to 1904 studied at the Moscow School of Arts. Strong influences included the Russian painters Serov and Korovin, and the work of Matisse and Gauguin. Saryan's early tempera and watercolor paintings lean toward dream-like Symbolism, and featured in the Crimson Rose (Alaya roza) and Blue Rose (Golubaya roza) exhibitions held in 1904 and 1907 by the Russian avant-garde.

From 1910 to 1913 Saryan travelled in Turkey, Egypt, and Iran, painting more robust, intensely colored Oriental scenes which gained him recognition with the wider public. In 1915 he went to Echmiadzin to aid fellow Armenians fleeing from genocide in the Ottoman Empire, and in 1916 helped organize the Society of Armenian Artists in Tiflis (now Tbilisi). From 1921 Saryan made Armenia his permanent home and concentrated on portraying its countryside and people. He also created its Soviet coat of arms, illustrated books, and designed for the stage. From 1926 to 1928 he visited Paris, but during the sea voyage home most of his work from this period was destroyed in an on-board fire.

By the time he died in 1972, Saryan had become a highly respected artist, deputy to the USSR Supreme Soviet and three times recipient of the Order of Lenin. His former home in Yerevan, now a museum, displays his bold, original, brilliantly colored work, characteristically optimistic and patriotic, pantheist in vision and humanitarian in tone.
Catherine Nicloson

Date 1915

Born/Died 1880–1972

Nationality Armenian (born Russian)

First exhibited 1904

Why It's Key Major Armenian painter of landscapes, still lifes, and portraits.

1910–1919

157

Key Person **Gertrude V. Whitney**
Founder of Friends of Young Artists

Born in New York, Gertrude Whitney was the great-granddaughter of Commodore Cornelius Vanderbilt, the famous American railroad and shipping tycoon. After her marriage to businessman Harold Payne Whitney in 1896, she began her formal study of sculpture, initially at the Art Students' League in New York and then with Auguste Rodin in Paris.

Many of her notable works were war memorials, which were most likely inspired by her experiences at a hospital that she founded during World War I in France. She developed her sketches of wounded soldiers into realistic monuments, such as the *Washington Heights War Memorial* (1921) in New York.

While her works received international acclaim, she is most famous for her patronage, support, and promotion of contemporary American artists, including Robert Henri, Charles Sheeler, Reginald Marsh, Edward Hopper, and Stuart Davis. In 1907, she established a studio in Greenwich Village in New York to exhibit the works of upcoming, prominent young artists. In 1915 she established the Friends of Young Artists before founding the Whitney Studio Club three years later, which not only boasted a large membership but also became the most active organization for promoting North American artists.

Her ultimate promotion of contemporary American artists occurred in 1930, the year that she founded the Whitney Museum of American Art in New York, which held over five hundred works from her own collection, an act that ensured that her legacy in American art would continue long after her death in 1942.
Heather Hund

Date 1915

Born/Died 1875–1942

Birth name Gertrude Vanderbilt

Nationality American

Why It's Key Tremendously influential in the patronage and promotion of contemporary American artists, whose work she purchased and ultimately used to found the Whitney Museum of Art. Also a notable sculptor.

Key Event
Futurism applauds the war

Futurism was a largely Italian and Russian artistic movement that included sculpture, painting, poetry, theater, architecture, and music. It was launched on February 20, 1909 when Paris newspaper *Le Figaro* published a manifesto by Italian poet Filippo Tommaso Marinetti, *Il Manifesto del Futurismo* (*The Futurist Manifesto*). The name, coined by Marinetti, was a bombastic rallying cry to celebrate change and innovation. The world was changing and the impact of the new technology was having significant effects on Western culture. Modern life and the machine age were the backdrop for Futurist thought, with its noise, speed, and dynamism.

Futurist artists such as Carlo Carrà, Gino Severini, Giacomo Balla, and Umberto Boccioni glorified the automobile, aircraft, and industry. They emphasized speed and energy, as embodied in the motion and force of modern machinery, and celebrated violence and aggression in calling for the destruction of traditional values and detachment from the past.

The Futurists' fetish with violence was seen in their glorification of modern warfare as the ultimate artistic expression. War was seen as positive and progressive, and many Italian Futurists supported the rise of Fascism, a new concept at that time, expecting that it would modernize the country. In 1914 and 1915, as World War I swept across Europe, Futurists put pressure on the Italian government to enter the war, which it did in 1916. After the war, in which key activists Umberto Boccioni and the architect Sant'Elia were killed, the Futurists lost much of their their verve and creativity.
Kate Mulvey

Date 1915

Country Italy

Why It's Key The glorification of war was a key component in the philosophy of the Futurist movement. It not only featured in their art, but also contributed to Italy entering World War I.

158

Key Event
Release of *The Birth of a Nation*

There have been numerous examples of art which, in their actual content, have served dubious causes. This would include the Futurists' reckless embracing of Fascism, and certainly hundreds of years of classical art that celebrated monarchs, popes, and other patrons responsible for some of history's heinous crimes. As the propaganda value of the painted picture was sidelined in the twentieth century – especially with the move toward abstraction – so the moving image emerged as the most potent vehicle of mass persuasion. Leni Riefenstahl's technically stunning but morally repugnant salute to Nazism, *Triumph of the Will* (1935), is the most notorious example, but running a close second is D.W. Griffith's epic movie, *The Birth of a Nation*, released in 1915. Set during and after the American Civil War, the film was a blatant polemic against the emancipation of slaves and any notion of racial equality. It was replete with grotesque ethnic stereotypes, and applauded the Ku Klux Klan as defenders of "American" values.

Nevertheless, amid heated controversy (while the film grossed an unprecedented US$10 million at the box office), liberal-minded film critics were forced to acknowledge it as a technical masterpiece. Devices such as multi-angle shots, parallel action, panning shots, fade-outs, total screen close-ups, and the use of night photography were pioneered in this remarkable work. Not all of these were completely original, but were used for the first time in a full-length "commercial" film. It even utilized color at the close. Despite its narrative content, Griffith's film was a key influence on the development of cinema as art.
Mike Evans

Date February, 1915

Country USA

Why It's Key This is a socially reactionary and morally dubious film, but it nevertheless broke new ground in many of its technical innovations.

Key Event
Formation of the Arensberg Salon

During World War I, many European artists gravitated to New York from a war-stricken and artistically immobilized Paris. After the controversial Armory Show of 1913, in which Marcel Duchamp's *Nude Descending the Staircase* and other European modernist works were received with outrage, it seemed that New York was destined to be the international center for avant-garde activity. Gathering places for interaction and debate centered around the salons of photographer Alfred Stieglitz at his 291 Gallery on Fifth Avenue, the Greenwich Village apartment of Mabel Dodge, who advocated freedom in behavior and the arts, and the apartment of Alfred and Louise Arensberg on West 67th Street.

Walter Arensberg, the son of an industrialist, was an avid collector of modern European art. Hospitable and supportive, the Arensbergs threw open their apartment to many of the livelier artists, poets, composers, and intellectuals in New York between 1915 and 1921. In the center of their circle was Duchamp and the almost nightly gatherings could include such artists as Francis Picabia and Albert Gleizes, plus Joseph Stella, Man Ray, Charles Demuth, and other Americans influenced by European modernism. Among the poets and writers were William Carlos Williams, Wallace Stevens, Walter Pach, and the English poet Mina Loy. This coming together of artists and enthusiasts fostered the American Dadaists and saw the formation of the Society of Independent Artists. In 1921,the Arensbergs moved to California and the Salon came to an end.

Sue King

Date 1915–1921

Country USA

Why It's Key Seminal meeting place for painters and poets.

159

Key Artwork *Village Church*
Lyonel Feininger

German-American artist Lyonel Feininger (1871–1956) began his career as an illustrator but by 1909 had taken up painting, finding inspiration from a number of sources, mainly Expressionism and Cubism. *Village Church* represents a number of important strands in Feininger's career. Depicting a village church in Weimar (he did thirteen oils on this subject, as well as many drawings), it is associated with the Germany he had to leave during the rise of Nazism. Stylistically it perfectly illustrates Feininger's distinctive use of angular lines and intersecting transparent planes. There is also agitation and movement, underlying his German Expressionist roots, as well as a desire to represent an object from differing viewpoints on the same canvas, which associates him with Cubism.

Feininger joined the Die Blaue Reiter group with Kandinsky in 1913 and was also a fellow teacher at the Bauhaus. He can be seen as highly original and experimental, borrowing from different sources but always bold and exuberant. He received his first retrospective in Berlin in 1931 and after World War II was largely exhibited (and collected) by American museums. He was also one of the very few fine artists also to draw comic strips as a cartoonist. He created two memorable, albeit short-lived, strips – The Kin-der-Kids and Wee Willie Winkie's World, exceptional for their wry, fey humor and graphic experimentation.

Lucy Lubbock

Date 1915

Country Germany

Medium Oils

Collection Mergbacker Collection, Switzerland

Why It's Key *Village Church* is an important example of Analytical Cubism.

Key Artist **Robert Gwelo Goodman**
Won Gold Medal at San Francisco International Exhibition

Robert Goodman was born in England to a railway employee and his wife. The family emigrated to South Africa in 1886, where Goodman worked as a railway clerk, taking night art classes in Cape Town under J.S. Morland. With financial backing from his father and Morland, Goodman attended the Académie Julian in Paris in 1895. His teachers included Bouguereau, Constant Bachet, and Gabriel Ferrie, and Matisse was a classmate. After financial support dwindled, Goodman moved to London and by 1898, the Royal Academy had accepted three landscapes. Three years later, Goodman returned to South Africa and had his first solo exhibition in Cape Town. He adopted the middle name Gwelo to honor a Rhodesian town.

Goodman's reputation as a landscape painter grew, and his first London exhibition was held in 1904. In 1915, at the San Francisco International Exhibition to honor the completion of the Panama Canal, Goodman won a Gold Medal for his pastel drawings. From his Cape Town studio, he continued to paint landscapes and added floral studies and architectural preservation to his repertoire. A 1919 Goodman exhibition in Johannesburg consisted of pictures of South African mines and floral studies, and a major exhibition in Johannesburg in 1924 featured 176 South African landscapes.

Goodman died in 1939 in South Africa. Exhibitions, such as the one at London's Tate Gallery in 1948, continued. Examples of Goodman's work, including the *New Gogh Gold Mine*, are on exhibit in the Johannesburg Gallery. Some works have been put up for auction.

Elizabeth R. Purdy

Date 1915

Born/Died 1871–1939

Nationality British (emigrated to South Africa)

First exhibited 1898

Why It's Key Goodman's works, which combined his British and South African heritages, exemplified the joining of the world's cultures in the early twentieth century.

Key Event
First transcontinental telephone call

Until the early twentieth century, it was impossible for one peron to synchronously communicate at any significant distance with another by means of the voice. That changed in 1915, when telephone inventor Alexander Graham Bell made the first transcontinental telephone call using a long-distance signal on the world's longest telephone line – consisting of 2,500 tons of copper wire and 130,000 telegraph poles.

Bell's call to San Francisco was the beginning of a revolution in communications. Even people without access to telephone services – then an expensive technology – understood and appreciated that the world had become smaller in 1915. Just one year previously, the first truly global conflict had begun, and by 1918 the number of global immigrants, travelers, and cultural adventurers would increase massively.

Global interconnection, which had long been a philosophical theory, had suddenly become real.

While the telephone carried a great deal of conceptual importance in the technologically interconnected world, it did not immediately displace more conventional methods of communication in the art world. Until well after World War II, the history of artists is largely the history of letters of introduction, meetings, pilgrimages, communes, and exhibitions. However, some forward-thinking artists assimilated the telephone into their lives and work almost immediately. In 1922 László Moholy-Nagy made his three *Telephone Paintings* by calling in directions for their creation to workers in a sign factory. It was a prescient anticipation of technology's ability to broadcast, replicate, and occult the artist.

Demir Barlas

Date 1915

Country USA

Why It's Key The world, and the art world in particular, got a lot smaller.

Key Event
Apollinaire is wounded in war

In 1911, Guillaume Apollinaire was detained by Paris police for a week on suspicion of stealing the *Mona Lisa*. It was an insult that left its mark and he subsequently took out French nationality and enlisted for the infantry in World War I. In a letter he described war as a "beautiful thing ... despite all the risks I run, the exhaustion, the total lack of water, of everything, I am not unhappy to be here." On March 17, 1916, in a wooded area outside Aisnes, Picardy, he was hit in the head by shrapnel, which penetrated his helmet. Surgeons had to drill into his skull, which left a star-shaped hole.

Guillaume Apollinaris de Kostrowitzky kept his origins secret, but he was raised by his gambling mother in Italy, in Monaco, on the French Riviera, and in Paris. At the age of twenty he settled in Paris, worked for a time in a bank, and contributed to such periodicals as *La Revue blanche*, *La Plume*, and *Le Mercure de France*. His friends were artists such as Pablo Picasso and André Derain, playwright Alfred Jarry, and the painter Marie Laurencin, who was his lover.

Besides writing poetry, Apollinaire was an innovator in the Theater of the Absurd, and made Cubism recognized as a school of painting in his study *Peintres Cubistes* (1913). Ten days after the appearance of the book, Apollinaire deserted Cubism for Orphism – a concept he also invented. He died in the great influenza epidemic of 1918 at his apartment on the Boulevard Saint-Germain. *Calligrammes*, an experimental, poetic record of his war experiences, was published a few months before his death.
Mike von Joel

Date March 17, 1916

Country France

Why It's Key One of the most extraordinary characters of the Belle Epoque receives a wound from which he never fully recovers.

1910–1919

161

Key Artist **Matthew Smith** British
"Francophile" flamboyantly absorbs Fauvism

Matthew Smith was 47 before he held his first one-man exhibition, at the Mayor Gallery, London, in 1926. After studying in Manchester and the Slade School of Art, Smith travelled to Pont-Aven in Brittany, where he began a life-long love affair with France. In 1911 he first exhibited in Paris, where he met Matisse, whose atelier he briefly attended. Matisse, together with the Irish artist Roderic O'Conner, whom he encountered in Paris after the war, were the two enduring influences on Smith's art. The war forced him to return to London, and in 1916 he was persuaded by Jacob Epstein to exhibit at the London Group. The same year he painted *Nude, Fitzroy Street No.1* and *Nude, Fitzroy Street No.2*, two of the earliest, and best, examples of his mature style.

Between the two world wars Smith lived largely in Paris and Provence. His Francophilia and his unalloyed delight in radiant color and lush brushwork often led to him being called an "English Fauve," a description he disliked. His voluptuous female nudes, abundant still lifes, and sun-drenched landscapes were all painted with characteristic gusto, their overwhelming sensuousness sometimes belying their solid structure.

Much admired by his fellow artists, including Francis Bacon, who wrote of him that he was "one of the very few English painters since Constable and Turner to be concerned with painting," Smith also received many official honours, culminating in a knighthood in 1954. A permanent display of his work is maintained at the Guildhall Art Gallery, London.
James Beechey

Date 1916

Born/Died 1879–1959

Nationality British

First exhibited 1911, Paris

Why It's Key *Nude, Fitzroy Street No.1* establishes the so-called "English Fauve" style.

Key Artist **Liubov Popova**
First abstract works

Born into an affluent Tsarist family near Moscow in 1889, Liubov Popova studied art with Zhukovsky in 1907, and from 1908 to 1909 attended the Moscow art school run by Yuon and Dudin. In 1909 she began to travel, first in Italy, where she studied early Renaissance masters, then in her homeland, where she was strongly affected by both traditional icons and the powerful Symbolist paintings of Mikhail Vrubel. In 1912 she worked at the Tower, a Moscow studio, then went to France and Italy to study Cubism and Futurism first hand.

By 1916 Popova had joined the abstract avant-garde and exhibited frequently in Moscow and Petrograd (St Petersburg). Her own bold, vivid genre, Painterly Architectonics, combined the dynamism of Cubism and Futurism with the flat perspective and linearity of traditional Russian icon painting.

After the October Revolution of 1917, Popova began teaching at Svomas (Free Art Studios), immersing herself in the Constructivist effort to harness art in the service of the new social order. In 1920 she moved to the theoretical research center Inkhuk (Institute of Artistic Culture), and from 1921 onwards, in line with Constructivism's total rejection of easel painting, confined herself to designing only utilitarian Productivist items such as textiles, clothes, books, ceramics, and theater sets. In 1923 she became head of the Design Studio at the First State Textile Print Factory, but died from scarlet fever a year later at the age of thirty-five.

Catherine Nicolson

Date 1916

Born/Died 1889–1924

Nationality Russian

First exhibited 1914

Why It's Key Prominent painter of the early modern Russian avant-garde.

opposite *Untitled* by Liubov Popova, 1910.

Key Artist **Antonio Sant'Elia**
Unfulfilled forward-looking Futurist architect dies

Antonio Sant'Elia died in 1916, his visionary architectural projects unfulfilled. Nevertheless, his imaginative drawings and town-planning ideas, particularly his Città Nuova (New City), were highly influential, constituting a new industrial Expressionism in the footsteps of Viennese architect Otto Wagner. Born in Como in 1888, Sant'Elia studied in Milan and at the University of Bologna, and set up as an architect in 1912. Alongside Futurist contemporaries Marinetti and Boccioni, Sant'Elia joined the army at the outbreak of war and died in battle defending Trieste.

After his death, Sant'Elia's reputation was nurtured by Marinetti, author of the Futurist Manifesto, who introduced his work to the Dutch de Stijl group in 1917. De Stijl reproduced several of Sant'Elia's renderings, as did *Der Sturm*, the Berlin Expressionist magazine. After

1918, the Sant'Elian concept of the multilevel city gained credibility, and ideas of technology and monumental architecture fusing into a cohesive urban machine proliferated in architectural circles.

Sant'Elia's *Messaggio*, a treatise on the problems of modern architecture, appeared in the exhibition of the group Nuove Tendenze in May 1914. The *Messaggio* articulates Sant'Elia's rejection of the architecture of the past, and anticipates the anti-Functionalist mood of Gropius and Le Corbusier in the 1920s. His name also appeared on the Manifesto of Futurist Architecture, although this has been questioned. Both texts embody the Futurist ethos of revolutionary cultural changes triggered by science.

Hermione Calvocorezzi

Date 1916

Born/Died 1888–1916

Nationality Italian

Why It's Key Although the possibility of a Futurist architecture perished with Sant'Elia, his architectural ideas were highly influential. His sketches exemplify the smooth, dynamic forms proclaimed in the Manifesto, and present utopian ideas for cities involving complex multilevel transport networks, huge skyscrapers, and aerial walkways.

Key Artist **Jean Arp**
First abstract sculpture

Born in the Franco-German border town of Strasbourg, the artist Jean Arp (also known as Hans Arp) trained in both countries, but became disillusioned with academic art and began experimenting with abstraction. He joined the Moderne Bund in Munich in 1910, meeting Kandinsky there in 1912.

Fleeing to Paris during World War I, he met Apollinaire, Modigliani, and Picasso. He was later expelled from France and moved to Zürich, where he became a founder of the Dada movement, making his first abstract sculptures in 1916 and 1917. In the 1920s he developed "biomorphic" abstraction, employing organic rather than geometric shapes, as exemplified by *Naval-Torso* (c. 1924–26).

Returning to France, he was involved with the Surrealists. As a member of the Cercle et Carré group and the Abstraction-Création movement, he worked in *papiers déchirées* (torn papers) and *froissés* (crumpled papers). From his studio at Meudon, outside Paris, he began using his biomorphic method in other media. His first sculpture of this type, *Fruit of the Hand* (1929), was made from sawn wood. In the 1930s, he began his *Concretions*, organic shapes fashioned in stone, plaster, or bronze. Many resemble sensuous torsos.

During World War II, Arp returned to Switzerland. After the war he was honored with prestigious public commissions and retrospectives.

Brian Davis

Date 1916

Born/Died 1887–1966

Nationality German

First exhibited 1910

Why It's Key Major figure in the avant-garde in the first half of the twentieth century, and pioneer of abstraction.

Key Artist **Thomas Eakins**
The death of one of America's foremost artists

In 1888 Walt Whitman said Eakins was the only artist he knew who could "resist the temptation to see what they think ought to be rather than what is." After four years in Paris (1866–70) studying in the atelier of Jean-Léon Gérôme Eakins, he returned to America and dedicated himself to portraying the everyday reality of American life through outdoor scenes and portraiture.

A fascination with deeper truths through the lens of specific details was characteristic of Eakins' work, and his aversion to flattery produced insightful portraits of people involved in sports, science, and the arts. The detail of the blood-spattered hand of Dr. Samuel Gross performing surgery on a living patient in *The Gross Clinic* (1875), the naked figures in *The Swimming Hole* (1883–50), and the artist's photographs of naked figures, which are reminiscent of his paintings, all attest to his passion for the specific as a gateway to the transcendent.

Eakins' scientific curiosity and direct gaze with regards to the nude led him to remove a loincloth from a male model in the presence of female students. This resulted in his resignation, in 1886, as director of the Pennsylvania Academy of Fine Arts, which under his guidance had become one of the most progressive art schools in America and one of the first to integrate photography into its curriculum.

Eakins saw photography as a modern medium, and his photographs of the human body as works of art in their own right. Only since his death has his reputation been secured.

Bryan Doubt

Date 1916

Born/Died 1844–1916

Nationality American

First exhibited 1871

Why It's Key The first American artist to integrate painting and photography in order to better understand the human figure, Eakins developed a realistic and expressive style of painting that influenced a generation of American artists.

Key Artwork *Flight*
Edward McKnight Kauffer

The American artist Edward McKnight Kauffer (1890–1954), who spent the greater part of his working life in Britain, was the foremost poster designer of the twentieth century. Virtually single-handedly, he revolutionised advertising design, aligning it with developments in modern art.

Flight, a stylized image of the geometric pattern formed by birds in flight, was originally drawn during the summer of 1916 when Kauffer was staying in the Berkshire countryside. Clearly indebted to Vorticism, the English movement that Kauffer had encountered on his arrival in the country the previous year, it also echoes the Futurists' obsession with speed as a metaphor of the machine age. The earliest surviving version of the design is a black-and-white woodcut made in 1917. The same year the image appeared in

the Poster Gallery section of the magazine *Color*. In 1919 it gained much wider currency when it was transformed into a poster to launch the *Daily Herald* newspaper under the slogan "Soaring to Success! Daily Herald: the Early Bird."

In the 1920s and 1930s Kauffer enjoyed a high public profile as a poster designer, particularly with a long series of posters promoting the London Underground. He was also a prolific illustrator, as well as a designer of book jackets, theater scenery and costumes, and photomurals. From 1923 he lived with the textile designer Marion Dorn, with whom he returned to the United States at the beginning of World War II.

James Beechey

Date c.1916

Country UK

Medium Woodcut

Collection British Museum, London

Why It's Key The most successful of Kauffer's designs, it has long been recognized as an iconic example of modern graphic art.

1910–1919

165

Key Person **Paul Guillaume**
Art dealer stages first solo show of André Derain

André Derain was related to the Picasso circle through Vlaminck, Apollinaire, Matisse, and the dealers Daniel-Henri Kahnweiler and Ambroise Vollard. He did the illustrations for Apollinaire's first book of poetry, *L'Enchanteur Pourissant* (1909), and also illustrated a collection of poems by Max Jacob in 1912.

In 1914 Derain was mobilized and remained in the army until 1919, fighting on the Somme and at Verdun. Despite his absence, Paul Guillaume gave him his first one-man show in 1916, with a catalog preface written by Apollinaire. The small, private exhibition comprised ten paintings, ten drawings, and ten prints and was very important for Derain, who felt his career had been frustrated by military service. This is indicative of the kind of attention Guillaume gave to the many artists with whom he had contact. Guillaume was a very modern

dealer. Unlike most of his contemporaries, he was from a humble background and identified with the daily lives and aesthetic aims of artists, as well as the business generated by their works. Modigliani painted a tribute portrait of Guillaume entitled *Novo Pilota* (or "new helmsman"), indicating Parisian artists' respect for the dealer who first held exhibitions in his own apartment.

Guillaume's premature death prevented him from transforming his collection into a museum of modern art. He had resolved to donate his collection to the Louvre. After much negotiation and some controversial maneuvers by his widow, the French state acquired the collection in two consignments in 1959 and 1963, and housed it in the refurbished Musée de l'Orangerie in Paris.

Mike von Joel

Date October 15–21, 1916

Born/Died 1891–1934

Nationality French

Other Key Works Published the influential magazine *Les Arts à Parts*, championing artists and collectors.

Why It's Key Paul Guillaume was an art dealer located on the Right Bank who enjoyed the confidence of all the avant-garde artists of his day.

Key Event
Dada movement launched

In 1916, Hugo Ball, Emmy Hennings, Tristan Tzara, Jean (Hans) Arp, Marcel Janco, Richard Huelsenbeck, Sophie Täuber, and others met to discuss art and put on performances in a Zürich backstreet cafe. Anti-war sentiments played a large part in uniting this disparate group of creative minds. Sited in the old town, the café, in Spiegelgasse 1, had been renamed the Cabaret Voltaire and opened on February 5, 1916. The first public Dada soirée occurred on July 14. Ball recited the inaugural Dada manifesto, and others followed. In 1918 Tzara wrote a Dada manifesto that is considered one of the most important in the canon of Dada writings.

The group was primarily involved in visual arts, literature (poetry, art manifestoes, art theory), theater, and graphic design; they also orchestrated public gatherings and demonstrations. The publication of journals incorporated an impassioned coverage of art, politics, literature, and cultural issues. With the Romanian poet Tzara at the helm, they published the Dada review in July 1917, with five further editions from Zürich and the final two in Paris.

However, when World War I ended in 1918, most of the Zürich Dadaists returned to their home countries, and a number began Dada activities in other cities: Richard Huelsenbeck gave his first Dada speech in Berlin in 1918; Picabia founded a Dada periodical in Barcelona and introduced the movement to Paris in 1919; Kurt Schwitters moved to Hanover, where he developed Merz, and in the autumn of 1919 Dada emerged in Cologne.
Mike von Joel

Date October, 1916

Country Switzerland

Why It's Key Dada was launched as an anti-Art movement and went on to pollinate Europe and America, becoming a precursor to Surrealism and Neo-Conceptual art.

opposite A 1918 edition of the *Revue Dada*. Reviews such as this one were crucial in covering cultural issues central to the Dada movement.

Key Artist **Hans Richter**
Joins Dada Group in Zürich

Richter was born in Berlin into a well-to-do family that was secretly Jewish. At the age of sixteen, he saw a Manet exhibition that provoked an ambition to become a painter; this was reinforced in 1912 when he visited a Cézanne exhibition and saw *Les Grandes Baigneuses*. Richter was an Expressionist from the beginning: his earliest known painting is *The Flute Player*, which he completed in 1905, when he was only seventeen. In 1913 Richter joined the group Der Sturm and later became acquainted with Die Brücke in Dresden. He joined the Dada Group in Zurich in 1916.

Dadaism had been invented in Zürich by a German refugee, the poet Hugo Ball, and his companion, Emmy Hennings; they were soon to be joined by other artists escaping the war. The group got together in 1916 in a tavern on the Spiegelgasse, the street where Lenin was living at that time. Rechristened the Cabaret Voltaire, it became a literary and artistic café where poetry readings, art exhibitions, and performances were held.

When Dada dissolved in 1919, Richter, then based in the Swiss countryside, completed his first scroll drawing, a series of geometric forms that became the basis of his pioneering experimental films. Concluding that filmmaking was governed by its own rules, different from those that apply to painting, he decided to discard form altogether and articulate time in various rhythms and tempos instead. Richter's first film work, *Film is Rhythm* (1921), had a running time of 90 seconds. It was erroneously claimed (by him) to be the first abstract film.
Mike von Joel

Date 1916

Born/Died 1888–1976

Nationality German

Why It's Key Politically active in the development of Expressionism, De Stijl, Constructivism and Surrealism, Richter became a prominent member of the Dada Group.

DADA 3

Directeur:

TRISTAN TZARA

Bois de M. Janco.

Je ne veux même pas savoir s'il y a eu des hommes avant moi. (Descartes)

Administration

Mouvement DADA

Zurich

Zeltweg 83

Fr. **1.50**

Key Artwork *Portrait of Tristan Tzara*
Jean Arp

In 1915 the poet, painter, and sculptor Jean Arp started collaborating with Sophie Täuber on collages and tapestries using geometric patterns. Choosing the universal language of abstraction was for him a way to reject figurative images of an absurdly war-torn world.

As one of the founders of Dada, Arp (1887–1966) introduced chance in his series *Collages According to the Laws of Chance* (1916–17): alone or with collaborators, he placed pre-cut square or rectangular pieces of paper at random onto a sheet, producing abstract non-compositions which questioned the traditional status of the artist as creator. Similarly eager to undermine the formal structures of language, Tristan Tzara suggested that to compose a Dada poem, one needed only to cut up words from a newspaper article, put them in a bag, pick them out at random one by one,

and read them in order. "The poem will resemble you," he promised. Meanwhile, Arp gradually moved toward more organic relief abstractions, often in polychrome wood. Contrary to Picabia's almost sarcastic mechanical works, these suggest the slow metamorphoses of nature. Though they do not directly represent natural forms, their soft curves evoke biomorphic elements. Arp maintained that this type of art was not abstract but, on the contrary, concrete. He used this organic idiom to illustrate Tzara's *Twenty-Five Poems*, a seminal Dada collection that mingles exhortations to the reader, visionary moments, incongruous images, obsessional repetitions, and onomatopoeic experiments. The picture's full title, *Entombment of The Birds and Butterflies (Portrait of Tristan Tzara)*, quotes from Tzara's text.

Catherine Marcangeli

Date 1916–17

Country Switzerland

Medium Painted wood relief

Collection Kunsthaus, Zurich

Why It's Key Abstract relief portrait of one of the founders of Dada is seminal Dadaist work.

Key Artist **Vilhelm Hammershøi**
Death of a painter applauded retrospectively

The revival of interest in Hammershøi's work in the 1980s particularly favored his interiors with figures reminiscent of Vermeer. They commonly represented a woman with her back to the spectator in a rigid formal arrangement, emphasizing the room's structure. The austere symphonic range of grays and the play of light in these compositions evokes mood and a spiritual dimension, embodying patience, quiet, and endurance.

Interiors were popular with Danish collectors, but Hammershøi's subjects extended to portraits, nudes, and architectural paintings. But landscapes were his first love and these paintings were distinguished by the monumentality of forms and the intimacy of their handling. Depicting the rolling scenery of Zealand, Hammershøi applied the formal simplification to color, structure, and space seen in his treatment of other

genres. A master of black in all its tones, he achieved a psychological intensity in his images that was ahead of his time but which has parallels in Nordic literature, which may have been an influence.

Hammershøi received private tuition in drawing before entering Copenhagen's Royal Academy of Fine Arts in 1879. He also studied at the more liberal Artists' Study School under Peder Krøyer, who may have encouraged him to look at Whistler, whose work became a strong influence. Between 1887 and 1904 he made protracted visits to Paris (his first opportunity to see Whistler's paintings), Italy, and London, where he painted scenes around the British Museum. Another important source was Golden Age Danish art from the early nineteenth century.

Martin Holman

Year 1916

Born/Died 1864–1916

Nationality Danish

Why It's Key A master of architectural and landscape painting, he expressed mood in domestic interiors to a level unequalled in his time.

Key Artist **Piet Mondrian**
Publishes *The New Plastic in Painting*

Born in 1872, Piet Mondrian studied at the Amsterdam Academy and began his career by painting landscapes influenced by seventeenth-century Dutch art and Impressionism. When he moved to Paris in 1911, he drew heavily on Cubist works, incorporating them in his painting *The Sea* (1912), which is dominated by geometric shapes and interlocking planes, although still representational.

In 1914 Mondrian moved back to the Netherlands and stayed at the Laren artists' colony, meeting Bart van der Leck and Theo van Doesburg, with whom he founded the journal *De Stijl* (*The Style*), publishing *The New Plastic in Painting* in twelve instalments between 1917 and 1918. Their aim was to produce art that restricted form to the rectangle, limited color to black, white, gray, and the primaries (red, yellow, and blue), and was composed of perpendicular planes asymmetrically arranged their its own "plastic" reality and devoid of any personal emotions.

After the war, Mondrian returned to Paris. Here he began producing grid-like paintings. His *Lozenge* paintings are some of his most minimalist works, with thick black lines separating the forms and tilted 45 degrees so that they hang in a diamond shape – as in *Composition With Blue* and *Composition in White and Blue* (1926). His monumental works *Broadway Boogie-Woogie* and the unfinished *Victory Boogie-Woogie* are highly influential in abstract painting, with shimmering squares of bright color that show the neon lights of New York and the kinetic feel of Jazz. Mondrian died of pneumonia in 1944, having dedicated his life to art.
Kate Mulvey

Date 1917

Born/Died 1872–1844

Nationality Dutch

Why It's Key Founded the *De Stijl* journal with Van Doesburg, and published the major treatise *The New Plastic in Painting*.

169

Key Artist **Auguste Rodin**
Death of the epic sculptor

Having failed the entrance exam to the Ecole des Beaux-Arts three times, Rodin became a decorative stone mason. Working under sculptor Albert Ernest Carrier-Belleuse, his first submission to the Salon, *The Man with the Broken Nose* (1864), was rejected.

In 1875 he traveled to Italy and studied the work of Michelangelo. On his return he made *The Age of Bronze* (1876), a male nude that was initially condemned as being cast from life, then bought by the state in 1878.

In 1884, he was commissioned to make the doors for the Musée des Arts Décoratifs. Eventually called *The Gates of Hell*, these remained unfinished at his death in 1917, but many of his celebrated free-standing works – including *The Thinker*, *The Kiss*, and *Carnal Love* – derive from them. Many versions of his sculptures exist. *The Burghers of Calais*, for example, was installed in Calais in 1895, while a bronze casting was erected in the gardens of Parliament in London in 1913.

His statues of Victor Hugo and Honoré de Balzac provoked scandal for their nudity and sexual power. Both were rejected, while monuments to the landscape painter Claude Lorrain and President Sarmiento of Argentina caused riots.

However, in the Paris World's Fair of 1900, 150 of his sculptures and numerous drawing were exhibited, securing his international reputation. In exchange for his entire output, the French state bought the hotel that was his Paris home. This became the Musée Rodin, Paris. Many of his original plasters are in the Musée Rodin, Meudon, formerly his country home, where he died.
Nigel Cawthorne

Date 1917

Born/Died 1840–1917

Nationality French

First exhibited 1876

Why It's Key The only modern sculptor considered on a par with Michelangelo.

Key Event
Première of the ballet *Parade*

In the spring of 1917, Pablo Picasso took a trip to Italy in the company of Jean Cocteau, Sergei Diaghilev, and Léonide Massine, three of his collaborators on the ballet *Parade*, which was then at the planning stage. Erik Satie, the composer, stayed in Paris, but Igor Stravinsky joined the group in Rome and swiftly became close friends with Picasso. In Rome they went to the puppet theater, and in Naples to the commedia dell'arte, experiences that not only helped shape *Parade* but also later directly inspired the ballet *Pulcinella*, which Stravinsky, Massine, and Picasso created in 1920.

Composed in 1916–17 for Serge Diaghilev's Ballets Russes, *Parade* premièred at the Théâtre du Châtelet in Paris with costumes and sets designed by the then Cubist painter, Picasso, choreography by Léonide Massine (Diaghilev's lover and a dancer), music by Erik Satie and conducted by Ernest Ansermet. Cocteau had met Diaghilev in 1909 and the Russian encouraged him to venture into the genre of ballet. Cocteau started writing, the theme being a publicity parade in which three groups of circus artists try to attract an audience to an indoor performance.

The poet Guillaume Apollinaire described Parade as "a kind of surrealism" (une sorte de surréalisme) in his 1917 program text, using the word three years before Surrealism emerged as a recognised art movement. The opening at du Châtelet was a disaster. "If it had not been for Apollinaire in uniform… women would have gouged our eyes out with hairpins," wrote Cocteau.
Mike von Joel

Date May 18, 1917

Country France

Why It's Key This artistic collaboration by Picasso, Cocteau, Diaghilev and Erik Satie is regarded as the first Cubist ballet.

Key Artwork ***Reclining Nude***
Amedeo Modigliani

When Modigliani (1884–1920) moved to Paris, then the focal point of the avant-garde, in 1906, he immersed himself into the decadence of Parisian life, and like other painters, wanted to paint what was real. His classical/naturalistic nudes, whilst easily understood, were controversial in their day.

Modigliani's frank depiction of pubic hair scandalized bourgeois society, and the lush painterly quality of his nudes gave them an earthly naturalism. They are pure flesh pushed up close to the front of the picture plane, often cut off at the knees; their exposed bodies are unapologetically sexy.

Modigliani painted over thirty nudes for his dealer, Zborowski, in a period between 1917 and 1919. *Reclining Nude* (1917) is the most sensual of his nudes. The face, as is typical of Modigliani, is reduced to essentials, which prevents the paintings from becoming pornographic. The model is lying on a bed, her head raised on a white cushion and her arm raised in the tradition of the nude by artists such as Botticelli, Giorgione, and Goya. The eyes are the focal point, demanding your attention with their frank, come hither gaze. Like the face, the body is generalized, yet well defined. As is typical of Modigliani, the cut-off point is the legs. The tantalising gaze and the show of pubic hair make the painting an erotic one, with an easy-on-the-eye, pin-up physicality. When Modigliani showed his nudes at his first one-man exhibition at the Berth Weill Gallery, 1917, the police were scandalized and shut it down.
Kate Mulvey

Date 1917

Country France

Medium Oil on canvas

Collection Staatsgalerie, Stuttgart, Germany

Why It's Key Modigliani's nudes are unique in their naturalistic, raw depiction of sexuality, which was at the time highly Modernistic.

opposite *Reclining Nude*

Key Event
The First Technicolor film

Though *The Gulf Between* (1917) was officially the first full-length Technicolor feature film, it was not until 1922 that the Technicolor Motion Picture Corporation could actually boast a Technicolor feature made for general release. *The Gulf Between* had been filmed using Technicolor's two-color Process Number One and, after a private showing in New York, it was sent for limited release in several Eastern cities in the US. Due to the complex Number One process, which required a special two-aperture, two-lens, two-filter projector to exhibit two strips of film simultaneously, *The Gulf Between* was destined to become the only film made using Process Number One. Owing to the technical problems of showing it, the process was abandoned and *The Gulf Between* became lost – only a few frames are known to be still in existence.

In 1922, Technicolor Process Number Two was introduced. This second innovation from the Technicolor Motion Picture Corporation involved a specially equipped camera that was designed to allow two exposures of the same scene to be made simultaneously through a single lens, rather than use a special projector (as with Process Number One). After numerous experiments with the process, *The Toll of the Sea* was shot in Hollywood. Originally intended as a "two-reeler" (approximately 20–24 minutes long), a total of five reels were deemed good enough to be used and Technicolor's first general-release feature film was made. Though it was only a moderate commercial success, it drew the positive attention of film critics and several major players in Hollywood, firmly establishing Technicolor's reputation.
Ian McKay

Date 1917

Country USA

Why It's Key Established motion pictures with the same color palette as other visual arts.

Key Artist **George Lambert**
Became Australia's war artist

Born in St Petersburg, Russia, George Lambert was the posthumous son of an American railway engineer and his English wife. He moved with his mother to Australia in 1887. Studying under Julian Ashton at Académie Julian in Sydney, he first exhibited with the Art Society and Society of Artists in Sydney in 1894. Early paintings depicted the life of Australian pioneers. His *Across the Black Soil Plains* was bought by the National Art Gallery of New South Wales for 100 guineas in 1899.

In 1900–01, he studied at the Académie Colarossi, under Auguste Delécluse, in Paris, where he was influenced by Edouard Manet, Diego Velázquez and Sandro Botticelli. After a year, he moved to London, where he exhibited at the Royal Academy from 1904 until 1911, and then became a notable portrait painter.

In 1917, he became Australia's official war artist and went to Palestine. In 1919, he traveled to Gallipoli and the Middle East to record the places where the Australians had fought. He produced over five hundred paintings and drawings for the Australian War Memorial, one of which, *ANZAC*, depicting the Gallipoli landing of 1916, has been continuously on display since the Memorial first opened in its Exhibition Building in Melbourne in 1922.

Returning to Australia in 1921, he continued producing portraits of family and friends and later turned to sculpture. However, he suffered from mitral valve disease and the physical labor of working in clay hastened his death.
Nigel Cawthorne

Date 1917

Born/Died 1873–1930

Nationality Australian

First exhibited 1894

Why It's Key George Lambert was a leading artist of the Australian War Memorial.

opposite George Lambert's *Anzac – The Landing*, 1916 (oil on canvas) has been on display since 1922.

Key Artwork *The Metaphysical Muse*
Carlo Carrà

From early in Carrà's life, art and politics had been joined and his political agenda influenced his style. Born in Quargnento, Italy, he left home aged twelve and traveled throughout Europe. In 1910, he signed Marinetti's Futurist Manifesto and collaborated with the group for six years, frequently publishing his work in their review, *Lacerba*.

Conscription at the outbreak of World War I cut short Carrà's pictorial researches. Recovering from injury in a military hospital in Ferrara, he met fellow artist Giorgio de Chirico. This had a decisive impact on Carrà's art and he abandoned the Futurist values of speed and movement and increasingly became interested in the expression of more human feelings.

Together, Carrà and De Chirico created the Metaphysical Art Movement in 1917. *The Metaphysical Muse* (*La Musa Metafisica*) dates from this year. Squeezed into a small room, different objects, detached from their daily use, share space to convey a dreamlike nostalgia. In the foreground, the faceless statue of a maiden stands as an anonymous guest. While the room's door and window open the space onto dark voids, the only reference to an exterior is conveyed by a map of Greece on the floor, suggesting that the only possible opening onto the outside world is through an oneiric pagan golden age.

In 1922, just as Mussolini was rising to power in Italy, Carrà moved away from Metaphysical painting and toward a more abstract phase in his work. Seduced by the Fascist rhetoric, he temporarily adhered to the movement.

Sophie Halart

Date 1917

Born/Died 1881–1966

Country Italy

Why It's Key Active in Futurism and Metaphysical painting, Carrà is the perfect example of the politically motivated artist, changing style as his political convictions evolved.

Key Artist **Georges Rouault**
Signs contract with Ambroise Vollard

Born in Paris in 1871, Rouault left school in 1885 and was apprenticed to a stained-glass maker and restorer. During this time he attended evening classes in art and in 1891 he entered the Ecole des Beaux-Arts, where he studied under Gustave Moreau. Influenced by Moreau, he initially imitated his method of painting but then went on to develop his own style, reminiscent of stained glass, with bold, bright colors and heavy black outlines. In 1898 Rouault was appointed as the curator of the Moreau museum in Paris. From 1895 he exhibited in many major shows, and in 1905 featured with other Fauvists at the Salon d'Automne. In 1907 he started on a series of paintings of kings, Christ, clowns, and prostitutes. From 1917, the year he signed a contract with the influential art dealer Ambroise Vollard, he searched for inspiration in religious subjects.

1930 saw Rouault exhibiting overseas, mainly in London, New York, and Chicago. In 1935 he painted *Heads of Two Clowns* and in 1937 *The Old King*, which is said to be his finest Expressionist work. In 1948 he was involved in designing some of the windows for the church in Plateau d'Assy, Haute Savoie; also involved in the designs for this church were Chagall, Bonnard, Matisse, Léger, and Braque. As well as being a painter, Rouault was a prolific printmaker. By the time he died, in Paris in 1958, he had destroyed three hundred of his own pictures.

Alan Byrne

Date 1917

Born/Died 1871–1958

Nationality French

First exhibited 1895

Why It's Key Early Fauve and Expressionist artist and one of the greatest modern religious painters.

Key Artist **Le Corbusier**
Co-founds Purism and *L'Esprit Nouveau* magazine

By 1917, Charles Edouard Jeanneret-Gris' ideas on how architecture should meet the demands of the machine age led him to develop, in collaboration with the artist Amédée Ozenfant, a new theory – Purism. In 1918 they published their ideas via the movement's magazine, *L'Esprit Nouveau*. In 1920 he changed his name to Le Corbusier (from Lecorbésier on his mother's side), and there followed art school in Switzerland, a spell with the family watch-enameling business, and the decision to set up shop in Paris as an architect. Impressed with advances in technology and mass production, Le Corbusier began to promote in magazines and books the modern ideas that he believed the new era of the twentieth century deserved.

His novel, factory-made International Style was defined by five principles: supporting columns, a plain exterior, an unrestricted interior space, wide windows, and a roof garden. He proclaimed a house to be "a machine for living," and produced tubular steel furniture to match. The high point of his metropolitan planning came with his designs for the Punjab capital city of Chandigarh in 1950, a development that still influences architects worldwide.

For all his stark stucco, Le Corbusier had the capacity to envision softer shapes. The lyrical Notre-Dame du Haut du Ronchamp in eastern France, built between 1950 and 1954, was devised in great detail, and is seen as one of the best examples of a happy marriage between functionalism and art. Le Corbusier continued to innovate until he died in 1965, and modernism has never really recovered.
Bill Bingham

Date 1917

Born/Died 1887–1965

Nationality Swiss-French

Birth name Charles Edouard Jeanneret-Gris

Why It's Key Le Corbusier was a highly influential Modernist urban planner, architect, and designer.

1910–1919

175

Key Artwork *Metropolis*
George Grosz

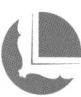

In retrospect, perhaps the most interesting thing about George Grosz's *Metropolis*, a painting that excoriates several elements of German life, is the way in which it serves as an analog for Grosz's hatred of both Germany and civilization. With his 1916 painting *Suicide*, Grosz created an artwork whose morals and methods were more conventional and less interesting: a skull-faced suicide at the feet of a femme fatale. Despite Grosz's own anarchist and communist commitments, *Suicide* shared with the German right – and, most spectacularly, Hitler – a repudiation of urban decadence.

Metropolis is best viewed against *Suicide*, as a demonstration of Grosz's descent into global misanthropy, failing as he does to embrace anything about the actual Germany of his day. The painting, forbidding scarlet with superimposing caricatures of figures in a hellish and vertiginous urban landscape, simultaneously damns liberated women, bankers (and possibly Jews), the urban bourgeoisie, urban architecture, and even Charlie Chaplin (who appears dreamlike in the background). *Metropolis* is better than *Suicide* precisely for the breadth of its hatred. Grosz at once rejects the entire fabric of urban Germany, and even of transnational concepts like the popular movie (of which Chaplin was the progenitor), placing himself beyond specific political affiliation and entering the realm of true misanthropy. *Metropolis* expresses this misanthropy in a riveting way, as Grosz is disciplined enough to range the objects of his hatred before us with a patient brush. Finally, the intensity of Grosz's feeling is more shocking than the objects of his dislike.
Demir Barlas

Date 1917

Country Germany

Medium Oil on board

Collection Museum of Modern Art, New York, United States

Why It's Key *Metropolis* is an apocalyptic portrayal of urban Berlin and is a good example of the New Objectivity movement developed in the aftermath of World War I, of which Grosz was one of the chief painters.

DE STIJL

MAANDBLAD VOOR DE MO-
DERNE BEELDENDE VAKKEN
REDACTIE THEO VAN DOES-
BURG MET MEDEWERKING
VAN VOORNAME BINNEN- EN
BUITENLANDSCHE KUNSTE-
NAARS. UITGAVE X. HARMS
TIEPEN TE DELFT IN 1917.

Key Event
De Stijl group founded

De Stijl (The Style) was the name of a journal founded in 1917 in Leiden, the Netherlands by two key pioneers of abstract art: Piet Mondrian (1872–1944) and Theo van Doesburg (1883–1931). The name De Stijl also came to refer to the circle of artists that gathered around the publication.

Because the Netherlands remained neutral in World War I, Dutch artists were not able to leave the country after 1914, and were isolated from the international art world, and in particular from Paris. Piet Mondrian, who had moved to Paris in 1912 (and there changed his name from "Mondriaan") had been visiting the Netherlands when war broke out and could not return.

The painter, poet, critic, and prime mover Theo van Doesburg had the pivotal role within De Stijl, and the group did not survive after his death in 1931. A forceful, flamboyant personality, his role as a writer provided a wide range of vital art-world contacts. When he began an association with the Bauhaus in 1921, the essence of De Stijl changed, as it did when he encountered Malevich and Russian Constructivism, causing Mondrian to leave the group in 1924.

Neo-Plasticism (Nieuwe Beelding) was another name for the type of abstract art the De Stijl circle practiced. Directly influenced by Cubism, it is based on a strict geometry of horizontals and verticals and a limited palette of only primary colors, and black and white. Other members of the group included Bart van der Leck, Vantongerloo, and Vordemberge-Gildewart, and the architects Gerrit Rietveld and J.J.P. Oud.
Mike von Joel

Date October, 1917

Country The Netherlands

Why It's Key De Stijl had a profound influence on the development of abstract art, particularly modern architecture and design.

opposite This "De Styl" poster from 1917 is by artists Theo van Doesburg and Vilmos Huszar.

1910–1919

177

Key Artwork *Amorous Parade*
Francis Picabia

In the nineteenth century, machines, as they appeared in paintings, were either sublimated into an ideal natural world, or portrayed as oppressors of the human spirit. In the early twentieth century, the painted machine escaped this dichotomy and attained subjecthood. In the pioneering work of Francis Picabia (1879–1953) and his Dada peer Marcel Duchamp (1887–1968), for example, the machine regularly crowded out humans and dominated the canvas. But in Picabia's *Amorous Parade*, the machine also flirted with sentience and humor. The imaginary machine painted in *Amorous Parade* was no longer the object of the painter's vision but the subject of its own consciousness, appearing to sustain and even parody itself, as evinced by its funny red cone and convoluted robot arm.

Picabia's machine was too elaborate for easy description, but its title gives us a clue as to its function. For Picabia and other avant-garde artists of the early twentieth century, the machine had become sexual, while the sexual had become machine-like (as in Alfred Jarry's *Supermale*, a surreal tale of a hero who has to copulate over eighty times in one day). For the avant-garde, the machine was no longer an intrusion into a pastoral world, but the world itself; and since the world has always been sexual, sexuality had to be reconfigured into the vocabulary of the machine.

The machine of *Amorous Parade* may not be specifically erotic, but its anthropomorphic qualities, its undeniable cuteness, and circular motion, slyly gesture toward the delirium, humor, and earnestness of sex.
Demir Barlas

Date 1917

Country France

Medium Oil on board

Collection Private

Why It's Key This innovative painting transforms the machine so that it has a central and sexualized place in the world.

Key Artist **Giorgio de Chirico**
Develops Metaphysical painting

Born in Greece to Italian parents, de Chirico became enamored of Greek mythology as a child. He trained in Athens, Florence, and Munich, where he was influenced by the bizarre narratives of Max Klinger's prints, and the paintings of Arnold Böcklin, who juxtaposed the commonplace and the fantastic. Back in Italy, de Chirico painted *Enigma of an Autumn Afternoon* (1910), revealing a parallel reality inspired by his reading of Nietzsche.

Moving to Paris in 1911, de Chirico met Picasso and Apollinaire, who admired his work. *Enigma of an Autumn Afternoon* was exhibited at the Salon d'Automne in 1912. He sold his first painting there the following year.

In 1915, de Chirico was conscripted into the Italian army. But he was diagnosed with a nervous condition and deemed too ill to fight, so he spent the war in a military hospital in Ferrara, though he continued to correspond with those in the art world, including the founder of Dada, Tristan Tzara. In 1917, he met Carlo Carrà and together they developed Metaphysical painting, though his earlier work can already be seen in that light.

After the war, de Chirico's work influenced the Surrealists, who read a Freudian interpretation into it. He rejected this, turning toward the classical Italian tradition and, by the 1930s, disclaiming his early work. However, from the 1960s, de Chirico returned to similar mysterious imagery in a style identified as Neo-Metaphysical.
Brian Davis

Date 1917

Born/Died 1888–1978

Nationality Italian

First exhibited 1912

Why It's Key Metaphysical painter who was a precursor to and influence on Surrealism.

Key Artist **Fernand Léger**
The Card Party ushers in his "mechanical period"

Born in Normandy of peasant stock, Léger moved to Paris, supporting himself as an architectural draftsman and a photographic retoucher while studying art at the Académie Julian. Initially an Impressionist, Léger fell under the influence of Cézanne and became friends with Robert Delaunay and Henri Rousseau. He experimented with Fauvism before moving into Cubism, producing his first major work, *Nudes in a Forest* (1909–10) in that style. After his one-man exhibition in 1912, he prospered, but experiences as an infantryman and stretcher-bearer during World War I turned him against abstraction. "Once I had got my teeth into that sort of reality, I never let go of objects again," he said.

After being gassed at Verdun, Léger was discharged in 1917 and, that year, completed *The Card Party*, which he described as "the first picture in which I deliberately took my subject from our own epoch." In the "mechanical period" that followed, he showed a fascination with machinery – even his figures look like robots – and joined Amédée Ozenfant and Le Corbusier in the Purist movement.

During World War II, Léger taught art in Yale University and Mills College, California, and painted acrobats, cyclists, and musicians. Returning to France in 1945, he joined the French Communist Party. Although Léger eschewed Socialist Realism, he favored proletarian subjects, which he hoped would be accessible to the working class. He picked up a number of large decorative commissions and won the Grand Prix at the 1955 São Paulo Biennale. Léger's home in Biot, near Antibes, is now a museum devoted to his work.
Brian Davis

Date 1917

Born/Died 1881–1955

Nationality French

First exhibited 1912

Why It's Key Léger brought the subject matter of painting closer to the common experience.

opposite *The Card Party*

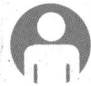

Key Artist **Viking Eggeling**
Avant-garde painter/filmmaker joins Dada

Born in Sweden into a German family, Eggeling emigrated to Germany at the age of seventeen to study art history and painting. From 1911 to 1915 he lived in Paris, then moved to Zurich, where in 1917 he joined the Dadaists and met Hans Richter.

Eggeling and Richter returned to Germany after World War I to collaborate first on scroll drawings then in film, aiming to create through form and movement a visual music or universal language of abstraction, as explained in their pamphlet *Universelle Sprache* (*Universal Language*, 1920). Eggeling's first film in this vein was the now lost *Horizontal-Vertikales Orchester* (*Horizontal-Vertical Orchestra*, 1920).

Eggeling's second film, *Symphonie Diagonale* (1924), originally 18 minutes long, now survives only in a 7-minute section reconstituted by Richter, with whom Eggeling had ceased to work. The film consists of abstract shapes drawn in black on a white background, photographed frame by frame then manipulated by moving a sheet of tin over them, adjusting their exposure or reversing them in a mirror. The result, projected in negative, is a measured, hypnotic sequence of enigmatic white-on-black patterns resembling musical notation or fragmented text, which expresses Eggeling's quest for a conscious lexicon of form, line, and movement, as well as the Dadaist rejection of story and subject. *Symphonie Diagonale* is one of the very first abstract animations or "absolute" films, and confirmed the medium as one governed by its own aesthetic laws. Sixteen days after its first public showing in 1925, Eggeling died in Berlin.
Catherine Nicolson

Date 1917

Born/Died 1880–1925

Nationality Swedish

First exhibited 1925 (film)

Why It's Key Eggeling pioneered experimental abstract film.

Key Person **Tristan Tzara**
Writes important Dada Manifesto

The firebrand that was Tristan Tzara was born in Bacau, Romania and met fellow Dadaists in neutral Zürich in 1916. With Hugo Ball, Emmy Hennings, Jean (Hans) Arp, Marcel Janco, Richard Huelsenbeck, and Sophie Täuber, he staged performances at the Cabaret Voltaire. At the inaugural public Dada soirée on July 14, 1916, the "first" Dada manifesto by Tzara was recited: *La Première Aventure céleste de Monsieur Antipyrine* (*The First Heavenly Adventure of Mr. Antipyrine*).

Two years later, there followed what is regarded as the most important Dada Manifesto: *Vingt-cinq poèmes* (*Twenty-Five Poems*). Later, in 1924, Tzara published *Sept manifestes Dada* (*Seven Dada Manifestos*). Dada was essentially an anti-war movement in Europe and at the Armistice, most of the Zürich Dadaists returned to their home countries. Tzara went to Paris and by 1922

was part of the artistic community of Montparnasse (with André Breton, Gala, Paul Eluard, Max Ernst, et al).

In Paris, Tzara and Breton joined Philippe Soupault and Louis Aragon to continue with a nihilistic attack on the city's established cultural values. Around 1930, he developed an interest in Surrealism, which he pursued with his customary zeal. He joined the Communist Party in 1936 and the French Resistance movement during World War II.

Tzara ended his life a lyrical poet, grappling with the angst of the human condition with works such as *Parler Seul* (*Speaking Alone*, 1950) and *La Face Intérieure* (*The Inner Face*, 1953). He died in Paris on Christmas Day 1963, and was interred in the Cimetière du Montparnasse.
Mike von Joel

Date 1918

Born/Died 1896–1963

Nationality Romanian

Birth name Samuel Rosenstock, aka Rosenstein

Why It's Key Tristan Tzara was the driving force behind Dada and a prolific writer of poems and texts explaining the Dada ethic.

opposite Surrealist poets André Breton, Paul Eluard, Tristan Tzara, and Benjamin Peret all signed this 1932 photograph.

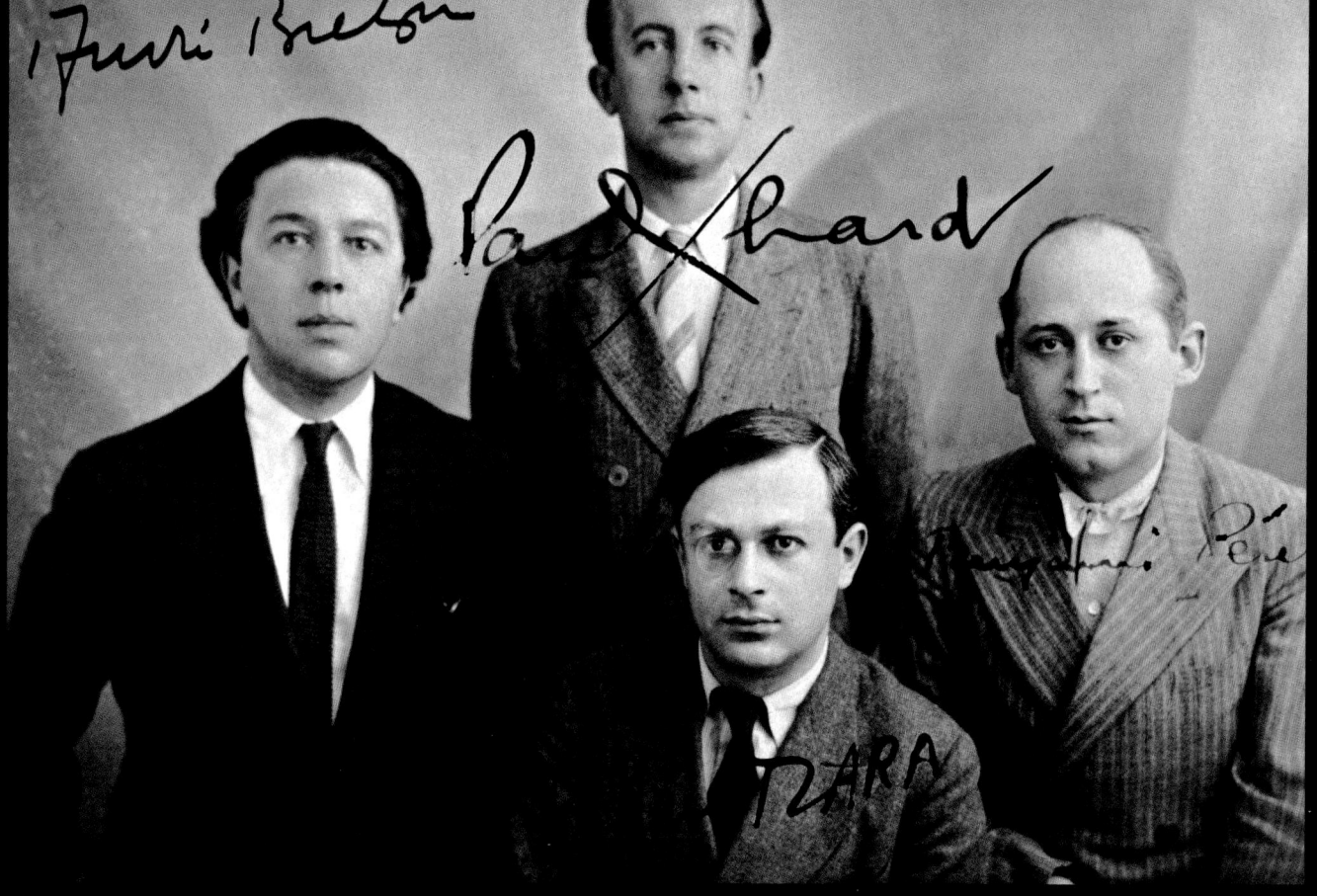

Key Artist **Giorgio Morandi**
Joins the Metaphysical school of painters

Giorgio Morandi was born in Bologna, where he lived and worked as an educator throughout his life. From 1907 to 1913, he attended the Accademia di Belle Arti; having established himself as an accomplished etcher, he was later to become professor of printmaking at the Accademia from 1930 to 1956.

In 1918 Morandi joined the Italian artists, including the Pittura Metafysica painters Giorgio de Chirico and Carlo Carrà, who were associated with the magazine *Valori Plastici* (published from 1918 to 1921, in Italian and French). The magazine advocated a return to a classical style of painting, a "return to order" as Jean Cocteau, who wrote for the magazine, was to call it.

During World War I he exhibited with the Futurists, although he never shared their aesthetic interests. By 1919 his work no longer showed the short-lived influence of the Metaphysical artists – de Chirico and Carrà – and by 1921, when he contributed to the *Valori Plastici* exhibition, which toured Germany, he had already abandoned the classicism associated with the movement. His work from the 1920s onwards demonstrated increasingly formal concerns with an understanding of Cubist structure and spatial ambiguity, Cézanne's analysis of color and tonal relations, and Chardin's profound but modest still lifes.

The majority of Morandi's work was produced after 1940, when he had established his method of painting a narrow range of simple vessels that he would rearrange in varying compositions. From 1958 he retired to his studio in Grizzana, where he continued his formal explorations until his death.

Sarah Mulvey

Date 1918

Born/Died 1890–1964

Nationality Italian

Why It's Key Member of the Pittura Metafysica group of painters, who advocated a return to a classical style of painting, his was the exemplary life of the contemplative artist who communicated his feelings in response to the visual world through a rigorous analysis of the formal relationships of light, tone, texture, and space.

Key Artist **Man Ray**
First major works by avant-garde photographer

Born Emmanuel Radnitzky in Pennsylvania in 1890, Man Ray showed early signs of artistic precocity. In New York, he learned the essentials of photography from the renowned photograper Alfred Stieglitz, and began to experiment on his own.

In 1915, he had his first solo show of drawings and paintings. His first proto-Dada object, an assemblage called *Self Portrait*, was exhibited the following year, and in 1918 he produced his first significant photographs. He joined the anti-art Dada movement in New York, yet later declared that "Dada can not live in New York, all New York is Dada" and moved to Montparnasse, Paris in 1921.

In 1925, Man Ray was represented in the first Surrealist exhibition at the Galerie Pierre in Paris, alongside Joan Miró, Pablo Picasso, Max Ernst, and other great artists. For the next twenty years he revolutionized photography. Together with his lover and fellow photographer, Lee Miller, he perfected the photographic technique of solarization. He also created a technique using photgrams he called rayographs.

A leading modernist, he was also a filmmaker, poet, and essayist. He famously documented the cultural elite living in France, with names including Gertude Stein and James Joyce sitting for his camera. He directed a number of influential avant-garde short films, known as Cinema Pur, such as *L'etoile de Mer* (1928). In 1934, Ray produced his iconic series of photographs depicting the Surrealist painter Meret Oppenheim, nude and standing next to a printing press. He went back to the United States during World War II, but returned to Paris in 1951, where he died in 1976.

Kate Mulvey

Date 1918

Born/Died 1890–1976

Nationality American

First exhibited 1915

Why It's Key Ray's first important pictures help launch Dada in New York.

opposite *Untitled (Rayograph)* by Man Ray taken in 1922.

Key Artist **Alexander Rodchenko**
Beginning of Black on Black series

Born in 1891 in St Petersburg, Alexander Rodchenko attended the Kazan School of Art. Whilst his early work was influenced by Futurist and abstract artists, by 1915, influenced by Suprematist Kazimir Malevich, Rodchenko directed his work toward the portrayal of everyday things. This was the first of his "designer programs," and he gravitated toward the avant-garde originating from Futurism.

His *Black on Black* non-objective work is indicative of just this move toward a total refiguration of painterly space. By 1921, Rodchenko abandoned painting and sculpture, turning to domestic design, typography, and photography, thus perfecting the productivist aspects of Constructivism – the creation of mass-produced utilitarian objects for everyday use. During the 1920s, Rodchenko concentrated on books, posters, and film titles. His graphic design and posters for such films as *Battleship Potemkin* (1925) and *Kinglaz* (1924) are considered the apex of film-poster art. From 1923 to 1928, Rodchenko collaborated closely on the layout of *LEF* and *Novyi LEF*, the publications for Constructivist artists. Many of his photographs appeared as covers of these journals. His unusual images, with their emphasis on dynamic, diagonal composition and the elimination of unnecessary detail, have influenced much of twentieth-century graphic design.

Rodchenko joined the October circle of artists in 1928, but was expelled after three years, being charged with "formalism." Attacked by Stalinists, his exhibitions were cancelled and he was dismissed from major projects. He lived in poverty until his death in 1956.
Kate Mulvey

Date 1918

Born/Died 1891–1956

Nationality Russian

Why It's Key Exponent of the New Order of postwar Russia, founder of Constructivism and the forerunner of graphic design.

opposite *Non-Objective Painting No. 80* by Rodenchenko, 1918 (oil on canvas) comprises part of the Black on Black series.

1910–1919

185

Key Artist **Egon Schiele**
Success comes in the last year of his life

Schiele exhibited a precocious talent for drawing and enrolled in the Vienna Academy of Fine Arts at the age of sixteen. There he was influenced by the Jugendstil movement of German Art Nouveau. Encouraged by Gustav Klimt, he joined the Vienna Secession, a group of artists united in their rejection of the stifling Academy of Fine Arts. In 1908, he held his first exhibition, and set up a studio the following year.

Embracing Expressionism in 1910, Schiele showed a particular interest in the human body, drawing and painting nudes and couples embracing in a blatantly sexual manner. He also created a large number of self-portraits. By 1911, he was exhibiting across Europe, but in 1912 he was charged with seducing an underage girl. His drawings were seized and one was publicly burnt in court. Although the charge was not proven, he was convicted of allowing children access to "immoral" drawings and spent twenty-four days in prison. He was traumatized by this and recorded the experience in a series of watercolors.

However, his reputation among the Expressionists did not suffer. In 1916, the Expressionist publication *Die Aktion* published an "Egon Schiele edition." In 1917, his talent was officially recognized when he was excused military service and given the materials to paint. In the Secessionist exhibition in Vienna in 1918, a room was set aside for his work. He died of the Spanish influenza later that year, three days after his wife, who died of the same illness.
Nigel Cawthorne

Date 1918

Born/Died 1890–1918

Nationality Austrian

First exhibited 1908

Why It's Key Schiele emerged as the champion of Expressionism.

Key Artist **Joseph Stella** *Futurist Brooklyn Bridge* is a seminal work in U.S. painting

Stella, born near Naples, was deeply impressed by the work of the Italian Futurist painters, which he saw at their group exhibition in Paris in 1912. There he met Matisse, Modigliani, and possibly Boccioni and Severini, remembering his exposure to the avant-garde as a "shocking revelation." The modernist idiom he adopted in 1913–14 was first expressed in the densely fragmented nocturnal vision of *Coney Island*. The suggestion of surging crowds and revolving machines was conveyed in intense arabesques and bold colors.

The excitement and urgency of U.S. urban growth is captured by his seminal work *Brooklyn Bridge* (1918–19), one of the nighttime images of the bridge that preoccupied Stella for two decades. Approaching it, he felt drawn to "the presence of a new Divinity"; by emphasizing its dynamic angularity and towering architectonics, Stella's painting implies a cathedral or shrine. Often described as a Futurist, Stella's link with the group was tenuous. Influenced by avant-garde circles that included Duchamp and Man Ray, his style nonetheless ranged widely during his career; his early work featured realist narrative scenes of immigrant workers, and he also produced small abstract collages that are very important. Between the wars, Symbolist still lifes and religious subjects increasingly displayed his sympathy for neo-conservative trends in art.

Since his training at New York art schools, he had been recognized as a brilliant draftsman. He brought to his study of Cubism formal rigor, linear precision, and scale that were uniquely his own contribution.
Martin Holman

Date 1918

Born/Died 1877–1946

Nationality American

Why It's Key Created the most important images of modern urbanism in the United States in the period at the end of World War I.

Key Event **Influential anti-Futurist magazine** *Valori Plastici* **launched**

Nine years after Italy produced the Futurist Manifesto, championing a violent break with tradition, a call for the return to Italian classicism took place in the art world. *Valori Plastici* (plastic values) was a new, critical, Italian art magazine, launched by the critic, artist, collector, and man of culture Mario Broglio and his Lithuanian artist wife, Edita Walterowna.

Published on November 15, 1918, in both Italian and French, the magazine was fervently anti-Futurist and proposed a return to Italian tradition. Futurism celebrated speed, violence, and the modern city, which it showed in its paintings, manifestos, and sculptures; the anti-Futurist stance of the magazine reflected the change in Italy's cultural landscape, as architecture and other art forms welcomed a return to order. The first issue of *Valori Plastici* featured writings by Carrà, de Chirico, Savinio, de Pisis, and Melli, who were exponents of the Metaphysical tradition, an art movement that was growing in Italy. It celebrated "spiritual" paintings that featured the unconscious and surreal, dreamlike landscapes. The second issue was devoted to the French, with poems by Cocteau, Breton, and works of Cubists Gris and Severini. Influential in turning the tide of art, the magazine existed alongside *La Ronda* (1919–23), a literary magazine with a similar "return to order" agenda.

Although *Valori Plastici* disbanded in 1921, its influence had been felt. Many artists in Europe and the United States were subsequently influenced by the philosophy of the magazine and shifted away from abstraction toward a more figurative art.
Kate Mulvey

Date November 15, 1918

Country Italy

Why It's Key *Valori Plastici* was an important and influential magazine that turned the tide of art.

1910–1919

186

Key Event
The Group of November is founded

The November Group (Novembergruppe) was founded in Berlin in 1918, taking its name from the failed Communist revolution in November of that year. At the end of World War I, Germany was demoralized by defeat; social unrest saw mass movements, uniting the workers and the military, spread across the country. Kaiser Wilhelm was forced to abdicate and a Republic was proclaimed. The revolution ended in 1919 when the Social Democratic Party took over.

Describing themselves as an alliance of radical artists, the November Group was mainly a consortium of Expressionists and Dadaists. Instigated by Max Pechstein and César Klein, its utopian ideals aimed at uniting revolutionary artists and architects. The purpose was to influence official policy in the new Republic through the visual arts and architecture. In their first manifesto, they declared that their duty was to the moral regeneration of Germany, and that they should collectively dedicate their creative abilities to the wellbeing of the new nation.

In January 1919, the group drew up a list of guidelines in which they demanded a "voice and an active role" in the reorganization of art school curricula and in all public architectural and town planning projects. It also demanded a say in legislation on artistic matters, lobbying for the protection of artistic property and an end to duties and taxes on artworks.

By 1922, the November Group had lost its political impetus but, until its demise in 1930, it attracted such members as Kandinsky, Walter Gropius and Mies van der Rohe, all of whom taught at the Bauhaus.

Sue King

Date 1918

Country Germany

Why It's Key Call for an alliance of radical artists and architects to determine the role of art in the revolutionary politics of the new Republic.

1910–1919

187

Key Artist **Morton Livingston Schamberg**
U.S. avant-garde painter, sculptor, and photographer dies

Born in Philadelphia in 1881, Morton Livingston Schamberg first trained as an architect at the University of Pennsylvania before studying painting at the Pennsylvania Academy of the Fine Arts under William Merritt Chase. In 1907 he traveled with his friend, Charles Sheeler, to Paris, where he was strongly influenced by the work of Cézanne, Picasso, and Matisse. In 1910 he returned with Sheeler to set up a commercial photography studio in Philadelphia.

Schamberg responded to his experience of Cézanne's paintings by using more simple, solid forms in his own work, and by 1912, under the influence of Cubist theory, had become fascinated by the phenomenon of dispersion, the splitting of light into its component colors. Still earning his living as a photographer, he exhibited at the legendary modernist Armory Show in New York in 1913, and later helped to introduce work from the show to his native Philadelphia. Around 1915 Schamberg met the Dadaist artists Duchamp and Picabia in New York, and in paintings such as *Mechanical Abstraction* (1916) went on to produce his most original work – intensely colored, Cubist-influenced treatments of mechanical subjects which express the Dadaists' ambivalent attitude to the machine while simultaneously invoking its formal beauty.

Until his untimely death, aged thirty-seven, in the 1918 influenza epidemic, Schamberg continued to live in the Philadelphia region and paint in the same near-abstract style, remaining to the end an active and eloquent supporter of the artistic avant-garde.

Catherine Nicolson

Date 1918

Born/Died 1881–1918

Nationality American

First exhibited 1913

Why It's Key Champion of the European avant-garde in his native Philadelphia, and precursor of Precisionism.

Key Artist **Raoul Hausmann**
Founding of Club Dada in Berlin

Vienna-born painter and writer Raoul Hausmann settled in Berlin in 1900. During the war, he contributed to the Expressionist magazine *Der Sturm* and the Communist publication *Die Aktion*, and founded with Grosz and Mehring the group Die Freie Strasse. His theoretical and political concerns earned him the nickname "Dadasopher." He was introduced to Dada by Richard Huelsenbeck and in 1918, they, with Franz Jung, co-founded Club Dada, "a club where everybody is the president." Hausmann also signed the Dada Berlin Manifesto, and founded the magazine *Dada* in 1919.

Club Dada organized events, sometimes attended by as many as a thousand people, where Hausmann would read his phonetic poems, their onomatopoeic nonsense a blatant rejection of the values of reason and progress that had led to the carnage of World War

I. In pamphlets and magazines, Dada Berlin also called for public revolt against the Weimar Republic and its bourgeois supporters, at a time of political and social chaos, when the Spartakist uprising was in the process of being crushed by the government.

The propaganda impact of these publications and posters rested largely on photomontage, a new technique developed by Hausman, Hannah Höch, and John Heartfield: cut-up press photographs, postcards, and typographical elements overlapped and exploded on the page to form dynamic compositions that played with disjunctions of planes and scale. The term photomontage had industrial connotations, unlike artistically pedigreed collage, as if to stress that the artist was but a humble technician at the service of the people.

Catherine Marcangeli

Date 1918

Born/Died 1886–1971

Nationality German

Why It's Key Major activist and publisher in the propagation of Dada.

Key Artist **Eric Gill** *Stations of the Cross*
created in Westminster Cathedral

Eric Gill was a sculptor, engraver, letter-cutter, typographic designer, calligrapher, writer, publisher, and teacher. He began his career articled to an architect, but in his spare time he studied letter carving at the Central School of Arts and Crafts. Between 1902 and 1910, he worked as a carver of tombstones and by 1909 had begun carving figures directly in stone, rather that using preparatory clay models as was vogue at the time. In 1912, his *Mother and Child* brought him to public attention and later that year, he provided the lettering for Epstein's *Tomb of Oscar Wilde* in Père-Lachaise Cemetery, Paris.

Having converted to Catholicism in 1913, he was commissioned to carve *The Stations of the Cross* in Westminster Cathedral, and much of his later work has a religious theme. Major commissions include the bas-

reliefs *Prospero* and *Ariel* (1931) over the main entrance of Broadcasting House in London, and *The Creation of Adam* (1935–38) in the lobby of the council hall of the Palace of Nations in Geneva.

With Douglas Pepler, he founded St. Dominic's Press in 1915, providing lettering and woodcuts, as well as controversial works embracing art, religion, and politics. He also provided engravings for the Golden Cockerel Press and designed typefaces including Perpetua (1925) and Gill Sans Serif (1927).

Nigel Cawthorne

Date 1918

Born/Died 1882–1940

Nationality British

First exhibited 1912

Why It's Key Revived direct carving in stone in England.

Key Person **Sergei Shchukin**
Collector's works taken by new Bolshevik government

Until the mid-1890s, Shchukin's interests appeared to reside in his father's textile business. Born to a wealthy bourgeois family – his mother belonged to the Botkin family, one of the great Moscow merchant art patrons – in 1893 Shchukin's father gave him the magnificent Trubetskoy Palace and he promptly sold its art collection and started to buy paintings while on business trips to Paris, where his brother lived.

In 1897, he visited Paul Durand-Ruel's gallery and discovered Impressionism. He immediately purchased Monet's *Lilacs at Argenteuil* (1873), which became the first Monet in Russia. This was the start of a vast collection that by 1914 contained 221 works, among them Monet, Matisse, Rousseau, Gauguin, Degas, Derain, Marquet, van Gogh, Cézanne, and fifty pictures by Picasso (curiously he ignored Seurat, Bonnard, and Manet).

From 1903, with the purchase of his first Cézanne, Shchukin concentrated on the Post-Impressionists and then, in 1906, he focused on the Fauves. In 1911, when he invited Matisse to Moscow to arrange his thirty-four paintings in the collection, Shchukin had already opened his doors every Sunday to the public. Both Matisse and the Cubist Picassos (purchased in 1908–14) were to have a profound effect on three visitors: Kazimir Malevich, Vladimir Tatlin, and Mikhail Larionov.

Soon after the 1917 October Revolution, the works were seized, while Shchukin escaped to Paris. In 1948 his collection, and that of Ivan Morozov, was divided between the Pushkin Museum of Fine Arts and the State Hermitage Museum in St Petersburg. Sergei Shchukin died quietly in Paris in 1936.
Mike Von Joel

Date 1918

Born/Died 1854–1936

Nationality Russian

Why It's Key His collection of French Modernist art, particularly by Picasso, Gauguin, and Matisse, influenced the development of the Russian avant-garde.

Key Artwork *Recumbent Nude with Legs Apart*
Egon Schiele

In his tragically brief life, the Austrian artist Egon Schiele (1890–1918) composed a number of striking studies of the female nude. *Recumbent Nude with Legs Apart* belongs to 1918, the twenty-eighth and last year of Schiele's life, at the end of which the artist and his wife Edith Harms would die of influenza. Edith was most likely the sitter for *Recumbent Nude*, which marks Schiele's maturing attitude to women. For a number of years, Schiele had painted women with pinprick or dolls' eyes whereas *Recumbent Nude* features large and soulful eyes that are, moreover, evading the gaze of the artist and the male voyeur.

While the nude's genitalia are open for inspection, her posture is not as twisted and frenzied as the early Schiele nudes, indicating a mellowing in the artist. He has overcome, by now, his essentially adolescent preoccupation with vaginas, and is interested in the overall promises and possibilities of the female body. Moreover, Schiele's technique has improved, as evinced by the drawing's assertive lines and representational precision, virtues formerly absent from the artist's work.

The issue of *Recumbent Nude*'s averted eyes is important because it limits the woman's vulnerability to inspection, and establishes her control over a space to which neither the artist nor the spectator is admitted.
Demir Barlas

Date 1918

Country Austria

Medium Charcoal on paper

Collection Private collection

Why It's Key Chastized as a pornographer by certain Austrian philistines – he was even arrested on this charge in 1912 – Schiele was in fact a sensitive and at times unbearably honest chronicler of desire, loneliness, and the secret self.

Key Event
The founding of the Bauhaus

The Staatliches Bauhaus was a German school of art and design that existed for barely fourteen years. It was founded in 1919 by architect and artist Walter Gropius, who sought "to create a new guild of craftsmen, without the class distinctions which raise an arrogant barrier between craftsman and artist." Several Bauhaus teachers were to become famous, including László Moholy-Nagy, Wassily Kandinsky, and Paul Klee. Gropius argued that following World War I a new style of architecture and design was needed, reflecting an age of mass production, and meeting a need for functional, attractive, and affordable buildings and products. Bauhaus philosophy was that the artist should be trained to work with industry, the old divisions between fine art and applied art being no longer relevant. The Bauhaus stayed in Weimar for six years until, in 1925,

after local right-wing politicians cut its funding, it moved to Dessau. Gropius left in 1928 and was replaced by the Marxist Hannes Meyer. But fears of further right-wing backlashes led to Meyer's replacement by Ludwig Mies van der Rohe, who sought to de-politicize the institution. The tide, however, was turning, and in 1932 the Dessau parliament closed the Bauhaus down. Van der Rohe reopened it in a Berlin factory as a private enterprise, but the following year the Nazis closed it for good.

Bauhaus visual style was characterized by austere, geometric solutions. But its principles shaped art and design education for a new age – in which technology produced new materials, new processes, and demanded new skills – that progress had separated from the historicism of the previous century.
Graham Vickers

Date 1919

Country Germany

Why It's Key The Bauhaus (Building House) was to exert an unparalleled influence on art, architecture, design, and typography.

opposite Photograph of the Russian post-impressionist painter Wassily Kandinsky, who became a Bauhaus teacher.

Key Artist **Jacques Villon**
Moves from Cubism to abstract painting

Born Gaston Emile Duchamp in 1875, Villon moved with his brother Raymond to Paris in 1894, where he studied law. In 1903 he helped organize the first Salon d'Automne, after which he studied art at the Academie Julian (1904–05). Early influences were Edgar Degas and Henri de Toulouse-Lautrec, but later he followed the Fauves, Cubists, and eventually the Abstract Impressionists.

After giving up law studies in favor of art, Villon worked as a cartoonist and illustrator and, in 1906, settled in Puteaux, on the outskirts of Paris, devoting himself to painting and printmaking. He changed his name to Jacques Villon to distinguish himself from his siblings, Raymond, Marcel, and Suzanne. In 1911 Villon and his brothers, Raymond and Marcel, organized a regular discussion group, known as the Puteaux Group,

with other artists, including Robert Delaunay and Fernand Léger. Their first exhibition, in 1912, contained over two hundred works by thirty-one artists.

By 1914 Villon was well-known, and in 1919 he began painting abstract works for the first time. By the 1930s he was more popular in the United States than in Europe, but his career in France was revived by the gallery owner Louis Carré in 1944, after which he received various honors at exhibitions, followed by the Carnegie Prize in 1950. He was made a Commandeur de la Legion d'Honneur in 1954 and in 1955 he designed the stained-glass windows for Metz Cathedral, France. The following year he was awarded the Grand Prix at the Venice Biennale. Villon died in his Puteaux studio in 1963.
Alan Byrne

Date 1919

Born/Died 1875–1963

Nationality French

Why It's Key Represented the link between Neo-impressionism, Cubism, and abstract painting.

Key Artist **El Lissitzky**
Meets Malevich and adopts Suprematism

In 1919, two great minds of the Russian avant-garde met and revolutionized the visual language of modern art. After meeting Kazimir Malevich, El Lissitzky adopted Suprematism as his own art form, politics, and lifestyle. Originally born Eliezer Lissitzky in 1890 in Vitebsk, Lissitzky changed his name to El after renouncing his Jewish heritage for Suprematism.

Suprematism articulated a "zero of form," and was centered around the idea of art as primarily utilitarian. In its prime after the February Revolution in Russia, it became a political movement as much as an art one, as Malevich wanted it to become the face of the Revolution. Together Malevich and Lissitzky founded UNOVIS (translated as "affirmers of new art"), an artistic group modeled after the Communist Party. In this way the integration of politics and art came to define Lissitzky's artistic contributions. Lissitzky's *Proun* series, for which he is most famous, marked his first step in a different direction from Malevich. It showcases his architectural flair, incorporating a series of geometrical shapes in conjunction with one another, and is distinctly three-dimensional, in contrast to Malevich's abstracts. Further, the *Prouns* move away from the circle and square formula into cubes, triangles, arches, and other shapes that are not considered Suprematist in their form and message.

Lissitszky broke from the Suprematist group in 1921, after the termination of UNOVIS, and worked on a number of projects, including promoting the avant-garde through writing and designing for a number of journals and magazines.

Emma Doubt

Date 1919

Born/Died 1890–1941

Nationality Russian

First exhibited 1922

Why It's Key The launch of the Suprematist movement was a seminal moment in the development of abstract art. His work with Malevich, though short-lived, is crucial to our conception of modern art, and articulated the shifting political climate of twentieth-century Russia.

opposite *Beat the Whites with the Red Arrow*, poster by El Lissitzky.

Key Event
The Cabinet of Dr Caligari released

Directed by Robert Wiene, *The Cabinet of Dr Caligari* was an early example of Expressionism in film, and has remained an influential classic ever since. The story line concerns a string of serial murders in a German village, perpetuated by the sinister doctor of the title and his hypnotized "slave" Cesare. The film was one of the first to use the "frame story," where the main narrative is told in flashback. In the instance of *Caligari*, the narrator is Francis, who is visiting the village with his friend Alan, and it's at the local carnival they first encounter Caligari and Cesare, whom the doctor is presenting as a fairground attraction. The mad doctor claims his servant will answer any question put to him; when Alan asks how long he has to live, Cesare replies "'till tomorrow," and the young man is found dead the next morning.

Francis and his fiancée Jane go on to discover that Caligari runs the local insane asylum, and has directed Cesare to commit a string of murders. Cesare dies after being chased by the angry townfolk, Caligari then admitting to his psychotic obsession before being incarcerated in his own asylum. The final twist, however, is that the whole story is Francis' fantasy, and Francis is actually a patient in the asylum with Caligari, his caring doctor.

The surprise ending, at the time a startlingly original plot device, was matched by the disorientation that marked the sets and direction, to achieve a dreamlike visual narrative which owed almost as much to Surrealism as its much-acknowledged debt to Expressionism.

Mike Evans

Date 1919–20

Country Germany

Why It's Key *The Cabinet of Dr Caligari* is one of the earliest and most influential German Expressionist films.

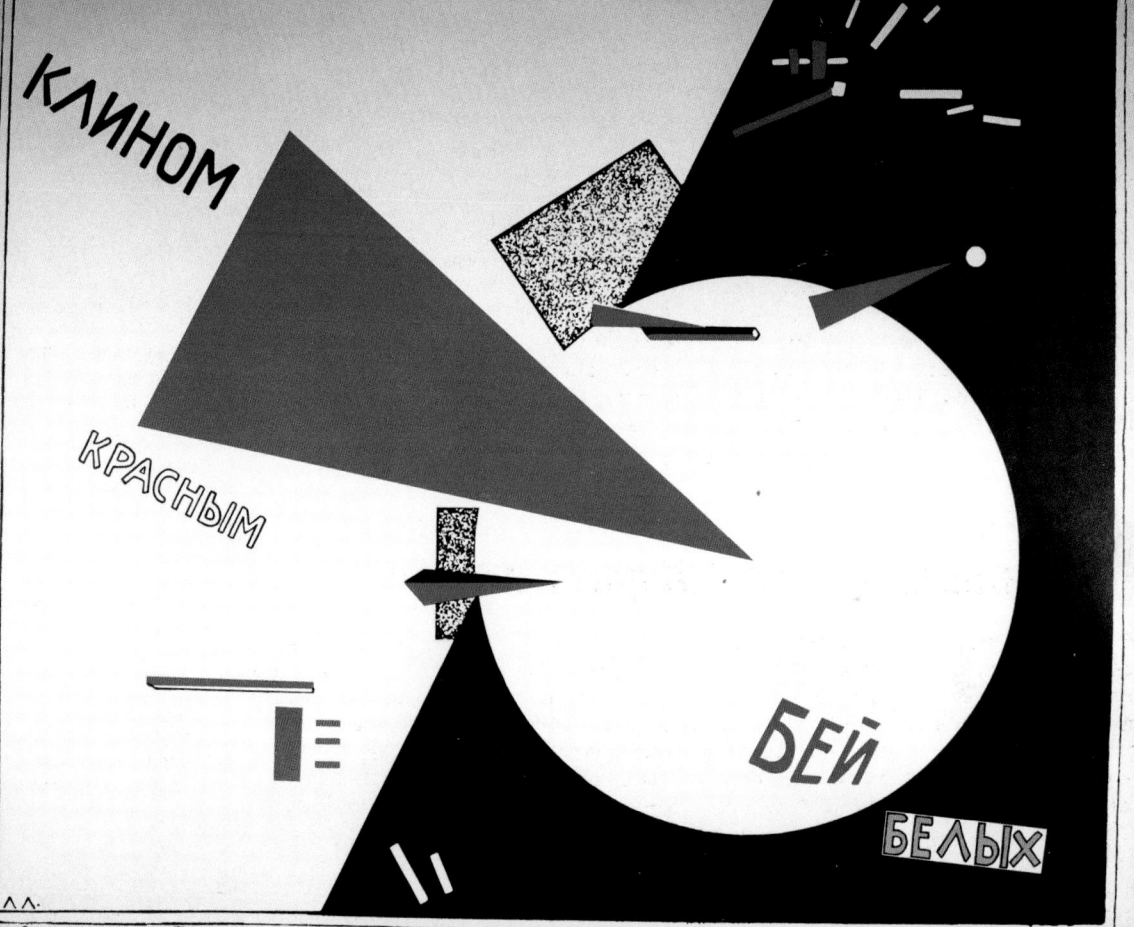

КЛИНОМ
КРАСНЫМ
БЕЙ
БЕЛЫХ

Key Artist **Max Ernst**
Founds Cologne Dada Group

Dada began in neutral Switzerland during World War I. Essentially an anti-war, anti-jingoist movement, it spread through Europe to New York from 1915 to 1923. Primarily involved with visual arts, art manifestos, poetry, theater, graphic design, public demonstrations, and publication of art/literary journals, it influenced art throughout the twentieth century.

In Zürich in 1916, Tristan Tzara, Hans Arp, Richard Huelsenbeck, Sophie Täuber, and others, put on performances in the Cabaret Voltaire. In February 1918, Richard Huelsenbeck gave his first Dada speech in Berlin. Kurt Schwitters, excluded from the German group, moved to Hanover, where he developed his distinctive type of Dada, dubbed Merz. Francis Picabia founded a Dada periodical called *391* in Barcelona and introduced the Dada movement to Paris in 1919.

Founded by Max Ernst, Dada in Cologne emerged in the autumn of 1919, when the terms of the Treaty of Versailles placed the city under British military control. In 1920, Ernst, Johannes Baargeld, and Hans Arp launched a controversial Dada exhibition, set up in a bar. It required that participants walk past urinals while being read lewd poetry by a woman in a communion dress. The police closed the exhibition on the grounds of obscenity, but it later re-opened when the charges were dropped.

Ernst had studied philosophy, psychiatry, and art history in Bonn. He moved to Paris in 1922, where he became a prominent member of the Surrealist group around André Breton. In 1925 he invented a graphic art technique called frottage, using pencil rubbings of objects as a source of images.

Mike von Joel

Date 1919

Born/Died 1891–1976

Nationality German

Why It's Key Introduced the Dada to Paris and the Surrealist Movement.

Key Artist **Jacques Lipchitz**
First solo exhibition and monograph

Sculptor Jacques Lipchitz moved from Lithuania to Paris in 1909 and found himself surrounded by the likes of Picasso, Gris, and Modigliani. Taken with them and their work, Lipchitz started to explore Cubism and, after several years in Paris, reached the peak of his own Cubist style. He presented his figures in a unique manner, seen from many angles and perspectives at the same time, resulting in a broken-up surface treatment. He juxtaposed these sculpted suggestions of contortion and movement with a solid mass of the stone, creating hugely innovative statuary – relying on the financial freedom that his 1916 contract with art dealer Leoncé Rosenberg afforded him to create them. Come 1920, he wanted to venture beyond Cubism, but Rosenberg urged him to keep working in his profitable early style. Meanwhile, Rosenberg mounted Lipchitz's

first solo show in his Parisian gallery, displaying strong early sculptures such as the *Pierrot with Clarinet* (1919). To accompany the exhibition, an influential first monograph on Lipchitz was produced.

Although it was unique for an artist to be this accomplished before the age of thirty, Lipchitz was unhappy with the emphasis on his Cubist work. He sought to end the show and broke with Rosenberg. A clause in their contract forced him to buy his work back from the dealer, effectively ending the show, but costing Lipchitz a huge sum of money.

Although the exhibition ended in disaster, the attention it received firmly established Lipchitz as an avant-gardist, bringing him commissions from celebrities such as Gertrude Stein and Coco Chanel.

Erik Bijzet

Date 1920

Born/Died 1891–1973

Nationality Lithuanian

Why It's Key His first one-man show, in Paris, puts Lipchitz among the avant-garde and French high society.

opposite *Sailor with Guitar* by Jacques Lipchitz.

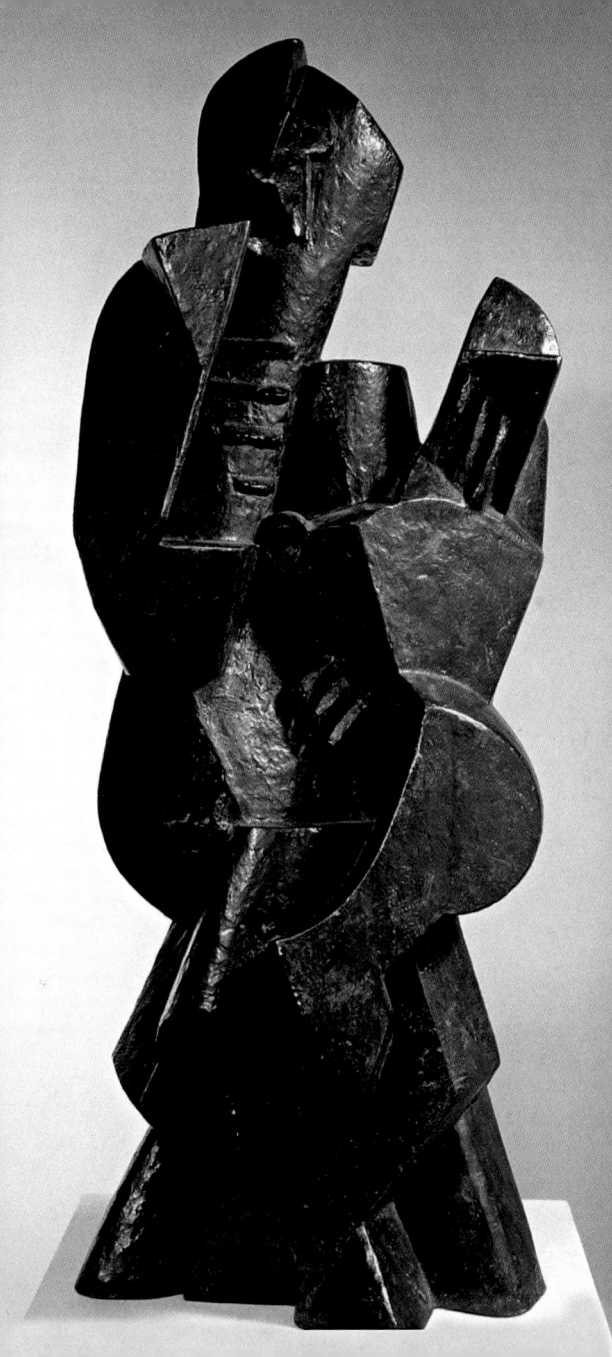

Key Artwork *Cut with a Cake Knife*
Hannah Höch

Many of the Dadaists chose to express themselves with montage, particularly from about 1918 onwards. John Heartfield and George Grosz made many hard-edged political statements, while Hannah Höch and Raoul Hausmann took photomontage a step further, bringing more personal, poetic, even playful imagery to the new medium.

In *Cut with a Cake Knife*, Hannah Höch stirs up a chaotic morass of wheels and cogs alongside human beings who are juggling, headless and disembodied, some without limbs, others tumbling through space into an empty void. There are fat ladies, elephants, and freaks in the circus-like spectacle; some wear suits, others military uniforms. Crowds, faces, and fragmented words pile on top of one another; some disintegrate into the background. The word "Dada" appears boldly in

amongst the scene of devastation, as though it has been cut with a cake knife. The painting is a powerful wake-up call and directly points to the corruption between bankers, industrialists, and the military in Germany between the world wars. Höch seems to be making a deliberate statement in an aesthetic and intuitive way. She uses pasted fragments from magazines and newspapers, along with photographs, and plays with unconventional perspective and juxtaposition of size and scale. The work has a surreal quality while emphasizing the illogical and absurd.

Hannah Höch and Raoul Hausmann had an artistic partnership and affair which lasted from 1915 to 1922. They were both part of the Berlin Club Dada and involved in political radicalism.

Carolyn Gowdy

Date 1919

Country Germany

Medium Photomontage

Why It's Key Hannah Hoch was not only very influential as a woman artist, but also as a Dadaist and photomontagist.

196

Key Event
Man Ray publishes *TNT* magazine

Man Ray published a single issue of his journal, *TNT*, in March 1919, describing it as "a political paper with a very radical slant." He wanted it to be viewed as a "tirade against industrialists, the exploiters of workers." However, despite this rhetoric, the journal itself didn't promote any specific political agenda. With a simple photograph of a bronze figure by Adolf Wolff on the cover, *TNT* experimented with the different ideologies circulating in intellectual circles in early twentieth-century America.

The two prominent features in *TNT* were the play *Theatre of the Soul*, by Nikolai Evreinof, and Man Ray's airbrushed image, *My First Born*. Man Ray chose to include an English translation of the Russian play, and had explored its theme of the three divisions of the soul in a previous work entitled *Suicide*.

My First Born is a prime example of the experimentation with different forms of image production for which Man Ray is known; this image depicts two inanimate objects that have been airbrushed, and was the first in the development of Man Ray's production of aerographs.

TNT did not take off as Man Ray hoped it would, but it was significant in that it showcased his new artistic invention of the aerograph, which presaged his groundbreaking rayographs, for which he is famed. This is indicative of the spirit of innovation that was certainly a defining factor in the images produced over Man Ray's career, and continues to be a defining factor of his prolific body of work.

Emma Doubt

Date March 1919

Country USA

Why It's Key Influential publication that included the first example of Man Ray's invention, the aerograph.

Key Artwork *A Battery Shelled*
Percy Wyndham Lewis

The Vorticists claimed that the Italian Futurists' way of decomposing motion was too impressionistic and failed to capture and convey the vital energy that should draw the viewer into the picture, toward a vortex. However, like the Futurists, Vorticist writer and painter Wyndham Lewis (1882–1957) had professed his enthusiasm for the pace, dynamism, and technical progress of modern life, and berated English culture's lack of virility.

The Futurist Filippo Marinetti embraced armed conflict and worshiped its machines, calling war "the only hygiene" that could rid society of its dead weights. Lewis did not share this bellicose enthusiasm: his fellow Vorticist, Gaudier-Brzeska, was killed in action in 1915, and he himself had enlisted in 1916, undergoing heavy artillery bombardments at the Battle of Ypres. In late 1917, Lewis became official war artist with the Canadian, and later British, troops, but he only painted *A Battery Shelled* after the war had ended.

On the left of the painting, three officers, depicted in an almost naturalistic fashion, are looking at the devastation caused by the shelling. A much more Vorticist idiom is used for the right-hand side of the picture: the smoke, the zig-zagging shells, and the robot-like soldiers carrying one of their comrades are schematized, as if the horror of the front deprived men of their very shape. The juxtaposition of these two styles, and the fact that Lewis should have chosen to depict a battery being shelled rather than a more heroic victory, seem to convey an ambivalence toward the modernity of a war Lewis called a "dreary and rotten business."

Catherine Marcangeli

Date 1919

Country UK

Medium Oil on canvas

Collection Imperial War Museum, London

Why It's Key Lewis allies naturalistic representation and Vorticist geometry to develop a new kind of war painting.

197

Key Artwork *Merzbild*
Kurt Schwitters

Kurt Schwitters (1887–1948) is best known for the invention of a famous collage technique and form of Dada which he called Merz. It was based on the practice of combining ordinary found items with formal artistic elements and was influenced by earlier experiments with Cubism and Expressionism. Schwitters' *Merzbild* works took the form of collage and encompassed large-scale reliefs, and the term "Merzbilder" was coined to describe the basic principle of his art.

Schwitters felt this technique offered ideal possibilities because of the way it brought disparate fragments together. Based on the second syllable of the German word for commerce, Merz posed questions about consumption, war, waste, and accountability, and underlined the artist's quest for cultural, political, and social freedom.

In *Merzbild* Schwitters worked with traditional and modern techniques, explaining that "I am a painter and I nail my pictures together." He combined found "artstrange" materials – the flotsam of modern society – such as tram tickets, ration coupons, beer labels, scraps of newspaper, fabric, candy wrappers, and rusty nails, with traditional oil paints and brushwork.

The early pieces exhibited an expressive rawness, and the diverse materials were scattered within dynamic compositions that were sometimes reminiscent of public calls to action or anarchic manifestos. Angular shapes and textures juxtaposed with circular fragments in a bold and improvisational way. The pictures also contained hints of narrative, not unlike music or poetry.

Carolyn Gowdy

Date 1919–1948

Country Germany/Norway/UK

Medium Collage, assemblage

Why It's Key These assemblages were ahead of their time and changed the language of collage.

Key Artwork *Monument to the 3rd International*
Vladimir Tatlin

In 1919, Lenin suggested that every town should erect a monument to the heroes of the revolution. Hence, the Commissar for Education Anatoly Lunacharsky asked the Constructivist artist Vladimir Tatlin (1885–1953) to design a monument to the 3rd Communist International, to be placed in the center of Moscow.

Constructivism was approved of in the experimentalist days of the pre-Stalinist revolution because it was in the spirit of the new Russia. It celebrated the raw materials of heavy industry that would build the future for the masses. Based on the idea that painting, sculpture, and architecture shared the same principles, the Constructivists' totally abstract constructions utilized materials such as iron, steel, wood, and glass, reflecting "the culture of materials" or "faktura", as Tatlin called it; the Constructivist was an artist/engineer, and the total opposite of the bourgeois easel painter.

The monument was to be a 1,300-foot kinetic, leaning, spiral tower. An iron framework holding three glass chambers, a cube, a cone, and a cylinder, each rotating at a different speed, it was a symbol of change. At the bottom was the cube, accommodating the legislative council. It made a total rotation once a year. Above this was the cone, housing the executive committees, which would complete its rotation once a month. At the top was the cylinder, which turned once a day. This was the information center from where propaganda messages were to be put out. The model was unveiled in 1920, but the tower was never built.
Sue King

Date 1919–1920

Country Moscow

Why It's Key Symbol of avant-garde modernist architecture that changed the concept of architectural form and materials.

Key Event **Animated cartoon**
The Adventures of Felix is released

Felix the Cat, with his black body, white eyes, and big grin, was the first animated film character to be instantly recognizable to audiences worldwide. The first Felix movie, *The Adventures of Felix*, was released in 1919, and by 1922 the feline film star, still in the era of silent film, had become an international icon in popular culture. He had his own newspaper comic strip, his picture appeared on everything from ceramic ornaments to stuffed toys, and there was even a hit record, *Felix Kept On Walking*, released in 1923.

The character was created by American animator Otto Messmer and the Australian cartoonist and film producer Pat Sullivan, though who was responsible for the original idea has long been a matter of conjecture.

Businessman Sullivan marketed the cat while the largely uncredited Messmer continued to make the cartoons, putting the animations directly onto white paper, with inkers tracing the drawings. The animators drew backgrounds onto pieces of celluloid, which were then laid on top of the drawings to be photographed. Any perspective work had to be animated by hand, as the studio cameras were unable to perform pans and such.

Although technically innovatory, the popularity of the Felix character was relatively short-lived. With the coming of sound, new cartoon icons such as Mickey Mouse took over. It was the Disney mouse, therefore, who would appear as a Pop Art icon in the work of Andy Warhol and others years later, following a path first forged by the pioneering creators of his silver-screen predecessor Felix.
Mike Evans

Date 1919

Country USA

Why It's Key First animated cartoon character to achieve international fame, with brand merchandizing and mass-marketing creating an early visual pop icon.

opposite Illustration of Felix the Cat sitting on cheese by Pat Sullivan.

Key Artist **Konrad Mägi**
Pühajärv (*Lake Püha*) shows influence of Expressionism

Konrad Mägi initially studied drawing in his hometown of Tartu and at the Stieglitz Art School in St Petersburg before studying sculpture and painting at private academies in Paris. Upon his move to Norway in 1908, he began what was to become a very successful career in landscape painting, which he continued after moving back to Paris in 1910.

While his landscape paintings from France and Norway were celebrated, those that he produced upon his return to Estonia in 1912 secured his fame as an influential landscape artist. He then abandoned the classical style of painting and developed his own style to portray his native landscape. He utilized vibrant colors and incorporated elements of Impressionism, Fauvism, and Pointillism, movements that impacted him during his stay in France.

His style further evolved in the 1920s, reflecting the influence of Expressionism, espousing the communication of emotion through visual forms. His palette became darker and the forms of his works more distorted, conveying the anxiety of the postwar climate, as displayed in works such as *Pühajärv* (*Lake Püha*, 1918–20).

Mägi's unique style enabled him to portray the essence of the lush, uncultivated elements of Estonian nature as had never been done before. In his aim to promote both Estonian and Expressionist art, he co-founded the art school of Pallas in his hometown in 1919. Before his death he spent time in Italy, where he gained a greater understanding of color, a development that is exhibited in his later Expressionist works.

Heather Hund

Date 1920

Born/Died 1878–1925

Nationality Estonian

Why It's Key Renowned for developing a new painting style to portray the landscape of his native Estonia.

Key Artist **Antoine Pevsner**
Publishes Realist Manifesto with his brother, Gabo

Born in Orel, Russia in 1886, Pevsner studied at the Academy of Fine Arts in Kiev from 1908 to 1910, and in St Petersburg in 1911, after which he went to Paris and fell under the influence of the Cubist art he saw there. When World War I started he joined his brother, Naum Gabo, in Norway. They returned to Russia in 1917, where Pevsner taught at the Moscow School of Fine Art.

The brothers published their Realist Manifesto in 1920, declaring their own artistic principles and the issues that twentieth-century art was confronting. In 1923, after the Russian Communist government began to suppress free artistic expression, the brothers decided to leave the country. Pevsner went first to Berlin and, in 1924, settled in Paris. Until this time he had been primarily a painter but now he turned to

sculpture and developed his distinctive style, using plastic and sheets of brass, copper, and zinc. He and Gabo collaborated on the designs for Sergei Diaghilev's ballet *La Chatte* in 1927.

Pevsner became a French citizen in 1930, and the following year was a founding member of the Abstraction-Création group. He and Gabo had a retrospective exhibition at the Museum of Modern Art, New York in 1948, and he continued to produce large public sculptures until his death in 1962.

Alan Byrne

Date 1920

Born/Died 1886–1962

Nationality Russian/French

Birth name Natan Borisavitch Pevsner

Why It's Key Leading sculptor of the Constructivist movement.

Key Artist **Joan Miró**
Miró settles in Paris

Joan Miró Ferra was born in 1893 in Barcelona. After a misplaced stint as a businessman, which was followed by a nervous breakdown, he resumed his art studies at Francesc Galí's Escola d'Art in Barcelona from 1912 to 1915.

He traveled to Paris in 1920, where he met Picasso and associated with the avant-garde who gathered in Montparnasse. Whilst his early work shows Fauvist and Cubist influences, he was deeply affected by Abstract Realism, and in 1924 joined the circle of Surrealist artists. While his painting took on their style – in particular their interest in Atomism and the use of sexual signals – he remained an outsider. But this did not deter the Surrealists' principle theorist, André Breton, who declared Miró to be "the most Surrealist of us all."

The excitement of Miró's art lies in its preoccupation, invention, and arrangement of shapes, colors, and space, and its flattened picture planes. It has a playful, naïve quality characterized by simple forms and bright, bold colors that are reminiscent of drawings done by children; it also has elements of Catalan folk art. Like many of the artists of the time, Miró liked to compare his visual art to poetry.

By the 1930s Miró, a modest, hardworking man, had attained international recognition. Known for his artistic autonomy, in his later years he worked in different media, producing a prolific number of ceramics, including *Wall of the Sun* at the UNESCO building in Paris, and sculptures such as *Woman and Bird* in Barcelona. He died in Mallorca in 1983.
Kate Mulvey

Date 1920

Born/Died 1893–1983

Nationality Spanish (Catalonian)

Why It's Key A leading painter, sculptor, and ceramist, Miró was a key exponent of abstract art that reflected a more romantic, rounded form than the angular abstract artists such as Mondrian.

Key Artist **Amedeo Modigliani**
Death after famously short and bohemian life

Born in Livorno in 1884, Amedeo Modigliani was a sickly child with recurrent bouts of pleurisy. He studied at the Institute of Fine Arts in Venice and then, like many other artists of the time, settled in Paris in 1906, where he lived for the rest of his short life.

Whilst his early art influences – Gauguin, the Fauves, and Cézanne – gave his work a Post-Impressionist feel, his readings of the philosopher Nietzsche fed his appetite for decadence and self-destruction. Despite living the typical lifestyle of the tragic artist – he was self-destructive on a grand scale, using absinthe and hashish – his artistic output in the early years was prolific and by 1907 he had developed his own unique style.

Modigliani often applied sculptural effects to his paintings. His female nudes, with their elongated heads, long necks, and long, raised ridges across the nose, became famous and his *Reclining Nude* (1917) was received to critical acclaim. However, when Modigliani's first one-man show opened at the Berthe Weill Gallery on December 3, 1917, Paris' Bourgeois society was scandalized and the show was closed within a few hours of opening.

Despite his output, Modigliani remained poor throughout his life. He had a voracious appetite for women, yet it was Jeanne Hebuterne who was the love of his life and the model for many of his paintings, in particular *Madame Pompadour*. He died in 1920 of tuberculosis.
Kate Mulvey

Date 1920

Born/Died 1884–1920

Nationality Italian

Why It's Key A sickly childhood and destructive behavior doesn't detract from a prolific artist.

Key Artwork *Suprematism: 34 Drawings*
Kazimir Malevich

Kazimir Severinovich Malevich (1878–1935) created the most radical abstraction to emerge from the European avant-garde of the early twentieth century. A painter, theorist, and philosopher, he dedicated a large part of his career to preaching his systematic aesthetic, which he coined Suprematism. The Ukrainian-born artist confidently characterized this influential style as "that end and beginning where sensations are uncovered, where art emerges as such." Right from his early years as an artist, Malevich's convictions roused widespread interest, culminating in five one-man shows and several publications devoted to his art, before he died at the fairly young age of 57.

An essential product of the artist's eagerness to promote his take on abstract art is his lithographed pamphlet *Suprematism: 34 Drawings* (*Suprematizm: 34*

Risunka), which reproduced annotated drawings made in previous years. It gives a valuable insight into the relationship between Malevich's thoughts and his enigmatic and severe pictorial practice. The illustrations show the geometric shapes that are so forcefully present in famous paintings such as the *Supremus* series. Derived from the three basic Suprematist elements: the black square, circle, and cross, they were either abstractions of natural shapes, or representative of the realm of sensation and pure feeling.

Suprematism: 34 Drawings played an important part in placing Malevich at the forefront of the avant-garde, and posthumously at the pinnacle of high modernism, leaving an enormous impact on the development of art ever since.
Erik Bijzet

Date 1920

Country Russia

Why It's Key This publication spread Kazimir Malevich's groundbreaking aesthetic to a large audience for the first time.

Key Artist **Charles Edenshaw**
Death of the great Native Canadian artist

Born Tahayghen, Edenshaw went to live with his maternal uncle in Queen Charlotte Islands, British Columbia. When his uncle died, he succeeded to his chiefly title of Eda'nsa, or Edenshaw.

Edenshaw began carving argillite and silver one winter at the age of around fourteen. The carving of argillite, a black carbonaceous shale, was traditional among Haida artists, but Edenshaw seems to have been the first to carve precious metals.

In the early 1880s, Edenshaw settled in Masset, where he made his living from his art, selling model poles, canoes, and houses, and chests, masks, bowls, and platters in wood and argillite. He also made gold and silver jewelry, which he reserved for Haida people.

In 1897, he gave German anthropologist Franz Boas the drawings that were published in 1927 in Boas'

classic *Primitive Art*. Tattoo designs commissioned by Boas were later published by John Reed Swanton of the American Museum of Natural History in New York. Edenshaw made models of poles, houses, and canoes, and a mask for Swanton.

Edenshaw's work was first featured as "fine art" at the Exhibition of Canadian West Coast Art at the National Gallery of Canada in Ottawa in 1927, an exhibition that later traveled to Paris. There are also major collections of Edenshaw's work in the Field Museum of Natural History in Chicago, the Royal British Columbia Museum, Vancouver's Museum of Anthropology, the Canadian Museum of Civilization and the Pitt Rivers Museum in Oxford, England.
Nigel Cawthorne

Date 1920

Born/Died 1839–1920

Nationality Canadian

Haida name Tahayghen

First Exhibited 1927

Why It's Key Charles Edenshaw was considered to be the first professional Haida artist and one of the most prolific and innovative of the Haida artists.

Key Artist **Raoul Dufy**
Develops trademark "stenographic" style

Raoul Dufy was born in Normandy in 1877. In 1895, at the age of eighteen, he started attending evening classes at the Ecole des Beaux-Arts in Le Havre. In 1900, after his military service, he won a scholarship which allowed him to attend the Ecole Nationale des Beaux-Arts in Paris. Here he met Georges Braque and was also influenced by Impressionist artists such as Claude Monet and Camille Pissarro.

In 1902 he showed work in Berthe Weill's gallery, and in the same year met Henri Matisse and was greatly impressed by his painting *Luxe, Calme et Volupté*. Because of this his interest was focused toward Fauvism and he adopted a Fauvist style of painting, using bold shapes and bright colors.

From 1920 his distinctive "stenographic" style of painting developed fully, with line becoming more important and his pictures becoming lighter and more luminous. He painted fashionable outdoor pursuits, such as horse racing and yachting, as well as flowers, nudes, and musical instruments, all of which showed an optimistic and cheerful attitude toward life.

In 1938 Dufy completed a huge fresco, *La Fée Electricité*, for the Exposition Internationale in Paris. He also worked successfully as a book illustrator, fabric and fashion designer, and muralist, as well as producing many designs for ceramics and tapestries.
Alan Byrne

Date 1920

Born/Died 1877–1953

Nationality French

Why It's Key A key Fauvist who moved to a more personal style.

203

Key Artist **Joaquín Torres-Garcia**
Attempts to break into the New York art scene

Joaquín Torres-Garcia was born in Montevideo, Uruguay but emigrated with his father to the latter's birthplace in Catalonia, near Barcelona when he was seventeen. After studying at the Escuela Oficial de Bellas Artes de Barcelona and the Academia Baixas, Torres-Garcia illustrated newspapers and books, collaborated with Gaudí on stained glass for several churches, including the Sagrada Familia, and worked as a muralist, painting two panels in Neo-classical style for Uruguay's pavilion at the Brussels Universal Exhibition of 1910.

In 1920, he went to New York, where he admired the vibrant cityscape but struggled to make a living, returning to Italy in 1922 to design wooden toys for sale in New York. In Paris, in the mid-1920s, he joined the Constructivists and, in 1929, co-founded the pro-abstraction journal Cercle et Carré (Circle and Square).

In 1934 Torres-Garcia decided, aged sixty, to return to Montevideo. In the last fifteen years of his life, he became South America's leading modernist, organizing conferences, writing, teaching, establishing a workshop, and championing his symbolic, schematic version of abstract art, which he named Constructive Universalism. He explained the thinking behind this blend of Renaissance painting, European formalism, and pre-Columbian influences in his 1935 manifesto, La Escuela del Sur (The School of the South), which included a map in which the northern hemisphere's conventional cultural domination is rejected by presenting South America upside-down, with the South Pole at the top.
Catherine Nicolson

Date 1920

Born/Died 1874–1949

Nationality Uruguayan

First Exhibited 1897

Why It's Key Pioneer of modernism in South America.

Key Artwork *Self-portrait with Doll*
Oskar Kokoschka

When Oskar Kokokschka's (1886–1980) great love, Alma Mahler, left him in 1918, the disillusioned painter commissioned a life-sized doll resembling her from a Munich doll-maker. The doll quickly became know as "beloved" and featured in many drawings and paintings, which often painfully emphasized its lifelessness. The Austrian painter openly fetishized the doll, which either characterizes his mental state at the time or his attempts to live up to his crazy reputation.

The doll prominently figures in this 1920 self-portrait of the artist, which features the flat, broad brushstrokes that Kokoschka was using at that time. His use of color makes us focus on the doll, while the figure of the painter blends into the dark background, with only part of his face and gestures highlighted. There are obvious sexual connotations in the rather awkward positioning of limbs in the painting. The inquisitive and pushy look of the painter, and the way the doll seems to turn away, might tell us that Kokoschka was hinting at the doll's inability to fill his lost love's place.

Eventually Kokoschka lost interest in the doll, stating, "Finally, after I had drawn it and painted it over and over again, I decided to do away with it. It had managed to cure me completely of my passion. So I gave a big champagne party with chamber music, during which Hulda exhibited the doll in all its beautiful clothes for the last time. When dawn broke – I was quite drunk, as was everyone else – I beheaded it out in the garden and broke a bottle of red wine over its head."

Erik Bijzet

Date 1920

Country Austria

Medium Oil on canvas

Why It's Key A major embodiment of Kokoschka's life and work, the painting illustrates his famous fetishistic behavior and painterly practice.

opposite *Self-portrait with Doll*

Key Exhibition
First International Dada Fair

The first – and only – International Dada Fair was organized by Marshall Propagandada George Grosz, Dadasopher Raoul Hausmann, and Dadamonteur John Heartfield. The show was bankrolled by Finanzdada and gallery owner Otto Burchard. While the catalog announced the abolition of the art market, a photomontage by Grosz and Heartfield claimed: "Art is dead. Long live Tatlin's new machine art!"

A parody of commercial trade fairs, the Dada-Messe included international artists working in different styles and media. From Dresden, Otto Dix brought vitriolic paintings of war veterans, cripples, and decadent bourgeoisie enjoying the fruits of their corruption. Hannah Höch, the only woman in Berlin's Club Dada, showed her collage *Cut with the Dada Kitchen Knife through the Last Weimar Beer-Belly Cultural Epoch in Germany*, a sarcastic view of the period's political confusion, interspersed with pro-Dada slogans. Picabia (from Paris) and Max Ernst (from Cologne) contributed machine drawings. The juxtaposition of photomontages, posters, assemblages, puppets with children's drawings subverted traditional artistic hierarchies. The most controversial exhibit was Heartfield and Schichter's *Preussischer Erzengel*, a dummy hanging from the ceiling, dressed as a German officer and wearing a pig's mask. It prompted a lawsuit against the organizers but the fine was minimal and the scandal soon subsided. As Dada gradually disbanded, Arp, Tzara, and Ernst left for Paris and took part in what would become the Surrealist movement.

Catherine Marcangeli

Date 1920

Country Germany

Why It's Key The last large-scale Dada event proclaims the end of bourgeois art and the advent of a new era.

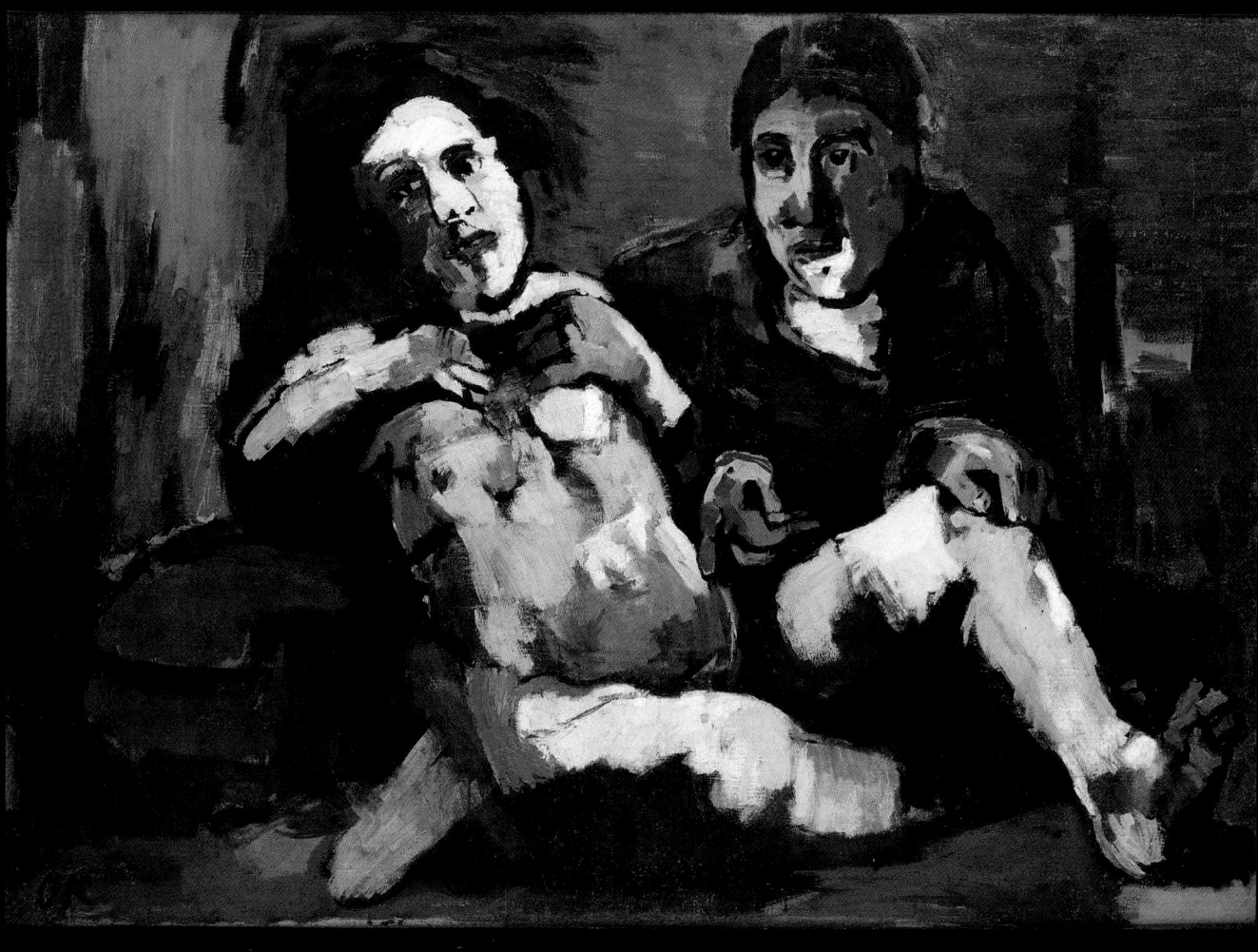

Key Artwork *Houses at Céret*
Chaim Soutine

Céret, a small Catalan town in the French Pyrenees, attracted many artists in the early twentieth century. In 1905, Henri Matisse and André Derain visited the town and Picasso came in 1911. Soutine traveled to the South of France in 1918 with his friend Amedeo Modigliano. Their dealer, Leopold Zborowski, advised Soutine to stay in Céret due to his lack of success in Paris. He stayed from 1919 for about three years, during which time he suffered recurring pain due to ulcers, poverty, and isolation from his peers.

Although the subject matter in his views of Céret was conventional, his style was considered wild and naïve. In this painting the distorted structures of landscapes and buildings seem to reel and collapse in the wake of a terrifying cyclone. It demonstrates the influence of the Post-Impressionists and the Fauves,

whose work he had seen while living in Paris. It also refers to Cézanne in the flattening of the picture plane and dispersal of forms away from the center, and to van Gogh in the morass of visceral, luminescent, violently applied impasto brush strokes.

Despite the purchase, in 1923, of many of his paintings by physician and self-made millionaire Albert C. Barnes, Soutine tried to destroy as many of the Céret landscapes as he could. Those that survived were assimilated into the twentieth-century canon by collectors in the 1920s and 1930s, and art critics in the 1940s and 1950s, who saw affinities with the work of the Abstract Expressionists. A retrospective of his work was held at the Museum of Modern Art in New York in 1950.

Sarah Mulvey

Date c.1920

Country France

Medium Oil on canvas

Collection Washington University Gallery of Art, Missouri, USA

Why It's Key Soutine's Céret landscapes shocked his contemporaries with their violent brushwork and distorted compositions, preceding the work of the Abstract Expressionists.

Key Event
The Group of Seven

The first exhibition of the Group of Seven was held in May 1920 in Toronto. Its origin developed from the meeting of Lawren Harris and J.E.H. MacDonald in 1911. They were joined by MacDonald's work colleagues at the commercial art studio, Grip Ltd, Arthur Lismer, Tom Thomson, Franklin Carmichael, and Frederick Varley. In 1913 A.Y. Jackson arrived from Montreal, and finally, the independent-minded Frank Johnston completed the group.

Stylistically, their paintings developed from the Impressionism of Maurice Cullen, William Brymner, and J.W. Morrice. Harris and MacDonald were also greatly impressed by a show of Scandinavian artists held in Buffalo, New York. Their shared aim was to rebel against the prevailing academic tradition. They deplored the current tastes of most Canadian

collectors, and sought inspiration from the landscape of Ontario on their frequent sketching expeditions into the wilderness. This was often done at weekends as painting was only possible in their spare time for most of them. Later, their travels would take in the Canadian Rockies and the North.

Despite the tragic death in 1917 of Tom Thomson, encouraged by the new national pride in Canada's wartime achievements, the Group staged its first show. Perceptive critics and buyers were quick to accept the fresh and vital works. International recognition soon followed and by the time of the last exhibition in 1931, the Group of Seven and its associates, for many, had become Canadian Art.

Stephen Bartley

Date 1920

Country Canada

Why It's Key Launch exhibition of the major Canadian breakaway group from "European" landscape art.

Key Event
Votes for women

The status of women's art is inextricably linked to the rise of the status of women. The women's suffrage movement between 1890 and World War I gave way to new freedoms and attitudes. Its militancy, picket lines, and unrelenting pressure sought to create change. In the United States, Congress passed the amendment in 1920 that gave women the right to vote; Britain followed suit in 1928.

Underpinning women's nascent freedom was the economic independence brought about by social change. The spread of department stores, for instance, meant jobs for women, as did work in munitions factories during the war, and more and more women started to devote their lives to their careers.

Public images such as the Gibson Girl – a healthy, athletic woman in stylishly simple dress – influenced a generation of female artists. The freedom to pursue higher education, as well as a psycological shift in self-perception led to female artists seeing themselves as independent beings and not just chattels. Institutions such as London's Slade School of Art had hitherto held separate classes for women, now they were mixed.

By the "roaring" 1920s, young women, dubbed "flappers," smoked, drank, and attended petting parties. Female artists such as Georgia O'Keeffe, Mary Cassatt, Sonia Delaunay, and photographer Diane Arbus became part of the bohemian avant-garde. They attended art colleges and went through higher education, giving women independence of mind and a desire to be taken seriously.

Kate Mulvey

Date 1920

Country USA

Why It's Key The law giving women the right to vote was the first step toward female equality, impacting on art, and leading to the second wave of feminism and status for female artists.

Key Event
Founding of Devetsil

Into the already rich artistic ferment of newly independent Czechoslovakia came the Devetsil, or Nine Forces, a collective of Czech artists whose work would be an important incarnation of early twentieth-century Constructivism and Functional Modernism.

Founded in 1920, the movement proved to be remarkably wide-ranging and internationally aware. Among its members, Jaroslav Seifer produced poetry, Vladislav Vancura wrote short stories and novels, Josef Chochol designed buildings, Toyen painted, and many others contributed artefacts ranging from screenplays to acting performances. One of the movement's founders, collage artist Karel Teige, arranged for avant-garde artists from all over Europe to visit Prague, turning the city into a cultural capital. Teige, who lent much of his character to Devetsil, believed in a creativity that rejected hard distinctions between the arts. This attitude helped break down methodological and professional barriers between Czech artists.

Dissolution in 1930 did not mark the end of the creative activity of its members, many of whom remained productive for decades to come, but the Soviet takeover of Czechoslovakia in 1948 ended the great period of artistic and personal experimentation that the collective championed and represented. Ironically, despite Devetsil's theoretical allegiance to essentially socialist principles, such as functional architecture, the USSR cracked down severely on Teige and other members. It was only after the Velvet Revolution of 1989 that the work of Devetsil was once more openly discussed and celebrated in its homeland.

Demir Barlas

Date 1920

Country Czechoslovakia

Why It's Key Influential collective of Czech artists turned Prague into a cultural capital and modeled an inclusive approach to creative production.

Key Artwork *Composition with Red, Blue, Black, Yellow, and Gray* (1921) Piet Mondrian

After World War I, Piet Mondrian (1872–1944) moved to Paris and frequented the avant-garde art scene. He flourished in its atmosphere of intellectual freedom, pursuing an art of pure abstraction for the rest of his life. He started to produce his grid paintings in 1919, and from 1920 was to pursue a single theme until 1938, a period which came to be know as his Paris period. During this time he made pictures based on the visual impact of color, exploring horizontal-vertical line and form in accordance with his theosophical beliefs as expressed in the De Stijl movement which he founded with Theo van Doesberg.

In the early grid paintings, the lines are thin and gray, as opposed to black. The colored squares take up most of the painting, and the actual colors are dull. The real change in style occurred in 1920, when he began applying neoplastic theories to his work, an approach which he pursued until his death in 1944. *Composition with Red, Blue, Black, Yellow, and Gray* (1921) is one of the early works from this period. Thick, black, shiny lines separate the forms into rectangles of varied sizes, and isolate the colored planes, which have become larger and fewer in number. Color is more pronounced, and the black lines are as visually forceful as the blocks of color. And where previously Mondrian had ended the lines at the edge of the painting by fading them out, they now end abruptly.

In the following years, the compositions become more sober, the red more brilliant, and the lines run along the edges of the canvas, leaving the center bare.
Kate Mulvey

Date 1921

Medium Oil on canvas

Collection Museum of Modern Art, New York

Why It's Key Marks the turning point in Mondrian's grid paintings where the pursuit of pure Plasticism is perfected and influences other modernist painters.

opposite *Composition with Red, Blue, Black, Yellow, and Gray* (1921).

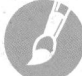

Key Artist **Gino Severini** Publishes *Du Cubisme au Classicisme* (*From Cubism to Classicism*)

When Severini published his treatise, *Du Cubisme au Classicisme*, in Paris in 1921, it was the culmination of his preoccupation with theory that spanned Futurism, Synthetic Cubism, and Neo-classicism in his search for a total aesthetic.

Born in Cortona, Italy, Severini moved to Paris in 1906, where he then spent most of his life allying himself to the Paris avant-garde. He was invited to join the Italian Futurists in 1909 and contributed to the Technical Manifesto of Futurist Painting in 1910. Although he was interested in their theories of speed and universal dynamism, he was less in tune with their interest in the dynamism of urban uprisings and violence, concentrating rather on the movement of the body and the dynamism of the boulevards, dancehalls, and cabarets. Divisionism, akin to Pointillism, led him to the scientific theories on optics and light, which informed much of his work.

After 1915, he abandoned Futurism and turned to Synthetic Cubism, painting landscapes and still lifes. Increasingly interested in classicism, mathematical and geometric methods of constructing paintings, such as the classical golden section, were progressively more important to him. At the same time he was producing portraits in the Neo-classic style that eventually led him to draw on the Renaissance and the techniques of Piero della Francesca. In *Du Cubisme au Classicisme*, he defends Cubism and focuses on classicism, science, and mathematics as a means toward a universal experience of dynamism in his search for a new purity, harmony, and order in art.
Sue King

Date 1921

Born/Died 1883–1966

Nationality Italian

Why It's Key Severini was an important modernist artist who argued for classical order in modernist art.

Key Artwork *The Three Musicians*
Pablo Picasso

In 1917 Picasso traveled to Italy with Jean Cocteau and worked on the set designs and costumes for the ballet *Parade*, to be performed by Sergei Diaghilev's Ballets Russes, with music by Erik Satie. Picasso was inspired by performances of the commedia dell'arte, a form of popular entertainment started in sixteenth-century Italy, having already shown his interest in music and performance in his Cubist paintings of musicians, guitars, and mandolins.

While Picasso was designing sets and costumes for other ballets, he also produced two versions of *The Three Musicians*, which show the commedia dell'arte characters of Harlequin, Pierrot, and a friar who appear in a stage-like space, each one playing an instrument.

The invention of papier collé by Georges Braque and Picasso's use of collage, which allowed color to be introduced into Cubist compositions, initiated the Synthetic phase of Cubism in around 1912. The two versions of *The Three Musicians* are parodic versions of the collage idiom. The figures and objects are made up of a series of flat planes, painted to appear as if constructed from paper cut-outs pasted onto canvas, and as such are self-referential, alluding to earlier Synthetic Cubist works. The planes have a decorative function, animating the surface, but also merging and overlapping in a series of complex geometric structures to create the illusion of a composite relief in shallow space, whilst also managing to convey the humour of the commedia dell'arte.

Sarah Mulvey

Date 1921

Country France

Medium Oil on canvas

Collection (Two versions) Museum of Modern Art, New York; Philadelphia Museum of Art

Why It's Key Last great works of Synthetic Cubism, painted in the same year as he embarked on his new figurative Neo-classical style of painting, which was his response to the return to tradition (*le rappel à l'ordre*) after World War I.

Key Person **Mies van der Rohe**
Glass Skyscraper project

Trained initially as a stonemason, Ludwig Mies van der Rohe revolutionized twentieth-century architecture with concepts he developed through the use of steel and glass. One of the leaders of modern architecture, he was a key figure of the so-called International Style. His reputation is founded not just on his buildings and projects but also on his rationally based method of architectural education. In 1921, he designed the Glass Skyscraper, which was never built but anticipated his realized skyscraper designs of the 1940s and 1950s.

Van der Rohe established his first office in 1912 in Berlin, a center of avant-garde activity. There he completed a large number of projects, all of which remained unrealized. The Friedrichstrasse Office Building of 1919 was one of the first proposals for an all-steel-and-glass building and established the principle of "skin-and-bones construction," which Mies came to stand for. The Glass Skyscraper, which followed two years later, applied this idea, with the skyscraper's transparent facade revealing the building's underlying steel structure. Both of these designs were revolutionary in their utter simplicity.

After closing the Bauhaus, of which he had been the director, due to Nazi pressure, Mies relocated to the United States. It was there that his dream of the glass skyscraper finally materialized. His Twin Towers in Chicago were completed in 1951, followed by other high-rises in cities such as New York, and Detroit, culminating in 1954 with the Seagram Building in New York, hailed as a masterpiece of skyscraper design.

Chiara Marchini

Date 1921

Born/Died 1886–1969

Nationality German

Why It's Key Leading figure in the development of modern architecture.

Key Artwork *The Elephant Celebes*
Max Ernst

The title for Ernst's *Chinese Nightingale* (1920) is taken from a fairy tale, by J.C. Andersen, about a singing competition between two birds, one mechanical, the other real. In the story, it is the latter's song which saves the king's life. At the center of this photomontage is a hybrid figure with human arms, a fan for a crest, and a body which is in fact a bomb, cut out from a scientific book extolling the wonders of World War I weaponry. Because of the angle of the photograph, however, the bomb's handle resembles a bird's beak, rendering the killing machine harmless.

Ernst's *Elephant Celebes*, though a painting, similarly combines mechanical and anthropomorphic elements into hybrid creatures. A headless female mannequin beckons, in a dreamlike landscape where fish swim in the sky and a model airplane swoops down in rings of smoke. A giant mechanical figure looks on, trunk protruding hose-like, its metallic body based on a Sudanese clay corn-bin featured in an anthropological journal. Again, the figure is associated with childhood themes and stories, its title taken from a cheeky rhyme, which begins: "The elephant from Celebes has sticky, yellow bottom grease."

Ernst described collage as "the systematic exploitation of the coincidental or artificially provoked encounter of two or more unrelated realities on an apparently inappropriate plane, and the spark of poetry created by the proximity of these realities." Unlike the photomontages of the Berlin Dadaists, Ernst's surreal juxtapositions are often seamless, and the viewer's double take adds to their poetic impact.

Catherine Marcangeli

Date 1921

Country Germany

Medium Oil on canvas

Collection Tate Modern, London, UK

Why It's Key The unexpected juxtapositions of collage are carried across into painting.

211

Key Artwork *The Red Spot II*
Wassily Kandinsky

Illustrating Kandinsky's ongoing concern with equilibrium, *The Red Spot II* achieves a balance of the dual forces of color and line. Following the prominent lines visually, we can notice an upward motion on the left of the canvas counterbalanced by a downward movement on the right. This movement circulates around the central red spot that gives the painting its title. The dull, off-white background to the center of the picture allows the interplay of the colored masses to be read all the more vibrantly, simultaneously establishing a picture-within-a-picture aesthetic.

By avoiding the classic horizontal/vertical orientation of his canvas, Kandinsky is taking an important step toward complete abstraction. However, the two long, trumpet-like forms radiating from the central red spot recall his many earlier variations of *The Last Judgment* – all the more so when we notice that one of these forms is even colored a brilliant yellow – suggesting that he had not yet abandoned representation altogether.

Though we must be careful not to ascribe too much formal representation to these shapes, it is within limits to suggest that the previous theme may still have been present in the artist's mind. The work shows the influences of both Kandinsky's earlier Russian period of mystical and iconic formal abstraction and the seeds of what was to come later in the artist's Bauhaus period, defined by its rigid, pure geometrical forms and colors.

Aimee George

Date 1921

Country Germany

Medium Oil on canvas

Collection Städtische Galerie im Lenbachhaus, Munich

Why It's Key This is an important transitional work for Kandinsky, moving from abstracted representation to a more purely geometrical period.

Key Artwork *Black Quarter Circle with Red Stripes*
László Moholy-Nagy

Hungarian-born Moholy-Nagy (1895–1946) adopted art as a career after World War I, and was strongly influenced by the Constructivists – in particular Kasimir Malevich, El Lissitzky, and Naum Gabo. In *Black Quarter Circle with Red Stripes*, symmetrical forms appear to float on top of one another, thereby creating a sense of gentle motion. The work perfectly illustrates Moholy-Nagy's preoccupation with capturing light and movement by using simple forms and basic color. While working in oils, he also suggests the subtle appearance of colored stripes of paper, which are used in his many collages.

Moholy-Nagy wished, like fellow Constructivists, to create universal art forms akin to industrial design, and to this end he experimented with different media that included collage, photography, film, and plastic materials. He taught at the Bauhaus, both in Germany and at the New Bauhaus in Chicago, where he eventually settled.

Moholy-Nagy is noted as the most strident advocate of Constructivist doctrine, namely that there should be no distinction between fine art and the environment in which we live and work. He promoted his ideas both in his teaching and his theoretical writings, which include *The New Vision: From Material to Architecture* (1929) and the posthumously published *The New Vision and Abstract of an Artist* (1947).
Lucy Lubbock

Date 1921
Country Germany
Medium Oils
Why It's Key Seminal example of Constructivism.

212

Key Artist **David Alfaro Siqueiros**
Begins painting large-scale murals

David Alfaro Siqueiros was born in 1896 in Chihuahua, Mexico. At fifteen he took part in a student strike, and at seventeen fought as a sergeant in the Mexican revolutionary army. In 1919 he toured Europe on a scholarship, met Diego Rivera in Paris, and accompanied him to Italy to study Renaissance frescoes. Back in Mexico City in 1922, he painted murals for the revolutionary government, and in 1923 helped to found an artists' labor union.

By the early 1930s, however, Siqueiros' political activism had led to jail and subsequent exile. During his banishment he produced political lithographs and taught in New York, where Jackson Pollock was one of his apprentices. In 1938 he served as a colonel in the Spanish Republican Army before returning to Mexico City to paint his celebrated anti-capitalist and anti-fascist mural, *Portrait of the Bourgeoisie* (1940). In 1939 he was jailed once more, after being implicated in an attempt to assassinate Trotsky, who was then in exile in Mexico City, and again in 1960, after allegedly starting a May Day riot.

Time spent in prison was the impetus for most of Siqueiros' easel paintings. His preferred medium was the mural, ideal for his emotionally charged style, dramatic use of three-dimensional perspective, and commitment to art's public, educational, and ideological role. With his compatriots Orozco and Rivera, Siqueiros went on to exhibit at the Venice Biennale of 1950, a sign that Mexican contemporary art had finally gained international recognition.
Catherine Nicolson

Date 1922
Born/Died 1896–1974
Nationality Mexican
First Exhibited 1922
Why It's Key Committed Communist activist and pioneer of the Mexican Mural Renaissance.

opposite Rectorate of the University of Mexico City's facade with Siqueiros' high relief mosaic decoration.

Key Event
Debut of the stage play *R.U.R.*

Western art entered its period of most intense preoccupation with the machine at about the same time as the debut of the Czech playwright Karel Capek's play *R.U.R.* (Rossum's Universal Robots). The play contributed the word "robot" to the international lexicon, but was seminal for a number of other reasons, most notably that Capek inserted a strong note of cynicism and anxiety into his treatment of technology, portraying a world in which robots committed a holocaust on human beings.

The play was prophetic of things to come. The imbricated horrors of technology, warfare, and genocide became apparent only after Capek's death in 1938, when Nazi Germany started applying scientific principles of automation to the destruction of human beings. The iconic figure of the robot survived Capek and became an emblem for the hopes and fears of not only artists but also ordinary people who found themselves in increasingly mechanized environments. After Capek, robots were everywhere: in the genre of science fiction, which entered its golden age in the decades after *R.U.R.*; in painting, which increasingly made use of the motifs of mechanization and automation; in film, which had a long flirtation with the killer robot; and in sculpture, which adopted the robotic body as a new figure of inspiration.

If anything, the attitude to the robot has softened since Capek's time, with the quotidian reliance on labor-saving machines, from defibrillators to personal computers, turning the robot into a normal and domesticated reality rather than a frightening fantasy.
Demir Barlas

Date 1922

Country Czechoslovakia

Why It's Key Capek's play gave the world the term "robot" and signaled the beginning of an ongoing artistic and cultural preoccupation with the machine.

opposite A scene from Capek's *R.U.R.* (Rossum's Universal Robots).

Key Artist **Sergey Konenkov**
Travels to America for exhibition and stays for 22 years

Born into a poor peasant family in a remote village near Smolensk, Sergey Konenkov studied at the Moscow School of Painting, Sculpture, and Architecture. A travel scholarship took him to Italy, where he was profoundly influenced by the work of Michelangelo. Later, at the St Petersburg Academy of Arts, his diploma piece, the large plaster statue *Samson Breaking His Bonds* (1902) – which for Konenkov represented the Russian people's longing for freedom – outraged his examiners with its unacademic vigor.

After taking an active part in the Revolution of 1917, Konenkov turned to direct wood carving of figures from peasant folklore. In 1923 he left for a short exhibition in New York but ended up staying for the next twenty-two years, sculpting portraits of celebrated people such as Rachmaninov, Dostoevsky, Chaliapin, Pavlov, and Einstein, and creating a series of drawings on cosmological themes, which reflected his interest in religion and metaphysics.

In 1945 Konenkov was permitted by Stalin to return to the USSR. Installed in a large central Moscow studio, he initially struggled to fit his variable, personal style into the rigid conventions of postwar Soviet Socialist Realism, and his monumental, rejoicing *Liberated Man* (1947) was officially criticized for its decadence. Later, however, Konenkov's sculptures of iconic historical figures such as Socrates, Darwin, and Bach, portraits into which he could instil emotion without contravening Socialist principle, gained him the Order of Lenin. He died at ninety-seven, a recognized Hero of Socialist Labor and People's Artist of the USSR.
Catherine Nicolson

Date 1922

Born/Died 1874–1971

Nationality Russian

First Exhibited 1906

Why It's Key Famous Soviet sculptor and revolutionary hero, known as "the Russian Rodin."

Key Event
Tutankhamun's tomb discovered

After fifteen years of increasingly desperate searching, Howard Carter found the steps leading to Tutankhamun's tomb on November 4, 1922. He wired his patron, Lord Carnarvon, and on November 26, 1922, with Carnarvon's daughter also in attendance, Carter made the famous "tiny breach in the top left hand corner" of the doorway. By the light of a candle he had his first view of the best-preserved and most intact pharaoh's tomb ever found in the Valley of the Kings.

Although Tutankhamun (1341–1323 BCE) was of only moderate historical significance, the romance surrounding his youth (he died at nineteen) and the amazing treasure trove of everyday, domestic items found in his tomb brought his life into sharp, three-dimensional focus. Across the world, newspaper readers goggled at the array of unique artefacts brought out of the tomb and designers were quick to adopt the motifs of the ancient Egyptian culture.

Hieroglyphics, lotus flowers, the scarab beetle, sphinxes, and colors such as "Nile green" were incorporated into everything. In jewelry design, gold and lapis lazuli dominated taste. Although more influential in the United States than Europe, Parisian designers such as Gustave Beer saw that every element of a woman's outfit was touched by the Egyptian look during the 1920s. Shoe shops advertised the Egyptian look in the *New York Times*, one article proclaiming a "complete change in furniture, decorations, jewellery and women's dress... as a result of the discoveries in the tomb of Tutankhamun."

Mike von Joel

Date November 4, 1922

Country Egypt

Why It's Key The discovery by Howard Carter of Tutankhamun's tomb received worldwide press coverage and sparked a rabid public interest in all things related to ancient Egypt.

opposite A porter carrying a bust of King Tutankhamun away from the tomb.

Key Person **Hans Prinzhorn**
Publishes book on art produced by the mentally ill

Hans Prinzhorn studied art history and philosophy at the University of Vienna and trained in medicine and psychiatrics during World War I. Between 1919 and 1921, he assisted Karl Wilmanns at the Heidelberg Psychiatric Clinic, expanding a collection of art created by patients. In 1912 Paul Klee had written to the magazine *Die Alpen*, saying: "The works of the alienated should be taken more seriously than all the museums of fine art together if we want to reform art today." Prior to Prinzhorn, the Italian Cesare Lombroso and French author Marcel Reja had also both investigated the dynamic of "outsider art." In 1922, Prinzhorn published his first and most influential book, *Artistry of the Mentally Ill*, illustrated from the Heidelberg collection, and the term Outsider Art was devised. The art world was immediately supportive – Kandinsky kept a copy in the Bauhaus library – and Prinzhorn's own responses to the German Expressionists are self-evident. He likens the art of the avant-garde to the "nature of schizophrenic configuration," citing a preoccupation with a "decisive turn inward upon the self," coupled with the "free treatment of the outside world [as] raw material to be reordered according to individual intentions."

He strove to view the work of the outsider using the same methodology as applied to the masters, asserting that "the most sovereign drawing by Rembrandt [and] the most miserable daubing by a paralytic are both valid expressions of the psyche." Prinzhorn's work was reassessed in the late twentieth century and its significance appreciated.

Mike von Joel

Date 1922

Born/Died 1886–1933

Nationality German

Why It's Key This seminal publication married an art-historical perspective with formal psychiatric analysis to assess the creativity of people who were mentally ill.

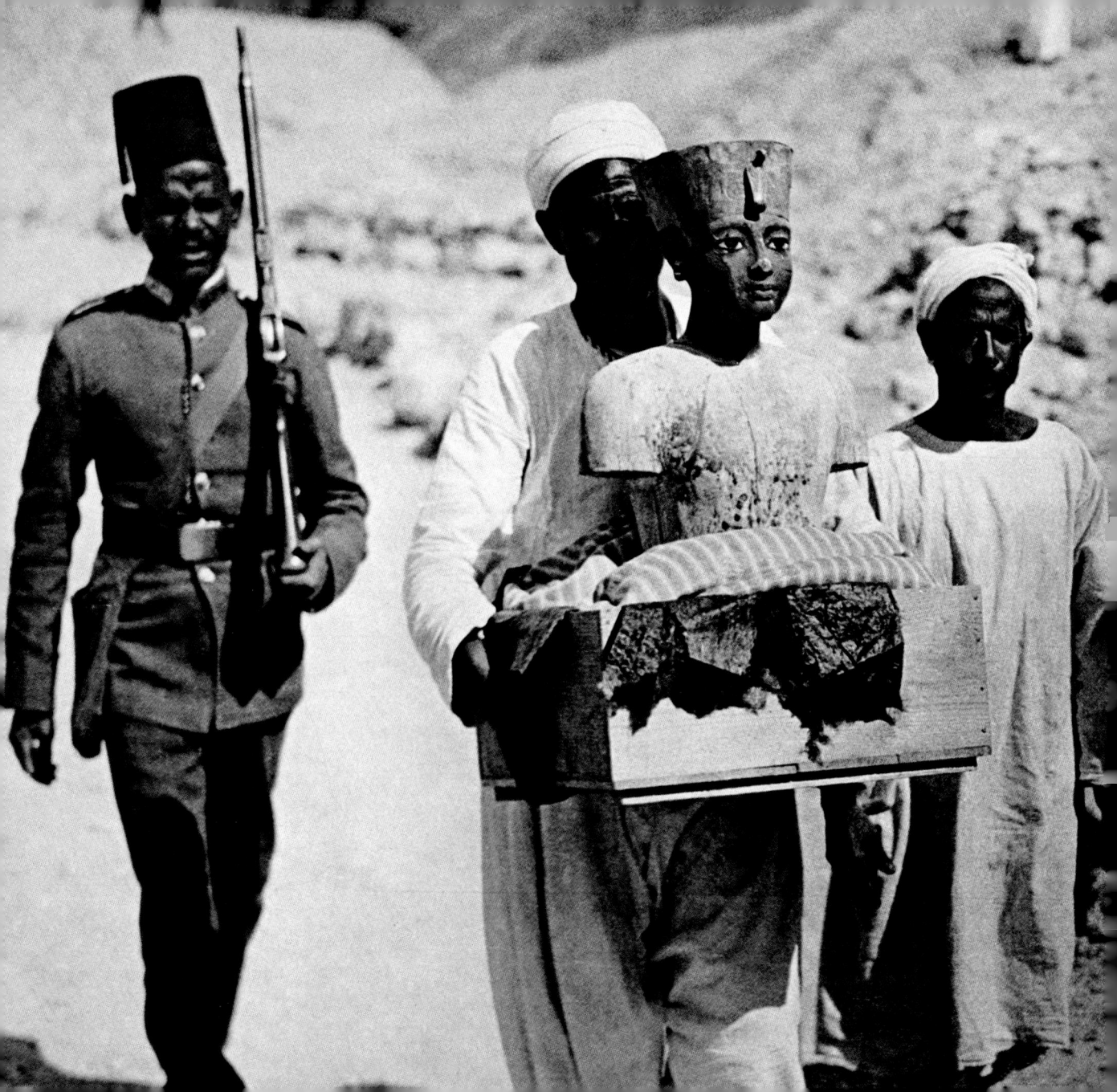

Key Artwork *Dedicated to Sadomasochists*
Otto Dix

At twenty-three, Otto Dix (1891–1969) began to serve in World War I, and remained on the front lines for the next four years, winning the Iron Cross (second class) and nearly dying when a shrapnel splinter hit him in the neck. Dix's uninterrupted experience of war, death, and trauma – almost unique among artists of his day – completely transformed his early work, which was of ordinary landscapes and objects from his native Thuringia. After 1918, Dix's imagination focused on the grisly absolutes of life and death, from the undisguised horror of war-torn bodies on the one hand to the specter of sex on the other.

Dedicated to Sadomasochists combines Dix's mature interests in a single painting of mortally injured and violated women. A palpable sense of horror pervades not only the painting but also extends to the real world, as Dix's title reminds us of actually existing violence and chillingly indicates his awareness of it.

Dix's violent sexual imagery is not documentary but stylized, indicating that he is attempting in some way to make friends with horror, or perhaps that horror has taken over his senses and is exercising its own imagination in *Dedicated to Sadomasochists*. However, it is precisely Dix's casual willingness to comb the horrific for emotional and stylistic details that makes his work unforgettable.

It is ironic that Dix came under censure by the Nazis, who labeled him as a "degenerate," because his postwar work anticipates, on a small scale, the spirit of the Nazi regime and the waiting horrors of World War II.
Demir Barlas

Date 1922

Country Germany

Medium Watercolor

Collection Private collection

Why It's Key Dix created some of the most disturbing images in art since Goya.

Key Artist **Gaganendranath Tagore**
Starts to follow Cubism trend

Gaganendranath Tagore, the nephew of poet and Nobel Prize winner Rabindranath Tagore, was an early innovator in Indian art, departing from both English colonial models and the Persian style of portraiture brought to India by its Central Asian conquerors. Tagore, who hailed from a wealthy and cosmopolitan family, followed the example of his uncle by sampling and assimilating global artistic influences while retaining inspiration from his native Bengal.

Initially trained in Western watercolor painting, Tagore moved on to experiment with Japanese influences before World War I. Afterwards, he was exposed to French art, Cubism in particular. He appears to have been particularly struck by a Kandinsky exhibition in Calcutta in 1920, and in 1922 he began to paint in the Cubist style. In doing so, he followed the path of many artists who, despite being geographically disconnected from the context of modern painting, nonetheless took up its spirit. Tagore was no doctrinaire emulator, however; while adopting Cubist techniques, he painted fantastic subjects, blending the pre-modern legacy of Indian mythology, and the postmodern techniques emerging from Paris, in a single canvas.

While Tagore did not leave behind a school after his death in 1938, his imaginative adoption of Cubism transformed him into the spiritual patron of future Indian artists who wished to embrace the syntax of Western art without jettisoning their native heritage. His fame also brought new developments in Indian art to the attention of European and American audiences.
Demir Barlas

Date 1922

Country India

Why It's Key The adoption of a modernist and European art form by a member of India's most prominent artistic family closed the cultural gap between East and West.

Key Exhibition
First Choson Art Exposition

The Japanese colonial rule of Korea, which extended from 1910 to 1945, is a bitter memory for Koreans. This period of colonial rule saw not just the political but also the aesthetic subjugation of Korea. For example, from 1922 to 1944, the colonial Japanese authorities both sponsored and judged the Choson Art Exposition, a salon-based exhibition that presented works grouped into East Asian art, Western art, and calligraphy.

The Choson Art Exposition showcased not only the work of Japanese artists resident in Korea, but also the work of Koreans themselves. This might appear to be a rare opportunity for Koreans during the period of Japanese rule, which saw many Koreans ordered to adopt Japanese surnames, forced into labor camps, and even conscripted as prostitutes for the Japanese army. However, the Choson Art Exposition neglected traditional models of Korean art and focused on Japanese art instead, circumscribing the amount of creative freedom allowed to Korean artists. In this way, the Choson Art Exposition was a mechanism of subordinating Korean aesthetic and political expression to a Japanese paradigm.

The impact of the Choson Art Exposition was minimal: after the expulsion of the Japanese and the end of the Korean War, North Korea adopted Russian and Chinese aesthetics, while the South Korean art scene returned to the traditional forms and sensibilities that had been suppressed under the Japanese. Accordingly, the Choson Art Exposition is remembered not for its artistic impact but as another imperial episode in the history of Japanese-occupied Korea.
Demir Barlas

Date Annually from 1922 to 1944

Country Korea (now South Korea)

Why It's Key Imperial Japan attempts, unsuccessfully, to force its understanding of art on Korea.

Key Artist **Mary Riter Hamilton**
Honored for her paintings of war-torn France

Mary Riter Hamilton was born and brought up in rural west Canada. Widowed at only twenty-three, she started up a successful china-painting school, then studied art in Toronto. In 1901 she studied with Skarbina in Berlin, moving on in 1902 to the Vitti Academy in Paris, where from 1905 her work was regularly accepted by the Salons.

In 1919 the Amputations Club of British Columbia commissioned Hamilton to paint European battlefields for a veterans' magazine, *The Gold Stripe*. Between 1919 and 1922, she made her home in French and Belgian No Man's Land alongside the Chinese workers shipped in to clear the detritus of war, enduring with them bitter weather, meager food, contaminated water, and makeshift shelters surrounded by rats, rotting corpses, and unexploded shells.

In this desolation Hamilton created over three hundred heartfelt, painfully resonant oil and watercolor paintings on canvas, paper, card, and plywood. These she refused to sell, regarding them as her nation's tribute to its fallen soldiers, but they were shown in 1922 and 1923 in London, Paris, and Amiens, where she was awarded the purple ribbon of Les Palmes Académiques by the General Council of the Somme. She is the only Canadian artist ever to have received this honor.

In 1926, poor, ill, and blind in one eye, Hamilton returned permanently to Canada, where she died in obscurity in 1954, having donated most of her battlefield paintings to the Public (now National) Archives in 1925.
Catherine Nicolson

Date 1922

Born/Died 1873–1954

Nationality Canadian

First Exhibited 1905

Why It's Key Painter of unique but little-known series of World War I battlefield landscapes.

Key Artist **Oskar Schlemmer**
Triadic Ballet performed at Weimar Bauhaus

The *Triadic Ballet* was a dance sequence Oskar Schlemmer had developed from Cubist ideas formulated as early as 1914. It premiered in Stuttgart in 1922, with music composed by Paul Hindemith. Embryonic performances dated back to 1916, with actors Elsa Hotzel and Albert Berger. It comprised three acts, with three participants (two male, one female), twelve dances and eighteen costumes. Each act had a different color and mood: the first was set against a lemon-yellow background, the second, on a pink stage, and the final act had a black setting intended to appear mystical.

In 1920, Schlemmer was invited to Weimar to run the Bauhaus sculpture department and stage workshop. His work with the theater department resulted in another production of the *Triadic Ballet* in 1923 and it was a great success. Using three dancers dressed in puppet-like costumes before various backdrops, it became the most widely performed avant-garde dance. Schlemmer reworked his figures into geometric forms. He found puppets and marionettes aesthetically pleasing. The human form reduced to abstract geometry led to the costume design, creating what he called his "figurines." The music followed, then finally, the dance movements. The "figurines" were shown in 1930 at the Société des Arts Decoratifs (Society of Decorative Arts), Paris, and in 1938 at the Museum of Modern Art's Bauhaus Exhibition in New York.

Persecuted by the Nazis, Schlemmer led a reclusive later life and, in 1942, made the small series of eighteen mystical *Fensterbilder*.

Mike von Joel

Date 1923

Born/Died 1888–1943

Nationality German

Why It's Key Although a Bauhaus polymath (painter, sculptor, teacher, dancer, composer, designer of jewelry and furniture), it was Schlemmer's famous dance that was to influence future generations.

opposite A group of students and teachers at the Bauhaus in Weimar. Schlemmer is left, second from the top.

220

Key Artist **Chaim Soutine**
Works bought by collector Alfred C. Barnes

Chaim Soutine was born in Smilovich, in what is now Belarus. After early studies in Minsk, he was admitted to the school of fine arts in Vilnius, Lithuania. In 1913 he went to Paris where he entered the Ecole des Beaux-Arts. He also worked in the Louvre, where he studied the work of the Old Masters.

He settled in La Ruche (the beehive), the artists' colony in Montparnasse. There he absorbed contemporary ideas and met influential artists, one of whom was Modigliani, who became a loyal friend and mentor. The cheap rents of the Ruche studios attracted artists from all over the world, most of whom – including Modigliani and Soutine – were Jewish. They came to be known as the Ecole de Paris.

Assimilating contemporary formal concerns with the work of the Old Masters, such as Rembrandt, Soutine applied the unrealistic colors of the Fauves, with impassioned brush strokes of thick impasto, to Cézanne-inspired compositions. The influence of German Expressionism is evident in his emotionally charged interpretations of traditional genres. And his artistic legacy to the American Abstract Expressionist painters has been well documented.

Soutine's most productive period, between 1919 and 1929, was spent in Céret in the Pyrenees, Cagnes on the French Riviera, and Paris. During this period, many of his paintings attracted, and were bought by, Alfred Barnes. By the 1930s, increasing depression had reduced his output. The Nazi occupation during World War II forced Soutine into hiding, during which time a perforated ulcer resulted in his death.

Sarah Mulvey

Date 1923

Born/Died 1893–1943

Nationality Russian

Why It's Key By purchasing a large number of Soutine's paintings Barnes helped Soutine's reputation grow and his work was bought by other wealthy collectors such as Madeleine and Marcellin Castaing, thus ensuring his financial success.

1920-1929

Key Exhibition
Primitive Negro Art

Primitive art enjoyed a long vogue in Europe, where it was championed by Picasso, but it was not until 1923 that the high-profile Primitive Negro Art exhibition at the Brooklyn Museum put this form of creative activity in the American spotlight. The exhibition, consisting of artefacts bought by Brooklyn Museum curator Stewart Culin in Europe, featured sculpture, masks, textiles, clothing, musical instruments, weapons, and other items then in common use in Central Africa, particularly the Belgian Congo.

While the Brooklyn Museum could have chosen to portray the exhibition as an ethnological curiosity, Culin took significant pains to explain that the purpose of the exhibition was to consider the assembled African artefacts as art. Culin himself was enamored of the African aesthetic, which he described in the exhibition catalog as originating from "fresh and direct observation of nature" that resulted in "an exceptional, amazing, living art."

Primitive Negro Art was a hit with the museum-going public and with the press, which duly reported on the wealth of art gathered at the Brooklyn Museum. The exhibition undoubtedly accelerated Americans' knowledge and appreciation of African art. For his part, Culin put a great deal of effort into selecting the finest pieces of art from among the five thousand pieces available, and rigged up an imaginative and meticulous installation that took advantage of all available wall and floor space. Many of the items from the original exhibition remain in the Brooklyn Museum's long-term installation, The Arts of Africa.

Demir Barlas

Date April 11–May 20, 1923

Country USA

Why It's Key Seminal show of African art.

opposite Gallery view of the Primitive Negro Art exhibition at the Brooklyn Museum.

Key Artwork *The Bride Stripped Bare by Her Bachelors, Even* Marcel Duchamp

Avant-garde artist Marcel Duchamp (1887–1968) brought a sense of humor to much of his work, but *The Bride Stripped Bare by Her Bachelors, Even* (most often called *The Large Glass*) is an exception. Made over the course of eight years on two large glass panels, *The Bride Stripped Bare* is at least a mournful comment on the impossibility of intimacy or at worst a depiction of a disembodied, apocalyptic world.

Much has been excavated out of the abstraction of *The Bride Stripped Bare*, in which two separate panels depict a bride alone and subsequently in the presence of her suitors, who are merely items of clothing suspended from a machine. Figuration is here reduced to the merest and most disturbing suggestions: a torn cloth, perhaps, for the bride; clothes for people; and unknown machine-like artifacts everywhere. These dynamics have suggested torture, masturbation, consumerism, and hanging to observers determined to render the figuration pliable, but *The Bride Stripped Bare* does not conform to any simple explanation of its dynamics beyond its frightening insistence on separation and alienation.

The Bride Stripped Bare is, in its barest form, a map of thwarted and impossible desire. The map might confirm a personal landscape – after all, Duchamp dressed as a woman for Man Ray's photograph "Rrose Sélavy," and was figuratively unable to unite Rrose and her suitor, Marcel Duchamp, in the same space. Or it might signify a larger topology of family, marketplace, or country. That desire is thwarted everywhere is a fact in favor of *The Bride Stripped Bare* and its frustrations.

Demir Barlas

Date 1915–1923

Country USA

Medium Oil, varnish, lead foil, lead wire, and dust on two glass panels

Collection Philadelphia Museum of Art, Philadelphia, USA

Why It's Key This seminal work, which consumed Duchamp, encapsulates many of the artist's ideas on art and is notorious for being enigmatic.

Key Event
First issue of *LEF* magazine

As economic policies began to change in the revolutionary Russia of the 1920s, so too did artistic trends, which were evident in a more conservative approach. *LEF* (Left Front of the Arts), the journal of Constructivist artists and writers, reflected these changes. *LEF*'s founders included the revolutionary poet Vladimir Mayakovsky, who was its editor in chief, Osip Brik, Boris Arvatov, and Sergei Tretyakov. Its editorial aim was to promote the Constructivist principles of the Productivists as the model for Socialist art.

LEF argued that painting pictures was not relevant to the revolution, and that skills should be applied to making new objects with new materials. All art, it said, should be utilitarian, the product of enterprises such as textile and clothing design, product and graphic design,

architecture, and especially film and photography. Instrumental in designing the layouts and covers of the magazine was the Constructivist artist Alexander Rodchenko, who used his experimental integration of typography and photomontage.

The first issue of *LEF*, which saw itself as a revolutionary platform for the arts, appeared in 1923, carrying its first three declarations under the headings: What is LEF Fighting For?; What is LEF Getting Its Teeth Into?; and Who is LEF Alerting? The journal was short-lived, existing as *LEF* from 1923 until 1925, reappearing in 1927 as *New Left Front of the Arts*, but surviving only until the end of 1928.

Sue King

Date 1923

Country Russia

Why It's Key An important Constructivist review which used some of Alexander Rodchenko's most innovative graphic designs.

Key Artist **Béla Kádár**
Shows work in Berlin at Herwarth Walden's gallery

Béla Kádár was born into a poor Jewish family in Budapest in 1877. After the early death of his father, his schooling was cut short and he was apprenticed as an iron-turner. Later he studied at the University of Fine Arts in Budapest and worked as a muralist. By 1910 he had already visited Berlin and Paris twice to acquaint himself with the European avant-garde, and in 1918 he left Hungary permanently.

Kádár first exhibited with his friend Scheiber in Vienna in 1919. Four years later, he took part in a group exhibition at the avant-garde publisher Herwarth Walden's Berlin gallery Der Sturm (The Storm). There he met Katherine Dreier of the Société Anonyme, who arranged two exhibitions for him at the Brooklyn Museum of Art. Kádár traveled to New York for the second of these, in September 1928.

In Berlin Kádár developed a gentle, romantic vision that combined scenes from Hungarian folk tales and peasant life with Expressionist and Surrealist fantasy, expressed in a decoratively flattened perspective. Sampling many brands of avant-garde style without committing to the formal demands of any, this work had great charm and became very popular.

In 1937, Kádár featured in the Nazi exhibition Entartete Kunst (Degenerate Art) and, after the German invasion of Hungary, was sent to the Budapest ghetto, where he was reduced to drawing and annotating scenes of ghetto life on the local doctor's prescription forms. He died in Budapest in 1955.

Catherine Nicolson

Date 1923

Born/Died 1877–1955

Nationality Hungarian

First Exhibited 1919

Why It's Key Pioneer Hungarian modernist and eclectic sampler of the avant-garde.

Key Artist **Miguel Covarrubias**
Influential Mexican illustrator arrives in New York

The Mexican Revolution of 1910 focused the United States' interest on its southern neighbor and, after the emergence of modern Mexico in 1917, sparked a period of cultural exchange between the two countries. The young Mexican artist Miguel Covarrubias was a fascinating, if unjustly forgotten, part of this exchange.

At the age of nineteen, Covarrubias arrived in New York with a vast talent for caricature in tow and soon found backers. Frank Crowninshield, editor of the popular magazine *Vanity Fair*, tapped Covarrubias to produce a series of caricatures for the magazine's Impossible Interview series. Covarrubias also went on to illustrate books by poet Langston Hughes, and composer W.C. Handy, the so-called "father of the blues."

Covarrubias' *Vanity Fair* caricatures remain one of the most celebrated elements of his oeuvre; he managed to infuse them with comic accuracy, striking color, and a sense of naïve or magical reality reminiscent of both Surrealism and Henri Rousseau. Covarrubias lent a modernist credibility to the hitherto stale genre of the caricature, and provided inspiration for Al Hirschfeld and other American artists. He returned to Mexico in the 1930s, where he taught and painted for much of the rest of his life.

Covarrubias' work was not prominently exhibited until nearly thirty years after his death, but has begun to attract increasing attention of late. In retrospect, Covarrubias deserves more serious consideration than was afforded him during his lifetime, not only as one of the most talented Mexican artists of the past century, but also for his universal caricatures.

Demir Barlas

Date 1923

Born/Died 1904–1957

Nationality Mexican

First Exhibited 1984

Why It's Key Breathed life into the genre of the caricature in influential U.S. magazines, providing inspiration for American artists such as Al Hirschfeld.

Key Exhibition
Exhibition of New Art

Constructivism, the artistic movement most deeply associated with the aesthetic of Russian Communism, became institutionalized some years after the October Revolution of 1917 and spread quickly to other European countries. Poland, various parts of which had been absorbed by Russia for centuries, was particularly quick to adopt Constructivism. The official mark of this adoption came with the June 1923 Exhibition of New Art in Wilno, Poland (now Vilnius, Lithuania).

The exhibition, organized by Polish artist and theoretician Wladyslaw Strzeminski, was nominally given over to Constructivism (and its cousin, Suprematism), but also included examples of Cubism. More problematically for the nativist Polish Right Wing, the exhibition opened the door to several artists from Russia (such as Wassily Kandinsky) and Germany (a naturalized Paul Klee), and counted a number of Jews among its contributors. Although the deliberately cosmopolitan nature of the exhibition raised hackles in the Polish press, it continued to Lodz later in 1923.

The Exhibition of New Art was a high point of unity in a Polish Constructivist movement that would soon splinter into many factions. Strzeminski himself would adopt Unism, the flow of Russian artists and ideas would be limited by Stalin's crackdown on art, and the Nazi invasion of Poland would remove modernist experimentation from the country's list of priorities. But in 1923 it still seemed plausible that a combination of rationality, practicality, and machine-enabled utopia might yet turn Poland into a Constructivist paradise.

Demir Barlas

Date June, 1923

Country Poland (now Lithuania)

Why It's Key Marks the launch of Polish Constructivism.

Key Artist **László Moholy-Nagy**
Appointed to teach at the Bauhaus

For László Moholy-Nagy, 1922 was the year that marked both the start of his public artistic career and that of his life-long engagement with the Bauhaus. He started to make art while enlisted in World War I, and later seriously began his artistic career in Budapest and Vienna, finding himself mostly drawn to Constructivist theory.

He moved to Berlin in 1920, where he worked as a correspondent for the Hungarian avant-garde magazine *MA* and made ties with some of the Dadaists who circulated around the Der Sturm gallery. It was there in 1922 that Moholy-Nagy was granted his first solo show, which was visited by Walter Gropius, the director of the Bauhaus. In 1923, Gropius appointed Moholy-Nagy to succeed to Johannes Itten as leader of the preliminary course at the Weimar school.

Moholy-Nagy shared the teaching of the course with Josef Albers, who took over the practical aspects while he taught the theory. His course had three main focuses: tactile perception, the distinction between composition and construction, and three-dimensional study. Key to his teachings and the ideology of the Bahaus was a balance between rational thought and intuition, as he illuminated in *Vision in Motion*, published in 1947, the year after his death.

It was largely thanks to Moholy-Nagy that the Bauhaus found new life in the United States after closing down in Dessau in 1933; in 1937 he took on the directorship of the New Bauhaus school in Chicago and continued its aims in the School of Design, which he founded in 1939.

Chiara Marchini

Date 1923

Born/died 1895–1946

Nationality Hungarian

First Exhibited 1922, Der Sturm gallery, Berlin

Why It's Key Moholy-Nagy was to articulate and then help propagate Bauhaus ideology after the school's closure in Dessau.

1920-1929

227

Key Artist **Georgia O'Keeffe**
Petunia No 2, her first large-scale flower painting

Born in Sun Prairie, Wisconsin, O'Keeffe studied at the school of the Art Institute of Chicago in 1904, and at the Art Students' League of New York three years later. She taught art in Texas from 1913 to 1918.

In 1916, American photographer and art gallery director Alfred Stieglitz – with whom O'Keeffe was romantically linked and later married – showed an interest in her abstract drawings. That same year, he exhibited them in his famous gallery in New York, the 291, marking a turning point in her career.

In 1923, Stieglitz held a major exhibit of O'Keeffe's work at the Anderson Galleries, the first of many of her showings. The following year, she painted a large-scale flower, *Petunia No 2*, in a style which would become her hallmark. The details of the flower are so enlarged that they become unfamiliar and abstract.

In 1929 Beck Strand, a friend and fellow modernist, invited O'Keeffe to New Mexico, where she found new inspiration for her large-scale paintings. She started collecting and painting bones, and two years later painted *Cow's Skull, Red, White and Blue*. In 1931, she suffered a nervous breakdown, and in 1949, three years after Stieglitz's death, she moved permanently to New Mexico, where she met fellow artists Frida Kahlo and Miguel Covarrubias in 1951.

In the 1960s, inspired by aircraft flights, she introduced elements of the sky and clouds into her paintings. One of her largest works was *Sky above Clouds* (1965). She died aged ninety-eight in Santa Fe.

Kate Mulvey

Date 1924

Born/Died 1887–1986

Nationality American

Why It's Key In her large-scale flower paintings, O'Keeffe created representational art which at the same time appeared abstract.

opposite Georgia O'Keeffe

Key Artwork *Violin of Ingres*
Man Ray

Man Ray (1890–1976, born Emmanuel Radnitzky), the photographer most closely associated with Surrealism and the international avant-garde that flourished after World War I, contributed many iconic images to posterity, but perhaps none was as seminal as his *Violin of Ingres*.

The photograph is of Man Ray's model and mistress Alice Prin, better known as Kiki de Montparnasse. Kiki, whose sobriquet was itself an allusion to sex, is here seen from the back in the style of a turbaned Ingres nude, but she features Ray-painted f-holes that suggest she is a human cello. The image is at once playful, bourgeois, and pornographic, depicting not simply the readiness with which Kiki's body can be turned into a possession but also the undeniable wit of the man who saw her that way.

While *Violin of Ingres* was later domesticated, even providing inspiration for a pop music video in the 1980s, it remains a transgressive image precisely because its artistry, humor, and cooperative subject clash with its petty-minded perversity. In this way *Violin of Ingres* is not just Kiki's backside but pleasure itself, a pleasure that cannot be easily untangled from themes of subjugation, submission, and domination. This is at least an honest complexity that distances itself from the occluded sexual politics of classical nude painting.

In an unexpectedly helpful way, Ray lays bare the dark superstructure of sex, pleasure, and relationships, and it is this conceptual vista, as well as the photograph's startling aesthetic, that keeps *Violin of Ingres* fresh and relevant.

Demir Barlas

Date 1924

Country USA

Medium Photograph (gelatin silver print)

Collection Worcester Art Museum, Massachusetts, USA

Why It's Key This is a seminal modernist image of the influential and innovative photographer Man Ray.

opposite Violin of Ingres

Key Artist **Otto Dix**
Publication of *The War* prints

Otto Dix was born in Untermhaus, Germany. After an apprenticeship with a painter-decorator, he attended the Dresden School of Decorative Arts, from 1909 to 1914. His education was interrupted by four years of fighting in the German army in World War I, during which time he produced six hundred drawings and gouaches on what he saw in the trenches. He then attended the Dusseldorf Academy from 1919 to 1922.

Initially Dix was influenced by avant-garde art movements such as Cubism and Futurism, and by the paintings of van Gogh. For a short period he experimented with Dadaist collages, through which he criticised the state's neglect of war veterans. But after World War I, in common with artists across Europe, he adopted a realist style of painting which, with the work of George Grosz, was termed Verist. In 1925 he

exhibited in the Neue Sachlichkeit (New Objectivity) exhibition in Mannheim. His work of the 1920s constituted a powerful attack on war, and on the poverty, corruption, and decadence rampant in the Germany of the Weimar Republic.

In 1933, when the Nazis came to power, he was forced to resign from his teaching post at the Dresden Academy and was not allowed to show his work in Germany, although he continued to exhibit abroad. He was exiled to the countryside and forced to choose less controversial themes. Some of his anti-war paintings were shown in the Nazis' 1937–38 touring exhibition of Degenerate Art. Dix returned to a more painterly, Expressionist style in his later work.

Sarah Mulvey

Date 1924

Born/Died 1891–1969

Nationality German

Why It's Key Dix's provocative set of etchings, entitled *The War*, are important depictions of the grotesque horrors of war, likely to have been influenced by Goya's *Desastres de la Guerra* (*Disasters of War*, 1810–1820).

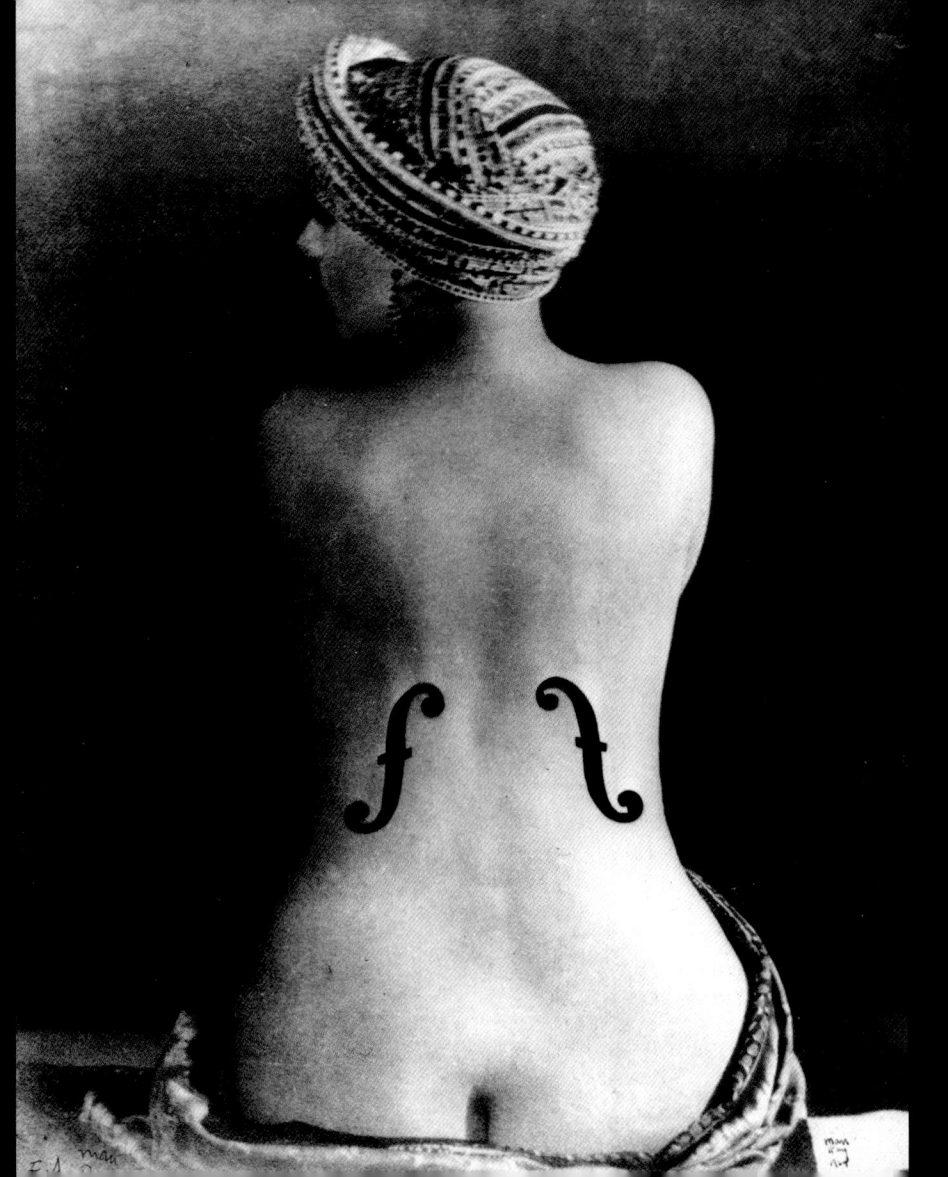

Key Person **André Breton**
Poet and author publishes the Surrealist Manifesto

Breton shared Dada's transgressive contempt for bourgeois society's belief in reason and progress. However, his anti-rationalism had more to do with a fascination for the workings of the unconscious. During the war, while posted in a psychiatric hospital, Breton had read Charcot's work on hysteria and Freud's *Interpretation of Dreams*, and was struck by the poetic potential of mental patients' disorders.

Breton, and his circle of poets and artists gathered around the magazine *Littérature*, looked for ways of bypassing the control of the conscious mind. In 1920, Breton and Soupault published *Magnetic Fields*, a seminal experiment in automatic writing. Collective creation was also encouraged in Exquisite Corpses, a variation on the parlour game of Consequences, whereby each player wrote or drew on a sheet of paper, folded it, and passed it on for the next person to continue, producing mysterious sentences such as "The exquisite corpse will drink the new wine." Word association games were also meant to give access to a surreality unhindered by reason or prejudice. As for dreams, they were considered as the "royal path" that led to the unconscious.

Chance played a crucial part in the creation of a new kind of beauty, inspired by Lautréamont's description of a "fortuitous encounter of an umbrella and a sewing machine on a dissecting table." Collage, the use of found objects, and dreamlike juxtapositions were part of this new surreal aesthetics which, as Breton insisted in his 1924 Manifesto, aimed to free the imagination in order to transform society as a whole.
Catherine Marcangeli

Date 1924

Born/Died 1886–1966

Nationality French

Why It's Key In his Manifesto, the "Pope of Surrealism" laid out the values and principles of the movement.

Key Artist
Jack B. Yeats

Although born in London, the son of the Irish portrait painter John Butler Yeats and brother of the poet W. B. Yeats, Jack B. Yeats grew up from the age of four in Sligo, Ireland. He went back to England to study at the Westminster School of Art in 1888, and found a fascination for the circus and horses, which inspired many of his most familiar works.

His early professional success was as an illustrator; in 1894 he produced the first cartoon strip version of Sherlock Holmes. Contributions followed to the *Manchester Guardian*, the *Daily Graphic*, *The Sketch* and Cassell's *Saturday Journal*. He featured in *Punch* magazine under the pseudonym W. Bird, and also edited and illustrated two monthly publications, *Broadsheet* (1902–03) and *Broadside* (1908–15). After success with drawing and watercolors, he switched to oils in the early years of the new century, and they remained his favorite medium, being laid on in thicker and thicker layers. He spent five years in the United States before returning to Dublin in 1910.

Fellow playwrights admired Jack: J.M. Synge was a walking companion who benefited from his illustrating skills, and Samuel Beckett admired how in Yeats' novel *The Amaranthers*, "the artist takes things to pieces and makes new things." His paintings graced many book covers such as James Joyce's *Dubliners*, Eilis Dillon's historical novels, and the Dublin telephone book.

Yeats's self-penned epitaph insists about his life: "We can say/ with that vanity which takes the place of/ self-confidence, even though we went without/ tickets we never were commuters."
Bill Bingham

Date 1924

Born/Died 1871–1957

Nationality Technically British, but lived most of his life in Ireland.

Birth name Jack Butler Yeats

Why It's Key Versatile painter, illustrator, and playwright, and brother of the renowned Irish poet W.B. Yeats.

Key Artist **José Clemente Orozco**
Debut as one of Mexico's leading political muralists

Along with Diego Rivera and David Alfaro Siqueiros, José Orozco was one of modern Mexico's leading politically motivated artists. Influenced from an early age by the work of the satirical illustrator José Guadalupe Podsada, from the start of Mexico's decade of revolutionary upheavals in 1910, he took a powerful moral stance in his work. A political cartoonist first, in 1912 he became a watercolorist, tackling what was to become one of his favourite themes: prostitution as a emblem of human exploitation. His series of pictures, *The House of Tears*, attracted much criticism at home and ultimately prompted him to relocate to the United States. There he produced little, returning to Mexico to create his first murals between 1923 and 1924.

The dramatic, cartoon-like nature of his frescoes for the National Training School again attracted criticism and most were destroyed or changed later. Only two survived: *Maternity* and *The Rich Banquet While The Workers Quarrel*. All were unequivocal statements of Orozco's fierce humanitarianism.

His second sojourn in the United States, from 1927 to 1934, was a happier one, producing a number of well-received murals. His outstanding series for Dartmouth College, New Hampshire, reflects an even more polarized and dramatic vision, contrasting a hellish capitalist society with a lyrical view of a pagan heaven.

Returning to Mexico something of a hero at last, Orozco worked from 1934 until his death in 1949 on ever more violently expressive works cataloging human misery and social injustice.

Graham Vickers

Date 1924

Born/Died 1883–1949

Nationality Mexican

First Exhibited 1912

Why It's Key Created controversial frescoes for Mexico's National Training School.

Key Artist **Xul Solar** Becomes involved with the avant-garde Florida (aka Martin Fierro) group

The artist hiding behind this intriguing pseudonym was a brilliant figure in Argentinean intellectual circles. A close friend of the writer Jorge Luis Borges, Solar was a painter, linguist, sculptor, writer, and an inventor of languages. Born to a Latvian father and an Italian mother, he developed an interest in languages from a very early age. In 1912, he boarded a ship for Europe and spent the next twelve years traveling on the continent. There he studied the painters of the Blaue Reiter, who strongly influenced his style.

Upon his return to Argentina in 1924, Solar met Eval Méndez, director of the avant-garde magazine *Martin Fierro*, whose contributors included Ricardo Güiraldes, Norah and Jorge Luis Borges, and other members of the Argentinean artistic world. The magazine and the eponymous group (also called Gruppo Florida) that derived from it, aimed at reconciling Argentinean national tradition with the modern aesthetics coming from Europe, especially the art for art's sake doctrine. Solar contributed as a painter and writer. At that time, he also developed a strong interest in philosophy, astrology, and religion, especially Buddhism.

Mostly famous for his pictorial work, Solar was the embodiment of the modern humanist, using his mind and imagination in an attempt to improve humanity. He developed a technique to learn piano in a third of the time that it normally takes, and he also created languages including the Panlengua, hoping that their universalism would improve communication between different civilizations.

Sophie Halart

Date 1924

Born/Died 1887–1963

Nationality Argentinean

Birth Name Oscar Augustin Alejandro Schulz Solari

Why It's Key One of the most important protagonists on the Argentinean cultural stage in the twentieth century.

Key Artwork *Paddock at Deauville*
Raoul Dufy

A painter whose life and personality were reputed to be as pleasant as his paintings, Raoul Dufy (1877–1953) found inspiration in the scenery of his native France. Born in the northern city of Le Havre, he moved to Paris in 1900 to study at the Ecole des Beaux-Arts, where he was influenced by the Impressionist landscapes of Camille Pissaro and Claude Monet. However, in 1905, his works began to reflect the vibrant colors and energetic brushstrokes of the emerging Fauvist movement.

Throughout the evolution of his styles, his works continued to present visually pleasing depictions of French life and culture, including luxurious recreational events such as regattas on the French Riviera and Parisian street parades. With *Paddock at Deauville* in 1924, he began to explore the theme of the horse

races, a theme that would continue to re-emerge in his works until his death.

The racetrack provided him with a variety of subjects to depict, from the pre-race festivities to the excitement of the crowd during the race. These scenes further allowed him to explore the relationship between color and movement, fusing the colors of the background while distinguishing individual figures with outline, as displayed in his depiction of the horses and riders in this work. The brilliantly delightful colors, including the deep reds, blues, and greens, further contribute to the picture's sense of recreational fun and enjoyment.

Heather Hund

Date 1924

Country France

Medium Oil on canvas

Collection Private collection

Why It's Key The first of Dufy's paintings to depict the horse races, which would come to be a popular theme in his works.

232

Key Artist **Edward Hopper**
House by the Railroad establishes an iconic style

A painter and a printmaker, Edward Hopper studied at the New York School of Art under Robert Henri. After exhibiting and selling a painting at the 1913 Armory Show (a major Manhattan art event that was to become a milestone in twentieth-century American culture) Hopper chose to make his living as a commercial artist until 1924, when he turned again to painting. The following year he produced the extraordinary *House by the Railroad*, a painting depicting an ornate antebellum house, complete with columns, standing in isolation next to a railway line. It set the tone for a lifetime of work that would most often be defined by bleak cityscapes, usually populated by just one or two disconnected individuals.

Hopper's work was quick to gain popular acceptance, and by 1933 the Museum of Modern Art

gave him a retrospective, which made his reputation. Although his distinctive style had been fully established during the 1920s, his most famous picture, *Nighthawks*, would not be painted until 1942. That iconic picture summarizes Hopper's preoccupation with urban isolation and loneliness even if, ironically, it was painted by a man who ostensibly enjoyed a stable and happy marriage – to a fellow ex-student of Robert Henri

Hopper was also greatly admired as a printmaker, even though he more or less abandoned the medium in the early 1920s. *Evening Wind* (1921) was a print that memorably established another of his recurring visual themes: the female nude in an urban interior.

Graham Vickers

Date 1925

Born/Died 1882–1967

Nationality American

First Exhibited 1913

Why It's Key Originated a uniquely American genre focusing on lonely city life.

Key Event
Release of the movie *The Battleship Potemkin*

In 1925, the Russian movie director Sergei Mikhaylovich Eisenstein was sent to Odessa by the Central Committee of the Union of Soviet Socialist Republics to make a film commemorating the Russian Revolution of 1905, which forced Tsar Nicholas II to change the government from an autocracy to a constitutional monarchy. During the revolution, the first Soviets, or workers' committees, were formed, laying the foundations for the Bolshevik Revolution of 1917.

Eisenstein's silent movie centers on the mutiny of the crew aboard the battleship *Potemkin* in the harbor at Odessa, which was sparked, according to the film, when the sailors were forced to eat rotten meat. In the movie, those who refuse to eat the rotten meat are condemned to death. But the crew rebels, kills its officers, and raises the red flag. One sailor, killed in mutiny, becomes a symbol of revolution. In one of the most famous scenes in cinema history, the people of Odessa rally around his body, but are cut down by the Cossacks on the steps leading to the port.

Seeing the movie at a private screening, the Hollywood producer David O. Selznick told his boss at MGM that it would be "very advantageous to have the organization view it in the same way that a group of artists might study a Rubens or a Raphael." In 1958, an international poll of critics voted it the best movie ever.

The movie's poster, designed by Vladimir and Georgy Stenberg, became an icon. The image of a screaming mouth and a shattered pince-nez features in Francis Bacon's painting *Head VI* (1949), inspired by Veláquez's *Pope Innocent X*.

Nigel Cawthorne

Date 1925

Country Ukraine

Why It's Key With its pioneering use of montage, generally considered one of the most technically innovative movies ever made.

Key Exhibition
Modern and Industrial Decorative Arts

The now familiar term Art Deco, derived in the 1960s, evokes popular images of the flamboyant jazz-age architecture of the 1920s and 1930s, filled with stylized, geometrically shaped objects, and typified by the Empire State Building or the Clarice Cliff tea set. The term, however, is drawn from one of the most important design events of the twentieth century, the Exposition Internationale des Arts Décoratifs et Industriels Modernes. Held in Paris in 1925, it was an international celebration of up-to-the-minute design for living. Included were various aspects of design, applied art, and architecture from all over Europe, as well as from Russia and Japan.

French in origin, Art Deco was not a movement, but a collection of different approaches to style, reflecting as it did varying responses to the materials of the new industrial age and mass production. For instance, at the exhibition there was a distinct difference between the purely decorative – ornate displays of luxury, drawing from such sources as ancient Egypt, Mexican Aztecs, Babylonian ziggurats and sleek animals – and a more considered approach to design, which was modernist, avant-garde, and aware of social change, and looked toward Futurism, Constructivism, the Bauhaus, and the machine aesthetic of Purism, represented by the L'Esprit Nouveau pavilion of Le Corbusier and Amadée Ozenfant. There was one source that united the two different categories and identified them as Art Deco, however, and that was Cubism.

Sue King

Date 1925

Country France

Why It's Key The first celebration of what was later known as Art Deco, it popularised modernity and drew attention to design for living in a harmonized environment.

Key Event **Sonia Delaunay launches fashion range at the International Exposition of Decorative Arts**

Sonia Delaunay, a member of the avant-garde movement in Paris in the early twentieth century, began a new concept in clothing design, fusing art and fashion. Her research into simultaneity served as a basis for her forthcoming fashions.

This new style was based on conveying rhythmic energy and dynamic movement through the creation of color contrasts on the painted surface. She created her first simultaneous dresses in 1913 to match the energy of the fashionable dances – the foxtrot and the tango – at the Parisian dance hall Le Bal Bullier.

In 1924 she founded her own company with the prominent fashion designer Jacques Heim, exhibiting her creations at charity balls, artistic gatherings, and other celebrations. She incorporated simple geometric shapes, stripes, spirals, zigzags, and discs. Colors were in contrasting hues, and the vibrant synergy of these colors conveyed Delaunay's concept of modernity, and the rhythms of the newly electrified city.

Her greatest triumph was the design and decoration of a "simultaneous boutique" at the prodigious Exposition Internationale des Arts Décoratifs with the help of Heim, also an established furrier. Called simply Simultane, their stand featured mannequins displaying her various creations, amongst which were fur coats in geometric style, simultaneous dresses, embroidered coats, accessories, and interior furnishings. After the exhibition, fabric manufacturers could not get enough of her work and luminaries such as Gloria Swanson and Nancy Cunard, and all of the beau monde clamored to wear her creations.

Kate Mulvey

Date 1925

Country France

Why It's Key Delaunay's pavilion, Simultane, heralded the radical new concept of fabric and clothing design that still has influence today.

opposite Two women wearing Delaunay swimsuits.

Key Artist **Tamara De Lempicka**
Popular painter producing glamorous, fashionable work

Born in Poland in 1898, De Lempicka moved to Paris, where she became one of the most sought after society painters in Europe. She mainly painted portraits of the burgeoning international society scene, for which her style was perfectly suited.

The exaggerated beauty in her images – body form reduced to a series of shapely curves and angles, facial features always heightened with extravagantly fashionable maquillage, sumptuous backgrounds implying wealth and taste – played to her rich patrons' vanity as it always emphasized perfection.

De Lempicka utilized the simple geometric forms of Cubism and then playfully softened everything via a flattering, tonal, airbrushed look. She also used spot lighting for massive dramatic effect, almost as if to suggest the subject were on a stage or a movie set.

All of this, along with the exaggerated approach to the human form in her paintings, and the focus on fashionable accessories and backgrounds, gave each portrait an air of Hollywood glamour. Even her color sense suggested a glossy fashion plate, with decadent reds and exotic greens highlighting a palette of sophisticated, buffed neutrals.

De Lempicka was fairly controversial in her time, often engineering an abandoned eroticism into her nudes and playing with the concept of lesbianism in many pieces, including *The Two Friends* (1923). She died in Mexico in 1980.

Emily Evans

Date 1925

Born/Died 1898–1980

Birth name Maria Gorska

Nationality Polish

Why It's Key Tamara De Lempicka was a stylized painter whose work reflected the Art Deco movement of the 1920s and 1930s.

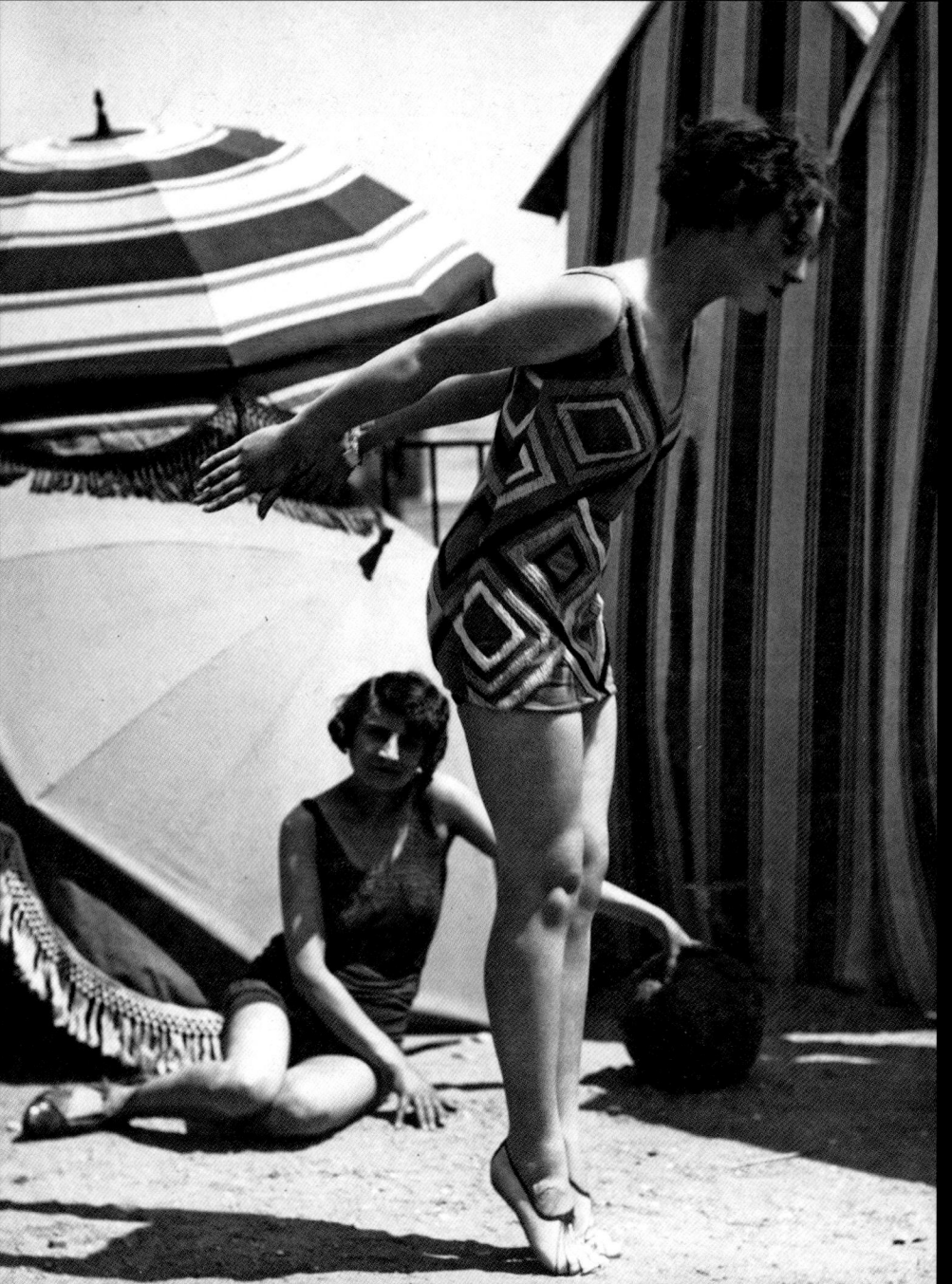

Key Artist **René Magritte** Develops personal Surrealist style under the influence of de Chirico

René Magritte gave Surrealists some of their most iconic images. One of the best-known, *Ceci N'Est Pas Une Pipe* (1928–29), as well as making a statement of the blindingly obvious, plays with recognition and subconscious suggestion, a vital aspect of Surrealism.

Magritte was the eldest of three boys who were born into a family that fell on hard times. He suffered a profound blow at thirteen when his mother committed suicide. After study at the Académie des Beaux-Arts in Brussels, he married his childhood sweetheart and made floral wallpaper designs. After an encounter with the work of de Chirico (1888–1978), he produced his first Surrealist images, *Le Jockey Perdu* (*The Lost Jockey*, 1925) and *The Menaced Assassin* (1926). Along with the poet Messens and others, he helped launch the Belgian Surrealist movement.

In Paris, he gained inspiration after meeting Miró, Dali, Buñuel, and André Breton, who asked (and answered) the question: "What is Surrealism? It is the cuckoo's egg placed in a nest – with René Magritte's complicity." However, he and Breton soon fell out, and the Magritte family returned to Belgium.

Magritte maintained his Surrealist credentials for the rest of his output, evoking the mysterious and subversive with his favorite symbols of apples, bowler-hatted men, coffins, and sky-filled silhouettes – all realistically drawn within shifted perspectives to unsettle the viewer, who had no choice but to smile. As Magritte put it: "For me the world is a defiance of common sense." The questions his images raise are still explored by neuroscientists and psychologists.
Bill Bingham

Date 1925

Born/Died 1898–1967

Nationality Belgian

Birth name René François-Ghislain Magritte

Why It's Key Magritte was a Surrealist painter whose images reverberate beyond the world of art.

Key Event
Dufy and Poiret collaborate

Raoul Dufy, one of the great innovators of twentieth-century textile design, changed the face of fashion and fabric design for ever. He formulated almost all modern fabric design between 1909 and 1930, and his application of art in fashion, with his visionary influences in color, texture, and imagery depicting cheerful, scenes of fashionable French life continues to influence commercial design today.

Dufy was one of the leading Fauve painters, and it was his particularly vibrant use of color that lent itself easily to design, and precipitated his move across into fabric design. In 1910, Paul Poiret, the French couturier whose unstructured Greek-inspired dresses freed women from the corset, commissioned Dufy to design fabrics for his collections after he was impressed with the artist's experiments in woodcuts.

Dufy's designs were hugely different from the available fabric designs at that time, which were usually of the order of small polka dots and quaint Paisley. He produced designs that were radical in their use of bold, rich color and content. They were used extensively by Poiret for his capes, coats, and dresses in luxurious silks and brocades block-printed with large designs. Dufy designed woodcuts for Poiret, who made the dresses and even took his models to the races to promote Dufy's designs.

In 1925 Poiret and Dufy cemented their partnership when they showed their designs and textiles at the famous Exposition International des Arts Décoratifs et Industriels Modernes,the event that gave Art Deco its name.
Kate Mulvey

Date 1925

Country France

Why It's Key Dufy's fabric designs were used in Poiret's famous couture creations, making Dufy one of the most influential twentieth-century textile designers.

Key Artist **Pavel Filonov**
Founds Collective of Masters of Analytical Art

Born in Moscow and orphaned at an early age, Pavel Nikolaevich Filonov moved to St Petersburg in 1897 and entered St. Petersburg Academy of Arts in 1908. However, he was expelled two years later when he refused to cohere to the mainstream current of art.

Over the next four years, Filonov contributed to the avant-garde arts group Soyuz Molodyozhi (Union of Youth). In 1912, he wrote the article "The Canon and the Law," in which he introduced the ideology of analytical art or "anti-Cubism."

For Filonov, Cubism only represented objects using surface geometry; in contrast, "analytical realists" would seek out their inner soul. Filonov articulated his theories in various manifestos, including "The Ideology of Analytical Art and the Principle of Madeness" (1923). He called himself "painter of the invisible" and remained devoted to these principles for the duration of his life.

In 1923 he became a professor at the St Petersburg Academy of Arts, and in 1925 he organized a large arts school of Masters of Analytical Realism, consisting of over seventy pupils and followers. Under his leadership, the school executed many projects, and its work influenced Suprematism and Expressionism.

However, by the 1930s, the Filonov school was becoming repressed by the Soviet government, which forbade a large exhibition of Filonov art at the Russian Museum in 1929. Despite destitution bordering on starvation, Filonov refused to sell his works to private collectors and, according to his wish, his sister donated them to the Russian Museum upon his death in 1941.
Mariko Kato

Date 1925

Born/Died 1883–1941

Nationality Russian

First Exhibited 1919, First Free Exhibit of Artists of All Trends at the Hermitage, St Petersburg

Why It's Key Now known as the Filonov School, his Collective was influential in aspects of Russian Suprematism and Expressionism.

1920-1929

237

Key Artwork ***Portrait of Antonin Artaud***
André Masson

After a Cubist phase, André Masson (1896–1987) joined the Surrealist group. While Breton, Soupault, and Desnos experimented with automatic writing, attempting to free themselves from the straitjacket of reason, taste, and propriety, Masson became the main proponent of automatic drawing, leaving his hand to run almost freely and uncensored across the paper, irrespective of conventional figuration or composition. His metamorphic abstractions were to have a great impact on Abstract Expressionists Gorky and Pollock, who saw Masson's work during World War II at Peggy Guggenheim's Art of This Century gallery in New York.

Masson worked with the magazine *La Révolution Surréaliste*.He also illustrated the transgressive works of the Marquis de Sade and the erotic writings of the dissident Surrealist Georges Bataille, and drew quasi-abstract line portraits of Desnos and Artaud, as frontispiece to their publications.

His *Portrait of Antonin Artaud* opens *L'Ombilic des Limbes*, a collection of Artaud's poems that takes on the taboos and prejudices of a culture whose repressive cult of reason smothers vital energy. "Where others offer works of art, my only ambition is to show what I am," wrote Artaud. "Being alive is to burn questions." He insisted that literature is not something to be consumed, but a crucial act, a combat. He was a man of extremes, whose *Theater of Cruelty* brought about a revolution in the Western conception of theater. His experiments with drugs and long spells in mental institutions led him to experience at close quarters the madness that Breton so romanticized.
Catherine Marcangeli

Date 1925

Country France

Medium Frontispiece engraving for Artaud's poetry collection, *L'Ombilic des Limbes*, published by NRF, Paris

Why It's Key: The most radical writer, artist, actor, and director of his time is portrayed by the main proponent of Surrealist automatic drawing.

Key Person **Herbert Bayer** Becomes director of Printing and Advertising at the Bauhaus

Born near Salzburg in 1900, Bayer became apprenticed to the Linz artist George Schmidthammer when he was nineteen. A year later he joined the workshop of the Viennese architect Emmanuel Margold at the Darmstadt Artists' Colony. There he was trained in the Art Nouveau styles and became interested in the book *Bauhaus Manifest*. He joined the Bauhaus as a student in 1921 and was taught by Paul Klee and Wassily Kandinsky from 1921 to 1924. In 1925 the brilliant young graduate was appointed director of the school's newly founded Printing and Advertising Department, responsible for opening the Bauhaus' new site in Dessau.

Walter Gropius, director of the Bauhaus at the time, commissioned Bayer to design a typeface for all Bauhaus communications. Called "Universal," Bayer's typeface became the prototype for all sans-serif, lower-case typefaces that were to follow. The now legendary signage for the Dessau Bauhaus complex was also one of Bayer's designs.

In 1928, Bayer left the Bauhaus to become the art director of *Vogue* magazine in Berlin, and then worked on the German publication *Die neue Linie* until moving to the United States in 1938. That year he collaborated with Gropius on the exhibition Bauhaus 1918–28 at the Museum of Modern Art in New York. In the United States, where he lived until his death in 1985, he was prolific as an architect, co-designing the Aspen Institute and restoring the Wheeler Opera House.

Charla Marchini

Date 1925

Born/Died 1900–1985

Nationality Austrian

Why It's Key Most famous for his contribution to typography (including the prototype for sans-serif typefaces), the Austrian Herbert Bayer influenced nearly every field of the visual arts in his international career as painter, graphic designer, architect, and teacher.

238

Key Event
Louis Armstrong's Hot Five

Jazz first hit the popular mainstream as a novelty dance music with the recordings of the Original Dixieland Jazz Band in 1917. But it was in 1925, with a series of ground-breaking records by Louis Armstrong and his Hot Five (and its augmented Hot Seven), that a fad which had previously been regarded as frivolous established itself as an art form – one which would change the language of music for ever, and much else in Western culture as well.

Already a master of his instrument at just twenty-five years old, Armstrong created the template for jazz improvisation – on cornet, trumpet, and scat-singing vocals – that would leave its mark on virtually all non-classical music that followed.

Jazz impacted on other disciplines, including visual art, almost immediately. As early as 1929 French intellectuals, led by Jean Cocteau, were demanding that jazz should be recognized as an art form on a par with cinema and abstract painting. The sheer modernity of the music was celebrated in paintings by artists as diverse as Nicolas de Staël (*Jazz Musicians*, 1952) and Piet Mondrian, whose 1942 *Broadway Boogie Woogie* was one of his master works.

And it was the intrinsic spontaneity of jazz that attracted the Surrealists and later the Abstract Expressionists, who believed in letting the painting take over and carry the artist (and subsequently the viewer) wherever it (or his/her subconscious) dictated. "When I'm in a painting, I'm not aware of what I'm doing," Jackson Pollock once said, talking like a jazz musician might about his art. "The painting has a life of its own." Mike Evans

Date November 1925–July 1928

Country USA

Why It's Key Established jazz improvisation in modern Western music, popularizing the notion of spontaneous creativity which would influence other art forms including theater, literature, and painting.

Key Event
The Harlem Renaissance

In the 1920s, prompted partly by the "Jim Crow" segregation laws and Ku Klux Klan activity, many African Americans moved north, and Harlem became the largest black community in the United States. It saw a flourishing of literature, music, theater, dance, cabaret, film, painting and sculpture, which was later dubbed The Harlem Renaissance. The movement was inspired by thinkers such as Harvard Professor of Philosophy Alain Locke. His 1925 essay "The New Negro" showcased prominent writers such as Langston Hughes, and included illustrations by Winold Reiss and Aaron Douglas. Locke sought to debunk the prejudices that denied black achievement and inhibited self-expression and self-determination.

Similar ideas were promoted by Harlem-based magazines, whose readership extended well beyond New York. They published fiction, poetry, critical essays, social analysis, and articles in support of civil rights, and commissioned covers by black artists. Such was the case for *The Crisis*, the magazine of the National Association for the Advancement of Colored People, and *Opportunity*, the National Urban League journal.

Locke's *Legacy of Ancestral Arts* (1925) challenged young artists to draw upon the power of African art to create truly modern forms, banishing stereotypes of simple southern country folk, and developing instead urban, dynamic, stylish and sophisticated models for black identity. Proclaiming his vision for a provocative black modernism, Aaron Douglas fused African-inspired imagery with geometric abstraction, recalling the syncopated rhythms of modern jazz improvisations.
Catherine Marcangeli

Date 1926

Country USA

Why It's Key A profusion of magazines and journals promote the advancement of black culture and art.

Key Person **Muneyoshi Yanagi**
Promotes traditional folk aesthetic

In the midst of late imperial Japan's relentless modernization and urbanization, theorist and art collector Muneyoshi Yanagi (also known as Soetsu Yanagi) and some like-minded Japanese peers decided to re-evaluate and rescue the country's disappearing folk aesthetic. Consequently, in 1926, Muneyoshi, along with the potters Shoji Hamada, Bernard Leach, Kenkichi Tomimoto, and Kanjiro Kawai, inaugurated the Mingei (folk crafts) Movement.

Under the aegis of Mingei, Muneyoshi and his companions scoured Japan for examples of pre-industrial, hand-made pots and crockery that displayed functionality and a regional aesthetic. Typically, Mingei crockery might date back to the Edo (1603–1867) and Meiji (1868–1912) eras of Japan, or it might originate in the Yi Dynasty (1392–1910) of Korea. Muneyoshi

collected many of these items during his career. Today, over 17,000 Mingei artifacts are on display at the Mingeikan Museum, which was established in 1936 and directed by Muneyoshi until his death in 1961.

The essence of the Mingei Movement was to reject mass production and non-functionality in pottery, and to valorize the work of ordinary potters and craftsmen in the pre-industrial period of Japan. These values resulted not only in a move to collect and display Mingei pieces but also in a revival of folk arts across Japan. Contemporary Mingei is crafted and sold all across Japan, and the distinction between the artisan and the artist (commoner in the West, and smacking of the elitism that Muneyoshi detested) is weaker as a result.
Demir Barlas

Date 1926

Born/Died 1889–1961

Nationality Japanese

Why It's Key Japan's influential Mingei Movement gets underway thanks to the value Muneyoshi places on the folk aesthetic.

Key Event
The Galerie Surréaliste opens in Paris

La Révolution Surréaliste (*The Surrealist Revolution*), the magazine set up by the Surrealists in 1924, already echoed the group's determination to bring its art to a wider audience. The Bureau des Recherches Surréalistes (The Bureau of Surrealist Researches), opened by the group in the same year, contributed to this propagandist spirit, welcoming visitors and encouraging them to submit ideas.

The group, whose members included Man Ray, Masson, Miró, and Klee, had held its first exhibition in 1925 at the Galerie Pierre. Following this event, the opening of the Galerie Surréaliste, in March 1926, by André Breton and Jacques Tual marked the acme of the group's ambition to unveil to the general public the strength of this "compulsive beauty" praised by Breton in his first manifesto. The gallery opened with an exhibition of photographs by Man Ray, which explored the links between modern aesthetics and primitive sculpture, an art the Surrealists always felt close to.

Between 1926 and 1929, the Surrealists, through their gallery and the publication of their magazine, maintained a homogeneous artistic line, exploring dreams and the unconscious as fuels for their work. However, starting in 1929, the group had to face some inner tensions, particularly relating to politics, and the growing authoritarianism of Breton led to the expulsion of key artists, including Artaud, Masson, and even Dalí. From that date, the Surrealists, while still remaining a group, took on a more individual turn, contrasting with the collective spirit of the early years.

Sophie Halart

Date March 1926

Country France

Why It's Key Secures the place of Surrealism as a highly influential movement in modern art.

opposite Title page from the exhibition catalog of "Man Ray and Objects from Islands," illustrated with *La Lune Brille sur l'Ile Nias* (engraving), for the opening of the Galerie Surréaliste.

Key Event
The introduction of public television services

Broadcast TV began hesitantly and ambiguously. Arguably, Britain led the way with its London-only service in 1926. Hardly anyone could view it, since TV receivers were virtually non-existent, so perhaps the first bona fide regularly scheduled television service was the one launched in 1928 at Wheaton, Maryland, in the USA – although the experimental station could only deliver silhouette film images for its first 18 months. World War II halted progress, effectively deferring public television broadcasting to the postwar years.

After the war, broadcast TV grew faster than the sophistication of its content, but it brought about one paradigm shift: greater public exposure to images. People might spend a couple of hours at the movies, or looking at pictures in a book, but TV spontaneously pumped images into the home for hours on end, making rolling visual information a ubiquitous utility like electricity and gas. Color transmission, starting in the late 1950s, upped the ante and, fifty years on, digital and high definition have rendered broadcast television highly sophisticated in terms of image quality.

The home TV became a 24/7 movie theater, news medium, educational tool, and purveyor of lowbrow entertainment. No longer limited to the living room, televised information is available on a range of digital devices, fixed and mobile, and, thanks to satellite broadcasting, has redrawn the global communications map. What started out as little more than a primitive shadow puppet show launched an era of electronically delivered visual information whose impact upon the world's perceptivity has been incalculable.

Graham Vickers

Date 1926

Country UK

Why It's Key An early indication of communications revolutions to come.

LE 26 MARS 1926

OUVERTURE

de la

GALERIE SURRÉALISTE

16, Rue Jacques Callot - PARIS (6e)

EXPOSITION

LA LUNE BRILLE SUR L'ILE NIAS

du 26 MARS au 10 AVRIL

TABLEAUX

de

MAN RAY

et

OBJETS DES ILES

Key Event
Gruppo 7 (Group 7) is founded

The Fascist-influenced Gruppo 7 (Group 7) was established in 1926 in Como, Italy, then the center of modern Italian architecture, and led by newly graduated architects Giuseppe Terragni, Sebastiano Larco, Enrico Rava, Luigi Figini, and Gino Pollini.

The group fought to move architecture away from neo-classical and neo-baroque revivalism, defining its position as rationalism and working toward the "spirit of a new age". It embraced material technology – with a strict adherence to logic and rationality – as an expression of function. The group was inspired by the modernist aesthetics of the Novecento Italiano movement (1923), which had established a specifically Italian modernism, renouncing the ambitious individualism that had characterized the Futurists in favor of discipline.

After World War I, Italy was eager to return to a sense of order and embraced rationality and Italian modernism. At this time, Gruppo 7 existed within the context of a Fascist political order. At the Third Biennale exhibition in Monza in 1927, Gruppo 7 presented its proposed town planning projects, and Terragni, the recognized leader of the movement, established an architectural practice in Como, where he executed groundbreaking projects. Gruppo 7 also merged with MIAR (Movimento italiano per l'architettura razionale).

Terragni's project, the Casa del Fascio (1932), in Como, has a façade composed of a partially open grid of thin, unornamented elements, and exemplifies the application of some aspects of modernism and Fascist politics. Gruppo 7 and the MIAR disbanded in 1931.
Kate Mulvey

Date 1926

Country Italy

Why It's Key Pioneers of the modern movement in Italy, Gruppo 7 designed groundbreaking projects based on rationalism.

Key Artist **Palmer Hayden**
Harlem Renaissance painter works in Paris

Born Peyton Hedgeman in Widewater, Virginia around 1890, the artist chose to keep an early mispronunciation, Palmer Hayden, as his working name. Otherwise untrained, he first joined the army in order to have time to paint and draw, then in 1919 moved to New York, where he was helped informally by Victor Pérard of the Cooper Union and Asa Randall at the Boothbay Art Colony in Maine.

In 1926 Hayden's Maine seascape, *The Schooners*, won him US$400 from the Harmon Foundation. This, with an additional US$3,000 from a wealthy female patron, enabled him to spend the next five years in Paris, first studying briefly then enjoying café life, making painting trips to the Brittany coast and developing his interest in African heritage, evident in his placing of a Gabonese tribal head alongside the

more conventional vase of lilies in *Fétiche et Fleurs (Fetish and Flowers*, c.1925–33).

In 1932 Hayden returned to Depression-era New York to become a salaried artist on the government-financed Works Progress Administration Scheme. After 1940 he concentrated on affectionate narrative portrayals of the rural South and urban Harlem. Some of these, such as *The Janitor Who Paints* (c.1939–40) and his *John Henry* series (1944–47), about the black Southern folk hero who died after defeating a railroad steam-hammer in a trial of strength, are mildly polemical. Hayden died in 1973, having won his own extraordinary contest with the establishment on behalf of black America, only to have his gentle humor and naïve style accused of parody and caricature.
Catherine Nicolson

Date 1927

Born/Died c.1890–1973

Birth Name Peyton Hedgeman

Nationality American

First exhibited 1926

Why It's Key Important African-American painter and contributor to the Harlem Renaissance.

Key Event
Release of *Metropolis*

Just as the Bauhaus was striving to bring together artist and artisan, Fritz Lang was making a futuristic movie about a society split into two. In his film, set in 2027, the planners live in luxurious towers while the workers toil underground to sustain the lives of those above. As a political statement it was not subtle, but as a sustained visual metaphor *Metropolis* was little short of staggering.

Lang's film owes much to German Expressionist films that preceded it, and like them, is replete with visual flourishes and heavy symbolism. Expressionist films had often looked highly dramatic, even if the drama was cheaply achieved, but *Metropolis* looked so elaborately good that it still impresses today. It was a silent film, but its silence spoke volumes as the city was revealed, blending the visual manners of Expressionism with the decorative effects of Art Deco and a truly architectural attention to scale and detail.

Complex miniatures brought to life a city studded with ominous citadels linked by aerial conveyors, overshadowed by towers of improbable height. Further enhancing the imagery was the Schüfftan Process, a precursor of the traveling matte, which had been developed specially for this movie. It was a mirror-based method of integrating live action into the tiny sets, which avoided the need for actors to stand in front of cheap sets representing a fragment of a whole seen only in a separate shot.

Although the plot doesn't bear close scrutiny, its legacy is essentially visual, and still influences the imagination of sci-fi dreamers today.
Graham Vickers

Date 1927

Country Germany

Why It's Key Fritz Lang's post-Expressionist science-fiction film invented highly influential imagery for its de-humanized city of the future.

Key Artist **Stanley Spencer**
Resurrection, Cookham purchased by Tate Gallery

One of the most original painters of his generation, Stanley Spencer attended the Slade School of Art in London from 1908 to 1912, where he won the Melville Nettleship and the Composition Prize for *Nativity*. The canvas remains at University College, London today.

Afterwards he returned to his birthplace, the village of Cookham in Berkshire, where he painted biblical scenes in modern-day dress throughout his career. These include *The Last Supper* (1920), *Christ's Entry into Jerusalem* (1921), and several versions of *The Resurrection*.

After serving in Macedonia during World War I, he was appointed an official war artist. In 1923, he was commissioned to paint murals for the memorial chapel at Burghclere in Hampshire. *Resurrection, Cookham* was purchased by the Tate Gallery, London, from a one-man exhibition in 1927. Another version, painted 1928–29, showing dead soldiers climbing from their tombs, adorns the walls at Burghclere.

Spencer courted controversy with the erotic content of some of his work. He resigned from the Royal Academy after his grotesque *St Francis and the Birds* was refused exhibition. He returned to the theme of the resurrection in 1950 with *The Resurrection: Port Glasgow* after being sent to paint the shipyards there. He was re-elected to the Royal Academy that year, and knighted in 1959.
Nigel Cawthorne

Date 1927

Born/Died 1891–1959

Nationality British

First Exhibited 1912

Why It's Key Spencer led English painting in the inter-war years.

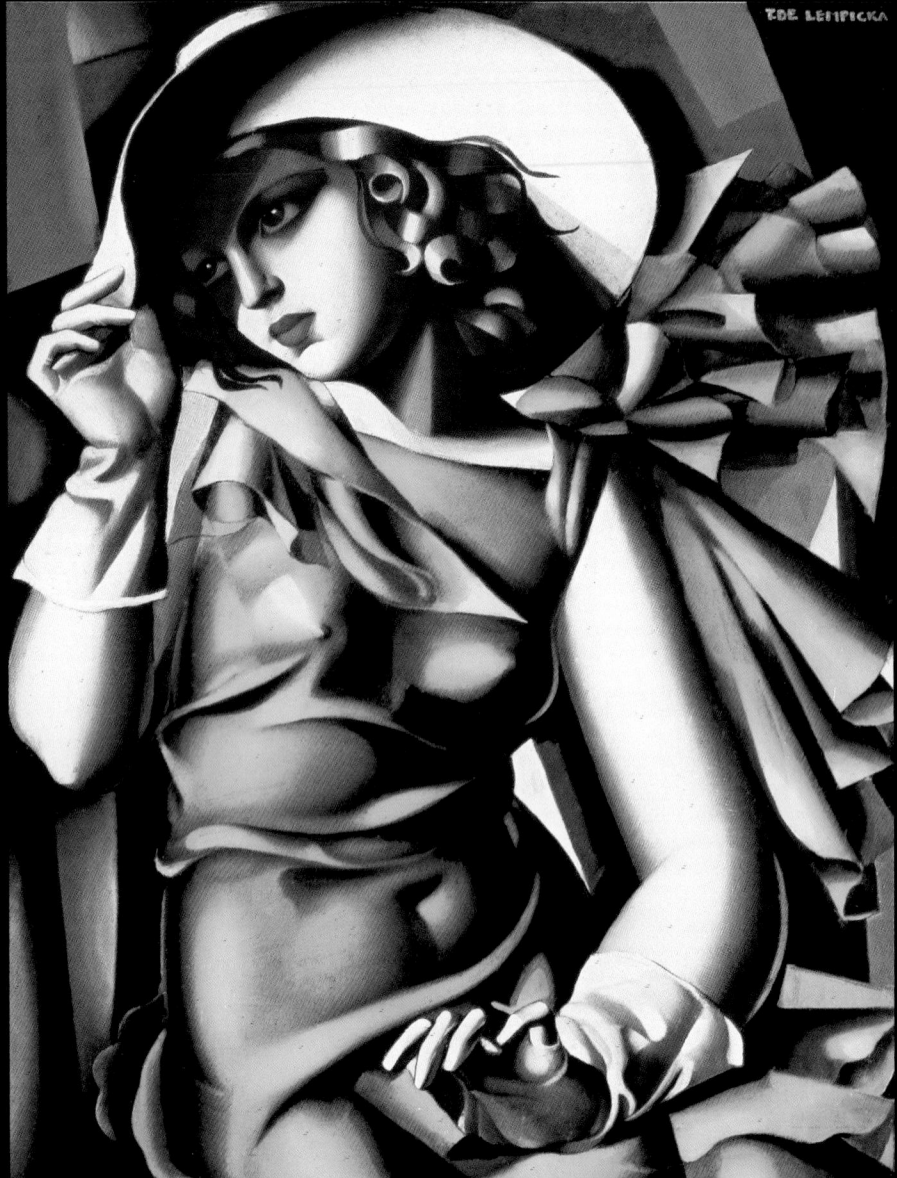

T.DE LEMPICKA

Key Artwork *Young Girl in Green*
Tamara De Lempicka

The Roaring Twenties roar memorably in the work of Tamara De Lempicka (1898–1980), the Polish painter, vamp, and society firebrand who so ably documented a decade of gilded excess. *Young Girl in Green* is the epitome of De Lempicka's work, invoking as it does a beautiful woman in a beautiful dress, a vision of a glamorous new age ferocious in her perfection and frightening in her unattainability. Completed in 1929, *Young Girl in Green* superimposes its model woman on a vaguely Cubist background whose purpose here is not analytical but stylistic: to bracket and emphasize a kind of haughty beauty whose posed body is decidedly pre-modern.

It is not easy to know what to do with *Young Girl in Green* because its banality of topic is so energetically overcome by the Art Deco style that De Lempica knew intimately. Also, read as an objectification of woman as consumer object, the painting is complicated by De Lempicka's own decidedly liberated lifestyle. *Young Girl in Green* is no odalisque; while she may bear the male-dictated marks of beauty, she is somehow opaque to male inspection or domination. Her gaze, not the gaze of the male spectator, drives the painting, and we are not allowed to see what she is looking at. That said, the girl is certainly the prisoner of seen and unseen fashion, and it is not entirely clear that she will profit from this captivity. But perhaps De Lempicki is making a more complicated statement: that freedom, captivity, surrender, and solitude are one.

Demir Barlas

Date 1927

Country France

Medium Oil on canvas

Collection Musée National d'Art Moderne, Centre Georges Pompidou, Paris, France

Why It's Key This painting, probably De Lempicka's most famous, epitomizes her mastery of Art Deco style.

opposite *Young Girl in Green*

1920–1929

245

Key Event
Film becomes multimedia

Abel Gance's epic silent film, *Napoléon* (1927), which tells the story of the rise of Napoleon Bonaparte, anticipated the costly Hollywood epics that were to follow later. This ambitious picture uses many innovations, including handheld cameras, rapid montage, and the hand tinting of frames.

With a running time of over six hours, *Napoléon* debuted at the Paris Opéra in April 1927, but the complex screening arrangement, as well as the picture's length, was a deterrent to its wide circulation in Europe. The final reel was intended to be screened as a three-panel (triptych) montage by means of triple projection, which Gance referred to as Polyvision, but when the rights to the film were bought by Metro Goldwyn Mayer, and it was cut to just 72 minutes, Gance's three-panel idea was abandoned.

Bearing little relation to what was first shown at the Paris Opéra, *Napoléon* was not well received when it debuted in the USA. However, another reason why Gance's dismembered film received such a lackluster welcome was that its arrival coincided with that of the talkies, the first feature-length example of which was *The Jazz Singer* (1927), produced by Warner Bros.

Although Warner embarked on several features that utilized a process to create synchronized sound (the Vitaphone sound-on-disc system) as early as 1926, those pictures only had synchronized scores and some sound effects. As the first feature-length movie that had synchronized dialogue as well as scores, *The Jazz Singer* heralded the decline of the silent film era, ushering in the age of multiple-media production.

Ian McKay

Date 1927

Country USA/France

Why It's Key Introduced a multimedia art form to popular culture, which was developed in more "formal" visual arts through the years that followed.

Key Artwork *Red Poppy*
Georgia O'Keeffe

Georgia O'Keeffe (1887–1986) began her series of large-scale flower paintings in the mid-1920s, often simplifying their form, line, and gradation of color in a manner that was daring and wholly original. Paintings such as *Red Poppy* (1927) were partly inspired by O'Keeffe's belief that the pace of urban life dissuaded city dwellers from taking time to appreciate natural beauty, and her larger-than-life flower paintings were therefore scaled to demand attention from her New York audience.

By the late 1920s, O'Keeffe was identified with the life-affirming qualities of such paintings and, in 1928, one of her flower paintings sold for US$28,000, marking her the first woman in the U.S. to claim a successful living from being a painter. As well as being significant in its own right, *Red Poppy* is historically significant in its anticipation of American color-field abstraction.

In 1946, however, the American art critic Clement Greenberg put forward his arguments for disregarding the achievement of O'Keeffe, who was then enjoying a retrospective at New York's Museum of Modern Art. He claimed her art had "very little inherent value," failing to note that the exhibition was the first ever retrospective granted to a woman by the museum. He summed up O'Keeffe's works as "pseudo-modern art" produced by a painter whose output added up to "little more than tinted photography." Though such a view held sway during the years of American Abstract Expressionism, O'Keeffe's art has always enjoyed a wide audience which, latterly, grew further due to the re-evaluation of her output from a feminist perspective.

Ian McKay

Date 1927

Country USA

Medium Oil on canvas

Collection Private collection

Why It's Key Anticipated American color-field abstraction and further established O'Keefe's reputation as the most important woman artist in the United States.

opposite *Red Poppy*

Key Person **Elie Faure**
Final volume of monumental *History of Art* is published

Faure was a French essayist and critic whose very personal and poetic approach to art inaugurated a new style of writing in intellectual circles. He upset the traditional approach to the history of art by vehemently stating his own aesthetic views. He was also criticized for his lack of objectivity, and a tendency to get carried away in long, lyrical sentences.

Born into a bourgeois family, Faure studied medicine but dedicated most of his life to art. His first book, on Velasquez, was published in 1903. In 1909, he undertook a titanic project: to write a *History of Art* to be published in four volumes: Ancient Art, Medieval Art, Renaissance Art, and Modern Art. In the last volume, published in 1927, Faure developed a new thesis: what really mattered in art, he claimed, was not so much the figurative content but the organization of

forms on the canvas. According to Faure, it was the deep meaning of these forms which best reflected the state of the society in which they were created.

In this work, Faure principally based his argument on the study of Cézanne's paintings. On the other hand, he did not hesitate to criticize Gauguin for escaping urban modernity to run after an illusory lost paradise in exotic islands. The artist's role and responsibility, said Faure, was to observe, witness, and report in his or her work the decadence of society, not to seek isolation and introspection within the walls of a studio.

Sophie Halart

Date 1927

Born/Died 1873–1937

Nationality French

Why It's Key Seminal work by the first modern critic to praise a subjective approach to art by scholars.

Key Artist **Emily Carr**
Invited to exhibit with Group of Seven

Emily Carr is best known for documenting the unique and vanishing Native American culture near her hometown of Victoria, British Columbia. She is also renowned for her expressive paintings of totem poles and nature, in particular the sky, water, and forests of the area.

In 1927, Carr was invited, through a chance meeting with an anthropologist, to participate in an exhibition of West Coast Indian art at the National Gallery of Canada. This was a particular turning point for Carr, who traveled east for the show. Her work was very well received and it was there that she met some of the members of the East Coast Group of Seven. She liked what she saw of their art, particularly Lawren Harris' paintings, and instantly discovered a bond with him. Harris declared, "you are one of us," and invited her to exhibit with the group. Carr found herself on the way to establishing a national reputation as a leading artistic figure in Canada.

Encouragement from the group during the late 1920s was important to Carr. It rekindled her spirit and motivated her return to painting after years of artistic isolation and struggle. She had always been a very determined, resourceful, and individualistic artist and while she departed from the others in technique, she was intuitively aligned to them in a spiritual and philosophic way. Already fifty-six years old at the time of the meeting, Carr returned to British Columbia, where she painted and wrote passionately over the next 18 years, until her death.

Carolyn Gowdy

Date 1927

Born/Died 1871–1945

Nationality Canadian

Why It's Key Carr was the only woman to be included in this influential group, which marked a turning point in her life and work.

248

Key Artwork ***A Group of Artists***
Ernst Ludwig Kirchner

It was during his return to Germany in 1927 that Ernst Ludwig Kirchner (1880–1938), one of the greatest exponents of Expressionism and co-founder of the artists' collective Die Brücke, produced a painting of a group of young men. The depicted figures are, in fact, the remaining members of Die Brücke just before it ceased to exist in 1913.

In a sense the painting summarizes Kirchner's life and work. When the members of Die Brücke moved from the rather contained environment of Dresden to the buzzing city of Berlin in 1911, Kirchner realized that they were no longer on the cutting edge. As they struggled to gain a grip on the metropolis, their interests diverged, resulting in an unfriendly break-up in 1913. Kirchner must have remembered these final years with his former friends when he passed through Dresden and Berlin again in the late 1920s. He therefore decided to paint himself and fellow Brücke-painters Erich Heckel, Karl Schmidt-Rottluff, and Otto Müller as a memento to this tumultuous time. The awkward relationship that resulted from the break-up and the melancholy that Kirchner must have felt are evident in the painting.

A Group of Artists is also a testimony of Kirchner's style after his exposure to the difficulties of city life. He uses the interplay of an array of blues and purples, along with a gritty realism, to create an uneasy feel to the painting. Kirchner's emotional attachment to the painting of his former friends shows in his diary, which documents his elation when he received news that the Nationalgalerie in Berlin purchased the canvas.

Erik Bijzet

Date 1927

Country Germany

Medium Oil on canvas

Collection Museum Ludwig, Cologne

Why It's Key Famously commemorates Kirchner's association with the artists' collective Die Brücke.

Key Artist **Henry Moore**
First one-man exhibition and first public commission

The son of a mining engineer, Moore studied at Leeds School of Art before winning a scholarship to the Royal College of Art in London, where he spent much of his time in the British Museum studying African, Oceanic, and pre-Columbian art. His aim was to remove "the Greek spectacles from the eyes of the modern sculptor."

From 1925 to 1931, he taught at the Royal College. In 1928, he was given his first one-man exhibition at the Warren Gallery in London, selling several sculptures and some thirty drawings. This led to his first public commission, a relief for the headquarters of London Underground, a work which was condemned in some quarters for its primitivism. In 1932, Moore started the sculpture department at the Chelsea School of Art, which he found less restricting than the Royal College.

He joined the Unit One group of young artists, which included Barbara Hepworth, her husband Ben Nicholson, and Paul Nash, and began experimenting with his trademark "pierce forms."

A war artist during World War II, he famously produced drawings of people sleeping in the Underground during the Blitz. In 1948, he won the International Sculpture Prize at the Venice Biennale, and in the decades that followed his reputation grew worldwide. In the 1950s he became famous for his reclining female figures which, no matter how abstract they appeared, retained a distinctly human form. In the 1960s he accepted commissions for monumental pieces for the Lincoln Center, New York, and the University of Chicago.

Nigel Cawthorne

Date 1928

Born/Died 1898–1986

Nationality British

First Exhibited 1928

Why It's Key Henry Moore was the most important British sculptor of the twentieth century.

Key Artist **Ben Nicholson**
Meets Alfred Wallis

Ben Nicholson was born into a distinguished artistic family. His father, Sir William Nicholson, was an illustrator, children's book author, and painter. His early work was traditional, not unlike his father's. He was soon attracted to modernism, although it is unclear whether Nicholson was aware of the rejection of established values pioneered by Pablo Picasso and others, who were looking at artefacts of "primitive" societies, folk art, and the unschooled artwork of children.

In 1928, Nicholson was walking back from the beach with fellow artists Winifred Nicholson (then his wife) and Christopher Wood during a visit to St Ives, Cornwall. Passing by an open door they glimpsed an intriguing sight – scraps of painted cardboard were nailed haphazardly across a wall with images of boats and houses. They knocked on the door and were greeted by

Alfred Wallis, who showed the group his pictures, which were about memories of life as a fisherman, and spoke of his passion for boats and the sea. "There is nothing on the water than beats a full-rigged ship," Wallis would later write in a letter to Nicholson.

Wallis' work was pure, simple, and eloquent. A former rag and bone man, he was conventionally uneducated, but he had a natural sense of poetry and sophistication. Wallis was the real thing and his paintings greatly influenced Nicholson's later work.

A founder member of Unit One, Nicholson emerged as the major name in British abstract painting during the 1930s.

Carolyn Gowdy

Date 1928

Born/Died 1894–1982

Nationality British

Why It's Key When Nicholson met the self-taught, naïve artist Alfred Wallis in the Cornish fishing village of St Ives, he recognized something special. Wallis was a pure original and Nicholson would be highly influenced by his paintings.

Key Artist **Maurice Utrillo**
Made chevalier of the Legion of Honor

Maurice Utrillo was one of the few painters of the golden age of Montmartre to have been born there. His mother was the model and artist Suzanne Valadon. When he fell prey to alcoholism as a teenager, she encouraged him to paint as a form of occupational therapy. Although initially attracted by Impressionism, he veered back toward Realism while his contemporaries moved into abstraction.

During his "white period," from 1908 to 1914, he made lavish use of zinc white, often mixed with glue, plaster, or cement to build up ageing, cracked walls with heavy impasto. During World War I his tortured view of the world found an outward expression, as in *Rheims Cathedral in Flames* (1914).

In failing health, he gradually withdrew to the safety of hospitals and nursing homes, where he painted from picture postcards. In 1923, in an effort to keep him away from the bars of Montmartre and drinking companions such as Amedeo Modigliani, his mother took him to live in a chateau near Lyon, and in 1929 he was made a chevalier of the Legion of Honor. In 1935, he married Lucie Pauwels and lived a respectable bourgeois existence in Le Vésinet, a fashionable suburb of Paris.

Despite his troubled life, he left thousands of oil paintings, along with a number of drawings and lithographs. Though his critical reputation went into decline after his death, he has remained popular with collectors and the public.

Nigel Cawthorne

Date 1928

Born/Died 1883–1955

Nationality French

Why It's Key Painted Montmartre when it was a famous artists' colony, and was eventually recognized by the French establishment.

Key Artist **Jan Theodoor Toorop**
Death of the influential Dutch Catholic artist

Born on the Dutch colonial island of Java in Indonesia, Jan Theodoor Toorop moved to the Netherlands in 1872, where he commenced his art studies in Delft and Amsterdam. However, his move to Belgium in 1882, which facilitated his exposure to French Impressionist art and his involvement in the foundation of Les XX, a Belgian avant-garde group, most significantly influenced his early works.

Despite the French stylistic influence, the subject matter of his early works gradually drifted away from the sunny landscapes of a typical Impressionist toward more somber, realistic subjects, as seen in *Alcoholisme* (1888). After becoming an ardent socialist, his work further evolved in the 1890s as he began to experiment with Symbolism, ultimately becoming one of the preeminent artists of the movement.

His works of this period, which often couple traditional, macabre Symbolist themes with decorative Art Nouveau backgrounds, are characterized by their mysticism and complexity. For example, in *O Grave where is thy Victory?*(1892), two floating women entangled in thorny vines hover over an open grave as mysterious faces leer and grasp at them through the surrounding shrubbery.

Upon his conversion to Roman Catholicism in 1905, he began to create works with religious themes, ultimately becoming one of the most progressive Dutch Catholic artists of his time. His death in 1928 marked the loss of one of the most influential Dutch Symbolist and Art Nouveau artists.

Heather Hund

Date 1928

Born/Died 1858–1928

Nationality Dutch

First Exhibited 1884

Why It's Key One of the leading Symbolist and Art Nouveau artists, whose conversion led him to become one of the most progressive Dutch Catholic artists.

opposite Toorop's *Fatality*, 1893 (chalk & pencil on paper).

Key Artwork *Girls in Swimming Costumes*
Sonia Delaunay

In the 1920s, Sonia Delaunay returned to Paris from Madrid and began her involvement in fabric design. Fusing art with fashion, Delaunay heralded the advent of a radically new concept in clothing design, applying bright colors to the tubular silhouette of 1920s Paris dresses. A champion of modernism, she produced designs for the jazz age.

Delaunay believed that art should be used to decorate modern life and that design should be artistic. *Girls in Swimming Costumes* exemplifies these beliefs and techniques; the painting exists on its own in merit and also as a design for fashion. The girls are set against a background of bright colors and suffused with light and their dresses are set in colorful, contrasting geometric designs. The linear geometry on the first dress expresses movement, as do the round discs on the other dress. The painting is in watercolors on paper, which gives the picture a lyrical, dreamy air.

With their bright colors, Delaunay's paintings and designs are reminiscent of Orphism, an offshoot of Cubism that was founded by Delaunay and her painter husband, Robert Delaunay, in 1913. The name, coined by poet Guillaume Apollinaire, referred to the lyrical quality of light and color, and aimed at a purity of expression akin to music.

Delaunay's designs were characterized by their sharp "simultaneous contrasts." Her patchwork coats and simultaneous dresses were worn by film stars including Gloria Swanson. She also made costumes for the ballet *Cleopatra*, produced by Sergei Diaghilev, who believed in the fusion of dance, painting, and music.
Kate Mulvey

Date 1928

Country France

Medium Watercolor on paper

Collection Private collection

Why It's Key A work that typifies Sonia Delaunay's fusion of art and fashion, and her work with simultaneous colors and geometric abstraction.

1920-1929

Key Artwork *Abstract Head*
Alexei von Jawlensky

Von Jawlensky (1864–1941) began painting his series of heads in 1921, based on icons from the Russian Orthodox Church. The faces became increasingly abstracted as he returned to this theme, until illness forced him to cease painting in 1937.

Associated with the Blaue Reiter (Blue Rider) group, through his friendship with his fellow Russian, Wassily Kandinsky, Jawlensky's paintings of heads in the latter part of his career express the ecstatic state he encouraged within himself when painting. Although he never fully embraced abstraction, the heads have been reduced to schematic forms that are sufficient to echo the Russian icons on which they were based.

In 1905 Jawlensky saw Matisse's work in the Fauve exhibition at the Salon d'Automne. He was inspired by Matisse's reduction of form, flat planes of decorative color, lack of perspective, and emphatic contours. This led him to investigate the expressive and sensual power of pure colors and simplified formal elements which, when freed from their naturalistic function, expressed the emotions of his religious experience.

Jawlensky was also influenced by Cubism and in his 1928 *Abstract Head* a Cubist-like distortion of form is evident; the black feathery lines, which delineate a diagrammatic facial structure on a warm ground, are disrupted by stippled brushwork in cool colors to create a fuzzy geometry within a shallow space. The influence of African masks is evident. By representing in simplified form a combination of a Russian icon and a "primitive" mask, religious experience is abstracted to an essential power and directness.
Sarah Mulvey

Date 1928

Country Russia

Medium Oil on carton

Collection R & H Batliner Art Foundation

Why It's Key Represents the culmination of Jawlensky's attempt to express religious experience through abstraction.

Key Artwork *Distribution of the Arms*
Diego Rivera

The Mexican artist Diego Rivera's (1886–1957) ability to unite historical, economic, and personal content in a single work is breathtakingly evident in his fresco *The Distribution of Arms*, which is part of his *Political Vision of the Mexican People* cycle.

The Distribution of Arms depicts an episode in the history of modern Mexican agrarian reform, which overthrew the nineteenth-century tendency to concentrate land ownership in the hands of elites. In *The Distribution of Arms*, Rivera combines deeply felt depictions of ordinary Mexican workers and peasants with figures from his own life, notably his eventual wife Frida Kahlo, who is distributing weapons at the center of the fresco. At the time of painting, Rivera was married to Guadalupe Marin but amorously involved with Kahlo, with whom he would have a famously

stormy relationship over the next two decades. He was also intimate with the model and activist Tina Modotti, who appears on the extreme right of the mural.

Rivera's women do not overshadow the fresco but are integrated with the composite picture of Mexican social and political struggle. They lend balance and subtlety to a work that might otherwise drown in heavy-handed imagery.

Rivera began the *Mexican People* cycle after returning from a European trip that better acquainted him with Renaissance-era frescoes. After this trip, he began to consider his work as a link between the pre-Columbian communal aesthetic and the modern future of Mexico; these elements are expertly mingled in *The Distribution of Arms*.

Demir Barlas

Date 1923–1928

Country Mexico

Medium Fresco

Collection Ministry of Education, Mexico City, Mexico

Why It's Key This fresco is a masterful example of Rivera's skill in creating an aesthetic that is at once political, personal, and popular, and is one of the works that established him as the artist who would change the direction of his country's art.

1920-1929

253

Key Event
Hugh Ferriss publishes *Metropolis of Tomorrow*

American architectural illustrator Hugh Ferriss (1889–1962) never designed an actual building, but his style of draftsmanship and aesthetic inspiration seeped into the blueprints of many buildings, actual and imaginary, from the 1930s onwards.

Defying the utilitarian turn in architectural practice and theory, Ferriss was unabashedly enamored of the aesthetic, the ornate, and the awe-inspiring. His renderings of actual buildings were moodily magnificent, but it was his imagination of the future of architecture in *Metropolis of Tomorrow* (1929) that endured. His designs for scientific, financial, and technological buildings were visionary in his day, but today they can be recognized in any modern metropolis. Ferriss also attempted to imagine what future temples, residences, and bridges might, or

should look like. His style also cast a long shadow over cinema and popular entertainment, turning up everywhere from Fritz Lang's seminal *Metropolis* (1927) to the Batman comic books, to Ridley Scott's *Blade Runner* (1982) and many other science fiction films.

The skyscraper is more ominous now than in Ferriss' day, not only because we have grown to question the benevolence of civic and commercial authority that Ferriss took for granted, but also because, in the wake of the 9/11 terrorist attacks, skyscrapers have taken on an aura of vulnerability that was completely absent from Ferriss' vision. That said, the skyscrapers and urban landscapes that we inhabit in daily reality and view in entertainment emanate from Ferriss and his faith in the future.

Demir Barlas

Date 1929

Country USA

Why It's Key The architecture of a commonly imagined future takes form in Ferriss' draftsmanship.

Key Event **Kampfbund für deutsche Kultur (Militant League for German Culture)**

The Kampfbund für deutsche Kultur (Kfdk) was founded by the intellectually influential member of the Nazi Party, Alfred Rosenberg, who is best known as the main author of Nazism's racial theories, rejection of Christianity, and opposition to "degenerate"' modern art. The role of the Kfdk was largely that of a political lobby group aiming for the "rescue" of German culture from what was considered the pollutants of modernism. Bauhaus art and Expressionism, atonal music, and left-wing criticism were all targets. Unlike some of the more populist Nazi initiatives of the period, the Kfdk was aimed at attracting the attention of Germany's educated elite.

The Kfdk was a complex organization with a convoluted hierarchy and numerous subdivisions and regional administrative sections. The culture of each community, however small, was often represented by a Kampfbund dictator, and from its inception the organization was responsible for local and regional demonstrations against "cultural Bolshevism," often in unison with the SA (the Party's paramilitary wing).

When Hitler finally took control of Germany in 1933, the Kfdk was responsible for numerous decrees that led directly to the expulsion of leading cultural figures, and for a brief period, the organization gained strength and favor. It quickly faded, however, as Rosenberg's unofficial position was challenged by officials such as Goebbels, Göering, and the Reich Culture and Education Minister, Bernhard Rust.
Ian McKay

Date 1929

Country Germany

Why It's Key An influential political lobby group that led directly to the expulsion and persecution of leading cultural figures in Germany.

Key Event
Screening of *Un Chien Andalou* (*An Andalusian Dog*)

Lasting only sixteen minutes, *Un Chien Andalou* reveals its uncompromising intentions early on with a close-up of a woman's eyeball being slit with an open razor. The film was the creation of Luis Buñuel and Salvador Dalí, its dream-logic content driven by their insistence that "no idea or image that might lend itself to a rational explanation of any kind would be accepted." Here was the challenging free-association of the avant-garde being applied to a medium usually associated with narrative storytelling.

Plotless and disjointed, the film is a sequence of unsettling images: a death's head moth; a woman's armpit hair transformed into a man's face; a human palm crawling with ants; dead donkeys in a grand piano. Telling no story and making no sense, it was so startling when it was first shown in Paris, in 1929, that it single-handedly established the notion of moving film – usually considered a vaudeville novelty – having the potential to be a serious artistic medium. Certainly the "reality" of moving images makes the eyeball-slitting a visceral experience unmatched by any static depiction of the same. Eighty years on, while graphic horror films are commonplace, not everyone can watch that grainy black-and-white incision with equanimity.

Dalí went on to be an outlandish cultural event all by himself, while Buñuel became a legendary director whose films usually contained surreal ideas linked by conventional (albeit scandalous) plots. But *Un Chien Andalou* redefined the possibilities of film at the time. Still referenced today, some see it echoed in the narrative-free, sensation-led, short music video.
Graham Vickers

Date 1929

Country France

Why It's Key Spanish Surrealism meets the French avant-garde in a revolutionary art-house film designed to shock rather than tell a story.

opposite Promotional poster for *Un Chien Andalou.*

UN CHIEN ANDALOU

UN FILM DE LUIS BUÑUEL ET SALVADOR DALI

Key Event
Inauguration of the Museum of Modern Art (MoMA)

In November 1929, a group of wealthy New York philanthropists, including Abby Aldrich Rockefeller, Lillie P. Bliss, and Conger Goodyear, opened the world's first museum of modern art. Initially the Museum of Modern Art occupied rented premises on 5th Avenue. When its first permanent building was constructed at West 53rd Street a decade later, its preeminent status was assured, and has been maintained ever since.

The Museum's success was due in large part to the founders' shrewd decision to appoint Alfred H. Barr Jr as its first director. For almost forty years Barr was synonymous with MoMA, the embodiment of its intellectual reputation. It was his vision that the Museum should not focus exclusively on painting and sculpture, but also embrace graphic art, photography, design, architecture, and motion pictures. He was responsible for a series of groundbreaking surveys of movements in modern art and for many memorable monographic exhibitions, notably those devoted to Matisse (1931) and Picasso (1939).

The acquisitions that Barr made included van Gogh's *Starry Night*, Picasso's *Demoiselles d'Avignon* and Mondrian's *Broadway Boogie Woogie*; and due to his friendship with Picasso the Museum was the custodian of *Guernica* from 1939 until its transfer to Spain in 1984. Uniquely, MoMA has shaped as well as reflected the history it was founded to document – many of the artists now represented in its collection, such as Pollock, de Kooning, and Rothko received crucial support from Barr early in their careers.

James Beechey

Date November, 1929

Country USA

Why It's Key Foremost depository of modern art, and the scene of numerous groundbreaking exhibitions.

opposite Early photograph of the Museum of Modern Art on 5th Avenue, New York.

257

Key Artist **Salvador Dalí**
First Paris exhibition

Born in Figueras, Spain, Dalí studied painting in Madrid, where he met the poet Federico Garcia Lorca and movie-maker Luis Buñuel. An arrogant exhibitionist, Dalí was expelled from the academy for inciting the students to rebel, and refusing to enter the exams, saying that his teachers were not qualified to judge his work. Nevertheless, he had his first one-man show in Barcelona at the age of twenty-one. At that time his work embraced Purism and Neo-Classical Cubism.

Moving to France in 1929, he joined the Surrealists and had his first one-man show in Paris that year. Between 1929 and 1937, he produced dreamlike paintings which he claimed were "hand-colored photographs" of his own delirium – notably *The Persistence of Memory* (1931), which shows limp, melting watches and a distorted, slumbering head in a bleak, sunlit landscape. These made him the world's most famous Surrealist artist. With Buñuel, he made the two Surrealist films *Un Chien Andalou* (1928) and *L'Âge d'Or* (1930), which only increased his notoriety.

In the late 1930s, he began to paint in a more academic style, influenced by Raphael, and was expelled from the Surrealist movement for his right-wing views and increasing commercial success. From 1940 to 1948, he lived in the United States, designing jewelry, stage sets, and the interiors of fashionable stores, while maintaining his Surrealist reputation with bizarre self-promoting stunts. After returning to Europe, Dalí concentrated on religious themes, though he continued painting childhood memories and erotic images, often centered on his wife, Gala.

Brian Davis

Date 1929

Born/Died 1904–1989

Birth Name Salvador Felipe Jacinto Dalí Y Domènech

Nationality Spanish

First Exhibited 1925

Why It's Key Leading Surrealist, who explored the imagery of the subconscious, but who more famously became renowned as an outrageous celebrity.

Key Artwork *Head of a Woman with a Necklace*
Henri Laurens

The vast and overlooked talent of the sculptor Henri Laurens (1885–1954) is apparent in his *Head of a Woman with a Necklace*, a terra cotta work that betrays stern traces of the artist's early Cubist influences while pointing to his increasing preoccupation with gentler faces. *Head of a Woman with a Necklace* captures many of Laurens' figurative preoccupations of the 1920s in one figure: a slightly frowning, hairless woman, face ascetically angular and culminating in a troubled moue, with a gaudy necklace – it might almost be primitive – just below her thick neck. The face transcends easy categorization: it is simultaneously furious, haughty, distant, and intimate, and perhaps as in no other work in his oeuvre, Laurens unites emotion with thought.

It is a last clear glimpse into Laurens' notion of woman before the artist's 1930s venture into faceless figures and larger sculptures, when many of Laurens' women are too obviously the representations of some tangible idea, too domesticated. *Head of a Woman with a Necklace* crackles with intrigue and erotic energy while expressing much of the brainy technique of Laurens' *Head of 1918*. The sculpture's iconic face is ambiguous enough to accommodate our hopes and fears without descending into pure plasticity, and gives evidence of a quiet artist's keenly analytical mind as well as of his heart.

Henri Laurens died sadly neglected in 1954, but *Head of a Woman with a Necklace* continues to testify eloquently on the artist's behalf.

Demir Barlas

Date 1929

Country France

Medium Terra cotta

Collection Musée Nationale d'Art Moderne, Paris, France

Why It's Key Pivotal example of the work of an often underrated sculptor.

258

Key Event
Wall Street Crash

During the 1920s, the stock market in the United States underwent a rapid expansion, but in September 1929 it began to decline. However, rampant speculation continued unabated. Then, on October 24, which became known as Black Thursday, the market began to plummet. The banks and investment companies bought large blocks of shares and managed to steady the market, but the following week, on Black Monday and Black Tuesday, they found they could not stem the tide and the market collapsed completely – and with it the lucrative New York art market.

As American institutions began to call in foreign loans made during World War I, the Great Depression spread worldwide. The market for mezzotint prints, for instance, which had been much sought after until then, collapsed and never recovered. However, with the rise of the Nazis in Germany – seen as a consequence of the Depression – artworks that were considered decadent came on the market after being ejected by the museums.

In the United States, art projects were sponsored by Franklin D. Roosevelt's New Deal, but economic order – and with it an orderly market for art – was not re-established until after World War II. The rise of the Nazis in Europe also led to a large number of Continental artists, particularly Jews, fleeing to the safety of the United States.

Nigel Cawthorne

Date October 1929

Country USA

Why It's Key Ended the period of optimism after World War I, leading to the Great Depression and World War II.

Key Artist **Jamini Roy** Exhibition at Calcutta Art School establishes him as a leading Primitivist

Born in rural Bengal, Jamini Roy was educated at the Government School of Art in Calcutta, where he primarily studied the Western art and methods that he employed upon beginning his career as a portrait painter in 1914. However, he found more inspiration in his native surroundings and began to create his own style in the early 1920s.

He studied Bengali folk painting, incorporating the techniques, conventions, and even materials in creating his celebratory depictions of Indian culture, which often incorporate rural and tribal themes. Despite financial struggles during this career change, he continued to create works in his innovative style. In 1929, one of his contemporaries, the artist Mukul Dey, recognized his talent and sponsored his first exhibition at the Government School of Art. The event was a great success, facilitating his recognition as one of the leading Primitivist artists in India and bringing him international acclaim. By the early 1940s, many Westerners had become avid collectors of his work, comparing his style to that of Picasso.

He continued to evolve as an artist, with his later works often depicting Christian themes in his unique, oriental style, as can be seen in *The Annunciation* (c. 1950). As his popularity increased, he established a workshop and hired apprentices to produce copies of his works, which he then sold at lower prices in order to increase the availability of his art. He died 1972, an internationally renowned artist, and his legacy lives on, as evidenced by his monumental impact on contemporary Indian art.

Heather Hund

Date 1929

Born/Died 1887–1972

Nationality Indian

First Exhibited 1929

Why It's Key Created art that glorified native traditions, paving the way for future contemporary Indian artists.

1920–1929

259

Key Exhibition
Aboriginal Art

In conjunction with the Aboriginal Art Exhibition, Mrs. Charles Barrett and A.S. Kenyon published *Australian Aboriginal Art*. Before 1929, Aboriginal art had been neglected in Australia. Frances Derham (1894–1987) became a key figure in promoting it, both as an educator and through her work with the Arts and Crafts Society of Victoria. Another major figure in this effort was the Australian abstract artist and printmaker Margaret Preston (1875–1963), who believed that Aboriginal artists had much in common with Cubists.

The focus of the Aboriginal Art Exhibition was the collection of bark paintings that Baldwin Spencer, the Director of the National Gallery, had begun collecting in 1912 from the area around the Alligator, East Alligator, and South Alligator Rivers in the Western Arnhem Land. After paying tribal elders a commission, Spencer had removed the paintings, which generally depicted animals and spirits, from the walls and roofs of shelters that had been erected as protection from the weather. Later, Spencer commissioned other bark paintings.

The most famous Aboriginal artist involved in the Aboriginal Art Exhibition was Tommy McRae (1830–1901), the first Aboriginal artist ever to be published in Australia. His *Ceremony*, a pen and ink sketch, was described in the exhibition catalog as exhibiting a European influence, reflecting the tendency of Australians of the time to judge Aboriginal art according to Western standards. Since 2001, Aboriginal art has a permanent home in Melbourne at the Bunjilaka Aboriginal Centre of the Melbourne Museum.

Elizabeth Purdy

Date July 9, 1929

Country Australia

Why It's Key First major exhibition of Aboriginal art held in Melbourne, which paved the way for recognition of this distinct art form by Westerners.

Key Exhibition
First National Art Exhibition of China

In 1929, the Republic of China underwrote the First National Art Exhibition of China, which crowned several years of diligent government patronage of art schools, artists, and museums. The purpose of the National Art Exhibition, curated by painter and Lingnan school leader Gao Jingfu, was to demonstrate a new kind of Chinese art that was divorced from Imperial Chinese aesthetics and traditions.

By 1929, Jingfu had spent nearly twenty years dedicating himself to a new kind of Chinese painting, one that would absorb Japanese and European influences in order to achieve a Realist vocabulary more accessible to ordinary Chinese people. Jingfu marshaled a number of artists to convey this new aesthetic, including names such as Lin Fengmian, Teng Baiye, Xu Beihong, Gao Qifeng, and Liu Haisu.

The Lingnan school was heavily represented in the National Art Exhibition.

As it turned out, the Chinese public, which was significantly less pro-Japanese than the leaders of the Lingnan school, was not inclined to bless the National Art Exhibition with popular approval. Japan's increasing hostility to China over the course of the 1930s permanently destroyed any hope of embedding a Japanese aesthetic (by way of European Realism) in the aesthetic heart of China, and Jingfu himself returned to traditional Chinese painting after the Japanese occupation of China.

Modernism would not return to China. After the cultural thaw of the 1980s, it was postmodernism that took root in the Chinese art world.

Demir Barlas

Date 1929

Country China

Why It's Key Chinese art circles embrace and exemplify a tenuous, borrowed modernism that soon collapses.

261

Key Artist **Candido Portinari**
Returns from Paris to Brazil

Brazil's Candido Portinari was part of the early- to mid-twentieth century wave of Latin American artists – most prominently including Mexico's Diego Rivera – who adopted the tools and techniques of European modernism to the scrutiny of their own countries' historical and social situations. Portinari followed a typical early career path for an artist of this kind: childhood promise of artistic talent honed in local schools followed by a pilgrimage to Paris.

Portinari won his path to Paris by earning first prize at the 1928 National Salon of Fine Arts in Rio de Janeiro. The award carried with it a fellowship that supported Portinari in Paris for three years, during which time the young Brazilian soaked up all the aesthetic developments underway in the world capital of modern art. This was a fallow time for the artist,

whose observation was far more prolific than his painting. It was only after his return to Brazil in 1930 that Portinari's European experience bore fruit, as the artist began painting Cubistic and Expressionistic images and people from his homeland. Before long, Portinari's work took on the robustly realistic tone so familiar from Rivera and Orozco, the towering Mexican muralists, and Portinari moved inexorably toward the mural form as well.

By the middle of the 1930s, Portinari had hit his stride, beginning a long period of socially, politically, and theologically conscious work that epitomized Brazil's own fascination with a sort of patriotic modernism. Without Paris, however, Portinari would never have entered the Brazilian aesthetic pantheon.

Demir Barlas

Date 1930

Born/Died 1903–1962

Nationality Brazilian

First Exhibited 1922

Why It's Key Having absorbed European influences, he turns an aesthetically trained and socially conscious eye on his own country.

opposite Candido Portinari

Key Event
Suicide of Vladimir Mayakovsky

On April 13, 1930, the prolific revolutionary poet Vladimir Mayakovsky committed suicide. Distressed by adverse criticism and a failed love affair, he shot himself with a prop pistol that had been used in one of his plays. Mayakovsky had been a significant figure in the evolution of Russian revolutionary arts, in an atmosphere of constant ideological change. Trained as an artist, in 1919 he became involved with Komfut – the Russian version of Futurism – for which he wrote poetry and prepared publications. Aligning Futurism with Communism, a prerequisite for which was membership of the Bolshevik party, he was inspired by the revolutionary atmosphere and wrote many poems in support of the Bolsheviks. He also designed posters and wrote propaganda plays and texts for the Russian Telegraph Agency (ROSTA). In 1923, with ideologically conservative shifts toward utility, functionalism, and accessibility, he co-founded the Constructivist journal *LEF* (Left Front of the Arts). His reputation and political connections allowed him to travel extensively in Europe, USA, Mexico, and Cuba. He was, however, increasingly alienated from Soviet reality. He wrote two plays that were critical of the NEP (New Economic Policy) of the previous years – *Bedbug* (c.1929) and *Bathhouse* (c.1930) – both of which made him unpopular with some writers and critics. In an attempt to prove his proletarian credibility, he joined RAPP (Revolutionary Association of Proletarian Writers) but harsher criticism ensued, adding to his depression and ultimately to his self-destruction. After his death, Stalin issued a statement supporting Mayakovsky and his work. He was rehabilitated in 1935.
Sue King

Date 1930

Country Russia

Why It's Key Important revolutionary poet and political activist who influenced art education, and helped to found Russian Futurism and the Constructivist journal *LEF*.

Key Event
Riot at *L'Âge D'Or*

After making *Un Chien Andalou* (*An Andalusian Dog*), Spanish artist Salvador Dalí and director Luis Buñuel, made the feature film *L'Âge D'Or* (*The Golden Age*). It comprised a series of vignettes showing a couple prevented from consummating their love by their families, the Catholic Church, bourgeois society, and random surreal events. At that time, French movies were censored, but the Commission de Censure was mainly concerned with suppressing Bolshevik films. A misleading synopsis was submitted, and the Commission passed the film without viewing it. On November 28, 1930, it opened at the cinema Studio 28. Fearing the worst, the producers stayed away; Dalí attended, but the sound system broke down. Then, on December 3, fifty members of the Young Patriots, an offshoot of the nationalist League of Patriots and the Anti-Jewish League, threw ink at the screen, smashed up the theater, exploded smoke bombs, beat up members of the audience, and trashed Surrealist paintings and books in the foyer. Nevertheless, the show continued, with paper stuck over the ink stain, and a police guard. On December 5, the Prefecture demanded a scene showing four decaying bishops be cut. Mussolini's ambassador protested on the 9th, and on the 11th, the movie was re-presented to the Commission, who complained that two "pornographic" scenes had been added, and two prints were impounded. *Le Figaro* called it *L'Âge D'Odure* (*The Age of Excrement*), saying it had been made by Judeo-Bolshevik foreigners. *L'Humanité* countered that it has been suppressed in the interests of the fascists and the bourgeoisie. The film got its U.S. première in 1979.
Nigel Cawthorne

Date 1930

Country France

Why It's Key Surrealism forces its way into the political arena.

Key Artwork *Composition*
Otto Freundlich

Writing in the publication put out by the Cercle et Carré group, Otto Freundlich stated that "the artist is the barometer of transformations. He senses them in his acts and his thoughts before they are realized in the world." Freundlich was certainly acting as such a barometer when he painted *Composition* in 1930. This work, well executed in the style of Constructivist painting, foreshadows the early mechanics of Pop art, with its large frames of color that play off one another. Our eyes are stimulated by the asymmetrical balance of color – the red and black hues contrasting the open white space in the center of the lower section of the painting.

This prismatic element encourages a deeper consideration of the refraction of light and color throughout the work, while offering the viewer a choice of perspectives: is it a white triangle integral to the image or an empty hole in the painting? This suggestion of physical absurdity demonstrates the influence of Dadaism alongside Cubism in Freundlich's art. Freundlich's *Composition* is now included in the Museum of Modern Art's Provenance Research Project, an investigation into the ownership history of works of art painted prior to World War II and kept in continental Europe between 1939 and 1945. While many of Freundlich's works survived the war, the artist did not. He was deported from France to a concentration camp in Poland, where he perished in 1943.

Rebecca Baugniet

Date 1930

Country France

Medium Oil on canvas

Collection The Riklis Collection of McCrory Corporation, The Museum of Modern Art, New York

Why It's Key *Composition* is one of the paintings Freundlich executed while he was a member of the Cercle et Carré (Circle and Square) group; it is presently included in the MoMA's Provenance Research Project.

1930–1939

263

Key Artwork *Coming From the Mill*
L. S. Lowry

Laurence Stephen Lowry (1887–1976) balanced his painting career with a full-time job as a rent collector and clerk with Pall Mall Property Co Ltd., Manchester, from 1910 to 1952. Ever secretive, he kept this part of his life private, even from close friends, but it gave him the opportunity to walk around the city and observe the street life that would be the lifelong subject matter for his painting. Lowry liked to say that the first thirty years of his art career were ignored, but in fact he exhibited regularly and widely, including submitting to the Paris Salon. In 1936, Salford City Art Gallery bought its first Lowry painting, *A Street Scene* (1928), from a Manchester Academy of Fine Arts exhibition.

Coming From the Mill was a subject Lowry returned to repeatedly. It was the beginning of a withdrawal from the immediate vicinity of the action to a more panoramic viewpoint whereby the all-important figures become more ant-like. His previous works, such as *A Street Scene* and other paintings from the later 1920s, featured more distinctive characters which repeatedly appear, such as the woman in the red shawl. Eventually this withdrawal would distil into Lowry's "white period" and the infamous "matchstick men" so popular with the public. Speaking of *Coming From the Mill*, Lowry noted that "the composition was incidental to the people. I intend the railways, the factories, the mills to be a background." The industrial traditions of northern England, captured here without sentiment, have long since been destroyed by "progress," and nostalgia plays a large role in the public affection for this often controversial artist.

Mike von Joel

Date 1930

Country UK

Medium Oil on canvas

Collection The Lowry, Salford Quays

Why It's Key This is a painting with the more "panoramic" viewpoint that heralded a move toward depictions of larger, more anonymous crowds and less defined individuals, eventually to become the "matchstick men" of popular appeal.

Key Artwork *American Gothic*
Grant Wood

Depicting an austere hay-farmer and his spinster daughter posing stiffly before their emphatically designed clapperboard home, *American Gothic* is one of a handful of paintings of any period known to the man in the street. Success accompanied its first exhibition, in the fall of 1930, at the Art Institute of Chicago's annual exhibition. Bought by the museum for US$300, it began appearing in newspapers across the United States and transformed the career of Grant Wood (1892–1942), who became one of the most widely acclaimed painters of the American Scene.

A variety of interpretations have existed from the outset about the subject of *American Gothic* and whether it mocks or celebrates Midwestern pioneer society. Precisely drawn details symbolize values and material accomplishments that, as a native Iowan, Wood intended to realize in this iconic image of the insular Victorian communities he had known in his youth. Working from memory and old photographs, he portrayed the kind of small-town people who resisted pressures to modernize with affectionate wit that was unprecedented in his art. The painting represented a pivotal moment for Wood, giving this all-purpose artist confidence to concentrate on rural themes in a style that drew heavily on the Americana of Currier and Ives prints, and folk art. Constructed around repeating geometries, as between the window, faces, and fork, the hard-edged realism of dress and setting is derived from Holbein, Memling, and Dürer. They offered a way to express regionalist consciousness, also nurtured by contemporary writers Sinclair Lewis and Jay Sigmund.
Martin Holman

Date 1930

Country USA

Medium Oil on composition board

Collection The Art Institute of Chicago

Why It's Key With humor and tenderness, Wood transformed the lore and rituals of American Midwestern life into a memorable image.

opposite *American Gothic*

Key Artist **Alfredo Ramos Martínez**
Founding Father of Mexican art moves to Los Angeles

Born in Monterrey, Mexico, Alfredo Ramos Martínez pursued his studies at the Academia Nacional de Bellas Artes in Mexico City. However, he was disillusioned by the formality of the teaching approach, and he often left to paint outdoor scenes of ordinary life. In 1897, he further pursued his studies of plein air painting in Paris, after receiving financial support from an American benefactor, Phoebe Hearst. Upon his return to Mexico in 1910, he became the Director of the National Academy before founding the Escuelas de Pintura al Aire Libre, a school of open-air painting for boys.

However, it was his move to Los Angeles in 1930 to seek better medical care for his daughter, Maria, that most influenced the development of his notable style. He began to explore Mexican rural culture in a modern style that stood in stark contrast to his earlier works, such as *La Primavera* (1905).

His utilization of a unique, native style in his exploration of the indigenous religion, landscape, and daily life, as depicted in *Mexican Mountain Landscape*, contributed to his recognition as the Founding Father of modern Mexican art. While his works have been overlooked in the past, he is now beginning to receive recognition for his contributions in initiating the Mexican modernist movement.

He continued to paint until his death in 1946, creating multiple murals in public places, including the Scripps College in Claremont, the Los Angeles County Museum, and the San Francisco Museum of Art.
Heather Hund

Date 1930

Born/Died 1871–1946

Nationality Mexican

First exhibited 1906

Why It's Key Influential in initiating the modernist movement in Mexican art.

Key Artist **Roy de Maistre**
Moves permanently to England

Born LeRoi Levistan de Mestre, he went to Sydney in 1913 to study music at the New South Wales State Conservatorium of Music, and painting at the Royal Art Society of New South Wales, under Norman Carter and Antonio Dattilo-Rubbo, who promoted Post-Impressionism. He also studied at Julian Ashton's Sydney Art School. In 1916, he exhibited Impressionist interiors and landscapes, showing an interest in the effects of light, later theorizing about the relationship between painting, music, and color.

Influenced by recent American books, he shared an exhibition of vivid flat-pattern landscape paintings in August 1919 with Roland Wakelin. This "color-music" exhibition became part of Australia's art folklore as "pictures you could whistle." Later in 1919 he painted but did not exhibit some of Australia's first abstract paintings.

In 1923 de Mestre was awarded a traveling scholarship. After three years in England and France, he returned to Australia to stage a series of one-man exhibitions. In March 1930 he left permanently, changed his name to Roy de Maistre and became an established artist in London. His paintings were generally Cubist in style, although he also produced academic society portraits and some Surrealist works. From 1951, he exhibited with the Royal Academy of Arts and was represented in Arts Council of Great Britain exhibitions. His work was bought for the Tate Gallery and other museums. He painted a series of Stations of the Cross for Westminster Cathedral and two triptychs for St Aidan's Church, East Acton. Alongside religion, his late painting often dwelt on the interior of his studio home.
Nigel Cawthorne

Date 1930

Born/Died 1894–1968

Nationality Australian

First exhibited 1916

Why It's Key Roy de Maistre produced the first Australian abstract paintings.

Key Artwork *Persistence of Memory*
Salvador Dalí

Persistence of Memory, the single most famous Surrealist painting, is another in a long series of Salvador Dalí's (1904–1989) precise descriptions of what cannot be described – in this case an impossibly lit landscape, a number of intangible concepts, and an non-rational dream-science that may in the end combine to form a reality more complete and convincing than our own.

Persistence of Memory centers on a series of soft, melting clocks draped over an artificial outcropping, a tree, and a melted, indistinct human face. In the distance loom cliffs remembered from Dalí's Catalonian childhood and an eerily artificial light. On the outcropping, ants ravage a rusted pocket watch, which is the only hard timepiece in the painting. A tongue emerges from the nose of the melted face. These

disturbing details, rendered as always in Dalí's exemplary draftsmanship, are designed to penetrate the defenses of the spectator's consciousness and convey a series of dreamlike concepts: the physical malleability of time (itself supported by the novel physics of Dalí's day), the persistence of the artist's memories of his natal landscape, and the fertile dissolution of form and function that continually takes place in the subconscious.

While *Persistence of Memory* is an important example of metaphysical or analytical art, it is Dalí's brilliant, distorted, and immaculately rendered imagery that ensures the painting's persistence in the public and critical mind. The melting clocks are by now part of the communal consciousness, an archetype and an icon that ably represent the psychic adventures of Surrealism.
Demir Barlas

Date 1931

Country France

Medium Oil on canvas

Collection Museum of Modern Art, New York, United States

Why It's Key This iconic painting is one of the most famous and finest examples of Surrealism.

opposite *Persistence of Memory*

Key Artist **Hans Hofmann**
Moves to the United States

Hofmann started out as a scientist, inventing a magnetic comptometer. But he also had a passion for art, and moved to Paris immediately before the outbreak of World War I, where he met Matisse, Picasso, and Braque. He learned color theory at first hand from Robert Delaunay, and set up his own art school in Munich, Germany, in 1915.

Hofmann remained closely involved with art education for most of his life, and when he moved to the United States in 1931, settling there permanently the following year, he opened another art school, the Hans Hofmann School of Fine Arts in New York.

Hofmann was a major influence on Abstract Expressionists such as Jackson Pollock, pioneering the splashing/pouring/dripping technique of applying paint. However, unhappy with what he perceived as his reputation as a mere academic and theorist rather than an artist, in 1958 he closed down his art schools and gave up teaching in order to concentrate on his own work.

The essence of his philosophy as a painter was that the surface of the painting had a life of its own, irrespective of subject or content, and had no obligation to look like or represent anything other than itself. Good examples of his paintings include *Transfiguration* (1947) and *Fantasia in Blue* (1954). These typically demonstrate the marriage of firmly defined abstract shapes with spontaneous-seeming gestural painting in bold, clear colors.

John Cornelius

Date 1931

Born/Died 1880–1966

Nationality German/American

Why It's Key Pioneer of Abstract Expressionism.

268

Key Person **Herbert Read**
Influential writer publishes *The Meaning of Art*

In Read's view of human experience, art, culture, and politics were integrated. He believed in the individual right to freedom of expression and that innate qualities were as important as external influences in forming a sense of reality. These attitudes pitted him against Marxist critics and, although he was a self-confessed anarchist, Read's outlook was characterized by the problem of reconciling the chaos of perception with the order of reason. A poet, literary critic, and editor, as well as a renowned philosopher of modern art, he campaigned for Surrealism and abstract art, editing key inter-war texts and co-organizing the London International Surrealist Exhibition in 1936. In 1947 he was joint founder of London's Institute of Contemporary Art, wich was a meeting place for avant-garde artists and their supporters.

Read is most associated with the British artists Henry Moore, Ben Nicholson, and Barbara Hepworth, settling near them in the 1930s in Hampstead, the intellectual center of north London, where Gropius, Gabo, Mondrian, and other continental modernists first sought refuge from war. His idealist views drew him to an interest in psychoanalysis, especially the theories of Carl Jung, which he applied to the criticism of art and literature. One of his most important books, *Education through Art*, analyzed children's art, and by 1949 he was an early commentator on existentialism.

As a soldier in World War I, Read received two of the highest decorations for his bravery in action, and in 1953 he was knighted for his services to literature.

Martin Holman

Date 1931

Born/Died 1893–1968

Nationality British

Why It's Key Seminal work by the foremost champion of modern art in Britain.

Key Event **Georges Vantongerloo founds the Abstraction-Creation Group**

By the 1930s, representational art had reasserted its influence over abstract art. In response, the artists Georges Vantongerloo, Hans Arp, Albert Gleizes, Auguste Herbin, Frantisek Kupka, and Jean Helion founded the Abstraction-Création Group, a loose front of abstract artists that exhibited and published regularly until 1936, at which point the group's activities began to wind down. While many of the founders were French, Abstraction-Création's membership grew to include many artists from the Nazi and Soviet spheres of influence, who had encountered those totalitarian regimes' hostility to abstract art first hand.

Abstraction-Création proved to be popular, drawing as many as four hundred members at its height and winning the participation of such masters as Kandinsky and Mondrian. Conceptually, Abstraction-

Création served as an umbrella group for Neo-Plasticists (such as Vantongerloo himself), Constructivists, practitioners of Concrete Art, and any artist generally driven by non-figurative techniques and motifs.

Abstraction-Création saw the work of its members as a political and scientific statement in defense of the freedom – then hotly contested all over Europe – to see the world in ways not conditioned by the ideologies of nationalism and racism. The group believed that what it called the purely plastic culture of non-figurative painting could also extend to the ways in which nations were governed and people saw each other. Sadly, the beginning of World War II within 8 years of Abstraction-Création's founding signaled that Europe was not yet ready for such a radical re-imagining of art and society.
Demir Barlas

Date 1931

Country France

Why It's Key A large and active group of abstract painters came together to make a statement against the aesthetic and political limitations of representation.

1930–1939

269

Key Artist **Frantisek "Frank" Kupka** Co-founds the Abstraction-Création Group

Kupka was born in Dobruska, Czechoslovakia, and as a boy he apprenticed to a firm of saddlemakers before traveling through eastern Bohemia, where he studied art informally. Initiated into spiritualism by his former employer, he was considered to have some gifts as a medium. This interest drew him toward the spiritual symbolism of color (he was later to describe himself as a "color symphonist") and he decided that painting did not require a figurative subject. He undertook formal studies at the Prague Academy of Fine Art from 1887 to 1891, moving on to Vienna, where he continued at its Akademie. In 1894, he spent a few months in London and Scandinavia before settling in Paris in 1895, where he stayed until his death in 1957.

Kupka's early painting was influenced by the Impressionists, as well as the Fauves and Expressionists

such as Georges Roualt. Yet he also had a scientific bent and predated the Futurists, and Marcel Duchamp, in his experiments with movement and light, further to contemporary experiments with chronophotography. However, the likes of Odilon Redon and the Symbolists led him finally toward abstract works, which he first exhibited in 1912 at the Autumn Salon, where they caused a sensation.

Kupka helped to found the Abstraction-Création Group, which was open to all forms of non-figurative, modern art, but increasingly became more concerned with geometric-mathematical rather than lyrical-expressionistic abstract painting. Kupka was not given due credit until the 1960s, although he had enjoyed the respect of a limited cognoscenti until then.
John Cornelius

Date 1931

Born/Died 1871–1957

Nationality Czechoslovakian

Why It's Key One of the true founders of abstract painting.

Key Artist **E.H. Shepard**
Groundbreaking illustrations for *The Wind in the Willows*

Born in London, Ernest Howard Shepard was the son of an architect. His mother was the daughter of a successful watercolorist and told him always to carry a pencil and notebook – which he did for seventy-nine years. He began contributing cartoons to *Punch* magazine in 1907 and, after winning the Military Cross in World War I, he joined the magazine's staff in 1921.

In 1924, Shepard illustrated A.A. Milne's book of poetry *When We Were Very Young*. He went on to illustrate Milne's *Winnie-the-Pooh* (1926), *Now We Are Six* (1927), and *The House at Pooh Corner* (1928). Pooh was modeled not on the toy owned by Milne's son Christopher Robin, but on Growler, a stuffed bear owned by Shepard's son.

Kenneth Grahame's *The Wind in the Willows* had first been published in 1908, but in 1931, Shepard provided new illustrations in his anthropomorphic style. He may have been recommended by Milne, who dramatized *The Wind in the Willows* as *Toad of Toad Hall* in 1930.

Shepard became the lead cartoonist at *Punch* in 1945, but was removed in 1953 when Malcolm Muggeridge became editor.

Brian Davis

Date 1931

Born/Died 1879–1976

Nationality British

First published 1907

Why It's Key Created pictures of human-like animals that led the way in children's book illustration.

270

Key Event
Opening of the Whitney Museum

The Whitney Museum owes its name to its philanthropic owner, the sculptress and art collector Gertrude Vanderbilt Whitney. Herself an artist, Whitney was trained in the art of sculpture in New York and then in France, under the mastership of Rodin.

In the United States, her wealth allowed her to become an influential patron of the arts, and in the 1920s she opened a space, the Whitney Studio Club, where young artists could exhibit their work. An important art collector as well, by 1929 she already possessed about seven hundred pieces by members of the subversive Ashcan school, including works by the realist Edward Hopper, and by older modernists such as Charles Demuth. The same year, Whitney offered her collection to the Metropolitan Museum of New York, hoping it would promote more visibility for her artists,

but the institution declined the offer. She therefore decided to open her own museum in November 1931.

Specializing in American modern art, the Whitney Museum now contains over 12,000 works. It has the widest collection of Hoppers in the world, the result of a bequest by the artist's widow in thanks for Whitney's support. The museum is also very active in the promotion of young and unknown artists. Starting in 1932, its series of Annual and Biennial exhibitions has now gained much popularity in the art world. Through these showcases, the museum has enriched its collection with the work of contemporary artists such as Louise Bourgeois, Mike Kelley, and Matthew Barney.

Sophie Halart

Date November, 1931

Country USA

Why It's Key The first museum to exclusively specialize in twentieth-century American Art.

Key Event
Completion of the Empire State Building

No urban landscape has come to represent sheer modernity more potently than that of Manhattan Island, the sky-scraping, glittering heart of New York. From the late nineteenth century, the earliest skyscrapers were being constructed. Based on a steel skeleton, which allowed for multistory building for the first time, they changed the city's skyline forever, and the only way seemed to be upwards.

After World War I, the mock-Gothic grandeur of constructions such as the Woolworth Building – dubbed the "Cathedral of Commerce" on its opening in 1913 – gave way to the jazzier lines of Art Deco. And even as the brittle winds of the Depression blew through Manhattan's concrete canyons, the glamorous 77-floor Chrysler Building briefly dominated the skyline when it was completed in 1930.

But the following year, the Empire State Building, designed by William Lamb of the architects Shreve, Lamb and Harmon, stole the Chrysler's crown as the tallest building in the world, just 140 days after construction began. Soaring to a breathtaking 1,472 ft (449 m), the 102-story tower became an instant icon and the epitome of Modernism. It was the world's tallest building for forty years, until the construction of the World Trade Center, which was completed at the end of 1970.

The building has been celebrated by artists, writers, and photographers over the years, famously in Andy Warhol's *Empire* (1964), a continuous black-and-white eight-hour film of the tower at night. But it is the giant ape scaling the skyscraper in the 1933 movie *King Kong* that has left its imprint on the popular perception.
Mike Evans

Date March, 1931

Country USA

Why It's Key Made the skyscraper – and the New York skyline in particular – the essence of modernity, and was a classic of Art Deco architecture in its own right.

Key Artwork *Storm in the Jungle*
Edward Burra

Edward Burra (1905–1976) is perhaps best known for his urban scenes of New York's Harlem, but his overlooked 1931 *Storm in the Jungle* is a reminder that the English painter also had an overheated tropical imagination and one that had been shared by the likes of Henri Rousseau (1844–1910).

Storm in the Jungle exemplified Burra's lifelong resistance to easy categorization, as the painting carries echoes of naïve art, exoticism, Surrealism, and a nameless tendency to crowd as much as possible into a tiny frame. The jungle, cats, birds of paradise, bricks, monkeys, distant mountains – *Storm in the Jungle* is a catalog of elements, if not yet of ideas. The frenzy in it is Burra wrestling with a great many creatures, colors, and ornaments that are not subordinated to any apparent vision.

From one point of view, this is a major weakness that wrecks the painting. From another, it is an honest depiction of the reality of travel, imagination, and encounter, which occur to us as ungovernable montages rather than as unitary narratives. Therefore, Burra might be offering direct access to what Kant called the sensuous manifold: the welter of confused impressions from which we later, and perhaps tenuously, derive a rational narrative of experience.

Surrealism was less automatic than it aspired to be. Burra's automatism of representation – the urge to set everything down as it enters his head – is a braver Surrealism than that practiced by many official adherents of the movement, and a doorway into our pre-verbal form of perception.
Demir Barlas

Date 1931

Country UK

Medium Gouache on paper

Collection Nottingham City Museums and Galleries, Nottingham, England

Why It's Key The style of representation in *Storm in the Jungle* resists easy categorization, but it shows a more courageous form of Surrealism than that practiced by many others.

Key Artist **Thomas Hart Benton** Created Regional Art for the New School For Social Research

In the 1920s and 1930s, while many American artists were influenced by the European avant-garde, there was also a substantial figurative movement. This mainly fell into two categories: Social Realism, in which artists drew on urban themes and tended toward the political left; and Regionalism or American Scene Painting, which looked toward the agricultural heartland. Accordingly, it reflected the conservatism of the farming communities.

Thomas Hart Benton was a Regionalist and opposed to modernism. Best known for his *American Historical Epic*, a series of mural-sized canvases depicting the history, myths, and roles of those individuals building America, many of his themes and narratives were drawn from his travels around southwest Missouri, northwest Arkansas, and Texas in the 1920s.

His first commissioned mural was for the newly built New School for Social Research on West 12th Street in New York, executed between 1930 and 1931. Impressed by the Mexican Muralist Orozco, who had been commissioned to do a set of murals for the school, Benton managed to secure a second set for the boardroom. Entitled *America Today* and painted in egg tempera, it was a series of vignettes intersected by geometrically patterned moldings. As reported in *Time* magazine, the walls were filled with stockbrokers, bootleggers, revivalists, politicians, and burlesque queens, painted in brilliant colors.

New York critics tended to dismiss Regionalism, as it was not Modernist, and among the criticisms were accusations of over-loudness and bad taste.
Sue King

Date 1931

Born/Died 1889–1975

Nationality American

Why It's Key During the Depression Benton created important murals on American themes for public spaces.

Key Person **Bill Brandt** Assisted Man Ray in Paris before moving to London

Bill Brandt was born in Germany to an English father in the prelude to World War I. Having contracted tuberculosis, he spent the post-war period in Switzerland, where he first learned photography. It was reputedly a portrait taken of Ezra Pound that resulted in an introduction to Man Ray in Paris. Brandt went to assist the Surrealist artist in 1929.

Brandt came from a privileged background and moved in elevated social circles. In 1933 he moved to England and, in stark contrast to his own situation, he became famous for his studies of social inequality and deprivation amongst the unemployed and working class of Britain. From a modern perspective, the irony is that some of his most memorable images of poverty and despair were faked – featuring friends, family, and paid extras. His first book, *The English at Home* (1936)

interlaced monochrome images of uppe- class privilege with the realities of the servant classes, thus forecasting the major political issue of peacetime Britain.

During 1940, Brandt worked for the Ministry of Information, documenting the London blitz. Eschewing "street photography" after the war, Brandt turned to reinterpreting the nude and created a celebrated series of *Perspective Nudes*, where the body often takes on the qualities of a surreal landscape.

Brandt is a major artist of the early twentieth century, with a body of work that encompassed all aspects of photography. Famously quiet and unassuming, almost reclusive, Brandt claimed that he "never really looked at his own pictures" and that "anybody could do what he did."
Mike von Joel

Date 1931

Born/Died 1904–1983

Nationality British (born in Germany)

Other Key Works A striking re-interpretation of the human figure in a series of studies known as the *Perspective nudes* (1945–61)

Why It's Key Brandt introduced powerful "social realist" imagery to Britain through the pages of the popular press during the inter-war years.

Key Artist **Kim Ki-chang**
First shown at Choson Exposition

In 1931, a teenage Korean artist named Kim Ki-chang (also known as Woonbo) was exhibited for the first time at the Choson Art Exposition, an annual show in Seoul mounted and judged by the Japanese colonial authority then occupying Korea. While the Choson Exposition was more notable for showcasing Japanese artists resident in Korea, and Korean artists who had adopted Japanese styles of painting, Ki-chang was one of the few uncompromisingly Korean artists to be accorded recognition there.

Ki-chang's early work, influenced by his mentor Kim Eun-ho, brought traditional ink drawing techniques to the representation of flowers, birds, and human figures, but he matured quickly, adding oil painting to his repertoire, and won a prize at the 1938 exhibition for the painting *Old Tales*.

After the Japanese left Korea in 1945, Ki-chang continued to evolve. In the late 1940s, he began to paint landscapes that combined traditional black brushwork with blue and green coloring, and in the 1950s he drew Jesus as a Korean. Later, in the 1960s, he adopted elements of abstract art, including Cubism, into his technique. Toward the end of his career, Ki-chang had achieved international recognition. He was exhibited in many countries and contributed to the official art portfolios of the 1988 and 1992 Olympic Games.

Despite Ki-chang's experimentation, he remained what he had been at the 1931 Choson Exposition: a recognizable Korean artist wedded to traditional brushes, strokes, and techniques, even when he chose to portray themes alien to traditional Korean art.
Demir Barlas

Date 1931

Born/Died 1914-2001

Nationality Korean

First exhibited 1931

Why It's Key A precocious and soon to be prolific Korean artist is recognized nationally for the first time.

273

Key Artist **John Lyman**
Returns to Canada after a long absence

Born to a wealthy family in Biddeford, Maine, Lyman studied in Montreal and at the Hotchkiss School in Connecticut before moving to Europe, where he enrolled at the Royal College of Art in London, and the Académie Julian and the Académie Matisse in Paris; the latter exercised a deep influence on his art and his thinking. In 1913 he exhibited avant-garde canvases in Montreal that met with hostile criticism. For the next eighteen years he exiled himself to Paris and traveled extensively.

Returning to Canada in 1931, he committed himself to promoting an internationalist outlook as an art critic for the *Montrealer* and as a teacher at the Atelier school. He attacked the Group of Seven – later the Canadian Group – for their nationalist and reactionary influence.

In 1939, he formed the Contemporary Art Society, which sought to improve exhibiting conditions for Canadian artists. In 1948, he became an art professor at McGill University in Montreal. Three years later he was appointed director of the Fine Arts Department.

As a painter, Lyman worked mainly in oils and his works exhibit formal concerns. Neither anecdotal nor picturesque, and simplified in form, he enclosed blocks of color within dark outlines. In subject matter he followed Matisse. Figures turned away from the viewer are set in sparse landscapes, as in *On the Beach (Saint Jean-de-Luz)* (1929-30), while interiors show figures engaged in banal pastimes, as in *Card Game* (1935).
Nigel Cawthorne

Date 1931

Born/Died 1886–1967

Nationality Canadian

First exhibited 1913

Why It's Key John Lyman paved the way for Modernism in Quebec.

Key Artist **Diego Rivera**
Mural for the Pacific Stock Exchange

Born Diego María Concepción Juan Nepomuceno Estanislao De La Rivera Y Barrientos Acosta Y Rodríguez in Guanajuato, Mexico, Rivera got a scholarship to study art at the San Carlos Academy in Mexico City at the age of ten. In 1907, a grant from the governor of Veracruz enabled him to study, first in Madrid, then in Paris, where he met Picasso, Braque, and Gris. Rivera quickly mastered Cubist techniques, but then turned to the simplified style of Cézanne.

Eager to return to Mexico to lend his talent to the revolution, Rivera was urged first to go to Italy to study the Renaissance murals there. Back in Mexico City, he joined the program of mural painting designed to educate the illiterate masses about their national heritage. His first government-funded mural was *Creation* (1922), for the National Preparatory School. It depicted Mexican history from ancient times to the modern day. Over the next fifteen years, Rivera painted a number of murals, drawing inspiration from pre-Columbian art, which he collected. From 1930–1934, he painted five murals in the United States. The first was *Allegory of California* (1931), for the Luncheon Club of the Pacific Stock Exchange in San Francisco. His work also appeared in Detroit and New York, where his *Man at the Crossroads* (1933) at the Rockefeller Center offended it sponsors because it included the figure of Lenin. When Rivera refused to remove it, he was fired and the mural was destroyed, though it was later reproduced by Rivera at the Palace of Fine Arts, Mexico City. Returning to Mexico, Rivera continued to paint murals, though the quality declined.
Brian Davis

Date 1931

Born/Died 1886–1957

Nationality Mexican

First exhibited 1910

Why It's Key Pioneer of modern art in the field of mural painting.

opposite Diego Rivera as he works on his mural for the Pacific Stock Exchange.

Key Artist **Hale Woodruff**
Joins faculty of Atlanta University

Hale Aspacio Woodruff was born in Cairo, Illinois, in 1900 to Augusta and George Woodruff. He moved with his mother to Nashville, Tennessee, after his father died, and was the cartoonist for his high-school newspaper. He studied at the Herron Art Institute in Indianapolis, Indiana, and in his late twenties relocated to Paris to study painting, where he was much influenced by exposure to Cubism. In 1931 Woodruff returned to the United States to join the faculty of Atlanta University where at a stroke he seemed to discover twin causes: teaching and the celebration in art of black American culture.

Over the next ten years, Woodruff developed what was effectively a one-man art department, tirelessly promoting a wide range of visual arts activities, and setting up the Atlanta University Art Annuals (1942–70), a thirty-year run of national art exhibitions for black artists.

Like several other African American artists, Woodruff had been inspired by the socially militant Mexican muralists José Orozco and Diego Rivera. He produced three mural series: *The Amistad Mutiny* for Talladega College, *The Negro in California History* for the Golden State Mutual Life Insurance Company in California, and *Art of the Negro* for Clark Atlanta University Art Galleries.

When Woodruff's highly influential tenure at Atlanta University came to an end he moved to New York, where he taught at New York University from 1948 until his retirement in 1968.
Graham Vickers

Date 1931

Born/Died 1900–1980

Nationality American

First exhibited 1931

Why It's Key One of the first college professors of studio art in the state of Georgia, he developed a distinctive American Regionalist style celebrating the black experience.

Key Artist **Gaston Lachaise**
Standing Woman was his most famous work

One of the major pioneers of modern sculpture, Gaston Lachaise emigrated from France to Boston, Massachusetts in 1906, and in 1912 moved to New York. The reason for his emigration was that at the age of twenty he had met and fallen in love with a married American woman, Isabel Dutaud Nagle. She was the inspiration for the vast majority of his female sculptures, and he went on to marry her in 1917.

For a time, Lachaise was an assistant to the sculptor Paul Manship, whose best-known work is the gilded bronze *Prometheus* (1933) that stands in the Rockefeller Center Plaza on New York's Fifth Avenue. Lachaise's father had been a highly skilled craftsman, a cabinetmaker. As a consequence, his sculptures are distinguished by their superlative craftsmanship and finish, whether executed in stone, metal, or wood.

Lachaise earned a living producing sculptures of animals, human figures, and portrait busts in a realistic or accessible style, but became renowned in avant-garde sculpture circles primarily for his simplified, sensuous female nudes, shedding the nineteenth-century academic tradition of formal sculpture. One prime example is his most celebrated work, *Standing Woman* (1932), which can be seen in the collection of the Whitney Museum in New York.

John Cornelius

Date 1932

Born/Died 1882–1935

Nationality French/American

Why It's Key Pivotal work in modern sculpture.

276

Key Event **Communist Party group, the Union of Soviet Artists, outlaws the avant-garde**

The outlawing of the avant-garde was more a process of attrition through ideologically critical campaigns than a single edict. Although the avant-garde had coexisted with Socialist Realism after the Revolution, in the politically conservative climate of the 1920s, organizations dedicated to accessible proletarian narratives, such as the AkhRR (Association of Artists of Revolutionary Russia), had become highly influential, while the avant-garde was accused of elitism. Persecution of the avant-garde began in Leningrad in 1926, when an article appeared in a party newspaper that criticized the Suprematist Malevich and the State Institute of Artistic Culture (IkhK). Shortly after, IkhK was closed down and Malevich was arrested. In Moscow, anti-avant-garde campaigns were in full swing by 1932, after the Constructivist Rochenko was critically attacked in an open letter in 1928, which openly accused him of plagiarizing the work of foreign artists.

After Socialist Realism was declared the official Soviet art in 1934, ideological Socialist Realists with union support were assured of small stipends and commissions. Avant-garde artists, however, were vilified as bourgeois formalists. Increasingly isolated, their work removed from public collection, it became impossible for them to make a living. The cultural purges, beginning in 1936, reinforced the strictures of Socialist Realism and Andrei Zhdanov, Stalin's State artist, vehemently attacked formalism. In a meeting of MOSSKh (Moscow Section of the Union of Soviet Artists) in 1938, he pronounced avant-gardists as enemies of the people.

Sue King

Date 1932

Country USSR

Why It's Key This event brings to an end Modernist innovative experimentalism in the Russian arts.

Key Event
The Bauhaus is closed

Ludwig Mies van der Rohe took over the Dessau Bauhaus from Hannes Meyer in 1930, with instructions to restore "order." Under Meyer, the school had made its first ever profit in 1929. He was also a dedicated Communist (he and a number of loyal students moved to the Soviet Union in 1930). With the influence of the Nazis in Dessau being all pervasive, Mies van der Rohe dissolved the "communist cell," and transformed the Bauhaus into a private school with no former supporters of Meyer being allowed to attend. This proved to be of no avail because on August 22, 1932, with twenty votes to five, the Municipality of Dessau decided to close "one of the most representative 'Judeo-Marxist' places on German soil."

The repeated changes of venue and leadership had resulted in a constant shifting of focus, technique, instructors, and political stance at the school. When it moved from Weimar to Dessau, for example, the profitable pottery shop was closed. The Bauhaus moved on to an abandoned factory in Berlin, where it was once again the target for Brown Shirt assaults and Nazi attacks. On April 11, 1933, thirty-two students were arrested accused of Communist sympathies and in May, Josef Goebbels incited the infamous "book burning" in university cities throughout Germany.

Mies van der Rohe decided there was no future in trying to survive in the worsening cultural climate following Hitler's accession to power in January, and in July 1933, the original Bauhaus closed for good.
Mike von Joel

Date August 22, 1932

Country Germany

Why It's Key This event symbolized the rise of Nazi interference with freedom of artistic expression in Germany.

Key Artist **Stuart Davis**
Creates mural for Radio City Music Hall in New York

Born in Philadelphia, Pennsylvania, Stuart Davis dropped out of high school at the age of sixteen and moved to New York to study painting under Robert Henri, a leading American Realist painter. By 1913, Davis had become accomplished enough to show five of his watercolors in the Armory Show, a highly influential international exhibition of modern art in New York.

After this show, Davis began to abandon Realism and explore other styles, ultimately fusing elements of Cubism into his unique style. His works are typically characterized by his usage of bright, bold colors, and his assemblage of geometric forms to create abstract compositions depicting elements of New York and American culture.

In 1930, the year following the onset of the Great Depression, Davis became active in the muralist movement, ultimately receiving a commission to create an oil painting for the men's smoking lounge at Radio City Music Hall. While the work is entitled *Men Without Women* (1932), it contains no human figures, depicting only a collage of objects typically associated with male recreational activities, including pipes and playing cards.

In the late 1930s, Davis, who believed that jazz was the musical counterpart to abstract art, began to utilize his unique style to visually portray the musical experience, as in the mural *Swing Landscape* (1938). During his lifetime, Davis came to be renowned as one of the foremost American modernist painters, receiving numerous awards and honors before his death in 1964.
Heather Hund

Date 1932

Born/Died 1892–1964

Nationality American

First exhibited 1913

Why It's Key Influential American abstract artist who developed his own style to portray New York and American culture.

Key Artist **Alfred Wols**
Moves from Germany to Spain, then Paris

Born in Dresden, Germany, as Otto Wolfgang Schultz, and later adopting a pseudonym, Alfred Wols was trained as a violinist and photographer. He moved to Spain in 1932 but was deported to Paris in 1936. He had already come into personal contact with, and had been influenced artistically by, George Grosz, Paul Klee, and Otto Dix. As a German, he was interned at the outbreak of World War II but was released in 1940, when he left Paris and moved to the South of France, where he lived in dire poverty. There he was befriended and supported by Simone de Beauvoir and Jean-Paul Sartre and was commissioned to illustrate books by Sartre and Franz Kafka.

Wols was in a long line of artists who could be described as "classic Bohemians," leading an eccentric, alcoholic lifestyle that has been described as a work of art in itself. Like Dubuffet, he was "anti-skill" and chiefly interested in the spontaneity of free-form painting as a key to the inner workings of the mind. There is an obvious parallel with the Surrealists' "automatic writing" experiments. He termed his mode of working Informalism (also known as Tachism).

Stylistically, he was reminiscent of Klee in some respects, but developed a free-form approach which crossed the Atlantic to influence the likes of Pollock and Motherwell – although they had reservations about Wols' work, feeling that it was somehow still in thrall to figurative painting and therefore not fully acceptable into the Abstract Expressionist fold.

John Cornelius

Date 1932

Born/Died 1913–1951

Nationality German

Why It's Key European Abstract Expressionist whose work crossed the Atlantic to influence the likes of Pollock and Motherwell.

Key Artwork *Mask of Fear*
Paul Klee

In 1932, at the age of sixty-three, the German artist Paul Klee (1879–1940) had seen enough of life to sum it up in the superbly epigrammatic *Mask of Fear*. The painting, created just before Klee left a Germany that would soon fall to Nazism, was of a giant mask whose model was a Zuni sculpture of a war god, behind which two pairs of thin legs stood.

The allegorical potential of such an image was rich, and Klee himself emphasized its aesthetic dimension, in which the mask represented art, and the thin legs humans who hid behind art. However, *Mask of Fear* also had a political dimension, as the time of its composition was the high tide of a European fascism that was hollow behind its mask of splendor and spectacle. *Mask of Fear* might also have been in the spirit of Ecclesiastes, pointing to the various vanities of earthly life at a time during which Klee must have been pondering his own mortality.

Given that Klee had long suffered from scleroderma, which brought with it daily musculoskeletal pain, muscle weakness, and other ailments, the frailty of the two figures behind the mask might also invoke the cruel physical condition of Klee himself, and his propensity to utilize art as therapy for his pain. These two Klees – earthbound sufferer and disembodied creator – might be behind the mask. *Mask of Fear* defies easy categorization as anything but a Klee, but it was featured in the Museum of Modern Art's 1936 Surrealist exhibition.

Demir Barlas

Date 1932

Country Germany

Medium Oil on burlap

Collection Museum of Modern Art, New York, USA

Why It's Key One of Klee's most famous paintings, the child-like *Mask of Fear* marks the beginning of Hitler's ascent and the crisis of the European avant-garde, as well as the state of the artist's soul.

Key Exhibition
The International Style

Usually referred to as The International Style, after the title of a book published by its curators in concurrence with the show, the landmark exhibition held at the Museum of Modern Art in 1932 crystallized a very specific kind of architecture that was going on internationally at the time, to the exclusion of others. The curators, Philip Johnson and Henry Russell-Hitchcock, presented a modern, geometric architecture that came mostly from Europe. The star architects of the show included the Europeans Le Corbusier, Ludwig Mies van der Rohe, and Walter Gropius.

The emphasis lay with the individual building, rather than urban philosophy, and the buildings selected displayed radically simplified forms and an utter rejection of ornament. Worried that the American audience might dismiss modernism as utopian or leftist, the curators steered clear of Expressionism and Organicism. It was Alfred Barr, the director of the MoMA at the time, who coined the name of the new architectural movement. Recalling the International Gothic, he suggested it be called International Style.

The exhibition toured the USA for two years and was one of the central events of a transformation of American architecture in the following decades. In 1992, 60 years after it first opened, the exhibition was almost completely recreated at Columbia University. In 2001, an exhibition at the MoMA entitled Mies in America proved that drawings by Mies van der Rohe had been redrawn by Johnson and Hitchcock in the 1932 show to emphasize geometric aspects of his buildings and support their definition of the International Style.
Chiara Marchini

Date February 10 to March 23, 1932

Country USA

Curators Philip Johnson, Henry Russell-Hitchcock

Why It's Key Defined modernist (mainly European) architecture.

Key Event
Group f/64 is formed

Group f/64 was a group of Californian photographers created in 1932. The significance of the name lies in the fact that f/64 is the smallest aperture setting on the large format cameras that they used, providing the greatest depth of field. Its key members included Ansel Adams, John Paul Edwards, Edward Weston, Willard Van Dyke, Preston Holder, and Henry Swift.

They rejected the popular soft-focus photography in vogue at the time, with its pictorial method that believed in copying painting, rendering pictures in black and white or sepia, and using methods such as special filters and lens coatings to manipulate the pictures.

In contrast, Group f/64 pioneered "straight" or "pure" photography. This they defined in their manifesto as "possessing no qualities of technique, composition or idea, derivative of any other art form." They espoused clarity of image, maximum depth of field, sharp focus, and attention to detail and texture. They wanted to render photographic images as accurately as possible and emphasized dramatic tonal range and smooth, glossy printing paper. They explored essential forms, and were obsessed with having nothing out of focus. As Weston famously wrote, his aim was: "To photograph a rock, have it look like a rock, but be more than a rock."

The group promoted its work at three group shows, their 1932 debut at San Francisco's De Young Museum being their most significant. Although the group broke up in 1935, the movement was groundbreaking and revolutionized American photography.
Kate Mulvey

Date 1932

Country USA

Why It's Key The group revolutionized American photography and pioneered groundbreaking methods.

Key Artist **Alexander Calder**
First "mobiles" exhibited in Paris

Born in Philadelphia, Alexander Calder was one of the most innovative and playful artists of the twentieth century. Both his father and grandfather were successful sculptors. He left Stevens Institute of Technology with a degree in mechanical engineering in 1919, enrolled at The Art Students League N.Y. in 1923, published his first book, *Animal Sketches* in 1925, and produced oil paintings of city scenes. In 1926 he moved to Paris, where he started work on his first wire sculptures and created a miniature circus in his studio.

Calder's first exhibition in New York was in 1928 and further exhibitions in Paris and Berlin earned him international recognition. After meeting Piet Mondrian, he began to work in an abstract style. His first moving sculptures were exhibited in Paris in 1932; Marcel Duchamp, who organized the exhibition, coined the term "mobiles" for these works. Later that same year, his success continued with an exhibition of his mobiles in the United States.

Throughout his life, he was prolific and versatile, executing work in the form of drawings, paintings, silk-screen prints, and etchings as well as jewelry, tapestries, theater design, and architectural interiors. From the 1940s Calder's large-scale sculptures have been sited in many major cities in the West.

Alan Byrne

Date 1932

Born/Died 1898–1976

Nationality American

Why It's Key Inventor of mobile sculptures.

opposite Calder with one of his mobiles.

Key Artist **Joseph Cornell**
One-man show at Julien Levy Gallery, New York

Having lost his job as a textile salesman in 1931, Cornell happened upon the newly opened Julien Levy Gallery, which was exhibiting some of the collages of Max Ernst. Cornell came up with some collages of his own, which went on show in the gallery's Surrealism exhibition in January 1932. That November, Cornell had his own show, comprising a number of "shadow boxes," a medium that would become his trademark. These were small circular or rectangular found boxes containing mounted or unmounted engravings or objects. Between 1932 and 1935, he learned woodworking from a neighbor and, by 1936, was producing his own boxes. His works were usually untitled.

In 1936, he screened his first film, *Rose Hobart*, a drastically edited version of the 1931 Hollywood movie *East of Borneo*, starring Rose Hobart. He continued to exhibit with the Surrealists but, being a Christian Scientist, he did not share their interest in the erotic. He made later forays into film with *Gnir Rednow* in 1955, and *Nymphlight* in 1957. Meanwhile, he continued producing his largely untitled boxes and collages, which now reside in the Museum of Modern Art in New York, the Pompidou Center, Paris, and the Guggenheim Collection in Venice.

Brian Davis

Date November 1932

Born/Died 1903–1972

Nationality American

First exhibited January 1932

Why It's Key One of the originators of assemblage.

Key Event
Black Mountain College opens

Black Mountain Collage was founded in 1933 near Ashville, North Carolina by John Andrew Rice and Theodore Dreier. They were joined by the German artist Joseph Albers, who had taught at the Bauhaus and brought with him many of its principles.

The college was established as a move away from the rigid higher education system that existed at that time, toward progressive reform. Conscious of the avant-garde spirit that existed in the arts in Europe, with its Modernist utopian ideals, and of the yearning for an intrinsically American cultural identity, the aim was to generate an atmosphere in which students were free to discover their creative individuality as a preparation for life. Independent from outside controls and operating on democratic principals, the college was owned and run by the faculty members. With the emphasis on experiment and experience, there was no core curriculum but a flexible system of self-directed study. The most important aspect of the program was the merging of curricular and extra-curricular activities. The college was viewed as a community where students, staff, and their families lived and interacted together on campus.

Now best remembered for the summer sessions in the late 1940s and early 1950s, Black Mountain attracted some of the most innovative figures within the arts to teach or participate in the workshops; among them were composer John Cage, choreographer Merce Cunningham, and painters William de Kooning and Robert Rauschenberg. It was forced to close down due to lack of funds in 1956.
Sue King

Date 1933

Country USA

Why It's Key Experimentalist approach attracted many important artists which, in turn, helped establish New York's position internationally as the center of avant-garde art.

opposite A class at Black Mountain College.

Key Artist **George Grosz**
Settles in America

George Grosz was born in Berlin, Germany, in 1893. After studying art in Dresden and Berlin, he began contributing cartoons to German magazines including *Ulk* and *Lustige Blatter*. He volunteered for the army, became invalided in 1916, and returned to Berlin. Two years later he joined the Berlin Dada movement and was a prominent member.

His drawings, many of them in ink and watercolor, had a unique graphic style, with an expressive use of line and aggressive, crude caricature. Known as the Neue Sachlichkeit (New Objectivity), this style was a reaction to the Expressionist trends of the decade. Grosz's caricatures and paintings provided some of the most vitriolic social criticism of the 1920s. His corrupt businessmen, disfigured veterans, and prostitutes are some of the prevailing images of Berlin and the Weimar Republic at the time. Grosz was an uncompromising opponent of militarism and National Socialism, and in 1921 was accused of insulting the German army, which resulted in him being fined. In such collections as *The Face of the Ruling Class* (1921) and *Ecce Homo* (1922), he uses art as a social weapon. After his apartment was raided and searched by the Gestapo, Grosz emigrated to America in 1933 and taught at the Art Students League in New York.

In 1937, he was included in the Nazi-organized exhibition of Degenerate Art and a year later was officially exiled from Germany. He became a U.S. citizen in 1938. He painted *Hitler in Hell* in 1944, showing the dead attacking Hitler. He died in 1959 in Berlin.
Kate Mulvey

Date 1933

Born/Died 1893–1959

Nationality German

Why It's Key One of the greatest caricaturists, draftsmen, and propagandists against Nazism.

Key Artist **John Heartfield**
Political illustrator flees Germany to Czechoslovakia

Helmut Herzfeld was a German citizen who, in 1916, railed against anti-British feelings in Germany by Anglicizing his name. A Communist and Dadaist, he founded a satirical magazine and, after meeting the militant playwright and theater director Berthold Brecht, turned his energies to creating photomontages for two Communist magazines. One of them, *Arbeiter-Illustrierte-Zeitung*, published some of his most famous works. At their heart was an understanding of the power of visual propaganda: if images could sell Fascism, counter-images could subvert it. It proved a powerful weapon. In 1932, Heartfield created one of his most famous images: *The Spirit of Geneva*, showing a white dove of peace impaled on a bayonet. His scathing photomontages sometimes undercut Fascist rhetoric by adding a satirical image. *Hurrah, The Butter Is Finished*

(1935) mocks Goering's call for austerity – he claimed that butter and lard made a country fat, while iron made it strong – by showing a family eating nuts, bolts, and ferrous pipes, with swastika wallpaper behind them.

In 1933, following the success of the Nazis in Germany, Heartfield went to live in Czechoslovakia, but by 1938 felt unsafe even there and moved to Britain. After World War II he returned to East Germany and Berlin. His work gave rise to new generations of political artists, of whom the British Peter Kennard was among the best-known. Heartfield was not the only photomontage artist with an agenda, but the lasting impact of his work today stands as testament to the effect it must have had in an age when the photograph was still fundamentally seen as a "truthful" image.
Graham Vickers

Date 1933

Born/Died 1891–1968

Nationality German/Czechoslovakian

Birth name Helmut Herzfeld

Why Key Transformed photomontage into political art.

Key Artist **Paul Klee**
Work denounced as degenerate by the Nazis

Klee was a painter, watercolorist, and etcher with one of the most original voices in modern art. His work, though mostly on a small scale, was so full of the spirit of investigation and experimentation that it is difficult to classify. It was characterized by expressive line, exceptional use of color, playful wit, and imagination.

He studied art in Munich, then an important center for avant-garde art, settling there in 1906. He became affiliated, for a time, with Der Blaue Reiter (The Blue Rider), an Expressionist group that became well known throughout Germany. From 1920 to 1931, he taught at the Bauhaus, Germany's most advanced art school, which eventually fragmented under political pressure. In 1931, Klee began teaching at Dusseldorf Academy, but was dismissed without notice by the Nazis, who termed his work "degenerate" and "the work of a sick

mind." In 1933, he was expelled to Switzerland, and in 1935 developed a crippling skin and wasting disease, which eventually killed him.

During his suffering, he was forced to develop a simpler style; while his early works had been remarkable for their lightness and delicacy, his late works were characterized by heavy black lines, and rough texture, with his subject matter becoming increasingly dark. The menacing *Death and Fire*, with its skull-like apparition, was painted in 1940. Klee died that year in Switzerland. He left an enormous oeuvre, which ranged in approach from representational to abstract. It would continue to inspire Surrealists, while also anticipating the emergence of Abstract Expressionism.
Carolyn Gowdy

Date 1933

Born/Died 1879–1940

Nationality German/Swiss

Why It's Key Leading avant-garde figure whose work reflected the spirit of Surrealism while anticipating the development of Abstract Expressionism.

opposite Paul Klee

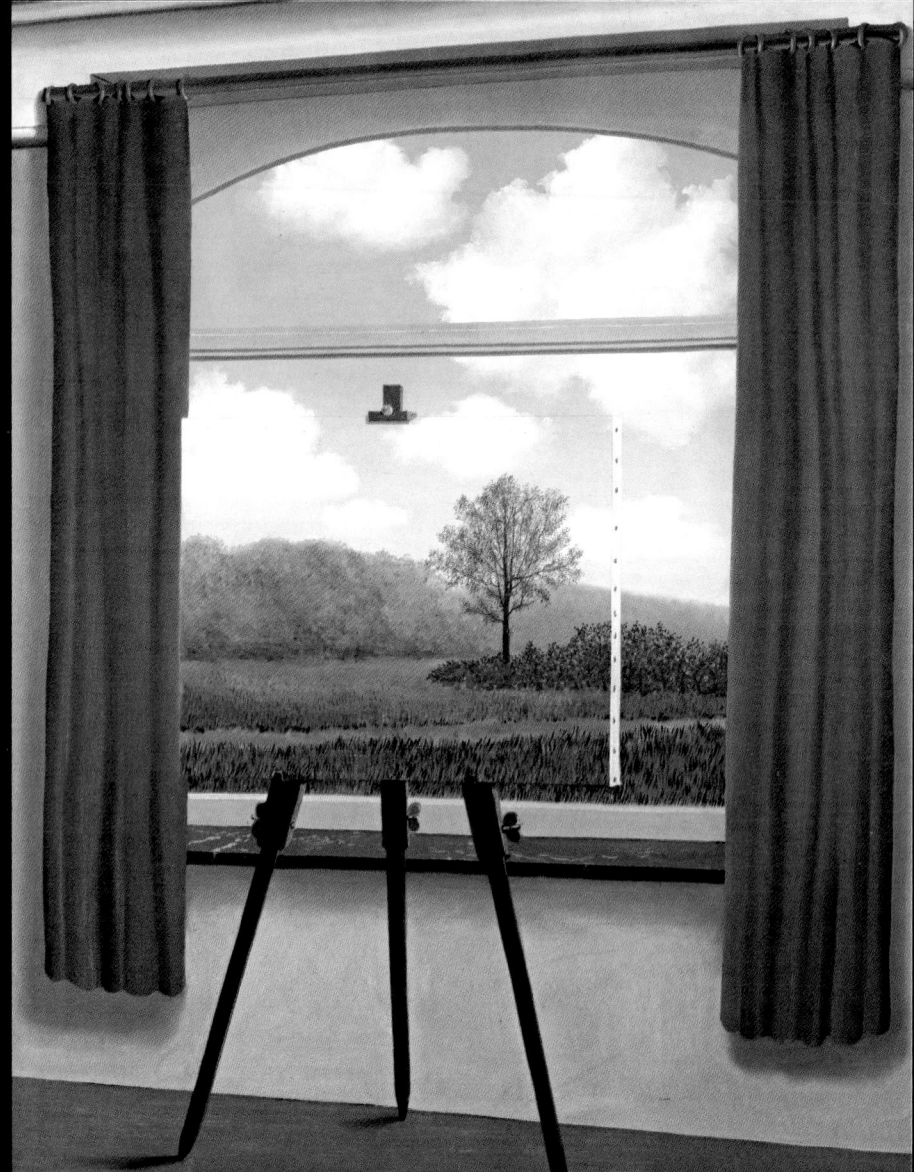

Key Artist **Joseph Albers**
Moves to Black Mountain College

Albers came to America from Hitler's Germany in 1933, having studied and taught at the Bauhaus. His teaching contract had been terminated and the Bauhaus was closed down by the Nazis, and he was offered a position at Black Mountain on the recommendation of Philip Johnson, then curator of architecture at the Museum of Modern Art. Johnson had visited the Bauhaus as the U.S. representative of the Circle of Friends of the Bauhaus, and had been impressed by Albers' Preliminary Course there.

On his arrival, Albers spoke very little English, but despite this he taught classes in drawing and color and was appointed professor of art. His Bauhaus theories fitted well with the progressive aims of Black Mountain, being Modernist, anti-eclectic, and anti-academic. He developed a curriculum with the emphasis on elements of form and the understanding of materials, stressing the importance of "seeing and perceiving" much as he had done at the Bauhaus. He devised a basic design course, which he called Werklehre, in which students used materials such as corrugated card, sheet metal, paper, wood, and found materials to make objects, rather than just drawing on paper. He stated that he wanted to open the eyes of his students and to help them acquire independence, critical ability, and "a disciplined education of the eye and hand."

At Black Mountain Albers maintained many aspects of the Bauhaus, keeping its spirit and its legacy alive, and becoming a leading and influential member of the faculty. He left in 1949.

Sue King

Date 1933

Born/Died 1888–1976

Nationality German/American

Why It's Key Brings Bauhaus ideas on art and design to America, and establishes Bauhaus teaching methods at Black Mountain College.

Key Artwork *La Condition Humaine (The Human Condition)* René Magritte

Painted in a realistic, almost traditional, and deceivingly simple style after René Magritte's (1898–1967) return from Paris, *The Human Condition* plays on age-old notions of painting as a window on the world, emphasized by the series of framing devices (canvas, window, curtains). Magritte described the picture thus: "In front of a window seen from inside a room, I placed a painting representing exactly that portion of the landscape covered by the painting. Thus, the tree in the picture hid the tree behind it, outside the room. For the spectator, it was both inside the room within the painting and outside in the real landscape."

The painting on the easel shows us what it is hiding, and yet we doubt the reality of what lies beyond the window. The double take provoked by the trompe l'œil is unsettling, and the quiet neutrality of the image is more sinister than any overt Surrealist distortion. The relationship between reality and representation cannot be taken for granted. Our relationship to language was similarly shaken in Magritte's *La Trahison des Images* (*The Treachery of Images*, 1929), a series underlining the arbitrary nature of language and its inadequacies by juxtaposing simplistic pictures of commonplace objects, such as a pipe, with the statement "This is not a pipe" in old-fashioned schoolteacher's handwriting.

These issues resurfaced in the work of conceptual artist Joseph Kosuth, who in *One and Three Chairs* (1965) presented together a wooden chair, a black and white photograph of that chair, and a dictionary definition of the word chair, to question the possibility of representation.

Catherine Marcangeli

Date 1933

Country Belgium

Medium Oil on canvas

Collection National Gallery of Art, Washington, USA

Why It's Key Surrealist trompe l'œil unsettles our notion of reality.

opposite *La Condition Humaine*

Key Artist **Paul Nash**
Co-founds Unit One group

Largely self-taught, Paul Nash had his first one-man exhibition in London in 1912, showing landscapes and drawings that hark back to the Pre-Raphaelites and late nineteenth-century illustration. During World War I, he served on the Western Front as an officer in the Artists' Rifles and, later, as an official War Artist. In 1918, his exhibition, Void of War, which featured shattered landscapes painted in a Cubist-influenced abstract style, confirmed his reputation and brought commissions from the British and Canadian War Records.

Settling in Dymchurch, Kent, he found in Romney Marsh a landscape that he could use to express emotion, his work influenced by Cézanne, and encouraged by Roger Fry and the Bloomsbury Group. In the late 1920s, under the influence of Giorgio de

Chirico and the Surrealists, he began further experiments with the avant-garde. In 1933, he formed Unit One with Henry Moore, Barbara Hepworth, and Ben Nicholson to forward the abstract in English art. The group dissolved after one exhibition.

In 1936, he became a member of the committee of the International Surrealist Exhibition in London and developed an interest in found objects. During World War II, he became a war artist again, working mainly for the Air Ministry, and continued to show Surrealist influences. His *Totes Meer* (*Dead Sea*, 1940-41) shows wrecked German aircraft metamorphosed into a storm-tossed sea.

Brian Davis

Date 1933

Born/Died 1889–1946

Nationality British

First exhibited 1912

Why It's Key Connects English landscape painting to the modern movement.

288

Key Artist **Alice Neel**
Public Works of Art Project

Although she painted still lifes and cityscapes, Neel's importance lay in her contribution to twentieth-century portraiture. Politically committed to left-wing causes, her preference was for ordinary people – she was commissioned by the Public Works of Art Project in 1933 – such as her neighbors in New York's Spanish Harlem, where she settled in 1938 in order to paint what she termed the "real facts of life." She also enjoyed the company of Manhattan writers and intellectuals and depicted both with emotion and engagement: "I get so identified when I paint them," she said. "When they go home I feel frightful. I have no self – I've gone into this other person."

By the late 1940s her figurative style lay outside the dominant abstract mainstream and her work was little appreciated until the 1960s, when the feminist

movement challenged the art world's traditional male supremacy. A retrospective exhibition in 1974, at New York's Whitney Museum, established her reputation, and other awards followed.

Enduring a difficult personal life, Neel viewed painting as a way of coming to terms with trauma. Her style, always characterized by its fluency, with paint built on confident draftsmanship, acquired greater dynamism between line, color, and shade in later years, which gave sculptural physicality to her portraits. She also chose to paint art-world personalities, including Warhol, retaining her uncompromising insight and empathy. Among her key works were *Pregnant Maria* (1964), *Nancy and Olivia* (1967), and *Marisol* (1981).

Martin Holman

Year 1933

Born/Died 1900–1984

Nationality American

Why It's Key Neglected by the art world for many years, Neel was one of the most outstanding psychological portraitists of the modern era.

Key Artist **Ben Shahn**
Works with Diego Rivera on mural for Rockefeller Center

Wealthy art collectors in America, including Nelson Rockefeller's wife, admired Diego Rivera (1886–1957), the controversial Mexican Social Realist mural painter. She persuaded her young husband to commission a mural from Rivera for the Rockefeller Center in New York and eventually a theme and a subject matter were negotiated.

Rivera invited Ben Shahn to apprentice on his fresco team. The Social Realist painter, political graphic artist, and photographer was best known for his commitment to social and economic reform and his early political work caught the interest of Rivera. The two artists worked together on the project for over a year and then newspapers reported that Rivera was painting a Communist mural. When the Rockefellers decided that the idealistic artwork was too radical and Rockefeller asked Rivera to replace an unexpected portrait of Lenin with someone unknown, Shahn and others urged Rivera not to compromise his art. Rivera refused to remove Lenin, but proposed to balance Lenin's portrait with one of an American icon, such as Abraham Lincoln. An unhappy Rockefeller sent an official to order Rivera, who was still painting, off the scaffold; Rivera was paid his commission in full, and escorted from the premises. His work was immediately covered up and Rockefeller had the almost completed mural chipped from the wall.

Shahn had learned first hand the risks of painting politically and socially sensitive subjects. Under Roosevelt's New Deal he would apply this experience and techniques he learned from Rivera and continue to focus on issues of injustice and human rights.

Carolyn Gowdy

Date 1933

Born/Died 1898–1969

Nationality American

Why It's Key Inspired by Rivera, Shahn focused on issues of injustice and human rights in his Social Realist murals. Like Rivera, he wanted his art to pose questions, to make people think and believed art and artists should be engaged in society. In his *The Shape of Content*, he argues for the role of humanist subject matter in art.

1930–1939

289

Key Event
Formation of Unit One

In a letter to *The Times* on June 12, 1933 Paul Nash announced the formation of Unit One, a group of English painters, sculptors, and architects whose members included, besides Nash himself, John Armstrong, John Bigge, Edward Burra, Wells Coates, Barbara Hepworth, Tristram Hillier, Frances Hodgkins, Colin Lucas, Henry Moore, Ben Nicholson, and Edward Wadsworth. The critic Herbert Read acted as Unit One's spokesman, and the dealer and writer on art Douglas Cooper officiated as its secretary. The name of the group was chosen, Read explained, because "though as persons, each artist is a unit, in the social structure they must, to the extent of their common interests be one."

However, the membership of Unit One shared no clear aesthetic identity beyond a general interest in avant-garde European movements, and a desire to form a closer bond between contemporary artists and architects. The group held only one exhibition, at the Mayor Gallery, London, in 1934, which subsequently toured to six provincial galleries in England, Wales, and Northern Ireland. Together with *Unit 1: The Modern Movement in English Architecture, Painting and Sculpture*, an accompanying book of statements and photographs edited by Read, it attracted considerable publicity and served both to promote and to polarize views about modern art in general and Surrealism in particular. But the lack of a common cause among the artists involved ensured that, by the time the tour ended in 1935, Unit One had effectively ceased to exist.

James Beechey

Date June 1933

Country UK

Why It's Key Seminal grouping of major names in the British modern movement.

Key Artwork *The Acrobats*
Fernand Léger

After fifteen years of painting objects, the French artist Fernand Léger (1881–1955) entered a human period in 1933 with *The Acrobats*, on the left side of which three naked and extremely malleable women bend their limbs for the viewer while a fourth woman, fully dressed, merely stares ahead. The right side of the artwork is occupied by a kind of constellation and a flame, although what they really might be is unclear. The background of the painting is a yellow-orange color field.

While it is a shock to see so many human figures appear in a Léger painting – it is as if they have arrived unbidden from some cosmos adjacent to Léger's aesthetic – there is still visual continuity between *The Acrobats* and the World War I-informed trend of the artist's oeuvre. The tubes that dominate Léger's work are still there, although this time in the form of arms and legs rather than table legs or railway guardrails. The so-called acrobats are just as expressionless as machines or beer mugs; their contortions mean nothing to us, and the acrobats are deliberately inscrutable.

While superficially indicating a return to the human, *The Acrobats* is in fact a restatement, from another direction, of Léger's long affair with the inert, the mechanical, and the tube, perhaps engendered by his wartime encounters with cannons and guns. Léger's trauma took the form of a lifelong obsession for duplicating and, through vivid color, domesticating the machine; but even the absent machine wins out in the *Acrobats*.

Demir Barlas

Date 1933

Country France

Medium Oil on canvas

Collection Private collection

Why It's Key *The Acrobats* marks Léger's entry into painting figures but still reflects the artist's interest in machines and inanimate objects.

290

Key Artwork *The Street*
Balthus

It is hard to imagine that this painting, in its original state, was once considered so disturbing that it had to be censored before taking up residence in New York's Museum of Modern Art (MoMA). Unsold after Balthus's first solo show, it was not until 1937 that an American businessman, James Thrall Soby, finally purchased *The Street*. Soby was eventually convinced, upon moving to a larger house in rural Connecticut, that he had the space for the large-scale piece. His five year-old son and the child's friends developed such a fixation over the painting however, that it had to be covered up. Still, the controversy over the passage where an adolescent boy grabs a girl's crotch spread throughout the neighborhood. Soby finally removed the painting from his living room to a fireproof garage where it remained for years.

Meanwhile Pierre Matisse, son of Henri Matisse, had been selling Balthus' work in New York since the 1930s, and by the 1950s Balthus had become better known in the United States than in Europe. He was invited to have a show at MoMA and Soby, now respected for his views on modern art, was invited to write the catalog. He intuitively knew that *The Street*, and the issue over the girl's crotch, would offend American audiences. Over time, however, Soby had earned the trust and friendship of Balthus, and managed to persuade the artist to revise the offending passage. In 1956, *The Street* was included in Balthus' exhibition at MoMA, and Soby donated it to the museum.

Carolyn Gowdy

Date 1933

Medium Oil on canvas

Collection Museum of Modern Art, New York

Country France/Poland

Why It's Key *The Street* was one of several controversial pictures that created a sensation in 1934, during Balthus' first solo show in Paris. Balthus always insisted the painting was intended as a straightforward celebration of everyday life.

opposite *The Street*

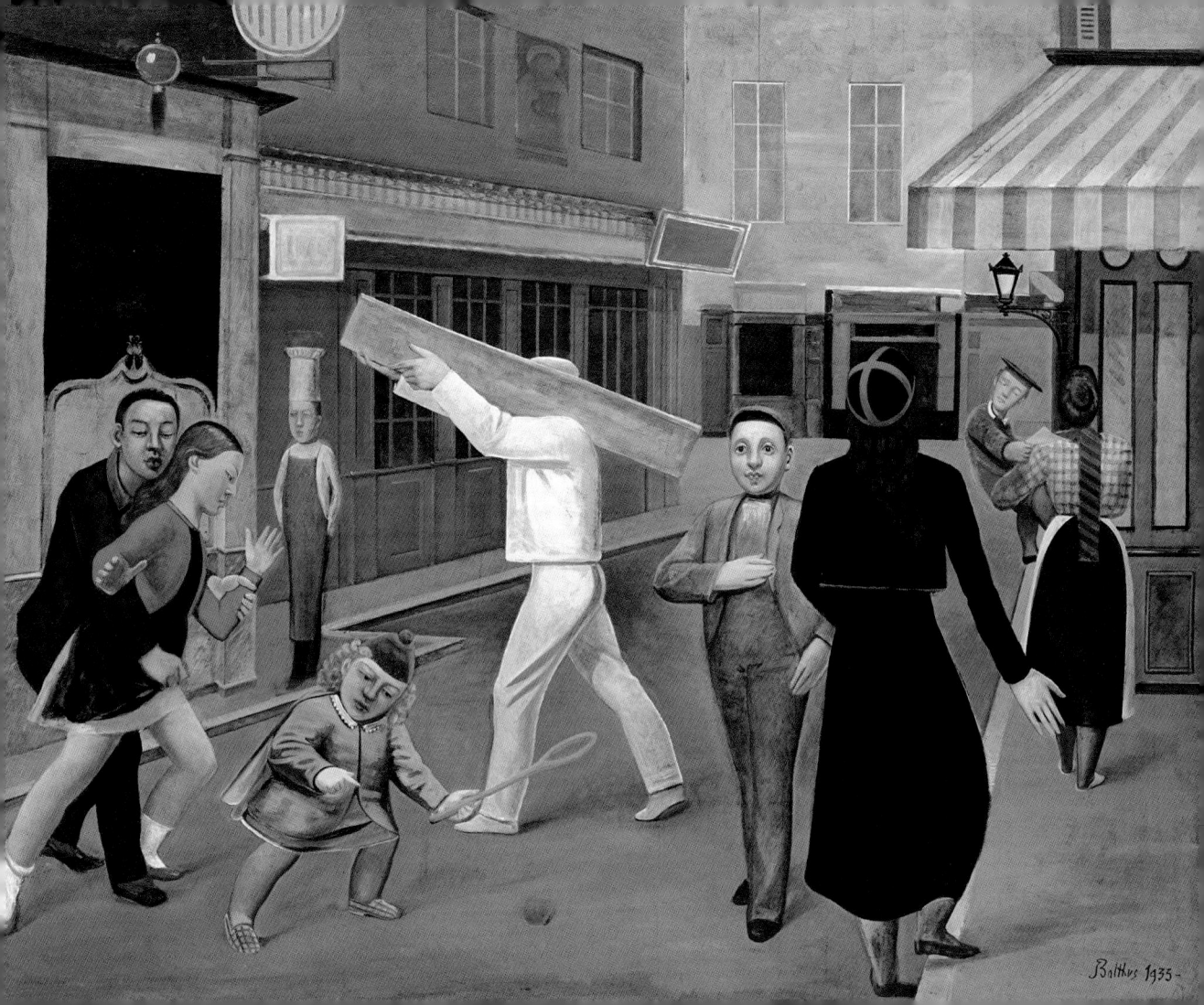

Balthus 1935

Key Artwork *Goering: The Third Reich's Executioner*
John Heartfield

John Heartfield (1891–1968) started experimenting with photomontage in his Berlin Dada days alongside Hausmann, Höch, and Grosz, while denouncing a Weimar Republic torn by political and social turmoil. He used the medium for political ends, and from 1930, his montages of photographs, postcards, or typography were regularly printed in the workers' paper *Arbeiter Illustrierte Zeitung*.

AIZ had a much wider circulation than the official Communist daily, *The Red Flag*, and Heartfield aimed to produce as clear, striking, and corrosive a message as possible to mobilize the paper's half a million readers. By appropriating mass-produced photographic material and news headlines, he underlined the mechanisms of truth manipulation by the mainstream and right-wing press. He also ridiculed Nazi slogans and Nazi symbols,

such as the swastika, to undermine their credibility. *Goering: The Third Reich's Executioner*, which portrays Goering dressed as a butcher, refers to the Reichstag fire of February 1933. The Nazis accused young Communists of setting the building on fire as a signal for a general uprising. The Communist Party was outlawed and hundreds of its leaders interned. *AIZ*'s premises were burned, and the editors fled to Czechoslovakia, publishing the paper from exile.

By giving Goering a bloody butcher's apron and chopper, Heartfield unequivocally points the finger at Hitler's minion, who was thought to have ordered the Reichstag arson. A sarcastic note at the bottom of the picture states that Goering's face is from an actual photograph and has not been touched up.

Catherine Marcangeli

Date 1933

Country Germany/ Czechoslovakia

Medium Photomontage reprinted on newspaper

Published in *AIZ* magazine, XII, 36, September 14, 1933

Why It's Key Pioneered photomontage used in the service of anti-Nazi propaganda. Though formally innovative, the drive of his photomontages was unapologetically propagandist.

Key Artist **Marie Hadad**
First solo show staged in Paris

The enigmatic Lebanese artist Marie Hadad was active on the world art scene for only seven years, from 1933 to 1940, but greatly impressed those who saw her work in Paris, London, and New York. Born in Lebanon in 1889, Hadad began to paint on her own and acquired some instruction from resident French artists in the 1920s. Her natural talent soon drew the attention of the Comte de Martel, then the French Ambassador to Lebanon, who invited Hadad to exhibit at the Autumn Salon in Paris. Hadad proved to be a sensation, and was soon offered a solo exhibition by Georges Bernheim, an important French dealer with a history of involvement with Impressionist and Post-Impressionist artists.

Hadad's exhibition showed off her arresting, Fauvist use of color and passionate understanding of

the human face in a series of portraits, while her landscapes brought details of her beloved Lebanon to Paris. Hadad won admiring reviews from the French and British press and, on the strength of her reception, toured the United States in 1939 and 1941.

The 1933 exhibition, held at the Bernheim Gallery between October 1 and 19 in Paris, presented Hadad at the peak of her power. Her activity thereafter grew sporadic and, due to the death of her daughter, Magda, in 1945, came to an end. Hadad came under the influence of the cult leader Dahesh and withdrew from the art scene without having had a chance to renew or deepen the impression she had left behind in Europe. Today much of her work is in New York's Dahesh Museum.

Demir Barlas

Date 1933

Born/Died 1889–1973

Nationality Lebanese

Why It's Key World debut of a seminal Lebanese artist.

opposite Hadad's *The Fortune Teller* (oil on canvas).

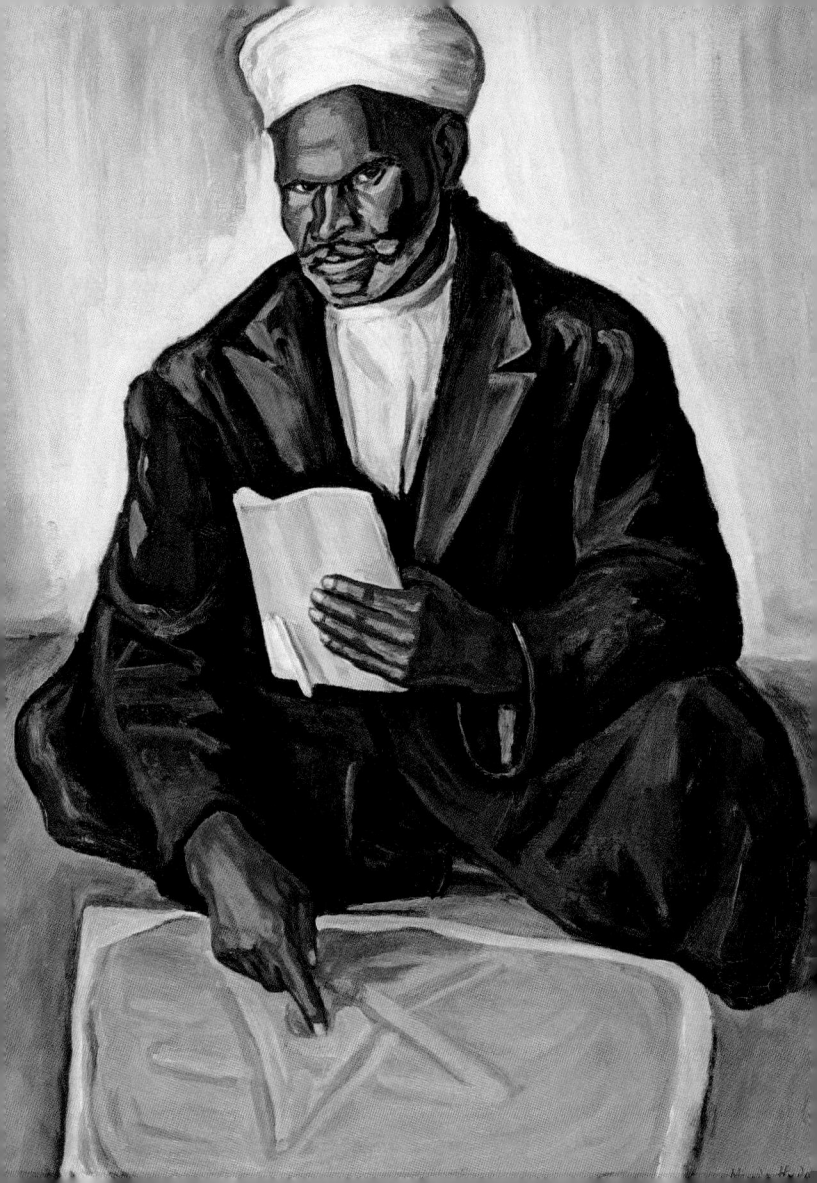

Key Event
Harry Beck's London Underground Map is launched

Henry C. Beck, known as Harry, was an engineering draftsman at the London Underground Signals Office in the 1930s. In his spare time, he devised what was to become one of the world's most famous pieces of graphic communication.

The drawbacks of "real" maps for subway systems now seem obvious: city-center underground stations are packed close together, while suburban ones are spaced out, and to show the lie of the physical land simply complicates things with information irrelevant to the subterranean train traveler.

Between 1908 and 1933, various representations of individual lines had been created and displayed within the trains, usually as straight lines with stations marked at regular intervals. This, Beck saw, was the key to arriving at a clear diagram of the whole, large, complex London Underground system. His solution was to use color to distinguish the many overlapping and intersecting lines, while offering broad directional clues to the system without following line layouts or distances. The only geographical element was a stylized River Thames, otherwise this map of London looked more like an electrical wiring diagram. That 1933 map looks remarkably similar to the one still in use today. Despite a proliferation of lines and some reconfiguration, the current London Underground map adheres closely to Beck's solution. Beck's map encapsulates an approach that can be recommended to any graphic designer: ignore existing solutions, go back to the fundamental problem, and solve it economically and without decoration or irrelevant florishes.

Graham Vickers

Date 1933

Country UK

Why It's Key A paradigm for good graphic design and the basis of many of the world's transport maps. As confirmed by its presence on postcards, t-shirts, and other tourist ephemera, it's now considered a visual icon in its own right.

opposite Beck's original London Underground map.

Key Event
Formation of the Krakow Group

The interbellum era was a tense time in Poland, squeezed as it was between the authoritarian parochialism of Pilsudski's Second Polish Republic and the Nazi terror still to come. The Polish art scene, too, was a hotly contested realm in which Realists of the nineteenth century vintage clashed with modernists who were actively influenced by the Western European avant-garde.

In 1933, many Polish modernists associated with the Academy of Fine Arts in Krakow banded together to form the Krakow Group. Some of these modernists had been active in the Zywi artistic collective and the Communist Association of Polish Youth. In terms of artistic influences, these artists, like many cultured Poles, were equally influenced by Russian (Constructivist) and French (Cubist) currents.

The Krakow Group rejected both what it considered the reactionary aesthetic of the Academy of Fine Arts and the atmosphere of fascistic and anti-Semitic jingoism then haunting Poland like a specter. Studded with such figures as Henryk Wicinski, Sasza Blonder, Jonasz Stern, Maria Jarema, Leopold Lewicki, and Stanislaw Osostowicz, the Krakow Group remained artistically and politically active for six years, until the Nazi invasion of Poland. Sadly, many works produced by the Krakow Group were destroyed by the Nazis. The group's legacy was not entirely lost, as it was revived after the war by surviving members Jarema and Stern, who had long collaborated artistically, and Marczynski. Ironically, some of these historically anti-Academy artists went on to teach at the Academy after the war.

Demir Barlas

Date 1933

Country Poland

Why It's Key Polish artists make a stand, bravely, but futilely, contesting their country's emerging fascism.

Key Artist **Xu Beihong**
Stages Chinese Art show touring Europe and USSR

Born in the Jiangsu Province, Xu Beihong studied Chinese classics, calligraphy, and Chinese painting from an early age. In 1919, he gained a government scholarship to study at the Ecole Nationale Superieure des Beaux-Arts in Paris. Over the next six years, Beihong studied European Classical and Renaissance art, and in particular the French academic mode, with which he portrayed famous Chinese historical scenes, such as *Tian Heng and His 500 Retainers* (1928). In 1923, his well-known oil painting *Old Woman* was selected for exhibition in the Salon des Artistes Français.

By the time he returned to China in 1927, Xu had mastered both Western and Chinese art, merging Western perspective and compositional methods with Chinese brush and ink techniques. He was appointed to prestigious posts at various art institutions, and was particularly noted for his *shumihoua* (ink and wash painting) portrayals of horses and birds.

Xu's fame continued to flourish in Europe, and he was invited by the French National Art Gallery in Paris to organize a Chinese art exhibition. Other invitations followed, and he toured Italy, Belgium, Berlin, Moscow, and Leningrad. Over the next few years, Xu took further successful exhibitions to Germany and India, and during the Sino-Japanese war, he donated proceeds from his exhibition in Singapore to help Chinese refugees.

When he died in 1953, Xu left a legacy of over 1,200 of his own works, and his reformation policies continued to pave the path for modern Chinese art.
Mariko Kato

Date 1933

Born/Died 1895–1953

Nationality Chinese

First exhibited 1923

Why It's Key Considered to be the pioneer of contemporary Chinese realist fine arts.

opposite *Four Horses*

297

Key Artwork *The Fleet's In*
Paul Cadmus

In 1934, like many American artists at the time of the Great Depression, Paul Cadmus (1904–1999) had joined the Works Progress Administration's Public Works of Art Project (PWAP), easel division. As was their brief, he painted genre scenes of American life. This early work however, not only had an abrasive satirical edge to it but also homoerotic overtones that, in the case of The *Fleet's In*, proved to be very controversial. Stylistically Cadmus was a Magic Realist, a form that in fine art married Renaissance realism and technique to fantasy narrative.

The Fleet's In depicts a group of sailors on shore leave. In the background, two sailors sit on a wall in a seemingly drunken state. Next to them sits a well-dressed man wearing a red tie. He suggestively offers one of the sailors a cigarette, while in the foreground others carouse with young women who, it is assumed, are prostitutes.

The painting was selected for the 1934 exhibition of PWAP artists at the Corcoran Gallery in Washington D.C. But after an irate letter to the editor of the *Washington Evening Star*, a public outcry called for its removal. *Time* magazine thought it was a product of a sordid and depraved mind, with little idea of real conditions of service. With added pressure from the Navy, Naval Secretary Claude A. Swanson ordered its removal. The media exposure had brought the painting to a wide audience and this helped Cadmus to become a successful artist. The painting currently hangs in the Naval Art Gallery, Washington DC.
Sue King

Date 1934

Country USA

Medium Oil on canvas

Collection Naval Art Gallery, Washington D.C.

Why It's Key Controversial Magic Realist painting.

Key Event
Works Progress Administration established

During the Great Depression, help agencies of all kinds were set up under the Works Progress Administration (WPA). As part of President Roosevelt's New Deal, the aim was to create work for the unemployed. Some of these programs, like the Federal Arts Project (known simply as The Project) were designed specifically to give employment to artists, while others, like the Farm Securities Administration (FSA), employed photographers to document the effects of the Depression on rural and urban life and conditions across the United States.

In 1936, under Roy. E. Stryker's direction, the FSA's photographic project was set up. He commissioned leading photographers including Walker Evans, Dorothea Lange, and Margaret Bourke-White to document the plight of migrant families, farmers, and sharecroppers in and around the Oklahoma Dust Bowl. Out of this came some of the most definitive and now familiar images of the Depression, best summed up in Lange's famous photograph of a migrant mother and her children.

An aid program for artists was first set up in 1933. The short-lived Public Works of Art Project commissioned artists to decorate public institutions with American themes, and although no particular style was stipulated, it tended toward Social Realism. It was not a success, lasting only six months, but it was re-established in 1935 as an agency of the WPA. Known as the Federal Arts Project, it had a broader attitude to the production of work, helping many young unknowns to get established, some of who became leading Abstract Expressionists.

Sue King

Date 1935–1943

Country USA

Why It's Key Produced the most comprehensive photographic archive of life and conditions in the Great Depression, and nurtured some of the leading American artists of the twentieth century – Jackson Pollock, William De Kooning, and Mark Rothko among them.

1930–1939

298

Key Artist **Oskar Kokoschka**
Founds the Oskar-Kokoschka-Bund

Oskar Kokoschka studied at the School of Applied Art in Vienna between 1905 and 1908. From 1911 he began a series of large oil paintings with biblical themes and psychologically penetrating portraits of fashionable Viennese celebrities. In 1912 Kokoschka started a tempestuous affair with Alma Mahler, the widow of the composer Gustav Mahler. He painted many pictures based on their relationship, notably *The Tempest (Bride of the Wind)* 1913. During his army service in World War I he was wounded, admitted to hospital and diagnosed as mentally unstable. In 1915 Alma separated from Kokoschka and married Walter Gropius (Bauhaus). Kokoschka never got over this rejection and produced a number of paintings expressing his love for Alma.

In 1916 his contract with Cassirer's gallery in Berlin guaranteed an income; and in 1919 he started teaching at the Academy of Art, Dresden. His Expressionist period ended in 1921; townscapes subsequently dominated his oeuvre. He left Dresden in 1923 and traveled, painting in Europe, North Africa, and the Middle East, returning to Vienna in 1933.

In 1934 the Nazis deemed him a "degenerate" artist. He fled from Austria to Prague where he founded the Oskar-Kokoschka-Bund with other expatriate artists to resist the restrictions being steadily imposed by the Nazis. Fleeing again to the UK in 1938, he became a British citizen in 1946, finally settling in Switzerland, and regaining Austrian citizenship in 1978.

Brian Davis

Date 1934

Born/Died 1886–1980

Nationality Austrian

Why It's Key Leading Expressionist painter who vainly resisted the spread of Nazism across Europe.

Key Exhibition
Machine Art

The 1934 Machine Art exhibition at MoMA was the first of its kind. Organized by Philip Johnson, it drew close to 32,000 viewers. Johnson drew inspiration for the exhibition from the museums's directors, Alfred H. Barr and Alan Blackburn, as well as architectural guru Henry-Russell Hitchcock. These three inspired Johnson to showcase the importance of the functional aspect of art, and prioritize the everyday object to the realm of high art in a prestigious gallery space.

Machine art came to stand for more than just the title of the exhibition. Johnson adopted the spirit of the Bauhaus movement, and took a distinctly anti-handcraft stance. The exhibition displayed objects in six different categories, including Industrial Units, Household and Office Equipment, Kitchenware, House Furnishings and Accessories, Scientific Instruments, and Laboratory Glass and Porcelain. Under these categories, dessert spoons were placed next to pipes, compasses next to ball bearings, ladles next to locks, and cash registers next to vacuum cleaners. This strange and wonderful pairing of mundane objects commented on the futility of the classification of high art, the glorification of American industry, and obsession with the ideology of the machine, the importance of function, and the beauty derived from the everyday.

Johnson went on to become the founding chairman of MoMA's Department of Architecture and Industrial Art, thanks to the success of Machine Art. The museum's commitment to the potential of modern art established MoMA's reputation as a leader in innovative and groundbreaking displays of modern art.
Emma Doubt

Date March 5–April 29, 1934

Country USA

Why It's Key Elevated everyday objects to the realm of high art.

299

Key Artist **Balthus**
The Street sparks controversy

Balthus was born in Paris into an artistic family. His father, Eric Klossowski, a distinguished art historian and painter, had written a book on Daumier. His mother, Elizabeth Spiro, was a painter and a pupil of Bonnard. When Balthus was eleven, she entered into a long-lasting relationship with the poet Rainer Maria Rilke. Rilke mentored Balthus and wrote the preface to a storybook of drawings the twelve-year-old made about the death of his cat, entitled *Mitsou* (1921). Already, the highly personal and narrative aspects of Balthus' oeuvre were evident, and this enigmatic feline would reappear in future paintings.

Balthus received no formal art training. He taught himself, copying masterpieces in the Louvre, including the neo-classical paintings of Poussin. In Florence, he emulated the frescoes of Piero della Francesca. Balthus revisited the techniques and approaches of the Old Masters in a quest to rejuvenate twentieth-century art with new meaning. He never joined any of the century's major art trends, nor was he associated with any group of artists. He remained a figurative painter at a time when this was out of step with mainstream art.

Balthus' paintings often depict adolescent girls, in erotically charged interior scenes, at a time of awakening sexuality. And in 1934, *The Street*, a mere detail of which shows a young boy grabbing a girl's crotch, sparked controversy. Balthus always maintained, however, that erotic titillation was not his intent. Many of the greats, including Picasso, Camus, André Breton, and Giacometti, were among Balthus' fervent admirers. He was also an illustrator and stage designer.
Carolyn Gowdy

Date 1934

Born/Died 1908–2001

Birth name Balthazar Klossowski de Rola

Nationality French/Polish

Why It's Key Balthus is considered one of the twentieth century's greatest figurative, Realist painters, best known for his intimate and enigmatic images of adolescent girls.

Key Person **Raymond Loewy**
Designs the Sears Coldspot refrigerator

Modern industrial design brought a heightened awareness of the aesthetic to the design of hitherto staid objects. The industrial designer Raymond Loewy's 1934 work for the Sears Coldspot refrigerator is a classic example of the attitude, and triumph, of modern principles of design. Prior to Loewy, the refrigerator had been a bland and boxy item best described by the term "icebox," and Sears' own Coldspot design resembled a bulky armoire. Loewy brought his refined sense of streamlining to the redesign project, incorporating a sleeker look, with symmetrical, intersecting lines, maintaining its function but boasting a more attractive appearance.

Loewy's redesign was immediately successful, sparking a 300 per cent increase in Coldspot sales, and vaulting the designer into a spectacular and prolific career that included work for Exxon, Coca-Cola, and many others. Most importantly, the Coldspot redesign marked the beginning of a new era in design and advertising – the triumph of form. While Loewy always maintained the importance of function, he inspired many designers who had less interest in performance and more of a stake in eye-catching aesthetics.

Consequently, industrial design after Loewy has a checkered record in terms of designing utility products, and a documented enthusiasm for the superficial. Design styles such as Googie, for example, sought the future while forgetting the needs of the present, a sin that Loewy never committed. The Coldspot refrigerator brand was retired in 1977, but Loewy is still fondly recalled in Sears' corporate history.

Demir Barlas

Date 1934

Born/Died 1893–1986

Nationality French/American

Why It's Key Loewy's masterful industrial design heralded the beginning of the age of appearance.

opposite Raymond Loewy featured on the cover of *Time*.

Key Event **Congress of Socialist Writers rubber-stamps Socialist Realism**

Throughout the 1920s in Russia, as the political atmosphere grew increasingly conservative under the influence of Stalin, so tensions grew between progressive and experimental artists and those who thought revolutionary art should depict the everyday life of the "heroic" proletariat. Of the many artists' societies and associations that fluctuated at that time, the AKhRR (Association of Artists of Revolutionary Russia) was, from its inception in 1922, committed to the latter way of thinking and was the catalyst of Soviet Socialist Realism.

In order to Curb the independence and rivalry of these groups and factions, in 1932 the Central Committee of the All-Union Communist Party decreed that all literary and artistic organizations be disbanded, and that those supporting the party platform should form one single union – although a (national) Union of Soviet Artists was not formed until the 1950s. However, the Union of Soviet Writers, formed in 1932, was to determine Soviet cultural policy.

The First All-Union Congress of Socialist Writers was held in 1934 with Maxim Gorky as its chairman. It was at this assembly that Andrei Zhdanov, Stalin's chief cultural commissar, announced that Socialist Realism was the only true medium for Soviet arts and, quoting Stalin, he stated that Soviet writers were "engineers of the human soul." In his address, he stressed that truthfulness in artistic portrayal should depict the reality of life as seen through revolutionary development. It should, he said, also ideologically remould and educate in the spirit of socialism.

Sue King

Date 1934

Country USSR

Why It's Key Sets the course of Soviet art along rigid party lines for the next three decades.

TIME

THE WEEKLY NEWSMAGAZINE

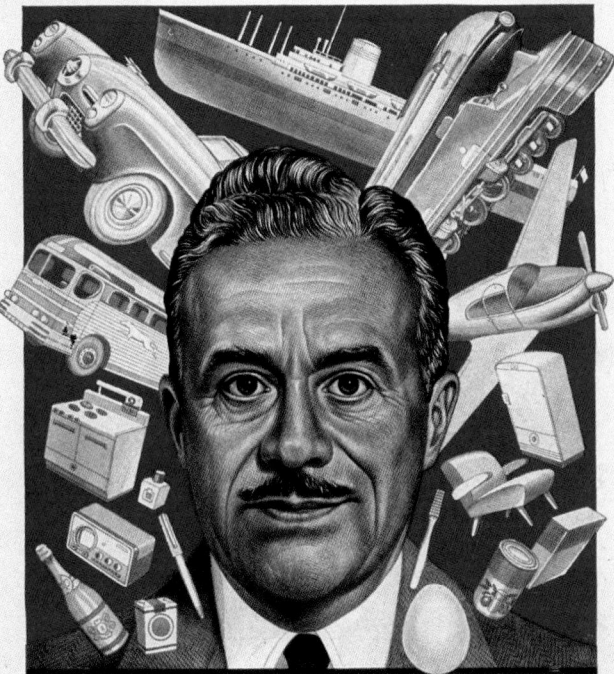

Artzybasheff

DESIGNER RAYMOND LOEWY
He streamlines the sales curve.

Key Artist **Isabel Bishop**
Moves into a studio in Union Square, New York

Born in Cincinnati, Isabel Bishop showed a prodigious talent for drawing from an early age and, at only sixteen, moved to New York to attend classes at the School for Applied Design for Women before, in 1920, transferring to the Art Students League. Influenced by her teachers, Kenneth Hayes Miller and, particularly, Guy Pene du Bois, she also drew inspiration from the social realism of the seventeenth-century Dutch and Flemish painters and there is a discernible relationship in her extensive nude studies to Rembrandt, Millet, and the French Impressionists.

A methodical, reserved woman, in contrast to her flamboyant friends and contemporaries Alice Neel, Georgia O'Keeffe, and Louise Nevelson, Bishop's work reflected her character. In over sixty years she produced fewer than 175 paintings.

In 1934 Bishop took a live-in studio at Union Square, to be her creative base until her death. Painter, illustrator, draftsman, and printmaker, Bishop reflected America's fascination with itself, and became one of the nation's most celebrated artists.

Women constituted her primary subject matter. The continuous drawing of the female nude gave her particular satisfaction and her paintings were of daily life, primarily "blue collar" women carrying out ordinary, everyday activity around Union Square. The dynamic and tension between her characters was invariably that of woman to woman. Her anecdotal and narrative paintings might be compared to works of the great reportage photographers of the period, such as Brassaï, Cartier-Bresson, or Robert Frank.

Mike von Joel

Date 1934

Born/Died 1902–1988

Nationality American

Why It's Key The location of Bishop's studio provided the source material for her art for over fifty years.

302

Key Artist **Amrita Sher-Gil**
Modern pioneer "re-discovers" Indian Art

Born into a family of intellectuals, with a Hungarian singer mother and an Indian scholar father, Amrita Sher-Gil grew up between Hungary and India. At the age of sixteen, she moved to Paris to study at the Ecole Nationale des Beaux-Arts, where she was taught a very academic approach to painting. But her stay in France also allowed her to discover Gauguin and his vivid depiction of the female body.

Leaving her exuberant lifestyle and her numerous lovers in France, she returned to India in 1934, where her work was influenced by the observation of people's daily lives. While her paintings initially retained the monumental sense of composition that she learnt in Paris, the facial expressions of her subjects reflect the artist's empathy. Her painting *Three Girls* (1935) dates from this period.

A year later, she met the collector Karl Khandalavala, who encouraged her to further her study of Indian artistic tradition, especially Moghul miniatures. At that point, Sher-Gil simplified her lines, and depurated the background to focus on the characters, which she depicted in colorful hues. As her sense of composition grew simpler, Sher-Gil developed a more complex political and social agenda. She became very concerned by the isolated fate of women dwelling in rural areas. The expressive strength of her brushstrokes resides in the deep, melancholic gaze of her protagonists, reflecting a sense of silent suffering.

Shortly after moving to the artistic town of Lahore, Sher-Gil suddenly died, aged twenty-eight, in still unexplained circumstances.

Sophie Halart

Date 1934

Born/Died 1913–1941

Nationality Hungarian/Indian

Why It's Key Amrita Sher-Gil was the pioneer voice of modern art in India, linking its ancestral artistic tradition to modern social and political concerns.

opposite Amrita Sher-Gil

Key Artist **Cassandre**
Exemplifies the synthesis of art and advertising

Born in the Ukraine to French parents, Cassandre moved at the age of 14 to Paris, where he later studied at both the Ecole des Beaux-Arts and at the Académie Julien. Despite his formal training and painting ambitions, his first success came in 1923 with a poster advertisement, *Au Bûcheron* (*The Woodcutter*), for a Parisian furniture store. While the work won the Grand Prix at the Exposition des Arts Décoratifs two years later, the dynamic nature of the poster, coupled with its prominent display throughout Paris, had already captivated the public. Thus began a notable career, defined by his ability to synthesize art and advertising.

In 1935, Cassandre designed one of his most famous works, a poster created for La Compagnie Générale Transatlantique to publicize the maiden voyage of the SS *Normandie*. His depiction of the ship, which occupies almost the entire work and steams straight toward the viewer, effectively conveys the gargantuan nature and unparalleled luxury of the vessel, whose splendor rivaled the *Titanic*. With the striking forms, dynamic compositions, and bold text in this and other works, his designs continued to generate public interest.

An exhibition of his posters at the Museum of Modern Art in New York in 1936 led to a brief career designing magazine covers for *Harper's Bazaar*. However, he returned to Paris in 1938 and joined the French army during World War II. After the war he pursued other artistic interests, including painting and stage design. He also created several typefaces, and the famous Yves Saint Laurent logo, before his suicide in 1968.

Heather Hund

Date 1935

Born/Died 1901–1968

Nationality French/Ukrainian

Birth name Adolphe Jean-Marie Mouron

First exhibited 1923

Why It's Key Influential in incorporating art into the public sphere.

opposite **Cassandre's** *Normandie*.

Key Artwork *Heads of Two Clowns*
Georges Rouault

Georges Rouault (1871–1958) was born in Paris into a poor Catholic family and at the age of fourteen was apprenticed to a stained-glass painter, with whom he stayed until 1890. From 1891, he studied under Gustave Moreau at the Ecole des Beaux-Arts. Initially Rouault imitated Moreau, but soon developed his own expressionistic method of painting.

In a letter written in 1905, Rouault describes his feelings on encountering a circus troupe: "The old clown in a corner mending his shiny and no longer motley costume; the sharp contrast between shiny, glistening things that are meant to amuse and this exceedingly sad life... later on I clearly realized that the clown was myself, he was all of us." He later used circus characters to reveal the sadness of the human condition.

Heads of Two Clowns was painted in 1935 when Rouault was at the height of his powers. The heavily outlined faces and glowing color within black outlines (the influence of his training as a stained-glass designer) show illusion juxtaposed with reality; clowns, generally regarded as funny or comical, here look sad. The two clowns in this formal design are looking in different directions and separated by a vertical line and different colored backgrounds, which serves to emphasize their isolation. The expressionistic style of painting emphasizes our subjective feelings or emotions rather than depicting things objectively.

Alan Byrne

Date 1935

Country France

Medium Oil on canvas

Collection Private collection

Why It's Key One of the greatest Expressionist paintings of the twentieth century.

Key Artwork *Saint Francis and the Birds*
Stanley Spencer

In 1935, the British expressionist Stanley Spencer's (1891–1959) *Saint Francis and the Birds* was rejected by the Royal Academy because the artist's Saint Francis is depicted in an unorthodox manner. The painting, half of which is dominated by the larger-than-life, Rabelaisian Saint Francis, was considered to veer close to caricature. At a remove of decades, however, *Saint Francis and the Birds* is apparent for what it is: a profoundly felt work of Christian art in which the kingdom of heaven has entered not only into the locale of an English farm but also into the techniques of Modernism.

The Saint Francis – and by extension the Christianity – on offer in Spencer's painting is both amiable and attainable. It is ironic that the heterodoxy of his time wished to keep such subjects safely removed and beatified. Alas, the devout of his time

failed to appreciate the idiom, while the aesthetes were unmoved by his religious subject.

One question worth asking about *Saint Francis and the Birds* is whether it lays bare the discomfort that even the devout might feel about aspects of religion. Can the belief that a human being could communicate with birds be sustained only by imagining the event in a stylized, innately unrealistic way? Is it that Spencer, despite himself, makes Saint Francis less believable by rendering him in circumstances and colors that we understand?

Whatever the case, Spencer would be one of the final painters to both take religion seriously and to adapt it into an experimental figurative idiom.
Demir Barlas

Date 1935

Country UK

Medium Oil on canvas

Collection Tate Gallery, London

Why It's Key This religious painting is memorable for its Modernist and unorthodox expression of a devout Christianity.

Key Artist **André Masson**
Draws first cover of influential review *Acéphale*

André Masson and André Breton were the instigators of the Surrealist movement, which can be broadly divided into two sections: the trompe l'oeil, dream images associated with the likes of Dalí and Magritte, and the realm of automatic writing, drawing, speaking, and painting of which Masson was a leading exponent. His relationship with Breton was close, but somewhat brittle, as Breton liked to take command of situations. In 1936, Masson drew the first cover of the influential review *Acéphale*.

Masson had some illuminating correspondences with Henri Matisse, in which they compared notes and found that they approached painting from opposite ends: Matisse worked from a figurative base, which culminated in abstraction, while Masson began with random, abstract "stream of consciousness" marks,

which he then coaxed into a recognizable form so that figurative elements materialized as a kind of "found" art. He experimented also with technique, applying paint direct from the tube and mixing it with sand. His themes were metamorphosis, violence, mental anguish, and eroticism. It is said that his perceived pessimistic outlook stemmed from his experiences in World War I, in which he was seriously wounded, and also the horrors of the Spanish Civil War. At the onset of World War II, Masson had clearly had enough and emigrated to the USA. There, he was able to forge a link between his automatism and Surrealism and the growth of Abstract Expressionism. He returned to Europe after the war and went to live in Aix-en-Provence, where he focused on landscape painting and spiritual concerns.
John Cornelius

Date 1936

Born/Died 1896–1987

Nationality French

Why It's Key Leading founder of the Surrealist movement.

opposite *Pasiphae* by Andre Masson.

Key Artwork *Objet (Object)*
Meret Oppenheim

Objects had a privileged status in the Surrealists' aesthetics, be they strange *objets trouvés*, found by chance, or assemblages of apparently incompatible items whose encounter triggers a poetic spark.

When invited to take part in an exhibition of Surrealist objects, Meret Oppenheim (1913–1985) entered a cup, saucer, and spoon that had been lined with gazelle fur. The idea had originally come to her at a café, after she had shown one of her fur-trimmed bracelets to Picasso and his partner, the photographer Dora Maar. Picasso is reported to have whimsically suggested that anything could be covered with fur, to which Oppenheim replied: "Even this cup and saucer."

Enchanted, Breton titled the piece *Déjeuner en Fourrure*, a reference to Manet's *Déjeuner sur l'herbe* and Sacher-Masoch's *Venus in Fur*. Oppenheim was more interested in the contrast between the hard, cold, white surface of the industrially produced objects and the soft, warm, and animal connotations of the fur.

Object is imbued with a perverse sensuality, similar to Giacometti's Surrealist sculptures, whose hollowed-out shapes are receptacles associated with femininity. Fur is associated with luxury as well as with female sexual parts; and yet the thought of bringing such a cup to one's mouth is somehow repulsive. *Objet* plays on the same attraction/repulsion dynamics as Man Ray's *Gift* (1919), an iron on which the artist fixed a line of nails that stick out threateningly, rendering it unusable: an iron should glide smoothly, but if used, this one would tear through fabric, summoning images of female domesticity mingled with cruelty and pain.

Catherine Marcangeli

Date 1936

Country France

Medium Fur-covered cup, saucer, spoon

Collection Museum of Modern Art, New York

Why It's Key An Iconic Surrealist object by one of the movement's female icons.

opposite *Objet*

Key Person **Roland Penrose**
Organizes first Surrealist exhibition In London

Trained as an architect, Roland Penrose became a painter and, while living in Paris from 1922, befriended Picasso and Ernst, who had the strongest influence on his art and taste, and most of the leading Surrealists, whose work he proceeded to collect.

In 1936, he returned to London and, with Breton, Eluard, and the poet David Gascoyne, organized the International Surrealist Exhibition. The exhibition, which included work by children and mental patients, and ethnographic objects, shocked the British press and public when Dalí delivered a lecture in a diving suit.

The following year, Penrose met American photographer Lee Miller, whom he was to marry after World War II. In 1938, he showed Picasso's *Guernica* in London to raise funds for Spanish Republicans, drawing large crowds. As war approached, he secured passage for many artists from Europe to England and the USA, including Schwitters and Dalí. As a Quaker, Penrose did not fight in the war, instead working on camouflage techniques. In 1947, he co-founded London's Institute of Contemporary Arts with Herbert Read, selecting important exhibitions such as 40,000 Years of Modern Art that reflected his interest in African sculpture.

His standard biography of Picasso was the first written in English, and his exhibition of the artist at the Tate Gallery was highly influential. These activities overshadowed his achievements as an artist and poet, although he created several memorable Surrealist images. Knighted in 1966, he donated many important works to the Tate Gallery and formed a foundation to assist contemporary artists.

Martin Holman

Date 1936

Born/Died 1900–1984

Nationality British

Why It's Key The artist, historian, and poet was a key figure in the development of modern art in Britain, chiefly responsible for bringing Surrealism to England.

Key Person **Meyer Schapiro**
Influential art historian and teacher

For over fifty years, Schapiro's working life as a multi-disciplinary critic, art historian, teacher, and radical was centered on New York's Columbia University. His influence, however, on the broader awareness of art as related to and dependent on social, religious, and intellectual developments was immense. His inspired dealings with living artists, such as Léger and the painters who emerged in the 1940s as the New York School Abstract Expressionists, often profoundly affected the future direction of their work. His exceptional ability came to attention beyond academia in 1931, when part of his doctoral dissertation on the Romanesque sculptures at Moissac Abbey appeared in the *Art Bulletin*. His distinctive approach recognized the correspondences between changes in art and individual perception, and embraced research into the wider implications of these changes. In contributions to left-wing journals through the 1930s, his view that cultural representations reflected the ideological interests of the ruling class established an enduring attitude in social art history, as well as being the basis for divergent opinions.

Later, Schapiro revised his position to acknowledge that aesthetic formations could be relatively independent of other interests, and that particular practices even nurture the rise of progressive ideas in society. Artists crowded his lectures at the New York School for Social Research, where he taught from 1936 to 1952, and for years his reputation outpaced the volume of published work. A student of painter John Sloan's evening art classes as a child, Schapiro continued to paint and draw for much of his life.
Martin Holman

Date 1936

Born/Died 1904–1996

Nationality Lithuanian/American

Why It's Key His early writings and lectures raised the caliber of discussion of modern art, connecting it with the broad development of culture.

310

Key Exhibition
Cubism and Abstract Art

Cubism and Abstract Art, shown at the Museum of Modern Art, New York in the spring of 1936, was the first coherent historical survey of modern art mounted by any museum. Together with Fantastic Art, Dada, Surrealism, shown at MoMA the following year, it established an essential framework for the history of modernism.

Cubism and Abstract Art included not only paintings and sculptures – by artists spanning the 1890s to the 1930s – but also photography, architecture, furniture, theater designs, typography, posters, and films. In total, almost 400 exhibits were shown, and the exhibition occupied all four floors of the museum's premises. Its opening was delayed by a week after U.S. customs initially refused to allow 19 sculptures to enter the country as works of art.

The impetus behind the exhibition was the desire of its curator, Alfred Barr, to establish modernism within the tradition of art history as well as to define its fundamental qualities. Barr divided abstract art into two main currents: the first, represented by Malevich, was "intellectual, structural, architectonic... rectilinear and classical in its austerity"; the second, exemplified by Kandinsky, was "intuitional and emotional rather than intellectual, organic or biomorphic rather than geometrical in its forms." Barr's famous diagram outlining the entangled genealogy of modern art (revised on many subsequent occasions) made its first appearance on the cover of the exhibition's catalog.
James Beechey

Date March 2–April 19, 1936

Country USA

Why It's Key First comprehensive overview of modern art to be staged by an individual museum.

Key Artist **Edward Burra** Exhibits in first International Surrealist Exhibition in London

Born to wealthy parents, a life-long illness robbed Burra of a formal education. But he was able to study art at Chelsea Polytechnic and the Royal College. Severely disabled with arthritis, he restricted himself mainly to watercolor painting, but as a determined advocate of the bohemian attitude chose to portray low-life subjects.

Taking ideas from Cubism, Dada, Surrealism, and the work of George Grosz, as well has the English satirical tradition of Hogarth and Rowlandson, he had a one-man show in London in 1929, which gained him a following. He exhibited with the Unit One group in 1934, and then notably at the International Surrealist Exhibition in London in 1936.

Burra spent much time in Spain, and began producing darker, more portentous works when the Civil War erupted. The outbreak of World War II kept him in Britain, where he sought out remote landscapes, creating large works by joining together sheets of paper that he worked on separately.

In the 1950s, Burra produced a series of bar scenes in Boston, Massachusetts, where he stayed with his long-time friend, the poet Conrad Aiken. He also made successful forays into book illustration and stage design, producing costumes and sets for Covent Garden and the Sadler's Wells opera houses in London.
Brian Davis

Date 1936

Born/Died 1905–1976

Nationality British

First exhibited 1929

Why It's Key Helped to bring Surrealism to England.

1930–1939

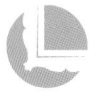

Key Artwork *The Inn of the Dawn Horse* Leonora Carrington

As a child, Carrington (b. 1917) was fascinated by nature and Celtic folklore. Then she became a convent school rebel, a runaway, and a miserable debutante before persuading her parents to allow her to go to art school. At the time of this portrait, Carrington had recently moved in with Max Ernst in London.

In this magical encounter, an animal guide emerges from a puff of ether. The young Carrington is clearly mesmerized. Overhead, a spirited rocking horse floats. The girl emulates the graceful hyena as she perches on the edge of the blue chair. This feminine chair sits passively. But like the horse, it seems capable of springing to life. There is something of the wild flower about this creature with her leaf-like arms. Carrington's shapely legs curve like stems into feet that are planted firmly on the ground. Do its earth hues hold soil deep with nutrients? Does the wild tendril-haired girl have her head in a cloud? Is the cloud a regal headdress? Is it a sacred halo? In the next moment, the viewer is spirited to another possibility. The cloud again becomes a rocking horse and Carrington's hair ripples into a horse's mane. The walls are painted a powdery blue. Then they become the sky. There seem a number of possibilities in this room and still others beyond the mirror. Is it, or are we, much more than we could possibly imagine? A golden curtain surrounds the magic looking glass. It invites the viewer to explore new paradigms that live beyond.

Through this self-portrait, Carrington redefines the Surrealist image of the "femme-enfant" or woman-child. Imagination is as limitless as the horizon.
Carolyn Gowdy

Date 1936–1937

Country UK

Medium Oil on canvas

Collection Private collection

Why It's Key This self-portrait marked a time of great personal transformation for Carrington and redefined the Surrealist image of the femme-enfant. She is more than just a passive muse. She is a powerful creative spirit and artist in her own right.

Key Event
The formation of the Photo League

The emergence of the Photo League occurred when the established Film and Photo League split in two in 1936. Paul Strand and Berenice Abbot became the leaders of the Photo League, a New York-based group which challenged existing expectations regarding the role of documentary photography.

Originally focused upon political protests and trade union activities, the Photo League soon turned its attention to everyday forms of social photography. The urban landscape became the backdrop for many depictions of the living conditions and struggles of working-class life. In addition to producing groundbreaking photographic work, the Photo League also ran informative courses on photography and issued an important newsletter entitled *Photo Notes*. Membership of the Photo League continued to grow as

professionals and amateurs alike joined this dynamic group. Some extremely influential photographers, including Dorothea Lange and Edward Weston, began contributing to the Photo League during the 1940s.

However, in the political climate in the late 1940s, it became increasingly difficult for the group to pursue its work. The Photo League's activities came under the scrutiny and suspicion of the American government for being against the country's best interests. During this period many members of the group, including Strand, were blacklisted. Under this increased pressure, the Photo League finally disbanded in 1951 but left behind it a strong legacy. The work created by the Photo League illustrates how the aesthetic charge of photography can be a powerful voice in the battle for social change.
Samantha Edgley

Date 1936

Country America

Why It's Key Influential group in the promotion of social-political documentary photography.

opposite Dorothea Lange's *Damaged Child, Shacktown, Elm Grove, Oklahoma* (1936).

Key Artist **Lois Mailou Jones**
Travels to Paris on education scholarship

Lois Mailou Jones studied at the School of the Museum of Fine Arts in Boston but found herself, as a black woman, being pushed toward graphic and industrial design rather than being encouraged to develop as a painter. She taught for a short period and then, on the advice of the sculptor Meta Warwick Fuller and Mary Beattie Brady of the Harmon Foundation, she moved (via an education scholarship) to Europe to live in Paris, which is where she found confidence in herself as a painter.

In 1938, she returned to Boston and held an exhibition at the Vase Gallery, which was considered a major achievement for a black female artist at that time. The work exhibited consisted of her Impressionist-influenced, figurative Parisian scenes. However, her later work began to embrace issues such

as racism and the discrimination experienced by women of Third World origin living in the United States. She also traveled extensively to Haiti and Africa.

Meditation (Mob Victim), painted in 1944, is an academic, figurative portrait of a black man who had been subject to racial abuse and had witnessed at first hand lynchings and the like in the "deep south" of the United States. In contrast, her *Moon Masque* (1971) is completely different in style, being an abstract which combines elements of collage, Op Art, and African motifs.

Jones was awarded a professorship in Fine Arts and taught at Howard University in Washington D.C. for a total of forty-five years.
John Cornelius

Date 1937

Born/Died 1905–1998

Nationality American

Why It's Key Important Harlem Renaissance painter and an internationally acclaimed black artist.

Key Artist **Kurt Schwitters**
Revolutionary artist moves to England

German painter, sculptor, writer, typographer, and maker of installations, Kurt Schwitters invented what was effectively a brand name for his multi-disciplinary art pieces: "Merz." At first influenced by Expressionism and Cubism, in 1918 he began making collages out of found objects such as bus tickets and cigarette packs, and in the following year was much taken with a typographical fragment he found when cutting out the word "Commerzbank" from a letterhead for use in a collage. "Merz" became the root of the names he gave his new experiments, which now enthusiastically embraced Dadaism. "Merzbilden" were collages and "Merzbau" were more monumental built constructs. *Merz* was also the name of a magazine Schwitters published from 1923 to 1932, in which his radical typographical experiments found a home.

In 1937, his art was deemed degenerate by the Nazis and he fled to Norway, but when the Germans invaded in 1940 he was forced to relocate once again, this time to England. Interned at first, he subsequently lived and worked in London from 1941 to 1945, and then moved to an old barn in the Lake District, where he worked on another Merzbau with financial assistance from New York's Museum of Modern Art. The day before he died, in 1948, he was made a British citizen.

Graham Vickers

Date 1937

Born/Died 1887–1948

Nationality German/British

First exhibited 1918

Why It's Key A leading figure of the Dadaist movement.

314

Key Artist **Roberto Matta** André Breton
invites Matta to join the Surrealist group

After training in Chile as an architect, Roberto Matta transferred to Europe in 1930. He became personally acquainted with René Magritte and undertook further studies in architecture under Le Corbusier. After joining the Surrealist group, he launched himself as a painter in 1938, eventually producing paintings which existed, tantalizingly, on the edge of realism, as they were abstracts conveying a sense of inner space and containing elements painted in a convincingly figurative style, such as *The Earth Is a Man* (1942). This synthesizes an experience comparable to a waking person experiencing the events of a dream slipping out of his/her grasp.

Matta escaped to New York along with many other European artists in 1939, prior to the outbreak of World War II. One of these was André Breton (1896–1966) who, together with Yves Tanguy (1900–1955), André Masson (1896–1987), and Max Ernst (1891–1976), formed a strong informal Surrealist group which had a major influence on artists such as Arshile Gorky (1904–1948) and Jackson Pollock (1912–1956), who was particularly taken with the notion that art arose from the subconscious. Pollock was encouraged by Matta's influence to experiment with automatic techniques.

Matta returned to Europe in 1948, living in Rome and also in Paris, where he executed a vast mural for the UNESCO building in 1956. He continued to paint, but also began sculpting in the 1950s.

John Cornelius

Date 1937

Born/Died 1911–2002

Nationality Chilean

Why It's Key One of the last Surrealists and an influence on younger artists such as Jackson Pollock.

opposite *Surrealist Landscape* by Roberto Matta.

Key Artwork *Guernica*
Pablo Picasso

The Spanish Civil War broke out in July 1936, headed by the Nationalist General Francisco Franco against the Spanish Republican government in Madrid. The following January, the Republican government asked Picasso (1881–1973), a Spaniard living in Paris, to produce a work for the Spanish pavilion at the Paris International Exposition that summer.

Mexican muralists such as Picasso's friend Diego Rivera had shown the expediency of using art in public spaces for propaganda effect, and Picasso accepted the invitation. But he was not inspired to start the work until he heard of the air raid on the Basque capital, Guernica, by Nazi bombers acting on behalf of General Franco on April 26 – the first occurrence of carpet bombing. The attack was all the more horrifying because it took place at the busiest hour of a market day, resulting in the death and mutilation of several thousand civilians. With no bombs or planes in the picture, Picasso concentrated on the victims. To convey stark horror, he restricted his palate to black, white, and shades of gray. Cubist fragmentation perfectly suits the physical destruction that took place. The picture is heavy in symbolism, from the lamp borrowed from the Statue of Liberty, to the fallen hero still clutching his sword, and the human-faced bull that Picasso said represented brutality and darkness.

The political message is calculated. The painting was "a deliberate appeal to people, a deliberate sense of propaganda," Picasso said. "Painting," he maintained, "is not made to decorate apartments. It is an instrument for offensive and defensive war against the enemy."
Brian Davis

Date April–June 1937

Country France

Medium Oil on canvas

Collection Centro de Arte Reina Sofia, Madrid

Why It's Key Picasso uses Cubism as a powerful means of propaganda.

opposite *Guernica*

Key Exhibition
International Exposition

The 1937 International Exposition in Paris was named "Arts and Technology in Modern Life." It was a classically modernist title in its invocation of modern life and the way it assumed parity between art and technology. Sadly, Paris, 1937, was the high point of modernism, an optimistic and constructive worldview that would shortly be overwhelmed by cruder, more destructive ideologies. The exposition staged this clash in stark terms, with Picasso's *Guernica* (1937) appearing close to the swastika-tipped German pavilion. Portentously, Germany and the Soviet Union were the only countries to complete their pavilions. Within a few years, Germany would successfully invade Paris, the capital of modernism, and suppress what it considered degenerate artistic activity across Central and Western Europe; meanwhile, the Soviet Union's de facto colonization of Eastern Europe would shut down the vibrant Polish and Czech art scenes.

Echoing the general European sentiment, the 1937 International Exposition did not understand that beneath the modernist veneer of Nazi architect Albert Speer's pavilion was a profoundly pre-modern and illiberal aesthetic. Speer received the Exposition's Grand Prize. Meanwhile, Stalinist architect Boris Iofan carried away a gold medal for his Palace of Soviets pavilion. Two years after Arts and Technology in Modern Life, the Axis would employ technology to very nearly put an end to modern life, thus destabilizing the optimistic assumptions of modernism. The 1937 International Exposition was perhaps the last time it was possible to embrace modernism in good faith.
Demir Barlas

Date May–November, 1937

Country France

Why It's Key The high point of modernism.

Key Exhibition **Grosse deutsche Kunstausstellung (Great Exhibition of German Art)**

The first of the annual Great German Art exhibitions, held in Munich in 1937, was largely staged as a propagandizing rival to the "Degenerate Art" show – the two exhibitions ran simultaneously – organized by the Nazi Party to discredit the many strands of modern art. For the Great Exhibition of German Art, Hitler had envisaged an exhibition that would celebrate a thousand years of German painting and sculpture. In his opening speech to the first of these annual events he announced: "When we celebrated the laying of the cornerstone of this building four years ago, we were all aware that we had to lay not only the cornerstone of a new home but also the foundation of a new and genuine German art."

What Hitler did not state in his opening speech was that so frustrated had he become with the problematic search for high-caliber contemporary artists from Germany (even those living outside of the Reich), that he had actually considered cancelling the exhibition altogether. Originally intended as a commercial show from which Germany's cultural elite could purchase works and thus support the country's contemporary artists, inevitably the annual exhibitions fell back onto art from the past that Hitler favored.

Nonetheless, due to the huge amount of publicity that was produced for the first of these exhibitions, 600,000 visitors attended in 1937. Hitler himself bought over two hundred works from the problematic 1937 exhibition, spending over half a million marks and thus assuring the appearance of success.
Ian McKay

Date 1937

Country Germany

Why It's Key A powerful public vehicle that was intended to legitimize Nazi cultural policy.

Key Event
New Bauhaus opens in Chicago

Both Walter Gropius and Marcel Breuer went to the United States to teach at the Harvard Graduate School of Design. Gropius had been architect-director of the Bauhaus (1919–1927) at Weimar and then Dessau. Breuer had been forced to resign from Dessau by Hannes Meyer and then had to emigrate to London to escape the Nazis in 1935.

The Harvard School in Chicago was enormously influential in the early 1930s – Philip Johnson, I.M. Pei, Lawrence Halprin, and Paul Rudolph were former students. Following the collapse of the short-lived Berlin Bauhaus in 1933, Mies van der Rohe also arrived in Chicago, sponsored by Philip Johnson, destined to become a leading international architect.

The Hungarian Constructivist painter László Moholy-Nagy was a former professor in the Bauhaus school and had replaced Johannes Itten. Gropius and Moholy-Nagy once planned to establish an English version of the Bauhaus, but could not secure finance in London. In 1937, Walter Paepcke, the Chairman of the Container Corporation of America, invited Moholy-Nagy to Chicago to become director of the New Bauhaus, located in a Prairie Avenue mansion designed for store magnate Marshall Field. Although still faithful to the Bauhaus principle of the integration of technology and industry into the arts, the project soon lost its financial backing. After only one academic year it closed. However, the influence on architecture was widespread.

In 1939, Moholy-Nagy opened a School of Design, which duly became the Institute of Design in 1944. He died of leukaemia in Chicago in 1946.
Mike von Joel

Date July, 1937

Country USA

Why It's Key Former Bauhaus associates move to Chicago to influence a whole generation of American architects.

Key Exhibition
Popular Masters of Reality

One of the most fascinating encounters in the history of art occurred when Henri Rousseau (1844–1910), "Le Douanier," attended a dinner given in his honor by Pablo Picasso (1881–1973) in 1908. It was at this dinner that Rousseau described himself the greatest painter in the modern style, while nominating Picasso as the finest painter of the older style. Rousseau got it wrong, of course – Picasso was the doyen of modernism, while Rousseau is considered the finest of the naïve painters. Rousseau, like many other painters exhibited in 1937's Popular Masters of Reality, had never been to an academy and was largely self-trained. Insulated from instruction in classical technique and developments in modernism, such painters were at times ridiculed for their idiosyncratic, untutored style. But among their works were masterpieces displaying unique vision.

The Popular Masters of Reality called attention to Rousseau and other naïve painters – such as André Bauchant (1873–1958), Louis Vivin (1861–1936), and Camille Bombois (1883–1970) – and reversed the indifferent or condescending attitude of earlier decades to this form of art. After success in Paris, the exhibition traveled to London, Zurich, and New York, all important centers of critical opinion. The exhibition was the beginning of a critical reappraisal of naïve art, which would lead to increased museum and collector interest in naïve paintings. Today, among the cognoscenti, naïve art enjoys a better reputation than academy painting and is valued as an important branch of late nineteenth- and early twentieth-century painting.
Demir Barlas

Date 1937

Country France

Why It's Key Popular recognition of naïve and primitive painting.

1930–1939

319

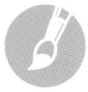

Key Artist **Max Beckmann**
Flees Germany for Amsterdam

Max Beckmann had an individual voice. Never an imitator, he never joined an art movement. His inspiration seems to have come from elsewhere. He painted subtle portraits of friends, family, and of himself, and mixed these with an assortment of symbolic characters in the mysterious theater of reality that he drew and painted. His narrative allegories drew on mythology, history, and philosophy, but were deeply rooted in his own experience. When Hitler came to power, Beckmann was something of a national treasure but Hitler condemned his work as dangerous and "degenerate." Beckmann had been at the height of his career, but dealers were no longer able to sell or show his work and hundreds of pieces were confiscated.

Shortly after the opening of the 1937 Degenerate Art exhibition mounted by the Nazis, which featured a

lot of Beckmann's work, the artist fled to Amsterdam. While in exile, his art was able to flourish. He painted the allegory on Nazi Germany, *Hell of the Birds* (1938) and spent ten years in Amsterdam, working in relative isolation. During this time of abrupt transition, Beckmann's frequent visits to cabarets, carnivals, and the theater inspired his theatrical paintings, such as *Schauspieler* (*Actors*, 1941–42) and *Karneval* (*Carnival*, 1942–43). After the war, Beckmann immigrated to the USA, taking up artist residency in St. Louis, later moving to New York, where he taught and painted constantly. On his way to an exhibition, on December 27, 1950, Beckmann had a heart attack outside the Metropolitan Museum of Art. He had just completed the ninth of his monumental triptychs, *Argonauten* (*The Argonauts*).
Carolyn Gowdy

Date 1937

Born/Died 1884–1950

Nationality German

Why It's Key Beckmann survived misfortune and Nazi persecution but in spite of this he managed to maintain a consistent level of excellence in his art and remain committed to an inner vision.

Key Artist **Peter Blume**
Completes anti-fascist *The Eternal City*

Peter Blume had a singular vision and skill for juxtaposing imagery in a powerful way into modern social themes. He made his mark during the Great Depression era with a surreal blend of precisely rendered epic tableaux. Many artists worked on federal patronage projects under the WPA scheme created as part of Franklin Roosevelt's New Deal, but Blume seems, for whatever reason, not to have participated. During the 1920s, the artist is known to have agreed to paint several post-office murals. He was also part of the bohemian Greenwich Village set. After that time, however, Blume struck out on his own. Blume's Magic Realism was created on a relatively small scale.

Blume's parents came from Russia to the United States when he was five, settling in Brooklyn, New York, in about 1912. In 1932, while on a Guggenheim fellowship to Italy, Blume explored the ruins of the ancient Roman Forum and the city itself. Scattered among debris, he found a papier-mâché image of a glaring Mussolini, and a small effigy of Christ covered by assorted gift trinkets that could be associated with the praying masses. It had been ten years since Mussolini's march on Rome. The irony was not lost on Blume. He returned to the United States, eventually beginning work on *The Eternal City*. The picture took two years to gestate, then swarmed with such fastidious detail that it required a further three to complete. In 1943, the week that Mussolini was deposed from power, the Museum of Modern Art purchased *The Eternal City* for its permanent collection.

Carolyn Gowdy

Date 1937

Born/Died 1906–1992

Nationality Russian (died United States)

Why It's Key *The Eternal City* was intended as a symbolic picture with a clear message. Today, it remains particularly relevant in a politically fraught world.

opposite *The Eternal City*

Key Artist **William Edmondson**
One-man show at Museum of Modern Art, New York

Born in Davidson County, Kentucky, William Edmondson grew up and lived in Nashville, Tennessee. His parents had been slaves in the nineteenth century. A self-taught artist, Edmondson is placed in the category of "naïve" or "outsider" art, terms generally applied to artists with no formal training who do not fit into any particular school or group. The terms "folk" and, more questionably, "primitive" have also been used to describe art produced within sophisticated societies by artists who are untrained outsiders in one way or another. These politically incorrect terms are redundant in esoteric circles where the artistic work produced in non-industrial societies, or by individuals isolated for any reason – mental or physical illness, race, age, education, or gender – is considered of equal merit and validity to any produced as a result of art education and training within an industrialized Western society.

The term "naïve" is usually applied to painting rather than sculpture, as simplified or symbolic sculpture is generally more predominant on a world scale than conventional "Western" sculpture. Edmondson's work takes the form of limestone sculptures, sometimes, as in the case of *Birdbath* (1940 1949), with a practical as well as artistic function. When Edmondson's 1937 solo show was held at New York's Museum of Modern Art, the then director of the museum, Alfred Barr, remarked on Edmondson's choice of a difficult medium and is noted to have observed, "Naïve artists usually work in the easier media. Edmondson, however, has chosen to work with limestone."

John Cornelius

Date 1937

Born/Died 1870–1951

Nationality American

Why It's Key First African-American to hold a solo show at New York's Museum of Modern Art.

Key Exhibition
Degenerate Art

The National Socialist policy on culture and race goes back to 1929, when Alfred Rosenberg, a leading Nazi spokesman on art and culture, formed the Combat League for German Culture to protect the beauty ideal of the Aryan race from being undermined by a Jewish/Bolshevik conspiracy.

In the summer of 1937, two art exhibitions opened within a day of each other, designed to confirm Nazi racial policy and the supremacy of German culture. Great German Art opened in a newly built gallery, displaying giant, heroic statues, neo-classical in style, and traditionalist paintings with Teutonic or classical themes.

Across the road was the Degenerate Art Exhibition. Expressionism particularly, with its distorted imagery, was a politically useful target for derision. The antithesis of the National Socialist policy on art, with its romantic visions of German purity, rooted in the blood and soil of a Gothic, peasant past, and artists like Dürer and Cranach, many Expressionists were non-German, or worse, Jewish.

Some 16,000 modernist works had been confiscated from public art museums. Many were burnt or sold to foreign collectors but 650 works, some by leading Expressionists, formed the exhibition. On the wall above works by Kirchner, Schmidt-Rottluff, and Nolde was a slogan that read: "The niggering of music and theater as well as the niggering of the visual arts was intended to support the racial instinct of the folk, and to tear down blood barriers." Significantly, the Degenerate Art show attracted considerably more visitors than the rival Great German Art exhibition.
Sue King

Date 1937

Country Germany

Why It's Key This anti-Modernist show of art confiscated by the Nazis, was used to demonstrate the "superiority" of traditionalist, racially "pure" art.

opposite Goering and Hitler examine "Entartete Kunst" (Degenerate Art).

1930-1939

322

Key Artist **Paul Delvaux**
Pink Bows begins his Surrealist career

After studying architecture and painting at the Académie des Beaux-Arts in Brussels, Paul Delvaux had his first one-man exhibition in 1925, in which he showed mainly landscapes. In the late 1920s and early 1930s, he made the significant move of adding nudes to the scenery. Then, under the influence of the Metaphysical painting of Giorgio de Chirico, which he had first encountered around 1926, Delvaux embraced Surrealism.

Among his first work in this vein was *Pink Bows* (1937) which, characteristically, shows a collection of nude and semi-nude women in a typically Surrealist landscape, featuring incongruous architectural backgrounds. These disquieting, dreamlike images would mark his largely unvarying trademark style for the rest of his life. Other key influences include his fellow Belgian Surrealist René Magritte, and Salvador Dalí, whose precise, almost photographic technique he emulated.

After World War II, Delvaux produced some large-scale murals, including those at the Casino in Ostend (1952), the Palais de Congrès in Brussels (*Earthly Paradise*, 1959), the Institut Zoologique at Liège University (*Genesis*, 1960), and the Casino de Chaudfontaine (*Mythical Voyage*, 1974). He was a professor of painting in Brussels from 1950 to 1962, and in 1982 the Musée Paul Delvaux opened at Saint-Idesblad, Belgium, a small town on the North Sea coast.
Brian Davis

Date 1937

Born/Died 1897–1994

Nationality Belgian

First exhibited 1925

Why It's Key Delvaux was a leading Belgian Surrealist.

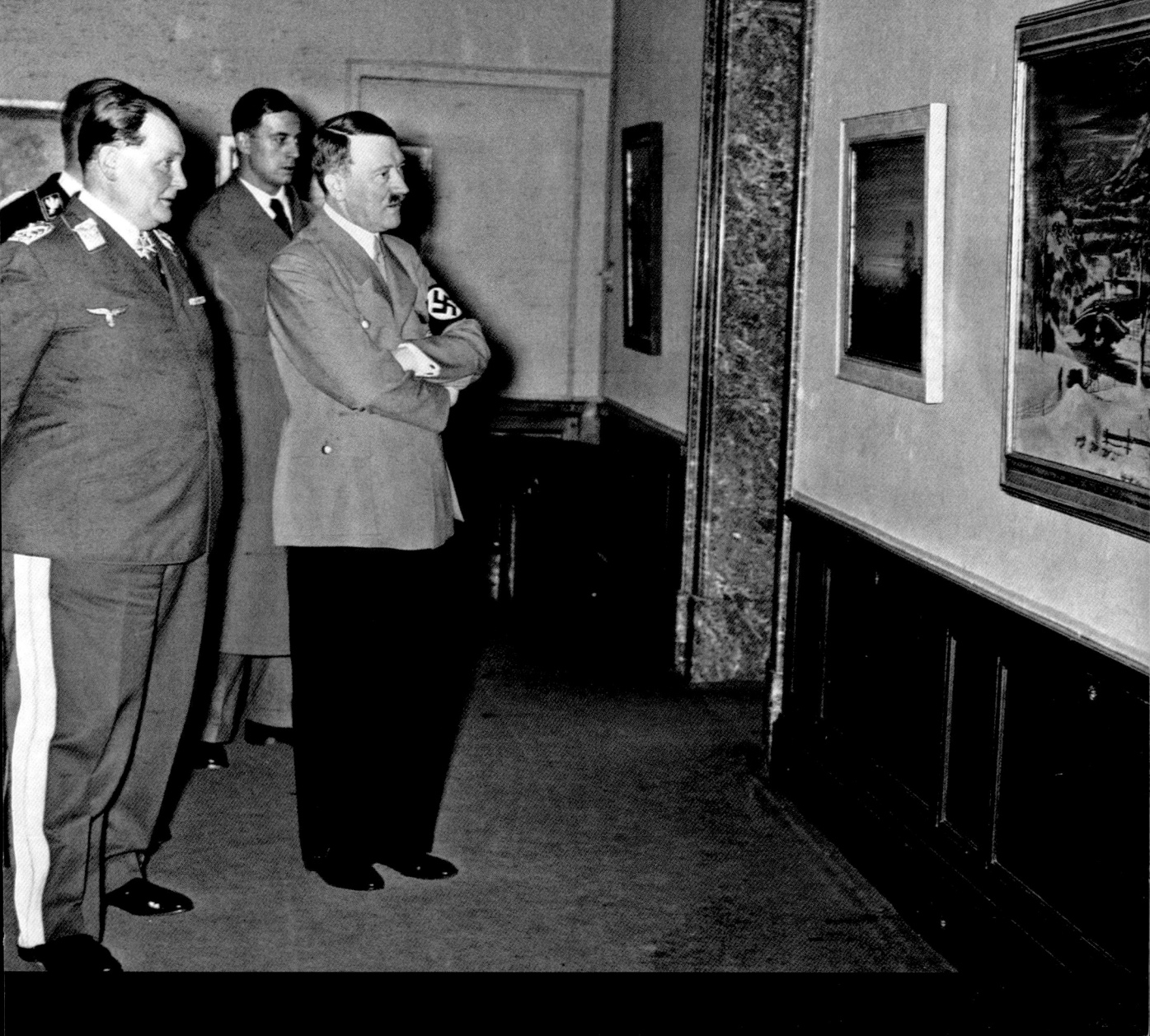

Key Event
Naming of the Euston Road School

In October 1937, the artists William Coldstream (1908–1987), Claude Rogers (1907–1979), and Victor Pasmore (1908–1998) established the School of Drawing and Painting in Fitzroy Street, London; shortly afterwards, the school moved to 314–16 Euston Road. The name "Euston Road School," was coined by the critic Clive Bell the following year. Among others to whom the name was applied were Graham Bell (1910–1943), Rodrigo Moynihan (1910–1999), Lawrence Gowing (1918–1991), and Geoffrey Tibble (1909–1952).

Euston Road painting emerged in reaction to the two main strands in modernist art, abstraction and Surrealism, and as an upshot of the prevailing economic climate of the 1930s. The school's teachers encouraged an aesthetic of impartial ob̶s̶e̶r̶v̶a̶t̶ion and verification, drawing inspiration from the c̶r̶e̶a̶t̶i̶v̶e̶ process of Paul

Cézanne and the subject matter of Walter Sickert. Although Coldstream and Bell were interested in the Mass Observation project of the late 1930s, and were persuaded by the anthropologist Tom Harrisson to make a painting expedition to Bolton in the north of England in 1938, the school as a whole eschewed social commentary in favour of a lyrical realism, characterized by a restrained palette and brushwork, and a reticent approach to traditional subjects. The school closed shortly after the outbreak of World War II, although its leading members remained in teaching. Coldstream, in particular, as Slade Professor of Fine Art from 1949–75, exerted a considerable influence, and a number of his students, such as Euan Uglow and Patrick George, continued in a style faithful to Euston Road.

James Beechey

Date 1938

Country UK

Why It's Key Collective term used to define artists associated with the school both as teachers and pupils, which eschewed abstraction in favor of a new realism.

Key Artist **Wilfredo Lam**
Moves to Paris and becomes a protégé of Picasso

Wilfredo Lam's life was filled with unfortunate circumstances, including his family's insistence that he study law, the death of his wife and baby in 1931, and the defeat of his beloved Republicans in the Spanish Civil War of 1937. But Lam was not destined to tragedy for the rest of his life. In 1937, the 35-year-old artist-turned-soldier received a wound and was sent to Barcelona to recuperate. There, Lam – who had studied art in Cuba and Spain from 1918 onward – made the acquaintance of the sculptor Manolo Hugue (Manuel Hugué), who provided Lam with a letter of introduction to Pablo Picasso. Lam fled Barcelona ahead of the fascists, and made it to Paris in 1938. Here he met Picasso, who was greatly impressed by Lam. Picasso opened the art world's doors to Lam, while Lam, in turn, found himself artistically influenced by Picasso.

Lam's arrival in Paris at the height of European modernism's fascination with so-called primitive art was a fascinating moment in art history. Lam, whose ancestry was African, Chinese, and Cuban, was a living pastiche of the traditions and histories that white European artists were attempting to invoke in their work. Lam embraced the glorious confusion of his identity, itself a reflection of the syncretism of Afro-Cuban history, and entertained a number of distinct techniques and motifs over his lifetime. In doing so, Lam anticipated the creative path of Third World artists who adopted modernism without losing their roots.

Demir Barlas

Date 1938

Born/Died 1902–1982

Nationality Cuban

First exhibited 1939

Why It's Key A serendipitous move to Paris launched the career of the Cuban artist who successfully fused modernism and Afro-Cuban motifs.

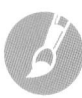

Key Artist **Loren MacIver**
First one-person show, New York

Loren MacIver was born in New York City and lived and worked mainly in Greenwich Village (and partially in Provincetown, Massachusetts). She studied at the Art Students League of New York and worked in a semi-abstract, semi-figurative fantasy field, having her first one-woman show in New York in 1938.

Although she traveled in Europe, MacIver lived most of her life in Greenwich Village, painting dreamlike half-abstract landscapes. In 1929, she married Lloyd Frankenberg, a poet, and they collaborated with their work. In 1935, her husband, without her knowledge, showed her paintings to Alfred Barr, director of the Museum of Modern Art, and by 1938 she was sufficiently regarded to have her first solo show.

A typical example of her work is *Skylight Moon*, painted in 1958, which is a dreamy indirect abstract hinting at a figurative or narrative content, which appears to lie just beyond the reach of the viewer in visual terms. *The Market at Toulon* similarly suggests, rather than depicts, a busy yet hazy location where some indefinable activity appears to be taking place. MacIver never moved entirely away from the figurative starting point in her work, and always aimed to retain a sense of wonder at the manifestations of nature. In her long career, she also worked in the realm of illustration, portraiture, and still-life painting. Her work has been exhibited in the Venice Biennale and at the Art Institute of Chicago, the Phillips Collection, and the Whitney Museum of American Art, among others.

John Cornelius

Date 1938

Born/Died 1909–1998

Nationality American

Why It's Key One of America's best-known female artists.

Key Artist **David Smith**
First one-man show

Smith revolutionized sculpture in postwar America and Europe with a three-dimensional version of Abstract Expressionism. Developing idioms pioneered by Cubism, González, and Giacometti, he used industrial leftovers and found metal objects to construct artwork that became increasingly ambitious in scale and scope. Facilitated by welding, sculptures graduated from open, gestural, linear forms of birds, landscape, or totem figures, to simpler, abstract combinations.

Executed in series, the *Cubi* and *Zigs* (1963 onwards) introduced forceful volumetric elements, color, and frontal viewpoints. "I do not work with a conscious and specific conviction about a piece of sculpture," Smith explained in 1952. "It is always open to change and new associations. It should be a celebration, one of surprise, not one rehearsed."

Smith was a welder in a Studebaker plant in the summer of 1925, before moving to New York to study painting with Sloan at the Art Students League. Introduced by a friend to Picasso's welded-steel work, he made his first sculpture from pieces of coral in 1931–32. In 1935 he committed himself primarily to sculpture. In his early work he applied the Cubist techniques of "drawing in space" to a collage aesthetic with Surrealist influences. Like Pollock and other contemporaries among painters, Smith sought truth from encountering himself at the most primitive level of being. Although his symbolism kept its full psychological meaning veiled, he regarded his materials as emblematic of masculinity and the machine age.

Martin Holman

Date 1938

Born/Died 1906–1965

Nationality American

Why It's Key An artist of fundamental importance, Smith was an outstanding sculptor of Abstract Expressionism.

Key Artist **Victor Vasarely**
Zebras considered first examples of Op art

Born and raised in Hungary, Victor Vasarely trained at the Bauhaus in Budapest before moving to France in 1929. He began working as a graphic artist in Paris in 1930, and continued to work as a commercial artist and designer for the next ten years, although he maintained an intellectual interest in visual psychology and perception, and became interested in attempting to create spatial and visual illusions through black-and-white geometrical abstraction, to the point of creating startling hallucinatory, visually disturbing patterns which were often difficult to look at as they appeared to jump about, change shape, or produce the illusion of shapes or colors that were not actually present. The series *Zebras* (*Zebres*) typified Vasarely's work at this time. After World War II, Vasarely moved on to large-scale kinetic work, tapestries, and public sculpture and reliefs, such as those at the University of Caracas (1954), Venezuela, and the French Pavilion at Expo 1967 in Montreal, Canada.

Op Art was very much concerned with the science of perception as much as it was with art philosophies, and was a more serious area of study than is popularly supposed in view of the fact that, unusually for abstract "modern" art, the images are accessible and familiar to the general public, particularly through the auspices of his more well known followers. He was a major influence on artists such as Bridget Riley (b.1931), and his son, Jean-Pierre Vasarely (1934–2002), is also an Op art/kinetic artist of some repute.
John Cornelius

Date 1938

Born/Died 1908–1997

Nationality Hungarian

Why It's Key Crucial pioneer of what became known as op art.

opposite Victor Vasarely's *The Metro*.

1930–1939

326

Key Event
Release of Leni Riefenstahl's *Olympia*

Leni Riefenstahl's *Olympia* has been both celebrated and condemned in equal measure. For her technical innovations in shooting live action at the 1936 Olympic Games in Berlin, and not least the poetry of her editing technique that makes *Olympia* so enthralling, Riefenstahl (1902–2003) is justly celebrated as one of cinema history's most important filmmakers. That she willingly deployed her skills to promote Nazism on such a captivating scale, and that she failed to accept any moral responsibility for her role in doing so, also led, however, to her being repeatedly castigated throughout her life. That said, *Olympia* is a *tour de force* that is justly studied as a key work of twentieth-century cinema.

The film was produced in two parts: *Festival of Peoples* (*Fest der Völker*) and *Festival of Beauty* (*Fest*

der Schönheit), but multiple versions exist due to the director's habit of re-editing for each re-release. Although many of the film's techniques are now industry standard (for example, the diversity of camera angles, smash-cut and jump-cut editing techniques, extreme close-ups, and remote camera tracking shots), and Riefenstahl's place as an innovator equal to Abel Gance (1889–1981) and Sergei Eisenstein (1898–1948) is thus assured, praise for the film and Riefenstahl's overall aesthetic has often drawn condemnation. For this reason, Riefenstahl remains one of the most controversial figures in the history of cinema, with opinion still divided on whether *Olympia* is a film about the Olympic Games or a work of Nazi propaganda.
Ian McKay

Date 1938

Country Germany

Why It's Key A controversial *tour de force* that combines technical innovation with questionable political motives.

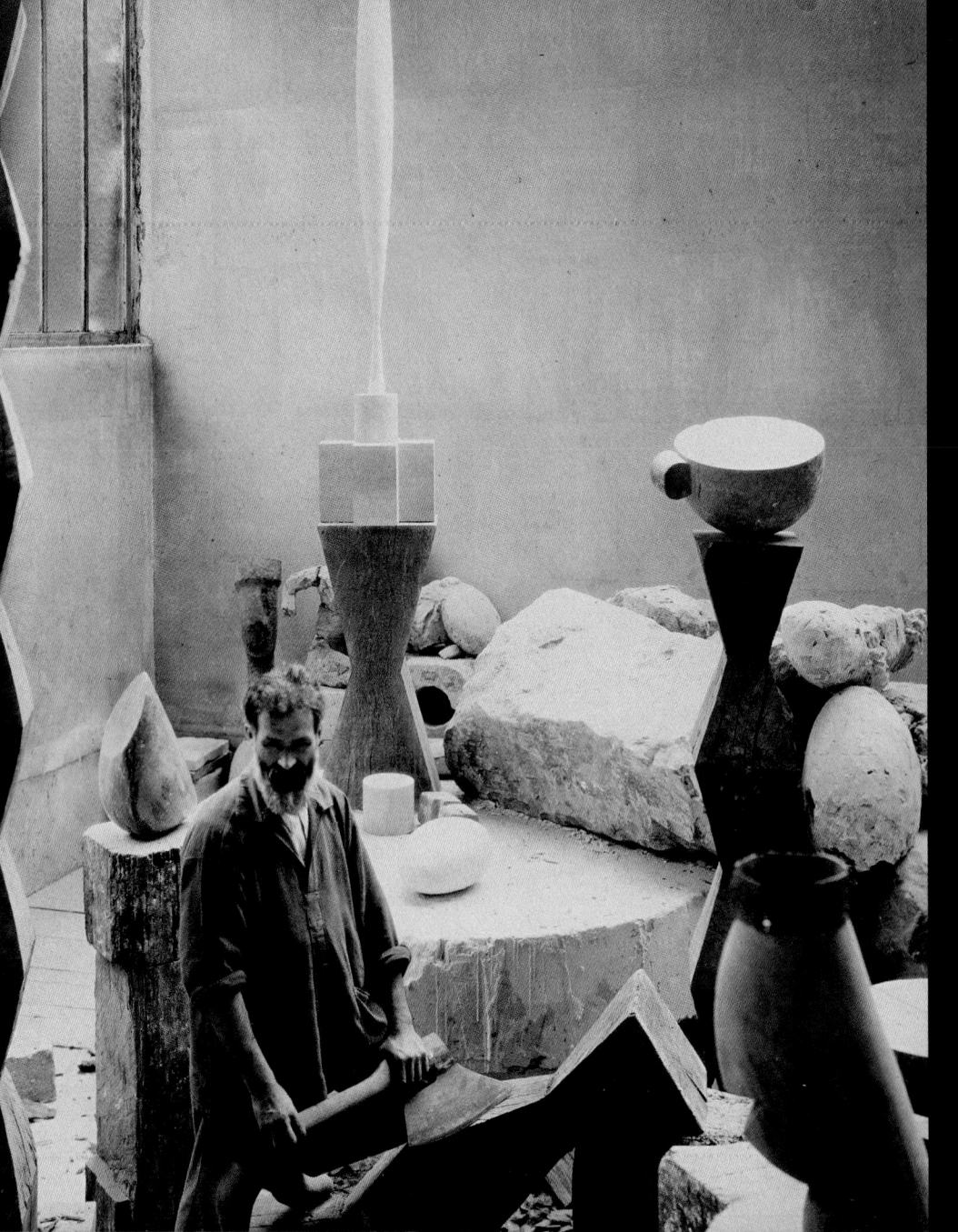

Key Artist **Constantin Brancusi**
Endless Column, a seminal later work

When a young Constantin Brancusi fled his village in Romania's Carpathian Mountains, he took with him its tradition for folk crafts. He first exhibited at the Romanian Athenieum in 1903, and, although Auguste Rodin was an early influence, Brancusi rejected the realistic style of sculpture popular at the time. His search for pure form by reducing his works to a few basic elements combined the directness of peasant carving with the modernist ideas of purity and refinement, influencing the development of twentieth-century sculpture.

In 1908, Brancusi created his first major work: *The Kiss*. It represents two lovers carved from a single block of stone (the established method was to model in clay) in a tender, loving embrace. Over time Brancusi would push these works toward pure abstraction by a long process of repetition, meditation, and refinement, to create the "Essence of Things," thereby introducing primitivism into sculpture. In 1913, he gained international fame when he showed five of his works in the Armory Show in New York.

Brancusi worked on repeated themes throughout his career, and throughout the 1920s was preoccupied by the theme of a bird in flight. In *Bird in Space* (1932–1940) he captures the essence of flight by eliminating wings and feathers, and reducing head and beak to a slanted oval plane. During the 1930s, Brancusi worked on public sculpture projects, particularly a war memorial for a park in Târgu Jiu, Romania, in 1935, and *Endless Column* (1938), one of his seminal later works.

Kate Mulvey

Date 1938

Born/Died 1876–1957

Nationality Romanian

First Exhibited 1903

Why It's Key Pioneer of abstraction in sculpture that led the way for modern sculptors.

opposite Brancusi in his studio.

1930–1939

Key Artist **Joe Shuster**
Toronto ex-pat creates *Superman* in New York

Joe Shuster was born in Toronto, Canada, his family moving to Cleveland, Ohio, when he was ten years old. At Glenville High School in Cleveland, Shuster met his lifelong friend and collaborator Jerry Siegel, who was to write the *Superman* stories which Shuster illustrated with his remarkable graphics. The pair produced a sci-fi fanzine even while they were at school, and made their first commercial venture with the comic *New Fun* in 1935, published by National Allied Publications, soon to become D.C. Comics.

Superman debuted as the cover feature for the first issue of *Action Comics*, published in July 1938. Shuster claimed that his drawing of Superman's alter ego, Clark Kent, was a self-portrait, while the features of Superman himself were based on the actor Douglas Fairbanks, Sr. The relationship with D.C. Comics ended in bitter acrimony in 1947. Siegel continued to write for other publications, but Shuster virtually disappeared, a poverty-stricken recluse with failing eyesight, although he continued to nurture his desire to be a serious painter, despite becoming virtually blind in later years.

Shuster and Siegel were effectively rescued from obscurity in the late 1970s when, under pressure from negative publicity, D.C. owner Warner Communications was shamed into paying the creative partners a comfortable if belated pension. Warner also restored the pair's byline to their published work, the main bone of contention over and above financial considerations. In 2005, Shuster was posthumously inducted into the Joe Shuster Creative Comic Book Hall of Fame, and an award for young cartoonists was set up in his name.

John Cornelius

Date 1938

Born/Died 1914–1992

Nationality Canadian/American

Why It's Key Co-creator of the *Superman* comic strip, a pop art icon in the truest sense of the word.

Key Artwork *Recumbent Figure*
Henry Moore

Henry Moore (1898–1986) was a twentieth-century British artist and sculptor. *Recumbent Figure* is a large-scale sculpture carved from a native British stone, green Hornton. It represents a recurrent theme in Moore's work, a reclining female nude. This is part of his greater preoccupation with human figures throughout his career and was influenced by the old European masterworks and possibly ancient Mexican sculptures. The style of Moore's figure, with its undulating contours and pierced areas, is typical of his work during this period, and parallels his contemporary Barbara Hepworth (1903–1975). They were among some of the first artists in Britain to embrace the Modernist movement of reduction and abstraction.

The *Recumbent Figure* also exhibits Moore's interest in organic forms and natural landscapes. It has affinities with forms shaped by nature; its asymmetrical composition and contours recall mountainous landscapes, its hollowed areas recall caves, and its textured uneven surface resembles weathering of natural materials. While creating a sense of dynamism and natural energy through this, he also instills a sense of gravity, calm, and stability from the thickness of the material and the balance of the figure's upright posture. The combination of these characteristics is typical of Moore's sculpture prior to World War II, and contrasts with some of his later, more angular and frantic forms.

Esmay Luck-Hille

Date 1938

Country UK

Medium Green Hornton stone

Why It's Key Typical large-scale work by Britain's best-known Modernist sculptor.

opposite Recumbent Figure

330

Key Event
New Group Formed

In 1938, after returning from Europe where they had studied art, a group of South African artists created the New Group to improve the quality of art being created in the country, provide financial assistance to struggling artists, make art materials more accessible to those who needed them, and promote the marketing of members' works. The New Group initiated an innovative barter system in which artworks could be exchanged for goods and services. New Group artists sought to develop a modern South African art style that merged African and European influences without sacrificing the South African identify.

Membership in the New Group was by invitation only, and members voted by secret ballot on which artists to include. The first exhibition on May 4, 1938, in Cape Town, showcased the talents of only seventeen artists, including Gerard Sekoto (1913–1993) and Alexis Preller (1911–1975). More than 1,000 visitors attended the exhibition. Over the next fifteen years, the New Group brought public attention to South African art through a series of exhibitions that showcased works by black South African artists from all walks of life. Founding members included Gregoire Boonzaier (1909–2005), Lippy Lipshitz (1903–1980), Frieda Lock (1902–1962), Cecil Higgs (1900–1986), Walter Battiss (1906–1982), and Terence McCaw (1913–1978). The New Group gained in influence for several years; however, by the end of World War II, the cooperative's effectiveness had begun to decline. After putting together an exhibit in Cape Town in 1953, the group dissolved. Many New Group artists continued to receive significant international attention.

Elizabeth Purdy

Date May 4, 1938 (first exhibition)

Country South Africa

Why It's Key As the most influential South African artist cooperative of its time, the New Group, with its combined African/European aesthetic, was responsible for highlighting and promoting artistic talents and for bringing the works of South African artists to international attention for the first time.

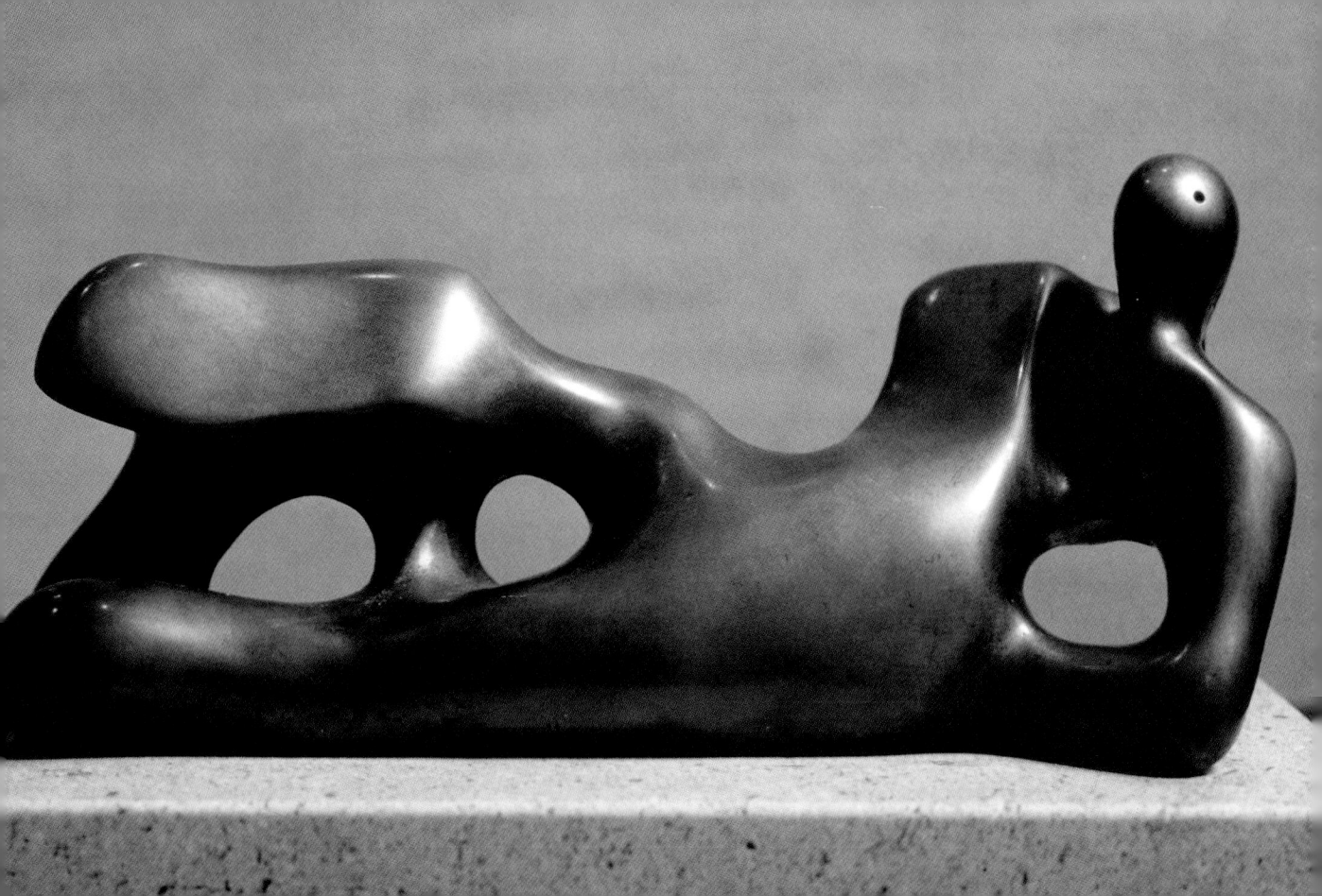

Key Artist **Grandma Moses**
American folk artist discovered by New York City dealer

In 1938, Louis Calder, a Hungarian émigré, engineer, and art collector, was passing through Hoosick Falls, Vermont. He was enchanted by some beautiful paintings in a drugstore window. They were about US$3 each. Calder snapped them up, traced the artist, and proceeded to purchase the remainder of her art. Moses, a seventy-eight-year-old grandmother and farmer's wife with five children, had recently retired from farm work. Born Anna Mary Robertson, Moses had begun painting rural scenes with her left hand when arthritis forced her to give up embroidery. They were about memories of life on the farm, her family, and their history. The paintings, mostly painted on old pieces of board, were full of life, color, and detail.

Louis Calder spent many months searching for a gallery that might be interested in taking his special discovery on, but no one seemed prepared to invest their time and resources in backing an elderly woman artist. Calder then heard on the émigré grapevine about a new gallery that had just been set up in New York City by a famous dealer from Austria, representing the works of Egon Schiele, Gustav Klimt, and others. Forced out of Europe by the Nazis, Otto Kallir had developed a wise indifference to certain conventions and artificialities within the art scene. Kallir viewed much of the art being shown in New York galleries at that time as derivative, and was able to appreciate the soul and authenticity in Moses's work. He immediately gave her a breakthrough show in 1939, which he titled, "What a Farmwife Painted."

Carolyn Gowdy

Date 1938

Born/Died 1860–1961

Nationality American

Why It's Key A renowned American artist and an inspiring example of an individual successfully beginning a career in the arts at an advanced age.

Key Artist **Albert Namatjira**
First solo show for important Australian Aboriginal painter

A member of the indigenous Aranda tribe, Albert Namatjira was born Elea Namatjira in the deserts of Australia's Northern Territory. When the family moved to a Lutheran mission, Elea was baptized "Albert." At age thirteen, Namatjira underwent the traditional Aranda initiation, living in the bush for six months and learning about his native culture. After marrying, Namatjira supported his family by doing odd jobs. He was inspired to paint after seeing an exhibition of two Melbourne artists in 1934. Within two years, painter Rex Batterbee was instructing Namatjira in watercolor techniques, in exchange for Namatjira showing Batterbee sites to inspire his own art.

Namatjira's reputation as an artist was originally derived from Western-style landscapes in which he depicted the Australian landscape in contrasting colors through works such as *Ajantzi Waterhole* (1937) and *Red Bluff* (1938). In Melbourne in 1938, Namatjira's first exhibition of forty-one works immediately sold out. Other successful exhibitions followed, and Namatjira was awarded the Queen's Coronation Medal in 1953.

Even though Namatjira had enough money to fulfill his dream of buying a cattle station, Australian law at the time prevented him from doing so. In 1957, public outrage led to Namatjira and his wife becoming the first Aborigines to be granted full citizenship rights in Australia. The following year, he was arrested for supplying alcohol to Aborigines. Namatjira never recovered from his unjust two-month imprisonment, and he stopped painting. By the time he died in 1959, several films had been made about his life.

Elizabeth R. Purdy

Date 1938

Born/Died 1902–1959

Nationality Australian

First exhibited 1938

Why It's Key Namatjira, who produced some 2,000 works, was recognized internationally as the foremost Australian Aborigine painter, influencing family members and others through his work and the school of painting that bears his name.

Key Artist **Yves Tanguy**
Leading Surrealist emigrates to the United States

After two years serving in the French merchant navy, Yves Tanguy met the poet Jacques Prévert while doing military service in the army; it was Prévert who introduced him to the Surrealists. After seeing a work by Italian-Greek painter Giorgio de Chirico in a gallery window in 1923, Tanguy turned his hand to painting. In 1925, he joined the Surrealists and, two years later, exhibited at the Galerie Surréaliste in Paris. In 1939, Tanguy moved to the United States with the New York-born painter Kay Sage, whom he married in Reno, Nevada, the following year. He became a naturalized American citizen in 1948. He and his wife lived and worked in a converted farmhouse in Woodbury, Connecticut, until his death in 1955.

Tanguy's paintings have a unique, immediately recognizable style of classic non-representational Surrealism. They show vast abstract landscapes, rendered usually in tightly limited colors, although occasionally showing flashes of contrasting color accents. These alien vistas are usually populated with strange abstract objects – some angular and sharp; others biomorphic. During his time in the United States, Tanguy's works took on a more metallic quality. His strange and enigmatic paintings remained faithful, however, to the basic precepts of Surrealism when others had long abandoned them.

Brian Davis

Date 1939

Born/Died 1900–1955

Nationality French (naturalized American)

First exhibited 1927

Why It's Key Took the purist form of Surrealism to the United States.

1930–1939

333

Key Event
The outbreak of World War II

The attack that started World War II took place on September 1, 1939, when Germany invaded Poland under the false pretext that the Polish had attacked a German border post. As the Nazis spread through Europe, their attitude toward art soon became apparent. The Nazi Party had already been propagating "good" and "bad" art during its rise to power. A typical artist under the patronage of Hitler was Arno Breker (1900–1991). His powerful neo-classical sculpture – bearing titles such as *Comradeship* (1940), *Torchbearer* (1940), and *Sacrifice* (1940) – typified Nazi ideals, and complemented the characteristics of the impressive classicizing Nazi architecture.

The importance of art to the National Socialist ideology – and its propaganda – became apparent when Hitler's troops started looting Europe's Old Masters to combine into an awe-inspiring sign of German culture called the Führer Museum. Most modern art, meanwhile, was categorized as primitive, childlike, or made by the mentally ill when it did not conform to the conservative "heroic" Nazi ideal. Modern artists who made this "degenerate" art were persecuted or exiled. These same artists often developed and became popular in the Allied countries, as they came together in artistic centers such as New York, providing the foundations for the famous postwar modern art movements in these cities.

Erik Bijzet

Date 1939

Country Poland

Why It's Key As World War II changed the social, political, and economic face of the earth, it also had major ramifications for the art world.

Key Event
Nazis march into Paris

On June 13, 1940, the city of Paris was captured by the Nazis. By the fall of that year, Hitler ordered all Jewish art collections to be confiscated, as these materials were now deemed ownerless by Nazi decree. Jews in France, as in most of Europe, no longer had property rights. The famous art collections of rich French Jews who had fled the country, such as the Rothschild family, Levy de Benzion, Seligmann, and Wildenstein were confiscated. Great works of art, including Manets, Cézannes, Sisleys, and van Goghs, were appropriated by the Nazis.

The Nazi confiscating agency, Einsatzstab Reichsleiter Rosenberg (ERR), embarked on huge-scale looting of more than 21,000 objects from more than two hundred Jewish-owned collections. Objects were delivered to the Jeu de Paume Museum in Paris. Some went to the Reich as part of the glorification of the German race, to the Führer Museum in Linz, or to the Hermann Goering collection.

Art looting had begun on an ideological basis as purification of what the Nazis termed degenerate art – art deemed modern, degenerate, subversive, or Jewish was banned by the Nazi regime. Between 500 and 600 items including works by Joan Miró, Francis Picabia, Paul Klee, Pablo Picasso, Moise Kisling, Max Ernst, and André Masson were burnt to cleanse the culture of degeneracy and promote Nazi propaganda. Many "degenerate" artists fled to the free zone in France during the Occupation. Jewish artists, Surrealists, and other modern artists sought refuge, before, in many cases, being forced to leave the country altogether.
Kate Mulvey

Date 1940

Country France

Why It's Key The Nazis' large-scale looting of Jewish art collections and destruction of "degenerate" art influenced the subsequent path of the art world, forcing many in the Parisian art community to flee to the USA.

opposite Senior Nazi officers, including Adolf Hitler, walking in front of the Eiffel Tower.

Key Artist **Germaine Richier** First introduces animals and insects into her sculpture

Apart from a brief abstract period around 1956, Germaine Richier's sculpture was derived from the human form throughout her career. Her forceful treatment of portrait busts, torsos, and figures in early work was informed by Auguste Rodin and Antoine Bourdelle. After 1940, however, she applied her hard manual training to forms based on distortion and instability. Alberto Giacometti's Surrealism and Richier's upbringing in southern France were important sources for her choice of nocturnal fauna, especially insects, as the inspiration for the disturbing hybrid forms that featured regularly in her work until her death.

Metamorphosis was the common theme for sculptures where rational man is shown submitting to animal energies and turning into lower forms of life. Threads of polygonal metal lacework often connect the extremities of groping limbs in these grotesque forms. While suggestive of a prison in which the mythical-like creatures exist, these wires also incorporate the modeled object into real space. Richier also placed her forms on irregular flat plinth-like bases, and often in front of painted panels or other artists' paintings, to create a spatial setting that organized the surrounding void. Her bloated full-length human figures of 1947–49, with battered bodies and fearsome featureless faces, exemplified the postwar revival of figurative imagery probing the human condition. Her use of found objects challenged established ideals. By 1959, however, younger artists' interests were shifting away from work that British sculptor Phillip King described as feeling "like scratching your own wounds."
Martin Holman

Date 1940

Born/Died 1904–1959

Nationality French

Why It's Key Richier's figurative imagery represented the scarred and vulnerable condition of postwar Europe.

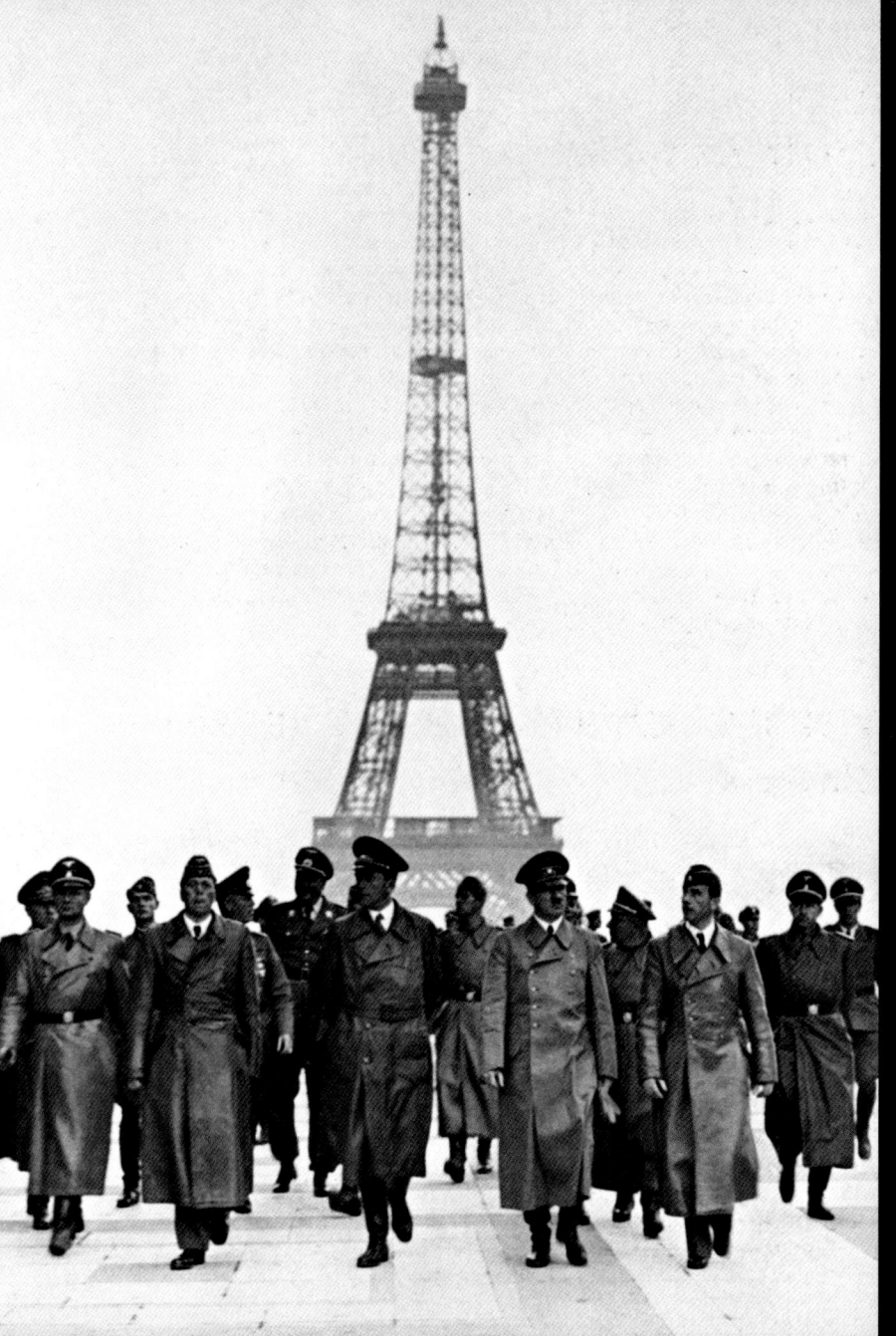

Key Artist **Paul-Emile Borduas** Experiments with automatism ("automatic writing")

B orn in St.-Hilaire, Quebec, Paul-Emile Borduas was apprenticed as a youth to the painter, muralist, and church decorator Ozias Leduc. After studying at the Montreal Ecole des Beaux-Arts, he traveled to Paris to study at the Ateliers d'Art Sacré. Returning to Canada, Borduas abandoned dreams of becoming a church decorator and, in 1937, was appointed professor at the Ecole du Meuble in Montreal. His work was figurative until he encountered the stream-of-consciousness writing of Surrealist André Breton.

Borduas's 1942 exhibition of 45 gouache drawings signaled the birth of pictorial automatism, a free-association style linked with the spirit of children and the energy of the unconscious. With his students, Borduas formed the automatiste movement, which led to the 1948 publication of *Total Refusal* (*Le Refus*

Global), a manifesto penned principally by Borduas. Refuting the conservative politics and Catholicism of Québec, *Refusal* announced the birth of contemporary art in Canada. *Sous le Vent de L'Île* (1947) was one of Borduas's notable paintings of this time. In it the impression of a windswept island is achieved through the suspension of multicolored geometric pieces swept up from their background, hovering in space.

From 1953–55, Borduas sought the liberal environment of New York, where he was influenced by the Abstract Expressionists. In 1955, he moved to Paris, and his final works are stark contrasts in black and white; *L'étoile noire* (1957), isolated black shapes against a white shimmering background, is the masterwork at the end of his life.

Bryan Doubt

Date 1940

Born/Died 1905–1960

Nationality Canadian

Why It's Key Founded the automatiste movement, and the main author of *Total Refusal* (*Le Refus Global*); both of these events heralded the birth of contemporary art in Canada.

1940–1949

336

Key Artwork *The Hands*
Paul Delvaux

B elgian painter and printmaker Paul Delvaux (1897–1994) was a contemporary of René Magritte (1898–1967) and he was also influenced by the Metaphysical art of Georgio de Chirico (1888–1978). *The Hands* typifies his distorted classicist approach to Surrealism, which harks back to a bygone age, the fiction of Jules Verne (1828–1905), and Greek mythology. Amongst other figures in this painting, two female nudes, one dark-haired and one blonde, stand silently in a dreamlike state in the foreground; their isolated and elegant hands seem to stroke the space in front of them, or in the case of the dark-haired woman, point to her own face, as if it did not belong to her.

Delvaux began his career as an architect before becoming a highly regarded painter. Precise draftsmanship is combined with a dreamlike approach

to erotic themes in an austere architectural backdrop. Delvaux's nudes often pose immobile with large-eyed, unfocused stares, and arms frozen in theatrical gestures. Delvaux is believed to have drawn inspiration from a mechanical anatomical nude and other morbid displays in the Spitzner Museum, which used to travel around Europe. Commonly Delvaux mixes somnambulent nudes with bowler-hatted men within a nineteenth-century railway station or classical environment. His work impressed Marcel Duchamp, who reflected the Freudian overtures with clothed male figures in close proximity to nude female figures in his collage *In the Manner of Delvaux*.

Surprisingly, Delvaux did not consider himself a "surrealist in the scholastic sense of the word."

Brian Davis

Date c.1941

Country Belgium

Medium Oil on canvas

Collection Unknown

Why It's Key This painting shows elements of erotic surrealism with classicist detail.

Key Artist **Alexander Liberman**
Leaves France for the United States

Alexander Liberman (as he is commonly known, though the accurate spelling is Lieberman) was born in Kiev, Russia, and educated in Paris. It was in the French capital that he first became involved in publishing, producing a pictorial magazine entitled *Vu* which was similar to the British *Picture Post* or *Life* magazine in the United States. He emigrated from Paris to New York in 1941, where he began working for the major magazine publisher Condé Nast, and he went on to become Editorial Director at the company from 1962–94.

In the 1950s, Liberman turned his attention to painting and, subsequently, sculpture. From that time, he painted and sculpted in abstract styles, often using the circle, which he asserted was the ideal shape. In his sculpture, he was revolutionary because of his use of industrial materials, factory building methods, and large-scale size. For these, he deployed large iron and steel industrial items such as girders, sections of pipe, oil drums, and the like, which he joined together as large-scale outdoor sculptures that he then painted in bright colors. These sculptures are required to be viewed in totality, that is, in the context of the landscape which contains and surrounds them. Examples of his work can be found at New York's Museum of Modern Art, the Smithsonian's Hirshhorn Museum and Sculpture Garden, London's Tate Gallery, and the Guggenheim Museum.

John Cornelius

Date 1941

Born/Died 1912–1999

Nationality Russian (naturalized American)

Why It's Key Major sculptor known for his large-scale outdoor works.

1940–1949

Key Artist **Jacob Lawrence**
Exhibition and publication of Migration Series

Jacob Lawrence is considered one of the greatest African-American artists of the twentieth century, and an important proponent of the Harlem Renaissance along with Romare Bearden. The *Migration Series* earned Jacob Lawrence a unique place during his lifetime as the definitive visual storyteller of the history and tradition of the African-American experience.

This sixty-panel work traces the exodus of the African-American community from the South to the North following World War I. Each image depicts a different incident in the story. The accompanying captions are incisive, for example: "they were very poor." Lawrence was only twenty-three years old and had already discovered his distinctive style when he created these powerful paintings. Vivid colors merge with strong shapes in a dynamic altered space. The work has an abstract quality, but Lawrence manages to communicate his message in a clear, accessible way.

In a PBS radio interview (2000), Lawrence was asked what he would like the audience to experience when looking at the *Migration Series*. The artist replied, "I'd like them to experience the beauty of life, the struggle, how people can overcome certain things that could be very frustrating or very demeaning. And people have the capacity to overcome these obstacles by various means, and this is an example of that. And I'd like the people to look, feel, 'Look, this is me. This is mankind or womankind.' And I'm talking about people in general, and I would like it to be a universal statement. That's how I feel."

Carolyn Gowdy

Date 1941

Born/Died 1917–2000

Nationality American

Why It's Key The *Migration Series* brought Lawrence enormous recognition when it was both exhibited in downtown New York and published in a 1941 issue of *Fortune* magazine.

Key Artist **Adolph Gottlieb**
Introduction of "pictographs"

Adolph Gottlieb was born in New York in 1903. He attended the Art Students League of New York 1920–21, then traveled in France and Germany for a year and studied at the Académie de la Grande Chaumière in Paris. In 1923, he returned to New York and studied at Parsons School of Design, Cooper Union, and the Educational Alliance Art School.

Gottlieb's early work was influenced by European Surrealism, but he rejected this in favor of "pictographs," and from 1941–51 he painted a series of these, which were an arrangement of compartments in a loose grid formation filled with symbols based on the unconscious and fantasy. From 1951–56, he produced his "Imaginary Landscapes," pictures which were semi-abstract with a horizontal dividing line and containing disk or ovoid shapes. Later,

from 1957, Gottlieb concentrated on exploring the relationship between two contrasting shapes, and produced a series of "burst" paintings containing exploding orbs of color; these continued until his death in 1974. He is considered to be a colorist of the highest order, and one of the first "color field" painters. His public works include murals at the Post Office in Yerrington, Nevada, and tapestries for the Synagogue, Millburne, New Jersey.

Alan Byrne

Date 1941

Born/Died 1903–1974

Nationality American

Why It's Key Gottlieb was a founder member of the New York school of Abstract Expressionists.

opposite Adolph Gottlieb

Key Artwork ***Totes Meer (Dead Sea)***
Paul Nash

The English war poets Siegfried Sassoon, Rupert Brooke, and Wilfred Owen, and the painter Paul Nash (1889–1946) were only four of those with first-hand experience of active service who, following the example of Goya, expressed their hatred of the horrors of war. Nash suffered a trench accident at Ypres Salient during World War I and was invalided home in 1917, before returning to the front and becoming an official war artist. His landscapes *Year of Our Lord* (1917; National Gallery, Ottawa), *Mud* (1918; Tate Britain), *Making a New World* (1918; Imperial War Museum), *Battle of Britain* (1941 (Imperial War Museum), and *Totes Meer* (1940–41; Tate Britain) are among many of Paul Nash's contributions to our realization of the filth, degradation, and obscenity of modern warfare. *Totes Meer (Dead Sea)* is a large oil painting showing a sea –

or, more appropriately, a graveyard – of fallen aircraft. It is a cold, stark moonlit scene; the shot-down corpses of the Luftwaffe lie in twisted wreckage. Nash's preoccupation with his own mortality infects the piece. It was made during his time as a World War II artist, about which he observed, "I have never before had such a stimulating adventure as an artist, yet all this time I have not once been able to explore the mysterious domain of the air." His frail health, in particular chronic asthma, meant that he was never able to do so. Nash wanted the painting to be a threat to the Nazi regime, expressing Great Britain's conviction that the Nazi's boasted invincibility was only a mockery, "of sound and fury, signifying nothing."

Richard Walker

Date 1940–1941

Country Cowley aircraft dump, Morris car factory, Oxford, UK

Medium Oil on canvas, 101.6 x 152.4cm

Collection Tate Britain, London

Why It's Key *Dead Sea* is a propaganda painting by World War II artist.

Key Artwork *Nighthawks*
Edward Hopper

Years before Andy Warhol's art images were claimed back by the popular culture that had inspired them in the first place, Edward Hopper (1882–1967) painted a picture that would become as iconic as any of Warhol's soup cans or Marilyns. *Nighthawks* (1942) is the classic example of Hopper's style. His nocturnal scene, with its four human figures harshly illuminated in a bleak diner, shows the exact reverse of a daytime scene. At lunchtime, the customers would be the shaded observers of the bright world outside. At night, they are the ones on display like fish in an overlit tank.

As is usual with Hopper, there is no clear narrative to infer. The man and the woman sitting together may be a couple, or they may be conducting some transaction. Yet compared to them the man sitting with his back to us looks more than just alone – he looks lonely. The diner's server observes, a neutral umpire in his white uniform. You cannot read the picture literally; you can only experience its strangely desolate effect. *Nighthawks* is still pressed into regular service for T-shirts, album covers, and numerous other artifacts. It is perhaps testimony to Hopper's unique talent that the specific 1940s look of the tableau in no way diminishes its timeless appeal as an emblem of human beings alienated in an artificial world.

Graham Vickers

Date 1942

Country USA

Medium Oil on canvas

Collection Art Institute of Chicago

Why It's Key Evocative masterpiece epitomizing Hopper's highly recognizable style that has become a pop culture icon.

opposite *Nighthawks*

341

Key Artist **Leonora Carrington**
Leading female Surrealist moves to Mexico

At nineteen, Leonora Carrington moved to Paris to be with her lover Max Ernst. He introduced to her to the Surrealist circle, also encouraging her to write and paint. For both artists, it was a time of prolific creativity. Then, in 1939, Ernst was arrested and interned in a Nazi prison camp. Carrington despaired, had a mental breakdown, and was eventually institutionalized in a Spanish asylum. She managed to escape the perilous situation in Europe, marrying a Mexican diplomat, and moved to New York. Later Carrington moved to Mexico City, where she was to meet her second husband, the Hungarian Jewish photographer Emerico "Chiki" Weisz.

During the 1930s, Carrington had drawn on magic realism, childhood inspiration, folklore, and autobiographical detail for her paintings. The experiences of madness followed by severe treatment, loss, and relentless change had been profound, however, and again transformed her. By the 1940s, the work she produced in Mexico had evolved. It retained a very personal narrative, but was based around more cosmic and universal themes, as an interest in alchemy and the occult propelled her on an inner and increasingly mystical journey. Carrington was hungry for knowledge. She continued to explore Celtic mythology, alchemical transformation, and metaphysics. She discovered a fresh affinity with the flora and fauna of Mexico, and developed a close friendship with the artist Remedios Varo. Carrington remained constant in her work as a painter, sculptor, and writer well into her nineties.

Carolyn Gowdy

Date 1942

Born 1917

Nationality British

Why It's Key Carrington was influential in bringing a feminine strand of Surrealism to Mexico. Her contemporaries there included Remedios Varos and Frida Kahlo. Carrington also became one of the last surviving Surrealists.

Key Person **Peggy Guggenheim** Opening of her gallery Art of this Century in New York

1940–1949

The daughter of a wealthy American mining family, Peggy Guggenheim (born Marguerite Guggenheim) was the niece of Solomon R. Guggenheim, founder of the Guggenheim Museum in New York. Her father, Benjamin, died on the *Titanic* in 1912; in 1919, she inherited his fortune. Discontent with her bourgeois lifestyle, she married avant-garde writer Laurence Vail and went to live in the bohemian quarter of Paris. Divorced in 1930, she moved to London where she opened a modern art gallery, the Guggenheim Jeune, in 1938, with Marcel Duchamp as her adviser. The gallery failed, but Guggenheim continued collecting, planning to open a museum. Her plans were curtailed, however, by World War II.

In 1941, she returned to the United States with Max Ernst, whom she married the following year. She set up a new gallery called Art of this Century on New York's West 57th Street in October 1942, the exhibition spaces of which were made into abstract and Surrealist environments by designer Frederick Kiesler. Alongside the European art she showed there, she became an important patron of the New York school of Abstract Expressionists, including Mark Rothko and Jackson Pollock. The gallery closed in 1947 and Guggenheim, now divorced from Ernst, moved to Venice, where she lived surrounded by her collection in an eighteenth-century palazzo on the Grand Canal until the end of her life.

Nigel Cawthorne

Date 1942

Born/Died 1898–1979

Nationality American

Why It's Key One of the most influential collectors of twentieth-century art and promoter of abstract painting.

opposite A young Peggy Guggenheim (right) and her sister.

342

Key Artwork *Medici Slot Machine* Joseph Cornell

The American artist Joseph Cornell (1903–1972) spent almost all of his physical life cloistered in New York; but his mental life, captured and magnified by his box constructions, ranged all over the world. Cornell's boxes, typically small pieces fronted by glass and containing assemblages of prints, photographs, and found materials retrieved from peregrinations of New York, won this outsider artist fame in the 1940s.

By 1942, the date of *Medici Slot Machine*'s composition, Cornell had been making boxes for eleven years. The piece represented the artist's ongoing fascination with portraits of Medici children (he would create a total of four such boxes during his career).

The boy in *Medici Slot Machine* is Piero de Medici, whose image Cornell took from the Renaissance artist Sofonisba Anguissola (1532–1625). Piero is here bracketed by a compass, small photographs, and strips of a map of Rome; with these references, Cornell situates Piero at the center of a new, postmodern world, one in which time runs concurrently and psychic location is far more important than physical location. The issue of location is especially pertinent given Cornell's hermetic reclusiveness. *Medici Slot Machine* is not just a re-imagining of a long-dead aristocratic child but an opportunity for Cornell to propel himself into a travel that he otherwise denied himself.

Beyond the general sense of movement across time and space, *Medici Slot Machine* is an opaque work, one that owes little to a specific aesthetic or analytical idea. Like the rest of Cornell's work, it is ineffably mysterious.

Demir Barlas

Date 1942

Country USA

Medium Construction

Collection Private collection

Why It's Key This is a famous work by one of the pioneers and celebrated practitioners of assemblage, a term used to refer to a three-dimensional work that is neither collage nor sculpture, but takes on the properties of both.

Key Artwork *Le Palais aux rochers de fenêtres*
Yves Tanguy

Yves Tanguy (1900–1955) may not be the best known of the Surrealists, but a handful of his paintings vies with those of Salvador Dalí as some of the most instantly recognizable. Less obviously representational than Dalí, Tanguy created pictures that were superficially identifiable as belonging to some sort of landscape tradition, even if closer inspection revealed that the weird objects inhabiting them were like nothing on earth. The titles were usually calculated to alienate: *The Certainty of the Never-Seen* (1933), *The Air in Her Mirror* (1937), and *The Satin Tuning Fork* (1940). His most famous picture, *Le Palais aux rochers de fenêtres* (1942) translates, not particularly helpfully, as *The Palace of Windowed Rocks*, and shows the kind of desolate lunar landscape beloved of the early sci-fi cartoonists, a terrain studded with towering ossified

fragments (pylons? pavilions?) defying identification beneath a bilious sky.

Coming late to both art and Surrealism (he was twenty-four with no training when he started painting), Tanguy exhibited all of the passion of the convert, painting prolifically and meticulously, creating a distinctive style that owed a lot to the spirit of his hero Giorgio de Chirico, but shared none of the Greek-Italian's bright colors or formal architectural elements. It was a style already fully formed by the time of Tanguy's first one-man exhibition in Paris in 1927. *The Palace of Windowed Rocks* came 15 years later, and it is this picture, with its unpalatial palace, its absent rocks, and its lack of glazing, that became one of his best-known works and a distinctive symbol of the Surrealists.

Graham Vickers

Date 1942

Country France

Medium Oil on canvas

Collection Musée National d'Art Moderne, Centre Georges Pompidou, Paris, France

Why It's Key A famous icon of the Surrealist movement.

344

Key Artist **Saul Steinberg**
Begins illustrations for *New Yorker* magazine

In 1942, a Romanian refugee arrived inauspiciously by boat in Miami, Florida and then caught a bus to New York. This tantalizing new continent, with its bizarre cast of characters, architectural marvels, and wide-open landscapes, inspired him. From then on, the *New Yorker* would provide a steady outlet for his drawings – drawings that would delight a nation, from the man in the street to the museum curator, with their wit and inventiveness. Saul Steinberg's visual metaphors were always masterfully drawn, both playful and challenging. They fused elements of cartoon, philosophy, illustration, and fine art into a language that defied boundaries. Drawing was, for Steinberg, a way of "reasoning on paper." He considered it a form of writing.

During the 1930s, Steinberg had first published his cartoons in *Bertoldo*, an Italian satirical magazine. After

briefly studying philosophy in Bucharest, he had enrolled as an architecture student in Milan. By 1940, however, when he received his architectural degree, the anti-Jewish racial laws in Fascist Italy prevented Steinberg from practicing his profession. In 1941, Steinberg fled Europe, from where, despite obstruction by authorities, he caught a boat to the United States. He created a "slightly fake" passport with his own rubber stamp, but was refused entry at Ellis Island. A relative urgently tried to persuade the *New Yorker* to sponsor Steinberg so that he could remain in the United States, initially without success, and the artist was deported. A year later, a visa was issued: the editor of the *New Yorker* had agreed to sponsor Steinberg.

Carolyn Gowdy

Date 1942

Born/Died 1914–1999

Nationality Romanian (naturalized American)

Why It's Key Steinberg would become famous across the USA as an artist and as a cartoonist for the *New Yorker*. Over the next sixty years, he created more than 1,200 drawings and nearly 90 covers for the magazine.

opposite An early Steinberg illustration.

Key Artwork *Rhythm in Four Squares*
Max Bill

As well as being known as a painter, Max Bill (1908–1994) was a Swiss-born sculptor, architect, designer, and academic theorist who developed the field of concrete art, typified by *Rhythm in Four Squares*, which he produced in 1943. Its principle was the use of mathematical formulae to fix the relationship between one part of an artwork and another. It anticipated the Minimalism of the 1950s and 1960s, a type of visual art including sculpture and construction, which was characterized by extreme simplicity of form and a complete lack of expressive, emotional, or figurative content – favored, it has been said, by those who are repelled by or fearful of emotive expressive art and/or motivated by authoritarian politics, whether from the extreme left or the extreme right.

Minimalists, however, denied that concrete art could truly be Minimalist, as it was generated by means of complex, even Byzantine, mathematical formulae. The reverse has been argued in that Minimalism and the related field of concept art are criticized as being content-free, whereas concrete art was intellectually meaningful, arrived at only through painstaking logical calculation. Nevertheless, perhaps ironically, it is considered that Max Bill's work, despite its purely rational mathematical root, has its own beauty and poetry, particularly where unyielding geometrical forms give way to flowing helixes and curves.

John Cornelius

Date 1943

Country Switzerland

Medium Oil on canvas

Collection Kunsthaus, Zurich

Why It's Key Example of concrete art by its prime theorist and instigator.

Key Artwork *Victory Girls*
Albert Tucker

Victory Girls is one of Tucker's *Images of Modern Evil* series, 1943–47, which depicted graphically the horrific and debasing results of war. Here, two debauched young girls, their lips painted a garish red, embrace two soldiers. Ironically their clothes are painted like the stars and stripes of the U.S. flag. This work suggests death and despair, rather than "Victory."

Albert Tucker (1914–1999), together with Sidney Nolan (a lifelong friend), is one of Australia's most important postwar artists. He was self-taught and particularly admired the work of German Expressionists (George Grosz, Otto Dix, and Max Beckmann, in particular) as well as the World War I poets and T.S. Eliot. Tucker was in Japan with Allied forces in 1947 (he depicted the devastation at Hiroshima), and his strong political views led him to the liberal artists and

writers group the Angry Penguins. After the war, he spent a number of years in Europe, having his first solo exhibition in Amsterdam in 1951. However, it was Australia that again inspired him in later years, when he drew inspiration from the extraordinary landscape; he also made many portraits, including some of Nolan. He always retained a somewhat biting edge to his work, however, remaining preoccupied with the darker side of the human soul.

Lucy Lubbock

Date 1943

Country Australia

Medium Oil on cardboard

Collection National Gallery of Australia, Canberra

Why It's Key Savage evocation of the effects of war.

Key Artist **Robert Motherwell** First solo show, Peggy Guggenheim's New York gallery

Robert Burns Motherwell graduated from Stanford University, California, in 1936 with a Bachelor of Arts degree in philosophy, then began graduate studies at Harvard before moving to Columbia University, New York, to concentrate on art. After this he traveled to Europe and held his first solo exhibition in Paris in 1939. He moved to Greenwich Village, New York, in 1941, where he met the expatriate Surrealists, joining them for an exhibition in 1942. His first American one-man show came soon after, in 1944, when he exhibited at Peggy Guggenheim's Art of This Century gallery in New York. The next decade saw him working both as a painter and a respected art critic.

Motherwell was one of the youngest and most articulate of the New York school of Abstract Expressionists, which included Phillip Guston, Willem de Kooning, Jackson Pollock, and Mark Rothko. His goal was to convey to the viewer the mental and physical engagement of the painter to his canvas. In 1948, he painted one of his best-known works, *The Crossing*. He represented the United States at the Venice Biennale in 1950, and at the São Paulo Biennale in Brazil in 1961. In 1953, he married the painter Helen Frankenthaler, and began his most famous series of paintings, *Elegies for the Spanish Republic*, which consists of more than 150 canvases and which he finally completed in 1976. His later works became less expressionistic and more elegant. His final works were large color field abstract paintings and silk-screen collages.

Alan Byrne

Date 1944

Born/Died 1915–1991

Nationality American

Why It's Key Motherwell was a founder member of the New York school of Abstract Expressionists.

1940–1949

347

Key Artist **Max Bill** Organizes the Concrete Art exhibition in Basle, Switzerland

Max Bill studied architecture at the Bauhaus in Germany and, in 1932, joined the Abstraction Création group in Paris, which was open to artists of all nationalities and styles within the field of abstract art, although the emphasis was on the technical and mathematical side of abstractionism, rather than the emotional or expressive. An artwork was declared to exist in its own right, without reference to anything else. Art was, therefore, "concrete" in the sense of having an independent existence, although it did relate to abstract intellectual mathematical processes.

The term "concrete art" ("Koncrete Kunst") simply refers to abstract art which does not rely on any figurative reference at all. It was a term coined by Theo van Doesburg, and the title of the 1930 manifesto *Art Concret*. Doesburg was the founder of the De Stijl group of artists, and the journal of the same name. Max Bill was responsible for introducing the term into Switzerland, to replace the word "abstract." His influence spread to Argentina and Italy, where his work and theories gave rise to a number of concrete art associations. He applied his principles to the design and construction of his house in Zurich in 1932, but perhaps his greatest legacy is his design for the school buildings at Hochschule für Gestaltung, Ulm, opened in 1955 as the postwar German replacement for the original Bauhaus buildings in Dessau and in Berlin, which were closed by the Nazis. The new school, sponsored in part by the domestic appliance manufacturers Braun, continues the Bauhaus's fully comprehensive, "joined-up design" philosophy.

John Cornelius

Date 1944

Born/Died 1908–1994

Nationality Swiss

Why It's Key Important European sculptor and pioneer of the concept of "concrete art."

Key Event
Liberation of Paris

On August 25, 1944, Paris was finally liberated from Nazi rule. The Liberation of Paris included an uprising staged by the French Resistance against the German Paris garrison. The simultaneous liberation of France by the Allies and the restoration of the French Republic had a great impact on the art world. Many of the artists who had gone into hiding during the occupation could now return. These included the Jewish, Surrealist, and "degenerate" artists (*Entartete Kunst*, a term adopted by the Nazi regime in Germany to describe virtually all modern art). Such art was banned on the grounds that it was un-German or Jewish/Bolshevist in nature, and those identified as degenerate artists were subject to sanctions such as being forbidden to exhibit or sell their art, and in some cases being forbidden to produce art entirely.

Many artists had left Paris – Hans Arp; his wife, Sophie; Sonia Delaunay; and Henri Matisse among them – and it was only after the liberation that they returned. Jewish artists who had lived in Paris such as Isis Kishka, many of whom were in camps during the war, came back to the city. As a mark of the new freedom, the first Autumn Salon exhibition was held since the occupation, in the newly liberated city. Picasso, who had remained in Paris during the occupation even though his work was tagged as "degenerate," was given a room of his own filled with examples of his wartime works. Despite a demonstration on the street, the exhibition was a huge success and marked him out once again as a great artist.

Kate Mulvey

Date 1944

Country France

Why It's Key Once Paris was liberated from the Nazis, banned art could finally re-emerge, and artists were once more free of ideological constraints.

opposite Crowds celebrate the liberation of Paris.

1940–1949

348

Key Artwork *Fairy Tale*
Hans Hofmann

German-born Hans Hofmann (1880–1966) was aged 63 when his first solo exhibition in New York opened at Peggy Guggenheim's Art of this Century gallery in 1944. It was an important event because, first, Hofmann had held back from showing his work since settling in the United States in 1931; secondly, the exhibition demonstrated his grasp of styles emerging in American art, especially abstraction and experimental formalism. Painted in that year, *Fairy Tale* was among the most resolved paintings in a period of transition. Hofmann's compositions moved from a commitment to the rational structure of nature toward the freer brushwork and spatial organization through color that distinguished his late paintings (from 1958–66).

A tool in this loosening of gesture and, thus, of his link to nature, was (perhaps unwittingly) the Surrealists'

automotive technique. Hofmann insisted that his images proceeded from an "inner necessity," a concept of psychic origins that he borrowed from Kandinsky. While he did not apply free association or introduce fantastical content, graphic innovations such as pouring (which anticipated Jackson Pollock's method) or spattering paint had, since around 1940, enabled him to convey radical notions of flux or impermanence inherent in physical phenomena. The predominant linear forms in *Fairy Tale* reflected the transitional nature of these works. Color was still secondary to or disconnected from drawn contours, yet, while line asserted the essential flatness of the picture plane, the image struck a fresh balance between construction and "free" shapes familiar in Abstract Expressionism.

Martin Holman

Date 1944

Country Germany

Medium Oil on panel

Collection Private collection

Why It's Key Points toward the revelations of Abstract Expressionism and Hofmann's own late style.

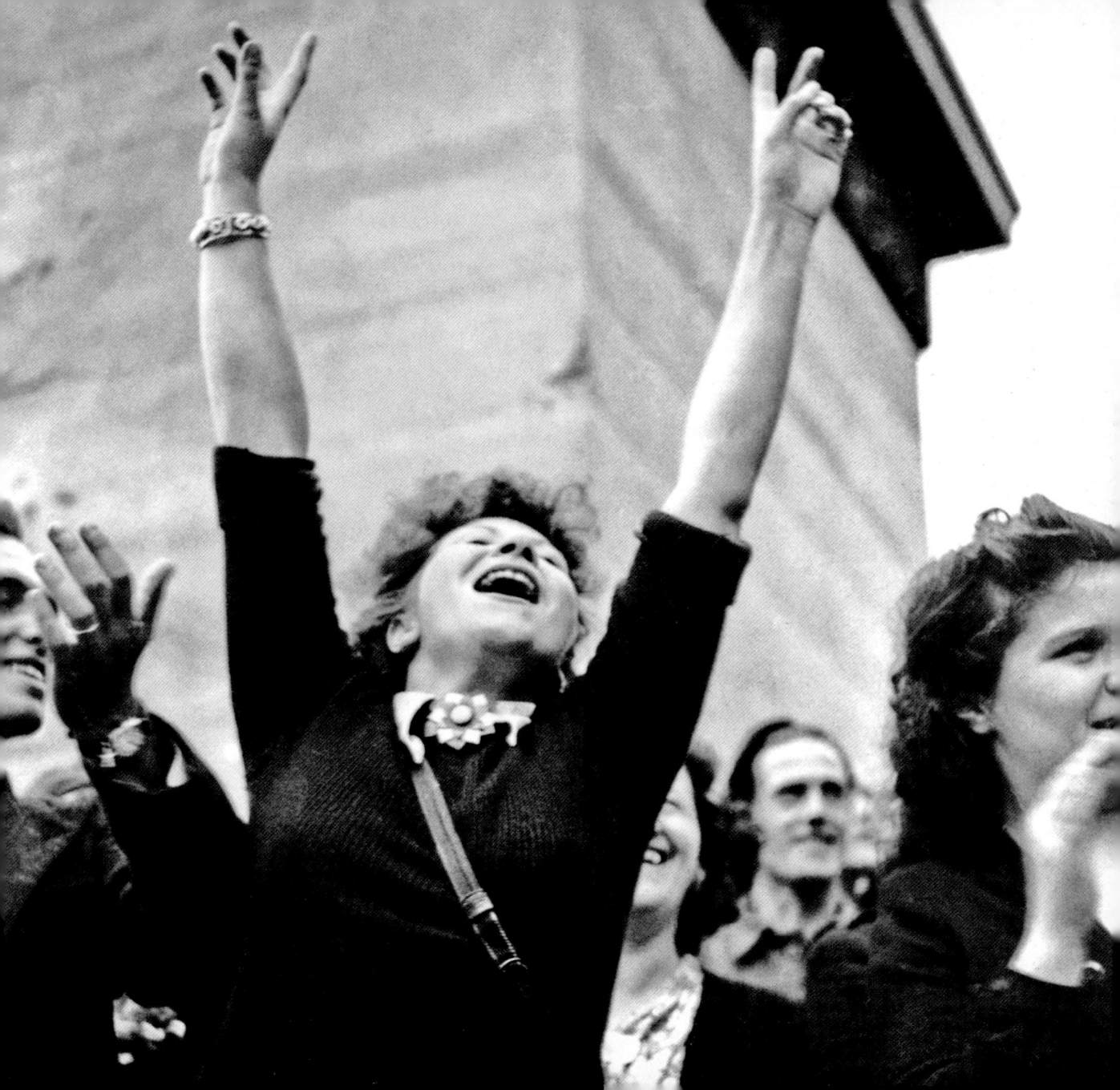

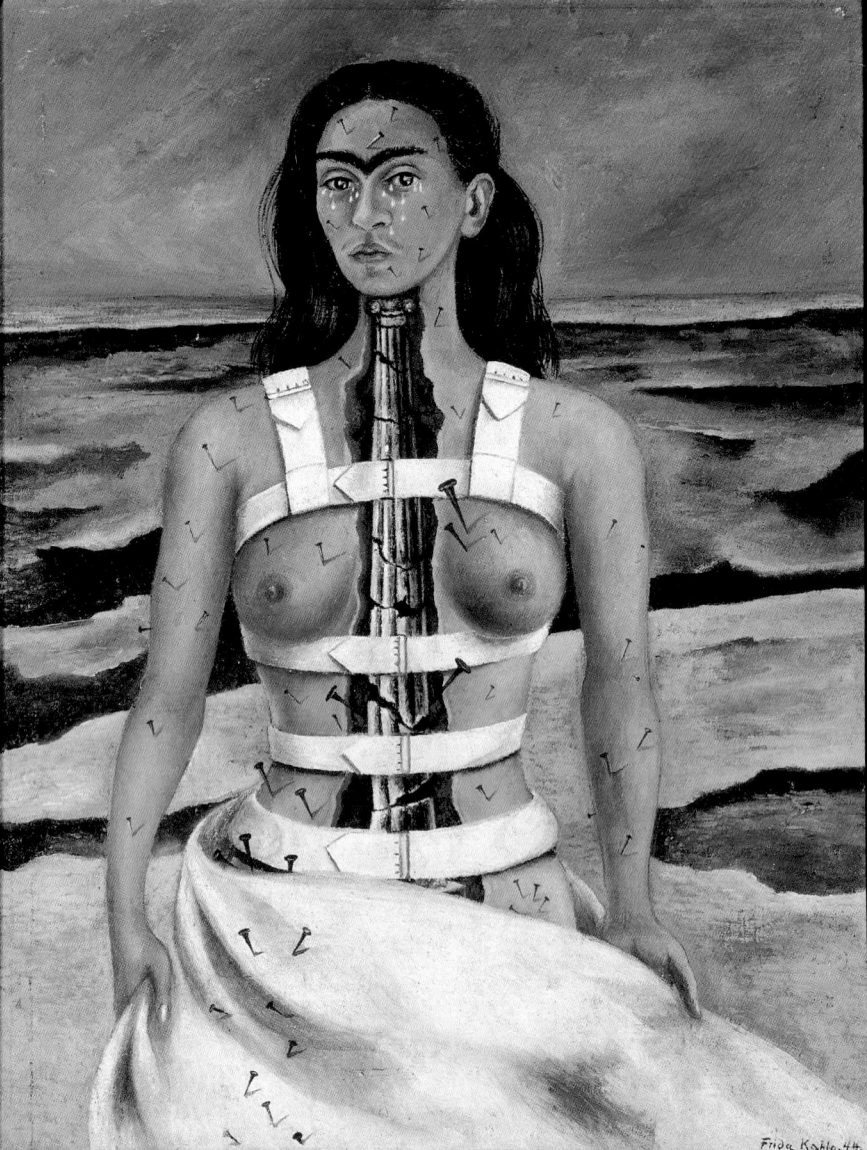

Frida Kahlo. 44.

Key Artwork *The Broken Column*
Frida Kahlo

The twin catastrophes in the life of Frida Kahlo (1907–1954) were an attack of polio when she was only six, and a horrendous trolley bus crash in 1925 when aged eighteen. She broke her spinal column, collarbone, two ribs, right leg, and foot. A metal rod also punctured her abdomen – she later falsely claimed it had impaled her through the vagina. This embroidery of the true facts of her medical condition, although continuously deteriorating, was to be a lifelong feature of her complex, narcissistic personality.

The polio caused deformity in the right leg and a period of quarantine, anguish for a vivacious, outgoing child suddenly at the sole mercy of a mother with hysterical hypochondria. Later, she went to great lengths to disguise her limp and orthopedic shoe. The crash had more serious and lifelong ramifications –

both physical and psychological – although initially she made a remarkable recovery.

Contrary to popular myth, Frida was able to stand and walk fairly soon after the incident, but her inability to have children was always blamed on these injuries. Throughout her life, Kahlo underwent much elective surgery, that is, treatment not immediately necessary on medical grounds. Eventually she needed corsets to support her failing spine.

The Broken Column depicts Frida as a victim (as is usual in her work) but a contemporary text tells how the artist "roared with laughter" on seeing a friend upset by the painting, saying "that is my little joke on pain and suffering – and [on] your pity."

Mike von Joel

Date 1944

Country Mexico

Medium Oil on masonite

Collection Dolores Olmedo, Mexico City

Why It's Key *The Broken Column*, painted toward the end of Kahlo's life, epitomizes her autobiographical and narrative oeuvre. The corset is poignantly on display in her room at the dedicated museum that was once her studio and home.

opposite *The Broken Column*

1940–1949

351

Key Event
Society of Industrial Designers founded

The Society of Industrial Designers was formed in 1944 by fifteen designers, based largely in the eastern half of the United States, who wished not only to legitimize the profession of industrial design, but also to embed a standard of quality in mass-produced products. The past ninety years of industrial design had been distinguished by an ad hoc approach to the discipline, and a reluctance to mix the functional with the aesthetic. The Society of Industrial Designers grew quickly, thanks partly to its organizational design – each member was required to bring a designer on board in 1945, and members were required to design no fewer than three products in varying industries. In 1965, the Society of Industrial Designers – then known as the American Society of Industrial Design – merged with two other design groups to create the Industrial

Designers Society of America, which remains active to this day.

The high point of the Society of Industrial Designers coincided with the rise of Pop Art in Britain and the United States. Both the society and the art movement anticipated, and helped to create, a world in which there was a diminishing difference between a mass-produced product and a work of art. The Society of Industrial Designers played an important role in this mid-century paradigm shift, in which product became art and art became product, thanks to its members' creations of such arty and iconic products as the Movado Museum watch, the Flight bathroom scale, the Ford Thunderbird, and the Apple IIc computer.

Demir Barlas

Date 1944

Country USA

Why It's Key Quality became an integral part of industrial design thanks to this group.

Key Artist **Karl Hofer**
Appointed director of the Berlin Academy

Born in Karlsruhe, Germany, Karl Hofer made the first of his prints in 1899, under the influence of the Symbolist painter Arnold Bocklin. Seeking new art forms, Hofer traveled to Paris in 1900, and was greatly impressed by Henri Rousseau's naïve painting and by the classical arcadian concept of Hans von Maries, to which Hofer's own style became increasingly aligned. Hofer's first one-man show was presented by Kunsthaus Zürich in 1904, and later shown in the Kunsthalle, Karlsruhe, and in Weimar in 1906. He divided his time between Paris and Germany, and joined the Expressionist artists' group Novembergruppe. On his fiftieth birthday, a retrospective was held at the Kunsthalle Mannheim in Berlin.

As the Third Reich dawned, however, Hofer was branded a "cultural bolshevist." He was expelled from teaching posts at the Academy of Art in 1937 and the Reichskulturkammer in 1938, and only readmitted to the latter after separating from his Jewish wife. More than three hundred of his works were confiscated from German museums and exhibited in 1937 in the Munich exhibition of "degenerate" art (*Entartete Kunst*). It was only at the end of World War II that Hofer regained recognition, appointed director of the newly founded Berliner Kunsthochschule by the Allies and nominated president of the Hochschule für Bildende Künste. His exhibition in 1946 presented paintings of those who had escaped responsibility for their criminal actions during the Nazi era, and his subsequent paintings often featured demons as the embodiment of his bitterness and despair.

Mariko Kato

Date 1945

Born/Died 1878–1955

Nationality German

First Exhibited 1904

Why It's Key One of the world's most prominent Expressionist painters, Karl Hofer was given postwar recognition after repression during the Nazi era.

Key Artist **Lee Krasner**
Marries Jackson Pollock

As a determined young art student Krasner painted *Self Portrait* in 1930. The artist is pictured standing defiantly outdoors in a setting full of dramatic contrasts. The painting sparkles. Yet Krasner was struggling. She had tried, but not managed, to fit within the traditional art school system. At least one tutor had found her "incorrigible." Finally, on a visit to the Museum of Modern Art in New York, Krasner discovered inspiration in the work of Picasso and Matisse. The experience had a profound impact. She eventually found a mentor in Hans Hofmann, notable teacher, European émigré, and proponent of modernism. Hofmann recognized Krasner's talent immediately and provided encouragement. She began experimenting with Cubism, making bold geometric abstractions.

Soon Krasner was a respected artist and a member of the vanguard. Her approach to image making was distinguished by its many bold transitions, and her oeuvre comprises a wide range of drawing, painting, and collage. She was one of three "unknown" American painters invited to take part in an exhibition of French and American Painting (1942). The other two "unknown" painters were Willem de Kooning and Jackson Pollock. Krasner was not familiar with Pollock's paintings. She visited the artist in his studio, a few streets away. Like the work of Picasso and Matisse, Pollock's work hit Krasner "like a bomb exploded" when she saw it. The attraction between these two kindred spirits was powerful and instant – there would be no looking back.

Carolyn Gowdy

Date 1945

Born/Died 1908–1984

Nationality American

Why It's Key Lee Krasner was the only woman artist who was part of the first generation of the New York school. For many years she was known primarily as the wife and artistic follower of Jackson Pollock, but Krasner was a powerful artist in her own right.

Key Event
World War II ends

With many European artists fleeing to the relative safety of the United States, the center of Western art shifted from Paris to New York during World War II. But nowhere was safe. World War II had been a global catastrophe. While some artists, such as the Italian Futurists, had sought a redemptive value in World War I, the Nazi extermination camps, the barbarity of the Japanese army, the Allied carpet bombing, and the dropping of the atomic bomb made this impossible after World War II. It came just twenty years after the "war to end all wars," and was followed immediately by the Cold War, the nuclear confrontation between the United States and the Soviet Union that threatened the very existence of humankind.

The reaction of many new artists was Abstract Expressionism, where paint was apparently just flung at the canvas. So-called "action painting" took hold, particularly in New York and Germany. This soon mellowed into color field painting, with canvases covered with flat areas of paint. It was as if the postwar world was too terrible to depict. In France, Jean Dubuffet challenged the value of art itself with *art brut* (raw art), exhibiting his scraped and smeared canvases alongside the work of asylum inmates. In Britain, the similarly untutored Francis Bacon produced distorted images of bodies inspired by the corpses he had helped to dig out of bombed buildings during the London Blitz. In sculpture, Alberto Giacometti produced thin, stick-like figures reminiscent of bodies charred in firestorms, while others worked on monumental structures that seemed to exclude the human form altogether.
Nigel Cawthorne

Date 1945

Country Japan

Why It's Key The dropping of the atomic bomb begins the nuclear age, heralding a world which sometimes seemed too terrible to depict.

Key Person **Weegee** On-the-scene crime photographer publishes first collection

Best known for his on-the-spot crime and car-crash photographs, with victims lying on the streets of New York in pools of their own blood, Weegee was born Usher Fellig in what is now the Ukraine, but was then in Poland. He changed his name to Arthur when his family moved to New York in 1909. He was dubbed "Weegee" after the way he would appear on the scene just minutes after the authorities were alerted, as if getting advanced information via a ouija board. In the late 1930s, Weegee was the only New York reporter with an official police shortwave radio in his car. With a purpose-built darkroom in the back of the vehicle, he often turned up on a crime scene before the police themselves, and got candid shots to the newspapers before any of his journalist competitors.

Weegee's stark black-and-white images for the *Daily News* defined "crime" photography from thereon in, but also included pictures of New York's underclass, a graphic chronicle of the city's destitute and dispossessed. Despite being self-taught, and a world away from "art" photography, he had some of his work shown at the Museum of Modern Art in 1943. Then, in 1945, the first collection in book form appeared; titled *The Naked City*, it inspired a 1948 film noir of the same name and, later, a seminal TV series. Undertaking non-tabloid commissions for the likes of *Life* magazine, Weegee was hugely influential in the world of photojournalism, as well as inspiring the "car-crash" images of Andy Warhol and filmmakers from Jules Dassin to Martin Scorsese.
Mike Evans

Date 1945

Born/Died 1899–1968

Nationality Polish (naturalized American)

Why It's Key Weegee's black-and-white photographs of New York street life influenced photojournalism, film noir, and pop art.

Key Artist **Sidney Nolan**
Begins first Ned Kelly series

Born in Melbourne, Australia, Nolan was largely untutored, preferring to educate himself in the public library. In 1938, he was a founder member of the Contemporary Arts Society in the Melbourne suburb of Heidelberg. In 1940, he held his first one-man exhibition in Melbourne, showing largely abstract works. That same year, he was commissioned to produce set designs and costumes for the Ballets Russes production of *Icare* in Sydney.

Nolan was drafted during World War II, and he spent part of his service during the war in the flat wheatlands of northwest Victoria, where he painted simplified landscapes. At the end of the war, he began a series of paintings featuring the outlaw and bushranger Ned Kelly, whom he had learned about from his police-officer grandfather. Nolan then turned

his attention to other subjects from Australian folklore, producing a second Ned Kelly series between 1954 and 1957. Visiting Slade Professor of Art at Oxford Kenneth Clark called him Australia's "only real painter."

Nolan left his homeland in 1953. Basing himself in London, he also lived in Greece and the United States. He produced set designs for productions at Covent Garden and had permanent exhibitions in New York's Museum of Modern Art and London's Tate Gallery. He was knighted in 1981, and became a member of the Order of Merit in 1983.

Brian Davis

Date 1945

Born/Died 1917–1992

Nationality Australian

First Exhibited 1940

Why It's Key Australia's most important twentieth-century artist.

Key Artist **Francis Bacon** *Three Studies for Figures at the Base of a Crucifixion* brings instant notoriety

Born in Dublin, Ireland, the son of an English racehorse trainer, Francis Bacon was banished from home at the age of sixteen for his homosexual proclivities. He drifted around Berlin and Paris before settling in London in 1928, where he worked as an interior decorator, painting in his spare time. Self-taught, he had a one-man show in London in 1934 which attracted the attention of influential critic Herbert Read, but discouraged by financial failure Bacon virtually stopped painting for ten years. In 1944, he finished *Three Studies for Figures at the Base of a Crucifixion*, which, when exhibited the following year, brought overnight success. Constructed as a triptych, the three panels each show a grotesque creature with an obscene phallic neck and screaming mouth.

Bacon painted from photographs and pictures ripped from magazines and newspapers. He frequently borrowed images from other sources, such as in the series *Screaming Popes*, where he distorted Diego Velázquez's *Portrait of Pope Innocent X* in a nightmare of hysterical terror. The horror and physical distortion, he said, came from his war work. Declared unfit for military service, Bacon was employed removing dismembered bodies from bombed buildings. From the 1950s, his reputation grew internationally as Britain's greatest modern painter. His gift was to reveal unflinchingly the fear and loneliness of the human condition.

Nigel Cawthorne

Date 1945

Born/Died 1909–1992

Nationality British

First Exhibited 1934

Why It's Key Britain's leading postwar painter, after overnight success triggered by controversial triptych.

opposite Francis Bacon

Key Artist **Lucio Fontana**
Publishes *White Manifesto*

Lucio Fontana was born in Argentina. After receiving a first degree in engineering, he studied art at the Brera Academy, in Milan, graduating in 1930. He returned to Argentina to work for his father, a sculptor, then set up his own sculpture studio. From the outset his work was experimental; in the *Scratched Tablet* (*Tavolette graffite*) series, for example, produced from 1931–34, he created Surrealist-inspired automatic drawings on colored concrete. In 1947, after a few years spent in Argentina, he returned to Milan and founded the *spazialismo* (spatialism) movement with other artists and philosophers, and produced the first of a series of manifestos which advanced the ideas he had first conceived in the *White Manifesto* in 1946.

He created the first of the Spatial Concept (Concetti spaziali) series in 1949, the label he gave all his work from that point onward. In that same year, he produced the first of the Perforations *(Buchi)* series – canvases perforated with holes, in which a transition, from three-dimensionality to a potentially infinite space, takes place in the canvas itself. Also in that year, he used neon light in the first *Spatial Environment* (*Ambiante spaziale*), which was installed in the Naviglio Gallery, Milan, and which prefigured installation art of the 1960s and 1970s. His most radical works, those for which he is perhaps best known, the Slashes (Tagli) series, were first produced in 1958. These further explored the idea of infinite space, viewed through a void made by the violent gesture of slashing the canvas with a box cutter, or Stanley knife.

Sarah Mulvey

Date 1946

Born/Died 1899–1968

Nationality
Argentinean-Italian

Why It's Key Fontana, inspired by the manifestos of the Futurists, published the *White Manifesto* (*Manifesto Blanco*) with other younger artists, in which he advocated the use of new industrial materials, technologies, and science to create dynamic movement and space.

opposite **Spatial Concept** *Waiting* (oil on canvas).

Key Artist **Dorothea Tanning**
American Surrealist painter marries Max Ernst

Dorothea Tanning was born in 1910 in Illinois, from where she set out for Chicago during the Great Depression with just US\$ 25 in her pocket. She studied at the Chicago Art Institute before proceeding to New York, where, while working as a freelance illustrator, she went to see the 1936 Museum of Modern Art exhibition of Dada and Surrealism. This inspired her to become a painter, and to travel to Paris in 1939, but she found the city deserted – Hitler was preparing to invade, and Americans were told to go home.

Back in New York, Tanning resumed illustration and developed her painting, catching the attention of expatriate Surrealists and exhibiting at the Julien Levy Gallery. In 1942, Max Ernst visited Tanning's Greenwich Village studio on an art-hunting expedition for his then wife, gallery owner Peggy Guggenheim. There, among other powerful works, he found an image of an unsmiling Tanning, bare-breasted and in exotic dress trimmed with tree limb tendrils. He suggested that she title it *Birthday* (1942). Enchanted by the model as much as her painting, Ernst married Tanning four years later in a double wedding with Man Ray and Juliet Browner in Los Angeles. At the reception, the Russian composer Igor Stravinsky provided the champagne. The couple each painted a portrait of the other, and from then on Ernst made a birthday picture every year, titling it "for D.T." The marriage lasted until Ernst's death in 1976.

Tanning also worked as a sculptor, writer, and set and costume designer, and continued into her early nineties making paintings and sculpture.

Carolyn Gowdy

Date 1946

Born 1910

Nationality American

Why It's Key When Dorothea Tanning, a major American Surrealist, married Max Ernst, she was provided with the opportunity to confirm her place in the pantheon of the U.S. avant-garde.

Key Artist **Clyfford Still** Solo exhibition at Peggy Guggenheim's New York gallery

Clyfford Still was born in North Dakota in 1904. He graduated in art in 1933, after studying at Spokane University in Washington. He cofounded the Nespem Art Colony in 1937 with Worth Griffin. In 1943, Still's first solo exhibition took place at the San Francisco Museum of Art, and he met Mark Rothko in Berkeley. Rothko introduced him to Peggy Guggenheim in 1945, and the following year she gave Still an exhibition at her Art of this Century gallery in New York.

It was at this point that Still began to develop his "color field" paintings. Influenced by Rothko, his paintings are completely non-figurative. Yet while Rothko (a color field Abstract Expressionist) arranged his colors simplistically, Still painted large abstract canvases with thick textural paint and vertical jagged slashes of color that look as if they have been torn off, revealing colors underneath. These flame-like colors are often cut off at the canvas edges, giving the viewer the sense that there is more to see. Still's *1957-D, No. I* (1957) is a case in point, with its black and yellow tears with patches of white and a touch of red. These four colors and their variations – often darker – are used extensively in his body of work.

One of the leading American Abstract Expressionists – a movement inspired by artists who wanted to create an American aesthetic – Still was a loner. He wanted total control of his work and often insisted his paintings shouldn't be separated. He died in New Windsor, Maryland. in 1980.

Kate Mulvey

Date 1946

Born/Died 1904–1980

Nationality American

Why It's Key One of the leading American Abstract Expressionists, Still was one of the foremost "color field" painters.

1940–1949

358

Key Artist **Karel Appel** First solo show

Karel Appel was born in Amsterdam in the Netherlands, and studied at the Rijksakademie in Amsterdam from 1940–43. He was a member of the Nederlandse Experimentele Groep, and in 1948 founded *Reflex* magazine. In November of that same year, he and other artists, poets, and writers founded the Cobra group. He exhibited with them until 1951, producing experimental work that aimed to liberate itself from bourgeois taste. Appel was influenced by European avant-garde and Expressionist art, and by those artists who looked for the irrational and the authentic in "primitive" or "outsider" art – in particular, the naïve paintings of Jean Dubuffet. Appel's paintings of the 1950s and 1960s are figurative, but border on abstraction, often painted in a spontaneous, roughly scrawled impasto of luminous colors which transforms animals, birds, and people into grimacing caricatures, in which can be seen the influence of children's paintings and tribal masks and figures.

In 1950, Appel moved to Paris, where he worked with the French art critic Michel Tapie, who had been instrumental in creating with Dubuffet La Compagnie de l'Art Brut in 1948. Appel collaborated with Tapie on several exhibitions. He experimented with a variety of art forms, producing painted reliefs and sculpture in different materials, including wood, aluminum, and found materials. He also worked on public murals, and was involved in printmaking and ceramics. His interest in the connections of art and poetry materialized in his 1982 collaboration with the Beat poets Allen Ginsberg and Gregory Corso.

Sarah Mulvey

Date 1946

Born/Died 1921–2006

Nationality Dutch

Why It's Key Appel's first solo exhibition was at Het Beerenhuis in Groningen; in the following year, he participated in the Jonge Schilders (Young Artists) show at the Stedelijk Museum.

Key Person **Gertrude Stein**
Death of influential writer, model, and patron

Born the youngest child of an upper-crust Jewish family, Gertrude Stein decided early on to be a writer. In fact, her whole life was supported by a trust fund administered by her brother Michael. From 1903 to 1914, she and her brother Leo lived in Paris and became central characters in the Montparnasse milieu. Between them they amassed one of the important, early collections of modern art, including works by Picasso (who became a friend), Matisse, André Derain, Georges Braque, Juan Gris, and others. Before World War I, their salon at 27 rue de Fleurus attracted the avant-garde and dealers, including Ambroise Vollard, Bernard Berenson, and the poet and critic Apollinaire.

Of her writings, *The Autobiography of Alice B. Toklas* (1933) and *Tender Buttons* (1914) are the most recognized. Her first published text consisted of "word portraits" of Matisse and Picasso, which appeared in Stieglitz' August 1912 edition of *Camera Work*. Stein's *Miss Furr and Miss Skeene* is one of the first coming out stories to be published and reflects her growing involvement with the gay and lesbian community. Her observation "A rose is a rose is a rose is a rose" is a timeless epigram.

Stein met Alice B. Toklas in 1907 and formed one of the most famous lesbian relationships in the Arts. Stein wrote in longhand and Toklas would collect the pages, type them up, and deal with the business side. They were together for 39 years.

Stein died at the age of 72 during surgery for stomach cancer in Neuilly-sur-Seine on July 27, 1946, and was interred in the Père Lachaise cemetery.
Mike Von Joel

Date 1946

Born/Died 1874–1946

Nationality American

Why It's Key Gertrude Stein was patron and catalyst to two generations of the avant-garde: the prewar Picasso coterie and the postwar Hemingway/Pound circle of Paris-based writers.

1940–1949

359

Key Artist **Elizabeth Catlett**
Receipt of fellowship to study art in Mexico

Born in Washington D.C., Elizabeth Catlett pursued her studies at Howard University, where she studied design and printmaking under several influential African-American artists before becoming the first person to receive a Master's degree in sculpture at the University of Iowa in 1940. Her talent was quickly recognized, and she received first prize upon exhibition of her thesis work, *Mother and Child* (1939), at the American Negro Exhibition in Chicago in 1940. It was the receipt of a fellowship in 1946 to study painting, sculpture, and lithography in Mexico, however, that determined the direction of her career.

In Mexico, Catlett worked with the People's Graphic Arts Workshop, a group of printmakers who attempted to use their art to encourage social change. She incorporated their medium and pursued the same goal in the production of her works, which aimed to empower African-Americans, particularly during the civil rights movement. Additionally, she utilized her art to honor African-American women and to convey the dignity of the working class. In her woodcut *Sharecropper* (1968), she combines these pursuits in her dignified portrayal of an elderly female farm worker who suffers under the oppressive and unjust sharecropping system.

Catlett, who married Mexican artist Francisco Mora, became a Mexican citizen in 1962. She has received numerous honorary awards for her artwork, and she continues to live in Mexico, producing artwork to raise awareness of political and social injustice, and to promote positive change in these realms.
Heather Hund

Date 1946

Born 1915

Nationality American (naturalized Mexican)

First Exhibited 1940

Why It's Key Catlett is an influential African-American contemporary female artist who utilized her art to promote social change.

Key Person **Frank Lloyd Wright**
Architect unveils plans for Guggenheim Museum

From its opening in October 1959, the Solomon R. Guggenheim Museum has been recognized as Frank Lloyd Wright's crowning achievement. Presented as a plan to the commissioner, Solomon R. Guggenheim's art adviser Hilla Rebay, in 1946, the building took another thirteen years to complete, saw the death of Solomon R. Guggenheim, and, six months before opening its doors, that of the architect himself. Intended to house the collection of non-objective painting of the Solomon R. Guggenheim Foundation, which had been formed in 1937, the building was conceived by Wright as an inverted ziggurat (a pyramidal temple of Babylonian origin), to be symbolic, with its main spiral, of "organic process." With the inclination of the ramp, Wright hoped to counteract the dominance of right-angled architecture over the flat plane of painting, and declared that building and painting would unite in "an uninterrupted, beautiful symphony such as never existed in the World of Art before."

Wright not only took into consideration the architecture and the art, but also clearly defined the experience he wished to give visitors to the museum. According to his original plan, visitors were meant to be taken up to the top floor by the elevator in the lobby, then descend the spiraling ramp at a leisurely pace. This and other aspects of Wright's original design, such as the plan for the tower to house artists' apartments and studios, were eventually abandoned for financial or practical reasons.

Chiara Marchini

Date 1946

Born/Died 1867–1959

Nationality American

Why It's Key The Guggenheim Museum is considered a milestone of modern architecture.

Key Artwork *A Little Night Music*
(*Eine Kleine Nachtmusik*) Dorothea Tanning

Of her birthplace, Galesburg, Illinois, Dorothea Tanning (b. 1910) once said, "Nothing happens but the wallpaper." As a girl, Tanning became an avid reader of Gothic fiction, which cultivated her imagination. She went to college and worked as a librarian before moving to Chicago to study art, then New York, and Paris and back, before the Nazis invaded there. Back in New York, she continued developing her painting while working as a freelance illustrator. Significantly, and perhaps paradoxically during these wartime years, *A Little Night Music* (*Eine Kleine Nachtmusik*) shares its name with Mozart's joyful piece of music. It was completed four years after Max Ernst had first visited Tanning's studio, and two years after her first solo exhibition at the Julien Levy Gallery. She married Ernst that same year: 1946.

This dream painting depicts two childlike girls immersed in a hypnotic trance. The moment seems laden with mysterious symbolism. One of them is partially dressed and leans against the wall. This hallway is dark with heaviness and yet a magical, transforming energy seems present. Is it the music? A disheveled sunflower with broken stem has come alive. The flower arches its tendril-like petals toward a golden light, stirring a similar response in the small girl who stands animated before it. Doors (perhaps representing choices or opportunities) and large empty hallways with peeling wallpaper continued to appear in Tanning's imagery during this period.

Carolyn Gowdy

Date 1946

Country USA

Medium Oil on canvas

Collection Tate Gallery, London

Why It's Key One of the leading American Surrealist painter's best-known works.

opposite *A Little Night Music*

Key Event
Art Club Founded in Vienna

In 1946, a number of Austrian painters (largely abstractionists and Surrealists) and sculptors founded the Art Club, a collective devoted to advancing the cause of avant-garde art. For nearly fifteen years, the German (and, after the Anschluss, Austrian) governments had terrorized avant-garde artists and art as the detritus of unwelcome social and political currents. By 1946, European fascism was spent and this struggle was over, so the time was right for the avant-garde to reassert itself. The Art Club proved to be Austria's most influential mechanism for this reassertion. Its catholic tastes and relatively loose structure appealed to many artists.

Thus, the Art Club provided a support structure not only for painters and sculptors but also for filmmakers, musicians, poets, architects, and other artists whose work tended toward the avant-garde. There was not a single profile for members of the collective; some, like the jazz aficionado Oswald Wiener, inclined to the Beat movement that was also gestating in the United States, whereas figures such as the poet Hans Carl Artmann were grounded firmly in the continental avant-garde. On the whole, the Wiener tendency won out, as the Austrian art scene would be deeply influenced by the quintessentially American happening. However, Art Club did not maintain its cohesiveness long past the 1950s as its constituents drifted into looser affiliation with each other.

The Art Club was opposed by a short-lived splinter group known as the Hounds Club, which never attained the influence or membership of its rival.

Demir Barlas

Date 1946

Country Austria

Why It's Key A number of Austrian artists renew post-war interest in the avant-garde.

363

Key Exhibition
Arts of the South Seas

Under the directorship of René d'Harnoncourt, the head of the New York Museum of Modern Arts' department of manual industry, and the sponsorship of the Rockefeller Foundation, the Musuem of Modern Art gathered 420 art objects in the Arts of the South Seas exhibition of 1946. The exhibit was the first time that most Americans had an inkling of the varied cultures that were represented in the South Seas, which stretch from Hawaii to Australia. Island cultures introduced in the exhibit included those of the Solomon Islands, New Zealand, Easter Islands, New Guinea, Micronesia, Melanesia, and the Marshall Islands.

New York's Museum of Modern Art spent eighteen months preparing for the exhibit, renovating the entire second floor and consulting experts in order to provide the proper background for showcasing the art works.

Walls were painted green, yellow, red, and white to symbolize the lands from which the objects had originated: dark green for jungles, red rock for the Australian desert, yellow for sand, and white for the brilliant lights of the coral islands. Objects, which were on loan from private collectors and museums in the United States and Canada, ranged from the mundane to the dramatic, including ancestry figures, ceremonial masks, jade, bone and carved wood, canoes, combs, shell jewelry, tortoise shell, effigies, and fabrics.

Some scholars credit French Post-Impressionist Paul Gauguin (1848–1903) with rediscovering and focusing international attention on the art of the South Sea Islands. Gauguin had retreated to the area to paint in the 1890s.

Elizabeth Purdy

Date January 30–May 19, 1946

Country USA

Why It's Key This was the first major effort to introduce Polynesian art to an international audience, and it set the standard for showcasing art objects according to history and anthropology, as well as aesthetics.

opposite The South Seas Arts exhibition.

Key Artwork *Ned Kelly*
Sidney Nolan

A former odd-job man, Nolan became a full-time painter at twenty-one, at first working on abstract themes. He held his first one-man show in 1940. He served in the Australian army during World War II, fighting for the Anzacs in the desert war, at which time he began painting distinctive Australian landscapes.

He read a great deal about the Irish-Australian outlaw (or freedom fighter, depending upon your point of view) Ned Kelly, and became obsessed with Kelly and the mythology surrounding him as a subject and starting point for a series of large works, numbering twenty-five in all. He visited the sites frequented by Kelly around Glenrowan, in Victoria. Of Irish stock himself, Nolan regarded Kelly as a historical phenomenon, rather than a hero as such. He worked rapidly, incorporating elements of landscape and semi-abstraction into fundamentally figurative but atmospheric, almost mystical work. He applied the same principles to grand themes such as the World War I battles at Gallipoli and classical themes such as the Greek myth of Leda and the swan.

Nolan held his first London exhibition in 1950, and remained living in England thereafter. In later years, he became known for a translucent, nebulous style of painting on hard and unforgiving hyper-smooth surfaces such as glass. Although his work can be described as pure painting, even though there is often a narrative element, Nolan was also a poet and writer in equal measure.

John Cornelius

Date 1946

Country Australia

Medium enamel on composition board

Collection National Gallery of Australia

Why It's Key Part of celebrated series of Australia's most important artist.

opposite *Ned Kelly*

364

Key Person **Samuel Courtauld** Death of the famous benefactor and collector of visual art

With money derived from the family's textile business, Samuel Courtauld began seriously collecting art in 1922 and, within a decade, had formed an outstanding collection of Impressionist and Post-Impressionist art, including Manet's last masterpiece, *The Bar at the Folies–Bergère* (1882), Renoir's *La Loge* (1874), major works by Degas, Monet, Gauguin, and van Gogh, and an exceptional group of paintings by Paul Cézanne. In 1923, he also gave the Tate Gallery UK£50,000 to buy modern French art, among which was Seurat's *Bathers at Asnières* (1884), since transferred to the National Gallery.

Courtauld's greatest benefaction was his endowment in 1931 of the Courtauld Institute of Art, the first UK centre for the study of art history. He donated the bulk of his collection to the institute, a gift supplemented by its co-founders, Lord Lee of Fareham and Sir Robert Witt. In 1934, Roger Fry, also instrumental in the creation of the Courtauld Institute, bequeathed it his collection of French and British Post-Impressionist art; it has subsequently been augmented by other donors, notably Count Antoine Seilern, who in 1978 bequeathed the spectacular Prince's Gate Collection, especially rich in the work of Rubens, and the Fridart Foundation, which in 2002 made a long-term loan of more than 100 examples of twentieth-century art. The Courtauld Institute, for more than fifty years housed in Courtauld's former home in London's Portman Square, and the Courtauld Gallery, opened in Woburn Square in 1958, have since 1990 been under one roof at Somerset House.

James Beechey

Date October 1947

Born/Died 1876–1947

Nationality British

Why It's Key Major philanthropist whose Courtauld Institute was the first British institution dedicated to the study of art history.

Key Artwork *I Was a Rich Man's Plaything*
Eduardo Paolozzi

In 1947, while living Paris, Eduardo Paolozzi (1924–2005) started using postcards, as well as photographs and advertisements taken from magazines given to him by American GIs, to make scrapbooks and collages. *I Was a Rich Man's Plaything* evokes American glamour, with a coy yet provocative pin-up perched on a tasseled cushion. She promises titillating "intimate confessions," the sexual nature of which is implied by a cherry (synonymous with "virginity"), while a slice of pie suggests she may or may *not* be as "sweet as cherry pie." American postwar prosperity is alluded to through food advertising and packaging: over there, cherries are juicier, fruit is "real gold," and Coca-Cola flows. Seen from a UK still subjected to grim rationing, such affluence must have seemed fascinating.

Similar fragments from pulp magazines and commercial logos would later form the basis of Pop iconography. Yet, unlike Roy Lichtenstein's slick comics or Andy Warhol's silk-screened rows of Coca-Cola bottles, Paolozzi's cheaply printed material has a roughness that befits its "scrapbook" status. Unceremoniously cut up and stuck onto card, the pictures are not juxtaposed to create some Surrealist poetic encounter, nor are they collaged into an elegant Cubist composition; instead, they reflect the omnipresence of mass-produced lowbrow disposable images in the contemporary urban landscape, and they examine the status of such cultural products, thereby anticipating the sociological concerns of the UK's Independent Group (IG).

Catherine Marcangeli

Date 1947

Country France/London

Medium Collage mounted on card

Collection Tate Gallery, London

Why It's Key The word "pop" first appears in a collage that mixes popular culture and consumer products.

opposite *I Was a Rich Man's Plaything*

Key Person **Alfred Hamilton Barr**
MoMA Director of Collections

The famous Museum of Modern Art in New York started as a philanthropic imperative by three prominent women socialites: Miss Lillie Bliss, Mrs. Cornelius J. Sullivan, and Mrs. John D. Rockefeller Jr. Its genesis through these remarkable ladies can be traced via Stieglitz' 291 exhibitions of avant-garde modern art and to the 1913 Armory Show when America awoke to the concept of Modernism and many new collectors were encouraged to begin acquiring paintings.

Anson Conger Goodyear, as recommended by Paul J. Sachs, offered Alfred Barr the directorship of the newly founded MoMA and he assumed the post aged only 27. Modern art wasn't museum art until Barr came along. Shortly before the 1929 stock market crash, Barr opened the first "blockbuster" exhibition: Post-Impressionists: Van Gogh, Cézanne, Gauguin, and Seurat at the original location on the 12th floor at 730 Fifth Avenue. Many landmark shows followed. His later Picasso retrospective of 1939–40 is now regarded as a template for the serious, educational survey show.

In 1943, Steven Clark became chairman of the board and Barr was fired in a clash of temperaments. That same year a special advisory position was created for him at MoMA and, on the appointment of René d'Harnoncourt as director in 1944, he became rehabilitated. In 1947, Barr assumed the title of "Director of Collections" and returned to his old office. He officially retired from the museum in 1967. Later, Alzheimer's disease was diagnosed and in 1975 he was committed to a nursing home. He died at the Salisburg, Connecticut facility in 1981.

Mike von Joel

Date 1947

Born/Died 1902–1981

Nationality American

Why It's Key Barr was the major catalyst for public acceptance of modern art in America and the progenitor of the "blockbuster" exhibition.

Intimate CONFESSIONS

POP!

TRUE

I was a Rich Man's Plaything

Ex-Mistress

I Confess

If this be Sin

Woman of the Streets

Daughter of Sin

CHERRY

Real Gold

Keep 'Em

Flying!

BOMBER

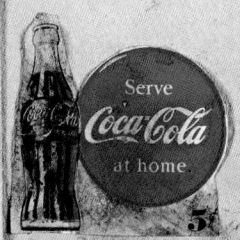

Serve Coca-Cola at home.

5¢

Key Artist **Hans Hartung**
First exhibition in Paris

Hans Hartung grew up and studied in Dresden and Liepzig, Germany, where he was exposed to classic European painters Lucas Cranach the Elder and Younger, El Greco, Rembrandt, and appears to have been unaware of contemporary developments in abstract art. He regarded abstract brushstrokes as a form of visual language akin to Chinese brush calligraphy and, while the brushstrokes in works such as *T1958–4* and *T1949–26* appear to have been applied with abandon, close inspection reveals that they are actually very considered and sharply defined, and betray little in the way of gestural spontaneity.

Being respectful of the graphic method of making images he saw all around him, he was an artist who restored black as a legitimate color in its own right and was unafraid to use it, believing that non-figurative

painting by definition "freed up" black as a legitimate element of the palette – unlike in the natural world, where black as a pure color is nonexistent. He was personally acquainted with Paul Klee and Wassily Kandinsky, but rejected the opportunity to study at the Bauhaus, which he regarded as restrictive and stifling. Instead, he somewhat belatedly toured Europe, absorbing new ideas direct. He rejected the tight mathematical school of abstract painting, preferring to (as he termed it) "act" on the canvas, which throwaway comment led to the use of the term "action painting."

During active service in World War II, Hartung was severely injured and obliged to suffer the amputation of his left leg. After the war, he became a French citizen, living in Paris and the South of France.
John Cornelius

Date 1947

Born/Died 1904–1989

Nationality German (naturalized French)

Why It's Key Abstract Expressionist, and pioneer of "action painting."

Key Artist **Constant Permeke**
Major retrospective in Paris

Constant Permeke, considered the most gifted of the Flemish Expressionists, was something of an anachronism. Inspired by van Gogh, and frequently adopting fishermen and farmers as subjects, Permeke was divorced from the thrusts and debates of modern art. In 1947, however, a major retrospective of Permeke in Paris signified that even the capital of modernism had grown to appreciate the earthy Flemish giant, and saw in his work something worth preserving against the tide of abstract, analytical, and industrial painting.

While the retrospective included a glimpse of Permeke's early vivacious landscapes – done while the painter was happily convalescing in England during World War I – it focused attention on Permeke's more enduring mature works, which depicted both nature and its human captives – including hungry, struggling

men, faceless survivors of daily toil, and stocky nudes – in dark colors devoid of social romance. Yet, despite his experiences of war, hard work, displacement, and personal loss, Permeke's vision was ultimately uplifting. His figures and landscapes were painted with great love, not cynicism, and his insistence on painting nature was at least an escape from the urban grotesqueries of World War II.

Looking at his work in retrospect, it is clear that Permeke staked his place in a tradition of Flemish art dating back to Pieter Brueghel the Elder that did not shy from ignoring international artistic fashions in order to depict quotidian Flemish life. As such, Permeke's works endure not only on their aesthetic merits, but also as witnesses to the vanished life of rural Flanders.
Demir Barlas

Date 1947

Born/Died 1886–1952

Nationality Belgian

First Exhibited 1921

Why It's Key The leading light of Flemish Expressionism is accorded much-deserved recognition toward the end of his career.

Key Artist **Pierre Soulages**
First show at the Salon des Surindépendants

As much of a paradox as it may seem, Pierre Soulages, the painter infamous for his work in the color black, was born in the South of France, in a land of blinding luminosity. It was while visiting the local abbey of Conques that the young autodidact decided to become a painter. During World War II, Soulages hid in the southern countryside, working as a peasant under a fake identity. Although he barely painted during this period, he did meet Sonia Delaunay, who had a strong influence on his later turn toward abstraction.

In 1946, Soulages moved to Paris. He was refused entry at the 1947 Salon d'Automne, and turned to the Salon des Surindépendants, an independent art fair without a jury. There, Soulages presented his first abstract works: monumental white canvases covered by sweeping brushstrokes of black or brown paint, somehow recalling the Chinese art of ideograms. The exhibition marked a turning point in his career, as he met fellow artist Francis Picabia, who encouraged him to pursue his research. The same year also inaugurated a new phase in Soulages' work, as he started creating quasi-monochromes where black was dominant. This technique, coined *outre-noir* by the artist, presented black as the quintessential representation of light and a chromatic prerequisite to the perception of other colors, a theory that the living Soulages still explores. An interdisciplinary artist, he also produced 104 stained-glass windows commissioned by the abbey of Conques, the very same one that had triggered his artistic career.

Sophie Halart

Date 1947

Born 1919

Nationality French

Why It's Key In a precursor to abstract art, Pierre Soulages is the artist who turned black into light.

1940–1949

369

Key Artist **Serge Poliakoff**
Wins the Kandinsky Award

Serge Poliakoff was born in Moscow, the thirteenth of fourteen children. He attended the Moscow School of Painting, Sculpture, and Architecture, but the revolution in 1917 caused him to flee. Arriving in Constantinople (now Istanbul) in 1920, he made a living as a guitar player. He traveled through Europe and eventually arrived in Paris in 1923, in 1929 enrolling at the Académie de la Grande Chaumière. His paintings were academic in style until he discovered ancient Egyptian art during a stay in London from 1935–1937, where he studied at the Slade School of Fine Art. Shortly after this, Poliakoff returned to Paris, where he met and was influenced by Wassily Kandinsky, Sonia and Robert Delaunay, and Otto Freundlich.

Poliakoff began painting abstracts and soon became recognized as a leading abstract painter in the New Ecole de Paris. In 1947 he won the presitigious Kandinsky Award, named for his late friend and mentor. He continued to paint and to make money playing music, and in the 1950s a contract helped him to gain more financial security. The 1962 Venice Biennale gave a room over to his paintings, and in the same year he became a French citizen. His paintings can now be seen in many museums in Europe and in New York. Poliakoff also worked with ceramics at the Manufacture Nationale de Sèvres.

Alan Byrne

Date 1947

Born/Died 1900–1969

Nationality Russian (naturalized French)

Why It's Key Leading Russian-born French abstract painter.

Key Event
Pablo Picasso turns to pottery

In 1947, Pablo Picasso (1881–1973) is sixty-six years old and famous. With the painter Françoise Gilot and their baby Claude, he leaves Paris for the South of France and settles in the village of Vallauris, known for its many potters' workshops. There, he is given a space in the Atelier Madoura. Picasso is fascinated by the medium, experimenting with chemical processes or baking techniques. The works are initially turned by experts, then decorated by Picasso. Using the surface as a blank canvas, he paints or etches his still lifes onto plates or bowls, depicting, for example, the very grapes or peaches that would usually be displayed in the dishes; he also celebrates the local Mediterranean heritage with images of goddesses, centaurs, or Arcadian fauns. Such decorative everyday objects enable Picasso to reach a wider public.

Interested in the combination of painting and sculpture since his early Cubist assemblages, he gradually moves away from his flat "painter's ceramics" to increasingly three-dimensional creations. Some are still made by potters to his specifications, and represent mythological creatures such as condors or Athena's owl of wisdom – from October 1947 to October 1948, Picasso makes about 2,000 pieces, among which are many owls, doves, and little draped figures he calls *tanagras*. He also begins to incorporate composite materials picked up in the street on his way to the studio: baskets, ropes, pans, shovels, shoes, or pieces of broken ceramics find themselves collaged into the shapes of birds, goats, or monkeys, later to be cast in bronze, thus acquiring artistic status as sculptures.

Catherine Marcangeli

Date 1947

Country France

Why It's Key A transitional art form which combines painting and sculpture.

Key Artist **Georges Mathieu**
Organizes Lyrical Abstraction show in Paris

Mathieu was one of the first French painters to recognize the New York school and was a prodigious organizer of exhibitions, writer of manifestos, and energetic promoter of Abstract Expressionism, particularly the variation he termed "lyrical abstraction." He began to paint seriously in 1942 and was influenced initially by the Surrealists Roberto Matta and André Masson, and, above all, Alfred Wols. He developed his own style, which was a form of Abstract Expressionism – the more unconscious, the better. He squeezed tubes of paint vigorously and directly onto canvases, working very rapidly. Described as "*l'art informel*," or "Tachisme," the style was most concerned with the physical act of painting and the "intrinsic authority of the work of art."

Mathieu was a colorful character who liked to perform in public, whether painting while wearing a suit of armor, or executing a 12-meter (40-foot) long painting in under twenty minutes (a feat he accomplished in Japan as a piece of performance art). His extrovert stunts led him to be dubbed the Salvador Dalí of *l'art informel*. Nevertheless, he is the author of several books elucidating the theories behind his work. Although utterly non-figurative, Mathieu's late paintings somehow retain a wry wit, which resides partially in the titling, as, for example, *Mathieu from Alsace goes to Ramsey Abbey* (1954), which is a canvas painted completely in a uniform crimson, save for a frantic scrubbing and splashing of black and white somewhat off-center.

John Cornelius

Date 1947

Born 1921

Nationality French

Why It's Key Leading European exponent of a version of Abstract Expressionism.

Key Artwork *Horseman*
Marino Marini

Marino Marini (1901–1980) started out professionally as a painter, lithographer, and etcher, and earned his living as a graphic designer. Between the two world wars, he traveled extensively all over Europe and visited the United States. He worked mainly in Milan, in northern Italy. Although he came into contact with a variety of artists from various groups or schools, he did not identify specifically with any of them and remained an individual voice.

Horseman exemplifies one of his most-repeated themes: that of the horse and rider. It was a subject which held some higher meaning or symbolism to Marini, and one which occurred repeatedly in his exaggeratedly drawn-out, spidery bronzes, which were essentially hypermodern. Yet the sculptor colored them using a polychromatic technique which had flourished in the Renaissance, at a time when sculpture was commonly painted in vivid colors. He also produced some portrait busts in bronze, but tended toward painting, almost entirely abstract, in his later years. His paintings were exhibited for the first time at Toninelli Arte Moderna in Milan in 1963–64. In 1973, a permanent installation of his work opened at the Galleria d'Arte Moderna in Milan, and in 1978 a Marini show was presented at the National Museum of Modern Art in Tokyo. There is also a museum in Milan dedicated to Marino Marini.

John Cornelius

Date 1947

Country Italy

Medium bronze

Why It's Key Archetypal work by Italy's greatest modern sculptor.

Key Artwork *T-1947-28*
Hans Hartung

When Hans Hartung (1904–1989) returned to Paris in 1945, after his wartime experience in North Africa with the French Foreign Legion, he joined a group of artists who had also returned to Paris from war. These artists began to produce work with a new sense of liberation, challenging the geometric abstraction and figurative tendencies of the inter-war years. The painterly abstraction of Kandinsky and the psychic automatism of the Surrealist André Breton seemed to offer artists such as Hartung, Georges Mathieu, Gerard Schneider, and Pierre Soulages vehicles through which to express their desire for an experimental art that would rely on instinctive processes.

Having already experimented with calligraphic mark-making in the 1930s, Hartung evolved a non-figurative style based on a calligraphic approach, influenced by the automatic drawing technique of the Surrealist artist André Masson. In Hartung's work, *T-1947-28*, lines and marks obey a relational logic as they traverse blocked areas of color in spontaneous and rhythmic gestures. These lines show the trace of the body of the artist as he works impulsively in a subconscious process that relies on unplanned relationships and harmonies; the final result seems less important than the process itself.

In 1948 Hartung contributed to the influential HWPSMTB exhibition, which also showed work by Wols, Francis Picabia, Michel Tapie, and other practitioners of *l'art informel* (art without form) who established a European counterpart to the work of the American Abstract Expressionists.

Sarah Mulvey

Date 1947

Country France

Why It's Key In 1947 the inaugural exhibition at the Galerie Lydia Conti in Paris showed Hartung's work; in the same year his work was also exhibited in the groundbreaking**.**exhibition L'Imaginaire, which included work by Georges Mathieu and Jean-Paul Riopelle, founders of Lyrical Abstraction.

Key Event
Formation of the Progressive Artists Group

Indian art, long caught between schools imposed or sustained by foreign rule, entered its period of greatest freedom in 1947 – not coincidentally, the year in which modern India obtained its independence from the departing British. At this time, Indian artists F. N. Souza, M. F. Husain, and K. H. Ara declared the founding of the Progressive Artists Group, which parted ways not only from the academic and romantic styles in vogue under the British, but also from the sentimental nationalist painting of the Bengal School of Art. The Progressive Artists Group signaled its intention to paint in freedom from these models, adopting the techniques of the past century of European Modernism and the politics of socialism as the means to achieve its goals.

While the Progressive Artists Group had taken inspiration from European paradigms of art, the group's activity often resulted in the reassimilation of classically Indian motifs, themes, and techniques. Harking back to the cosmopolitanism and syncretism of Gaganendranath Tagore, the pre-independence Indian artist, some members of the Progressive Artists Group deliberately crossed civilizational borders in their attempts to create truly felt and liberated art, while other members (such as the Goan Christian Souza, who drew inspiration from Western mythology) stuck closely to Western motifs and techniques. The Progressive Artists Group dissolved less than a decade after its founding, thanks in part to the emigration of many key members, but the spirit of the group continued to animate the tone and ambition of modern Indian art.

Demir Barlas

Date 1947

Country India

Why It's Key Young Indian artists founded a school of modernism coinciding with the independence of India.

372

Key Artist **Fernando de Szyszlo**
First solo show

In 1947, the Peruvian artist Fernando de Szyszlo had his first solo show in Lima, Peru, marking the beginning of his successful project of blending abstraction and indigenous influences in a personal artistic vocabulary.

Szyszlo was only twenty-two on the occasion of his first exhibition, which showcased his work in abstraction. Given his young age and lack of experience, it was no wonder that Szyszlo had not yet discovered a mature and powerful idiom; however, his early work gave promise of the integration yet to come. In 1949, he departed for Europe, where he encountered not only the Renaissance icons of European art but also inundated himself in the Modernist experimentation of the day. Interestingly, Szyszlo's first brush with European art did not unmoor him from his Peruvian roots, but rather instilled in him a determination to render a Peruvian idiom with the tools of Modernism. Thus, in such works as the *Cajamarca* series of the 1950s, Szyszlo mined the indigenous narratives for artistic material. While Szyszlo remained firmly abstract in inclination, the dark reds of *Cajamarca* indicated the emotional heft of the source material.

Szyszlo called for a specifically Latin American approach to art that would first make itself aware of history and specific manifestations of culture, then attempt to forget these interventions and allow them to ferment within the artist. Such an approach, Szyszlo argued, would allow Latin American artists to not only become more authentic creators but also to overcome their identity crises.

Demir Barlas

Date 1947

Born 1925

Nationality Peruvian

Why It's Key Key Latin American abstractionist launches his career.

Key Event
Lisbon Surrealist Group founded

As Surrealism announced itself to the world at large in 1924, the movement appealed mainly to a wide range of artists leading avant-garde lifestyles in the permissive environment of Paris. But Surrealism's deepest creative and political appeal was reserved for artists living in repressive countries and climates. As such, the founding of the Lisbon Surrealist Group in 1947 was a particularly utilitarian moment in the otherwise fantastic history of Surrealism. Post-World War II Portugal was ruled by the right-wing dictator Antonio de Oliveira Salazar, who presided over a particularly blinkered and parochial stretch of Portuguese history.

Some Portuguese artists staunchly refused to follow their government's lead. For example, Mário Cesariny, who had been a student in the prestigious Parisian art school Académie de la Grande Chaumière, returned to Lisbon full of inspiration to deploy the art of the unconscious against the barriers to free thought in his native country. Having met André Breton, the so-called "pope" of Surrealism, Cesariny was especially enthused about bringing the Surrealist aesthetic to Lisbon. Cesariny was joined by people such as the professor, writer, and critic José Augusto França, poet Alexandre O'Neill, and other painters, poets, and writers. While some members of the newly formed Lisbon Surrealist Group dropped out or formed rival collectives – Cesariny himself created the Dissident Surrealist Group – the spirit of the group continued to live on in Portugal's art scene even as Surrealism in Paris and the other European cultural capitals faded.
Demir Barlas

Date 1947

Country Portugal

Why It's Key Surrealism vivified the Portuguese art scene during a time of right-wing dictatorship.

1940–1949

373

Key Artist **Gerard Sekoto**
Moves to Paris in self-imposed exile

Gerard (also spelt Gerhard) Sekoto was born at a Lutheran mission in South Africa's Northern Province in 1913. He grew up in the Middleburg District, where his father taught at the mission school. New dimensions were added to Sokoto's drawings when he was introduced to colored pencils as a teenager. Sekoto trained as a teacher at the Anglican Teacher's College before taking art classes for black South Africans at the St. Peters School in Johannesburg. The first showing of his work was at a student exhibition at the Gainsborough Gallery in Johannesburg. That success led to his first solo exhibition in Pretoria in 1939.

In 1947, Sekoto left South Africa for Paris. By working as a cabaret musician, he was able to study art at the Académie de la Grande Chaumière. Sekoto is best known for his depictions of urban life, most notably for his drawings, gouache, and oils of landscapes and figures. After becoming the only black included in a touring exhibit of South African art in 1948, Sekoto earned international renown.

Sekoto's celebrated early works include *Sopiatown* (1938), *District Six* (1942), *Eastwood* (1945), and *Early Paris* (1947), all of which depict specific periods in his life. Sekoto satisfied his longing for his homeland by returning to South Africa in 1967. Within two years, he was back in Paris. Sekoto died there in 1993, but continued to gain fame. Exhibitions of the more than three thousand Sekoto works have been held all over the world, and remain on display in South Africa and France.
Elizabeth Purdy

Date 1947

Born/Died 1913–1994

Nationality South African

First Exhibited 1939

Why It's Key A member of South Africa's New Group, Sekoto is considered a master artist who was successful in combining his African heritage with European art styles, and his contribution to the education of young South African artists through the Gerard Sekoto Foundation is immeasurable.

Key Event
The COBRA group is formed

After World War II, the Modernist belief in progress seemed hardly tenable. The Modernist project had culminated, in the view of the COBRA artists, in an irrelevant formalism. They advocated a socially committed figurative art, but rejected Socialist Realism. The name of the group was formed from the first letters of three cities: COpenhagen, BRussels, and Amsterdam. The artists had previously been members of revolutionary experimental groups such as the Surrealist-Revolutionary group from Belgium, the Host group from Denmark, and the Reflex group from the Netherlands. In common with their contemporaries in the *art informel* and Tachisme movements in Europe, and Abstract Expressionism in the USA, they drew on the legacy of Surrealism, which viewed art as a spontaneous, irrational activity, and which explored the subconscious. Unlike these movements, however, they did not fully embrace abstraction.

Influenced by German Expressionism and by artists such as Jean Dubuffet, who imitated "outsider" art – art produced by artists from "primitive" cultures, by children, and the insane – the COBRA group believed that art was not a specialist intellectual activity. Their paintings can be characterized by a lack of formal sophistication, unhindered by aesthetic rules, and enlivened by a rudimentary gestural energy. The COBRA movement lasted three years, but artists such as Constant and Jorn became members of the Situationist International, a revolutionary art movement which aimed to bring together the spheres of art and life, which are separated in bourgeois culture.

Sarah Mulvey

Date November 8, 1948

Country France

Why It's Key The artists Asger Jorn, Joseph Noiret, Constant Nieuwenhuys, Corneille Hanuoset, and Karel Appel, and the writer Christian Dotrement, signed the manifesto *The Case Was Heard* (*La Cause etait entendue*), written by Dotremont, which formed the starting point of the COBRA movement.

Key Artist **Arshile Gorky**
Suicide of Abstract Expressionist pioneer

Arshile Gorky, who had emigrated from Russia to America in 1920, studied in New York and Boston before his first one-man exhibition in Philadelphia in 1934. Like many young artists, he looked to tradition to help solve problems in his work. Unusually for an American painter, he identified Cubism as the latest stage in that tradition, becoming especially inspired by Picasso's studio interiors of the late 1920s, where cage-like structures acted as foils to irregularly shaped organic forms around them. Miró's poetical illusionism was also strongly influential.

In contrast to the abstract still lifes he produced in the prewar years, Gorky also painted portraits of himself, his sister, and of the artist with his late mother, where memory and true-to-life reality were mixed within tensely composed images. A distinct contribution to the art of portraiture, they influenced Willem de Kooning, who shared a New York studio with Gorky at this time. Gorky discovered his mature painting style in the 1940s. He adopted nature as his principal theme, visiting his wife's parents' Virginia farm for inspiration. The *Garden of Sochi* series (1940–43) possibly recalled his father's farm, which, according to local stories, was imbued with mystical powers of love and fertility. Invoking his past released emotional associations into painting which became broadly revelatory of universal feelings that his audience could share. Loosely painted configurations of richly colored biomorphic forms, bounded by wiry contours of varying thickness, were derived from drawings made with the automatic technique.

Martin Holman

Date 1948

Born/Died 1904–1948

Nationality Turkish Armenian (naturalized American)

Why It's Key Gorky's synthesis of abstract painterliness and Surrealist motifs anticipated and pioneered Abstract Expressionism.

opposite Arshile Gorky

Key Artist **Victor Pasmore** Important British figurative painter turns to abstraction

Victor Pasmore showed an interest in painting at school, but with the premature death of his father he was forced to find employment as a clerk. Pasmore attended evening classes at the Central School of Arts and Crafts, becoming a member of the London Group in 1934 and exhibiting at the Objective Abstractions exhibit, though his work at this time was influenced by Henri Matisse and the Fauvists. Pasmore himself made some abstract pictures after the exhibition, but destroyed them.

In 1937, he quit his job, thanks to the financial support of Kenneth Clark, who later described Pasmore as "one of the two or three most talented English painters of this century." With Claude Rogers and William Coldstream, he formed the Euston Road school, which focused on social reality in the manner of the Post-Impressionists. In 1942, he moved to Chiswick and began to paint the River Thames.

In 1948, Pasmore began a dramatic conversion to abstraction. Under the influence of Ben Nicholson and after subsequently reading *Art as the Evolution of Visual Knowledge* by American artist Charles Biederman in 1951, he began to construct abstract reliefs, usually in wood, but sometimes employing plastic and glass. This move was "the most revolutionary event in postwar British art," according to the critic Herbert Read.

Brian Davis

Date 1948

Born/Died 1908–1998

Nationality British

First Exhibited 1934

Why It's Key Seminal turning point in the career of a leading UK abstract artist.

Key Artist **Grace Hartigan** First abstract works significant in the Abstract Expressionist movement

Born in New Jersey, Grace Hartigan briefly studied with local artist Isaac Muse before moving to New York in 1945, where she was profoundly influenced by Jackson Pollock's show of large-scale "drip" paintings in 1948. She quickly became integrated into the Abstract Expressionist scene, befriending artists including Jackson Pollock, Willem de Kooning, and Mark Rothko. Her early works, such as *The Massacre* (1952), are defined by her use of thick black lines, wide brushstrokes, and a general abstract spontaneity, all characteristic of the movement. Exhibitions of these early Abstract Expressionist works in New York during the early 1950s initially attracted attention to her talent.

By the late 1950s, Hartigan had become quite well known, and in 1959 she was the only female artist chosen to participate in New American Painting, an exhibition organized by the Museum of Modern Art in New York that traveled to eight European countries. In 1960, she moved to Baltimore, Maryland, where she currently resides and serves as the graduate director at the Maryland Institute College of Art. While her work has evolved over time as she has explored several styles and themes, ranging from history to modern pop culture, she continues to be one of the pre-eminent American contemporary female artists.

Heather Hund

Date 1948

Born 1922–

Nationality American

First Exhibited 1950

Why It's Key Influential contemporary female artist.

Key Artist **Kenneth Martin** Figurative painter turns away from naturalist style painting

Kenneth Martin became associated with geometrical abstract art after 1950. Under the influence of Victor Pasmore, whose work had already made the transition, he had moved from a naturalist style of landscape painting to images that emphasized elements of structure in the late 1940s, opting for abstraction from 1948. A strong inspiration was the work of Gabo and his brother, Antoine Pevsner, which had virtually dispensed with volume; Martin was attracted to its intrinsic dynamic content. In 1951, he began to apply his interest in intervals and random arrangements to making constructions, using wire or thread, wooden rods, and, later, materials such as copper and brass. By hanging them, he reduced volume and mass to a minimum and suggested weightlessness. The rotation of these open-formed, simple, and typically small mobiles by wind or motors created new, unpredictable spatial forms. Cerebral and composed, his sculptures achieved a taut balance between the stillness of logical arithmetic sequences and infinite kinetic changeability. From 1970, his "random drawings" introduced chance into an otherwise ordered process, to release infinite linear combinations comparable with the twist and movement of his mobiles.

Martin studied at London's Royal College of Art from 1929–32, meeting there Mary Balmford (1907–1969), whom he married in 1930. She was the first "constructionist" to abandon painting for reliefs in 1951. The two often exhibited together, and contributed to the seminal 1956 This Is Tomorrow exhibition.

Martin Holman

Date 1948

Born/Died 1905–1984

Nationality British

Why It's Key Leading figure in British constructivist art, Martin turned from naturalistic landscape painting to abstraction.

Key Artist **Barnett Newman** Beginning of characteristic *Onement* series of paintings

Barnett Newman was born in New York City in 1905, to Russian Jewish immigrants. After attending City College of New York to study philosophy, he worked in his father's clothing business, and started painting in the Expressionist style in the 1930s; however, he destroyed all of these early pictures.

In the 1940s, he began exhibiting pictures in a Surrealist style at Betty Parson's gallery, and in 1948 held his first solo exhibition. His mature style, characterized by areas of color separated by thin vertical lines, which he called "zips," was reached at this time with his *Onement* series. These vertical lines were rough-edged, as though torn or ripped in order to create a sense of tension on the canvas. He also used size for impact, with some of his pictures filling the viewer's vision: *Anna's Light* (1968), named for his mother, is, for example, 28 feet wide by 9 feet tall.

After recovering from a heart attack, Newman painted a series of black-and-white pictures called *The Stations of the Cross* (1958–64), which has been said to be the peak of his achievement. He also made a small number of sculptures, some etchings, and a series of lithographs. It was only as he approached the end of his life that he became properly appreciated.

Alan Byrne

Date 1948

Born/Died 1905–1970

Nationality American

Why It's Key Newman was a leading color field painter who developed a new pictorial form, and was an important influence on many young painters.

Key Artist **Antoni Tàpies** Co-founds Dau al Set, Spanish Surrealist movement

Born in Barcelona, Antoni Tàpies began to produce paintings clearly influenced by Vincent van Gogh while recovering from a lung infection in 1942. He was studying law at Barcelona University, but abandoned his studies in order to paint in 1946. In 1948, he was one of the founders of Dau al Set ("Seven-sided Dice"), a group of Surrealist writers and artists in Spain who were influenced by Joan Miró and Paul Klee. He held his first one-man exhibition in Barcelona in 1950. Traveling to Paris on a French government scholarship, he saw the works of Jean Dubuffet and subsequently began to turn toward abstraction.

His work used a thick impasto, to which he would add chalk, clay, powdered marble, and discarded material such as rags and string. In 1958, he won first prize at the Carnegie International in Pittsburg, and the UNESCO and David E. Bright prizes at the Venice Biennale, securing for himself an international reputation. In his later works, Tàpies began to incorporate larger objects, including mirrors, buckets, silk stockings, and bits of furniture. He also produced sculptures, etchings, and lithographs. The Tàpies Foundation in Barcelona, which opened in 1990, houses some two thousand works by the artist.

Brian Davis

Date 1948

Born 1923

Nationality Spanish

First Exhibited 1950

Why It's Key Best-known Spanish painter to emerge since World War II.

378

Key Artist **Jack Tworkov**
Shares studio with Willem de Kooning

As a painter, Jack Tworkov was one of a generation strongly influenced by Willem de Kooning in the 1950s. His work assimilated the slashing gesture of Abstract Expressionism into more lyrical painting which, while displaying restlessness in bold diagonal brushstrokes and vigorous color, remained controlled and purposeful. In canvases such as *Watergame* (1955), a geometrical structure began to emerge as an organizing principle that eventually led, in the next decade, to gridlike compositions. By the 1970s, Tworkov had introduced the numerical Fibonacci sequence; geometry, he claimed, enabled the painter "to impose calm on myself."

Tworkov attended Columbia University and the National Academy of Design. He met de Kooning around 1935, when both men were involved with WPA art projects. At that time, Tworkov's inspiration came principally from Cézanne, and his figurative style often featured solitary subjects. From 1948–53 his studio adjoined de Kooning's on Fourth Avenue, New York City. But around 1950, in common with several other painters (such as Franz Kline and Philip Guston), he abandoned figuration for abstract styles. By the mid-1950s, he had distanced himself from de Kooning's example and embarked on perhaps the most interesting ten years of production.

Tworkov taught at several art colleges, most notably at Yale, where he became chairman of the art department, and at North Carolina's Black Mountain College, alongside John Cage, Merce Cunningham, and other leading figures.

Martin Holman

Date 1948

Born/Died 1900–1982

Nationality Polish (naturalized American)

Why It's Key Member of the second–generation New York school, and influential teacher.

Key Artwork *Performers*
Max Beckmann

By the age of sixty-four, the German artist Max Beckmann (1884–1950) was approaching the end of his life and was in a highly philosophical mood. *Performers* belongs to his artistic coda, which holds the conviction that life is a masquerade.

Beckmann had long exploited the themes of masking and performance – which he located everywhere from Parisian high society to circus tents – but *Performers* is different. We are allowed to look nowhere other than at its masked man and woman, who are more clearly allegorical than figures from Beckmann's early and middle career. The skull in the woman's right hand is an invocation of all mortality while her feline mask, and the heavily muscled bulk of her male companion, suggest a kind of realization of Beckmann's 1912 idea that modern art ought to construct heroes and gods for contemporary people.

There is undeniable, if weary, humor in the stance of this masked couple, but no way of telling whether the joke is on them or on us. If we eavesdrop on gods, we find that they are something like us in their sly masquerade. If we eavesdrop on fellow humans, we do not know if they are friend or foe, if the skull in the cat-woman's hand and the stick in the blue-masked man's hand are threats, or slapstick paraphernalia. This is, ultimately, the poignant ambiguity that Beckmann leaves. He has achieved no certainty, and the masked couple know it; they are remote from him as well as from us.

Demir Barlas

Date 1948

Country USA

Medium Oil on canvas

Collection Saint Louis Art Museum, Saint Louis, Missouri, United States

Why It's Key This painting at the end of Beckmann's life crystallizes the artist's exploration of the allure of the masked performer as allegorical figure.

1940–1949

379

Key Artist **Willem de Kooning** First solo show of "figurative" Abstract Expressionist

Willem de Kooning was born in Rotterdam, the Netherlands. He left school at the age of twelve and was apprenticed to a firm of commercial artists and decorators, studying art at Rotterdam Academy for eight years. In 1926, he arrived in the United States and worked as a house painter and commercial artist; in 1929, he met Arshile Gorky, who became one of his closest friends. De Kooning began working on the Works Progress Administration Federal Arts Project in 1935 and won the Logan Medal of the Arts working with Santiago Martinez Delgado. In 1937, they both had to resign from the project because of their alien status. He started working on a series of paintings of the male figure in 1938, including *Two Men Standing*, *Man*, and *Seated Figure*, and a series of abstract paintings including *Pink Landscape*. Gradually the two styles began to intermingle, and in 1945 he produced *Pink Angels*, perfectly merging both styles.

Too poor in 1946 to buy artists' pigments, de Kooning made a series of paintings in black and white using house paint, showing these pictures at his first one-man show at New York's Egan Gallery in 1948. By the mid 1950s, he was recognized as being one of the leading Abstract Expressionists. Through the 1960s, his work became almost pure abstraction, although more related to landscape than the human form. His final works, most never exhibited, caused disagreement among critics and have not yet been seriously assessed.

Alan Byrne

Date 1948

Born/Died 1904–1997

Nationality Dutch (naturalized American)

Why It's Key Major Abstract Expressionist who pioneered "new figuration" in New York painting.

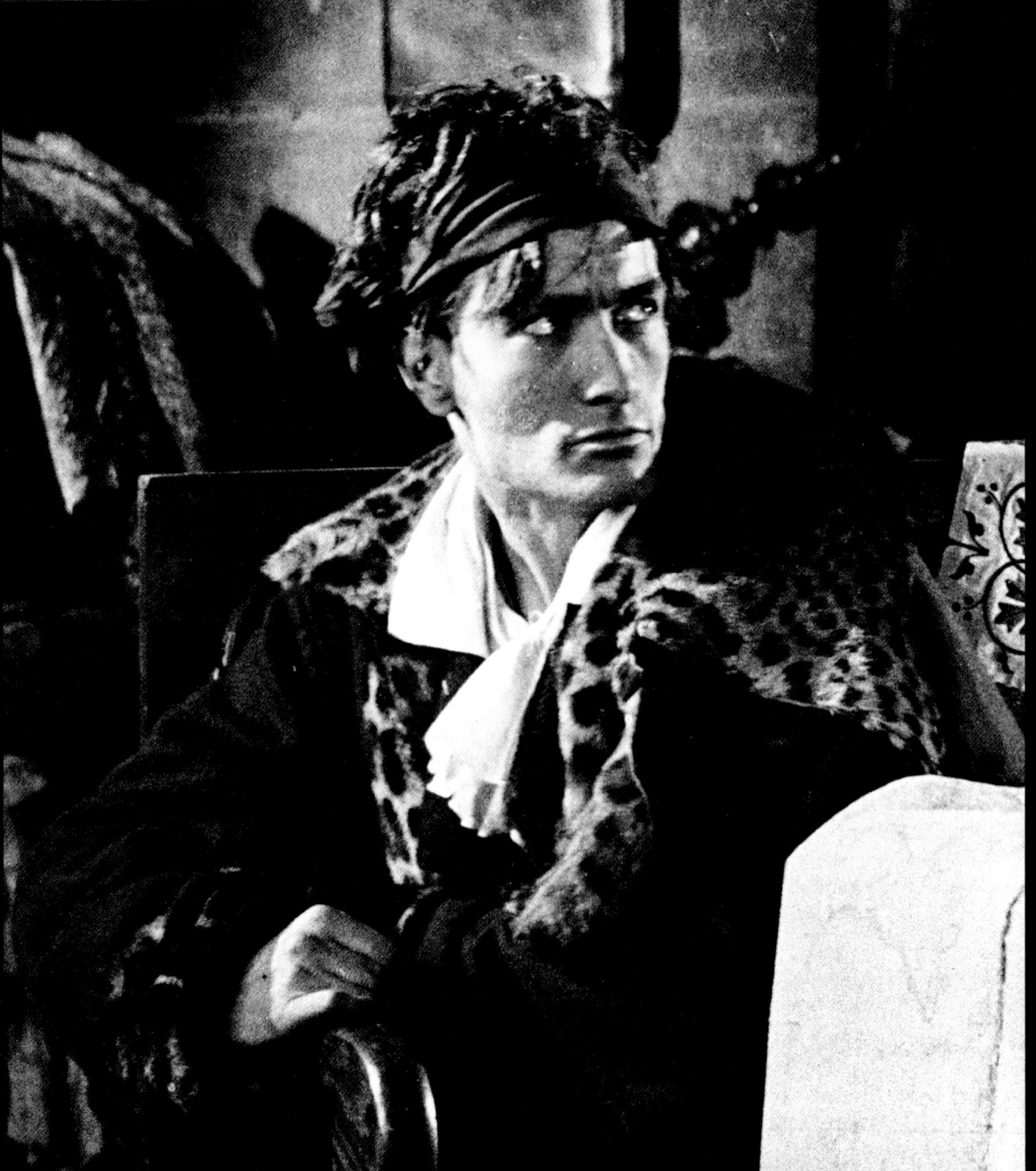

Key Person **Antonin Artaud** Death of influential writer, draftsman, and playwright

Artaud's concept of theater confronted the accepted values of his time and helped to redefine drama. His objective was to reject theater as "representation" by using drama to destroy drama. He advocated a return to primitive rites and ceremonies concerned with human needs and emotions. Dismissing plot and rational language, sounds, stylized gestures, and movements communicated ideas. He attempted to realize these theories in a series of spectacles in the 1930s which Paris theater-goers received with ridicule. The project was called the Theater of Cruelty, a unique style of performance based on cacophony and a visceral impact on the audience. His experiments assured him the status of an inspirational figure in twentieth-century dissident culture, especially among the theatrical innovators and "performance artists" of the 1960s.

Vehemently opposed to the artificial values imposed by a repressive social order, he considered madness as its only alternative and deliberately retreated into psychosis and addiction to release extreme images. An ardent promoter of Surrealism, Artaud's disagreements with Breton led to his expulsion from the movement in 1926. His performances left few material traces and, apart from his writings, his drawings about identity made in the five years before his death remain the most vivid aspect of his work. Encouraged as therapy when he was institutionalized in asylums from 1937–46, many originate in his compulsion to introduce images when written language proved inadequate. They now exert his greatest influence.
Martin Holman

Date 1948
Born/Died 1896–1948
Nationality French
Why It's Key Theories marked radical departure in thinking about theater.

opposite Antonin Artaud

1940–1949

381

Key Artwork *Christina's World*
Andrew Wyeth

The year 1945 was a powerful turning point for Andrew Wyeth (b.1917). His father, the illustrator N. C. Wyeth, was killed along with a small grandchild when their car stalled at a railroad crossing in Chadds Ford, Pennsylvania. The tragedy had a profound impact on the young Wyeth. He had already achieved commercial and critical success as a precocious and well-connected emerging artist. Now he felt the need to do something more meaningful with his talent and training. Wyeth was fortunate to discover that he could channel some of the emotion associated with grief into his art. His perception of the landscape took on a completely different quality. A hillside became a portrait of his father in *Winter* (1946). A boy was seen to be running down it, through light and shadow.

Wyeth's wife had first introduced him to her long-time friend Christina Olson, crippled by polio in childhood, during the summer she and Wyeth were married. Olson's weather-beaten clapboard house in Maine had made an indelible impression on the artist. After his father's death, Andrew was drawn back to Maine and to Christina's house. He set up his painting studio in one of the rooms. Wyeth admired the power and beauty of Christina's transcendent personality and values. She had overcome adversity. In 1948, he portrayed her pulling herself up a hillside from her family's cemetery toward her weathered home. Christina was wearing a pink dress. It was to become one of the most familiar images in twentieth-century American painting.
Carolyn Gowdy

Date 1948
Country USA
Medium Tempera and gesso on panel
Collection Museum of Modern Art, New York
Why It's Key Andrew Wyeth's most famous work and one of the best-known images in twentieth-century American art.

Key Artwork *The Cry of Freedom*
Karel Appel

A s reconstruction took place after World War II, the Dutch artist and writer Constant Nieuwenhuys warned in his 1948 *Declaration of Freedom* that artists needed to break free of the vestiges of the existing culture in order to produce a revolutionary art. Constant's *Declaration* became the basis of the COBRA group's manifesto. The group's members were optimistic that a new experimental collaborative art that would cross international boundaries would emerge from the ruins of a devastated Europe. They looked to the art of the outsider – for example, tribal art, children's art, and the art of the insane, as a way to realize this freedom.

The Cry of Freedom, painted by Karel Appel (1921–2006), could be interpreted as fulfilling this desire. The hybrid fetish-like figure in this painting, part human, part animal, is painted crudely, with bright unmodulated colors. There is no attempt to analyze space, light, and form from an illusionistic, decorative, or conceptual standpoint. It has the appearance of a child's painting. It is not, however, wholly without artistry; it betrays a sophisticated aesthetic, revealing the influence of the German Expressionists in its use of roughly applied bold colors and Picasso's allusions to the "primitive." These references suggest that the task of bypassing the heritage of Western art and entering a state of unmediated creativity, even when reproducing the immediacy and ungainliness of a child's painting or the ritualistic singularity of a tribal fetish, could not be realized because the "primitive" or child art had already become symbolic and therefore conventional.

Sarah Mulvey

Date 1948

Country The Netherlands

Medium Oil on canvas

Collection Stedelijk Museum, Amsterdam

Why It's Key Karel Appel painted this work in the same year that the COBRA group was formed.

382

Key Artwork *Peinture (Painting)*
Pierre Soulages

S oulages (b.1919) resumed painting after the war when he went to live in Paris in 1946. He started to use black predominantly in his paintings and to investigate its potential as an expressive color with reflective qualities. He distanced himself from the fine art tradition by using decorators' paint, such as the walnut stain used on furniture, large brushes, and other common painting tools. By 1948 he had developed an experimental approach, which is evident in a work such as *Peinture* of that year. Without any preconception of the final look of the painting, Soulages laid wide, vigorous brush strokes onto a large canvas. The size of the canvas required the involvement of the whole body in order to complete the painting in one continuous, spontaneous performance.

Despite the unplanned nature of the execution, the controlling presence of the artist is evident; the painting is highly structured, the upright precise strokes of opaque black paint reflecting the verticality of the support and creating a rhythmic and spatial dynamic. For Soulages the intuitive, physical act of applying paint constituted the essence of the work.

Along with Hans Hartung, Georges Mathieu, and Gerard Schneider, Soulages produced abstract works that adopted a calligraphic approach, influenced by the automatic drawing of the Surrealist artist André Masson, and by the expressive potential of oriental calligraphy. First used in 1951, the term Tachisme (staining) describes the work of these artists and others for whom the gesture is paramount.

Sarah Mulvey

Date 1948

Country France

Medium Walnut stain on canvas

Collection Museum of Modern Art, New York

Why It's Key In 1948, Soulages contributed to the influential Französische Abstrakter Malerei exhibition and to the HWPSMTB exhibition which also showed practitioners of *l'art informel*.

opposite *Peinture*

Key Artwork *The Drinker*
Bernard Buffet

In 1948, the young French artist Bernard Buffet's (1928–1999) *The Drinker* (*Le Buveur*), sometimes called *The Sitting Drinker*, epitomized the crisis of modern France – at once urbanized, lonely, deprived of its communal Napoleonic mission, and witnessing the inexorable decline of France as a colonial power. *The Drinker* is a stark, angular painting of a stark, angular man at a table. The man, like France, has become too small for his suit, and stares away from his table on which a denuded glass, bottle, and plate keep themselves company. The repast is over, and the man does not know – perhaps is tormented by – what happens next. This pose echoes not only the philosophical ambiguity of existentialism, in which humans enjoy a terrible freedom to go in any direction they choose, but also the historical indeterminacy of France in Bernard Buffet's time.

The Drinker was acquired by the prolific collector Maurice Girardin in 1948. It proved to be one of the elderly doctor's last acquisitions, as he died three years later and willed the painting to the Paris Museum of Modern Art, in the permanent collection of which it remains. Buffet, who was only twenty when he painted *The Drinker*, went on to have a rich career and died in 1999. *The Drinker* might have seemed overly sentimental in the context of a post-painterly post-figurative artistic environment, but France was still very much concerned with what it was, what it had lost, and what it might be – all concerns engaged directly, if grimly, by Buffet.

Demir Balas

Date 1948

Country France

Medium Oil on canvas

Collection Musée d'Art Moderne, Paris

Why It's Key Early evocative work by Buffet, whose later more successful output became gradually more stylized.

Key Artist **Jean Dubuffet**
Forms the Compagnie de l'Art Brut

Born in Le Havre, France, Dubuffet studied academic painting in Paris, but grew discontented with what he saw as the artist's privileged position in society. In 1924, he gave up painting and made his living as a wine merchant until the age of forty-one, when he quit and returned to art. Dubuffet began to exhibit, and quickly drew the attention of critics and intellectuals. Then, influenced by Hans Prinzhorn's book *Artistry of the Mentally Ill*, Dubuffet outlined the theory that the work of professionally trained artists was intrinsically inferior to the raw emotion expressed by children, criminals, and the mentally ill, coining the term *art brut* ("raw art") for the untutored art he began to collect.

In 1948, he formed the Compagnie de l'Art Brut, the aim of which was "to seek out the artistic productions of humble people that have a special quality of personal creation, to create a taste for it and encourage it to flourish." Dubuffet organized exhibitions such as L'Art Brut préféré aux arts culturels, held in Paris in 1949, which featured two hundred works by sixty-three artists. His own work became increasingly childlike, incising crude images into a thick impasto made of ashes, sand, and gravel, bound with glue and varnish. In 1972, Dubuffet presented his own collection of *art brut*, comprising more than five thousand items, to the city of Lausanne, Switzerland, where they are on display in the Château de Beaulieu.

Brian Davis

Date 1948

Born/Died 1901–1985

Nationality French

First Exhibited 1944

Why It's Key Dubuffet promoted the idea that anyone could produce art.

Key Artist **Ernest Mancoba**
Shows in Host COBRA exhibition, Copenhagen

Ernest (also spelled as Ernst) Mancoba was born in the Johannesburg area of South Africa. He studied art at the University of Fort Hare and established a reputation in the 1930s for combining African and Western norms of iconography and aesthetics in both ecclesiastical and secular works. Carved of indigenous yellow wood, Mancoba's controversial barefoot *African Madonna* (1929) is perhaps the first non-European depiction of the Holy Virgin. Mancoba's greatest influences were sculptors Lippy Lipshitz and Elza Dziomba, who encouraged him to leave South Africa. In 1938, Mancoba emigrated to France. He became a citizen and remained in Europe for the rest of his life.

Over time, Mancoba turned toward painting, drawing, and printmaking. His first oil painting, *Composition*, was completed in 1940. Mancoba became known for his intense colors, emphatic brushstrokes, and unique ornamentation. *Tegning*, a pen-and-ink drawing (c. 1940), is considered an important and unique example of twentieth-century imagery. In 1948, Mancoba joined Karel Appel and Asger Jorn Constant in founding the influential art group COBRA, named after three European cities where the main participants lived: Copenhagen, Brussels, and Amsterdam. The COBRA artists continued to have a major influence on artists of the latter half of the twentieth century. In 1994, Mancoba returned to South Africa to attend Hand in Hand, a retrospective exhibition of his work. He died near Paris in 2002, and his son returned his father's ashes to Dunswart, South Africa.

Elizabeth Purdy

Date 1948

Born/Died 1904–2002

Nationality South African (naturalized French)

First Exhibited 1934, All African Convention, Bloemfontein, South Africa

Why It's Key Mancoba brought the prevailing African and Western styles together in his ecclesiastical and secular works, and his *African Madonna* (1929) has continued to inspire the African people and other artists.

Key Artist **Zainul Abedin** Helps found Institute of Fine Arts in Dhaka, Bangladesh

While the Indian province of Bengal made vital contributions to the Indian subcontinent's art and culture during the British Raj, it was not until 1971 that it achieved independence as Bangladesh. The state of Bangladesh, however, received a head start in terms of its ability to nourish artistic talent with the founding of the Institute of Fine Arts on the campus of Dhaka University (then part of East Pakistan) in 1948. The Bengali artist Zainul Abedin played an important role in this founding. Abedin, a Bengali born in India in 1914, was something of a prodigy, having been invited to teach at the Government School of Art in Calcutta while himself a student. In 1938, the year of his graduation, Abedin's work was exhibited in London, and the artist went on to achieve considerable exposure abroad.

Abedin's heart, however, was very much in his native Bengal. In 1948, dismayed by the lack of a viable art scene in Dhaka, Abedin took the initiative of proposing – then serving as principal of – the Government Institute of Arts and Crafts, later renamed the Institute of Fine Arts. The institute went on to nurture and promote a host of Bengali artists, many of whom were influenced by Abedin's stark, folksy modernism. While Abedin soon left his administrative role at the Institute of Fine Arts to travel abroad and renew his creative activity, he remained bound in spirit to the school and was buried close to it upon his death in 1976.

Demir Barlas

Date 1948

Born/Died 1914–1976

Nationality Bangladeshi

First Exhibited 1938

Why It's Key An important incubator of Bangladeshi art got its start before Bangladesh itself became independent.

Key Artwork *Reform and Fall of Empire*
Jose Clemente Orozco

Jose Clemente Orozco (1883–1949) was described as a Socialist Realist in much the same way as his compatriot Diego Rivera. However, Orozco's canvas was larger than socialism or reality. In the 1948 mural *Reform and Fall of Empire* (also known as *Juarez*), Orozco provided a fiery summing up of the two themes that had transfixed him since the 1920s: the revolutionary potential of Mexico and the hideousness of coercion, whether economic, religious, or military.

In *Reform and Fall of Empire*, Orozco depicts Benito Juarez (1806–1872), founder of the Mexican Republic, as floating above a sea of crushed faces belonging to imperial Mexico. Here lies all the detritus of empire, swept underfoot not only by the floating Juarez but also by the citizen-soldiers of Mexico. These are indigenous faces while the faces of empire are pomaded foreigners or, as in the case of Catholic figures, monsters. The scene's passion tempers its tendentiousness; it is as if we can see the honest face of its creator staring back at us through Juarez.

For his part, Juarez was a recurring personage in Orozco's late work; *Juarez Reborn* (1948) addresses many of the same themes as *Reform and Fall of Empire*. The rich ambiguity of these works lies in their ability to espouse popular revolution while embracing Juarez as supernatural savior. *Reform and Fall of Empire* transcends the doctrinaire tediousness of Socialist Realism and succeeds in depicting a national scene with national spirit, which was the hallmark of Orozco's best work.

Demir Barlas

Date 1948

Country Mexico

Medium Mural

Collection Museo Nacional de Historia, Mexico City, Mexico

Why It's Key This is a major work by a leading Mexican political muralist.

opposite *Reform and Fall of Empire*

Key Artist **Mark Rothko**
Major abstractionist initiates his classic style

Mark Rothko was born in Dvinsk, Russia. He emigrated with his Jewish family to the United States in 1913, enrolling at the Art Students League in 1925. From 1929–52, he taught art at the Brooklyn Jewish Center. His "multiforms," produced from 1946–49, form a transition between the "biomorphics" of the early 1940s which drew upon Surrealism and the mythic symbolism found in "primitive" and archaic art, and the classic works. While abandoning any figurative element, Rothko denied that his paintings were abstract, and explained that he was not interested in the formal elements of art; his was a transcendental art, based on fundamental human emotions.

At the same time as Rothko's reputation was growing, as part of the emerging New York art scene in the early 1950s, he was increasingly disturbed by perceived misconceptions of his art. The emotional energy that was invested in the process of painting, allied with his mistrust of unsympathetic viewers, especially critics, encouraged Rothko to control the way in which his paintings were received, directing the hanging and changing the lighting conditions of an exhibition, as if it were a theatrical production. In the late 1950s, Rothko introduced darker colors into his work. His installation in the Rothko Chapel, in Houston, Texas, shows the darker hues and hard edges as a response to the abstraction of painters such as Frank Stella and Ad Reinhardt, and a preoccupation with death. Increasing alcohol intake and bouts of depression marked these later years. He committed suicide in 1970.

Sarah Mulvey

Date 1949

Born/Died 1903–1970

Nationality Russian (naturalized American)

Why It's Key Rothko initiated a process of painting that he developed into his classic style: large-scale canvases on which horizontal bands and rectangles of scumbled color hover over, and touch, the monochrome spaces in between, and which involve the viewer in their totality. They were first shown in 1950, at the Parson Gallery.

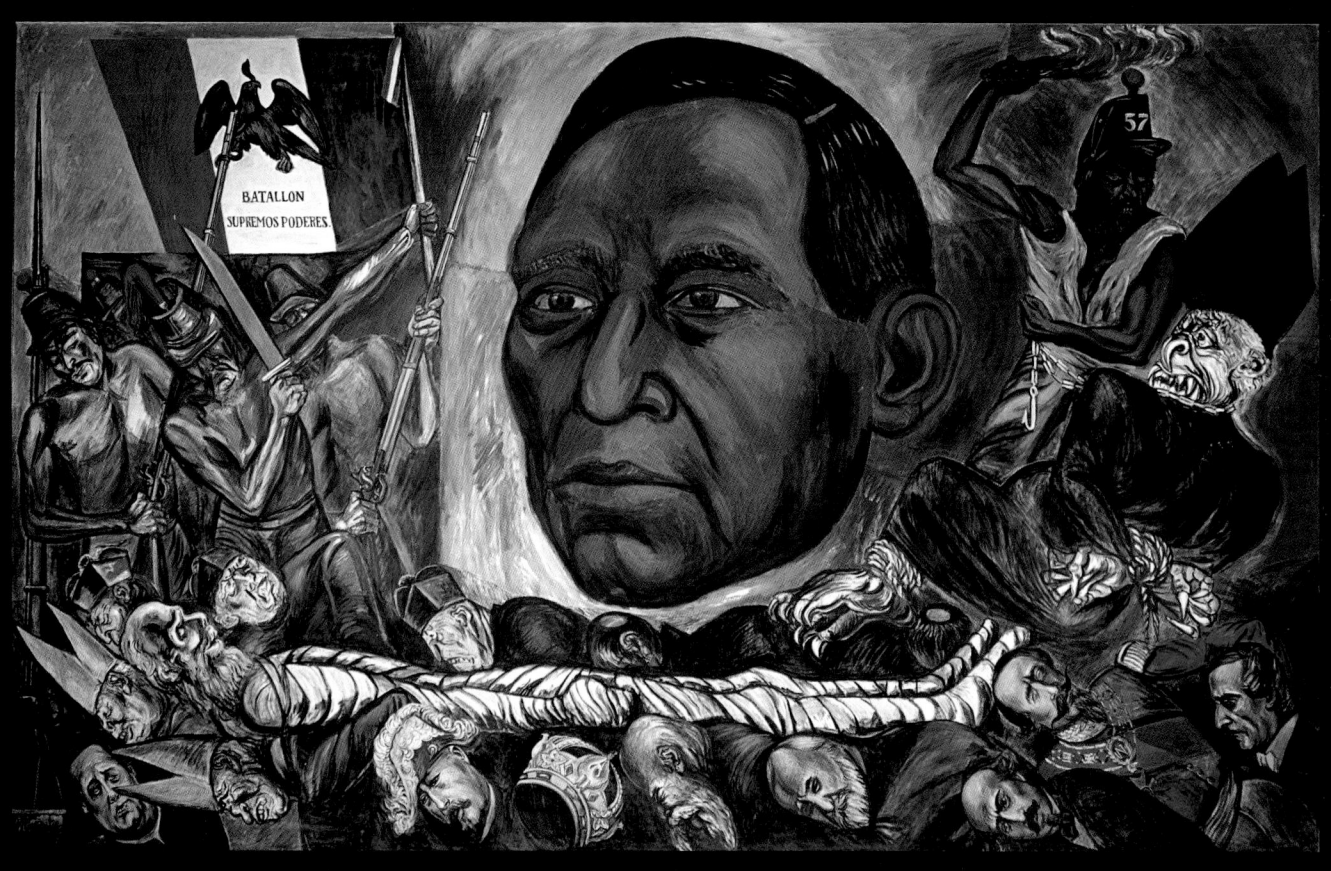

Key Exhibition
Third Sculpture International

Organized by the Fairmont Park Art Association at the Philadelphia Museum of Art, far from New York's infamous hotbed of art activity, the Third Sculpture International exhibition from May–September 1949 was nevertheless a seminal groundbreaking event which exposed the international mass media to avant-garde sculpture. Among the 250 sculptors from around the world whose works were installed in the museum and surrounding outdoor areas were such significant figures as Jacop Epstein, Jacques Lipchitz, A. A. Weinman, Alexander Calder, and Pablo Picasso. Calder's 20-foot-high *International Mobile*, designed to be the centerpiece of the exhibition, still hangs in the location where it was placed in 1949.

In an era when art was still a relatively esoteric subject, *Life* magazine ran a major picture spread in its June 20, 1949, issue featuring a photograph of seventy of the sculptors, taken on the interior staircase of the museum, accompanied by images of many of their works. Although the most famous members of the exhibition were present in the photo, some of the participants remain unidentified, and scholars still search for the names of the anonymous participants. What is known for certain, however, is that the exhibition's scope and significance in the history of sculpture remain unrivaled.

Ana Finel Honigman

Date May–September 1949

Country Museum of Art, Philadelphia, USA

Why It's Key First high-profile exposure of international modern sculpture.

opposite The sculptors posing for a group picture during the International Third Sculpture.

1940-1949

388

Key Artist **Jackson Pollock**
article appears in *Life* magazine

On August 8, 1949, a four-page spread on Jackson Pollock in *Life* magazine asked its twelve million readers: "Is he the greatest living painter in the United States?" It failed to proffer an answer, and the article was far from supportive of the key figure in action painting, but the exposure made Pollock's name and fixed it in the public conscious. Pollock's blue jean, brawling alcoholic cowboy pedigree was something with which a lot of ordinary Americans could identify.

Pollock was introduced to the use of liquid paint in 1936 by the Mexican muralist David Alfaro Siqueiros. He later used paint-pouring techniques on canvases during the early 1940s. Moving to Long Island, with cash help from Peggy Guggenheim, he developed what was later called his "drip" technique – which required paint with a fluid viscosity. Pollock used the then-new synthetic resin-based paints made for industrial purposes, cheaper than artist's oil paints. His major works were between 1947 and 1950, but he denied these were "accidental," claiming that it was about body movement, the flow rate, and the way paint was absorbed into the canvas.

In the summer of 1950, Hans Namuth took more than five hundred seminal photographs of the artist in action. The pressure of this intrusive session allegedly tipped the unstable artist back into alcoholism. Six years later, following days of binge drinking, Pollock drove his Oldsmobile 88 into a tree and was killed. That year (1956) *Time* magazine printed the now famous "Jack the Dripper" article, describing Pollock's unique painting style.

Mike von Joel

Date 1949

Born/Died 1912–1956

Nationality American

Why It's Key The combination of media exposure and the explosive photographic image created the first American "superstar" artist – an art world equivalent of James Dean.

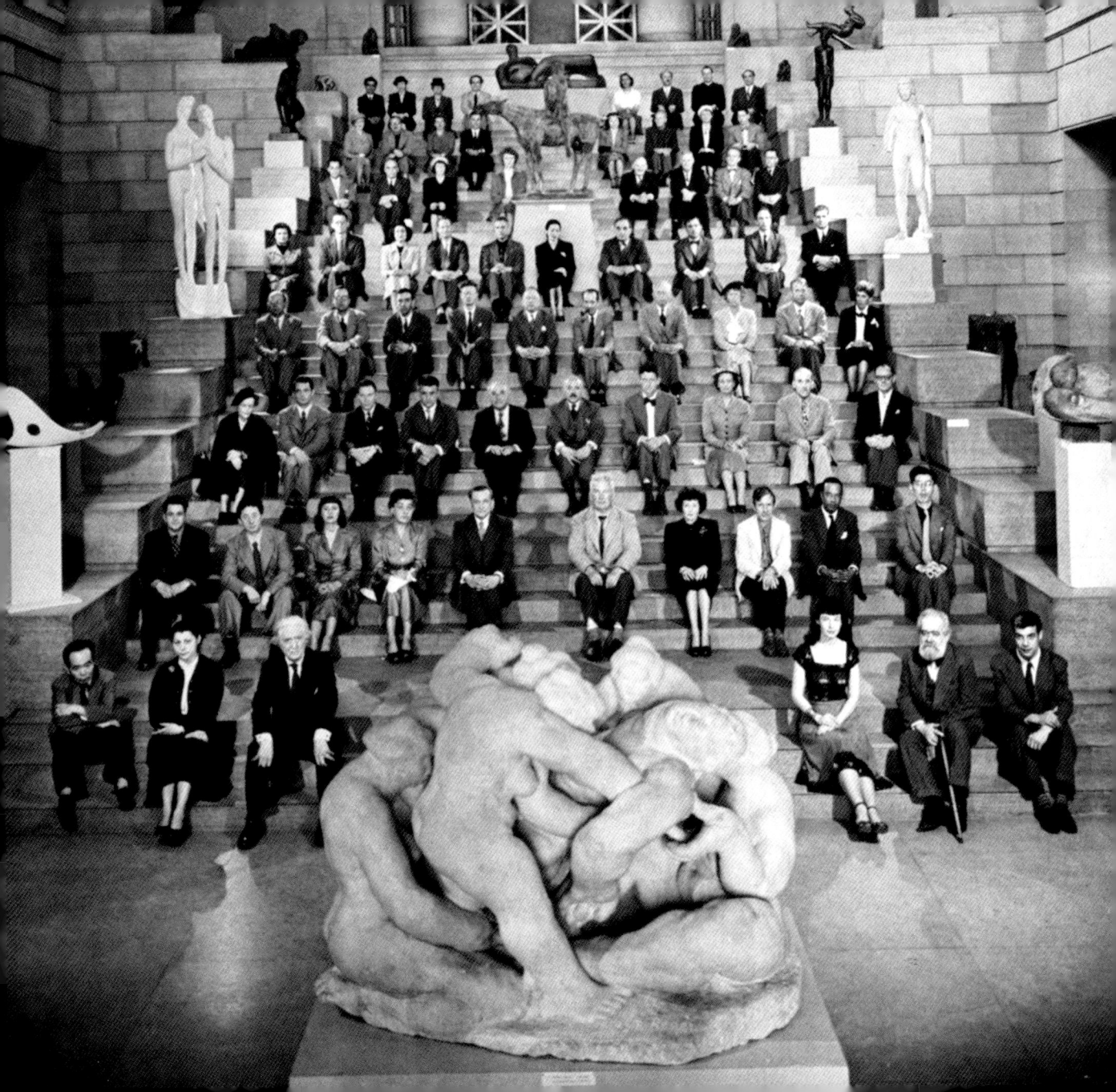

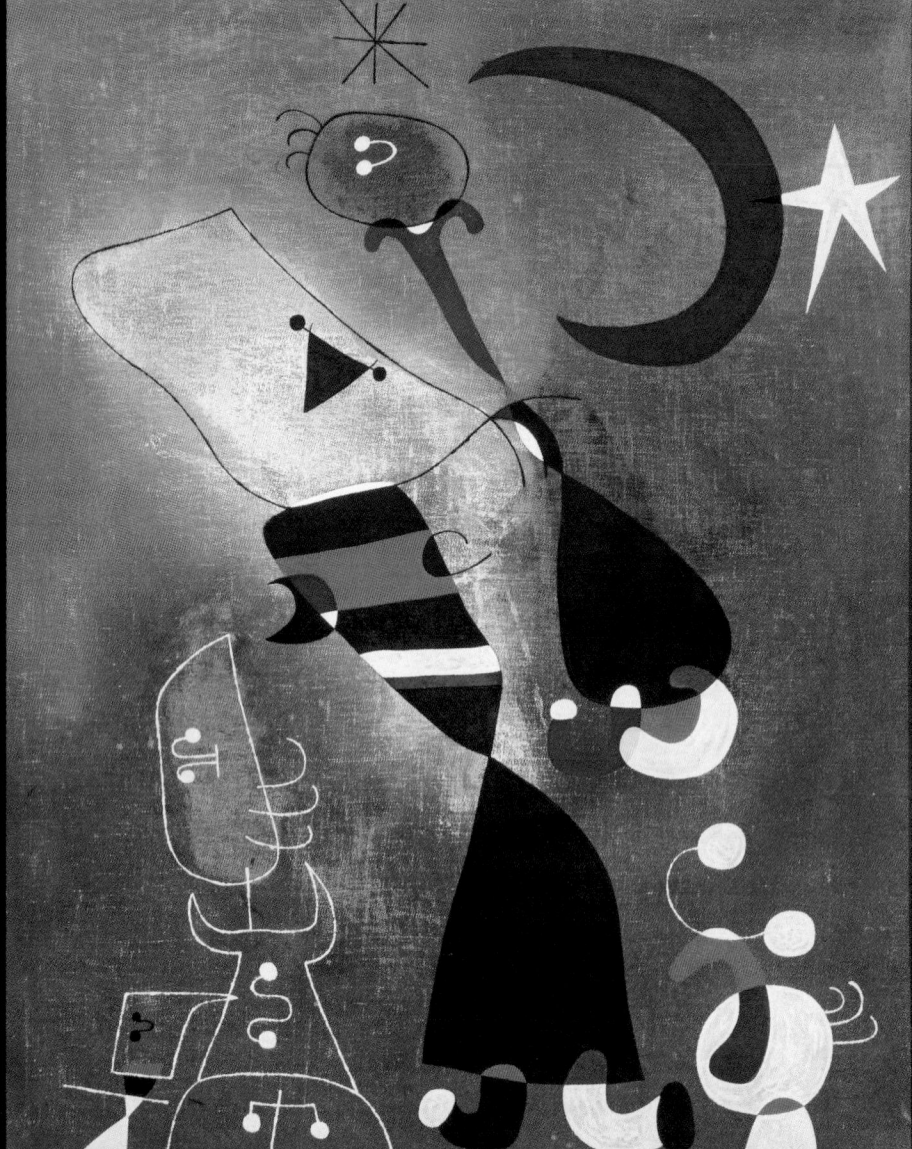

Key Artist **Jacques de la Villeglé** Begins his *décollage* works, peeling posters off walls

In 1947, on a beach in Brittany, Villeglé picked up pieces of barbed wire and metal, considering them to be sculptures even though no artist's hand had shaped them. Such appropriations of anonymous fragments of reality would become the hallmark of his *nouveau réaliste* work. When, in 1949, his art school friend Raymond Hains shot an experimental film showing torn posters on the walls of Paris, the two artists started collecting these urban images on which passers-by had left their trace. For Pierre Restany, founder and theorist of *nouveau réalisme*, Villeglé thus became "the great archivist" of the urban art of his time, and of its mass-communication language.

For Villeglé, these posters were all the more precious as they had been pasted, then partly torn or lacerated, by anonymous hands. At a time when the Parisian art scene was dominated by the grand gestures of Lyrical Abstraction, Villeglé chose not to add new images, but to recycle existing ones. The artist-*flâneur* was to explore the city, selecting frames, almost like a photographer. But whereas Duchamp dismissed aesthetic "retinal" qualities, Villeglé's choice of readymade pictures was guided by color or word content, and was to have a social relevance: "laceration is for me a primal gesture, it's a guerilla of pictures and signs (...) The torn posters were a way of bringing art closer to life." Not until 1957 did Villeglé and Hains exhibit these works, at Colette Allendy's gallery. Meanwhile, Alain Dufrêne in Paris and Mimmo Rotella in Rome were tackling similar subject matter.
Catherine Marcangeli

Date 1949

Born 1926

Nationality French

Why It's Key A major player in the *nouveau réaliste* movement with his "found" urban artworks.

Key Artwork *Women and Bird in the Moonlight* Joan Miró

André Breton, the so-called Pope of Surrealism, once described Miró as the most Surrealist of painters. Despite Miró's refusal to officially join the Surrealist movement, which he circumnavigated for decades, his *Women and Bird in the Moonlight* demonstrates why Breton made that comment, and why Miró received nearly universal praise from his modernist and avant-garde contemporaries.

Women and Bird in the Moonlight is distinguished by Miró's dreamlike amoeba-shaped people, sharp bright colors, and subconscious whimsy. The women and bird of its title stand underneath a crescent moon and a star; a dog is at their feet. It is an automatic and playful tableau, but one that posits a complex harmony between the celestial, human, and animal spheres.

One of the chief debates surrounding Miró has been about his place within modernity. *Women and Bird in the Moonlight* is an excellent gateway into that discussion, as the painting seems to contain distinctly modernist affects (it is hard not to think of a depoliticized *Guernica* in light of the bottom left of *Women and Bird in the Moonlight*) while seeming to skirt or bypass any commitment to modernist notions of progress, analysis, and politics.

Women and Bird in the Moonlight, despite its high degree of abstraction, is a premodern painting in the skin of modernism, which is one of its many puzzles and delights. It represents a kind of poetry and innocence that became rare in a time of painting that was jaded by war and beguiled by analysis.
Demir Barlas

Date 1949

Country France

Medium Oil on canvas

Collection Tate Gallery

Why It's Key Miró's painting is a catalyst for the debate around the artist's place within modernity, while earning the high praise of his modernist and avant-garde contemporaries.

opposite *Women and Bird in the Moonlight*

Key Artist **Auguste Herbin**
Publication of *Non-Figurative Non-Objective Art*

Born in Quievy, Nord, Auguste Herbin studied drawing at the Ecole des Beaux-Arts in Lille before settling in Paris in 1901. Although he was initially influenced by Impressionism, he gradually became more aligned to Cubism after he met Picasso, Braque, and Gris, with whom he shared the Bateau-Lavoir studios in Montmartre in 1909. Herbin was exhibited in the Salon des Indépendants in 1910, and held his first one-man exhibition at the Galerie Clovis Sagot, Paris, in 1912. After briefly turning back to a more figurative style of landscapes and portraits, Herbin embarked on abstraction in 1926, cofounding the artist association Abstraction-Création. From 1938, an interest in the Italian Trecento led to a strictly two-dimensional painting style with simple geometric forms, and, in 1946, Herbin developed the "alphabet plastique," a compositional system based on the structure of letters.

In 1949, Herbin invented a system of abstract painting and his own theory of color, which he set out in the treatise *Non-Figurative Non-Objective Art*. Based on Goethe's theory of color and Rudolf Steiner's theosophical thought, the treatise described the creative force behind Herbin's recent works, articulating a vocabulary that was distanced from any type of formalism. In 1953, he became paralyzed on his right side, which forced him to paint with his left hand. Nevertheless, his architectural approach and positive colors greatly influenced subsequent abstract painters and brought him continued international success until his unexpected death in Paris in 1960.

Mariko Kato

Date 1949

Born/Died 1882–1960

Nationality French

First Exhibited 1910

Why It's Key Renowned French painter publishes an influential treatise on abstract art.

Key Artist **Asger Jorn**
Features in Experimental Art exhibition

By co-founding COBRA in 1948, Asger Jorn demonstrated his commitment to collaboration, through exhibitions, murals, and a journal. Wide enquiry was the root of his practice, and it encompassed philosophy and theory, as well as painting, sculpture, printmaking, ceramics, weaving, and writing. Imagination, he claimed, could mitigate humankind's alienation, and popular culture was an influence on his work, as were inartistic materials and graffiti. They fueled a career characterized by experiment and polemic to advance the critique of everyday life. After a period of study with Léger and Le Corbusier, he adopted Surrealist ideas, which developed into a linear technique reminiscent of automatism. His style into the 1950s was neither figurative nor abstract; it featured the liberated subjectivity common among the postwar European avant-garde, with scrawling marks of free, organic expressiveness and mythical heads.

Resident in Paris and Italy after 1954, from 1957 Jorn was the central artist of the Situationist International. The period up to 1961 when he withdrew to the group's margins produced many of his most powerful images, including, from 1959, the *Modifications*. Using kitsch bourgeois portraits and decorative landscape paintings scavenged from flea markets, Jorn overpainted them with primitivist figures, COBRA-like gestures, and slogans. Much critical speculation surrounded Jorn's comment of the time: "Painting is over. You might as well finish it off. Detourn. Long live painting."

Martin Holman

Date 1949

Born/Died 1914–1973

Nationality Danish

Why It's Key Artist and writer who co-founded the avant-garde group COBRA and the Situationist International movement.

opposite Asger Jorn

Key Artwork *Covenant*
Barnett Newman

In his own words, this painting represents the quest by Barnett Newman (1905–1970) to produce an image that would represent "the mysterious sublime rather than the beautiful." Newman's take on the concept of the sublime was derived from that of philosopher Edmund Burke (1729–1797). According to Burke, the sublime was a contemplation of vastness, infinity, and power of such tremendous proportions that its conception was enough to inspire terror and a sense of insignificance in the beholder. With this in mind, Newman intended for the grand scale of his canvas to completely envelop and awe the viewer.

The painting has two basic elements: a large area of pure and unmodulated color and two interspersed vertical columns of brown and yellow. Together, the two components are meant to convey the transcendental and poetic awakening of humankind. In this and other artworks, Newman sought to symbolize the feeling of terror and amazement felt by the first *Homo sapiens* in the moment he conceived of the world around him from a solitary vertical standpoint, rather than on all fours. The upright stance of this first human represents humankind's evolution from an animal state of spiritual darkness toward an astonishing awareness of the cognitive realm. The columns therefore visually embody all the knowledge humans would eventually gain beyond the boundaries of the physical world. *Covenant* stands as a conceptual expression of the power of knowledge, and humankind's tragic state of self-awareness.

Amelia George

Date 1949

Country USA

Medium Oil on canvas

Collection Washington Hirshhorn Museum and Sculpture Garden, Smithsonian Institution

Why It's Key The painting is a prime example of Newman's conception of the mysterious sublime and Abstract Expressionism's search for a primordial image.

Key Artist **Walter Battiss** Leading South African abstract painter meets Picasso

Walter Battiss was born in Somerset East, South Africa, in 1906. As a teenager, he became interested in archaeology and in primitive art. His art education began in 1929 with a short drawing course at a technical school and evening painting classes. In 1931, Battiss began taking etching classes with Emily Fern while studying to be a teacher. He developed an avid interest in rock art. In 1938, Battiss met painter Abbe Henri Breuil and became a co-founder of the New Group. Battiss was also a respected art critic, publishing his first book, *The Amazing Bushman*, in 1939.

By the 1940s, Battiss' work had begun exhibiting a religiously symbolistic character. In 1944, copies of Battiss's rock paintings were exhibited in Johannesburg, helping to raise the legitimacy of this art form. In 1948, Battiss lived among the Bushmen of the Namib Desert and won a bronze medal at the International Olympiad Exhibition. While on a trip to Europe in 1949, Battiss met and became friends with Picasso, who is considered a major influence on his innovative, whimsical style. Battiss' work of the 1950s reflected the influence of Ndebele beadwork. In 1954, his first exhibition outside his homeland was held in Lourenço Marques, Mozambique. Battiss continued to experiment, using palette-knife color mixing in combination with sgraffito delineation of forms. After his retirement from academic life, Battiss focused on his fictional "Fook Island." The concept derived from this thoroughly developed world earned an international following. A museum bearing Battiss' name was opened in his birthplace in 1981.

Elizabeth Purdy

Date 1949

Born/Died 1906–1982

Nationality South African

First exhibited 1927, Masonic Hall, Rustenburg, South Africa

Why It's Key Influenced by his friend Picasso, Battiss, known for his woodcut and abstract oil paintings, is considered by many to be the foremost South African painter of the twentieth century.

opposite *Mapungubwe* by Walter Battiss.

Batters

Key Artwork *Homage to the Square*
Josef Albers

American artist Josef Albers (1888–1976) loved color. He introduced it to the square, and there was immediate chemistry. *Homage to the Square*, the first in 1949, became the title for a series which would span nearly three decades and countless variations. No two squares were ever the same. Albers chose a format and approach that were as impersonal and dispassionate as possible. The square was ideal. Albers wanted to give the colors a neutral space to breath. He then took himself out of the equation, stepping back to observe.

Albers was fascinated by the way various colors behave when placed side by side. When processed by the human eye, color combinations could project anything from opposition to a magnetic attraction. They could even create optical illusions. Like a scientist in a laboratory, Albers experimented relentlessly with color relationships. He found he could make colors sing or bounce off one another, producing an aura in the form of a radiant glow. Albers was like a light worker, uniting disparate voices from across the entire spectrum. He became sensitive to every whisper, aligning his squares to timeless and elemental systems. Color found an abstract voice in the sky, the earth, the sun, the seasons, the before and after, the never before. In color, Albers had found a kind of sacred energy.

Carolyn Gowdy

Date 1949

Country USA

Medium Oil on masonite

Why It's Key In the series entitled *Homage to the Square*, Albers used the minimum of tools to play with relationships between color and space. He posed questions about perception. Squares were the ideal shape and proportion into which to superimpose his colors.

opposite *Homage to the Square*

1940–1949

397

Key Artist **Sam Francis**
Settles in Paris

Sam Francis began to paint while recovering from spinal tuberculosis after a crash landing during wartime service in the US Army Air Corps. He received tuition from figurative painter David Parks and was impressed by El Greco's work on his first museum visits. His first abstract painting was made in 1947, and in 1948–1950 he studied art at Berkeley, the university he had attended as a medical student from 1941–1943. Initially indebted artistically to Arshile Gorky, Mark Rothko, and Clyfford Still, Francis's own style of one-color corpuscular shapes in a fluid painterly application was emerging by 1950 when he moved to Paris to attend the Académie Fernand Léger. There his light palette intensified into combinations of blues, reds, and blacks, especially after summers spent in Aix-en-Provence. His painting also acquired distinctive calligraphic rhythms, partly in response to the contemporary French style of *l'art informel*. His first solo show occurred in Paris in 1952, and New York's Museum of Modern Art made two important purchases in 1955. In 1956–1957, he executed his first major mural, at the Basle Kunsthalle.

A world trip in 1957 led to significant stylistic developments and his discovery of affinity between Japanese aesthetics and the process of abstract painting. It inspired thinner paint textures, printmaking, and lyrical compositions where colored forms were compressed to the canvas edge by extensive areas of white. Inspired by Oriental mysticism, Francis explored these spaces further for expressive potential in huge works executed, often with rollers, on the studio floor.

Martin Holman

Date 1950

Born/Died 1923–1994

Nationality American

Why It's Key A vital link between European Tachisme and American abstract expressionism early in his career, Francis later became attuned to Japanese aesthetics.

Key Artist **Franz Kline**
First one-man show, New York

Both Willem de Kooning and Jackson Pollock regarded Kline as the "purest" of the Abstract Expressionists because his radicalism was not encumbered by the history of modernism. Instead, Kline found expression through paint itself, uncovering what could be said in its abrasive manipulation, rather than by painting what had to be expressed. This realization brought about the dramatic reorientation of his work in the late 1940s, from figurative subjects in the American Scene tradition to canvases distinguished by broad, gestural brushwork and a palette in which black and white predominated. His interest in Japanese art, however, is disputed as a source.

Recognition as one of the major Abstract Expressionists quickly followed Kline's first solo exhibition, at the Egan Gallery, New York, in 1950. Misleadingly simple and spontaneous, these compositions were carefully painted to convey weight and non-directional movement. Structure became submerged as mark-making progressed into events, rather than forms. Kline was preoccupied with painting out, so thick surfaces of paint were built up as strokes were revised repeatedly to preserve their tensile individuality. Even when not present, color governed the emergence of increasingly complex paintings in his last years, and it can be claimed that emotional engagement and human processes rather than style determined his work. The crude grittiness of Kline's canvases captured the gloomy postwar mood and was broadly derived from the visual world, although titles such as *Dahlia* (1959) and *Hewn Forms* were not intended as a clue to their specific interpretation.

Martin Holman

Date 1950

Born/Died 1910–1962

Nationality American

Why It's Key Leading New York Abstract Expressionist whose calligraphic paintings conveyed crisis and engagement.

398

Key Person **Ernst Gombrich**
Wrote the seminal *The Story of Art*

Several million copies have been sold of Gombrich's classic survey, *The Story of Art* (1950), making it the best-selling art book ever. It has been reprinted many times and in some twenty languages. Gombrich conceived the book as an introductory overview and wrote it in an accessible style, claiming that it was compiled almost entirely from memory and was simply meant to be read as a "story." Originally intended for young people, its insight and clear style made it accepted by universities and art schools as a standard textbook.

Ernst Hans Josef Gombrich was born in Vienna, the son of the lawyer Dr Karl B. Gombrich and Leonia Gombrich, a pianist who had been taught by Bruckner. His mother's friends included Freud, Gustav Mahler, and Schoenberg. From 1928 to 1935, Gombrich studied history of art and archaeology at the University of Vienna; he also attended lectures on psychology and philosophy. A thoroughly accomplished scholar and historian, Gombrich married Ilse Heller and they fled the Nazi threat for England in 1936. Most of his family who remained in Austria were killed after the Anschluss. During the war he served with British Intelligence, monitoring German broadcasts and, after the war, joined the Warburg Institute, a preliminary to many senior appointments: Slade Professor of Fine Arts at Oxford, 1950–53, then at Cambridge, 1961–63; Unity Professor of Fine Art at Harvard in 1959; and Warburg Director from 1959 to his retirement in 1976.

Sir Hugh Trevor-Roper listed his *Art and Illusion* (1960) as one of the five most influential books of the late twentieth century.

Mike von Joel

Date 1950

Born/Died 1909–2001

Nationality Austrian

Other Key Works Wrote renowned studies of Giulio Romano, Oskar Kokoschka, and Saul Steinberg

Why It's Key *The Story of Art* is the world's best-selling art primer and most successful art book of all time.

Key Artist **Leon Kossoff**
Studies under David Bomberg

Leon Kossoff is an exclusively figurative painter who nevertheless deployed an unbridled, deep impasto technique. Francis Bacon was a significant influence in the early stages of Kossoff's development as a painter. Born of Russian-Jewish immigrant stock in London's East End, Kossof used his early environs to provide the subject matter of his paintings. He studied at evening classes under the tuition of David Bomberg from 1950–52, along with Frank Auerbach. Kossoff shares many stylistic similarities with Auerbach, although Kossoff's work always remained recognizably figurative. The two were arbitrarily (some might say) grouped together with Francis Bacon, Michael Andrews, Lucian Freud, and R. B. Kitaj. It was Kitaj who coined the group name the "London school" in 1976, although there was some controversy as to whether the term had any real meaning in terms of a common philosophy or technique.

Kossoff's style of painting was influential in British art schools of the late 1960s and early 1970s, particularly in terms of the life class, and in landscape painting, where figurative painting was still clinging on, concerning itself with spatial and plastic considerations. It deployed extremely generous, expressively applied dollops and layers of paint – an approach which, despite similarities with Bacon's overtly expressive painterliness and determination to render space, was nevertheless in direct contrast to the controlled meticulous observation of, for example, Lucian Freud, highlighting the essential arbitrariness of the group's collective identity.

John Cornelius

Date 1950

Born 1926

Nationality British

Why It's Key Important member of the London school. The group was given currency in Alistair Hicks' 1989 book *The School of London: The Resurgence of Contemporary Painting*. Hicks, however, expanded the term to include Howard Hodgkin and sundry others.

1950-1959

Key Artist **Alan Davie**
First solo show, Gimpel Fils Gallery, London

Born in Scotland in 1920, Alan Davie is an individualistic painter who works parallel to, but not as part of, the mainstream of British art and is not classed with any particular group or movement. He identifies with the deep-rooted European concept of the role of the artist: "The artist was the first magician and the first spiritual leader, and indeed today must take the role of arch-priest of the new spiritualism.... I paint because I have nothing, or I paint because I am full of paint ideas, or I paint because I want a purple picture on my wall or I paint because, after I last painted, something appeared miraculously out of it, something strange, and maybe something strange may happen again."

His painting was influenced by Jackson Pollock, although he was just as strongly influenced by poetry, mythology, native world art, and jazz. Indeed he was a professional jazz musician for a period, traveling through Europe in the late 1940s. This gave him the opportunity to observe at first hand the developments in American and European art in Paris, and to study Abstract Expressionism at the Peggy Guggenheim Museum in Venice before many other British artists had the opportunity. He has enjoyed an international reputation since 1950. An example of a key work is *Heavenly Bridge No. 3* (1960), which typically combines formal geometrically enclosed spaces with freeform expressionistic/gestural brushwork. He has also involved himself in diverse craft-based activities from sculpture to silversmithing and jewelry.

John Cornelius

Date 1950

Born 1920

Nationality British

Why It's Key Davie's art and aesthetic perpetuates the traditionally rooted role of the artist as magician and shaman.

TARSILA

Key Artwork *Chief*
Franz Kline

In the 1950s, Franz Kline (1923–1962) created a way of painting that was largely limited to contrasts of black-and-white planes and strokes, although he used other colors, sparely, in paintings early in the decade and with greater vigor toward the end of his life. The abstract nature of this work contrasted dramatically with his previous Regionalist style that mostly depicted trains and coal-blackened Pennsylvanian hills and which was derived from the realist American Scene tradition pioneered at the start of the century by John Sloan, among others. He was not familiar with Cubism, or with Surrealism and its interest in myth, or the complex cultural sources that fueled the first generation of Abstract Expressionists.

Around 1948, according to Elaine de Kooning, a friend of Kline's since 1943, Kline enlarged some of his quick brush sketches through a balopticon. A four-by-five-inch drawing of a rocking chair expanded into "gigantic black strokes which eradicated any image, the strokes expanding as entities in themselves, unrelated to any reality but that of their own existence … From that day, Franz Kline's style of painting changed completely."

The title, *Chief*, is likely to derive from Kline's lifelong interests in trains, bridges, and working landscapes that nurtured his gritty and melodramatic art. Paintings often waited years to be named, however, and Kline claimed to paint "not what I see but the feelings aroused in me by that looking." That process was long and careful, requiring constant painting out to achieve this image of sustained non-directional energy.

Martin Holman

Date 1950

Country USA

Medium Oil on canvas

Collection Museum of Modern Art, New York

Why It's Key Early example of Kline's dynamic abstraction.

1950–1959

401

Key Artist **Tarsila do Amaral**
Retrospective at Museum of Modern Art, São Paulo, Brazil

Tarsila do Amaral was an unlikely modernist. Born in Brazil to a family of old-fashioned landowners in 1886, her social and cultural environment was worlds removed from the modernist experiments then taking place in Paris, London, and New York. The young Tarsila began to draw in high school, however, and in 1920 went to study art in Paris. This proved to be an invigorating trip for Tarsila, who would return to Brazil with a keener appreciation of modernism. She developed a special attraction to Paris, which she visited again in 1923. Paris was stunned by the beautiful Brazilian artist who had taken lessons from Fernand Léger and who painted the Cubist-inspired *La Negre* during her stay.

Meanwhile, in São Paulo, Tarsila connected with a number of Brazilian modernists and joined the Group of Five, which blended select modernist techniques with indigenous Brazilian themes and preoccupations. Over the next several decades, Tarsila successfully blended warm Brazilian colors and iconography with Cubist and Surrealist influences to produce more than two hundred paintings. In the early part of her career, Tarsila preferred landscapes, as well as portraits of flora and fauna, but after a 1931 visit to the Soviet Union began to incorporate elements of Socialist Realism into her style. Tarsila achieved iconic status in Brazil, but never tasted the international celebrity of Mexico's Frida Kahlo, possibly because her life was both less tempestuous and more fulfilled. Tarsila, for her part, was never overshadowed by any of her male peers or companions.

Demir Barlas

Date 1950

Born/Died 1886–1973

Nationality Brazilian

First Exhibited 1922

Why It's Key Brazil's consummate modernist painter receives her country's imprimatur toward the end of a long career.

opposite Tarsila do Amaral's *Le Pecheur dit aussi Paysage Exotique* (*The Fisherman or Exotic Landscape*) (oil on canvas).

Key Artwork *Pope II*
Francis Bacon

Francis Bacon (1909–1992) was fascinated by the traditions of art. As can be seen in the reconstruction of the artist's studio in Dublin, Bacon surrounded himself with documentation – clippings, photographs, and art books – depicting the artworks of earlier masters which echo throughout his output. This is especially apparent in the series of "Pope" portraits. On the one hand unique and extremely personal inventions, but on the other reminiscent of impressive images from the past, these series represent some of Bacon's best work.

In the fall of 1951, Bacon painted a second series of "Pope" portraits – the first was destroyed because he was dissatisfied with it – for a solo exhibition at the Hanover Gallery in London. *Pope I*, *II*, and *III* – the last of which was also disposed of at some point – are famously related to Diego Velazquez' seventeenth-century portrait of Pope Innocent X. They are, however, also closely related to a photo of the contemporary Pope, Pius XII, found in his atelier. Where *Pope I* was a relatively quietly sitting figure, the iconic *Pope II* appears to us violently screaming. As the throne seems to warp into a constraining frame, the indefinable space comes across as in rapture, taking possession of the figure. The grasping pain that is depicted in *Pope II* was to become a classic example of Francis Bacon's ability to uncomfortably mesmerize his audience. It is a testimony of Bacon's status today.
Erik Bijzet

Date 1951

Country UK

Why It's Key One of the first and grandest of the preserved paintings that Bacon derived from papal portraits.

opposite *Pope II*

402

1950-1959

Key Artist **Ellsworth Kelly**
First solo show, Galerie Arnaud, Paris

Early in his career, Kelly fought the notion of "composition," especially as it was promulgated in postwar European geometric abstraction infused with Mondrian's example. In Paris from 1948–54 on the government-sponsored GI Bill to study at the Ecole des Beaux-Arts (and where his first solo show occurred in 1951), Kelly drew inspiration from his surroundings, such as window mullions and cathedral masonry, which he reconstructed as abstract painted reliefs that he termed "already mades." "Rather than making a picture that would be an interpretation of an invented contents," he said, "I found an object and I presented it 'as is.'"

This tentative approach of transferring shapes to the canvas from the outside world (cast shadows, or an arch and its reflection) was followed by the introduction of chance as a way to avoid composition, suggested by John Cage, then visiting France. *Colors for a Large Wall* (1951), where each unmodulated color is a separate canvas unit in the gridded ensemble, was derived from random patterns of street awnings. Thus Kelly arrived intuitively around 1958 at the format of hard-edged unmodulated monochrome paintings of rectilinear shapes. He allowed color to create form, and to set up tensions with other color areas and surrounding space. He concentrated on shapes, and figure-field interaction was avoided by experimenting with curved planar sculpture (in which surface texture was also explored). In the 1970s, he adopted volumetric curved-edged canvases for serial combinations of monochrome paintings. Kelly effectively anticipated Minimalism and, from the 1960s onward, was also a prolific printmaker.
Martin Holman

Date 1951

Born 1923

Nationality American

Why It's Key Kelly's reductivist abstraction condensed details from nature and architecture into colors and shapes with an objectivity that anticipated Minimalism.

Key Artist **Cy Twombly**
First solo show, Kootz Gallery, New York

Cy Twombly drew early inspiration from Paul Klee, the Surrealists' automotive technique, and Willem de Kooning and Franz Kline. Travel was also significant – he visited Spain, North Africa, and Italy on a traveling scholarship in 1952 with Rauschenberg. As a Rome resident from 1957, his work in painting, constructed sculpture, and on paper seemed to engender light. Unlike the autographic gestural styles of contemporaries who defined Abstract Expressionism, Twombly found his aesthetic outside his own life story. From the mid 1950s, his mobile strokes in paint, chalk, pencil, or crayon occupied a space between writing and painting. Although comparisons with Jackson Pollock were made, Twombly's approach lacked heroic pretension; it suggested experiment rather than assertion, and aligned him with John Cage and Jasper Johns's early work.

Twombly drew on large traditions, invoking the wider culture of literature, history, and myth with fleeting images, letters, and evocative words. Graffiti – anonymous, layered over time, and affected by climate – were cited as sources for his patched and accreted surfaces and his spiky quality of line. Using collage to enliven surfaces further, he created several polyptychs and an ambitious cycle inspired by Homer's *Iliad*. Random only in appearance, his ambiguous "anti-compositional" scrawls teased out the sense of each work, like recorded encounters. He was regular exhibitor after his first solo show in New York in 1951, and Twombly's unapologetic pursuit of the act of making inspired fellow artists, as diverse as Francesco Clemente and Jean-Michel Basquiat.
Martin Holman

Date 1951
Born 1929
Nationality American
Why It's Key Highly influential artist whose work blended emotional expansiveness and intellectual sophistication.

opposite Cy Twombly's *Untitled*.

404

Key Artist **Edouard Pignon**
Communist painter joins Picasso in southern France

Pignon was, after Picasso – his close friend – and alongside Fernand Léger, the most high-profile artist to join the French Communist Party. The son of a miner from northern France, he worked the mines in his youth before moving to Paris, where he found employment in the Renault and Citroën car factories. In the 1930s, Pignon embarked on a career as a painter, focusing on depictions of miners, factories, and workers' meetings. He joined the Communist Party in 1936 and was active in the Resistance during the Occupation. Pignon first met Picasso in 1936, but did not become close to him until after World War II. In 1951, Picasso invited Pignon to join him at Vallauris in the South of France. For a while Pignon and Picasso worked together there; at Picasso's suggestion, Pignon also started making ceramics and, in 1952, the two

artists held a joint exhibition of their decorated pottery at the Maison de la Pensée Française, Paris.

Pignon's friendship with Picasso was of crucial importance for his development as an artist at a time when, despite his commitment to the communist cause, he rejected the hardline Socialist Realism that the party advocated in favor of a semi-abstract style, distinguished by a vigorous sense of form and a bold use of color. He eventually resigned from the Communist Party in 1980 in protest at the Soviet Union's attempt to suppress the Polish Solidarity movement. Pignon was married to the novelist Hélène Parmelin, author of several valuable books on Picasso which draw on her and her husband's conversations with the artist.
James Beechey

Date 1951
Born/Died 1905–1993
Nationality French
Why It's Key Communist artist who, under the influence of Picasso, eschewed Social Realism in favor of semi-abstraction.

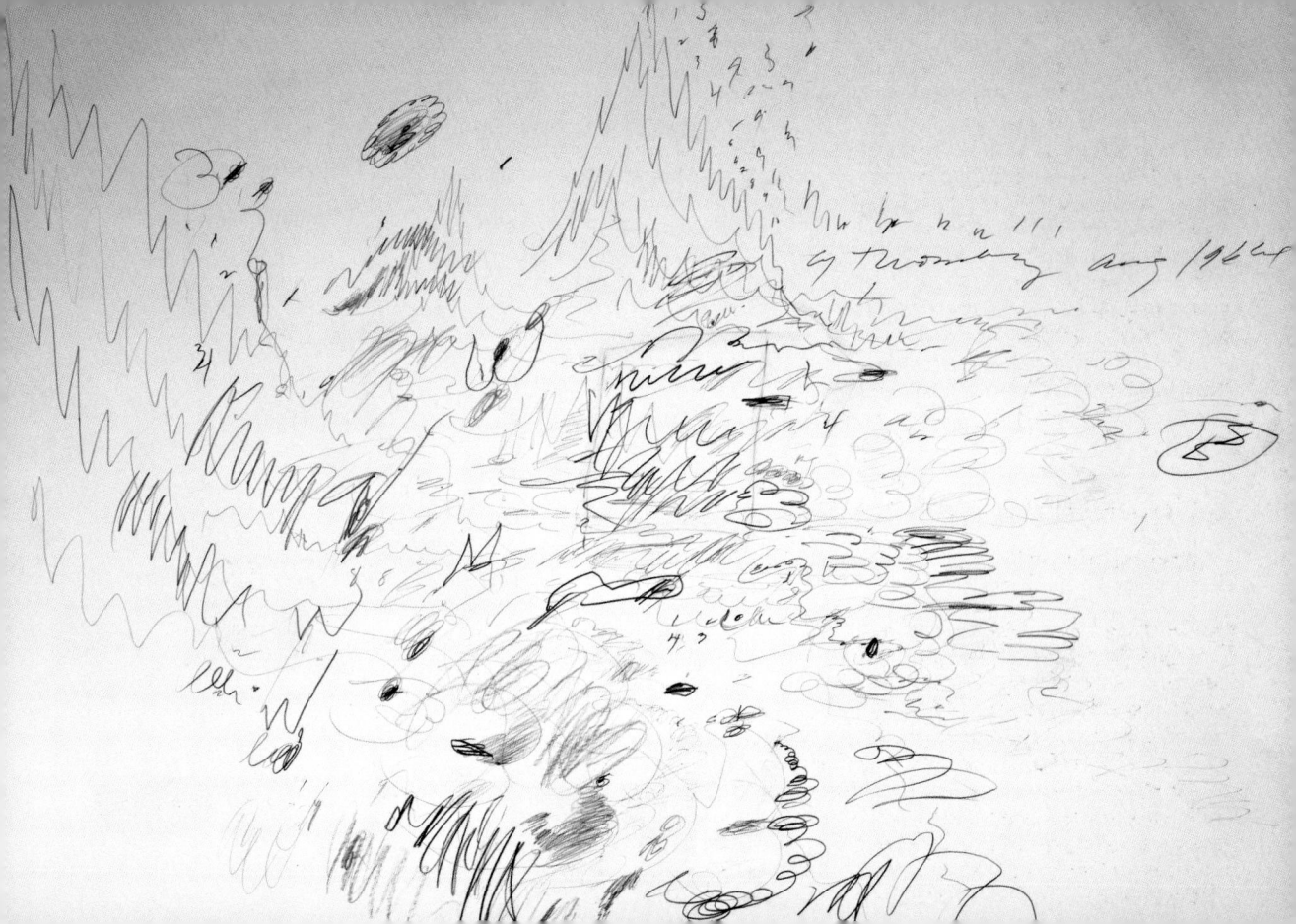

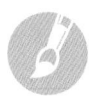

Key Artist **Terry Frost**
Works as assistant to Barbara Hepworth

Born Terence Ernest Manitou Frost in Leamington Spa, Warwickshire, Frost started as a figurative painter in his late thirties while he was a prisoner of war in Bavaria, and used his ex-serviceman's grant to pay for formal training at St Ives and Camberwell schools of art. Time spent with Victor Pasmore, Ben Nicholson, Peter Lanyon, and, crucially, assisting the sculptor Barbara Hepworth steered the young enthusiast toward his signature shapes and colors of "abstract image-equivalence." Exposure to the Russian Constructivists and New York Abstract Expressionists Robert Motherwell and Barnett Newman also drew him toward working in mixed media. His distinctive crescents, half-circles, and other loose geometry in bold primary colors come from what he called "a state of delight in front of nature."

Frost's attitude to his art – "Just to think in terms of color is enough to set the soul alight" – meant that he was much collected, and a popular teacher at Bath Academy, Leeds University, Leeds School of Art, Newcastle University, and the University of Reading. His primary thesis was that the interplay of color and shape could realize an event or image more successfully than imitation. Terry Frost was elected to the Royal Academy in 1992, and knighted in 1998. He lived and worked in Cornwall until his death in September 2003.
Bill Bingham

Date 1951

Born/Died 1915–2003

Nationality British

Why It's Key Frost was Britain's foremost creator of abstract images and a central figure of the St Ives community.

406

Key Artist **Lucian Freud**
Festival of Britain prize for *Interior at Paddington*

British realist painter Lucian Freud has been quoted as saying that "the task of the artist is to make the human being uncomfortable." In his 1951 painting *Interior at Paddington*, which is sometimes known as *Interior Near Paddington*, the human Freud tested his theory upon was his friend, the photographer Harry Diamond. For six months, Diamond posed before Freud, in a stance intended to reference Holbein's portraits of Henry VIII.

Despite the regal reference, Freud's image emanates drab depression and sensual poverty. The painting was commissioned in connection with the Festival of Britain, but there is nothing festive to the image in either context or tone. His colors are muddy and dim while the composition is tense and vaguely off-kilter. In the image, Diamond wears a soiled

mackintosh and clutches a cigarette in his heavily nicotine-stained hand. Though Diamond is central to the image, the painting's title (in both versions) undercuts his importance and ignores his presence.

While the painting took six months to complete (a fact Diamond complained about to the Walker Art Gallery staff in 1971, when he was living in Liverpool on a photographic commission), the narrative brilliantly represents the harried and stressed reality of everyday urban living in a gray and dreary 1950s England.
Ana Finel Honigman

Date 1951

Born 1922

Nationality German/British

Why It's Key Seminal point in the career of the foremost postwar British realist.

Key Artist **Emiliano di Cavalcanti**
Shown at São Paulo Biennal

Emiliano di Cavalcanti was born in Rio de Janeiro at the end of the nineteenth century and held his first exhibition in São Paulo in 1917. He quickly became part of the local artistic group that later founded the Week of Modern Art (Semana de Arte Moderna) in 1922. Between 1923 and 1925, di Cavalcanti lived in Montparnasse, Paris, working for a newspaper and attending the Académie Ranson, where he was introduced to European modernists such as Picasso and Matisse.

In 1926, he returned to Rio de Janeiro and spent the next ten years developing his work and support for a strong Brazilian artistic identity. In 1929, he began working in interior design, designing two panels for the Teatro João Caetano (João Caetano Theater) in Rio, as well as an exhibition at the Roerich Museum, New York.

During this period he joined the Communist Party and was jailed in 1932, where he first met his future wife, the painter Noêmia Mourão. The couple lived in Paris from 1937–40, returning to Brazil during the Nazi invasion.

Di Cavalcanti's work received major recognition in the first of the Biennals at the Museu de Arte Moderna at São Paulo in 1951. Over the next twenty-five years, he built relationships with other South American artists interested in forging national art forms. Despite his communist sympathies, di Cavalcanti's art was generally apolitical, eschewing the revolutionary agendas of Mexican contemporaries such as Diego Rivera and David Siqueiros in favor of the benign qualities of unromanticized Latin life.
Jay Mullins

Date 1951

Born/Died 1897–1976

Nationality Brazilian

Why It's Key One of Brazil's most celebrated painters, di Cavalcanti used his experience of European modernism in his pursuit of a true Brazilian art.

Key Exhibition
The 9th Street Show

Many of the new artists who settled and worked in New York after World War II did not attract the immediate attention of the established art world, but that was all to change very quickly, and a seminal event in that process was the exhibition staged at 60 East 9th Street, which became known as the 9th Street Show.

Most of this new wave of painters were war veterans, working out of studios in the then low-rental area of Greenwich Village between 8th and 12th Streets, forming what became known as the Downtown Group. They represented a new breed of artist, shunned by the majority of critics, and in 1949 founded the Artists' Club at 39 East 8th, a catalyst in what became known as the New York school. Out of the club's weekly discussion meetings came the idea for an exhibition of

their work; the first floor and basement of a derelict store was chosen as venue, and Franz Kline created a linocut poster to advertise the show.

The first American curatorial exercise by Leo Castelli before he went on to open his groundbreaking gallery in 1957, the exhibition was as much an expression of the community spirit of the artists involved as it was an exposure of their work. Among those showing were soon-to-be-celebrated names including Willem de Kooning, Helen Frankentheler, Hans Hofmann, Philip Guston, Franz Kline, Lee Krasner, Robert Motherwell, Jackson Pollock, and Ad Reinhardt – sixty-one cutting edge artists in all, the nucleus of Abstract Expressionism, who collectively were about to change the face of American painting.
Mike Evans

Date May 21–June 10, 1951

Country USA

Why It's Key First major showing together of the "New York School" of Abstract Expressionist painters.

Key Event
Opening of the Peggy Guggenheim Collection

After World War II, collector Peggy Guggenheim moved to Venice, taking her collection of modern art with her to show at the 1948 Venice Biennale. That same year, she bought Palazzo Venier dei Leoni, a Grand Canal palace attributed to the architect Lorenzo Boschetti, who left it unfinished in 1749. She lived there for thirty years, opening her house as a museum in 1951. In 1976, she bequeathed her collection to the Solomon R. Guggenheim Foundation in New York, who have run the museum since her death in 1979. Among the artists represented in the collection are Pablo Picasso, Georges Braque, Wassily Kandinsky, Paul Klee, Piet Mondrian, Constantin Brancusi, Giorgio de Chirico, Alberto Giacometti, Marcel Duchamp, Salvador Dalí, René Magritte, Jean Arp, Max Ernst, Joan Miró, Yves Tanguy, Alexander Calder, Mark Rothko, Jackson Pollock, and Francis Bacon.

As well as the Peggy Guggenheim Collection – known as the Permanent Collection – the museum houses twenty-six masterpieces of Italian Futurism on long-term loan from the Gianni Mattiolo Collection, and other works belonging to the Solomon R. Guggenheim Foundation, while works from the Raymond D. and Patsy R. Nasher Sculpture Collection of Dallas, Texas, are on display in the garden. There is also an annual program of temporary exhibitions.

Nigel Cawthorne

Date 1951

Country Italy

Why It's Key Modern art finds leading outlet in the classical environment of Venice.

opposite Peggy Guggenheim in her Venice gallery.

408

Key Artist **Bill Reid**
Begins work in the Haida tradition

Born to a father of European descent and a Haida mother whose Anglican upbringing led her to conceal her Native origins, Reid only became aware of his First Nations heritage from the jewelry worn by visiting aunts. At the age of twenty-three, he visited his mother's home village of Skidegate on Queen Charlotte Islands, British Columbia, where he met his grandfather, a carver of argillite and engraver of silver bracelets who had been trained by Charles Edenshaw (c.1839–1920). Working as a radio announcer for the Canadian Broadcasting Corporation in Toronto, Reid enrolled on a jewelry-making course and studied Haida culture.

In 1951 he returned to British Columbia, where he set up a workshop for making jewelry. He began salvaging artifacts, including carved totem poles. He helped in the reconstruction of a Haida village in the University of British Columbia Museum of Anthropology, where he carved a pole which he completed in 1962. From making jewelry he turn to making larger sculptures in bronze, red cedar, and Nootka Cypress (yellow cedar), portraying figures, animals, and scenes from folklore in a Haida style. *The Spirit of Haida Gwaii (The Black Canoe)* (1991) was made for the Canadian Embassy in Washington D.C. and the second bronze casting of it, *The Jade Canoe* (1994) adorns Vancouver International Airport in British Columbia. *The Spirit of Haida Gwaii* represents the aboriginal heritage of the Haida Gwaii region in the Queen Charlotte Islands.

Reid died of Parkinson's disease in 1998 and his ashes were returned to his mother's village. His work is featured on Canada's 2004 $20 note.

Nigel Cawthorne

Date 1951

Born/Died 1920–1998

Nationality Canadian

First exhibited 1962

Why It's Key Bill Reid revived native Haida traditions and brought them to sculpture.

Key Artist **Frank W. Benson**
Death of the last of The Ten American Painters

When Frank W.Benson died on November 15, 1951, it severed the last living link with American Impressionism. Born in Salem, Massachusetts, he studied at the Museum of Fine Art in Boston before traveling to Paris in 1883 to attend the Académie Julian. It was there he came in contact with fellow American artists Childe Hassam, Willard Metcalf, and J. H. Twatchman, among others, with whom his career would be intertwined after his return to the United States. At that time he was painting straightforward landscapes, albeit increasingly influenced by the French Impressionists.

On his return to the US in 1885, he opened a studio in Salem, before moving to Boston in 1888 and teaching at the Boston Museum School, of which he became co-director with his friend Edmund Charles Tarbell in 1891. In 1888 he had enjoyed his first taste of acclaim with his first showing with the prestigious Society of American Artists in New York, but by this time his work was moving away from conventional landscapes to the highly atmospheric, luminous portraits (primarily of his wife and daughters in their summer home in Maine) for which he would become famous. At the end of 1897, protesting against the growing commercialism of the Society of American Artists, the Ten American Painters (a.k.a. The Ten) simultaneously resigned from the Society. They included Benson, Hassam, Metcalf, Tarbell, and Twatchman, and were regarded as *the* voice of Impressionism in the American art world. Benson's association with them reinforced his commitment to Impressionism; he once said to his daughter Eleanor: "I follow the light, where it comes from, where it goes."

Mike Evans

Date 1951

Born/Died 1862–1951

Nationality American

Why It's Key Benson was the last surviving member of "The Ten" group of American turn-of-the-century Impressionists.

1950–1959

411

Key Exhibition
The Festival of Britain

Against a background of postwar austerity, and with London and other centers still bearing the scars of Nazi bombs, the Labour government of the day launched the Festival of Britain as "a tonic for the nation." The idea was to give the British a feeling of progress and recovery after the war, and to promote the very best in design and technology in the rebuilding of the Blitz-ravaged cities. In 1948, Hugh Casson was appointed director of architecture for the festival, and he set about commissioning a spectacular collection of buildings for the main exhibition space on the South Bank of the River Thames. As well as leading architects such as Basil Spence, Maxwell Fry, and Ralph Tubbs, the Festival of Britain enlisted the talents of major artists and sculptors, including Victor Pasmore, Barbara Hepworth, Henry Moore, and Jacob Epstein. The festival also featured touring art exhibitions, including "Sixty Paintings for '51," which spotlighted key names in British modern art such as Francis Bacon, Lucian Freud, Paul Nash, Ben Nicholson, and Edward Burra.

The Festival of Britain proved hugely popular – at the main site, in regional exhibitions, and via the media. As well as bringing the work of artists such as Hepworth and Moore to a wider audience, its iconic landmarks such as the Dome of Discovery and cigar-shaped Skylon genuinely introduced modernism to the British public for the first time. Somewhat vindictively, Churchill's incoming Conservative government demolished the entire South Bank site (except for the Royal Festival Hall) in 1953, judging it too "socialist" for its liking.

Mike Evans

Date May 3–September 30, 1951

Country UK

Why It's Key Featured the first examples of modernist architecture to be widely seen in Britain, and was a major platform for contemporary UK painting, sculpture, and design.

opposite The South Bank site of the Festival of Britain.

Key Event *Theater Piece No.1*
John Cage

As a visiting teacher at several summer sessions, in 1952 avant-garde musician and composer Cage staged an evening of performance at Black Mountain Collage. This event demonstrated the experimental nature of the curriculum. Interdisciplinary and flexible, it stressed the value of extracurricular activities.

The event was held in the college dining hall, where the seating had been arranged in four inward-facing triangular blocks forming a square, and dissected by diagonal aisles. The activities took place all around the audience. Preceding the performance Cage, seated on top of a ladder, read from a lecture on the relationship of music and Zen Buddhism, punctuating his reading with silences (his preoccupation with silence as musical form was demonstrated in his silent composition *4 minutes and 33 seconds*, published that

year). Poems were read by faculty members Charles Olsen (writing and literature) and M. C. Richards (literature and drama), perched on another ladder. David Tudor (music) played on a "prepared" piano, and Cage later performed *a composition with a radio* while the artist Robert Rauschenberg played old records on a wind-up gramophone. Merce Cunningham, together with other dancers, moved around through the aisles. Rauschenberg had suspended four of his white-on-white paintings from the ceiling in the shape of a cross. He also projected abstract slides and film clips onto the ceiling, gradually moving them down the wall. It was a landmark event and the precursor of the later happenings developed by Allan Kaprow, Jim Dine, Claes Oldenburg, and others.

Sue King

Date Summer session, 1952

Country USA

Why It's Key What can be described as the first happening, this experimental event of unstructured performances was the precursor of a significant art form in the 1950s and 1960s, developing into performance art in the 1970s.

Key Artist **Richard Lindner**
Moves from U.S. magazine illustration into painting

In 1933, the day Hitler rose to power, Lindner fled Munich for Paris, abandoning his job as art director of a publishing house. He was briefly interned in France when war broke out, before serving out the war in the French army. Lindner then worked as a commercial artist, inspired by the work of Oscar Schlemmer, a leading Bauhaus artist, and the painter Fernand Léger. In 1941, he arrived in New York, where his reputation as a German poster designer and illustrator preceded him, and Paul Rand and other influential figures in graphic design were already admirers of his work.

Lindner would become a very successful book, magazine, and advertising illustrator in the USA. While working for *Vogue* and *Harper's Bazaar*, he was commissioned for assignments alongside artists such as Ben Shahn, whose work bridged the area between

fine and applied art. In 1949, an article about Lindner's personal approach to illustration was featured in the highly influential *Graphis* magazine. From the time he had arrived in New York, Lindner made contact with other artists and German emigrants there. In 1952, he began painting full-time, declaring his independence as an artist. The paintings which emerged drew on some of the imagery he had produced as an illustrator, but were much bolder in their content. His work was often characterized by a quality of decadent urban satire, with powerful erotically charged women portrayed alongside robot-like men in uniform. In 1953, Lindner painted *The Meeting*, featuring his friend Saul Steinberg with his cat, wife Hedda Sterne, and others, and in 1954 he held his first solo exhibition at the Betty Parsons Gallery.

Carolyn Gowdy

Date 1952

Born/Died 1898–1969

Nationality American

Why It's Key Lindner was influential in introducing a refined European aesthetic to the bold vernacular of American popular imagery. His work anticipated the Pop Art movement of the 1960s.

First meeting of the Independent Group

The Independent Group brought together young British artists, designers, and writers who gravitated toward London's Institute of Contemporary Art (ICA) as the only place to see and discuss modern art and design. Its members shared the common desire to re-evaluate modernism, and included William Turnbull, Eduardo Paolozzi, John McHale, Nigel Henderson, and Richard Hamilton, although the prime movers were critics Reyner Banham, Toni del Renzio, and Lawrence Alloway. Architects Alison and Peter Smithson joined in 1953.

With its purpose to study themes and organize speakers for the ICA's public program, the group's activities were directed toward two sessions of seminars, in 1953–54 and 1955. As well as discussion, ideas were disseminated in polemical displays such as Parallel of Life and Art in 1953 and Man, Machine, and Motion in 1955. Displaying applications of technology, showed science's impact on society and culture, and challenged perceptions of what a gallery could exhibit. The Independent Group's approach to modernism as a starting point from which to analyze culture within "a fine/pop art continuum" continued in its members' work. The 1956 exhibition This Is Tomorrow projected individual members' appreciation of modern technology and mass media, and belief in innovative exhibition design. American-inspired consumerism had a dramatic effect on postwar Britain, and the group's interests ranged from delighting in the rapid obsolescence of imagined tomorrows, the iconography of packaging, cinema, science fiction, and automobile styling, to questioning the motivation behind advertising.

Martin Holman

Date Early 1952 (as the Young Group); fall 1952 (Independent Group)

Country UK

Why It's Key Ideas worked on by the group were seminal for British Pop Art.

1950–1959

413

Key Artist **Eduardo Paolozzi**
Co-founder of the Independent Group

Like Paolozzi, the Scottish sculptor William Turnbull spent two years in Paris after leaving the Slade School of Art. He also shared Paolozzi's passion for collecting images: "My studio walls were covered with them," he recalls. "Magazines were an incredible way of randomizing one's thinking ... food on one page, pyramids in the desert on the next, a good-looking girl on the next: they were like collages." In his "Bunk!" lecture, Paolozzi projected on screen the scrapbooks he had started in Paris in 1947: postcards of American war planes, adverts for cars or food, cuttings from magazines, science-fiction journals, and comics flashed by in no particular order, and without comment or explanation. This Dada-inspired presentation evoked the way modern audiences, particularly in the United States, were now surrounded by such messages.

Paolozzi's lecture without words was greeted with a degree of deriding skepticism – after all, "bunk" was slang for "junk." Yet popular culture in all its forms was soon to be at the heart of the Independent Group's debates, as critic Lawrence Alloway refined his concept of a continuum between fine art and popular art: defining culture as "what a society does," Alloway dismissed past hierarchies between high and low, between Picasso and ad men. The artist was thus free to explore the field of mass communication, and to react to it. Seen as documentation rather than finished artworks, the Bunk! collages were issued as silkscreen prints only in 1972 – by which time, Paolozzi was hailed as one of the fathers of Pop Art.

Catherine Marcangeli

Date 1952

Born/Died 1924–2005

Nationality British

Why It's Key Paolozzi delivers his "Bunk!" lecture for the Institute of Contemporary Art's Young Group in April 1952.

Key Artist **Robert Rauschenberg**
First "combines paintings"

Beginning with *White Paintings* (1951), the American artist Robert Rauschenberg began to create what he would call "combines paintings," with various materials attached to them. By 1952, the combine method was firmly in place. Rauschenberg rigorously applied it first to his *Black Paintings*, which were executed on a surface of old newspapers rather than on canvas. The *Red Paintings* expanded the idea of the combine by incorporating a wider range of objects – including mirrors, pieces of metal, and even umbrellas – into the body of the work. Over the course of the 1950s, Rauschenberg's combines would grow ever more fantastic, swallowing stuffed bald eagles, goats, and blankets in a headlong quest to create an art of encountered objects.

The combines posed a critical temptation to decipher his iconography. However, Rauschenberg distanced himself from the use of consistent vocabularies, preferring to pose as a conduit for the transmission of eclectic objects, ideas, and impressions. It was a quintessentially modernist attempt to disarm cognition and court a direct impression of the tumult of lived reality. The best of the combines served as maps for an urban and American reality that predated and outweighed the attempts of bourgeois art to transfix the manifold into a specific, determined slice of experience. However, given Rauschenberg's own cultural and iconographic limitations, the combines did not necessarily transcend the American experience and achieve universality. By the beginning of the 1960s, the combines had lost their original character, as Rauschenberg began to insert found objects into them.

Demir Barlas

Date 1952

Born 1925

Nationality American

Why It's Key Rauschenberg launches the distinctive method of collage that would bring him fame.

Key Artwork *Football Players at the Parc des Princes*
Nicolas de Staël

An exceptionally energetic, prolific artist who in many ways exemplified the archetypal concept of the "modern artist" in the public mind, Nicolas de Staël (1914–1955) was born of a Russian aristocratic family. He escaped to Europe and subseqently joined the French Foreign Legion in Tangier, where he stayed for a year. De Staël almost single-handedly established abstract art in France. In his early years as a painter, he turned his hand to any work which came along in order to support his family, while continuing to paint prolifically in both abstract and figurative modes. He committed suicide in 1955.

In early 1952, he went to see a floodlit international soccer game between France and Sweden. This inspired him to produce numerous sketches, studies, and finished oil paintings deploying broadly rendered, bold forms and vivid primary colors. De Staël, whenever he could afford the amount of paint required, preferred to paint in a heavy impasto technique using very substantial quantities of pure color, smeared on with a trowel. The success of the soccer series encouraged him to pursue similar large-scale work with a figurative base, such as *The Bottles* and *The Musicians*.

John Cornelius

Date 1952

Country France

Medium Oil on canvas

Collection Royal Academy, London

Why It's Key Typical example of de Staël's blending of abstract and figurative painting.

opposite *Football Players at the Parc des Princes*

Key Person **Harold Rosenberg**
Publishes "The American Action Painters" in *Art News*

In 1952, Harold Rosenberg assessed the revolution taking place in the New York art world: "the canvas began to appear to one American painter after another as an arena in which to act – rather than a space in which to reproduce, re-design, analyze or 'express' an object, actual or imagined. What was to go on the canvas was not a picture, but an event." In his comments on the bold gestural style of Jackson Pollock, Robert Motherwell, and Franz Kline, Rosenberg thus emphasized the act of painting itself, rather than the finished work.

Coining the phrase "Abstract Expressionism" in 1946, Clement Greenberg had inscribed New York school artists in a lineage that included Manet and Cézanne, and whose logical outcome was to be pure abstraction. Each art must define its specific area of competence, Greenberg argued, and the medium itself, paint applied onto a flat surface, must become the only subject of the painting. In contrast to this formalist approach, Rosenberg foregrounded the existential struggle, the inner drama which underpinned the work: "to forget the crisis – individual, social, aesthetic – that brought Action Painting into being ... is to distort fantastically the reality of postwar American art."

In a post-Holocaust, post-Hiroshima, angst-ridden Cold War context, color field painter Barnett Newman highlighted the centrality of the individual: "Instead of making cathedrals out of Christ, man or 'life,' we are making them out of ourselves, out of our own feelings." Similarly, Pollock declared, "Painting is self-discovery. Every good artist paints what he is." The monumentality of their canvases echoed these ambitions.

Catherine Marcangeli

Date 1952

Born/Died 1906–1978

Nationality American

Why It's Key An influential critic, Rosenberg coins the expression "action painting" to describe the gestural style of the New York school.

1950-1959

416

Key Artwork ***Women***
Willem de Kooning

Willem de Kooning (1904–1997), started depicting the *Women* series in the late 1940s. Between 1950 and 1953, he painted a series of six three-quarter-length female figures, executed in bold colors and loose gestural brushstrokes. At the Metropolitan Museum, he had been impressed by Mesopotamian idols, whose wide eyes and prominent breasts he transposed in the *Women* pictures; he also drew inspiration from Cycladic figurines, as well as from modern painters such as Picasso, and magazine pin-ups, whose smiles are literally collaged onto his paintings. "I used to cut out a lot of mouths and then I painted those figures and then I put the mouth more or less in the place where it was supposed to be ... it helped me immensely to have this real thing," he recalled. These exaggerated smiles, features, and breasts, along with de Kooning's uningratiating colors, partake of the paradoxical appeal of the *Women*: caricatural and threatening, incongruously erotic, they are imposing even while their bodies dissolve into paint. When the series was exhibited in March 1953 at the Sidney Janis Gallery, critics and artists were perplexed, seeing *Women* as a betrayal of Greenberg's Abstract Expressionist tenets. Yet, like most painters of his generation, de Kooning had been trained as a Realist, and incorporated newspapers, comics, and magazine cuttings into his works. In his eyes, "this real thing," landscape or body, constituted a valid subject for his experiments with textures and physical brushwork: "Flesh was the reason oil paint was invented," he declared, refusing to acknowledge a dichotomy between abstraction and figuration.

Catherine Marcangeli

Date 1952

Country USA

Medium Oil on canvas

Collection Museum of Modern Art, New York

Why It's Key The Abstract Expressionist idiom at the service of figuration.

opposite *Women*

Key Artist **William Turnbull**
Works shown at 26th Venice Biennale

With James Butler, Lynn Chadwick, and Eduardo Paolozzi, Turnbull transformed British sculpture after World War II. After active service as an R.A.F. pilot, international tension in the 1950s informed the slender, taut, and pared-down forms of his early sculptures selected by Herbert Read for the 1952 Venice Biennale. Turnbull had lived in Paris and knew Alberto Giacometti, although his work eschewed the latter's psychological intensity for control, order, gentleness, and serenity that remained its leading characteristics.

Early features of his objects were incipient movement and the interrelationship between separate elements; the counterpart in his paintings was linear gesture. His emphasis on unitary forms continued and, although his practice was radical and advanced (he was closely involved with the Independent Group), he made no overt references to the modern world, preferring memory and ancient history as sources. Elemental shapes placed one on another recalled Constantin Brancusi, and this additive approach was extended in the 1960s with painted rigid readymade steel geometric units. Turnbull's concern for direct confrontations between objects and the viewer anticipated Minimalism. Later, he returned to working with bronze, his favorite material, and organic forms in poetic fusion.

Groundbreaking exhibitions in London of new American art in 1956 and 1959 had a strong impact on Turnbull's painting. Monochrome canvases with broad brushwork developed into sustained color field surfaces articulated by bands or diagonals. They were highly influential for younger British abstract painters.
Martin Holman

Date 1952

Born 1922

Nationality British

Why It's Key This Scottish sculptor, painter, and prolific printmaker was highly influential in postwar British art.

Key Artwork *Girl with a White Dog*
Lucian Freud

Lucian Freud (b.1922), who hewed to Surrealism during the early part of his career, devoted himself to portraiture beginning in the early 1950s. In 1952, *Girl with a White Dog* gave notice of Freud's newfound affiliation to the human subject as theme and Realism as technique. The style owed itself to Ingres. Freud had plucked the girl herself from a nearby reality: she was his wife, Kitty Garman, who is seated anxiously on a sofa with her right breast exposed and a calm white dog resting its head on her knee. The canvas offers little space around Garman, who seems frankly trapped in her own body and is, but for the composed and neutral attitude of her head, recoiling from the painter.

One of Freud's conceits was his insistence that he painted the truth of his subject. In the case of *Girl with a White Dog*, this was not a hollow claim. The painting manages to capture a number of facts about Garman and her relationship with Freud: her fragile beauty, which had ensorceled Freud out of a relationship with Joan Wyndham; the growing distance between herself and her husband, whose four portraits of her disclose an uneasy accord between painter and temporary muse; and the poignancy of everyday life, whose sad signifiers (dogs, sofas, flowers) caparison lonely people and impossible relationships rather than invigorating the scene.

Girl with a White Dog indicates Freud's ability to convey these disturbing emotions in a non-maudlin way while employing the maudlin tools of realism.
Demir Barlas

Date 1952

Country UK

Medium Oil on canvas

Collection Tate Gallery

Why It's Key This painting exemplifies Freud's ability to capture the truth of his subjects (in his words "how they happen to be") in illuminating detail.

opposite *Girl with a White Dog*

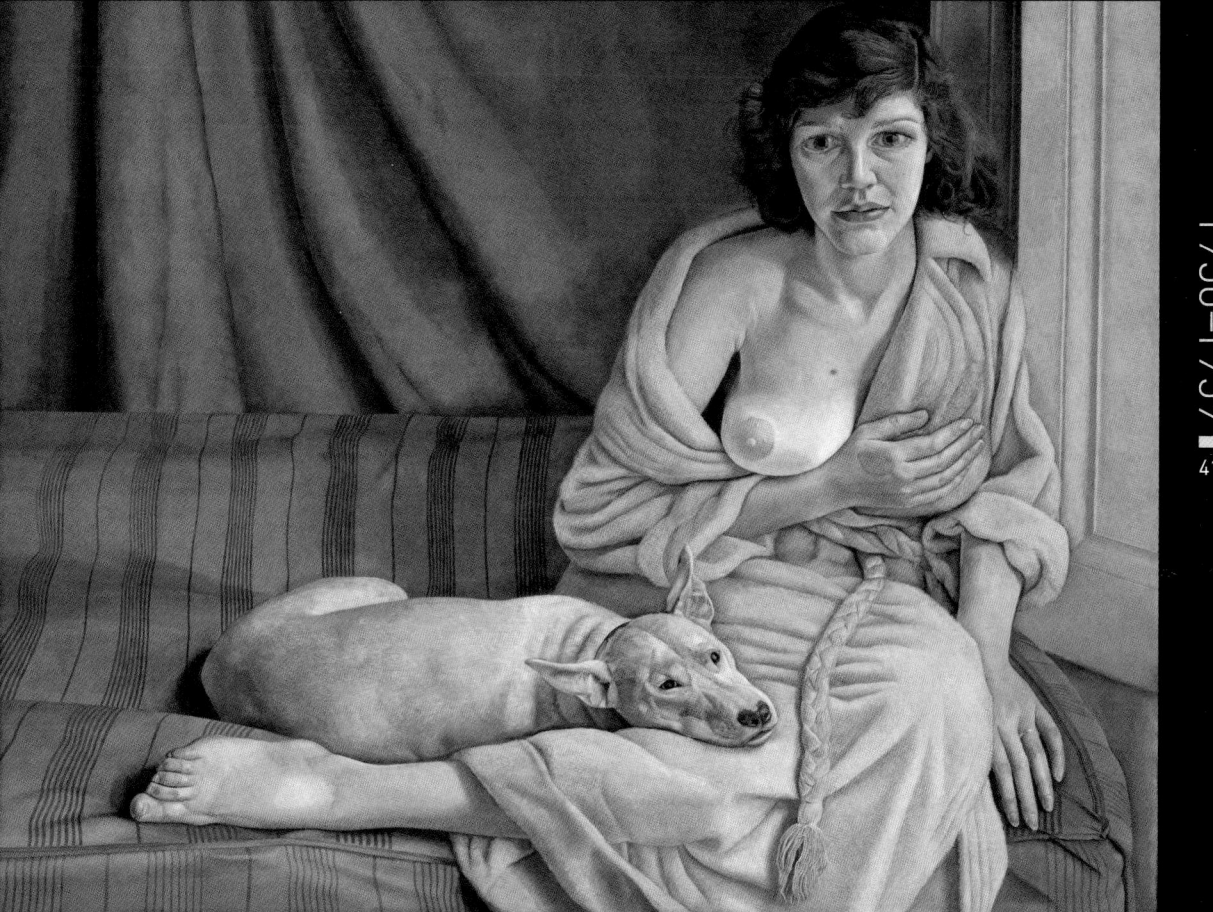

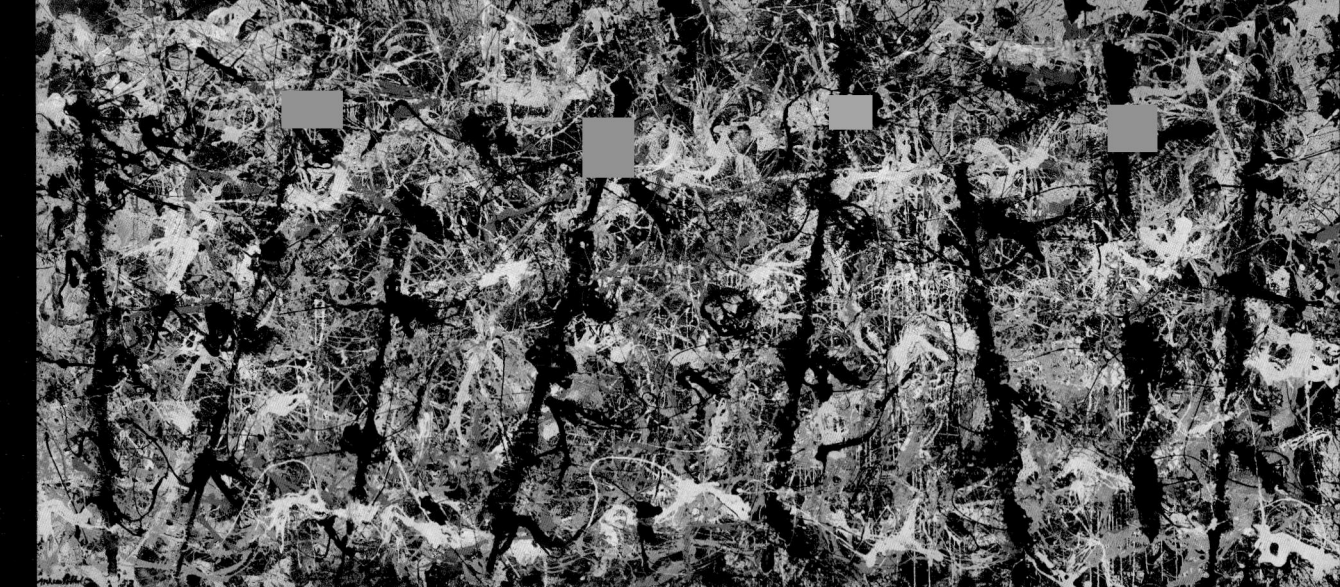

Key Artist **Marino Marini**
Grand Prize for Sculpture, Venice Biennale

From the age of sixteen, Marini studied at the Accademia di Belle Arti in Florence. Although he never gave up painting, Marini soon chose to focus on sculpture. He was inspired by the Etruscan art of antiquity. From 1928 Marini made several extended trips to Paris where he mixed with de Chirico, Picasso, and others. From 1929 Marini was based in Milan, where he also taught sculpture. He established a studio there, which would remain a base throughout his life.

Marini is known for three motifs in his sculptural oeuvre, of which symbolism plays a part. The female *Pomona* was inspired by the ancient fertility goddess. The *Horse and Rider*, for which he would become best known, addressed man's complex relationship with an animal instinct. Martini also made portrait sculptures. Often based on other artists, subjects included Henry Moore, a lifelong friend, and Marc Chagall. Marini strove always for simplicity of form, grace, and expressiveness. In 1943, much of Marini's Milan studio was destroyed by bombing. He fled Italy with his wife to settle in her hometown of Ticino. While in Switzerland Marini met Giacometti, and other leading contemporary sculptors. They encouraged him in his ambitions and inspired his art. Marini returned to Milan four years later. *Angel of the City*, a major work, soon followed.

In 1952, Marini was awarded the prestigious first prize for sculpture at the Venice Biennale. He is considered one of the leading Italian sculptors of the twentieth century and a museum in Florence has been dedicated to the preservation, display, and documentation of his life and work.

Carolyn Gowdy

Date 1952

Born/Died 1901–1980

Nationality Italian

Why It's Key When Marini won the sculpture prize at the Venice Biennale it established his international reputation.

421

Key Artwork ***Blue Poles***
Jackson Pollock

Blue Poles was first seen at Pollock's (1912–1956) solo exhibition at the Sidney Janis Gallery, New York, in November 1952, where it was entitled *Number 11, 1952*. The date has frequently and mistakenly been given as 1953, but it is clear from the inscription on the painting that Pollock initially dated it "53," and then changed the "3" to a "2."

Controversy has dogged this work since its inception. In 1972, Stanley P. Friedman reported in *New York* magazine that a close friend of Pollock had initially painted on the canvas that subsequently became *Blue Poles*. The "truth" of this rumour was dispelled by the announcement that: "Pollock, Barnett Newman and Tony Smith were in Jackson's studio and he showed them the way he was 'flipping' paint onto the canvas. Barney and Tony each tried a flick, their total contribution to the very beginning of the under-painting of a canvas that, ultimately, many layers later, became Blue Poles." This correction was allegedly confirmed by Lee Krasner, Newman, and Pollock himself.

In 1973, the Australian National Gallery, Canberra, purchased *Blue Poles* for US$2 million, then a world record for a work by a twentieth-century artist, and so politically controversial it allegedly brought down the Whitlam Labor Government. Now worth more than US$140 million, *Blue Poles* is the pride of Australia's national collection and one of the most popular paintings on earth. It was one of the last great paintings Pollock produced before an alcoholic spiral led to a fatal car crash in 1956. For the twelve months preceding his death, he did not create a single work.

Mike von Joel

Date 1952

Country USA

Medium Oil on canvas

Collection National Gallery of Australia

Why It's Key One of Pollock's last great "drip" paintings, made at the climax of his powers. *Blue Poles* is a work frequently accompanied by controversy that has served to keep it in the public eye.

opposite *Blue Poles Number 11, 1952*

Key Artist **Nicolas de Staël**
Breakthrough solo shows in London and Paris

De Staël personified the romantic idea of the bohemian painter. Born in St Petersburg, the son of a general in the Tsar's army, his family emigrated to Poland. He was sent to an institution for child emigrés in Brussels when his father died, ran away, and was adopted by another expatriate Russian family and sent to the Royal Academy of Arts in Brussels. Traveling to the Netherlands and France, he discovered the Dutch masters and the French Post-Impressionists. He turned his hand to portraiture and theatrical scene painting, but lived a life of privation with his lover and fellow painter Jeannine Guillou, to whom he was devoted, and who bore his daughter Anna in 1942. They lived together, mostly in dire poverty, until her death in 1946.

In April 1944, together with Wassily Kandinsky, Alberto Magnelli, and César Domela, he boldly took part in an exhibition at the Galerie l'Esquisse in Paris, in the midst of the Nazi occupation. At the same venue the following month, he had his own one-man show, blatantly displaying abstract "degenerate" works, although most of his key works do have a figurative link. After two solo shows in London and Paris in 1952, de Staël became widely recognized as a significant – and prolific – painter. He was prone to bouts of deep depression, however, and exhausted himself with overwork, eventually committing suicide in March 1955. His legacy is his leadership of the postwar Paris school, and his major achievement the breaking down of barriers between abstract and figurative painting, notably in his late "Midi" period involving abstract meditations on Mediterranean themes.

John Cornelius

Date 1952

Born/Died 1914–1955

Nationality Russian (naturalized French)

First Exhibited 1944 (Paris)

Why It's Key Established abstract painting in France.

422

Key Artist **Frida Kahlo**
Only solo show in native Mexico during her life

Magdalena Carmen Frida Kahlo y Calderón was born and died in the same house on the outskirts of Mexico City. During her life, her work and achievements were overshadowed by a lifelong relationship with – and two marriages to – the leading Mexican muralist Diego Rivera. In the 1980s, however, revisionist art history combined with feminism and a modernist interest in "ethnic" source material elevated Kahlo into the major league.

Kahlo's life was plagued with misfortune. She contracted polio aged six, then in 1925 was involved in a trolley bus crash, causing horrific injuries to her abdomen and lower limbs. Contrary to popular belief, Kahlo was able to walk following her recuperation, although plagued by pain and psychological side effects of the trauma. Unable to study, she turned to painting during her long recovery, developing a complex visual language of symbols and signs drawn from Mexican and religious traditions. She then met and married (1929) the famous older painter Rivera and embarked on a stormy life with the notorious womanizer and active Communist. Dressed in elaborate Tehuantepec or Oaxacan costume, Kahlo established an identity that matched the biographical nature of her paintings – many produced while in bed following more elective operations and hospitalization. In 1953, Lola Alvarez Bravo announced a major retrospective of her work at the National Institute for Fine Arts and, in April, it opened in the Galería de Arte Contemporaneo. A semi-invalid, Frida Kahlo was brought to the opening in her famous canopied bed.

Mike von Joel

Date 1953

Born/Died 1907–1954

Nationality Mexican

Why It's Key One of the first signs of the emergence of contemporary Mexican art onto the world stage.

opposite Frida Kahlo

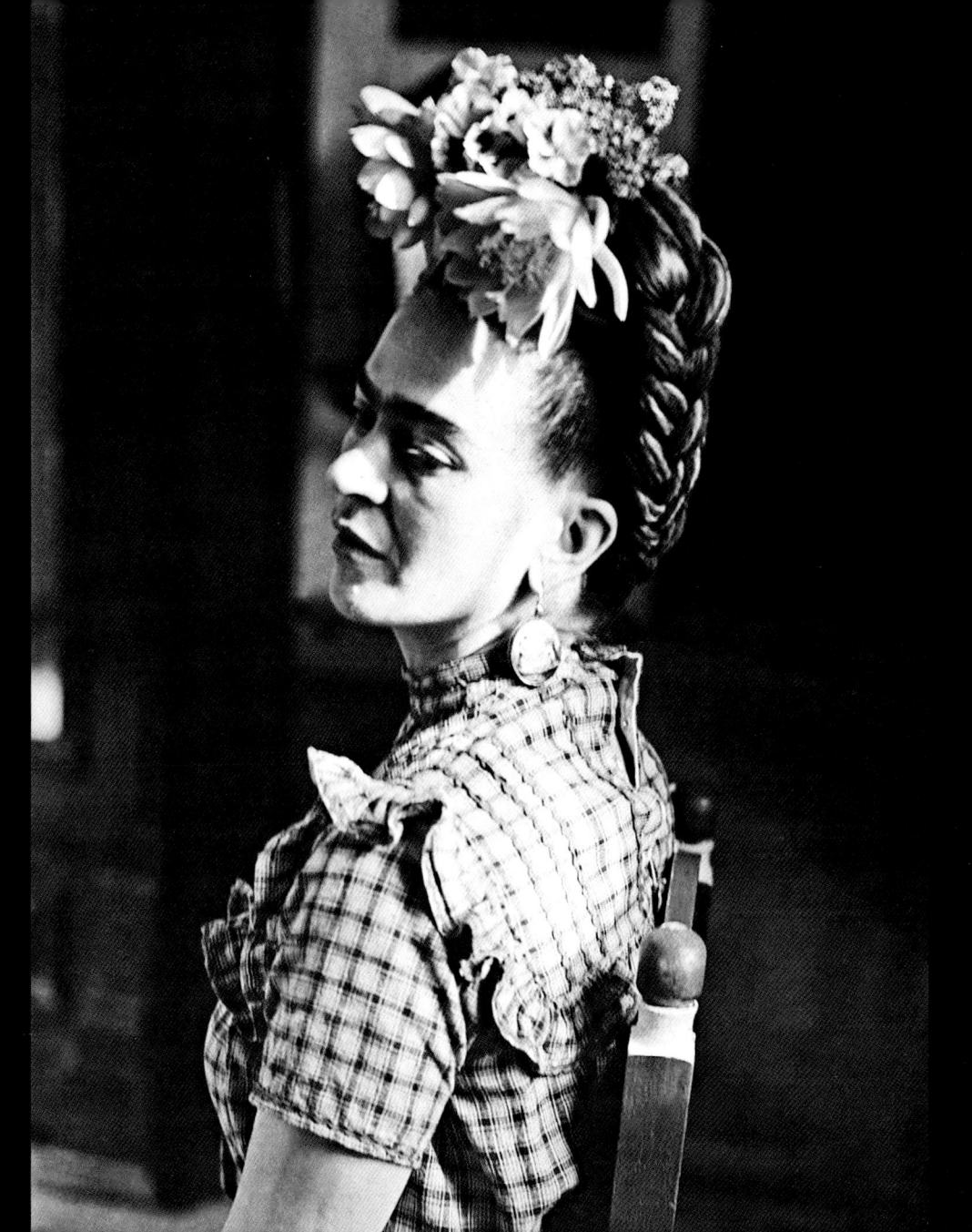

Key Person **Alfonso Ossorio**
Organizes Jackson Pollock's first Paris show

Born in Manila, in the Philippines, and educated at Harvard, Alfonso A. Ossorio discovered Abstract Expressionism at the end of the 1940s and never looked back. The multidimensional canvases of Jean Dubuffet heavily influenced the found objects component of Ossorio's work in the early 1950s, which he called "congregations." He recognized similarly expressive ingredients in Jackson Pollock's paintings, which had gained substantial recognition in the United States around that time. The two men became acquainted in 1949, forming a relationship that led to Ossorio's assistance in bringing Pollock's reputation to Europe.

Pollock first came to the attention of Ossorio in Betty Parson's gallery. Fascinated by the organizational qualities of Pollock's drip panels, Ossorio eventually befriended him, frequently visiting the painter at his East Hampton home before taking up permanent residence in the area. Three years later, Ossorio provided financial assistance for Pollock's first Paris exhibit. Opening at Studio Facchetti under the additional guidance of Michel Tapié, the show didn't make a splash in the media, but it caught the eye of the international art community. Both Georges Mathieu and Dubuffet expressed their interest in Pollock's paintings, while four of the exhibited works sold for decent sums. Pollock's reputation in the United States continued to grow, thanks to an exhibit that same year at the Museum of Modern Art in New York. Nevertheless, European sales that Ossorio helped to secure may have convinced Pollock that he needed to bolster his profits on the home front, as he severed his professional ties to Parsons a few months later.
Erik Kohn

Date 1952

Born/Died 1916–1990

Nationality Filippino (naturalized American)

Why It's Key An important collector, Ossorio organizes Pollock's first Paris show.

1950-1959

Key Artist **Helen Frankenthaler**
Paints pivotal work *Mountains and Sea*

At twenty-four, Frankenthaler made a breakthrough when she intuitively began spilling oil paint diluted with turpentine onto a large unprimed canvas. Inspired by nature and landscape, she began the process by making a few swift lines of charcoal underdrawing. She then stained the canvas with pools of luminous color. Out of this, an exceptional painting emerged entitled *Mountains and Sea*. Sometime before, the young artist had been taken to visit Jackson Pollock's studio on the invitation of her friend and mentor, Clement Greenberg. Pollock's energetic work made such a powerful impression on Frankenthaler that she completely changed her method of painting. Greenberg, and others, would proceed to champion Frankenthaler's art.

The youngest daughter of a New York Supreme Court Justice, Frankenthaler received a private education in New York, studying with the Mexican painter Rufino Tamayo in high school before attending Bennington College (1945–49), a progressive school in Vermont. It was while exploring modernism and Cubist painting there that Frankenthaler met Greenberg. After graduating, she returned to New York determined to make her mark in the art world. With Greenberg at her side, she traveled in powerful art circles. Eventually Frankenthaler married the Abstract Expressionist artist Robert Motherwell in 1958. They exhibited together, having been chosen to represent the USA at the Venice Biennale in 1966, but later divorced. Frankenthaler remained constant as an artist, bringing beauty, vitality, and innovation to her work. Her extensive oeuvre of paintings and prints now spans more than five decades.
Carolyn Gowdy

Date 1952

Born 1928

Nationality American

Why It's Key *Mountains and Sea* put Frankenthaler at the forefront of the American avant-garde scene, alongside Abstract Expressionists such as Jackson Pollock, Willem de Kooning, and Mark Rothko.

Key Exhibition
Canadian Abstract Art

While the influence and popularity of abstract art spread over much of the world in the first half of the twentieth century, Canada remained insulated from artistic modernism. Until 1952, a handful of Francophile Canadians were the only artists to paint in the new style, and Canada as a whole had little taste for anything other than bland landscape painting. That changed when painter Alexandra Luke organized Canadian Abstract Art, a touring show that ended up going all over Canada and shaking up the country's artistic status quo. The show unleashed a host of abstract painters, many of them from Ontario, onto the Canadian scene, flooding spectators with a number of major abstract styles that had hitherto been invisible in galleries and exhibitions. The core artists of the show went on to found Painters Eleven, which from 1952–60

succeeded in embedding abstract art in Canada's cultural consciousness.

A number of ongoing trends in Canadian art can be traced back to Canadian Abstract Art. Toronto, hitherto best known for its English-language theater and literature scenes, became a center of artistic activity and art patronage. The younger generation of Canadian artists drew more inspiration from the abstract Painters Eleven than from earlier, non-abstract Canadian collectives, such as the Group of Seven. Finally, abstract Canadian painters such as Jack Bush, Alexandra Luke, Kazuo Nakamura, Harold Town, Ray Mead, Tom Hodgson, Walter Yarwood, and others went on to have successful careers of their own, in the wake of Canadian Abstract Art.

Demir Barlas

Date 1952

Country Canada

Why It's Key The first abstract art exhibition to penetrate the Canadian cultural consciousness launched several careers, and aligned Canada with modernist trends.

1950-1959

425

Key Artist **Larry Rivers**
Paints *Washington Crossing the Delaware*

For many Americans, Washington's crossing of the Delaware was associated with Leutze's 1851 painting, reproduced in books and hung in classrooms across the land. The painting attracted massive media attention in 1952 – the crossing's 175th anniversary. Meanwhile, reading Tolstoy's *War and Peace* in 1953, Rivers was fascinated by its combination of historical fact and descriptions of daily life; he decided to "get in the ring with Tolstoy," and transpose a similar mix of "high" and "low" to an American context. Rather than a patriotic gesture, Rivers's *Washington* is an ironic comment on the very idea of "hand-on-chest heroism." Leutze emphasized the dignity of the figures, organized around the central hero. With Rivers, the flag has disappeared, and the fragmentation and repetition of images convey a sense of panic, enhanced by the

technique: a cloth dipped in turpentine is used to wipe sections of oil paint and charcoal, lending the picture a translucid quality that accentuates the contrast between sharp details and more gestural fluid, almost dissolved areas. Critic Clem Greenberg had called Rivers "an amazing beginner," but was disgusted by such "kitsch" history painting. Further breaching Abstract Expressionist orthodoxy, Rivers based this composition on a number of preparatory studies. He also quoted from art history, including Rembrandt's *Old Man in Hell*, on which he based Washington's face. Himself a jazz saxophonist, Rivers suggested that if the great masters of jazz integrated fragments from classics within their own improvisations, then painters, too, should be able to quote from artistic golden oldies in their compositions.

Catherine Marcangeli

Date 1953

Born/Died 1923–2002

Nationality American

Why It's Key A trademark "history" painting in the Abstract Expressionist idiom.

Key Artist **Ossip Zadkine**
To a Destroyed City a monument to the tragedy of war

Born in Russia in 1890, Ossip Zadkine was educated in Sunderland, in the north of England, and London, before attending the Ecole des Beaux-Arts in Paris in 1909. Influenced initially by Auguste Rodin, he nevertheless had a brief flirtation with Cubism, and, although his work was abstract and semi-abstract, it was emotional rather than purely intellectual, as Cubism tended to be. He settled in Paris and fought for the French in World War I, but was invalided out in 1915, after being subject to gassing.

Zadkine continued to live and work in France until the outbreak of World War II, at which time he removed to New York, where he taught for a time at the Art Students League, the famous progressive art school with an open-door policy and no entry requirements, other than those of artistic merit and ambition. He returned to Paris in 1944, and died there in 1967. *To a Destroyed City*, completed in 1953 and which stands in Rotterdam harbor in the Netherlands, is his greatest commission and the one which gave Zadkine an international reputation as a significant modern sculptor. His most famous work, it celebrates the power of the human will to rebuild and recover, as well as serving as a monument to the destruction and death wrought by war.

John Cornelius

Date 1953

Born/Died 1890–1967

Nationality Russian

Why It's Key The most celebrated work of an important twentieth-century sculptor.

426

Key Person **Richard Buckminster Fuller**
Creates the geodesic dome

After 1922, and the death of his young daughter from complications from polio and spinal meningitis, Fuller's numerous inventions and discoveries were directed toward developing design patterns that maximized the social uses of the world's energy and industrial capability. Frequently eccentric in his methods and with dogmatic views, his designs anticipated and encouraged later research into controlled living environments that eliminated the inadequacies that contributed to spreading ill health. His ingenious free-standing Dymaxion House (1927) – a neologism for "dynamic plus maximum efficiency" – was capable of mass production and delivery by air, and assembled accommodation around a core providing mechanical essential services. Dubbed a "machine for living in," it had no aesthetic pretensions. In 1933, he created an omnidirectional motorized version. The geodesic dome emerged from Fuller's study of structures. It makes use of the assumption that directionally oriented forces in nature provide maximum strength with minimum structures. The nested tetrahedron pattern of organic compounds was Fuller's inspiration for a geometric framework the strength of which increases in relation to its size. Fuller proposed enclosing entire cities; realized projects were smaller, although achieving record-breaking clear spans, as at Baton Rouge.

Although not a trained architect (his Harvard career lasted two years from 1913–15), his impact on architectural practice and theory has been considerable.

Martin Holman

Date 1953

Born/Died 1895–1983

Nationality American

Why It's Key Developed the geodesic dome, the only large dome that can be set directly on the ground as a complete structure and has no delimiting dimensions. His ideology has been applied to problems of overcrowding by the Japanese and in Britain to unrealizable neo-futurist concepts of the city by Archigram and the solutions of architect Norman Foster.

Key Artist **Alberto Burri**
Exhibits at New York exhibition of new European painters

Alberto Burri was born in Città di Castello, Umbria. He served in the Italian army as a doctor during World War II. During his incarceration in a prisoner-of-war camp in Hereford, Texas, he started to paint on sugar sacks. He continued to paint when he moved to Rome in 1946, and had his first solo show in 1949 at the Galleria La Margherita. In increasingly abstract reworkings of Cubist and Dadaist collages, Burri used a variety of materials, such as tar, wood, metal, and unmodulated red and black paint.

In 1951, the Gruppo Origine, of which he was a founder member, exhibited at the Galleria dell'Obelisco in Rome. In their manifesto, they criticized the decorative quality of abstract art of the period. Burri experimented with the expressive textural qualities of coarse canvas sacks, sewn together and stuck to a support, using the physical qualities of the often deteriorating materials to suggest form. By the mid 1950s, he was using destructive, barely controllable processes, such as burning, as a method of manipulating materials to trace the immediacy of artistic intervention. He began to use industrial materials: welded iron sheets in the 1950s; melted and scorched plastic in 1960s; fired ceramic, to form cracked earthlike surfaces, in the 1970s; and Cellotex in the 1980s and 1990s. His works are often discussed as metaphors for the destruction of war and industrialization, but are more a testament to a profound formal language which emphasizes an organizing framework, underpinning the unpredictable physicality of materials and processes, and prefiguring the development of Minimalism (*arte povera*) in Italy.
Sarah Mulvey

Date 1953

Born/Died 1915–1995

Nationality Italian

Why It's Key Burri exhibited at the Younger European Painters exhibition, at the Guggenheim Museum, New York, which demonstrated the potential of European abstraction, termed *l'art informel* by the French critic Michel Tapié, to equal American Abstract Expressionism.

427

Key Artist **Reg Butler**
Winner of the Unknown Political Prisoner competition

The British sculptor and architect Reg Butler's 1953 entry to the Unknown Political Prisoner competition was a sensitive and controversial response which won first prize, but which was sadly never realized. The UK Institute of Contemporary Art announced the contest, part of the International Sculpture Competition, in 1952. It was hoped that the winning sculpture, one of 3,500 entries from across the world, would be installed on a site of international importance, eventually chosen to be the border between East and West Berlin. Only the Soviet bloc countries opted out. The entries of 140 finalists were displayed at the Tate Gallery, the prize of £4,500 being awarded to Butler.

Initially, his bronze entry created confusion, amid complaints that it was difficult to imagine a work some 300-400 foot high by looking at an 18-inch maquette. Moreover, a young Hungarian called Szilvassy damaged the work, protesting that the reduction of prisoners to scrap metal showed a lack of humanism. Butler's model consisted of a tower structure and three female "watchers" (to be 8 foot high in reality), all situated on a rock which would house an internal staircase. The forms are reminiscent of Alberto Giacometti's early Surrealist work. The tower evokes cages and watchtowers, although the form does not explicitly refer to the Nazi death camps. In spite of the debate, Butler went on to beat British contemporaries such as Eduardo Paolozzi and Barbara Hepworth. Interminable discussions revolved around deciding on a site, but owing to both practical objections, and the Bonn government's reservations, the monument was never built.
Hermione Calvocorezzi

Date 1953

Born/Died 1913–1981

Nationality British

Why It's Key Catapulted a major figure in British sculpture into the ranks of household-name celebrity.

Key Event
Team X formed

Team X brought together the ideas of nine architects who challenged the functionalism in architectural style promoted by an older generation that included Le Corbusier and Gropius. This led to the philosophy of CIAM (Congrès Internationaux d'Architecture Moderne), set up in 1928 to harmonize modernist responses to urban planning. Architects convened periodically, and at the ninth congress these younger practitioners were entrusted with preparing CIAM X, and were therefore known as "Team X." Whereas CIAM was associated with imposing on society generalized solutions that implied mass production, Team X criticized its limitations.

Team X promoted a particularized approach based upon architects accepting the principle of individual responsibility for creating order through forms that acknowledged the existing structure of communities to foster belonging – "identity" – and neighborliness. While its radical members pursued the established modernist idea of the "street in the air" in high-density residential developments, their aim was to re-create street life above ground level, encourage low-rise building, and integrate projects into the landscape, rather than isolate them from it. Prominent members were Peter and Alison Smithson, whose optimistic sensibility was informed by studying London's East End working-class neighborhoods; Aldo Van Eyck, whose criticism drew on experience of primitive cultures; Jacob Bakema; and Shedrach Woods. Their approach was pluralist and contained contradictions, but their ideas gave comprehensible form to urban variety and had far-reaching effects throughout the world.

Martin Holman

Date 1953

Country France

Why It's Key European group working for a fresh approach to architecture, emphasizing the importance of identity and association in planning postwar cities.

428

Key Artwork *Edge of August*
Mark Tobey

In 1935, following time in China and Japan, American painter Mark Tobey (1890–1976) returned to Dartington Hall, a progressive school in Devon, England, where he had taught for some years. One night Tobey was filled with a memory of New York City. He tried to capture the frenetic energy of the place within a small picture. Out spilled streaks of blue and white into a tangled nest of brushstrokes, somehow managing to capture the rhythm and light of the weaving traffic, and the stream of humanity. But it was strange. Tobey recalled the silence of that moment. He was conscious only of the darkness outside and of horses breathing in the field next to him.

It was puzzling the way this small picture, in the corner of the studio, kept distracting the artist. What he had learned in the Orient, however, had affected Tobey more than he realized. He found he couldn't shake it off. It was as if he needed to express the powerful vision before it consumed him. As a part of Tobey was creating something new, another part seemed to protest the unsettling change taking place. The "white writing," however, continued to emerge in a way that was relentless. Mark Tobey suddenly had a whole new concept of painting. *Edge of August*, painted nearly two decades later, is an example of the mature development of Tobey's visionary approach where networks of fine white lines are often painted against a dark ground. A dynamic interplay is established between light and dark, with separate strands becoming a unified whole, the totality of its parts more important than any given detail.

Carolyn Gowdy

Date 1953

Country UK

Medium Casein on composition board

Collection Museum of Modern Art, New York

Why It's Key A classic example of Mark Tobey's "white writing," in which, from as early as the 1930s, he anticipated Abstract Expressionism.

Key Artist **Robert Indiana**
Moves to New York

Robert Indiana studied printmaking at the Art Institute of Chicago before a fellowship enabled him to travel to the UK to study in Edinburgh and London in 1953. In 1954, Indiana arrived in New York from London aboard the steamship *Italia* using money borrowed from the American embassy. Born Robert Clark ("I thought if Tennessee Williams could do so well ..."), early on he was involved with poetry, journalism, and the symbolism of the Christian Scientists. Brought up by his mother, who worked in diners, Robert's formative years were surrounded by the signage and neon advertising of Midwest truck stops. In time, he will refer to himself as: "an American sign painter."

Indiana entered New York at a pivotal moment. It was a city synonymous with the Abstract Expressionists, but a new sensibility was evolving that took its impetus from urban America, as opposed to Mid-European intellectualism. Indiana's own iconography (formed by his deep interest in religion and thus numbers and words) and his skills in printmaking were perfectly poised for the Pop Art of the 1960s. He got a work space at Coenties Slip on the tip of Manhattan (alongside James Rosenquist and Ellsworth Kelly) and started a series of assemblages using found materials and began adding words to his works with stencils. In 1965, Indiana was commissioned to create a Christmas card for the Museum of Modern Art. Inspired by a book written by his mentor, Bishop Pike of St John the Divine cathedral, he juxtaposed "L.O.V.E.' into a design that became the emblem of the 1960s counterculture and one of the most famous Pop Art images of all time.

Mike von Joel

Date 1954

Born 1928

Nationality American

Why It's Key A chance meeting with Ellsworth Kelly provided a template for Indiana's art and influenced the juxtaposition of color and form that made his reputation.

1950–1959

429

Key Person **David Sylvester**
Influential critic coins the term "kitchen sink"

Sylvester was recognized during his lifetime as one of the finest writers on modern art, a position complemented by prominence as a curator. In 1993, he was the first critic to be awarded the prestigious Golden Lion award at the Venice Biennale for his exhibition about Francis Bacon, who had died the previous year. As art critic from 1951 for the *Listener*, *New Statesman,* and *Nation*, and other influential UK periodicals, Sylvester was a powerful supporter of figuration derived from late modernism. Writing in *Encounter*, he characterized as "kitchen-sink realism" a broad international trend in painting, introducing a term later focused by others on four British artists, including John Bratby.

Sylvester was also prolific in making films about artists and reporting on soccer, cricket, and cinema for national newspapers. Organizing his first exhibition in 1951, Henry Moore's retrospective at the Tate Gallery, he subsequently arranged important shows devoted to Alberto Giacometti, Miró's bronzes, Willem de Kooning, Oriental carpets, Picasso's late work, and René Magritte (whose entire oeuvre he also cataloged), distinguished by the careful selection and placing of exhibits. Sylvester identified Francis Bacon as the most important contemporary British painter in the early 1950s, and their published interviews have become major documents of art history. In them is reflected Sylvester's intense engagement with artworks; his writings typically conveyed his physical and emotional reactions originated primarily in the concentration and clarity of his looking. For this reason, visiting exhibitions he organized has been described as a visceral experience.

Martin Holman

Year 1954

Born/Died 1924-2001

Nationality British

Other Key Works *Interviews with Francis Bacon* (1975) and collected essays in *About Modern Art* (1996)

Why It's Key Influential writer on art who championed the work of Francis Bacon, among others, and caught the public imagination with his description of the British Social Realist painters as "kitchen sink."

Key Artist **Alex Katz**
First one-man show, New York

Alex Katz was best known as a painter of people, especially the artist's family and circle of friends. As with all his subjects, including urban and landscape scenes, sitters were treated in a sharp, simplified style, often isolated in his compositions. From the mid 1950s, his technique became flatter and more hard-edged; this, and his spare handling of groups where interaction is limited, gave Katz's paintings an abstract quality.

Reaction against the gestural nature of Abstract Expressionism may have been the cause; the decade's dominant style had informed the painterliness of early figurative work. It was also an expression of Katz's belief that ambition, elegance, detachment, and large scale were indicative of "high style" in painting; "you have no power unless you have traditional elements in your painting," he observed. Another inspiration was billboard painting, in which scale, color, composition, and form were emphasized. These elements contributed to the reflective, timeless dimension of literal images that interpreted particular aspects of contemporary life, its fashions and attitudes.

A prolific printmaker with a range of techniques, Katz also used the medium to investigate new directions. Making linoleum cuts and working with stencils in the 1950s helped to his move to flat static colors in paintings. He also made cutout planar sculpture. An influence on the re-emergence of figuration among younger practitioners, Katz exhibited internationally after his first solo show in New York in 1954, receiving a comprehensive retrospective at the Whitney Museum of American Art in 1986.
Martin Holman

Date 1954

Born 1927

Nationality American

Why It's Key New York figurative painter whose hard-edged style influenced a younger generation of artists.

1950–1959

Key Artist **Graham Sutherland**
Portrait of Winston Churchill destroyed by Lady Churchill

British artist Graham Sutherland began his career as a printmaker, making pastoral etchings after the fashion of English romantic painter Samuel Palmer. In the 1940s and 1950s, Sutherland won growing acclaim as a landscape painter, an official war artist, and for his religious commissions, notably his *Crucifixion* (1946) for St Matthew's church in Northampton, England, and his vast tapestry for Coventry Cathedral (1958). In 1949, he embarked on a parallel career as a portraitist, in which he made a series of highly original and memorable images of mostly elderly, distinguished sitters, including Somerset Maugham and Lord Beaverbrook.

In 1954, Sutherland was commissioned by an all-party committee of members of both houses of the UK Parliament to paint a full-length portrait of Sir Winston Churchill, to be presented to the former British Prime Minister on his eightieth birthday. At the committee's request, the portrait showed Churchill in his familiar House of Commons clothes: black coat, waistcoat, striped trousers, and spotted bow tie. After various experiments, Sutherland settled on a seated pose, showing Churchill in "bulldog" mode: four-square, legs apart, hands gripping the arms of his chair, with an expression of grim determination. Churchill loathed the portrait, complaining both that it "makes me look half-witted, which I ain't" and that it appeared as though he were sitting on the toilet. Following its presentation, the painting disappeared, and after Lady Churchill's death in 1977 it was revealed that she had destroyed it twenty years previously. Its destruction was, in Sutherland's own words, "an act of vandalism ... rare in history."
James Beechey

Date 1954

Born/Died 1903–1980

Nationality British

Why It's Key Important British landscape painter, war artist, and portraitist.

opposite Graham Sutherland

1950-1959

431

Key Artist **Takis (Takis Vassilakis)**
Settles in Paris

At first glance, some of Takis' work would almost seem to come from a place outside of art. He is self-taught, by choice, having avoided the study of art in an institution. Is he a scientist, inventor, magician, poet, composer, musician, designer, or performer?

Takis is a sculptor who defies boundaries, even gravity. Over a career spanning more than fifty years, he has created artworks as diverse as his trademark *Magnetic Walls*, *Musical Spheres*, and *Gongs*, *Olympic Spirals*, *Aeolian Signals*, and *Light Signals*, as well as stage designs and drawings. His work is both scientific and metaphysical; he poses questions, explores the universe, and stands up for artists' rights.

As a youth, Takis experienced life under a dictatorship, witnessed the German invasion of Greece, and participated in the resistance. Soon after moving to Paris in 1954, he declared himself a "citizen of the world," and moved in avant-garde circles; his art flourished in the years to come.

In 1959, just as the rest of the planet was entering the space age, Takis made a remarkable breakthrough in his art. He levitated a nail, attached to a nylon string, in mid air through the attraction of a magnet. Soon his sculptures were also humming to the cosmos. The Beat poets were inspired to write about him, and John Lennon would later declare that "Takis taught me what contemporary art is." In 1960, during a pioneering performance at the Galerie Iris Clert, he levitated a person dressed in a space suit. Takis's magnetic manifesto read: "I am a sculpture. . . I would like to see all nuclear bombs on earth turned into sculptures."

Carolyn Gowdy

Date 1954

Born 1925

Nationality Greek

Why It's Key Along with Tinguely, Takis was a founding pioneer of kinetic art and his work was recognized as a vital presence on the international art scene of the 1960s and 1970s.

Key Artwork *Flag*
Jasper Johns

Jasper Johns (b.1930) is a great ancestor: the Abstract Expressionist whose iconography and influence wind up in everything from Pop art to Minimalism to Conceptual art. Johns casts a long shadow over American art, so it is fitting that one of his most famous works is *Flag*, which takes up an everyday icon, the American flag, and renders it in a way that both gestures toward and transcends the Pop art that would succeed Johns.

Like future Pop work, the flag lacks texture; but, at the same time, it is not a shiny plastic product, happily imprinted and reproduced, but an individual, weathered creation whose daubs of paint are visible. Johns' flag is not rendered so idiosyncratically as to foreclose on certain interpretations. *Flag* might be patriotic or a tarnishing of patriotism; it might be ironic or straightforward; it depends not on the work but on the viewer. It thus models the strand of modernity that transfers the awesome powers of interpretation, decision, and creation from the artist to the spectator.

This is not at all a trivial transformation, as it might be in strict Pop art, because the American flag is a loaded weapon. It can mean danger and revolution in the hands of the poor and symbolize the status quo for the rich. It can represent oppression for blacks and complacency for whites. That Johns stands out of the way of *Flag*'s interpretation without abdicating all responsibility for its creation is the hallmark of his art.

Demir Barlas

Date 1954

Country USA

Medium Encaustic, oil, and collage on fabric, on three panels of plywood

Collection Museum of Modern Art, New York, United States

Why It's Key One of the most famous of Johns' works, *Flag*'s influence is pervasive.

opposite *Flag*

Key Artist **John Bratby**
New Realists dubbed "kitchen sink"

Englishman John Bratby was a painter, writer, and teacher. He attended Kingston College of Art from 1948–50 and the Royal College of Art from 1951–54, where he was awarded a travel scholarship. He used the money to travel to Italy, but while there decided he preferred to paint domestic life in Britain. His work was harsh and realistic, the paint applied thickly, in bright colors often squeezed straight from the tube onto the canvas. His domestic interiors depicted members of his family and the clutter of everyday life – for example, *Still Life with Chipfryer*, painted in 1954, which is in the Tate Britain, London.

The "kitchen sink" painters, a term coined in 1954 by the critic David Sylvester in the journal *Encounter*, was a loose-knit group within the Social Realist movement, and included Derrick Greaves, Edward Middleditch, and Jack Smith. These were sometimes known as the Beaux Arts Quartet, and were selected in 1956 to represent Britain at the Venice Biennale.

Bratby's teaching career was brief: Carlisle College of Art (1956) and the Royal College of Art (1957–58). From the late 1960s to the 1980s, he undertook a series of celebrity portraits. After divorcing his first wife, Jean, he married Patti Prime, who encouraged him to travel – particularly to Venice, where he produced numerous cityscapes in the 1980s. In this period, he also produced self-portraits and pictures of his wife in intimate poses. Bratby was also a successful novelist.
Alan Byrne

Date 1954

Born/Died 1928–1992

Nationality British

Why It's Key Leading member of the Social Realists ("kitchen sink" painters).

opposite John Bratby's *Still Life with Wardrobe*.

Key Artwork *Mindoro II*
Victor Vasarely

Born in Hungary, Victor Vasarely (1906–1997) initially studied medicine. It left a strong impact on him as, throughout his life, he explored art with a scientific rigor. He also studied the principles of Bauhaus, from which he retained the conviction that art should be used as a social tool adapted to communitarian life and modern industry. In 1930, he moved to Paris, where he started working as a graphic artist in an advertising company. Through his personal research, Vasarely gradually came to feel that mimetic art was unable to signify the world and that, to depict the inner truth and organization of nature, the artist had to turn toward abstraction and explore the strength inherent to forms and colors.

The painting *Mindoro II* dates from his black-and-white period and is very close in aspect to his graphic work. On a large canvas, the artist interlaced patches of black and white paint in a network of lines, creating a dizzying effect. The painting announced the principles of Op Art in the active role it conferred to the beholder. Indeed, according to Vasarely, the aesthetic experience was an active one where the eye worked at re-creating one's understanding of the painting. This idea presupposed the disappearance of figuration and emphasized the importance of reception in the artistic encounter. The following year, Vasarely published his *Yellow Manifesto*, in which he pleaded for an art of movement, an idea he developed throughout his entire career, constantly working to create a living art accessible to everyone.
Sophie Halart

Date 1954–1958

Country France

Medium Oil on canvas

Collection Musée National d'Art Moderne, Centre Pompidou, Paris

Why It's Key Vasarely was the founding father of Op Art, a movement which redefined the role of the beholder's gaze in the aesthetic experience.

Key Artwork *Sackcloth with Red*
Alberto Burri

After 1945, Italian avant-garde artists produced a torrent of ideas about how to deal with the reality of postwar European disillusion. They formed groups and movements, and issued manifestos with the desire to break with the Italian figurative tradition. Notwithstanding their sympathies with the Left, they also rejected the Realism of the European socialists. In 1949, Alberto Burri (1915–1995), Ettore Colla (1896–1968), Giuseppe Capogrossi (1900–1972), and Mario Ballocco (1913-2000) formed the Gruppo Origine (Origin Group), and in 1951 published their manifesto in which they proposed an art that would return to an original form of consciousness; that would reject the formalism and decorative nature of past abstract art, and concentrate on the expressive function of color and a coherent, rigorous vision.

Burri's response to this challenge was to emphasize the physicality of the often lowly materials he used, and to avoid any metaphorical references. *Sackcloth with Red*, one of a series of *sacchi* (sacks), uses jute sacking, sewn and glued to the canvas, and paint to create an abstract collage which exists in an ambiguous state between relief and painting. Color is used structurally, contrasting the artificiality of the smooth unmodulated red with the degraded, tactile neutrality of the coarse sacking. These works declare a provocative renunciation of the illusionism and idealism of high art. Burri's influence on twentieth century abstraction has been undervalued. It is significant that both Cy Twombly and Robert Rauschenberg visited Burri's studio in 1953, and Burri's work was exhibited in major galleries in the USA.

Sarah Mulvey

Date 1954

Country Italy

Medium Sackcloth, oil paint, Vinavil glue on canvas

Collection Tate Modern, London

Why It's Key Burri's manipulation of humble materials that exposes their intrinsically expressive qualities looks forward to the 1960s and *arte povera* in Italy.

436

Key Artwork *Meta-Mechanical Automobile*
Jean Tinguely

In 1953, Jean Tinguely (1925–1991), moved from Switzerland to Paris, where he befriended Alexander Calder. The American sculptor had been producing metal constructions activated by an electrical engine. Tinguely had experimented with kinetic sculpture in his stage set for a ballet by Daniel Spoerri; in 1954, he started a series based on Constructivist works – *Meta-Malevitch* or *Meta-Kandinsky* featured abstract elements rotating at different speeds, creating a multitude of configurations in ever-changing pictures. In his *Meta-Mechanical* series, Tinguely attached brightly colored geometric plates and wires to a motor. *Meta-Mechanical Automobile* is a machine *about* machines (hence the prefix *meta*, meaning "about"); with its rickety wind-up mechanism, it examines the very idea of mechanical precision, and undermines it. This is an

"auto-mobile," as far as it moves on its own, but its movements do not follow regular, logical sequences.

Tinguely's machines are cobbled together, they creak and clang, jerk and jam, parts jump out of their hinges, the clogs get stuck and start again. Such unpredictable accidents imbue each with a personality and life of its own. According to how fast or slow they go, or the rhythm of their panting, they appear happy, angry, tired, or in pain. There is a deliberate random element. Chance does not intervene at the moment of creation (as in Dadaist Jean Arp's *Collages According to the Laws of Chance*), but at the moment of reception, in the spectator's space and time. This contributes to the impact of these dysfunctional sculptures, grotesque yet almost lyrical and heroic in their absurdity.

Catherine Marcangeli

Date 1954

Country France

Medium Metal construction and motor

Collection Pompidou Center, Museum of Modern Art, Paris

Why It's Key Kinetic sculpture takes on a life of its own.

opposite Jean Tinguely

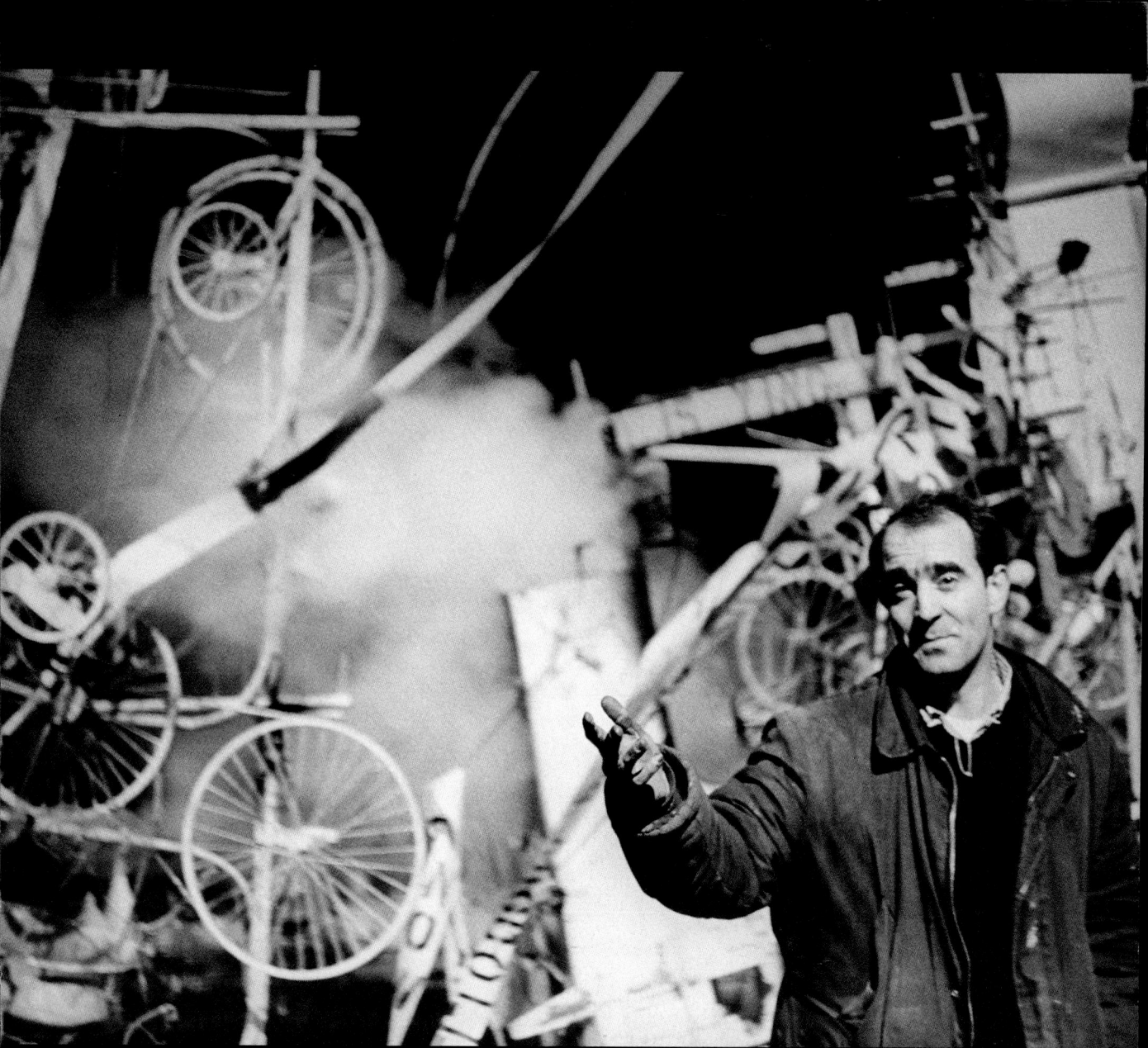

Key Event
Formation of the Gutai group

In 1954, Yoshihara Jiro, a well-established avant-garde painter, started the Gutai Bijutsu Kyokai (Gutai Art Association), with a following of young artists – Kanayma Akira, Murakami Saburu, Shiraga Kazuo, and Shimamoto Shozo. The word *gutai* is a combination of two Japanese characters, *gu* meaning "tool" and *tai* meaning "body," which translates as "concreteness," or "embodiment." The group's first exhibition was called Experimental Outdoor Exhibition of Modern Art to Challenge the Midsummer Burning Sun. Many of the exhibits were unclassifiable in terms of traditional genres such as painting or sculpture, and were created through interaction with the environment or other non-traditional ways of working such as violent action.

The Gutai had twenty-one exhibitions between 1955 and 1972 incorporating performance art and the use of space, such as the International Sky Festival using balloons to suspend the exhibits. Yoshihara wrote *The Gutai Manifesto* in December 1956, which was published in the art magazine *Geijutso-shinco*. The central tenet of the Gutai was "to combine human creative ability with the characteristics of the material." The archives of the group and a large collection of its works are held at the Ashiya City Museum of Art and History in Japan. After Yoshihara died in 1972, the group was disbanded. A retrospective exhibition of its work was held in Paris in 1999.

Alan Byrne

Date 1954

Country Japan

Why It's Key A breakthrough group of avant-garde Japanese performance artists and painters.

opposite Yoshihara Jiro's *Untitled*.

Key Person **Frank McEwen**
Helps found National Gallery of Rhodesia

The British colony of Rhodesia, now Zimbabwe, was an apartheid state in 1954, the year in which Frank McEwen helped to found the National Gallery of Rhodesia. McEwen, who had been Fine Arts Officer at the British Council, had been active on the European art scene for a decade. He had studied art history and painted in Paris, and helped to organize the Picasso-Matisse Exhibition at the Victoria and Albert Museum in December, 1945.

On April 1, 1956, McEwen became the first Director of the National Gallery of Rhodesia, and spent the next seventeen years not only building the international prestige of the gallery but also serving as a tireless encourager of Zimbabwean artists. He formed the Central African Workshop to support local artists in 1957, and in 1962 presided over the International Congress of African Art and Culture. McEwen made both his own time and the National Gallery's resources freely available to African artists until 1973, the year ill health forced him to resign. In the six years before his resignation, McEwen had succeeded in arranging exhibitions of stone sculpture in Paris, London, and New York, preparing the way for an overdue international recognition of Zimbabwean sculptors.

During his tenure at the National Gallery of Rhodesia, McEwen was instrumental in attracting the international spotlight to Zimbabwean painting and sculpture. By the time the Rhodesian apartheid state finally fell in 1979, Zimbabweans were able to take pride in a local artistic legacy that McEwen had helped to safeguard.

Demir Barlas

Date 1954

Born/Died 1907–1994

Nationality British

First Exhibited 1930

Why It's Key The first Director of the National Gallery of Rhodesia puts his museum on the map, and works tirelessly to support and encourage local artists.

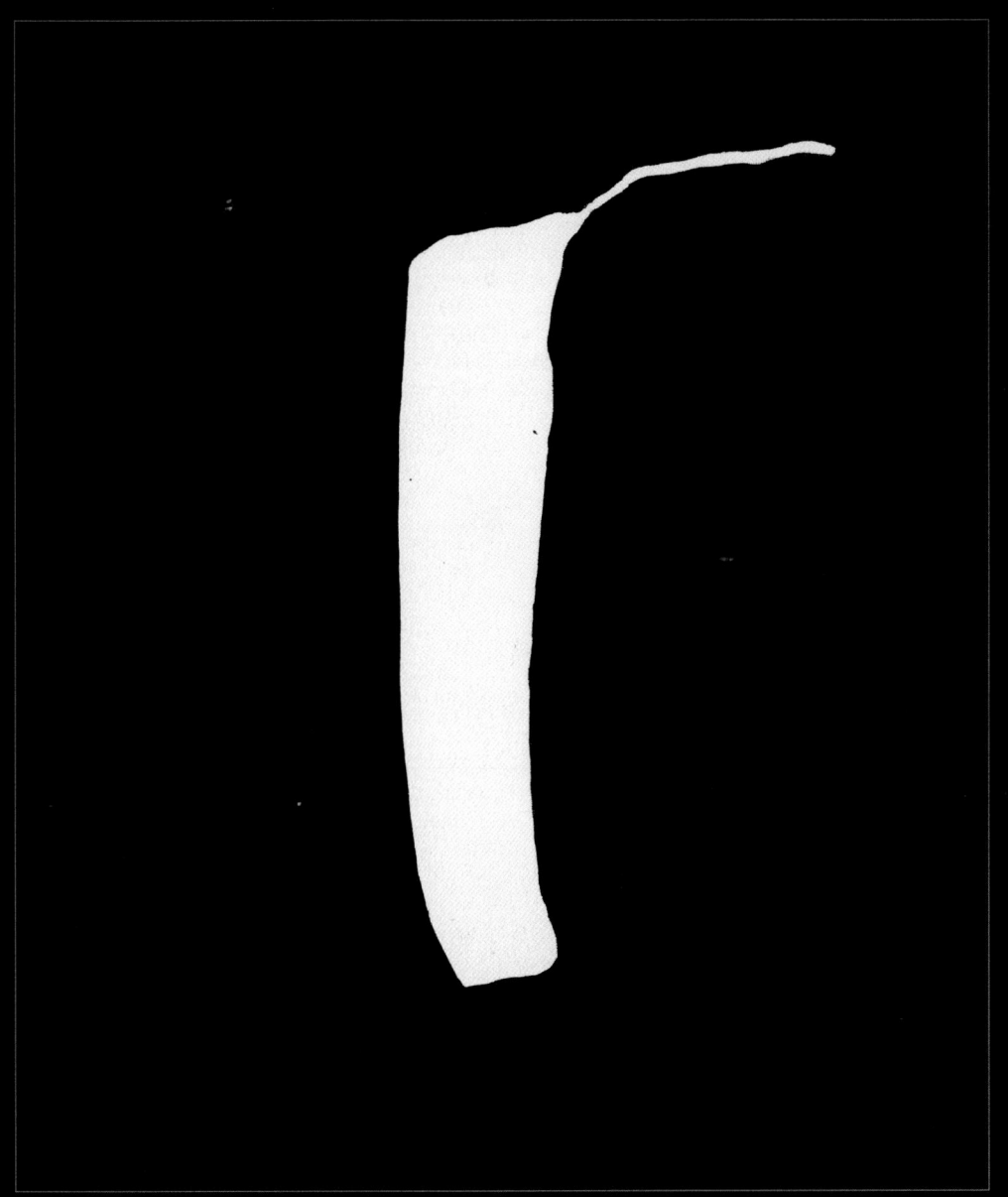

Key Event
First exhibit of Painters Eleven

While areas of Canada such as Quebec welcomed the emergence of abstract art in the early 1950s, Ontario remained conservative, as evidenced by the continued popularity of the Group of Seven, a faction of classical landscape painters. Abstract art was perceived to be primitive and childish, a sentiment that frustrated contemporary Ontarian artists. Thus, in 1953, eleven Toronto artists, comprising Jack Bush, Oscar Cahén, Hortense Gordon, Tom Hodgson, Alexandra Luke, Jock Macdonald, Ray Mead, Kazuo Nakamura, William Ronald, Harold Town, and Walter Yarwood, banded together to found the Painters Eleven.

While the group shared a commitment to promoting modernism in art, each member retained his or her individual style. The first exhibition of the group occurred in February 1954, at the Roberts Gallery in Toronto. While no sales were made, the exhibition drew large crowds and facilitated the group's success in publicizing modern art by generating both criticism and acclaim. The group continued to exhibit, and in 1956 attracted international attention when it collaborated with the American Abstract Artists in an exhibition at the Riverdale Museum in New York. Although dissension among the members led to the dissolution of the group in October 1960, the impact of Painters Eleven in the realm of contemporary art was enduring. Over the six years of the group's existence, the members fostered the acceptance of contemporary art through their exhibitions, thus pioneering the development of abstract art in Canada by enabling young artists to pursue their goals in this spectrum.
Heather Hund

Date February, 1954
Country Canada
Why It's Key First show organized by a group of abstract painters promoting contemporary art in conservative Ontario.

440

Key Artist **Willi Baumeister**
Death of the influential abstract painter and muralist

Although his career began at the time German Expressionism was burgeoning, before World War I Baumeister spent a lot of time in Paris, and came under the influence of Cubism. After the war, he developed his celebrated series (which he termed "Mauerbilder") of wall paintings which in their execution incorporated thickening textural materials such as gravel, sawdust, and putty.

After meeting Fernand Léger and Le Corbusier, Baumeister developed his work in a more figurative direction, and he was acclaimed as an established painter in France. In 1928, he was appointed Professor of Typography at the Stadel School in Frankfurt, Germany. He was banished from this post by the Nazis in 1933, on the grounds of "degeneracy," and was obliged to disappear and work in obscurity in Stuttgart, where he began to develop a style which he termed "abstract surrealism." This gave rise to his deep interest in the workings of the subconscious mind. During this period of ostracism, he wrote his definitive book on the subject, *The Unknown in Art*, which was published in 1947. During the postwar years until his death in 1955, Baumeister became something of a hero and legend in his own lifetime to young German abstract artists. He was reappointed in 1946 to a professorship in Stuttgart.
John Cornelius

Date 1955
Born/Died 1889–1955
Nationality German
Why It's Key Highly respected abstract painter, muralist, typographer, and academic.

Key Artist **Richard Hamilton**
Man, Machine, and Motion exhibition

Born in London, Richard Hamilton was educated at the Royal Academy schools between 1938 and 1940, before studying engineering draughtsmanship at a Government Training Centre in 1940, then working as an industrial designer. His first major exhibition was at the Gimpel Fils Gallery, London, in 1950, and featured engravings based on D'Arcy Wentworth Thompson's 1913 text *On Growth and Form*. But Hamilton's breakthrough moment came four years later when he devised an exhibition Man, Machine, and Motion for the Hatton Gallery, Newcastle-upon-Tyne.

The exhibition reflected not only Hamilton's preoccupation with popular culture and advertising – suggesting a "pop art" sensibility still somewhat ahead of its time – but also summarized the concerns of the Independent Group, an informal discussion forum he

had co-founded with artist Eduardo Paolozzi and critic Lawrence Alloway, and which tested prevailing assumptions about art. Intellectual curiosity was to define Hamilton's entire career. Hamilton later went on to teach at King's College, Newcastle-upon-Tyne, and in a long and protean career has since tackled a prodigious variety of subjects – cultural, political, and literary – not only through print and paint, but also by undertaking industrial design projects and setting up intermittent creative collaborations with others.

Graham Vickers

Date 1955

Born 1922

Nationality British

First Exhibited 1950

Why It's Key A leading pioneer of British Pop Art and champion of boundary-free artistic expression.

Key Exhibition
Documenta

Documenta, launched to accompany the 1955 Bundesgartenschau (German Federal Horticultural Show), was the initiative of Arnold Bode, a Kassel painter and art professor. The first exhibition surveyed modernism's impact on Europe from early in the century with the work of 148 artists from six countries, selected by Bode and art historian Werner Haftmann. With the show's public success, its historical thesis was extended to the postwar era four years later with Documenta 2. Haftmann was again director, and once more in 1964 when work chosen on individual merit asserted the primacy of "abstraction as world language."

The organizers' focus on an older generation caused controversy among younger artists at Documenta 4 (1968). Demonstrations disrupted the opening ceremony, and radical elements were in

conflict with the show's institutionalized structure. By 1972, these groups were in dialogue with the artistic director, Harold Szeemann; given overall responsibility for the fifth show, he broke with previous practice by adopting a theme and choosing work with the potential to articulate it. Subtitled "Inquiry into Reality – Today's Imagery," Documenta 5 was significant for marking the institutional acceptance of Conceptual art, and for Szeemann's controversial attempt to group exponents into distinct categories. Daniel Buren, Marcel Broodthaers, Hans Haacke, Gerhard Richter, and many others took part, while several, including Carl Andre and Donald Judd, protested and some withdrew. Successive exhibitions, with their guest directors, each explored different formats.

Martin Holman

Date July 16–September 18, 1955

Country Germany

Why It's Key Major postwar celebration of modern art. Held every four or five years, by 1972 it was established as the most important international group show of contemporary art. Documenta X (1997) sought art's future direction by critically reviewing fifty years' "tradition of innovation." Documenta lasts 100 days and remains a public success.

Key Person **Clement Greenberg**
Publishes influential essay "American-Type Painting"

In 1955, Clement Greenberg published in the *Partisan Review* the essay "American-Type Painting," a key text in the critical reception of Abstract Expressionism. The essay gained a wider audience when reprinted in Greenberg's best-known book, *Art and Culture* (1961). Greenberg, whose early thinking was molded by the formalism of Roger Fry and Clive Bell, as well as by his own youthful adherence to Marxism, made his mark as a critic with an earlier essay, "Avant-Garde and Kitsch" (1939), in which he robustly defended modernism. His prominence coincided, however, with the advent of Abstract Expressionism. He was a passionate, eloquent champion of Jackson Pollock, to whom he was especially close, as well as of Willem de Kooning, Hans Hofmann, and Clyfford Still. In the aftermath of Abstract Expressionism, Greenberg favored color field painters such as Barnett Newman, Morris Louis, and Kenneth Noland, and coined the term "post-painterly abstraction" to describe their work. He was also a powerful advocate of the sculptors David Smith and Anthony Caro.

Greenberg was the most important American critic of the twentieth century, and one of the greatest writers on art of any age. But, from the mid 1960s, was also one of the most vilified figures in the art world, denounced for not supporting Pop art, Conceptual art, and Minimalism, and for his later, forthright opposition to Postmodernism. He was also accused of manipulating reputations and telling artists how and what to paint. Despite his influence on writers such as Michael Fried and Rosalind Krauss, his reputation remains contentious, and "Clembashing" is still popular among critics today.

James Beechey

Date 1955

Born/Died 1909–1994

Nationality American

Why It's Key Leading twentieth-century American art critic and major advocate of Abstract Expressionism.

opposite Clement Greenberg

Key Artwork *Still Life – Nightshade*
Ben Nicholson

Still Life – Nightshade was a successful assimilation of Nicholson's (1894–1982) old and new work that also introduced novel elements. The work suggested an abstracted table containing largely quadrilateral shapes in various shades of brown, with blue and yellow also present. The palette was an immediate departure from his 1953 colorful and cheery *Contrapuntal*, but it was not yet threatening. Rather, the black background brought out the color effects in the foreground, not quite in the sharp relief that characterized Nicholson's work in the 1930s, but with enough force to focus the eye on the foreground.

Nightshade thus echoed, if distantly, the contrastive effects of the painted reliefs and sculptures that had initially put Nicholson on the map in the 1930s, but the painting's softer borders also suggested that Nicholson had abandoned his austere geometries of the late 1930s. Borders were a key concept in *Nightshade*, whose fields of color may suggest land as well as table-sized objects. By the 1950s, Nicholson had developed a passionate interest in the spiritual significance of land, and *Nightshade* might allude to some kind of ideal geography as well.

Nicholson carried *Nightshade*'s mood over into his 1956 *Val d'Orcia*, whose structure is similar. *Val d'Orcia* won the first Guggenheim International Award and elevated Nicholson to international renown.

Demir Barlas

Date 1955

Country UK

Medium Oil and pencil on board

Collection Private collection

Why It's Key *Still Life – Nightshade* helped to re-establish Nicholson on the international avant-garde radar.

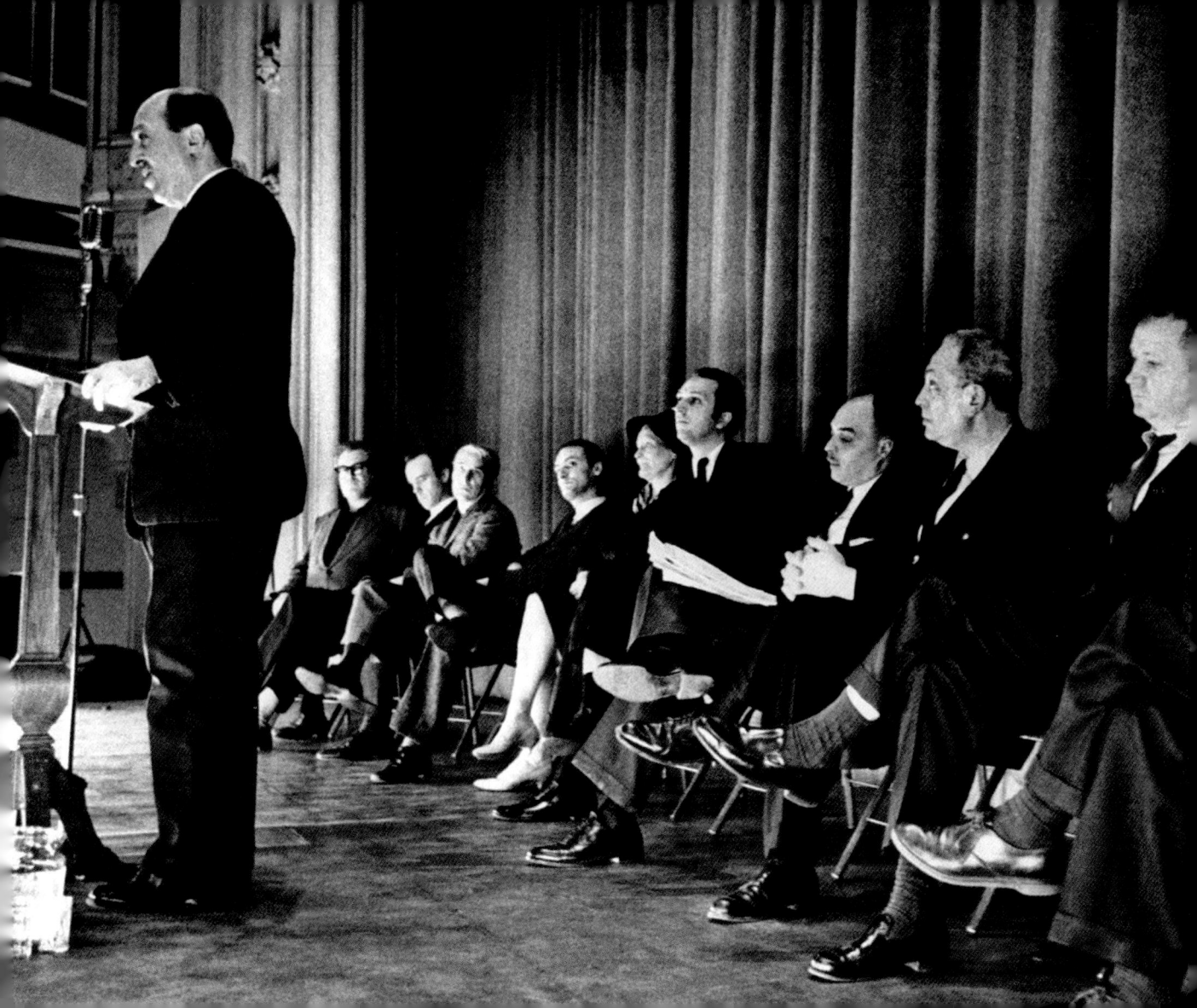

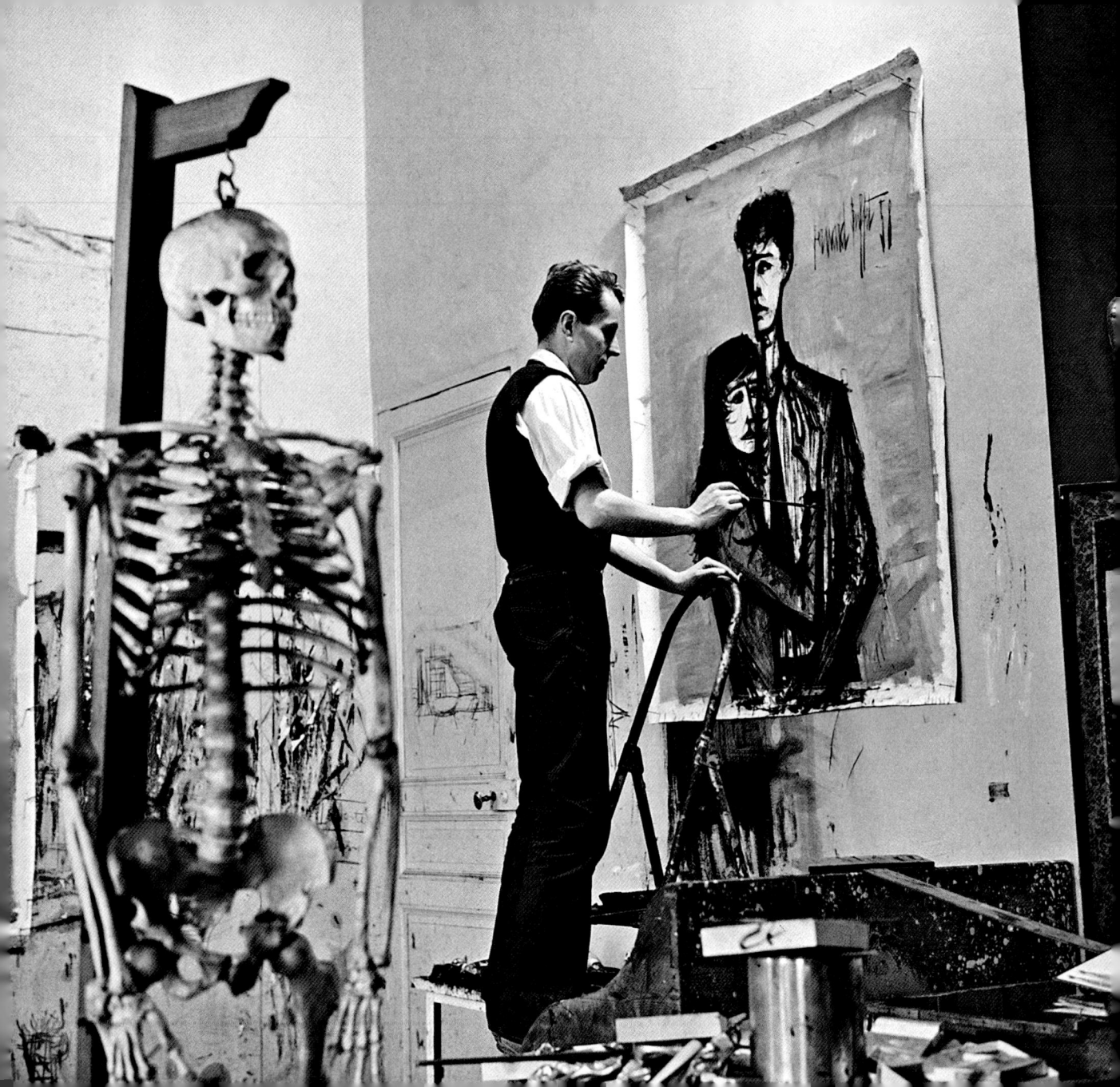

Key Artist
Bernard Buffet

Born in Paris in 1928, Buffett joined the Ecole des Beaux-Arts at the age of fifteen. He developed a sparse graphic style deploying bold but economic outlines, with a limited and somber palette. His figure paintings and portraits verge on caricature, depicting emaciated, defeated individuals, symbolic of the ultimate destiny of humankind, but also in a very literal sense reflecting the condition of humanity across much of war-torn Europe. He also made disturbing images of giant insects and birds, and his series on the streets and buildings of Paris (typified by *The Opera* of 1955 and the *Place de la Concorde* painted a year later) shows a desolate city stripped of its familiar poetry and magic, which may have reflected his recollection of the occupied city of his youth. Buffet was an independent painter who did not belong to any particular group. Nevertheless, his first exhibition was held at the Gallery of Impressionist Art in 1947, and in 1948 he was awarded the Prix de la Critique. His paintings began to fetch very high prices, and there were numerous solo exhibitions at the prestigious Drouant-David gallery, the themes of which included the Passion, Landscapes, Nudes, Joan of Arc, War, and the Circus). In 1952, he illustrated a reprint of *Chants de Maldoror* by the definitive Symbolist poet Lautréamont, and completed several other illustrative commissions. His late work is regarded as decorative and stylized, commercial success having perhaps softened the existential bleakness of his youthful vision.

John Cornelius

Date 1955

Born/Died 1928–1999

Nationality French

Why It's Key Expressive painter whose success led to a more mannered style.

opposite Bernard Buffet

Key Artwork *The Toilet*
John Bratby

John Bratby (1928–1992) was the father of kitchen-sink realism, a school of painting named by critic David Sylvester in response to Bratby's 1954 *Kitchen Sink*. As a cultural trend, kitchen-sink realism chose to stare frankly into the abyss, which in Bratby's case consisted not of hell but of unvarnished household locales and situations. *The Toilet* is a case in point. The painting, done in yellow and brown colors that expressly invoke human waste, directs the eye down toward a gaping toilet, complete with brown stains.

Bratby treats his ugly subject beautifully. His work is by no means a "Pop" gesture, or even a distant invocation of Duchamp's urinal, but a diligent and conventional treatment. It is only the object of the treatment, the taboo toilet, that distinguishes the painting.

For Bratby and other adherents of kitchen-sink realism, the move to the object problematized questions of modernity. Modernism in art had undeniably shifted the big mysteries – meaning, beauty, experience – out of the painting and into the spectator; but modernism was more than just a philosophical and conceptual shift. It was a determination to look into unexamined places: the subconscious, the stream of consciousness, the taboo. *The Toilet* demonstrates the tension between these two aims of modernism. It certainly looked in a forbidden place, and this spirit of transgression was modern, but Bratby's act of looking was itself conventional. The combination of transgression of location and vapidity of glance suspends *The Toilet* in one of modernism's contradictory spaces.

Demir Barlas

Date 1955

Country UK

Medium Oil on board

Collection Tate Britain, London

Why It's Key *The Toilet*, an example of kitchen-sink realism, holds the tension in the different aims of modernism.

Key Artwork *Two Figures (Menhirs)*
Barbara Hepworth

From the long-standing theme of the pair of abstracted figures in Barbara Hepworth's sculpture a series of works emerged bearing the subtitle "Menhirs." The first pair in this series was *Two Figures*, which was carved from teak wood and completed in 1955. Hepworth (1903–1975) simply explained the works from the *Menhir* series as "just two presences, bound by their nature in eternal relationship." The series is recognizable by the masterfully carved oval elements pierced by circles in every left-hand figure, and the vertical slots cut into the right.

Hepworth's piercing of "holes" in her sculpture was an important contribution to British abstract art, denying the mass of the material and taking the spectator into the surrounding space inside her work. In this particular example, the internal shapes are painted in the purest white, beautifully contrasting with the play of the teak's grain. The use of wood helps to emphasize the verticality of the composition by its grain, and complements the natural origins of the shape of the *Two Figures*. The reminiscence of nature in *Two Figures (Menhirs)* is a product of the Trewyn Studio in St Ives, Cornwall, where Hepworth lived and worked from 1949. Here she found a studio, a yard, and a garden in which the sculptor could work in open air and space. The natural beauty of this part of Cornwall inspired Hepworth to create many of her most famous works.

Erik Bijzet

Date 1955

Country UK

Medium Teak and paint

Why It's Key A prominent example of Hepworth's important paired figures.

opposite *Two Figures*

Key Artist **F. N. Souza**
Solo show, Gallery One, London

Francis Newton Souza, an important Indian modernist painter who first exhibited in the seminal 1947 Progressive Artists Group show, did not enter the limelight until 1955, the year of his career-making exhibition at London's Gallery One. Souza, born in 1924, had not waited long for notoriety. Despite his tender years, he had been a leading member of the Progressive Artists Group, the collective that launched Indian modernism. With the shrewdness and practicality that served him well through life, Souza left India two years later in order to make his way in London, a much likelier place for an Indian artist to win public and critical success.

In 1955, Souza struck gold when Gallery One decided to exhibit his work. Souza was a major attraction thanks not only to his credentials as an Indian modernist, but also because of his striking aesthetic, which incorporated several influences into a distinctly personal style. It was the eclecticism of Souza's paintings that struck critic John Berger, who helped to solidify Souza's international reputation. Combined with Souza's tireless work ethic and genius for self-presentation – he did his best to create and promote an *enfant terrible* persona, abetted by numerous failed marriages and affairs – the Gallery One success launched him to the forefront of internationally active Indian artists. His fame thereby eclipsed his Progressive Artists Group peers. Souza remained passionately active until the year before his death, at which time a host of paintings and drawings in his estate came on the market.

Demir Barlas

Date 1955

Born/Died 1924–2002

Nationality Indian

First Exhibited 1947

Why It's Key A leading Indian artist begins a long period of fame thanks to a showing at a London gallery.

Key Artwork *Just What Is It that Makes Today's Homes So Different, So Appealing?* Richard Hamilton

Today it is hard to imagine a time in which the images of commerce were seen as startling subjects for art, but that was the world into which a 1956 Whitechapel Gallery exhibition, This Is Tomorrow, was pitched. Its defining exhibit, *Just What Is It that Makes Today's Homes So Different, So Appealing?*, was a collaborative effort by Richard Hamilton, John McHale, and John Voelcker. McHale supplied a very specific "plan" for the collage, which Hamilton amended and executed.

Onto a photograph of McHale's living room is grafted a smorgasbord of visual elements: a Californian bodybuilder; a female pin-up; a giant can of ham; a reel-to-reel tape recorder; a woman vacuum-cleaning the stairs; a movie theater; a working TV set; an American comic book as a framed art poster on the wall. The bodybuilder holds a giant Tootsie Pop with the word "Pop" conspicuous on the wrapper. The intentionally anachronistic piece shows a "home" exclusively defined by graphic representatives of an increasingly pervasive commercial world. Some are prescient: Roy Lichtenstein did not turn to celebrating comic books as art until the early 1960s, and Warhol did not start to fetishize food cans until the same decade. As a result this small collage is the world's bona fide first notice of Pop Art.

Graham Vickers

Date 1956

Country UK

Medium Collage

Collection Kunsthalle Museum, Tubingen, Germany

Why It's Key The collage that heralded pop art.

opposite Just What Is It that Makes Today's Homes So Different, So Appealing?

Key Person **Iris Clert**
Opens gallery promoting Klein, Tinguely, and others

Iris Clert opened the "smallest art gallery in Paris" at 3 rue des Beaux-Arts in February 1956, in one small room 20 meters (215 feet) square. It had the advantage of a large picture window and a location near the Ecole des Beaux-Arts and opposite the Minotaure, a surrealist bookstore. A Greek national who was active in the French Resistance in World War II, Clert brought to art dealing modern techniques of presentation. Openings were remembered as *événements* (happenings), as in 1957 when Yves Klein led a march to the popular Deux Magots café and released 1,001 blue balloons, and performed a one-note sound composition in the gallery in front of which the sidewalk was painted blue.

Clert displayed an unshakeable belief in the destiny of the artists she represented in spite of press and public skepticism. Until it moved to larger premises in 1961, the gallery was a place for groundbreaking exhibitions and international collaborations. Opening on Klein's thirtieth birthday in 1958, Le Vide (The Void) featured an empty whitewashed room "impregnated" with the artist's spirituality. By inviting a cabinet minister, Clert succeeded in having Republican Guards in full regalia flanking the street door at the opening and caused a furore. Other important exhibitions were Jean Tinguely's Méta-Matic (1959), and Arman's Le Plein (Full Up) in 1960, when the artist filled the gallery, floor to ceiling, with accumulated trash. Always financially insecure, the gallery closed in 1972. Clert then employed other channels, including a glass-sided truck, to bring art to the streets.

Martin Holman

Date 1956

Born/Died 1917–1986

Nationality Greek

Why It's Key Paris dealer who championed the work of Yves Klein and *nouveau réaliste* artists.

Key Artist **Ivon Hitchens**
British Council retrospective at Venice Biennale

Ivon Hitchens studied at the Royal Academy schools during World War I. In the 1920s and 1930s, he lived in Hampstead, London, close to other avant-garde artists who were later to become well known, such as Ben Nicholson, Barbara Hepworth, Henry Moore, Naum Gabo, and Paul Nash. In 1940, during World War II, a bomb landed close to his studio and caused him and his wife, Mollie, to move from London to Sussex, where they had bought a few acres of land the previous year. They built a new house and studio, adding on to it as he became more commercially successful. Hitchens continued living and working there for the next forty years.

Worked directly from nature, his paintings display spontaneity and vigor, some allowing the original planning marks to show through, and toward the end of a series he would often paint directly onto the canvas. He also made line drawings of his family, and of people working the land, throughout his life. Hitchens also painted murals – the largest, completed in 1954, was more than 20 meters (65 feet) long. He continued painting increasingly bold, brightly colored canvases until the last weeks of his life, and died at the age of eight-six.
Alan Byrne

Date 1956

Born/Died 1893–1979

Nationality British

Why It's Key International recognition for leading English colorist.

Key Artist **Joan Mitchell**
Recent American Watercolorists tours France

With their dense brushwork, assertive arcing strokes and full color, Mitchell's paintings from the late 1950s onward are quintessential examples of the second generation of the New York school. Yet from 1959 she painted only in France, and the expatriate decades may have accounted for the relative neglect of this Chicago-born artist in her native country.

Abandoning a Cubist style around 1950 in order to paint more freely, Mitchell applied interests in aspects of Kandinsky, Duchamp, Gorky, Mondrian, and Pollock to the influence exerted on her work by the gestural paintings of de Kooning and Kline. Settled in the 10th Street district of New York during the 1950s, where Philip Guston also worked, she developed a lyrical calligraphic treatment of images that often re-created the intensity of certain landscape scenes from memory. Painting for her became a primary conveyor of feeling and was increasingly informed by the poetry of Rainer Maria Rilke, Frank O'Hara, and William Wordsworth. She also enjoyed a long friendship with Samuel Beckett.

Compared with the existential aggression of the first generation's images, the work of Mitchell and contemporaries such as Guston and Jack Tworkov resonated with a multilayered experience of modern life in its openness, transience, disorderliness, and ambiguity. Above all, it proposed that avant-garde art could give pleasure. Included in the important traveling exhibition Nature in Abstraction in 1958, Mitchell was accorded a ten-year retrospective in 1974 at New York's Whitney Museum of American Art.
Martin Holman

Date 1956

Born/Died 1925–1992

Nationality American

Why It's Key Combined the inspiration of nature and poetry with the gestural painting of Abstract Expressionism.

Key Artist **Nicolas Schöffer**
Creates first cybernetic sculpture in art history

Despite participating in a wide range of creative activity, the Hungarian artist Nicolas Schöffer is best remembered for his *CYSP (Cybernetic Spaciodynamic) 1*, the first-ever cybernetic sculpture in art. *CYSP 1*, which was introduced to the world at the Sarah Bernhardt Theater in Paris in May, 1956, was at once a complex machine and a thought-provoking piece of art. Perhaps 11 or 12 feet tall, *CYSP 1* was something like a small tower; it contained a round base that supported three metal rods attached to a smaller collection of metal shapes at the very top of the sculpture. Remarkably for its time, *CYSP 1* was fully interactive. The sculpture's turning plates projected colors in response to the presence of humans, and could sense the projection of colors onto itself; it moved in response to sound (allowing it to be

employed in a subsequent ballet performance by Maurice Béjart); and its rudimentary but real artificial intelligence redefined what sculpture could be in an age of computers.

Schoffer's ambition for *CYSP 1* was not simply to present a machine as art, but to suggest that a machine, like a human, could be creative. Schoffer's pioneering artwork, made possible with the technical assistance of the Philips Company, paved the way for an emerging generation of cybernetic artists. While the focus of contemporary cybernetic art has shifted from the merely robotic to the altered human body, *CYSP 1* still stands at the head of art's encounter with the (thinking) machine.

Demir Barlas

Date 1956

Born/Died 1912–1992

Nationality Hungarian

First Exhibited 1937

Why It's Key Schöffer's *CYSP 1*, a pioneering creation, heralded art's involvement with artificial (computerized) intelligence.

1950–1959

455

Key Artist **Gillian Ayres**
First solo show, Gallery One, London

At thirteen, Gillian Ayres informed her head teacher at St Paul's School in London that she wanted to be a painter. This precarious notion was discouraged. How would she live? Her parents shared similar concerns. Nothing, however, could stop the young Ayres from following her dream, first as an art student at the Slade, then Camberwell (1946–50), where she met fellow painters Terry Frost and Henry Mundy. Ayres abhorred the figurative work of the fashionable Euston Road school. A photograph of Jackson Pollock, at work in his studio, made a powerful impression. She began pouring and dripping a combination of house enamel and oil paint directly onto canvas. Exuberant with energy, Ayres could relate to both the emerging Abstract Expressionists in the United States and the Tachists in Europe.

Following art school, Ayres worked in London at the AIA gallery, sharing her post with Mundy, whom she later married. In 1956, Ayres held her first solo exhibition at Gallery One. Throughout the 1960s, she produced radical action painting and spontaneous brushwork. Ayres was the only woman included in the pivotal RBA Situation exhibition (1960). This was followed by a succession of distinguished solo survey exhibitions at the Museum of Modern Art, Oxford (1981); Serpentine Gallery, London (1983); the Tate Gallery (1995); and the Royal Academy, (1997). Over time, she moved from working with thin vinyl paint and limited color to thick riotous oil impasto. Even now, Ayres continues to climb ladders to paint her huge canvases, and to hurl paint.

Carolyn Gowdy

Date 1956

Born 1930

Nationality British

Why It's Key Debut of one of the most admired and respected painters in Britain. Ayres is well known for a bold style and sensually exuberant use of color. Dismissive of art theory, she strives to create a visual language that is uplifting.

Key Exhibition
This Is Tomorrow

The encompassing theme of This Is Tomorrow was design. Its twelve exhibits were created by twelve teams, each comprising an architect, painter, and sculptor, and the imaginative installation drew spectators through miniature environments designed in deliberate contrast to one another, "split up like market stalls at a fair," as Colin St John Wilson, an architect team member, remarked. The experience was sensory and intellectual, with the layout imitating the chaos of an urban street. There was no presiding aesthetic, although the interface of art with technology and popular culture linked many exhibits. That concept was associated with the Independent Group, a study forum of young artists and writers centered on London's Institute of Contemporary Arts who were prominent in the show's organization. It was most apparent in the display created by Richard Hamilton, John McHale, and John Voelcker which featured cutout reproductions of Marilyn Monroe and Robbie the Robot, two current movie stars. Also included were soft flooring, a jukebox, fluorescent colors, and perception tests presented like signs to deeper meanings. Similarly symbolic in its impact was the post-apocalyptic vision of a British "tomorrow" by Eduardo Paolozzi, Nigel Henderson, and Alison and Peter Smithson. Called *Patio and Pavilion*, their display showed a crude future of basic shelterless structures and objects offering little entertainment.

Hamilton's proto-pop collaged poster image was a parody of postwar consumerism where technology erased distinctions between public and private. The catalog, too, represented an advance in graphic design.

Martin Holman

Date August 9–September 9, 1956

Country UK

Why It's Key Highly influential as a collaboration between artists and architects, the exhibition is often celebrated as the birthplace of UK Pop Art. With 19,341 visitors, This Is Tomorrow was among the year's most popular shows.

Key Exhibition
Modern Art in the United States

Drawn almost entirely from the collection of New York's Museum of Modern Art, the exhibition's 209 exhibits surveyed painting, sculpture, and printmaking between 1898 and 1954. From Maurice Prendergast's pioneering Post-Impressionism, it continued through the Realist, romantic, and primitivist traditions. The strongest impact, for visitors able to respond to it, came from Abstract Expressionist paintings by Franz Kline, Willem de Kooning, Jackson Pollock, Mark Rothko, and others in the last room, which, predicted the art critic of *The Times*, "may well have important consequences." At the time the British art establishment was resistant to new American visual art, especially its blurred distinctions between "high" and "low." The success of exhibitions by Picasso, Matisse, and the Lyrical Abstraction of the École de Paris had confirmed Paris in postwar London as the cultural center of gravity. The emergence, however, of the ICA and the Independent Group by the early 1950s marked a trend toward image, spectacle, and style as key interests of avant-garde inquiry, and the view that high culture was respected, but not essential. The exhibition set out to challenge European art's centrality. Comments such as Patrick Heron's, that Abstract Expressionism was the "most vigorous movement we have seen since the war," reflected the radical shift it hastened among artists toward the formal qualities of U.S. modernism: gesture, flatness, large scale, and the mark as image. New York was acknowledged as the center of artistic renewal; for Robyn Denny, "suddenly art was future-oriented; it was no longer historically oriented." The Tate's 1959 show the New American Painting confirmed this shift.

Martin Holman

Date January 5–February 12, 1956

Country UK

Why It's Key The reception of this influential exhibition had a huge impact on the British avant-garde, confirming that New York had supplanted Paris as the center of the contemporary art world.

opposite Main participants in the Modern Art in the United States exhibit.

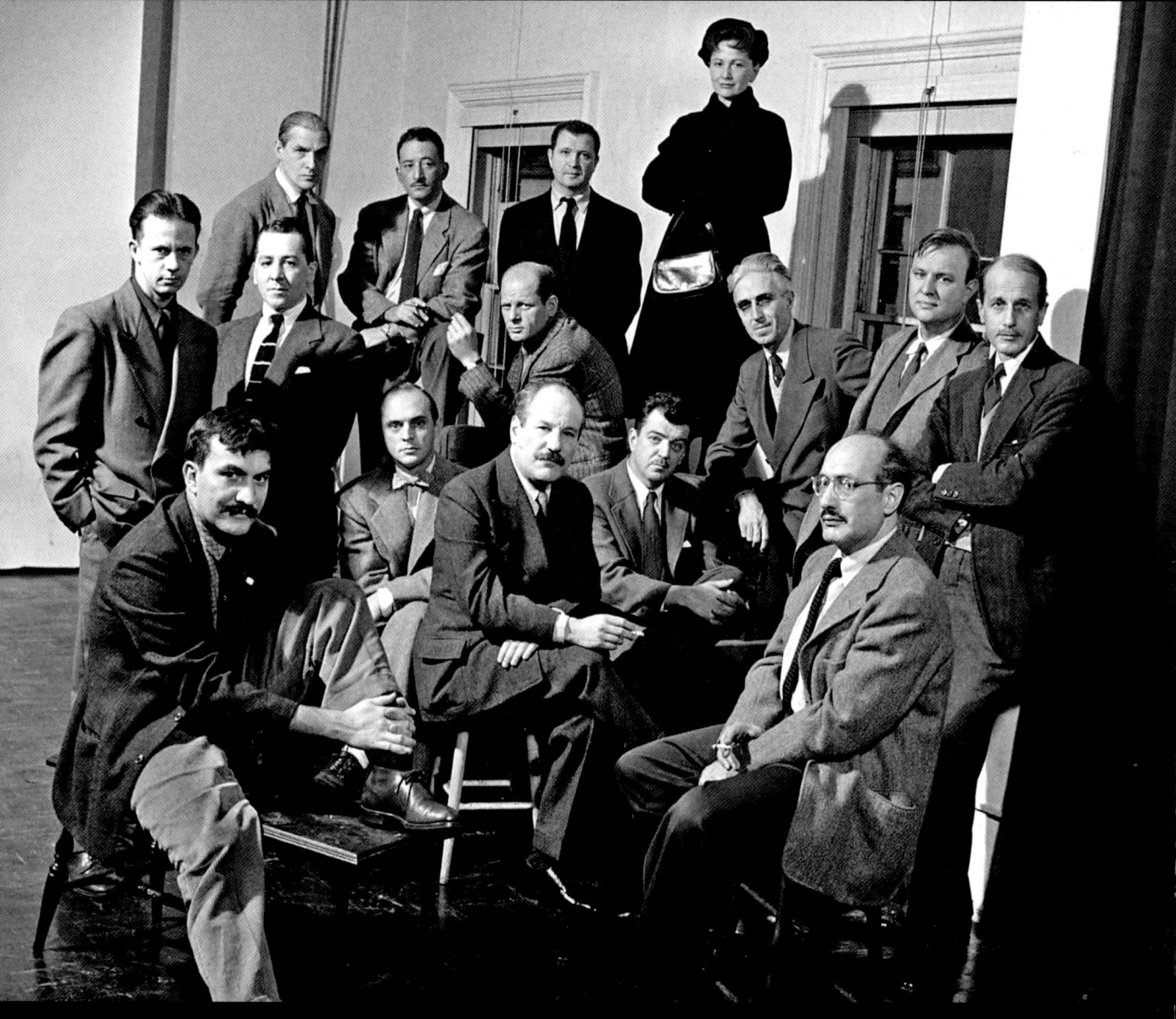

Key Event
Première of *The Mystery of Picasso*

Henri-Georges Clouzot (1907–1977) said that he often fantasized about the idea of sitting in the same room as Mozart while he composed *The Jupiter Symphony*, or with Rimbaud as he wrote *Le Bâteau Ivre*. He was unable to resurrect these dead geniuses, but he was able to achieve a similar ambition with a modern master, Picasso. Rather than just sitting in the artist's studio watching him work, Clouzot devised a method of transforming the screen into Picasso's canvas.

Released two years after Luciano Emmer's academic Italian documentary *Picasso*, Clouzot's 78-minute film, *Le Mystère Picasso* (*The Mystery of Picasso*) shows the artist at work, producing specially commissioned drawings and paintings for the camera. He works on a transparent "canvas" with the camera behind it, so that the audience can see the work being created without looking over the master's shoulder. Time-lapse photography is used so that the audience can witness the creation of fifteen works. All of them were deliberately destroyed after the production, so they now only exist in the film.

The movie premièred at Cannes on May 5, 1956 and won a Special Jury Prize. It went on general release in France on May 18 and was first shown in the United States, in New York, on October 7, 1957. Although it was also released in Belgium, Sweden, Finland, West Germany, Brazil, Italy, and Spain, the film was a commercial flop, despite its groundbreaking content. It was re-released in the United States in 1986, appearing again in Finland and Germany in the 1990s.
Nigel Cawthorne

Date May 5, 1956

Country France

Why It's Key This is the first film to show a twentieth-century master at work.

458

Key Artwork **The horizontal mobile**
Alexander Calder

Following graduation from engineering school in 1919, Calder took time to travel and reflect. While sailing off the Guatemalan Coast from San Francisco to New York, he woke on deck and saw a fiery, red sun rise from one side of the boat while the moon receded on the other. He later described this as "an inspirational vision." Could this moment have played a part in one of his most magical inventions? By 1930, Calder was experimenting with abstract wire sculptures, using the wire to suspend flat metal ovals, painted either black or a bright color, into space. The result was somewhat like a solar system. Marcel Duchamp would later term it the "mobile."

In 1923, Calder left mechanical engineering to study drawing and painting full-time at The Art Students League. Both his parents were artists and he knew it could be a challenging and uncertain life, so he worked as a freelance reportage illustrator to support himself.

While researching the circus, he began making a miniature model with wire and found objects. By 1928 he was supporting himself in Paris with performances of this circus, which had motor-driven parts and other elements suspended by wires. The circus attracted attention from both within and outside the lively arts community. Joan Miró attended a performance and Calder met many other important modernists, such as Léger, Mondrian, and Jean Arp. The following year he had a one-man show in Paris, and then in Berlin. Calder was on his way.
Carolyn Gowdy

Date 1956

Country USA

Medium Wire, painted metal

Why It's Key Calder is considered the inventor of the horizontal wire mobile, which could be set in action by the breeze. He was a pioneer of kinetic art and quietly revolutionized the idea of what sculpture could be.

Key Artist **Jiro Yoshihara**
Writes the *Gutai Manifesto*

Jiro Yoshihara was born in Osaka, Japan, in 1905. He worked originally in Surrealist and Abstract Expressionist styles. In 1954, he started the Gutai Bijutsu Kyokai (Gutai Art Association) with a group of young followers. The group held exhibitions twenty-one times between 1955 and 1972; these were not exhibitions in any traditional sense, but more forerunners of the happenings, events, action painting, and installations that evolved subsequently elsewhere, and were created through interaction with the environment or violent action. He wrote the seminal *Gutai Manifesto* in 1956.

In 1957, Yoshihara developed a relationship with the French art critic Michel Tapié, who advocated a similar approach with *l'art informel* painting. Tapié became interested in the group after he had seen the manifesto, sent to Hisao Domoto in Paris. The American action painter Jackson Pollock, one of the most influential painters of the twentieth century, accompanied the French art critic to Japan for many meetings with members of the group. Yoshihara and the Gutai became involved with the *l'art informel* movement, and held major exhibitions in the United States and Europe. While working with the Gutai, Yoshihara continued with his own work and produced more than a thousand pieces. In his final years, he devoted himself to repeatedly painting circles reminiscent of *satori*, the enlightenment of Zen.

Alan Byrne

Date 1956

Born/Died 1905–1972

Nationality Japanese

Why It's Key Leader of the pioneering avant-garde group the Gutai Art Association.

Key Artist **Chang Dai-chien**
Master of traditional Chinese art meets Picasso

Chinese artist Chang Dai-chien's 1956 meeting with Picasso was, in additional to its personal overtones, a momentous summit of the arts. The aging painters – Dai-chien was fifty-seven; Picasso seventy-five – represented the best of their respective traditions. Dai-chien had mastered numerous styles of Chinese painting and introduced innovations absorbed from his exposure to Western art. Picasso, who played host in his villa in Nice, France, treated him with great respect. The year 1956 was an important one for Dai-chien – not only because he met Picasso, but also because that was the year in which two French museums exhibited the Chinese artist's work. One of the exhibitions, in the Cernusci Museum, turned out to be of work that Dai-chien claimed to be ancient Chinese art from his collection, but was in fact the artist's own. It was partly this legacy of forgery – which, to be fair, Dai-chien considered a gesture of appreciation for the past as well as bravura performance of his own – that tainted the artist's reputation in Europe.

While Picasso appreciated Dai-chien's ink painting, the Chinese master never made an enduring impression on the Western art scene. Today, despite leaving behind a legacy of 5,000 works that demonstrate breathtaking mastery over any number of styles (as many as 25,000 more disappeared during China's Cultural Revolution), Dai-chien still has little fame outside China and Taiwan. This cannot be ascribed simply to his forgeries, and is better understood as part of an ongoing trivialization of Chinese art in the West.

Demir Barlas

Date 1956

Born/Died 1899–1983

Nationality Chinese

First Exhibited 1944

Why It's Key The greatest practitioner of Eastern painting meets the West's foremost artist.

Key Artist **Lynn Chadwick**
Wins the International Sculpture Prize at Venice Biennale

In 1956, Lynn Chadwick became only the second British winner (after Henry Moore) of the International Sculpture Prize at the Venice Biennale, against competition from, among others, Giacometti, Richier, and César. Aged forty-one, Chadwick had been a professional sculptor for just six years. Having trained as an architect and designer, he started making mobiles, constructed of balsa wood and aluminum wire, as adornments for trade exhibition stands, and only began to think of them as sculptures when the London dealer Gimpel Fils showed one in its shop window.

The Venice Biennale was the scene of Chadwick's first public triumph when, in 1952, he was one of a group of eight young sculptors, including Robert Adams, Kenneth Armitage, Reg Butler, Eduardo Paolozzi, and William Turnbull, invited to exhibit in the British Pavilion.

Their work was characterized by anthropomorphic imagery and spiky, aggressive forms that conveyed the foreboding and alienation prevalent in the immediate postwar years. In reviewing the Pavilion, the critic Herbert Read famously coined the phrase the "geometry of fear" to describe their collective unconscious.

Chadwick's most compelling sculptures belong to this period. Technically complex, their symbolic imagery carries a powerful emotional charge, accentuated by their often pitted and encrusted surfaces. Following a short-lived experiment with abstraction in the 1960s, Chadwick returned to figuration, embarking on a prolific sequence of increasingly monumental seated bronze figures, which, though much in demand for open-air sites, lack the psychological tension of his earlier work.
James Beechey

Date 1956

Born/Died 1914–2003

Nationality British

Why It's Key Major British sculptor of the 1950s – a constructor, rather than a modeler, Chadwick possessed remarkable engineering skills.

opposite *Marquette for Two Dancing Figures*

Key Exhibition
Direction 1

Twentieth-century Australian art was much enlivened by the feud between figurative and non-figurative artists. In 1956, non-figurative art had an important if inconclusive moment of dominance as Sydney's Macquarie Galleries put on Direction 1, an exhibition of abstract artists including John Passmore, Eric Smith, and Robert Klippel. Conceptually, the exhibition bridged the early Australian abstraction of Ralph Balson, Grace Crowley, Margo Lewers, and others, and the period of color abstraction still to come in the 1970s.

New York loomed large over Direction 1, not only thanks to the influence of the abstract work then being done in the city, but also via the New York model of art marketing. Before and after Direction 1, Australian art critics (including Paul Haefliger) and groups such as the Sydney Contemporary Art Society argued strenuously

on behalf of the new art, attempting to increase the pool of money and influence available to abstract artists in Australia. The attempt was successful in its aims, but not in displacing Australia's strong tradition of figurative iconography. Only three years after Direction 1, the figurative artists known as the Antipodeans would mount their own triumphant show in Melbourne, continuing an ongoing dialogue, battle, and exchange with the Direction 1 artists. In retrospect, Direction 1 may have marked the beginning of mingled popular, critical, and corporate acceptance of abstract art in Australia. Although many talented Australian artists retained figurative influences, Direction 1 also helped to re-establish the connection between international currents in art and the Australian scene.
Demir Barlas

Date December, 1956

Country Australia

Why It's Key One of the first major shows of Australian abstract act gestured to the past and presaged trends yet to come.

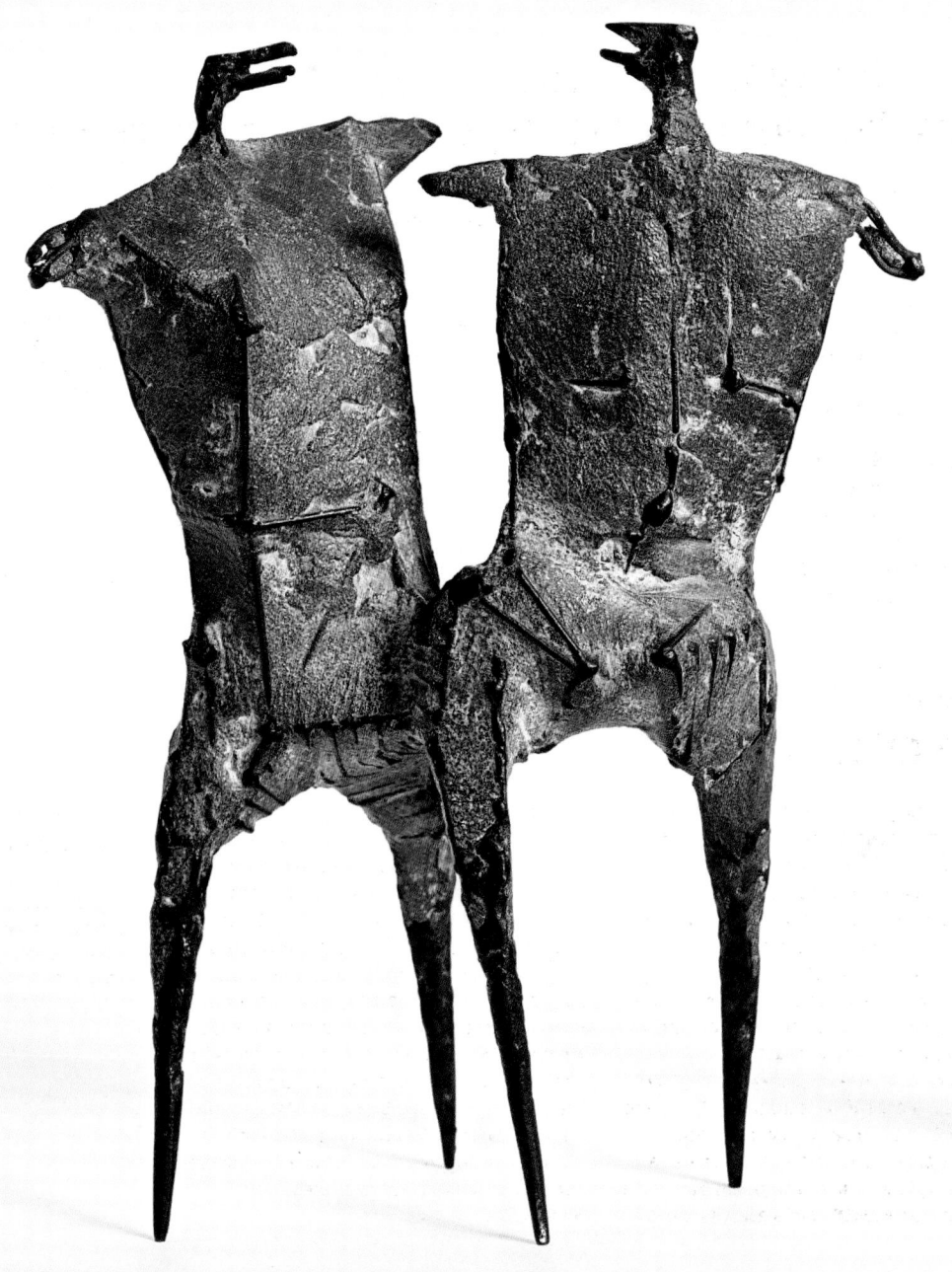

Key Artist **Roger Hilton** Begins working in Cornwall, as part of the St Ives group

On leaving art school in London, Roger Hilton studied in Paris in the 1930s, returning there regularly after World War II. Turning to abstraction in 1950, he was influenced by the techniques of Tachisme, where equal potential was given to every part of a painted surface. From 1952, he simplified forms into bold, irregular shapes animated by ragged applications of a restricted palette of strong colors. He described these dynamic compositions as "machines for the activation of surrounding space," concerned that they should connect with spectators' experiences. Inspired by Mondrian's mature work and utopian theories of non-representational art, Hilton perceived that artistic expression gave "an intuitive contact with a superior set of truths." From 1956, he began visiting St Ives, where Patrick Heron and other British painters knowledgeable about modernism had studios, taking his own studio there the following year, in Newlyn. A degree of allusion had always been present in his abstraction, and landscape and seasonal changes increasingly informed the colors and rhythms of his paintings. When overt figurative references re-entered his work after 1961, they remained indeterminate. By fully integrating drawing into his painting, Hilton balanced subjective emotional feeling with factual linear elements building vibrant spontaneity from the tentative exploration of form. After 1972, his health deteriorated. Unable to use oils, he created works with childlike subjects on paper. Made with cheap materials, these were humorous, defiant, and unsentimental distillations of complex life experience and joyous artistic inventiveness.

Martin Holman

Date 1957

Born/Died 1911–1975

Nationality British

Why It's Key Hilton's postwar paintings sustained a connection with European modernism rare in British art.

Key Artist **Piero Manzoni** Signs the Gruppo Nucleare *Manifesto against Style*

Piero Manzoni's interest in art dates from a very early age, as his family had befriended Lucio Fontana, a key figure in Italian modern art. Following his first exhibition in 1956, Manzoni signed the Gruppo Nucleare *Manifesto against Style*. The group, led by Enrico Baj, placed itself as the historical heir of Impressionism, Cubism, and abstraction in its battle against artistic conventions muzzling artistic freedom. The manifesto particularly attacked the notion of style, understood as the repetitive pattern blocking artistic innovation. According to the Gruppo Nucleare, artists had to differentiate themselves from decorators by proposing an eternally new and organic art, free from this idea of stylistic repetition. In the same year, Manzoni started his series of *achromes*, white monochromatic canvases made out of glue and kaolin, where the rough material became the work of art itself through a self-sufficient logic. In this aspect, Manzoni adhered to the nuclear art philosophy, as the canvas contained no sign of the artist's hand and therefore each work was new and void of style.

In 1959, Manzoni drifted away from the Gruppo Nucleare and founded his own gallery, Azimuth, and an eponymous magazine. His work evolved toward Conceptual art as he started to question the notion of authorship. His most famous work is the subversive *Merda d'artista* (1961), where he defecated into ninety tin cans, which he then sealed, labeled in Italian, English, French, and German, and sold at the current price of gold. Manzoni died at the age of twenty-nine, after suffering a heart attack.

Sophie Halart

Date 1957

Born/Died 1933–1963

Nationality Italian

Why It's Key A radical innovator and critic of artistic academism, Manzoni was a pioneer in two decisive movements in Italy: *arte povera* and Conceptual art.

Key Artist **Carel Weight**
Professor of Painting, Royal College of Art

Early one morning, Carel Weight made a familiar journey. He passed the Victoria and Albert Museum, its stone wall decorated by shrapnel reminders of the Blitz. He proceeded past the Lion and Unicorn insignia above a main door, and along a corridor scented with turpentine to the large painting studio. There he was astonished to find a student bathing in the sink. His name was David Hockney. Weight loved to tell this amusing story. He was a popular and respected tutor who felt his "job was not to teach them how to paint, but to teach them how to paint what they want to paint."

Weight, best known for figurative paintings which contain mysterious narratives along with a certain aura of unease, studied at London's Hammersmith School of Art and Goldsmiths as a youth. He admired William Sickert, Stanley Spencer, and Edvard Munch. Weight soon established himself as a painter and was made an Official War Artist by (Sir) Kenneth Clarke. The experience would make a profound impression. Weight was struck by how quickly signs of war were erased from streets and places, even though the consequences to people were lasting. From then on, Weight sought to capture the essence of people he knew well, and parts of London in which he had lived or grown up. He painted portraits, townscapes, and nature. The inhabitants of Weight's paintings have a transient quality – they could be tourists passing through their own lives. Weight looked for the extraordinary in the everyday.

Carolyn Gowdy

Date 1957

Born/Died 1908–1997

Nationality British

Why It's Key One of the most interesting painters of twentieth-century Britain who also helped to nurture many exceptionally talented artists that passed through the Royal College of Art.

463

Key Person **Arne Jacobsen**
Wins grand prize at Milan Triennale

In a career spanning nearly half a century, Arne Jacobsen designed everything from posters, bathing facilities, and spoons to Oxford colleges, Danish government buildings, and gas stations. But some of the Danish designer's most enduring design was done in the realm of chairs. In the four and a half decades between 1925 – when Jacobsen received a silver medal for a chair exhibited in the Paris World Exhibition – and 1970, the Dane would design a number of extremely popular and influential chairs. In 1957, Jacobsen's genius was recognized at the Milan Triennale, which awarded him a grand prize for his Chair 3140 design. The design, subsequently also known as the Grand Prix Chair, was a variation on Jacobsen's 1952 Ant Chair, a narrow-waisted single-piece chair with a three-legged base that combined elegance, functionality, and a sense of lightness – three characteristics that would come to form the core of Danish design.

After the Triennale, Jacobsen remained active in chair design, contributing the famous Egg, Swan, Seagull, Oxford, and 3300 models to the repertoire of modern furniture. Jacobsen would also go on to design tables, drawers, lamps, and other accessories to complement his signature chairs. This burst of design activity succeeded in broadcasting Jacobsen's aesthetic all over the world, and won him recognition from museums as well as from the marketplace. While Jacobsen's greatest formal triumphs may have been as an architect, his reputation outside Denmark rests largely on his furniture designs, of which the Grand Prix Chair was a remarkable example.

Demir Barlas

Date 1957

Born/Died 1902–1971

Nationality Danish

First Exhibited 1929

Why It's Key One of the most enduring furniture designs in history is recognized at an international exhibition.

Key Person **Leo Castelli**
Influential dealer opens gallery

One of the United States' most influential art dealers, Leo Castelli helped to launch the 1960s Pop Art movement onto the world stage. Castelli's first show as a curator was the 9th Street Show in 1951, an important event in Abstract Expressionism, and he subsequently burst onto the art scene in 1957 when he opened his own gallery. The Leo Castelli Gallery, in a townhouse on East 77th Street, in New York, initially showed Surrealist art; Abstract Expressionists Jackson Pollock, Willem de Kooning, and Norman Bluhm were some of the artists also featured. In 1958, Castelli who was known for his love of finding the next "new thing" in the art world, gave Jasper Johns his first one-man show. In that same year, Robert Rauschenberg joined the gallery, thus heralding the gallery's turn away from Abstract Expressionism toward Pop Art, Minimalism, and Conceptual art.

In the 1960s through to the 1970s, Castelli made the careers of other Pop artists, including Andy Warhol – he was the first dealer to sell Warhol's *Soup Can* paintings. Other cutting-edge artists who joined the Castelli stable at that time include Roy Lichtenstein, Cy Twombly, Donald Judd, and a young Frank Stella, fresh out of art college. In the 1970s, Castelli opened a SoHo arm of the Castelli gallery at 420 West Broadway, and in the 1980s opened a second downtown gallery space on Greene Street, also in the SoHo area.

Kate Mulvey

Date 1957

Born/Died 1907–1999

Nationality Italian (naturalized American)

Why It's Key As one of the United States' key art dealers, Castelli put Pop art and the 1960s American art scene onto the world map.

Key Event
Situationist International founded

In July, 1957, the founding conference of the Situationist International took place at a meeting in the Italian village of Coscio d'Arroscia, Italy. This consisted of several neo-avant-garde artistic groups: the union of the International Movement for an Imaginist Bauhaus (IMIB, with Asger Jorn, Giuseppe Pinot-Gallizio, Piero Simondo, and others, which had resulted from splits in the postwar COBRA that Jorn had helped to found), the Lettrist International (a Paris-based collective of radical artists and theorists 1952–57), and the London Psycheographical Association. The groups united in their desire to revolutionize life. Anti-capitalist, they rejected art as part of the "spectacle" that reduced people to passive consumers. As art had become part of bourgeois society, the Situationist International was

anti-art. Its goal was to liberate life, by constructing situations independent of the established structures and social orders. The Situationist International sabotaged the spectacle, to create a new situation (*détournement*) that was real. Politically subversive, the group's members deliberately broke all the rules of the game, eventually influencing events in Strasbourg in 1966 and the Paris student riots of 1968.

International, but Paris-based, the Situationist International Paris was formed in 1958, with Guy Debord as its most prominent member. There were always conflicting tendencies within the organization, leading to expulsions and a split in 1962, when a rival Second Situationist International was set up by Jörgen Nash, with the main Situationist International led by Debord.

Kate Mulvey

Date 1957

Country Italy

Why It's Key One of the most influential subversive international anti-art movements, it has inspired among other cultural phenomena the New Wave cinema of the 1950s and the 1970s punk movement.

Key Event
Publication of *On The Road*

When Jack Kerouac's novel *On The Road* was finally published in 1957, after five years of rejection from publishers, it marked the debut of the so-called "Beat Generation." They included Allen Ginsberg – whose epic *Howl!* the same year did for poetry what Kerouac's rule-breaking novel did for prose – and later William Burroughs, who broke even more taboos of style and content with his much-banned *Naked Lunch* when it first appeared in 1959. However, Kerouac's seminal novel, which he based on various trips across the USA between 1947 and 1950, heralded more than just a new literary movement; the "beat" phenomenon reflected an increasingly radical American postwar culture that manifested itself in all the creative arts.

Although written from copious notes that Kerouac made on his hedonistic journeys with his companion (and inspiration) Neal Cassady, the actual creation of the first finished manuscript of *On The Road* took just three weeks in April, 1951. In a burst of benezdrine-fuelled energy, he wrote the saga on one 120ft "scroll" made from lengths of teletype paper taped together. This, he reasoned, avoided the interruption to his flow occasioned by changing sheets of typing paper.

Kerouac's stream-of-consciousness approach, with its inspiration in improvised jazz rather than literary style, had much in common with the "unconscious" spontaneity sought by the Surrealists and, later, Abstract Expressionists like Jackson Pollock. And, crucially, it marked a seismic shift in artistic and social attitudes, signaling the beginning of a more liberal and genuinely "open" culture in the years that followed.

Mike Evans

Date September 1957

Country USA

Why It's Key This seminal novel ushered in the "Beat Generation" and its subsequent impact on modern culture.

1950-1959

465

Key Event
Equipo 57 formed

In 1957, a number of Spanish artists – including Agustín Ibarrola, José Duarte, and Juan Serrano – formed Equipo 57 in Paris. It was a dark time for Spanish painting, thanks to the repressive regime of Francisco Franco. While Equipo 1957 did not directly challenge the Spanish regime, the group's experiments in color, plasticity, and forms were a conceptual alternative to the rigid lines of Francoism.

Equipo 57 – inspired by Russian Constructivism, geometry, abstract mathematics, and the notion of colored space – turned out sculptures, paintings, and furniture at a rapid rate between 1957 and 1961, when the arrest of Ibarrola for his communist views put a damper on the movement. In retrospect, while some of Equipo 57's output may superficially resemble a depoliticized form of abstract art, the group's aesthetics were clearly informed by its radical politics. What appear to be pretty patches of color in Equipo 57 paintings are often depictions of mathematical ratios or principles, and the overall purpose of the group's output was to situate the observer in a direct relationship with material reality. For example, many of the group's paintings employed contrasting tones and clearly delineated borders between patches of color to model a diverse world. Unlike other socialist artists, however, Equipo 57 did not insist on subordinating this diversity to the revolution; rather, Equipo 57 artists allowed different colors and shapes to coexist in a non-hierarchical fashion. Politically, this rendered the group alien not only to Francoism, but also to the collectivizing impulse of Soviet art.

Demir Barlas

Date 1957

Country France

Why It's Key Postwar Spanish art received a brief but intense shot in the arm thanks to a collective with an aesthetic that defied dogmas of the Right and Left.

Key Artist **Fred Williams**
Discovery of Australian bush launches signature style

Melbourne-born Williams attended the National Gallery of Victoria Art School in Melbourne for his initial training in 1944. He was sixteen, and the gallery school took a traditional academic approach to art, training students in the formal disciplines of painting. At this time, Williams would paint nudes and group scenes, and was clearly an admirer of the work of Honoré Daumier. After his stint there, which lasted until 1946, Williams went on to the George Bell Art School (1946–1949), where he was introduced to modernism, something which suggested new directions to him.

Relocating to London, England, for five years (1951–56), Williams attended Chelsea Art School and the Central School of Arts and Crafts, producing vivid caricatured sketches of contemporary London life. Only upon his return to Australia in 1957 did he finally embark upon the kind of paintings that would bring him fame: an exploration of the Australian bush – not for its relationship to humankind or for its picturesque qualities, but as a medium through which to develop a personal visual language. *Charcoal Burner* (1959) is a good example; abstracted and stylized, it does feature a small figure, but suggests that this human presence is merely incidental to the ancient and remote setting. In his later years, Williams would turn to other subject matter, including marine scenes, but it is as a very personal chronicler of Australia's vast primeval terrain that he came to be regarded as one of the world's premier landscape painters.

Graham Vickers

Date 1957

Born/Died 1927–1982

Nationality Australian

Why It's Key Offered a highly personal view of Australia's landscape that contrasted with those of Sidney Nolan and Russell Drysdale.

466

Key Artist **Jasper Johns**
One-man exhibition at New York's Leo Castelli Gallery

Born in Augusta, Georgia, in 1930, Jasper Johns moved to New York when he was twenty-three. He became intellectually involved with avant-garde artists including Robert Rauschenberg and John Cage, and in 1954–55 he produced his seminal "Flag" painting, *White Flag*, which consisted of newspaper cuttings painted in multiple layers. While it was the beginning of his many flag paintings, his breakthrough came in 1958, with his one-man show at the Leo Castelli Gallery in New York. He was represented at the Venice Biennale in the same year.

During the 1950s and 1960s, Johns appropriated popular iconography: everyday images such as targets, beer cans, and flags which he transformed into an art context. Influenced by Marcel Duchamp, he played with the notion of *détournement* (displacement), taking an object from its original context and altering the way the viewer sees everyday symbols, parodying the original meaning. Called neo-Dada, Johns's early paintings laid the groundwork for subsequent movements such as Pop art, concept, minimalist, and performance genres. The painting process was more important to Johns than the subject matter – which is accidental; his works are often luxurious and painterly. His recurring motifs – numerals, letters, and maps of the United States – were used repeatedly, recycled, and combined in series. His acclaimed *Cross Hatch* paintings of the 1970s, with insignia suggested by passing cars on an expressway, gave way to a self-referential style in the 1980s and 1990s, typified by *The Four Seasons* (1985–86). He currently lives in Sharon, Connecticut.

Kate Mulvey

Date 1958

Born 1930

Nationality American

Why It's Key Johns had a significant impact on the emergence of Conceptual art movements: Pop art, minimalism, and performance art, among others.

Key Artist **Allan Kaprow**
Organizes the first happening to be staged in New York

For Allan Kaprow, Pollock's legacy lay in the performance component of action painting, and in canvases that were so embracing that "they became environments." In the mid 1950s, Kaprow had started making environments, which he called "action-collages." In *Penny Arcade* (1956), he created a quasi-theatrical setting for visitors to move through: a multitude of objects and papers hung from the ceiling of the Hansa Gallery, and noises, including telephones, erupted unpredictably. Art, Kaprow argued, should "utilize the specific substances of sight, sound, movements, people, odors, touch," in order to "come to grips with the world, to do something revelatory which in turn could make things about us more meaningful."

These principles informed Kaprow's development of "happenings" (the term first appeared in print in 1958) as scripted multidisciplinary non-narrative events, involving interaction between the participants and objects or their environment. In his seminal *18 Happenings in 6 Parts* (Reuben Gallery, 1959), Kaprow divided the space into three rooms, with clear plastic walls. Visitors were given instructions that choreographed their actions for each sequence, as they moved between rooms to watch a girl squeezing oranges or an artist lighting matches and painting. Robert Rauschenberg, Jasper Johns, Alfred Leslie, and Lester Johnson were among the performers. The idea that the artwork should not be an object, but a process or an event, was essential to Jim Dine, Robert Whitman, Claes Oldenburg, Red Grooms, and Carolee Schneemann, who took the form into different directions.
Catherine Marcangeli

Date 1958

Born/Died 1927–2006

Nationality American

Why It's Key Publishes "The Legacy of Jackson Pollock" in *Art News* (Oct. 1958), and calls for a "really new art." The new, concrete art was made of everyday materials, such as "paint, chairs, food, electric and neon lights, smoke, water, old socks, a dog, movies, and a thousand other things."

Key Artist **Yves Klein**
Notorious Empty exhibition

In 1955, Klein hung his first monochrome paintings on the walls of the judo school he had just opened. The physical and mental discipline of judo as coupled, for him, with the influence of Rosicrucian spirituality, the theorist of which, Max Heindel, spoke of as "immaterial sensibility" and of the need for the mind to free itself from solid bodies to be at one with the boundlessness of space.

In Klein's 1957 show at Colette Allendy's, one room was left empty, to figure the "immaterial origin of art." For his notorious Empty exhibition at Iris Clert's gallery in 1958, the invitations were blue, the windows were painted blue, but the gallery itself was totally empty – inducing the viewer to meditate on the "spatialization of sensibility," critic Pierre Restany explained in his catalog essay.

In two Sorbonne lectures, "The Evolution of Art towards Immateriality" and "The Architecture of Air" (1959), Klein argued that beauty already existed in an invisible state, the artist's task being to capture cosmic energies, and reveal them to others. The work of art was but the trace of a communication between the artist and the world, he concluded: "my pictures are only the ashes of my art." Klein thus sold his first "zones of immaterial pictorial sensibility" in 1959. The artist's raw material – creative energies – could be bought for twenty grams of gold dust. The buyer was given a receipt certifying he owned a zone of pure imagination and creativity. In an alchemy-like exchange, Klein would then throw the gold dust down the River Seine, the buyer destroying his certificate.
Catherine Marcangeli

Date 1958

Born/Died 1928–1962

Nationality French

Why It's Key With *Le Vide* (Empty/Void), Klein develops the concept of immaterial art.

Key Artist **Barbara Hepworth**
Awarded the CBE

Fascinated by natural forms, at the age of fifteen, Hepworth decided to become a sculptor. In 1919, she enrolled at Leeds School of Art, where she met Henry Moore. She went on to the Royal College of Art in London, then accompanied English sculptor John Skeaping to Rome, where they married, and she began working in stone. They exhibited together at the Beaux-Arts Gallery in London in 1928.

Like Moore, she was interested in non-Western art and began "piercing the form," opening it to space and light. But during the 1930s, she abandoned the human form, although she continued her liking for biomorphic curves. In 1932, she exhibited with Ben Nicholson, whom she married after divorcing Skeaping. The two visited France, befriending Picasso, Braque, Arp, and Brancusi. In 1933 they joined Abstraction-Création. The

following year, they founded the group Unit One and, in Hampstead, they surrounded themselves with a loose association of avant-garde exiles, including László Moholy-Nagy and Piet Mondrian. From 1935, Hepworth exhibited with the 7&5 Society and participated in the seminal Abstract and Concrete exhibition in Oxford.

In 1939, she moved to St Ives, Cornwall, which became her permanent home. In 1950, she took part in the Venice Biennale and in 1951, the Festival of Britain. Her reputation grew internationally. In 1958, she was awarded the CBE and in 1959 won a major prize at the São Paulo Biennale. Her large bronze, *Single Form*, was unveiled at the United Nations in New York in 1964. She was made a Dame in 1965 and, following her death, her studio became an outpost of the Tate Gallery.
Nigel Cawthorne

Date 1958

Born/Died 1903–1975

Nationality British

First exhibited 1928

Why It's Key Barbara Hepworth produced some of the earliest abstract sculptures in England.

opposite **Barbara Hepworth**

1950–1959

Key Artist **Agnes Martin**
First solo exhibition at Betty Parsons Gallery, New York

Agnes Martin was born in Saskatchewan, Canada. From 1934, she lived in the United States, and studied for teaching qualifications in art, working in public schools and colleges. She gained an M.A. in fine arts and arts education from New York's Columbia University in 1952. In 1946, she first went to New Mexico, eventually settling there permanently. In 1957, though, she was living in Coenties Slip, Manhattan, where other artists had studios – Ellsworth Kelly and Barnett Newman lived nearby – and in 1958 had her first solo show. At this time her paintings were losing their figurative elements, and by the 1960s were acquiring distinctive gridlike structures, created with graphite lines over monochromatic washes, in muted tones.

Unlike Minimalist artists, with whom she is sometimes associated, she eschewed the strategy

of modular assemblage. She identified with the Abstract Expressionists in whose work the often dramatic trace of the artist is visible. The surfaces of her paintings exhibit a restrained materiality, however, the result of her attempt to find an aesthetic with which to reveal her ideas of classical perfection and beauty. Her Presbyterian upbringing and her interest in Zen Buddhism and Taoism (which were popular in artists' circles in the 1950s) were important influences on the integrity of her work. Following a personal crisis in 1967, she stopped painting until 1974, gradually replacing her grid structures with simple bands of pale color, delineated with measured lines which travel across large-scale (six-foot square) canvases. She continued to experiment with color and line until her death in 2004.
Sarah Mulvey

Date 1958

Born/Died 1912–2004

Nationality Canadian (naturalized American)

Why It's Key Martin's work signals a transition in American painting, drawing on the emotional expressiveness of Abstract Expressionism and anticipating the anonymous repetitive aesthetic of Minimalism in the 1960s.

Key Artist **Marisol Escobar**
First exhibition, Leo Castelli Gallery, New York

Born Maria Sol Escobar, Marisol Escobar is often known simply as Marisol. Marisol's Venezuelan parents led a wealthy and nomadic existence, alternating between Europe (she was actually born in Paris) and Caracas. When the child was eleven her mother died, and Marisol's father sent her to boarding school. As an adolescent she was deeply influenced by Catholicism, kept long periods of silence, and practiced self-inflicted acts of penance. Silence has long been an integral part of both Marisol's work and her life. It was during evening art classes in Los Angeles that Marisol rediscovered her creative voice and her passion for painting and drawing. Marisol's father supported her in following her own path.

In 1949, she studied art in Paris, moving on to New York, where she attended the Art Students League, the New School, and Hans Hofmann's painting school (1951–54). Hofmann, a leading Abstract Expressionist, became a mentor. Marisol embraced the radical New York bohemian art scene, frequenting the Cedar Street Tavern and becoming a lasting friend of Willem de Kooning. During a trip to her native South America, some of the primitive sculpture there had a profound impact on Marisol, inspiring her to move beyond painting into three-dimensional work. Back in New York, Marisol took some evening classes in sculpture, but from then on remained largely self-taught. She began to develop a way of painting, drawing, and carving onto found objects in an assemblage technique. In 1958, Leo Castelli offered Marisol her first exhibition. It was a huge success, and, although reticent about her sudden celebrity, Marisol was on her way to greatness.

Carolyn Gowdy

Date 1958

Born 1930

Nationality Venezuelan (USA)

Why It's Key Although Marisol is most associated with pop art, her work drifts across many movements. She is known for making serious statements with gentle wit and satire, for being herself, and for addressing the human condition in her sculpture.

opposite **Marisol Escobar**

1950–1959

471

Key Artist **Louise Nevelson**
Breakthrough exhibition, Moon Garden + One

Louise Nevelson spent many years of struggle and isolation as an artist. Born Leah Berliawsky, she emigrated from Russia as a young child to Rockland, Maine, with her family. She married at twenty-one. Her husband Charles Nevelson was a wealthy steamship owner. They had a son, and moved to New York, where Nevelson studied visual and performing art throughout the marriage. It ended in 1931 when Nevelson, who always believed she was destined to fulfill herself as an artist, became dissatisfied with family life. She went to Europe to study with the famous art teacher Hans Hofmann, also working as an extra in films. She returned to New York in 1932. During the 1930s and 1940s, Nevelson taught briefly on the WPA scheme and assisted Diego Rivera, as part of a large team, on various murals.

During the 1930s, Nevelson also began a period of intense experimentation with sculpture. By the 1950s, she had evolved her three-dimensional wood collages, which were assembled from a scattered jigsaw mixture of discarded materials, often rescued from streets around the city. These included parts of furniture, wooden crates or barrels, and architectural remnants such as stair railings or mouldings. Nevelson carved and scroll-sawed the wood. Her structures began to resemble large abstract paintings, but in one color only, usually black. In 1958, the exhibition Moon Garden + One, at Grand Central Gallery in New York, consisted of a totally black environment that included her first wall construction, *Sky Cathedral*, now in New York's Museum of Modern Art.

Carolyn Gowdy

Date 1958

Born/Died 1899–1988

Nationality Russian (naturalized American)

Why It's Key Unique assemblage artist specializing in large – usually black – wooden reliefs, often occupying an entire wall.

Key Artist **Mark Tobey**
Receives City of Venice Award at Venice Biennale

Throughout his life, Mark Tobey embraced a fascination for spiritual and creative development. He was born in a small Wisconsin town, Centreville. As a youth Tobey attended Saturday art classes at the Art Institute in Chicago, but this marked the extent of his formal art education. Tobey found his way to the city of New York, where his dream was to be a fashion illustrator and a mural painter. He worked for *McCalls* magazine, and also became successful with his stylish charcoal portraits. In 1923, Tobey moved to Seattle, Washington, to teach art, and was introduced to Chinese calligraphy. His experiences in the Pacific Northwest, along with travels to Europe and the Orient, were important in connecting Tobey with the visual and philosophical sources from which he later developed his signature calligraphic style.

From 1918 onward, Tobey adapted the Baha'i faith, to which a friend had introduced him while living in New York. Baha'i belief, that all of the separate religions are actually speaking about similar things in different ways, inspired Tobey's approach to the art. Tobey became interested in connecting separate strands of energy into a unified whole. "White writing" emerged as Tobey's signature calligraphic style, where the sum of the parts was more important than any particular focal point. It represented Tobey's visual manifestation of the interrelationship between humankind and the universe. In 1958, Tobey gained intenational fame as the first American since James McNeill Whistler to be awarded First Prize in the prestigious Venice Biennale. He died in Switzerland in 1976.

Carolyn Gowdy

Date 1958

Born/Died 1890–1976

Nationality American

Why It's Key Inspired by oriental calligraphy, Tobey's aim – like that of Mark Rothko – was to create abstract images for meditation.

472

Key Artist **Arthur Boyd**
Represents Australia at Venice Biennale

Arthur Merric Bloomfield Boyd was born in Murrumbeena, Victoria, in 1920. His father was a potter and his mother a painter; other relatives were also artists. He studied with his grandfather, but his only formal training was part time at the National Gallery Art School, Melbourne. Boyd's early work was mainly portraits and paintings of Port Phillip Bay, on which Melbourne and its suburbs are situated. After moving to Melbourne's inner city in the 1930s, he met European refugees and started to paint fanciful characters in urban settings. His first solo show was in 1937, after which he spent some time in the army. In the 1940s, he was a member of the Angry Penguins, a modernist artistic and literary group, and in 1943 founded a pottery in Murrumbeena. He painted a series of pictures in the 1950s called *Love, Marriage,*

and Death of a Half-Caste, based on his experiences with Australian Aborigines in Alice Springs in 1951, and in 1955 he made a 9-meter (30-foot) ceramic totem pole for Melbourne's Olympic Swimming Pool.

After representing Australia at the Venice Biennale in 1958, Boyd moved to England in 1960 and had his first London show. In 1966, he started another series, called *Nebuchadnezzar*, which relates to the human condition. Returning to Australia in 1971 as one of the country's most respected artists, he settled in Bundanon on the Shoalhaven River, New South Wales. He donated this 11,000-hectare (27,180-acre) property to the people of Australia in 1993. All major Australian galleries hold Boyd's work, and he was awarded the Order of Australia in 1979.

Alan Byrne

Date 1958

Born/Died 1920–1999

Nationality Australian

Why It's Key One of a group of artists who broke away from the conventions of traditional Australian art.

Key Artist **Bernard Cohen**
First solo shows in Nottingham and London

In an interview conducted in 2006, Bernard Cohen was to state that, "My Sixties and the determination of artists to do their own thing goes from about 1958 to 1963; the establishment starting taking control after that." Always an anti-establishment artist, Cohen's first exhibitions at the Midland Group Gallery, Nottingham, and Gimpel Fils, London, saw him developing a visual vocabulary that was to become manifest most publicly with the seminal Situation exhibitions of 1960 and 1961, replete with his portal and lintel motifs and proscenium compositions with which, for a few years, he was to become most identified.

In 1958, Cohen still perceived himself and many of his contemporaries as being independent of the art establishment, and the works on show in both London and Nottingham might be seen to have confirmed as much. In 1952, he had won a summer composition project while still a student at the Slade School of Fine Art – with a painting loosely based upon T. S. Eliot's *The Wasteland* – and subsequently traveled to France and Italy, immersing himself in both visual art and existential literature, the influence of which was already in evidence in the exhibitions of 1958. At this time, he was already an admirer of Jackson Pollock, Lucio Fontana, Jean Dubuffet, Joan Miró, and Salvador Dalí, but was still finding his individual voice. Although the first Situation exhibition of 1960 did not get much more than thirty visitors a day, it nonetheless marked the coming of the end of any pretension that Cohen and his contemporaries could have with regard to the sense of independence that their early exhibitions asserted.

Ian McKay

Date 1958

Born 1933

Nationality British

Why It's Key Marked the beginning of that short period when a new generation of British artists saw themselves as working outside of the establishment.

1950–1959

473

Key Artwork *Afternoon in Barcelona*
Robert Motherwell

Robert Motherwell was a New York Abstract Expressionist painter with connections to Jackson Pollock and Barnett Newman. He married Helen Frankenthaler, another Abstract Expressionist, who was influenced by Mark Rothko, smearing paint thinly in the form of a staining technique, using rags, rather than densely applied after the manner of Pollock. Motherwell, in turn, adopted this technique to an extent.

Motherwell was a Harvard graduate in Art History. As a personality, he was noted to be a sensualist and bon vivant. As an artist, he was an abstract painter from the outset, with what might be termed a European intellectual rationale. He maintained that true abstraction was impossible in that every nuance of color had an echo in real life, therefore in his view there was always a figurative or narrative element, even where pure color was concerned; for example, a particular shade of green is always suggestive of freshness, trees, or grass, no matter what the context, and red always has associations with blood, flame, and so on.

Afternoon in Barcelona is part of a series of a hundred which Motherwell produced from 1949–65 collectively entitled *Elegies to the Spanish Republic*. Many of these were executed in black and white. Motherwell stated that "the pictures are general metaphors for life and death and their interrelation." A connection between sex and death is identified in the erotic but sombre abstract imagery. There are similarities with the hard edge and color field schools, except that the paint is applied in a gestural, painterly manner, with exuberant drips and splashes.

John Cornelius

Date 1958

Country USA

Medium Oil on canvas

Collection Whitney Museum, New York

Why It's Key Example of European influence on American Abstract Expressionist work.

Key Person **Eduardo Chillida**
Gains international recognition at the Venice Biennale

Neither figurative nor geometrically abstract, Chillida's concise, austere shapes in iron, alabaster, steel, or paper appear to grapple for harmony between elemental forces such as light and dark. A former soccer goalkeeper, Chillida explained that: "The hand has the richest articulation of space." This form appeared frequently as counterpoint between mass and enveloping space, the boundary between being a line like the seminal contour of the horizon. This basic realism attained a tense equilibrium, and among Chillida's most remarkable creations are the *Wind Comb XV* installations that project from the climate-beaten cliffs near the artist's native city, San Sebastián. Massive pronged structures seem to play the elements like an instrument, coaxing silent music from iron and air, line and mass, near and remote.

Chillida's technique emerged from Cubist and Constructivist traditions and partly from Basque crafts and the jagged rhythms of Spanish wrought-ironwork. Like David Smith, he developed a technically advanced sculptural style in which space increasingly became an element. The synthesis into concentrated shapes of captive energy – what writer Octavio Paz called "a pact of warring twins" – looked superficially stable yet flowed inexorably toward another form. "The unknown and its call," Chillida said, "lies even in what we know." Work on paper was also important and never subservient to or reliant on sculpture; drawing was distinct from object-making because volume was absent. Monochromatic calligraphy of properties, planes, and ribboned eddies articulated reflections on matter, line, space, and time.

Martin Holman

Date 1958

Born/Died 1924–2002

Nationality Spanish

Why It's Key Chillida's sculpture distilled form to a powerful bare minimum that fused tradition and modernity, and influenced a generation of Spanish sculptors who achieved international attention from the late 1980s.

474

Key Event
Wiener Gruppe (Vienna Group)

The Wiener Gruppe was an avant-garde circle that comprised the writer and linguist, Hans Carl Artmann; a former architect, Friedrich Achleitner; the concrete poet Gerhard Rühm; jazz musician Oswald Wiener (who contributed the first Wiener Gruppe manifesto in 1954); and writer Konrad Beyer. Between 1952 and 1960, this group of writer-performers met in Vienna for readings, cabaret performances, and what – with hindsight – might be thought of as precursors to happenings. Often likened to Dada cabaret, the activities of the Wiener Gruppe anticipated the radicalism of other literary and artistic groups of the late 1950s and early 1960s, such as the Situationist International, the Independent Group, and Fluxus.

Artmann, as the eldest of the Wiener Gruppe, was arguably the most important of its members, in the sense that his influence was seen to maintain a relative balance of interest between Surrealism and Constructivism. When Artmann drifted away from the group in 1958, followed by Wiener in 1959, the remaining members became almost solely preoccupied with literary constructivism. Nonetheless, in the early 1950s, the Wiener Gruppe was the vanguard of Austria's avant-garde, and its influence and wider importance, at a time when Vienna was still a city divided between the administrative powers of the United States, the UK, France, and the Soviet Union, should not be underestimated.

Ian McKay

Date 1958

Country Austria

Why It's Key Proto-actionists who anticipated art happenings and the radicalism of 1960s art movements.

opposite First literary cabaret by Wiener Gruppe with members (left to right) Ruehm, Wiener, Achleitner, and Bayer.

Key Artist **Jim Dine**
Stages his first happening, *The Smiling Workman*

Jim Dine's description of his first happening conveys the excitement and energy of the experience: "There was a table with three jars of paint and two brushes on it, and the canvas was painted white. I came around with one light on me. I was all in red with a big, black mouth ... I painted 'I love what I'm doing' in orange and blue ... I was going very fast, and I picked up one of the jars and drank the paint, and then I poured the other two jars of paint over my head, quickly, and dove, physically, through the canvas. The light went off. It was like a thirty-second moment of intensity. It was like drawing. I did not have to think about it."

This "thirty-second moment of intensity" is reminiscent of the "arena" in which Harold Rosenberg's action painters operated. Moreover, Dine's analogy with automatic drawing also suggests a kinship between *Smiling Workman* and the freedom associated with Pollock's instinctive and impulsive work. As for Dine drinking paint and diving through the picture, it takes to an almost caricatural extreme the physical, volcanic, and symbiotic relationship between action painter and canvas. While Allan Kaprow's audiences were usually given scripts or instructions, thus becoming active participants in the happenings, in Dine's *Smiling Workman*, or in *Car Crash* (1960), the audience's role was limited to being spectators, and the theatrical effects, such as lighting, make-up, and costume, remained the preserve of the performer. For both artists, however, the event itself, rather than some object, constituted the artwork.

Catherine Marcangeli

Date 1959

Born 1935

Nationality American

Why It's Key Dine's first happening, at Judson Church, New York, harnesses the energy of action painting.

opposite Jim Dine's *Ten Formal Fingers*.

Key Artist **Patrick Heron**
Winner of first prize at John Moores exhibition

Patrick Heron was born in Headingley, Leeds. From 1937–39, he studied, part-time, at the Slade School of Fine Arts. Toward the end of World War II, he worked as an assistant in Bernard Leach's pottery in St Ives. He then moved to London and wrote articles about art for the *New English Weekly* and *New Statesman*. He had his first solo show in 1947. During his early years as a figurative painter, Heron absorbed the work of the French artists of the early twentieth century. He was drawn to Henri Matisse's and Pierre Bonnard's articulations of color in space, and George Braque's volumetric compositions.

Heron's return to Cornwall in 1956 marked a move toward abstraction, inspired by European *l'art informel* and Tachisme, and the work of the Russian Nicolas de Staël. He was impressed by the American abstract Expressionist painters, especially the work of Mark Rothko. Throughout the 1950s and 1960s, Heron explored the potential of Matisse-inspired decorative color. He produced gestural stripe paintings in the late 1950s, then soft-edged squares and circles, which developed into the more hard-edged structures of the 1960s and 1970s. As a critic, Heron championed the work of twentieth century British abstract painters, from Ben Nicholson to the work of his contemporaries, as a riposte to what he perceived as the cultural imperialism of the New York school. In his late work he reintroduced figuration, in more sparsely painted, calligraphic works. He lived and worked in Cornwall until his death.

Sarah Mulvey

Date 1959

Born/Died 1920–1999

Nationality British

Why It's Key The prize signaled the importance of the progressive abstract art practiced by Heron and his contemporaries Terry Frost, Roger Hilton, Peter Lanyon, and William Scott, during the 1950s and 1960s, who became known as members of the St Ives school.

Key Exhibition
Sixteen Americans

In her catalog introduction, Dorothy C. Miller (1904–2003) claimed for the exhibition she had selected "an unusually fresh, richly varied, vigorous and youthful character." The sixth in the remarkable periodic series of American shows that Miller had initiated in 1942, Sixteen Americans featured a larger proportion than its predecessors of "newcomers to the New York scene," most significantly Frank Stella, who showed four austere black paintings alongside work by Ellsworth Kelly, Jasper Johns, Louise Nevelson, Robert Rauschenberg, Richard Stankiewicz, and ten others. Miller's American exhibitions were controversial with critics, and one wrote on this occasion (in a letter to the museum) that "these are the sixteen artists most slated for oblivion."

The exhibitions also followed a particular pattern which, by limiting itself to a select group, allowed each artist to include several works in a separate small gallery. Miller did not attempt to unite the exhibitors as a movement or trend, but to present contrasting personalities. Another significant feature of the series was the slender catalog made up principally of artists' statements, as Miller wanted the makers to speak for themselves and allow visitors to form their own opinions without intervention from the museum's curator. The series of exhibitions displayed Miller's strong conviction and remarkable eye for important new trends. The seventh and last, in 1963, featured fifteen artists, including many associated with Pop art, such as Robert Indiana, Richard Lindner, Claes Oldenburg, and James Rosenquist.

Martin Holman

Date December 16, 1959–February 14, 1960

Country USA

Why It's Key Landmark group exhibition that propelled Frank Stella onto the international scene.

478

Key Artwork *Red on Maroon*
Mark Rothko

Rothko (1903–1970) was suspicious both of his newfound fame and of the impure motives of the art marketplace, which he considered to be indifferent to the truths embodied in his work and more concerned about remaining in touch with artistic fashion. *Red on Maroon* was part of the Seagram commission, painted at precisely the time that Rothko realized that he was being swallowed by the implacable machine of capitalism. In response, Rothko imbued *Red on Maroon* and the other Seagram works with a dark palette and claustrophobic images.

Red on Maroon suggests a window on to nowhere, a kind of revenge that Rothko wanted to inflict on complacent restaurant patrons and corporate patrons alike. Finally, tired of the psychic turmoil that accompanied the commission, Rothko refused the work and instead turned his paintings over to the Tate Gallery in symbolic reclamation of his artistic freedom.

While Rothko would extricate himself from this particular compromise, his late work remained enamored of dark palettes and trapped views. The subtle, liberating color boundaries of his early work were in *Red on Maroon* replaced by a stark division between inside and outside – a representation, perhaps, of the alienation from popular taste and critical appreciation that Rothko had come to feel.

Demir Barlas

Date 1959

Country USA

Medium Oil on canvas

Collection Tate Gallery, London, England

Why It's Key Abstract Expressionist who refused to accept categorization of his work endured a spectacular late-career crisis.

opposite *Red on Maroon*

Key Artist **R. B. Kitaj**
Enters Royal College of Art; meets David Hockney

Born Ronald Brooks, R. B. Kitaj adopted the surname of Dr Walter Kitaj, whom his divorced mother married in 1941. A merchant seaman at seventeen, Kitaj studied art in Vienna and at the Cooper Union in New York City. After two years in France and Germany in the U.S. Army, he attended the Ruskin School in Oxford (1958) on the GI Bill, before enrolling at the Royal College of Art in 1959 – alongside David Hockney, Derek Boshier, Peter Phillips, Allen Jones, and Patrick Caulfield. The older man's sophistication had a resounding influence on his younger colleagues, especially Hockney, who remained a close friend for fifty years. For Kitaj, poetry and literature – in particular, the works of Franz Kafka – were central to his art, as were interests in baseball, brothels, hypochondria, history (in the shape of the Spanish Civil War), and, inevitably, portraiture. He left the Royal College to enjoy a resounding one-man show at the famous Marlborough Fine Art in 1963. Later, in 1982, Kitaj was to become the first American Royal Academician since John Singer Sargent (1856–1925).

Kitaj was perceived as being in the doldrums during the Minimalist flourish and Neo-Expressionist boom of the 1970s and 1980s. A Tate Gallery retrospective in London in 1994 was, therefore, a momentous event. Kitaj endured extensive press criticism, however, some related to his obsession with a Jewish inheritance and his confessional style of painting. It destroyed his love of England and his confidence. His second wife (Sandra Fisher) died suddenly of an aneurysm at forty-seven, only fifteen days after the exhibition ended. In 1997, he left Britain permanently for Los Angeles, California.
Mike von Joel

Date 1959

Born/Died 1932–2007

Nationality American

Why It's Key Kitaj introduced his fellow students to a more sophisticated vision of painting based on his own international perspective.

1950–1959

481

Key Artwork *IKB 79*
Yves Klein

In his first one-man show at the Club des Solitaires (1955), Yves Klein (1928–1962) exhibited monochromes of various colors. In 1957, he embarked on his Blue Period because, he declared, "all colors trigger associations with concrete ideas ... whereas blue at the most reminds the viewer of the sea or the sky, which are the most abstract things in nature." Like Giotto's dense skies, which Klein had admired at Giotto's frescoes at Assisi, blue figured the immaterial, the spiritual. Applying paint with sponges and later with rollers, Klein experimented with various pigment and fixative techniques to give his ultramarines a subtle velvety texture, an almost intangible presence. He often hung his canvases slightly away from the wall, letting the color hover as if it were pure energy in suspension. On March 9, 1960, Klein presented his Anthropometry of the Blue Period at the International Gallery of Contemporary Art in Paris. In front of an audience, three naked models, covered in IKB, pressed themselves against sheets of paper or canvases on the wall or the floor. To the sound of a Monotone Symphony (consisting of one note), these "living paintbrushes" were both the image and the medium, as they left behind the imprint of their presence. Dressed in a tuxedo, Klein stood at a distance, conductor-like, giving instructions – an approach he insisted differed radically from action painting. Klein did not confine himself to IKB, but went on to ally blue (immaterial spirituality) to pink (incarnation) and gold (symbolic of the passage between the two) in a variety of works and installations, including his 1961 *Ex-Voto* to Saint Rita.
Catherine Marcangeli

Date 1959

Country France

Medium Paint on canvas on wood

Collection Tate Gallery, London

Why It's Key International Klein Blue (patented as IKB) is the "most abstract of colors."

opposite *IKB 79*

Key Event **Daniel Spoerri** Founds
Multiplication d'Art Transformable (MAT) Editions

In 1959, Swiss artist and theorist Daniel Spoerri (b.1930) founded *Multiplication d'Art Transformable* (MAT) Editions, which served as a mechanism for producing certain forms of three- (and indeed four-) dimensional art. MAT Editions, for which Spoerri recruited artists including Marcel Duchamp, Hans Arp, and Christo, sought to establish prototypes for certain artworks that would then be copied a hundred times. Works thus copied undermined the notion of originality while exalting it, for the act of copying would serially introduce new creative acts into the process.

MAT Editions was an actual working out of some of the themes and problems raised by German theorist Walter Benjamin's influential 1936 essay "The Work of Art in the Age of Mechanical Reproduction." Benjamin had noted that mechanical reproduction would divorce

art from its aura of importance, which was often used to enforce a kind of top-down cultural totalitarianism. MAT Editions, too, believed that an artwork specifically designed for reproduction would democratize the process of making, selling, and viewing art. In a way, MAT Editions reversed Duchamp's famous dictum that he believed not in art but in artists; MAT Edition re-situated the artist as part of an assembly line (partially anticipating Andy Warhol's Factory), and demystified the artist's traditional position as lonely demiurge.

MAT Editions was not particularly prolific, churning out a few hundred reproductions at best, but it certainly prepared the way for the more intense questioning of art, capitalism, and mechanical reproduction that would take place throughout the 1960s and beyond.
Demir Barlas

Date 1959

Country France

Why It's Key An avant-garde artist draws attention to the mechanics and meanings of mass production in art.

Key Artwork *Canyon*
Robert Rauschenberg

Canyon is a particularly raucous creation whose main element is a real, stuffed bald eagle that flies out of the canvas. Stylistically, the resulting piece is a hybrid of painting, collage, and sculpture, but its formal elements are outweighed by the striking reality of the eagle in flight.

In building *Canyon* around the eagle, Rauschenberg topped his Abstract Expressionist peer Jasper Johns' series of depictions of the American flag. While Johns and later Pop artists would adopt iconic symbols – flags, maps, soup cans, and so forth – Rauschenberg incorporated an actual icon into his work. The bald eagle is, after all, real; and, defying its traditionally two-dimensional pose in American iconography, it is flying directly at the viewer. This is a fascinating effect, representing as it does both the

revenge and the reality of the object. In Rauschenberg's day, artistic fashion had tipped away from emotion, movement, and nature, three elements that combine to marvelous effect in *Canyon*. It is a work that invokes all the imagined dynamism of the American landscape, here stripped of its bloody histories and rendered back to an insistent nature.

That said, *Canyon* remains whimsical enough to distance itself from its iconic subject matter and serve instead as an example of kitsch, if this is what the spectator requires the work to do.
Demir Barlas

Date 1959

Country USA

Medium Rauschenberg-termed "combine" of oil, pencil, paper, fabric, metal, cardboard box, printed paper, printed reproductions, photograph, wood, paint tube, and mirror on canvas.

Collection Private collection

Why It's Key His helter-skelter combinations of paint, fabric, photographs, and stuffed animals embody a mixture of kitsch, Pop, and Americana.

Key Event
Inauguration of the Guggenheim Museum

Through the 1920s, Solomon R.Guggenheim, the wealthy turn-of-the-century American industrialist, had formed a large collection of early modernist paintings from artists such as Paul Klee, Piet Mondrian, and Wassily Kandinsky. He founded the Museum of Non Objective Painting in 1937, in conjuction with German artist Hella Rebay, to showcase avant-garde art. In 1943, Rebay commissioned architect Frank Lloyd Wright to create a new structure for Guggenheim's museum. He embarked on a war of wills with the client, making numerous sketches and drawings, a battle which lasted until the museum's inauguration in 1959.

Opening on October 21, to an enraptured public, the edifice divided architecture critics. Its radical structure – and its attempt to revolutionize the museum experience – meant to some that it was the most breathtaking building in the United States; to others, it overshadowed the art. Wright's last major work – he died six months before it opened – the Guggenheim led the way for innovative architecture. Wright eschewed conventional design, creating a white cylindrical form that is slightly wider at the top than the bottom. Situated next to Central Park on Fifth Avenue, it rises like a monolithic spiral. Inside, visitors took an elevator to the top of the building, then viewed the artworks by following a gentle slope of a central ramp. An open rotunda meant that different levels could be viewed at the same time. In 1997, the Guggenheim Museum Bilbao opened in the city of Bilbao in Spain, with architect Frank O. Gehry's titanium and steel structure rivaling Wright's now-iconic Manhattan landmark.
Kate Mulvey

Date October 21, 1959

Country USA

Why It's Key Radical iconoclastic design that has innovated architecture since it was built.

1950-1959

483

Key Artist **Frank Stella**
Exhibits at the Sixteen Americans show

After taking art classes while studying history at Princeton, Stella moved to New York. There he abandoned Abstract Impressionism after seeing Jasper Johns's flag and target paintings. He began his *Black Paintings*, which were simply black stripes painted on raw canvas, and four were shown in the Sixteen Americans exhibition at the Museum of Modern Art in 1959, with the museum subsequently buying one. Stella repeated the exercise with his *Aluminum Paintings* in 1960 and *Copper Paintings* in 1960–61, which included more elaborately shaped canvases the shape of which the patterns aped. He then introduced color, using metallic and sometimes fluorescent paints. The patterns became ever more complex, but he always retained the flatness of the picture space. A picture is "a flat surface with paint on it – nothing more," he maintained. "What you see is what you see."

In the 1970s, Stella abandoned this hard-edged style for more organic shapes, rendered in a spontaneous, graffiti-like manner. In the 1980s, he developed Minimal sculpture. He also took up a residency at the American Academy in Rome, where he studied Italian art. The resulting lectures given at Harvard were published as *Working Space* in 1986. In the 1990s, Stella turned to public art projects and architecture, working on a new theater in Toronto where paintings, murals, and sculpture were to be incorporated into the design.
Brian Davis

Date 1959

Born 1936

Nationality American

First Exhibited 1959

Why It's Key High-profile debut of pioneer of Minimalism.

UNA PELÍCULA DE
Jean-Luc Godard

À Bout de Souffle

JEAN PAUL
BELMONDO

JEAN
SEBERG

(Al final de la escapada)

UN FILM ESCRITO Y DIRIGIDO POR **JEAN-LUC GODARD** GUIÓN ORIGINAL DE **FRANÇOIS TRUFFAUT** ASESOR TÉCNICO Y ARTÍSTICO **CLAUDE CHABROL**
MÚSICA DE **MARTIAL SOLAL** FOTOGRAFÍA DE **RAOUL COUTARD** PRODUCTOR **GEORGES DE BEAUREGARD**

Key Event
New Wave cinema

The New Wave (*nouvelle vague*) is the term for a group of iconoclastic filmmakers of the late 1950s and early 1960s in France. Rebelling against the classic "literary" style of French cinema, the movement didn't conform to the current filmmaking rules and created the first "art house" cinema. The work of particular filmmakers such as Jean-Luc Godard and François Truffaut was highly influential throughout Europe and set the radical style that changed cinema irrevocably. *Breathless* (*A Bout de souffle*), directed by Godard, was his first full-length feature film, and shocked audiences at its debut in 1960 with its audacious style. Written with Truffaut, it debuted a year after Truffaut's equally seminal *The 400 Blows* (Les Quatre Cents Coups).

Every aspect of New Wave films was a conscious departure from what had gone before. Low budget, they often used unknown actors. Handheld cameras meant directors could film on location instead of in a studio, giving the films a "natural" look. A colleague's apartment, a local coffee bar, and the street itself became the New Wave backdrops. Jump cuts gave sequences a sense of discontinuity – Godard was particularly fond of this technique – and actors were encouraged to improvise their dialogue and talk over each other, as in real life. Most importantly, the New Wave established the idea of the director as *auteur* – author – of the work, bringing a new appreciation to the work of "commercial" filmmakers such as John Ford and Alfred Hitchcock.

Kate Mulvey

Date 1959

Country France

Why It's Key Modernist films in form, style, and content which shocked and influenced cinema throughout Europe and the rest of the world.

opposite **Poster for Godard's movie *A Bout de Souffle*.**

485

Key Artist **César Baldaccini a.k.a. César**
Founding member of *nouveaux réalistes*

Until the 1950s, César welded wrought iron, screws, and scrap metal into figurative compositions often likened to the work of Germaine Richier. In 1960, after discovering the potential of industrial hydraulic presses, he exhibited his first automobile *Compressions*. Weighing up to one ton each, these rectangular pieces of crushed metal were no longer shaped by the hand of the artist. Yet, César insisted, they were not ready-mades in the Duchampian sense: "It was the work of a sculptor, not an intellectual process, the day I compressed a car. I did not say, 'here is a package, and this package is a work of art'; it is a sculptor's concept, the concept of a man who was trained as a sculptor. I waited years before using cars."

Far from leaving the process totally to chance and anonymity, César was soon able to anticipate the look of the finished product; in his "directed compressions," he therefore used the press to obtain the desired color arrangement or composition. Craftsmanship, whether visible or not, was always crucial to him, and these geometric machine-made objects involved aesthetic decisions that, despite superficial resemblances, set César well apart from the Minimalist sculptors emerging at the time. The critic Pierre Restany saw in this use of recycled materials a homage to the leftovers of industrial society, in keeping with his definition of New Realism as a "direct appropriation of the real." César was one of the founding members of the *nouveaux réalistes* group, signing its first manifesto in 1960.

Cataherine Marcangeli

Date 1960

Born/Died 1921–1998

Nationality French

First Exhibited Lucien Durand Gallery, Paris, 1954

Why It's Key Important new realist sculptor using machine-driven applications to recycle materials.

Key Artist **Julio le Parc**
Founding member of the Visual Arts Research Group

Julio le Parc was born on September 23, 1928, in the town of Mendoza, Argentina. Although an unexceptional student at school, he discovered a talent for art when he began sketching celebrities' portraits. He moved with his family to Buenos Aires at the age of fourteen and attended the Academy of Fine Arts while holding several low-paid jobs.

Upon graduation from the academy, an angry and confused le Parc rebelled against what he saw as an authoritarian society. He left his job, disowned his family, and fell in with groups of Marxists and anarchists in an attempt to learn about different sociological ideals. Suffering feelings of isolation, le Parc rejoined the Academy of Fine Arts in 1955, where he became heavily involved with the student activist groups that eventually forced an expulsion of the school's principals.

In 1958, bored with the Argentinean artistic scene, le Parc and some of his close friends decided to move to Paris, where they studied the work of avant-garde artists. It is here that le Parc began to experiment with the use of light in his work. He was particularly interested in how alterations to the angle and intensity of light sources generated image and color variations in his art.

In 1960, le Parc and his colleagues formed the Visual Arts Research Group (GRAV), a place for kinetic artists where ideas and experiences were shared and evaluated. In 1966 Le Parc was honored with the award for painting in the Venice Biennale.
Jay Mullins

Date 1960

Born 1928

Nationality Argentinean

Why It's Key One of the most influential kinetic artists of the twentieth century.

opposite Julio le Parc's *Serie 14 No2* (1970).

Key Artist **John Hoyland**
Took part in first exhibition of "Situation" artists

John Hoyland was born in Yorkshire, England, in 1934, and studied at Sheffield College of Art (1951–56), then at the Royal Academy schools from 1956–59. The New American Painting exhibition at the Tate Gallery in 1959 made a big impact, and in 1964, using a Peter Stuyvesant travel bursary, he visited New York and saw more American abstract paintings that influenced him – particularly those by Mark Rothko.

Regular trips to the United States brought him into contact with Morris Louis, Kenneth Noland, Hans Hofmann, Robert Motherwell, and others. In 1960, along with eighteen other British artists, he took part in the first of three annual London shows dubbed as "Situation" (short for "Situation in London now"), featuring large abstract pictures at least 30 feet square aimed at filling the viewer's field of vision.

During the 1960s, Hoyland's painting developed into a distinctive style using simple shapes and bright colors, but during the 1970s he had moved beyond his early formality and was producing thickly painted and highly textured pictures.

Hoyland has taught at many art schools, including Chelsea School of Art (1962–70), where he was principal lecturer from 1965; the Royal Academy schools; the Slade School of Art in London; and Colgate University, New York. He had a solo exhibition at the Whitechapel Gallery in London in 1967, and another at the Arts Council, showing paintings from 1967–79. He won first prize at the John Moores Liverpool Exhibition in 1982, and was appointed a Royal Academician in 1991. Hoyland is also a printmaker and set designer.
Alan Byrne

Date 1960

Born 1934

Nationality British

Why It's Key A leading British abstract painter.

Key Artist **François Morellet**
Founding member of GRAV

François Morellet's work is characterized by radically simple preconceived self-generating abstract systems in two or three dimensions that can be easily comprehended by the viewer. Since the 1950s, he has augmented a practice that, through mathematical deduction, avoids subjectivity and artistic intuition as its origins, while also allowing chance to create an aesthetic disorder. In early oil paintings called *Chance Divisions* (*Réparations aléatoires),* he borrowed numerical sequences from telephone directories and other sources to randomize the distribution of identical elements over the painting's surface.

As co-founder in 1960 of the Groupe de Recherche d'Art Visuel (GRAV) with eight other European and South American artists, he explored the kinetic possibilities in visual art in scientific and experimental ways. During this time, Morellet introduced manufactured materials into his work, such as neon tubing. Among the many other media he has used are acrylic paint, adhesive tape, strips of metal, twine, and tree branches.

Morellet's impersonal method draws on ideas from Constructivist art, especially those of Moholy-Nagy and Theo van Doesburg. Since the 1970s, he has also worked within architectural frameworks, often adopting a provocative approach to the buildings he is commissioned to complement. While frequently associated with geometric abstraction, he is temperamentally close to the irreverent spirit of Dada and Marcel Duchamp. His early interest in process, rather than result, was important to younger artists.

Martin Holman

Date 1960

Born 1926

Nationality French

First Exhibited 1950

Why It's Key Influential name in the areas of Op, kinetic, and Minimalist art.

488

Key Artist **Claes Oldenburg** Early examples of "environments" and "happenings"

Born in Stockholm, Sweden, the son of a Swedish diplomat, Oldenburg came to the United States as a child, taking his citizenship in 1953. After studying art and literature at Yale, he took classes at the Art Institute in Chicago, supporting himself as a cub reporter. In 1956, Oldenburg moved to New York, where he joined a group of artists who were in revolt again Abstract Expressionism.

In 1959, he had his first one-man exhibition, showing figurative drawings and papier-mâché models. In a second show in 1960, called The Street, with Jim Dine, Oldenburg incorporated found objects into his work. Within this setting, he staged his first "happening," *Snapshots from the City* – a piece of performance art that did away with portrayal of character, narrative, and logical sequence. Next, he produced plaster replicas of everyday objects and sold them from *The Store*, an "environment" created in a gallery. Later, he took over a real store on New York's East Side and sold plastic replicas of foodstuffs. He made giant replicas of foodstuffs, usually using canvas stuffed with foam rubber, such as *Dual Hamburger* (1962). He also made "soft sculptures" of hard objects, such as typewriters, electric fans, and washbasins.

Oldenburg's soft and grossly enlarged versions of everyday items have now found homes in the Museum of Modern Art in New York, the Guggenheim, the Tate Gallery in London, the Pompidou Center in Paris, and other major galleries. With his wife Coosje van Bruggen, Oldenburg has also produced similar large outdoor installations.

Brian Davis

Date 1960

Born 1929

Nationality Swedish (naturalized American)

First Exhibited 1959

Why It's Key Pioneer of Pop art.

opposite Oldenburg's *Ice Cream Sundae on a Tray* (1962).

Key Exhibition
Situation

The exhibition's title was an abbreviation of "the situation in London now." It had no institutional allegiance; the painters who showed were linked by two criteria. First, the work contained no literal representation of recognizable objects; this excluded an older generation whose abstraction was rooted in observing nature. Secondly, no painting measured less than 30sq ft. Size underscored a new relationship with the spectator, whose visual impressions of a single work had to be built from a sequence of viewpoints. The "shock of confrontation" was the painting's real subject.

The twenty exhibiting artists had no group identity, but represented a "tough-minded" peer group of art professionals (in opposition to an art establishment which they perceived as parochial and amateurish). Impressed by how American artists looked, many wore stylish suits. They practiced several styles from the gestural (Ayres, Richard Smith) to the linear (Denny, John Plumb) and geometric (the Cohen brothers, Hoyland), while William Turnbull's 8ft-tall canvas, *25/59*, comprised intense saturated monochrome. Several of the participants were students of Turnbull's "active teaching" at London's Central School of Art, including Brian Young, John Epstein, and Peter Coviello.

Although poorly attended, Situation, held at the Royal Society of British Artists Galleries in London, signified urban modernity in the subjects and materials of British abstract painting. Its new attitudes to scale and objecthood were taken forward in New London Situation in 1961, and applied successfully to sculpture with the New Generation shows.

Martin Holman

Date September 1960

Country UK

Why It's Key First of three annual shows in London which were highly influential in reshaping the direction of painting in Britain.

Key Event
Launch of the New Realists

New Realism (*nouveau réalisme*) evolved in postwar France in an environment of industrial redevelopment, growing consumerism, and the coming of age of advertising. The New Realists, regarding themselves as "new" avant-gardists, needed to confront the changing world on different terms to those of their predecessors, transposing Dada and Duchamp into the milieu of the 1960s. Highly individual in style and approach, they were bound together by the theories of art critic and philosopher Pierre Restany.

In October 1960, this group of artists, together with Restany, met at the studio of Yves Klein to form a new avant-garde movement. They included Arman, Raymond Hains, François Dufrêne, Martial Raysse, Daniel Spoerri, Jean Tinguely, and Jacques de la Villeglé (they were later joined by Niki de Saint Phalle and Christo). Declaring that New Realism meant a new perception of the real, what bonded them was their "collective singularity." The common base for their collaborative work was appropriation, whether of public spaces or the recycling of urban detritus.

Villeglé and Hains collaborated anonymously to protest against advertising propaganda in public spaces by lacerating and tearing off sections from advertising posters. The opposite of collage, they called it *décollage*. Tinguely used everyday found objects such as fur, plastic toys, and metal wheels to make his kinetic sculptures, while Spoerri made assemblages from crockery, opened cans, glasses, and the debris of finished meals, nailed to a table. Unlike Pop artists, they abandoned old art skills to create the "new real."

Sue King

Date October 1960

Country France

Why It's Key Spotlighting New Realism (*nouveau réalisme*), which reassessed what constituted "the real" in the postwar consumerist society and challenged traditional methods of creating art.

opposite Villeglé with décollage work at 53, Beaudricourt Street.

Key Artist **Wayne Thiebaud**
First solo exhibitions, in San Francisco and New York

Like Edward Kienholz and Edward Ruscha, Wayne Thiebaud is a West Coast artist whose work was labeled "pop" in the 1960s because of its subject matter. Gumball machines, hot dogs, ice-cream cones, and banana splits in repetitive patterns and near-geometric displays have remained common features, typically rendered in juicy, thick pigment against solidly colored backgrounds with no specific location.

But the luscious handling, and graphic treatment of single isolated objects repeated at tense intervals may owe less to Pop than to Thiebaud's background in cartoon studios and advertising; it may even pre-date Pop. The postwar Bay Area figurative idiom was informed by Abstract Expressionism, and Thiebaud had spent time in New York around 1956 among artists such as Willem de Kooning and Franz Kline. Thiebaud's family had moved from Arizona to Southern California soon after his birth, and the barely settled area may account for the emptiness and detachment in his paintings. Almost in his thirties when he began studying art, by 1952 he was teaching at Sacramento City College and, in 1960, became assistant professor at University of California, Davis, where he remained into his eighties.

His first solo exhibitions, in 1960, at the San Francisco Museum of Art, and at Staempfl and Tanager in New York, were little noticed, but led to his inclusion in several groundbreaking surveys, including the New Realists at the Sidney Janis gallery in 1962. His brilliantly lit images, while emphasizing stark synthetic qualities, also directly portray the pleasures of looking, manipulating, and analyzing.

Martin Holman

Date 1960

Born 1920

Nationality American

Why It's Key A Bay Area (San Francisco) figurative artist with a rich painterly style often associated with Pop art who came to prominence in the early 1960s.

Key Artist **Richard Smith**
Exhibits in Situation, the landmark abstract art show

Born in Hertfordshire, England, Richard Smith studied at Luton School of Art from 1948 to 1950. After serving in the Royal Air Force, he attended St Albans School of Art from 1952 to 1954, then the Royal College of Art from 1954 to 1957. He won a Harkness Travel Fellowship in 1959, which enabled him to live in New York until 1961, when he had the first of several solo exhibitions at the Green Gallery.

Smith exhibited with the London "Situation" abstract artists in 1960, and in 1962 showed at the Institute of Contemporary Arts. He showed at the Kasmin Gallery in 1963, and at the Tokyo Biennale. He won a prize at the Venice Biennale, and in 1967 won the grand prize at the São Paulo Biennial. In 1973, he exhibited at the Hayward Gallery in London and, in 1975, had a retrospective exhibition at the Tate Britain gallery.

Smith produced paintings that combined the formal qualities of American painters such as Mark Rothko and Sam Francis with the commercial culture of American advertising. This, along with his interest in the work of commercial photographers such as Irving Penn and Bert Stern, brought him briefly into contact with the Pop art movement. After about 1968, he moved away from this way of thinking and into more purely abstract concepts using shaped canvases or boards, and brightly colored paint in grid patterns. Smith is also a printmaker, having made prints in most media.

Alan Byrne

Date 1960

Born 1931

Nationality British

Why It's Key One of the first Pop artists and a leading British abstract painter.

Key Artist **Alma Thomas**
Retires from teaching to paint full-time at age sixty-nine

Alma Thomas taught art at the same school, Shaw Junior High in Washington, for thirty-six years and lived in the same family house in Washington D.C. for seventy-one years. She graduated from Howard University, Washington, in 1924 and became the first Howard student to obtain a degree in Fine Art and the first African-American woman to do so.

Thomas set up the School Arts League Project "to foster keener appreciation of art among negro children in Washington." In 1938, she established the first art gallery in the state public school system. In 1960, she became a full-time painter, achieving international recognition on her retirement, at the age of sixty-nine, and subsequently became the first African-American woman to hold a one-woman art exhibition at the Whitney Museum of American Art in New York (1971).

In the same year, her work was shown in the milestone exhibition Contemporary Black Artists in America.

Thomas was known for her sensitivity to, and exploration of, color within the context of her "color field" abstract paintings, and also her sculptures and her puppet making. She sought to promote joy and positive thoughts in the face of the negative elements of human existence. In 1981, a posthumous retrospective exhibition was held at the Smithsonian's National Museum of American Art, which also keeps her paper archive.

John Cornelius

Date 1960

Born/Died 1891–1978

Nationality American

Why It's Key Several milestone achievements as an African-American artist.

Key Artwork *Royal Tide V*
Louise Nevelson

Born in 1899 to a timber merchant, Louise Nevelson (1899–1988) is reported to have played constantly with wood as a child, growing up in the coastal town of Rockland in Maine, United States. At age ten she told a local librarian, "I'm going to be a sculptor." Over the years, Nevelson explored painting, printmaking, and sculpture, as well as experimenting with many different materials, including stone, cast metal, and terra cotta. Ultimately, however, she was drawn back to wood, her childhood passion, and with it she made her pioneering art.

Nevelson's box-like recesses and grids often contain a poetic and secretive quality. Like *Sky Cathedral*, *Royal Tide V* inhabits a distinctive Nevelson cosmos, vast, elemental, and intimate at the same time. She usually painted her sculptures black (black

was her favorite color because "it is the essence of the universe"); however, she also used white or gold, as in *Royal Tide V*, to unify the disparate elements. Nevelson, who had a Jewish background, also took an interest in various spiritual disciplines and areas of mysticism during her life, such as Christian Science, New Thought, Zen Buddhism, and Rosicrucianism.

Royal Tide V captures the majesty of the ocean. It is infused with a golden patina of mystery and enchantment. Wooden fragments, once lost or discarded in a vast sea of flotsam, have been found and given new worth, life, and meaning. As with many of Nevelson's works, it has the pictorial quality of an abstract painting, but is freestanding and can be looked through from either side.

Carolyn Gowdy

Date 1960

Country USA

Medium Found wood assemblage sculpture

Collection Private collection

Why It's Key Nevelson is best remembered for her abstract wooden assemblages, of which *Royal Tide V* is a powerful example.

Key Artist **Jean Tinguely** Creates the auto-destructive artwork, *Homage to New York*

As a child, Tinguely experimented with mechanical sculptures, hanging objects from the ceiling and rotating them with an electric motor. He studied at the Basel School of Fine Art from 1941–45, and began painting in the Surrealist style. In 1953, with Daniel Spoerri, he created *Autothéâtre*, where the spectators become participants in a ballet of moving scenery. That same year, he moved to Paris, where he began making kinetic sculptures which he called *méta-méchaniques*, or "meta-mechanicals," which featured in an exhibition of kinetic art, Le Mouvement.

Tinguely also made painting machines which turned out abstract art while giving off odd noises and noxious smells. One at the first Paris Biennale in 1959 produced 40,000 different paintings for visitors who put a coin in its slot. He also developed machines that would destroy themselves, and in 1960 created a 27-foot-high meta-mechanical *Homage to New York*, which was supposed to self-destruct outside the Museum of Modern Art in New York. It failed to tear itself apart, the job having to be done by two city firemen after it caught fire. However, *Study for the End of the World* annihilated itself successfully, and an exploding sculpture faithfully blew up at a fiesta in honor of Salvador Dalí in Figueres.

Tinguely went on to make kinetic machines out of found junk objects, but his most famous work is more traditional – the Beaubourg Fountain (correctly titled *La fontaine Stravinski*) (1980) outside the Pompidou Center, Paris, replete with mechanical birds and beasts, which he created with French artist Niki de Saint Phalle.
Brian Davis

Date 1960

Born/Died 1925–1991

Nationality Swiss

First Exhibited 1953

Why It's Key Pioneer of kineticism and junk art.

opposite Tinguely at work in his studio.

494

Key Artist **Frank Auerbach** Creates seminal work, *Head of Julia*

Born of Jewish parents in 1931, Frank Auerbach was sent to England to escape Nazism at the age of eight, where he has remained ever since. He attended St Martins School of Art, from 1948–52, and studied with David Bomberg at Borough Polytechnic. His first exhibition was held at London's Beaux-Arts gallery in 1956, and, while he received criticism for his painterly techniques, his so-called expressionist works have since been applauded for their distinct sculptural quality.

Many of his paintings show an extremely thick impasto, which during the 1960s grew even heavier. It was later decreased by scraping his paintings down while he worked. Given that some of his figurative works can often take up to a year, the reworking is extensive, and has given his work an explosive quality. Another distinctive Auerbach trait is that lines are sometimes defined not by their color, but by the impression left by Auerbach's painting knife slicing through thick paint.

A figurative painter, Auerbach uses regular models, including his wife Julia, who featured in his seminal painting, *Head of Julia*, in 1960. He also uses Juliet Yardley Mills and his friend and lover Stella West. His oils and drawings also depict scenes around London and Camden Town, where he works at his studio. Exhibited around the world, the first major retrospective of Auerbach's work was in 1978 by the Arts Council of Great Britain for the Hayward Gallery.
Kate Mulvey

Date 1960

Born 1931

Nationality German (naturalized British)

Why It's Key Pioneering distinct painterly techniques, Auerbach is one of Britain's most talented postwar painters of international renown.

Key Event
Brasília becomes capital of Brazil

In 1956, construction began on Brasília, which would be declared the new capital of Brazil in 1960. The new capital, first foreseen in the Brazilian constitution of 1891, but officially launched by President Juscelino Kubitschek in early 1956, displaced the administrative role of the port cities of Rio de Janeiro and Salvador de Bahia, vaulted Brazil past the aesthetic legacy of Portuguese colonial architecture, and attracted many Brazilians to the previously underpopulated interior.

Brasília was envisioned by two Brazilians, the urban planner Lucio Costa (1902–98) and the architect Oscar Niemeyer (b.1907), who between them brought a modernist and utilitarian sensibility to the layout and architecture of the city. The governing concept of the Brasília project was to construct a city that denoted the theme of flight, while remaining embodied in functional materials and methods. Costa and Niemeyer succeeded admirably in these aims. Today, viewed from space, Brasília – depending on the imagination of the viewer – looks like a bird, butterfly, or airplane, while Niemeyer's interest in concrete manifested itself in the National Congress, the Brasília Cathedral, and the Palácio Itamaraty.

Remarkably, despite the inherent limitations of his preferred material, Niemeyer succeeded in imbuing his buildings – which proliferated all over Brasília from 1956 to 2007 – with a sense of airy fantasy and aspiration. Largely as a result of Niemeyer's work, Brasília has become not only the administrative heart of Brazil, but also one of the most important architectural destinations in South America.
Demir Barlas

Date 1960

Country Brazil

Why It's Key A new capital embraces new architecture.

opposite Niemeyer's Brasília Cathedral, Brazil.

Key Artwork *Newstead Abbey*
Frank Stella

In his famous but very short lecture, delivered at the outset of 1960 at the Pratt Institute, Frank Stella (b.1936) summed up his painterly practice. He described to his audience that as a painter he faced two principal problems, one spatial and one methodological:

"In the first case I had to do something about relational painting, i.e. the balancing of the various parts of the painting with and against each other. The obvious answer was symmetry – make it the same all over. The question still remained, though, how to do this in depth. A symmetrical image or configuration symmetrically placed on an open ground is not balanced out in the illusionistic space.

"The solution I arrived at... forces the illusionistic space out of the painting at constant intervals using a regulated pattern. The remaining problem was simply to find a method of paint application which followed and complemented the design solution. This was done by using the house painter's technique and tools."

Logical as it may have sounded, the lecture – like his work – testified to Stella's feelings about earlier modern art such as Cubism and Abstract Expressionism. *Newstead Abbey* – one of the famous series of aluminum paintings – is a translation of the artist's lecture to canvas. The symmetric regular pattern that fills and even shapes the canvas makes the painting seem like a space itself. Despite their formal appearance, Stella's works are seldom devoid of meaning. In this case, his impression of the famous ruined abbey near Nottingham, England, became an equally iconic image.
Erik Bijzet

Date 1960

Country USA

Medium Aluminum oil paint on canvas

Collection Albright-Knox Gallery, Buffalo, NY

Why It's Key This textbook example of Stella's art combines all the elements that characterize him as an artist.

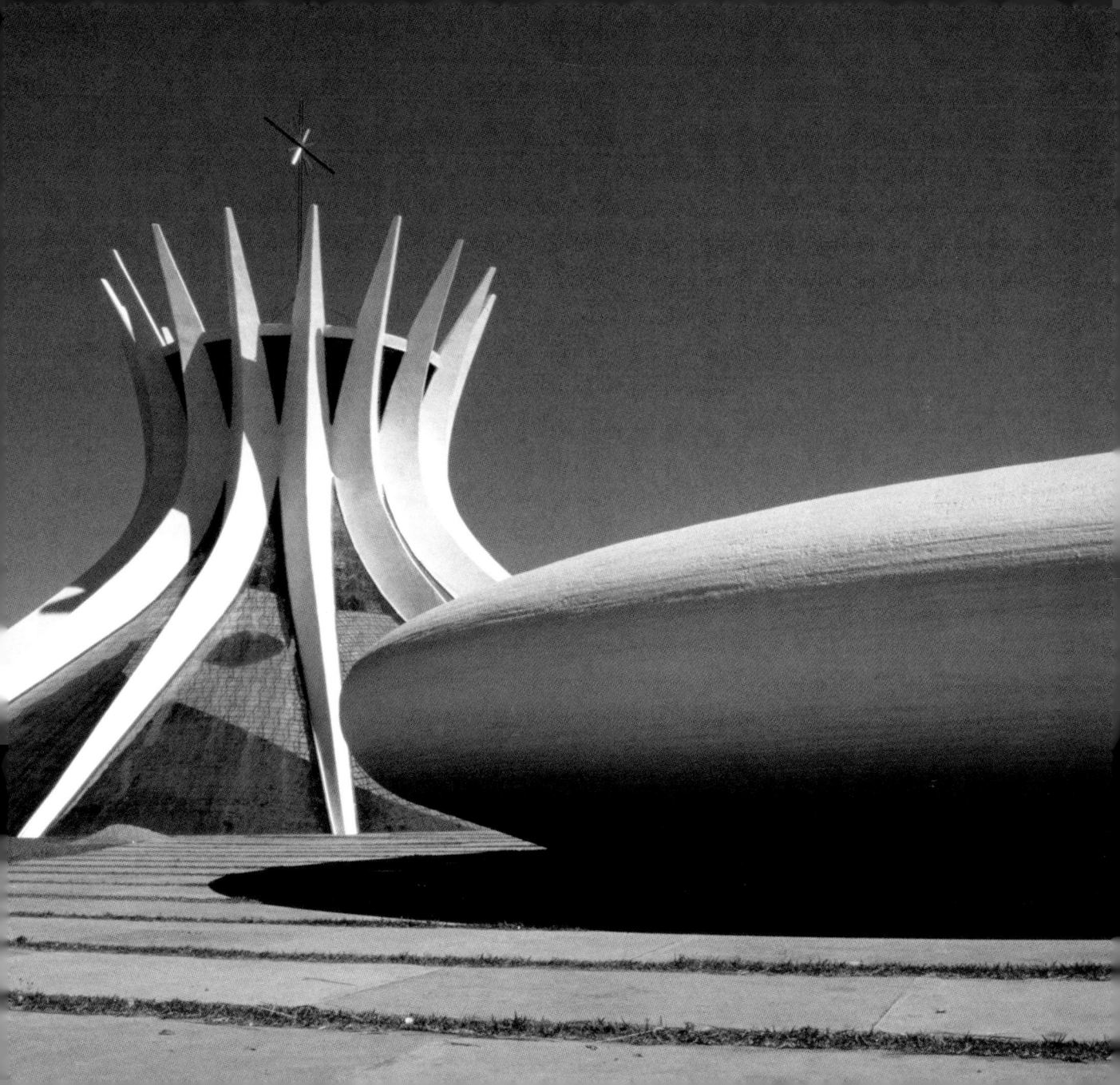

Key Artwork *Midday*
Anthony Caro

In 1960 the English sculptor Anthony Caro (b.1924), a one-time assistant to Henry Moore, debuted his *Midday*, an abstract sculpture done in yellow, painted steel. *Midday* departed both from Caro's figurative work of the 1950s and from the traditional plinth, which he eschewed in favor of a free-standing approach. *Midday* marked the beginning of an artistically rich period in Caro's life during which he worked extensively in steel and attained international fame.

Midday itself was a complex piece that combined sagacity, humor, and alienation – characteristics seldom, if ever, successfully blended in steel sculpture. The bright yellow piece looked something like a children's slide whose chute was obstructed by three standing extrusions: one that distinctly recalled a menhir (of which Caro had seen many during a 1959 trip to Brittany); one set of parallel planes that seemed strictly geometrical; and a kind of music stand. Like a slide, *Midday* was placed directly on the ground and invited interaction with spectators.

Midday's striking yellow humanized and domesticated the piece, invoking the bright magic of childhood; but the obstructions on the sculpture's chute also issued a plangent reminder that *Midday* was no simple or linear journey. The chute was not, after all, a method of easy conveyance for the human, although it might be conveying history, music, and mathematics somewhere. While the non-plinth method of *Midday* invited interaction, the dynamics of the sculpture forbade it; the work allows us to eavesdrop upon intangible themes, but does not allow us to join them.
Demir Barlas

Date 1960

Country UK

Medium Painted steel

Collection Museum of Modern Art, New York, USA

Why It's Key Marked the beginning of a period when Caro worked extensively in steel and became internationally famous.

498

Key Artist **Arman**
Fills Iris Clert Gallery with garbage

In 1960, French sculptor Arman put on a show entitled Le Plein (The Full) in the Iris Clert gallery in Paris. The show consisted of garbage that had been packed into the gallery so densely as to prevent anyone from getting in. The gesture consciously echoed Yves Klein's 1958 Iris Clert exhibition entitled Le Vide (The Void), in which the gallery had been emptied of art and painted entirely white.

Arman's Le Plein was an important riposte to Klein's airy aesthetic of weightlessness and emptiness. Arman – the epitome of Benjamin's destructive character – issued a reminder that garbage, rather than clean space, was the stuff and essence of the world, the enduring substrate out of which art is formed and to which art returns. In this way, Arman's aesthetic was both more grounded and more politically aware than Klein's ultimately bourgeois stance, which was so brutally rebuffed by Le Plein.

These shenanigans were partly inspired by the New York art scene and represented the latest flowerings of a Franco-American cultural exchange that had begun when Duchamp attempted to display *Fountain* in New York in 1917. Arman was influenced by American Pop art and would eventually become an American citizen, but also represented a half-century tradition of Continental art tricksters. Bridging the Pop of America with the Dada of France brought Arman growing renown in the 1960s. He made a big splash during his 1961 trip to New York, which would be his home for most of the next four decades.
Demir Barlas

Date 1960

Born/Died 1928–2005

Nationality French

Why It's Key A seminal anti-art gesture predicated on trash and destruction shakes up the slumbering French art scene.

Key Artist **Robert Moskowitz**
Collage paintings launch him onto New York art scene

A minimalist expressionist painter, Moskowitz was born in Brooklyn and continues to live and work in New York. His subjects or themes have included iconic buildings such as the Empire State Building and the former World Trade Center. Moskowitz formed the New Image group of painters together with Elizabeth Murray and Susan Rothenberg, and his collage paintings of 1961–63 made him one of the bright young stars of the New York art scene.

His interpretation of Minimalism often relies on part-images borrowed from classical paintings and sculptures, which he then isolates and suspends in a spacious, almost empty monochrome canvas, thereby changing the meaning and the impact of the borrowed image. The paintings are sometimes exhibited in the form of a series, similar to a set of contact prints or movie stills, but on a larger scale. Examples are taken from Rodin's *The Thinker*, Giacometti's *Standing Woman*, Brancusi's *Bird in Space*, and also Michelangelo's "Hand of God" detail from the Sistine Chapel murals.

Moskowitz spent the spring of 2002 at the American Academy in Rome as an artist in residence, and this proved to be a catalyst in generating a new body of work, much as it did for Philip Guston during his stay in Rome in the late 1940s. This connection is perhaps significant, as Guston's work was considered an important influence on the group of painters – also including Moskowitz – brought together thirty years ago in Richard Marshall's 1978 exhibition at the Whitney Museum entitled New Image Painting.

John Cornelius

Date 1961

Born 1935

Nationality American

Why It's Key Co-founder of New Image group.

Key Artist **Ed Kienholz**
Exhibits first installation, *Roxy's*

As an essentially self-taught artist, Edward Kienholz had worked as a vacuum cleaner salesman, a manager of a dance band, a secondhand car salesman, and a carpenter, among other things, but he had not gone to art school. His aesthetic was formed by a strong sense of social injustice and a fascination with the sort of arranged environments he had witnessed in churches, funeral parlors, domestic interiors, dusty curiosity shops, and grange halls in and around his native Fairfield, Washington.

It was when he settled in Los Angeles that he became involved in the arts, opening galleries, including the NOW Gallery in 1956, and the Ferus Gallery the following year. As an adolescent he had visited a brothel in Idaho, and in 1961 his first installation, *Roxy's,* was based on that experience. It would go on to cause a sensation at the Documenta 4 exhibition in Germany in 1968.

From the early 1970s Kienholz collaborated with his wife Nancy Reddin, moving to Berlin, Germany, where in 1973 he was a guest artist of the German Academic Exchange Service. After the exhibition Die Kienholz-Frauen in Zurich in 1981, all his work was co-authored with his wife. They moved from Los Angeles to Hope, Idaho, in 1973, dividing their time between there and Berlin. Kienholz died in Idaho in 1994.

Carolyn Gowdy

Date 1961

Born/Died 1927–1994

Nationality American

Why It's Key Kienholz's first installation, *Roxy's*, marked a pivotal breakthrough for the artist. The creation of a stagelike setting for the whorehouse would provide him with the perfect vehicle for making his powerful and controversial statements.

Key Artist **Meera Mukherjee**
First solo show of her sculpture

Indian sculpture goes back at least five thousand years, during which time it was largely limited to the depiction of gods, goddesses, and heroes. In 1960, Indian sculptor Meera Mukherjee contributed to a major innovation in the tradition. Mukherjee's work, exhibited for the first time, was not of divine bodies, but of ordinary working bodies, often in the midst of labor and struggle.

While departing from the time-honored subject matter of Indian sculpture, Mukherjee was deeply versed in Indian sculpting techniques. After studying sculpture in Germany from 1953 to 1956, Mukherjee returned to India, where she acquired skills in the metal castings of the ancient Dhokra style. This was not simply an apprenticeship in technique, but a journey deeper into India, as Mukherjee spent time living with Dhokra artisans. The result, when Mukherjee first exhibited in 1960, was the debut of a sculptor of truly universal proportions. Indian critics found in Mukherjee a figure who had bridged the distance between historical tradition and modern problems. This estimation solidified over the course of Mukherjee's career, as she began to adopt historical and mythological themes and figures in her later work without ever compromising the integrity and simplicity of her approach.

While much of Mukherjee's work emerged from an awareness of social and economic problems, and from very specific techniques of metal casting, she evaluated her own creative process in somewhat mystical terms, preferring to portray it as total identification with an idea, rather than as an iterative process of construction.

Demir Barlas

Date 1960

Born/Died 1925–1997

Nationality Indian

First exhibited 1960

Why It's Key Groundbreaking Indian artist who focused a new kind of attention on modern Indian sculpture.

Key Event
African Art Center founded

The African Art Center (AAC), founded in 1960 in an old station building in Durban, South Africa, sells items ranging from silks and tailormade clothing, to spices and incense. It is non-profit and dedicated to showcasing the work of aspiring and established artists while concentrating on artists from the province of KwaZulu Natal. To encourage local artists, the center provides on-site facilities for painting, sculpting, and crafting, and takes on responsibility for marketing all artworks. The art gallery displays works of interest, and the gift shop markets paintings, sculpture, beadwork, tapestries, rugs, dolls, dishes, ceramics, and carvings, making them available to locals and visitors on site and to an international audience via the Internet.

KwaZulu Natal is known for its beautiful crafts, and the Durban area specializes in grass and telewire weaving. Local artists use these materials to create bowls, plates, trays, and other items. Hand-painted embroidered items range from tablecloths with matching placemats and napkins, to cushion covers and wall hangings. Other popular crafts include beadwork and ceramics.

The AAC offers both traditional and innovative designs of Zulu and Zhosa beadwork. Zulu beer pots are popular, and the center offers these items in the traditional Ukhamba and Uphiso forms, which originated with the Nala family. Painters produce both traditional and modern art, and sculptors create objects made from indigenous woods. Nelson Mandela, crocodiles, snakes, violins, and flutes are popular subjects for these carvings.

Elizabeth Purdy

Date 1960

Country South Africa

Why It's Key Provides a way for African artists to earn a living while promoting their work and culture, allowing the most gifted to earn international acclaim.

opposite South African Zulu beer pot from KwaZulu Natal. Zulu beer pots such as this one are popular craft items offered for sale at the African Art Center.

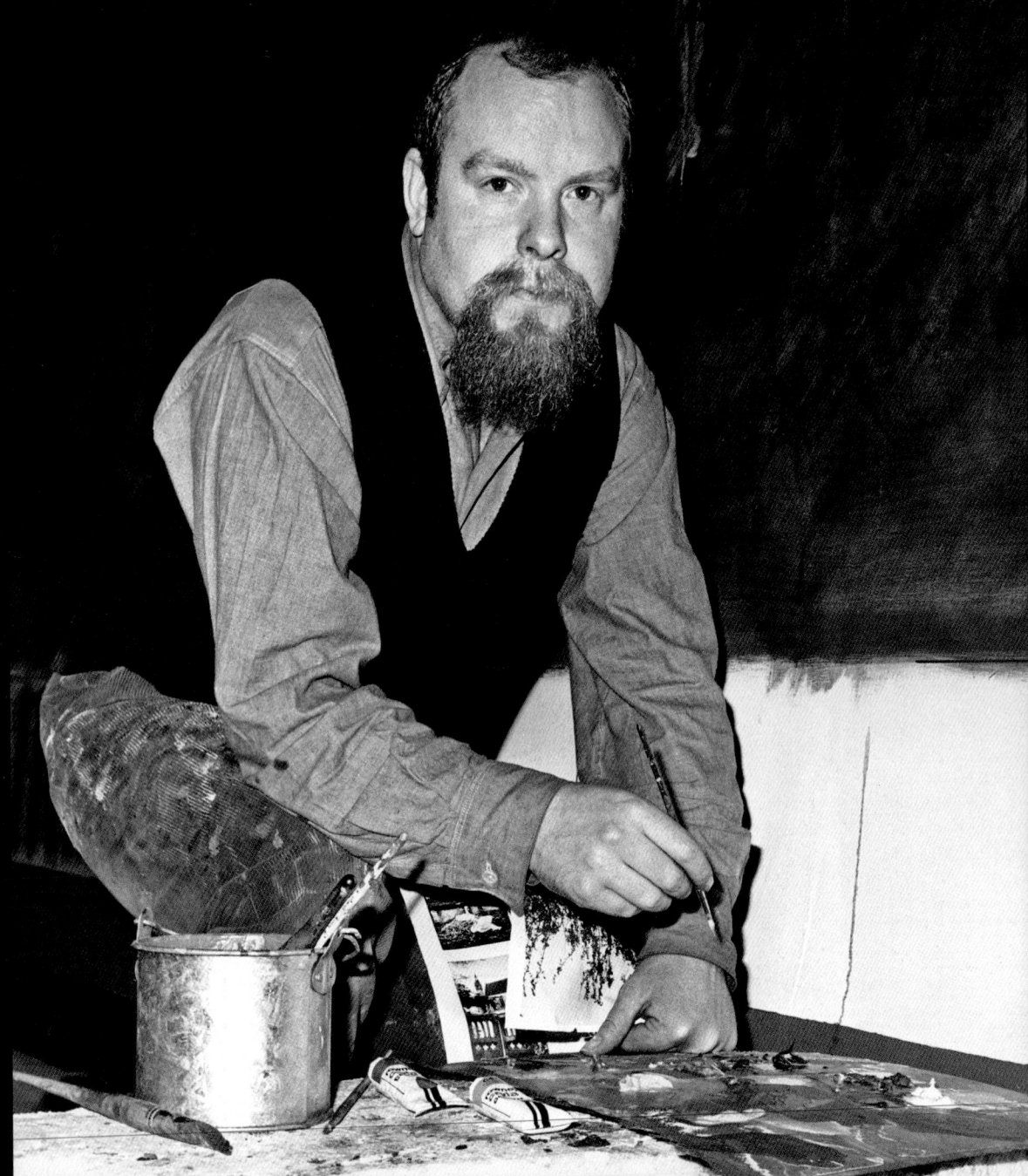

Key Exhibition **Young Contemporaries**
Landmark London show of UK Pop art

This annual exhibition, at the Royal College of Art, London, offered an important opportunity for graduates from art schools in the UK to show work to a broad and knowledgeable audience of fellow artists, critics, curators, and the general public. It signaled significant new trends among young artists. In 1952, with their early manifestation of kitchen sink realism, Derrick Greaves and Edward Middleditch prompted the critic John Berger to comment that: "Slowly but quite certainly something is happening to British painting." Kitaj attracted notice at the 1960 show, and Caulfield in 1963.

At the exhibition of 1961, Pop art's British identity emerged as a coherent movement when paintings by Hockney, Kitaj, Boshier, and other Royal College of Art painters were hung together in the galleries by fellow RCA exhibitors Allen Jones and Peter Phillips, both student members of the organizing committee. Selector Lawrence Alloway's catalog entry noted that "For these artists the creative act is nourished on the urban environment they have always lived in."

From the exhibition's inception in 1949, a committee of artists and art specialists selected exhibits until students assumed control in 1969. The controversial show in 1970 was the last until 1974 when, renamed New Contemporaries, the event resumed, continuing for twelve years. Fundamentally reorganized, with financial sponsorship and professional administration, the exhibition was relaunched in 1989. Previously shown only in London, at the Institute of Contemporary Arts and other venues, it now regularly toured to regional cities.

Martin Holman

Date 1961

Country UK

Why It's Key This exhibition defined British Pop art as a coherent movement.

1960–1969

Key Artist **Peter Blake**
Self-Portrait with Badges

The pinter, printmaker, and sculptor Peter Blake began his career with two seemingly incongruous enthusiasms: the spirit of the British countryside and the potent iconography of American popular culture. At the start of the 1960s, he nailed his colours firmly to himself with his *Self-Portrait with Badges*, a visual allusion to Gainsborough's *The Blue Boy* (c.1770).

Blake's blue garb, however, was not satin, but rather Levi Strauss denim, and his pose was anything but self-confident, as he portrayed himself as an unprepossessing provincial lad standing awkwardly bedecked with trophies from the other side of the Atlantic. The painting won a prize when it was exhibited at Liverpool's John Moores Exhibition in 1961, and it rapidly became an icon of the British Pop movement. Blake's picture celebrated a kind of wishful thinking about the United States (the badge of Britain's Union flag is dwarfed by a larger, more expansive one of the Stars and Stripes) and a yearning for the vigorous land of Elvis and rock 'n' roll.

Ironically, even as Blake's picture was being honored in Liverpool, local lads The Beatles were about to become the very first British group that did not look like a pale imitation of an American band. Blake would go on to celebrate them many times.

Graham Vickers

Date 1961

Born 1932

Nationality British

First exhibited 1961

Why It's Key Blake began his Pop art career by pledging his allegiance to American contemporary culture.

opposite Peter Blake in the early 1960s.

Key Artist **Peter Phillips**
Shows at the Young Contemporaries exhibition

Phillips was a graduate of the Royal College of Art in 1962, and was part of the group which included Derek Boshier, David Hockney, Allen Jones, and R. B. Kitaj. In the Pop art convention of the time, his early work was drawn largely from secondhand American cultural images which included pop star/movie star photographs or pin-ups, jukeboxes, automobiles, pinball machines, and the like, painted in an appropriately brash and glossy "commercial art" style.

From 1962 to 1963, he taught at the Coventry College of Art and the Birmingham College of Art. In 1963, he was represented at the Paris Biennale, and in 1964 his work was included in the Pop Art exhibition shown at the Hague, Vienna, and Berlin. In 1964, Phillips was awarded the Harkness Fellowship, which brought him to New York, where he lived from 1964

until 1966. From the 1970s onward, Phillips' work underwent a substantial change in style, moving in a more original and painterly direction, with very finely executed, dreamlike landscapes, reminiscent of those Surrealist paintings which are almost, but not quite, figurative, despite being painted in a convincingly figurative manner.

His late works are rich in color and texture, and are based on collages made from abstracted cut-out part-images from magazines. For instance, a portion of an object is cut out from a magazine picture – rather than the whole object or figure – leaving a partially but not quite fully recognizable image.

John Cornelius

Date 1961

Born 1939

Nationality British

Why It's Key Leading exponent of British Pop art.

504

Key Exhibition
Australian Aboriginal Art

After the 1929 Aboriginal Exhibition in Melbourne, Australians began to recognize the cultural significance of Aboriginal art. It was not until the 1943, however, when the Primitive Art exhibition toured the United States and Canada, that the art form was fully recognized by the Western art world. Most native art was showcased within Australia in museums of natural history, rather than in art galleries, until the 1950s. Aboriginal art gained legitimacy as a valid art form in the 1960s when major collections were gathered in Darwin at the Northern Territory's art galleries and museums, and in Canberra at the National Ethnographic Collection.

In 1960, Egyptian-born Tony Tuckson (1921–73), who had settled in Australia at the end of World War II, began organizing the next major exhibition of

Aboriginal art for the state art galleries of Australia. Titled simply Australian Aboriginal Art, the exhibit toured all the major state capitals of Australia, showcasing Aboriginal bark paintings, carved figures, and religious and domestic objects.

An Abstract Expressionist artist and the deputy director of the National Art Gallery of New South Wales, Tuckson is generally credited as the motivating force behind the 1960s movement to redefine Aboriginal art forms as fine art, rather than natural history. By the following decade, both solo and group exhibitions of Aboriginal artworks were being held throughout Australia, but it was not until the 1990s that recognition and popularity of Aboriginal art took off.

Elizabeth Purdy

Date Toured 1960–1961

Country Australia

Why It's Key Helped to legitimize the works of Aboriginal artists.

opposite Aboriginal Australian artist Kaapa Tjampitjinpa's *Goanna Dreaming*, 1973 (paint on paper).

Key Artist **Joe Tilson**
Represented at the Paris Biennale

scot

Born in London in 1928, Tilson worked as a carpenter and cabinetmaker from 1944 to 1946, before being drafted into the Royal Air Force. Discharged in 1949, he studied at St Martins School of Art, London, from 1949 to 1952, and participated in the Young Contemporaries exhibitions at the RBA Galleries in 1950. He moved to the Royal College of Art, studying there from 1952 to 1955 with Peter Blake and Richard Smith. That year, Tilson won a travel award to go to Rome and traveled widely in Italy and Spain until 1957. At that time, he was a conventional figurative artist who painted the things around him and scenes from his travels.

After seeing an exhibition of American Abstract Expressionist art at the Tate Gallery in London, Tilson tried his hand at monochrome color field painting. In the late 1950s, he used his carpentry skills to make abstract reliefs, and when Pop art erupted he adapted his craft to make colorful objects reminiscent of children's toys. Later Tilson turned out screen prints, multiples, and typographical compositions combining visual symbols and words.

From 1958 to 1963, Tilson taught at St Martins School of Art, London. In 1961, he was represented at the Paris Biennale. The following year, he had his first one-man exhibition at the Marlborough Gallery in London, and in 1964 his work was shown at the Venice Biennale. In 1966, he lectured at the School of Visual Arts, New York, and has since had major retrospectives around the world.

Brian Davis

Date 1961

Born 1928

Nationality British

First exhibited 1950

Why It's Key Influential figure in British Pop art.

Key Artwork *Yellow Abstract*
Victor Pasmore

The English artist Victor Pasmore's (1908–1998) aesthetic journey is a microcosm of the journey of modern art. Pasmore was trained in academic painting, passed through various modes of figuration, and settled into abstract painting during the mature portion of his career. *Yellow Abstract* (1961) belongs to this late period of the artist's life. Its subject is an ochre quadrilateral that resembles nothing so much as a television screen, although it more conventionally hints at an amoeba-like life force or stands in for pure geometry.

Yellow Abstract solidified Pasmore's reputation as the leading abstract painter in England, and took part in the ongoing and unresolved international dialogue about the role of color in art. However *Yellow Abstract* carried a different, and perhaps greater, significance than much of the other work being done in color fields at the time, precisely because Pasmore had found his way there after decades of figurative work. This progression was a living rebuttal to the notion, still in popular circulation in Pasmore's day, that color field abstraction in particular, and non-figurative art in general, was a kind of hoax. That Pasmore had come to this kind of abstraction via the academy, and through his interest in the canonical Turner and Whistler, demonstrated that non-figurative art was in fact a genuinely felt endpoint.

Ironically, given his early immersion in the figurative, Pasmore's *Yellow Abstract* was quite uncompromising in its insistence on a geometric aesthetic. Drained as it was of emotion, the painting modeled the triumph of a post-affective aesthetic.

Demir Barlas

Date 1961

Country UK

Medium Oil on board

Collection Tate Gallery, London, England

Why It's Key This painting solidified Victor Pasmore's reputation as the leading abstract painter in England.

opposite Pasmore's *Yellow Abstract*.

Key Artist **Derek Boshier**
Included in the Young Contemporaries exhibition

Derek Boshier is a British artist who, along with fellow Royal College of Art students including David Hockney and Allen Jones, having absorbed the observations of Marshall McLuhan in *The Medium Is the Message*, established Pop art in the UK at the Young Contemporaries exhibition of 1961 and the 1964 New Generation show, both at London's Whitechapel Gallery. He spent a year traveling in India and, in 1962, he appeared in a BBC *Monitor* film with Peter Blake, directed by Ken Russell.

Boshier shared common ground with the American West Coast painter Mel Ramos in that his specific concerns were with the manipulative forces of advertising and the increasing Americanization of British culture, welcomed and espoused by the likes of Peter Blake. Rather than taking the path to

superrealism, however, or indeed pure "pop," he moved increasingly toward a non-figurative semiabstract style. He merged the human figure with the subject of the advertisement, as in *Identi-Kit Man*, where the limbs of the figure are synonymous with the striped toothpaste. This is considered one of his pivotal early works.

The figurative elements of his work were gradually eliminated, and after 1964 Boshier became a purely abstract painter. He continued to work in Plexiglas sculpture, colored light, film, and Conceptual art, and throughout the 1980s taught painting at the University of Texas.

John Cornelius

Date 1961

Born 1937

Nationality British

Why It's Key Important figure in the British manifestation of Pop art.

Key Artist **Sadequain**
Wins prize at Paris Biennale

Born in 1930 in Amroha, India, Syed Sadequain Ahmed Naqvi – better known as Sadequain – was Pakistan's most famous painter. At the age of eighteen, he graduated from the Art History department of Agra University and set out for the newly created Muslim state of Pakistan. Here, the prolific young artist set about creating portraits and murals, many of which were exhibited in important Pakistani buildings such as Karachi Airport and Jinnah Central Hospital.

Sadequain's star was on the rise. The early 1960s were particularly important: he received the Tamgha-e-Imtiaz, or medal of excellence, from Pakistani President Muhammad Ayub Khan, won First Prize in the Pakistan National Exhibition of Paintings, and received an invitation to visit France in 1961. In Paris, Sadequain won the Laureate Biennale for his painting *The Last*

Supper (1961). The award focused international attention on him, with the French particularly enamored of his style.

Sadequain became the darling of *Le Monde*, which compared the range of his talents to Picasso's. In 1962, Sadequain exhibited twice in Paris and once in Le Havre, where he won a medal. The next year Sadequain toured the United States and UK, but returned to his beloved Paris for an exhibition in 1964, the year he was chosen to illustrate Albert Camus' *The Stranger*. The 1960s proved to be the high point of Sadequain's career in the West, as he spent most of his remaining career in Pakistan, with tours to the Middle East and India.

Demir Barlas

Date 1961

Born/Died 1930–1987

Nationality Pakistani

First exhibited 1954

Why It's Key Pakistan's most talented artist wins international recognition.

Key Artwork *American Dream*
Robert Indiana

In May 1961, Robert Indiana (b.1928) participated in a significant two-man show with fellow artist, Peter Forakis, at the David Anderson Gallery in New York. Indiana showed "assemblages" from found materials stencilled with words, and paintings, one of which was entitled *The American Dream*; this was the inaugural painting that was to herald an ongoing series under the same title. This first painting had started life in the late 1950s and been continuously reworked until it became a "pivotal canvas and a crucial one," of which Indiana himself says "[his motifs] changed from a classic white geometry to the neon polychromy (sic) of Now America." It was also significant insofar as it attracted the legendary Alfred Barr to purchase *The American Dream* for MoMA in 1961. The first *American Dream* is a "dark" painting (unlike future works in the series) that reflected the artist's depressive state of mind on first arriving in New York. The references to pinball and jukeboxes were deliberate and relate to Indiana's formative years following his mother around endless roadside diners, where she worked as a cook and waitress. "Those hundreds of grubby bars and roadside cafes," he notes, "[that are the] alternate spiritual home of the American."

As the initial image progressed to a cycle, the mood remained "caustic" and "cynical" corresponding to Indiana's encoded and symbolic commentary on memories of his father's unemployment and his family's subsequent poverty. By the fifth emanation (*The Demuth American Dream*, 1965) the negative aspects had withdrawn: "They are all celebrations" Indiana says of his future painterly explorations.

Mike von Joel

Date 1961

Country USA

Medium Oil on canvas

Collection Museum of Modern Art, New York

Why It's Key This work signals a pivotal re-direction of the artist's engagement with image and form and the start of an extended series, the first of which was purchased by the world-famous MoMA.

1960–1969

509

Key Exhibition
Five Painters from Regina

Over several months in 1961, the works of Canadian abstract artists Kenneth Lochhead (1926–2006), Arthur McKay (b.1926), Douglas Morton (1927–2004), Ted Godwin (b.1933), and Ronald Bloore (b.1925) were showcased in a national tour of prairie art that came to Canada's National Gallery in the Five Painters from Regina exhibition. All five artists were from Ontario and the prairies, and all had studied art elsewhere before moving to Regina, Saskatchewan. Lochhead and McKay, who worked together at Regina College, now the University of Saskatchewan, had for several years been involved in the Emma Lake Artists Workshop, held each August. A turning point came in 1959 when American minimalist expressionist painter Barnett Newman, a workshop leader, encouraged the Regina artists to hold an exhibition. Clifford Wiens had originally been part of the group, but was omitted from the national tour.

Influences on the Regina Five included three other Americans: formalist critic Clement Greenberg and color field painters Kenneth Noland and Jules Olitski. Bloore was the motivating force behind the Five Painters from Regina exhibition, understanding that Canadians were anxious to see examples of the new prairie art, which reflected the unique contemporary style of the artists of Western Canada. By 1967, Lochhead, Bloore, and Morton had all left Regina, as did Godwin in 1982. All five artists continued to paint and teach. Lochhead received acclaim as both an artist and educator, winning the Order of Canada (1971) and the Governor General's Award in Visual and Media Arts (2006).

Elizabeth Purdy

Date 1961

Country Canada

Why It's Key The "Regina Five" exhibition introduced Canadians to prairie art and identified Regina as a valid arts center, establishing the national reputations of the five artists.

Key Artist **Dame Elisabeth Frink**
Solo exhibitions in Los Angeles and New York

Sculptor and printmaker Eisabeth Frink was the daughter of a Guards officer, and spent her youth in close proximity to horses, dogs, and handsome men. These were to be the wellspring of her passionate depictions of animals and their relationship to people. However, World War II brought her other images to contemplate – she was much affected by news footage from Belsen, and also survived a close air raid.

After the war, life at Guildford and Chelsea art schools in 1950s meant hard work by day and jazz clubs all night. She was excited by Giacometti, and followed his example of working with plaster applied to an iron armature and subsequently attacking the surface to produce additional textures for her castings. Her work was quickly spotted by collectors, including the Tate Gallery, and she won a prize in a competition caled Monument to the Unknown Political Prisoner. Still in her twenties, she was invited to teach at Chelsea, and later at St Martins School and the Royal College of Art. As her renown spread worldwide, many doctorates and trusteeships followed. She participated in numerous group exhibitions and notably in solo exhibitions in Los Angeles and New York in 1961.

Animals, birds and, above all, men continued to fascinate her; she said she focused on the male because to her he was a subtle combination of sensuality and strength with vulnerability. She only made one female figure, the *Walking Madonna* at Salisbury Cathedral. After six years in France, Frink returned to live and work in Dorset in 1973. She was appointed a DBE (Dame Commander of the Order of the British Empire) in 1982.

Bill Bingham

Date 1961

Born/Died 1930–1993

Nationality British

Why It's Key One of Britain's leading sculptors and most remarkable twentieth-century artists.

opposite Elisabeth Frink in January 1953.

510

Key Event
The Sydney Nine group is formed

In response to what some saw as the exclusivity of Australia's Antipodeans abstract exhibition of 1959 and the ongoing debate about how to define Australian abstract art, in 1961 a group of artists from Sydney and Melbourne formed the Sydney Nine to exhibit their works and call attention to the legitimacy of the diversity of form in abstract art. The Sydney Nine began the Melbourne exhibition with an attention-getting flourish, arriving at the city in a helicopter and waving abstract paintings as they disembarked.

Italian-born Stanislaus Rapotec (1911–1997), Australia's leading abstract painter, garnered international attention when he won the coveted Blake Prize for his *Meditation on Good Friday* (1961). Other members of the Sydney Nine included painters Hector Gilliland (b.1911), Leonard Hessing (b.1931), John Olsen (b.1928), Carl Plate (1909–1977), Bill Rose (1929–1997), Eric Smith (b.1919), and Peter Upward (1932–1983), and the sculptor Clement Meadmore (1929–2005). Noted sculptor Robert Klippel (1920–2001), who was living in New York in 1961 but returned to Australia in 1963, had strong ties to the Sydney Nine.

The exhibitions reflected the diversity of talents and influences on individual members, as well as the wide spectrum of styles represented in Australian abstract art during the 1950s and 1960s. The Sydney Nine dissolved as members became less unified in their intellectual perceptions of Australian abstract art and as members moved out of the area. Individually, the Sydney Nine continued to exhibit their works at home and abroad, winning a number of prestigious honors.

Elizabeth Purdy

Date 1961

Country Australia

Why It's Key The entry of the Sydney Nine into the art scene focused attention on abstraction as a serious element of contemporary Australian art.

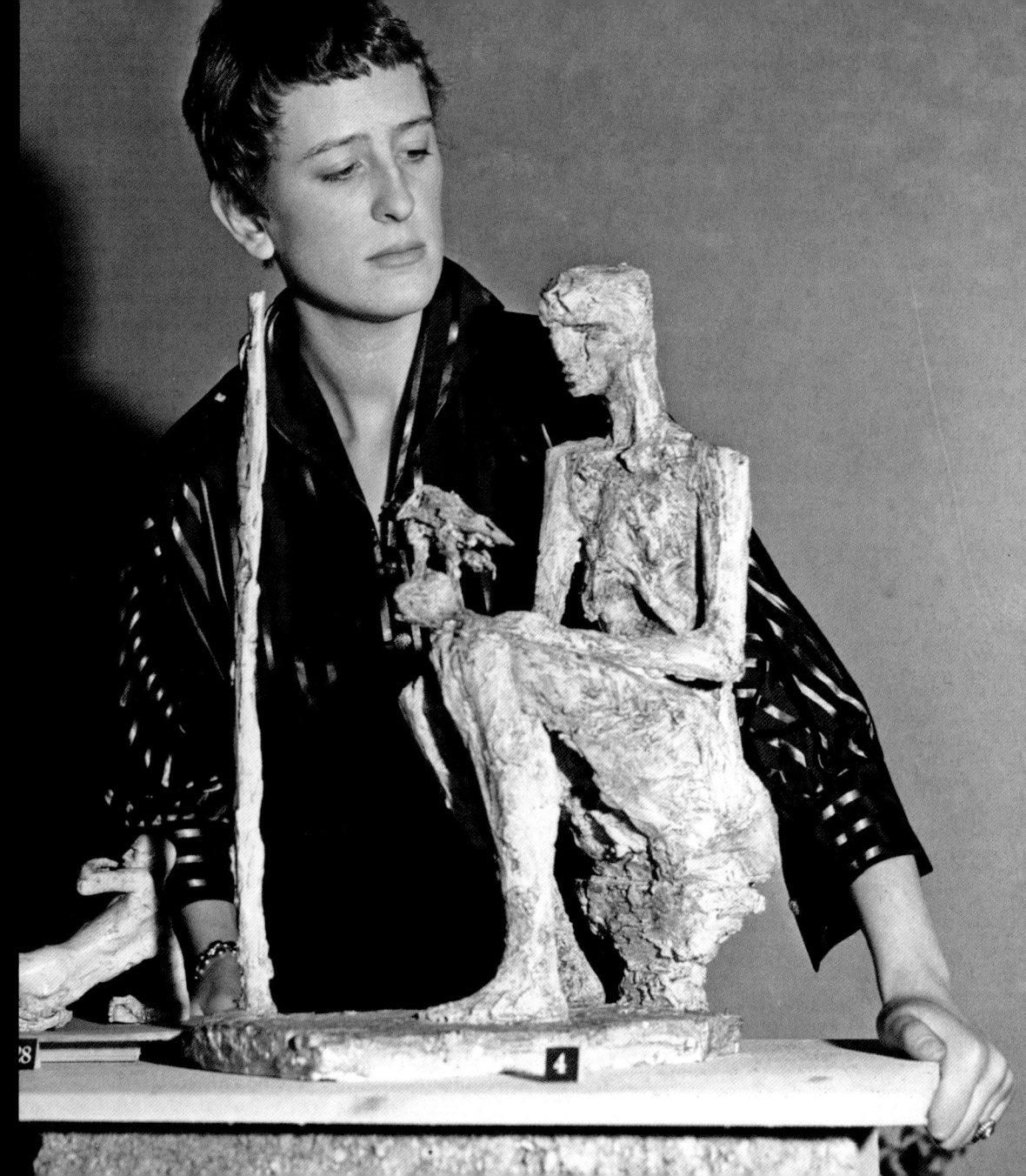

Key Artwork *I Love You with My Ford*
James Rosenquist

The fractured composition of *I Love You with My Ford* is an example of the work of James Rosenquist (b.1933) which clearly owes a debt to partially completed billboard advertisements (he was a billboard artist early in his career) in which previous advertisements can be discerned under current images.

The images are silk-screened onto canvas, then overpainted by hand or airbrush, a technique which gives the illusion of highly refined Vermeer-like painterliness deployed to create images which were confusingly contemporary. In this example, the top third of the painting comprises the meticulous photorealistic painting of the radiator grille and hood of a Ford car; the middle section is a monochrome painting mimicking the black and white of an old Hollywood movie showing a massive close-up of an embracing couple; the bottom third is a vivid orange hyperrealistic painting of spaghetti in tomato sauce.

On one level, this is an arbitrary juxtaposition of unrelated images. On another, there is a subliminal link in the subject matter, after the fashion of the beat writer William Burroughs's literary cut-ups. An erotic link has been identified between the image of the car, the faces of the kissing couple (which, on this scale, have themselves almost become a landscape), and the sensuous writhing of the spaghetti.

This way of working is a product of Rosenquist's early work experience, but also reflects the kaleidoscopic visual experience of traveling in a bus or car along a city-center street and experiencing the fractured images flashing by.

John Cornelius

Date 1961

Country USA

Medium Silk screen on canvas, overpainted

Collection Moderna Museet, Stockholm

Why It's Key One of the pioneers of American Pop art, Rosenquist specialized in images with a similar urban source on a massive, billboard-sized scale.

Key Artwork *Masterpiece*
Roy Lichtenstein

In 1960, dissatisfied with his early Cubist and Abstract Expressionist experiments, which he found "derivative," Roy Lichtenstein (1923–1997) turned his attention to everyday images from popular culture. He came to prominence in 1962, with pictures that looked like enlargements of cliché adventure and romance comic strips. These triggered a controversy over both subject matter and technique: there seemed to be no distance between the image and the medium, no transformation, because, as Lichtenstein put it, the picture "doesn't look like a painting of something, it looks like the thing itself."

That impression was reinforced by the sharp contours and simplified colors – yellow for hair, pink for skin – typical of mass printing. Moreover, benday dots, instead of disappearing to reveal the image, were blown up. Many therefore argued that Lichtenstein was slavishly duplicating, rather than creating, pictures – a criticism wittily addressed in a 1963 painting, the subject of which asks: "What do you know about my Image Duplicator?" The irony lies in the fact that the images were *obviously* taken from their source, but only *looked* like reproductions.

Lichtenstein painstakingly worked over his studies, yet this never showed in the final picture, and the subject matter thus overshadowed the formal rigor and abstract qualities of his compositions. This paradox is ironically highlighted in *Masterpiece*, which plays on the contrast between our romanticized idea of artistic genius and this apparently machine-made work.

Catherine Marcangeli

Date 1962

Country USA

Medium Oil on canvas

Collection Private collection

Why It's Key Quintessential example of Lichtenstein's Pop art pictures, which are inspired by advertisements and comic strips.

Key Exhibition
The New Realists

In 1948, the art collector Sidney Janis (1896–1989) opened a gallery on 57th Street, New York, and soon gained a reputation for showing European masters such as Bonnard, Mondrian, and Léger alongside Abstract Expressionist newcomers.

He also contributed to the rise of Pop art with his 1962 exhibition New Realists. A spate of Pop exhibitions was already underway by then: in 1960, New York's Martha Jackson Gallery had included Robert Rauschenberg, Jasper Johns, and Allen Kaprow in its neo-Dadaists show; in 1962, the Pasadena Art Museum's New Painting of Common Objects introduced Jim Dine, Roy Lichtenstein, Andy Warhol, and Wayne Thiebaud to the West Coast. Meanwhile, the French New Realists were being shown in New York: Arman, Daniel Spoerri, Jacques de la Villeglé, and

Mimmo Rotella were included in the Art of Assemblage (1961) at the Museum of Modern Art.

Janis was original, however, in gathering artists who came from different countries, yet shared an interest in integrating reality to their work. British, Swedish, Italian, and French artists were displayed with American "painters of common objects," fostering fruitful comparisons. César's *Compressions* took on a different meaning next to John Chamberlain's sculptures; the deadpan style of Lichtenstein, Tom Wesselmann, and Robert Indiana, inspired by mass-media imagery, could be contrasted with the less slick, and more literal, appropriations of the real by Rotella, with his torn posters, or Arman, with his *Accumulations*.

Catherine Marcangeli

Date November 1962

Country USA

Why It's Key First international survey of Pop and *nouveau réalisme* art.

Key Event **Founding of Fluxus**
Neo-Dada avant-garde group

George Maciunas (1931–1978), a Lithuanian American, was employed as a designer by the American air force in Germany, when he independently coined the term Fluxus, and organized the group's inaugural celebration. An international assortment of artists, poets, and musicians gathered in London for the Festival of Misfits. Fluxus became an official movement during this Festum Fluxorum European tour, 1962–63.

The Fluxists were best known for their irreverence toward the conventional art system. They created an alternative anti-art reality that placed importance on chance. This opposed the increasingly market-lead structure which often placed value on predictable style and repetition. Humor, imagination, daily experiences, improvisation, and the use of found materials determined the Fluxists' basic approach. Their work

was conceptually based, minimal and often surprising. They also held "happenings," an early form of performance art. The aim was to integrate life into art, and to make work that was affordable and easily available. From his home in New York, Maciunas acted as a cultural entrepreneur, helping to organize and promote the Fluxists. It was intended to be ephemeral, for use rather than display. Items were often provocative, or amusing and produced in multiples.

Maciunas collaborated with a number of artists, including Yoko Ono and Christo. He developed their ideas into formats including small worlds within boxes, objects, records, films, tiny books, games, charts, and posters. Production was done by hand and volunteers used the cheapest materials possible.

Carolyn Gowdy

Date 1962

Country Germany/UK

Why It's Key An international group of artists, poets, and musicians would become loosely connected under the title "Fluxus." Their playful, innovative, and anarchic approach recalled the spirit of various Dada groups active during the early part of the century.

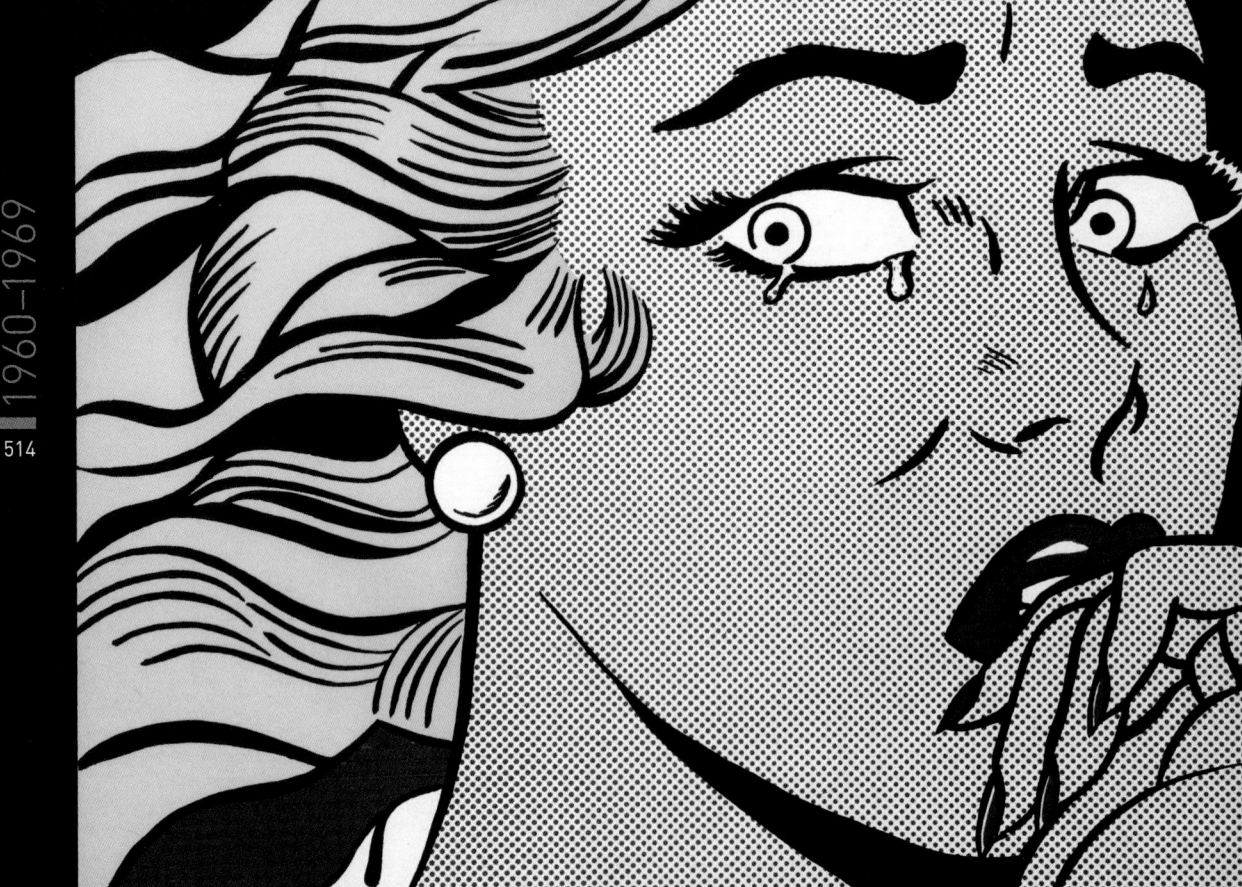

Key Artist **Roy Lichtenstein**
First one-man exhibition takes New York by storm

Born in New York, Roy Lichtenstein studied under the Realist Reginald Marsh, before being introduced to abstraction at Ohio State University. He dabbled in Cubism and Abstract Expressionism, while supporting himself as a teacher. While teaching at Rutgers University, New Jersey, he began reproducing frames from comic strips, complete with the benday dots used in printing, on large canvases. He also drew inspiration from small advertisements. His first one-man exhibition opened in the Leo Castelli gallery in New York in 1962.

Quickly attaining an international reputation, Lichtenstein became the first American to exhibit in London's Tate Gallery in 1966. His most famous image, *Whaam!* (1963), based on an image from D.C. Comics' *All-American Men of War* of 1962, was purchased by the Tate after the exhibition. His other iconic cartoon images hang in major galleries around the world, including the Museum of Modern Art in New York.

Lichtenstein further depersonalized his style by moving into printmaking. He parodied twentieth-century styles such as Cubism, Purism, Surrealism, and the Abstract Expressionism he had abandoned. Later, he took the linear devices from his canvases into painting bronzes, to produce three-dimensional but flat-looking representations of familiar objects.

In the late 1970s and 1980s, he received commissions for major public works, including *Mermaid* (1979) in Miami Beach, Florida; *Brushstrokes in Flight* (1984) at Columbus International Airport, Ohio; and the five-story *Mural with Blue Brushstrokes* (1986) in the atrium lobby of New York's Equitable Tower.
Nigel Cawthorne

Date 1962

Born/Died 1923–1997

Nationality American

First exhibited 1949

Why It's Key A true original of American Pop art whose style came to epitomize the genre.

opposite Lichtenstein's *Crying Girl* (1963).

515

Key Artist **Tom Wesselmann**
Exhibits in New Realists exhibition

Tom Wesselmann studied psychology at the University of Cincinatti in 1951. Enlisted into military service in 1952, he started drawing cartoons and became interested in pursuing this as a career. He completed his psychology studies in 1954 and enrolled at the Art Academy of Cincinatti. Moving to New York in 1956, he was accepted into the Cooper Union college of science and art.

During visits to museums and galleries, he became interested in contemporary artists such as Robert Motherwell and Willem de Kooning, although his prime influence was Henri Matisse. A fellow student at Cooper Union was Claire Selley, who became his friend and model, and, later, his wife. He started exhibiting small collages in 1959, and to make a living he taught art and mathematics at a school in Brooklyn. In 1961, he started his *Great American Nude* series of paintings using paint and posters taken from subway stations, and his work became the size of billboards.

After exhibiting in the seminal New Realists exhibition in New York in 1962, Wesselmann was seen as part of the American Pop art movement, although he was never happy with the label. Throughout the 1960s, he continued to paint large-format pictures. In the 1970s, he started work on the *Bedroom* series which shifted the scale and focus of objects around the nude. The 1980s saw him producing works using aluminum and steel. After 1993, he began to describe himself as an abstract painter and, in spite of failing health in his last ten years, continued painting and exhibiting until his death in 2004.
Alan Byrne

Date 1962

Born/Died 1931–2004

Nationality American

Why It's Key Wesselmann was one of the greatest influences on Pop art.

Key Artwork *Campbell's Soup Cans*
Andy Warhol

Already a successful commercial illustrator in the late 1950s, Warhol (1928–1987) produced paintings based on comics before turning his attention to emblematic American products such as Coca-Cola and Campbell's Soup. In 1962, he exhibited a series of thirty-two canvases representing soup cans at the Ferus Gallery, Los Angeles. Their bold, graphic style contrasted with the more painterly facture of his earlier works, introducing a deadpan equivalence between image and medium through the use of silk screen, a mechanical mode of reproduction deemed more appropriate for the endlessly duplicated images of advertising than for true, unique works of art.

Critics bemoaned Warhol's apparent disregard for artistic originality: what was the value of these works if they looked so much like "the real thing"? Warhol played up such controversies, provocatively declaring: "I want to be a machine."

The Campbell's canvases were presented in a row, as though on a supermarket shelf. Variations on a theme are common in art, witness Monet's series of haystacks or poplars in the 1890s. Yet Warhol's seriality partakes more of repetition than of variation. Many interpreted this as a condemnation of materialism, while others saw it as a celebration of capitalist prosperity. Warhol cultivated the ambiguity, and carried on exploring it in the American Supermarket, a 1964 group exhibition at the Bianchini Gallery, where "sculptures" such as Brillo Pad boxes looked uncannily like the consumer products on which they were modeled, thus flirting with the notion of ready-mades.
Catherine Marcangeli

Date 1962

Country USA

Medium Silk screens on canvas

Collection Museum of Modern Art, New York

Why It's Key Banal subject matter repeated endlessly.

opposite *Campbell's Soup Cans*

Key Artist **Howard Hodgkin**
First one-man show, Whitechapel Gallery, London

Sir Howard Hodgkin's work is generally small-scale. It appears to be totally abstract and inaccessible, as it takes the form of loose, apparently haphazard swirls, splashes of paint which breach the boundaries of the canvas and often cover the frames of the pictures. He also paints on flat wooden surfaces such as cupboard doors that have raised elements which serve as frames.

Although appearing spontaneous, his paintings are heavily worked over a long period. Much of his work is actually of figurative origin, and the seemingly abstract compositions are in fact fairly faithful to original images, such as an aerial view of a couple making love on a bed or the plan of a lushly planted garden. In that regard, the division between "representational" and "abstract" art becomes blurred. Hodgkin has travelled to exotic locations including Morocco and India, and claims that his preference for flat bold colors and decorative borders stems from his admiration for Indian miniatures.

He mounted key exhibitions, including his debut one-man show at the Whitechapel Gallery in London in 1962. Hodgkin is now an establishment figure in the art world. He represented Britain in the Venice Biennale in 1984. He has been a trustee of the Tate Gallery and the National Gallery, and was awarded the Turner Prize in 1985. He was knighted in 1992, and awarded the Companion of Honor by the Queen in 2003.
John Cornelius

Date 1962

Born 1932

Nationality British

Why It's Key Prominent British painter with a characteristic "semiabstract" (or "semifigurative") style.

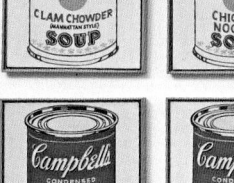
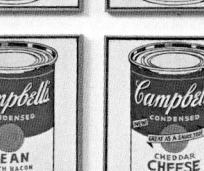

Key Artist **David Hockney** Four paintings shown at the Young Contemporaries exhibition

Considering that David Hockney's talent and versatility have streamed like a river through his work for more than four decades, *Demonstrations of Versatility* was an intriguing title for the paintings he submitted to the Young Contemporaries, an annual juried showcase for the work of young artists, in 1962.

It is as though Hockney was sketching a winning outline for a future script: I have something to offer and I am what I am. Hockney knew how to sell himself, and he was aligned with a bigger picture. London was rising from the ashes of postwar austerity, and, like Hockney, it was springing into life. Hockney had recently been inspired by a major Picasso exhibition at the Tate Gallery in London, and had also met the art dealer John Kasmin, with whom he would have a sellout show the following year.

Hockney had read Walt Whitman, and painted *Doll Boy* (1960), *Adhesiveness* (1960), and other love paintings. While on his first trip to New York in 1961, he had two of his prints bought by the Curator of Prints at the Museum of Modern Art. The young artist had already begun work on the sixteen etchings for *A Rake's Progress* (1961–1963).

Hockney had some important supporters behind him, and was winning prestigious awards and prizes. The work was fresh, full of passion and optimism. Hockney had stepped into himself with an interesting artistic maturity. He was already creating work that would stand the test of time.

Carolyn Gowdy

Date 1962

Born 1937

Nationality British

Why It's Key The same year Hockney graduated from the Royal College of Art with a gold medal, and was viewed as one of the rising stars of the Pop art movement. He is now one of the best-known artists of his generation.

opposite Hockney's *Life Painting for Myself* (1962).

Key Artist **Morris Louis** Death of influential color field painter

Morris Louis, born Morris Louis Bernstein, attended the Maryland Institute of Fine and Applied Arts (now Maryland Institute College of Art), but left before finishing his course. He originally worked in the late Cubist manner, but was to become an Abstract Expressionist. Louis was elected president of the Baltimore Artists' Association in 1935, and, from 1936–40, he worked in the Works Progress Administration (WPA) Federal Arts Project in New York; it was during this period that he dispensed with his last name.

Louis returned to Baltimore in 1940 and worked privately as a teacher. In the 1950s, he was working with acrylic emulsion artists' paints. These had recently become available and had characteristics which were distinct from oil paints and their associated traditions,

in that they could be painted or poured onto unprimed canvas producing color of great clarity and elasticity. They could be thinned with water and dried quickly.

In 1953, he met Helen Frankenthaler and was influenced by her stain paintings; the thinned paint, poured onto the canvas, produced a stain rather than a layer. In his *Veil* series (1954–58), he uses the thinned-down paint to produce translucent color washes on the bare canvas. *Florals* (1960–61) used thicker paint applied in a more haphazard manner. The *Unfurled* series (1961) and *Stripe and Pillar* series (1961–62) again used colored bands.

Louis died of lung cancer in 1962, aged fifty-nine.

Alan Byrne

Date 1962

Born/Died 1912–1962

Nationality American

Why It's Key Louis is the greatest exponent of color field painting.

Key Artist **Alberto Giacometti** Wins Grand Prize for Sculpture at the Venice Biennale

Alberto Giacometti was born in Switzerland in 1901 and studied at the Geneva School of Arts and Crafts in 1919, after which he went to Paris to study under the sculptor Antoine Bourdelle (an associate of Auguste Rodin) from 1922–25. Giacometti experimented with sculpture in the Cubist and Surrealist styles. With pieces such as *The Palace at 4 a.m.* (1933), a skeleton holding suspended figures and objects, he became one of the leading Surrealist sculptors of the 1930s.

From 1936–40, he concentrated on the human head, focusing on the model's gaze. By 1948, his distinctive style had developed, the figures became elongated forms with the limbs and torso stretched out, and his drawings and paintings became a web of lines and strokes that delineated the forms. There is a frailty to these desolate creatures; the spatial relationships are quite different from the monumental quality of traditional sculpture.

In 1962, Giacometti was awarded the Grand Prize for Sculpture at the Venice Biennale, which brought him celebrity worldwide. In his later years, he held exhibitions throughout Europe, and in 1965 he traveled to the United States for an exhibition of his works at the Museum of Modern Art in New York. As well as a sculptor and painter, he was also a prolific printmaker.
Alan Byrne

Date 1962

Born/Died 1901–1966

Nationality Swiss

Why It's Key Key player in the Surrealist movement and a strong influence on younger sculptors with his later works.

Key Artist **James Rosenquist** First one-man show at the Green Gallery, New York

Rosenquist studied art at the University of Minnesota from 1952 to 1955, and was awarded an Art Students League scholarship to New York. He had already experienced student vacation work as an industrial painter, working on unyielding surfaces on a vast scale. His tasks included applying paint to the outside of warehouses and grain silos. This led to further slightly more skilled vacation work handpainting billboards for advertising companies.

Working on a vast scale on billboards and the like made a profound impression on him, and he describes the experience of painting a surface the size of a football pitch and the distortion which takes place when working on such a scale at close quarters, when images take on an entirely different meaning. After working on the 30ft by 100ft billboard of the Astor Victoria cinema in Times Square, he noted that: "You couldn't see the whole thing at once, it was like infinity... everything looked different."

International acclaim came in 1965 with the room-sized painting *F-111*. Other key works of Rosenquist include *Taxi*, *White Bread*, *Front Lawn*, *The Swimmer*, and a print, *Time Dust* (1992), considered at 7ft x 35 ft to be the largest fine art print in the world. Rosenquist said that he saw himself as fulfilling Fernand Léger's requirement for "a painter of modern life," reassessing as he does graphic and package design as elements of works within the realm of fine art.
John Cornelius

Date 1962

Born 1933

Nationality American

Why It's Key Crucial Pop artist who produced large-scale, almost cinematic work, which was influenced by billboard advertising.

Key Artist **John Piper** Designs stained-glass window for the new Coventry Cathedral

Painter, printmaker, and writer John Piper was born in Epsom, Surrey, in 1903. He worked for his father's legal firm before attending Richmond School of Art and the Royal College of Art. Primarily a representational artist with an interest in buildings within the English landscape, notably churches and abbeys, he nevertheless made forays into abstract art and joined the group known as the "Seven and Five," which included Ben Nicholson, Henry Moore, Barbara Hepworth, Ivon Hitchens, Frances Hogkins, and Winifred Nicholson.

With contemporaries such as Moore and Paul Nash, Piper was recruited into the War Artists scheme in 1940 to record historic architecture before (and after) the German aerial bombardment. Piper wrote extensively on modern art, and collaborated with the poet John Betjeman on several books, notably the *Shell Guides to the English Counties*.

His most celebrated project is the 1962 stained-glass windows for the postwar rebuilding of Coventry Cathedral. He also designed tapestries for Chichester Cathedral, and produced theater set designs, including those for Benjamin Britten's production of *A Midsummer Night's Dream* at the Royal Opera House. He also launched the avant-garde art magazine *Axis*, in which he was generous in his promotion of contemporaries such as William Coldstream and Victor Pasmore.

He eventually returned to landscape work in the English romantic genre. Nevertheless, he imported elements of abstraction which gave his later work a contemporary feel.

John Cornelius

Date 1962

Born/Died 1903–1992

Nationality British

Why It's Key Piper was a distinguished painter and printmaker at the forefront of the prewar Modernist movement in Britain.

521

Key Artist **Ad Reinhardt** His "black paintings" herald Minimalism

Art, Yasmina Reza's immensely popular 1994 play, centers on the debate between two cosmopolitan intellectuals over the definition, meaning, and purpose of art after one of them buys an entirely white canvas for a massive amount of money. In spite of the arguments advanced by the collector's friend, sensitive viewers standing before a canvas by Ad Reinhardt, the New York-born and based Conceptual Minimalist painter whose monochrome paintings inspired *Art*, would have little difficulty in understanding their potency.

Reinhardt, who studied art at Columbia University, began painting a series of all-black canvases in the 1960s. The impact of these iconic works comes largely from the fact that they are all-black, but not all the same black. From a distance, the canvases look almost like a very deep and dark opening in the wall. The sense produced by staring at them is like looking into a black hole. Up close, it becomes clear that the canvases actually contain various shapes formed out of different shades of black.

On a philosophical level, these paintings compel viewers to question the nature of truth in a world in which even a single color painted on canvas is more complicated than it appears. And on a purely aesthetic or sensual level, the monochromatic canvases and their images are a refreshing, calming balm to the busyness of everyday life and mass visual culture. These elements made Reinhardt's all-black and later all-white canvases into "art."

Ana Finel Honigman

Date 1962

Born/Died 1913–1967

Nationality American

Why It's Key Important critic of Abstract Expressionism and pioneer of Conceptual and Minimal art.

Key Artist **Edward Ruscha**
Included in Pasadena Common Objects show

While Warhol showed his soup cans, Ruscha pioneered imagery derived from signage in Los Angeles. Inspired to become an artist by reproductions of Johns' flags and targets, Ruscha was most associated with large canvases, begun in 1962, that depicted a single word (such as Annie, Automatic, or Oof) or phrase against a field of color or an illusionistic sky in which the words appeared to hover. The importance of Ruscha's word paintings lay first in incorporating vernacular devices, like advertising, into so-called high art, and second in representing words as significant objects. Presented as visual clichés with ambiguous meanings, these paintings posed searching questions of aesthetic judgement to viewers.

Just as groundbreaking were Ruscha's small photographic books; between 1965 and the mid-1970s

he made twelve, uneditioned to distinguish them from conventional artists' prints. With the same deadpan tone and containing no text, they contained neutral images of bland, blatant reality. *Every Building on Sunset Strip* illustrated each building, vacant lot, and intersection on the famous street as a fold-out panorama to be "read" in either direction. Photographed frontally at noon, the facades resembled a Western movie town. Reporting factually in the same detached manner, the books emphasized the act of seeing and its semantic interpretation, and implied a vacuity in modern life.

Raised in Oklahoma City, Ruscha settled in Los Angeles in 1956 to study commercial art. His early work was showed at the New Painting of Common Objects exhibition at the Pasadena Art Museum in 1962.
Martin Holman

Date 1962

Born 1937

Nationality American

Why It's Key Edward Ruscha is an influential painter and photographer whose deadpan images reflect a world depleted in meaning.

Key Artist **Andy Warhol**
Begins iconic portraits of Elvis and Marilyn

By the end of the 1950s, Andy Warhol (born Andrew Warhola) was already a successful commercial artist. An affiliation with the Pop art movement was, therefore, a logical progression. In July 1962, Warhol's first solo Pop exhibition was held at Irving Blum's Ferus Gallery in Los Angeles, featuring thirty-two different canvases of Campbell's soup cans. In August that year, the first silk-screen portrait was made – of the actor Troy Donahue. This was rapidly followed by Marilyn Monroe, Elvis Presley, Elizabeth Taylor, Marlon Brando, and the *Mona Lisa*. Upon Monroe's suicide in August 1962, Warhol appropriated a publicity photograph by Gene Korman from the 1953 film *Niagara* as a basis for his most famous and iconic portrait homage.

Warhol's first "commissioned" portrait was to be of Ethel Scull in 1963. It is famously based on pictures

taken in a "four-for-a-quarter" Photomat in a pinball arcade at 52nd and Broadway, and Warhol reportedly instructed the art collector to "start smiling and talking, this is costing me money," until the machine had generated more than 24 strips, each with four images.

The multipanel portrait, *Ethel Scull Thirty-Six Times*, is now regarded as a seminal Pop image. It set a trend that was later capitalized on by Warhol's business manager, Fred Hughes. A Texas-born social climber, Hughes became publisher of *Interview* newspaper soon after meeting Warhol in 1967. He cleverly orchestrated a never-ending stream of silk-screen portrait commissions from wealthy American socialites, devising a standard "rate" for the job of US$25,000 for a 40 sq in picture.
Mike von Joel

Date 1962

Born/Died 1928–1987

Nationality American

Why It's Key Twenty years of "celebrity portraits" funded the whole of Warhol's career path and his other multifaceted activities.

opposite A typically enigmatic photo of Warhol.

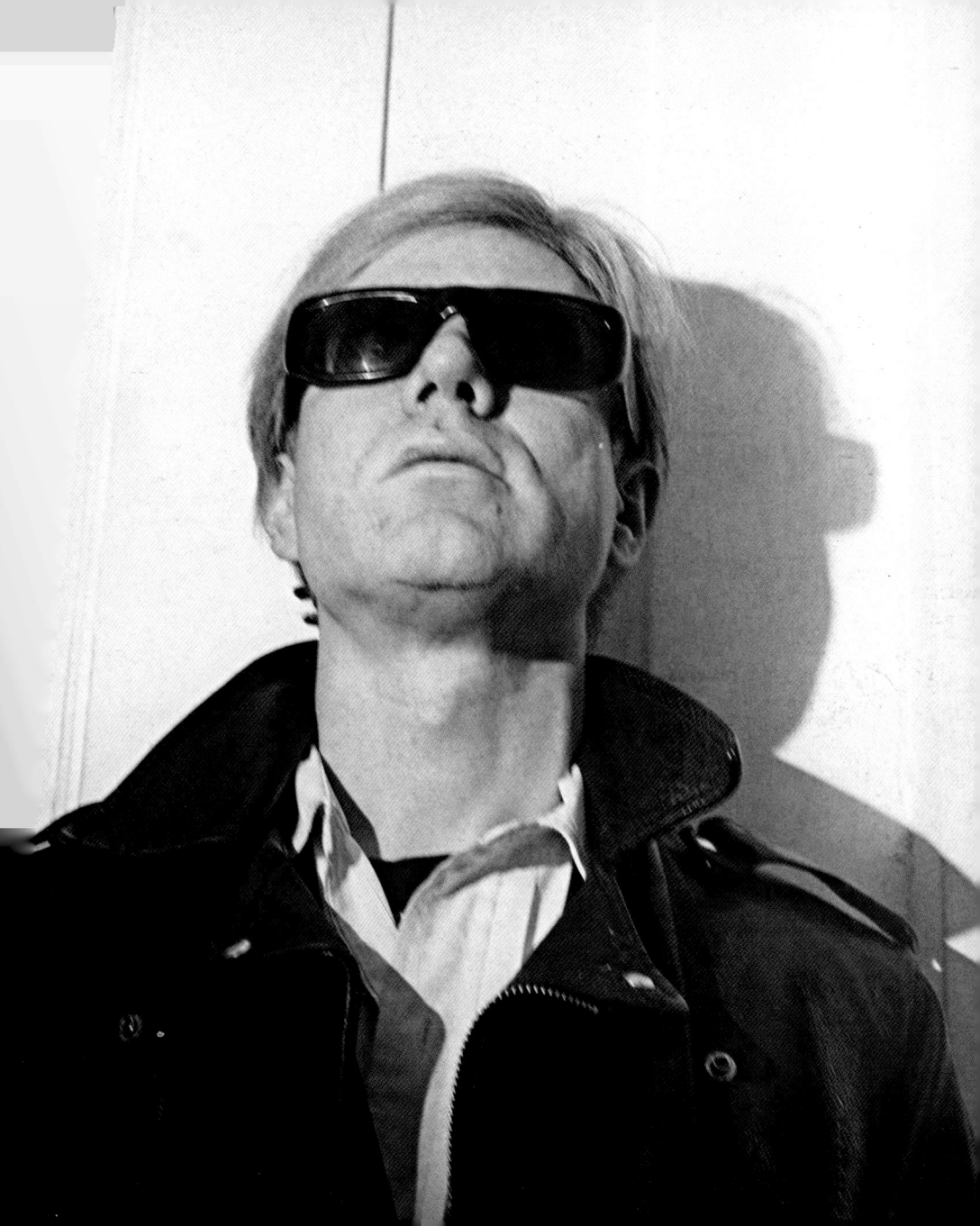

Key Exhibition
New Painting of Common Objects

American artists on both coasts had been working in Pop art for a few years when, in 1962, curator Walter Hopps of the Pasadena Museum of Art, California, brought together the movement's leading artists in a single show. New Painting of Common Objects united the New York wing of the Pop art movement, represented by Andy Warhol, Roy Lichtenstein, and Jim Dine, with the California-based wing, represented by such artists as Ed Ruscha, Joe Goode, Phillip Hefferton, and Wayne Thiebaud.

Walter Hopps was the ideal curator for the show, not only because of his bicoastal sensibilities, but also because he co-founded the Ferus Gallery in Los Angeles, where Warhol had had his first solo exhibition just a few months before. New Painting of Common Objects reached more spectators and critics than the

Ferus Gallery did, and within months had launched the careers of its up-and-coming contributing artists (Ed Ruscha, for example, sold his first painting as a result of the exhibition), while solidifying the reputations of Warhol and Lichtenstein.

The buzz Hopps created also provided the impetus for the Guggenheim Museum to do its own Pop art show in 1963, but by this time frothy, evanescent Los Angeles was inextricably associated with the movement. New Painting of Common Objects captured the very moment at which a handful of talented American artists deserted Abstract Expressionism to work in Pop art, and began a wave of publicity and acceptance that would propel the movement into the forefront of American art.

Demir Barlas

Date 1962

Country USA

Why It's Key The first American museum exhibition of Pop art.

524

Key Artist **George Segal**
Acclaimed at the New Realists show, New York

A slow starter, Segal spent years off and on at many American art colleges, including New York University. He painted "expressionist nudes" and earned his living as a chicken farmer until 1958, at which time he turned to sculpture. By the early 1960s, he had begun to develop the unique style for which he is best known. This took the form of tableaux involving life-sized objects such as furniture mixed in with his unpainted plaster sculptured figures, which are cast from life, using friends and family. He enhanced these unique, sometimes bleak and disturbing, scenes by the judicious use of light and sound.

The tableaux very often required the involvement of their spectators to experience the event fully. Segal's work therefore straddled the domains of Pop art, naturalistic sculpture, and environmental art. In

1962 he was acclaimed at the New Realists show at the Sidney Janis Gallery, New York, which helped to secure his fame and to propel Pop art into the limelight. Although nominally an American expressionist painter and sculptor, Segal was latterly grouped together with environmental artists wherein, as in works such as *Photobooth* (1966), the artist creates a three-dimensional space which owes as much to painting as to sculpture.

Other significant works include *The Gas Station* (1963), *Cinema* (1963), and *The Restaurant Window* (1967). Segal has exhibited widely in the United States and in Europe, including the shows at the Robert Fraser Gallery in London, which consolidated the status of artists broadly categorized as "pop."

John Cornelius

Date 1962

Born/Died 1924–2000

Nationality American

Why It's Key Artist whose work transcends the categories of Pop art, sculpture, environmental art, and even happenings.

Key Exhibition **Festival of Misfits**
Various Fluxus artists show at Gallery One, London

Festival of Misfits was held at Gallery One, a cutting-edge gallery which was run by Victor Musgrove, on D'Arblay Street in London. It was co-hosted by the Institute of Contemporary Arts. The challengingly playful agenda of the festival, held between October 23 and November 8, 1962, made an interesting and anarchic contribution to a world that was caught up in the tension of the Cuban missile crisis.

The festival featured a collective international mix of auto-destructive, Fluxus, and *nouveau réaliste* artists. They all embraced avant-garde ideals in one way or another, and the work involved innovative forms of poetry, performance, art, and music. The artists included Addi Koepcke, Gustav Metzger, Robin Page, Ben Patterson, Robert Filliou, Daniel Spoerri, Per Olof Ultveldt, Emmett Williams, and Ben Vautier. Vautier

lived, as a work of art, in the gallery window for much of the festival. His window was adorned with phrases such as: "I was young and wanted fame," and "Whatever you do I did it before you."

Gustav Metzger managed to provoke even the other artists with his exhibit of a page from the *Daily Mirror* on the Vietnam War. One of the highlights of the festival, according to Victor Musgrave, was a *Guitar Piece*, where, "at an evening of action music at the ICA, Robin Page wore a crash helmet and kicked a guitar down the street." The destruction theme, especially of conventional musical instruments, was common in early Fluxus.

Carolyn Gowdy

Date 1962

Country UK

Why It's Key The term "Fluxus" had been coined only one month earlier to describe the group's activities. Fluxus co-founder George Maciunas defined their objectives as: "The fusion of Spike Jones, vaudeville, gag, children's games, and Duchamp... obtainable by all and eventually produced by all."

1960–1969

525

Key Artwork *Camels*
Larry Rivers

Starting in 1959, Larry Rivers (1923–2002) produced versions of cigar and cigarette packets in the way he would have composed musical variations on a theme. As in his 1953 work *Washington Crossing the Delaware*, in *Camels* (1962), he appropriated instantly recognizable images, this time taken from the realm of consumer products.

In constrast to Roy Lichtenstein or Andy Warhol, whose deadpan graphic style duplicated its mass-culture sources, Rivers' idiom did not coincide with his subject matter: he used cloths dipped in turpentine to rub off certain areas, giving the picture a gestural quality verging on abstraction, while other areas were crisply detailed. Such banal, almost vulgar imagery marked Rivers out as a traitor to the Abstract Expressionist cause, a status he relished: "I was

branded a rebel against the rebellious abstract expressionists, which made me a revolutionary."

The conjunction of high and low had an even greater ironic impact in his *Dutch Masters* cigar boxes, as Rivers reinstated to the world of art the Rembrandt masterpiece that had been appropriated by advertising. Rivers nevertheless insisted he was interested only in the formal qualities of his works, and that his use of commercial clichés should not be interpreted as a comment on contemporary society: "Because I move into some of my work things you recognize as portions of Camel Cigarette packs... it does not mean that... as an artist I'm agitated to introduce these images of mass production as some socially significant statement... I am not interested in the art of holding up mirrors."

Catherine Marcangeli

Date 1962

Country USA

Medium Oil with collage on canvas

Collection Fitzwilliam Museum, Cambridge, UK

Why It's Key High and low consumer products in a painterly idiom.

Key Artwork *First Toothpaste*
Derek Boshier

A member of the significant group of students of the Royal College of Art, London, who comprised the nucleus of the British Pop art movement, Boshier worked in a painterly style, unlike some of his contemporaries, using loose brushwork thinly applied to almost bare canvas. This was in conjunction, conversely, with solidly painted blocks of color but with traces of underdrawing and outlining left visible to show the genesis of the painting. Such mundane sources as toothpaste, as in his 1962 *First Toothpaste*, led to further experimentation with color and form, to an abstract style of painting from which, gradually, all identifiable figurative references disappear.

Critical opinion places Boshier in the first line of UK Pop artists, despite being less famous and/or flamboyant than some of his colleagues. He moved into sculpture, photography, and film, returning to painting in the mid-1970s. He is resident in the United States and continues to address social concerns, such as gun control, police brutality, and the negative impact of the multinationals, in his later work.

Although perhaps one of the lesser-known personalities from the early Pop art movement, he has been the subject of critical acclaim and is considered to have stood the test of time. In the mid-1960s, he was very much in the gallery "stable" of Robert Fraser, together with the likes of Eduardo Paolozzi and Bridget Riley.

John Cornelius

Date 1962

Country UK

Medium Oil on canvas

Collection Sheffield Galleries and Museums, Sheffield, UK

Why It's Key Archetypal example of British Pop art.

Key Artwork *Annie*
Edward Ruscha

Annie (1962) was one of the first large-scale canvases painted by Ruscha (b.1937) which featured a single word or nonsensical group of words. One reason he chose this form of image was that he had been inspired by Jasper Johns' paintings of the late 1950s, in which Johns investigated his interest in the relationship of thought and language to objects in the real world. Another was his attachment to a critical way of making art, which required the viewer to consider the aesthetic qualities of an object encountered in a museum with its origins in commercial or popular culture, such as advertising signage.

On this occasion, Ruscha isolated one word appropriated as a "readymade" image from the graphics of the comic strip Little Orphan Annie and set it against two blocks of color. The lettering was very well known from comic books, while the background recalled the contemporary color-field abstraction of a painter such as Ellsworth Kelly. The resulting painting, therefore, represents a paradox of meaning and value, appearing simultaneously as figurative and abstract, "high" and "low" art. Later paintings deepened this ambiguity, "portraying" words with a three-dimensional quality reminiscent of objects or combined with the image of a substance, such as a liquid.

Ruscha's work may have anticipated Conceptual art. Its humorous quality and inclusion of allusive, vernacular imagery also linked him with Pop art, although tenuously. Unlike Pop artists who made art about other art, Ruscha commented on the nature of contemporary life.

Martin Holman

Date 1962

Country USA

Medium Oil on canvas

Collection Private collection, Beverly Hills, California

Why It's Key *Annie* is one of the artist's first trademark large canvases that depict just a single word.

opposite Ed Ruscha

Key Artist *Wiring the Unfinished Bathroom*
Jim Dine

The use of found objects in the constructions of artworks is termed assemblage or bricolage, and was a strategy of Dada artists, such as Kurt Schwitters in his collages, and Marcel Duchamp in his readymades, to disrupt the bourgeois aesthetic hierarchy.

In the early 1960s, Jim Dine (b.1935) started to experiment with assemblage, attaching everyday objects to painted canvases. He was inspired by Robert Rauschenberg, who had started attaching found objects to canvases in the mid-1950s. In these the choice of objects is seemingly arbitrary, whereas Dine chooses objects drawn from memories of his childhood and everyday life, and which act as signposts, directing us to the personal narrative of the painting.

In 1962 Dine started to produce assemblages that make reference to the walls of domestic interiors. In *Wiring the Unfinished Bathroom*, he affixes to the canvas two lamps and connecting wire, with toothbrushes in one corner. There is an incongruity between these concrete parallels to the banal activity of DIY and the painted layer beneath, which imitates contemporary color-field painting. In this way Dine juxtaposes the anti-art strategy of bricolage with the sublimated formalism of post-painterly abstraction and creates an ambiguous interplay between the humdrum and high art.

Dine has often been described as a Pop artist, but instead of exploiting the language of advertising and commerce he chooses to use imagery that celebrates ordinary life, and aims to rejuvenate painting by reintroducing realism into the cul-de-sac of abstraction.
Sarah Mulvey

Date 1962

Country USA

Medium Mixed-media and oil on canvas

Collection Louisiana Museum of Modern Art

Why It's Key Dine contributed work to the New Painting of Common Objects exhibition at the Pasadena Art Museum, which showed works by key Pop artists including Warhol and Lichtenstein.

opposite Jim Dine (with helper) in his studio.

Key Artwork *Giant Hamburger*
Claes Oldenburg

In 1960, Claes Oldenburg and Jim Dine collaborated on a series of "happenings" and "environments," intent on breaking down the boundaries between art and life. For *Snapshots from the City*, staged at the Judson Memorial Church in Greenwich Village, New York, Oldenburg replicated fragments of city streets, using paper, objects, and materials found in the neighborhood, some of which he painted black and white.

In the winter of 1961–62, Oldenburg opened The Store in his Lower East Side storefront studio. There, he displayed sculptures made of chicken wire, covered with muslin and burlap, then dipped in plaster and splattered with enamel paint. Drip painting met commercial logos in these larger-than-life brightly colored replicas of pastries, vegetables, hamburgers, and clothes dangling from hangers.

This paradoxical shop debunked the premises of consumerism and embodied, in Oldenburg's words, a "sort of commercial nightmare."

Oldenburg's soft sculptures, made of fabric or shiny vinyl, were first exhibited at the Green Gallery, New York, in 1962: outsize ice cream, fries, and hamburgers were shown alongside floppy telephones, typewriters, and bathroom appliances. Distorted in scale and material, these consumer products became incongruously anthropomorphic. Thus deprived of their original function, the flaccid toilet seat or the inedible *Giant Hamburger* were comical. Although familiar, they were also disturbing, in the way certain Surrealist objects altered the viewer's relationship to reality.
Catherine Marcangeli

Date 1962

Country USA

Medium Two versions: cloth and vinyl

Collection Art Gallery of Ontario, Toronto, Canada

Why It's Key A new kind of sculpture evolves out of props used for happenings and environments.

Key Artist **Greg Curnoe**
Stages first "happening" in Canada

Painter Greg Curnoe worked principally in the fields of sculpture, collage, and mixed media. He was responsible, in 1962, for Canada's first "happening," a stage-managed event or phenomenon which is given sufficient leeway in its design and planning for impromptu or unexpected incidents and/or spectacles to take place serendipitously. The term was coined by Allan Kaprow as far back as 1959 and was intended to mark the rejection of the traditions of skill, craftsmanship, and permanence within the visual arts.

Curnoe was a founding member of the Nihilist Spasm Band, an anarchic outfit which arguably pioneered the concept of "noise music." He was also a member of a group called the Nihilist Party of Canada, urging many Canadians to destroy their election ballot papers. In London, Ontario, he founded *Region*

magazine in 1961, Region gallery in 1962, and the Forest City Gallery in 1973. In 1968, he helped to found, with artist Jack Chambers, CARFAC, the Canadian Artists' Representation (Le Front des artistes canadiens), which represented the interests of artists.

He was a keen cyclist, and bicycles were a favorite subject of his work. Tragically, a distracted driver of a pick-up truck failed to see a group of riders on a club ride and plowed into them. Curnoe, one of the riders, was killed, and several others were seriously injured.
John Cornelius

Date 1962

Born/Died 1936–1992

Nationality Canadian

Why It's Key Canadian pioneer of the mixed-media "happening," and activist in promoting the arts in Ontario, Canada.

Key Artwork *Annette IV*
Alberto Giacometti

In the years following World War II, Swiss sculptor and painter Alberto Giacometti (1901–1966) produced his best-known works. While his prewar works were largely influenced by the Surrealist movement, his postwar works, often featuring emaciated, elongated figures, such as *Tall Figure* (1949), were lauded for their ability to convey the human condition of postwar Europe, displaying the emotional and physical effects of the horrors of the war.

While Giacometti's postwar period was his most prolific, it was also marked by his obsession with achieving perfection. At one point, he became so preoccupied with reducing the size of his sculptures that they began to crumble to dust. Furthermore, he became fixated on certain subjects, rendering them in multiple works in both painting and sculpture. These

include his brother, Diego, and Annette Arm, one of his greatest muses and also his wife. He met Annette, a woman more than twenty years younger than him, in 1943 in Geneva, and later married her, in 1949, in Paris.

Annette IV belongs to a series of eight busts depicting Annette that he created from 1962 to 1965. Like many of his other postwar works, it reflects the process of creation through the exhibition of rough surfaces. Unlike in some of his other works, he focuses on creating a bust, refining her facial features in an attempt to create a unique portrait of beauty. He concurrently developed an infatuation with another woman, however, a prostitute named Caroline, who would become another one of his great muses toward the end of his life.
Heather Hund

Date 1962

Country Switzerland

Medium Bronze

Collection Tate Modern, London

Why It's Key Part of a series of eight sculptures depicting his wife that indicates the obsession that plagued the end of Giacometti's career.

opposite *Annette IV*

Key Artist **Robyn Denny** Exhibits in British Painting in the Sixties, Whitechapel Gallery, London

1960–1969

After studying in Paris in 1950 and in London, Robyn Denny developed a style initially influenced partly by Mark Rothko in terms of form, but without the emotional content or sensational impact. Denny painted large canvases, but his abstract forms were of hard-edged geometrical shapes.

"Hard-edged" painting refers to what was essentially a revolt against Abstract Expressionism. That is, calm, static painting formulated from geometrical shapes with "hard," sharp outlines and absolutely flat colors. It is a reaction against gestural or spontaneous "painterliness" and in particular the mystification or conjuring trickery of painters in the traditional manner who require the "willing suspension of disbelief" if the illusions of depth, light, shade, solidity, and such are to be taken on board. Denny was the leading British exponent of the "hard-edged" school, and was selected to show his work at the British Painting in the Sixties exhibition at the Whitechapel Gallery, London in 1963.

The "hard-edged" school has been criticized as a safe haven for the talentless and/or the unimaginative, and described as cold and a cultural dead end. Its aims were "physical openness of design, or towards linear clarity, or both," according to critic Clement Greenberg.

Acknowledged leading exponents of the style were Helen Frankenthaler, Al Held, Elsworth Kelly, Morris Louis, Kenneth Noland, Frank Stella, and Jules Olitski. One of its major British practitioners, Robyn Denny was a prominent name in the 1960s around the London galleries, and taught at the Slade School of Art.

John Cornelius

Date 1963

Born 1930

Nationality British

Why It's Key Leading British exponent of the "hard-edged" school of abstract painting.

Key People **Jean Cocteau**
Influential novelist, filmmaker, and Surrealist dies

Jean Cocteau died aged seventy-four on October 11, 1963, the same day as his friend Edith Piaf. His last public act was to broadcast a tribute to her on French radio. As the catalyst for many of the most significant experiments in French Modernism, Cocteau never renounced the desire to shock and surprise. He was variously a poet, novelist, playwright, artist, designer, filmmaker, and boxing promoter – although some maintained that he put the greater part of his genius into his life, above all into conversation.

A social and cultural gadfly, Cocteau transformed himself from a "frivolous prince" of the Belle Epoque into an ally of Picasso and an indefatigable evangelist of the avant-garde. He was a mass of contradictions: a serial violator of taboos in his youth who later became a Catholic convert; a Surrealist *avant la lettre*, who was loathed by the Surrealists; a narcissist who nonetheless had a brilliant talent for collaboration. His protégés included the ill-fated young novelist Raymond Radiguet; the boxer Al Brown, whom he coaxed out of retirement to win a world championship; Jean Genet, whom he saved from prison; and the actor Jean Marais, the star of many of his later films.

He was also the impresario of the group of composers known as Les Six. Besides his role as the originator of the ballet *Parade* (1917), Cocteau's best claims on posterity are his films, from his experimental debut *La Sange d'un poète* (1930) to his later baroque fantasies *La Belle et la bête* (1946) and *Testament d'Orphée* (1960).

James Beechey

Date 1963

Born/Died 1889–1963

Nationality French

Why It's Key Cocteau was a versatile catalyst for the French avant-garde.

opposite **Cocteau** in the 1920s.

Key Artist **Anthony Caro**
Groundbreaking show at Whitechapel Gallery, London

Born in Surrey, England, in 1924, Anthony Caro received a degree in engineering from Christ's College, Cambridge. From 1946 to 1947, he studied sculpture at Regent Street Polytechnic (now the University of Westminster), then at the Royal Academy Schools until 1952. He worked as an assistant to Henry Moore during the 1950s.

After a visit to the United States in 1959, where he met David Smith, Caro abandoned traditional cast-metal sculpture and began constructing abstracts made of sheet metal, girders, pipes, or pieces of steel welded or bolted together. These were either painted in primary colors or allowed to rust. Some other works were freestanding pieces of metal arranged on the floor.

Caro achieved international success in the 1960s after a landmark solo exhibition of his abstract steel sculptures at Whitechapel Gallery in London. He was also an influential teacher at St Martins College of Art (now Central St Martins School of Art), where he inspired a new generation of British sculptors including Phillip King, who was once his assistant.

It is often claimed that Caro was the first to remove the sculpture from its plinth, but it must be said that both David Smith and Constantin Brancusi had taken steps in that direction. From the 1980s, Caro's work changed in style when he started making large-scale installations and using more literal elements and figures from classical Greece.
Alan Byrne

Date 1963

Born 1924

Nationality British

Why It's Key One of the first sculptors to remove the sculpture from the plinth and place it on the floor, thereby removing a barrier between the viewer and the work.

Key Artist **Nam June Paik**
Stages first video show

Paik wanted to humanize technology, and to explore its full capacity as a vehicle of artistic expression. He proposed a creative, interactive alternative to television, which he saw as a one-way avenue of communication that deadened the imagination. The diverse nature of his art, which includes television projects, video merged with electronic and digital media, installations, robotic art, and collaborative performances is a testament to the power of his inventiveness.

In 1963, Paik staged his first video art show, Exposition of Musik/Electronic Television, at the Galerie Parnass in Wuppertal, Germany. It was the first exhibition ever to use TV monitors. In 1982, he staged an "accident" with his remote-controlled robot *Paik's Robot K-456* (1964) on the sidewalk in front of the Whitney Museum of Modern Art, New York. Guiding it across Madison Avenue, Paik ensured the robot was struck by a car. He declared that the lesson to be learned from this performance piece is that technology dominates our lives and we must not let it control us.

Paik created *TV Cello* (1971) using television sets mounted on each other to resemble a cello. The neck and strings of a real cello were attached to it, making it playable. Further, it transmitted electronic signals to the TV screens, which played live images of the performance as well as other pre-recorded images. This is a tribute to Paik's rich collaboration with the cellist/performance artist Charlotte Moorman and calls upon his musical training. Paik's work later evolved in his collaboration with Norman Ballard to include laser sculptures to create spaces of moving light.
Bryan Doubt

Date 1963

Born/Died 1932–2006

Nationality Korean/ American

Why It's Key Paik was a musician and pioneering video artist whose prolific career had a profound impact on the media culture of the late twentieth century.

Key Artist **Larry Poons**
Paints *Sunnyside Switch*

The primary objectives of Poons's paintings were to communicate movement, color, spatial relationships, and, from the early 1970s, texture. Best known for large-scale work in the mid-1960s that featured simple geometric shapes in fields of saturated color – such as *Sunnyside Switch* (1963) – Poons has been associated with post-painterly abstraction, color field painting, and Op art.

Later, Poons began cropping paintings from larger works to imply their infinite extension, and staining canvases with acrylic medium. After 1971, his style intensified, turning away from hard-edged compositions to surfaces onto which paint was thrown or poured to make looser, pictorially dynamic images. Reminiscent in appearance of Monet's late landscapes, they were distinguished by complex rivulets of impasto that flowed or pooled into dense downward layers. Colors appeared to decompose luminously while retaining their opticality.

In Poons' early career, the syncopated rhythms of Mondrian's New York canvases, Pollock's all-over drip technique, and Newman's color field paintings were strongly influential. As important were ideas about the role of chance in creativity emphasized by the Fluxus artists and John Cage's classes on random musical composition, which Poons attended at New York's School for Social Research; dots and ellipses in his paintings recalled music's temporal notation of beats and pauses. Briefly part of Clement Greenberg's circle, Poons had his first solo show in New York in 1963.
Martin Holman

Date 1963

Born 1937

Nationality American

Why It's Key *Sunnyside Switch* was an early example of Poons' color field paintings, and verges on Op art.

1960–1969

535

Key Artist **Dan Flavin**
First exclusive use of fluorescent lighting

Important art is illuminating – highlighting the ways we see the world and altering our perspective. Using nothing but commercially available colored fluorescent light fixtures, American Minimalist sculptor Dan Flavin changed the appearance of interior spaces, the experience of looking at art and the way that art is understood.

Flavin was born in New York. After serving in the United States Air Force as an air weather meteorological technician in Korea, he returned to Manhattan to attend art history classes at the New School for Social Research and Columbia University. He began using commercial light in 1961, with a series which he titled his "icons" that he developed for his first solo exhibition at the Judson Gallery, New York City. These works consisted of eight colored square box-forms, which were he constructed with his then wife Sonja Severdija. One of the "icons," which were fluorescent lamps and incandescent bulbs attached to the beveled edges along their sides, was dedicated to Flavin's brother, who died of polio in 1962.

A year after his brother's death, Flavin began presenting exclusively fluorescent sculptural installations located in specific areas of exhibition space rooms, where they spotlighted aspects of the architecture. Flavin's "corner pieces," "barriers," and "corridors" consisted of colored lights located along the corners or centers of walls, where their glow drew attention to the structure and form of the room, as well as toward their own understated poetic beauty.
Ana Finel Honigman

Date 1963

Born/Died 1933–1996

Nationality American

Why It's Key Important Minimalist in his pioneering use of fluorescent lighting.

Key Artist **Faith Ringgold** African-American female activist begins American People series

Faith Ringgold was born and raised in Harlem, New York, and completed an MA in Art at the City College of New York in 1959 after teaching art in public schools. Influenced by the work of James Baldwin and Amiri Baraka – both writers and political activists in the struggle for racial equality – she then started working on her American People series.

With paintings such as *Between Friends*, *God Bless America*, and *American Dream*, Ringgold sets out to confront particularly American racial barriers in social relationships. The series was the first major breakthrough in what has been a prolific artistic career. It reflects her stylistic fusion of art and politics, and her active dedication to equal treatment (and exhibition) of African-American and female artists. Ringgold joined the Ad Hoc Women's Art Group in 1970, and cofounded the black artists' group Where We At in 1971. In 1991, she extended her career to writing and illustrating children's books. She also started work on her innovative storybook quilts. These narrative quilts serve as an intervention for Ringgold, as she inserts black figures into representations of art made up of only white figures, and in this way questions our processes of interpretation.

Ringgold has received many awards, from the National Endowment for the Arts Award for sculpture and painting to the *New York Times* Best Children's Book Award in 1992 for *Tar Beach*. She is a professor at the University of California in San Diego, and her work as artist, curator, writer, educator, and activist remains unrivaled in the field of contemporary art.

Emma Doubt

Date 1963

Born 1930

Nationality American

First Exhibited 1966

Why It's Key Infused racial politics into her art in late twentieth-century America, becoming especially recognized for her innovative story quilts.

opposite *Between Friends* from Ringgold's American People series.

1960–1969

537

Key Artwork *Fission* Bridget Riley

Riley began her career as a figurative artist and also as graphic artist in an advertising agency (J. Walter Thompson), having attended Goldsmiths College and the Royal College of Art in London, where she had been a contemporary of Robyn Denny, Peter Blake, and Frank Auerbach – a fairly diverse group in terms of the styles with which they later became associated.

Bridget Riley's early Op art work, a continuation of pioneering work done in this field by the Hungarian painter Victor Vasarely, and of which *Fission* (1963) is an example, was almost exclusively black and white, although she began to introduce color in the mid-1960s and is now known as much for the vibrant color juxtapositions of her work as for the dazzling black and whites of the early 1960s, which was very much a part of the visual culture of that decade and influenced the design of items such as clothes and furniture. She won the International Painting Prize at the Venice Biennale in 1968.

Although her work is associated with vibrant, visually agitating patterns, one of her lesser known and very successful commissions was for the interior decor of the Royal Liverpool Hospital in 1983. The subtle bands of muted color deployed there have been reported as having helped to create a calm atmosphere and reduce the incidence of unauthorized graffiti and vandalism.

John Cornelius

Date 1963

Country UK

Medium Tempura on board

Collection Museum of Modern Art, New York

Why It's Key Early example of exploitation of optical effects in what became known as "op art."

Key Artist **Norman Rockwell**
Ends *Saturday Evening Post* work after four decades

Studying at the Chase School of Fine Art, every Saturday morning the young Rockwell attended the National Academy of Design during his sophomore year. He later transferred to the more liberal Art Students League in 1910. It is during his time here that Rockwell received his first commissions: firstly for four Christmas cards and then to illustrate a series of children's books. Shortly after he was hired as the art director of *Boys Life* magazine, the official publication of the Boy Scouts of America. Rockwell continued to work with the Scouts for an astonishing fifty years.

Rockwell began freelancing for magazines such as *Life* and *Literary Digest*, and in 1916 sold his first cover to *The Saturday Evening Post*. The artwork entitled *Mother's Day Off*, featuring a young boy pushing a pram, is one of his best known. In total Rockwell created 321 covers for *The Saturday Evening Post* and each and every one perfectly portrayed typical American life and values at the time. His covers were so popular that 75,000 extra copies would be sold whenever he featured.

In 1963 Rockwell parted company with the *Post* and went to work for *Look* magazine. Some of his most powerful, political work came from this period. In 1971 he established a trust to protect his work, ultimately leading to the establishment of the Rockwell Museum.

Perhaps most fittingly Rockwell's last published work was the cover of *American Artist*. In the piece he depicts himself draping a Happy Birthday banner on the Liberty Bell in observance of the fourth of July and the 200th anniversary of the Declaration of Independence.

Emily Evans

Date 1963

Born/Died 1894–1978

Nationality American

Why It's Key Magazine illustrator Norman Rockwell was one of America's best-loved artists.

opposite A *Saturday Evening Post* spread celebrating the work of Norman Rockwell.

538

Key Artwork ***Man Woman***
Allen Jones

British-born Allen Jones (born 1937) is known as a Pop artist who examined a wide range of subject matter in a range of media. Like Hockney, he was very much under the spell of R. B. Kitaj as a young painter in terms of finding a way to reintroduce figurative painting in a post-abstract climate. Undoubtedly, however, he is most associated, in the public mind with his glossy, sexual – some might say "sexist" – life-sized and lifelike sculptures, often dressed in fetishist underwear, for example the well-known *Girl Table* and the hermaphrodite *Man Woman* (1963) figure.

These figures would often double up as quasi-utilitarian objects such as coffee tables or hat stands, which did nothing to endear Jones to the militant feminists. An article in *Spare Rib* in 1973 speculated that Jones was suffering from a "castration complex."

Feminists decried his work as being sexist and/or misogynist, as it featured what Jones himself described as "high definition female parts." In his defence it has been said that the sculptures captured the ambiguous nature of "free love" in the 1960s era, including the discrepancies between female emancipation and sexual experimentation. The works also allude, in their shiny, glossy tackiness, to the seedy glamor of prostitution and the New York gay fetishist scene with their sadomasochism references and vibrant "tasteless" colors.

John Cornelius

Date 1963

Country UK

Why It's Key Classic example of Jones' "explicit eroticism."

Painted by Norman Rockwell *Text by Four American Writers*

The deserved fame of Norman Rockwell has grown through the years in America as he has painted his human interpretations of everyday people. Now his interpretation of The Four Freedoms in terms of these characters will become known to all freedom-seeking men round the Post is forwarding reprint of these magnificent canvases all over the world.

The Four Freedoms were made an integral part of the Atlantic Charter, expressed in words of faith is precise objectives which are so less vital than our war effort but what do these Freedoms really

mean to us and to all peoples? Because art is a universal language—direct and unmistakable—The Saturday Evening Post has published this series to symbolize The Four Freedoms as they exist in terms of American life.

In sending you these reproductions, we feel that you will want to know about the artist himself. More than, reprinted from the Post of February 13, is the story of a man whose brush can do more than track the good humor of the American people. Here is a man who catches the spirit of their freedoms.

Ideas may be expressed in terms of art, as shown by Norman Rockwell's paintings of the Freedoms. Ideas may be illustrated in another way—by pictures which are written. The Post commissioned four American writers, not to explain the paintings, but to put into words their own conceptions of The Four Freedoms.

Three of these men are known well—the philosopher, Will Durant, who speaks of Freedom of Worship; the novelist, Booth Tarkington, who tells a parable in illustrate Freedom of Speech; and the historical writer, Stephen Vincent Benét, who describes the

growth of Freedom from Fear. The fourth is a Filipino poet, Carlos Bulosan. He writes of Freedom from Want with a simple conviction which rises from his own experience and close association with these in need.

The Saturday Evening Post has published these sincere interpretations of The Four Freedoms in the hope of giving deeper meaning to the principles the world now fights to maintain.

—THE EDITORS

Norman Rockwell, a power with a paintbrush. From his good has come the simple, faithful humor in which emerge America's recognize themselves.

Friends, neighbors and more pose, gratis. A Rockwell cover often became a community affair, with the neighbors as models, onlookers and copyists.

Mr. Mrs. Rockwell and their boys pose, through his studio two have posed more than five decades of these stories laid in paint.

COVER MAN

By JACK ALEXANDER

NORMAN ROCKWELL, whose series of paintings on the Four Freedoms will begin in the Post next week, discovered the Century of the Common Man a generation before the statesmen did. This was appropriate enough, for great painters—and great novelists, poets and associate—have always jumped the gun on history while the political leaders were squatting back on their haunches awaiting an audible signal or a significantly planted tree. Intuition is a wonderful thing.

Rockwell's Century of the Common Man began in the early spring of 1916 when he was a skinny, twenty-one-year-old artist toddling abroad a studio in New Rochelle, New York. He was scurrying along blithely on fifty dollars a month, which a kept

magazine with paying him for drawing the cover of each issue, illustrating two stories and performing the duties of art editor.

It was a 'thankless' grind, and his studio mate, a cartoonist named Clyde Forsythe, kept telling him he ought to be aiming, instead, at the cover of America's foremost magazine, The Saturday Evening Post.

"Cook, the Post," was all young Rockwell said at first. But the idea struck it his mind like a bur god he soon began experimenting with sketches They were pictures of sprout, glorified girls dawdling around with collar ad even. The Post, Forsythe

advised him patronizingly, didn't use that kind of cover; it wanted sprues showing real people in unappetizing, everyday situations. Forsythe was pretty well established as a newspaper artist and knew the ropes. Under the paraphernalia of Vic, he was drawing a popular, sports-page comic strip based upon the adventures of a hash-prone fighter named Axel and his manager, Flossy. Vic's current strip, Joe Jinks, is the lineal descendant. Rockwell turned to superior knowledge, and did two paintings on the subject he knew best—boys. He added a rough sketch of a third.

Although started at his own breakfast, young Rockwell prepared timidly for his raid in Philadelphia. He was, and still is, the impulsive type of

person who gets his fingers tangled in the string while untying a package. To avoid such a fiasco and also to impress the art editor, he had a harness maker build a big wooden case for his paintings. Except for the fact that it was covered with black oilcloth, the case might easily have been mistaken for a child's casket. But it opened and shut easily, and had a simple latch.

The third art editor, Walter H. Dower, removed the paintings and the rough sketch with a took of mild amusement at Rockwell's terrifying man and took them into his private office. Rockwell, with his rose across his knees, sat nervously and waited for the verdict, looking like one of his subsequent cover subjects. He glanced at the walls of the ante-

room and saw hanging their originals by well-known Post artists. That gave him a sinking feeling. Two men, who, he later learned, were Irvin S. Cobb and Samuel G. Blythe, sauntered through the room and stopped. Rockwell stared at them, and they started at the black case on his lap. With exaggerated bravura, they walked around and around it. Just then Dower came out of his office and said he was buying both the paintings and wanted Rockwell to go ahead with the painting of the third. Further, he said, he had consulted George Horace Lorimer, the editor, and they had decided that they ought to have three more covers from the new artist. Dazed, Rockwell accepted a check Dower proffered and got up to leave.

Cobb stopped him. "Young man," he said, pointing to the box, "is that a violin?"

Rockwell mumbled that it wasn't.

"That's good," said Cobb. "We were afraid you had a ready to it."

Cobb and Blythe laughed, and Dower laughed, and the strain having been broken, Rockwell laughed too. When he got outside, to way a joyful telegram to Forsythe and went to Atlantic City and celebrated. The happy outcome of Rockwell's self-introduction to the Post resulted in the promulgation of an office rule assuring the personal attention of the art editor, or his assistant, to any artist bringing his wares to the editorial offices.

It was lots of fun! right.

(Page)

For twenty-seven years the common man has made the cover of the Post his front porch. Here's the common man who put, and keeps, him there—Norman Rockwell, who next week in these pages begins a series of paintings based on his conception of the Four Freedoms.

Key Artist **Sigmar Polke**
Stages Capitalist Realism exhibition

Sigmar Polke studied art at the Staatliche Kunstakademie from 1961 to 1967. His Pop-inspired work of the 1960s took banal and kitsch images from advertising and reworked them in simplistic drawings. At the same time, inspired by Roy Lichtenstein, he enlarged the screen dots used in the printing of newspaper photographs to re-create the moiré patterns that are formed when printing screens are overlaid at inexact angles, as a way of foregrounding the mechanics of image production.

Throughout his career, Polke has pursued a neo-Dadaist strategy, experimenting with techniques which expose the interconnected structures of high and low art. In the 1960s, he started to use store-bought fabrics as a support instead of canvas, thus incorporating the machine-made fabric patterns as a background for his moiré patterns and imported imagery. While still a student, he organized an exhibition with Gerhard Richter and Konrad Lueg called Kapitalistischer Realismus (Capitalist Realism), which criticized both the Socialist Realism of the Eastern bloc countries and American Pop art for its celebration of consumer culture.

In the 1980s, he used layers of artificial resins to make polyester supports transparent in places, to create "windows" through which the stretcher bars were revealed, thus exposing a "readymade" modernist grid. His experiments with various chemical compounds, which, when poured then agitated on the surface of a support, mutate according to changes in temperature, light, and the passage of time, parody the unpredictable nature of gestural painting.

Sarah Mulvey

Date 1963

Born 1941

Nationality German

Why It's Key Polke's work enforced a disruptive dialogue between the languages of fine art and mass-produced culture.

Key Event
Amadlozi Group formed

In 1963, six artists – Cecil Skotnes, Egon Guenther, Sydney Kumalo, Giuseppe Cattaneo, Cecily Sash, and Edoardo Villa – formed the Amadlozi Group in South Africa. The purpose of Amadlozi (which in Zulu means "spirit of the ancestors") was to emphasize African themes in the works of its members, of whom only Kumalo was black.

The impetus for the group's founding came from gallery owner and jeweler Egon Guenther, who had reached out to the other artists in Johannesburg. Guenther, Cattaneo, and Villa were all immigrants to Africa, while Skotnes and Sash were raised within the country's white culture. As such, these artists were versed in the artistic influences and techniques of European modernism rather than in any particularly African tradition. Instead of attempting to imitate regional techniques, Amadlozi simply decided to train its European tool kit onto African themes. In this way, Amadlozi avoided an inauthentic and imperial appropriation of traditional African drawing and sculpting techniques, and decided to pay homage instead. Amadlozi remained stylistically European, while becoming iconographically African.

Amadlozi was not only a spirited – and at the time countercultural – collective, but also a mechanism of drawing attention toward indigenous South African art, such as the sculpture of the San people. Amadlozi helped to situate the value of such art, which non-indigenous peoples had hitherto subjected to anthropological rather than aesthetic evaluation. Furthermore, Amadlozi modeled a successful black–white cultural exchange and collaboration in a way that anticipated the emergence of modern South Africa.

Demir Barlas

Date 1963

Country South Africa

Why It's Key South African art becomes African as a handful of artists determine to apply modernist techniques to African themes.

opposite Cecil Skotnes' *Station of Cross* painting hangs in St Mary's Anglican Church in South Africa.

Key Artist **Carl Andre**
Major debut in Shape and Structure exhibition

Carl Andre was born in Quincy, Massachusetts. He went to Phillips Academy, Andover (Mass.) in 1951 as a scholarship student. From 1955–56, he served in the U.S. Army in North Carolina, then in 1958 moved to New York, where he met Frank Stella and later shared a studio with him. Andre worked as a freight brakeman and conductor for the Pennsylvania Railroad in New Jersey from 1960–64, and in 1965 his work was shown for the first time in New York in the Shape and Structure exhibition at the Tibor de Nagy Gallery.

His early works showed the influence of Constantin Brancusi, but after he left his railway employment he started to produce Minimalist sculptures made up of easily available identical mass-produced objects such as timber, bales of hay, concrete blocks, and such, arranged in repeating or arithmetical patterns. In 1972, the Tate Gallery in London bought his *Equivalent VIII* (1966). Its title derived from a series of cloud photographs taken in the 1920s and 1930s by Alfred Stieglitz, and the original sculpture had been dismantled but remade in 1969. Quickly to become known as "The Bricks," this arrangement of 120 firebricks in a rectangle on the floor caused an international outcry and debate.

Andre also produces a kind of concrete poetry, which consists of non-grammatical patterns of words. In 1985, his wife, the artist Ana Mendieta, died after falling from a 34th-floor window in New York eight months after their marriage. Andre was tried and acquitted of her murder.

Alan Byrne

Date 1964

Born 1935

Nationality American

Why It's Key Leading Minimalist sculptor.

Key Artist **Yoko Ono** *Grapefruit: A Book of Instructions and Drawings* is published

In 1955, Yoko Ono moved with her family from Tokyo, Japan, to New York, where she studied music at Sarah Lawrence College. While a student, Ono was attracted to the avant-garde scene. She began creating her own experimental compositions and events. She was still living with her parents, however, and becoming increasingly distanced from their lifestyle and traditional musical values. Unable to communicate with them, she began to drift away.

In Manhattan, Ono met Toshi Ichiyanagi, a student at Julliard. Like Ono, Japanese-born Toshi had embraced the avant-garde. During the late 1950s, the young couple married and began performing their own artistic productions. These included loft concerts on Chambers Street, along with John Cage and others. At the same time Chambers Street became a central venue for New York's evolving Fluxus movement. It was also at this time that Ono began creating her instructional art. *Painting To Be Stepped on* (1960) instructed people to put an empty canvas on the floor or in the street, and wait for people to walk on it; *Painting to See the Skies* (1961) instructed people to drill two holes into a canvas and hang it where they could see the sky.

Ono employed music, singing, poetry, and dance in a way that broke the rules and cut through convention. She eventually put these instructional pieces together in a book titled *Grapefruit*. It was published in a limited edition by the Wunternaum Press in Tokyo in 1964; not long after, it – and its author – would catch the attention of John Lennon.

Carolyn Gowdy

Date 1964

Born 1933

Nationality Japanese (naturalized American)

Why It's Key A fresh and uncompromising work made by Yoko Ono at the beginning of her career as a Conceptual artist, coinciding with the Fluxus movement.

Key Artist **Patrick Caulfield**
Exhibits in New Generation show, London

Caulfield was a retiring individual from an ordinary working-class background, but was considered an innovative genius by many of his contemporaries. He was one of a group of graduates of London's Royal College of Art which included David Hockney, Allen Jones, Derek Boshier, and Peter Phillips.

In the wake of Peter Blake, Francis Bacon, Eduardo Paolozzi, and Richard Hamilton, they were consolidating the position of British Pop art. They were stylistically influenced by Richard Smith and R. B. Kitaj in terms of painterliness, at least in the early stages of the Pop movement when figurative/narrative painting was trying once more to find its feet in a new world.

Caulfield made his initial impact at the groundbreaking Young Contemporaries exhibition in 1961 together with Hockney, Jones, Boshier, and Phillips, a reputation further enhanced in the New Generation show, also in London, in 1964. He was "adopted" and championed by the eccentric London gallery owner Robert Fraser, who was at one stage commissioning Caulfield to produce work.

An extract from a letter from Fraser to Caulfield reads: "Dear Pat, I'm just writing to confirm the arrangements we talked about on Saturday and I am enclosing a cheque too for £35, which amount we will be sending to you each month until your show... I am hoping that it will be possible for you to produce nine or ten paintings between now and then." The terms of this "retainer" reveal an interesting insight as to how works of art were often generated.

John Cornelius

Date 1964

Born/Died 1936–2005

Nationality British

First Exhibited 1961

Why It's Key Noted British exponent of Pop art.

1960–1969

543

Key Artist **Kenneth Noland**
Represents the United States at the Venice Biennale

Kenneth Noland lived and worked in Washington D.C. and became a leading light in a group of painters known as the "Washington Color Painters." Their concern was with pure painting. One of Noland's slogans was: "What you see is what you see." In other words, the function of the painting was not to represent or conjure into existence anything other than itself, thereby dismissing all narrative, literary, objective, emotional, or gestural painting – a philosophy which excludes almost all other schools of painting.

Noland worked in acrylics rather than oils and used them in a liquid, staining consistency, rather than in the form of thick quantities of dense paint. In that sense, Abstract Expressionism was anathema to the group, although they were influenced by the Abstract Expressionists and Helen Frankenhaler's use of transparent stains in painting, which was itself influenced by the work of Mark Rothko.

In the 1950s and 1960s, Noland commonly deployed a target-like or chevron-like motif to act as a containing device for his carefully calculated color planes, but no relationship was claimed between the recognizable shapes of the motif and anything in real life. In 1964, he represented the United States at the Venice Biennale.

Noland was also influenced by the color theorizing of Robert Delaunay and the mathematical/scientific approach of Josef Albers. He moved on to very long, rectangular canvases covered in horizontal stripes, and in 1966, influenced by his contemporary and friend Anthony Caro, began to make painted sculptures.

John Cornelius

Date 1964

Born 1924

Nationality American

Why It's Key Leading exponent of "hard-edged" abstract painting.

Key Artist **Ulrich Rückriem**
First solo show held in Cologne

After earlier experiments with steel, and his first solo show, held in Cologne in 1964, Ulrich Rückriem worked exclusively with stone from 1968, usually granite or porous German dolomite stone. A former stonemason at Cologne Cathedral, he built a rigorous artistic practice on the seemingly narrow base of "handling materials and understanding the process of what's done to them."

For Rückriem, this process started with quarrying, as each stone carried its own history from the ground where it formed, and continued through traditional methods of cutting and splitting, to siting the work in a gallery or open space. His intervention could be minimal, but the stone carried marks of human contact through marking, hewing, polishing, and chiseling. Rückriem's work, sometimes exhibited as sequences and usually based upon the geometry of the square, was large-scale, reminiscent of ancient standing stones, and abstract in that it was not illusionistic beyond physical reality. But intangible qualities were also integral to its logic, such as the light and shadow of surrounding space and the history associated with the material (in architecture, sculpture) that made it part of the world.

Although informed by American Minimalism, Rückriem also recalled primitive and premodern artifacts, or organic formations that elicited universal, instinctual interpretations. His sculpture conveyed a subtle beauty in its coloring, and its simple statements permitted a spectrum of thoughts and meanings.
Martin Holman

Date 1964

Born 1938

Nationality German

Why It's Key Postminimalist sculptor whose abstract work releases resonances from handling and working material.

Key Artist **Boyle Family**
Began *Journey to the Surface of the Earth*

Ex-soldier Mark Boyle met fellow Scot Joan Hills in Harrogate, Yorkshire in 1957. She had studied art and architecture, he was a poet. Together they decided to "make a kind of art that would not reject anything… almost inevitably it came to mean the acceptance of any place – on the surface of the Earth."

Their best known work is their *Journey to the Surface of the Earth*, where randomly selected rectangles of the Earth's surface are cast and reproduced in painted fibreglass. Begun in 1964, the work encompasses many different series, such as the *London Series*, *Tidal Series*, *Thaw Series*, *Japan Series* and their lifelong project, the *World Series*, where 1,000 random sites were selected from a giant map of the world by blindfolded visitors to London's Institute of Contemporary Art in 1969.

Their project expanded to include studies of mankind; living organisms; physical and chemical change in events, and projection pieces that led to them working with other artists, performers, musicians, filmmakers, and dancers, including Jimi Hendrix and the psychedelic jazz – rock band Soft Machine. From their infancy their children, Sebastian and Georgia helped out. Works initially appeared under the name "Mark Boyle" and then under "Mark Boyle and Joan Hills." They adopted the collective title "Boyle Family" in 1985.

The Boyle Family represented Britain at the Venice Biennale in 1978 and the São Paulo Bienal in 1987.
Nigel Cawthorne

Date 1964

Born/Died Mark Boyle (1934–2005); Joan Hills (b.1931); Sebastian Boyle (b.1962); Georgia Boyle (b.1964)

Nationality British

First exhibited 1963

Why It's Key Took the idea of the found object to encompass the whole world.

opposite A study from the Boyle Family's *Tiled Path* series in the 1980s.

Key People **Marshall McLuhan**
Understanding Media is published

Marshall McLuhan, is remembered best for his phrase "the medium is the message," which first appears in his book *Understanding Media*, published in 1964. McLuhan was a professor of literature who became the media guru of the 1960s. Often referred to as the prophet of the electronic age, he was also universally known for his conviction that new electronic communications would create a "global village."

Writing and lecturing at a time when modern mass media and communications (as we now know them) were in an early stage of development, his thinking was based on the premise that new media would alter the way we relate to each other and to our communities. He first addressed these themes in *The Mechanical Bride* (1951) and *The Gutenberg Galaxy* (1952), but it was with *Understanding Media* that his cult status was established. In the introduction, he refers to the "immediacy of action and reaction" in the new electronic age, but warned that we still think in an old and fragmented way. He saw new technology as an extension of the mind and body, and it was the scale, pace, or pattern it brought that extended our functional associations and actions.

With the phrase "the medium is the message," McLuhan proposed that, in the new media age, it is not the content that is primary, but the way in which it is delivered. This statement, in particular, impacted on visual artists who saw the potential of communicating through new technology, especially video.

Sue King

Date 1964

Born/Died 1911–1980

Nationality Canadian

Why It's Key Influential book on the effects of mass media. The author became the "pundit" of new media thinking in the 1960s.

1960–1969

547

Key Exhibition
New Generation

In 1964 and 1965, the Whitechapel Gallery in London hosted exhibitions of painting and sculpture that permanently shook up the staid and austere postwar aesthetic of England. The 1964 New Generation exhibition, dedicated to painting, brought prestige to Pop art in particular. New Generation called public and critical attention to David Hockney, Peter Phillips, and Derek Boshier, who were the collective face of England's Pop scene. Patrick Caulfield, through his affinity with kitsch and color, was also associated with the Pop sentiment of the show. Finally, New Generation also showcased non-Pop but still avant-garde artists such as abstractionists Allen Jones and Brett Whiteley.

The 1965 New Generation exhibition, dedicated to sculpture, was the death-knell of so-called traditional sculpture in England. Anthony Caro is the sculptor credited with removing the plinth from English sculpture, and he cast a long shadow over New Generation. His 1962 steel sculpture *Early One Morning* set the tone for the show, which exhibited the work of many of Caro's students from St. Martins School of Art. These students, recast into mature artists by their success at New Generation, included David Annesley, Michael Bolus, Phillip King, Tim Scott, William Tucker, and Isaac Witkin.

In retrospect, the two New Generation exhibitions were not so much about the emergence of monolithic movements – even though the 1964 painting exhibition is closely associated with Pop art – but about the determination of many young artists then active in England to break free from existing models of figuration, painterliness, and artistic engagement.

Demir Barlas

Date 1964

Country UK

Why It's Key Aligned England's international trends in art.

opposite English painter John Hoyland talks with Princess Margaret at the New Generation exhibition.

Key Event
Opening of the Maeght Foundation

Aimé and Marguerite Maeght opened their Paris gallery in 1945, exhibiting major figures including Bonnard, Matisse, Kandinsky, Braque, Léger, Miró, Giacometti, and Calder, as well as younger artists such as Ellsworth Kelly, Antoni Tapiès, Eduardo Chillida, and Jean-Paul Riopelle. Having visited several private art foundations during a trip to the United States, and keen to commemorate their younger son, who had died of leukemia in 1953, the Maeghts created a foundation in 1964 to present their extensive collection.

The choice of a site came quite naturally: they had opened their first gallery in Cannes in 1936, and several of their artist friends lived or spent time on the Riviera. They settled on a pine-covered hill near the picturesque village of Saint Paul de Vence. Construction lasted from 1960 to 1964. The Catalan architect Lluis Sert, who had designed Miró's studio, allied stone and brick with raw concrete, giving a definite contemporary feel to the rambling building. Painters and sculptors also collaborated – walking figures for the Giacometti courtyard, a labyrinth of sculptures and ceramics by Miró, Marc Chagall mosaics, a shallow pool and stained-glass windows by Braque. And in the garden, sculptures by Arp, Arman, and others.

The Maeght Foundation was opened by writer André Malraux, then France's culture minister, with a concert by Ella Fitzgerald and Yves Montand. The collection is displayed in thematic or monographic exhibitions which attract more than 200,000 visitors each year, while the foundation's library, with its 20,000 books, is a precious resource for scholars.
Catherine Marcangeli

Date 1964

Country France

Why It's Key One of the largest private collections of modern and contemporary art in France.

548

Key Artist **Marcel Broodthaers** First showing of his initial art object, a book of his poems embedded in plaster

The combination of language and object characterized Broodthaers' practice from the creation of his first "artwork" in 1964. A poet who realized that artists were making money doing with objects what he was doing with words, he wrapped in plaster fifty unsold copies of his book, *Pense-Bête*, and two small spheres. Removing a volume to read it destroyed the sculpture. Thus he had become an artist and established his assault on art's tradition and contexts.

In the radical spirit of 1968, Broodthaers transformed himself again, into a gallery director. His *Musée d'Art Moderne*, a sustained critique of art institutions, was initially installed at his apartment and proposed the view that objects gained meaning by their selection for display in museums. His museum, he said, was a "jumble of nothing"; the "department of eagles" comprised about 240 found fragments, paintings, comic strips, and wine labels bearing an eagle's image, a symbol of authority and power. Carefully assembled and eruditely catalogued, the exhibits were labelled, "This is not a work of art," echoing Magritte's 1929 painting of a pipe and inscription, *The Treason of Images*. Comic in its invented pretension, the museum typified the artist's poetic vision: could objects be "thought" back into imaginative autonomy?

Classified with Pop, Conceptual, and other art forms, and using diverse media, Broodthaers simultaneously connected with and parodied many styles with the systems and variations that proliferated through his work to scrutinize the nature of contemporary art production.
Martin Holman

Date 1964

Born/Died 1924–1976

Nationality Belgian

Why It's Key Crucial figure in emergence of "institutional critique" in European art.

opposite Broodthaers' *Little Cage with Eggs*.

Key Artwork *Abstract Painting No. 34*
Ad Reinhardt

In his essay "Art as Art," which appeared in *Art International* in 1962, the American artist Ad Reinhardt (1913–1967) wrote that the culmination of modernism would be an art of nothingness and anonymity. In the *Black Paintings* (1953–1967), gesture, self-expression, color, allusion to myth, narrative – everything extraneous to art's existential presence – was rejected.

Reinhardt's aim to reduce art to a singularity was influenced by the abstract reductionism of Piet Mondrian's gridlike structures and by climactic modernist works such as Kazimir Malevich's *Black Square* (1915) and *White on White* (1918). By 1960, his paintings had arrived at a final, uniform configuration: a 60 square inch format in which a minimal grid is achieved through the barely discernible division of the canvas into nine equal squares; the composition was repeated until his death in 1967. The notion of paradox is central to Reinhardt's art. *Abstract Painting No. 34* (1964) varies only minutely from the paintings that precede and follow it, and yet exists as a self-sufficient unit. It seems to defy interpretation and yet, on closer inspection, the image of the Greek cross can be made out within the grid, disturbing the perceived monotony.

Reinhardt's paintings are beautifully crafted; each one varies slightly in the choice of muted colors, so dark that they approach blackness. Visible brushstrokes have been eliminated so that the trace of the artist is no longer visible and craftsmanship is repudiated. His polemical desire to unite opposing ideas parallels the notion of oneness in Zen Buddhism in which Reinhardt became interested through the writings of D. T. Suzuki.
Sarah Mulvey

Date 1964

Country USA

Medium Oil on canvas

Collection National Gallery of Art, Washington D C

Why It's Key From 1953 until his death in 1967, Reinhardt focused on his *Black Paintings*, which signaled for him the end of painting and inspired many Minimal and Conceptual artists in the 1960s.

opposite Typical Reinhardt abstract paintings on display.

Key Artwork *Chair with Fat*
Joseph Beuys

German-born Joseph Beuys (1921–1986) was one of the 1970s' most influential and controversial performance artists, a cultural figure with an almost cult-like following. In 1944, as a member of a German combat bomber unit, he was in a plane that crashed on the Crimean Front. After he rose to prominence as an artist in New York, he told interviewers the story of how he had been rescued from the crash by Tartar tribesmen. According to Beuys, his saviors wrapped his broken body in animal fat and felt for warmth and insulation. They nursed him back to health, and provided him with the two materials that would become his artistic signatures.

Beuys' 1964 *Chair with Fat*, a wooden chair which was displayed in the gallery with its seat covered in fat, had originally been part of a performance in which Beuys placed a block of fat on a chair and invited spectators to sit on a slowly melting area. The sculpture's meaning and significance were dependent on Beuys' personal mythology, but it was also a compelling Surrealist object with a tactile beauty that functioned outside the context of Beuys' life story.

Art historians and Beuys' contemporary art critics have viewed *Fat Chair* (as it is sometimes known) as a statement on a range of topics pressing hard on mid-1960s cultural boundaries such as sexuality, the Vietnam war, and racial tensions. Despite the many political meanings ascribed to the piece, Beuys' explanation for *Fat Chair* was more abstract. In an interview, he explained that his desire was to reintroduce fat with its "chaotic organic energy."
Ana Finel Honigman

Date 1964

Country USA

Medium Wooden chair, animal fat

Why It's Key Seminal piece of Conceptual sculpture.

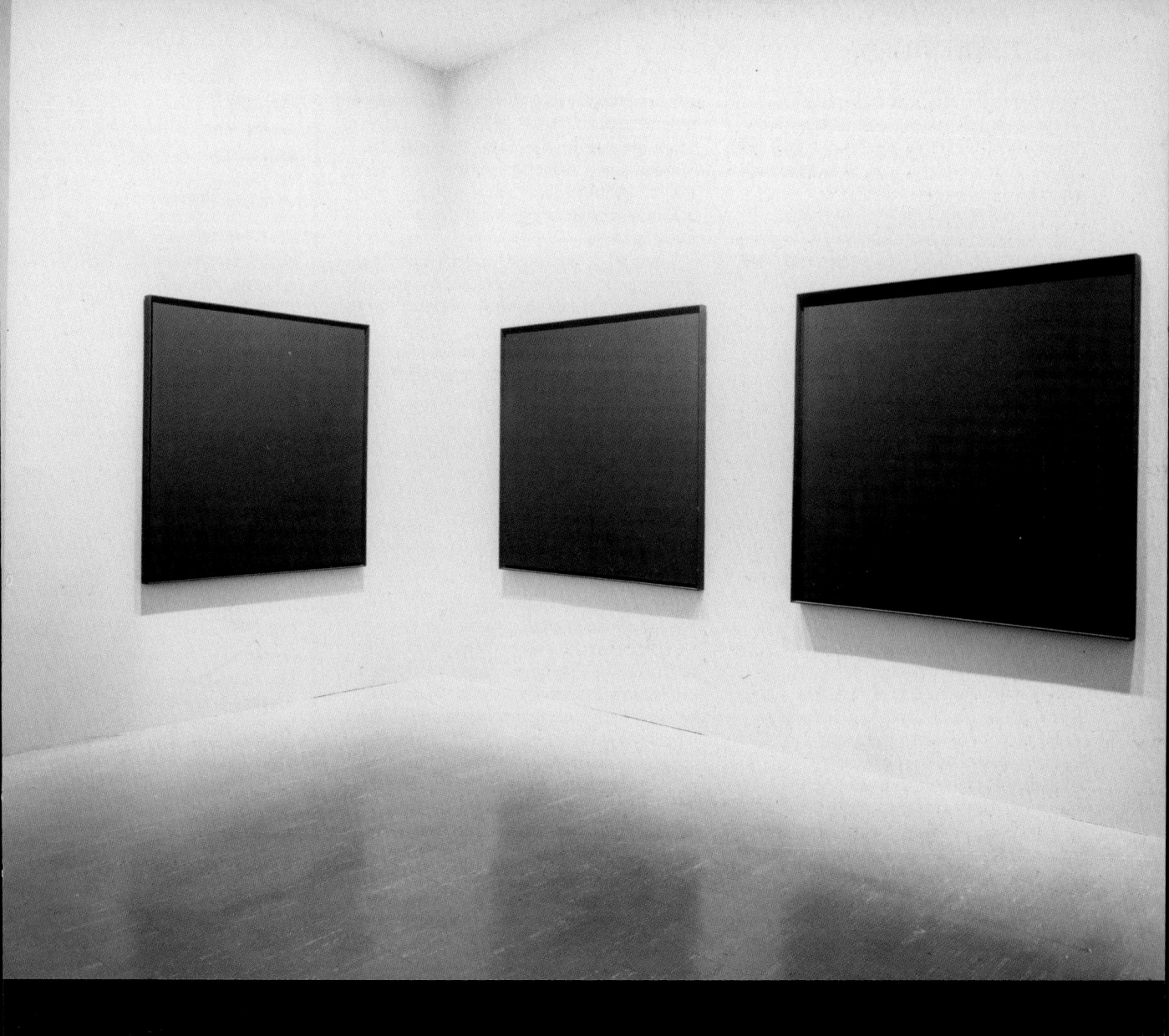

Key Artwork *The Birthday*
Ed Kienholz

The Birthday remains open to interpretation. A cryptic note has been left in the tableau: "Dear Jane... I couldn't come down now because Harry needs me here. Ma says she might make it later. Keep a stiff upper lip Kid. (ha-ha)... Dick."

Many questions are left unanswered. What happened in this abandoned room? Who was involved? What events preceded the result of a seemingly illegal abortion? We are left with an absence of evidence. There is something eerie and brutal about the scene which feels as though it has been casually stumbled upon. The viewer could just as easily flee, leaving the unpleasantness behind. Perhaps it is best forgotten now. It is sometimes safer not to know too much.

Ed Kienholz (1927–1994) wanted to draw our attention to the marginalized and disenfranchised members of society via these large-scale environments and asssemblages of found objects. In *The Birthday* he has created a portrait of a squalid, frightening, and desperate side of the human condition. The viewer is confronting the consequences of something that has occurred at a particular time and place in a world where we all live.

Many artists have raised "women's issues," for instance, but Keinholz gets behind the stereotype and, despite using a factory-produced mannequin, imbues it with a specific identity, though never attempting a conventional portraiture. If the woman in *The Birthday* should come to life, we would recognize her at once.
Carolyn Gowdy

Date 1964

Country USA

Medium Mannequin with electrically lighted lucite, gynecologist's examination table, suitcase, clothing, paper, flock, fiberglass, paint, and polyester resin

Collection Staatsgalerie Stuttgart, Germany

Why It's Key Classic Kienholz work, drawing attention to uncomfortable moral, social, and political issues.

opposite *The Birthday*

Key Event
Happsoc

Fluxus, the international movement dedicated to turning life into art, received its start in the experimental atmosphere of New York in the late 1950s, but shortly afterwards took on a new political significance in Eastern Europe. For example, three Fluxus artists – Stano Filko, Alex Mlynarcik, and Zita Kostrova – declared the city of Bratislava, Czechoslovakia, to be an artwork for one week in 1965, and referred to the act as Happsoc.

On the surface, this might appear to be another in a line of formalist experiments (silence as symphony, orange-squeezing as theater) that characterized happenings in the 1950s, but it was, in fact, far more important. Bratislava, the historical capital of Slovakia, had come under Czech Communist rule in 1948, and by 1965 had suffered nearly two decades of authoritarian repression. A particularly strident architecture (perfectly reflected in the Slovak Radio building) and other measures signaled Moscow's determination to sublimate the ethnic and cultural identity of the Slovaks. Happsoc was a subversive but effective way to fight back.

It was impossible for the Communist authorities to crack down on an entire city, the newfound status of which as art contested, complicated, and defied its official past. Happsoc rendered every inhabitant of the city a temporary dissident, and reasserted the sovereignty of art and humor over that of the secret police and the tank. It proved to be a powerful and efficacious model for conceptual Fluxus art in other rules of political repression, such as in Latin America.
Martin Holman

Date 1965

Country Czechoslovakia

Why It's Key Fluxus turns Bratislava into a work of art for one week, exercising a subversive liberty under Soviet influence.

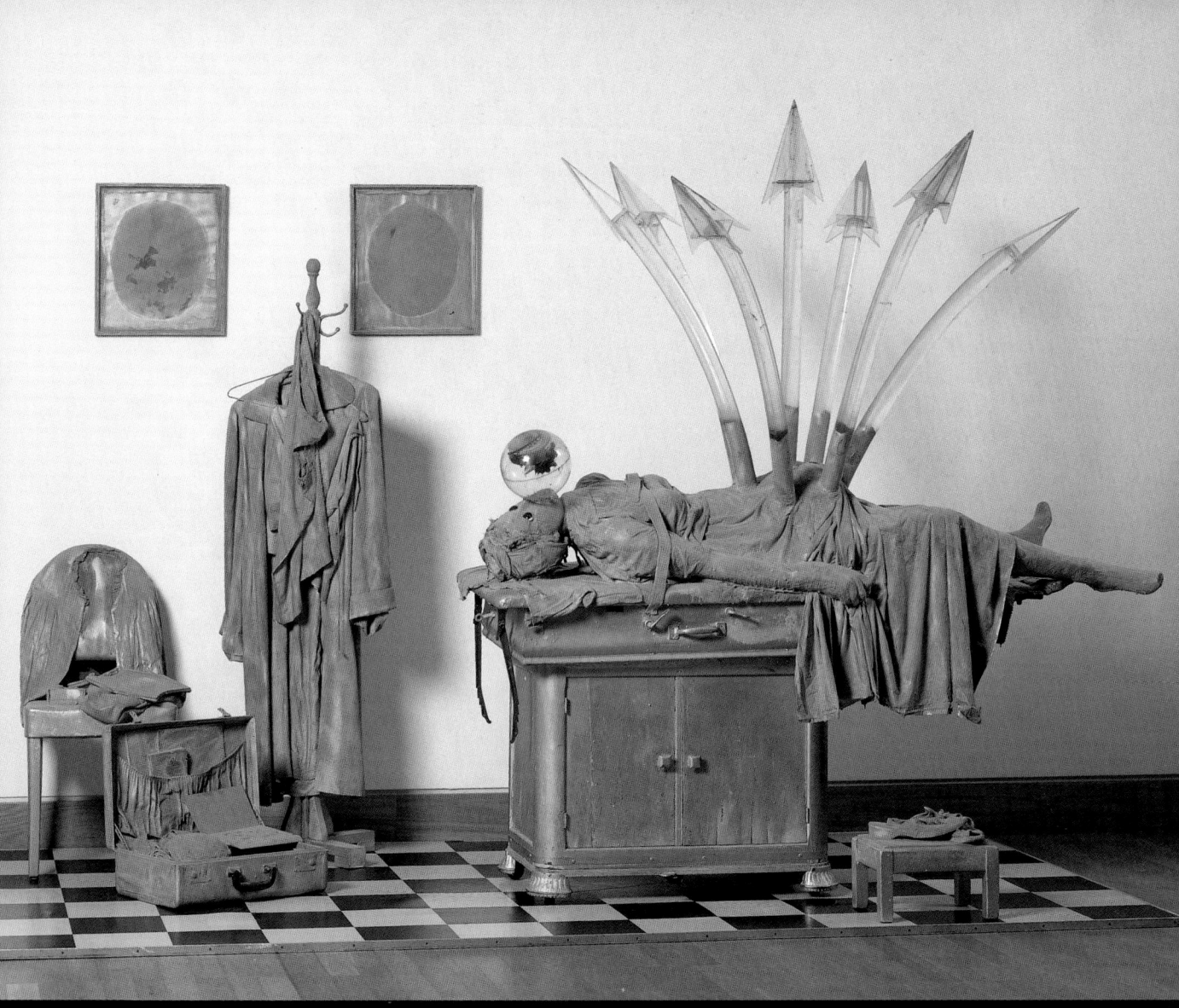

Key Artist **Ilya Kabakov**
Made member of Union of Soviet Artists

Soviet political conditions made it difficult for artists unrecognized by the state to polish their craft and advance their careers. Thus, when Russian artist Ilya Kabakov became a member of the Union of Soviet Artists in 1965, he escaped the fate that claimed many of his contemporaries.

Kabakov was accorded his own studio, a steady income from book illustration contracts, the ability to purchase painting materials, and the psychic and economic space in which to produce his own unsanctioned work. This was an important period of development for Kabakov, who was neither a firebrand nor an outright dissident. Rather, Kabakov's eventual deconstruction of the Communist experience – through drawings, found objects, texts, and, eventually, installations – required a long period of incubation.

From 1965 to 1987, Kabakov remained comfortably ensconced in his official role, developing his wistful visions of failed progress in secret; after perestroika, Kabakov finally ventured abroad, and decided to settle in the United States in 1992. The artist launched into a period of extreme productivity, as he no longer faced Soviet restrictions, and set about creating scores of installations in Europe and the United States. This was Kabakov's crowning work, presenting as it did an almost total psychic and physical documentation of the Soviet Union at the very time that it had ceased to exist.

Kabakov's subtle voice could easily have been rubbed out in the strident world of Soviet official art, but his 1965 appointment preserved it – as it turned out, for the delectation of Western audiences.

Demir Barlas

Date 1965

Born 1933

Nationality Russian

First Exhibited 1965

Why It's Key Obtaining official status and privileges at that time gave a Russian painter the opportunity to polish his craft.

Key Exhibition
The Responsive Eye

The Responsive Eye was an influential 1965 exhibition curated by William C. Seitz and mounted at the Museum of Modern Art in New York. The show focused on the perceptual aspects of art, in particular, the illusions of movement and depth created by the artist's calculated manipulation of static elements. It was, however, the exponents of newly fashionable Op art whose work attracted the most attention.

The term "Op art" (echoing "Pop art" and suggestive of optical illusion) had been coined by *Time* magazine in October of the previous year, but it could be backdated to include work from the 1930s – for example, Victor Vasarely's *Zebras* (1938) – as well as the more contemporary offerings of a group of painters of whom the most famous was Bridget Riley. If the critics largely dismissed Op art as gimmicky, it was

Riley, especially, who matched the mood of the moment and caught the attention of the public.

The show's popular appeal was such that it prompted advertising to hijack Op art, and some of the movement's more famous images were used in various commercial contexts. Bridget Riley unsuccessfully attempted to sue one company that used one of her paintings as the basis of a fabric design.

The Responsive Eye included some quite catholic contributions and, as well as Vasarely, also represented were Josef Albers, Paul Feeley, and collective work by Equipo 57, a group of Spanish artists. An unlikely memento of the show's opening night can be found in Brian De Palma's 20-minute documentary *The Responsive Eye* (1966).

Graham Vickers

Date 1965

Country USA

Why It's Key Launched Op art as a popular movement.

opposite The Responsive Eye exhibitor Brigit Riley's *Fission* (1963).

Key Artist **Mel Ramos**
Produces his classic pop image *Philip Morris*

A West Coast Pop artist, Ramos' work has been described as "high-quality pornography," although the images are touchingly innocent by today's standards. He has described his own work as "Art that attacks the eyes." He began his career as a painter by celebrating comic-book heroes and heroines, the very stuff of what has become a convention of Pop art typified by artists ranging from Andy Warhol through to Peter Blake, Robyn Denny, and Roy Lichtenstein.

But he soon abandoned this phase for a personal iconography based on nude pin-up "girlie" photos and is latterly classified as a superrealist who favored punning titles which referred to past masters, notably *You Get More Spaghetti with Giacometti* and *You Get More Salami with Modigliani*. *Philip Morris* (1965) was a typical example of classic Ramos. It shows a giant packet of Philip Morris cigarettes upon which is seated a nude girl, the entire image being overwhelmed by an all-pervasive chrome-yellow background, contrasting with the red, white, and blue of the cigarette pack.

In contemporary society, such an image posted as a billboard would, of course, scarcely raise an eyebrow as regards its sexual content, but rather because of its currently unfashionable subsidiary content, tobacco. Ramos produced a later, almost identical image entitled *Vantage*.

John Cornelius

Date 1965

Born 1935

Nationality American

Why It's Key Ramos' pin-up girl "posters" are archetypal Pop art.

Key Artist **L. S. Lowry**
Given Freedom of the City of Salford

Laurence Stephen Lowry spent his whole life in the northern English mill city of Manchester. He was an only child, and his mother dominated the family. Her suffocating control and ignorance of Lowry's talent caused him psychological damage, leading him to be secretive and reclusive. On his mother's death in 1939, Lowry neglected himself to such a degree that his house was repossessed by 1948. Not short of money, he bought The Elms in Mottram-in-Longdendale, Manchester, where he lived until his death.

It is a common fallacy that Lowry was an amateur. From 1905 to 1915, he attended classes at the Municipal College of Art, where he was tutored by Adolphe Valette. From 1910 to 1952, he was employed as a rent collector and clerk (a fact he kept well hidden), while he actively participated in the professional art business. He exhibited with the Manchester Academy of Fine Arts and the Royal Academy, London, and entered for the Paris Salon. The prestigious London gallery Lefevre held solo exhibitions between 1939 and 1976. The [Crane] Kalman gallery exhibited him from 1952 in Manchester and London. The Tate Gallery, London, and Museum of Modern Art, New York, hold works.

Throughout, Lowry's talent was acknowledged: he was elected member of the Manchester Academy and RSBA (1934); elected ARA (1955) and a full Royal Academician in 1962. And in 1965, he received the Freedom of the City of Salford. The Lowry Centre in Salford Quays holds a major collection – in 2000, it was transferred from Salford Art Gallery, which had acquired his work since the 1930s.

Mike von Joel

Date 1965

Born/Died 1887–1976

Nationality British

Why It's Key Lowry was finally given an "award" ordinary people from the region could appreciate – who generally, and erroneously, viewed Lowry as a local amateur painter, albeit a popular one. His subject matter was invariably scenes of northern working-class street life, characters, and landmarks.

Key Artist **Bridget Riley** Acclaimed at The Responsive Eye exhibition, MoMA, New York

Training at Goldsmiths College, London, 1949–52, and the Royal College of Art, 1952–55, Bridget Riley painted impressionistic landscapes and figures, particularly in the pointillist style, until the 1960s.

In 1961, she began working in black and white, producing geometric patterns that created a sensation of movement. The stark contrasts, as in the *Blaze*, *Twist*, and *Circle* series, appeared to make a violent assault on the eye. One of her paintings was used on the cover of the catalog of The Responsive Eye exhibition at the Museum of Modern Art in New York in 1965, an exhibition which launched the Op art movement. This sealed Riley's reputation, and in 1968 she won the painting prize at the Venice Biennale.

By then she had introduced gray into her paintings, and then color, though her geometric rhythms continued to dazzle. In 1981, she visited Egypt, whose colors influenced her future output. To achieve her precision effect, she chose acrylics over oils. Like others of the period, she employed an assistant to complete her pictures, although she maintained complete control by supervising the work and producing sketches and full-scale color studies. However, in the finished work, she made sure that there was no hint of a "painter's signature."

Nigel Cawthorne

Date 1965

Born 1931

Nationality British

First exhibited 1962

Why It's Key Bridget Riley is a leading name in the 1960s Op art movement; in an abstract context, Op art exploits visual ambiguities to trick the eye.

557

Key Artist **Robert Mangold** First solo show at the Fischbach Gallery, New York

Robert Mangold studied at the Cleveland Institute of Art in Ohio, although he lived and worked in New York, the home of American Abstract Expressionism. He was particularly influenced by Clyfford Still's work. Still was an artist who, while acknowledged as a leading Abstract Expressionist, kept himself aloof from that group and had more in common with Mark Rothko in terms of spirituality and general otherworldliness and earnestness. Minimalism in art takes matters a stage further and excludes the spiritual and emotional dimension as well as the concept of composition. It celebrates, if that is the right word to use in such a Spartan context, the aesthetic purity of simple geometric forms.

Mangold works in a variety of media, including acrylics and printmaking. An example of his work is *Four Triangles within a Circle No. 2*, which is a circular canvas painted in slate blue with thin, barely discernible lines to delineate the overlaid geometric shapes. In 1965, the Jewish Museum in New York held the first major exhibition of what was called minimal art, and included Mangold. He had his first solo show at the Fischback Gallery, New York, the same year.

In 1967, he won a National Endowment for the Arts grant, and in 1969 a Guggenheim Fellowship. In 1971, he had his first solo museum exhibition at the Guggenheim Museum. He has been featured in the Whitney Biennial four times, in 1979, 1983, 1985, and 2004.

John Cornelius

Date 1965

Born 1937

Nationality American

Why It's Key Important Minimalist painter working in a variety of media.

Key Exhibition **Joseph Beuys performs *Explaining Pictures to a Dead Hare***

On the occasion of the opening of Joseph Beuys' first solo exhibition at the Galerie Schmela in Dusseldorf, 1965, the enigmatic artist staged on of his most memorable and – because it was filmed – most replayed performances. This performance, or "Aktion," as he called his theater, involved Beuys moving around his own exhibition for about three hours, cradling a dead hare. With his head covered in gilding and honey, he murmured in the hare's ears, explaining his work to the lifeless animal.

Beuys himself recognized this as the Aktion that most captured the people's imagination. He thought that everybody consciously or subconsciously recognized the problem of having to explain things, particularly things that involve a certain mystery or questioning, such as works of art on the walls of a gallery. According to Beuys's diary, the idea of explaining things to an animal conveys a sense of the secrecy of the world, and of the existence that appeals to the imagination.

Less profound comments perhaps reveal more about the symbolism of *Explaining Pictures to a Dead Hare*: Beuys sometimes preferred dead animals to the humans of his time because he felt that even a dead animal would preserve more powers of intuition than stubborn rational man.

Erik Bijzet

Date 1965

Country Germany

Why It's Key The most memorable performance of Beuys' spontaneous theater or "Aktion," as he called it.

opposite **Beuys performing in Darmstadt, Germany.**

Key Artwork ***Untitled*** Donald Judd

Attached to the walls of many of today's modern art galleries, the vertical sculptures that came to be known as "stacks" are some of the most recognizable pieces in Donald Judd's (1928-1994) body of work. The original stack – although consisting of only seven units instead of the eight or ten in later versions – served as a model for all the ones that followed. The later stacks show a great variation of applied material. They show experiments with lighting and an array of different metals, worked or painted in several ways.

Untitled (1965) consists of boxlike units hanging above one another on the wall. They are distanced in such a way that the spaces in between have the same dimensions as the boxes, creating an alternating whole. With these works, Judd looked for an effect that linked spatiality in art and architecture. As the work connects the floor and the ceiling, the vertical stack measures out the vertical space it is in, while the protruding boxes intersect the space horizontally. The alternation ensures transparency, not deducting any of the spaciousness of both the architecture and the sculpture.

This last quality – giving nothingness a spatial identity – was one of Judd's major achievements, bringing him to the forefront of the artistic current called Minimalism.

Erik Bijzet

Date 1965

Country USA

Medium Galvanized iron

Why It's Key As the first of his "stacks," it marks a shift in Judd's attitude toward art.

Key Artwork *Still Life with Jug and Bottle*
Patrick Caulfield

Patrick Caulfield (1936–2005) has been compared to Roy Lichtenstein in that he relied on figurative images with very bold, graphic outlines. Arguably, however, this is where the similarity ends. Caulfield can be seen as a pure abstract painter who happened to use shapes which could be read as recognizable objects, instead of relying solely on esoteric geometrical forms.

Lichtenstein was concerned with enlarging and re-examining comic-book images that retained a narrative impact and suggested three-dimensional objects and figures functioning in an approximation of reality, no matter how far removed in real terms. Caulfield, on the other hand, used recognizable shapes – pots, cutlery, furniture, and the like – within an abstract context. That is, the shapes "just happened" to coincide with that of objects which exist in reality, but which, within the world of the painting, were no more and no less than abstract shapes at the service of composition and design, which in Caulfield's case incorporated bold, even pure primary colors.

Caulfield used still-life themes, as in *Still Life with Jug and Bottle* (1965), only to experiment in terms of abstract shapes with bold black outlines and strident primary colors. These were abstractions not unrelated to "hard-edged" painting, but with the thought process that the shapes deployed might just as well be based on recognizable objects as neutral geometric shapes. Therefore, *Still Life with Jug and Bottle* is not, strictly speaking, a figurative painting at all.

John Cornelius

Date 1965

Country UK

Medium Oil on canvas

Why It's Key Important example of one of the UK's leading Pop painters, often hailed as a genius by his fellow artists.

opposite Caulfield's *Colored Still Life* (1967), from his early still life-themed collection.

Key Artwork *Red Blue Yellow Green*
Ellsworth Kelly

In order to break from equivalence with figure-ground relationships in his paintings, Kelly returned in 1965 to making multipanel paintings consisting of monochrome canvases, such as *Red Blue Yellow Green* (1965). He had previously worked in this way in the early 1950s when living in Paris, but the canvases a decade later showed a new feeling for scale and color. This development was facilitated by making metal sculpture of elemental, silhouetted shapes.

Kelly also wanted to create paintings that affected architectural environments. Although each panel was an individual painting, when placed together canvases in the grouping appeared to communicate with each other across the space, forming a total environment. In addition to abutting or being spaced on the wall, panels could be jointed at right angles to project into a room. Although at the time viewers described the installations as being about color, their spatial interventions were primarily about shape and its positive role in setting up a kind of gestalt.

Whereas the isolation of primary colors to form a color world had precedents in modern art – for example, with Piet Mondrian – Kelly was more concerned with color's sensual effects than with its symbolic significance in conjuring an aspect of "reality." For although color was inherently symbolic in Kelly's work, on this occasion it conveyed *joie de vivre* and visual excitement. Nonetheless, the formality of dividing surfaces between colors, and the anonymous, uninflected technique that eliminated illusion, identified each painting as a distinct structured object.

Martin Holman

Date 1965

Country USA

Medium Oil on canvas

Why It's Key Kelly's multipanel paintings allowed their subjects, color, and shape to establish form.

Key Event
Galeria Foksal is founded

The creation of Galeria Foksal in 1966 was the initiative of two art critics and four artists, among them Tadeusz Kantor and Wieslaw Borowsky, although state involvement was compulsory in the People's Republic. Allocated space by the authorities in Warsaw's historic center, rebuilt after its wartime devastation, the gallery was overseen by the state-run Crafts Workshop.

Yet, within the constraints of these relationships, a program of exhibitions, articles, installations, and manifestos enabled the organizers to establish a vigorous position for experimental activity. Its main interest was Conceptual and Minimalist work, and from the 1970s it became known as an Eastern-bloc outpost for new developments. The "white cube" form of the gallery itself was often the subject of installations, and Anselmo, Boltanski, and Weiner were among Western

artists showing alongside Polish contemporaries such as Stanislaw Drózdz and Edward Krasinski.

After the Communist regime ended in 1989, the gallery entered a new phase. In the mid-1990s, Borowsky, for some time its sole director, was joined by three younger art historians, and the focus of its projects and publications became the gallery's history and strategies examined by artists of different generations and nationalities. To protect its past as an archive for creative interpretation, the Foksal Gallery Foundation was set up in 1997, splitting from the original gallery in 2001 and moving to its own premises in Warsaw. The program has thrived and expanded, with the Foundation representing Polish artists commercially abroad, including Wilhelm Sasnal and Pavel Althamer.
Martin Holman

Date 1966

Country Poland

Why It's Key Developed an international reputation as a state-sponsored gallery that fostered progressive art movements in Communist Poland.

Key Artist **Gerhard Richter**
Starts trademark *Color Charts* series

Gerhard Richter was born in Dresden, East Germany, where he attended the local art academy from 1952 to 1957. Just before the Berlin Wall was erected, he escaped to Düsseldorf in West Germany, and attended the art academy there (1961–64). While a student, he created the group Capitalist Realists with Sigma Polke and Konrad Fischer.

Richter's oeuvre can be distinguished by the quantity and diversity of his output, and by the lack of a consistent style. He has produced photorealist paintings since the 1960s, using a variety of photographic sources. In 1966, he started painting his *Color Charts* (*Farbtafeln*) series, which look like the color charts that decorators use, and are painted in a random structure on canvas. In 1988, he seemed to be making a political statement in his use of photographs

of the dead members of the Baader-Meinhof gang, while at the same time adding to his extensive range of painterly abstract works in which squeegees were used to apply and scrape off paint.

In all Richter's photorealist work, an overt painterliness is evident. He projects an image onto the canvas, which he then copies with varying degrees of distortion and elimination of detail. In this way, the mechanical means of reproducing an image is subverted by a creative/destructive process. In the manner of nineteenth-century Realists such as Gustave Courbet, he chooses subject matter from modern life and from history, and reproduces it in a way that does not seek to idealize it, but rather to re-create it with a painterly distance.
Sarah Mulvey

Date 1966

Born 1932

Nationality Germany

Why It's Key One of the most influential contemporary artists.

opposite Gerhard Richter

Key Artist **Brice Marden**
First solo show in New York

Brice Marden's monochromatic paintings after the mid-1960s contributed to the development of Minimalism. His preoccupation with rectangular canvases and off-key tones was established by 1963, when he received a MA from Yale's School of Art and Architecture. Independent of reference to natural phenomena, paintings from these years were notable for the emotional subtlety of their surface quality, achieved by mixing beeswax with oil and pigment. A strip of unpainted canvas was left at the bottom edge to enable the viewer to apprehend the process.

Jasper Johns was an early influence on Marden, who became general assistant to Robert Rauschenberg in the fall of 1966, the year of his first one-man exhibition at the Bykert Gallery, New York. By 1968, Marden's practice had evolved into horizontal and vertical formats of multiple panels, each a separate color, and primary hues began to be used in 1974. By that time, he was visiting the Mediterranean region annually, absorbing the light and color of its landscape, and traveling to Greece and Italy to pursue his interest in classical art and architecture. Latin terms, such as references to mythology, began to appear as titles.

Marden has emphasized that, "Within... strict confines... I try to give the viewer something to which he will react subjectively." An inspiration from the 1980s onward was Far Eastern calligraphy; it informed a trend toward gestural linear marks against background color fields. This development departed from Marden's earlier formal simplicity, while sustaining his concern for touch, surface, and color.

Martin Holman

Date 1966

Born 1938

Nationality American

Why It's Key Painter and printmaker whose abstract color fields conveyed a refined, subjective sensibility through touch, surface, and tone.

opposite Brice Marden's *Red, Yellow, Blue Painting No. 1* (1974).

1960–1969

565

Key Artist **On Kawara**
Conceptual artist creates first "date paintings"

Born in Aichi prefecture, Japan, Conceptual artist On Kawara exhibited his earlier work in Japan in the 1950s before traveling around the world in 1959. He eventually settled in New York in 1965. Time, captured in its familiar denominations of days, years, and so on, is the dominant theme in Kawara's work. In 1966, he launched the lifelong project, "date paintings," or the *Today Series*. Each "date painting" is a monochrome canvas on which is painted the date of the day it is produced, in the language and in the calendrical conventions of the country Kawara is in at the time.

The craftsmanship is meticulous and uncompromising – four coats of acrylic paint are applied to a rectangular canvas, on which the outline of the text is drawn and filled with white paint. Much time is spent eliminating imperfections and making adjustments. Each "date painting" is then cataloged, and stored in a handmade cardboard box labeled with the date, often with a newspaper cutting from that day. If the piece is not finished by midnight, it is destroyed. Now numbering into their thousands, the "date paintings" are exhibited across the world in various groups and themes.

Like the *Today Series*, Kawara's other works are also meditations on the nature of time, such as a series of telegrams sent to various people bearing the message: "I AM STILL ALIVE." Refusing ever to be documented in his own words, Kawara continues to express himself only through his work.

Mariko Kato

Date 1966

Born 1932

Nationality Japanese

First Exhibited 1953

Why It's Key Kawara's "date paintings" are a continuing life project, and an important part of the history of Conceptual art.

Key Artist **James Turrell**
Creates *Afrum-Proto*, his first work using projected light

James Turrell was born in Los Angeles and his undergraduate studies at Pomona College focused on psychology and mathematics. Only later did he turn to art, receiving a masters degree in fine art from the Claremont Graduate School. A lifelong Quaker, Turrell dedicated himself to exploring light and space, and manipulating them to create an emotional and spiritual response in the observer. Underpinned by his studies in perceptual psychology and optical illusions, Turrell's work is best illustrated by two projects: the *Roden Crater Project* and *Afrum-Proto*.

Roden Crater, located in Arizona's Painted Desert, is an extinct volcano the artist has for the past 30 years been treating as an ongoing project, transforming it into a celestial observatory for the naked eye. *Afrum-Proto* (1966) was the first of several "corner projection"

pieces developed during the 1960s, this one creating the illusion of a three-dimensional solid made out of light. From an optimal vantage point, the projected rectangle of light will resemble a three-dimensional white cube, but as the observer approaches it disintegrates into a simple light projection.

Turrell is sometimes associated with the land art, or earthworks or earth, movement, where the earth itself is transformed into artistic constructs. In fact, he is probably too individual to be seen as part of any movement, an idiosyncratic artist dedicated to creating light-and-space art that is essentially prelingual, offering the viewer a transformative spiritual experience simply by being in its presence.
Graham Vickers

Date 1966

Born 1943

Nationality American

Why It's Key Turrell specializes in working with light and space.

opposite Artists Robert Irwin (left) and James Turrell work together in Los Angeles on their Art & Technology Project.

1960-1969

566

Key Artwork *Photobooth*
George Segal

Pop sculptor George Segal's (1924–2000) 1966 *Photobooth* is a lifelike and straightforward depiction of a man sitting in a photobooth and gazing ahead placidly with his hands in his lap. While bearing many of the hallmarks of Pop – the cheerful realism, corporate competence of design, and superficial absence of emotion – *Photobooth* raises questions deeper than those typically posed by Pop.

In this sense, *Photobooth* is akin to Robert Whitman's *Shower* (1963), which employs sculpture and filmed projection to create a very realistic illusion that a woman is showering in the gallery. While *Photobooth* is not intended to be as convincing an illusion as *Shower*, it raises the same questions: what if artworks have lives of their own? What if we are eavesdropping on entities that enjoy some degree of

intelligence? In a way, this effect would conform to the Pop idea that the product, the mannequin, and the simulacrum are as real as we are; but Segal took the conceit a step further by taking the reality of the person in the photobooth more seriously than Andy Warhol took his soup cans. *Photobooth* is as much a created artifact as it is an artifact that creates, an elegant combination of the painterly and the castoff.

Segal's importance in art history goes beyond his sculptures and paintings. The term "happening" was coined by Allan Kaprow to refer to Segal's New Jersey farm, which was the site of much creative collaboration, experimentation, and innovation in the 1950s.
Demir Barlas

Date 1966

Country USA

Medium Plaster, wood, metal, glass, fluorescent and incandescent light

Collection Private collection

Why It's Key Segal's work extends the range of questions typically raised by Pop.

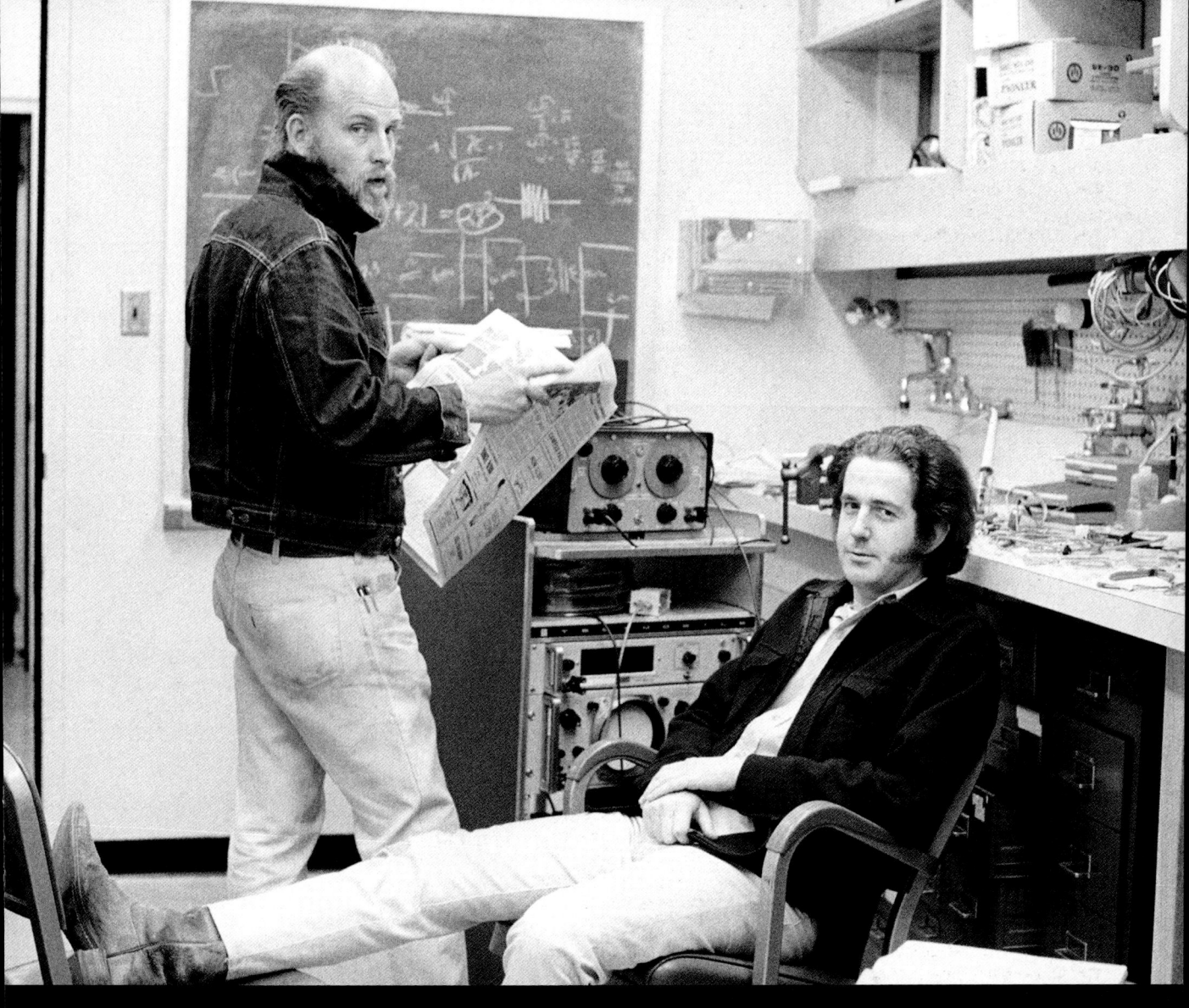

Key Artist **Niki de Saint Phalle**
First collaboration with Jean Tinguely

Brought up in New York, Niki de Saint Phalle became a fashion model at the age of sixteen. Two years later, she eloped with author Harry Matthews but, after giving birth to two children, found that she was living the bourgeois life she sought to escape.

She began to paint and moved to Spain, where she was influenced by Antonio Gaudí. Moving on to Paris, she first exhibited her naïve oils in Switzerland in 1956. However, she first came to public attention in 1960 with her *Shot* series – reservoirs of paint in plaster were ruptured when shot at, staining the surface of the work. She went on to depict women in the *Brides* series in 1963 and the *Nanas* series in 1964.

She had met Swiss experimental sculptor Jean Tinguely in 1955. In 1960, after both divorced, they moved in together in a studio in the Impasse Ronsin,

where they met Constantin Brancusi, Marcel Duchamp, Salvador Dalí, and other artists. In 1966, she collaborated with Tinguely on the large-scale installation *She: A Cathedral* in the Moderna Museet in Stockholm, Sweden. This was a giant reclining woman, 28 meters long, entered between the legs and containing rooms, including a bar and a cinema.

Saint Phalle continued making monumental sculptures, often aimed at children, sometimes with Tinguely, whom she married in 1971. In 1979, she created the Tarocchi Garden in Tuscany, a sculpture park that takes its themes from tarot cards. With Tinguely, she made the Stravinsky Fountain at the Pompidou Center in Paris in 1983. She also illustrated books, made films, and designed ballet sets.

Nigel Cawthorne

Date 1966

Born/Died 1930–2002

Nationality French

First exhibited 1956

Why It's Key She was a sculptor specializing in large-scale, colorful public works.

opposite Niki de Saint Phalle

Key Artwork *hon-en katedral*
Niki de Saint Phalle

Niki de Saint Phalle (1930–2002) became known for her "shooting paintings," in which she arranged containers of paint on a wooden board covered with plaster. In a series of performances held in Paris, Sweden, Malibu, California, and Amsterdam, she shot at the board with a .22 caliber rifle, so that the bullets would penetrate the paint containers and force their contents over the board surface.

From this violent, macho series of works, Saint Phalle progressed to making cheery, psychedelically colorful abstract papier-mâché sculptures of plump female forms, inspired by her pregnant friend Claire Rivers, the wife of American painter Larry Rivers. She envisioned the series as archetypically female figures and named it and them "Nana," after the iconic Parisian prostitute in Zola's nineteenth-century novel.

In 1966, Saint Phalle collaborated with her boyfriend, Jean Tinguely, and Per Olof Ultvedt on a large-scale sculptural installation entitled *hon-en katedral* (Swedish for "She – a Cathedral") for Stockholm's Moderna Museet. It consisted of a massive Nana which could be entered by walking into the space between the splayed legs. Press images showed an orderly queue of nicely suited men and daintily dressed ladies lined up to explore the plush lounge in Nana's insides.

By playfully satirizing women's subordinate, objectified position in 1960s society, while at the same time playing up to the attention she received as a beautiful, sexually confident woman, Saint Phalle embodied sophisticated, seductive yet impassioned and intellectually rigorous French feminism.

Ana Finel Honigman

Date 1966

Country Stockholm, Sweden

Medium papier-mâché

Why It's Key Major work by iconic 1960s female artist.

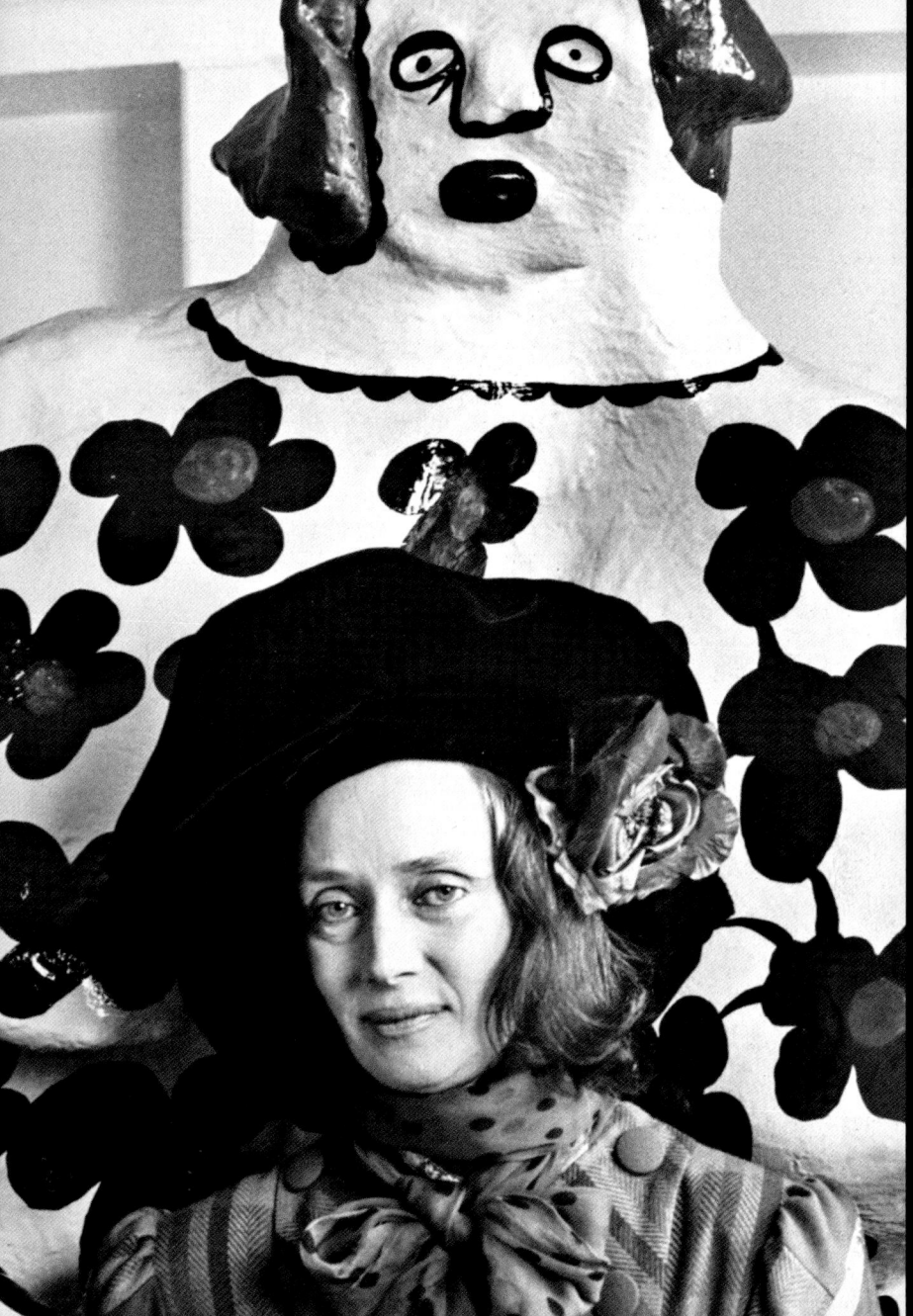

Release of Warhol's *Chelsea Girls*

As Andy Warhol (1928–1987) developed his Factory studio of production-line art and nurtured his entourage of "superstars," something like his 1966 film *Chelsea Girls* was almost inevitable. Directed by Warhol and Paul Morrisey (another acolyte of the Factory scene), the six-and-a-half-hour movie consisted of a series of candid vignettes shot in various locations inside New York's infamous Hotel Chelsea. The "stars" of the film were regular Warhol protégés such as Nico, Gerard Malanga, Ingrid Superstar, and International Velvet. Notably absent in the final version was Warhol's most celebrated camp follower Edie Sedgwick, who was filmed at the Chelsea, but later withdrew permission for her contribution to be used.

Warhol's idea was to make a movie that addressed "white" and "black" – innocent and more disturbing – sides of life in equal measure. To achieve this, he and Morrisey selected twelve sequences, which they projected side-by-side (the "white" simultaneous with the "black") to achieve a juxtaposition of mood over what thereby became a three-and-a-quarter-hour event.

As the synchronization of two projectors could never be exact, central to Warhol's concept was the fact that every viewing of the film would be a differing and therefore unique experience. The film became an instant classic of experimental cinema, and paved the way for subsequent art installations utilizing the medium of film and, later, video and digital technology.

Mike Evans

Date 1966

Country USA

Why It's Key Typical of Andy Warhol's Factory studio, featuring his stable of "superstars."

opposite Warhol behind the camera.

Key Artist **Barry Flanagan**
First solo show at the Rowan Gallery, London

Barry Flanagan was born in Prestatyn, North Wales, and studied at Birmingham College of Arts and Crafts from 1957 to 1958 and at St Martins School of Art, London, from 1964 to 1966. He taught at St Martins and at the Central School of Arts and Crafts (now amalgamated to become Central St Martins College of Art and Design) from 1967 to 1971.

Flanagan is probably best known for his bronze sculptures of leaping hares, some of which are installed in world capital cities, such as *Hare on Bell* in New York and *Nine Foot Hare* in London. He has also been known to sculpt other animals, such as horses, elephants, and cougars. In 1995, his bronze *The Cricketer* won the Wollaston Award for the most distinguished work in the Royal Academy Summer Exhibition. His first solo exhibition was in London in 1966, at the Rowan Gallery, and Flanagan subsequently quickly established himself as a sculptor with an international reputation.

Since 1968, he has shown at the Museum of Modern Art, New York (1974), Centre Georges Pompidou, Paris (1983), Tate Gallery, London (1986), and held a major retrospective at the Fundación "la Caixa," Madrid, in 1993. He represented Britain at the Venice Biennale in 1982, was elected a Royal Academician in 1991, and has exhibited worldwide in many major international galleries.

Alan Byrne

Date 1966

Born 1941

Nationality British

Why It's Key Debut exhibition of one of the world's leading figurative sculptors.

Key Artist **Ian Hamilton Finlay**
Poet and conceptual artist begins creating *Little Sparta*

The avant-gardening odyssey later known as *Little Sparta* began life as a small seed in rural Scotland. It was in 1966 that Ian Hamilton Finlay made the most momentous decision of his life when he moved with his wife into a house at Stoneypath. Their small property was surrounded by a wild and rambling plot of land which would eventually unite the strands of his poetry and philosophy into a celebrated shrine to pacifism.

Educated in Scotland, at the age of thirteen, with the outbreak of World War II, Finlay had been evacuated to the Orkney Islands. After serving in the British army during the war, he began to write short stories and poems. Books included *The Sea Bed and Other Stories* (1958) and *The Dancers Inherit the Party* (1960), then in 1963 he published *Rapel*, his first collection of the visual concrete poetry for which he became renowned.

At Stoneypath, Finlay worked with a collaborator that clearly inspired him, the natural world. He began drawing on his skills as concrete poet and playwright, carving words into stone sculptures and other constructions in the scenic setting of the garden of *Little Sparta*. He created the concepts, then worked in partnership with various craftsmen.

As a cumulative and complex work encompassing the pastoral, classical, and polemical, *Little Sparta* reflected Finlay's ongoing exploration of various themes. These included the war, the French Revolution, sea fishing, pre-Socratic philosophy, romantic love, Western landscape painting, and classical mythology. His work was austere, but also at times witty, and even darkly whimsical.

Carolyn Gowdy

Date 1966

Born/Died 1925–2006

Nationality British (born Bahamas)

Why It's Key *Little Sparta* was the garden that would become central to Finlay's life's work.

Key Artwork ***Gas* "happening" at Montauk Bluffs**
Allan Kaprow

Jim Dine and Claes Oldenburg, who had been among the earliest proponents of "happenings," were producing sculptures and paintings by the early 1960s. Meanwhile, Allan Kaprow (1927–2006) published *Assemblage, Environments, and Happenings* (1966), continuing to explore a form that "is art but seems closer to life." Ephemeral and immaterial, happenings were thus defined not as commodities that could be sold on the art market, but as events that stimulated our awareness of the world around us.

Throughout the 1960s, Kaprow's spectators became increasingly involved participants in large-scale outdoor projects across the United States. The billboards for *Fluids* (1960) worked both as recruiting posters and as scripts or scores for the event. They invited the participants to build ice walls at various locations in Pasadena and Los Angeles: "During three days, about 20 rectangular enclosures of ice blocks (measuring about 30 feet long, 10 wide and 8 high) are built throughout the city. Their walls are unbroken. They are left to melt."

Gas (1966) was another vast collaborative happening, in which the participants had an input through preparatory discussions. On the day, the crowd followed precise instructions as to where and how they were supposed to move, while swathes of fire-extinguishing foam poured down the Montauk Bluffs on the coast of Long Island, New York, and onto them. Sponsored by CBS, the event was a little too spectacular for Kaprow's liking, and he subsequently dissociated himself from the extravaganza.

Catherine Marcangeli

Date 1966

Country USA

Medium Happening

Why It's Key The distinction between the artist and the audience is increasingly blurred in large-scale collaborative happenings.

Key Event
The Lunch: In Memoriam Batu Khan

The notion of a happening, an audience-friendly performance art session typically involving several artists, developed in the United States in the 1950s and spread to Europe in the 1960s. In 1966, Hungary's first happening, *The Lunch: In Memoriam Batu Khan*, was organized by the artists Gabor Altorjay, Miklos Erdely, Tamas St Auby M. Varanni, and G. Jankovics.

Held on June 25, 1966 at the Blaha Lujza Square underpass, Budapest, *The Lunch: In Memoriam Batu Khan*, like other happenings, served as a stage for various forms of performance, including poetry, poster art, and photography. More important than the content of the happening was its social and political context. Hungary had been a Soviet satellite since the end of World War II, and had experienced a brutal crackdown during the stillborn Hungarian Revolution of 1956. For

Hungarians to express dissent – even the passive dissent of art – was thus to court armed suppression from the People's Republic of Hungary and its patron, the Soviet Union. In this way, *The Lunch: In Memoriam Batu Khan* was an act of political and cultural resistance, as well as an aesthetic spectacle.

In the aftermath of the happening, a number of Hungarian artists took up Conceptual art more seriously and played an important role in modeling and rallying the anti-Soviet resistance that culminated in the birth of the Republic of Hungary in 1989. After 1966, many Hungarian Conceptual artists affiliated themselves with the Fluxus movement, the essence of which was to find and occupy the space between traditional media, such as painting and photography.

Demir Barlas

Date 1966

Country Hungary

Why It's Key Hungary's first happening heralded the birth of Hungarian Conceptual art.

573

Key Event
Cultural Revolution

The "Great Proletarian Cultural Revolution" launched in 1966 was essentially an attempt by Mao Zedong to regain control over the Chinese Communist Party. Following the political mistakes of the "Hundred Flowers" campaign and the disasters of the "Great Leap Forward," Mao had become something of a titular deity in the Communist Party – officially prayed to, but ignored in practice.

In an effort to counteract his sidelining, Mao and his associates encouraged groups of urban youths ("Red Guards") to attack traditional values and question all forms of authority, especially Party officials. In essence, Mao, in an attempt to wrest back power from other senior Party members, turned these youths against the very system that he had created. In the ensuing years, hundreds of thousands, if not millions,

died in the violence which the revolution engendered. A consequence of this was the devastation of much of China's artistic heritage. Historical artifacts, as physical reminders and manifestations of the traditional views being brought into question, were particularly vulnerable to destruction.

Red Guards plundered and destroyed possessions such as books, paintings, jewelry, and musical instruments. Many of these actions were state-sponsored, as Mao, although a well-read and cultured individual, sought to plunge China into an intellectual vacuum. Mao declared the Cultural Revolution complete in 1969, but China remained culturally desolate until his death and the subsequent arrest of his closest collaborators in 1976.

Dennis Casey

Date 1966–1976

Country China

Why It's Key The Cultural Revolution resulted in widespread death and social disruption, and the destruction of much of China's cultural heritage.

Key Artwork *A Bigger Splash*
David Hockney

Hockney (b.1937), along with fellow Royal College of Art student R. B. Kitaj, emerged early as one of the most prominent figures of British Pop art. On moving to Los Angeles in 1963, he started painting Californian houses and interiors. In 1966 he produced a series of swimming pools, including *The Little Splash* and *The Splash*, based on increasingly rigorous compositions.

A Bigger Splash (1967), too, is built on horizontal and vertical straight lines, be it the shape of the modern house, the wall-sized windows or the perpendicular pool under an undisturbed blue midday sky. The only diagonal line is the yellow diving board, which introduces an element of depth in this otherwise flat picture. Planeity is further emphasized by Hockney's technique: several layers of acrylics are applied with rollers, the brush being used only for a few details – on the chair or the grass, and for the finely rendered splash. Hockney recalls: "It took me about two weeks to paint the splash... I loved the idea of painting this thing that lasts for two seconds." There is no accident or expressionist spontaneity in this painstakingly recreated event, and a sense of stillness and controlled, cool geometric abstraction emerges from the scene.

In *Peter Getting Out of Nick's Pool* (1966), Hockney focused on the swimmer, his lover, whose body was celebrated. On the contrary, *A Bigger Splash* seems devoid of human presence: the composition and the title draw our attention to the splash, whereas the figure has disappeared underwater, and only the director's chair suggests his existence.

Catherine Marcangeli

Date 1967

Country USA

Medium Acrylic on canvas

Collection Tate Gallery, London, UK

Why It's Key Hockney's best-known painting combines Pop subject matter and rigorous geometric composition.

575

opposite *A Bigger Splash*

Key Artist **Robert Ryman**
First solo show at Paul Bianchini Gallery, New York

Robert Ryman emerged in the late 1960s. Although he first exhibited in 1958, his first solo show was at the Paul Bianchini Gallery in New York in 1967; two years later he participated in When Attitudes Become Form and a notable group exhibition at New York's Whitney Museum. By that time his intention to "paint the paint," by isolating and exploring the basic material properties of painting, was established. After 1955, he largely restricted himself to white paint because of its neutrality, and to square supports that prevented the viewer being distracted from examining the physical surface of an image.

Although Ryman appeared to reveal the process of a painting's creation in its gridded surface, as if it could be unraveled and reconstructed, in fact his method set up temporal disruptions in the painting's skin. His paints varied considerably in their viscosity, translucence, and finish. Brushstrokes were gestural or linear, and media ranged from oil, enamel, and casein to acrylic. Supports were numerous, including newsprint, tracing paper, cardboard, steel, linen, and fiberglass, and brushes up to a foot in width were used to apply paint, as were knives and ballpoint pens.

These elements interacted with each other, the painting's scale, and its alignment with the wall to determine the experience of each work. "If you were to see any of my paintings off the wall," Ryman commented, "they would not make any sense at all." Consequently, how the support fixed to the wall became significant. Ryman has been the subject of numerous international exhibitions.

Martin Holman

Date 1967

Born 1930

Nationality American

Why It's Key Ryman's paintings eliminated illusionism to focus on the material properties of painting.

Key Exhibition
Arte Povera

In September 1967, the art critic Germano Celant organised a group show of *arte povera*, or "impoverished art," at the Galleria La Bertesca in Genoa, Italy, entitled Arte povera e IM Spazio. Between this exhibition and his important manifesto in the magazine *Flash Art* two months later, in which the tenets of *arte povera* were analyzed, Celant identified twelve Italian artists as its exponents, including Giovanni Anselmo, Luciano Fabro, Mario Merz, and Alighiero Boetti.

The term described less a style than a process of ongoing and open-ended research that challenged the settled order within art after Minimalism, and which valued process over production. Its practitioners shared a concentration on commonly available materials, such as sand, wood, stone, and newspaper, and a reaction to technology and to the distortion they perceived in postwar consumerism. A reconnection with naturalness, combined with a material's metaphorical potential, was characteristic of these artists' way of working.

Kounellis explored the interaction between organic and inert substances and, by teasing the form of a sapling out of a planed timber plank (*Alberro di 8 metri*, 1969), Giuseppe Penone "reversed" technology through gesture. Michelangelo Pistoletto achieved striking revelations of historical memory alongside a critique of the present. In *Venus of Rags* (1967) a classical nude statue, representing the ideal of order, is juxtaposed with a pile of fabric scraps that allude to contemporary chaos.

Martin Holman

Date 1967

Country Italy

Why It's Key Celant's show brought together the key proponents of *arte povera*, which marked the recovery of the legacy of Italy's prewar avant-garde, and remains a strong inspiration for artists.

opposite **Alighiero Boetti's** *Untitled* (embroidery) from the Arte Povera exhibition.

Key Artwork *Window or Wall Sign*
Bruce Nauman

Bruce Nauman's spiral-shaped pink-and-white neon sign declaring that "The True Artist Helps the World by Revealing Mystic Truths" became the figurehead artwork for 1960s and 1970s Conceptualism, as a hard-hitting, bare-boned, and bold-faced challenge to the inner self-examinations of artists and the prejudices and expectations of viewers and critics. Inspired by a beer sign, Nauman's 1967 *The True Artist Helps the World by Revealing Mystic Truths (Window or Wall Sign)* was first displayed in the storefront window of the former grocery in San Francisco, California, where he lived with his wife and infant son after graduating from the University of California, Davis.

In the grocery-store window, the neon sign's gnomic message was a flashing contrast to the usual advertising that occupied shop's display spaces, which the piece initially resembles. And when it was later installed in TK gallery, it resonated in the way Nauman describes in a PBS interview, "It's true and not true at the same time. It depends on how you interpret it and how seriously you take yourself. For me it's still a very strong thought."

Seen against the background of *Krefeld Project, Dining Room Scene 2*, the photograph by popular 1970s photorealist painter Eric Fischl of sloppy drunk art collectors lounging in front of pieces by Warhol and Ritcher, Nauman's *Window or Wall Sign* is still a stand-out signifier of artistic integrity.

Ana Finel Honigman

Date 1967

Country USA

Medium Neon light

Why It's Key Important landmark in Conceptual art in the 1970s.

Key Artist **Andrew Wyeth** First retrospective held at the Whitney Museum of American Art, New York

Born in Chadds Ford, Pennsylvania, in 1917, the youngest of five children, Andrew Wyeth – one of the best-known American Realist painters of the twentieth century – was home-tutored, learning art from his father Newell Convers Wyeth. In 1937 at age twenty, he had his first one-man exhibition of watercolors at the Macbeth Gallery in New York City. All the paintings quickly sold out, and Wyeth's career was launched.

Wyeth's art settled into what was to be an enduring style after the horrific death of his father and three-year-old nephew on a railway crossing in 1945. His color palette became more subdued, his actual imagery more strikingly realistic, and his pictures featured emotionally powerful symbolic objects and people. In 1967, he ventured beyond his meditative world in rural Maine to witness a phenomenal sight.

Crowds of people lined up outside the Whitney Museum in New York to view his work. The only other exhibition ever to have attracted a larger crowd in the United States had been da Vinci's *Mona Lisa*.

What was it about Wyeth's desolate landscapes, empty rooms, and forlorn houses that had caught the pulse of a nation? Having rarely, if ever, traveled beyond his Maine and Pennsylvania homes for subject matter, Wyeth has remained committed to painting what he knows best and what involves him emotionally. Sometimes referred to as the "painter of the people" due to his popularity with the American public, Wyeth has a virtuosic approach that combines both abstract and realistic qualities. His art speaks with eloquence about qualities that are held silently beneath the surface.

Carolyn Gowdy

Date 1967

Born 1917

Nationality American

Why It's Key Wyeth's first retrospective at the Whitney Museum of American Art in New York breaks the museum's all-time attendance record for a living artist.

Key Artist **Raymond Saunders** Writes influential pamphlet *Black Is A Color*

Born in Pittsburgh, Pennsylvania, Raymond Saunders studied at the Carnegie Institute of Technology in Pittsburgh and California College of Arts and Crafts in Oakland. He is known for his mixed-media work, using paint splashes, calligraphy, graffiti, and stenciled letters, as well as materials from daily life such as handbills and comics, to portray contemporary black urban life. The painting *Jack Johnson* (1971), in which he depicts the first African-American prizefighter to become world heavyweight champion, exemplifies Saunders's rich, bold expressionistic style.

Rising rapidly to prominence, Saunders wrote the pamphlet *Black is a Color* in 1967. In it, he argues that "racial hang-ups are extraneous to art," and asks, "Can't we get clear of these degrading limitations, and recognize the wider reality of art, where color is a means

and not the end?" He declares that African-American artists should not feel restricted to representational art that celebrates blackness or black identity.

Saunders' voice influenced subsequent black artists, freeing them to express themselves as they wished. He continues to win many awards and presented many exhibitions nationally and internationally. In 2005, the Taft Museum of Art in Cincinnati held an exhibition of contemporary African-American art titled Black is a Color: African-American Art from the Corcoran Gallery of Art, featuring such prominent artists as David Driskell and Lorna Simpson, as well as Saunders.

Mariko Kato

Date 1967

Born 1934

Nationality American

First Exhibited 1952

Why It's Key African-American artist who challenged idea of a presumed racial obligation, which freed subsequent black artists to express themselves more freely.

Key Artist **Bruce Nauman**
Signs with dealer Leo Castelli

Bruce Nauman's work embodied the assertion that art-making is an intuitive process. In his search for alternatives to conventional painting and sculpture, he sought meaningful form by using a wide diversity of methods and media. Language and his own body had dominant roles. To language he brought almost unprecedented physicality; words and their meanings (especially double meanings) were explored as indicative of human and social conditions. With his body as a regular template for work, he rejected traditional forms of art production, using humor to puncture art's perceived aloofness.

In *Self-Portrait as a Fountain* (c.1966), Nauman photographed himself spouting water from his mouth, simultaneously debunking standard self-portraiture and outdoor sculpture, and paying homage to Duchamp's

Fountain (1917) as the essential readymade. From early in his career, Nauman turned the sculptural object into an act of inquiry. By casting in concrete the space beneath his chair, he represented negative, non-material space; he also photographed the mess on his studio floor, making "leftovers" the subject of an artwork.

Nauman's neon signs, begun in 1967, translated verbal expressions into form, often highlighting small alterations that caused major changes in meaning, as in *Raw War* (1970). The risk of failure was often addressed in work that trod a line between sense and nonsense, idealism and mundanity. After his first solo show at the Leo Castelli Gallery, New York, in 1968, this influential artist regularly exhibited internationally.
Martin Holman

Date 1968

Born 1941

Nationality American

Why It's Key Quintessential Conceptual artist.

579

Key Artist **Lawrence Weiner**
Declaration of Intent and first book, *Statements*

A turning point in Weiner's approach came in spring 1968, when he concluded that the physical construction of a work was not a requirement of art. Early work had included systematic experiments with shaped canvases and, since 1967, projects had been formulated in words before execution. When a piece created for an outdoor exhibition organized by gallery owner Seth Siegelaub in Vermont was damaged in its vulnerable location, Weiner realized that its written description ensured its permanence. Subsequently, once the linguistic specification was grasped, its registration in the mind's eye was sufficient; making the work from these instructions became only an option.

As the subjects of Weiner's art were often materials, an action, or process, this strategy gave him a way of representing relationships in an objective

manner. All traces of the artist's hand, taste, and emotion were eliminated. "Art is always representation," he said. "It is never an imposition." By focusing on generalities with elusive, succinct statements, Weiner delegated responsibility for an artwork's completion to the viewer or "receiver," a shift set out in 1968 in the artist's Declaration of Intent: "(1) The artist may construct the piece. (2) The work may be fabricated. (3) The work need not be built."

Weiner made words and the structure of language proper subjects for artists to investigate. Applied to the gallery wall, spoken, or printed as books, they could be presented in any medium and in different places simultaneously. Siegelaub published Weiner's *Statements* in 1968.
Martin Holman

Date 1968

Born 1942

Nationality American

Why It's Key Conceptual artist who decided his work could be presented using only language.

Key Artist **Keith Milow** Exhibition of experimental works at London's Royal Court Theatre

Keith Milow studied in London, at the Camberwell School of Art and later at the Royal College of Art, where he produced representational paintings of modern architectural imagery. His signature style incorporates methods of both painting and sculpture, with mathematical and architectural references such as Greco-Roman classicism.

Upon graduation in 1968, Milow publicly announced his innovative style at the Royal Court Theatre, which launched his career. Many notable works followed, including a series of wall hangings made of resin, crayon, and fiberglass titled *Improved Reductions* (1970), and *Infinity Drawings* (1975), in which a plasterer's comb was used to score surfaces painted with Aquatec gel mixed with oxidized copper powder. The characteristic *Cenotaph* series, begun in

the 1970s, displays a juxtaposition of traditional symbolism and geometric abstraction, with familiar forms made of wood or concrete being restructured to distort the shape.

After settling in New York in the early 1980s, Milow experimented with perspectival illusion in his expressionist paintings, but soon returned to reliefs made of plywood covered in sheets of lead, such as *Man Made Art* (1986). In 1998, he was commissioned to produce a work for London's Canary Wharf, for which he used a millennial concept in a series of four rusty discs carved with names of influential artists, composers, writers, and architects over the previous hundred years. He moved to Amsterdam in 2002.

Mariko Kato

Date 1968

Born 1945

Nationality British

First Exhibited 1968

Why It's Key Milow's self-promoted exhibition was a launch pad for the career of this innovative, contemporary UK artist.

1960-1969

580

Key Event **Atelier Populaire produces posters for Paris student uprising**

In May 1968, the Paris uprising saw thousands take to the streets in an unprecedented wave of violence, strikes, and demonstrations. Ten million workers went on strike across France, and factories and universities were taken over by workers and students. On May 16, art students, painters, and striking workers occupied Paris' main art school, the Ecole des Beaux-Arts, to produce posters to support the revolutionary movement.

Painters who occupied its studio wrote over its entrance: "Atelier Populaire: Oui. Atelier Bourgeois: Non." (Popular Workshop: Yes. Bourgeois Workshop: No.) Their intentions were made clear in a statement the group published: "The posters of the Atelier Populaire are weapons in the service of the struggle... and their rightful place is in the centers of the conflict... in the streets and on the walls of the factories."

Like the radical newspaper *Action*, the posters were distributed free of charge. The artists never signed their posters, thus denying the individuality of the work and promoting the idea of the group. Posters are historically the visual representation of revolt, reaching a public directly without the need for a marketplace. The Atelier Populaire always refused to put the posters on sale.

The posters of the Atelier Populaire were carried on demonstrations and plastered over walls all over France. Approximately three hundred artists participated. While the 1968 Atelier Populaire was a brief moment in design history, it was an important one. Key posters such as *Retour à la Normale*, *Reformes Chloroforme*, and *Oui, Usines Occupées* still resonate today.

Kate Mulvey

Date 1968

Country France

Why It's Key The Atelier Populaire was a significant group of radical students producing anti-capitalist posters that influenced an explosion of street art.

opposite Typical poster from the Atelier Populaire

TOUTE LA PRESSE EST TOXIQUE

lisez : les tracts
les affiches
le Journal Mural

Key Artwork *The 1962 Beatles*
Peter Blake

Pop artist Peter Blake's fascination with the bright, commercial imagery of the entertainment industry spanned boxing and wrestling, fairgrounds, Hollywood pin-up posters, and, of course, pop music. He was a fan first and foremost, and his early paintings were primarily celebrations. But as the 1960s progressed, Blake (b.1932) would sometimes introduce quirky artificial flourishes to his visual tributes, inventing, for example, a family of wrestlers each with a detailed CV. In the Beatles, however, Blake – who famously designed their *Sgt Pepper's Lonely Hearts Club Band* album sleeve in 1967 – found real-life heroes who lived uneasy parallel existences with their popular images.

The 1962 Beatles is a strangely unsettling painting which Blake completed toward the end of the group's extraordinary career. Incongruously, it draws on magazine photographs taken of the four band members when they were fresh out of their Hamburg apprenticeship, and still on the cusp of global fame. The four-panel structure of the picture harks back to the imagery of a fairground or wrestling poster, a stylized graphic device that simultaneously separates and combines the four individuals, who are further unified by their signature haircuts and the artist's palette.

John, Paul, George, and Ringo are being celebrated, but it is a strangely conditional celebration that somehow hints at a kind of uncomfortable harmony enforced by their singing and their success.
Graham Vickers

Date 1963–1968

Country UK

Medium Oil on board

Collection Tate Gallery, London

Why It's Key An iconic portrait of the Beatles, signifying on Blake's part a move away from the United States to the UK as a source of Pop art subject matter.

opposite *The 1962 Beatles*

Key Artist **Ray Johnson**
First meeting of the New York Correspondence school

Born in Detroit, Michigan, Ray Johnson attended Black Mountain College, an experimental institution in North Carolina. There, Johnson was lectured by such influential figures as Albert Einstein and studied under key artists such as Josef Albers. When he moved to New York in 1949, Johnson was inspired by Dadaist collage, and started to make "constructs moticos," using small pieces of ink drawings and clippings.

Soon, however, Johnson was cutting up even his own collages, combining the fragments with images of popular figures such as Elvis Presley and Marilyn Monroe, anticipating the style of Andy Warhol. Johnson also became known for his trademark depiction of bunny heads, which he claimed were a form of self-portrait. In the 1960s, he began to explore mail art, the origins of which are often traced to Futurist and Dada artists. He built an international network of friends and strangers with whom he exchanged ideas and artwork. It became known as the New York Correspondence school, and on April 1, 1968, its first meeting was held in New York, establishing mail art as a distinct art form.

When Warhol was shot, however, and Johnson himself was brutally mugged on the same day in June that year, Johnson left the city for a small town on Long Island. He lived there in solitude for the rest of his life and refused to exhibit his work. On January 13, 1995, his body was found floating in a cove in Sag Harbor, New York.
Mariko Kato

Date 1968

Born/Died 1927–1995

Nationality American

First Exhibited 1966

Why It's Key Pop artist Ray Johnson was a key figure in the mail art movement, which had its genesis in the New York Correspondence school.

Key Artist **Donald Judd**
First retrospective at the Whitney Museum, New York

On February 27, 1968, a retrospective exhibition of Donald Judd's art opened its doors to the general public. Organized by the Whitney Museum's William Agee and Dudley del Babo, it looked back at Judd's formative years as a sculptor. In 1968, Judd had been concerned with three-dimensional art for only about eight years, developing himself alongside the equally new current in modern art, Minimalism.

The term "minimalism" came from a group of artists who chose to reduce the means and materials with which they worked to a minimum. It thus responded to the complexity of earlier postwar art. The neutral look of Minimalist art – which was reached by removing representation and metaphor to enable anyone to fully comprehend it – is aimed to an immediate and personal experience of a specific work.

The fact that the Minimalists had their art manufactured in factories deeply shocked the people of older generations in the art world. While the old modernists emphasized the importance of complete authorship by the artist, artists such as Donald Judd sent their designs to metalworkers, challenging the idea that only the artist's intervention can turn an object into art. The show in the Whitney Museum testified that both Judd and Minimalism were being well received. At the time, many Minimalist artists sold their work easily to private collectors and museum curators of their own generation. That these buyers vied for this art while it was still contentious also showed their devotion to the mode of art which would soon find universal appreciation.

Erik Bijzet

Date 1968

Born/Died 1928–1994

Nationality American

Why It's Key Confirmed the pioneering status of Judd in the Minimalism movement just a couple of years after it came into being.

Key Event
Paris student revolt

In May 1968, a student revolt led to street battles with the police in the Latin Quarter of Paris. A general strike ensued and the French president, Charles de Gaulle, had to go into hiding. However, a broadcast on May 30 brought massive demonstrations of support for the government and the Gaullists won a landslide victory in elections for the National Assembly on June 23.

As part of the revolt, the Sorbonne was occupied and, on May 8, students at the Ecole des Beaux-Arts went on strike. On May 13, one million students and strikers took to the streets. The following day, they occupied the Ecole des Beaux-Arts and issued a communiqué criticizing the teaching of art – and particularly architecture – on Marxist grounds.

Students began producing striking posters and leaflets supporting industrial action and condemning the Gaullist government and the war in Vietnam which they distributed for free. Calling themselves the Atelier Populaire (Popular Workshop), they called for the establishment of other "People's Studios" everywhere.

Following the Gaullist election victory, a large force of police surrounded the Ecole des Beaux-Arts at 4 a.m. on June 27 with a writ from the Court of State Security. They arrested 106 artists and students. During the occupation, the Atelier Populaire had produced 600,000 copies of 350 different posters. Afterwards, architecture was dropped from the curriculum and de Gaulle's reputation had been so badly damaged by the events of May 1968 that, the following year, he stepped down.

Nigel Cawthorne

Date 1968

Counntry France

Why It's Key Art takes to the streets.

Key Artist **Luciano Fabro**
Begins *Italia* series

For Luciano Fabro, art was a form of knowledge, often conveyed as metaphor. A prominent *arte povera* artist, he was fascinated with non-traditional materials that, through direct presentation, visibly corresponded with a larger concept. In *Sisyphus* (1994), Fabro employed a cylindrical marble shaft and a bed of flour to evoke the Greek myth of the king sentenced by Zeus to roll a bolder uphill for eternity. The shaft imprinted a drawn image of the artist as Sisyphus in the flour as it rolled forward; when rolled back, the image disappeared. This metaphor of continual labor represented life as well as artistic creativity. Marble implied the formidable tradition of Italian sculpture while flour was a staple of human existence.

Fabro believed that labor ensured an artist's material and spiritual survival associations with manual and material activity abounded in his work, taking numerous forms. The monumental *Feet* (*Piedi*), grotesque and exotic claw-like sculptures dressed with silks, brought the image "down to earth." Made in metal, glass, or marble, they simultaneously recalled hunted beasts and classical remains. Indeed, Fabro's objects typically resonated with cultural associations.

The *Italia* series, begun in 1968 with *Italia e Folce*, provocatively treated the geographical outline of Italy as a shape to manipulate. Recognizable whether inverted, dismembered, gilded, or fetishized, or fabricated in canvas, metal, or tubing, the map reminded viewers of their rootedness in the land.
Martin Holman

Date 1968

Born/Died 1936–2007

Nationality Italian

Why It's Key A leading *arte povera* artist whose work drew on mythology, science, history, and philosophy.

Key Event
Art and Language formed

Art and Language was a seminal group of artists in the development of Conceptual art in the late 1960s, and the most influential of the experimental and political art scene at the time. The name "Art and Language" was devised in 1968 as the collective name under which the founders worked. It was also the title of a new Conceptual art journal. The UK founders Terry Atkinson, David Bainbridge, Harold Hurrell, and Michael Baldwin formed the partnership in 1968. Teachers and students who came out of the antiquated British art school system, they were opposed to the fact that the dominant 1960s American art scene was at the center of art discourse and Britain was on the periphery.

The two significant activities of the group were the publication of its journal, *Art and Language* (1969) – an alternative means of communication – and the teaching of a course entitled "art theory" at Coventry art college from 1969 to 1971 by Atkinson and Baldwin. Art and Language believed in art-as-argument, and pursued the idea that art practice should be theorized, thus separating it from craft.

The second issue of the journal, with Joseph Kosuth as U.S. editor, indicated the internationalism of the group, and in 1971 they formed with Roger Cutforth the Society for Theoretical Art. In the 1970s, Art and Language gained in influence. It produced Conceptual art in various forms, including texts, performances, and paintings. From its inception until 1982, up to fifty people were associated with the group.
Kate Mulvey

Date 1968

Country UK

Why It's Key An influential group of British – and later American – artists, Art and Language was significant in the development of Conceptual art.

Key Exhibition
The Field

The Australian commitment to abstract painting began late, with a large body of non-figurative painters rising to prominence only in the 1950s. From then on, however, an increasing number of Australian artists became active in abstract painting, which in the late 1960s tipped toward color abstraction. This movement – variously known as, or overlapping with, color field painting, hard-edge abstraction, and post-painterly abstraction – distanced itself from the emotional and painterly affects of Abstract Expressionism, while retaining that movement's non-figurative commitment.

Artists at the Field exhibition held at the National Gallery of Victoria, Melbourne and the Art Gallery of New South Wales, Sydney including the American James Doolin, as well as the Australians Alun Leach-Jones, Dick Watkins, Janet Watson, and Michael Johnson. They modeled the cerebral and aesthetic possibilities of color field abstraction that had first been mined and explored in New York. As such, the Field demonstrated that artistic developments in Australia were now more closely aligned with events abroad, and participated in a cross-border dialogue.

Color field painting proved to be enormously influential among Australian abstract painters active during the late 1960s and 1970s, and inserted a welcome note of the contemplative and analytical into the emotionalism of Abstract Expressionism.

Demir Barlas

Date 1968

Country Australia

Why It's Key Marked the beginning of the Australian color field abstraction movement.

opposite Fred Williams' *Landscape* (Silver and Gray series) 1967–69 (oil on canvas).

587

Key Artist **Eva Hesse**
First solo sculpture show, New York

Hesse and her Jewish family fled her native Hamburg in 1939 for America. She studied drawing in New York in 1954 and started psychotherapy that continued until her death. At Yale she was taught by Albers, and in New York in 1960 met LeWitt and other artists who became influential friends. Her work significantly advanced during a residency in Germany in 1964–65. She died of a brain tumor in 1970.

Her short career marked a moment between Minimalism and what came after. Formally innovative, Hesse's practice was centered on a process that emphasized the properties of a wide array of materials that included latex, fiberglass, and cheesecloth; simultaneously her work evoked the body in extreme ways that disrupted conventional conceptual assumptions of grid-based regularity. Intimate allusions to the erotic being were often purposefully contradictory: in *Ingeminate* (1965), two seed-like forms connected by drooping cord referenced female and male anatomy. Other oppositions – tough/fragile, hard/soft, precision/chance, absurdity/pathos – were common, implying at once internal psychological drama, and a work's material and metaphorical instability.

Hesse's first solo sculpture show took place in New York in 1968. Her work attracted feminist interpretations and it was distinguished by its witty play of dark and light emotions. Her techniques still defy characterization; her combination of sculptural materials in drawing, and her expressive line, simultaneously mechanical and gestural in all media, contributed to her becoming highly influential for successive generations.

Martin Holman

Date 1968

Born/Died 1936–1970

Nationality American (born German, naturalized in 1945)

Why It's Key Eva Hesse was a key figure in post-Minimalism; she created work of singular beauty and formal innovation.

Key Artist **Nancy Graves**
First one-woman show at the Whitney Museum, New York

Nancy Graves was born in Pittsfield, Massachusetts, and attended the Art Students League, New York, and Yale University, where she was awarded a Fulbright-Hayes fellowship for painting, via which she studied painting in Paris. Continuing her international travels, she then moved on to Florence. During the rest of her life, she would also travel to Morocco, Germany, and Canada, while living and working in New York.

She was known as an abstract/semi-abstract painter and sculptor of animals and shamanistic objects, reflecting the culture of Native Americans. As well as natural forms, her concerns were similarly for cartography and anthropological relics. Graves' most famous sculpture, *Camels*, was first displayed in the Whitney Museum, New York, in 1969, making her the first woman to have her own exhibition there. The sculpture features three separate camels, each made of many materials, among them burlap, wax, fiberglass, and animal skin. Each camel is also painted with acrylics and oil colors to appear realistic. The camels are now stored in the National Gallery of Canada.

In her works, *Nike* and *Variability and Repetition of Similar Forms* (1971) ephemeral totemic shapes and forms are deployed to construct airy sculptures and mobiles, using materials as diverse as steel, latex, gauze, oil, marble-dust, acrylic, and wax. Color is organic but bold and unambiguous.

Nancy Graves' work has been shown widely in Brooklyn Museum, Knoedley Gallery, New York, MoMA, and the Whitney Museum.

John Cornelius

Date 1969

Born/Died 1940–1995

Nationality American

Why It's Key Her work was concerned with natural forms, often reflecting the culture of Native Americans.

Key Artwork *Verso l'infinito*
Giovanni Anselmo

Verso l'infinito (*Toward Infinity*) is a block of steel, just under five inches high, eight inches wide and about sixteen inches in length. On the top side is engraved the symbol for infinity. One of several objects made in 1969–70 by the Italian artist Giovanni Anselmo (b.1934) that meditated on time and metamorphosis, it challenged assumptions of stability and permanence with fragility and constantly altering reversibility.

As an artist associated with *arte povera*, the trend in Italian art from the mid-1960s that experimented with the properties and resonances of everyday materials, Anselmo investigated extreme oppositions of texture and time, often through combinations of ephemeral and durable elements, like vegetation and marble.

In this work, he applied a coating of antioxidation varnish to part of the block to stall the process of erosion that would otherwise inexorably alter and reduce its appearance and materiality. As with other works in iron from the time that were similarly partially treated with grease, exposure to air would ultimately lead to the disintegration of the untreated part through long-term entropy or depletion of molecular energy.

Anselmo articulated material transformation as a product and measure of temporality. This display of reality highlights the implication of the process on the development of sculptural shape and form. "I, the world, things, life – we are all situations of energy," Anselmo observed. "The point is not to fix the situations, but to keep them open and alive – like life processes."

Martin Holman

Date 1969

Country Italy

Medium Iron, transparent antioxidation varnish, incision

Collection Collection Herbert, Ghent

Why It's Key An artwork that makes the viewer aware of being a part of the natural forces of the world.

Key Artist **Neil Jenney**
Begins painting career with *Husband and Wife*

Born and raised in Connecticut, Neil Jenney studied at the Massachusetts College of Art in Boston before moving to New York in 1966. While he began his career as a sculptor, exhibiting linear wire sculptures in his first exhibition in 1967 in New York, he is better known for his painting career, which he commenced in 1969.

Over the next year and a half, he created some of his most well known and innovative paintings, including *Husband and Wife* (1969), a work depicting an angry man standing with his back to his seemingly sad and worried wife, whose hands are clasped in anxiety. While the space separating them is small, their emotional alienation seems as vast as the empty, expansive green space that surrounds them. The uncomfortable tension that permeates the situation is

further conveyed through the chaotic brushstrokes that compose the background. Like many of his works from this period, this painting juxtaposes the subjects of the title to convey the reality of the relationship between the two. Ironically, his unique style and technique was later criticized as "bad painting" by Marica Tucker, the former founding director of the New Museum of Contemporary Art in New York.

While his figurative art stood in stark contrast to that of his abstract contemporaries, he pioneered a new style of realism, paving the way for future figurative painters. In 2001, an exhibition jocularly entitled "Neil Jenney: The Bad Years," celebrated his contributions during the beginning of his career.
Heather Hund

Date 1969

Born 1945

Nationality American

First Exhibited 1967

Why It's Key Influential in re-establishing the merits of contemporary representational painting.

Key Artist **Allen Jones**
Creates the artwork *Chair, Table and Hat Stand*

One of Britain's leading Pop artists emerging out of the 1960s, Allen Jones is best known for his provocative fetishist-like sculptures and paintings featuring girls in rubber underwear and boots. In the series *Chair, Table and Hat Stand*, three female figures, each slightly larger than life-size and cast in fibreglass, are holding up a piece of furniture, adding to the brutality of the pieces and the sadomaschostic theme.

Jones considers *Chair, Table and Hat Stand* (1969) his most radical statement and says about it: "They are not so much about representing woman, but the experience of woman, not an illusion." In their rendering and their simplicity, they also conform to a very pure Pop art aesthetic, which is the real thrust of Jones's broader body of work. Aside from his focus on explicit images of women as seen through a man's imagination,

Jones' borrowing of images from the mass media sits him firmly alongside the other great British Pop artists, Sir Peter Blake and Richard Hamilton.

A contemporary of David Hockney at the Royal College of Art, Jones was deeply influenced by Jungian psychology and by Nietzsche in his early work. He developed the idea of male and female form and identity being integrated as a visual representation of their theories. This principle features throughout Jones' work, from the boldly coloured Pop art painting *Hermaphrodite* (1963), with its headless male and female forms melting into one another, to the massive erotic sculptural form of his intertwined *Dancers* (1987).

Jones lives in London, has designed stage sets and costumes, and is a talented printmaker.
Emily Evans

Date 1969

Born 1937

Nationality British

Why It's Key Allen Jones is an important British Pop artist, best known for his fetishist sculptures.

Key Artist **Joseph Kosuth**
Publishes his *Art after Philosophy* manifesto

Joseph Kosuth was born in Toledo, Ohio. He attended the Toledo Museum School of Design (1955–62); the Cleveland Art Institute (1963); and the New York School of Visual Arts (1965–67). In response to what he considered the formalism of Abstract Expressionism and the commercialism of Pop art, Kosuth proposed an art that would reveal the mediated structure of language and the intermediate function of institutions, such as the museum, in the experience and meanings of art.

Kosuth first published his manifesto, *Art after Philosophy*, in the London magazine *Studio International*. He advocated that the role of the artist was to question the nature and function of art in postmodern society. He proposed a new language of art as idea that would not rely on redundant traditional art materials, but instead – in the shadow of the Dadaist Marcel Duchamp's readymades – through found texts and photographs, would explore how meaning is constructed within the context of art itself. Thus in his work *One and Three Chairs* (1963), which presented three different representations of a chair – a real chair, a photograph of a chair, and a definition of a chair on a gallery wall – a tautology is created which has no referent other than to itself and the institutional context of the gallery space.

To remove the paradox that his idea-based work was in danger of being objectified within the gallery, Kosuth started to publish his texts anonymously in media publications (1968–69), then, in the work *Text/Context* (1979), by using billboards in different cities in various countries.

Sarah Mulvey

Date 1969

Born 1945

Nationality American

Why It's Key Kosuth's *Art after Philosophy* became an influential text for Conceptual artists.

Key Artist **Gilbert and George**
Produced first "singing sculpture"

Gilbert Proesch was born in San Martin de Tor in the Italian Dolomites, and studied art at the Wolkenstein School of Art and the Hallein School of Art in Austria, and the Akademie der Kunst, Munich, before moving to England. George Passmore was born in Plymouth, England, first studying art at the Dartington Hall College of Art and the Oxford School of Art, then part of the Oxford College of Technology.

The two met at St Martins School of Art in London in 1967, and they have lived and worked together since 1968. Reacting against the elitism of art, they moved into the then working-class district of Spitalfields in London's East End and turned themselves into "living sculptures," initially attracting attention as performance artists. In 1969, while still at art school, they painted their faces and hands gold and, dressed in their trademark neat suits, mimed to the 1930s' Flanagan and Allen song *Underneath the Arches*.

Although they abandoned performance art in 1977, they frequently appear in their own work and consider their whole lifestyle a work of art. Since 1971, their work has consisted mainly of "photo pieces" – arrays of photographs in black, white, and garish colors, assembled on a grid. Themes are often violent, homoerotic, scatological, or politically provocative and seem designed to inflame outrage.

Their work has been exhibited worldwide. They won the Turner Prize in 1986 and represented the UK at the 2005 Venice Biennale. However, they are considered by some critics to be the masters of self-advertisement and hype.

Nigel Cawthorne

Date 1969

Born Gilbert, 1943; George, 1942

Nationality British (Gilbert is Italian-born)

Why It's Key Gilbert and George turned their lives into art.

opposite Gilbert and George

Key Artist **Jannis Kounellis**
Exhibits live horses as a painting

In 1969, the Greek artist Jannis Kounellis exhibited twelve horses at the Gallery L'Attico in Rome, where he had resided since 1956. The horses, tethered to the walls of the gallery, famously defecated on the floor and were described as a painting by Kounellis. This was the epitome of his 1960s incorporation of animals into his Conceptual work. He later went on to fold fire, smoke, and other elemental materials into his aesthetic.

Bringing horses into the gallery was an interesting move, because it simultaneously allowed Kounellis to remind spectators of the centrality of animals, hitherto denuded of their physicality, in art. It also allowed him to enact an *arte povera* gesture of demystifying elite art in favor of earthy realities and to bring a whiff of the rural to the pristine urban space of the gallery. Kounellis would restage the exhibit years later in London.

The black-and-white photographs of the installation came to acquire a great deal of fame, backhandedly explaining the reactionary nature of the traditional art that Kounellis was attacking in the first place. Kounellis' insistence on vitiating the depicted image in favor of a real image – one that could not be capitalistically reproduced, and whose on-the-scene immediacy was a rejection of the packaged experience – was in turn co-opted by the bourgeois insistence on turning art into mass-produced spectacle.

The fact that Kounellis could exist in the same conceptual space as artists who deliberately mass-produced their work illustrates one of the unresolved tensions at the heart of Conceptual art.

Demir Barlas

Date 1969

Born 1936

Nationality Greek

Why It's Key Live animals leave a big mark on Conceptual art through the aesthetic of Jannis Kounellis.

Key Exhibition
When Attitudes Become Form

Harold Szeemann, director of the Swiss art museum Kunsthalle Bern, had followed developments in postminimalist art forms in New York and elsewhere. The broad definition of Conceptual art that his exhibition, When Attitudes Become Form, presented was embodied in its subtitle – Works, Concepts, Processes, Situations, Information – and contrasted with the narrower interpretation offered by the less institutionalized but equally important show, January 5–31 1969, in New York that year.

In his selection of sixty-nine Swiss and international artists, Szeemann brought together a range of procedures, including earth art, anti-form and *arte povera*, that had reacted to Minimalism's formal rigidity. Nonetheless, categories were openly resisted and the informal nature of the exhibition projected an affinity

with how works were conceived. Twenty-eight overseas artists installed their artworks specifically in sites within and around the museum, including major contributions by Beuys, Kounellis, and Michael Heizer. The notion that exhibition-making was itself an art form extended to the catalog which documented the show's organization.

Szeemann's role was as collaborator with artists rather than institutional figure. He would become an influential example to museum curators in future years. His selection was notable as much for its omissions (Art & Language, Buren, and Broodthaers) as its inclusions (Hesse, Long, Nauman, Serra). But the exhibition motto – "Live in Your Head" – embodied the objectives of disparate artists whose work had rendered the material object incidental to art.

Martin Holman

Date 1969

Country Switzerland

Why It's Key Marked high point in the reception of Conceptual art in Europe.

opposite View of a gallery at the Kunsthalle, exhibiting (left to right): *Untitled* (1968) by Jannis Kounellis, *Untitled* (1967) by Robert Morris, and in the background: *Most Wanted Men No. 6* (1964) by Andy Warhol.

Key Artist **Robert Wilson**
Produces *The Life and Times of Sigmund Freud*

The challenging, experimental theatrical productions Robert Wilson choreographed and directed for his performance troupe, The Byrd Hoffman School of Byrds, exemplify many people's ideal or nightmare urbane, avant-garde art.

After studying business administration at the University of Texas in Austin, Wilson switched to architecture and in 1963 he enrolled on a course at Brooklyn's Pratt Institute. During his time there, he attended lectures by Sibyl Moholy-Nagy, widow of the Bauhaus designer, László, and studied painting with George McNeill at the American Center in Paris as well as working with learning-disabled children in New York.

Named for a dancer who helped Wilson to overcome a speech impediment while a gawky teenager in Waco, Texas, The Byrd Hoffman School of Byrds, aroused almost a cultish devotion for Wilson. Visually astounding and sensationally surreal, his elaborate productions lacked a coherent narrative but awed his audiences with their masterful visuals and emotionally intense performances. His work is immediately identifiable and arrestingly beautiful.

One defining early production was *The Life and Times of Sigmund Freud* (1969), which was Wilson's first major critically acclaimed work. Freud was an obvious subject for Wilson, whose dark, dream-like productions explore the recesses of the subconscious. Manipulating time and space, Wilson's dancers perform motions excessively slowly or repeatedly. The effects resonate deeply with many viewers, though they lack obvious meaning.

Ana Finel Honigman

Date 1969

Born 1941

Nationality American

Why It's Key Important Conceptualist using dance and theatrics in elaborate performance pieces.

Key Artist **Michael Craig-Martin**
First solo show at the Rowan Gallery, London

Listing Velázquez and Jasper Johns as strong influences, Michael Craig-Martin decided to become an artist at the age of twelve when he realized that art would always refuse absolute answers. Educated in the United States, he studied Fine Arts at Yale University before returning to England in 1968.

In 1969, he held his first solo show at the Rowan Gallery in London. At that time, his work mainly consisted of sculptures. Works such as *Four Identical Boxes with Lids Reversed* (1969) played with the mind by creating a tension between the title and the work's appearance. Craig-Martin displayed four cardboard boxes. Cutting lids of different shapes into each of them, he placed the fourth lid upon the first box and so on, creating different-looking boxes out of the four boxes which were initially – and essentially remained – similar.

In 1973, Craig-Martin became a teacher in the department of Fine Arts at Goldsmiths College in London. His students included Sarah Lucas, Julian Opie, and Damien Hirst. Through them, he was an important influence on the YBA movement, the group of young painters, sculptors, Conceptual, and installation artists who dominated the British art scene in the 1990s.

Craig-Martin's work gradually shifted toward painting, particularly wall painting, as he created stylized images of daily objects. His sense of humor often appears in the title of works, such as his 1999 commission for the Museum of Modern Art in New York: *16 Objects, Ready or Not*, an ironic reference to the Duchampian readymade.

Sophie Halart

Date 1969

Born 1941

Nationality Irish

Why It's Key Contemporary sculptor, painter, and teacher who had a decisive influence on the Young British Artists (YBAs).

Key Artist **Georg Baselitz**
Begins his "inverted" paintings

Georg Baselitz's work focuses on his preoccupation with Germany's wartime legacy, and his cultural and social identity, through means of subverting traditions and assumptions of institutional art history. To this end, until 1969, he had proved the possibilities of somewhat mischievous action within the canon of figurative painting. But the immediate critique was most clearly made when Baselitz produced his first entirely "inverted" picture, *The Wood On Its Head*, in 1969.

Baselitz has remained an outsider since being thrown out of art school in East Berlin in 1956. Moving to West Berlin, he came into contact with the Abstract Expressionism of Phillip Guston and Jackson Pollock. He was drawn to this abstract art and, by rejecting the Socialist Realism of the Communist regime, took the influence of jazz on the Americans and turned it into

social disruption. Influenced by the unsettling images of Matthias Grünewald, Chaim Soutine, and Théodore Géricault, Baselitz used Germanic iconography of the hunter, the dog, and so forth, transcending the boundary of the northern tradition and the influence of mannerism to create a grotesque beauty.

By 1969, the artist had realized the influence of Antonin Artaud's *Theatre of Cruelty* (1932) and Hans Prinzhorn's studies of the art of mentally ill (1922), returning to watercolors and memories of himself as a fifteen-year-old in 1943, growing up some 30 kilometers (20 miles) from Dresden. With one simple motion in 1969, Baselitz revealed uncomfortable realities of art history and cultural identity, turning art and cultural tradition, quite literally, on its head.
Rebecca Harris

Date 1969

Born 1938

Nationality German

Why It's Key After his rebellious action against the traditions of painting, Baselitz began to achieve art-world celebrity.

1960-1969

595

Key Artist **Jules Olitski** First living American artist to solo at the Metropolitan Museum of Art, New York

Post-painterly abstraction was the first art movement of the 1960s, and Jules Olitski emerged as one of its leading painters, alongside Kenneth Noland and Morris Louis. In 1960, Olitski's style moved from "matter" paintings, thickly encrusted surfaces built up from rough smears and trails, to canvases stained with high-keyed uninflected colors within simple biomorphic shapes applied with acrylic resin. The change was prompted by meeting the critic Clement Greenberg, and influenced by Noland. Soon Olitski's work exemplified the formalist ideals of color, flatness, and openness promoted by Greenberg, who increasingly advised both artists.

Olitski's breakthrough came around 1964, with the realization that he could "dematerialize" painting by spraying paint onto canvas to create an unworldly haze

of color with a disembodied texture. These effects established the work's dimensions, and cropping the canvas left bands that defined a decisive edge. Independent of allusions to nature these paintings were a highpoint in modernism's belief in creating non-representational art. "Painting is made from inside out," he remarked. "I think of paintings possessed by a structure... born of color feeling."

Olitski represented the United States at the Venice Biennale in 1966, and his 1969 one-man exhibition at New York's Metropolitan Museum was unprecedented for a living artist. But although he was initially acclaimed, critical reversals, work in sculpture, and stylistic change using gels to thicken paint into vagrant pastoral tones later eroded his public reputation.
Martin Holman

Date 1969

Born/Died 1922-2007

Nationality Russian (naturalized American)

Why It's Key By the mid-1960s, Olitski's paintings and teaching embodied the objectives of post-painterly abstraction.

Key Artwork *Mornington Crescent*
Frank Auerbach

German-born, British-based painter Frank Auerbach was sent from Berlin to England by his artist parents to escape Jewish persecution by the Nazis. At the age of eight, he was relocated to a boarding school for refugees near Faversham in Kent, where his expressionist style of painting soon earned him a reputation as an artistic prodigy.

He went on to train at St. Martins School of Art (1948–52), before studying with David Bomberg at Borough Polytechnic. As a seventeen-year-old student, Auerbach met a thirty-two-year-old widowed amateur actress, Stella West, who ran a boarding house in Earl's Court, London. For the next twenty-three years, and throughout his marriage to his wife (and model) Julia, she was his regular model and they were lovers. His most celebrated series was not figurative or autobiographic but the personal, abstract cityscape under the collective title *Mornington Crescent*.

"Mornington Crescent" referred both to the Camden Town area in London where Auerbach painted the series and to his artistic ethos, which he famously summed up thus: "It seems to me madness to wake up in the morning and do something other than paint, considering that one may not wake up the following morning."

Ana Finel Honigman

Date 1969

Where UK

Medium Oil on board

Why It's Key One of a major series by the leading British painter.

opposite *Mornington Crescent, Winter*

Key Artist **Francisco Zúñiga** First major retrospective at the Modern Art Museum, Mexico City

The son of a religious sculptor, Francisco Zúñiga was born in Guadaloupe, Costa Rica, in December 1912. He spent his formative years as his father's assistant, learning the craft of a sculptor, as well as taking lessons in painting and drawing. By the mid-1930s, however, Zúñiga had grown tired of producing religious statues and enrolled at the School of Fine Arts, San Jose. While there, he supplemented his studies with courses in stone sculpture and engraving.

In 1935, Zúñiga produced one of his most iconic works, the bronze statue *La Maternidad*, which won him first prize in the Salón de Escultura en Costa Rica, one of Latin America's most prestigious sculpture competitions. A year later, Zúñiga traveled to Mexico City, where he studied at La Esmeralda, eventually being appointed to the faculty and remaining there until his retirement in 1970. During this period, Zúñiga produced some of his most important work.

Preferring to model initially in clay and plaster before sculpting in bronze, Carrara marble, or alabaster, Zúñiga won acclaim and popularity in Mexico, the United States, and beyond with his sensuous, majestic sculptures of Native American peasant women. In 1969, his first major retrospective opened in the Modern Art Museum, Mexico City. By this time, he had already picked up several international awards and prizes, and was recognized as one of the leading Latin American artists of his generation. Zúñiga continued to work up until his death on August 9, 1998, at his studio in Mexico City.

Jay Mullins

Date 1969

Born/Died 1912–1998

Nationality Costa Rican

Why It's Key One of Costa Rica's leading artists, Zúñiga's classical Latin American sculptures have found international recognition.

Key Artist **Jean-Paul Riopelle**
Made a Companion of the Order of Canada

Jean-Paul Riopelle's tutelage under the Quebec abstract painter Paul-Emile Borduas (1905–1960) was pivotal. In 1945, he joined Borduas's *automatiste* movement, taking inspiration from the Surrealists' notion of "automatic writing." In 1948, Riopelle signed a manifesto penned by Borduas called *Total Refusal* (*Refus Global*), which challenged the conservative values of a Quebec society dominated by the Catholic Church. The document inaugurated Quebec society into the modern age, exposed it to international thought, and helped to define modern art in Canada as expressed by the *automatistes*.

Riopelle was drawn to Paris, however, and spent most of his career in France, first with the Surrealists, then with the Lyrical Abstraction group. While there, he diversified his means of expression with ink on paper, watercolors, lithography, collage, and oils; his work became more chaotic, where the material of his art became integral to its subject and seemed to further free its form. The large-scale *Point de Rencontre* (1963) is an important painting of this period. The upper torso of an abstract figure with outstretched arms beckons the viewer; the primary colors of the applied paint traveling in a myriad of intersecting directions capture the atmosphere of momentary encounters before the next journey.

Riopelle was made a Companion of the Order of Canada in 1969 in recognition of his contribution to the arts in Canada. His last major work, *L'Homage à Rosa Luxembourg*, painted in 1992, is a narrative fresco more than 130 feet long and made using aerosol spray.
Bryan Doubt

Date 1969

Born/Died 1923–2002

Nationality Canadian

First Exhibited 1945

Why It's Key Widely identified as one of the most important founders and practitioners of Canadian contemporary art.

598

Key Exhibition
January 5-31: O Objects, O Painters, O Sculptors

In 1969, the Conceptual promoter Seth Siegelaub presided over January 5-31: 0 Objects, 0 Painters, 0 Sculptors, which was perhaps the first exclusively Conceptualist group show. Held in Burnaby in British Colombia, Canada, January 5-31 marked the high point of Conceptualism, which coalesced in the early 1960s, temporarily ran out of steam in 1975, and provided a forum for many artists in the movement's vanguard.

The Conceptualism of the 1960s never agreed on the role of the artist, and these tensions – which threatened to overload the movement with a kind of incoherence – remained active in January 5-31. While Siegelaub's subtitle (0 Objects, 0 Painters, 0 Sculptors) signaled a conviction that Conceptual art dynamited the categories of art and artist alike, many Conceptualists themselves never adopted this view.

Conceptualism's godfather, Marcel Duchamp, always insisted on the reality and importance of the artist, and this view was taken up by later Conceptualists such as Robert Rauschenberg, who in 1961 sent a telegram reading: "This is a portrait of Iris Clert if I say so," that intended to serve as a portrait; other Conceptualists retained a faith in the importance of the artwork, even if its definition had shifted.

In 1969, however, these ideas still clashed on a happy battleground. There was not yet any pressure on Conceptual art to decide what a concept (or lack of one) might be and, in the absence of such a differentiation, there was no reliable way to wall Conceptual art off from representational bourgeois art.
Demir Barlas

Date 1969

Country Canada

Why It's Key The first big Conceptualist exhibition in North America marks the movement's heyday, but does not resolve its fatal incoherence.

Key Event
The Moon landing

The Moon has been a icon in art since ancient times, and space travel influenced artists prior to the Moon landing by Neil Armstrong and Edwin "Buzz" Aldrin on July 20, 1969. *Nouveau réaliste* Yves Klein made *Planetary Relief, RP23* in 1961 from descriptions of the Earth as a blue sphere by the first man in space, Soviet cosmonaut Yuri Gagarin, by immersing a sphere in his own International Klein Blue pigment. Later that year he produced *Planetary Relief, Moon, No. 1* from relief maps of the Moon. Even painter and illustrator Norman Rockwell had featured astronauts as modern American heroes in his late work.

American artist Robert Rauschenberg celebrated the Moon landing with his series *Stoned Moon* beginning in 1969, while Argentinean artist Raquel Forner's *Return of the Astronaut* (1969) now hangs in the National Air and Space Museum in Washington, D.C. The Belgian painter Paul Van Hoeydonck had begun his work depicting space exploration with *Spacescape* in 1961, drawing on his childhood love of Jules Verne and Flash Gordon. His miniature sculpture *Fallen Astronaut* (1971) was placed on the surface of the Moon by the crew of *Apollo 15* as a memorial to those who had died in the exploration of space.

Nigel Cawthorne

Date 1969

Country The Moon

Why It's Key Gave mankind a new perspective on its place in the universe, and proved an inspiration to artists of many disciplines.

1960–1969

599

Key Event
Korean Avant Garde Association formed

Until the 1950s, East Asian art and painting remained firmly wedded to traditional models, with no official or organized space for the regional avant-garde. That began to change after World War II when Gutai in Japan (formed 1954) and the Korean Avant Garde Association (formed 1969) began to shake up the East Asian art scene and aligned it with a new mood of experimentation and liberation. Until the formation of these groups, Japanese and Korean avant-garde artists had worked largely in isolation from each other and from international currents.

The Korean Avant Garde Association was not only a collective of contemporary artists but also an official vehicle of theory. On the one hand, the Association served as an incubator for artists such as Kang So Lee, and on the other it published a journal entitled *AG* that published such influential work as Lee Ufan's "A Preface to the Phenomenology of Encounter: Preparing a New Theory of Art."

The Korean Avant Garde Association was not immediately successful in changing South Korea's official approach to art, which leaned toward private collections and did not offer much public place or support for contemporary or experimental work. That did not deter Korean avant-garde artists from finding other opportunities to expose their work, which they did vigorously in the late 1970s and 1980s. In the 1990s, Korea's official art scene warmed up to the vanguard and today the scene is one of the most dynamic in East Asia.

Demir Barlas

Date 1969

Country South Korea

Why It's Key The nascent East Asian avant-garde scene began to mature with the formation of this group.

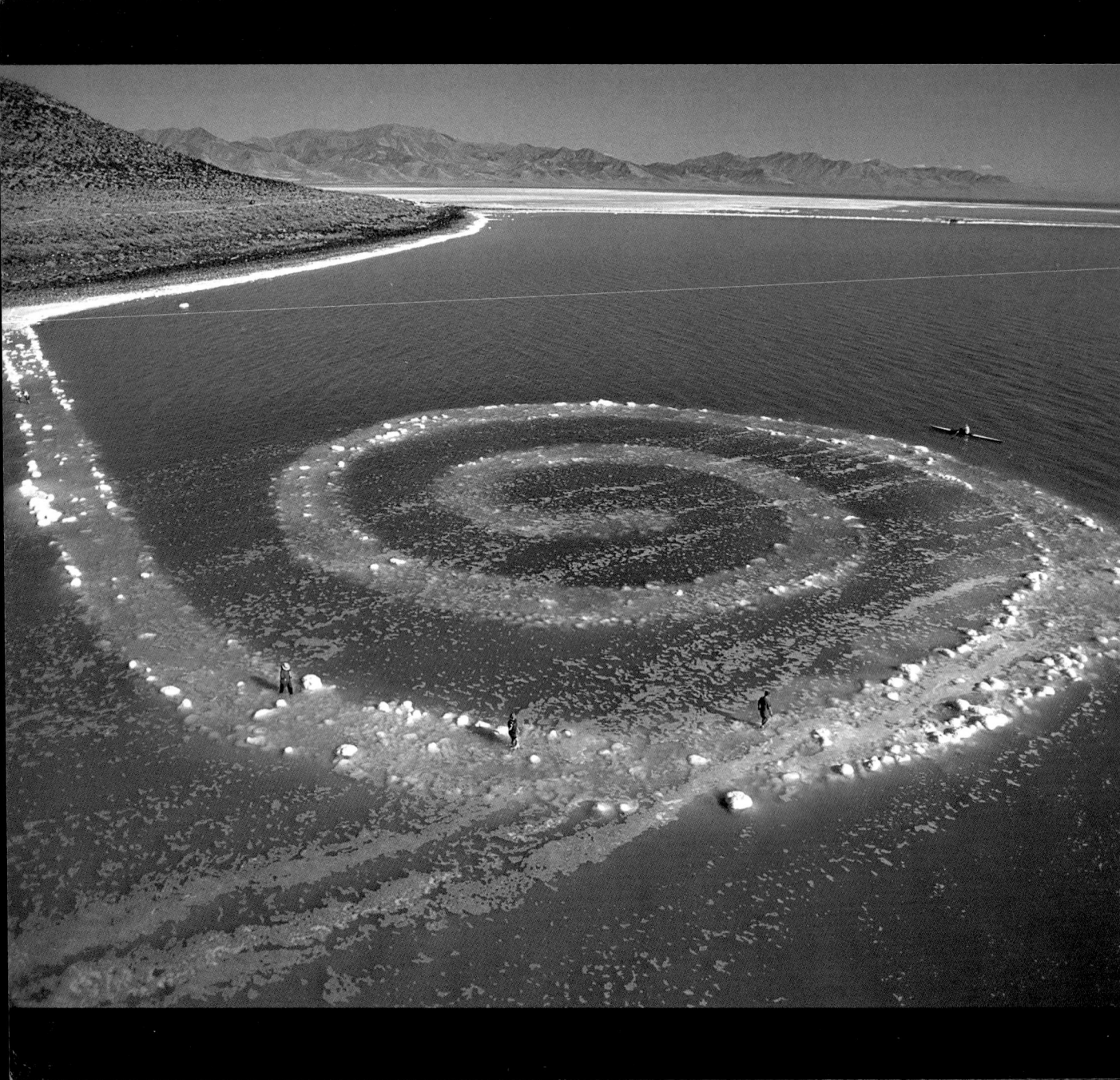

Key Artwork *Racetrack (South Africa)*
Malcolm Morley

Malcolm Morley, the inaugural winner of the Turner Prize in 1984, discovered art while serving a three-year stint in Wormwood Scrubs prison, London, for petty theft. After his release he studied art in London, but a 1956 exhibition of Abstract Expressionism at the Tate Gallery led him to move to Manhattan to be closer to the New York school of painters. Yet he finally found his individual style as a photorealist painter.

In the 1970s Morley developed a style of transferring photographs to canvas. Using a complex raster technique, Morley reconciled the differences between photorealist painting and his early abstract beginnings. By the later 1970s, he was combining realist images, observed through a camera obscura system, with gestural components and collage, complicating his slick style and adding an underlying layer of violence that reflected the reality of his war-inspired imagery.

His 1970 painting *Racetrack (South Africa)* became surprisingly political when, with the concurrence of his dealer Tony Shafrazi, he painted a giant red X over the scene of the action. The quintessential photorealist artist described the decision to add that editorial detail in a 2005 interview with the *Art Newspaper* as, "Not only was it putting an X through apartheid in South Africa it was X-ing out the photorealist movement."

Ana Finel Honigman

Date 1970

Country USA

Medium Oil on canvas

Collection Ludwig collection, Aachen, Germany

Why It's Key Major work marking a break with what had become the formalities of photorealism.

601

Key Artist **Robert Smithson**
Creation of major earthwork, *Spiral Jetty*

Robert Smithson was born in Passaic, New Jersey. He attended the Art Students League and the Brooklyn Museum School while still at high school. He moved to New York, to practice as an artist, and in 1959 he had his first solo exhibition at the Artists' Gallery. Smithson expanded the range of what could be constituted as artistic practice. His oeuvre includes essays, proposals, sculpture, and earthworks.

By 1964 he was using the Minimalist idiom to problematize visual perception and language. The impetus toward environmental work began earlier, when he traveled in remote areas of America. In 1968 he started producing his Nonsites which involved intervening in the landscape by displacing material from a site to the gallery, and presenting it in minimal-style receptacles, with maps. His structured positioning of mirrors in the gallery, and in the environment (the *Mirror Displacements* of 1969–70), acted as a deferring mechanism in which perception was further removed when relying on the photographic records produced.

In 1969 Smithson took his work out of the gallery and concentrated on his lifelong interest in entropy, as explained in his 1966 essay "Entropy and the New Monuments," that is, the inevitable decline of matter, systems, and networks into decay and disorder. Gravitational pours, where industrial materials would be poured down a slope in the landscape and the resultant unpredictable flow filmed, demonstrated his interest in the random nature of energy. In 1970 he created his major earthwork, *Spiral Jetty*.

He was killed in a plane crash in 1973.

Sarah Mulvey

Date 1970

Born/Died 1938–1973

Nationality American

Why It's Key One of the first artists to create earthworks, of which *Spiral Jetty*, in the Great Salt Lake, Utah, is probably the most famous. The subsequent effects of time, water, and weather on the basalt rocks used were of great interest to him.

opposite Smithson's *Spiral Jetty* earthwork.

Key Artist **Judy Chicago**
Organises first Feminist Art Program in the United States

Strongly influenced by the radical feminist movement of the 1960s, Los Angeles sculptor Judy Chicago started addressing feminist issues in her art while developing a feminist pedagogy for women art students. In 1970, she created a radical Feminist Art Program at Fresno State College in California. Classes took place in a studio space off-campus and the fifteen students devised their own curriculum.

Much of the work was based on group discussions and workshops questioning issues of traditional gender roles and stereotypes. Students held consciousness-raising sessions, and shared their personal histories and experiences as women, thus linking the personal to the political. They analyzed the mechanisms of social oppression, and produced studio work under Chicago's supervision.

This interdisciplinary approach went hand-in-hand with a multimedia practice, ranging from diary-writing to photography, sculpture, or performance, as well as collaborative techniques usually associated with female folk art, such as patchwork or needle work. This approach undermined the canons of formalist art and traditional hierarchies of male-dominated art history.

Students were encouraged to represent the female body. Assertively reappropriating a usually derogatory term, they produced "cunt art," often using "abject" materials such as blood, sex toys, or tampons. Under the impetus of Miriam Schapiro, a successful New York painter then teaching at the California Institute of the Arts, the Feminist Art Program moved to Cal Arts in 1972, raising the profile of feminist art.

Catherine Marcangeli

Date 1970

Born 1939

Birth Name Judy Cohen

Nationality American

Why It's Key Chicago's art program was an educational experiment based on feminist theory and practice.

Key Artist **Tom Phillips** Creates the artwork
A Humument: A Treated Victorian Novel

In 1966, Phillips made an arbitrary rule that he would purchase the first book he could find for three pence. He bought a Victorian novel titled *A Human Document* by W. H. Mallock, and set out to alter it systematically and methodically. At first he recalls that he "merely scored out unwanted words with pen and ink." But it was not long before the possibility became apparent of making a synthesis of word and image; this more comprehensive approach called for a widening of the technique to be used and of the range of visual imagery.

Painting (in acrylic gouache) became the basic technique, with some pages still executed in pen and ink only, some involving typing and some using collaged fragments from other parts of the book. Phillips also mimicked different styles, from Abstract Expressionism to Constructivism or Pointillism. The first page of the *Humument* reads: "The following sing I a book, a book of art, of mind art, and that which he did, reveal I." Appropriately, the narrator of *A Human Document* finds a manuscript "broken by pages after pages of letters, by scraps of poetry, and various other documents." Phillips' obliterations let that text peek through in places, thereby creating a new, "found" or "revealed" poetic narrative.

A Humument recounts the unrequited love of its protagonist, Bill Toge, whose surname can only occur on pages which originally contained words like "together," while other pages range from the comical to the cryptic, sometimes echoing the "exquisite corpses" of the Surrealists, as in *Sixteen Portraits Hanging From a Dream*.

Catherine Marcangeli

Date 1970

Born 1937

Nationality British

First exhibited Young Contemporaries exhibition, London, 1964

Why It's Key Mixing concrete poetry with painting and collage, Phillips turns an insignificant text into a work of art.

Key Artist **Adrian Piper**
Begins *Catalysis*, a series of street performances

Adrian Piper was born in Harlem, New York where she studied art at the School of Visual Arts (1966–69) and philosophy at City College (1970–74). She received a doctorate in Philosophy from Harvard University (1981). Piper began her career as a Minimalist/Conceptual artist in the 1960s, using text, drawing and photographs on paper.

In 1970 she adopted a politicized awareness of the potential to use her own body as the object in performances in order to highlight issues of gender and racial stereotypes, beginning a series of street "performances" she named *Catalysis*. As a mixed-race female artist she could disrupt immutable ideas about difference. In order to become more socially engaged and to reach a more general audience she took her art out of the gallery and into non-art environments. In

Mythic Being (1973–1975) she disguised herself as an African-American male as a way of questioning rituals of feminine image-making and disrupting theories of racial categorization.

Throughout her career she has experimented with a range of new media: performance, installation, text-based interventions in the media, audio and video work. In a series of video installations from the early nineties, such as *What it's like, What it is* (1991), *Please God* (1991), and *Black Box/White Box* (1992), she used a pared-down, Minimalist aesthetic to expose the injustices that African Americans face and show how racial stereotyping effaces the complexity of individual difference. Piper is a professor of philosophy and has taught at many American universities.

Sarah Mulvey

Date 1970

Born 1948

Nationality American

Why It's Key Used her body to displayed various incongruous forms of behavior in the performances. She photographed these events and people's reactions to them.

1970–1979

603

Key Artist **Dorothea Rockburne**
First solo show in Bykert Gallery, New York

Born in Montreal, Canada, Dorothea Rockburne studied at the city's Ecole des Beaux-Arts and later at the experimental Black Mountain College in North Carolina, U.S.A., where she was greatly influenced by mathematician Max Dehn. She moved to New York in 1956. During the 1960s, Rockburne took abstract black-and-white photographs, and danced with the innovative Judson Theater group. She then went on to experiment with folding paper into geometric forms, which was to become her trademark art form.

Rockburne's first solo exhibition was held in 1979 at the Bykert Gallery in New York. It launched her career as a visual artist. She went on to produce many monochromatic works, inspired by her life-long interest in mathematics, as well as artistic sources as diverse as the Golden Section, Italian Renaissance frescoes, and

Mandelbrot's ideas about fractals. Her notable works during that time include the series *Drawings Which Make Themselves* (1972), which is composed with paper squares with carbon-paper markings, folded following the principles of mathematical set theory.

In the late 1970s, Rockburne began to free herself from the objectivity of Minimalism, revealing emotional qualities through experimentation with vivid colors, as seen in the *Robe Series* (1976). In the early 1990s, she exhibited installations including *Parameters and Perimeters* (1992), created with swirling lines over diagonal planes of bright color executed directly onto the gallery wall.

Mariko Kato

Date 1970

Born 1932

Nationality Canadian

First Exhibited 1966

Why It's Key Debut of important Canadian artist, whose artworks applied mathematical theory to innovative visual experimentation.

Key Artist **Joel Shapiro**
First solo show in New York City

Massive monochrome metal rectangles connected like joints and often forming vaguely organic shapes may seem like as simple enough idea, but few sculptors have successfully executed a streamlined a sense of form and figuration as New Yorker Joel Shapiro. Since his first one-man exhibition in 1970, at the New York Paula Cooper Gallery, Shapiro has been the subject of more than a hundred solo shows and retrospectives internationally. His works can be seen in public sites throughout the world, including the Holocaust Museum in Washington D.C.

Shapiro's father was an internist and his mother was a microbiologist. He received his BA from New York University in 1964 and planned a career as a physician. But after two years in India with the Peace Corps, he returned to NYU to study for an MA in art.

His first works were small-scale sculptures of houses and chairs. But since the mid-1970s, his sculpture has hinted at the human form without explicitly depicting anything recognizable. His blocky forms are not people, in the sense that there is no gender, no fleshy softness, no "individualizing" features, but they do resonate as figures.

Shapiro's art is often cited as the linking point between 1960s Minimalism and the art of the 1970s and 80s, which focused on the body as the vehicle and symbol of sociocultural and political identity. By paring the body down to its most universal components, Shapiro has made simple, elegant art that speaks to wide audiences about the complexities of existence.
Ana Finel Honigman

Date 1970

Born 1941

Nationality American

Why It's Key Important sculptor whose abstract pieces retain a non-explicit "human" identity.

Key Artist **Philip Guston**
Breaks away from Abstract Expressionism

When Philip Guston and Jackson Pollock bonded as high school students in Los Angeles, it was as if the universe had arranged it. When Hitler declared the supremacy of Social Realism and made every effort to eliminate degenerate and abstract tendencies, abstraction became a vanguard for freedom and democracy in Europe and America. This created a symbolic division between abstract and representational painting.

When the American art critic Clement Greenberg put his weight behind Jackson Pollock and Abstract Expressionism, Guston, having already created beautiful and virtuosic figurative painting as a young artist, was drawn into the hallowed circle. He went abstract and was considered a prominent figurehead in the movement for nearly two decades. Many greats

had transitioned from figurative work into abstraction. They didn't look back. Abstract Expressionism was heralded for its purity. It was considered the pinnacle of artistic development.

In 1970, when Guston exhibited at Marlborough in New York, his work caused an uproar. He'd moved from abstract back to representational. It was unheard of. Some of his new paintings were now grotesque with a ham-fisted quality. Sacrilege! But the artist was just doing what he needed to do. For Guston, the continuity of his own painting required transformation, and ongoing adjustment. He needed to stay alive as a creative artist. Many colleagues and former friends shunned him. Guston became isolated and marginalized for a time, but he kept painting.
Carolyn Gowdy

Date 1970

Born/Died 1913–1980

Nationality Canadian

Why It's Key Heralded the shift from modernism to post-modernism.

Key Artist **Peter Stämpfli**
Exhibits at Venice Biennale

The Swiss artist Peter Stämpfli adopted the tire as his primary motif in 1969. In the Venice Biennale of 1970, Stämpfli's paintings of tires and tire treads, often on canvases of arresting size, stood out from the overall tone of the exhibition. While his work bore a resemblance to Pop art, it was clear that he did not propose to showcase the banality or the reproducibility of the tire. It was, for him, a genuine preoccupation rather than a conceptual or calculated gesture.

Stämpfli always believed that focusing on small objects (such as hands holding cigarettes, or parts of machines) would render his work less emotional, less susceptible to affect, but in fact his Venice work was tangibly optimistic. It was difficult to see Stämplfi's work in either an ironic or a forbidding light; rather, he seemed to embrace the simple perfection of the tire,

and was eager (via his paintings of tire treads, which he would often execute on gallery floors) to propel his spectators on the same journey. Stämpfli himself maintained that he did not glorify industrial society or its products, but his exacting attention to detail also betrayed an unmistakable love for the object.

Shortly after Stämpfli's tire obsession began, oil shortages and wars reminded the world that the automobile was, perhaps, a temporary artifact. Stämpfli's Venice work stands a reminder of a less constrained time, one in which the use and possession of a car was seldom weighed against environmental and sociopolitical realities.

Demir Barlas

Date 1970

Born 1937

Nationality Swiss

First Exhibited 1962

Why It's Key Stämpfli's preoccupation with tires gets a high-profile airing in Venice.

1970–1979

605

Key Exhibition
22 Realists

In the spring of 1970, the 22 Realists exhibition at New York's Whitney Museum signaled the beginning of a trend in which major museums refocused attention on realism in art, thereby bestowing new legitimacy on so-called Hyperrealism.

At the time, realism had been undergoing what some art critics identified as a credibility gap. Two smaller exhibitions, Realism Now at the Art Gallery of Vassar College, May 8–June 12, 1968, and Aspects of New Realism at Milwaukee's Art Center, June 21–August 10, 1969, had paved the way for the Whitney's efforts to refocus public attention on the genre.

Under the direction of museum curator, James Monte, 22 Realists highlighted the talents of both new and established artists in seventy-six separate paintings. Exhibitors included Alfred Leslie, William

Bailey, Gabriel Laderman, Philip Pearlstein, Jack Beal, John Clem Clarke, Sperone Westwater, Chuck Close, and Howard Kanovitz. Alfred Leslie was considered instrumental in the effort to restore realism to a position of legitimacy in American art.

A major controversy erupted when New York Times art critic, Hilton Kramer reviewed the exhibit on February 15 (under "Dear Reader, Worry No More"). Kramer accused Monte of designing the exhibit for a visiting relative who knew nothing about art. He vilified Monte for omitting major realist painters from the exhibition, opting to focus on "soap opera, nostalgia, souvenir-collecting, and daydreaming." Artists around the city fired back at Kramer, accusing him of being prejudiced against realist painting.

Elizabeth Purdy

Date 1970

Country USA

Why It's Key Marked the return of exhibitions of realist painters to major museums and the ascendancy of what came to be known as Hyperrealism (aka Super Realism).

Key Artist **Ronnie Tjampitjinpa**
Begins painting in the Pintupi style

Ronnie Tjampitjinpa was born near Muyinnga in the bush lands of Australia's Northern Territory. His family traveled extensively, but during apartheid, they were forced to move into the Alice Springs area. Tjampitjinpa first won recognition as an artist in 1970 when he began painting in the Pintupi style, which was derived from the desert art movement taking place in Papunya. He continued to travel until he moved his family to Kintore when it was established in 1981, allowing them to live according to Aborigine traditions.

Tjampitjinpa's work is characterized by strong circles and connecting lines that represent Australia, the Aborigine people, and the secret "Dreamtime" of the Tingari song cycle. His paintings describe traditions that are 40,000 years old, symbolizing the ceremonies that initiated men perform at significant rock holes, sand hills, sacred mountains, and desert sites. The most dominant colors in Tjampitjinpa's works are vivid reds, blacks, and yellows.

Throughout the 1980s, Tjampitjinpa's work was included in exhibits of desert art in Sydney and Melbourne. In 1989, he won the prestigious Alice Springs Art Prize. His first solo exhibition at Melbourne in 1989 was a significant achievement in the recognition of Aborigine artists. Since then, Tjampitjinpa's work has been included in exhibits in the United States, France, Russia, and Germany, and his paintings are found in public and private collections around the world.

Elizabeth Purdy

Date 1970

Born c.1943

Nationality Australian

First Exhibited 1971, Papunya Tula Exhibitions

Why It's Key One of the first Aborigine artists to combine ancient stories with modern artistic media, influencing younger artists to carry on this tradition.

opposite Tjampitjinpa's *Dream of Two Women* (1990).

Key Event
Inhibodress Collective Formed

The Inhibodress Gallery and Collective coalesced in 1970, when the young artists Mike Parr, Peter Kennedy, and Tim Johnson set up their own working and display space in Woolloomooloo, Sydney. The founding artists represented a number of discrete traditions within Conceptual art. Mike Parr acquired infamy for his self-mutilating and linguistically-oriented performance art, Tim Johnson presented delicate and ethereal paintings of Buddhist, Hindu, and Aboriginal themes, and Peter Kennedy worked in mixed media and installations.

This heady mix of Conceptual artists and approaches shook up the hitherto staid and dealer-dominated Australian art scene, propelling Parr, Kennedy, and Johnson into the spotlight. One of the long-term results of Inhibodress was the reinvigoration of Sydney as a free zone for Australian artists, many of whom had established closer connections to London, New York, and Tokyo because of those cities' corporate support for art and greater openness to artistic exploration. Another result was the increased prestige of performance art in Australia, which contributed not only Parr but also Stelarc to the international scene. Finally, Inhibodress provided a point of departure for the budding art critic Donald Brook, who theorized much of what Parr was doing in ways that distinguished the artist's work from concrete poetry.

If the Australian Conceptual avant-garde is now firmly established, and the prestige of the Lyrical Abstractionism of the 1960s forgotten, it is largely thanks to Inhibodress' appearance on the Sydney art scene just in time for the turbulent and revolutionary 1970s.

Demir Barlas

Date 1970

Country Sydney, Australia

Why It's Key An artist-run gallery changes the rules of the Australian art scene.

Key Artist **Scott Burton**
First performance piece

Burton was one of several artists, among them Donald Judd and Richard Artschwager, who worked in the gap between sculpture and furniture in the 1970s. His chairs, benches, and tables were cut from raw stone with clarity of form, precise edges, and great style. While they extended the rigor of Minimalism's plain abstract surfaces into public use, they built upon earlier traditions of functional modernism, particularly Russian Constructivism, the Bauhaus, and De Stijl.

Furniture had been an interest of Burton's since childhood. His knowledge extended to American vernacular nineteenth- and twentieth-century types, such as the rustic Adirondack furniture carved from bark-covered tree trunks that informed his own work in granite. Rietveld's simple, tensile geometries and primary colors were also influences, and combinations of inspiration and materials distinguished Burton's designs, as when mixing mother-of-pearl and steel.

After studying painting with Hofmann, Burton took a literature degree; by the mid-1960s, he was a freelance art critic. Turning to performance, he came to notice with *Eighteen Pieces* (1971) in New York; featuring chairs animated by slow body movements, it contained elements found in his later sculpture. After 1975, when he exhibited tableaux of furniture without actors, he fabricated his own designs and worked on publicly-sited projects. His approach also threw new light on other artists. Organizing an exhibition about Brancusi, he controversially displayed several of the Rumanian's carved plinths without their sculptures.
Martin Holman

Date 1971

Born/Died 1939–89

Nationality American

Why It's Key Scott's work dissolved aesthetic boundaries between furniture and sculpture, private artwork and public use, fine and applied art.

Key Artist **Nancy Spero**
Creates pivotal work *Codex Artaud*

It was as an activist, and early feminist, that Spero first began to find her artistic voice. From 1959 to 1964, while living in Paris with her husband, the artist Leon Golub (1922–2004) she first became profoundly aware of the writings of the legendary artist, poet, and theorist, Antonin Artaud. In *Codex Artaud* (1971–72) Spero would later devise a pictographic language where various incidents fused into a scroll-like format. Collaged, printed, and cutout images were pasted together into a 25-foot stream of paper. The material was often emotive, and combined words and images to reconstruct various ways that women have been represented throughout time.

Spero is known for art that vigorously celebrates the important, and often undervalued, contribution of women to society. In 1972, she was one of the founding members of A.I.R. gallery, a non-profit organization for women artists. From 1976 through 1979, Spero researched and worked on *Notes in Time on Women*, again creating a very long paper scroll. Woman, the most important character, was referred to in various ways, with quotations. The story of struggle rolled rebelliously across history and cultures. Spero developed this theme still further in *The First Language* (1979–81) another scroll, this time without text.

In recent years, Spero has expanded into installation based work. In 2007, her *Maypole: Take No Prisoners*, was displayed at the Venice Biennale. Nearly two hundred aluminum cutouts of tortured heads were suspended from its ribbons.
Carolyn Gowdy

Date 1971–1972

Born 1926

Nationality American

Collection Museum of Modern Art

Why It's Key *Codex Artaud* is a pivotal work in Spero's highly respected oeuvre. She addresses the effects of war and oppression through political and sexual dramas which link archetypes of modern life with the world of history and mythology.

opposite Spero's *Maypole* installation (2007).

Key Artist **Hans Haacke**
Cancellation of exhibition at Guggenheim Museum

Only weeks before Haacke's exhibition opened, Guggenheim Museum director Thomas Messer questioned the validity of the presentation that was divided into Physical, Biological, and Social Systems. The latter included one visitors' poll and two pieces that involved New York City real estate holdings.

In 1974, Haacke exhibited a set of brass-framed charts detailing the Museum's Board of Trustees and their corporate affiliations revealing the link between two of the trustees and the Kennecott Copper Corporation. By using easily attainable data, Haacke revealed the Museum's family interest and the implication on the mineral wealth of underdeveloped countries.

Since 1965 Haacke had lived in the USA, working with principles (taken from General Systems Theory introduced by Ludwig von Bertalanffy in 1936) creating environmental systems that reflected on "dialectics of transformation." Having sat between Minimalism and phenomenological concerns of European post-formalism, Haacke moved on to consider institutional systems, challenging the notion of art and the artist in "real time." In 1969, he exhibited a chart documenting his findings from a survey of the audiences' places of residence at the Howard Wise Gallery. This was the first of several related surveys conducted between 1969 and the mid-1970s. With these works, Haacke confronted the art world with its "self-portrait," – the walls of the gallery as much a part of his work as the items displayed. Not drawing conclusions, Haacke implicates the audience in reading the data, revealing the ideological and economical underpinnings of a culture.
Rebecca Harris

Date 1971

Born 1936

Nationality German

Why It's Key Curator Edward Fry was fired when he publicly took Haacke's side and talked of the dangers of censorship. Proving the inseparability of money-politics and art, the cancellation did more to focus on Haacke's work than any previous exhibition at the Guggenheim.

Key Artwork *Dutch Mountain, Big Sea I*
Jan Dibbets

Throughout his career Jan Dibbets (b.1941), has experimented with photographic illusions that aesthetically explored the oddities of human perception. Photographed windows recur often. When cut out and stuck to colored paper or a painting, these windows become a part of a whole that warps as we look at it. Dibbets thus used photography in such a way that it brought the amazing perspectival tricks in Old Master paintings back to art. Bringing such feats into photography made him very influential, and gained him his international reputation.

Dutch Mountain: Big Sea I (1971) also shows an interest in fooling our eye. It consists of a group of collaged pictures of the same stretch of Dutch coastline. With each shot Dibbets changed the camera angle by 15 degrees before presenting all of them like one panorama. In this way the normally flat Dutch landscape appears undulating, hence the humoristic title of this work of art.

This and several other pieces in modern art collections around the world stem from a period in which Dibbets was associated with Richard Long and other artists concerned with Land Art. Instead of changing the land as his colleagues did, Dibbets manipulated photographs to emphasise aspects of the geometry of landscape.
Erik Bijzet

Date 1971

Country Netherlands

Medium Collaged photographs

Why It's Key Prime example of the period in which Dibbets was concerned with Land Art.

opposite Jan Dibbets

For Michael Compton, in friendship Hamilton 1982

Key Artist **Harold Cohen** Becomes guest scholar at the Artificial Intelligence Laboratory of Stanford University

When photography was invented, it was often mistrusted as a technology that would make painting obsolete, and concerns about machines replacing human artists will never fade. In the early 1970s, British born painter Harold Cohen became interested in computer programming, and especially the emerging field of artificial intelligence.

Cohen received his degree in painting at London's Slade School of Fine Arts, where he later taught in the visual arts department while exhibiting in major shows and representing the UK in the Venice Biennale, Documenta 3, the Paris Biennale, and the Carnegie International. After a visiting professorship in San Diego, in 1971 he was invited to spend two years at the Artificial Intelligence Laboratory of Stanford University as a Guest Scholar. There he developed a machine-based simulation of the cognitive processes underlying the creative act of drawing. Original "freehand" drawings by AARON, the resulting and still ongoing program, have been exhibited in museums and science centers including the Los Angeles County Museum, Documenta 6, the San Francisco Museum of Modern Art, the Stedelijk Museum in Amsterdam, the Brooklyn Museum, the Tate Gallery in London, and the IBM Gallery in New York.

More intriguing than a computer's ability to create a drawing is the comforting fact that AARON is a terrible artist. AARON's images are rote, rough in appearance, and infinitely less interesting than Cohen's intellectually expansive and dynamic achievement in implanting "creativity" into a machine.
Ana Finel Honigman

Date 1971

Born 1928

Nationality British

Why It's Key Heralding the age of information technology, leading experimentation in the area of "robot" intelligence creating works of art.

opposite Harold Cohen's computer-generated *Untitled Computer Drawing* (1982, ink and textile dye on paper).

1970–1979

613

Key Artwork *Wordline*
Bill Vazan

Canadian artist Bill Vazan (b.1933) is known internationally for his Land Art works. He has developed his ephemeral pieces all over the globe, creating large-scale drawings on the Peruvian Nazca plains (1984–1986), in Toronto (*Ghostings*, Harbourfront, 1978–1979), and in Sweden (*Socle Circulaire*, Gotland, 1997). Vazan's land art is always influenced by the geological and historical characteristics of each site, which the artist partly re-creates through his work.

From the end of the 1960s, Vazan's work changed notably. He stopped using photography purely as a way to document his work and started producing photo-montages; most importantly, his work took a definite Conceptual turn. The motif of the line was always prominent in Vazan's Land Art work, and it also proves particularly central to his more Conceptual work. Thus, for the *Wordline* project (1971), Bill Vazan traced a segment with black tape on the floor of twenty-five locations in the world, and then proposed to join all those segments to create a virtual line which would go all around the world.

Vazan's *Wordline* renders visible the links uniting objects and men, in a local as well as in a modern global environment where distances seem greatly reduced. For the artist, the line is also the form that precedes all other forms, and alludes to the linearity of human existence. And whether through Conceptual pieces such as *Wordline* – but also *Intercommunication Lines* (1968–2002) – or in Land Art pieces, the line symbolizes a certain cosmology and rationalization of the universe.
Adelia Sabatini

Date 1971

Country Twenty-five locations worldwide

Medium Tape on floor

Why It's Key Linking twenty-five locations on the face of the earth associates Conceptual elements to Land Art.

Key Artist **Nobuyoshi Araki**
Sentimental Journey honeymoon photo-diary

Araki's work runs along as an almost parallel line to his own biography. To Araki, photography suspends feelings and links them to a particular moment, sublimating the link between the two as the photographed exterior becomes a symbolic signifier for the artist's inner turmoil.

It was through his job as a cameraman that Araki met his wife and started taking pictures of their conjugal life. In 1971, he published at his own expense a thousand copies of his work *Sentimental Journey*. In a series of a hundred pictures, he recorded important moments of his honeymoon with his wife Yoko. The photo-diary combined official pictures such as the traditional groom-and-bride shot with candid shots taken in intimate moments of nudity, sensual bliss, or melancholia. Following the publication of the

Sentimental Journey, Araki published another photo-diary in 1989 entitled *Winter Journey* where his camera followed his wife's struggle against cancer all the way until her death. In a similar mode to the first work, Araki alternated street and anonymous shots with pictures of intense intimacy. Araki's approach to photography recalls the Japanese literary genre of the personal novel, focusing on the intimate and private aspects of daily life.

After his wife's death, Araki's work shifted in a different direction and expressed a cruder poetry as the artist focused on empty landscapes, macro photography of flowers and seafood, as well as on portraits of nude and bondaged young women, reminiscent of Japanese Shunga erotic books.
Sophie Halart

Date 1971

Born 1940

Nationality Japanese

Why It's Key Araki introduced the style of the autobiographical diary in photography.

opposite Araki's *Bondage*, 1997 (gelatin silver print).

614

Key Artist **Dieter Roth**
First major show, Graphics and Books

The Fluxus high jinks of Dieter Roth turned trash into art-historical treasures. His primary legacy is creating mountainous messes from the ephemera, litter, and junk collected in his daily life. These disorderly time capsules memorialize the role of the artist as representative of his era, but also have their own overwhelming yet subversive sense of bizarre beauty.

Roth's earliest pieces from the 1950s were finicky, precise geometric design pieces mainly centered on the juxtaposition of primary colors. But his installations are the works that earned him his striking standing in contemporary art history, sprawling constructions of wood scraps, rotten food, old television sets, and other junk. Roth's sense of play, by all accounts fueled by alcohol, has resulted in a immense series of library shelves stacked with 623 chronologically arranged

office binders filled with trash. His archives of everyday objects contain peach pits, used napkins, hotel receipts and many moldy cigarette butts.

His first major show, Graphics and Books (Grafik und Bücher), opened at The Hague in 1972 and then traveled to Basel, Zurich, London, Berlin, Düsseldorf, and Vancouver. Roth, who worked as a book and textile designer, began producing his signature installations after he encountered the Swiss artist Jean Tinguely's 1960 self-destroying *Homage to New York* (which failed to destroy itself).

The exhibition was significant as Roth's first move toward Destructivism, the movement of which his installations of dying and discarded objects made him the most evergreen proponent.
Ana Finel Honigman

Date 1972

Born/Died 1930–1998

Nationality Swiss

Why It's Key Major name in "found" and auto-destructive art.

Key Artist **Miriam Schapiro**
Curates *Womanhouse* installation in Los Angeles

Since the 1970s, Judy Chicago has galvanized critics and other artists into dismissing her work and its politics or embracing her work because of its politics. But Miriam Schapiro, the woman who joined Chicago in founding the CalArts Feminist Art Program for the California Institute of the Arts in 1971, is often forgotten. Arguably the stronger artist, Schapiro is a figure whose place in feminist art history should not be overlooked.

Schapiro was born in Toronto and studied painting in New York and Iowa. In 1946, she began to develop a reputation as a successful hard-edge geometric painter. But she emerged with a distinctive style during the 1960s, when she became active in the feminist movement. Her style of collage incorporated banal, often domestic or "feminine" objects and materials, such as lace, fabric scraps, buttons, sequins, and tea towels into multi-layered compositions which she dubbed "femmage." Schapiro has also been credited as starting the Pattern and Decoration movement, which spotlights a multicultural decorative art tradition.

In 1972, Schapiro co-curated *Womanhouse*, a woman-only installation and performance space located for a month in a seventeen-room mansion in Hollywood. With rooms titled *Menstruation Bathroom*, the *Womb Room*, the *Lipstick Bathroom*, and *Nurturant Kitchen*, it was a space devoted to debunking stereotypes of femininity and female passivity.

Schapiro helped women artists to realize their creative potential. Her subversive stitching validated women's hand-craft tradition, blazing a path for artists like Tracey Emin, Ghada Amer, and others to follow.

Ana Finel Honigman

Date 1972

Born 1923

Nationality Canadian

Why It's Key Seminal figure in the feminist art movement.

616

Key Artist **Clifford Possum Tjapaltjarri**
Joins Papunya Tula School of indigenous artists

In 1972, Australian schoolteacher Geoffrey Bardon encouraged a number of indigenous artists who had lately inhabited the Western Desert to express Aboriginal lore on the canvas rather than on sand. The resulting explosion of creativity in the settlement of Papunya Tula gave birth to the Papunya Tula school, whose indigenous painters become a major force in the world of Australian art.

Among the school's acknowledged masters was Clifford Possum Tjapaltjarri of the Anmatyerre, who had acquired extensive wood carving experience before giving himself over to painting at Papunya Tula. Tjapaltjarri worked in the abstract Aboriginal style known as "dot painting," whose motifs were places, spirits, and shapes sacred to the inhabitants of the Western Desert. At first, Tjapaltjarri's paintings tended to be small, but by the mid-1970s his work started to become more ambitious and larger in scale than that of his peers, and he had also come to demonstrate a robust mastery of color. Much of Tjapaltjarri's mature work focused on mapping the Western Desert – not in any bland cartographic sense, but with lines, dots, and daubs of color that represent not just the fact of the land but its mythological pathways as well.

Tjapaltjarri died in 2002. Today he is represented in many museum collections, and in 2007 his *Warlugulong* sold for nearly one and a half million euros, setting a record for any indigenous artwork in Australia. It was part of a series of paintings that mapped the Anmatyerre portion of the Western Desert.

Demir Barlas

Date 1972

Born/Died c.1933-2002

Nationality Australian

First Exhibited 1970s

Why It's Key The dean of Australian Aboriginal painting encounters a new medium through which to tell his people's sagas.

opposite *Warlugulong* (1976, synthetic polymer paint on canvas).

Key Artist **Vito Acconci**
Produces *Seedbed*, his most famous work

In the late 1960s Acconci abandoned the creation of poetry works and turned to performance, installation, and body art. As a poet, however, he had used the page as an area in which to act, defining words as "props for movement." In his shift to visual art, he replaced the page with the space of the gallery. Using his own physical and psychological presence, he proposed a new form of material object by doing away with distinctions between an artist and his audience, art's conventional context, and a temporal event.

In *Proximity Piece*, Acconci stalked exhibition visitors he did not know, standing unusually close so they would move. In other pieces he tested his endurance or masculinity with masochistic ordeals that involved biting his own body or stepping up and off a stool repeatedly for long durations. In his most famous work, *Seedbed* (1972), the sound of his voice penetrated the gallery while the artist lay beneath the floor, a specially constructed platform, masturbating as he fantasized about the people walking over him. Connecting the areas with amplified sound, the performance highlighted the strength of social conventions that governed the human environment.

A preoccupation of his early activity was the distance between public and private space; using a gallery as an arena for mental interaction between the artist, the viewing public and the resulting artwork, he made onlookers "active." From 1980 he investigated these themes with installations and sculpture, and after 1988 he worked with experimental design and architectural projects.

Martin Holman

Date 1972

Born 1940

Nationality American

Why It's Key A pioneer of body and video art.

618

Key Artist **Michael Heizer**
Begins major earth work, *Complex One/City*

Michael Heizer was born in 1944 in Berkeley, California into a family tradition of anthropologists and geologists. He studied briefly at the San Francisco Art Institute from 1963–1964, moving to New York in 1966. In 1967 Heizer and his collaborator de Maria left New York to develop a new, large-scale form of "land art" in the western desert, gouging 240,000 tons of earth out of the Virgin River mesa to create the two mighty (though now somewhat eroded) incisions that make up *Double Negative* (1969–70).

In 1972, Heizer began his five-phase masterwork, *Complex One/City*, a huge, enigmatic, steel-reinforced earth installation in Nevada, inspired by traditional Native American mound-building and the architecture of pre-Columbian South America. The second complex in Phase One of *City* is 70–80 feet high and a quarter of a mile long, just one element in a sequence of massive, mystifying modernist shapes planned to extend right across the valley.

Heizer has also produced abstract paintings, and large sculptures inspired by Native American forms and prehistoric artifacts. Increasingly reclusive, in 1995 he developed polyneuropathy, which reduced his ability to use his hands. Nevertheless work on *City* should be completed before 2010, by which time the project will have cost well over US$25 million. Funds have been provided by gallery-owner Virginia Dwan and the Dia Art Foundation amongst others, but *City* is regularly threatened by a proposed railway to transport nuclear waste to nearby Yucca Mountain, and is not yet open for public viewing.

Catherine Nicolson

Date 1972

Born 1944

Nationality American

First Exhibited 1969

Why It's Key Nevada land artist and creator of the largest piece of sculpture in the world.

opposite *Guennette*, one of Michael Heizer's land art pieces, was created in Massachusetts in 1977.

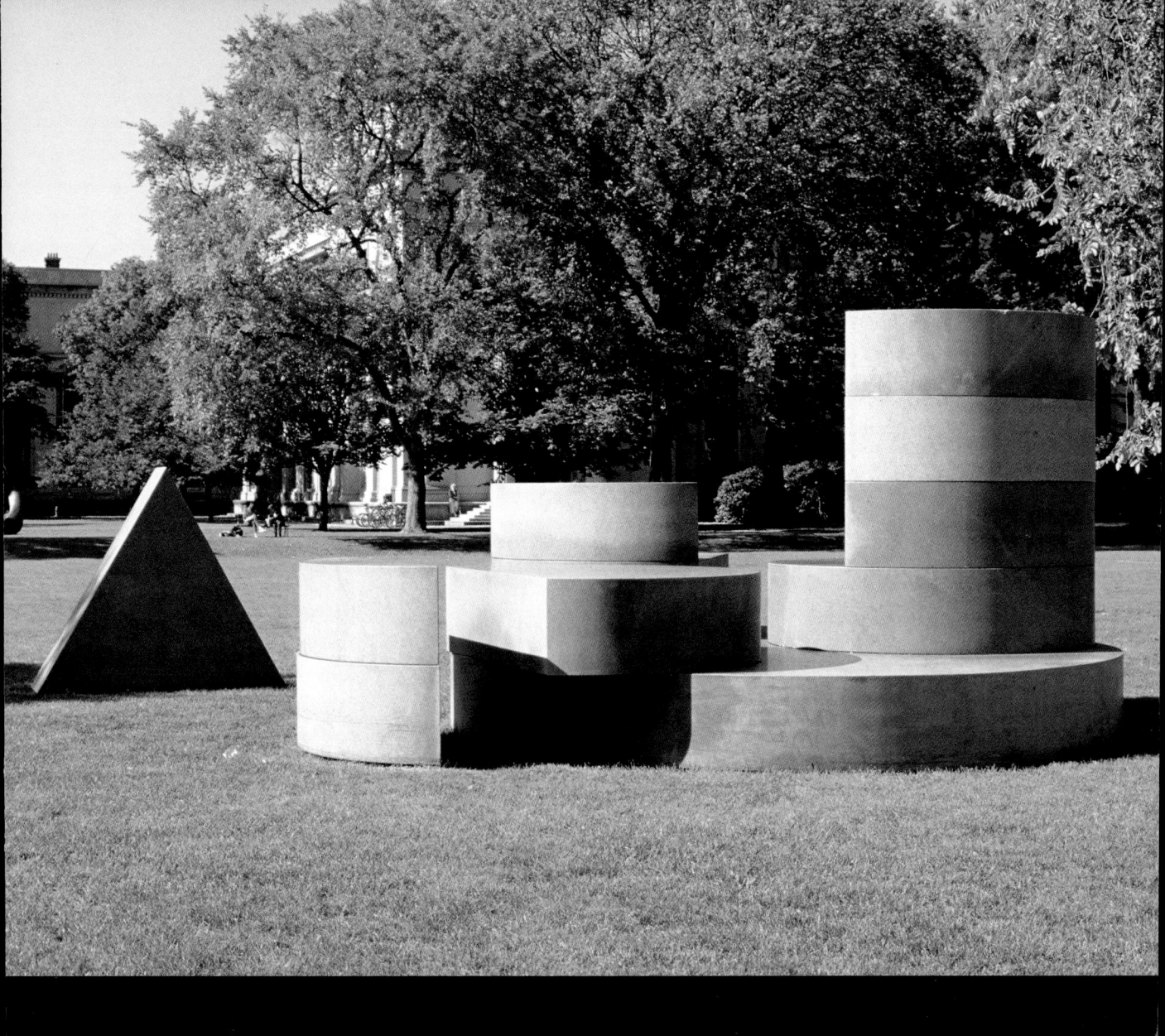

Key Artwork *Group of Four Trees*
Jean Dubuffet

Jean Dubuffet (1901–1985) was endlessly fascinated by what he called "l'Art Brut." He sought to create as free an art as that of the mentally ill and children, leading him to produce works that often appear primitive and child-like. While his earlier output seems introvert, tragic, and disturbed, he later switched to the more outgoing abstract shapes, such as the enormous sculptures and wall paintings he made as his popularity grew.

The black lines and white planes in his series of objects called *l'Hourloupe* certainly still bear the intuitive and loose qualities of *l'art brut*. Dubuffet's explanation of *l'Hourloupe* confirms why the works from this series seem to have sprouted from a child's mind. To the artist the term implied "some wonderland or grotesque object or animal" while the works are "the figuration of a world other than our own."

Dubuffet's 1972 artwork *Group of Four Trees*, as seen situated on the plaza in front of the Chase Manhattan Bank in New York today, does feel like part of another world, and is grotesque to say the least. Although dwarfed by the surrounding skyscrapers, the sheer size and three-dimensionality that comes with the interplay of the painted boxes and different heights of the trees make the *Group of Four Trees* an overwhelming and surreal sight.

Erik Bijzet

Date 1972

Country USA

Medium Synthetic plastic over an aluminum frame

Why It's Key An extremely public and large-scale work from the famous *l'Hourloupe* series.

1970–1979

621

Key Artist **Claudio Bravo**
Move to Tangier, Morocco triggers change of style

Claudio Bravo stands as a marginal in the contemporary art scene, defending academic notions of composition, light, and color and a canon of artistic beauty often declared obsolete by modern art.

Born in Valparaiso, Chile, in 1936, he attended a Jesuit school before studying painting in Santiago. He held his first exhibition at the age of seventeen and was also a dancer at a professional level. In 1961, he left Chile and moved to Madrid where he frequented the museum of El Prado and studied the works of the Old Masters, particularly Velázquez and Zurbaràn.

Bravo's canvases testify of a minute attention to composition and the alternations of light and shade. Particularly attentive to textures, the works of his Spanish period, such as his still-lifes of wrapping paper, recall a certain hyperrealism. Regularly exhibiting in New York in the 1960s, Bravo developed an affinity with the painter Mark Rothko as the two men shared a deep concern for the transcendental strength of color.

In 1972, he moved to Morocco and settled in Tangier. In the work of this period, one notices a stylistic shift as the artist developed a strong interest in light and color, certainly influenced by Morocco's weather. Focusing on the art of portraiture and still lifes, his later works surprise by the contrast between the realist representation of his protagonists in a style which may be reminiscent of orientalism and the almost abstract background. The painting *Pink Gandura* (1999) illustrates this point quite cogently.

Sophie Halart

Date 1972

Born 1936

Nationality Chilean

Why It's Key Bravo embodies an alternative trend in contemporary art as his pictorial classicism contradicts the Modernist tendencies of Pop Art or Conceptual Art.

opposite Claudio Bravo

Key Artwork *Ode to Ang*
Mel Ramos

Mel Ramos (b.1935) is categorized as a Pop artist, whose early work was inspired by comic book characters and styles of graphic execution. This interest in cartoon heroes was later followed by a style loosely classified with the Superrealists because of his slick, impersonal, pseudophotographic technique when rendering surfaces. He also makes humorous references to other artists in his punning titles.

Although *Ode to Ang* (1972) borrows an image from the neo-classicist painter Jean Auguste-Dominique Ingres (pronounced "Ang," thereby completing the pun), the female shown in the pose of a caryatid has echoes of Botticelli's Venus in the awkward positioning of the neck. The lushly painted figure stands below a cluster of fig leaves, with a stoat at her feet. The quality of paint is creamy and glossy to the point of sickliness and is reminiscent of the technique of Salvador Dalí in the absence of any logical light source.

Explicit sexual situations are referenced elsewhere in Ramos' work by means of phallic items of food or consumer goods such as Coca-Cola bottles and corn cob (Miss Corn Flakes). His later works included animals such as pelicans, gorillas, and pumas, hinting at some kind of decadent perversion. Ramos' work is nevertheless regarded as light-hearted, witty, and glamorous, very much of its time, and satirical in its references to the values of Madison Avenue advertising agencies with their exploitation of the then-current theory of Freudian psychoanalysis.

John Cornelius

Date 1972

Country USA

Medium Oil on canvas

Why It's Key Typical Ramos, referencing classic art along with Pop-inspired sexiness and humor.

Key Event
Westworld released

Westworld was the first major feature film to use Computer Generated Imagery (CGI), an innovation that was deployed for scenes showing the point of view of the movie's robotic villain. It was only 2-D CGI but its impact was to trigger rapid developments in the sector. This futuristic movie focused on an amusement park in which visitors live out their fantasies through the use of robots that can provide anything they want. After a computer malfunction two visitors find themselves stalked by a rogue robot gunslinger whose point of view needed to be chillingly artificial yet realistic.

Triple-I, an early computer company founded in 1962 in Cambridge, Massachusetts, created the digitised PoV shots, some of which took eight hours to render completely. By the time of the sequel (*Futureworld*, 1976), CGI could be rendered in 3-D and from then on was to play an ever more sophisticated role in the movies. Through *Star Wars*, Dire Straits' "Money For Nothing" music video, *Total Recall*, *Jurassic Park*, *Toy Story*, *Fight Club,* and *Lord of The Rings*, CGI kept advancing in sophistication, and radically altered the way human beings perceived imagery.

Digital retouching had long since exploded the myth that the camera never lies. CGI went on to produce even more dramatic proof that virtual reality could be entirely indistinguishable from the real thing, even in full motion on the big screen. In 2006 a short film, *Elephants Dream*, was released on DVD with all 3-D models, animatics, and software included, free for anyone to use.

Graham Vickers

Date 1973

Country USA

Why It's Key *Westworld* was the first mainstream movie to used computer generated graphics.

Key Artist **Chuck Close**
First exhibition at MoMA

When Chuck Close suffered a spinal artery collapse in 1988 on the day he was to give a speech at an art awards ceremony, the international art world mourned the apparent loss of his immense talent. Prior to his illness, the Washington-state born painter's meticulously detailed, large-scaled Photorealist portraits of other artists wearing slightly awkward expressions and snap-shot-style casual clothing had propelled him into every significant art institution.

Close had his first solo show in 1970 and was exhibited at New York's Museum of Modern Art only three years later, just ten years after he graduated from Yale University. But his stature as a major figure in American art was nothing compared with the admiration and adoration he earned when he returned to painting after losing all mobility in his body.

Instead of relying exclusively on assistants, Close first re-started to paint by holding the brush between his teeth; but he eventually regained the use of his arm and now paints with a brush strapped to his arm. His works have been conceptually similar to the large portraits he painted before his illness, but they are visually far more complex.

Close developed a unique style of pixilated portraits. In these paintings, he divided the canvas into a grid and painted each square separately, so that each section looks like an abstract design when the viewer stands nearby, but the whole suddenly comes together to form a strikingly recognizable portrait when seen from a distance.

Ana Finel Honigman

Date 1973

Born 1940

Nationality American

Why It's Key Close is a technically groundbreaking Photorealist painter.

Key Artist **Gary Hill**
Begins working with video

Gary Hill is one of the most important video artists of his generation, known for his exploration of the relationship between words and images. In 1969, he studied at the Art Students League in New York, where he trained as a sculptor. Although his sculptural background partly influenced his later work and he was awarded the Leone d'Oro Prize for Sculpture in the 1995 Venice Biennale, in 1973 he started working with video, which would stay his medium of choice during the rest of his career.

Hill then created more and more complex video installations, which are often influenced by literary works. *Incidence of Catastrophe* (1988), one of his most famous videos, is inspired by Maurice Blanchot's existentialist novel *Thomas l'obscur*, and *Hapenstance* (1982–83) by the philosophy of Heidegger, while *Why*

Do Things Get Into a Muddle (Come on Petunia) (1984) refers to *Alice in Wonderland*. Language and words are placed at the heart of Hill's video work, which explores their "physicality" by using sounds and staging bodies in his videos. *Hapenstance* shows computer-generated shapes composed of letters or words becoming images, and images morphing into text floating on the screen, appearing and disappearing one after the other while a voice is heard pronouncing some words. This is a way for Hill to point to the intangibility of the language, its elusiveness.

Hill has exhibited widely, most recently in 2007 in the Cartier Foundation in Paris. He now lives and works in Seattle.

Adelia Sabatini

Date 1973

Born 1951

Nationality American

First Exhibited 1971

Why It's Key Pioneer of video art.

Key Artist **Lucas Samaras**
Photo-Transformations series

Born in Greece, painter, sculptor, and photographer Lucas Samaras emigrated to the United States with his family in 1948. There, he graduated from Rutgers University, New Jersey where he met artists George Segal and Allan Kaprow and participated in Claes Oldenburg's and Allan Kaprow's Happenings. In 1959, Samaras moved to New York to attend Columbia University, where he studied History of Art with Meyer Shapiro. He also enrolled in an acting course at the Stella Adler Studio Theater.

Samaras' early work mostly consisted of paintings, performances, and sculptures. At the beginning of the 1960s he produced the *Boxes* series, that is, sculptures in the same box format which usually contained bright or colored elements (glitter, feather, and such) and were incrusted with sharp objects (razor blades, pins, shards of glass, mirrors), and sometimes a photo of the artist himself (*Box #61*, 1967). From 1969, Samaras started experimenting with photography. His famous *Photo-Transformations* series (1973) present us with distorted and often mutilated self-portraits – all elements being very representative of his photographic work. The distortions of the *Photo-Transformations* were obtained by manipulating the wet dyes of Polaroid prints.

Samaras also worked with multimedia collages, always focusing on his body as the subject of his work and remaking his own image through varied montages and distortions, which has led to criticisms of Samaras' work as self-obsessional – perhaps fuelled by the artist's reputation of reclusiveness.

Adelia Sabatini

Date 1973

Born 1936

Nationality Greek

First Exhibited 1955

Why It's Key Experimental photographic work.

opposite From the *Photo-Transformations* series.

Key Artist **Paul McCarthy**
Creates performance video, *Painting, Wall Whip*

If it were not for the conceptual framework giving Paul McCarthy's art its meaning, he would have been committed to an asylum as a deranged lunatic.

McCarthy's art is brutal, vile, perverse, rude, and brilliant. Bestiality, incest, scatology, and pain are his themes, while he wears children's Halloween masks and covers his body in filthy food or other messy materials. In his videos and performances, McCarthy indulges in abject self-humiliation to trigger his audience's adrenaline and push their gag-reflexes far enough to compel them to acknowledge the latent filth and hypocrisy that hides in bland and banal pop-culture and "grown-up" society.

Born in Salt Lake City, Utah and originally trained as a painter, McCarthy brought the anarchic intensity of Viennese Actionism to California and, along with his friend Mike Kelley, became a father of the LA art scene. In a 1974 video, *Painting, Wall Whip*, McCarthy beats the walls of an empty loft with a tarpon soaked in paint before he smears his body with paint, ketchup, mayonnaise, raw meat, and faeces. Mocking painting and the self-importance of artists who refuse to address issues outside art in their work, *Painting, Wall Whip* forced black humor into the white-wall gallery.

Ana Finel Honigman

Date 1974

Born 1945

Nationality American

Why It's Key Important performance and installation artist who works mainly in video and sculpture.

Key Artist **Stephen Buckley**
Creates *La Manche*

From the late 1960s, Buckley's bold, assured, abstract paintings proposed a vigorous alternative to the prevailing Minimalist and Conceptual styles. His use of plexiglass, resin, industrial enamels, carpet, plastic tubing, and old clothing as well as oil and canvas emphasized the physical properties of each work.

Strong, simple painted forms often referred to everyday patterns, like sidewalk paving, and paintings comprised several panels and shaped stretchers, sometimes cantilevered into the spectator's space. Scale was carefully assessed, and titles referred to the processes in a work's making, such as *Cut, Burnt and Tied*, or to place, mood, or history, although these allusions were tenuous, like a train of thought that allows the viewer to consider multiple meanings. His 1974 work *La Manche*, for example, related equally to French phrases for the English Channel and "sleeve"; made of twelve connected canvases in a spatially diverse, wave-like formation, it reminded Buckley of wartime aerial dogfights in the Battle of Britain.

Through studying art in Newcastle-upon-Tyne under Richard Hamilton between 1962 and 1967, Buckley came into contact with leading British Pop artists including Richard Smith and Paolozzi. He also encountered the work and ideas of Picabia, Schwitters, and, especially, Duchamp, which strongly influenced his interest in changing the functions of objects. In addition to brushwork, framing, coloring, tearing, stitching, tacking, and fragmenting were techniques in a practice that broke down material qualities in order to rebuild them with new possibilities.

Martin Holman

Date 1974

Born 1944

Nationality British

Why It's Key In the 1960s and 1970s his vibrant constructed paintings challenged conventions in the wake of Minimalism's relative austerity.

626

Key Artwork *Tree Bones*
Carl Andre

Out of all the materials handled by Carl Andre (b.1935), wood is probably the one he feels closest to as, to the artist, it represents the quintessential raw material unadulterated by man's intervention. Andre, trained as a painter, turned toward sculpture in 1958. He was highly influenced by the work of Brancusi and he formed, along with Frank Stella and Donald Judd, the forefront of Minimalism, a movement that aimed to reduce forms to their most simple features.

The work *Tree Bones*, displayed at the Ace Gallery in Vancouver in 1974, is a sculpture made of thirty-seven units of wood arranged in different rows, extending side by side along one of the gallery's walls. The fragmentation of the material illustrates Andre's understanding of sculpture as a modular structure where different parts create the exhibited whole.

Moreover, the work lies on the floor, thus upsetting the common understanding of sculpture as a vertical entity. This aspect of Andre's work profoundly alters not only the artist's relation to his work but also the audience's reception of the sculpture as, instead of gazing at it through a circular movement spinning around the work, one can capture the whole sculpture in one gaze and physically walk through it, an idea that echoes Andre's theory of sculpture as a place.

This vision of art through the concept of spatiality is essential to the understanding of Andre's art as, on top of his sculptures, the artist also creates concrete poems where words form visual patterns upon the sheet.

Sophie Halart

Date 1974

Country Canada

Medium Wood

Why It's Key A leader of the Minimalism movement, Carl Andre upset the traditional understanding of sculpture.

Key Event **Formation of the Association for Native Development in the Performing and Visual Arts**

In 1974, as Canadians worked at making Canadian art more representative of the people as a whole, the Association for Native Development in the Performing and Visual Arts (ANDPVA) was founded in Toronto. The idea originated with Cree Elder James Buller, a boxer and musical comedy singer, who saw the association as an avenue for increasing employment and for developing the artistic talents of Native artists, with the added advantage of attracting mainstream attention to aboriginal works.

As part of the endeavour, ANDPVA established the Native Theatre School, which became the Centre for Indigenous Theater in 1994. This school continues to provide Native Canadians with training in all aspects of theater work, including acting, producing, directing, and playwriting. Each summer, the Centre for

Indigenous Theatre holds a seven-week session. Students spend the first four weeks in training and preparation. Plays are written and polished collectively before students take their work on tour. In 1998 the Centre initiated a three-year training program to advance Native culture and traditions in conjunction with more traditional theater training.

Throughout its history, ANDPVA has remained true to its original goals of promoting the art and culture of Canadian aborigines. In honor of Buller's contributions to Native art, since 1994 the Centre has bestowed four awards each year: Best Playwright, Best Male Actor, Best Female Actor, and the Award for the Advancement of Aboriginal Theater.
Elizabeth Purdy

Date 1974

Country Canada

Why It's Key The Association provided a means of integrating the culture and history of Native Canadians with those of other Canadians, while advancing aboriginal talents.

1970-1979

627

Key Artist **Red Grooms**
Ruckus Construction Company project

Charles Rogers "Red" Grooms was born in Nashville, Tennessee during the Great Depression. He began his studies at the Art Institute of Chicago, then Peabody College in Nashville. In 1956, he moved to New York to study at the New School for Social Research, also studying in 1957 with Hans Hofmann.

In 1975, under the direction of Grooms, Manhattan was reconstructed by an anarchic team of playful and high-spirited artists into a monumental and life-enhancing piece of public art, the *Ruckus Construction Company*. This environmental sculpture was a melting pot of worlds within worlds, capturing the full range of humanity and psychic energy of the city with remarkable virtuosity. The project was made from a wide range of mixed media, including paper maché, wood, plaster, fiberglass, and assemblage.

The piece included sights, sounds, and smells, taxis, buses, full-size wooden figures of pedestrians, rivers, parts of central park, The Apollo Theater, Brooklyn Bridge, the Chase Manhattan Building, the Chrysler building, 88 Pine St., Federal Reserve Bank, Fulton Fish Market, City Hall interior, 42nd St. interior, NYT, interior and exterior of Woolworth's, Stock Exhange floor, Trinity Church, and the World Trade Center. Much of the sprawling installation encouraged the audience to walk through it.

Red Grooms' love affair with New York would inspire an ongoing series of additions to this project over the following decades, which took the form "sculpto-pictoramas," combining painting and sculpture characterized by a humorous and satirical approach.
Carolyn Gowdy

Date 1975

Born 1937

Nationality American

Why It's Key One of the earliest practioners of the happening and associated with the Pop art movement for his Constructions. The daily ruckus of city life provides the energy and humor for much of Groom's art.

Key Artwork *Small Durand Gardens*
Howard Hodgkin

Howard Hodgkin (b. 1932) describes his paintings as "representational pictures of emotional situations." Painted from memory (sometimes over many years), they aim to recreate the intensity of a specific experience and at the same time to create a visual equivalent of that experience. Among the recurring subjects of his paintings are social gatherings in domestic interiors and encounters with fellow artists or with friends from the art world.

Small Durand Gardens (1974) combines elements from both these categories. Its title refers to the London address of the curator and writer Richard Morphet, who organized Hodgkin's first major retrospective at the Tate Gallery in 1976; and the painting commemorates a dinner-party given by Morphet and his wife, the figure discernible at the left of the image leaning inwards toward her guests. But although Hodgkin has characterized works such as *Small Durand Gardens* as "narrative paintings," they resist a merely literal interpretation.

In the early 1970s he began to eliminate the overtly figurative references that had pervaded his work in the previous decade. He developed a distinctive vocabulary of semi-abstract marks: dots, stripes, bands, arcs, splodges, and squiggles, assembled in a densely-wrought mosaic. Hodgkin's delight in sensuous and sumptuous color, one of the hallmarks of his art, is demonstrated in this painting in several unusual, and apparently incompatible, juxtapositions: mustard yellow and cobalt blue; bright orange and scarlet red; lime green and purple.

James Beechey

Date 1974

Country UK

Medium Oil on wood

Collection Private Collection

Why It's Key Typical work of the individualistic British artist who blurs the distinction between figurative and abstract painting.

opposite *Small Durand Gardens*

628

Key Artist **Fairfield Porter**
Death of key figurative painter and writer

Of the same generation as many of the Abstract Expressionists, most of whom he knew, his painting never departed from figuration. Porter regarded Impressionism as the painterly way of re-creating the presence of reality, and de Kooning, a close friend since the 1930s, as the modern painter most in touch with the great European traditions exemplified by Vuillard and Velázquez. In seeking a new visual unity in which "painting is physical and material – a reality itself," he especially admired these artists' approach.

Born in Illinois, Porter lived mostly in New York and Maine after graduating in art history from Yale. Taught at the Art Students League by the dry and graphic Thomas Hart Benton, he gravitated toward left-wing groups, painting murals with a social commentary that linked ideas and actuality. Still impatient with art as the background for theory, his postwar paintings dealt with everyday interiors, portraits and landscape in light but rich colours. Like his writing, they stayed close to specific subject matter yet were in accord with the more advanced work of de Kooning, Johns, and Lichtenstein, and the music of John Cage.

His wider reputation grew from 1951 when he began to exhibit regularly and to write frequently for *Art News* (recommended by Elaine de Kooning), *Partisan Review*, and *The Nation*. Independent and sharp-minded, his reviews identified fresh individual talent rather than new trends or ideologies. He wrote the first consequential piece about Alex Katz, championed Larry Rivers, and featured Roy Lichtenstein's first show.

Martin Holman

Date 1975

Born/Died 1907–1975

Nationality American

Why It's Key His work as a figurative painter during the heyday of abstraction, and as a fair-minded critic with artist's insight, influenced other painters.

Key Artist **Susan Rothenberg**
First solo show at Greene Street Gallery, New York

Susan Rothenberg grew up in Buffalo, New York. She went to college at Cornell, in Ithaca, New York to study sculpture, but failed the course after her teacher told her she had no talent. It seems that an early sculpture, an alarm clock with teeth, was not appreciated. She then took a break, travelling to Greece. On her return, Rothenberg was accepted into the painting department at Cornell, but soon left to study at the Corcoran School of Art in Washington DC.

At around 25, Rothenbert went through a depression. She made another trip to Europe, tried to live in Israel, then came home to her parent's house and packed a suitcase. She was in a train station on her way to teach English in Canada when mysteriously she felt the impulse to return to New York. Within a short while she found a loft and began painting again. "It was a miracle turnaround," she said. In the first year she danced in Joan Jona's avant-garde pieces and apprenticed with the artist Nancy Graves. Inspired by Jasper Johns, Philip Guston, the prehistoric cave paintings of Lascaux, Native American art, and her own experiences, Rothenberg began painting horses. It was a powerful beginning, both dynamic and meditative.

Three large canvases comprised Rothenberg's first solo show at Greene Street Gallery, New York in 1975. They were figurative paintings of horses, both minimal and expressive. Animals, nature, and daily experience still inspire her work. Rothenberg has lived in New Mexico since the early 1990s and she is now married to the artist Bruce Nauman.

Carolyn Gowdy

Date 1975

Born 1945

Nationality British

Why It's Key Celebrated in avant-garde circles for her fresh poetic vision, Rothenberg would become recognized as a Neo-Expressionist, and for helping to establish figurative art in the 1970s after a period when Abstract Expressionism and Conceptual art had dominated the world.

630

Key Artist **Sean Scully**
Moves to the United States

Scully was short-listed twice, in 1989 and 1993, for the prestigious British award, the Turner Prize, because his paintings "demonstrated the power of abstract art to embrace personal experience and psychological depth." Restricted in format since the early 1980s to irregular-shaped panels bearing stripes, bars, and checkered patterns, their simplicity and emphatic physical presence were deceptive, and masked sonorous energy and meditative potential. Surfaces were characterized by sweeps of paint that set up broad nuances of color and tone.

Scully chose stripes for their neutral forms; independent of specific reference, they communicated meanings from beyond the canvas itself through color, line, and facture while remaining unaltered. By combining panels, motifs were constructed of vertical and horizontal bands associated with places, people, thoughts or moods, such as those that triggered the circumstances of an image's making.

Born in Dublin, Scully moved to London in 1949, and studied art in Croydon, Newcastle, and at Harvard. Awarded a Harkness Fellowship in 1975, he settled in New York and taught at Princeton University from 1977 to 1983. His early paintings featured tightly meshed grid structures and rhythms of line and color that placed images beyond easy ldescription. Frustration with their formal properties led to the bold, almost architectural qualities of his later work on canvas and paper. Scully's approach recalled Rothko's abstraction, but also reflected a deep regard for the tradition of European painting from Velázquez to Goya and Manet.

Martin Holman

Date 1975

Born 1945

Nationality Irish

Why It's Key Scully showed a vigorous commitment to the spiritual dimension in abstract painting.

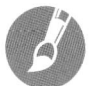

Key Artist **Julian Schnabel**
First solo exhibition in Houston, Texas

In their combination of "low" culture materials and high-art allusions, Schnabel's large-scaled paintings exemplified the re-emergence in the 1980s of gestural, expressive painting and representation. Dubbed "a new spirit in painting" by the groundbreaking exhibit of that name at London's Royal Academy of Arts in 1981, this postmodernist attitude supplanted the perceived impersonality of abstract Minimalism with demonstrable manual skill and pleasure in execution.

Seen as controversial for painting since 1978 on broken dishes and other ceramic fragments attached to bulky wood stretchers, Schnabel assimilated in his energetic and ambitious art numerous styles and influences. He quoted Renaissance masters and Rauschenberg, derived his sense of scale from Newman, and his preoccupation with material (for example, painting on velvet) from Beuys and Johns. He likened this almost indiscriminate borrowing to a computer programmed with a plethora of information, with simultaneity as a condition of the age.

Schnabel sought to combine what was to hand into new meanings. His methods appeared unconventional from the outset, and his adoption of collage in order to uphold painting was criticized as a backward step for a technique originally conceived to break open the medium. Others, however, welcomed this interrogation of modernist assumptions implied by confrontational surfaces that broke with the prevailing coherent canon of styles. Their impact was compared with Abstract Expressionism, while his multiple drawing styles recalled Pollock.

Martin Holman

Date 1975

Born 1951

Nationality American

Why It's Key High-profile representative of the postmodernist "new spirit" in painting in the 1980s.

Key Artwork **Head**
Philip Guston

When Philip Guston (1913–1980) put Abstract Expressionism behind him and plunged himself into a new style of figurative painting, many turned their backs on him. For the next decade he created an anarchic, expressionistic fusion of personal, everyday narrative, referencing Pop art, comic books, junk food, and even garbage. There was an uproar, but the artist was ahead of his time. By 1975, the year Guston painted the emotive *Head*, he knew what it felt like to be judged. Critics had thrown sharp stones. Egos had reached for their hammers. It was cold out there.

The experience seems to have left the artist raw, isolated, bruised, and worn down. He would spend his final years in isolation, before being redeemed. *Head* has no mouth, and yet it speaks of pain and brutality. It is ugly and beautiful, frightening and lovable at the same time. It is like a Cyclops baby or alien creature. It appears to be covered in blood and bruises. Has it been tortured? Or has it just been born? Guston is working with a challenging aesthetic and yet there is something darkly comic about it. Much of his work was based on day-to-day existence, facing each challenge to his artistic credibility as it came.

Carolyn Gowdy

Date 1975

Country USA

Medium Oil on canvas

Collection Estate of Philip Guston

Why It's Key *Head* was completed five years after Guston's bold transition into a new kind of painting. Life had not been easy.

Key Exhibition
New Topographics

Ansel Adams' photographs of idealized, often human-free landscapes influenced American landscape photography for decades, but there were plenty of aesthetic and political dissenters from his style. In 1975, one such group of photographers issued a counter-blast to the dominant school of landscape photography by exhibiting images of human-altered landscapes. The works of these artists – including Robert Adams, Joe Deal, Frank Gohlke, Stephen Shore, and others – gestured not to the unaffected beauty of nature but to human, industrial, and banal landscapes.

In contradistinction to Adams, the artists who exhibited at New Topographics: Photographs of a Man-Altered Landscape at the International Museum of Photography and Film, New York, depicted a highly transformed world with human fingerprints all over it,

not a pristine invocation of nature. Moreover, the photographers attempted to drain these depictions of certain forms of technique, seeking to transform the photograph from a document of the photographer's skill into an objective record.

New Topographics was only partially successful in this aim, as even its sterile photographs of banal objects produced aesthetic affects in spectators. Moreover, the group's positivist belief in the existence of a particular kind of objectivity was both outmoded and misled. For example, New Topographics consisted almost exclusively of white American men, who were limited by birth, education, and training to a certain view of the world that they naïvely considered unaffected.

Demir Barlas

Date 1975

Country USA

Why It's Key American landscape photography became less sentimental and more documentary in the modernizing aftermath of New Topographics.

Key Artist **Robert Mapplethorpe** Gift of Hasselblad camera establishes photographer's classic style

Mapplethorpe was born in Queens, New York. He attended the Pratt Institute of Art to study painting, drawing, and sculpture but left without completing his course. His early works were photo-collages made with magazine pictures and spray paint.

The acquisition of a Polaroid camera allowed him to produce photographs that were more spontaneous and intimate than usual, because of the "instant" format of the camera. In 1969 he became the staff photographer for Andy Warhol's *Interview* magazine, then in 1972 he met Sam Wagstaff, a curator of modern art, who was to become his lover and benefactor. By the mid-1970s he was using a large-format press camera; and, using the loft in New York that Wagstaff had bought him as a studio, was taking photographs of men and women whose beauty and bodies he admired.

Mapplethorpe's first solo show was at the Light Gallery, New York in January 1973 and the cultural celebrities he met then were to become models for his portraits.

In 1975 Wagstaff gave him a Hasselblad medium-format camera, which he used mostly for studio work. This, with its improved image quality and heightened detail, was what he had been waiting for. He was also interested in classical sculpture, and used the poses and compositions found there for his works, which were often of a specifically homoerotic or sado-masochistic nature.

He continued to exhibit with success and controversy in equal measure until his death from AIDS in 1989.

Alan Byrne

Date 1975

Born/Died 1946–1989

Nationality American

Why It's Key Mapplethorpe took fetish and homo-erotic/sadomasochistic imagery into the mainstream.

opposite Mapplethorpe's *Ajitto*, 1981 (gelatin silver print).

Key Artwork *If Not, Not*
R. B. Kitaj

In the early 1970s, Ron Kitaj's (b.1932) painting moved away from fragmentation and collage toward pictures that were reminiscent of the surreal, dreamlike paintings of Hieronymus Bosch. It coincided with his increasing, some say obsessive, awareness of his Jewish heritage. As an American in exile, he identified with and referred to himself as the "wandering Jew," culturally displaced with an inheritance of European literary and artistic traditions. His writings are useful adjuncts to decoding the complex web of symbols and associations contained within his pictorial imagery, and none more so than in *If Not, Not*, painted in 1975.

In *If Not, Not* a fantastical landscape is dominated by the gatehouse at Auschwitz, fronted with images of despair and destruction, while a secondary theme references T.S. Eliot's *The Waste Land*. The howl of rage in this picture is against "the greatest and most horrible crime ever committed in the whole history of the world" [Churchill] – the mass murder of the European Jews.

Kitaj has noted: "This sense of strewn and abandoned things and people was suggested by a Bassano painting, showing a ground after a battle... the general look of the picture was inspired by my first look at Giorgione's *Tempesta* on a visit to Venice, of which the little pool at the heart of my canvas is a reminder. However, water, which often symbolizes renewed life, is here stagnant in the shadow of a horror – also not unlike Eliot's treatment of water. I've [since] read that Buchenwald was constructed on the very hill where Goethe often walked with Eckermann."

Mike Von Joel

Date 1975

Country UK

Medium Oil on canvas

Collection Scottish National Gallery of Modern Art, Edinburgh

Why It's Key Kitaj's growing personal obsession with his Jewish heritage reaches an apotheosis with an intimate and confessional cry of pain at the reality of the Holocaust.

opposite *If Not, Not*

635

Key Artist **Leon Golub**
Begins *Mercenaries* and *Interrogation* series

The recurrent theme in Golub's deeply politicized paintings was the organized abuse of power through violence by the state, although his subject-matter was specific, often stimulated by American military involvements in Vietnam, then Latin America, and the civil rights struggle.

With Abstract Expressionism at its peak in the 1950s, Golub realized that the symbolic portrayal of figures, actions, and events was crucial for experiencing society as a whole. Classical art and mythology gave way to current affairs as his expressive channel with the *Vietnam* series, where the lacerated body personified the pain and distress of all conflict. In the later *Mercenaries* series, begun properly in 1979, the tension between life-sized figures and the solid colored background was emblematic of the individual's ambiguous relationship (and the artist's, too) with world events. In the *Interrogation* series that followed, brutalized males, joking between themselves, gazed out at the spectator in assumed complicity with their aggressive acts. The making of these images echoed their tough subjects; they were painted on the floor, and layers of acrylic-based paint were applied, dissolved, scraped away, and built up again.

Golub attended the School of the Art Institute of Chicago and first came to prominence as part of the "Monster Roster" in the early 1950s when Dubuffet, German Expressionism, psychoanalysis, and his antipathy with Abstract Expressionism were inspirations. From 1959 to 1964 he lived in Paris before moving to New York with his wife, Nancy Spero.

Martin Holman

Date 1976

Born/Died 1922–2004

Nationality American

Why It's Key Golub's figurative style drew on the tradition of history painting, and represented another side of modernism from mid-century onwards.

Key Artist **Duane Hanson**
Major retrospective tours the United States

Just like the waxwork figures in Madame Tussauds museum, Minnesota-born and South Florida-based sculptor Duane Hanson's hyperreal polyester resin, fiberglass, Bondo, and bronze figures are unnervingly life-like. But while Madame Tussaud modeled entertainment stars and historical greats, Hanson's subjects were exactly like the people most ordinary people know in real life.

Whether or not most gallery-goers wanted to admit it, encountering a disarmingly realistic couple of typical tacky, middle-aged tourists, or a lug with a beer in his hand and his big belly exposed, or a junkie nodding off against a wall, was not only shocking because the figures were fake, but also because it is so rare to see those demographics in an art gallery in the first place. The verisimilitude of Hanson's art evoked awe in viewers who were often alienated by Conceptual and Abstract art, even as it forced more seasoned art devotees to confront their class prejudices and unspoken tendency to objectify less educated or less stylish groups of people.

From 1976 through to 1978, a major retrospective of Hanson's sculptures went on an extended museum tour throughout the United States, where the widest possible swath of people had the opportunity to engage with Hanson's amazingly accessible, life-like and life-affirming sculptures.

Ana Finel Honigman

Date 1976
Born/Died 1925–1996
Nationality American
Why It's Key Important Hyperrealist sculptor.

636

Key Artist **Stuart Brisley**
Peterlee Project

Brisley came to prominence in the early 1970s when performance-based art established itself as an extension of, and response to, Conceptual art. Both practices marked the shift from end product to process, which was documented with photographs and film. Unlike Conceptual art, which was characterized by dematerialization and impersonality, performance acknowledged the bodily presence of the artist.

Although initially a painter and sculptor, Brisley chose performance to democratize artistic practice; the social responsiveness of his work had parallels with European groups, such as the Actionists in Austria. Unlike American male artists, among them Nauman, Acconci and Chris Burden, whose performances tended to examine general expectations about men's physical strength and emotional vulnerability, Brisley's extreme displays engaged critically with contemporary concerns. By lying in a bath of black liquid and debris for two weeks for *Art for today, Nothing* (1972), he created rich metaphors of the risks to social cohesion of individual alienation.

Brisley's inspirations came from Marxist counter-cultural politics; questioning the power of political and cultural institutions was his work's distinctive factor. In portraying the "body in struggle," he proposed means of resistance to promote individual autonomy. With the *Peterlee Project*, which he started in 1976, he initiated a living archive of inhabitants' memories, and his contribution to Documenta in 1977 challenged the American cultural hegemony that he perceived other exhibitors represented.

Martin Holman

Date 1976
Born 1933
Nationality British
Why It's Key Related severe trials of endurance to contemporary social issues.

Key Artist **Christo**
Completes *the Running Fence* project

The *Running Fence* project (1972–76) in Sonoma and Marin Counties, California, was another collaboration between husband and wife team Christo Vladimirov Javacheff and Jeanne-Claude Denat de Guillebon. Having made joint art projects for nearly fifty years, they are notoriously sensitive about the works being ascribed to Christo alone. At the end of 1974, Christo marked the path of the fence and on April 29, 1976, the work began. Approximately 200,000 m of nylon, 2,050 steel posts and 145 km of steel cable were used. By September 10, *Running Fence* was completed.

In 1957, Christo had escaped Communist Bulgaria and arrived in Paris, where he met Jeanne-Claude in 1958. The couple married on November 28, 1962. The artists still decline all grants, foundation money, and commissions – they also refuse all volunteer help or commercial involvement. Christo and Jeanne-Claude always pay the entire cost of the artworks themselves.

Since 1964, Christo and Jeanne-Claude have lived at the same address in the United States (for the first three years they were illegal aliens), and in 1973, Christo became a United States citizen. That same year, he began preparations for *Running Fence*: a "veiled fence, made from steel posts and steel cables, running through the landscape and leading into the sea." Christo works alone in his studio on the drawings which show what a project will look like. The couple earn all their money through the sale of these preparatory studies, early works from the 1950s and 1960s and original lithographs on other subjects.
Mike von Joel

Date 1976

Born 1935

Nationality Bulgarian (naturalized American)

Why It's Key The first project by Christo as an "American" artist – he gained citizenship in 1973 following many years of being "stateless" after illegally escaping Communist Bulgaria.

Key Artist **Michael Snow**
One-man show at MoMa, New York

Born in Toronto, Canada, Michael Snow studied at the Ontario College of Art, specializing in design. He launched his career with his first solo exhibition in 1957, beginning his contribution to Pop and Minimalist art movements. In the 1960s, he traveled to Europe where he spent his time drawing and playing music before moving to New York in 1963 with wife and fellow Canadian artist Joyce Wieland. He began to feature the *Walking Woman* as the exclusive icon in much of his work over the next few years.

Gradually, Snow's contribution to the arts began to extend beyond visual art, showing his talents in experimental film, sculpture, photography, and improvisational music. In 1967, he made the highly influential film *Wavelength*, which consisted of a 45-minute zoom across a loft, interrupted by a cryptic narrative involving a murder, ending on a photograph of ocean waves. Even while his work in film and music gained prominence, Snow's artistic accomplishments continued to be highly acclaimed.

Since 1962, much of his gallery work had been photo-based or holographic, but his 1976 exhibition at the Museum of Modern Art in New York displayed his flexibility and fluidity between media. Entitled *Ten Photographic Works*, the show contained only two photographic prints; the other eight were mixed-media works in which the photograph was merely generative. It reflected some concerns similar to those in films, including the instability of the image provoked by the mechanics of the camera and the conditions of light.
Mariko Kato

Date 1976

Born 1929

Nationality Canadian

First exhibited 1957

Why It's Key A central figure of the American avant-garde.

Key Artist **Walter De Maria**
Completes *Lightning Field* in New Mexico desert

Sculptor De Maria studied history and art at the University of California, Berkeley from 1953 to 1959, before moving to New York in 1960. His early sculptures were influenced by Dada and other modern art movements. This influence led De Maria into using simple geometric shapes and industrially manufactured materials such as stainless steel and aluminum – materials which are also featured in much Minimalist art. He became involved in various artistic movements, including happenings, installations, Conceptual art and – most significantly – Land Art.

Located in a remote area in the high desert of southwestern New Mexico, 7,200 feet above sea level, his *Lightning Field*, which he completed in 1977, is the most significant Earth Work sculpture ever executed. Commissioned and maintained by the DIA Art Foundation, it comprises 400 polished stainless steel poles. Each pole averages around 20 feet and 7½ inches in height and is spaced 220 feet apart from its neighbors. The poles are arranged in a grid measuring one mile by one kilometer.

Viewers often report that seeing *Lightning Field* during dusk or dawn, when the slanting rays of the sun illuminate the poles in a sequence, is a nearly divine experience. But the work's title refers to the rare moments when it becomes truly spectacular as the poles act as conduits for lightning during thunderstorms. The danger, majestic beauty, and intimate relationship of the piece with nature makes it the most compelling demonstration of De Maria's maxim: "Art reminds us we're alive."

Ana Finel Honigman

Date 1977

Born 1935

Nationality American

Why It's Key Responsible for one of the most important works of Land Art ever created.

opposite De Maria with his earlier Land Art piece *Sphinx*.

Key Artist **Jenny Holzer** Former abstract artist begins text-driven concept with *Truisms*

Born in Ohio, Jenny Holzer studied at the state University, then at Rhode Island School of Design before following an Independent Study Program at the Whitney Museum of American Art in Manhattan. After moving to New York permanently in 1977 she made the radical switch to working with ideas expressed in text, and displayed in a variety of imaginative ways in (usually) urban settings. Her *Truisms* (1977 and ongoing) peppered New York with aphorisms on phone booths, LED billboards, posters and, by 1999, even extended to decorating a BMW entered in the 24 Heures du Mans endurance race.

Hers was a remarkable *volte-face*, abandoning a non-representative aesthetic for one of slogans expressed through a wide a range of media. Sometimes the concept is a general one (*Please Change Beliefs*, 1995, was created for an Internet art gallery), and sometimes the location brings its own resonant associations (as in the spooling poetry Holzer had drifting across a giant wall in the lobby of 7 World Trade Center, New York).

Although Holzer remains something of a one-off, her desertion of abstract art in favour of moral sloganizing and fortune-cookie wisdoms may be seen to reflect society's shift of sensibility away from the reflective and subjective aesthetic of painting toward a more muscular kind of contemporary art. It is art that trades in the visual vernacular of the day: advertising slogans, subtitles, news headlines, urban signage, and the big, impersonal delivery systems that most frequently disseminate them.

Graham Vickers

Date 1977

Born 1950

Nationality American

Why It's Key Reintroduced pure ideas to contemporary conceptual art without the distraction of imagery.

Key Artist **Donald Sultan**
First one-man show at the Artists Space, New York

Born in Asheville, North Carolina, Donald Sultan studied at the University of North Carolina at Chapel Hill and at the School of the Art Institute of Chicago. In 1975, he moved to New York to pursue his artistic career. His first solo exhibition was mounted in 1977, at the Artists Space in New York, and launched him into prominence. His work is voluminous and varied, displaying his talents as a painter, printmaker, and sculptor. Sultan became particularly celebrated as a painter and draftsman of subjects such as lemons and flowers in large-scale still-life paintings created with bold contrasts of bright color and deep black forms.

Despite their roots in still-life tradition, Sultan's compositions are, first and foremost, abstract. They are considered studies in contrast, with large pieces of fruit, flowers, or dominoes set against a stark, black background. New concepts develop from the traditional objects, with the oval of his lemons leading to a series of oval-blossomed tulips and dots from dice becoming oranges. Instead of canvas, Sultan uses masonite covered with 12-inch vinyl floor tiles that dictate a geometric format.

Sultan is highly acclaimed for fusing organic shapes with a formal simplicity. Although much of his work is powerfully sensual, it is also paradoxical, with Sultan describing it as "heavy structure, holding fragile meaning" with the ability to "turn you off and turn you on at the same time."

Mariko Kato

Date 1977

Born 1951

Nationality American

First exhibited 1977

Why It's Key Versatile contemporary painter, printmaker, and sculptor, who is best known for his still-life work.

Key Artist **Jeff Wall**
Produces his first back-lit photo-transparency

Canadian artist Jeff Wall first exhibited large-scale photo-transparencies mounted on light-boxes in 1977, after noticing back-lit advertisements in bus stops across Spain and London.

Vanvouver-born Wall received his MA from the University of British Columbia in 1970, with a thesis titled "Berlin Dada and the Notion of Context," and did postgraduate work at the Courtauld Institute from 1970–73, where he studied with the Manet expert T.J. Clark. He served as assistant professor at the Nova Scotia School of Art and Design (through 1974 and 1975), was associate professor at Simon Fraser University (1976–87), and also taught for many years at the University of British Columbia.

Many of his images are updated adaptations of well-known paintings from the art history canon by Velázquez, Hokusai, and Edouard Manet, while others were inspired by literary sources such as the writings of Franz Kafka, Yukio Mishima, and Ralph Ellison. Wall's use of an advertising gimmick to promote his "high culture" source material was a brilliantly subversive way of combining mass media with intellectual culture.

The glow of the bright light behind the images made the act of seeing them as interesting as the complex theory and thinking underpinning Wall's philosophical approach to appropriation. By carefully staging his images, faithfully declaring his admiration for his sources and setting them in the light-boxes where they glowed with an arresting appearance of greatness, Wall's art illuminated individual artists' humble yet aspirational relationship with art history.

Ana Finel Honigan

Date 1977

Born 1946

Nationality Canadian

Why It's Key Wall is a unique "appropriationist" photo artist.

opposite Wall at the installation of *The Stumbling Block*.

Key Event
Pompidou Center opens

Centre Georges Pompidou was a slap in the face for the traditional aesthetic of grand public buildings. Built in the Beaubourg district of Paris between 1971 and 1977 to house a huge public library, a museum of modern art, and a center for music and acoustic research, it was always going to enjoy a high profile as one of France's biggest and most ambitious Grands Projets.

Devised by signature architects Richard Rogers and Renzo Piano, along with engineers Ted Happold and Peter Rice, it was a world-famous example of architectural iconoclasm: a playful building with an exposed skeleton of services and mechanical systems that not only were not hidden in the traditional way, but very conspicuously celebrated with an explosion of colours. The colours used echoed those of a services diagram: green for air, blue for water, red for transportation, and yellow for electricity. Such coding was of course entirely unnecessary, but that was part of the point.

The Pompidou Center, named for French President Georges Pompidou, who died in 1974, was about making access to culture fun. The playful concept extended to the public square outside, which featured the Stravinsky Fountain with its colourful moving water sculptures, including works by artists Jean Tinguely and Niki de Saint Phalle.

Graham Vickers

Date 1977

Country France

Why It's Key Revolutionized architecture and the visual palette of the late twentieth century with an iconic building turned inside out.

opposite Centre Georges Pompidou, Paris.

642

Key Artist **Richard Prince**
Begins re-photographing magazine advertisements

Today, stores such as Topshop poach designs mere days after they hit the runways, rap singers sample songs from all over and whenever, and Intellectual Property is one of the most highly contentious and confusing areas of the law. In this postmodern era, imitation is not only the sincerest form of flattery, it is an artistic device for the age. And appropriation's acceptance in contemporary art practices is largely thanks to Richard Prince.

Trained as a figurative painter, Prince began working in collage, primarily with photographs, in 1975. His image, *Untitled (Cowboy)*, a re-photographed cigarette advertisement, was the first "photograph" to raise more than US$1 million at auction when it was sold in New York in 2005, despite violating numerous copyright laws. Prince began re-photographing photographs from the *New York Times* in 1977. By photographing and then exhibiting other people's photographs, the then twenty-eight-year-old artist sparked serious debate about the meaning of authorship, authenticity of photographic images, and copyright law about images.

In 1981, Sherrie Levine became the darling of appropriation theorists by exhibiting her *After Walker Evans* series, which re-photographed Evans' iconic images. But Prince got there first and stuck to appropriating cheap, cheesy, and compellingly commercial mass media imagery. Still coveted by collectors, curators, and critics, Prince's high-low allure and irreverent dark humor have defined his impact as a contemporary artist.

Ana Finel Honigan

Date 1977

Born 1949

Nationality American

Why It's Key Prince is an audacious master of the "re-photographed" artwork.

Key Exhibition
The first Sol Lewitt retrospective

After pursuing an interest in design for years, Sol Lewitt was employed at entry level in the Museum of Modern Art in New York in 1960. In retrospect, exhibitions, such as the Sixteen Americans show, that were staged during his years in the Museum were of great importance to Lewitt's artistic development. This development took Lewitt from employee to the star of a solo exhibition in the same museum within eighteen years. His first retrospective, in 1978, showed some of his wall drawings, framed drawings, and several "structures" – a term he preferred to "sculpture" – media on which the artist would leave a grand impression.

Most of the structures in the show – or indeed in his career – were based on connected open cubes and had titles like *Double Modular Cubes*. His early wall drawings were also often based on geometry and therefore got him characterized as a Minimalist. Lewitt's later works however were usually colorful, optimistic, and quite complex. His overwhelmingly present and often enormous wall paintings in particular are illustrative of Lewitt's take on art. These geometric patterns often encapsulate the viewer and can consist of any color scheme, from neon to earth tones to black and white.

Lewitt would leave his designs vague so that the team of assistants who carried a work out – sometimes taking weeks – were permitted to participate in the creative process. Nevertheless he made sure that the end result pleased him.

Erik Bijzet

Date 1978

Country USA

Why It's Key First retrospective of the enormously influential American artist who helped to establish Conceptualism and Minimalism.

opposite LeWitt's *Wall Structure: Five Modules with One.*

1970–1979

645

Key Artwork *The Feathered Prison Fan*
Rebecca Horn

Few artists suffered for their craft as dramatically as the German artist and poet Rebecca Horn (b.1944), and fewer still used their suffering so effectively. Horn enrolled in the Hamburg Academy of Fine Arts instead of studying economics as her parents had planned. But her art education lasted only a year because she contracted severe lung poisoning from working with glass fiber without a mask.

Because media like fiberglass and polyester became off-limits for Horn, whose lungs had become too fragile to be exposed to such toxic substances, she began to work with softer and more prosaic materials, particularly feathers. When she returned to art school, her long illness and suffering informed her art, and padded body extensions and prosthetic bandages became her signature pieces.

In the late 1960s, she began creating performance art and continued to use bodily extensions. Her 1978 work *The Feathered Prison Fan* was originally made for her film *Die Eintänzer*. The kinetic sculpture took on its own life as more than a mere prop, but rather as an exemplification of Horn's particular aesthetic. The tension in the work's title between the harsh and frightening "prison" versus the sweet, gentle, and tickling "feathers" exemplifies Horn's poetic sensibility and her frustration at limiting her artistic options by a self-inflicted illness.

Ana Finel Honigman

Date 1978

Country Germany

Medium Feathers

Why It's Key Unique use of body modifications as an art form.

Key Artist *Untitled Film Stills #15*
Cindy Sherman

The curvy pretty blond dancer gazing out from her studio window in Cindy Sherman's (b. 1954) *Untitled Film Still #15* (1978) is both an anonymous young woman who could be found in any big city, and one of the most famous and important artists of the late twentieth century. The fact that Cindy Sherman was able to morph for her camera into a seemingly endless array of familiar archetypal characters made her into a leading practitioner of postmodern art.

In *Untitled Film Stills*, Sherman posed for a series of sixty 8x10 black and white photographs recalling publicity stills from 1950s and 1960s B-grade movies. In these images, she presents herself in the guise of various stereotypes of femininity - louche, glamorous, downtrodden, smouldering, innocent or the embodiment of another stock characteristic.

Her ability to perfectly represent these often incompatible qualities demonstrated that identity, and particularly gender identity, is a mutable and essentially cultural construct, not an innate fact. Feminists and other theorists loved Sherman for her ability to illustrate these ideas, but the real impact of her art is its unfailing power to stimulate discussion while also stirring emotions.

The girl in *Untitled Film Still #15* might be Sherman acting out a part, but we still feel there is a real person sitting in that window, looking out at the city.

Ana Finel Honigman

Date 1978

Country USA

Medium Monochrome photographs

Why It's Key Part of the conceptual self-portraiture photography series that made Sherman world famous.

opposite **Number 7** in Cindy Sherman's Untitled Film Stills series depicts a young star on location at her seaside hideaway.

646

Key Artwork *The Destroyed Room*
Jeff Wall

Given that Canadian-born Wall (b.1946) was educated as an art historian, it is not surprising to learn that he was influenced by Delacroix's *The Death of Sardanapalus* (1827) in the making of *The Destroyed Room* (1978). Delacroix's painting depicts an Assyrian monarch on his deathbed, ordering the destruction of his possessions and the slaughter of his concubines in a last act of defiance against invading armies.

In Wall's large-scaled work we do not know what prompted the destruction of the room, but the staged evidence of it fills the frame: from left to right in a diagonal turbulence articles of furniture and clothing from what seems to be a woman's bedroom are cast about. There is an upturned bed with its torn mattress, a ransacked chest of drawers on which stands a statue of a dancing girl, a broken table, shoes, sunglasses, a

quilt, and various articles of clothing thrown about. This is a self-consciously staged urban violence with its own order: shoes and other articles that mirror each other, objects carefully placed to complement one another, the line of tears and the shape of holes artfully designed and a palette of reds, pinks, and mauves that suggests an eerie harmony and provides an inherent unity. The boards seen through the doorway seem to prop up this theatrical set, suggesting, as Wall himself has said, an unreal space that could belong to anyone.

This painterly photograph launched Wall as an innovative artist who is inspired by photography as a pictorial art that references cinema and the history of painting as much as it does photography.

Bryan Doubt

Date 1978

Country Canada

Medium Silver dye bleach transparency; aluminium light box

Collection National Gallery of Canada

Why It's Key First photograph in which Wall lights a large color transparency from behind, creating a light-box format, which he called cinematographic, thereby extending the possibilities of photography.

Key Artist **Ofelia Rodriguez**
First solo exhibition in Cartagena, Colombia

Born in Barranquilla, Colombia, and trained in Bogota, Paris, New York, and New Haven, Ofelia Rodriguez made a splash in her native country in 1978, the year of her first solo show at the Galeria El Marques, Cartagena. Her metaphysical paintings traded in wit, dread, and philosophy, carrying on a tradition that dated back to Duchamp, Magritte, and de Chirico, while her symmetrical and hard-edged use of color suggested post-Surrealist trends in analytical painting. She incorporated found objects – such as band-aids, animal tongues, and book cut-outs – into her work.

Her iconography provided oblique references to the cultural hybridity and political turmoil of Latin America. Assembled in a seamless whole, these various elements of her aesthetic combined to mark the emergence of an important painter who simultaneously engaged modernism, postmodernism, and pre-Columbian Latin American history in her thought-provoking work.

While Rodriguez achieved a measure of recognition in Colombia, the larger fame she deserved was slower in coming. In the 1980s, she exhibited mainly in Colombia, with her few foreign exhibitions occurring in Le Touquet, Stockholm, and Freiburg. She had her first New York show twenty-five years after Cartagena, and has been neglected by critics. Her career suffered by overlapping with an epoch in international art that shied away from metaphysics, statement, and modernism. Moreover, in the West, the vogue for Frida Kahlo has tended to exclude other Latin American female artists from attention.

Demir Barlas

Date 1978

Born 1946

Nationality Colombian

First exhibited 1969

Why It's Key A witty, metaphysical, and engaging Latin America artist begins her career close to home.

Key Artist **Emily Kngwarreye**
Forms Utopia Women's Batik Group

A village elder, Kngwarreye had learned the traditional songs, dances, and body and sand painting designs used during the *awelye* ritual women's ceremonies to symbolize the actions of ancestral Dreamtime beings. She discovered batik techniques during a women's bush workshop, resulting in 1978 in the formation of the Utopia Batik Group at Alhalkere in Central Australia.

The Utopia women's idiom was quite distinct from the animal tracks, stylized implements, concentric circles, and other dot motifs typical of the Western Desert Panuya community which had come to the art market's attention in the 1970s. Theirs was a freer style that integrated the stains, fluid lines, wax puddles, and other accidents specific to the batik medium, with motifs loosely inspired by plants and objects pertaining to *awelye*. Their work was shown in a major exhibition at the 1981 Adelaide Arts Festival. By the late 1980s, the Group had expanded and their batiks toured nationally and internationally.

Kngwarreye produced her first works on canvas during A Summer Project (1988–1989): Utopia Women's Painting, organized by the Central Australian Aboriginal Media Association. Like many of the women, she preferred the immediacy of acrylic to "continually boiling and boiling the fabric, and lighting the fires, and using up soap powder." She developed her own painting style of overlaid colors and images, dots of various sizes, colors overlapping to obscure the motifs, and an increasingly bold gestural style, prompting comparisons with Pollock's Abstract Expressionism.

Catherine Marcangeli

Date 1978

Born/Died c.1910–1996

Nationality Australian (Anmatyerre Aborigine language group)

Why It's Key Emily Kngwarreye empowered Aboriginal women through the transposition of traditional designs to modern media.

opposite Kngwarreye's *My Country* (acrylic on canvas).

Key Artist **Sophie Calle**
Produces *The Sleepers*

C alle researches the mystery of the human condition, asking questions and conducting fearless experiments that illuminate people's public and private selves. In 1979, she returned to her native Paris after traveling the world for seven years. Feeling lost, not knowing what to do with her life, Calle began following people around the city. She took notes and secret photographs, then wrote imagined stories.

Later that year, she was inspired to invite 29 friends and strangers to sleep eight-hour shifts in her own bed. She photographed them every hour and conducted interviews. One participant, a stranger Calle had met in a market, told her husband about the project, called *Sleepers*. He invited Calle to contribute to a group exhibition he was curating for the 1980 Paris Biennale, and Calle became an artist almost by accident.

In 1981, Calle disguised herself in a blonde wig and followed a man from Paris to Venice. For two weeks she took notes and photographs, which were published in her first book, *Venetian Suite* (1983). Later, in *Hotel* (1984) she posed as a maid in a Venice hotel, documenting untidy rooms and the contents of guest's suitcases.

After the painful break-up of a relationship, Calle interviewed people about their experiences of pain, and retold her own story until she was tired of it. Later, this evolved into the project *Exquisite Pain*, the text of which was adapted into a performance in 2004 by Forced Entertainment, a theatrical company based in Sheffield, England. At her gallery shows Calle frequently supplies suggestion forms on which visitors are invited to provide ideas for her work.

Carolyn Gowdy

Date 1979

Born 1953

Nationality French

Why It's Key Now one of France's best-known Conceptual artists, Calle represented France at the Venice Biennale in 2007. She is a writer, photographer, and installation artist, internationally recognized in galleries and museums.

650

Key Artwork *The Dinner Party*
Judy Chicago

T hrough the 1970s, the women's movement sought out its own hidden history, with exhibitions such as the 1972 Old Mistresses: Women Artists of the Past at the Walters Art Gallery, Baltimore, or Women Artists: 1550–1950, curated by Linda Nochlin and Ann Sutherland Harris in 1976. At Fresno, Judy Chicago (b.1939) had consistently encouraged her students to research this forgotten heritage, which she celebrates in *The Dinner Party* (1979).

In this reinterpretation of The Last Supper, a triangular table covering 1,000 square feet is laid with thirty-nine place settings. On each plate, a flower-like vulva design represents the honored guests, mythical or real, ranging from Ishtar ("Great Goddess of Mesopotamia, the female as giver and taker of life") to Amazon ("embodiment of Warrior Women who fought to preserve gynocratic

societies") to Virginia Woolf to Georgia O'Keefe. The names of another 999 Significant Women are inscribed on the 2,300-tile floor. Embroidered runners and napkins question the prevailing "high and low" formalist hierarchy, reminding us that women have traditionally been confined to the decorative arts.

Executed over five years, the work was collaborative, with four hundred female contributors compiling historical research or painstakingly executing the embroidery and ceramics. This prompted some to accuse Chicago of exploiting women's good will, while paradoxically depriving them of any real creative input. Others objected to heroines being represented only through their genitalia. The work nevertheless remains a seminal icon of feminist art.

Catherine Marcangeli

Date 1979

Country USA

Medium Mixed media

Collection Elizabeth A. Sackler Center for Feminist Art, Brooklyn Museum, New York

Why It's Key *The Dinner Party* is Chicago's best known and most ambitious collaborative artwork, celebrating women forgotten by history.

opposite *The Dinner Party*

Key Artist **Wijdan**
Founds Royal Society of Fine Arts, Jordan

Wijdan – also known as Her Royal Highness Wijdan Ali, first cousin of Jordan's late King Hussein – is responsible for a lot of firsts in her native Jordan. She was the first woman to serve in Jordan's Ministry of Foreign Affairs, the first female Jordanian to represent her country at various United Nations meetings, and the first Jordanian royal to take an interest in the arts.

In 1979, Wijdan (as she signs her own work) founded the Royal Society of Fine Arts, which in turn established the Jordan National Gallery of Fine Arts. Her vision was to turn Amman, Jordan, into a capital for art from the contemporary Muslim world as well as from developing countries. Both the Royal Society for Fine Arts and its gallery worked toward this end, and Wijdan herself worked tirelessly to support, exhibit, and encourage artists from the heartlands of Islam. Wijdan prepared exhibition catalogs, underwrote exhibition and lecture spaces, and leveraged her academic training in art history to write extensively on the art of Islamic civilization. In addition to all of this activity, Wijdan also painted, typically combining calligraphy with abstraction. Much of her work is represented by London's October Gallery.

The Royal Society of Fine Arts has played a leading role in exposing both Western and Muslim audiences to the work of contemporary Muslim (especially Arab) artists. Meanwhile, the Jordan National Gallery's permanent collection has grown to nearly two thousand works, a remarkable achievement considering that it began with only seventy-seven.

Demir Barlas

Date 1979

Born c.1939

Nationality Jordanian

Why It's Key A Jordanian institution founded by a remarkable princess offers opportunities to contemporary Muslim artists.

opposite Wijdan, born 1939 in Amman, *The Desert* (1979, oil on canvas [131 x 190 cm]). Collection: Jordan National Gallery of Fine Arts, Amman.

1970-1979

653

Key Exhibition
Art of the Pacific Islands

For the first time since the 1946 Art of the South Seas exhibition at the New York Museum of Modern Art, the Washington D.C. National Gallery's Art of the Pacific Islands show of 1979 presented an extensive survey of Polynesian art. New discoveries had surfaced among the hundreds of cultures and wide range of styles classified as Pacific Island art, adding distinction to the exhibit.

The motivating forces behind the exhibition were museum trustee Franklin Murphy and exhibit designer Douglas Newton, the chair of the New York MoMA's Department of Primitive Art. Objects included in the exhibit were on loan from private and public collections from the United States, Europe, and Pacific countries. The purpose of the exhibit was to showcase art that had been made before the Western influence entered the islands, and no object was included that had not been used for domestic or religious purposes.

More than 400 items were exhibited, including figures, masks, canoe ornaments, shields and weapons, ceremonial relics, carved house posts, shell ornaments, and feather capes. Encompassing 26 historical and geographic sections, the exhibit was allotted 18,000 square feet in 21 spaces in the museum's East Building Concourse.

Other celebrations of the Polynesian culture were arranged to coincide with the opening of the exhibit, including an open pit luau and performances of Hawaiian dances. After leaving Washington, the exhibit toured eight American cities before closing in Honolulu, Hawaii in 1982.

Elizabeth Purdy

Date 1979

Country USA

Why It's Key By presenting the diversity of Polynesian art forms as they existed before Westerners arrived on the islands, the exhibit established a new understanding of Pacific Island art.

Key Exhibition
5,000 Years of Korean Art

In 1979, 260 artifacts representing five millennia of Korean art – ranging from comb-pattern pottery (Jeulman) from the third millennium BCE to twentieth-century painting – toured the United States. It was an occasion not only for eager American audiences to get their first exposure to the entire continuum of Korean art but also for art historians and other scholars to begin a reappraisal of the country's art history.

As art historian Jonathan W. Best noted in his essay on the exhibition, Korea has always been considered as an intermediate space between China and Japan, and the country's art has been accorded a correspondingly interstitial status. However, 5,000 Years of Korean Art made a spectacular case for a re-evaluation of this received view. Its massed artifacts, which included exquisite ceramics, porcelain, gold and bronze work, and Buddhist pieces, depicted a Korea that had absorbed many extraneous cultural and political influences over its history, but that always folded its own aesthetic values into its artwork.

5,000 Years of Korean Art began its run at the Asian Art Museum in San Francisco, California, which worked closely with South Korea's National Museum of Art to organize the exhibit. It went on to visit the Metropolitan Museum of Art in New York, and stopped in many regional museums on the way. Over the rest of the 1980s, the Asian Art Museum went on to co-organize and exhibit landmark collections of Chinese and Mongolian art, and in 1989 hired the first curator of Korean art outside Korea.

Demir Balas

Date 1979

Country USA and Korea

Why It's Key The breadth and originality of Korean Art from antiquity onwards makes the case for a new popular and scholarly appraisal of the nation's art.

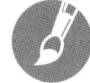

Key Artist **Bill Woodrow**
Begins his Breakdown series

The source of Woodrow's materials was the streets around his London studio. Well-used and discarded appliances, relatively free of art associations, were available cheaply from stores and skips, and all were connected with everyday domestic life. At first Woodrow embedded these items in concrete or plaster, and then chipped away to part reveal them like fossils unearthed by archaeologists.

But with his 1979 *Hoover Breakdown*, the technique for which Woodrow was best known was established: it presented parts of a vacuum cleaner fanning out before a wooden replica of the original machine, as if the replica was vacuuming up the parts. This work set up the binary relationship between a household object's former and invented identities that was developed in the ensuing decade. A guitar could be clipped and folded from the casing of a twintub washing machine, and an ethnographic sculpture drawn three-dimensionally from upholstery.

Woodrow's work confirmed a shift in artists' interests from landscape to urban culture. His ad-hoc technique with found materials was informed by *arte povera*'s reaction to Minimalism's formal rigidity, and while his sculpture questioned consumerism with subversive narratives characterized by wit and inventiveness, the non-discursive, poetic quality was equally significant in its treatment of aesthetic issues of representation and simulation. In the 1990s he began casting large objects in welded steel and bronze, which retain the symbolic and story-telling elements of earlier work. In 1986 he was short-listed for the Turner Prize.

Martin Holman

Date 1979

Born 1948

Nationality British

Why It's Key Prominent in the "new wave" of British object-based sculptors who focused on the city.

Key Artist **Cindy Sherman**
Completion of *Untitled Film Stills*

Born in New Jersey and growing up in Long Island, Sherman was a latecomer to art. She did not begin painting until she attended State University New York, Buffalo, but soon tired of a medium that she felt mainly involved duplication. "I was meticulously copying other art and then I realized I could just use a camera and put my time into an idea instead," she said.

She used herself as a chameleonic model, affecting the costume, props, make-up and hairstyles of a variety of characters and photographing the result. Her first major series, *Untitled Film Stills*, spanned 1977-80 and made her world-famous. Using monochrome photography Sherman created a gallery of double impersonations, donning the guise of an actress in stills from imaginary films.

Sherman gradually removed herself from her pictures and moved towards more lurid imagery, as in her *Fairy Tales and Disasters* series from the late 1980s. Its depictions of vomit, body parts, and grotesque fables was in shock-contrast to earlier work, which had become familiarly comfortable in the public eye. Her *The Sex Pictures* series, a protest against a wave of censorship and cuts in arts funding, featured medical mannequins in various sexual acts.

Sherman's work, deploying the camera to explore themes of artifice, identity, celebrity and notoriety, seemed to strike a chord with the public from the early 1980s onwards. She remains an endlessly fascinating artist as much for her preoccupations as for any individual piece or series.

Graham Vickers

Date 1980

Born 1954

Nationality American

Why It's Key First major series after she rejected painting in favor of conceptual self-portraiture photography.

1980–1989

655

Key Artwork *Bilderstreit*
Anselm Kiefer

In *Bilderstreit* – or *Iconoclastic Controversy* as it was later coined in English – Kiefer (b.1945) staged the battle between the forces of the Byzantine Emperor Leo III who sought to rid the Christian church of religious imagery in the eighth and ninth centuries, and the pro-image forces. In order to tell this story Kiefer would cover his studio floor with soil and lay out a battle between toy soldiers, incorporating all kinds of other objects, and take photos. In this case the Emperor's troops are represented as modern tanks made of clay, whereas the iconophiles are represented by plastic soldiers on a damaged painter's palette. The tanks, which are surrounded by the names of important iconoclasts, take aim at art, represented by the pro-image Byzantines who would restitute religious imagery.

With *Bilderstreit* Anselm Kiefer sought to illustrate his idea that spiritual things, such as art, are always menaced by real physical power. The childlike rendering of the subject is not a form of exalting the vision of a child as purer than that of adults. Kiefer chose to use a battle of toys because he thought notions like the use of power to control or suppress art were archetypal parts of human nature.

Erik Bijzet

Date 1980

Country Germany

Medium Gouache and pen and ink on photograph on paper

Why It's Key One of Kiefer's narratives. As a historical theme and a contemporary commentary at the same time, it is a quintessential example of Kiefer's art.

Key Artist **Eric Fischl**
First solo show at Edward Thorp, New York

Born in New York, Fischl grew up first on suburban Long Island, then, in 1967, the family moved to Phoenix, Arizona. Fischl has published a statement that his early life was "against a backdrop of alcoholism and a country-club culture obsessed with image over content." This vision of contemporary American white, middle-class dysfunction, has informed his work throughout four decades.

In 1970, Fischl enrolled at the California Institute for the Arts in Los Angeles. Universally known as CalArts, it is famous as a breeding ground for a generation of West Coast artists who grasped the Neo-Expressionist resurgence in painting and gave it a Californian "intellectual" twist – in sharp contrast to the graffiti-inspired New York equivalent. Faculty members included Allan Kaprow, John Baldessari, and Judy Chicago.

Eric Fischl's first one-man show was at the Edward Thorp Gallery, New York, in 1980. It created a sensation and revealed Fischl as a new breed of American Realist, approaching the taboos and frustrated desires of suburban communities in a suggestive and unashamed manner. Fischl's neat trick was to force the viewer into the hypnotic role of voyeur, a witness to something disturbingly familiar from the experience of private fantasy. It revealed an uncomfortable world of privileged dysfunction, alienated kids, and seething, unexpressed sexuality. Fischl has been compared to Degas on more than one occasion. Parallels are seen with Degas' often cruel observations in the vignettes he created of bourgeois Parisian society. Fischl has since formed a long association with the Mary Boone Gallery, New York.
Mike von Joel

Date 1980

Born 1948

Nationality American

Why It's Key The exhibition shocked the sensibilities of the cultured class with its voyeuristic suggestions of suburban dissolution and established Fischl as laureate of the new American Realism.

Key Artist **Helmut Middendorf**
Exhibits with the "Young Fauves"

Born in the city of Dinklage in northern Germany, Helmut Middendorf moved to Berlin in the early 1970s, where he studied at the Berlin Hochschule der Künste. There, he experimented with different contemporary methods for creating form, although his work was still dominated by angular, three-dimensional shapes.

However, in the late 1970s, at the suggestion of his teacher, Karl Horst Hödicke, the doyen of Berlin Neo-Expressionists, Middendorf turned to a more representational style. In 1977, together with other pupils of Hodicke such as Salome, he founded the Galerie am Moritzplatz in Berlin-Kreuzberg, which showed films, photos, and performances as well as painting, drawing, and objects The name "Die Neue Wilden" (Young Wild Ones) was given to the artists in connection with their exhibition Les Nouveaux Fauves – Die Neuen Wilden in Aachen in 1980.

Middendorf propagated "vehement painting," large-scale compositions that distort the original characteristics and motifs with collage or graffiti. His themes are drawn from his immediate environment and personal experience, to produce series in different combinations of lurid color and light. He captured the convulsive movements of Berlin disco dancers or the pose of a rock singer, turning them into "modern icons." A group-show of "Vehement Painting" mounted in the early 1980s at the Berliner Haus am Waldsee made him famous overnight, and he came to be representative of the height of Neo-Expressionism.
Mariko Kato

Date 1980

Born 1953

Nationality German

First exhibited 1980

Why It's Key Leading figure in the Neo-Expressionist "Young Wild Ones"

opposite Middendorf's
City of the Red Nights II.

Key Artist **Jean-Michel Basquiat**
Launch of Neo-Expressionist graffiti artist

Born in 1960, Jean-Michel Basquiat was a self-taught American painter of Haitian and Puerto Rican parentage. Working with friends he started out making graffiti with felt pens – signed off (tagged) with the name SAMO B. He also made drawings on all manner of found surfaces, including sheet metal and junk. His work was soon picked up by galleries and dealers and he began showing formally to great critical acclaim. In 1981 poet and art critic Rene Richard published an article on Basquiat entitled "The Radiant Child" in *Artforum* magazine and this helped to launch Basquiat's career to an international stage.

Through the early 1980s Basquiat's crayon and paint drawings on unprimed canvas, combining tribal imagery with graffiti-like slogans and messages, brought him huge success. Crudely drawn figures and scientific notations, sections of maps and handwritten text all combine on distressed, layered, colored backgrounds. And it is this mutli-layered effect which speaks so boldly about the streets of New York, Basquiat's creative heartland. Often using a crude and tribal-inspired palette of black, red, and dark yellow, Basquiat plays with notions of ethnicity and the stereotypes that surround black artists. Multi-ethnicity, hip-hop, graffiti art and street culture all combine in his primitive, montaged works.

Basquiat literally achieved success overnight and at twenty-two he collaborated with Andy Warhol and Clemente before his untimely death at the age of twenty-eight from a heroin overdose.
Emily Evans

Date 1981

Born/Died 1960–1988

Nationality American

Why It's Key Basquiat was an important 1980s graffiti-style Neo-Expressionist artist and very much of his time.

1980–1989

659

Key Event
Personal computer launched

The digital communications revolution was a coalescing of many technological advances, all galvanized by the surge of research and development for the *Apollo 11* manned moon landing of 1969. Until then computers had been large, expensive systems beyond the reach of all but major corporations and research centers. The microprocessor development led to miniaturization and mass manufacture, leading in turn to personal computers. The IBM Personal Computer, commonly known as the IBM PC, was launched in 1981 and although the term "personal computer" had been used as early as 1972 in relation to a failed Xerox product, it was the IBM platform, initially aimed at business, that came to connote any microcomputer compatible with IBM's specification. The PC's only serious rival was Apple, a company with a sustained genius for marketing but destined only ever to occupy a niche in the computer market: typically less than 4 per cent in the United States and around 2 per cent globally.

Beloved by journalists and designers, the Mackintosh punched beyond its weight, and together the two platforms democratized computing as the PC became the hands-on symbol of the digital revolution, available to anyone with a couple of hundred dollars or so. Print, movies, photography, and much else gradually ebbed away from the sometimes fiercely protected specialisms of their native technologies, went digital, and were now available to anybody. Finally, the delivery of the Internet via personal computers ensured that the launch of the PC would dwarf the invention of the printing press in its social importance and cultural resonance.
Graham Vickers

Date 1981

Country USA

Why It's Key Marked the beginning of the democratization of digital communications.

opposite The now-dated IBM home PC of the 1980s and 1990s.

Key Artist **Tony Cragg**
Creates *Britain Seen from the North*

When Liverpudlian artist Tony Cragg visited England in 1981 after moving abroad to Wuppertal, Germany, the county of his birth seemed beset by social and economic problems. Cragg expressed his disappointment and displeasure in his country's condition with *Britain Seen from the North*, a composition of plastic and mixed-media arranged on the gallery wall in the shape of the island.

Cragg placed himself in the work, as a lone figure made of the same mixed-media as the silhouette of Britain, but positioned off to the left, where he stands helplessly watching his homeland set adrift on the white gallery wall. Though he was born British, Cragg's self-position in relation to the mixed-media installation, as well as its oddly distant title, identify him as an outsider looking at Britain with a sense of detachment.

Originally employed as a a laboratory technician, Cragg is frequently cited for making art which illustrates aspects of particle physics, such as the "relationship of the part to the whole." In *Britain Seen from the North*, which was eventually bought by the Tate Gallery, Cragg demonstrated that while he himself is a separate entity, he is still composed of the same stuff which is the very essence of his native country – an illustration of John Donne's teaching that no man is an island.

Ana Finel Honigman

Date 1981
Born 1949
Nationality British
Why It's Key Leading name in contemporary British sculpture.

opposite **Tony Cragg's** *Britain Seen from the North*.

Key Artist **Syed Haider Raza**
Indian Government awards prestigious Padma Shri

The abstract painter and sculptor Syed Haider Raza achieved worldwide success but never abandoned his Indian roots. The artist, who moved to France permanently in 1952, continued to maintain his ties to India, and in 1981 was awarded the Padma Shri, the fourth most prestigious civilian award in India, by the government.

The Padma Shri recognized nearly three decades of Raza's creative work, which began when the young artist enrolled in the Sir J.J. School of Art in Bombay, which incubated many of India's finest painters. In 1947 Raza was one of the founders of India's Progressive Artists Group, the most important modernist collective in post-independence India. Three years later, Raza went to Paris to continue his studies and thereafter remained in France, but India still loomed large in his

work. For example, his Bindu series of sculptures made explicit reference to Hindu customs, and his frequent trips to India provided him with ideas for color and composition. Raza's *Bindu Rajasthan* drew its inspiration from one of India's most prominent deserts, *Kali* references a Hindu goddess, and many of his paintings are titled after locations in India.

In 2007, Syed Haider Raza won the Padma Vibushan, which is India's second most important civilian honor. It has only rarely been awarded to artists, and further confirms Raza's position in the pantheon of Indian artists. Raza is also a recipient of the Prix de la Critique (Paris, 1956) and has exhibited in Paris, Venice, Sao Paolo, New York, and New Delhi.

Demir Barlas

Date 1981
Born 1922
Nationality Indian
First Exhibited 1956
Why It's Key A pioneering Indian artist who won recognition from his homeland.

Key Artist **Rufino Tamayo**
Opening of the Tamayo Contemporary Art Museum

Zapotecan Indian artist Rufino Tamayo was born in Oaxaca, Mexico during the summer of 1899. Enrolling at the Escuela Nacional de Bellas Artes, New Mexico in 1911, Tamayo was soon exposed to many modern artistic styles, including Cubism, Fauvism and Impressionism. These he used to explore his own passion for Mexican culture, producing pieces which celebrated Mexico's everyman. Unlike many of his contemporaries, who used their artwork as a means of communicating a political agenda, Tamayo was only interested in depicting the everyday lives of his fellow countrymen. Consequently, he was branded a traitor and shunned by his peers. Feeling oppressed and resented, Tamayo moved to New York in 1926.

Tamayo was one of the pioneers of the "Mixografia" technique, producing three-dimensional, textured artwork on handmade paper. His fame and recognition grew during his stay in New York, where he completed some of his finest pieces. He lived in Paris from 1949 to 1958 before moving back to Oaxaca, where he founded the Museo Rufino Tamayo. His crowning glory was the opening of the Tamayo Contemporary Art Museum in Mexico City in 1981, which became a repository for his vast collection of artwork.

Tamayo died at the age of ninety-one on June 24, 1991. In November 2007 he made the headlines again when his 1970 painting *Three People*, was auctioned at Sotherby's in New York for US$1,049,000. Stolen in 1987, the painting was discovered lying in the street by a member of the public who was unaware of its history and value.

Michael Mullins

Date 1981

Born/Died 1899–1991

Nationality Mexican

Why It's Key One of the first artists to adopt the "Mixografia" technique.

opposite **Tamayo's** *The Cry.*

663

Key Exhibition
A New Spirit in Painting

The style that emerged in the late 1970s (and dominated the contemporary art world until the mid-1980s) was Neo-Expressionism – a direct reaction to the emotional sterility of Minimalism and Conceptual art. In America, artists like Jean-Michel Basquiat and David Salle experienced a rags-to-riches, helter-skelter ride, transformed into international stars in the boom market for "new wild" painting, itself fuelled by a sustained surge on Wall Street.

The nascent "East Village" art scene promulgated the milestones of the Neo-Expressionist graffiti fusion: Fashion Moda's graffiti exhibition curated by nineteen-year-old Crash (John Matos) in the Bronx (1980); Collaborative Project's (Colab) Times Square Show (1980); and PS1's New York/New Wave spectacular on Long Island devised by Diego Cortez in 1981. But it was a major exhibition in London that same year – at a historic venue – that sealed official recognition of the Neo-Expressionist movement. Art world heavyweights Norman Rosenthal, Christos Joachimedes, and Nicholas Serota created the seminal exhibition, A New Spirit in Painting, at the Royal Academy, which is accepted as the official beginning of the Neo-Expressionist and postmodern 1980s.

Controversial at the time, the show is now viewed as a classic prognosis of things to come. Some 150 works by 38 artists had a focus on German painters (eleven exhibitors) and all artists in A New Spirit in Painting were living except two – one being Picasso. There was not a single work by a woman.

Mike von Joel

Date January, 1981

Country UK

Why It's Key This exhibition is accepted as the "authenticated" beginning of the Neo-Expressionist and postmodern 1980s. It heralded a renewed interest in painting, especially figurative painting, and brought into fresh focus older artists sidelined by the Minimalist juggernaut.

Key Exhibition
International Furniture Fair

The historical continuum of furniture design has typically run from the functional on the one hand to the ornate on the other; in 1981, however, a third option – postmodern design – forcefully asserted its presence at the 1981 International Furniture Fair in Milan, Italy. This was the occasion for the Memphis Design Group led by Italian designer Ettore Sottsass to introduce postmodern themes and motifs such as kitsch, bright color, and humor into furniture design, and to embrace the industrial and the popular in the mode of Pop art.

Until the late twentieth century, furniture designers – like painters of the nineteenth and previous centuries – had been primarily concerned with questions of craft and technique. However, just as a post-painterly aesthetic inevitably infiltrated art, Sottsass' Memphis Design Group (named after the Bob Dylan song "Stuck Inside of Mobile with the Memphis Blues Again") proved to be in the vanguard of a post-designerly aesthetic.

Memphis abandoned taught concepts of color, taste, function, and decoration in order to embrace the found effects of juxtaposition, shock, and experiment. This proved to be an enormously influential approach, one whose playfulness, iconoclasm, superficiality, flamboyancy, and all-around excess seeped into the DNA of contemporary design, creating a clear point of demarcation between the serious past and the playful present. In this group, the Memphis Design Group became the most influential postmodern/Pop movement in furniture design, with its success mirroring the way in which the unrestrained amateurism of rock music had displaced the craft of classical music.

Demir Barlas

Date 1981

Country Italy

Why It's Key The Memphis Group introduces its postmodern furniture designs in Milan.

Key Artist **William Wegman**
His dog, Man Ray, made *Village Voice* "Man of the Year"

After William Wegman's work, it seems silly not to change the name of the Weimaraner breed of dogs to "Man Ray." Man Ray was the first of Wegman's graceful, stately, and highly accommodating Weimaraners, which the Massachusetts-born photographer posed in costumes and made into models for his camera. By 1982, Wegman's photographs of Man Ray were so popular that the New York *Village Voice* newspaper declared the dog to be "Man of the Year" in 1982.

But Wegman's images of Man Ray, with whom he had a fruitful twelve-year collaboration, and his subsequent Weimaraner models are not merely whimsical but lightweight pictures of doggies doing funny things. Instead, they are works that explore the nature of identity and the constructs of civilization which are highly respected in the established art community. For example, seeing Man Ray in a suit, looking somber and poised, makes us rightly wonder what sets humans apart from naturally elegant animals.

Wegman's photographs are included in permanent collections of the Hammer Museum, the Los Angeles County Museum of Art, the Smithsonian American Art Museum, and other leading institutions. He is also one of the highly select group of artists to have been featured on the TV program *Sesame Street*.

Ana Finel Honigman

Date 1982

Born 1943

Nationality American

Why It's Key Seemingly quirky photographs that question our own image and identity.

opposite William Wegman with dogs.

Key Artist **John De Andrea**
Creates a Hyperrealist *Déjeuner sur l'Herbe* after Manet

1980–1989

Sharp Focus Realism, the title of the first exhibition John De Andrea participated in 1970, echoes the artist's Hyperrealist approach to art. Trained as a painter, he discovered microfiber during his studies and started using the material to make molds of models that he then turned into life-scale sculptures. His work plays with the sensation of verisimilitude that it creates in the beholder. De Andrea's sculptures are often naked, a fact which allows the artist to reflect upon human fragility in contemporary society. Moreover, whether alone or in a group, his statues seem absorbed in a secret melancholia, lost in a world of their own which contrasts with their public display in galleries.

Following Picasso, De Andrea created his own interpretation of Manet's painting *Le Déjeuner sur l'Herbe* (*Luncheon on the Grass*) in 1982. The work presents three protagonists, a naked woman and two men in the same position as in the original work. However, De Andrea's variation on Manet's painting presents some particularities. Leaving Manet's colorful palette, the sculpture's general hues are black-and-white, a reference to the first photographic reproduction of the painting viewed by the artist. Moreover, the two men (portraits of the artist and his assistant) wear modern clothes splashed with paint. These characteristics reinforce the feeling of a "work in progress" as if the beholder had just walked into the studio where the artist enjoyed a break from work, an organic and living aspect that De Andrea tries to confer to all his work.
Sophie Halart

Date 1982

Born 1941

Nationality American

Why It's Key With his life-sized hyperrealist creations, John De Andrea takes sculpture to a new level of anthropomorphic verisimilitude.

opposite De Andrea's *Expulsion*.

Key Artist **Sudhir Patwardhan**
Exhibits at the Contemporary Indian Art exhibition, London

India broke away from British academic and colonial painting styles in the early twentieth century, but audiences in Britain didn't have much of a chance to learn about India's artistic independence until 1982. That was the year in which the Royal Academy of Arts hosted a Festival of India that included the seminal Contemporary Indian Art exhibition.

This exhibition was one of the first venues in which the young Indian figurative artist Sudhir Patwardhan, a practicing radiologist and self-taught painter, won exposure before a foreign audience. Patwardhan was an intriguing artist, combining as he did the social preoccupations of India's first generation of modern artists with seemingly non-judgmental techniques. This contradictory mix helped to inform the richness of Patwardhan's paintings, many of which depict ghetto scenes, workers, peasants, and other tired, hungry people whose lives Patwardhan glimpsed firsthand in his role as a doctor. Working in Thane, an industrial and fairly depressed part of Bombay, had not only given the artist long opportunity to confront spectacles of survival but also provided direct scenic inspiration for many of Patwardhan's paintings.

In retrospect, the 1982 exhibition marked the beginning of an ongoing vogue for Indian art, one that rewarded younger artists like Patwardhan as well as the established doyens of Indian art. After Contemporary Indian Art, Patwardhan exhibited nine more times in the 1980s and emerged as one of the biggest names of Indian art in the 1990s. Recently, the artist has exported his signature realism to the medium of sculpture.
Demir Barlas

Date 1982

Born 1949

Nationality Indian

First Exhibited 1979

Why It's Key Indian naïve figurative painter becomes part of a seminal exhibition.

Key Artwork *Anthony and Cleopatra*
Gillian Ayres

Evoking a disturbing warmth and passion, the colourful abstraction of Gillian Ayres' *Anthony and Cleopatra* belies its production during the bitter winter of 1981–82. The painting was composed at Ayres' studio in Llaniestyn, North Wales, while the artist was temporarily snowed in due to bad weather. Indeed, the distinctive quality of the painting is often attributed to the fact that Ayres was unable to leave the house to purchase white lead during this period, and was forced instead to use ochre for the ground.

Less crowded than most of her 1970s pieces, *Anthony and Cleopatra* is made with a diverse range of gestural oil markings to generate a sense of the sublime in the audience. As was often the case with her art, Ayres' primary goal was to move the viewer to feel strong emotion, and she tended to think of a title only once a painting was complete. She chose the title *Anthony and Cleopatra* because it communicated the mood rather than the subject of the piece.

Today, the painting perfectly underscores the gestural exuberance that marked her oil-based work of the 1980s. These characteristically feature rich colors coupled with a bold physicality of composition. Oil paints were applied, blended, and built up into thick surfaces to draw the viewer into the canvas. Often the effects were achieved using her hands. *Anthony and Cleopatra* was purchased in 1982 by the Tate Gallery in London.

Michael Mullins

Date December 1981–January 1982

Country Wales

Medium Oils

Collection Tate Gallery, UK

Why It's Key *Anthony and Cleopatra* epitomizes the powerful non-representational nature of Ayres' artistic agenda.

opposite *Anthony and Cleopatra*

Key Artist **Rosemarie Trockel**
First solo shows, in Bonn and Cologne

German artist Rosemarie Trockel established herself on the international art scene by combining juxtaposing symbols in jarring contexts. In 1985, Trockel started to exhibit works produced by a knitting machine. She knitted tapestries containing Playboy bunnies, the hammer and sickle, and the Woolmark brand, contrasting knitting's highly feminine associations with the mass-produced commercialization of ideologies, gender ideals, and assumptions about gender, politics, and identity.

As well as the knitted, patterned logos she made, Trockel also created a series of pictures of webs spiders had made, and their effects if having taken various mind-altering drugs. She says it depicts their loneliness and their weak figures, because their webs would not be strong enough to catch any prey to survive, and they would eventually die. These spider web series can be seen at the Museum of Modern Art in New York.

Having studied anthropology, sociology, theology, and mathematics, Trockel was well-equipped to address the conceptual underpinnings forming society's constructs of masculine and feminine identity. A sufferer from severe agoraphobia, Trockel's refusal to travel defined her early years as an artist, and she had her first solo shows with the Philomene Magers Gallery, Bonn, and Monika Spruth Gallery in her native Cologne.

Trockel's agoraphobia debilitated her so, Monika Spruth often attended openings and events posing as her. Yet Trockel's work resonated with feminists and other artists to such an extent that she became one of Cologne's most recognized artistic exports.

Ana Finel Honigman

Date 1983

Born 1952

Nationality German

Why It's Key Leading name on contemporary German art scene.

Key Artist **Julian Opie**
First solo show, Lisson Gallery, London

Born in London, Julian Opie studied at Goldsmiths College, London from 1979 to 1982, where he was taught by painter and Conceptual artist Michael Craig-Martin, who briefly hired Opie as his assistant. Just one year after graduating, Opie already had his first personal exhibition at London's Lisson Gallery. This rather unusually early gallery success proved an example and an incentive for the following generation of Goldsmiths students, including Damien Hirst and several other Young British Artists. Opie's early work consisted mainly of often humorous metal sculptures with household objects painted on their surfaces, such as *Making It*, (1983) which represents a large-scale saw, screwdriver, hamme,r and drill attached to large planks of wood, and *This One Took Ages to Make*, also in 1983. His most popular work, however, is undoubtedly the album cover he designed for *Blur: The Best Of*, which exemplifies his now trademark minimal design, using computer technology to reduce the complexity of the human face to its most basic elements: simple black outlines, a circle for the eye, and flat uniform zones of color to represent skin tone and hair color.

Made in the same minimal style, Opie's *Imagine You Are...* series attempted to reduce ordinary activities such as walking or driving to a few visual elements. For *Imagine You Are Driving Fast* (2002), Opie created a 60-meter-long colored wallpaper installation representing portraits of several famous drivers juxtaposed with images of the Silverstone Grand Prix racetracks – thus creating a spatial and visual experience recalling digital simulation games.
Adelia Sabatini

Date 1983

Born 1958

Nationality British

First exhibited 1983

Why It's Key Important precursor of the YBA generation.

1980-1989

671

Key Artist **Tim Rollins**
First work with K.O.S. (Kids of Survival)

From 1980, Rollins was active in Group Material, one of several neighborhood art collectives that developed New York Conceptualism in a militantly political direction, an inspiration being Artists Meeting for Cultural Change, radicalized artists and writers who challenged institutionalized art structures. Rollins had attended Weiner's seminars at New York's School of Visual Arts, like many Group Material members; they collaboratively rented a storefront in the then unfashionable East Village. It became their gallery and spotlit broad social themes rather than showing individual artists; local residents were encouraged to participate by loaning objects to shows. Rollins later reflected: "I realized... This is what democracy might look like. It was full of fantasy and surprise and humor and wit – all the things so often lacking in 'political art'."

Rollins applied this ideology to teaching special-needs teenagers in P.S. 52 in South Bronx from 1982, starting with an after-hours studio program called Art and Knowledge Workshop. The following year it moved to a local community center where the Kids of Survival was created. Made up of boys and girls whose reading ability lagged behind their creative skills, K.O.S. created artworks that combined educative and artistic objectives. After reading texts by established authors, the group discussed imagery for appropriation into images, made graffiti-style on book leaves pasted in a grid on canvas, as with the joyous golden forms in *Amerika* inspired by Kafka, or drawn on individual pages in bound books. Authorship was shared by the group, and members first exhibited together in 1983.
Martin Holman

Date 1983

Born 1955

Nationality American

Why It's Key Neighborhood collaborations developed creativity and learning through art, especially for urban teenagers.

opposite Tim Rollins with some of his K.O.S. collaborators.

Key Exhibition
Primitivism in 20th Century Art

It was after a visit to the ethnological collections of the Trocadéro that Picasso completed his ultimate masterpiece, *Les Demoiselles d'Avignon*. Picasso is just one of many modern artists who claimed to have been influenced by the so-called "primitive." But the term "primitive" is as debated as the supposed link between modern artists and the products of various non-Western cultures. Both these issues were addressed, in ways which the critics deemed more or less successful, in the exhibition Primitivism in 20th Century Art: Affinity of the Tribal and the Modern, which opened at the Museum of Modern Art in New York in 1984.

The exhibition featured all the big names and movements of twentieth-century Western art, including Gauguin, Brancusi, Henry Moore, the Surrealists, and the Abstract Expressionists. William Rubin, the curator

of the exhibition, distinguished between the terms "influence" and "affinity" in defining the links between modern Western works of art and non-Western artifacts of various periods.

A criticism of the exhibition was that while the use of the term "affinity" implied a common basis for art worldwide, visual relationships were established between tribal and modern works without the work's essential significance being explored. Another point of attack was that several uses of the term "primitive" were excluded from the exhibition, such as the use of it which defines pre-Renaissance art, or that which refers to naïve, non-professional artists, such as Henri Rousseau, who figured strongly in twentieth-century art.
Chiara Marchini

Date 1984–1985

Country MoMA, New York, USA

Why It's Key Controversial exhibition which generated discourse around issues of the representation of the "other."

opposite Poster for the MoMA exhibition.

Key Artwork *Zydeco*
Jean-Michel Basquiat

Basquiat (1960–1988) used art "to process what he knew about history, about the cultural richness of the African Diaspora and his Caribbean roots specifically, and about the epic historical struggle of African Americans. He knew about music, especially jazz and nascent hip-hop, and about sports, particularly boxing and baseball" [Mayer]. In *Zydeco*, Basquiat deals directly with the re-emergence of an Afro-Louisiana accordion-based music form onto the New York club scene.

A central figure plays the accordion against a predominantly green background that possibly refers to the "green beans" – *les haricots* -from which "zydeco" arrives by way of a Cajun-Creole bastardization of the original French. The artist was raised as a multilingual son of a black Haitian American father, thus French was a familiar language.

Extrapolating the literal, totemic emblems in Basquiat's vocabulary, the association of "cool" with this jazz-related sound is depicted by "icebox," "freezer," and "Westinghouse" (American makers of refrigerators) alongside stark white – "cold" – rectangles. On the right are references to the broadcast media by which means black jazz, blues, and soul artists – and other ethnic originators of "cool" music – made themselves heard within American culture.

Zydeco is one of Basquiat's most complex and yet readable images. It demonstrates a confidence and brio born of commercial success and a coherence that was soon to be eclipsed by drug addiction and death only four years later.
Mike von Joel

Date 1984

Country USA

Medium Acrylic on canvas (three panels)

Collection Private collection

Why It's Key *Zydeco* is a work, produced midway between the artist's emergence and death, which ably demonstrates the intellectual and coherent nature of his painterly language and the development of an authentic Neo-Expressionist voice.

"PRIMITIVISM" IN 20TH CENTURY ART
Affinity of the Tribal and the Modern

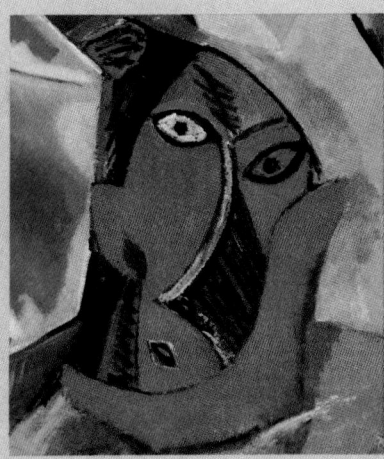 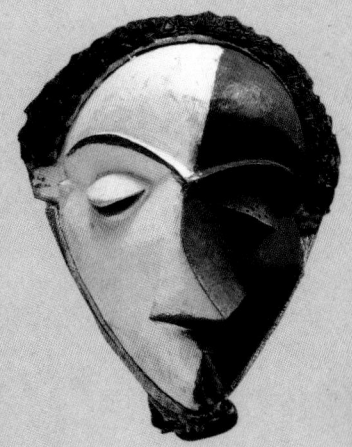

The exhibition and its national tour are
sponsored by Philip Morris Incorporated.
Additional support has been provided
by the National Endowment for the Arts.

The Museum of Modern Art, New York
September 27, 1984–January 15, 1985

Key Exhibition
Koori Art '84

In 1984, the art of Australia's Aboriginal peoples was finally recognized by an international art audience when the group exhibition Koori Art '84 was held at the Artspace exhibition space in Sydney. The exhibition drew attention to work by Australia's indigenous people, including work that pre-dated European colonization, as well as contemporary art by Aborigines based on Aboriginal cultural heritage.

Although by the 1970s bark paintings and then canvases from the desert had become increasingly popular, the art of city-based Aborigines was still regarded as not authentically Aboriginal, and was therefore neglected. This attitude reflected generally held views about urban Aboriginal people.

First the Contemporary Aboriginal Art Exhibition at Bondi Pavilion in 1983, and then Koori Art '84,

organized by a group of Sydney-based artists, were landmark exhibitions, which heralded the emergence of urban artists. However, the continued lack of opportunities for these artists resulted in the formation of cooperatives, such as the Boomalli Aboriginal Artists Cooperative, established in Sydney in 1987, to provide shared studio and exhibition space.

Sadly, rabid exploitation of the artists has followed the community's success and soured political debate surrounding the movement's popularity. But despite the complications accompanying Aboriginal art's rise to prominence, the international respect and regard its artists have brought their oft-abused community is well-deserved and long overdue.

Ana Finel Honigman

Date 1984

Country Australia

Why It's Key Widespread recognition of urban Aboriginal art for the first time.

Key Exhibition
Te Maori

The 1984 Te Maori exhibition at the Metropolitan Museum of Art in New York was a turning point in the history not only of Maori art but also of exhibition politics. The exhibition, first proposed in 1973, had been painstakingly planned so as to accommodate the wishes and customs of the Maori people whose objects were to be shown. For example, Maoris approved the terms of the exhibition in the first place, then participated in its opening with traditional ceremonies. Maoris accompanied the exhibition throughout, serving as guides and caretakers of their heritage. Thus, spectators in New York and elsewhere encountered Maori sculptures, masks, cloaks, and other artifacts within their inalienable cultural context, itself narrated and framed by the indigenous people whose tradition was on offer.

After its resoundingly successful MoMA run, Te Maori moved on to other American and European cities before returning to New Zealand. Te Maori introduced a hitherto cloistered indigenous art to a global audience, which not only put Maori art on the map but also increased the visibility and prestige of the Maori cultural revolution then underway in New Zealand. Interestingly, Te Maori was a revelation to New Zealand's non-indigenous people, the mass of whom had never been introduced to Maori artistic traditions. Te Maori provided spectacular evidence of a Maori culture that had been suppressed in New Zealand from the 1840s onward. In this way, the return of Maori prestige in New Zealand can be attributed partly to Te Maori.

Demir Barlas

Date September 10, 1984–January 6, 1985

Country USA

Why It's Key Maori art receives its first international exposure, altering the politics of exhibition and the balance of cultural power in New Zealand in the process.

opposite Photograph showing Te Maori exhibition staff just before the exhibition opened at the Auckland City Art Gallery.

TE MAORI

Te hokinga mai. The return home.

Key Artist **Ansel Krut**
First solo exhibition in Johannesburg

Ansel Krut was born in Cape Town, South Africa. After studying at the University of Witwatersrand in Johannesburg he attended the Cité Internationale des Arts, Paris (1982–83), and then received an MA from the Royal College of Art, London (1986).

Krut's earliest works found support in Europe in the 1980s when a backlash against the Conceptualism and identity politics of the previous decade was accelerated in 1981 by two influential exhibitions. The first was A New Spirit of Painting at the Royal Academy, London, which promoted Neo-Expressionist painting and Les Realismes: 1919–1939 at the Centre Pompidou, Paris, which proposed figurative painting, in between the two world wars, as an alternative to the avant-garde. Krut's elegant works of the 1980s and 1990s, thinly painted with a muted palette, show beguiling narratives that draw upon art historical sources and hint at an underlying disquiet. By 2000 animals, children and hybrid creatures, in strange fairy tale-like settings, bring to mind the monstrous creations of Goya's etchings and whimsical nineteenth-century children's illustrations.

Krut's most recent paintings and drawings have incorporated a more primitive rawness into his enigmatic figures. Naive, childlike drawing has taken over from the sophisticated painterliness of his earlier works. An unsettling traducing of childhood images takes place, such as in the mutilation and evil expressiveness of a Mickey Mouse-like figure (2005) and the abject subject matter of *Man Eating his Own Intestines* (2006).

Sarah Mulvey

Date 1984

Born 1959

Nationality South African

Why It's Key His style has a cartoon-like simplicity which is reminiscent of Picasso's grotesques of the 1960s and 1970s and Philip Guston's return to figurative painting in the late 1960s.

Key Artist **Bhupen Khakhar**
Wins India's prestigious Padma Shri award

Ironic distance, playfulness, and subversion found a consummately Indian expression in the work of Bhupen Khakhar. Something of a naïve painter, he was once an accountant, and made his mark on the Indian scene in 1965, when he first exhibited in Bombay. Khakhar, who had no links to the atmosphere of serious-minded socialism in which modern Indian art was born, retained both his naïveté and a sly – although sometimes macabre – sense of humor in his paintings, which in the 1980s began to display explicitly homosexual themes.

Khakhar's work, controversial for India, did not deter him from receiving official recognition. In 1984 he received the Padma Shri, the fourth most prestigious civilian award in the country. The award heralded Khakhar's entry into India's pantheon of painters, but the artist remained proudly distant from the usual subject matter of Indian modernism. In 1985, Khakhar painted the homoerotic *Two Men in Benares*. And in 1987, his *Yayati* queered a scene in Hindu mythology, drawing the ire of religious fundamentalists and social conservatives. In the 1990s, the aging Khakhar turned racier than ever – for example, in his 1995 *An Old Man From Vasad Who Had Five Penises Suffered From A Runny Nose*.

Despite painting explosive subjects, Khakhar's style was often ironic and distanced from the subject of its portrayal. Many of his human figures – including his 1990 portrait of Salman Rushdie, *The Moor* – stare away from the spectator, creating an atmosphere of vague unease and alienation that underlies Khakhar's vibrant colors and spirit of humor.

Demir Barlas

Date 1984

Born/Died 1934–2003

Nationality Indian

First Exhibited 1965

Why It's Key A sly and subversive gay Indian artist won recognition from his homeland.

Key Artist **Alison Wilding**
First major solo show

Alison Wilding's sculptures whisper mysteriously in a way that eludes language. They beckon the viewer to slow down for a moment, to step out of the world's often frenetic pace, and find stillness. Only then is it possible to enter Wilding's intensely private territory.

Wilding explores abstract relationships between shapes, surfaces, hues, and scales with a patient and investigative curiosity. Her work is distinguished by the use of contrasting materials to set up a balance or tension between two distinctly separate elements. This duality may present itself as light/dark, solid/transparent, interior/exterior, male/female, and it may be found in Wilding's combination of modern and traditional materials that would seem to have nothing in common, juxtaposing them in strange but satisfying ways.

Hand to Mouth (1986) is a sculpture made of two forms, the one rounded and sensual containing a small pool of beeswax, lying at the base of and contrasting with the other, a vertical steel structure with bolts clearly visible. The uncertain relationship between the two structures and the variety of material used by the artist (leaded steel, brass, wood, lead, beeswax) create an intriguing dynamic.

After a period of study at Nottingham College of Art (1967–68), Ravensbourne College of Art and Design (1968–71), and the Royal College of Art (1971–73), Wilding rose to prominence as one of the New British Sculptors in the 1980s. This led to a major solo show at the Serpentine Gallery (1985) and was followed by international acclaim.

Carolyn Gowdy

Date 1985

Born 7 July, 1948

Nationality British

Why It's Key Wilding's first major solo show at the Serpentine Gallery was followed by international acclaim with Projects, a solo show at the Museum of Modern Art, New York, in 1987.

Key Artist **Isamu Noguchi**
Isamu Noguchi Garden Museum, Long Island NY

Born of an American writer mother and a Japanese poet father, sculptor and designer Isamu Noguchi grew up in Japan. In 1918, he was sent to school in the United States where he studied medicine before deciding to become a sculptor.

In 1927, Noguchi moved to Paris where he became Brancusi's assistant and met abstract sculptor Alexander Calder – artists who both deeply influenced Noguchi's work, as did Surrealism. In the following years, Noguchi also repeatedly traveled to Japan where he worked with organic elements such as stone, terra cotta, or water. As a result, his abstract expressive sculptures evoke the life, shapes, and power of nature.

In addition to the large-scale public sculptures he built around New York (*Rockefeller Center*, 1938) and other cities (*Bolt of Lightning*, 1984, in Philadelphia,

Dodge Fountain, 1978, in Detroit), Noguchi also designed sculptural furniture and gardens – mostly in the Japanese style. His career as landscape architect proved very successful: in 1956 Noguchi is commissioned to design a Japanese garden for the UNESCO headquarters in Paris for instance.

But even more important is the opening in 1985 of the Noguchi Garden Museum in Long Island, which occupied a part of the artist's studio. The museum and its sculpture garden display over five hundred works of the artist (sculptures, photographs, etc). The Noguchi Garden Museum also went down in history as the first museum in the United States to be founded, curated, and funded by an artist for the display of his own work.

Adelia Sabatini

Date 1985 (museum opening)

Born/Died 1904–1988

Nationality American

First Exhibited 1929

Why It's Key Prominent abstract sculptor and landscape designer.

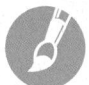

Key Artist **Jonathan Borofsky**
Initiates his celebrated *Hammering Man* sculptures

Born in Boston, Massachusetts, Jonathan Borofsky studied at Carnegie Mellon University, Ecole de Fontainebleau in France and Yale University in Connecticut. Borofsky moved to New York City in 1966, and began an introspective period of mind-clearing activity during which he recorded his thoughts and observations, presenting them in *Thought Book* (1969), and writing consecutive numbers on paper that he later exhibited in a stack.

Borofsky became renowned for complex installations that merge traditional media such as painting and sculpture with newer elements such as sound, video, and mechanized movement. They often reveal detailed contents of his mind and his dreams, such as *I Dreamed I Was Taller Than Picasso at 2,047,324* (1973). Borofsky's first major exhibition of all his artworks and found objects, was held in 1975 in New York.

A number of recurring images began to appear in his work, including the *Hammering Man* sculptures which he began through 1984 and 1985. They feature a lanky silhouette figure with his head lowered, striking a piece of metal with a hammer held in the hand of a perpetually moving arm. The image holds multiple meanings: the archetypal manual laborer, the model citizen, and the artist himself as a constant worker. They are installed in various cities across the world, with the tallest in Seoul, Korea, at 72 feet, which was constructed in 2002.

Mariko Kato

Date 1985

Born 1942

Nationality American

First exhibited 1973

Why It's Key Prominent contemporary artist Jonathan Borofsky produces his most famous works, the *Hammering Man* sculptures.

opposite One of the *Hammering Man* sculptures in Seattle.

678

Key Artist **Haim Steinbach**
Creates *Fantastic Arrangement*

Although initially a painter, Steinbach was best known for a prolific series begun in 1984 of different objects, each one represented by one or more examples, arranged on standardized triangular, plywood shelves covered with Formica. Consumer products – timepieces, children's toys, health-care apparatus, ceramics – were presented ambiguously, regardless of function or rational relationships, and juxtaposed by shape and color. While their serial nature implied Minimalism, their orientation toward the everyday world of commodities recalled Pop art's interest in blurred distinctions between high and low art forms. Another apparent theme was appropriation, recognized again as an important practice in the mid-1980s and reminiscent of Duchamp's readymades. The most significant aspect, however, of Steinbach's work was its investigation of contemporary consumer culture and capitalist society's attachment to things for their value in communicating distinctions, what the philosopher, Jean Baudrillard, termed the "commodity-as-sign." Exploring the sign-commodity's differential nature distinguished Steinbach from, for example, Koons who was employing similar material. His assemblages of products implied that values related to usefulness and taste were overridden by the desire to consume, fuelled by superficial but sophisticated factors like design and display that could be applied to any object. The four digital clocks alongside another shaped like a basketball in *Fantastic Arrangement* (1985) embodied this proposition; in *related and different*, five plastic goblets like devalued Holy Grails were equated with one pair of Nike sports shoes shelved next to them.

Martin Holman

Date 1985

Born 1944

Nationality Israeli/American

Why It's Key A Conceptualist whose works directly equated artworks with commodities. From 1990, works included words placed directly onto walls, and furniture and antiques were introduced.

Key Artist **Luc Tuymans**
First solo show staged in Ostend, Belgium

Tuymans emerged as a painter just as renewed passion was sparking for what some viewed as a dying tradition. It arrived in the form of Neo-Expressionism, and the 1982 Zeitgeist exhibition in Berlin which featured a new generation of inspired European painters. Tuymans had already studied fine art and painting at various schools in Belgium from 1976 to 1982 before losing faith in the medium. He then proceeded to study art history from 1982 to 1986. Tuymans gave up painting for two years, but continued to practice art in the more contemporary form of filmmaking. In 1985, Tuymans' first solo show, Belgian Art Review at the Palais des Thermes in Ostend, marked a return to painting, but attracted only moderate interest. Tuymans would, however, persist with his idiosyncratic vision, going on to develop a stellar international career.

The experiment with filmmaking provided Tuymans with a fresh way of looking at a canvas. He began to use cropping, framing, sequencing, and close-up techniques to make visual statements, never spending more than a single session on a painting. The images were often based on extensive research and planning beforehand. He would look for meaning beyond the surface of the content, translating images from mass media, taking his own Polaroid photographs, employing film-stills, or drawing from found materials. Tuymans' paintings are often modest in scale, but engage with major issues; politics, power, corruption, child abuse, slavery, Belgian colonialism, daily violence, and modern consumerism. Titles range from the ominous *Gas Chamber* (1986) to something as seemingly ambivalent as *Rumour* (2001).
Carolyn Gowdy

Date 1985

Born 1958

Nationality Belgian

Why It's Key Belgian Art Review at the Palais des Thermes in Ostend marked a return to painting by one of the most influential painters of his generation.

opposite **Luc Tuymans**

1980–1989

681

Key Artist **Lisa Milroy**
First inclusion in John Moore's Liverpool Exhibition

Born in Vancouver, Milroy studied at London's St Martins School of Art and Goldsmiths College. She took part in the Young Blood exhibition at Riverside Studios (1983) and in Problems of Picturing at the Serpentine Gallery (1984). Every other year, Liverpool's Walker Art Gallery organizes a painting competition, which is open to any artist living or working in the UK – previous prize winners include Peter Blake, David Hockney, Richard Hamilton, Adrian Henri, Sean Scully, and Bruce McLean. Milroy featured in two John Moore exhibitions before being awarded its First Prize in 1989.

Handles (oil on canvas, 1989) belongs to a period when she repetitively painted the same everyday objects, whether shoes or books, with taxonomical rigor. Four rows of four handles are methodically arranged on a monochrome background, the restricted palette

unifying the composition while neutral lighting reinforces the Magritte-like distance of this inanimate display. Presented as in a mail-order catalog, yet without captions to give us reassuring interpretative pointers, the objects are isolated, suspended, disembodied. Milroy's purpose is not to produce a photorealist imitation of reality; paradoxically, her objects are usually painted from memory, not from photographs or still-life drawings. Her concerns are decidedly formal, and she sees *Handles* as "an abstract painting of lines, dots and circles, of moments of local detail and overall pattern."

Her interest in tensions between abstraction and figuration continues in her later work – depictions of Greek ceramics or Japanese designs – inspired by her travels in Italy, Japan, America, and Africa.
Catherine Marcangeli

Date 1985

Born 1959

Nationality Canadian (lives in Britain)

Other Key Exhibitions First one-woman show, Nicola Jacobs Gallery, London, 1984

Why It's Key This is the first time Milroy was included in a John Moore exhibition; eventually, in her third inclusion in 1989, she won First Prize.

Key Artist **Mohammad Reza Irani**
Work exhibited in Munich, Germany

While the Iranian Revolution of 1979 marked the beginning of the bleakest epoch of Iran's cultural history, the theocratic regime did not crack down on all painters. For example, Iranian painter Mohammad Reza Irani was allowed to exhibit both in his homeland and in numerous foreign countries, and took part in the first Biennial of Iranian Painters at the Museum of Contemporary Arts, Tehran.

Irani's first exposure in, and to, the West came in 1985, when he was invited to exhibit in Munich, Germany. The exhibition was not groundbreaking – indeed, by European standards, Irani's technique and preoccupations were nearly a century behind the artistic mainstream – but nonetheless reminded the world that creative activity continued in Iran. While some of Irani's work, notably his still lifes of flowers,

was hackneyed, the artist's oil paintings of Azeri village landscapes rose to much greater heights. These pastoral landscapes demonstrated a fine eye for detail and color, and cataloged a world that was vanishing in the aftermath of Iranian urbanization. Meanwhile, Irani's drawings of human subjects – including his wife, son, and himself – evinced an excellent eye for representation and imitation.

After Munich, Irani – himself of Azeri Turkic origin – went on to exhibit in Azerbaijan and Turkey, where he found new audiences and admirers. Sadly, Irani's career was cut short when he was struck by a van in Iran. He was buried in Tabriz. Today Irani is proudly claimed not only by Iran's theocratic regime but also by Azeris in Iran and Azerbaijan.

Demir Barlas

Date 1985

Born/Died 1954–1994

Nationality Iranian

First Exhibited 1981

Why It's Key Leading Iranian artist wins exposure in the West.

Key Event
Beijing Young Artists Association formed

Internal discontent with China's Communist Party reached a high point in 1989, when the Tiananmen Square uprisings demonstrated that the winds of change were blowing in the Middle Kingdom. Chinese artists were particularly upset with the Communist regime and its limits on artistic expression. In 1985, a number of these artists joined forces to create the Beijing Young Artists Association, which bravely mounted an exhibition the next year. The Beijing Young Artists Association not only called attention to the individual work of such artists as the painter Li Guijun and the sculptor Suo Tan but also signaled that an entire generation of Chinese artists – similar to the so-called fifth generation of Chinese cinema active in the 1980s – was ready to interrogate and challenge the status quo.

The formation of the Beijing Young Artists Association was an act of great courage, as the Cultural Revolution of the 1960s had seen the wholesale destruction of Chinese art and the murder of many Chinese artists. While the worst excesses of the Cultural Revolution did not recur in the 1980s, the Chinese government was still averse to artistic expression and engaged in a standoff with dissident artists, many of whom left the country. However, after Deng Xiaoping's famous 1992 speech promoting the adoption of capitalism, the Chinese government inevitably came closer to the side of the very artists it had persecuted in the 1980s. Thus, the excitement and dynamism of the contemporary Chinese art scene owes itself to artists and politicians in equal measure.

Demir Barlas

Date 1985

Country Beijing, China

Why It's Key China's new wave of artists resisted their country's official ideology and helped to begin China's thaw.

Key Artist **Paula Rego**
Influential woman artist begins *Girl and Dog* series

A painter, illustrator, and printmaker, Rego was born into a wealthy Portuguese family. An only child, she grew up in Lisbon during the right-wing Salazar regime. She came to London where she trained at the Slade art school from 1952–56. There she met fellow painter, Victor Willing (1928–88) whom she would later marry. Rego returned to Portugal and was eventually joined by Willing where they both lived until 1963. In the mid-1950s they began a family and from the early 1960s onwards, divided their time between Portugal and England.

During these years, Rego exhibited in Portugal and received critical acclaim for her semi-abstract paintings. They contained emotive and political content, which drew on Rego's own experience of the tension and distress caused by life under a fascist dictatorship. In 1975, Rego moved permanently to England with her family. Victor Willing would die of multiple sclerosis in 1988.

In the 1980s Rego began to develop a narrative, representational approach. She was inspired by text and illustration, and began studying the work of artists like Beatrix Potter, and political caricaturists from the past, such as Hogarth and Gilray. She became part of the London Group, exhibiting with David Hockney and R.B. Kitaj. She was the first associate artist at the National Gallery, and was short listed for the Turner Prize in 1989. In the 1980s Charles Saatchi had also begun collecting her work. Rego was freed from financial constraints to give her art a renewed and intense focus, and it was at this time that she created the *Girl and Dog* series.

Carolyn Gowdy

Date 1986

Born 1935

Nationality Portugese/British

Why It's Key The *Girl and Dog* series marked Rego at mid-career, but moving into her most productive phase, to become one of the most influential women artists of her time.

1980–1989

683

Key Artist **Ashley Bickerton**
Fantastic Four show at the Sonnabend Gallery, New York

A s part of the 1986 Fantastic Four show at the Sonnabend Gallery, the Barbados-born, intellectual beach-boy artist Bickerton rode the Neo-Geo wave into art-stardom alongside Peter Hally, Meyer Vaisman, and Jeff Koons. Though his surfer background is often included in his bio, Bickerton's art is anything but light and chill. His work has a cool surface quality, but the issues he addresses are deep and expansive. He explores the commidification of the art object and his work is often a jarring critique of capitalism. In the late 1980s he advanced environmental concerns as key to his art practice, leaving the other members of the Fantastic Four show to focus on the significance of urban Pop culture and trends within mass media.

As a child, Bickerton moved among different beach-locales across four continents, thanks to his father's work as a linguist and scholar of Creole and pidgin languages. Born a British citizen, Bickerton was naturalized as a citizen of the United States in Hawaii in the 1980s. He moved to New York City to attend the Whitney Museum Independent Study Program and stayed for twelve years before moving to Bali, where he lives today. Though geographically far from the main hub of American art activity, Bickerton remains central to today's art discourse, and even had concurrent New York City solo shows at the highly prestigious Lehmann Maupin Gallery and Sonnabend Gallery in 2006.

Ana Finel Honigman

Date 1986

Born 1959

Nationality British (Barbados) (nationalized American)

Why It's Key Mixed-media artist whose work addresses the commidification of the actual art object.

Key Artist **Davida Allen**
Wins prestigious Archibald Prize for portraiture

Davida Allen was born in 1951 in Charleville, Queensland, to a wealthy family. She was educated at the Stuartholme Convent in Brisbane where she studied art with Betty Churcher until 1969. Afterward, she continued her studies with Roy Churcher at Brisbane Central Technical College. Allen, who has four grown daughters, was pregnant at her first exhibition in Brisbane in 1973. Major influences on her work include Expressionist painters Emil Nolde, Henri Matisse, and the Fauves.

Allen's work is known for its strong palettes and heavy brushwork that depict the ongoing struggle between the individual and his/her environment with both power and urgency. Allen's paintings often focus on the domestic, and she frequently uses herself and family members as subjects. Her 1986 prize-winning portrait featured her father-in-law, Dr John Shera, hosing down his celtus trees. Other foci of Allen's work are female sexuality, as depicted in the *Rude Painting* (1984), and feminine fantasy, as exhibited in the Sam Neill series (1986). Allen earned unwelcome notoriety with the erotic *Fantasy of Sam Neill*.

In addition to her paintings, Allen has written and illustrated *The Autobiography of Vicki Myers: Close to the Bone* (1991) and *What Is a Portrait?* Her short film, *Feeling Sexy*, has been featured in several international film festivals, including Cannes. Her artwork has been showcased in solo and group exhibitions in Australia, the United States, New Zealand, Japan, France, Italy, and Ireland and is included in public and private collections around the world.

Elizabeth Purdy

Date 1986

Born 1951

Nationality Australian

First Exhibited 1973, Ray Hughes Gallery, Brisbane

Why It's Key One of the few times that an Australian female artist has won the prize, and her bold depictions of ordinary life are winning her cult status in the art world.

Key Artist **Keith Haring**
Mural on Berlin Wall at Checkpoint Charlie

Born in 1958, Keith Haring was one of the celebrity artists of the 1980s, inhabiting the fashionable worlds of Andy Warhol, Stephen Sprouse, and Debbie Harry as well as New York's clubby underworld. His graffiti-like drawings became a type of logo for all that was cool in New York. Often the drawings contained images of children, animals, aliens, and vehicles, but it is probably for his AIDS-inspired imagery that he is best known: simple but upfront political messages and their simplified, featureless human forms. Haring used clean colors, always outlined in black – most graphically when in zingy neons: but most painterly when using various colors together, and often creating almost tribal patterns redolent of Aboriginal wall paintings.

The 1986 mural on the Berlin wall was executed at the request of the Checkpoint Charlie Museum.

Checkpoint Charlie was designated as the single crossing point by foot or car between East and West Berlin for foreigners or members of the Allied forces during the Cold War. The mural, approximately 300 meters in length, depicted linked figures in the colors of the German flag – yellow, red, and black – symbolizing the quest for unity between East and West Germany. Over time the mural was covered over by the work of other artists prior to the destruction of the wall in 1991.

Though trained as an artist, Haring turned his back on the formal art world and looked to street art for inspiration. Filling empty black advertising hoardings in subway stations with his unique figures, he eventually got attention from the major galleries, although he continued to produce pieces for public spaces.

Emily Evans

Date 1986

Born/Died 1958–1990

Nationality American

Why It's Key His mural on a political hot-spot promoted the celebrity status of this high-profile painter. His work eventually became eminently licensable, being used for books, clothing, and toys.

opposite Haring at work on the Berlin wall.

Key Artist **Peter Halley**
Launch of "neo-geo" at New York's Sonnabend Gallery

In the late 1980s New York City, no term was trendier than "neo-geo." For anyone hip to art-world trends, the jazzy little catchphrase stood for a new wave of abstract, geometric, day-glo painting. It was the brainchild of Manhattan-born – and based – artist, Peter Halley.

Halley, who received his BA in 1975 from Yale, and Masters degree in Fine Art from the University of New Orleans in 1978, first exhibited in 1985 at International with Monument, a gallery in the East Village area of Manhattan.

Now the director of graduate studies in painting/printmaking at the Yale School of Art, Halley was the founding editor of *Index* magazine, and launched the movement in 1988 with a group show of key practitioners at New York's Sonnabend Gallery.

Typified by Kenny Scharf's urban primitive paintings, Michael Young's beige paintings which were termed a "Band-Aid for culture," and Halley's bright abstractions, the movement was intended to lay bare the new "geometricization of modern life" and capitalize on the slick and intense look of 1980s urban life. Speaking about his own paintings, Halley was quoted by *Frieze* magazine as saying that he wanted his work to be viewed quickly and look "hot" or even "turbo charged."

Though the neo-geo movement lost its velocity by the 1990s when Conceptual art returned to the forefront of the art world's attention, "neo-geo" remains one of the last century's big buzz words.
Ana Finel Honigan

Date 1986

Born 1953

Nationality American

Why It's Key Central to a new wave of New York abstraction in the late 1980s.

Key Artist **Richard Deacon**
Wins Turner Prize

Deacon was among the British sculptors who came to prominence in Objects and Sculpture, the 1981 exhibition shown in London and Bristol. Alongside peers mostly born in the late 1940s, including Cragg, Gormley, and Woodrow, Deacon announced a new interest among artists in objects connected with urban culture in opposition to British sculpture's preoccupation with landscape since Moore. They did not form a coherent artistic group, however, and their diversity was part of the importance of this "new wave."

Unlike Cragg, Deacon typically used materials known to sculpture, like wood, galvanized steel, ceramic, plastics; and unlike Woodrow or Gormley, his work was, at root, abstract. His starting point was the material, which he manipulated with obvious craftsmanship: the manner of making – riveting, gluing, nailing, binding –

was openly displayed, hence his insistence on being called a "fabricator." By testing materials' possibilities, images emerged in forms that connected metaphorically with everyday experience especially, by implication, with the body's shapes and orifices. Being more concerned with surface and structure than with mass, Deacon's biomorphic forms could reveal space inside, outside, and around simultaneously, or contrast open with cloth-covered closed elements. These allusions, whose echoes of language, speech, and song are hinted at in titles, were explored in a long-running series of small-scaled objects, collectively called *Art for Other People* (1978 onwards).
Martin Holman

Date 1987

Born 1949

Nationality British

Why It's Key Winner of the Turner Prize for "new wave" work, his abstract objects nonetheless connected with 1960s sculptural concerns. His enquiry into materials resulted in innovations that included using clay for large-scale, sinuously-shaped sculpture.

opposite Deacon's *For Those Who Have Eyes*.

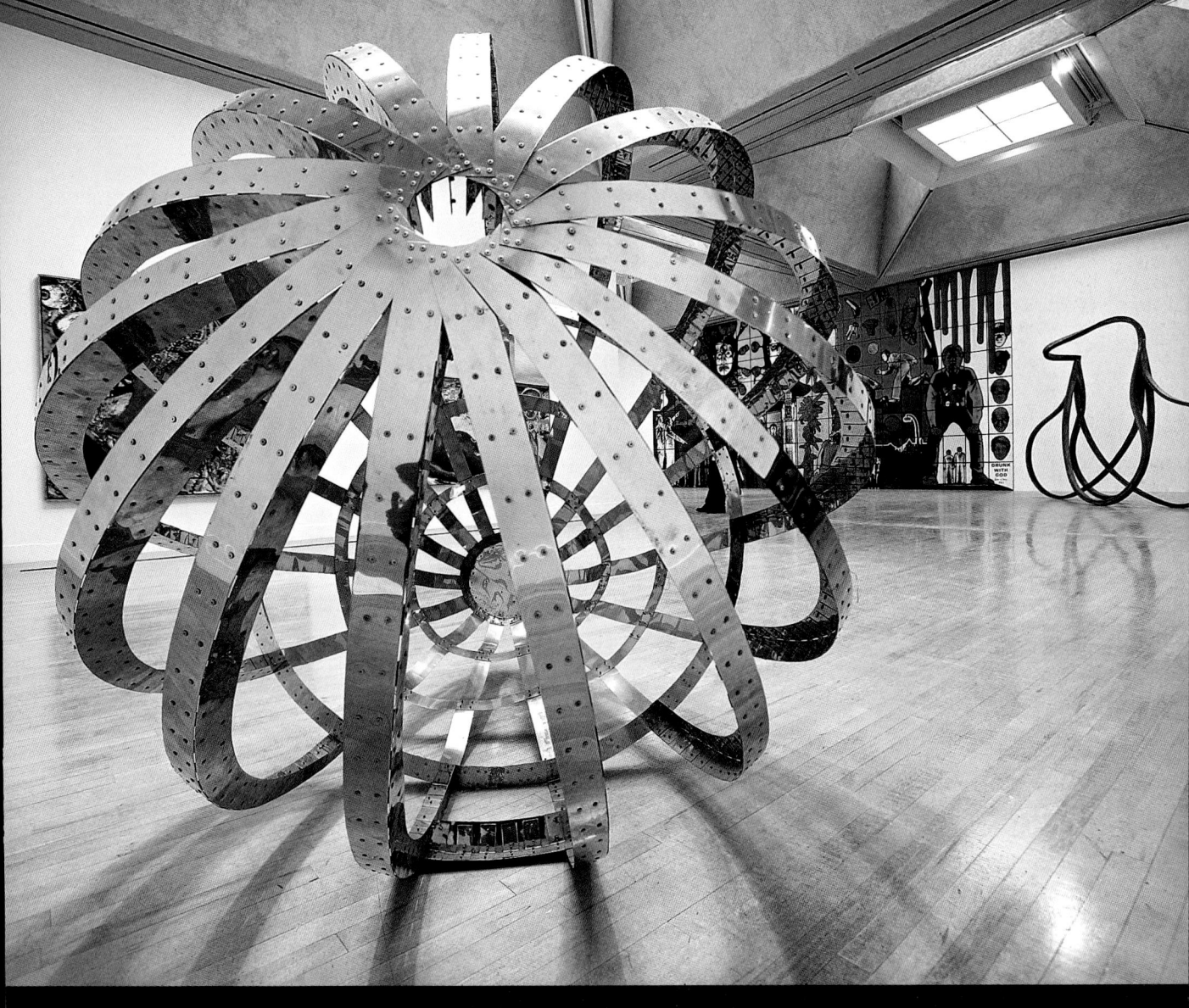

Key Artist **Allan McCollum**
Five Perfect Vehicles series

Sculptor, painter, and photographer Allan McCollum never received any academic training in art. He worked for an art-haulage firm, however, and was always mainly interested in questioning the business side of the art world. If his early work was influenced by Minimalism and artists like Donald Judd and Daniel Buren, in the 1980s McCollum turned to Appropriationism and sought in his work to question the status and meaning of the art piece, demythologizing it, examining its uniqueness in a world constituted in mass production, and its value in the mercantile art market.

Those themes are particularly well exemplified in his famous Perfect Vehicles series, started in 1985. The *Perfect Vehicles* pieces are sculptures which all bear the exact same form – that of traditional Chinese jars –

but they differ in size and color. Those Vehicles can thus measure from thirty centimetres to over two metres, and they are all painted in a uniform everyday acrylic color – red, blue, black, or yellow for instance.

The object of a jar is here presented devoid of any utility value – as McCollum's vases have no opening – and functions merely as an aesthetic sign, a vehicle not for conserved goods but for any meaning we may want to ascribe to it.

The questionings of artworks' uniqueness marks McCollum's entire work as shows the *10,000 Individual Works* series (1987), or his 2005 Shapes Project – a system designed to produce over six billion completely unique shapes – one for every person on the planet – without repeating.

Adelia Sabatini

Date 1987

Born 1944

Nationality American

First Exhibited 1969

Why It's Key Interrogates the status of the artwork in the age of mass production.

Key Artist **Tim Head**
Awarded First Prize in John Moores Liverpool Exhibition

The London-born artist Tim Head studied at on the Advanced Sculpture Course run by Barry Flanagan at St Martins School of Art in the capital, obtaining a postgraduate diploma in sculpture. He had first graduated from the Fine Art course at Newcastle University, where he studied from 1965 to 1969, his teachers including Richard Hamilton and Ian Stephenson. In 1968 he went to New York where he worked as an assistant to Claes Oldenburg, and met Robert Smithson, Richard Serra, Eva Hesse, Sol LeWitt, John Cale, and other key figures. He assisted Robert Morris in putting together his landmark show at the Tate in 1971.

Since the turn of the twenty-first century, Tim Head has concentrated on computer-generated abstract images, often reflecting in their titles the

work of the Old Masters, for instance *Laughing Cavalier*, after the iconic, popular image by Frans Hals, and *Weeping Woman* after a famous work by Pablo Picasso. Others, such as *A Hard Day's Night*, which obviously borrows its title from the Beatles' feature film, reflect contemporary or recent popular culture.

His work received prestigious recognition when Head won the first prize in the bi-annual John Moores Exhibition held at the Walker Art Gallery in Liverpool.

He has exhibited widely and internationally, and his work is to be found in a wide variety of permanent collections, from the British Museum to the Guggenheim Museum in New York.

John Cornelius

Date 1987

Born 1946

Nationality British

Why It's Key Important contemporary sculptor working with computer-generated images.

Key Artist **Susana Solano**
Shows at the Venice Biennale

Born in Barcelona, sculptor and draftswoman Susana Solano is one of the rare contemporary Spanish artists to have achieved international success. Solano trained at the Real Accademia Catalana de Bellas Artes de San Jorge in Barcelona but she didn't start making sculptures until she was in her thirties. Her first solo exhibition was held as soon as 1980 in the Fundació Joan Miró, Barcelona, although the artist is not best known for her early work (1980–84) but for the large-scale minimal iron sculptures she produced from the mid-1980s. She uses mostly iron, wood, or plaster to construct large container-like sculptures, exploring the relationship between interior and exterior with ambiguous constructions that often combine openings in their structure with a general air of impenetrability (Associaciò Balneria, 1987).

Some of her works, however, are less ambiguous and more straightforwardly claustrophobic, such as the austere and cage-like *Dos Nones* which she produced in 1988, the year she was invited to represent Spain at the XLIII Venice Biennale for the first time. A prominent figure in Spanish contemporary art, Susana Solano was to take part in the Venice Biennale again in 1993 and contributed to Documenta in 1987 and 1992.

Solano also works with photography which she started incorporating to her works in the 1990s (*Hidroterapia*, 1991–92), and she produces many simple drawings, etchings, and collages, usually abstract, minimal, geometric and often black and white works on paper. Susana Solano still lives and works in Barcelona.

Adelia Sabatini

Date 1988

Born 1946

Nationality Spanish

First Exhibited 1980

Why It's Key Leading figure of the Spanish contemporary art scene.

689

Key Artist **Boyd Webb**
New Zealand artist shortlisted for Turner Prize

In the late 1960s Boyd Webb removed from New Zealand to attend Canterbury University School of Fine Arts, from which he graduated in 1971. He then undertook a three-year postgraduate course in sculpture at the Royal College of Art in London.

He came to prominence at the same time as contemporaries such as Richard Wentworth, Richard Deacon and Alison Wilding. As well as sculpture and photography, Boyd Webb is known for his large-scale cibachromes, which involve participants in bizarre and absurd events. These often quirky works involve the production of fantasty tableaux, which are then reproduced in the form of richly colored photographs. It was in the 1970s that Webb began taking photographs of these carefully staged scenes consisting of actors and props arranged in dramatic settings. A key feature of his work has also been his concern with ecological issues such as pollution, nuclear waste, and the impact of technology. Webb's wit and humor, and talent for allegorical visual statement, has made his work increasingly popular.

Since 1976 he has exhibited widely in New Zealand, London, and the United States. In 1988 he was short-listed for the major UK award, the Turner Prize, and went on to represent New Zealand in the Sydney Biennale in 1995.

He has also made several short experimental films, including *Scenes and Songs* made in 1984, *Love Story* from 1996, and, in 2002, *Horse and Dog*.

John Cornelius

Date 1988

Born 1947

Nationality New Zealander

Why It's Key Important figure on the New Zealand art scene who works in a variety of media.

Key Event
Founding of the Critical Art Ensemble

The original members of the Critical Art Ensemble, Steve Barnes, Dorian Burr, Steve Kurtz, Hope Kurtz, and Beverly Schlee used their various skills, including performance, critical writing, photography, graphic design, computer art, and film/video to challenge issues endemic to pan-capitalism and what they perceived as authoritarian Western culture.

Biotechnology, bioart, and contestational biology have been a focus in recent years. For example, in response to the Human Genome Project, based on the DNA of a single woman, CAE created Cult of the New Eve (CoNE), an interactive performance piece. Participants eat genetically modified beer and wafers, mirroring the Catholic ritual of communion. The hope is that people will be sceptical of the new cult of science, asking probing questions about transgenetics.

Molecular Invasion is a science-theater work in which CAE try to reverse genetically modified canola, corn, and soya plants through the use of non-toxic chemical disrupters, providing a more democratic control over environmental experiments that affect us all. GenTerra parodies a pseudo-biotech company in which the public has the chance to create their own transgenetic organism using human DNA from blood samples. BioCom's Flesh Machine is a critique of reproductive technologies and eugenics, participants giving blood samples for DNA extraction to determine their value in the genetic market economy.

CAE aims to advance debate on the disconnection between the public and scientific knowledge through the intersection of both traditional and new art forms.
Bryan Doubt

Date 1987

Country USA

Why It's Key Highly influential in exploring the intersection between art, media, technology, critical theory, and political activism.They created events using lecture, dialogue, participatory theater, and written text in sites such as galleries, the Internet, and the street of Europe and North America.

690

Key Event
AIDS Quilt Project

While planning the annual march in 1985 honoring gay San Francisco Supervisor Harvey Milk and Mayor George Moscone, both assassinated in 1978, gay rights activist Cleve Jones learned that over 1,000 San Franciscans had lost their lives to AIDS. He asked each marcher to write the name of someone they knew who had died of AIDS, and when the placards were taped to the San Francisco Federal Building, they resembled a patchwork quilt. Inspired by this, Jones teamed up with Mike Smith and others in June of 1987 to organize the NAMES Project Foundation to create an AIDS memorial.

The inaugural display was on Qctober 11, 1987, on the National Mall in Washington, DC, during the March on Washington for Lesbian and Gay Rights. It covered a space larger than a football field, included 1,920 separate panels, and was visited by one million people.

Since then over 14 million have visited the quilt, there are 35 NAMES Project chapters in America, and 46 Quilt affiliates worldwide. Currently more than 44,000 individual 3-by-6-foot memorial panels (equaling twenty football fields) comprise the Quilt. Techniques such as appliqué, patchwork, embroidery, collage, and fabric painting were used to weave items, messages, and materials into each panel. Suede, mink, taffeta, metal, feathers, buttons, records, stuffed animals, condoms, jackets, jeans, hats, and even a bowling ball, evoke the memory of a loved one. The Quilt has inspired articles, theatrical pieces, and musical performances, and featured in the award-winning documentary *Common Threads: Stories from the Quilt*, the year that it was nominated for a Nobel Peace Prize.
Bryan Doubt

Date 1987

Country USA

Why It's Key The Quilt is the largest community art project in the world, and it redefined the tradition of quilt-making in response to contemporary issues.

opposite Inaugural display of the project in Washington D.C., 1987.

Key Artist **Jeff Koons**
Exhibits his "Banality" series

Good taste and bad taste were much easier to tell apart before Jeff Koons exhibited his "Banality" series in 1988 as a homage to middle-class kitsch aesthetic values.

As a young man, the Pennsylvania native loved Salvador Dalí, so much that he made a pilgrimage to meet Dali at the St. Regis Hotel in New York City. Koons later attended the Art Institute of Chicago and the Maryland Institute College of Art, where he studied painting, and later supported his art as a Wall Street commodities broker. A notoriously goofy-looking and gnomic good-natured person, Koons looks and acts like a kid from a 1950s TV commercial, and the art he makes reveres that same sugary Pop superficiality.

Koon's Banality show brought his brand new Pop art to the art-world's attention, bringing laughter and the tinkle of money into white-box galleries. The show included *Michael Jackson and Bubbles*: billed as "the world's largest ceramic," the work was a life-sized, gold-leaf-plated Rococo-styled statue of Jackson blissfully cuddling Bubbles, his real-life pet chimpanzee and "best friend." Though critics disparaged him for "debasing" art with his mirthful homage to the patron god of celebrity weirdness, three years after it was first shown, *Michael Jackson and Bubbles* sold at Sotheby's New York for US$5,600,000. The sale tripled Koons' previous record. The statue was acquired in 2002 by the Astrup Fearnley Museum of Contemporary Art in Oslo, Norway where it is now exhibited.
Ana Finel Honigman

Date 1988

Born 1955

Nationality American

Why It's Key Hugely popular sculptor who injected kitsch humor into his Pop art creations.

opposite *Michael Jackson and Bubbles* (1988), by Jeff Koons.

693

Key Artist **Barbara Bloom**
Four-room installation, *Esprit de l'Escalier*

In the summer of 1988 Barbara Bloom was responsible for the artwork shown in the American Pavilion at the Venice Biennale. This four-room installation called *Esprit de l'Escalier* was singled out as the best in the show as a jury picked Bloom for the prestigious Aperto award that year.

Esprit de l'Escalier – a French expression for a witty remark you wished you made in an earlier situation – was a provocative installation spread out over four large and elegant rooms. Like most of her work – usually installations likewise consisting of a group of majestic rooms – it questioned and explored how the fictions of identity and desire are created. Sound effects, music, and lighting regulated the perception of the interior. The Venetian installation especially emphasized the interplay between visibility and invisibility, addressing the relationship between vision and desire.

Bloom studied at Bennington College in Vermont before gaining a BFA at the California Institute of the Arts in Valencia, California in 1972. After an artist's Fellowship in Berlin and the Visual Artist's Fellowship in Photography via the National Endowment for the Arts, both in 1986, she was awarded the Venice Aperto – the Due Mille Prize – two years later. Other awards and fellowships have included the Louis Comfort Tiffany Foundation Award in 1989, the Frederick Weisman Foundation Award in 1991, and a Guggenheim Fellowship in Visual Art in 1998. In 2007 she was a Visting Scholar at the Getty Research Institute. Barabara Bloom lives and works in New York City.
Erik Bijzet

Date 1988

Born 1951

Nationality American

Why It's Key Award-winning example of Bloom's constructions of rooms.

Key Artist **Damien Hirst** Curates the influential Freeze show while still at college

The most influential and acclaimed member of a group of British artists emerging from Goldsmiths College in the early 1990s, Damien Hirst last year became the most successful living artist of all time when his diamond encrusted, life-size skull sculpture was sold for £50 million.

Between 1988 and 1990 Hirst curated a series of art exhibitions by his contemporaries, including the highly acclaimed group show Freeze, while still a student at Goldsmiths College; this show launched the successful careers of many young British artists, including his own. Hirst's star ascended when he was featured in the controversial 1997 Sensation show at the Royal Academy. His monumental sculptures, featuring creatures suspended in formaldehyde-filled tanks, inspired and provoked. The most famous of these featured a predatory shark, and another a cow bisected for anatomical review. Both confront the viewer with questions about one's own mortality and the nature of our existence. Each of Hirst's pieces, although often shocking and intimidating, is consistently undercut with a simplicity and a restrained modernity. This elegance and graphic eye can further be seen in Hirst's works on canvas, including his early *Amyl Nitrate* dot paintings and his later spin works and butterfly pieces.

Hirst has also made pop videos and records, and has owned restaurants. He has recently devoted much time and finances to the renovation and restoration of a massive stately home in Devon, which he intends to turn into a museum housing his own massive collection of contemporary art.

Emily Evans

Date 1988

Born 7 June, 1965

Nationality British

Why It's Key Hirst is a high-profile British painter and sculptor whose work is produced by a "factory" team of assistants.

Key Artwork **The Dance**
Paula Rego

In Rego's (b. 1935) picture story, the events read as if they had stepped from the pages of a novel into the theater of life. The narrative would appear to move from stage left to right. Who is the wistful woman from a bygone era, arms outstretched with emotion? Even her petticoat seems to swirl with anxiety. She stands powerless over what is now perhaps only a painful memory. Has she been abandoned? Questions are left unanswered. Was she the wife or lover of the handsome man in the dark suit? He is now dancing intimately in the moonlight with a woman in a yellow dress. Do gentlemen really prefer blondes?

Whatever the case, these events appear to impact on the lives of the three women seen dancing in the background. Was the woman in the petticoat left holding a baby to raise on her own? Now a grandmother, she dances with her own daughter and grandchild. They join hands and skip lightly beside the steep rock face of the cliff behind them. Soon the skipping grandchild will grow into a beautiful young woman. On stage left she can be seen to dance somewhat anxiously with a man who bears an uncanny resemblance to her grandfather. The young woman wears a yellow polka dot dress. She is heavily pregnant.

This picture is full of silent intrigue. It is about the human condition, and it speaks in the mysterious language of the heart. There are many different ways of interpreting it.

Carolyn Gowdy

Date c.1988

Country UK

Medium Acrylic on paper laid on canvas

Collection Tate Gallery, London

Why It's Key Part of a series, which marked Rego's transition, in the late 1980s, from spontaneous caricature-like paintings into more realistically rendered works on more of an epic scale.

opposite *The Dance*

Key Artwork *Why and What (Yellow)*
Sean Scully

Scully (b.1945) started out as a figurative painter, but since his first attempt at abstraction he has never deviated. He concurs with Kandinsky's view that "the depiction of the appearance of the real world somehow obstructs access to the spiritual domain." This is the domain that Scully seeks. He also takes a lead from Mark Rothko and Piet Mondrian insofar as he is not given to experimentation, but rather an in-depth, reinterpretation of his central motif – the stripe. These directional stripes are always made up of separate panels so that there is a collision when the different orientations meet. Scully deliberately paints this way to avoid confronting the notion of painting the end of a stripe.

Between 1978 and 1984, Scully taught at Princeton and Parsons School of Art, New York. In 1983, the Irish-born painter became an American citizen and maintained a studio on Long Island. In the painting *Why and What (Yellow)* Scully feels he returned to his earlier concerns with Mondrian and Jackson Pollock, and has created a painting-within-a-painting, which in turn makes a reference to one of his personal heroes, Velásquez. The steel plate is a counterpoint to the surface of the canvas, the skin of the painting which corresponds to the flesh of the body. Scully has an engagement with the metaphor of the window, which he equates to hope, and there is a clear reading possible in this respect.

However *Why and What (Yellow)* only goes to reiterate Sean Scully as one of the most articulate and coherent of artists practicing today.

Mike von Joel

Date 1988

Country USA

Medium Oil on linen with steel

Collection Hirshhorn Museum, Washington, DC

Why It's Key Scully introduces a secondary element – steel – into his painting and reinforces the window metaphor in a quite literal way.

696

Key Exhibition
Freeze

In July 1988, the London Docklands Development Corporation and property developers Olympia and York sponsored an exhibition for students from London's Goldsmiths College at the LDDC's administrative block in the docklands to promote the area's regeneration. Damien Hirst, a second-year student at the college, emerged as the show's organizer. His fellow exhibitors included a number of artists who would later be identified as the "Young British Artists," or YBAs.

The sixteen students exhibiting were Steven Adamson, Angela Bulloch, Mat Collishaw, Ian Davenport, Angus Fairhurst, Anya Gallaccio, Damien Hirst, Gary Hume, Michael Landy, Abigail Lane, Sarah Lucas, Lala Meredith-Vula, Richard Patterson, Simon Patterson, Stephen Park, and Fiona Rae.

Goldsmiths lecturer Michael Craig-Martin used his influence to get Norman Rosenthal from the Royal Academy and Nicholas Serota from the Tate Gallery to attend. The collector Charles Saatchi also visited the exhibition. He bought Mat Collishaw's *Bullet Hole* and later became a patron of Damien Hirst, who emerged as a high-profile British painter and sculptor. Other artists secured dealers as well.

The name of the show came from Collishaw's *Bullet Hole* – a photographic blow-up of a bullet hitting a human head, which the catalog said was "dedicated to a moment of impact, a preserved now, a freeze-frame." A second show, Freeze 2, was mounted a few months later, although it lacked the impact of the first.

Nigel Cawthorne

Date July, 1988

Country UK

Why It's Key This exhibition heralded the emergence of the YBAs.

Key Exhibition
Dreamings: The Art of Aboriginal Australia

As part of Australia's bicentennial celebrations, the Asia Society held a landmark exhibition of twentieth-century Aboriginal art, including paintings on bark and wood from Arnhem Land, acrylics on canvas from Central Australia, sculptures from Cape York, and *toas* or message sticks from Lake Eyre. Many of the motifs were derived from the traditional body and sand paintings handed down through generations and used during ritual ceremonies to retell the sacred narratives of the Dreamtime. In the 1970s Aboriginal communities, such as the Papunya cooperative or the Utopia Women's Batik Group, were encouraged to transfer these designs to modern media, which made the works more saleable, but raised artistic and ethical issues.

The designs were increasingly judged by aesthetic standards and often compared to abstract art; yet their credibility and value rested largely on their original context. Their spiritual content was a large part of the attraction for Western audiences tired of postmodernist cynicism and hungry for mythic significance. Symbols that had been part of a collective lore, whose social function was to perpetuate religious beliefs and cultural identity, were becoming the artistic productions of individual "authors." The commodification of sacred, and to a degree secret images, raised concerns in Aboriginal communities when it infringed the rights of the traditional "owner" of the dreaming. However, new forms less directly inspired from dreamings lost some authenticity. Although now integrated into the artistic canon, the shift from ancestral culture to contemporary art needs constant renegotiation.

Catherine Marcangeli

Date 1988

Country USA

Why It's Key This is the first large display of Aboriginal art in America, including over a hundred items.

Key Exhibition **The Neglected Tradition: Towards a New History of South African Art (1930–1988)**

Throughout the years of British colonial rule, followed by the apartheid regime imposed by the South African government from 1948, the major South African galleries concentrated on "traditional" Western art, marginalizing the work of contemporary black artists, and relegating craft-driven work to the category of "native" folk art. When the Johannesburg Art Gallery staged The Neglected Tradition in 1988, the title itself was an indication of how widespread the denial of black art by the white establishment had been. There had been earlier moves by black artists to assert their identity collectively, of course, but always in the context of the broader social constraints of apartheid. During the fifties the Polly Street Art Centre in Johannesburg produced work that represented a synthesis of African and Western traditions on the part of painters like Lucas Sithole, Cecil Skotnes, and the sculptor Sydney Kumalo. And after the Centre closed in 1962, Skotnes, Kumalo, and Edoardo Villa were among the founders of the Amadlozi group, which shifted the emphasis to one of a more deliberate "Africanism."

Throughout this period, the Johannesburg Art Gallery displayed conventional "Art" with a capital A, and nothing much else. But things were changing all around. In 1985 director Christopher Till instigated a policy of including traditional and new black SA art, and to this end The Neglected Tradition show in 1988 collected together the work of a hundred black artists previously ignored by the art establishment. For South African art, it was a precursor to the final dismantling of apartheid in the early nineties.

Michael Evans

Date 1988

Country South Africa

Why It's Key First comprehensive large-scale exhibition of black artists by a major South African gallery.

Key Artist **Fiona Rae**
Work acclaimed at Damien Hirst's Freeze exhibition

Acclaimed as one of the most promising talents of the YBAs (Young British Artists) when she first garnered approval via the Damien Hirst-curated Freeze exhibition in 1988, Fiona Rae's work has highlighted some of the inherent contradictions in that movement.

Born in Hong Kong in 1963 and moving to Britain in 1970, she studied at Croydon College of Art in the mid-eighties before attending Goldsmith's College, when it was the catalyst for the UK art explosion of the nineties. Her classmates there included Gary Hume, Julian Opie, and Hirst, and soon her undoubted talent as a painter was seemingly subsumed in the collective pursuit of Cool.

An Abstract Expressionist for the Nineties, her work has featured a postmodern juxtaposition of painterly applications and references which caught the art mood of the time as effectively as that of her more celebrated contemporaries. She was nominated for the Turner Prize in 1991, and in 1993 for the Austrian Eliette von Karajan Prize for Young Painters. After showing in Charles Saatchi's Sensation exhibition in 1997, she was increasingly lauded by the art establishment, and is now a Royal Academician and Trustee of the Tate Gallery.

Her work of late, though still appearing accidental and often almost arbitrary in its execution, has become increasingly structured, revealing an underlying discipline in her control of paint and style. The casually vacuous, neutral stance of the Cool school which permeates classic Rae canvasses like *Untitled (Parliament)* (1996) is counter-pointed by a firm commitment to the "traditional" values of modern art.
Mike Evans

Date 1988

Born 1963, Hong Kong

Nationality British

Why It's Key A postmodern take on Abstract Expressionism.

opposite Fiona Rae's *Moonlight Bunny Ranch* (2003).

Key Artist **Tatsuo Miyajima** Produces his first digital counters in the form of LEDS

Born in Tokyo, Tatsuo Miyajima graduated from the Tokyo National University of Fine Arts and Music in 1986. His earliest works were exhibited in the Hara Annual and at the Venice Biennale in 1988.

Miyajima initially experimented with various elements of electrical gadgetry, but by the end of the 1980s, he had settled on producing installations with LEDs (Light-Emitting Diodes). Digital counters in dark rooms, mounted on walls, floor, under water, and even on model dodgem cars, marked the passage of time. His compositions comment on contemporary society and the way humans live, using these digital counters as a lingua franca.

Notable works include *Region no. 126701–127000*, which is constructed with 300 LED panels counting perpetual sequences between one and ninety-nine, each with its own rhythm. It exists in an eerie state of constant change without repetition. The installation is a composition of units of red and green counters, and Miyajima includes a stamped certificate with each panel that outlines the sequence and rhythm. The various timescales are seen as metaphors for the pulse of human beings, in units of couples, families, or tribes.

Miyajima continues to work on different installations, reflecting the ways in which time can be perceived, including *Spiral Time* (1992) and *Running Time* (1994). In 1998 he produced *Floating Time*, an interactive installation in which visitors can change its numbers and colors. Since the 1980s, three basic concepts have informed his work: Keep Changing, Connect with Everything, and Continue Forever.
Mariko Kato

Date 1988

Born 1957

Nationality Japanese

First Exhibited 1988

Why It's Key Important artist addressing various time-based concepts via digital installations.

Key Artist **Richard Serra**
Controversial *Tilted Arc* scrapped in New York

Scandals over sexually explicit or politically incendiary imagery are common in the recent annals of art history, but there is no instance in which bare, unadorned steel caused more outrage and controversy than Richard Serra's *Tilted Arc*. Commissioned by the Arts-in-Architecture program of the U.S. General Services Administration, which earmarks 0.5 per cent of a federal building's cost for artwork, *Titled Arc* was installed in New York City's Federal Plaza in 1981. The $175,000, 20 foot-long and 12 foot-high, steel, site-specific sculpture cut the Federal Plaza in half.

Inconvenience was part of Serra's aesthetic mission. He expressed his objective for *Tilted Arc* as, "The viewer becomes aware of himself and of his movement through the plaza... Contraction and expansion of the sculpture result from the viewer's movement. Step by step the perception not only of the sculpture but of the entire environment changes." But the people who worked in Federal Plaza were frustrated by being forced to act as "viewers" of an object disrupting their day and making it hard to find a spot to eat lunch. Locals also accused the sculpture of attracting graffiti and rats, and providing a tempting site for terrorist activity.

In 1989, after a prolonged public hearing and bitter artistic dispute, *Tilted Arc* was cut into three pieces, removed from Federal Plaza, and carted off to a scrap-metal yard.

Ana Finel Honigman

Date 1989

Born 1939

Nationality American

Why It's Key Important Minimalist sculptor noted for his large-scale sheet metal constructions.

opposite The ill-fated *Tilted Arc*.

Key Artist **Huang Yong-Ping**
Emigrates to Paris

Contemporary visual artist Huang Yong-Ping was born in the southwestern Chinese province of Xiamen in 1954, and spent the early part of his life at the Academy of Fine Arts in Hangzhou where he studied oil painting. Influenced by Dadaism and the ancient Chinese concept of numerology (the mystical relationship between numbers and physical objects), Huang became one of the founding members of the Xiamen Dada movement in the 1980s. He became enamored with artists such as Joseph Beuys and the *arte povera* movement, and sought to include aspects of their work in his pieces.

In 1989 Huang emigrated to Paris where his international fame grew. He became well known for his work in combining different forms of media, and some of his bizarre installations (including the use of live scorpions and snakes) attracted great press attention. A finalist in the biennial 1998 Hugo Boss Prize held in New York, he went on to represent France alongside his friend Jean-Pierre Bertrand at the Venice Biennale in 1999.

One of Huang's most famous installations is *Bat Project 2* (2002), a gigantic piece consisting of a life-size recreation of an American reconnaissance aircraft cockpit filled with stuffed bats. Modeled on the EP-3 which collided in 2001 with a Chinese fighter, the work was removed by the foreign ministry just days before it was to be exhibited at the Guangdong Museum of Art. In October 2005 Huang's first retrospective entitled House of Oracles opened at the Walker Art Center, Minneapolis, USA.

Jay Mullins

Date 1989

Born 1954

Nationality Chinese

Why It's Key One of the founders of the Xiamen Dada movement, Huang's bold and provocative installations have drawn both admiration and controversy.

Key Artist **Richard Long**
Wins Turner prize after fourth nomination

Richard Long was born in Bristol – where one of his pieces, *Delabole Bristol Slate Circle*, acquired from the Tate Modern in 1997, is a central piece in the city's main Museum and Art Gallery. He studied art there at the West of England College of Art from 1962 to 1965, and graduated from St Martins School of Art in London in 1968.

Being nominated for London's Turner Prize is a crest in any British artist's career. Of course, artists often grumble about the experience, because the British don't like to appear content, but they mainly benefit from the affiliation. Except for Richard Long, who must have felt diminishing emotional returns even after he won, after being nominated four times.

Though perhaps Long has no real use for the urban art-world's accolades. As one of the foremost earth-artists since 1967, the English artist created sculptural installations representing the sensual and philosophical experience of walks he takes in the Highlands of Scotland, the Alps, the Andes, the Sahara, and Lapland.

He also represents his interactions with nature through photography, text, and maps of the landscapes he traverses. In 1989, when he finally won the Turner for *White Water Line*, Channel 4 aired a film about his life and work entitled *Stones and Flies*. As humble as these references might appear, Long is the forefather of the Green art movement that is now turning white-box galleries into places to worship the great outdoors.
Ana Finel Honigman

Date 1989

Born 1945

Nationality British

Why It's Key One the best known British Land artists.

Key Artwork *Highland Shore Study*
Boyle Family

Mark Boyle (1934 – 2005) and his wife Joan Hills (b 1931) began making "Earth Pieces" in 1963. Random sites of the Earth's surface are chosen and recreated as painted fibreglass reliefs. Their children Sebastian (b. 1962) and Georgia (b.1963) worked with them from an early age and since 1985 they have exhibited as Boyle Family.

Highland Shore Study (1988-89) presents an area of worn brown sandstone rock from the coast of Scotland, showing the erosion of layers of softer rock over thousands of years. Exactly how Boyle Family cast their work has remained a secret, but their reproduction of a piece of ground 72 inches by 72 inches is technically perfect and convincingly lifelike. The idea was to present random selections of reality, unfiltered and unadorned, in an attempt to teach themselves to see. The resulting works seem to rip pieces of the Earth's surface from its context and hang on a gallery wall like evidence in a trial.

This approach began with the London series and then expanded to a World series with 1,000 sites randomly selected from a giant map of the world in London's Institute of Contemporary Arts by blindfolded visitors throwing a dart. Since then there have been a number of related series – the Sand, Wind, and Tide series, the Thaw series, the Japan series, and the Docklands series. Collectively they are known as *Journey to the Surface of the Earth*.
Nigel Cawthorne

Date 1989

Country UK

Medium Resin and fibreglass

Collection Private collection

Why It's Key This work is considered one of the finest of their "Earth Pieces."

opposite *Highland Shore Study*

Key Artwork *Untitled (Your Body is a Battleground)*
Barbara Kruger

Politically charged and visually striking, *Untitled (Your Body is a Battleground)* is a canonical image from the feminist arts movement. Barbara Kruger originally designed this artwork to be displayed as a billboard-size poster to support the pro-choice campaign in America. It was used during the Pro-Choice March, Washington DC, in April 1989.

Kruger's art deals with oppositions – male/female, text/image – and focuses upon the negative effect these distinctions can have upon the marginalized. Kruger's former employment as an art director for the magazine industry influenced the development of her signature style, which is displayed to full effect in *Your Body is a Battleground*.

The combination of text with image allows Kruger to challenge these methods of communication, and asks onlookers to reassess the way they read the visual world. In *Untitled (Your Body is a Battleground)*, Kruger selected a mass media image of a female face upon which to convey her message. The face stares directly back at the viewer, returning the gaze with confidence. The nameless female is representative of all women at the center of such a contentious issue. A dramatic use of red punctuates the images, and demands focus upon the authoritarian tone of the accompanying text. The image itself is also divided between the negative and positive print, suggestive of the alternate views regarding the abortion debate.
Samantha Edgley

Date 1989

Country USA

Medium A found photographic mass-media image

Why It's Key By using text and image, Kruger was able to draw upon the influence of the mass media to create this artwork – which is as politically confrontational as it is artistically engaging.

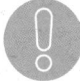

Key Event
Ronnie Tjampitjinpa's first solo show

In 1971, Ronnie Tjampitjinpa (c.1943–2001), a member of the Pintupi tribe of Australia's Western Desert, began to depict his people's Tingari Cycle of religious and ecological story-telling in dot painting. Tjampitjinpa's work, typified by the repetition of simple and bold geometric forms, was first exhibited at the Papunya Tula school that was so seminal in encouraging indigenous Australians to carry on their traditional artwork with the assistance of Western tools.

By the end of the 1980s, Tjampitjinpa's work would be known not just in the small coterie of critics and buyers interested in indigenous art, but across all of Australia. His 1989 solo exhibition in Melbourne positioned Tjampitjinpa as a figurehead of the indigenous art movement, which steadily gained recognition, prestige, and respect from that year forward.

Tjampitjinpa's first solo show was at Melbourne's Gallery Gabrielle Pizzi, which opened its doors in 1987 and subsequently emerged as a leading specialist in Australian indigenous art. Gabrielle Pizzi had been championing and exhibiting this work since the early 1980s, and became the conduit through which Tjampitjinpa, Emily Kngwarraye, and Mick Tjapaltjarri gained exposure. Tjampitjinpa's 1989 show was a watershed in indigenous Australian art. Before 1989, this kind of art was dismissed as an ethnological curiosity by the staid gatekeepers of the Australian art establishment; after 1989, the vibrancy and power of Tjampitjinpa's work could no longer be denied, and the traditional art he represented attained an undeniable aesthetic status that propelled it into public collections.
Demir Barlas

Date 1989

Country Australia

Why It's Key This exhibition is a landmark in the recognition of the art of Australia's indigenous population.

opposite Tjampitjinpa's *Kaapa Mbitjana (Budgerigar Dreaming)*, synthetic polymer powder paints, earth pigments, and PVA on composition board.

Key Artwork *Ignorance = Fear*
Keith Haring

From the beginning, the HIV/AIDS epidemic was accompanied by an epidemic of fear, ignorance, and denial, leading to stigmatization and discrimination. The stigma itself became recognized as the single greatest challenge to slowing the spread of the disease. Fear prevented people from even being diagnosed and changing unsafe behavior. It inhibited them from seeking support.

Until the early 1990s, HIV infections turned swiftly into full-blown AIDS, and many patients quickly lost the battle, dying within a short time of diagnosis. Panic was widespread, and Americans still didn't fully understand that you couldn't catch the virus through a kiss, a cough, or a touch.

Bold outlines frame these primitive cartoon figures. Haring (1958–1990) called them his "radiant babies." They are animated, divine beings full of light and life, but the "radiant babies" face enormous challenge. They have something important to say. Fear is as dangerous in today's world as it was then. You can't catch it by holding hands.

Carolyn Gowdy

Date 1989

Country USA

Why It's Key Keith Haring was an artist and social activist whose work responded to the New York street culture of the 1980s. When Haring discovered, in 1988, that he had AIDS he turned much of his artistic attention to educational works about the danger of the disease. In 1990, at age thirty-one, Keith Haring's life was cut short due to an AIDS-related illness.

706

Key Exhibition **Magiciens de la Terre**
First major show of modern African art, Paris

This exhibition set out to address widespread cultural attitudes that perceived art from non-Western countries as primarily "ethnographic" in interest; its makers were often considered craftsmen and their production as expressing local folklore. "International" art was predominantly regarded as meaning "Western," and as the British art critic, Guy Brett, pointed out in 1991, "'Universal' is rarely construed to mean 'plural.' Our art-historical maps are still largely a one-way projection from a fixed Western point of reference."

Magiciens de la Terre, however, accelerated the shift toward Western institutions viewing artists from outside the West as equals, at least to a certain extent. Organized by Jean-Hubert Martin, a curator at the Centre Georges Pompidou, the show was the first in a leading European museum to feature worldwide contemporary developments. Fifty artists from the West and fifty from elsewhere were selected, with many artists making work especially for the exhibition.

Criticism of Martin's criteria for choosing artists according to their works' "visual and sensual experiences," came from commentators and from artists within the show, like Barbara Kruger. Especially controversial was the decision to label artists as "magicians," a term strongly recalling past associations with ritualistic behavior, and to restrict selection to mostly Western experts. Martin responded that any other framework for these sensitive objectives had similar flaws, and that the choice of artists challenged notions of Western art's centrality.

Martin Holman

Date May 18–Aug 14, 1989

Country France

Why It's Key Advanced the debate on post-colonial Western attitudes to "Third World" art and accelerated interest in new art from beyond the West. After 1989 many important institutions exhibited non-Western art, notably (and controversially) Documenta X in 1997, with particular interest in Far Eastern developments.

opposite Magicien de la Terre exhibitor Barbara Kruger's *Your Body Is a Battleground* (1989).

Your body is a battleground

Key Artist **Bodys Isek Kingelez**
Shows work at Les Magiciens de la Terre exhibition

Born in 1948 in Kimbembelelhunga, Congo, Bodys Isek Kingelez (born Jean-Baptiste) is known as an artist of futuristic and imaginative architectural models.

Throughout the 1960s Kingelez worked as a restorer of African masks at the National Museum of Kinshasa. When he lost his job at the start of the 1970s he became fascinated with building urban scale models using card, glue, and paper which he dubbed "extrêmes maquettes," or "extreme models." Despite not having any architectural training he was invited by André Magnin to exhibit his work in Paris at Les Magiciens de la Terre (Earth's Magicians) in 1989. Soon the Parisian gallery owner Jean-Marc Patras was financing and exhibiting his developing body of work.

A visionary or imagined depiction of a future Kinshasha, *Ville Fantôme* (1996) manifests Kingelez's penchant for using everyday urban materials to re-imagine urban spaces. Incredible model buildings are constructed from bottle caps, tinfoil, corrugated cardboard, and other domestic objects.

Exhibited all over the world in countries as diverse as Mexico and Japan, Kingelez's work has appeared across Europe since 2000, namely in Germany, France, and Britain. To date he has created over three hundred models. It could be argued that Kingelez's forward-thinking art is to some extent inspired by a reaction against the African relics he handled while working at the National Museum of Kinshasa. By suggesting possible future configurations of urban life, his extreme models challenge the viewer's traditional perceptions of Africa as a continent defined by its tribal past.
Jay Mullins

Date 1989

Born 1948

Nationality Congolese

Why It's Key Highly influential in the African fringe, Kingelez's unique models visualize the possibility of fantastic futurescapes.

Key Artist **Anish Kapoor**
Anglo-Indian sculptor represents UK at Venice Biennale

Anish Kapoor was born in Bombay, (now Mumbai) India to a Hindu father and a Jewish-Iraqi mother. He moved to England in 1972 and attended Hornsey College of Art and then Chelsea School of Art and Design. His first works were in wood and mixed media. In the 1980s he came to prominence with his work in stone and metal. His early pieces were often covered with powdered pigment reminiscent of the piles of powdered spices seen in Indian markets, or were painted with intense, vibrant colors. Later sculptures relied more on simple, elegant shapes with tactile or reflective surfaces, or solid stone pieces with cavities or voids carved into them. Kapoor visits his birthplace regularly and acknowledges that his work is influenced by both Western and Eastern cultures. Since the 1990s he has produced larger works, including *Taratantara*

(1999) a 35-meter-tall sculpture in Gateshead, England, and *Marsyas* (2002) a big steel and PVC construction in the turbine hall of Tate Modern, London. Other large-scale works are to be seen in major cities around the world. Kapoor was chosen to represent the UK at the Venice Biennale in 1990, won the Turner Prize in 1991, and had a major exhibition at the Hayward Gallery, London in 1993.
Alan Byrne

Date 1990

Born 1954

Nationality British/Indian

Why It's Key A major modern sculptor linking Western and Eastern cultures.

opposite **Kapoor's** *Marsyas* dwarfs a visitor.

Key Artist **Anselm Kiefer**
Awarded the Wolf Prize

The Wolf Prize is awarded by Israel's Wolf Foundation annually to living scientists and artists for achievements in the interest of mankind and friendly relations among peoples irrespective of nationality, race, color, religion, sex, or political views. In many categories it is as prestigious as the Nobel Prize. The German artist Anselm Kiefer was selected in 1990 because he had created an art that synthesizes human history and mythology with the contemporary condition of life.

Born in Donaueschingen in 1945, in 1966 Kiefer left law studies at the University of Freiburg to study at art academies in Freiburg, Karlsruhe, and Dusseldorf. He first came to artistic prominence in the 1970s with subjects that dealt derisively with German heritage like the Nazi period. As a result he was regarded as a national embarrassment for years in West Germany, his art being riddled with German taboos, and often seeming rather dark and neo-Romantic in style and thus out of date. While the press in the Federal Republic chastized the artist not a single other German artist – not even Joseph Beuys – enjoyed such a huge international following during his lifetime.

After receiving the Prize – actually in the same year as German unification – Kiefer decided to return the U.S.$100,000 cheque to the Wolf Foundation to establish a scholarship to help young promising Israeli artists mainly in pursuit of studies abroad.
Erik Bijzet

Date 1990

Born 1945

Nationality Germany

Why It's Key Acknowledged Kiefer's role as a defiant artist in West Germany.

opposite Kiefer's *Markishe Heath*.

1990-1999

711

Key Artwork *Six Foot Leaping Hare on Steel Pyramid*
Barry Flanagan

Imbued with a physical vibrancy that stretches the animal's form to its limits, *Six Foot Leaping Hare on Steel Pyramid* epitomizes Barry Flanagan's long line of bronze animal sculptures.

The artist's preoccupation with hares can perhaps be attributed to the naturally expressive nature of their form. Flanagan is able to invest the animal's loping legs and long ears with subtle emotions that would otherwise be difficult to convey in a statue with human proportions. Flanagan's leaping hares are thus rendered innately human, making it easy for the viewer to identify with his subject.

The artist's first leaping hare sculpture, *Gilded Hare*, was completed in 1980 and is held in the Courtauld Institute. Since then the distinctive animal motif has become recognized around the world, to the extent that Flanagan was commissioned by Kawakyo Company, based in Osaka, to produce two bronze leaping hare sculptures to adorn the main entrance of a hotel on the Japanese coast.

A number of famous urban spaces have been used to exhibit Flanagan's iconic bronze hare sculptures. In May 2006 six pieces ranging in height from 9ft to 23ft were installed in O'Connell Street, Dublin. Marking the completion of the thoroughfare's refurbishment, the project included the *Nijinsky* dancing hare and *Thinker on Rock*. Prior to this Flanagan's work featured in Park Avenue in New York between 1995 and 1996, and Chicago's Grant Park in 1996.
Jay Mullins

Date 1990

Country UK

Medium Bronze

Collection Waddington Gallery, London

Why It's Key The bronze sculpture captures the essence of Flanagan's archetypal animal subject.

Key Artwork *Body*
Luc Tuymans

*B*ody shows a doll-like figure, an image based, as in all Tuymans' work, on a photograph. Tuymans degrades his photographs by copying and recopying them so that they lose their clarity as images.

Tuymans' paintings are accompanied by titles which exist in parallel to the image. In the case of *Body* this title conjoins the image of a stuffed doll with a child's lifeless body. A zip runs across the doll's chest as two lines, which suggest wounds or surgical incisions. The counterpoising of image with text is unsettling, with its undercurrent of banality and violence. For Tuymans the violence is initiated by cropping the image as if it were viewed through the lens of a camera. This body has been cropped at the neck and the thighs, reduced to an insignificant torso; the identity disdained.

The juxtaposition of a minimal image with an ambiguous title suggests rather than dictates to the viewer, who has to reconstruct potential meanings; we may have seen an image like this before which we may have forgotten or suppressed because of its abject quality. Its ambiguity does not allow us to categorize it or label it with confidence, and we remain anxious in front of it. The anxiety is not diverted by any aesthetic strategy. Insipid, washed-out skin tone colors are laid onto the canvas with awkward brushstrokes. Tuymans avoids expressive virtuosity or beauty to show us that when memory is mediated through images, paintings can only show a partial recreation of an event.
Sarah Mulvey

Date 1990

Country Belgium

Medium Oil on canvas

Collection Xeno X Gallery

Why It's Key This painting appeared in the 1995 exhibition Superstition at the University of Chicago – Tuymans' first American show.

712

Key Artist **Orlan**
First of nine performance surgeries on her own body

*O*rlan (not her real name) is the first artist to use the operating room as her atelier and performance site. Wearing costumes designed by noted designers such as Issey Miyake, and reciting texts or poetry or answering questions from spectators during the process, Orlan allows her body to be transfigured while playing the role of subject and object at the same time. Accompanied by music, these nine performance pieces, entitled *The Reincarnation of Saint Orlan*, were broadcast live to various galleries and sites around the world.

A self-proclaimed feminist, Orlan's performance pieces reference ideal portraits of women from the history of art. Using surgeons and, later, computer-generated images, she remodels her face, extrapolating features from various artworks, such as the forehead of da Vinci's *Mona Lisa* and the chin of Botticelli's Venus in

The Birth of Venus. In her seventh operation Orlan asked the surgeon to place implants, which are normally used to make cheekbones more prominent, into her temples, creating two protruding bumps, challenging our notion of a standardized style of beauty.

Referring to her art as Carnal Art, Orlan makes it clear that she is not against plastic surgery but against a dominant male ideology of unattainable beauty that imposes itself on feminine flesh. In the tradition of self-portraiture, Orlan uses her skin as a mediating tissue between the internal and external self, challenging the Christian notion of the sacredness of the body and what she calls the lottery of genes. Opening the body, copying it, duplicating it, watching it, and being inside it allow for a fluid and constantly fluctuating sense of self.
Bryan Doubt

Date 1990

Born/Died 1947

Nationality French

First Exhibited/Performed Early 1970s

Why It's Key At the forefront of contemporary transgressive art, she used her body as the agent of her art in a series of plastic surgery operations.

opposite Orlan with the image of herself *African Self-Hybridization: Ndebele Giraffe Woman of Ngumi Stock, Zimbabwe, with Euro-Parisian Woman.*

Key Artist **Eulalia Valldosera**
Produces the first of her *Burns* photographs

1990–1999

Much of the history of figurative art and photography is given over to male scrutiny, construction, and control of the female body. Only in the 1960s did conceptual and performance art begin to return the female body to the woman, as performer and owner of the iconographic power of her own body.

The Spanish photographer Eulalia Valldosera invoked that tradition in her *Burns* photographs, the first of which appeared in 1990, but with a twist. While female performative traditions of the 1960s often staged the attractive and healthy body, Valldosera's work called attention to the photographer's own body in an anonymous medical setting. This marked an ongoing trend in Valldosera's controversial work, which did not shy away from presenting the female body – typically her own – as somehow powerless in, or fetishized by, the face of disease, fire, or the male gaze. While Valldosera thereby left herself open to charges of self-hatred, *Burns* demonstrated the artist's refusal to shy from a topic or treatment simply because it was politically vulnerable. This refusal to edit her own work constituted a kind of activism in itself.

Burns fit into the aesthetic of what Valldosera calls remainders – cigarette butts, bandages, indeterminate flesh, and other cast-offs of the human condition. It is through this depiction, sometimes contrasted with the larger body that uses them, that Valldosera achieves her disjointed and provocative effects of self-representation. After *Burns*, Valldosera began to work in video, mixed media, and installations more frequently than in photography.

Demir Barlas

Date 1990

Born 1963

Nationality Spanish

Why It's Key A Spanish photographer memorably directs her gaze upon her own body.

714

Key Artwork *Semen and Blood II*
Andres Serrano

Controversy has surrounded the Honduran-Afro-Cuban American artist Andres Serrano since a copy of his photograph of a wood and plastic crucifix placed in a four-gallon tank filled with the artist's urine entitled *Piss Christ* was ripped up on the floor of the Senate in 1989 and denounced by the Christian Right. "I am drawn to subjects that border on the unacceptable," Serrano said in 1993, "because I lived an unacceptable life for so long. *Semen and Blood II* is another work in which he uses his own bodily fluids to create an image that challenges the viewer's tolerance, bringing to light difficult and disturbing issues in a way that seduces and unsettles.

Consider Serrano's use of blood and semen as paint spilled onto the black background of the image. We might be looking at an abstract painting, vivid red mixed with white to create a damask sea-like creature, a swirling amoeba seeking the reaches of outer space. Blood and semen as life-giving forces are powerfully mixed in an aesthetic with its own sensual beauty.

Yet in the context of AIDS, blood and semen become dangerous and toxic, the discharge of a body we can no longer contain, in the same way politicians could not suppress a global awareness of AIDS.

Bryan Doubt

Date 1990,

Country USA

Medium Cibachrome print, silicone, plexiglaş, wood frame

Why It's Key A provocative use of the bodily fluids of blood and semen to create a photograph at a time when awareness of AIDS as a general epidemic was growing.

Key Artist **Guillermo Kuitca**
First New York solo show

From September 13 to October 29, 1991, the Argentinean painter Guillermo Kuitca received his first solo show in New York, at the Museum of Modern Art. Kuitca, a prodigy, was thirty at the time of the exhibition but had already been painting for twenty-four years (he was first exhibited in Argentina at the age of thirteen).

Kuitca's art – in both paintings and installations, such as *Burning Beds* – tends to share the common and interrelated themes of mapping. In addition to maps of city streets, roads, family trees, sporting arenas, and other identifiable locations, Kuitca's work invokes the notion of the mind map, a concept also pivotal in Australian indigenous art. However, in contrast to such indigenous work, Kuitca's art is often about not knowing where one is, or how to navigate the surrounding world, despite the presence of maps. Human figures in Kuitca's maps sometimes emphasize the possibility of being overwhelmed by information, or the indeterminacy of direction.

Most importantly, Kuitca's maps are not made of placid matter; his map of Bogota was rendered with syringes in place of streets, and in another work bones designated apartments. While this kind of imagery can be read as regionally inspired – in Kuitca's case, by the enormities of military rule in Argentina – it also reflects global anxieties about violence, displacement, and the effacement of the human.

It was this timely aesthetic that MoMA spectators saw in action in 1991. Since then, Kuitca has exhibited repeatedly in the United States.
Demir Barlas

Date 1991

Born 1961

Nationality Argentinian

First Exhibited 1974

Why It's Key A Latin American prodigy makes his mark on America.

Key Artist **David Hammons**
House of the Future installation

The elusive African-American artist David Hammons was quoted in a *New Yorker* profile written by staff art critic Peter Schjeldahl as saying "I decided a long time ago that the less I do the more of an artist I am. Most of the time, I hang out on the street. I walk."

So while the art-world hungered for Hammons' racially charged Conceptual art such as stones covered in hair that he collected from Harlem barbershops, or massive strips of paper marked with the imprint of a dirty basketball, Hammons ignored the audiences and stayed away from the limelight.

But Hammons' most significant work, the 1991 *House of the Future*, spotlighted the class and racial divides that affect the lives of those far removed from the art world's loving gaze. Located on America Street in Charleston, South Carolina, the *House of the Future* was a ramshackle, rough, barely functional two-story edifice. Approximately six feet wide and twenty feet long, it was pieced together with found columns, a discarded door, and scraps of wood which made it look dilapidated the moment it was built. The piece playfully mocked the Southern fixation with landmarking architecture while also commenting on the harrowing way in which African-Americans were forced to live in most cities.

In a *New York Times* review, the writer mused, "It was becoming increasingly difficult to tell who the real architect was, Mr. Hammons or the residents of the black neighborhood, although only he could be responsible for such an inspired and unpredictable communal invention."
Ana Finel Honigman

Date 1991

Born 1943

Nationality American

Why It's Key Influential installation artist known mainly for his works in and around New York City in the 1970s and 1980s.

Key Artwork *Self*
Marc Quinn

Marc Quinn's (b,1964) *Self* is the work for which the artist is probably still best known. A work of mixed media, the centrepiece of *Self* is 4.5 liters of the artist's own blood, cast and frozen in the form of his head and housed in a refrigeration unit. While the work's detractors have sought to identify it as a headline-grabbing gesture that is merely intended to scandalize, when it first appeared it was nonetheless thought to offer a pertinent comment on issues of identity in an age of AIDS, cloning, and DNA fingerprinting. Aside from the sociopolitical nature of the work, it might also be seen to function in the tradition of death masks and funerary sculpture too.

Increasingly, Quinn's work has become more concerned with genetics and corporeality, beauty and artifice, yet *Self* remains his best-known work, partly due to a widely circulated urban myth. Though the artist has strongly denied the story, it is said that due to a power failure at the home of its owner, Charles Saatchi, *Self* melted, spilling the 4.5 liters of artist's blood onto the floor. While an unlikely story, it nonetheless serves to show that part of the fascination with works such as *Self* does indeed result from a populist appetite for the macabre. Works such as *Self*, and Quinn's more recently controversial portrait of a pregnant disabled sitter, *Alison Lapper*, trade on the curiosity of a tabloid culture to achieve notoriety.

Ian McKay

Date 1991

Country UK

Medium Mixed media

Collection Private collection

Why It's Key A pertinent comment on issues of identity in an age of AIDS and DNA fingerprinting, also revealing a popular appetite for the macabre.

Key Artwork *The Physical Impossibility of Death in the Mind of Someone Living* Damien Hirst

Since the 1990s, conversations about English art, and many on the subject of contemporary art in general, have included some mention of "the shark." The 14ft tiger shark, immersed in formaldehyde and displayed in a vitrine by Damien Hirst for his sculpture, *The Physical Impossibility of Death in the Mind of Someone Living*, has become one of art history's most controversial works of art. A large part of the controversy was over the sculpture's cost. Charles Saatchi commissioned the shark sculpture in 1991. To create it, a fisherman in Australia was engaged to catch the shark and Hirst purchased its corpse for £6,000. Saatchi then purchased the final piece for £50,000. He exhibited it in a 1992 group show titled Young British Artists at the Saatchi Gallery. In response to the show, the *The Sun* newspaper ran a headline reading: "£50,000 for fish without chips."

In 2004, Saatchi sold the shark to hedge fund billionaire Steven A. Cohen for US$8 million, making Hirst the second most expensive artist in the world. Hirst went on to become the most expensive living artist in 2007 with the sale of *Lullaby Spring*, a medicine chest, for £9.65 million at London's Sotheby's.

Currently on display at the Metropolitan Museum of Art in New York, *The Physical Impossibility of Death in the Mind of Someone Living* is actually an arresting, beautiful, and poetic piece. A play on the idea that sharks need to constantly move ahead or die, the work addresses the reality of death with quiet resignation and poignant humility. Strip away the shock of the shark, and it is possibly an immortal work of art.

Ana Finel Honigman

Date 1991

Country UK

Medium Tiger shark, glass, steel, 5 percent formaldehyde solution

Collection Metropolitan Museum of Art, New York City (on loan)

Why It's Key Controversial sculpture that established Hirst as the UK's best known, and most financially successful Conceptual artist.

opposite *The Physical Impossibility of Death in the Mind of Someone Living*

Key Artist **Ken Currie**
Shocks to the System exhibition

British artist Ken Currie paints memorable images articulating the fear people feel when contemplating the myths and reality of their mortality. When Currie contributed to the 1991 touring group show, Shocks to the System: Social and Political Issues in Recent British Art from the Arts Council Collection, his work established itself among the most moving and disquieting paintings produced in the UK. Along with the work of other major artists emerging in the UK such as Mona Hatoum and Susan Hiller, Currie's images came to define the Shocks to the System show. While other, more sensationalist artists were using death as their subject matter, Currie addressed death in a subtler, more mature manner that was therefore more unsettling and complex.

Cancer is the subject of most of Currie's oeuvre. Until recently, the disease was highly stigmatized in Western society. In her ground-breaking essay, "Illness as Metaphor," cultural theorist Susan Sontag wrote, "Cancer patients are lied to, not just because the disease is (or is thought to be) a death sentence, but because it is felt to be obscene – in the original meaning of that word: ill-omened, abominable, repugnant to the senses."

Today, cancer is tragically too common to have such isolating myths ascribed to it. As an artist, Currie has created a body of work that brilliantly explores the emotional ramifications of such sickness and the notion of disease in its many and manifold social, political, and personal states.

Ana Finel Honigman

Date 1991

Born 1960

Nationality British

Why It's Key Scottish-based artist whose work has addressed sociopolitical issues, as well as concerns of the individual human condition.

Key Artist **Vivian Sundaram**
The Gulf War inspires work in engine oil and charcoal

In 1991, after the conclusion of the Gulf War, Indian artist Vivian Sundaram created *Gulf War* in engine oil and charcoal on paper. The work was important for two major reasons: it demonstrated the solidification of an international attitude among politically-minded Indian artists, and it registered the increasing value of ecological themes in Indian art.

Not surprisingly for a former colony, the politics of India's art scene remained inwardly-facing for a number of years. It was a time to renew interest in Indian themes and issues that had been shelved under British rule. However, by the time of Sundaram's *Gulf War*, Indian artists began to reconnect with a more global form of politics. In this regard, exhibitions in the early 1980s had paved the way by bringing Indian artists into intimate contact with the Western art world.

Sundaram's *Gulf War* was less interested in partisan denunciation of any particular belligerent than in documenting the manifest horrors of a world whose axes were blood, oil, and war. Such a status quo, unlike the imperialist order of the nineteenth century, had the potential to destroy the earth with an ecological catastrophe. As such, Sundaram's richly evocative abstract work demonstrated not only what the world was but also what it had the potential to become. This was a bold display of global and temporal awareness that improved on the previous century's static and locally-oriented denunciations of colonialism. Sundaram's work thus announced a new era in the political consciousness of Indian artists.

Demir Barlas

Date 1991

Born 1943

Nationality Indian

First Exhibited 1966

Why It's Key An Indian painter who demonstrated a truly international sensibility in the aftermath of the Gulf War.

Key Artists **Jake and Dinos Chapman** Beginning of tableaux series based on Goya's *The Disasters of War*

Dinos and Jake Chapman both left the Royal College of Art in 1990 and, after an apprenticeship with Gilbert and George, they decided to work together.

Their oeuvre is, in effect, an homage to Georges Bataille (1897–1962) the French philosopher, whose influence on Surrealism, post-structuralism, and Postmodernism has been increasingly recognized. The Chapmans' interest in Goya in the early 1990s can be traced back to Bataille's own enquiry into Goya's work. Through the remodeling in different media of Goya's etchings, at different times in their career, they have invoked the violence and degradation inherent in Bataille's concept of base materialism.

The sculptures which introduced them to a wider public when they were shown at the Sensation exhibition at the Royal Academy in London – *Zygotic*

Acceleration (1995) and *Tragic Anatomies* (1996) – show children's bodies with sexual organs instead of noses and mouths, made from deformed shop dummies. These were inspired by the photographs of Hans Bellmer's fetishistic dolls, in the Winter 1934–35 edition of the magazine *Minotaure* which, in turn, was inspired by Bataille's journal *Documents*. Both Bellmer's dolls and the Chapmans' mannequins interpret Bataille's concept of *l'informe* which describes the erotic and primitive morass which underlies civilization, and by extension art, and is a theme throughout their work.

A direct quote from Bataille's essay "The Accursed Share" was scribbled over an etching which was shown as part of the Chapmans' Rape of Creativity show at Modern Art Oxford in 2003.
Sarah Mulvey

Date 1991

Born Dinos, 1962; Jake, 1966

Nationality British

Why It's Key The tableaux of miniture hand painted models, based on Goya's etchings were a manifestation of the early 1990s obsession with the notion of the abject in art.

1990–1999

719

Key Artist **Gordon Bennett** Wins Moët & Chandon Australian Art Fellowship

Gordon Bennett was born in 1955 in Queensland but grew up in Victoria. He only learned of his Aborigine heritage at the age of eleven. Bennett became interested in art as an adult, graduating from Queensland College of Art in 1988 and gaining recognition as a multimedia artist who combined language and art. He created John Citizen, a Pop-art symbol, to tear down racial stereotypes and exemplify the commonalities among Australians.

Bennett's work is often described as violent, in part because of his bold depictions of the dispossession of Australian Aborigines and his language columns that include such words as annihilation, genocide, and nothingness. Bennett's *Self-Portrait* (1990)) showcases the artist as a four-year-old in a cowboy suit, accompanied by the words "I am dark" and "I am light"

on either side. He won the prestigious Moët and Chandon Australian Art Fellowship in 1991 and the John McCaughey Memorial Art Prize in 1997. In the late 1990s, Bennett came under the influence of African-American New York artist Jean-Michel Basquiat. In 1999, Bennett's *Notes to Basquiat: Culture Bag* honored Basquiat's graffiti-like style.

Bennett produced a series of works describing the terrorist attacks on New York on September 11, 2001. Two years later, the *Camouflage* series depicted the war in Iraq and government secrecy after 9/11. Since his first solo exhibition in 1989, Bennett has exhibited in Australia, China, Italy, Cuba, the United States, the United Kingdom, Germany, Austria, the Czech Republic, Denmark, Canada, South Africa, and Japan.
Elizabeth Purdy

Date 1991

Born 1955

Nationality Australian

First Exhibited 1989, Bellas/Milani Gallery, Brisbane

Why It's Key Bennett was the first Aborigine artist to win the prize, bringing recognition to his works, which highlight world tragedies, particularly the plight of Aborigines under apartheid.

Key Exhibition
Africa Explores

African art in the Western imagination has gone through three great phases: the anthropological, during which African art was seen as an ethnological curiosity; the appropriative, during which modernists such as Picasso appreciated and borrowed elements of it; and the international, during which it entered the global marketplace on equal terms with other artworks.

One of the events that signified the transition of African art into the international period was the Africa Explores exhibition of 1991. The exhibition showcased 133 objects divided between New York City's Center for African Art (whose director, Susan Vogel, curated the show) and New Museum of Contemporary Art. Its five thematic categories included Urban Art and International Art, which housed artworks that did not rely on traditional or functional African art for their inspiration. In these domains, artists such as the Nigerian Sokari Douglas Camp and the Zairian Cheri Samba demonstrated how effectively African art could engage politics, avant-garde style, and other contemporary concerns.

The exhibit included mass-produced Yoruba Ibeji dolls that filled in for the hand-carved kind. This was a powerful reminder that even traditional African artists have a long history of both improvisation and pragmatism, and should therefore not be considered as abettors of a frozen aesthetic orthodoxy.

Africa Explores thus invited spectators into a more intimate relationship with African art, which Vogel painstakingly situated as international without denying its regional qualities and aesthetics.

Demir Barlas

Date May 16–December 31, 1991

Country USA

Why It's Key Africa's contributions to international art are highlighted. Africa Explores pointed out how traditional African art was neither monolithic nor stationary.

Key Artist **John Cage**
Death of composer influential in dance and visual art

A pioneer of the postwar avant-garde, and one of the twentieth century's most influential composers, Cage's theories on chance greatly inspired the spheres of visual art and dance. The latter was forged primarily through collaboration with choreographer Merce Cunningham, his partner. In 1960s New York, Cage and his colleagues were associated with artists such as Calder and Pollock. Following in Parisian composer Satie's footsteps, Cage changed the nature of music more radically than any other modern composer through his disregard of tradition. Chance and indeterminacy, not individual intention, Cage argued, should dictate both composition and performance. He even went so far as to toss coins to make decisions about note pitch and length, a procedure derived from the ancient Chinese text I Ching, or "Book of Changes."

Studying under Schoenberg in California in the 1930s, Cage created percussive orchestras to perform "non-serial twelve-note compositions," using tin cans, buzzers, and electrical devices. This allowed Cage to pursue his interest in rhythmic, rather than harmonic, structuring as the prime feature of music: the building of forms from numerical patterns of sound.

At the Black Mountain College in 1952 he was responsible for the first-ever happening entitled Theater Piece # 1. Also in 1952, his 4' 33 consisted of no notated sound at all. Instead, the accidental sounds of the audience create the work. This is the ultimate expression of Cage's attempt to eliminate the filtering of his own personality: "The music I prefer" he states, "is what we are hearing if we are just quiet."

Hermione Calvocorezzi

Date 1992

Born/Died 1912–1992

Nationality USA

Why It's Key John Cage revolutionized contemporary music by challenging the conventions of musical composition, also impacting on visual and multimedia art.

opposite John Cage

Key Artist **Robert Gober**
Major untitled installation in New York City

From the late 1970s Gober's sculpture interrogated the house as the center of ordinary domestic life. Objects with an existence in reality are metamorphosed into "subjects". Sinks, urinals, doors, and cribs recurred as autonomous forms, hand-crafted by the artist in wood, plaster, and other common materials, not bought ready-made as appearances initially suggest. Duchamp's example informed this ambivalence about origins, and Gober's disembodied wax-cast torsos or limbs, often dressed, booted, and seemingly protruding from (or trapped by) walls, combined associations with mortality and erotic pleasure reminiscent of Surrealism. Gober also produced multipart room-like installations after the late 1980s. The inclusion of wallpaper with pastoral imagery conflated public and private space, manifesting in bright patterns, repeating representations of genitalia or vignettes of violence, pointing to a chilling anxiety about the outside world. In this emblematic fashion, Gober exposes unsettling fissures in the veneer of normality. *Installation*, shown at the Dia Art Center, New York, for nine months from September 1992, was a forceful expression of his themes, revealing home and memory as repositories into which fears and desires drained. Merged into hand-painted murals of forest scenery were plumbed and running sinks, prison windows, boxes of rat bait, and stacks of newspapers. Scrutiny showed each element was "fake", including the tragic news reports, and a component in an ambiguous narrative resonant of experience recalled in dream. The exit, a steel door edged with light but firmly closed, implied futility in escape.

Martin Holman

Date 1992

Born 1954

Nationality American

Why It's Key Developed narrative sculpture with insistent themes of childhood, sexuality, discrimination and power from an autobiographical perspective.

Key Person **Charles Saatchi**
Young British Artists exhibition

Saatchi came to notice in Britain in the early 1970s as an innovative advertising executive. By 1979 he and his brother were internationally known when their agency, Saatchi & Saatchi, masterminded the marketing of Margaret Thatcher's successful campaign to become British prime minister. As their company's reputation grew, so did Saatchi's acquisition of art which had started in 1970 when he purchased a LeWitt drawing for £100. Although the extent of his formidable collection has never been disclosed, by 1985 he was able to open 30,000 square feet of gallery space in north-west London, beautifully designed by architect Max Gordon for the exclusive exhibition of works from his holding of American Minimalism, British postwar art and Neo-Expressionism ranging from Schnabel to Kiefer. The strengths of his collecting were its depth and quality, facilitated by advice from Doris, his first wife; the regular displays brought London a new experience of viewing modern art.

Having controversially disposed of numerous artworks in 1988–91 during a global economic slump, Saatchi began buying from young British artists like the Chapman brothers, Marc Quinn, and, most famously, Damien Hirst whose tiger shark sculpture he commissioned. His enthusiasm and voracious appetite for buying was sufficient to establish artists' careers, and some alleged that his periodic sales could handicap a reputation. Saatchi personally oversaw the installation of themed shows in his gallery, which moved to larger premises in 2003 and 2008. He also made generous donations of artworks to British public collections.

Martin Holman

Date 1992

Born 1943

Nationality British

Why It's Key Influential collector who helped to create the international phenomenon of "Young British Artists" in the 1990s.

opposite **Charles Saatchi**

Key Artwork *The Garden*
Paul McCarthy

The Garden installation that Paul McCarthy (b.1945) created is a horrific dystopia that has become a contemporary art lover's paradise. It consists of a life-sized landscape which McCarthy built from tree trunks that were formerly used as props on the set of the TV show *Bonanza*. Slightly concealed within the comically idyllic, yet overly artificial set are two partially clothed mechanical men. One fervently humps a tree and the other thrusts into a hole in the earth.

Mixing real perversion with the fake set, McCarthy's *The Garden* was one of the abject artist's first pieces to launch the aesthetic that has become emblematic of LA's art scene. McCarthy first exhibited *The Garden* in Helter Skelter, his debut solo show at LA's MOCA in 1992. High-profile New York art advisor and dealer Jeffrey Deitch purchased *The Garden* and

then widely exhibited it in Europe. The piece jacked up McCarthy's international popularity and became his signature sculptural installation.

In 2000 Vanessa Beecroft used *The Garden* as the set for a fashion shoot that she directed in which all of Deitch's artists, including McCarthy and Beecroft herself, posed among the plastic trees and shrubs. Although the scenery was fake, the shock of McCarthy's vision remained undoubtedly authentic.

Ana Finel Honigman

Date 1992

Country USA

Medium Wood, fiberglass, latex rubber, foam rubber, wigs, clothing, artificial turf, rocks, pine needles, trees

Collection Jeffrey Deitch, Deitch Projects

Why It's Key *The Garden* is a major installation by a leading contemporary American artist.

opposite McCarthy's *The Garden*.

Key Exhibition
Land, Spirit, Power

The title of the exhibition identified a theme common to eighteen contemporary First Nations artists representing peoples from Alaska in the north to Mexico in the south. The exhibition recognized a uniquely First Nations perspective on the land, its expropriation and destruction, and most significantly, its soul within their cultural knowledge and experience.

Drawing on notions of change and adaptability as part of the dynamic tradition of Native communities, they expressed their spiritual legacy in a distinct variety of art forms and materials. Painting, sculpture, photography, videotape, installation art, masks, and mixed media drew on their tradition of storytelling as an immediate form of communication. Found objects, wood, animal bones and skins, human hair, the Canadian flag, and a Micmac canoe were part of the

fabric of these authentic voices, addressing an audience more familiar with the image that others construct about Native peoples than the one they create about themselves.

The artists established a central space for themselves refuting their marginality, a Native landscape that spoke for itself in contemporary discourse on art. Combining elements from traditional crafts with contemporary art forms and materials, they celebrated their survival by weaving elements of their past into a cultural experience of the present.

As one of the artists, Dempsey Bob, said: "I am from a heritage of great art, this inspires me to do new works that are valid today. We are still here and we still have a living culture."

Bryan Doubt

Date September 25–November 22, 1992

Country Canada

Why It's Key One of the first major international exhibitions featuring contemporary First Nations artists.

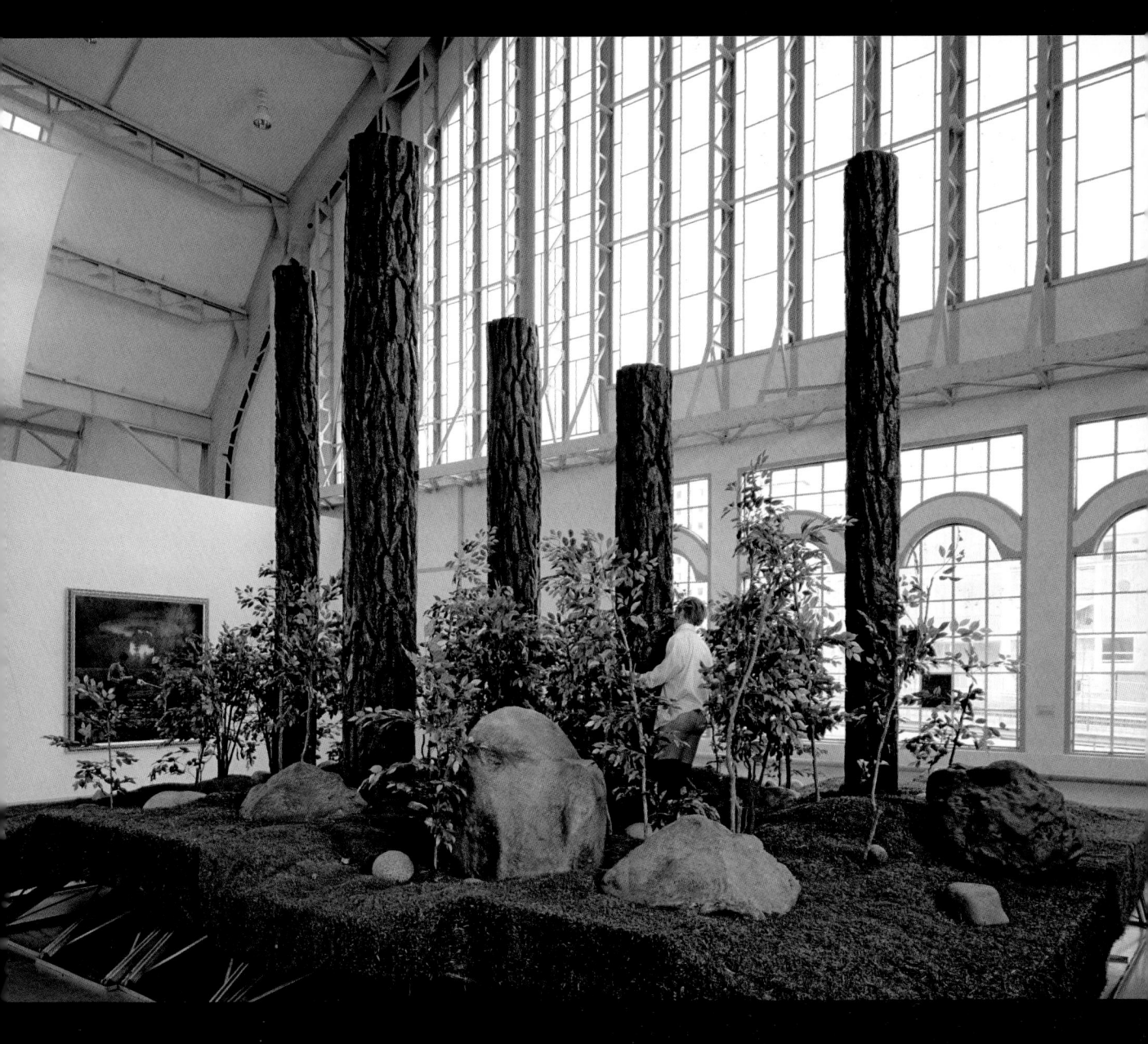

Key Artwork *John*
Chuck Close

Typifying his preoccupation with the depiction of people and faces on a grand scale, Chuck Close's (b.1940) *John* is also nevertheless recognized for consolidating his movement away from the Photorealist style that made him famous.

Comprising 120 colors, *John* was created by placing a grid over an original photo of the subject that enabled Close to scale up the image cell by cell in acrylics. Each cell was filled with rough assortments of colors to achieve a low-resolution style that became Close's trademark following a tragic blood clot in 1988 that left him partially paralysed.

The subject of the painting was John Chamberlain, a fellow American artist who had become well known for his Abstract Expressionist sculptures of broken down cars and machinery.

John was exhibited at The Virginia Museum of Fine Arts in 1993, which went on to acquire a silkscreen version of the painting in 1998. Measuring roughly 5½ feet by 4½ feet, this version is a masterpiece of printing, consisting of multiple screens assembled to combine 126 colors. Fittingly, three of John Chamberlain's sculptures are also held in the VMFA's collection. The silkscreen was published by Pace Editions and remains highly faithful to the original.

One of many other notable works that Close has produced is *Lucas* (1986–87), a portrait of fellow artist Lucas Samaras composed in acrylic and displayed at the Metropolitan Museum of Art in New York.
Jay Mullins

Date 1992

Country USA

Medium Acrylic

Collection The Virginia Museum of Fine Arts

Why It's Key This giant face of a fellow artist perfectly captures Close's imaginative low resolution art.

726

Key Artist **Sarah Lucas**
Exhibits in Young British Artists II, Saatchi Gallery

While at Goldsmiths between 1984–87, Sarah Lucas formed a relationship with Damien Hirst, then Gary Hume and Angus Fairhurst. All four artists would go on to play prominent roles in the 1990 London art scene, with Hirst as the leading man. In 1988, Lucas took part in Freeze, an independent student exhibition, which was curated by Hirst, then a second-year student. Charles Saatchi, whose first gallery space had opened a few years earlier in St Johns Wood, was a sympathetic visitor. He would go on to collect Lucas' work. In 1991 he bought the whole of her first solo show at City Racing, an alternative art space in recession-hit London. He then exhibited it in Young British Artists II the following year.

Lucas would use the money garnered from the sale of her art to finance "The Shop," a project run with friend Tracey Emin in 1993. They poked fun at the status quo, and at their more successful contemporaries. Lucas sold ashtrays with her former flame Damien Hirst's face on the bottom. Emin sold bonds for investment in her art.

Lucas turned sexual slang on its head. Referring to the subtle misogyny of British tabloids and the titillating Page 3 Girl, she laid a metal bucket with two melons to represent a woman and a cucumber with a pair of oranges to represent a man, on a stained mattress and called it *Au Naturel*. Posing for *Self Portrait with Fried Eggs* (1996) Lucas created a powerful statement with lightness of touch.
Carolyn Gowdy

Date 1992

Born 1962

Nationality British

Why It's Key Known for Conceptual and installation-based work, Sarah Lucas was an important member of an emerging group of young UK artists, "YBA" so-called from the Young British Artists shows at the Saatchi Gallery.

Key Artist **David Salle**
Early Product Paintings

Salle's early canvases were peopled by women smoking, lost in a daydreaming ennui. Through the 1980s, his work included increasingly disparate items drawn from design, furniture, or scientific books, as well as comics and magazines, and quotes from other artists. These appropriations from the databank of art history were often placed by stylized, sometimes painfully contorted nudes painted from photographs he took. Modelled on film techniques – split screen and montage – the juxtaposition and layering of superimposed images created a sense of heterogeneity and disconnection, thereby thwarting the viewer's attempts to read Salle's pictures in a traditional narrative manner.

Such is the case for his Early Product Paintings, where Expressionist brushstrokes are applied to crisp images of 1960s goods, appliances, cigarettes, and interiors. The imagery and scale of these canvases, split into several panels and segments, are reminiscent of the work of Pop artist Robert Rosenquist. They exude a retro feel that could be interpreted as nostalgia for a remote heroic period of history and art. Yet the fragmentation of the surface produces a discordant polyphony characteristic of the disjointedness of dream images; the fragments float nonchalantly across the painting, puzzling the viewer and keeping a deliberately uncomfortable distance. Salle sought such remoteness: "I think that my work and my responses to things have always followed along a particularly American classicism but in a detached, ironical way." That detachment and irony have come to be seen as central to the postmodern stance.

Catherine Marcangeli

Date 1993

Born 28 September, 1952

Nationality American

Why It's Key David Salle's work exemplifies a post-modernist appropriation of the databank of art history, including Pop Art. His work included quotes from artistic greats; Hopper, Marsh, Landseer, Géricault, Freud, Magritte, and Jasper Johns.

Key Artist **Rachel Whiteread**
Wins Turner Prize

Born in London in 1963, Rachel Whiteread studied painting at Brighton Polytechnic from 1982 to 1985 and sculpture at the Slade School of Art from 1985 to 1987, holding her first solo exhibition in London's Carlyle Gallery the year after graduating. The first monumental sculpture to bring her recognition was *Ghost* (1990) – a plaster cast of the interior of an ordinary room, showing details of the fireplace with its gas fire, impressions of the door and windows, and incorporating traces of wallpaper and flakes of color from the paintwork. This idea was expanding in *House* (1993), where she made a plaster cast of an entire Victorian terraced house, recently demolished, which was exhibited at 193 Grove Road, East London – the site of the original house. This provoked intense controversy, winning both the prestigious Turner Prize and the K Foundation art award "for the worst artist of the year." At first she refused the £40,000 prize – twice that of the Turner Prize – but reluctantly accepted when told the money would be incinerated. She gave it to needy artists and the housing charity Shelter.

In 1997, she exhibited *Untitled (One Hundred Spaces)*, resin casts of the space under chairs, at the Royal Academy's Sensation exhibition. The following year, she installed a resin cast of a *Water Tower* on a rooftop in New York. She produced *Nameless Library* (2000) for the Judenplatz Holocaust Memorial in Vienna and installed a resin cast of the fourth plinth in Trafalgar Square upside down on the fourth plinth. She has since filled the Turbine Hall at Tate Modern with 14,000 casts of cardboard boxes.

Nigel Cawthorne

Date 1993

Born 20 April, 1963

Nationality British

First exhibited 1988

Why It's Key Rachel Whiteread is a controversial sculptor, creating art objects that copy real-world objects and thus revitalizing the interest in object-based sculpture; through these works she has gained an international reputation as one of the finest sculptors of her generation.

Key Artist **Rebecca Horn**
Retrospective exhibition, Guggenheim Museum, New York

As a young art student, Horn worked with fiberglass, making art about the female body. While using this material in an enclosed and unventilated space, however, she accidentally damaged her lungs. Horn spent a year in hospital and a further two years in isolation. Her parents also both died. While lying in bed, Horn fought grief through creative expression. She began sewing sculptural extensions for her arms and other body parts.

When she returned to the Hamburg Academy for Fine Arts, Horn created performance works with these extension pieces. In *Cornucopia* (1970), she bandaged a pair of lungs to her chest with a breathing pipe, which extended like a lifeline from her nipples to her mouth. In *Unicorn* (1970–72) Horn filmed a naked and bandaged woman wearing a head extension as she roamed the countryside. In *Finger Gloves* (1972), Horn created absurdly extended fingers with which she tried to pick up some objects from the floor. Horn's body extensions often seemed to struggle with desires which were somehow just out of reach.

During the late 1970s Horn began to create mechanized sculptures. Their qualities alternated between playful wit and hollow Frankenstein-like menace. Musical instruments hover in suspended animation. Pendulums move, paint spatters. The work often contains an alchemical, transformative, or mystifying element. It is usually based in some way on the human body, with nature also a prevailing theme.

Carolyn Gowdy

Date 1993

Born 1944

Nationality German

Why It's Key Working in drawing, sculpture, performance, installation, and film, Horn is perhaps best known for her mechanized sculptures.

1990–1999

Key Artist **Chris Ofili**
Begins using elephant dung in his paintings

Chris Ofili was born in Manchester, Engalnd, in 1968. He studied at the Chelsea School of Art and later at the Royal College of Art. He is best known for bringing Nigerian culture into British popular consciousness.

Ofili's work was the subject of one of the twentieth century's most heated cultural battles over a piece of art – *The Holy Virgin Mary*, a mixed-media painting that he exhibited in the touring Sensation show of art from Charles Saatchi's private collection. The painting, which represented an African Mary surrounded by images from "blaxploitation" movies and close-ups of female genitalia cut from pornographic magazines, rested on two balls of elephant dung. Although the pornographic imagery was often mentioned in the massive controversy that ensued when New York's then mayor Rudy Giuliani sued the Brooklyn Museum of Art to compel it to stop showing the work, it was the elephant dung that sparked the shocked attention of the mass media press and general public.

Remarkably, Ofili had been using elephant dung in his paintings since 1993 without controversy. In actuality, the substance is used in African rituals. While detractors contend that he "splatters" or "rubs" it on his canvases, Ofili actually uses it reverently, in the form of dried spherical lumps as details, or supports for his colorful expressionistic oil on canvas paintings. The strident reactions to his use of the material have certainly been more base and barbaric than his careful, controlled, and measured use of the dung itself.

Ana Finel Honigman

Date 1993

Born 1968

Nationality British

Why It's Key British painter acknowledged for his references to cultural elements of his Nigerian roots.

opposite Chris Ofili's *The Holy Virgin Mary*.

Key Artist **Miroslav Balka**
Represents Poland at the Venice Biennale

Born in Warsaw, sculptor Miroslav Balka graduated from the Warsaw Academy of Fine Arts in 1985. His experiences growing up in Catholic and socialist Poland greatly influenced his work and especially contributed to a rather somber and tragic vision of history, as well as a great proximity of the idea of death and memory – which may be influenced by the profession of his father and grandfather who both engraved tombstones.

Miroslav Balka's early sculptures focussed on realist representations of the human body (*History*, 1988) but they slowly became more complex, with Balka experimenting with new materials such as ashes or salt. During the 1980s, Balka also briefly took an interest in performance art and staged a number of happenings in the style of Joseph Beuys.

From 1990 onwards, however, Balka started producing more Minimalist, non-figurative sculptures. The reference to the human body is still very present in those works: through the objects Balka chose as models (beds, coffin) which, by their function, evoke the shape of the body, but also through the titles given to those pieces. The sculptures are also often named by numbers which refer to corporeal dimensions (for instance 190, the artist's height).

Balka's later sculptures, although non-figurative, retain their narrative and metaphorical character, and constitute his best-known work. Miroslav Balka's international recognition came in 1993 when he represented Poland at the Venice Biennale with the piece *37,1*, before his solo show at Tate Modern in 1995.
Adelia Sabatini

Date 1993

Born 1958

Nationality Polish

First Exhibited 1985

Why It's Key Brings international recognition to prominent Polish sculptor.

Key Artist **Sam Nhlengethwa**
First solo show, Johannesburg and Durban

In 1993, the year before South Africa's first open elections and accession into the post-apartheid era, painter Sam Nhlengethwa had his first solo exhibition at the Market Gallery in Johannesburg and the NSA Gallery in Durban. While Nhlengethwa had been involved in group exhibitions since the early 1980s, 1993 was the year his career blossomed. Partly on the strength of his solo show, Nhlengethwa won the Standard Bank Young Artist Award in 1994, and has exhibited actively since then.

The 1993 show was perfectly timed. South Africa was finally becoming a vehicle of political and cultural expression for its black citizens – particularly urbanites like Nhlengethwa, who had borne the brunt of the apartheid regime. Nhlengethwa's work was ready not only to tell the story of the past but also to gesture

toward a future in which black South Africans would escape the townships and reclaim, in both iconography and politics, the spaces that had long been cordoned off from them. Nhlengethwa's creative response to his formative experiences in Johannesburg was to adopt jazz as both method and motif for his work, feeling and depicting the rhythms of black urban life, love, and work in his oeuvre. Nhlengethwa demonstrated a truly jazz-like range in applying his touch to everything from Johannesburg street life to portraits of American musicians such as Ella Fitzgerald and Thelonius Monk.

Much of Nhlengethwa's extant work, including oil paintings that incorporate collage as well as lithographs, is represented by the Goodman Gallery in Johannesburg.
Demir Barlas

Date 1993

Born 1955

Nationality South African

First Exhibited 1981

Why It's Key On the eve of the post-apartheid era, South Africa celebrates a spirited, jazz-inspired painter.

Key Artwork *House*
Rachel Whiteread

With *House*, Whiteread (b.1963) literally turned a spatial world inside out, making a concrete cast of the interior of a turn-of-the century terrace house in the run-down neighborhood of Bow, in London's East End. *House* attracted a mixture of praise and condemnation as well as graffiti, usually of the "wot for?" and "why not?" variety. Hundreds visited daily, and a campaign was generated to have its short life extended by six weeks.

Is it Art? The house that Whiteread built sparked a national controversy, which began in Bow and escalated across the UK. Eventually the case for demolition provoked a television debate, and a session with a government committee in the House of Commons. It was decided that residents of the local community would be given the final say over what to do with *House*.

A former resident of the building made his position clear when interviewed by the *Evening Standard*: "Inside-Out 'Art' Turned My Home into a Freak Show" the paper proclaimed. In the end *House* became a "Ghost Story." "The House that Rachel Built Comes Tumbling Down" announced the headline of the *Daily Express*. Some in London were not ready for Whiteread's poetic vision. "The Brutal Fact of Life in the City of Dreams" seemed to sum things up. *House* was demolished in January, 1994.

Carolyn Gowdy

Date 1993

Country UK

Medium Concrete cast

Why It's Key At thirty, Whiteread became the first woman to win The Turner Prize. She has gone on to become one of the most respected sculptors and installation artists of her generation.

731

Key Artwork *Blotter*
Peter Doig

During the 1990s, when he was based in London, Peter Doig (b.1959) produced a number of paintings that depicted snow-covered landscapes with figures, many of them referring to skiing, an activity in which Doig had participated as a boy growing up in Canada.

Blotter shows a young man looking at his reflection in the ripples of a layer of water on the surface of a frozen lake. Above a bank of snow is a tree-covered slope. The image has been cropped so that the sky cannot be seen. This allusive painting was based on a photograph – Doig uses photographs as a prompt to explore moments of self-awareness from past memory.

Photographs also allow Doig to push images towards abstraction. The figurative elements of nature – water, ice, snow, and trees – are exploited for their decorative qualities, and in the case of *Blotter*, are depicted with a multiplicity of thickly-painted brushstrokes, blobs, flicks, tracings, and flat areas of muted color. Despite the lively nature of the mark-making, the painting achieves a stillness which is reinforced by the compositional device, used in many of Doig's paintings, of dividing the canvas into three bands, which correspond to lake, bank, and wooded slope, and to alternating zones of light and dark.

The figures in Doig's paintings exist as a tentative focal point, partly obscured by the maelstrom of brush marks. He does not offer any psychological insight into these, usually male, figures, whose faces are hidden, rudimentary, or mask-like. They do however suggest the awkward presence of the estranged self in a defamiliarized landscape.

Sarah Mulvey

Date 1993

Country UK

Medium Oil on canvas

Collection Walker Art Gallery, Liverpool

Why It's Key *Blotter* won the first prize in the 1993 John Moores Exhibition.

Key Artist **George Milpurrurru**
Australian National Gallery show by an Aboriginal artist

Born among the Aboriginal Ganalbingu people in Arnhem Land in the north of Australia, George Milpurrurru was one of the first Aboriginal artists to gain international recognition. Also a ceremonial leader of his tribe, a skilled hunter and traditional healer, Milpurrurru is considered as one of the major bark painters of Arnhem Land.

While Milpurrurru's work is based on the classical tradition of bark painting – which was done on the interior strip of cherry tree barks and used for instructional and ceremonial purposes by Aborigines – it remains very innovative. Milpurrurru's imagery is largely drawn from nature and the life of the swamplands where he lived (crocodiles, magpie geese, fishes, etc are recurring themes), as well as from the traditional sacred narratives of his people. However, he experimented in the designs, forms, and size of his works, occasionally adding three-dimensional elements such as birds' nests to his pieces, and he created an unusually large painting for the 1979 Sydney Biennale.

His paintings are also characterized by repetitive geometrical patterns – a repetitiveness which was originally to be found in sacred ceremonial paintings.

George Milpurrurru's work was represented in three Sydney Biennales and in major Australian and international galleries: the Hermitage Museum, the British Museum among others. Most importantly, in 1993 – the Year for the World's Indigenous Peoples – he became the first Australian artist to be honoured with a solo retrospective exhibition during his own lifetime at the National Gallery of Australia in Canberra.
Adelia Sabatini

Date 1993

Born/Died 1934–1998

Nationality Australian

First Exhibited 1985

Why It's Key Prominent Aboriginal artist.

opposite Aboriginal artist George Milpurrurru with canvas depicting dug-out canoes in the Yarrafurra swamp area of his clan country, near Ramingining, Arnhem Land.

Key Artwork *Cinderella (Fay's Fairy Tales)*
William Wegman

Wegman (b.1943) began his pioneering dog portraits in the 1970s and was soon respected for them. In 1985, several years after his first dog, Man Ray, died, Wegman found a female puppy and named her Fay Ray. He began photographing her in costumes and the results caught the eye of a producer on the children's TV program *Sesame Street*. Wegman was hired to create entertaining educational videos and when Fay Ray gave birth to a litter of puppies, Wegman began photographing them too. Soon the dogs were making regular television appearances on *Sesame Street*.

Wegman has rewritten Perrault's classic fairy tale, adding his own surreal humor to the narrative. In the anthropomorphic tradition of the nineteenth-century illustrator Gustave Doré, Wegman brings this story to life in a theatrical series of photo shoots featuring his beloved dogs dressed as people. Fay Ray goes on a journey from bleak existence with broom and dustpan to a transformation so grand that she is destined to live happily ever after.

Wegman creates convincing sets and decks his cast of canines out from head-to-tail in bewitching costume. Fay Ray is outstanding in the role of Cinderella. She is featured on the cover of the book, gazing wistfully out the window of her pumpkin carriage. Clearly it has been a memorable evening of social whirl and dog delight. Her silky blonde wig and false eyelashes add to the glamor.

William Wegman's photographs, videotapes, paintings, and drawings are exhibited in galleries and museums around the world.
Carolyn Gowdy

Date 1994

Country USA

Medium Book

Why It's Key *Cinderella*, the first of Wegman's picture books featuring photographs of his expressive Weimaraner dogs playing the various roles in the fairytale, became extremely popular with both children and adults.

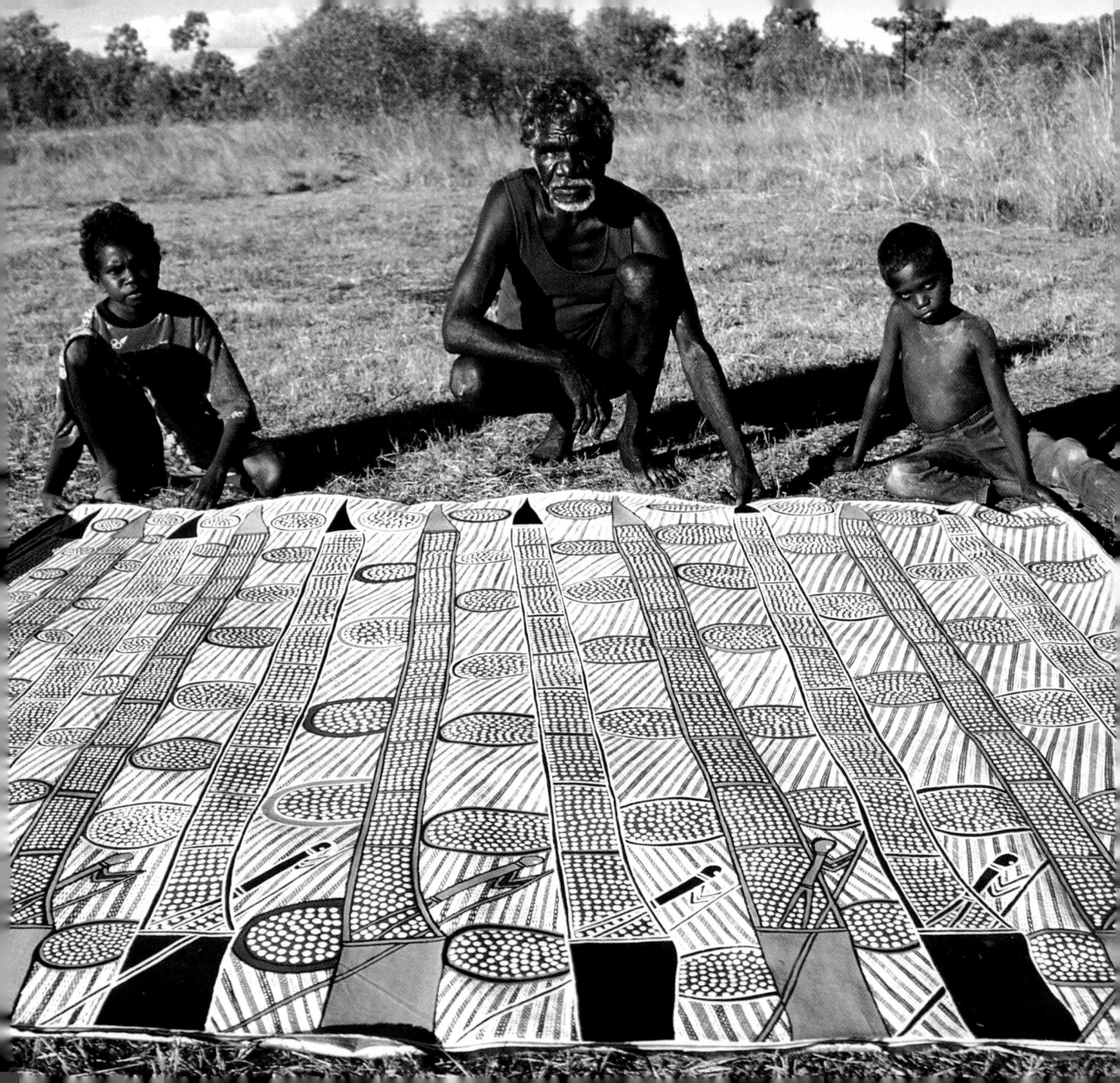

Key Artist **Leonard Baskin**
Holocaust Memorial, Ann Arbor, Michigan

The son of an orthodox rabbi, Baskin was educated at a yeshiva (Jewish school). Its medieval atmosphere would influence his aesthetic. As a boy, Baskin was mentored by the sculptor Maurice Glickman. When the artist was seventeen, Glickman sponsored his first one-man show in NYC. From then, Baskin saw himself primarily as a sculptor. He was interested in expressing aspects of the human condition, like emotion. Baskin completed a formal art education in America, subsequently studying art in Florence and Paris.

Eventually Baskin became a Renaissance man, working with considerable achievement in many different fields. He was inventive from the 1940s onward, with woodcut, lithography, and etching. He taught sculpture and printmaking at Smith College for over twenty years. Baskin was a writer and illustrator of books ranging from the Bible to children's stories. He mastered watercolor in mid-career. His subject range was also extensive, from portraits to biblical, classical, and mythological subjects. He was a traditionalist in the era of Pop art and Abstract Expressionism.

In 1942, while on a scholarship to Yale, Baskin started the Gehenna Press with a book of his own poems. As a young man with Communist sympathies Baskin was attracted to the democratic potential of printmaking. He was inspired by the example of William Blake and later went on to collaborate with the British poet, Ted Hughes. The Gehenna Press would become, by 2000, the longest-running privately owned press in the USA, raising standards of design and production.

Carolyn Gowdy

Date 1994

Born/Died 1922–2000

Nationality American

Why It's Key Baskin intended it as a reminder of the anguish victims experienced, saying "My sculptures are memorials to ordinary human beings, gigantic monuments to the unnoticed dead."

opposite **Leonard Baskin**

1990-1999

Key Artist **Glenn Brown**
"Dalí" work pulled from London exhibition

In 1997, Brown, a graduate of Goldsmiths College, London, (1990–92, MA Fine Art) rose to prominence along with other YBAs when he was included in the Sensation (1997) exhibition at the Royal Academy, but Chris Foss, the illustrator whose science fiction book cover image he had "appropriated" had not been fully credited. The matter went to the legal department, but was settled out of court. In 2000, Brown was short-listed for the prestigious Turner Prize. However his painting The Loves of Shepherds, 2000, was "revealed" on the front page of The Times newspaper to be an uncredited "stroke-by-stroke copy" from a 1974 science fiction book cover by illustrator, Anthony Roberts. The matter was again settled out of court.

A lot has already been said in the ongoing debate about the work of Glenn Brown. Is he a visual archaeologist with a curatorial approach to making art, or a plagiarist who has crossed the line between inspiration and theft? Brown uses other artists' images as the starting point for his own work, choosing from the archives of art history. He then manipulates scale, sometimes distorting compositional elements and colors, as he meticulously "copies" the original into a myriad of tiny swirling brushstrokes. Brown deliberately assigns canvases a curious "déjà vu" quality. A virtuoso craftsman, Brown imbues the processed images with seductiveness that can be both disturbing and strangely beautiful. The final surface of the paintings is smooth, giving them the quality of photographic reproductions.

Carolyn Gowdy

Date 1994

Born 1966

Nationality British

Why It's Key In the early 1990s, the Salvador Dalí Estate sued Brown for copyright infringement, alleging that his "appropriation" or "homage" paintings bore too close a resemblance to Dalí's original works. The matter was eventually settled out of court.

Key Artwork *Great Deeds Against the Dead*
Jake and Dinos Chapman

At different times in their career the Chapmans have returned to the theme of the horror of war through reference to Francisco Goya's *Disasters of War* etchings (c.1810–20), which depict atrocities that took place during Napoleon's Peninsular War in Spain. One etching, *Heroic Feat! With Dead Men!* shows male bodies which have been tortured, dismembered, and castrated, and a severed head and limbs, tied to a tree.

The Chapmans' *Great Deeds Against the Dead*, which replicates this scene using life-sized mannequins, is a dispassionate subversion of the aim of Goya's original. A puerile wit trivializes Goya's exposure of the destructive reality of war by transforming it into a feeble masquerade, parodying the horrifying materiality of Goya's image. By using retail mannequins, with the added comic effect of artificial wigs and cartoon-like wounds, in a kitsch tableau, it refuses to sublimate this abject scene into High Art; we are anything but moved by the fate of mutilated shop dummies in a gallery space. Artistic empathy is shown to be illusory; an obscene joke.

The Chapmans' sculpture is aimed at satirizing the banality of human degradation and suffering in our commodified society. The point is more emphatically stated in *Sex 1* (2003) where the passage of time since *Great Deeds* was made is symbolized by rotting skeletal figures arranged in the same configuration, and covered with maggots and flies bought from joke shops, in a scene of schlock putrefaction, recast in bronze. Goya's epic project is deconstructed through the trashing of death itself.

Sarah Mulvey

Date 1994

Country UK

Medium Mixed media with plinth.

Collection Saatchi Collection

Why It's Key This sculpture appeared in the Sensation exhibition at the Royal Academy in 1997 along with other works by the Chapman brothers.

opposite *Great Deeds Against the Dead*

736

Key Artist **Sam Taylor Wood**
Achieves breakthrough with *Killing Time*

Detractors often dismiss Sam Taylor Wood as a privileged fashion plate, whose art-star standing is derived more from her marriage to Jay Jopling, the powerhouse dealer of the White Cube gallery, than from her talent. But Taylor Wood consistently produces work which validates her position within the art world.

Born in London, as a teenager she moved to Brighton with her then boyfriend, the artist Jake Chapman (who is represented with his brother Dinos by White Cube), to attend fashion college. Failing the requirements for a degree, Taylor Wood attended North London Polytechnic before she transferred to Goldsmiths College to complete a Fine Art degree in 1990.

Her career breakthrough came in 1994 with *Killing Time*, in which four people mimed an opera score. Subsequently multi-screen video works would become the main element in her work. In 1995, she had her first solo exhibition at White Cube, entitled Travesty of a Mockery. The main work in the show was a ten-minute film depicting a man and a woman having an argument, whose parts were separated and projected simultaneously on two screens.

The man's space was occupied by a chair standing against a blank wall, while the screen representing the woman's side was illustrated by a fridge and a fragment of kitchen sideboard. Sparse and inspired by French existentialist cinema, it lacked the special effects and sprinklings of celebrity cameos which mark her later work, but nevertheless established her as a legitimate artist deserving of her place in the Young British Artist's pantheon.

Ana Finel Honigman

Date 1994

Born 1967

Nationality British

Why It's Key Leading "Young British Artist" working mainly in photography and video.

Key Artist **Tracy Emin**
First solo show, White Cube gallery

In the early 1990's Emin sent letters to various people, offering them bonds for investment in her art. Jay Jopling responded by offering Emin her first solo show, My Major Retrospective at Jay Jopling/White Cube, London. That same year Sarah Lucas, a prominent YBA, hired Emin to help her run The Shop on Bethnal Green Road.

The following year Emin set out with Carl Freedman on Exploration of the Soul-Journey Across America. Emin gave readings, on this subject, to help pay for the trip, and was photographed under a clear blue sky as she perched on a vintage chair in the desert. Across the upholstery, Emin had hand-stitched lettering and appliqué with the words "There's A lot of Money in Chairs." Emin dedicated the chair to her grandmother who had given her this wise advice.

Returning to London, Emin opened Tracey Emin Museum, in Waterloo Road (1995–98). In 1997, her tent *Everyone I Have Ever Slept With 1963–95* was exhibited in Sensation at the Royal Academy of Arts as part of Charles Saatchi's YBA collection. In 1999 Emin was short-listed for The Turner Prize, where she exhibited *My Bed*. Now a prominent artist and celebrity, Emin would become as reputed for drunken outbursts on live network television, for instance, as for her art. Pieces like the tent and bed were sparking controversy on a grand scale. However, even critics would describe Emin's work as "full of passion and striving and liveliness." It has been also been called "emotional realism" and "thinking with the body."

Carolyn Gowdy

Date 1994

Born 1963

Nationality British

Why It's Key Tracey Emin's first solo show was comprised of diaries, letters, and other intimate memorabilia. Along with Damien Hirst, she has since become one of the best known of the "Young British Artists."

opposite **Tracy Emin**

738

Key Artist **Peter Doig**
Ski Jacket shown in Turner Prize exhibition

Born in Edinburgh, Scotland, Peter Doig spent his youth in Trinidad and Canada. He graduated from St Martins School of Art in 1983, and in 1990, after returning to Montreal for a few years, he attended Chelsea School of Art. Success followed with awards, group, and solo exhibitions, culminating in his nomination for the Turner Prize in 1994. His position as an influential contemporary artist was secured when he became a trustee of the Tate Gallery the following year.

From an archive of movie stills, postcards, and personal, newspaper, and magazine photographs, he appropriates images, using collage and photocopying techniques, for a media-literate audience. Personal narrative themes, many of which are drawn from his teenage experience in Canada, are introduced into atmospheric, large-scale landscapes (he has admitted

the influence of early twentieth-century landscape painters such as David Milne), which are populated with isolated figures or buildings. The elaborate surfaces of these paintings are built up with painterly techniques, culled from the work of Fauvist and Post-Impressionist artists such as Bonnard and Gauguin. They have a physical presence, and, at times, an almost awkward, naïve character. Doig has not been afraid to experiment with very different themes and painting styles.

In 2002 he moved with his family to Trinidad where he set up a studio in Port of Spain. His work has achieved international status, demonstrated by his inclusion in Charles Saatchi's Triumph of Painting exhibition (2005), alongside such prominent figures of international contemporary art as Marlene Dumas and Luc Tuymans.

Sarah Mulvey

Date 1994

Born 1959

Nationality British

First Solo Exhibition 1984

Why It's Key Doig's nomination for the Turner Prize signalled a revival in narrative and representational painting which, at the time, was at odds with the dominant Conceptual style of YBAs such as Damien Hirst and Sarah Lucas.

Key Artwork *Human Shits*
Gilbert & George

Gilbert & George made feces fashionable and dandy elegance deliciously decadent. Gilbert Prousch (or Proesch) was born in San Martin, Italy and met George Passmore, of Devon, on September 25, 1967 while the two were studying sculpture at St Martins School of Art. George had attended the Oxford School of Art and Gilbert had studied in Australia and Munich before the pair met. But it was only when they teamed up that they realized and actualized the eccentric and strikingly consistent aesthetic that has made them seminal figures on the British art scene. The story goes, George was the only person who understood Gilbert's poor English. The common, though unverified, assumption is that they were, and still are, lovers.

Their early work mostly consisted of getting drunk on gin and recording the effects. In 1986, they won the Turner Prize. But despite their accolades, they settled on the illustrious style that became their signature only later. In 1993, they created their first series of stained-glass windows. Using the fundamental bodily hues (yellow, brown, and crimson) along with black and white, they mixed Christian symbolism with happy homages to urine, semen, blood, and excrement. Their *Naked Shit Pictures*, stained-glass windows showing the two artists standing proud and nude amidst floating turds, combined two major taboos in a lovely, noble format. They later moved on to their *PUNK BLOOD PISS SHIT SPIT* works, while always appearing in public wearing fine, elegant matching suits.

Ana Finel Honigman

Date 1994

Country UK

Medium Back-lit photo-montage

Why It's Key Part of important series, in an artistic collaboration that has moved from performance art to their signature photo-montages, with themselves as "living sculptures."

740

Key Artist **Robert Morris**
Major retrospective, Guggenheim Museum, New York

An artist, writer, and theorist, Robert Morris is acknowledged as a leading exponent of Minimalism although he has experimented with Land art, Conceptual art, and performance art during his career. His three-dimensional work includes large-scale geometric forms and soft hanging materials.

One of his concerns is to stress the process by which an artwork comes into being, rather than to celebrate the "finished" item. In 1968 he wrote an influential article entitled "Antiform" which was published in the American journal *Artform* in May 1968. In this, he expounded in favor of ephemeral or changeable art which arrived by chance, citing the example of shapes and form created by the loose stacking, hanging, or folding of materials. He experimented with soft materials such as felt before moving several steps further on to totally transient "media" such as steam.

There is a relationship between these forms of "process art" and the paintings of Jackson Pollock, and the soft sculptures of Claes Oldenburg. Morris' *Untitled 1970*, for example, is a disturbing, black shiny sculptural form, fundamentally abstract but which suggests a variety of subjects, from a large shoe or chair thrown against a wall and smashed, or, alternatively, some kind of gigantic cockroach or beetle.

John Cornelius

Date 1994

Born 1931

Nationality American

Why It's Key Influential leader in the field of Minimalism.

opposite Happening of New York artists Yvonne Rainer (dancer) and Robert Morris (sculptor) in Art Academy assembly hall, Dusseldorf (1964).

Key Artist **Bill Viola**
Represents the US at the 46th Venice Biennale

Bill Viola is an American artist who uses the modern media of video and sound recording to explore a wide range of existential questions, human emotions, and their expressions. While his media are inherently grounded in modernity, the themes he explores find echoes in ancient philosophy and extreme-oriental literature and religions, especially Buddhism, which he got to study during his journeys throughout Asia.

In 1995, Bill Viola was selected to represent the United States at the 46th Venice Biennale. In the American pavilion, the artist displayed a five-piece installation called *Buried Secrets*, a title he borrowed from a Persian poem. A collective of four video and one auditory pieces, the work functioned as journeys through existential themes of human life, each piece focusing on one pair of complementary opposites such

as life and death, darkness and light, body and soul, interior and exterior, and past and present. In this work, Viola questioned the difficulty – if not impossibility – of living in society and communicating with others while maintaining an inner sense of integrity. Some of his work may also be read from a political angle such as the inaugural piece of the *Buried Secrets* installation, *Hall of Whispers*, where the visitor was faced with the video projection on a screen of gagged faces struggling to convey a message no one could decipher.

By the beginning of the twenty-first century, Viola widened his field of practice and collaborated with opera directors, creating video installations functioning as stage-sets.

Sophie Halart

Date 1995

Born 1951

Nationality American

Why It's Key Official recognition for Viola, who uses new technologies to create atmospheric installations that explore themes such as birth, death, and religion.

Key Artists **Jane and Louise Wilson**
Included in British Art Show

Identical twins Jane and Louise Wilson were born in 1967 in Newcastle. From 1986 to 1989 Jane trained at Newcastle Polytechnic while Louise studied at the Duncan of Jordanstone College of Art. Both graduated from Goldsmiths College in 1992, having completed their MAs together. In 1995 the Wilson sisters were included in the British Art Show, a major exhibition organized every five years to showcase the forefront of contemporary British art.

Using film, photography, and sculpture the Wilson twins create highly theatrical and atmospheric installations that talk of fears, phobias, unwanted memories, and things that are often repressed in our society. One of their first collaborations, the result of spending sixteen months together in Germany, was their seminal film *Stasi City* (1997), an exploration of the

eerie Stasi headquarters (the Ministry of State Police, the East German secret police), abandoned with the demise of the Berlin Wall and now kept as a museum.

Described often as key to the new brutalist school, one Wilson twin's video installation features a lush New Zealand exterior and then pans down and into an abandoned sanatorium empty but for a pile of mattresses, flies, and graffiti. In another piece, a photograph of an empty room with a leather bunk that bears the imprint of a departed patient is made all the more sinister as the bed is dark with dead bluebottles.

The Wilsons were shortlisted for the Turner Prize in 1999 after their applauded exhibition at the Lisson Gallery in the same year. They continue to work together as part of the Delfina Studios artists group.

Emily Evans

Date 1995

Born 1967

Nationality British

Why It's Key Jane and Louise Wilson are cutting-edge installation artists whose work explores the power relationship between human beings and architectural space.

Key Artwork *Myra*
Marcus Harvey

When *Myra* was included in the Royal Academy leg of the touring Sensation show, it caused a controversy as heated as the hysterical response that New York's mayor Giuliani drummed up over Chris Ofili's culturally specific and personal representation of the Virgin Mary. But in New York, Myra Hindley is virtually unknown and therefore her portrait, with Marcus Harvey's (b.1963) chilling depiction of her, remained under the public's radar.

Harvey's painting struck deep into English viewers' sensibilities, however, and was one of the seminal works defining the Young British Art movement as a callow crew of cynical and insensitive young punks. The controversy surrounding the painting was due to Harvey's skillful mixture of Pop appropriation and a Gothic sensibility in reproducing the 1965 mugshot of infamous Myra Hindley, one half of the "Moors Murderers" who killed five children.

Harvey, who was born in Leeds in 1963, was too young to have been aware of the crimes, but their impact must have struck his parents, and perhaps indirectly heightened his awareness of his own vulnerability as a child. In his portrait, the children have revenge on Myra, as her visage is made up of tiny hand-prints. Caressing her, or maybe just defining and obliterating her identity, the children's palm-prints form an unnerving image of modern-day evil – which is fundamentally a far more contestable topic than Ofili's depiction of Christian goodness.

Ana Finel Honigman

Date 1995

Country UK

Medium Monochrome painting, based on famous photgraphs, comprising children's handprints.

Why It's Key Iconic image of evil which caused public outrage.

1990-1999

743

Key Artist **Cornelia Parker**
The Maybe, Serpentine Gallery, London

Sculptor and installation artist, Parker works with processes of destruction and transformation. During the 1990s, when YBAs sprang into life as one of the most prominent art movements since the Pre-Raphaelites, Parker emerged somewhat independently, as though from another era, or different part of the garden. She produced art from her kitchen table, much of it playfully deconstructing domesticity. She might rescue *A teapot that fell off the White Cliffs of Dover* (1992) or flatten an assortment of silver plates with a steamroller in *Thirty Pieces of Silver* (1988–89) later reconfiguring them into something beautiful. In 1991 Parker asked the British Army to blow up a garden shed and its miscellaneous contents. Parker collected the wreckage and reassembled it into a constellation of fragments, which documented and transformed the moment of detonation. *Cold Dark Matter: The Exploded View* contained a light bulb at its center. From this, a myriad shadows cascaded in suspension of disbelief. In *The Maybe* (1995), a take on Sleeping Beauty, actress Tilda Swinton lay mysterious and asleep inside a glass case for seven days while Parker arranged artefacts belonging to distinguished and departed souls around her. These included a cushion from Freud's couch, and Churchill's last cigar. Swinton's close friend, filmmaker, Derek Jarman had died of AIDS the previous year. *Mass (Colder Darker Matter)* was shown at The Tate in 1997. Constructed from charred remains of a Texas church that had been struck by lightning. "Cold dark matter" is a scientific term for an unquantifiable and unchanging essence. Parker's work is similarly multilayered.

Carolyn Gowdy

Date 1995

Born 1956

Nationality British

Why It's Key Enchanted both the art world and the general public with her adaptation of Sleeping Beauty, *The Maybe*.

Key Artist **Gavin Turk**
Young British Artists III, Saatchi Gallery, London

Gavin Turk is known for having died before he became a much talked about young artist. He failed his MA at the Royal College of Art with a final year show that featured only an empty studio. Instead of producing examples of art completed over the two years, he placed a small blue plaque on the wall. This was a parody of an English Heritage Plaque. It read, "Borough of Kensington, Gavin Turk, Sculptor, 1989–1991 worked here."

Turk is something of a chameleon. He also has a way of climbing into other human beings like a mysterious body snatcher. Turk investigates what it's like to be a celebrity icon, a legendary political activist, or a homeless person. This may involve extensive research, creating a life-scale waxwork or simply turning himself into a prop. He creates alchemy with ordinary objects, from plastic cups to garbage bags. The work re-examines aspects of identity, authenticity, and originality.

Like many of the YBAs, Turk's work communicates through multiple layers. Sometimes quoting other artists directly, he transforms perception with a subtle "sleight of hand" approach. In *Pop* (1993), Andy Warhol meets Sid Vicious in an Elvis Presley pose. While exploring what it means to be an artist, Turk is drawn deep into the mines of art history. He pays homage to various heroes, such as Duchamp, Manzoni, Beuys, and Warhol, in what seems an examination of meaning and purpose. The world is full of both illusion and artifice. Who do we believe? What is real?

Carolyn Gowdy

Date 1995

Born 1967

Nationality British

Why It's Key The show that brought the UK Conceptual artist to prominence.

opposite Gavin Turk in his London studio.

1990–1999

745

Key Artist **Francis Acea**
First solo show, Centre of Art and Design, Havana

Born in Havana, Cuba, in 1967, Francis Acea graduated from the Havana Superior Design Institute in 1991 and with Diango Hernandez formed the Ordo Amoris Cabinet Collaborative in 1994, Ordo meaning Order and Amoris meaning Love, a name that some have felt camouflages the more subversive aspect of their art. Acea first exhibited with the Collaborative in 1995, which was soon followed by a solo show also at the Centre of Art and Design, Havana.

Acea quickly began displaying his work internationally in group and solo shows at such venues as the Royal College of Art, London (1998), Kunsthaus Berlin, Germany (1998), ArtPace, San Antonio, Texas, (2001), and most recently at the Magnan Emrich Contemporary in New York and the Kunsthaus Miami, Miami. He has held artist residencies at the Banff Centre for the Arts, Canada (1997), in Aachen, Germany (1998), and in San Antonio, Texas (2001).

Acea's earlier installation art is preoccupied with a critical perception of reality: observing art in everyday objects such as cars (*Taxi-Limosina*, 1998) or antennas (*Antennas: Network Transmission*, 1998). This focus shifted to the reality that is created through the power of technology, culture, media, and communication. In his most recent exhibitions, the *Money* series and *D.B.A* (Doing Business As) series have dealt with consumerism, value, and economics, with particular attention paid to the art market and to the role of the artist within it. Acea presently lives and works in Miami, and has lectured on Cuban contemporary art at institutions in Cuba, Costa Rica, Canada, and in Europe.

Rebecca Baugniet

Date 1995

Born 1967

Nationality Cuban

First exhibited 1995

Why It's Key Francis Acea is an internationally recognized, contemporary Cuban artist whose provocative work transforms everyday objects into an art that critically examines politics, culture, and communication in Cuba and beyond.

Key Artist **Marlene Dumas**
Africus, Biennale of Contemporary Art, Johannesburg

Marlene Dumas was born in South Africa. In 1975 she graduated with a fine art degree from the University of Cape Town, and in 1976 studied art in the Netherlands which she then made her home. In 1979 she studied psychology in Amsterdam.

Much of Dumas' work refers to personal experience of the political. In the 1980s and early 1990s many of her paintings were reactions to her upbringing as a white female under apartheid, problematizing issues of race and social injustice. She has also used her paintings as a site to connect ideas and emotions about pornography, love, and eroticism, through images of the body, especially the female body.

Although she uses second-hand images, sourced from the media, she also uses personal photographs of family and friends to comment on pivotal events in her own life. In 1989 her daughter was born, and she turned her attention to the subject of pregnancy and birth. She painted her daughter as she grew up, producing disquieting images of babies and childhood.

Dumas' treatment of her subject matter in her drawings and paintings is always ambiguous. Her drawings are equivalent to the photographs she uses, but are simultaneously disrupted by the expressive gestures of translucent washes of restricted color. Titles are used to add further layers of meaning.

Throughout her career she has exhibited in solo and group exhibitions, appearing at the Biennale of Contemporary Art in Johannesburg, the Venice Biennale, and Documentas VII and IX, Germany, and in other major art centres.

Sarah Mulvey

Date 1995

Born 1953

Nationality South African

First Solo Exhibition 1979, Paris

Why It's Key The exhibition aimed to place South Africa in the international art scene after the ending of apartheid.

opposite *Wet Dreams* by Marlene Dumas.

Key Exhibition
Brilliant! New Art from London

The importance of this exhibition was the overview it offered of recent dramatic changes in the way new art was being seen and promoted in London during the preceding seven years. Supplanting the traditional infrastructure of commercial dealers in the city's West End as the prime location for cutting-edge exhibitions were informal, often impromptu spaces in disused shops or redundant industrial buildings in the working-class East End, where the young artists attracting critical attention for provocative or unconventional work had studios. Organized by the Walker's chief curator, Richard Flood, Brilliant! comprised 22 artists, ranging in age from 22 to 35. Most were graduates of London art schools, notably Goldsmiths College and the Slade School of Fine Art, and had risen to prominence in the aftermath of Freeze, the landmark exhibition created in 1988 by Damien Hirst, then a Goldsmiths' student, in a rundown Docklands warehouse. That show signaled the new entrepreneurial spirit, when the art market was depressed, of collective self-promotion among artists.

Brilliant! charted the ensuing developments, and highlighted the vibrant interdisciplinary practices of the artists that came to characterize new British art in the 1990s. Among the works were pieces by Glenn Brown, the Chapman brothers, Emin, Hirst, Hume, Lucas, Ofili, Wearing, and Whiteread that showed constant questioning of conventional media and forms of presentation, and a desire to use any materials at their disposal. The scope and subject-matter of Brilliant! anticipated Sensation, first seen in London in 1997 chosen from Charles Saatchi's collection.

Martin Holman

Date October 22, 1995–January 7, 1996

Country UK

Why It's Key The exhibition was highly influential in reshaping the direction of painting in Britain.

Key Artist **Douglas Gordon**
Wins Turner prize

The Tate Britain's Turner Prize is the most sought after and seriously scrutinized art event in contemporary Britain, but it has often gone to artists who use black humor as their medium of expression.

Such was the case with the Scottish-born artist Douglas Gordon. He won the prize in 1996 for the presentation of his work at the Van Abbemuseum in Eindhoven, and for his contribution at Southbank's overall unpopular The British Art Show, where he showed *Hysteria*, an appropriated medical film from the 1980s. His aim has been to motivate viewers to become more aware of the changing subjectivity of their perception of the world around them, with particular reference to their relationship with the moving image.

Gordon was born in Glasgow, Scotland in 1966. He attended Glasgow School of Art from 1984 to 1988, and he then studied at the Slade School of Art until 1990. He provided dark wit with projects such his 1993 *24 Hour Psycho* piece, in which he slowed down the running speed of Alfred Hitchcock's classic movie *Psycho* to almost a standstill so that it screened for twenty-four unnerving hours. Offering an explanation for this piece on the Tate Gallery's website, Gordon says that he wanted to demonstrate that, "we can be attracted to the spectacle of cinema while watching something completely repulsive."

Ana Finel Honigman

Date 1996

Born 1966

Nationality British

Why It's Key Conceptual artist working in installations and subsequently film.

748

Key Artist **Vincent Desiderio** First US winner of the International Contemporary Art Prize, Monaco

Born in Philadelphia, Pennsylvania, Vincent Desiderio studied art at Haverford College, and at the Pennsylvania Academy of the Fine Arts. Throughout the 1980s he exhibited in New York; presenting his first show at the Lawrence-Oliver Gallery in 1986.

After a year abroad in Italy during his student years, Desiderio soon abandoned abstract art in favor of realism. He emulated artists such as Ribera, Velazquez, and Gericault, working with a subdued palette that evoked seventeenth-century oils. Often composed as large three-part figurative tableaux, many of his works are evocative triptychs, often allegorical, in dimly lit, dreamlike scenes.

However, the narrative of the scenes is frequently intimate and familiar, often featuring figures in resting positions, painted with intricate detail and sensitive color. Much of his work explores the theme of family: a father sleeping on his side, a man squatting before a window or a woman propping her head up with her hand. In *Elegy* (1995), a boy, perhaps Desiderio's own disabled son Samuel, lies in bed, connected to respirator tubes, and surrounded by books on the floor, a fire extinguisher, and a cup of coffee.

Desiderio's international status rose throughout the 1990s, and he exhibited widely throughout the world. In 1996, he became the first American artist to receive the International Contemporary Art Prize, awarded by the Prince Pierre Foundation of the Principality of Monaco.

Mariko Kato

Date 1996

Born 1955

Nationality American

First Exhibited 1986

Why It's Key Brought international recognition for contemporary realist artist.

Key Artist **Gary Hume**
Represents the UK at the São Paulo Biennale

In 1996, two entirely different forums selected Gary Hume's supremely slick and streamlined enamel on aluminum paintings to illustrate Cool Britannia. That year, when Hume was nominated for the Turner Prize, he was also chosen to represent the UK in the São Paulo Biennale. Although Hume lost the Turner to video artist Douglas Gordon, his participation in the world's second oldest art biennial (after Venice), established him as a reigning figure on the British art scene.

Hume, who famously painted abstract portraits of pop culture icons Kate Moss and Patsy Kensit with high-gloss house paint, participated in the iconic Freeze show that launched the careers of rougher and rawer art icons including Tracey Emin and Damien Hirst. Poppy, punchy, bright, and cheery, Hume's aesthetic is sexy and sleek but also a subtle statement on the superficial concerns of contemporary mass culture. His subjects range from public figures in entertainment and politics to religious references or the owls and landscapes he showed in Brazil. But he renders them all in an equally surface-oriented manner, which attracts the eye but allows judgments to slide off their polished surfaces. As the artist representing the UK, Hume showed São Paulo that Britain was becoming cool to the point of turning cold.

Ana Finel Honigman

Date 1996

Born 1962

Nationality British

Why It's Key Important figure in the Young British Artists movement representing the talent of the British art scene.

1990–1999

749

Key Artist **George Pemba**
Cape Town exhibition for major South African painter

Born in Port Elizabeth, Geoge Pemba was encouraged by his father to paint from an early age, winning local prizes. In 1936, after obtaining a teaching diploma, he was granted special permission to study for four months at Rhodes University, during which time he studied watercolor painting. Pemba also began working for the Lovedale Printing Press, and supported his large family by teaching and painting commissions in the place of his father who had died in 1928.

In contrast to other black artists of his generation, Pemba remained in South Africa. During the 1940s he met John Mohl and Gerard Sekoto, who encouraged him to change his medium to oils, and to extend his subject matter from portraits to aspects of township life. In 1944 he secured a grant to travel across South Africa, introducing him to new themes of indigenous cultures and tribal life. During the apartheid years of the 1950s, Pemba expressed his anger through paintings of the struggle of black people. His unique touch, however, lay in his impressionistic style, avoiding propagandistic traits, and portraying his subjects with intensity and dynamicity.

Although Pemba became well established in Port Elizabeth, it was only in 1996 that he received full national recognition, when a retrospective exhibition was presented at the South African National Gallery. Despite consistent poverty, Pemba's career spanned six decades, providing a visual commentary on South African history. He was posthumously awarded the Order of Ikhamanga for achievements in arts and culture.

Mariko Kato

Date 1996

Born/Died 1912–2001

Nationality South African

First Exhibited 1928

Why It's Key Through his art, Pemba was an important recorder of the black South African experience during the years of apartheid.

Key Artist **Cecily Brown**
First solo show, Spectacle, in New York

At 16, Brown left school to do art. After completing a BTEC diploma at Epson College of Art and Design, she took courses at Morley College, London. Brown then studied painting at the Slade (1989–93), where she received a BA in Fine Arts. Following graduation from the Slade, she received a Churchill Memorial Scholarship to work in New York. In the beginning Brown also waitressed while making a bold animated film, *4 Letter Heaven*, from spontaneous watercolor sketches based on rabbit characters.

Soon this project spilled into her painting. Spectacle, her first solo show in 1997 at Deitch Projects in New York City, featured these rabbits reveling in their sexuality and was a critical and commercial success. It was followed by *High Society* (1998) and other works inspired by technicolor fantasies of Hollywood musicals.

Brown described them as "lush frenetic orgies of potent color, at once vulgar and subtle." Copulating bodies fuse with swelling shapes and luscious colors. Mixing figuration with a baroque form of abstraction and expressionism, Brown handles paint like a virtuoso. She pays homage to Abstract Expressionists such as Guston and De Kooning, while also being inspired by the figurative work of the Old Masters. Brown has become well known for dynamic paintings that are sensual, and infused with eroticism. She has become well known in the United States with profiles in *Vogue* and *Vanity Fair*, exhibitions in major museums, and regular solo shows in commercial galleries. In 2005, she was the subject of a retrospective, Cecily Brown: Painting at Modern Art, Oxford.

Carolyn Gowdy

Date 1997

Born 1969

Nationality British

Why It's Key Brown is now considered an important figure in the late 1990s' revival of painting.

751

Key Exhibition
Sensation

The importance of this exhibition in displaying significant trends in contemporary British art was largely concealed by controversies over the choice of work, sustained by the mass media, at two of the show's three international venues, London and New York. Only in Berlin did Sensation take place without notable incident, and the planned tour to Canberra, Australia, was canceled.

The original selection of 110 works by 42 artists was made from Charles Saatchi's collection for London's Royal Academy of Arts. Many of the pieces were already famous, such as Hirst's tiger shark in formaldehyde, but public attention focused on Marcus Harvey's huge interpretation of a well-known portrait of Myra Hindley, one of Britain's most famous child murderers. The image, painted with hundreds of copies

of a child's handprint, drew protests from, among others, the mother of one of Hindley's victims. The painting remained hanging although ink and eggs were thrown at it in the gallery. In New York, a painting by Chris Ofili provoked instant reaction from political and religious authorities. Its depiction of a black Madonna surrounded by angels formed from images clipped from pornographic magazines was deemed insulting by some, and calls made to revoke state funding to the venue, Brooklyn Museum of Art, were temporarily successful. Protests continued outside the museum and the painting was once smeared with graffiti.

Nonetheless, Sensation attracted over 300,000 visitors in London and in Berlin it was so popular that its closing date was postponed.

Martin Holman

Date September 18– December 28, 1997

Country UK

Why It's Key Controversial exhibition of new British art from Charles Saatchi's collection.

opposite **Harvey's controversial Hindley portrait being cleaned in the Royal Academy after eggs were thrown at it in protest.**

Key Artist **Gillian Wearing**
Wins Turner Prize

After graduating from Goldsmiths in 1990, Wearing started doing interviews with people in London streets. Soon she began inviting passers-by to write messages of their own choosing on a piece of paper. With permission, she photographed them holding their statement. As this research developed, Wearing captured spontaneous moments which were revealingly intimate, and often poignant, ranging from light-hearted to painful. A young businessman wearing a well-pressed suit made a suprising sign that read "I'm desperate." A woman, having strolled through the park, simply wrote "I love Regents Park." In 1993 Wearing exhibited the series, *Signs That Say What You Want Them To Say And Not Signs That Say What Someone Else Wants You To Say* at a small London, artist-run gallery. The work attracted public acclaim.

In 1994 Wearing placed an ad in *Time Out* magazine "Confess All on Video. Don't worry you will be in disguise. Intrigued? Call Gillian." The work was inspired by fly-on-the-wall documentaries and confessional TV chat shows. Volunteers wore comic masks which encouraged them to feel uninhibited enough to tell the truth about things they would never normally admit. Along with these projects, Wearing also explored group behavior with, for instance, *Sixty Minute Silence* (1996). A number of volunteers dressed in police uniform then attempted sitting still for sixty minutes.

Wearing has continued to develop a solid and expansive body of work. More recent projects range from unusual portrayals of her own family to personal studies of drunks and down-and-outs on the street.

Carolyn Gowdy

Date 1997

Born 1963

Nationality British

Why It's Key Wearing became the second woman to win The Turner Prize out of what was, unusually, an all-woman shortlist. Her work challenges "handed down truths" and is based within the experience of the everyday, real world.

752

Key Artwork ***Ruben's Flap***
Jenny Saville

Feminist art historians bitterly contest the omission of women from the art historical canon. But ironically, few of the self-proclaimed or acknowledged feminist artists are painters, although painting is the medium that dominates Western art history. Jenny Saville (b.1970) is a vital and fascinating exception.

Saville's unflattering yet masterfully executed paintings of overweight nude women, often herself, in intimate and awkward poses provide painful insight to women's rituals of self-scrutiny and self-deprecating misery. Her monumental paintings capture the private moments when women pick apart the minutia of their physical flaws, and allow those elements to overrun their lives.

Saville, whose parents were educators in Cambridge, England, studied at the Glasgow School of Art. But it was during a six-month scholarship at Cincinnati University that she discovered the full possibilities of obscenity. She has been quoted as proclaiming that her experience in the United States offered her, "Lots of big women. Big white flesh in shorts and T-shirts."

Although she was fascinated by the grotesque reality of obese bodies, Saville's real interest was depicting women's psychological conflicts with their physicality. *Ruben's Flap*, a fragmented and distorted portrait of Saville's body, multiplied to fill the artwork, represents the sense that women have of being close to, but never really at one with, their bodies.

Ana Finel Honigman

Date 1997–98

Country UK

Medium Oil on canvas

Why It's Key Influential artist who addresses "female issues" of nudity and physical appearance.

opposite *Ruben's Flap*

Key Artist **Martin Kippenberger**
Shows at Documenta X exhibition

After dropping out of an apprenticeship as a decorator, Martin Kippenberger studied painting at Hamburg Art academy in 1972. In 1978, he moved to Berlin where he founded the Kippenbergers Büro. A prolific painter, sculptor, architect, and underground club manager, he constantly reinvented himself and his art.

Iconoclastic, Kippenberger's desire to destabilize the status quo lay at the centre of his controversial, polemical works. Deliberately out of synch with the aesthetic of the time, he mocked German Neo-Expressionists along with Markus and Albert Koehler, George Herold, and Gunter Forg, who were known as much for their "bad boy" carousing as for their art.

Influenced by Pop art and the way Dada used language and collage technique, his texts undermined images from mainstream media and commented on German society at the time. His work draws on popular culture, politics, history, art, and his own life. A year before he died of cancer, he showed his irreverence of his own morality with the *Raft of the Medusa* series (1996).

A large-scale project was *Metro-Net*, a global underground system that led nowhere, because the entrances were painted on. Kippenberger's *The Happy Ending of Franz Kafka's Amerika*, is a large installation, taking its inspiration from the 1927 novel by Frank Kafka, satirizing the bureaucratic machine of the social order. His tendency to mix media, styles, and processes influenced younger artists internationally. He died in 1997 in Vienna, after he was exhibited for the first time in the avant-garde Documenta X exhibition, in Kassel, Germany.

Kate Mulvey

Date 1997

Born/Died 1953–1997

Nationality German

Why It's Key An important German artist, who worked in various media and influenced a whole generation of "bad boy" artists internationally.

754

Key Artwork *The Hot One Hundred*
Peter Davies

Inspired by late night Top 100 TV shows and best-seller lists, Davies paints spreadsheet-like lists and ven diagrams in faux-amateur style.

His idiosyncratic charts rank the recognizable names of his friends, peers, and art heroes according to indeterminable attributes such as being "hip" or "fun." Next to each name are often titles of the artists' works or scathingly funny descriptive sentences. With his squiggly scrawl and use of cheerful basic colors, these works visually resemble props for a grade-school kid's classroom presentation. But their benign appearance does not undermine the intelligent nastiness in his satire of the art-world's cliquey market-driven mentality.

Some of the pleasures of viewing Davies' paintings are contemplating the rises, falls, and come-backs since his canvases made contemporary art history out of contemporary art's fickle fashion. *The Hot One Hundred* rates Richard Patterson, who paints oil paintings of plastic figurines, as #1, five slots above Damian Hirst. When Davies painted *The Hot One Hundred*, he was twenty-seven and his chutzpah in stating "who is Who" is part of the piece's charm. Peter Davies' paintings will be an invaluable primary source for any future student writing their dissertation on the incestuous links within the international art world at the end of the twentieth century.

Ana Finel Honigman

Date 1997

Country UK

Medium Acrylic on canvas

Why It's Key Important Conceptualist whose use of language and color achieves a "user friendly" accessibility to his work.

opposite. *The Hot One Hundred*

THE HOT ONE HUNDRED

#	Artist	Description
1	BRUCE NAUMAN	ALMOST all of it (90-95%)
2	SIGMAR POLKE	Paganini
3	MIKE KELLEY	More Love Hours than can ever...
4	RICHARD PRINCE	Biker Girls/Jokes/Hoods
5	ANDY WARHOL	Brillo boxes- Jackie O
6	DONALD JUDD	Perspex+Metal Wall Pieces
7	J.M.W. TURNER	little boat in storm at sea
8	BRIDGET RILEY	B+W OP art lines
9	KASIMIR MALEVICH	Monochromes
10	MARCEL DUCHAMP	Fountain
11	JOSEPH ALBERS	Homage to square – colours
12	AGNES MARTIN	small rectangles - subtle colours
13	PIET MONDRIAN	severest Hard edge stuff
14	JASPER JOHNS	Flags + Alphabets
15	SOL LE WITT	Wall drawings
16	ELLSWORTH KELLY	V. big squares of colour together
17	THOS. GAINSBOROUGH	Bad early Portraits
18	MARK ROTHKO	Seagram Murals
19	ROBERT RYMAN	white on white !!
20	FRANK STELLA	Grey line paintings
21	GILBERT + GEORGE	As themselves - shit cunt
22	SEAN LANDERS	Text
23	WILLIAM HOGARTH	Paintings not etchings
24	JACKSON POLLOCK	Long brown skilful ones
25	BARNETT NEWMAN	V. Big e.g. Voice of Fire
26	GERHARD RICHTER	Baader Meinhof
27	JEAN-MICHEL BASQUIAT	Miles Davis Play List
28	DAMIEN HIRST	shark + Dots
29	EL GRECO	Light on Face of Monkey
30	JULIAN SCHNABEL	Plates + Sail cloths
31	HOWARD HODGKIN	Frames
32	NIELE TORONI	Dabs on wall installations
33	CY TWOMBLY	scribbles (Lot of it the same)
34	WILLEM DE KOONING	More abstracted less tit gun dress stuff
35	JONATHAN LASKER	When doodle's big...
36	LEON KOSSOFF	Swimming Pools
37	CHRISTOPHER WOOL	Text with swearinger single words
38	JOHN BALDESSARI	Hand Pointing + Instructions
39	GEORG BASELITZ	Upside down - white + yellow checks
40	PHILIP TAAFFE	More B+W/B+Colours Op Art ones
41	JOSEPH BEUYS	Talking to Hare / Rabbit?
42	BRICE MARDEN	Earlier Hard Edge strips of colour
43	PETER HALLEY	More the conduits the cin cells
44	CLAES OLDENBURG	Soft Sculpture + bedroom
45	JEFF WALL	Steves farm + Nosebleed
46	ROY LICHTENSTEIN	Brush strokes
47	MORRIS LOUIS	Corner Drips
48	JULIAN OPIE	sculpture + wall drawing together
49	JOHN McCRACKEN	Planks
50	CHUCK CLOSE	Recent Big Portraits (Not realist)
51	TITIAN	...featuring monsters/dragons
52	JEAN DUBUFFET	Grungier ones
53	DAVID SALLE	Porno ones
54	FIONA RAE	Whatever she's just done
55	KAREN KILIMNIK	TV Film Bad portraits
56	RICHARD ARTSCHWAGER	Formica Furniture
57	JEFF KOONS	V. Big Sculpture, New paintings
58	ANDREAS GURSKY	MONTPARNASSE
59	LARRY CLARK	Tulsa
60	ROSS BLECKNER	concentric circle white dots on black
61	MICHAEL CRAIG-MARTIN	Biggest, brightest Wall drawings
62	DANIEL BUREN	stripe constructions
63	RACHEL WHITEREAD	House
64	B+K BECHER	Water Towers
65	LAWRENCE WEINER	Letters carved into wall
66	GARY HUME	Both Figurative + Doors
67	ROBERT SMITHSON	Hotel Tape/slide
68	NAN GOLDIN	Transvestite photos
69	DUANE HANSON	Jogger + tourists
70	CINDY SHERMAN	Pigs snout
71	FELIX GONZALEZ-TORRES	Dancing queen + light bulbs
72	ED RUSCHA	Funky word paintings
73	FISCHLI + WEISS	Carved studio junk
74	ANDRES SERRANO	Ku Klux Klan pics
75	DAN FLAVIN	Circular Straight...
76	CHARLES RAY	Mannequins + Fire truck
77	RICHARD DEACON	Varnished cardboard with triangles
78	KIKI SMITH	Waxone from Somewhere Mad...
79	JOHN CHAMBERLAIN	Car Crash Sculptures
80	THOMAS RUFF	Single Portraits Head + shoulder
81	ANISH KAPOOR	Shiny Metal + Dixie 7 Mountains
82	RICHARD SERRA	Heavy Metal
83	VICTOR VASARELY	Circle + Square coloured op
84	LOUISE BOURGEOIS	Shiny bronze phallic stuff
85	ED KIENHOLZ	That bar you could walk into
86	RENE MAGRITTE	
87	RICHARD PATTERSON	Thomson skagging + Moto crosser clk
88	NAM JUN PAIK	T.V. Pyramid with J. Beuys
89	ALLAN McCOLLUM	Plaster Surrogates
90	ALEX KATZ	V. big womens heads
91	PAUL McCARTHY	Bossie Burger
92	MARTIN KIPPENBERGER	As a whole
93	EVA HESSE	Translucent Wall hang/Lean thing
94	FRANCIS PICABIA	Realist nude women
95		Tall Figures with carved plinth
96	JESSICA STOCKHOLDER	When Wall is ripped out
97	MILTON AVERY	Coastal scenes
98	SARAH LUCAS	Sod You tits, eggs, kebabs et al
99	IAN DAVENPORT	Fine Line bright colour ones
100	IVAN HITCHENS	Bigger bolder brush marks (coughing)

Key Event
Opening of Guggenheim Museum Bilbao

The opening of the Guggenheim Museum in Bilbao in 1997, a project costing approximately $100 million, heralded both the rise of computer-aided architecture, and the economic revival of a depressed industrial port through the opening of a major cultural institution. Unusually, the building was executed on time and within budget. The "Bilbao effect," a term now used to describe comparable success stories elsewhere, refers to the boom in tourism and boost to the Atlantic port's economy brought about by the modern art museum.

Harvard-educated Frank Gehry's deconstructivist architectural language is based upon fluid fractals, exemplified in his Bilbao masterpiece. Clad in identical light-reflecting titanium rectangular scales, the curved ship-like building is sensitive to changes in the Nervion River, and the unpredictable coastal weather. Gehry looked to nature, to feathers and fish-scales, for inspiration. The "random" forms of the museum are like petals or leaves on a branch, and visitors are channelled from the various wings back into the central atrium which overlooks mountains. The interior of the museum encapsulates Gehry's reaction to the "white cube" space. There is great variation in the color, lighting, and shape of the galleries – the building has even been criticized for upstaging the works, including those by Klee, Kandinsky, and Picasso. A central "fish" gallery displays large-scale sculpture, whilst smaller rooms are more appropriate for prints. Using the French software CATIA, Gehry systematized multiple forms with slight changes, unlike identical mass-produced units used in modern architecture previously.

Hermione Calvocorezzi

Date 1997

Country Spain

Architect Frank Gehry

Why It's Key It revived a run-down Basque town in an unprecedented fashion. Visitor numbers are approximately one million per year, with half of that figure coming from abroad.

1990–1999

757

Key Artwork *My Bed*
Tracey Emin

"For some reason, all my tiny horrors have been liveable. I have not died." Emin describes *My Bed* as having taken "a lifetime to make." She is known for exploring relationships and feelings, in both her art and life, with a brave spirit of enquiry.

Sometimes her drawings are like emotional cardiograms, which begin and end in fits and starts. They tremble with boldness and alternating hesitancy. In this installation Emin shares tangled feelings and beliefs in what she terms "emotional realism."

As a mixture of testimony and personal confession *My Bed* is like a cry for help. If the bed could speak it might say, "My life is a mess. Tracey has been lying here with her whole body and on her own in an alcohol induced coma for days. Before that she was in the most indescribable anguish. It is frightening to think she could have died in this room. I can't understand why she is doing this to herself? Life is just so unmanageable around here. Help!" "People think my work is about sex, but actually a lot of it is about faith…"

Emin has transformed her experience into art. Apart from the glowing candle on the bedside table, there is nothing pleasant or seductive about this scene. The sheets are stained with bodily fluids. Condoms, dirty underwear, and menstrual pads are strewn alongside an empty Absolut Vodka bottle, a pair of scissors, a battery pack, newspaper, mirror, cigarettes, photographs, pills, coins, and other crumpled bits of detritus.

Carolyn Gowdy

Date 1998

Country UK

Medium Installation

Why It's Key *My Bed* is one of Emin's best-known works. In 1999 it was exhibited at Tate Britain where Emin had been short-listed for The Turner Prize. It provoked widespread criticism and debate in the media.

opposite *My Bed*

Key Artist **Ann Hamilton**
Represents United States at the Venice Biennale

Ann Hamilton's art contrasts verbal thought with sensual experience. Born in Lima, Ohio, Hamilton trained in textile design at the University of Kansas before she received an MFA from Yale University.

Shortly after Yale, she started creating lauded works, such as her *Toothpick Suit*, in which she layered thousands of toothpicks on top of a suit's fabric and then wore the porcupine costume as she posed for photographs.

The site-specific installation that she created when she represented the United States at the 1999 Venice Biennale featured a mechanical system that sifted waves of fuchsia-colored powder slowly down the walls in response to viewers' movements within the space. This sensual experience was counteracted by the brutal historical reality expressed in text and written in Braille on the walls, which Hamilton extracted from Charles Reznikoff's poetry volumes, *Testimony: The United States 1885–1915 Recitative*.

Reznikoff's poems transformed information from turn-of-the-century legal documents into intense poetic expression that responded to harrowing violence and deprivation. *Time* magazine reported that "*Codes and Whispers*, Ann Hamilton's severe meditation on violence in America create[d] a buzz at the Venice Biennale." But the installation went beyond mere buzz, and cemented Hamilton's standing as a thoughtful and significant American artist.

Ana Finel Honigman

Date 1999

Born 1956

Nationality American

Why It's Key Important contemporary American artist whose work includes installations, photographs, videos, performances, and objects.

opposite **Ann Hamilton**

Key Artist **Richard Wentworth**
Curates Thinking Aloud UK exhibition tour

Wentworth came to prominence in the late 1970s with other British sculptors, among them Deacon and Woodrow, whose objects made use of readymade materials and consumer products. His work was often irreverent and questioning, with clarity of form and ingenuity in assigning new functions to the media he assembled. With immaculate craftsmanship, he created unrepresentational objects with already useful items, such as ladders, pails, cans, ladles, and crockery. While these ingredients retained their individual appearance, their new roles accrued fresh meanings. Resting a thick plug of concrete on light bulbs contained in a wire basket in *Hurricane* (1987) implied destructive natural forces and a topical allusion to freak climatic events that year in southern England. The lightness and incongruity of combined shapes elicited visual rhymes: the spectator could meditate on their abstract qualities and material contrasts, be kept alert by their teasing matter-of-factness, and goaded by the wordplay in titles. Making serious points about current events with impoverished materials in a playful manner was a strong point and once caused political controversy. His fascination with objects extended to curating, and making photographs of bizarre, improvised solutions to practical necessities observed in the street. Collected into a research archive titled "Making Do and Getting By" (1970 onwards), these images informed his work by underpinning an artistic philosophy that promoted imaginative freedom. Through teaching in London and Oxford, his creative attitude to everyday materials, wit, and paradox influenced younger artists, including Hirst and Opie.

Martin Holman

Date 1999

Born 1947

Nationality Samoan/British

Why It's Key Leading British post-Minimalist artist and influential teacher.

Key Artist **Mark Wallinger**
Ecce Homo, Trafalgar Square

Wallinger's inventive use of numerous media and humor in his work reflected the prominent trend among British artists in the 1990s to transform whatever materials were at their disposal. This artist, however, stood apart from his contemporaries for his intelligently critical approach to the representation of politics in art, and his willingness to address major questions about class, race, and religion with a formal clarity that was accessible to a broad audience.

After studying at Goldsmiths College, Wallinger came to attention as a painter and quickly established the continuous theme in his work: the exploration of how the individual defined himself in relation to the state and accepted systems of belief. Wallinger pursued a line of thought through painting, object-making, performance, film and, on one occasion, by owning a thoroughbred racehorse named A Real Work of Art which competed in the 1994 flat-racing season. The aesthetics, contradictions, and social implications of a national preoccupation with breeding provided the common thread. The near-universal acceptance of *Ecce Homo* indicated the intellectual acuity of his provocative practice. The sanded resin sculpture depicting a life-sized Christ-like figure was set up on an existing plinth in London's Trafalgar Square in 1999–2000; dwarfed by its surroundings, it appeared vulnerable before the city crowds. The work simultaneously addressed the nature of belief and the tradition of public commemorative statues. *State Britain* recreated in the Tate Gallery a protester's famous vigil outside Parliament against British policy in Iraq.

Martin Holman

Date 1999

Born 1959

Nationality British

Why It's Key Conceptual artist whose work maintains a compelling moral commentary on contemporary beliefs, and who won the Turner Prize in 2007.

760

Key Artwork ***Flower Chucker***
Bansky

London-based graffiti artist Banksy's *Flower Chucker* stencil-on-canvas illustrates the arresting issues at the core of his illegal street and coveted gallery work. Banksy was raised in Bristol but his distinctive imagery has become part of cityscapes across the world and come to define a distinctive London-centric graffiti aesthetic. While other graffiti writers or artists typically spray paint images, Banksy sprays over pre-fabricated stencils which are often provocatively playful.

Despite international art shows and positive attention paid to him in the massmedia, Banksy has maintained his anonymity. Unlike members of the tagger subculture, Banksy did not limit himself to spray painting an identifiable moniker on urban surfaces, but instead launched an investigation into the aesthetics, politics, and civic purpose of graffiti.

The most interesting issues surrounding graffiti arise when it technically can be termed art and yet its illegal presence in the urban environment still frightens and offends people. The issue then is whether graffiti itself is considered offensive by authority figures, or whether they are offended by the reminder that irreverent and often alienated groups exist who aim to claim rights over communal space.

In *Flower Chucker* a masked guerilla fighter raises his arm to aggressively to hurl a bouquet of pretty flowers. This gesture symbolically represents Banksy's whole street practice. He forces his intelligent, intriguing, and often beautiful art in our faces. Over thirty years into graffiti's official history, it is still a revolutionary gesture.

Ana Finel Honigman

Date 1999

Country UK

Medium Stencilled graffiti

Why It's Key One of the key images via which Banksy has raised graffiti-painting from urban vandalism to high-profile, provocative art.

opposite *Flower Chucker*

Key Artwork *Smoker #1 (3-D)*
Tom Wesselman

In 1999, Tom Wesselman, America's sleekiest and sexiest Pop artist, produced the last work in a series he had started in the late 1960s. Wesselman's "smoker" series began when Peggy Sarno, a friend and model whose mouth Wesselmann was painting, lit a cigarette during a break. The pictorial recording of that gesture led to a series of works that were to become one of the artist's most recurrent themes through the 1970s and beyond.

Wesselman had started his academic career as a psychology major at the University of Cincinnati before serving in the army, working briefly as a cartoonist, and then later relocating to New York, where he took up drawing at the Cooper Union. In the 1950s, he founded the Judson Gallery with Marc Ratliff and fellow Cincinnati native and seminal Pop artist Jim Dine. But it was not until 1961 that his series entitled *Great American Nude* brought him to the art world's attention. Wesselman used a limited palette in these works and incorporated material from magazines and discarded posters stripped from subway station walls. By the mid-1960s, sexuality started to seep into his imagery and his slinky, streamlined nudes came to define the erotic aesthetic of his era. *Smoker #1*, the work Wesselman realized in 1999, was a three-dimensional relief in aluminum. Started decades before, when smoking was still considered cool, the "smoker" series and its jaunty glamour and sex appeal exemplified Wesselman's credo, which he described to Irving Sandler in a 1984 interview as, "Painting, sex, and humor are the most important things in my life."

Ana Finel Honigman

Date 1999

Country USA

Medium Painted relief in aluminum

Why It's Key Final work in iconic Pop art series begun the the 1960s.

1990–1999

763

Key Artist **Louise Bourgeois**
Maman inaugural work in Turbine Hall, Tate Modern

Bourgeois has often declared that "art is memory." Her subject matter is indeed largely, almost obsessively, autobiographical and it draws on childhood traumas and betrayals, such as her father's oppressive presence, and his long-running affair with the family governess, which is evoked in installations such as *The Destruction of the Father* (1974).

To address issues of femininity, sexuality, identity, and alienation, Bourgeois experimented with a variety of media, ranging from drawings, prints, and paintings, to sculpture, performances, and installations, and culminating in a series of *Cells* which draw the viewer in a sculptural, theatrical, but also psychological space. In an unorthodox approach to materials, she used not only marble and bronze, but also less noble media such as latex, fabric, rope, glass, and mirrors.

Bourgeois was the first artist commissioned by the new Tate Modern to occupy the gigantic Turbine Hall in the reclaimed Bankside Power Station. She produced her largest and most dramatic work, a 35-foot bronze spider titled *Maman*. For decades, particularly in drawings, Bourgeois had used spiders to explore recollections of her mother, whom she remembered as "deliberate, clever, patient, soothing, reasonable, dainty, subtle, indispensable, neat, and useful as a spider." *Maman's* monumental size contrasts with her delicately arched legs. Paradoxically, she is not threatening. Instead she is a nurturing and protective figure, as suggested by the gem-like, white marble eggs suspended in a steel mesh sac below the insect's giant abdomen. The spider is a haven where reconciliation can occur, albeit momentarily.

Catherine Marcangeli

Date 1999

Born 25 December, 1911

Nationality French, natualized American

Why It's Key Bourgeois' strategies for tackling gender issues and disregard for the canons of artistic techniques were seminal for generations of female and feminist artists.

opposite *Maman* at the Tate Modern, London.

Key Artist **Julian Opie**
Creates album cover for *The Best of Blur*

Julian Opie was born in London in 1958 and studied at Goldmiths School of Art from 1979 to 1982, a good ten years before his Young British Artist contemporaries. However, it is with those young radical artists of the early nineties that he has become associated. Working quietly but consistently with the Lisson Galley, Kölnischer Kunstverein and the Fondation Cartier throughout the 1980s, it was in 1993 that Opie's work was featured at the Hayward Gallery and thus reached a broader audience on another level.

Best known for a style that he has made all his own, Opie uses symbolic graphic gestures to make a Minimalist statement. Often inspired by street signs and also by the simplicity of some comic art, his images inspire and intrigue in their lack of surface detail. His cover art for the British band Blur's album

Best of Blur (2000), which featured the four members of the group transformed into Opie's style, is probably his most well-known work, but really it is just representative of whole bodies of art built on his unique Minimalist principles. In his paintings, Opie almost takes the idea of painting by numbers and gives it a creative integrity; his paintings focus around portraits but also feature landscapes, nature, and cityscapes.His sculptural work becomes almost toy-like in its cut-out style and street-sign two-dimensionality.

More recently Opie has been working on short animations, bringing his characters to life, but in his inimitably understated way: a character may just wink or flick her hair or walk in a straight line. Opie's understatement is consistent throughout.

Emily Evans

Date 2000

Born 1958

Nationality British

Why It's Key Opie is a leading contemporary UK artist with a distinctive Minimalist signature style.

Key Exhibition
Inside Out: New Chinese Art goes on tour

Inside Out: New Chinese Art is a testament to the explosion of artistic creativity in China beginning in the last two decades of the twentieth century after the Cultural Revolution (1966-76), and coinciding with the incorporation of Hong Kong into Mainland China as China opened its borders to the world.

Curated by Gao Minglu, the exhibition was first shown in New York in 1998 at the Asia Society and P.S. 1 Contemporary Art Center. It then traveled to San Francisco, Mexico, and Seattle in 1999, before a further North American and Asian tour in 2000.

Inside out featured over eighty works representing fifty-eight artists and groups of artists from four regions: mainland China, Taiwan, Hong Kong, and the."Third Space," referring to Chinese artists who emigrated to the West in the late 1980s. All the artists represented were

grappling with the social, economic, political, and cultural changes of this tumultuous period. The use of ink and calligraphy, oil painting, photography, video, installation, and performance art dramatized the creative tension between the more traditional Chinese art forms and materials, and the changes to those traditions initiated by transnationalism and commercialization.

Installation works such as Xu Bings's *Book From The Sky* (1987-91), comprised of hand-printed books; Yin Xiuzhen's *Woolen Sweaters* (1995), featuring women's and men's woolen sweaters, unraveled; Zang Xiaogang's 1994 *Bloodline: Family portrait No 2*; and Zhang Huan's 1997 photograph titled *To Raise The Water Level in A Fishpond*, all attest to the variety of artistic medium at the exhibition.

Bryan Doubt

Date 2000

Country Parts of North America and Asia

Why It's Key First major exhibition of contemporary Chinese Art.

opposite Four canvases by Chinese artist and Inside Out exhibitor Geng Jianyi at the exhibition of contemporary Chinese art at the Museum of Fine Art in Bern.

Key Artist **Ryoji Ikeda**
Sonic Boom show at London's Hayward Gallery

Japan's leading sound artist and electronic composer, Ryoji Ikeda started working as a DJ in 1990 before turning to sound art. In 1994, he joined the multimedia art group Dumb Type as composer and created his own record label, CCI Recordings. His first record, *1000 Fragments*, came out the following year. From 1995 onwards, Ikeda showcased his work internationally through many concerts, recordings, exhibitions, and sound installations. He was awarded the Ars Electronica Golden Nica Prize for digital music in 2001.

Ikeda's work explores ultrasonic frequencies, and the essential characteristics of sound itself, using sine waves, white noise, and electronic sounds among other elements. One of the most radical and innovative contemporary sound artists, Ikeda is renowned for his "microscopic" precision, deconstructing sounds to reduce them to an ultra-Minimalist essence and often creating multi-faceted sensory experiences. He also uses light and image in some of his installation pieces. His 2004 installation *Spectra* in JFK Airport's Terminal 5 thus played with intensely bright lights and ultra-frequences to challenge the spectator's perceptions.

Ryoji Ikeda participated in the first major exhibition of sound art in the UK: the Sonic Boom show held at the Hayward Gallery, London, in 2000. Curated by David Toop, the show featured installations by twenty-three influential sound artists, including Brian Eno and Angela Bulloch. For Sonic Boom, Ikeda created an installation in a white tunnel, using sine tones to create a mesmeric and unreal atmosphere, very representative of the main body of his work.

Adelia Sabatini

Date 2000

Born 1966

Nationality Japanese

First Exhibited 1995

Why It's Key Emblematic ultra-minimalist sound artist.

Key Artwork *Untitled 4.8*
Phillip Argent

One of the ironies in art and design is how every era's vision of the future appears dated to subsequent generations. Essex-born painter Phillip Argent's abstract landscapes have the sleek, graphic, appearance of sixties futuristic fashion, design, architecture, and art. But as they celebrate the beauty of artificial environments, they pull us back to the aesthetic of their time. In 2003 his work was featured alongside eleven other painters from the United States, UK, and Germany in an exhibition of Post-Digital Painting at the Cranbrook Art Museum near Detroit, Michigan, all of whose work reflected the new visual perspective of the computer age.

Untitled 4.8 (2001) is a particularly glossy and attractive image, combining candy-hued acrylic paint and diamond dust on canvas. Hung on its edge, the square canvas looks like a portal into a mythic distant dimension or alternately a map of a streamlined, future cityscape. Argent's compositions are filled with rounded forms and curved, snake-like lines which seem to be floating separately but actually work beautifully in tandem to create a dreamy and sweetened sense of an optimistic future.

Ana Finel Honigman

Date 2001

Country UK

Medium Acrylic and diamond dust on canvas

Collection Shoshana Wayne Gallery, Santa Monica, USA

Why It's Key Contemporary artist whose work resonates of the new millennium.

opposite *Untitled 4.8*

Key Artist **William Kentridge**
Major touring retrospective begins

William Kentridge, well known for an innovative use of charcoal drawing and animation, grew up in Johannesburg as part of a privileged white elite. In an effort to better understand the South African situation, he studied politics and philosophy at university. But he was eventually drawn to art and theater as a way of finding meaning within the tragedy of apartheid.

Kentridge examined his role as witness and part of the white population, which had condoned the atrocities. He later channelled these findings into his art, becoming well known for a series of animated films, *Drawings for Projection*, which began in 1989. They feature two white South Africans: the anxious artist, naked lover, and dreamer, Felix Teitlebaum and brutal, often corrupt industrialist, Soho Eckstein. Moments unfold then dissolve mysteriously. Charcoal marks leave ghostly traces of life and messiness behind. Hypnotic forms of free association whisper cryptic stories that have no determined outcome.

Kentridge's films are created with a homemade animation technique based on "erasure." They are usually set in the landscape of Johannesburg, where he lives. Dreamlike symbolism, sex, desire, money, capitalism, and death are all intertwined.

2001 marked the launch of a substantial survey of Kentridge's work. A major touring retrospective between 2001 and 2003 began at the Hirshhorn Museum in Washington DC, then traveled to New York, Chicago, Houston, Los Angeles, and Cape Town.

Carolyn Gowdy

Date 2001

Born 1955

Nationality South African

Why It's Key Uses his innovative combination of charcoal drawing and animation to explore and understand the atrocities of apartheid in South Africa.

Key Artwork *New Coca-Cola*
Wang Guangyi

New Coca-Cola expresses one of the principal themes in the work of the contemporary Chinese artist Wang Guangyi (b.1956), the leader of the New Art Movement that emerged in China in the late 1980s. As part of the Political Pop Movement, Wang Guangyi was interested in the power of imagery to reduce a culture to agitprop and/or kitsch propaganda.

New Coca-Cola goes even further, juxtaposing recognizable Maoist propaganda with American corporate advertising to depict the meeting of East and West. In poster format, three idealized workers from Mao's China eagerly face the future with confident expressions on their faces, their huge masculine fists grasping a pen rather than a hammer or shovel, the pen serving as a mast for the Chinese flag. One of them clutches Mao's *Little Red Book*, at one time mandatory reading for all Chinese. The all-too-familiar Coca-Cola logo, that symbol of American capitalist imperialism, dominates the right-hand corner of the poster.

The irony of the juxtaposition of these icons of Eastern and Western culture is unmistakable. The color red provides an even brightness to both the imposed values of Mao and corporate America without distinction. *New Coca-Cola* serves as a kind of warning: that the socialist values of Maoist China corrupted once by the oppressive forces of the Cultural Revolution (1966–76) are again threatened by the influx of the elixir of Coca-Cola and capitalism.

Bryan Doubt

Date 2002

Country China

Medium Lithograph in an edition of 199, 34" x 30"

Why It's Key Captures Wang Guangyi's intent to dramatize the clash between symbols from China's Maoist past and those of its capitalist present.

opposite Wang Guangyi's *Great Criticism – (Green) New Coca-Cola* (2006) from the "New Coca Cola" series.

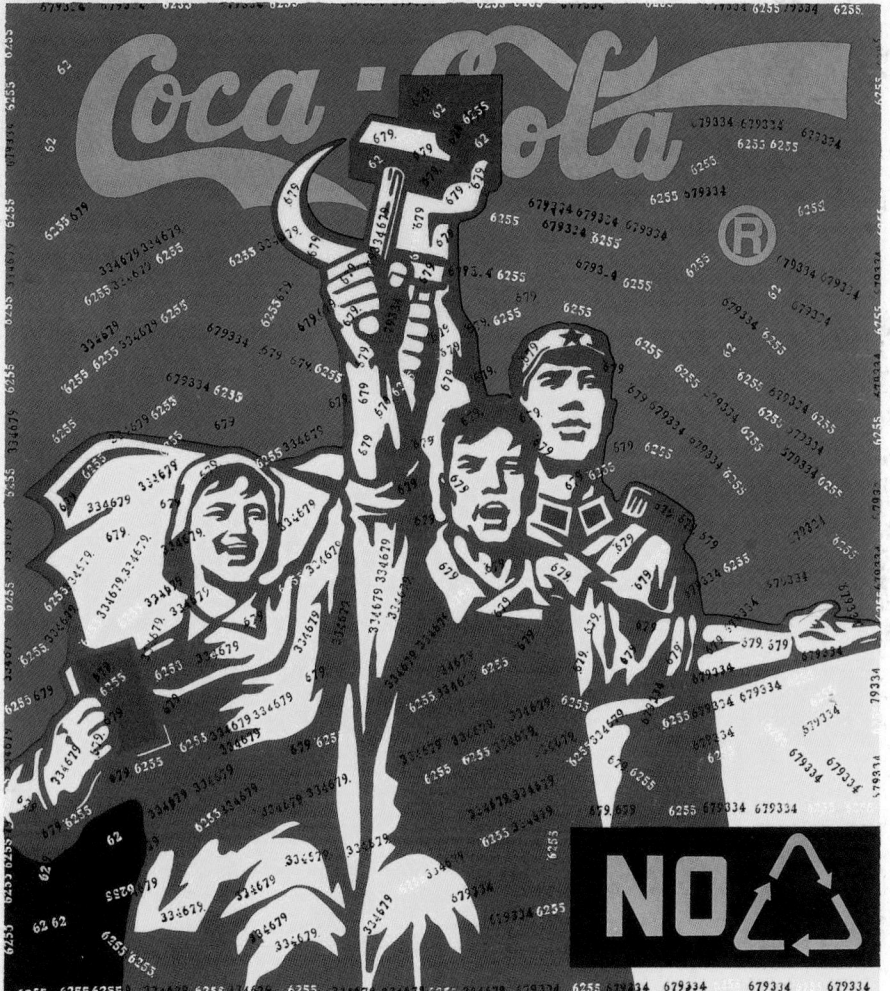

144/99

Key Artist **Mike Parr**
Performs *Close the Concentration Camps*

One of Australia's most important artists, Mike Parr works with very diverse media including performance, photography, sculpture, video, drawing, and printmaking. Parr is largely self-taught as an artist; he attended the National Art School in Sydney only very briefly in 1968. However, he started exhibiting extensively from 1970 onwards, the year in which he created Inhibodress, an alternative art space for performance and video art, with artist Peter Kennedy.

Born with a mutilated arm, Mike Parr is best-known for his confronting and radical performance pieces, which explore the limits of the self and the body, often using self-mutilation and endurance to question the notions of identity and creativity, as well as raise awareness on political issues. The performance piece *Close the Concentration Camps*,

presented in 2002 at the Monash University Museum of Art, was thus designed as a protest against Australia's unjust treatment of asylum seekers in detention centers. It showed the artist with his eyes, mouth, nose, ears, and cheeks sewn up, sitting in silence for five hours beneath an inscription on the gallery wall which read "Close the Concentration Camps" in large black lettering. In Parr's work, the body therefore becomes the very surface onto which his message is ascribed, his own punished body directly representing that of the Australian refugee for instance.

Mike Parr's performance work is part of a larger project centered on self-portrait, which also includes the video *100 Breaths*, as well as series of self-portrait drawings and prints.
Adelia Sabatini

Date 2002

Born 1945

Nationality Australian

First Exhibited 1970

Why It's Key Radical Body Art performance artist.

Key Artist **Anthony Gormley**
Creates his major work, *Asian Field*

Born in London in 1950, Anthony Gormley attended Trinity College Cambridge, studying history of art with anthropology and archaeology. After travelling in India for a number of years, he returned to the UK in order to study at the Central School of Art, Goldsmiths College, and the Slade School.

Over the past twenty-five years Gormley has become key in British figurative sculpture, exploring the relationship between figure and surroundings, and also the memory and transformation within the individual, by using his own body as both a subject and a tool. A major work in his increasingly high public profile was *Asian Field*, a 2003 installation of 180,000 small clay figurines (each between 8 and 26 centimeters tall) crafted by 350 Chinese villagers in five days from one hundred tons of red clay.

Blind Light (2007), an installation of life-size figures scattered around the roof tops of London, and *Another Place* (2005), with its collection of figures positioned at various depths within the Mersey Estuary, emerging and disappearing with the flow of the tide, explore these preoccupations to the full. In other pieces, the human form disappears as the focus of his work and the viewer is left to take over in exploring pieces that are all about the space around us, how that space is filled and the impact these experiences have on our physical memory.

Anthony Gormley's work has been exhibited extensively with solo shows throughout the UK, including exhibitions at the Whitechapel, Tate, and Hayward galleries, and the British Museum.
Emily Evans

Date 2003

Born 1950

Nationality British

Why It's Key Anthony Gormley is a high-profile British sculptor with prominent works set in public places.

opposite **Anthony Gormley** with his *Asian Field*.

Key Artist **John Currin**
Solo show tours Chicago, London, and New York

Born in Boulder, Colorado, John Currin studied at Carnegie Mellon University in Pittsburgh, where he graduated as a Bachelor of Fine Arts in 1984. He went on to obtain his Masters from Yale two years later.

When other artists were producing installations, photography, and video, Currin decided to stand out from the crowd by playing it straight and returning to figurative painting. His solo show at the Rosen Gallery in 1992 was filled with easel-sized portraits of aging Park Avenue doyennes, painted in a flat, linear style. Currin said, provocatively, that they were "paintings of old women at the end of their cycle of sexual potential – between the object of desire and the object of loathing." The art critic for the *Village Voice* said: "boycott this show," inevitably producing a stampede to the gallery.

Currin responded to accusations of sexism by painting girls with enormous breasts, as in *The Bra Shop* (1997). Many of his paintings show female nudes; he often distorts or exaggerates the natural form of the human body. However, men fare little better and his work also invites the accusation of homophobia.

Currin's solo show toured Chicago, London, and New York in 2003. He has had retrospective exhibitions at the Whitney Museum of American Art, New York and the Museum of Contemporary Art, Chicago. He is also represented in the permanent collections of the Hirshhorn Museum and Sculpture Garden in Washington DC and the Tate Gallery, London.
Nigel Cawthorne

Date 2003

Born 1962

Nationality American

First exhibited 1989

Why It's Key John Currin revived figurative painting by giving it a satirical edge.

Key Artwork *Cloud Gate*
Anish Kapoor

The finely polished surface of *Cloud Gate* (2003), located at the Millennium Park, Chicago, reflects the city's myriad skyscrapers as they merge with puffs of ethereal mist dotting the blue horizon. A daily stream of humanity passes underneath the belly, or "omphalos," as people move through the surrounding plaza. Gazing upward, the viewer is reflected in the mirrored surface as one of an infinite number of animated brushstrokes in a swirling cosmos. From a distance the enormous sculpture resembles a drop of liquid mercury.

Cloud Gate transforms both the space and the people around it. It challenges perception, stimulating imagination and inviting all participants to ascend into a magical realm. At night the lights of the city are reflected like a constellation of glowing stars in a mysterious universe. By day, the expressive qualities of

both children and adults merge with sounds, shapes, and atmosphere of the bustling city. Humanity becomes an integral part of the art.

Because of *Cloud Gate*'s legume-like shape, people of Chicago affectionately refer to it as "The Bean" as it is often compared to a simple jellybean. Kapoor was initially disturbed by this, but now accepts the public's playful spirit of collaboration on the title of the popular piece. "The Bean" clearly speaks to people in many different ways. Kapoor intended, from the beginning, for the sculpture be a gateway. In this he has admirably succeeded.
Carolyn Gowdy

Date 2003

Country USA

Why It's Key Kapoor's first public outdoor installation in the United States has become an icon of Chicago. It is so popular with the public that the mayor declared May 15, the day the sculpture was officially dedicated, to be "Cloud Gate Day."

opposite Kapoor's *Cloud Gate* in Chicago.

Key Event
Second Life is launched

F ew aspects of contemporary life are as strikingly like science fiction as *Second Life* (2003), the interactive 3-D rendered virtual world that fulfils the Internet's promise of a disembodied utopian future. Unlike other Internet locations, where visitors imagine meeting the people they encounter, chat up, and befriend, in *Second Life* the fantasy is the final and ultimate goal. The old, young, fat, ugly, or isolated bodies that users actually happen to occupy are irrelevant there, because they can select any appearance and temperament that they feel best represents them.

They can also shop for clothes, toys, products, and art. On an information site describing the game, there is the following advisory: "The Marketplace currently supports millions of U.S. dollars in monthly transactions. This commerce is handled with the in-world unit-of-trade, the Linden dollar, which can be converted to U.S. dollars at several thriving online Linden Dollar exchanges."

Part of the Marketplace is the Ars Virtua gallery, a virtual nonprofit arts organization. With a quote from Baudrillard professing the truth of the simulacrum on its homepage, the Ars Virtua gallery's alleged 3000-square-meter, two-story exhibition space successfully hosts shows, maintains artists in residence and commissions projects. It functions as a legitimate experimental forum for creative exploration, thereby demonstrating that virtual reality can be more than a game or a fantasy.

Ana Finel Honigman

Date 2003

Country The worldwide web, via the USA

Why It's Key A virtual world heralding, among other things, "virtual" art created by "virtual" artists.

Key Artist **Esam Pasha**
First post-Saddam Hussein mural in Iraq

B orn in Baghdad to a well-established Iraqi family (his grandfather was prime minister in the 1950s), Esam Pasha is a self-taught artist: he first trained in languages and administration, only becoming a full-time artist in 1998.

The shortage of art supplies caused by the embargo imposed on Iraq from 1990 onwards proved inspirational for Pasha. It led him to experiment with new materials, in particular hot wax he obtained from melting crayons. Using this technique, he produced the brightly-colored *Tears of Wax* series during the war. In 2000, he also executed a panorama for the United Nations Development Program in Baghdad, representing the history and civilization of Iraq.

Pasha's most famous work, however, is *Resilience*, a colorful 13-foot mural representing the atmosphere and history of Baghdad, which was painted over a portrait of Saddam at the entrance of the Ministry of Social Affairs building in 2003, shortly after the fall of Saddam Hussein's regime.

Although Esam Pasha refuses to call his art "political" and describes himself as an "expressionist abstract" painter, the very symbolic gesture this mural represented – the first in the post-Saddam era – soon caught the attention of several Western journalists. As a result, Pasha was offered several exhibitions in the United States, including the Ashes to Art exhibition in New York's Pomegranate Gallery in 2006. Since then he has stayed in the United States as an asylum applicant, working in Connecticut where he was offered a residence, and in New York.

Adelia Sabatini

Date 2003

Born 1976

Nationality Iraqi

First Exhibited 1998

Why It's Key Best-known modern Iraqi artist.

opposite Esam Pasha in his studio.

Key Artist **Mike Kelley**
Day Is Done exhibition at Gagosian Gallery, New York

Mike Kelley is the Big Daddy of art that reminds us of the wisdom in Margaret Atwood's brilliant observation that "children are only cute to adults. To each other, they are life-sized." The iconic Los Angeles "abjection" artist is responsible for making soiled stuffed animals do devious and naughty things to each other on gallery floors.

As a poet, a founding member of LA's Destroy All Monsters punk-rock conceptual noise band, and an art critic as well as a multimedia artist, Kelley's boundary-breaking brilliance is his anarchic attitude toward divisions between creative disciplines. Born in Detroit's urban wasteland, Kelley moved to California in 1978 to attend the California Institute of the Arts and grew to become one of the most influential figures in LA's art scene. He is currently a faculty member in the graduate department of fine art at Art Center College of Design in Pasadena, from where he has spawned a following of artists interested in bringing dirty, raw, and rotting insanity to the inside of galleries.

Day is Done, Kelly's most exhaustive and expansive exhibition, filled New York City's Gagosian Gallery in November 2005. The show included unsettling funhouse-like multimedia installations, automated furniture, and nightmarish ceremonies inspired by vintage high school yearbook documentations of pageants, sports matches, and theater productions. *Village Voice* art critic Jerry Saltz described the show the ultimate in "clusterfuck aesthetics."

Ana Finel Honigman

Date 2005

Born 1954

Nationality American

Why It's Key Influential artist who is unafraid to work across several media.

2000–

776

Key Artist **Barbara Kruger** Receives Lifetime Achievement Award at the Venice Biennale

Since the advent of postmodernist appropriation, many artists have taken their inspiration from mass media imagery and popular culture. But few have given back and influenced general cultural as profoundly as Barbara Kruger. Born in Newark, New Jersey, she attended Syracuse University in the early 1960s before studying at New York's Parsons School of Design, where she was a student of Diane Arbus and Marvin Israel, the graphic designer and art director for *Harper's Bazaar*.

Kruger left Parsons after a year to work as an entry-level designer at the ladies' lifestyle magazine *Mademoiselle*. She was quickly promoted to head designer, and later worked as a graphic designer, art director, and picture editor in the art departments at *House and Garden* and *Aperture*. But it was only when she employed her signature and arresting graphic aesthetic to politically charged conceptual art, that she gained widespread appreciation.

Kruger's work is immediately recognizable and often replicated by other artists and editorial directors. She uses a signature red-white-and-black palette with bold letters and striking juxtapositions between her borrowed images and text. Her images have become powerful slogans for the anti-consumerist, feminist, pro-choice, and anti-war messages she promotes in her art. When she was awarded the Golden Lion for Lifetime Achievement at the 51st Venice Biennale in 2005, it was unspoken but understood that her most significant achievement was using art for good, not just making good art.

Ana Finel Honigman

Date 2005

Born 1945

Nationality American

Why It's Key International recognition of important Conceptual artist.

Key Artist **Bansky**
Graffiti mural on Israeli-Palestinian barrier

Thought to hail from Bristol, England, Banksy is the ultimate international guerila artist. Working consistently under cover in disguise in the dead of night, his identity is unknown to all but a select few. And despite working almost entirely on the street and illegal graffiti being his genre, he is yet to be caught.

His work falls into various pockets of description. First, there are the visual jokes that run the gamut from a pair of scissors and a "cut here" line painted on the wall to a painted TV being thrown out of a painted window. Then there is the more politically charged work: a little girl carrying a bomb and "Thug For Life" scrawled next to a stenciled policeman.

Recent 2005 political work includes nine stenciled pictures painted along the Palestinian side of the 425-mile long wall that separates Israel from Palestine. One picture shows two gleeful children with bucket and spade standing beneath a hole in the wall that opens onto the view of a tropical paradise.

Simple messaging is also a big feature of Banksy's work, such as "Designated Graffiti Zone" on a fresh white wall and "Mind The Crap" painted along a step leading up to an art gallery. Then there is work which is purely irreverent – such as the Queen's guard urinating against the wall – and there are also common themes or icons that reappear throughout bodies of work, such as rats, monkeys, and policemen. Banksy's graffiti style is often based around simple one-color stencils, which was a street art style made popular in France in the 1980s. More recently Banksy has featured work within commercial shows in Los Angeles and London.

Emily Evans

Date 2005

Born c.1974

Nationality British

Why It's Key Bansky is a "guerilla" artist whose work owes more to political street art than contemporary graffiti styles.

Key Artwork *Extolling our Motherland, 2005*
Zhao Bo

In *Twilight of the Idols* Frederick Nietzsche declared that, "Nothing succeeds if prankishness has no part in it." Zhao Bo's paintings exemplify the truth of this statement. His brightly colored, mischievously comical depictions of Chinese city dwellers laughing, shopping, and chatting while surrounded by evidence of contemporary China's clash between modernity and tradition have given him a prominent place among young artists pioneering contemporary Chinese art.

Born in 1974 in Chongqing Sichuan province, Bo is a leader in a generation of young Chinese artists who are experiencing a surge of success as China becomes an increasingly important capitalist power. The incongruous but oddly harmonious mix of Western and Eastern brand images coupled with allusions to past revolutionary images and idealism in *Extolling our Motherland, 2005* is representative of "Cynical Realism," a movement which blends political messages with a jaunty Pop art aesthetic.

On the website www.chinesecontemporary.com, Bo proclaims: "In this chaotic world, people are becoming sly, untruthful, preposterous, full of malicious symbols that are morphing and becoming conceptualized in the course of society's progress... Yet this is also what makes this age and this type of environment most moving and surprising."

Ana Finel Honigman

Date 2005

Country China

Why It's Key The new dynamic running through contemporary Chinese society is reflected in the work of young Chinese artists like Zhao Bo.

Key Artwork *Another Place*
Anthony Gormley

The idea was to test time and tide, stillness and movement, and somehow engage with the daily life of the beach. This was no exercise in romantic escapism. The estuary of the Mersey at Crosby Beach, near Liverpool, England, can take up to five hundred ships a day and the horizon was often busy with large container ships. In the end, the piece of one hundred cast-iron, life-size figures of Gormley's (b.1950) own body, all looking out to sea, stretched two-and-a-half kilometers down the coast and one kilometer out to sea, with an average distance between the pieces of five hundred meters. They were all on a level and those closest to the shore were buried as far as their knees.

"The ones closest to the horizon will stand on the sand, those nearer the shore being progressively buried," said Gormley in his proposal for the artwork.

"At high water, the sculptures that are completely visible when the tide is out will be standing up to their necks in water." A whispering communication with forgotten levels of history, as well as a kind of acupuncture of the landscape, the work is also an acupuncture of people's dreamworld.

However, it's clear Gormley predominantly wants the work to be about the people. He seems to love the way it takes on a new life with every new person who visits, with their own memories and connotations. "The seaside is a good place to do this," he says. "Here, time is tested by tide, architecture by the elements, and the prevalence of sky seems to question the Earth's substance. This sculpture exposes to light and time the nakedness of a particular and peculiar body."

Bill Bingham

Date 2005

Country UK

Medium Cast-iron

Why It's Key Monumental work in a public space by one of Britain's leading figurative sculptors.

opposite Gormley's *Another Place* on Crosby Beach.

Key Artwork *Ruth Smoking* series
Julian Opie

For one of Britain's foremost figurative artists, whose simplified, slinky portraits are often streamlined into near stick-figures, Julian Opie is a surprisingly erudite and complex artist. His work engages us and is evidence of how quickly the mind registers signs and symbols. What he makes are visual haikus, which read as "cool" or "hot" in the most direct ways possible. The sparsity of his visual vocabulary speaks to our most basic desires, as his figures establish themselves as "beautiful," "elegant," "sexy," or even "rich" with shockingly few lines and colors.

Opie's *Ruth Smoking* series (2006) consisted of large-scale animated portraits of an attractive brunette smoking a cigarette and blinking. Ruth is an art collector living in Geneva who had purchased a few of Opie's works before commissioning him to do her portrait. Opie had been thinking of creating images of a woman smoking and invited Ruth to come to his studio and be photographed in various items of her own clothing while she smoked and they chatted. In the ensuing images, Ruth models her cigarettes while wearing different eyewear and posing in a bikini, a red strapless bra, a lace bra, or while braless in a sheer blue open shirt.

"Eighteenth-century Japanese wood cuts give this series its direction," Opie said in an interview. "My work is not a homage to past art or artists. It is something entirely of itself, but the references give it direction and make it rich. The references give the work its legs. The more references there are, the faster it runs."

Ana Finel Honigman

Date 2006

Country UK

Medium Screenprint

Why It's Key Trademark series of contemporary British figurative artist.

Key Event **Damien Hirst's US$100 million diamond skull is unveiled**

PLATINUU

When an investment group purchased Damien Hirst's latest high-profile creation for US$100 million, reportedly paid in cash, it came as no great surprise. On its unveiling in June 2007, the diamond-encrusted human skull *For the Love of God* was already being hailed as the most costly object in contemporary art.

The original skull, thought to belong to a thirty-five-year-old European who lived between 1720 and 1810, was bought by Hirst in a shop in Islington, north London. The skull was cast in platinum, and completely covered in 8,601 pavé-set diamonds weighing a total of 1,106.18 carats. The centrepiece of the creation, a pear-shaped pink diamond, was alone said to be worth over US$4 million. Estimates of the total cost of the artwork, which Hirst financed himself, ranged from between

US$20 million and US$30 million. The unveiling of the skull to an expectant gathering of media folk took place at the White Cube Gallery in London's smart St James district. It was part of an exhibition called Damien Hirst: Beyond Belief, which also occupied Jay Joplin's other White Cube space in the East End of the city.

Three by three, and with their viewing time limited to ten minutes each, the journalists were ushered into a totally dark "holy of holies," in which the glistening artifact stood alone, lit by four narrow beams of light. Some reported the dazzle was so great they could hardly see the piece itself, though no doubt the subsequent purchasers had a good look at what they were getting for their money.

Mike Evans

Date 2007

Country UK

Why It's Key Damien Hirst upped the stakes in the art market with what was reputed to be the most expensive piece of contemporary art.

Key Exhibition **From Russia: French and Russian Master Paintings 1870–1925 from Moscow and St Petersburg**

London's From Russia exhibition brings together French and Russian masterpieces from Russia's four principal museums. In so doing, this exhibition showcases the artistic interaction between Russia and France from 1870 to 1925 – an exchange that resulted in some of the world's most astounding art.

One of the exhibition's highlights are the findings of Russia's great impressionist and post-impressionist collectors Ivan Morozov and Sergei Shchukin. Shchukin's commission of such artworks as Matisse's *The Dance II* is at the forefront of the controversy over the Royal College of Art's London exhibition. Russia had called for the cancellation of the exhibition to protect ownership of its French-origin masterpieces. Only anti-seizure legislation passed in the UK at the last minute ensured that Russia would release the paintings.

The Dance II is raw in its simplicity – which initially caused outrage among bourgeois viewers of the 1910 Salon D'Automne in Paris – and yet represents a game of abstract pattern, a burning of primary colors, a primitivism that echoes post-colonial findings, such as African masks that were being discovered and displayed in Europe for the first time during that period. And yet standing in front of it, the playfulness of its subject at once sidesteps the politics that have brought this painting once again to the fore.

The Dance II was commissioned in 1909, and confiscated from its Russian owner after the Russian Revolution in 1917. It eventually resurfaced when the Soviet Union fell in 1991, only to land in the middle of a diplomatic dispute between Russia and the UK in 2008.

Jenny Doubt

Date 2008

Country UK

Why It's Key The exhibition demonstrates the ability of art to cause controversy – even a century after the commission of one of its most important paintings.

opposite Matisse's *The Dance II*.

INDEX OF ARTISTS

INDEX OF ARTWORKS

788

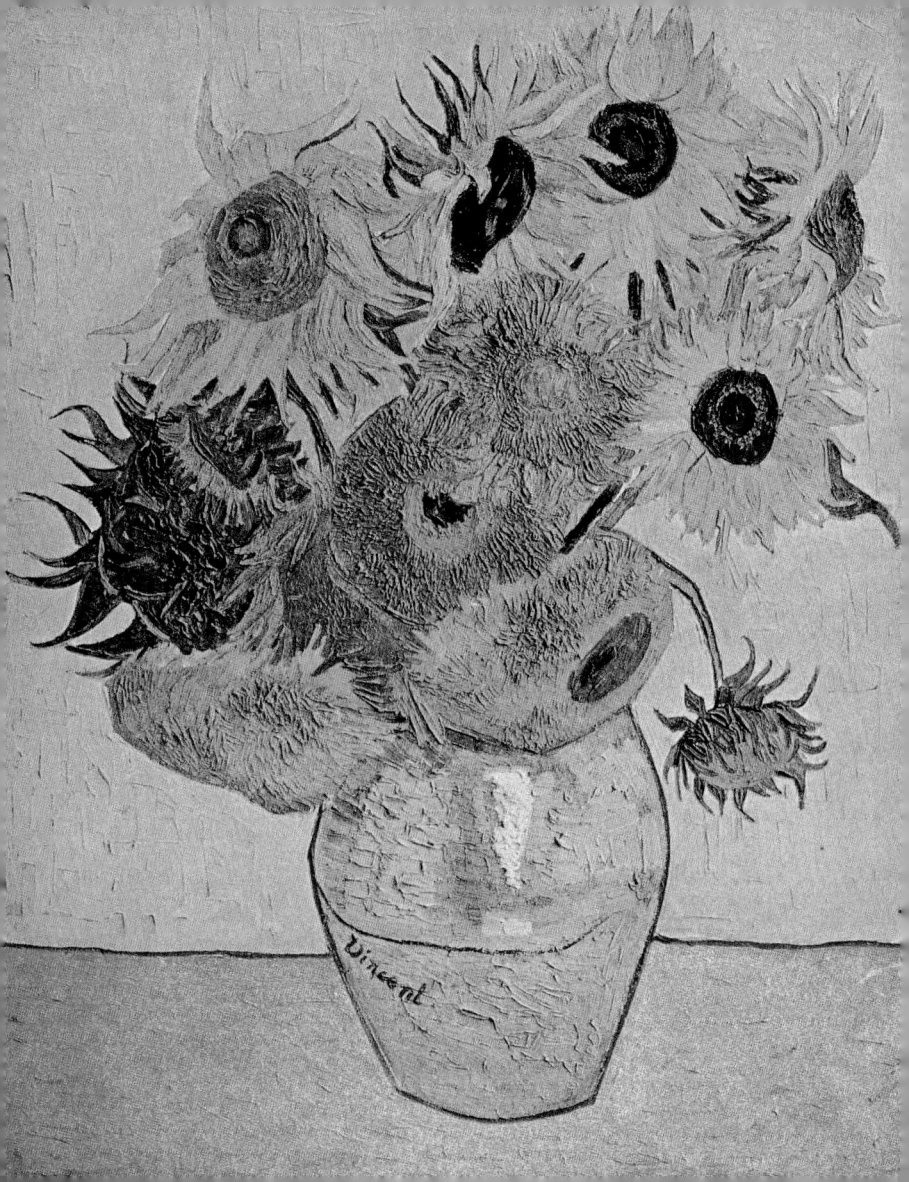

GENERAL INDEX

ACKNOWLEDGEMENTS

Index compiled by Pamela Ellis

Picture Research Sarah and Roland Smithies

With thanks to Ana Finel Honigman for her assistance with sourcing contributers.

800